A Dictionary of
WOMEN ARTISTS
OF AUSTRALIA

A Dictionary of
WOMEN ARTISTS
OF AUSTRALIA
Max Germaine

Foreword by
Anne von Bertouch

CRAFTSMAN HOUSE

Also by Max Germaine
ARTISTS & GALLERIES OF AUSTRALIA & NEW ZEALAND, 1979
ARTISTS & GALLERIES OF AUSTRALIA, 1984
ARTISTS & GALLERIES OF AUSTRALIA, 1990

First published by Craftsman House BVI Ltd, Tortola, BVI
Distributed in Australia by Craftsman House,
20 Barcoo Street,
Roseville East, NSW 2069, Australia

Distributed internationally through the following offices:

USA	UK	ASIA
STBS Ltd.	STBS Ltd.	STBS (Singapore) Pte Ltd
PO Box 786	PO Box 90	Kent Ridge PO Box 1180
Cooper Station	Reading	PO Box 1180
New York	Berkshire RG1 8JL	Singapore 9111
NY 10276	England	Republic of Singapore

ISBN 976 8097 13 2

Design concept *Nevill Drury*
Typesetter *Netan Pty Limited, Sydney*
Printer *The Book Printer, Melbourne*

Contents

List of Illustrations

Foreword

Max Germaine's new book *A Dictionary of Women Artists of Australia*, which follows his commendable series *Artists and Galleries of Australia*, may be seen by some as sexist. Why not *A Dictionary of Men Artists*?

In art as in other fields of opportunity Australian women have always been at a disadvantage.

The book is a welcome help in the direction of righting an imbalance, an imbalance that occurs everywhere, even in National and State parliaments where throughout the country, without exception, women members are in a disconcertingly small minority.

Many Australian women achieve great things: Elizabeth Evatt, Betty Churcher, Robyn Archer, Margaret Fink, all of these come to mind. But it is more difficult for women. Max Germaine's book, therefore, is all the more important.

To name a few artists would be partisan. The author has already named the many, emphasising the contribution of artists from remote areas, particularly Aborigines. He has documented the work of little-known as well as established women, placed them in archives in a work that will be a standard reference in libraries, schools, art galleries, universities, grants offices and government departments.

Congratulations to the author for his refreshing even-handedness, to Craftsman House for its adventurous spirit, and most of all to the women artists for having won their way into this milestone publication.

Anne von Bertouch June, 1991
von Bertouch Galleries
Newcastle

Preface

The need for a biographical reference book covering Australia's living professional women artists was first suggested to me back in 1977. However it seemed to be more appropriate to write about both men and women artists and galleries at that time, so now after three editions of *Artists and Galleries of Australia* the time has come to highlight the outstanding contribution by women to the visual arts in Australia during the 1980s, including some of those working in remote Aboriginal areas.

A book of this nature is only as good as the information provided by the artists and/or their agents and there must be some errors and/or omissions for which no responsibility can be accepted, except to say that any mistakes will be put right in the next edition.

My grateful thanks go to a number of special people in public and private galleries and other art institutions who have showered me with information and kept me on my toes. I shall always remember them.

Max Germaine June, 1991

Abbreviations

ABC	Australian Broadcasting Commission
ACAF	Australian Commercial Art Fair
ACCA	Australian Centre for Contemporary Art
ACP	Australian Centre for Photography
ACT	Australian Capital Territory
AFAS	Australian Flying Art School
AGNSW	Art Gallery of New South Wales
AGRA	Australian Guild of Realist Artists
AGSA	Art Gallery of South Australia
AGWA	Art Gallery of West Australia
AICA	International Association of Art Critics
AMA	Australian Medical Association
AMP	Australian Mutual Provident Society
ANG	Australian National Gallery
ANU	Australian National University
ANZ	Australian and New Zealand
AO	Officer of the Order of Australia
ARCA	Associate of Royal College of Arts
ARSASA	Associate of Royal South Australian Society of Arts
AWI	Australian Watercolour Institute
BA	Bachelor of Arts
BArch	Bachelor of Architecture
BEc	Bachelor of Economics
BFA	Bachelor of Fine Arts
BP	British Petroleum Co.
BSc	Bachelor of Science
CAC	Contemporary Art Centre
CAI	City Art Institute
CAE	College of Advanced Education
CAS	Contemporary Art Society
CCA	Crafts Council of Australia
CIT	Caulfield Institute of Technology
Co	Company
Cr	Councillor
CRTS	Commonwealth Rehabilitation Training Scheme
CSIRO	Commonwealth Scientific & Industrial Research Organisation
CTC	Central Technical College
DAAD	German Academic Exchange Service
DDIAE	Darling Downs Institute of Advanced Education
Dept	Department
Dip	Diploma
DipEd	Diploma of Education
DipFA	Diploma of Fine Arts
DipT	Diploma of Teaching
DLit	Doctor of Literature
ESTC	East Sydney Technical College
FILEF	Federation of Italian Migrant Workers
FRMIT	Fellow of the Royal Melbourne Institute of Technology

FRSA	Fellow of Royal Society of Arts
Govt	Government
HM	Her/His Majesty
Hon	Honorary/Honourable
Hons	Honours
HQ	Headquarters
HRH	Her/His Royal Highness
IAE	Institute of Advanced Education
IHE	Institute of Higher Education
IMA	Institute of Modern Art
MA	Master of Arts
MEd	Master of Education
MFA	Master of Fine Arts
MOCA	Museum of Contemporary Art
MPAC	Mornington Peninsular Arts Centre
MTC	Melbourne Technical College
NGV	National Gallery of Victoria
NIDA	National Institute of Dramatic Art
NSW	New South Wales
NT	Northern Territory
NTMAG	Northern Territory Museum and Art Gallery
NY	New York
NZ	New Zealand
OUP	Oxford University Press
PCA	Print Council of Australia
PhD	Doctor of Philosophy
PIT	Phillip Institute of Technology
PNG	Papua New Guinea
QAG	Queensland Art Gallery
QCA	Queensland College of Art
QIT	Queensland Institute of Technology
Qld	Queensland
QVMAG	Queen Victoria Museum & Art Gallery, Launceston, Tasmania
RA	Royal Academecian; Royal Academy
RAS	Royal Art Society
RASNSW	Royal Art Society of New South Wales
RBA	Royal Society of British Artists
RBS	Royal Society of British Sculptors
RCA	Royal College of Arts
RGAV	Regional Galleries Association of Victoria
RMIT	Royal Melbourne Institute of Technology
RNA	Brisbane Royal Show
RQAS	Royal Queensland Art Society
RSASA	Royal South Australian Society of Arts
SA	South Australia
SASA	South Australian School of Arts
SCOTA	Sydney College of the Arts
SGIO	State Government Insurance Office
SWAA	Society of Wildlife Artists of Australasia
TAAB	Tasmanian Arts Advisory Board
TAFE	Technical and Further Education
Tas	Tasmania/Tasmanian
TC	Technical College

TCAE	Tasmanian College of Advanced Education
TMAG	Tasmanian Museum & Art Gallery
TSA	Tasmanian School of Arts
TSIT	Tasmanian State Institute of Technology
TSTC	Trained Secondary Teachers Certificate
TTC	Technical Teachers Course
UK	United Kingdom
UNESCO	United Nations Educational, Scientific, and Cultural Organisation
UNICEF	United Nations (originally International Children's Emergency Fund)
USA	United States of America
USSR	Union of Soviet Socialist Republics
VAB	Visual Arts Board
VA/CB	Visual Arts & Craft Board
VAS	Victorian Artists' Society
VCA	Victorian College of the Arts
VCG	Victorian Ceramic Group
Vic	Victoria/Victorian
VIP	Very Important Person
VRC	Victoria Racing Club
VTU	Victorian Teachers' Union
WA	West/Western Australia
WAC	Workshop Arts Centre
WAIT	Western Australian Institute of Technology
WAR	Womens' Art Register
WAS	Wildlife Art Society
WC	Watercolour
WEA	Workers' Educational Association
WTC	Wangaratta Technical College
YMCA	Young Women's Christian Association

A

AARONS, Anita QLD
Born Sydney NSW 1912, arrived Australia from NZ in the early 1930s. Sculptor, and teacher.
Studies Sculpture at night school, East Sydney Technical College under Raynor Hoff, Moorfield, Frank Medworth and Lyndon Dadswell; Married Albert Date during this time; Completed the diploma course full-time; When still a student, invited to join the Contemporary Art Society; Founding member of the Society of Sculptors, NSW 1950; Lectured at East Sydney Technical College 1951; Moved to Melbourne and taught at the Kindergarten Training College and then joined the Victorian Sculptors' Society 1955; Helped organise and publicise a large sculpture exhibition open to all Melbourne sculptors at the VAS building; Taught at Caulfield Technical College until 1964; During this time, due to a back injury, took up jewellery, printmaking, drawing 1956–57; Left Australia for New York for First World Craft Congress; Remarried to architect, Meston Chambers and made Canada her home; Activities in Canada have included co-editor of *Architecture of Canada*; Consultant to the Art Gallery of Ontario and organisation of travelling exhibitions of environmental art; Assisted in persuading the Canadian Government to devote one per cent of its federal public works budget to art and the Arts Bank (an eight-million-dollar fund instituted to buy non-commissioned works available for rent by public buildings); Received Canada Council Grant for Printmaking 1964; Special consultant to the Art Gallery of Ontario 1969–72; In 1976 was appointed as Director of the government funded The Art Gallery at the Waterfront in Toronto, where she stayed for ten years. She returned to live in Queensland in 1986 where her experience and enthusiasm assisted the opening of a Queensland Regional Gallery at Noosa Heads. Presently working with watercolours and prints and writing articles for *Artlink*.
Awards 1983 awarded Canadian Conference of the Arts Diplome d'honneur. (Canada's most prestigious arts award in recognition of distinguished services to the arts in Canada).
Represented 'Playground Sculpture' in Phillip Park, Sydney; Institutional and private collections in Australia and overseas.
Bibliography Article, *Australian Sculpture Since 1945*, Lenton Parr, *Art in Australia*, May 1963; *The Development of Australian Sculpture* by Graeme Sturgeon, Thames & Hudson 1978; *Australian Sculpture* by Ken Scarlett: Nelson 1980. *Artlink* Vol.8/3 1988; *Artists & Galleries of Australia*, Max Germaine: Craftsman House 1990.

ABBOTT, Angela VIC
Born Melbourne Vic. Impressionist painter of genre subjects in oil, acrylic, watercolour.
Studies National Gallery School, Melbourne, drawing under Ian Armstrong 1960–61; followed by further courses in use of watercolour and acrylic; Lived and painted in Central Australia 1966–68; Studied oil painting with Shirley Bourne at Victorian Artists Society 1969–73; Member, Seven Painters Group; Council member of VAS; Committee member, Melb. Society of Women Painters and Sculptors. Studied and painted in London 1984–85. Teaches painting at the VAS.
Awards Alice Bale Art Travelling Scholarship to UK 1983.
Exhibitions First one-woman show at Rosalind Humphries Galleries (Russell Davis) 1974 and others at Russell Davis Gallery, Melbourne 1976, 1977 and Malvern Fine Arts Gallery 1981. VAS 1985–86–88.

ABERNETHY, Lorraine NSW
Born Armidale, NSW 1952. Painter and teacher.
Studies Hornsby TAFE 1982–84; Townsville TAFE 1985–86; former member of the

AFAS; taught at TAFE Colleges 1985–87; conducts private workshops; President of Murwillumbah Community Printmakers.

Exhibitions Solo shows at Community Centre, Cairns 1986; Art 19, Mackay 1987; Martin Gallery, Townsville 1987; Whole Works Gallery, Palm Cove 1988, 89; Capricorn Gallery, Melbourne 1989. Numerous group shows include Tweed River Regional Gallery 1990, 91.

Awards Mackay Art Society 1982; Hornsby TAFE 1984; Mackay Major 1986; Tweed Festival 1986; Townsville Art Society 1986; Ministry for the Arts 1987; Hinchinbrooke Shire 1987, 88; Murwillumbah Prize 1990.

Represented Municipal, institutional and private collections.

ACKLAND, Margaret NSW

Born Sydney NSW 1954. Painter of expressionist landscapes and portraitist.

Studies National Art School, Sydney 1973–76; Dip. Ed. Sydney Teachers College 1977; Recently returned to painting after some years absence due to family responsibilities; Overseas study 1985.

Exhibitions Bonython Gallery, Sydney 1976; Wagner Gallery 1985, 87, 89, 91; Delmar Gallery 1986, 89; numerous group shows.

Awards Sydney Morning Herald Travelling Art Scholarship 1983–84; Portia Geach Prize 1988.

Represented James Fairfax & Sons Collection; Holmes à Court Collection, corporate and private collections around Australia.

ACTON, Prue VIC

Born Australia 1943. Designer and painter.

Studies Diplomas in Art and Textile Design from RMIT; Swinburne TC, life drawing 1986–89 and with Clifton Pugh from 1988.

Exhibitions Dempsters Gallery, Melbourne 1989.

Awards Many awards over the years include Wool Supreme 1971; David Jones Supreme 1972; FIA Hall of Fame; Olympic Uniforms Design for Montreal 1976; Lake Placid 1980; Moscow 1980; Los Angeles 1984; Seoul 1988; and Expo uniforms for Osaka 1971 and Brisbane 1988; awarded OBE for services to the arts.

ADAMS, Julie Joy VIC

Born Victoria 1956. Painter and teacher.

Studies Dip. Art & Design, CIT 1974–76; Dip. Ed. State College, Hawthorn 1978; Dip. Visual Arts, Gippsland IAE 1986–87; currently lecturer in Painting and Drawing, Monash University College, Gippsland.

Exhibitions Solo show at Latrobe Valley Arts Centre 1988; Numerous group shows since 1976 and recently at 70 Arden St. Gallery 1989.

ADAMS, Mae VIC

Born Victoria 1952. Painter, printmaker, sculptor, teacher.

Studies Dip. Fine Art. Bendigo CAE 1970–74; Dip. Ed., Hawthorn State College 1976. Has taught art in various Secondary, Technical and Tertiary Institutions around Australia.

Exhibitions Solo show at Wangaratta Centre Gallery 1975; Many group shows since 1975 and more recently at 70 Arden St. 1985; AGWA 1985; ROAR Studios and Latrobe Valley Arts Centre 1987; Mildura Sculpture Triennial and Sale Regional Gallery 1988; ACCA, Melbourne and Centre for the Arts, Hobart 1989; Araluen Centre, NT 1989.

ADAMS, Margaret Ruth VIC

Born Kyabram Vic 1918. Painter, sculptor, teacher.

Studies Swinburne Technical College 1936–39; Hobart Teachers College 1940; Launceston Technical College 1941–42; Taught art at Charles St Practising School, Launceston

1941–46; Art Teacher, Methodist Ladies College Melbourne 1947; Melbourne Technical College sculpture and modelling with Lenton Parr and George Allen 1959–60; Worked as artist and model maker at the Institute of Applied Science, Melbourne 1959–61; Member of Victorian Artists Society and Victorian Sculptors Society in past years; In 1980 she gave 2.4 hectares of garden at Sherbrooke, Vic, to the Victoria Conservation Trust to be developed as a memorial to her late husband George Tindale and this project has occupied most of her time in recent years. Showed at Mellerish Gallery 1985.

Awards Shared prize for small sculpture Mildura 1961.

Represented National Gallery of Vic; Geelong Art Gallery.

Bibliography *The Development of Australian Sculpture* by Graeme Sturgeon: Thames and Hudson 1978; *Australian Sculptors* by Ken Scarlett: Nelson 1980.

ADAMSON, Karen (Roberts) VIC
Born Northern Ireland 1948, arrived Australia 1964; Painter and teacher.

Studies National Gallery School, Melbourne 1968–69; SA School of Art, Diploma of Painting 1973; State College of Vic, Diploma of Education 1974; Member CAS Vic; Employed as senior tutor/demonstrator in painting, fine art section, CAE Bendigo 1975; Study tour of France and UK 1976; Employed as lecturer in painting, fine art section, CAE Bendigo 1977, 1978.

Exhibitions One-woman show at CAS, Adelaide 1975; Tolarno Gallery, Melbourne 1978; Participated in Flinders University Art Exhibition; Adelaide University Art Exhibition; 'Young SA Painters', Sydenham Gallery, SA 1972; Bangladesh Appeal Exhibition 1972; Print exhibition, Sydenham Gallery, SA 1973; 'Six Young SA Artists', Habitat Gallery, SA 1973; CAS members exhibition 1973; Final year diploma students, SA School of Art 1973; Alice Springs Art Foundation Exhibition 1975; CAE Bendigo 1977.

ADLER, Edith Marion (Dr) NSW
Born Paris, arrived Sydney 1951. Expressionist oil paintings and etchings.

Studies Ashfield Technical College and as a private pupil 1961–62 with Maximilian Feuerring; Also etching with Elizabeth Rooney 1967; Completed a years course in Chinese brush painting 1981; Her art training plays its part in carrying on her practice as a Doctor of Psychiatry which involves pyschotherapy and the creative process of guided mental imagery.

Awards Goulburn Art Prize 1963.

ADSHEAD, Soosie VIC
Born Melbourne 1947. Graphic designer, sculptor.

Studies Cert. Art, Prahran CAE; Dip. Art Sculpture, PIT; currently studying architecture at RMIT.

Exhibitions RMIT Gallery 1980; Adelaide Uni. Gallery 1982; Paraphernalia Gallery, Melbourne 1977; Meat Market Centre 1984.

Bibliography *150 Women Artists*, VAB Melbourne 1987.

ADYNS, Claire VIC
Born Belgium. Graphic artist and painter of Flemish influenced landscapes.

Studies Royal Academy of Fine Arts, Antwerp; Worked for some time as a freelance commercial artist in Antwerp, Brussels and Melbourne.

Exhibitions One-woman show at Gallery Art Naive, Melbourne 1983, 85.

AGOTAI, Liz NSW
Born Budapest Hungary 1933. Impressionist painter of landscapes, birds and flowers in oil.

Studies East Sydney Technical College 1953–56; Julian Ashton School 1975–76.

Exhibitions Solo show at Realms Gallery, Sydney 1971; Participated at Ashfield Rotary 1980; Ryde Annual 1974, 1977; Mossman Art Show 1980–81. Has not been very active in

recent years, but some paintings have been shown in Bathurst and other country areas up to 1988.
Represented Private collections in Australia and overseas.

AITKEN, Gillian-Kaye NSW
Born Boyupbrook WA 1944. Maritime artist.
Studies No formal art training. Has worked aboard Jacques Cousteau's ship 'Alcyone'. Was official artist for the Kookaburra America Cup Syndicate.
Exhibitions Colonial Art Gallery, Perth and Ric's Art Gallery, Dalkeith WA; Many marine and yachting group shows.
Awards Claude Hotchin Bequest Prize, WA 1970.
Represented Institutional and private collections in UK. Europe, USA and Australia.

AKERS, Mary VIC
Born London UK 1932. Painter in oil and pencil.
Studies Diploma of Art, Salisbury School of Art, Rhodesia; BSc (Hon), London University; Interpretations officer at Sovereign Hill Historical Park, Ballarat Vic 1979.
Exhibitions One-woman shows at Oldbank Gallery, Buninyong Vic and National Theatre, Ballarat 1978.

ALADJEM, Cathy ACT
Born Brunei Borneo 1956, arrived Australia 1957. Painter.
Studies Part-time studies at School of Art, Hobart 1970–72; East Sydney Technical College, full-time 1974–76.
Exhibitions Gallery Huntly, ACT 1983; Participated in Canberra Women Artists 1982; Bitumen River Gallery, ACT 1982; Diamond Valley Award Vic 1982.

ALBISTON, Valerie VIC
Born Melbourne 1911. Semi-abstract painter oil, gouache, mixed media. Sister of artist Yvonne Cohen.
Studies RMIT National Gallery School, Melbourne and also under George Bell. Member of CAS Vic and Victorian Society of Artists.
Exhibitions One-woman at Riddell Galleries, Melbourne 1941; Georges 1945; John Martins, Adelaide 1956 and Barry Stern 1965. Many mixed shows.
Represented Private collections in UK, USA and Australia.

ALDER, Suzanne NSW
Born Sydney 1951, Naive painter.
Studies Degree in Behavioural Sciences from Macquarie Uni.
Exhibitions Lewers Bequest and Penrith Reg. Gallery; Naughton Studio of Naive Art 1987, 88.

ALDERSON, Alexandra Janet VIC
Born Melbourne 1934. Painter.
Studies Nat. Gallery School and RMIT; Worked in UK, Europe 1962; Japan 1969; Europe 1973– ; presently living and working in Australia and Spain.
Exhibitions Numerous solo shows in UK, Europe since 1962 including NSW House, London 1984, 88 and Australian Embassy, Paris 1989; local shows at Australian Galleries, Melb. and Bonython Gallery, Sydney 1969–72 and Christine Abrahams Gallery, Melb. 1989.

ALEXANDROVICS, Judith VIC
Born Melbourne 1944. Painter, printmaker, teacher.

Studies Graduated from RMIT in Fine Arts (painting) 1970; study tours to UK, Europe 1979 and USA 1981; Senior art teacher, Swinburne Technical School, Melbourne 1971–82.
Exhibitions Solo shows at Warehouse Galleries, Melbourne 1972, 1975–78; Holdsworth Galleries, Sydney 1979, 1981, 1984; Standfield Gallery, Melb. 1979–83, 88, 89; Qantas Gallery, London UK 1981; Hawthorn Gallery, Melbourne 1982; Distelfink 1985; Participated in many important group shows since 1974 and more recently Woman and Arts Festival, Sydney 1982 and Brisbane Annual Purchase Show 1982; Phillip Institute, Postgrad. Show 1985.
Represented National Gallery, ACT; Artbank; National Gallery of Vic; Mornington Regional Gallery; VAB Collection; Regional Galleries at Ballarat and Swan Hill; Private collections in UK, USA and Australia.

ALLAN, Micky VIC
Born Melbourne 1944. Painter, photographer and teacher.
Studies Bachelor of Fine Arts, Melbourne University 1965–67; Diploma of Painting, National Gallery School, Melbourne 1968; Taught at Preston Institute of Technology 1975–76; Artist-in-residence, Art Workshop, Sydney University 1979; Lecturer in Photography, South Australian Art School, Adelaide 1981–82; Travelled to France having been offered the Owen Tooth Cottage, Michael Karolyi Foundation, Vence 1983. Resident, Power Studio, Cité Internationale des Arts, Paris 1985.
Exhibitions Solo shows at Watters Gallery 1978, 1980, 1983, 1984, 1986, 1988, 1989; Ewing and Geo. Paton Gallery, University of Melbourne 1978; Art Gallery of SA 1979; Australian Centre for Photography 1980; Festival of Arts Rotunda, Adelaide 1982; Art Gallery of NSW 1982; 200 Gertrude St. Melb. 1985; Retro show 1975–87 at Monash Uni. Gallery, Vic 1987; City Gallery, Melb. 1988; ACCA, Melb. 1989. Participated in many important shows in Australia and overseas since 1975 including Australian Perspecta 1981, Art Gallery of NSW; *Fruit and Flowers* and *Three Years On*, Art Gallery of NSW 1981; Serpentine and ICI Galleries, London, UK 1982 and City of Elizabeth Show, SA 1982. Qld Uni. Art Museum 1983; Holdsworth Contemporary Galleries 1986; Centre for the Arts, Hobart 1986; New England Reg. Gallery 1986; ANG 1987; Max Watters Collection, Muswellbrook Gallery 1988; First Aust. Contemporary Art Fair, Melb. 1988; Vic. Govt. Paint a Tram Award 1989.
Represented ANG, AGNSW, AGSA, NGV, Artbank, regional galleries, institutional and private collections in UK, Europe and Australia.
Bibliography *LIP* 1978–79; *Australian Perspecta* 1981 Catalogue; *Art and Australia* Vol 20 No 1; *Australian Art Review*, Leon Parossien 1982; *Artists & Galleries of Australia*, Max Germaine: Craftsman House 1990.

ALLAN, Valerie Ann NSW
Born Adelaide 1935. Painter of Australiana in watercolour.
Studies Studied under Donald Begbie for two years.
Exhibitions Solo shows at Barry Stern Gallery, Sydney 1987; Included in Qantas sponsored shows in 1982, 83. Completed a corporate commission involving a series of Australian Fauna 1988. Solo show at Rebecca Hossack Gallery, Windmill St. London UK 1991.
Represented Private and corporate collections in Aust., UK, Europe, USA.
Bibliography *Artists & Galleries of Australia*, Max Germaine: Craftsman House 1990.

ALLEN, Carol (Rodwell) TAS
Born Hobart 1947. Painter and teacher.
Studies School of Art, Hobart then taught with Tas. Education Dept. Overseas study tour 1972; Studied Devonport Technical College on return 1973–75 and has taught art since then.
Exhibitions Solo shows at Devonport Gallery and Arts Centre 1978, 1982. Group shows

include Devonport Gallery 1974, 76 and Cockatoo Gallery, Launceston 1985.
Represented Devonport Regional Art Gallery.
Bibliography *Tasmanian Artists of the 20th Century*: Sue Backhouse, Pandani Press 1988.

ALLEN, Davida QLD
Born Charleville Qld 1951. Expressionist painter, mostly in oils.
Studies Stuartholme Convent, Qld under Betty Churcher 1965–69; Central Technical College, Brisbane 1970–72.
Exhibitions Solo shows at Ray Hughes Gallery, Brisbane 1973, 75, 78, 81, 85, 87; MOCA Survey, Brisbane 1987–88; Gallery Tamura, Tokyo 1988; Powell St. Melb. 1989; Group shows include: Townsville Reg. Gallery 1982; Fourth Biennale of Sydney, AGNSW 1982; Uni. of Tas. 1982; NGV 1983, 87; Fifth Biennale of Sydney 1984; MOMA, New York 1984; Vienna 1985; Aust. Perspecta 1985; Ray Hughes in Dallas USA 1986; QAG 1987; Japan 1987; MOCA, Brisbane 1987; Dublin, Ireland 1988; Galerie San Vidal, Venice 1990; QAG 1990.
Awards Archibald Prize 1986.
Represented ANG; NGV; AGWA; QAG; AGSA; University of Queensland Art Museum Brisbane College of Advanced Education Collection; Artbank; Atlantic Richfield Co. Brisbane National Art Gallery of New Zealand (Wellington); Gold Coast City Council.
Bibliography Catalogue, *Australian Perspecta* 1981; *Art and Australia* Vol 18 No 4, 'Six Brisbane Artists'; Catalogue of *Biennale of Sydney* 1982, Art Gallery of NSW; *Artists & Galleries of Australia*, Max Germaine: Craftsman House 1990.

ALLEN, Helen QLD
Born Sydney 1949. Contemporary landscape painter.
Studies National Art School, Sydney 1967–69.
Exhibitions Solo show at Eaglehawke Galleries, Sydney 1991; numerous group shows since 1988 include Noosa Regional Gallery 1989, 91; Australian Flying Art School Gallery 1989, 91.

ALLEN, Joan (Creese) TAS
Born Hobart, Tas. 1918. Painter; art and music teacher.
Studies Diploma of Fine Arts and Commercial Art, Hobart Technical College under Jack Carington Smith and Mildred Lovett 1935–38, 45; Phillip Smith Teachers College 1937–38. Art teacher with Tas. Education Dept. 1935–48. Member, Tas. Art Society.
Exhibitions Solo shows at Foscan Gallery, Hobart 1976, 79; Arts Centre Gallery 1981; Lady Franklin Gallery 1986. Recent group shows include: Saddlers Court Gallery 1987; Burnie Art Group 1976, 87; Long Gallery, Hobart 1987; Adult Education Centre 1988; Lady Franklin Gallery (three artist) 1988.

ALLEN, Joyce NSW
Born Brisbane Qld 1916. Painter and printmaker in oil, gouache and watercolour, maker of Carton Pierre figures.
Studies One year at Workshop Art Centre, Willoughby NSW; Otherwise self-taught; Currently teaching at Berrima District Art Society; Formerly teacher Workshop Art Centre, Willoughby; Hartfield; Frensham, Mittagong; Formerly member of Australian Watercolour Institute; Sydney Printmakers; Print Council of Australia; Printmakers Circle.
Exhibitions British International Print Biennale, Bradford England 1968, 1970; Print Council of Australia 1967, 1969, 1971; Solo, Willoughby Art Centre, 1973; Berrima District Art Society 1967; Survey exhibition 1947–86 at Scheding Berry Gallery, Sydney 1986; Blaxland Gallery, Sydney 1990.
Awards Rockdale Watercolour Prize 1955 and 1967; Warringah Watercolour Prize 1955; Berrima District Art Society Watercolour Prize 1968; Berrima Prize 1972; Taree Art

Exhibition 1962; Scone Arts and Crafts Prize 1977.
Represented Art Gallery of NSW; Queen Victoria Museum and Art Gallery Launceston; University of NSW; Private and institutional collections, Australia and abroad.

ALLEN, Norma NSW
Born Newcastle NSW. Figurative painter ceramic artist and portraitist in all media.
Studies Newcastle Technical College under Paul Beadle and John Passmore 1954–58; Taught part-time at Newcastle Technical College, Rankin Park Hospital, W.E.A., Society of Artists, Newcastle and for Community Programmes, University of Newcastle.
Exhibitions Solo shows at von Bertouch Galleries 1965, 67, 80, 85; North Adelaide Galleries 1966; Gallery 62 (Newcastle) 1981; Armstrong Gallery 1982; many group shows since 1960, more recently *Collectors Choice*, von Bertouch Galleries, 1988.
Awards Cessnock open 1959; Mt Gambier Watercolour 1961.
Commissions Memorial portrait of Headmaster Mr R.F. Hodge for Maitland Boys High School; Portraits of: Mr C. O'Neill, Mrs James Essington Lewis, Mrs Frances Clack, Mrs Gem Flood, Mrs Paul Cant; 'Horseshoe Beach, Newcastle' for Dr. P. Furey, 1978; Cover for 'Anthology', Hunter Valley Poets, 1973, Nimrod Press, University of Newcastle.
Represented Maitland City Art Gallery, University of Newcastle, Stanthorpe Gallery, Queensland, Booragul and Maitland High Schools and private collections in Australia and overseas.

ALLISON, Dael NSW
Born Sydney NSW 1952. Painter and sculptor; no formal art training.
Exhibitions Solo shows at Gallery 460, Gosford NSW 1982–83.
Represented Bronze sculpture acquired for Transfield Collection in 1980; Private collections in Australia and overseas.

ALLISON, Joy TAS
Born South Africa 1961, arrived Aust. 1978. Printmaker, painter, teacher.
Studies BA Fine Art, Uni. of Tas. Taught art at Murray High School, Queenstown 1983–85; Ogilvie High School, Hobart 1987–.
Exhibitions Uni. of Tas. 1982; MPAC 1986; Devonport Reg. Gallery 1987, 88; Hibiscus Gallery 1986; Upstairs Gallery, Hobart 1988. Has participated in fifty group shows since 1982 in NSW, Vic, Qld, WA and Tasmania.
Represented Regional, institutional and private collections around Australia and in South Africa.
Bibliography *PCA Directory* 1988.

AMOS, Irene QLD
Born Qld. Abstract painter in oil, acrylic, watercolour, collage and teacher.
Studies Part-time at Central Technical College Brisbane gaining Diploma Certificates; Attended summer schools at universities of Qld and New England; Life member and office bearer of Qld Art Gallery Society; Has lectured to many summer schools and workshops since 1970; Overseas study tours 1971–72, 1976, 1981, 1983; Graduated M. Creative Arts, Uni. of Wollongong 1986; and Ph.D. 1990. Artist-in-Residence Uni. of Wollongong 1988 and at QAG 1989.
Exhibitions Has held over thirty-five solo shows between 1961–76 and participated in over three hundred group shows since 1961 and in recent times at Noosa Reg. Gallery 1987; Qld. College of Art 1987. Prentice House Gallery, Grafton 1988; MPAC, Vic 1988; World Expo Convention Centre, Brisbane 1988; Downlands College, Toowoomba 1988; Penrith Reg. Gallery 1988; The Centre Gallery, Gold Coast 1988.
Awards Has won over forty-five first prizes since 1961 and recently at Toowoomba Caltex Open 1983, Modern 1986; Gold Coast Oil Purchase 1985; Ipswich City Council 1988;

Aberdare, Bicentennial 1988, OAM 1991.

Represented Art Gallery of Qld; Regional galleries at Toowoomba, Grafton, Armidale, Stanthorpe; Sam Pees Collection, Allegheny University, Pennsylvania USA; Artbank and many institutional and private collections in Australia and overseas.

Bibliography *Encyclopedia of Australian Art*, Alan McCulloch, Hutchinson 1984; *A Homage To Women Artists in Queensland, Past and Present*, The Centre Gallery 1988; *Artists & Galleries of Australia*, Max Germaine: Craftsman House 1990.

ANDERSON, Beryl VIC

Born Sydney NSW 1927. Figurative expressionist painter of landscapes and genre in oil and acrylic.

Studies East Sydney Technical College 1946–50; Overseas study tour 1954, including some time with advertising and commercial art consultants in London; Married industrial designer, Peter Anderson and returned to Sydney in 1959 to establish a graphics and industrial design practice; Returned to London in 1961 for three years and back to Sydney in 1964; Moved to Geelong Vic 1967, where her husband was lecturer in industrial design at Gordon Institute of Technology; Taught drawing and design at the institute from 1968–73 and undertook a Diploma of Fine Arts under the NEAT scheme in 1974 and began painting, receiving her Diploma in 1975; Member of Vic Artists Society.

Exhibitions First one-woman show at RAS Gallery, Melbourne 1976.

Awards Won Caltex Flinders Award and Artist of the Year Award at RAS 1976.

Represented Hawthorn State College Collection; Private collections in Australia and overseas.

ANDERSON, Lisa SA

Born Queensland 1958. Painter and teacher.

Studies BA, Uni. of Qld (incomplete); Dip.Teaching Kelvin Grove CAE, 1977–79; Grad.Dip. City Art Institute 1982; MA Visual Arts, City Art Institute 1984–86; Studied UK, Europe 1983–85. Currently lecturing in painting and drawing at SASA, Adelaide.

Exhibitions Ipswich Reg. Gallery 1981; Roslyn Oxley9 Gallery 1985; Ivan Dougherty Gallery 1986; Penrith Reg. Gallery 1988; Artspace, Sydney 1988; Numerous group shows include Mori Gallery 1985; Arthaus 1985; WAC, Willoughby 1986; Holdsworth Contemporary Galleries 1987; Blaxland Galleries 1987; Macquarie Galleries 1987; Uni. of Tas. 1988; Penrith Reg. Gallery and Nth. Sydney Contemp. 1988; Roz MacAllan Gallery, Brisbane 1989.

Awards VAB Travel 1983; Studio at Dublin School of Art 1984; Occupied Moya Dyring Studio, Cité Internationale des Arts, Paris 1985.

Exhibitions Grant 1986.

Represented Institutional and private collections in UK, Europe, Australia, PNG.

ANDERSON, Patricia Jane NSW

Born Canberra 1950. Painter, gemmologist, teacher.

Studies Riverina CAE, Dip.Teaching 1969; Dip.Art Ed., ESTC 1973; Taught art at Fort St. High 1976–78. Education officer AGNSW 1978–84; Lectured part-time City Art Institute 1984–85; Fellow, Gemmological Institute of Aust. 1985; Established the Contemporary Jewellery Gallery, Woollahra, NSW 1985.

Exhibitions 'Imagination and Metaphor' Griffith Reg. Gallery 1988.

Publications *Contemporary Jewellery, The Australian Experience 1977–87*, Millenium 1988.

ANDERSON, Sue VIC

Born Melb. 1962. Printmaker, teacher.

Studies B.Ed. Art and Craft, Melb. CAE 1980–83. UK, Europe, Japan 1985–86; taught art part-time 1984–91.

Exhibitions Rhumbarallas Gallery 1984, 86; The Womens Gallery 1990. Numerous group shows include Gryphon Gallery 1986; Linden Gallery 1989; Robb St. Gallery, Bairnsdale 1989; State Library 1989; Flinders Lane Gallery 1991; 'Churchie' Exhibition, Brisbane 1991.
Represented ANG, institutional and private collections.
Bibliography *PCA Directory* 1988.

ANDREWARTHA, Jai VIC
Born London UK. Printmaker.
Studies Smithsonian Institute, Washington DC, USA 1981.
Exhibitions PCA Gallery.
Bibliography *PCA Directory* 1988.

ANDREWS, Lynne TAS
Born Hobart, Tas. 1942. Painter and teacher.
Studies Hobart TC and University of Tasmania, TDA and FAD (Painting). Overseas study UK, Europe, Middle East 1968–69; taught art at high schools in Tas. and UK 1962–64; 1965, 68, 70; BA Vis. from TCAE Hobart 1977–80. Currently conducts Studio 1 School of Drawing & Painting at Mt Rumney.
Exhibitions Solo shows at Mt Rumney Studio 1984, 88; Freeman Gallery, Hobart 1988; Clarence Council Chambers 1990; numerous group shows since 1962.
Awards International Year of Child Grant 1977–80; Tas. Bicenten. WC Award, Burnie 1988; Bolands Award 1990.
Represented Institutional and private collections in UK, Europe and Australia.

ANDREWS, Prue NSW
Born Sydney 1956. Painter, Ceramic sculptor, mostly self-taught.
Exhibitions Geo. Styles Gallery 1988; The Saints Gallery 1989; Noella Byrne Gallery 1991.
Awards 1st Prize Ceramics, Sydney RA Show 1987, and Craft Australia Award 1988.
Represented Institutional and private collections in Europe, USA, Hong Kong, Australia.

ANNESLEY, Alison QLD
Born China 1931. Watercolourist.
Studies Tylen School of Art, Temple University USA.
Exhibitions Spring Hill Gallery and Boston Gallery Qld (one-woman).
Awards King of Prussia Cultural Centre; Phila USA; Townsville Art Society; North Queensland Calendar and Lettercards 1980, 1981.

ANSON, Nora-Anne QLD
Born Louvain Belgium 1947, arrived Australia 1974. Printmaker, painter, teacher.
Studies Academie de la Grande Chaumière and Nationale Superieure Des Beaux Arts et Des Arts Decoratifs, Paris and later in 1973 printmaking and colour printing at the Paul Franck Graphic Workshop; Taught printmaking at Waverley-Woollahra Art Centre and Dept of Education WEA; Presently lecturer, printmaking Qld C of A.
Exhibitions One-man shows at Foundation Belge, Paris 1970; International House of The Cite Universitaire, Paris 1972 and Macquarie Galleries, Sydney 1975, 78; Victor Mace Gallery 1976, 78; Qld C of A 1981; Art Centre, Brisbane 1985; Group at von Bertouch Galleries, Newcastle 1975 and Macquarie Galleries, Sydney 1976–77; Qld Arts Council 1979; Tas. S of A 1984; Atelier Paul Franck, Belgium 1984; Qld C of A 1987; QAG 1987.
Awards Texas Drawing 1980; Stanthorpe Print 1980.
Represented Frans Masereel, Belgian State Centre of Graphic Arts; National Museum of Ibiza, Ibizagraphic Biennale; Plantin and Moretus Cabinet des Estampes, Antwerp

Belgium; Bibliotheque National de Paris; City Hall, Brisbane; Gold Coast Collection.
Bibliography *A Homage to Women Artists in Queensland, Past and Present*: The Centre Gallery 1988; *Artists & Galleries of Australia*, Max Germaine: Craftsman House 1990.

ANTILL, Judy VIC
Born Brisbane 1952. Painter, no formal art training, studied overseas for some years.
Exhibitions City of Caulfield Gallery, Melb. 1985; Gray St. Gallery, Hamilton Vic. 1988; Little Gallery, Melb. 1989.
Awards Campagnet Art Award, Canberra.
Represented Institutional and private collections in UK, Europe, Australia.

ANTMANN, Giselle NSW
Born Munich West Germany 1946, arrived Sydney 1955. Painter in mixed media, sculptor, ceramicist, freelance writer and teacher.
Studies Graduated BA (Hons) English Literature, Sydney University and awarded Commonwealth Postgraduate Scholarship 1969; Dip Ed 1975; Teaching art at Sydney High Schools 1977–83; ESTC (part-time) 1987–89; Freelance writer 1982–89.
Exhibitions Contemporary Art Society 1970; London exhibition reviewed by *London Arts Journal* and International *Herald Tribune* 1972; Solo exhibition, 'Dreamscapes', Rex Irwin Gallery, Sydney 1978 and 1981; Participated Mori Gallery 1984; Aust. Perspecta, AGNSW 1985; Holdsworth Contemporary Galleries 1986, 88; Castlemaine Arts Festival, Vic. 1988.
Represented Visual Arts Board Collection; Art Gallery of NSW; Australian National Gallery; Private collections in Australia and overseas.

ANTON, Joy VIC
Born Sydney. Painter of modern landscapes.
Studies Completed three year course at East Sydney Technical College before starting a career in advertising field and working with Hansen-Rubensohn, Sydney, and Young & Rubicam, London, UK. Member, Melbourne Society of Women Painters and Sculptors.
Exhibitions Solo show at Mornington Gallery 1982; Greenhill Galleries, Adelaide 1990; Gallery 545, Edgecliffe NSW 1991; The Gallery Wall, Sydney 1991; Numerous group shows.
Represented Artbank, institutional and private collections.

APELT, Rachel QLD
Born Qld 1964. Painter, designer, illustrator.
Studies Dip. Art Qld C of A 1982–84.
Exhibitions Solo shows at MOCA 1990; McWhirters Artspace, 1991; has worked on numerous art commissions and projects since 1985.

APPLETON, Jean NSW
Born Sydney NSW 1911. Painter, printmaker and teacher. Wife of artist Tom Green.
Studies Diploma of Drawing and Illustration from East Sydney Technical College and later at the Westminster School of Art, London 1936–39, Taught at Julian Ashton School 1946–49; the National Art School, East Sydney 1948–56; Workshop Art Centre 1960–68; and Guild Teachers College (part-time); from 1945 to 1956 was a lecturer at the schools attached to the Art Gallery of NSW; Travelled in UK and Europe 1938–39, 1950–51, 1968–72; Since then painting and printmaking at Moss Vale NSW; Member, Society of Artists 1943, Contemporary Group 1943; Sydney Printmakers and Print Council of Australia.
Exhibitions One-woman shows at Macquarie Galleries 1940, 1949, 1960, 1967, 1977 and Murray Crescent Galleries, Canberra 1978 and 1980; Greenhill Galleries, Adelaide 1981, 1988, 89; Perth 1982, 89; The Painters Gallery, Sydney 1983, 1985, 1986, 1988; Jim

Alexander Gallery, Melbourne 1984; Many group shows throughout NSW and Qld including a two-person show with her husband Tom Green. Showed with Sydney Printmakers at Blaxland Gallery, Sydney 1990.

Awards Rockdale 1958; D'Arcy Morris Memorial 1960; Bathurst 1961; Portia Geach 1965; Orange 1977; Manly 1977.

Represented AGNSW; AGSA; QAG; AGWA; NGV; New Zealand Art Gallery (Wellington NZ); Auckland City Art Gallery; Australian Regional Galleries of Bendigo, Mitchell (Bathurst), Newcastle, Rockhampton; City Galleries of Orange and Wagga Wagga; and a number of University and Teachers College collections.

Bibliography *Australian Women Artists, 1840–1940* by Janine Burke: Greenhouse 1980; *Artists & Galleries of Australia*, Max Germaine: Craftsman House 1990.

ARCHER, Hilary (Wrigley) VIC
Born Calcutta India 1934. Sculptor and teacher.

Studies East Sydney Technical College 1950–55; Taught at Canberra Technical College 1962–72; Travelled UK, Europe, Far East 1965; Teacher at School of Environmental Design, Canberra College of Advanced Education 1976.

Exhibitions Aust. Sculpture Gallery ACT 1970; Bonython Gallery 1972; Bitumen River Gallery ACT 1985.

Represented Australian National University, Canberra; Philip Morris Collection; Queen Victoria Museum and Art Gallery, Tas.

Bibliography *Australian Sculptors* by Ken Scarlett: Nelson 1980.

ARCHER, Suzanne NSW
Born Guildford UK 1945, arriving Australia 1965. Contemporary painter and ceramic artist, specialising in oil and acrylic, teacher.

Studies Specialist art course at Sutton East Secondary Modern School 1960–62; Sutton School of Art, UK 1962–64; Returned to UK; Study tour 1969–70; Since 1974 has taught at technical colleges and School of Art, Alexander Mackie CAE (part-time).

Exhibitions One-woman at Clune Gallery, Sydney 1969; Pinkney Gallery, London 1970; Watters Gallery, Sydney 1974, 1976, 1978; Abraxas Gallery, ACT 1975, 1977; Raffin Gallery, Orange 1976, 1977; Watters Gallery 1978–79; Powell Street Gallery 1980, 1983; David Reid Gallery, Sydney 1980–81; Rex Irwin Gallery 1983, 1986, 1988; Michael Milburn Galleries, Bris. 1987; Has participated in many important group shows over the years and more recently in 'Australian Art of the Last Ten Years' ANU Canberra 1982; 'Collaborative Collages' with David Fairbairn, Robin Oxley 1882; 'From the Inside Out', Womens Festival, Craft Gallery, Sydney 1982; 'Australian Women Artists', Blaxland Gallery 1982; The Opera House Anniversary Show, Art Gallery of NSW 1982; Australian Perspecta 1981; Melville Hall, Canberra 1982; Roslyn Oxley9 Gallery 1982; Australian Perspecta 1985; Holdsworth Contemporary Galleries 1986.

Awards Shoalhaven Drawing Prize 1966; Woollahra Painting Prize 1967; Royal Easter Show Painting Prize (Second) 1968; Crafts Board Grant 1974; Warringah Art Prize (painting) 1977; Campbelltown Art Prize (painting) 1977; Travel Grant Visual Arts Board for travel in USA, UK and Europe; Resident VAB Studio, New York and Power Studio, Cité Internationale Paris 1978; Cairns, Wollongong and Alice Purchase Prizes 1980; Hunters Hill, Gold Coast, Bathurst and Alice Prizes 1981; Camden Purchase 1982; Georges and Campbelltown Prizes 1982; Faber Castell Award 1985; Pring Prize 1988; Numerous district prizes 1983–89 and the SMH Heritage Prize 1989.

Represented Art Gallery of NSW; National Gallery of Vic; Regional Galleries at Bathurst, Mildura, Gold Coast, Dubbo, Wollongong; Melbourne State College; Municipal Collection at Warringah, Campbelltown, Gosford, Cairns, Hunters Hill and Camden; Artbank; Philip Morris; Macquarie University; Alexander Mackie College; Family Law Court, Canberra; Alice Springs Art Foundation; The Federal Courts in Melbourne; Private collections in UK,

USA, Holland and Australia.
Bibliography Catalogue of Australian Perspecta 1981; Art Gallery of NSW; *Australian Contemporary Drawing*, Arthur McIntyre, Boolarong 1988; *Artists & Galleries of Australia*, Max Germaine: Craftsman House 1990.

ARENT, Marion NSW
Born Aust. 1953. Painter
Studies Nat. Art Schools in Sydney and Newcastle, Dip. Painting 1977.
Exhibitions Solo at Barrenjoey Galleries 1983, 84; Orient Hotel, The Rocks 1987; Casey Galleries 1988.
Commissions Moby Dick Club, Whale Beach 1985; S.S. Fairstar 1989.

ARMFIELD, Joan VIC
Born Brisbane 1928. Potter.
Studies Watsonia TC and later with Peter Laycock.
Exhibitions Victorian Ceramic Group; Arts and Crafts Society of Vic.; NGV; Australian Galleries, Melb. 1975; Craft Revival, Sydney 1981; Numerous studio shows with husband, painter David Armfield, with many pots decorated by him.
Represented ANG; Shepparton Art Gallery; Institutional and private collections in UK, Europe, Australia.

ARMSTRONG, Ardell (Snow) TAS
Born Hobart 1918. Printmaker, graphic artist, teacher.
Studies Hobart Technical College, TCAE 1930–36, 1977–80. Commercial artist with *The Mercury*, Hobart 1938–40; taught at Fahan School, Hobart 1938–41. Adult Education with Helen Holzner 1972. Overseas study tours 1938, 72, 77.
Exhibitions Solo shows at Art Poster Gallery 1982, 83; Coughton Galleries 1984; Gallery Z, Zeehan 1984; Rialto Gallery, Burnie 1984; Freeman Gallery 1986; Sullivans Cove 1986; Sadlers Court Gallery 1988. Group shows include Art Centre 1981; Strickland Gallery 1984, 85; Gallery Z 1983, 84.
Awards Circular Head Printmaking 1987; Commissioned to produce 156 prints for the new Hobart Sheraton Hotel 1987.
Represented Artbank, Parliament House, Canberra; Australian Embassy, Moscow, USSR.
Bibliography *Tasmanian Artists of the 20th Century*: Sue Backhouse, Hobart 1988.

ARMSTRONG, Betty TAS
Born Opotiki, NZ 1912. Painter, teacher, graphic artist.
Studies Hobart Tech. College under Lucien Dechaineax and Mildred Lovett 1929–32, 35–36; Worked for the Hobart *Mercury* and at various locations in Aust. and New Guinea until 1948. Taught art 1949–62.
Exhibitions Solo shows at Adult Education Library, Perth WA 1942; Lindisfarne Library 1971, 77, 82, 86; Derwent Reg. Library 1980, 81. Regular exhibition over the years with the Art Society of Tas. and the CAS.
Bibliography *Tasmanian Artists of the 20th Century*, Sue Backhouse 1988.

ARMSTRONG, Coralie SA
Born Warren NSW 1945. Traditional and semi-abstract painter in oil, acrylic, watercolour.
Studies B.Sc. Uni. of Sydney; Ph.D. Microbiology, Uni. of NSW 1976; Evening art classes at RAS of NSW 1966–67, 1980 under Hanson and Bates; Landscape classes with C.K. Townshend 1967; Evening classes Chelsea-Westminster Institute UK 1968–69; Landscape classes with F. Bates 1970–80; Evening classes East Sydney Technical College 1971–76; Tutorials at RSASA 1981–83; Associate of RAS of NSW and RSASA; Member, AWI; moved to Adelaide 1981 from Sydney.

Exhibitions Holdsworth Galleries 1976; Lithgow Valley Pottery 1977; Lombard Gallery, Adelaide 1985 and with the AWI.
Awards Condoblin NSW, 1972–73, 1975; Wellington NSW open 1976.
Represented Alice Springs Collections and private collections in UK and Australia.

ARRIGHI, Luciana UK
Born Rio de Janeiro 1940 of Italian father and Australian mother. Painter, stage and film designer.
Studies Childhood and education in Australia; Art, East Sydney Technical College and then worked as assistant to Desmond Digby at the Elizabethan Theatre Trust, before moving to Europe for further study; Now divides her time between Europe and Australia; Her design credits include: Television — *Isadora*, *Rousseau* and *Rossetti*, Ken Russell, director, BBC-TV; Feature films — *Women in Love*, Ken Russell, director; *Sunday Bloody Sunday*, John Schlesinger, director; *The Night the Prowler*, Jim Sharman, director; *Watership Down*, (background and myth sequences) from the Richard Adams novel; *My Brilliant Career*, Gillian Armstrong, director; Theatre — *I and Albert* (musical), John Schlesinger, director; Opera — *Cataline*, Scottish Opera; *Gilbert and Sullivan* (various), D'Oyly Carte.

ARRIGHI, Donna Niké (Borghese) HONG KONG
Born Nice, France. Painter and teacher.
Studies Under Justin O'Brien and Jeffrey Smart; Taught art in Hong Kong 1975–80; Sister of Luciana.
Exhibitions Bonython Gallery, Sydney 1975; Eddie Glastra Gallery, Sydney 1987, 89, 90.

ARROWSMITH, Veda QLD
Born in Sydney NSW 1922. Contemporary painter in acrylic, oil, collage and printmaker.
Studies Brisbane Technical College; Qld University and University of New England summer schools; Started painting when she lived in Sabah, Borneo for over three years 1945–48; Travelled and painted widely in SW Pacific before returning to Australia; Further study tours to Central Australia 1967, USA 1968, Timor and New Guinea 1969.
Exhibitions One-woman shows at Barry Stern Galleries, Sydney 1964; Chevron Hotel, Gold Coast 1964; Kennigo Street Gallery, Brisbane 1966, 1967; Qantas Gallery, Fifth Avenue New York City and San Francisco USA 1968; Sydney University in conjunction with the Twenty-second International Conference on Co-ordination Chemistry 1969; Moreton Galleries, Brisbane 1970; Verlie Just Town Gallery, Brisbane 1980, 1981, 1984; Martin Gallery, Townsville 1983; Schubert Gallery Gold Coast 1986; The Gallery Image Armidale NSW 1986; Barry Stern Gallery 1987; Group exhibition University of Qld in conjunction with ANZAAS and Australian Biochemical Society 1971; Leveson Street Gallery, Melbourne 1972, 1976; Lidums Art Gallery, Adelaide 1972; Norwood Galleries, Adelaide 1975; Group exhibition, Sydney Opera House 1975; Group print exhibition, Sydney 1975; Anvil Gallery, Albury/Wodonga 1976; Fantasia Galleries, Canberra 1976; Trinity Gallery, Cairns 1977; Martin Gallery, Townsville 1977; The Gallery Uptop, Rockhampton 1977; Silk Screen Prints, Qld Art Gallery 1982; Group Print Show, Raya Gallery, Singapore 1982; Recent group shows at The Centre Gallery, Gold Coast, World Expo 88 Convention Centre 1988.
Awards The Scone Art Prize, open abstract 1969; The Shell Chemical Art Prize, Qld 1969; The Royal National Agricultural and Industrial Association of Qld Contemporary Art Award 1969; Caltex Art Award, La Trobe Valley Vic 1970; The Townsville Pacific Festival Art Prize 1970; The Scone Art Prize, open abstract 1970; The Westfield Art Prize, Brisbane 1971; The Jean Trundle Art Prize 1975; Labrador Apex 1976; Gold Coast City Art Prize print purchased 1976, 1979, 1980; Marymount Prize 1893; Beenleigh Rotary 1984; SGIO 1984; St Albans 1984; Trinity Prize 1984; St Kevins 1986.
Represented QAG; Dunedin Public Gallery NZ; St Francis Theological College, Brisbane;

St John's College, University of Qld; Darnell Collection, University of Qld; Townsville City Gallery; Gold Coast Civic Collection, print; James Cook University, Townsville, print; Margaret Carnegie Collection; Commonwealth Club Collection; In private collections in Australia, UK, USA and Canada; Qld Art Gallery.

Bibliography *Directory of Australian Printmakers*, 1988; *Contemporary Australian Printmakers*, Franz Kempf 1976; *A Homage to Women Artists in Queensland Past and Present*: The Centre Gallery 1988.

ARWELL, Maeve NSW
Born Melbourne Vic 1932. Painter, teacher, film maker, innovator.

Studies Attended National Gallery of Vic Art School 1949–51; Was a teacher, mainly with National Art School, Sydney for a number of years; graduated BA (Hons) in Philosophy from University of Sydney 1980; Travelled Italy and Sardinia 1981, and Europe, USA, Iceland 1982.

Exhibitions Barry Stern Galleries, Sydney 1964; 'Woman of Stamina', Watters Gallery, Sydney 1970; 'Butterflies and Other Paintings', Watters Gallery, Sydney 1974; 'Turn of the Square', link show, Art Gallery of SA 1976; 'Big Diamond', Watters Gallery, Sydney 1976; Participated in 'Ocker Funk', Watters Gallery, Sydney; Inaugural exhibition, Gallery Society, Devonport Tas; 'Woman in Art', WA Institute of Technology 1975; 'Ocker Funk' Exhibition touring Vic Regional Galleries 1976, 1977; 'Ocker Funk', Realities, Melbourne 1976; George Crouch Invitation Exhibition, Ballarat Art Gallery, Vic and 'Watters at Pinacotheca', Pincotheca Melbourne 1977; Further solo shows at Watters Gallery, Sydney 1981–82, 83, 85, 87, 89; Participated Differenca Gallery, Lisbon, Living Art Museum, Rejkjavik, Modern Art Galerie, Vienna, Glassel School, Rice University, Houston USA 1982; Modern Art Galerie Vienna 1982; First Aust. Contemporary Art Fair, Melb. 1988; First Draft Gallery, Sydney 1988; Max Watters Collection, Muswellbrook Gallery 1988; MCA, Brisbane 1988.

Represented ANG, AGNSW, institutional and private collections in UK, Europe, Australia.

ASH, Martha VIC
Born Poland, arrived Australia 1949. Painter in all media, sculptor, silversmith and producer of enamels and glass mosaics.

Studies Since 1956 studied art at RMIT; sculpture at Caulfield Institute of Technology; Silver-smithing and enamelling at Collingwood Technical College and Melbourne University, and glass mosaics in Venice; President of the Bezalel Fellowship of Arts, Australia and Executive Governor of the Academy of Arts and Design, Jerusalem.

Exhibitions Solo shows at English Speaking Union, Melbourne 1966 (ceramics); Pinacotheca Gallery 1968 (ceramics); Manyung Gallery 1979 (enamels and watercolours); Artmart — National Gallery of Vic 1980–81 (enamels and watercolours); Vic Artists Society 1982 (enamels and watercolours) and at the Caulfield Art Centre 1983.

Represented Murals, plaques and mosaics in many industries; Institutions and private collections in Australia, Israel and USA.

ASH, Shaneen QLD
Born Brisbane Qld 1956. Abstract painter and photographer in acrylic, crayon and conti.

Studies Certificates of applied art and photography at Seven Hills CAE 1974–79.

Exhibitions Solo shows at The Artist Gallery Brisbane 1980–81, and Community Arts Centre, Brisbane 1981.

Awards 1st and 2nd prizes at Brookfield Art Show 1969.

ASHCROFT, Pamela VIC
Born Adelaide 1942. Painter.

Studies Deakin Uni. Vic. Dip. Fine Art 1977.
Exhibitions Stuart Gerstman Galleries 1982; Deakin Uni. Gallery 1984; Geelong AG 1982.
Bibliography *150 Victorian Women Artists*, VAB Melb. 1987.

ASHWORTH, Olive QLD
Born Brisbane. Illustrator, textile designer.
Studies The Art Training Institute, Melb.
Exhibitions QAG 1982; Qld. Wildlife Artists Society 1983–88; The Centre Gallery, Gold Coast 1988.
Bibliography *A Homage to Queensland Women Artists, Past and Present.* The Centre Gallery 1988.

ASOVTSEFF, Alexandra NSW
Born Russia 1910. Portraitist and painter of birds and flowers. Lived and painted in China 1930–53, and around the North Sydney area for the past thirty years.
Exhibitions Solo shows at the RAS of NSW and many group shows.

ASQUITH, Pat NSW
Born Melb. Painter, portraitist, teacher.
Studies Newcastle TC; BA Fine Art, Hunter IHE; Taught at WEA and Newcastle Arts Centre.
Exhibitions Numerous shows since 1973 and recently at von Bertouch Galleries, Newcastle 1980, 81; Morpeth Gallery 1987, 88, 89; Lake Macquarie Gallery 1989; Schubert Gallery, Gold Coast and Kimberley Gallery, Brisbane 1990.
Awards Newcastle Regional 1976, 77.
Represented Institutional and private collections.

ATHERTON, Joy NSW
Born Sydney NSW. Painter, crafts woman, gallery director, North Shore Gallery, Sydney.
Studies Macquarie Evening College; Castle Hill Art Society; Orban Studio with Rhonda Walters, and privately with Sid Barron.
Awards Painting 1st and Jewellery 1st at Castle Hill 1970.

ATKINS, Christine F. QLD
Born Aust. Painter.
Studies BA Fine Art from University of Qld and privately with Frank de Silva. Member of the Ascot Art Group.
Exhibitions Blue Marble Gallery, Buderim.
Awards RNA Seascape 1989; Wide Bay Festival 1989; Mt Gravatt Open 1990; Quota Arts Festival 1982, 84.

ATKINS, Rosalind VIC
Born Terang, Vic. 1957. Printmaker.
Studies RMIT.
Exhibitions MPAC 1984; Society of Engravers, UK 1984, 85, 89; Griffiths Uni. Gallery, Qld. 1985; Royal Society of Printers, Etchers and Engravers, London 1986; Society of Wood Engravers 1986–87; PCA, Melb. 1988.
Bibliography *PCA Directory* 1988.

ATKINSON, Marea VIC
Born Aust. 1952. Printmaker.

Studies MA Fine Art, Cranbrook Academy of Art, Michigan USA 1981–83.
Exhibitions Since 1982 has shown in many international shows in USA, Canada, Spain, Korea, Poland, Japan, Brazil, Yugoslavia and Denmark; in Australia at CAS, Adelaide 1985; Uni. of Hobart 1987; Glyde Gallery, Perth 1987; MPAC 1988; 70 Arden St. 1988.
Awards Wesleyan Acquisitive USA 1983; MPAC 1988.
Commissions PCA 100 x 100 Print Portfolio 1988.
Represented Institutional and private collections in UK, Europe, USA, South America, Australia.
Bibliography *PCA Directory* 1988.

ATKINSON, Yvonne (Daniell) VIC
Born Melb. 1918. Landscape and genre painter.
Studies George Bell School, Melb.
Exhibitions Avant Galleries, Melb.; VAS Gallery; AGWA.
Represented AGWA, institutional and private collections.

AUDETTE, Yvonne NSW
Born Sydney NSW. Painter, mostly in watercolour.
Studies East Sydney Technical School and Julian Ashton School, Sydney; Has spent some time working and exhibiting in UK, USA and Europe.
Exhibitions Numerous solo shows in Europe 1958–66 and since then at Bonython Gallery 1968; Holdsworth Gallery 1970, 72, 75; Lyttleton Gallery, Castlemaine, Vic. 1986; Garry Anderson 1986.
Awards Nat. Academy Scholarship, New York 1953.
Represented Institutional and private collections in UK, Europe, Australia, USA.
Bibliography *Art and Australia* Vol 5 No 4; *Australian Watercolour Painters 1880–98* by Jean Campbell: Rigby 1982; *Artists & Galleries of Australia*, Max Germaine: Craftsman House 1990.

AUSTIN, Esther (Sticpewich) QLD
Born Sydney NSW 1938. Traditional painter of landscapes, portraits, still life, and teacher.
Studies Haberfield Demonstration School 1933–39; East Sydney Technical School 1945–46 and seminars at Canberra Artists Society, University of Qld; Darling Downs IAE and RQAS. Taught Port Moresby, PNG 1975–76; Director Gowan Gallery, Brisbane; Study tour to UK and Europe 1978; Member of Canberra Artists Society for ten years and member of Royal Qld Art Society since 1967.
Exhibitions Solo show in Port Moresby 1975; Group shows at Canberra Artists Society and RQAS; Stephens Gallery 1986; Gowan Gallery 1988; RQAS 1967–89; Pastelist Society 1987.
Commissions John Sands Art Calendar 1983.
Represented Institutional and private collections in UK, Europe, Japan, PNG, Australia.

AYLIFFE, Janet (Mrs. Glen Ash) SA
Born Aust 1950. Painter and illustrator.
Studies SA School of Arts and with Ruth Tuck.
Exhibitions Five solo shows in Adelaide.
Commissions Illustrations for a number of childrens books and in 1988 designs for 'The Night Sky' for Adelaide Festival Trust.
Bibliography *Australian Watercolour Painters*; Jean Campbell: Craftsman House 1989.

AYLWARD, Sarah NSW
Born NZ 1949. Painter and teacher.
Studies Hornsby TC and Dip. Fine Art, Alexander Mackie CAE 1979–81; Dip. Claremont

S of A, WA 1983.

Exhibitions Fremantle S of A 1983; Howard St. Galleries, Perth 1985; Claremont S of A 1986; Fremantle Art Gallery 1988. Numerous group shows.

Represented Institutional and private collections around Australia.

B

BACKEN, Robyn NSW

Born Canberra 1957. Sculptor, designer, craftworker, teacher.

Studies Dip. Visual Arts, SCOTA 1977–79; Salzburg, Austria 1980; Gerrit Rietveld Academy, Amsterdam 1981–83; Salzburg 1982–83; B. Visual Arts, SCOTA 1983.

Exhibitions Solo show at The Contemporary Jewellery Gallery, Sydney 1986 and a performance show at Roslyn Oxley9 Gallery 1990. Many group shows in Europe, Asia and Australia since 1979 including Cologne, Munich, Amsterdam and London 1982; Bonn, Salzburg, Washington DC 1983–84; Albury Regional Art Centre 1988; ANG 1988; Victoria & Albert Museum, London and Powerhouse Museum, Sydney 1989; City Square, Melbourne and Marimura Art Museum, Japan 1990.

Awards VA/CB Overseas Study 1981 and project grant 1985.

Represented ANG, AGWA, Powerhouse Museum, Sydney; Institutional and private collections in UK, Europe, USA, Japan and Australia.

BACKHOUSE, Sue TAS.

Born Hobart 1955. Photographer, teacher, art researcher.

Studies Hobart School of Art 1973–76. Taught with Tas.Ed.Dept. 1977–78, Hobart S of A 1978–79. Studied UK, Europe 1980; Assistant curator TMAG 1981–83; tutor in photography, Rosny College 1981–83; presently assistant curator Australian art, TMAG.

Exhibitions With Kathie Crawford, Bellerive Art Centre 1979; participated Gallery One, Hobart 1976; Warehouse Gallery 1977; Burnie Art Gallery and TMAG 1979; Burnie Art Gallery 1980; Fine Arts Gallery, Uni. of Tas. 1981; Long Gallery, Hobart 1982.

Awards VAB Grant 1984.

Publications Numerous curatorial publications also two with Hendrik Kolenberg and with J.B. Kirkpatrick *Native Trees of Tasmania*: Hobart 1985 and in 1988 her comprehensive reference book *Tasmanian Artists of the Twentieth Century*: Pandani Press, Hobart.

Represented TMAG; Burnie AG; institutional and private collections in Australia and overseas.

BADMAN, Beveley NSW

Born NSW, Watercolour painter.

Studies Wollongong Technical College, art certificate and postgraduate.; Has exhibited at Australian Watercolour Institute Annual exhibitions.

Award Ryde Watercolour Prize 1978.

Represented Wollongong City Council Collection and private collections.

BAILEY, Juanita NSW

Born Aust. Painter and teacher, gallery director.

Studies Wollongong TAFE 1978 after graduation 1979–86 also studied UK, Europe.

Exhibitions Juanita Gallery.

Awards Wollongong, Dubbo, Gunnedah, Katoomba.

Represented Institutional and private collections in Australia and overseas.

BAILEY, Louise NSW
Born Bulli NSW 1961. Potter and teacher.
Studies Wollongong TAFE 1982–83, 86–87; ESTC 1984–85; works at own pottery workshop.
Exhibitions Bathurst College
Awards Wollongong 1984, 85.

BAILLIEU, Marianne VIC
Born Melb. Painter.
Studies Canterbury University, Christchurch N.Z. and Monash University, Melb. Founded and directed Realities, Melb. 1970–80.
Exhibitions Reconnaissance Gallery, Melbourne 1983; Yuill/Crowly, Sydney 1984–87; Institute of Modern Art, Brisbane 1986; Yuill/Crowley, Sydney (Collaboration; Marianne Baillieu and Imants Tillers) 1988; Yuill/Crowley 1989. Group shows include Artspace Sydney 1984; Perspecta 1985 AGNSW; ACCA, Melb. and IMA, Brisbane 1985. Nat. Gallery, Wellington and Auckland City Gallery NZ 1988.

BAIRD, Susan NSW
Born Sydney 1964. Painter.
Studies Dip. Graphic Design from KVB Visual Arts School 1981. Overseas study tours Europe, Greece 1984, Sardinia, UK, Europe 1986–87.
Exhibitions Solo shows at Schubert Gallery, Gold Coast 1986; Barry Stern Sydney 1988, 89; Group shows include Casey Galleries, Sydney 1985, 86; The Centre Gallery, Qld 1988; International Corn Exchange Hotel, Sydney 1991.
Represented Institutional and private collections in UK, Europe and Australia.

BAKER, Coral NSW
Born Cessnock NSW 1936. Painter, photographer, printmaker.
Studies With Mary Beeston 1972–74; Newcastle School of Art & Design 1976–79.
Exhibitions Newcastle Society of Artists 1977; Australian Student Printmakers 1979. Morpheth Gallery 1982, 83, 86, 88; Possum Brush Gallery 1987; Newcastle Contemporary Gallery 1988.
Awards Weston Award 1975, 1977; Newcastle Society of Artists Scholarship 1977; Gosford Acquisitive Print 1979. Raymond Terrace 1982, 83.
Represented City of Cessnock Collection, Newcastle TC, Gosford City Collection and Westmead Hospital NSW, Wyong City Collection.
Bibliography *PCA Directory* 1988.

BAKER, Dorothy VIC
Born Mundoona Vic 1914. Realist painter in oil, watercolour, enamel on copper; Writer and teacher.
Studies National Gallery Art School, Melbourne Technical College and George Bell Art School; President Vic Artists Society 1980–83.
Commissioned to produce cover and six illustrations for book *To Go Among Strangers*, Dorothy Buchanan; Hon life member of Malvern Artists Society and Sesame Artists Society; Member, Society of Women Painters and Sculptors and the Realist Guild of Australia; Art writer for Melbourne *Weekly Times* 1960. Taught at VAS and Malvern Artists Society.
Exhibitions Many group shows and seventeen solo shows during the past thirty six years, the last being at Gallery Art Naive, Melb. 1985.
Awards VAS 'Award for Distinguished Service to Art'; The American Biographical Institute Commemorative Medal of Honour.
Represented NGV, institutional and private collections in UK, Europe, Korea, China, Australia.

Bibliography *International Who's Who in Art and Antiques,* Melrose Press, UK. *Encyclopedia of Australian Art;* Alan McCulloch: Hutchinson 1984; *Artists & Galleries of Australia,* Max Germaine: Craftsman House 1990.

BAKER, Jeannie **NSW**
Born Croydon UK 1950. Representational painter, relief collage, miniatures; Writer and illustrator of children's books.
Studies Croydon College of Art 1967–69; Brighton College of Art, UK, Diploma, Art and Design (Hons) 1969–72; Worked as illustrator for *Nova* and *London Times.*
Exhibitions One-woman shows, London 1975, Hobart 1977 and Robin Gibson Galleries, Sydney 1979; NGV 1988; Noosa Reg. Gallery Qld 1988; Penrith Reg. Gallery, NSW 1988; Roslyn Oxley9 Gallery, Collage, Book and Film 1988. Exhibited collages at Royal Academy Summer Exhibition, London 1974, 1975 and at the Portal Gallery, Bond Street, London 1975. Crafts Council, Sydney 1978, 81; Albury Reg. Gallery 1982; Noosa Reg. Gallery 1986; Lewers Bequest Gallery, Penrith 1984, 86, 87.
Awards and Commissions Australia Council, Visual Arts Award 1978; Three of her children's picture books have been published by Andre Deutsch, UK; The artwork of her books *Polar* and *Grandfather* has travelled to exhibitions throughout the world; also *Millicent,* Deutsch and Hutchinson 1983 and *Home in the Sky:* Greenwillow, USA 1984.
Awarded residency VAB New York Studio, Oct.–Dec. 1980, 83.
Represented Many institutional and private collections in Australia, UK, Europe and USA, and National Collection, Canberra and Queensland Art Gallery.
Bibliography *Artists & Galleries of Australia,* Max Germaine: Craftsman House 1990.

BAKER, Louise **VIC**
Born Eynsford UK. Semi-abstract painter in acrylic, gouache, watercolour, printmaker; Teacher.
Studies Bromley School of Art, Kent; Diploma of Art (commercial), St Martin's School of Art, London; Drawing and painting, School of Visual Arts, New York USA; Diploma of Printmaking, Prahan College of Advanced Education, Vic; Screenprinting, Pratt Manhattan Centre, New York USA; Part-time teacher in graphic arts, RMIT seven years; Also screenprinting workshop, arts programme, RMIT Union.
Exhibitions Group show 'New Images', Bartoni Gallery, Vic 1977; Australian Printmakers, Bartoni Gallery 1978; 'Teacups and Rockbuns', Bookshelf Gallery, Melbourne 1978.
Represented Private and institutional collections in Australia, USA and UK.

BAKER, Nyukana **NT**
Aboriginal batik painter of the Pitjantjatjara people in the Ernabella region which straddles the border area of SA/NT. Has studied in Japan and Indonesia.
Exhibitions Bloomfield Galleries, Sydney 1989.
Represented ANG; NTMAG; AGSA; Robert Holmes à Court Collection.

BAKER, Su **WA**
Born Perth WA 1955. Contemporary, figurative painter in all media, and portraitist.
Studies BA, Fine Art from WAIT 1976–78, and Diploma of Education 1980.
Exhibitions 'Women Artists', Perth, 1980; Group Shows, Nexus, 1982; One-Person Exhibition, Galerie Dusseldorf, Perth 1983, 87, 88. Participated Australian Perspecta 1989, AGNSW.
Awards York Art Fair, First Prize 1977.
Commissions Portraits: Noel Counihan 1980; Professor Bill McDonald 1983.
Represented WAIT Collection; R & I Bank Collection; Wagga Regional Gallery; Private collections.

BAKOS, June NSW
Born Wellington NZ Colour painter, predominantly in pastels.
Studies Hornsby Technical School 1976–79.
Exhibitions Solo shows at Vivians Gallery, Sydney 1981–82; Munchin and View, Vic 1981;
Saints Gallery, Sydney 1983; Group shows at Duke of Wellington, NSW 1982; Barrington
Francis, Kingsford NSW 1983. Solo show ANZ Bank, Martin Place, Sydney 1986.
Awards Spectrum Art Award, Macquarie Uni.; Blacktown City Art Prize.
Represented Private collections in UK, USA, Europe and Australia.

BALDEY, Marilyn QLD
Born Brisbane 1954 Printmaker.
Studies Qld. C of A.
Awards SGIO Drawing Prize 1985.
Bibliography *PCA Directory* 1988.

BALDRY, Jennifer June (Hinder) NSW
Born Sydney NSW 1929. Semi-abstract painter in oil and acrylic; Constructions and wall
reliefs in aluminium and perspex.
Studies Julian Ashton School 1949–50; Studied painting and design under John Coburn
and Tom Gleghorn, Canberra Technical College 1968–69; Has been more involved in
historical research than painting in recent years.
Exhibitions One-woman show at Sculpture Gallery, Canberra 1969; Participated in
Contemporary Art Society and other mixed shows at Gallery A, Sydney.
Awards Gallery A Award at the 'Young Painters' Exhibition (twice).
Represented Private collections in NSW.

BALDWIN, Helen NSW
Born Blayney NSW. Watercolour paintings of Central Australia and fine petit point
tapestry.
Studies East Sydney Technical College; Worked as a commercial artist in her early days of
art; Travels in Central Australia to paint Aboriginals in their natural habitat and landscape;
From her paintings she creates outstanding petit point tapestries.
Exhibitions Prouds Gallery, Sydney 1980–81; Canberra 1981–82. Galeria Tapande,
Canberra 1981, 82, 84; Gallery 21, Melb. 1986–87; Styles Gallery, Sydney 1988; Blaxland
Gallery 1990.
Represented Many important collections in Australia and overseas.

BALFOUR, Charlotte SA
Born Winchester UK 1947, arrived Australia 1980. Watercolour painter and teacher.
Studies Educated in Oxford UK; Read English at Sussex University, taught in London
schools for two years and in Cairo Egypt for two years. Travels in North Qld and NT.
Exhibitions Eastgate Gallery, Chichester UK 1979; Newman Rooms, Oxford 1980;
Greenhill Galleries, Adelaide 1981; Old Clarendon Gallery, SA 1982; Bethany Gallery,
Barossa Valley SA 1983; Australian Galleries, Melbourne 1984. Barry Stern, Sydney 1987.
Represented NSW Regional Arts Board Collection and private collections in UK, Europe
and Australia.

BALLARD, Kathlyn VIC
Born Melbourne Vic 1929. Impressionist watercolour painter and teacher.
Studies Swinburne Technical College 1946–49; Member of first Students' Representative
Council formed at the college; Worked as a commercial artist for the following six years,
becoming art director of a Melbourne advertising agency; After travelling overseas married
fellow artist, Stanley Ballard in 1956; Then concentrated on her main interest, watercolour;

Member of Australian Guild of Realist Artists, Vice-President 1976–8; President, Old Watercolour Society's Club 1986–89; VAS Council Member 1979–81; Executive member of the Conference of Art Societies 1977–80; taught watercolour painting 1969–77; founded WC course at Prahran CAE 1976; Patron of Montag Group 1976; Produced WC training film for Chisholm IT, Melb.

Exhibitions Twenty solo shows since 1962 and eleven joint shows with her husband Stan. Recent solo shows at Greenhill Galleries, Perth 1983; major retrospective at Castlemaine Reg. Gallery, Vic. and Gould Galleries, Melb. 1984; Kensington Gallery, Adelaide 1985, 88; Gould Galleries 1986; Greythorn Galleries, Melb. 1988. Recent group shows include guest artist at Camberwell Rotary Art Show 1983; McClelland Reg Gallery 1983; VAS Heritage Show 1985; *Ten Watercolourists Salute Victoria,* Melb. and London 1985.

Awards Camberwell Rotary Special Award 1973; The Portland Harbour Trust Watercolour Prize 1974; Kylor Invitation Award 1976.

Represented Castlemaine Reg. Gallery; Artbank Rockhampton City Art Gallery; Sale Regional Art Gallery; T and G Collection; Hotham La Trobe Collection; Australian National Line Collection; Scotch College, Melbourne; Private collections throughout Australia and in USA, Canada, UK, Sweden, Austria, Japan, Syria, Hong Kong, Germany.

Bibliography *Art and Australia* Vol 20 No 1; *Australian Watercolour Painters 1780–1980,* Jean Campbell, Rigby 1983; *Artists & Galleries of Australia*, Max Germaine: Craftsman House 1990; *Australian Impressionist & Realist Artists*, Tom Roberts: Graphic Management Services, Melbourne 1990.

BANCROFT, Bronwyn NSW

Aboriginal painter, fashion designer and founder of Designer Aboriginals Pty. Ltd. Rozelle, NSW 1986.

Studies Dip. Fine Art, Canberra S of A. 1979, Grad. Dip. 1980; Member, Boomalli Aboriginal Artists Co-Op from 1987, Chairperson 1990. Tutor, Moree Plains Gallery in conjunction with Yurundali artists 1991; Co-ordinator, Dept. of Fine Arts, John Power Institute Public Education Programme 1991.

Exhibitions Her work has been shown widely around Australia since 1979 in exhibitions and fashion parades and recently at Victoria and Albert Museum, London UK 1989 and Australian Perspecta 1989, 'A Koori Perspective' at Artspace Gallery, Sydney; also at Capricorn Gallery, Cairns 1988; Performance Space 1987; Tin Sheds Gallery 1987; Seoul, South Korea 1989; Boomalli Co-Op 1989, 90; Wilderness Society, Melbourne 1989; Coo-ee Gallery, Sydney 1989, 90, 91; Japan 1990; England and Scotland 1990; University of NSW 1990; Culture Shop Gallery 1991.

Represented ANG; National Museum of Australia; Australian Museum; Sydney and Wollongong Universities; Moree Plains Gallery, institutional and private collections around Australia and Government House, Tokyo.

Bibliography *Artists & Galleries of Australia*, Max Germaine: Craftsman House 1990.

BANETH, Erica USA

Born Budapest Hungary 1928, arrived Australia 1948. Painter, sculptor and teacher.

Studies Melbourne Technical College and later Caulfield Technical College graduating with Diploma of Art in Sculpture 1955–62; Further studies at National Gallery School, Melbourne 1963; Taught at Presbyterian Ladies College, Melbourne 1963–65; Studies at Hammersmith School of Architecture and Arts UK 1966–67; Taught Monash University, Melbourne; From 1970 until 1977 worked and travelled overseas until settling down under her new married name of Foti in California USA.

Awards Moomba Jewish Art Festival Prize, Melbourne 1964; Maude Vizard-Wholohan Prize for Sculpture, SA 1965.

Represented Art Gallery of SA; Monash University Collection; Dallas Art Museum, Texas USA.

Bibliography *Australian Sculptors*, Ken Scarlett, Nelson 1980.

BANITSKA, Tina VIC
Born 1950. Painter and ceramic artist.
Studies RMIT Melbourne.
Exhibitions Solo shows at Chrysalis Gallery, Melbourne and Golden Age Galleries, Ballarat 1981; Participated in Invergowrie State College, Vic 1978; Frankston State College, Vic 1978; and *Ceramics in Victoria Exhibition* at Ballarat Fine Arts Gallery, Vic 1982.

BANKS, Gillian NT
Born Vic. 1943. Painter and teacher.
Studies RMIT 1964; B. Fine Art, Deakin Uni. 1988. Member, Museum and Art Galleries of NT Board 1985.
Exhibitions Solo shows at Leichhardt Gallery, NT 1981; Darwin Centre 1987; Museum and Art Galleries of NT 1989. Numerous group shows since 1979.
Awards Brian Lambert Acquisition 1985; Esplanade Gallery Acquisition 1986.
Represented NTMAG, institutional and private collections in UK, Europe, USA, Australia, India, Malaysia.

BANNISTER, Megan VIC
Born Taiping 1958. Painter and printmaker.
Studies Prahan CAE, Melbourne 1978–80.
Exhibitions Solo shows at Tolarno Gallery, Melbourne 1980; Art Projects, Melbourne 1981, 1983; Auguste Blackman Graphics, Melbourne 1982; Participated at Oz Print Gallery 1979; *Sex in Art*, University of Tas 1982.

BARAN, Beatrice Madge VIC
Born 1911. Painter.
Studies Under Gunnar Neeme 1980–82; Kate Hellard 1983–84; Joan Gough 1985–87. President Hawthorn Artists Society 1981–85. Published *Images of Hawthorn* 1987.
Exhibitions Malvern Artists Society 1980–86; Hawthorn Artists Society 1981–86; C.A.S. 1985–87.
Awards Inez Hutchinson Award 1986, Contemporary Artists Society 'Individual Framers' prize 1987.

BARAN, Susan NSW
Born Sydney 1959. Painter, Printmaker.
Studies ESTC 1980–82; Post Grad. City Art Institute 1985; teaching printmaking ESTC 1986–87. Studied Asia, Europe 1982, Europe, USSR 1985.
Exhibitions Solo shows at Hogarth Galleries 1985, 87, 88; participated 70 Arden Street 1988; Greenhill Galleries 1991; and in over 35 group shows.
Commissions Print Workshop, Sydney 1987–88; PCA 100 x 100 Print Portfolios 1988.
Bibliography *PCA Directory* 1988.

BARBER, Elizabeth Blair WA
Born Perth WA 1909. Painter.
Studies With Van Raalte, Perth; Melbourne Art Gallery School under Lindsay Bernard Hall for three years and later in London; founder of Cremorne Art Gallery, Perth WA.
Exhibitions First one-woman show at Newspaper House, Perth 1939, followed by others at Boan's Gallery, and the Tas Tourist Bureau, Cottesloe WA; Group shows with Guy Grey-Smith and Audrey Greenhalgh in Adelaide; 'West Australian Artists', Commonwealth Institute, London; Also with NZ and South African artists at South Audley

Street Gallery, London and the Augustine Gallery in Norfolk UK; Won the Busselton Art Award, WA. Showed at Gomboc Gallery, Perth 1988.
Represented Private collections in Australia and overseas.

BARBERIS, Irene **VIC**
Born London UK 1953. Realist painter, muralist and designer.
Studies Prahan College of Advanced Education 1972–73; Study tour to USA and Europe 1974–75; Preston Institute of Technology 1975–76; Designed costumes for *Glimpses,* Australian Ballet Company production 1976; Commissioned to complete a mural by the Victorian Ministry for the Arts for their 'Art in the Streets' project 1977.
Exhibitions 'Drawing — Some Definitions', Ewing and George Paton Galleries, Melbourne University Union and at Institute of Modern Art, Brisbane 1976; 'Eight Women Realists', Vic College of the Arts Gallery 1978; Coventry Gallery, Sydney 1978. The Art Gallery, Melb. 1988; Luba Bilu Gallery, Melbourne 1991.

BARKER, Jill **WA**
Born Queensland, 1950. Painter and teacher.
Studies B.Sc. University of Queensland 1969–72; BA (Fine Art), Perth TC 1982–85, 86–88. Lectured at University of WA Summer School 1989; Tutor in Painting & Drawing, Curtin University 1989–90.
Exhibitions Numerous shows include Fremantle Art Gallery 1986; Underwood Gallery 1987; Bathurst NSW 1987; Perth Concert Hall 1988; PICA 1989; Customs House 1989.
Represented Institutional and private collections.

BARKER, Roslyn **SA**
Born Parkside SA. Ceramic artist and teacher.
Studies SA School of Art, Diploma FA (painting); Studying for graduate diploma in further education and teaching part-time.
Exhibitions Working in ceramics which are exhibited at the Jam Factory Gallery and at Aldgate Crafts, Adelaide.
Represented Institutional and private collections in Australia.

BARLOW, Ann **VIC**
Born Melbourne Vic 1954. Painter and printmaker.
Studies Prahan CAE, Melbourne 1973–76; Vic College of the Arts 1977–78.
Exhibitions Participated in Australia Student Printmakers 1977; Henri Worland Memorial Prize Exhibition 1977–78; Graduate Exhibition VCA 1978; Mosman Art Prize, NSW 1979.
Awards Warrnambool Art Gallery, Vic Purchase 1978.

BARNARD, Judy **VIC**
Born Woodend Vic 1938. Traditional painter of landscapes and seascapes, no formal art training.
Exhibitions Has held ten one-woman shows since 1973 and more recently at Mentone Gallery, Melbourne 1980; Anvil Gallery, Wodonga Vic 1981; Spectrum Gallery, Melbourne 1982.

BARNES, Judy **NSW**
Born Sydney NSW.
Studies Julian Ashton Art School and East Sydney Technical College; Worked as a commercial artist for some time.
Exhibitions First one-woman show at Strawberry Hill Gallery, Sydney 1977; Group shows at same gallery 1974, 1975, 1976, 1977, 1978. Solo show Prouds Gallery, Sydney 1985.

Commissions Work purchased by Federal Government in 1977 and selected for printing by UNICEF, New York 1978.
Represented Private collections in USA, Switzerland, Germany, South America, France and Australia.

BARNES, Minji WA
Aboriginal Warlpiri/Walmatjarri painter.
Exhibitions AGSA 1988.

BARNES, Valda QLD
Born Qld. Watercolourist.
Studies Hobart, Tas with Vernon Hodgman; Now lives in Qld.
Exhibitions Three one-woman shows at Foscan Gallery, Hobart 1973, 1974, 1975 and group shows in Tas.
Represented Private collections in Tas and Qld.

BARR, Coralie NSW
Born Aust. Painter
Studies Nat. Art School, Wollongong; Desiderius Orban School, Sydney; Oskar Kokoschka Acadamy, Salsburg, Austria. Member, Board of Trustees, Wollongong City Gallery 1974.
Exhibitions Illawarra Society of Artists.
Awards Co-winner, Helena Rubenstein Portrait Prize 1963. Commissioned to paint six portraits of past Chairmen of Illawarra County Council.
Represented Institutional and private collections in USA, NZ and Australia.

BARR, Maria Olwyn (Hunt) QLD
Born Warialda NSW 1950. Landscape and genre painter, no formal art training. Painted in New Guinea and Scotland 1968–87.
Exhibitions Pitlochry Festival Theatre, Scotland. Presently paints on commission and shows at Highland Studio, Toowoomba.

BARRETT, Di SA
Born 1947. Photographer and teacher.
Studies B. Visual Art, Underdale SACAE 1983–86. Has worked and taught widely since 1985. Presently Lecturer, Foundation Studies, School of Art, University of SA.
Exhibitions Numerous shows include Jam Factory 1984, 87; Underdale SACAE 1986, 87, 88, 89, 90; ROAR II, Melbourne 1988; Ivan Dougherty Gallery, Sydney 1989; Wagga Regional Gallery 1990; Loft Gallery, Adelaide 1990; AGSA 1990; Greenhill Galleries, Adelaide 1991; Qld Touring Show 1991.
Awards Maude Vizard-Wholohan Purchase 1990, AGSA.
Represented AGSA, SACAE and private collections.

BARRIE, May (Voorwinden) NSW
Born Denmark WA 1918. Sculptor, in stone and bronze.
Studies East Sydney Technical College; Diploma in Sculpture 1938–41; Study tours to UK, Europe and South Africa 1946–48; UK and Europe 1973; Europe, Middle East, South Africa and India 1976–77.
Awards Hunters Hill, Sydney 1963.
Commissions Many works in stone and metal since 1948, refer bibliography for full list which includes *Winged Bull of St Lukes* at St Lukes, Liverpool NSW and granite portrait of R.C. Mills at Australian National University, Canberra.
Bibliography *Australian Sculptors*, Ken Scarlett, Nelson 1980.

24

BARRY, Eva Maria NSW
Born Hungary 1935, arrived Australia 1957. Semi-abstract painter.
Studies Under D. Orban Studio, Sydney. Taught at Orban School, Sydney 1983–86,
Randwick and Kogarah TAFE Colleges (ceramics) 1987.
Exhibitions Her first Solo Exhibition was opened by Desiderius Orban at the ·ANZ
Exhibition Centre, Sydney 1983; Group exhibitions: — The Orban Student Exhibtion;
Sculpture Centre; Gallery Eight; Delmar Weekend Gallery; Copperfield Gallery; Mosman
Woollahra, and Waverley Municipal Exhibitions; The Q Gallery, Sydney 1983. Penrith
Reg. Gallery 1988; Seymour Centre, University of Sydney 1990.

BARRY, Kay VIC
Born Vic. 1933. Watercolour painter and theatre designer.
Studies RMIT and in UK, Europe.
Commissions Designs for National Theatre and ballet groups, Melbourne.
Bibliography *Australian Watercolour Painters*: Jean Campbell: Craftsman House 1989.

BARSA, Tatipai QLD
Born Thursday Island 1967. Torres Strait painter in acrylic.
Studies Graduated from Associate Dip. of Art Course at Aboriginal and Torres Strait
Islander College of TAFE, Cairns.
Exhibitions Pacific Hotel, Cairns 1986–88; Qld. Museum 1988; Festival of Art,
Townsville 1988; Cairns Art Society 1988; Rockhampton Art Centre 1989.
Awards Cairns Art Society Encouragement 1988.
Represented ANG, Canberra; Long Beach Museum of Art, USA; private collections in
Australia and overseas.

BARTLETT, Beverley NSW
Born Sydney. Painter and teacher.
Studies Meadowbank TC 1962–63. Conducts childrens art classes at Castle Hill Art
Society.
Exhibitions Solo show at Fantasy Fair Gallery, Dural; numerous group shows.
Awards Castle Hill Art Prize.

BASS, Lenore M. NSW
Born Bangalow NSW 1917. Painter in oil and watercolour and sculptor.
Studies Royal Art Society, Sydney 1934–35; Datillo Rubbo Art School, Sydney 1935–39;
Fashion artist at Farmers Dept Store 1935–39; Retrained at Liverpool Technical College
1966–67, and engaged on teaching staff 1978–79; Commissions include murals at RC
Church at Warren and at Yass NSW 1957–58; Civic Square ACT, Coat of Arms 1959; P & O
Building, Sydney, copper clock 1960; Mosaic mural, Charleville Qld 1962; Unilever
Factory Complex, Balmain 1875.

BASSER, Nanette NSW
Born Sydney 1939. Painter.
Studies Graduated from ESTC in 1959 and worked in commercial art for some years.
Exhibitions Solo show at Eaglehawke Galleries 1990.
Awards RAS of NSW 1988; Warringah 1988; Ashfield 1988; Caleen Award, Cowra 1989.

BASSETT, Helen VIC
Born Melbourne Vic 1939. Expressionist painter in oil, nude, landscape, still life, interiors.
Studies Certificate of Art (advertising); Caulfield Institute of Technology, Vic 1955–56;
Two terms of tonal painting, Max Casey School of Painting, Melbourne 1976; Twelve years
freelancing in illustration and graphic design; Now painting full-time and instructed in

painting at Sherbrooke Art Society, Vic 1978; Participated *Contemporary Women Painters*, Eltham 1982.

Awards Brighton City Council Award 1976; Frankston City Council Award 1977; Caulfield City Council Award 1977; Commonwealth Bank Award 1977.

Represented Brighton City Gallery, Vic; Frankston Municipal Collection, Vic; Caulfield Municipal Collection, Vic; Commonwealth Bank Collection, Vic; Private collections Australia, UK, Hong Kong, Singapore.

BATTLEY, Sieglinde WA

Born East Prussia, Germany. Painter, printmaker.

Studies Graphic Design at Kunstschule Carlo Ruppert, Frankfurt 1960–63; Worked Europe 1964–71; Indonesia 1972–76; Iran 1976–78; Dip. Fine Art, Claremont S of A, Perth 1979–81; BA Fine Art, Curtin University, Perth 1982.

Exhibitions Solo shows at Gallery 52 1982; Galerie Dusseldorf 1982; Broome Art Gallery 1985, 86; West Germany 1986, 87, 88; Delaney Galleries 1989. Many group shows since 1982.

Awards Manjimup 1982, 84; Port Hedland 1983; Katanning 1983; WA Arts Council Fellowship 1986; Telecom Award 1987; Holmes à Court Award 1989.

Represented AGWA, institutional and private collections in Europe and Australia.

BAWDEN, Mardi VIC

Born Melb. 1944. Printmaker.

Studies Mt. Gambier TAFE College S.A.

Exhibitions MPAC 1986. Warrnambool Reg. Gallery 1988.

Awards Cth. Bank Print Award and Hamilton North Rotary 1983, 84.

Bibliography *PCA Directory* 1988.

BAXTER, Anne NSW

Born NZ. Printmaker, painter, teacher.

Studies ESTC; Gymea TAFE College, NSW; President of Southern Printmakers Association 1983; Teacher printmaking part-time, and is a regular exhibitor in group printmaking shows in Australia and overseas; Member, WAC, Willoughby.

Exhibitions Southern PCA Printmakers 1984; Mini Prints, Cadaques, Spain 1985–86.

Awards Drummoyne Print Prize 1979, 1981.

Represented Institutional and private collections around Australia and overseas.

Bibliography *PCA Directory* 1988.

BEAMISH, Winifred NSW

Born UK 1913, arrived Australia 1949. Painter in watercolour and oil in impressionist abstract style. Stydy travel to UK, Europe 1980–82.

Studies Art in UK and was originally a black and white artist; In recent years she has become known for her paintings of old houses and Australian landscapes; Associate of the Royal Art Society of NSW.

Exhibitions 'Profiles of Australia', Sebert Galleries, Sydney 1973; Has also shown in Japan and USA; Barbizon Gallery, Sydney 1981; Berrimas Gallery NSW.

Represented Many private collections in Australia and overseas.

Bibliography *Art and Australia,* Volume 9/4, page 363; *Who's Who in Art and Antiques,* Melrose Press, UK 1978.

BEARDMORE, Joy NSW

Born Sydney NSW 1943. Figurative and landscape painter in watercolour, gouache, mixed media and oil.

Studies Art Scholarship to attend The National Art School at East Sydney Technical

College, Sydney, 1959–63; Attained Painting Diploma, ASTC; Sydney Teachers College 1964; Art Teacher with the Department of Education 1965–66; Study tours to Hobart, Tasmania 1971, Perth 1972, Bali 1977, UK and Scotland 1978, Spain and France 1981 and presently organising a 12 month study tour in Spain; Director of Gallery 156, Lane Cove, Sydney 1980–83.

Exhibitions One-woman shows at Old Bakery Gallery, Lane Cove NSW 1976, 1977, 1979; Gallery 156, Lane Cove 1982; Participated in group shows, Darlinghurst, Sydney 1975; Lane Cove 1975; Gallery 156, Lane Cove 1980–81. Giles St. Gallery, Canberra 1986; Solander Gallery, Canberra 1987; Holdsworth Galleries, Sydney 1989.

Awards Acquisition Prize, Campbelltown NSW 1961.

Represented In private collections, Australia, UK and Spain.

BEAZER, Elizabeth VIC
Born Melbourne Vic 1947. Portrait and genre painter.

Studies BA Dip Ed, Melbourne University; Self-taught as an artist; Worked as a portraitist in London 1974 and painted portraits on commission in Melbourne from 1976; Works as a psychologist with the Vic Education Dept.

BECHER, Poppy NSW
Born Cottesloe, WA 1938. Ceramic artist.

Studies Apprenticed to Richard Brooks 1979; Ceramics Certificate Course, Brookvale TAFE 1982–85.

Exhibitions Solo show at Victor Mace Gallery, Brisbane 1988; group shows include 'Illawarra Ceramicists' Wollongong Art Gallery; First Prize Wheel Throwing Novice, Port Hacking; Professional Involvement, 'Clay Things' Co-Operative, Balgowlah 1987.

BECHET, Kate VIC
Born Melbourne Vic. Gold and silversmith.

Studies Diploma of Fine Arts (gold and silversmithing) RMIT.

Exhibitions Kibbutz Ein-Gew, Israel; Old Ruytonians Exhibition, Studio Gallery, South Yarra Vic.

Awards McMillan Award for Goldsmithing RMIT; Council member for Contemporary Art Society, Melbourne 1978.

BECK, Deborah NSW
Born Sydney NSW 1954. Painter and teacher.

Studies National Art School, Sydney 1973–74; Alexander Mackie CAE — Diploma in Art 1975–76; Travelled Europe, UK 1978; Teaching at TAFE Colleges 1979–88; lecturer in drawing Macarthur IHE and teacher, St. George TAFE 1989.

Exhibitions Numerous shows since 1976 and recent solo shows at Hogarth Galleries 1986, 88, 89; Distelfink, Melb. 1989.

Represented Artbank, Regional Galleries and private collections.

BECK, Erika NSW
Born Zagreb, Yugoslavia 1939. Painter and teacher.

Studies Anatol Sergejev, Zagreb 1958–59. Nat. Art School, Sydney 1968–69; Desiderius Orban Studio. Study tours UK, Europe 1974, 76, 80, 84, teaches at Ku-ring-gai Art Centre. Exhibiting member of Ku-ring-gai Art Society and Pensinsula Art Society. Foundation member of the Australian Society of Miniature Art.

Exhibitions Solo show at Ku-ring-gai Community Centre 1989, Brown Boveri office 1988; Delmar Gallery 1989–90; Wycombe Gallery 1990; The Gallery Wall, Edgecliff 1991.

Awards Ku-ring-gai Art Society 1987, 90; Royal Easter Show 1988.

Represented Institutional and private collections in UK, Europe and Australia.

BECK, Lucy (Boyd) VIC

Born Melbourne, 1916. Potter and ceramic artist, daughter of Merric Boyd.

Studies She met her future husband Hatton Beck (born 1901) in 1927 and there started a
significant partnership which was to hold many joint exhibitions, carry on the traditional
Boyd Pottery at Murrumbeena and give Lucy great scope for her inherited talent in ceramic
painting and decoration of myths and romantic figures. Lives in Melbourne, still working in
recent times.

Represented ANG; AGV; many regional, municipal, institutional and private collections.

BECK, Joan NSW

Born Moree NSW 1916. Painter in oil and acrylic. Mostly abstract, science fiction but occa-
sional traditional Paddington terraces.

Studies With Desiderius Orban in the 1950s; Julian Ashton School 1956–57; Part-time at
East Sydney Technical College, life drawing classes to 1976.

Exhibitions One-woman shows since 1964 at Walk Gallery, Hornsby; Crana Gallery,
Wollongong; von Bertouch Galleries, Newcastle; Participated in many group shows includ-
ing Tas Museum and Art Gallery, Hobart, Blaxland Galleries and Underwood Galleries,
Sydney; Swan and von Bertouch Galleries, Newcastle; Gallery Mucha, Brisbane; St Ives Art
Society annual shows and Delmar Gallery at Trinity Grammar School.

Awards Goondiwindi Art Prize 1971 and Grenfell Henry Lawson Prize 1972.

Represented Sears Roebuck Collection, USA; Tas Museum and Art Gallery; Private collec-
tions in Australia, USA, NZ and UK. (Died 1989)

BECK, Margot VIC

Ceramic artist, wife of Robert Beck, daugher of artist Friedl' Gardner.

Exhibitions Has shown widely over the past seventeen years with her husband. Last major
show at von Bertouch Gallery, Newcastle NSW 1988 and *The Little Gallery,* Melb. 1989.

BECK, Vivienne TAS

Born Hobart 1955. Printmaker and teacher.

Studies School of Art, Hobart 1973–76. Taught for the Tas. Education Dept. 1977–79.

Exhibitions Devonport Gallery and Art Centre Tas. 1976, 78 where her work is included in
the permanent collections.

Bibliography *Tasmanian Artists of the 20th Century*, Sue Backhouse 1988.

BEE, Avenel SA

Born Adelaide SA 1921. Painter of surrealistic landscapes and abstracts in oil, acrylic, water-
colour.

Studies SA School of Arts and later with Moy Grigg; Associate of the Royal SA Society of
Arts; Director of Avenel Bee Gallery, Stirling SA.

Exhibitions Has held three solo shows in Adelaide and participated in a number of RSA and
group shows.

Represented Private collections in Australia, Europe and USA.

BEESTON, Mary NSW

Born Melbourne Vic 1917. Painter, textile and tapestry designer, teacher and art critic.

Studies National Art School, Newcastle 1954–61; Study Tour Scandinavia, UK and Mexico
1973; Textile Design at Frederika Wetterhoff School, Finland 1973; Research and Study
Tour Thailand, Nepal, India, Kashmir, Pakistan, Afghanistan, Iran 1978–79; Tapestry at
Daniel Drouin School, France 1978; Chemical dyeing Roy Russell School, U.K.; Linen
spinning Patricia Baines, UK 1979; Tutor in Colour and Design since 1970 for Crafts
Councils, Handweavers and Spinners Guilds, and Community Groups in NSW, Vic and SA;
Lecturer at First Australian Fibre Conference 1981, and New Zealand Woolcraft Festival

1982. Tutoring tour of New Zealand for Spinning Weaving and Woolcraft Society 1983.
Exhibitions One-woman shows (painting), Leveson Street Gallery, Melbourne 1964, 1966, 1972; von Bertouch Galleries, Newcastle 1965, 1968, 1969, 1971, 1976, 1980; Bonython Art Gallery, Adelaide 1971; Armstrong Gallery, Morpeth NSW 1982; One-woman shows (Tapestry) (Woven by Larry Beeston); von Bertouch Galleries 1969, 1974, 1980; Pokolbin Gallery, Pokolbin NSW 1973; Thrumster Gallery, Port Macquarie 1975; Solstice Gallery, Edinburgh Scotland, 1979; Galerie Maverick, Amsterdam Holland 1979; Beaver Galleries, Canberra 1981; Old Bakery Gallery 1982; Crafts Council Hobart 1982; Westwal Gallery, Tamworth 1983. Since 1957 has participated in a host of group shows with paintings and many tapestry shows in conjunction with her husband weaver Larry Beeston, a notable one being at von Bertouch Galleries, Newcastle in March 1989, they have also shared exhibitions in Scotland, Holland, Japan and Australian capital cities.
Awards (Painting) Fairfax Prize for Human Image 1963; Albury Prize (City's Choice) 1964; Newcastle Agriculture, Horticultural & Industrial Association Prize 1965, 1972; Helena Rubinstein Regional Prize for Portraiture 1966; Newcastle May Day Art Prize, Blue Mountains Acquisitive Prize 1967; Newcastle May Day Art Prize 1969; Crafts Board of the Australia Council Grant (with Larry Beeston) 1980. The Hunter Tapestry in the great Hall at University of Newcastle 1986.
Represented Artbank, Tamworth City Collection, Uni. of Newcastle and many institutional and private collections in UK, Europe, Japan, Australia.
Bibliography *Artists & Galleries of Australia*, Max Germaine: Craftsman House 1990.

BEEVERS, Dianne VIC
Born Taree NSW 1946. Painter, teacher, curator, radio broadcaster.
Studies Dip. Art Ed. Nat. Art School, Newcastle 1964–67. Overseas study 1968, 86; taught art 1976–83; Founding Curator, Discovery Room, Museum of Vic. 1985–88.
Exhibitions Armstrong Gallery, Morpheth 1977, 78; Newcastle College of TAFE 1979; Lake Macquarie Community Gallery 1980, 82, 84; Qld and Canberra S of A Galleries 1984; New England Reg. Gallery 1984; Artspace, Sydney; Jam Factory, Adelaide, Albury Reg. Gallery 1985; ACCA Melb. 1985; Roar 2 and Reconnaissance, Melb. 1989; View Factory, Newcastle 1990.
Commissions History of Williamstown Mural 1985.
Represented Institutional and private collections in UK, Europe, India, USA, Australia.
Bibliography *Artists & Galleries of Australia*, Max Germaine: Craftsman House 1990.

BEIER, Georgina VIC
Born UK. Painter, muralist and sculptor.
Studies Art in UK and has travelled and worked in many countries; Now resident in Vic.
Exhibitions One-woman shows at Mbari Gallery, Ibadan Nigeria 1963; Mbari Mbayo Gallery, Oshogbo 1964; IMF Gallery, Washington DC 1974; Andris Lidums Gallery, Adelaide 1975; Gambamuno Gallery, Port Moresby 1976; Women's Art Society, Washington 1976; Holdsworth Gallery, Sydney 1977; Solidarited Gallery, Manila 1977; Gallery de Tastes, Melbourne 1978; Participated in Berliner Festwochen, Berlin 1964; Galerie Viruly, Amsterdam 1965; Neue Munchner Gallerie, Munich 1966; Gallerie der Oper, Ingolstadt 1967; University of PNG, Port Moresby 1969; Third Festival of the Arts, Ife 1970; Otis Art Institut, Los Angeles 1971; American University, Washington DC 1971; 'Artist from Around the World', New York 1971; Hood College, Maryland 1972; Goethe Institut, Nairobi 1972; Fifth Festival of Arts, Ife 1973; Solidarited Gallery, Manila 1974; Gambamuno Gallery, Port Moresby 1977.
Commissions Murals for the palace of the King of Otan, Western Nigeria; Murals for the palace of the King of Iddo Oshun, West Nigeria; Murals for Chief Ovia Idan's residence, Benin City Nigeria; Mosaic for the University of Ibadan, Oshogbo Nigeria; Murals for the Mbari Mbayo Art Gallery, Lagos Nigeria; Mosaic pavement, African studies residence,

University of Ife; Welded iron Sculpture, Vice-Chancellor's residence, University of Ife; Welded iron gates, Fry Drew and Atkinson Architects, Lagos Nigeria; 36-foot-high welded iron sculpture for Institut of African Studies, University of Ife; Welded iron gates and mural, Institut of Papua New Guinea Studies, Port Moresby.

Bibliography *Georgina Beier*, Monograph for Washington exhibition, Jean Kennedy 1976; *Gebrauchsgrafik*, Munich 1972, and *Georgina Beier and Papau Pocket Poets*, essay on Georgina Beier's graphic work, Walter Plata; *Aboriginal Mith in Nigeria*, anon; *Jedermann in Oshogbo*, special issue of Tendenzen 1967, Munich, David Walters; *Experimental Art School*, Nigeria magazine number 86, 1963, Ulli Beier; *Contemporary Art in Africa*, Ulli Beier, Pall Mall, London 1968, and Praeger, New York 1968; *Modern Images From Niugini*, Georgina Beier, Jacaranda Press 1974.

BELL, Heather QLD
Born Wagga NSW, 1936. Realist painter in watercolour and teacher. Member AWI.
Studies East Sydney T.C., Fellow, RSASA, Adelaide.
Exhibitions Numerous solo shows since 1970 and recently at Old Brewery Gallery, Wagga 1980, 81, 82, 84, 85, 86, 88; Gallery 460, Gosford 1983, 85, 89; Greenhill Galleries, Adelaide 1988, 91; Kenthurst Galleries, Sydney 1989–90; Schubert Gallery, Qld 1990; Hamilton Regional Gallery, Vic. 1986; Studio Z, Adelaide 1987; Barry Newton Gallery 1987; Riverina Galleries, Wagga 1989, 90, 91; Griffith Park Galleries, Gold Coast 1990; Greenhill Galleries, Perth 1991; and many group shows.
Awards Has won many prizes at local shows, and received commissions from Rheem Ltd. HMAS Watson-RAN and Harpers Magazine, UK.
Represented Institutional and private collections in UK, Europe, Australia.

BELL, Margaret VIC
Born Melbourne Vic 1949. Painter, sculptor and teacher.
Studies Preston Institute of Technology and Prahran College of Advanced Education 1967–70; Lived and worked in London and travelled Far East 1971; Taught at Teachers Training College Hawthorn, and Fawkner Technical School 1972; Swinburne Technical School, Hawthorn 1973–75.
Exhibitions and Awards Student exhibition, Ewing and George Paton Gallery, Melbourne 1970; Exhibited in London 1971; Exhibited Sculpturescape 'The Garden', Mildura 1975; In 1976 — Received Special Project Grant from Visual Arts Board; Three-woman show, Ewing and George Paton Gallery, Melbourne; 'The Drawing Show', Institute of Modern Art, Brisbane; 'Conservation and Environment' Show, Mornington Regional Art Gallery; In 1977 — Received second Special Project Grant from Visual Arts Board; 'Money Show', Ewing and George Paton Gallery, Melbourne; Invitation show, Parnell de Gruchy, IMA Brisbane; Women's Show, Experimental Arts Foundation, Adelaide; Portrait Show, Ewing and George Paton Gallery, Melbourne; In 1978 — Mildura Sculpturescape; 'Map Show', Ewing and George Paton Gallery, Melbourne; RMIT Benefit Exhibition, Paraphernalia Gallery, Melbourne; Artists in Schools Project, Australia Council to the Arts; Two lectures, Preston Institute.
Represented Private and institutional collections in Australia and overseas.
Publications *Three Statements on Environment* 1976; *Women's Art Forum* magazine 1978; *Women's Show* Adelaide magazine 1977; Mildura Triennale Catalogues 1975–78; *Post Object Art,* Noel Sheridan.

BELL, Roberta NSW
Born Sydney NSW. Semi-abstract painter in oil, watercolour, shellac; Gallery owner.
Studies East Sydney Technical College — Diploma of Design (Hons); Taught at ESTC Design School in the 1950s with Phyllis Shillito; Foundation member of Society of Interior Designers NSW.

Exhibitions Participated in shows at Bonython and Greenhill Galleries, SA.
Awards Australian Watercolour Institute prize.
Represented Private collections in Australia and overseas.

BELL, Sue NSW
Born Sydney 1941. Figurative painter in all media, teacher.
Studies Under Brian Blanchard and Greg Turner.
Awards Hastings Heritage Award 1986; Macquarie Prize, Sect. 4 and Lassiandra Festival
WC Prize 1988.

BELLETTE, Jean Mary MAJORCA
Born Hobart Tas 1919. Painter of landscapes and still life, many in neo-classical style, most-
ly in oil.
Studies Hobart Technical College under Emile Deschaineaux and Mildred Lovett; Julian
Ashton School under Adelaide Perry and Thea Proctor; The Westminster Art School,
London under Bernard Meninsky and Mark Gertler; Returned to Sydney in 1939 where she
became a leader in the art world with her husband, Paul Haefliger before departing to live in
Majorca in 1957; Many of her Spanish-inspired landscapes and still lifes were exhibited in
Australia in the 1960s.
Exhibitions Numerous one-woman and group shows at the Australian and South Yarra
Galleries, Melbourne and the Macquarie Galleries, Darlinghurst Galleries and Holdsworth
Galleries, Sydney; Her work was included in Arts Council of Great Britain exhibition at
New Burlington Galleries, London 1953; Following the death of her husband in March
1982 she visited Australia for his retrospective exhibition at Holdsworth Galleries, Sydney
in 1983.
Awards Sulman Prize 1942, 1944; Metro-Goldwyn-Mayer Prize 1952; Second Prize,
Jubilee Art Competition 1951; Bathurst Prize 1951; Second Prize, Georges Invitation Art
Prize 1965.
Represented National Collections, Canberra; State Galleries of NSW, Vic, SA, WA;
Regional galleries in Newcastle, Bendigo, Geelong; Private collections in Australia and
overseas.
Bibliography *Australian Painting 1788–1970,* Bernard Smith, Oxford University Press
1974; *The Art of Jean Bellette,* Dr Ursula Hoff; *Meanjin,* Volume 1/4, 1952; *Encyclopedia of
Australian Art,* McCulloch, Hutchinson 1977; *Australian Women Artists 1840–1940,* Janine
Burke: Greenhouse 1980. (Died Majorca, Spain 16th March 1991)

BELLISS, Isabel Esther NSW
Born Masterton NZ 1926. Painter, sculptor, teacher.
Studies Wellington TC. Ealing School of Art and Hornsey School of Art, London UK grad-
uating with Diploma of Art and Design 1948–50; Taught in New Zealand in 1952 and
moved to Sydney in 1959 for further studies with a stone mason and a teaching job at Sacred
Heart Convent, Rose Bay until 1967 when she started work as a full-time sculptor and
studied at the Julian Ashton School.
Exhibitions Many shows include Society of Sculptors; Mildura Triennials and recently at
Masteron Art Centre NZ 1991.
Awards Rockdale Sculpture Prize 1963.
Commissions Many works in bronze and stone around Australia, NZ and UK, for full list
refer bibliography.
Bibliography *Australian Sculptors,* Ken Scarlett, Nelson 1980.

BEN-MEIR, Judy VIC
Born Manchester UK 1939. Sculptor and ballerina.
Studies Graduated in Fine Art from RMIT.

Exhibitions Solo show Melbourne 1991.
Bibliography *Alice 125*; Gryphon Gallery, University of Melbourne 1990.

BENNETT, Anne VIC
Born Melb. 1962. Painter and teacher.
Studies BA (Painting) RMIT 1981–83; M. Fine Art (Painting) University of Tas. 1985–86;
Part-time tutor at Northern Metropolitan College of TAFE Melb. 1990–91.
Exhibitions Solo shows at Centre for the Arts, Hobart 1986; Tolarno Gallery, Melbourne
1988; Pinacotheca Gallery 1991. Group shows include RMIT 1983, 84; Swan Hill
Regional Gallery 1984; Tolarno Gallery 1987; Blaxland Gallery 1990.
Awards VA/CB Desiderius Orban Award 1987.
Represented NGV; institutional and private collections.

BENNETT, Barbara WA
Born Singapore 1948. Printmaker.
Studies Dip. Printmaking, Perth TC.
Exhibitions Solo show at Vancouver Arts Centre, WA 1988; numerous group shows.
Awards Graigie Prize 1982; RAS Purchase 1983, 84; Haese Prize 1987.
Bibliography *PCA Directory* 1988.

BENNETT, Jane NSW
Born Sydney 1960. Painter and teacher.
Studies Alexander Mackie CAE — Dip. FA 1979–81; City Art Institute — Grad. Dip. Art
Studies 1982; Teaching art Hornsby Evening College 1987–89.
Exhibitions Solo shows at Blaxland Gallery 1986; von Bertouch Galleries, Newcastle 1987.
Access Gallery, Sydney 1989 Group shows include MPAC 1986; Hogarth Galleries 1986;
Painters Gallery and Access Gallery 1988.
Awards Pring Prize 1990.
Represented Institutional and private collections.

BENNETT, Joanne VIC
Born Melbourne 1959. Painter.
Studies BA Fine Art (Painting) RMIT 1980.
Exhibitions Solo show at Access Studio Gallery 1983; numerous group shows.
Represented Municipal, institutional and private collections.
Bibliography *150 Women Artists*; Visual Arts Board/Womens Art Movement, Melbourne
1988.

BENNETT, Portia M. WA
Born Balmain NSW 1898. Traditional painter of landscapes, still life, wildflowers in oil and
watercolour.
Studies Under Horace Moore-Jones and at the Royal Art Society, Sydney with Dattilo
Rubbo 1913–14; Sydney Teachers College, Sydney 1915–19 and a short period at the Julian
Ashton School, Sydney.
Exhibitions One-woman show at Cremorne Gallery, Perth 1972; Participated in many
group shows over the years; First exhibited with the Sydney Society of Artists in 1918;
Joined with Rah Fizelle for a joint showing at Anthony Hordern's Gallery, Sydney 1925;
Included in the Sydney 'Australian Women Painters' Exhibition and had a joint exhibition
in Perth with Muriel Southern, F.V. Hall and Margaret Johnson; A constant exhibitor with
the Perth Society of Artists.
Awards Hotchin Prize for Watercolour 1952.
Represented Art Gallery of WA; University of Sydney; Northam Municipal Collection;
WA; Australian National Gallery, Canberra (silk fan); Private collections in all states. (Died

BENOIT, Margaret WA
Born Sydney NSW 1941. Realist painter in oil and watercolour.
Studies No formal art training; Won numerous art prizes at school and the Sydney *Sun Herald* art contest in 1956 which won her a trip to the Olympic Games; Worked in commercial advertising and art for some years and lived in Belgium with her husband and two children 1972–75.
Exhibitions First one-woman show in Perth 1976 and the second in 1977; Earl Gallery Geelong, Vic 1987; Fremantle Arts Centre 1988.
Awards Busselton Purchase Prize (watercolour) 1976 and Wongon Hills Art Prize 1977; Has been commissioned to paint portraits of a number of civic and academic figures in Perth.
Represented Mitsui Corporation, Japan; Municipal and institutional collections in Australia and overseas.
Bibliography *Artists & Galleries of Australia*, Max Germaine: Craftsman House 1990; *Australian Impressionist & Realist Artists*, Tom Roberts: Graphic Management Services, Melbourne 1990.

BENTATA, Esther SA
Born Egypt 1913. Ceramic artist.
Studies Fine art, crafts and ceramics at SA School of Art 1959–67; Fellow of Royal SA Society of Arts.
Exhibitions Her work was included in Australia Ceramics Exhibition touring all states 1974, 1976.
Awards Won SA Potters Club First Acquisitive Prize 1974.
Represented Art Gallery of SA.

BENWELL, Margaret (Meg) VIC
Born Melbourne 1925. Painter.
Studies National Gallery School, Melbourne and studied with George Bell in the late 1950's. Member, Womens Art Register.
Exhibitions Numerous solo shows since 1950 include Munster Arms Gallery 1970; Drummond Street Gallery 1982; Distelfink Gallery 1984, 86, 88; Rathdowne Street Gallery 1990.
Bibliography *Encyclopedia of Australian Art*, Alan McCulloch, Hutchinson First Edition 1967.

BERGER, Kirsti VIC
Born Tampere Finland 1947. Painter, textile designer, arrived Australia 1958.
Studies Completed Higher Diploma of Teaching (art and craft) at Melbourne State College 1975.
Exhibitions Solo shows at Manyung, Bartoni and Gallery 33 galleries; Participated in the Mornington Rotary Exhibition, Melbourne.

BERKMAN, Christine QLD
Born Brisbane 1939. Painter, printmaker, theatre set designer.
Studies Central TC, Brisbane; RMIT and completed Dip. Art at Caulfield IT; Studied overseas 1972;. Artist-in-Residence, Victorian Tapestry Workshop 1982.
Exhibitions First solo show at Argus Gallery 1966; Ray Hughes Gallery 1976, 80; Niagara Galleries 1982, 84, 87; Numerous group shows include Kyneton Art Gallery 1974, 77; George Paton Gallery 1979; Golden Age Gallery, Ballarat 1983; AVAGO Gallery, Sydney 1983.
Awards VAB Grants 1977, 81.
Represented NGV; Artbank; institutional and private collections in Australia and

overseas.

BERKOWITZ, Lauren VIC
Born Melbourne 1965. Sculptor, painter.
Studies BA Fine Arts (Sculpture), RMIT 1983–85; Grad. Dip. Fine Arts (Sculpture) VCA 1988–89.
Exhibitions Solo shows at Realities, Melbourne 1988, 90; Heide – Ministry of the Arts, Melbourne 1990; Numerous group shows include ROAR Studios 1985; Westpac Gallery 1987; Charles Nodrum Gallery 1987, 88; NGV 1988; Heide Park & Art Gallery 1989; University of Melbourne 1989; ICI Touring Exhibition 1989–91; Realities 1990; Blaxland Gallery, Melbourne 1990; Linden Gallery 1990; Deutscher Brunswick St. 1990.
Awards David Rosenthal Prize, VCA 1988; VA/CB Grant 1990; commissioned sculpture for Tract Consultants, Melbourne 1986.
Represented Institutional and private collections.

BERNDT, Eileen NSW
Born Melbourne Vic 1910. Painter in oil and watercolour, linocuts.
Studies Julian Ashton School and with Grace Crowley; Central School of Arts, London UK; Study tour to UK, Europe 1973; Honorary Life Member of AWI.
Exhibitions Has shown in all capital cities over the years and recently with the AWI and Beth Mayne Studio Gallery, Sydney.
Represented Watercolour in Art Gallery of NSW and etching in National Gallery, Canberra.

BEST, Helen NSW
Born Condobolin NSW. Printmaker.
Studies Serigraphy with Finn Thorwaldson, Workshop Arts Centre, Willoughby NSW 1966; Drawing with Isabel Irvine and lithography with Sue Buckley 1969.
Exhibitions Regularly with Print Circle and Sydney Printmakers 1970 – 90; Casey Gallery, Sydney 1988.
Awards Lane Cove 1972–76; Boggabri 1977.
Bibliography *PCA Directory* 1988.

BEUKENKAMP, Frieda TAS
Born Amsterdam 1947. Painter and printmaker.
Exhibitions Cockatoo Gallery, Launceston, Tas.

BEUMER, Lois (Howden) QLD
Born Melb. 1932. Painter, portraitist, potter, teacher.
Studies Diploma of Art, Swinburne Technical College 1948–1951; Diploma of Art (Pottery) Swinburne Technical College 1952; Part-time teacher at Swinburne 1961–1963; Commercial Artist until 1982 then specialising in watercolour and teaching. Founder President of the Watercolour Society of Queensland, Member of the RQAS, WSQ, SCAG, and Friend of the Royal Society of Painters in Watercolour (London).
Exhibitions Solo shows at RQAS and other venues.
Awards McArthur Park WC 1983, 84; Nambour Open 1983, WC 1985, 87, 88, Peoples Choice 1988; Yandina Ginger 1988.
Represented Municipal institutional and private collections in UK, Europe, NZ, Australia.

BEZOR, Annette Thea SA
Born Adelaide SA 1950. Contemporary painter in oil and pastel, teacher.
Studies Diploma of Fine Art (painting) from SA School of Art 1974–77; Co-founder of Roundspace Artists Collective 1978; Travelled Europe and Israel 1979; Part-time teaching

at Centre for the Performing Arts and Hartley CAE 1981–82; In residence Power Studio, Cité International des Arts, Paris 1986–87.

Exhibitions Solo shows at Roundspace Gallery 1981; SA School of Art Gallery 1986; Fine Arts Centre University Centre, Hobart; Roslyn Oxley9 Gallery, Sydney 1986, 87, 88, 90; Experimental Art Foundation, Adelaide 1990. Important group shows include Australian Perspecta 1981; Biennale of Sydney 1984; Macquarie Galleries, Sydney 1985; Broken Hill and Mt. Gambier SA 1987; CAC of SA 1988; AGNSW 1989; The Art Gallery, Melb. 1989; S.H. Erwin Gallery, Sydney 1989; Lake Macquarie Gallery 1990.

Awards and Commissions Power Studio, Paris 1986–87; Co-winner Maude Vizard Wholohan Prize, Art Gallery of SA, 1980; VAB Grant 1982; Commission, two paintings for Adelaide Law Courts Foyer; SA Dept. of the Arts Grants 1988, 89.

Represented NGV, AGSA, AGNSW, Artbank, Regional Galleries and Private Collections.

Bibliography *Artists & Galleries of Australia*, Max Germaine: Craftsman House 1990.

BIAGIONI, Roma WA
Born Cue, WA 1936. Painter and teacher.

Studies Lived in Tuscany, Italy 1940–50. Part-time student; Diploma in Art Studies, Midland Technical College, Forrestfield Technical College 1980; Currently teaching Design at Forrestfield TC.

Exhibitions Solo shows at Stafford Studios, Cottesloe WA 1989; Kensington Gallery, Adelaide 1991. Numerous group shows since 1985.

Awards Forrestfield Drawing 1984, 85, 86; Bruce Marshall Prize; Kalamunda Shire Prize 1986. Several painting commissions in Europe and Australia.

Represented Institutional and private collections in Europe and Australia.

BIERENBROODSPOT, Pam (Mai) VIC
Born Geelong, Vic. 1933. Painter.

Studies Privately with Don Rogers, David Taylor and Carol Boothman. Foundation member of Waverley Art Society; member VAS.

Exhibitions VAS, Melb.; Five Ways Gallery, Vic 1989.

Represented Australian and overseas collections.

BIERZYNSKI, Annie (Freedman) NSW
Born Grenada, West Indies 1956. Arrived Australia 1977. Painter and teacher.

Studies Sorbonne University, Paris 1976–77; ESTC 1979; BA (Visual Arts) CAI 1980–82, Grad. Dip. Ed. 1984; Grad. Dip. Professional Art Studies, CAI 1987–88. Has taught at Patrician Brothers College, Fairfield since 1985.

Exhibitions Solo show at Arthaus, Sydney 1982.

BIESUZ, Bianca VIC
Born Feltre Northern Italy 1947, arrived Australia 1953. Naive painter; Paints on commission in Gippsland Vic.

Represented Australia, Scotland, Italy, Holland, Sweden.

BIEZAITIS, Margarita SA
Born Latvia 1921. Painter, printmaker and teacher, arrived Australia 1949.

Studies Early art studies in Latvia and Germany and later at the SA School of Art; Has taught art since 1956 at Western Teachers College and later at the Torrens CAE; A member of the Royal SA Society of Arts.

Exhibitions Latvian Art Festivals; Adelaide Festival of Arts and regular exhibitor at RSASA shows.

Bibliography *Latvian Artists in Australia*, Society of Latvian Artists ALMA 1979.

BINNS, Vivienne NSW
Born Wyong NSW 1940. Painter, printmaker, enamellist and jeweller, teacher.
Studies Completed Diploma in Painting and Drawing at National Art School, Sydney 1962; One-year television course at Gore Hill Technical College 1969; Taught art and enamelling in Sydney from 1973.
Exhibitions Paintings at group shows in Sydney, Melbourne, Canberra 1962, 1967; Solo show, Watters Gallery, Sydney 1967; 'From the Funk Tradition', Watters Gallery, Sydney 1977; Shows at environmental lightshow *Woom* with Ellis D. Fogg, Watters Gallery 1971; In 1972, Environment HTCT with Tim Burns at Steven Roberts Theatre, Sydney University; *The Jo Bonomo Story — A Show of Strength,* a group happening at Watters Gallery; *See That My Grave's Kept Green,* an evening of song at Watters Gallery; *The Quick Brown Fox Jumps over the Quick Brown* performance with Aleks Danko and Mark Underwood, Macquarie University 1974; Vitreous enamels at Exhibitions 'Funky Enamels' at Watters Gallery 1971; 'Enamel Panels' at Raffins Gallery, Orange NSW; 'Enamel Panels' at University of Tas 1973; Exhibitions of silkscreened enamel panels with Marie McMahon at Watters Gallery, Sydney, Ewing Gallery, Melbourne and Fantasia Gallery, Canberra 1976; Australian Perspecta 1981 — Art Gallery of NSW; ICA and Serpentine Galleries, London UK 1982; Biennale of Sydney 1982. Recent solo shows at Watters Gallery 1985, 87, 88, 89; Bellas Gallery, Brisbane 1988; participated Uni. Art Museum, Qld. 1985; ANG, Canberra 1985–86; MOA, Brisbane 1987; David Jones' Gallery, Sydney, First Australian Contemporary Art Fair Melb. and The Max Watters Collection, Musewellbrook Art Gallery 1988.
Awards Artist-in-community in central western region of NSW covering 50 towns; Awarded OAM for services to the arts 1983; Australian Artists Creative Fellowship 1990.
Commissions Tectural, decorative enamel plaques, Neutral Bay Synagogue 1971; Copper wall, 110 Pacific Highway, North Sydney 1972; Enamel plaques, Lakeside Motel, Canberra 1972; Copper wall, Australian Securities Limited building, 167 Clarence Street, Sydney 1973; Enamel wall motif, 38 Oxley Street, Crows Nest 1972, 1973. Australian Artists Creative Fellowship 1990.
Represented ANG, Qld Uni. Art Museum, MCA, Brisbane, Benalla Art Gallery and private collections around Australia.
Bibliography *Vivienne Binns,* Ann Berriman; *Craft Australia,* No 3 1980; Catalogues, *Australia Perspecta* 1981, Art Gallery of NSW and Biennale of Sydney 1982; *New Art Two*: Craftsman House: Nevill Drury 1988; *Artists & Galleries of Australia*, Max Germaine: Craftsman House 1990.

BIRD, Eileen and June NT
Emerging Aboriginal batik painters from the Utopia Station region, the traditional home of the Anmatyerre and Alyawarre peoples 240 kms NE of Alice Springs.
Exhibitions Bloomfield Galleries, Sydney 1989; Coventry Gallery 1989.

BISCHOFF, Robyn WA
Born Kellerberrin WA 1943. Painter and ceramic artist.
Studies Mostly self-taught in painting and ceramics but some study with John Ogburn 1964, Kristen Berge Group, Kensington UK 1967–68 and Craig Gough Workshop at Fremantle Arts Centre 1977; Relief lecturer, Burbury Technical College 1980–83; Lecturer, Busselton Technical College 1983.
Exhibitions One-woman show in Munich West Germany 1968; Participated in many group shows in Whyalla SA, Rockhampton Qld and Bunbury area 1974–83, Delaney Gallery, Perth 1989.
Awards Portrait Prizes, Harvey WA 1978–79; Manjimup WA 1982.

BISHOP, Olive SA
Born Melbourne Vic 1941. Ceramic artist; Married to artist Tony Bishop.

Studies SA School of Arts but mostly self-taught.

Exhibitions Major show at Ray Hughes Gallery, Brisbane; Faenze Italy 1978 and the Sydney Biennale 1979.

Represented The Australian War Memorial, Canberra; State Galleries of Vic and SA; Private and institutional collections in Australia and overseas.

BLACK, Antonia UK

Born Perth WA 1938. Watercolour painter and teacher.

Studies ESTC 1956–59; Slade School of Fine Art, London 1961–65; has taught art in various schools and colleges in UK, USA and Majorca since 1966.

Exhibitions Numerous solo shows in UK and USA since 1978; has participated regularly in group shows which include The Royal Academy, London; The Australian Embassy, Washington DC and leading galleries; also shows periodically with her local agent Robin Gibson Gallery, Sydney.

Awards Sydney WC 1958; London WC 1972; Royal Academy 1986, 88; British America Tobacco Prize 1987.

Represented Corporate, institutional and private collections in UK, Europe, USA and Australia.

BLACK, Sandra WA

Born Bairnsdale, Vic. 1950. Potter, teacher.

Studies Assoicateship in Art Teaching, WAIT. Part-time lecturer Canberra S of A, and ANU Student Guild 1982. Member VA & Crafts Panel, WA Dept for the Arts 1987; attended 1st International Ceramics Symposium Canberra S of A 1988.

Exhibitions FAC 1981, 88; Jam Factory, Adelaide 1985; Potters Gallery, Brisbane 1986.

Awards WA Arts Council Travel 1978; Lambert Old Bakery, Sydney 1987; Fletcher Challenge NZ 1988.

Represented NGV, AGWA, Crafts Board Aust. many institutional and private collections around Australia.

BLACK, Sue NSW

Born NSW 1941. Printmaker.

Studies National Art School, Canberra; Orban School, Sydney and Workshop Art Centre, Willoughby NSW, Member of the Nine Sydney Printmakers Group.

Exhibitions Sydney Printmakers 1970–75; Mosman Gallery 1975.

Awards Berrima 1970, Yass 1971, Cowra 1972, Ryde 1974, Canberra and Mosman 1975, Hornsby 1976.

Bibliography *PCA Directory* 1988.

BLACK, Wendy VIC

Born Macarthur, Vic. 1954. Printmaker.

Studies RMIT 1972–75. Artist-in-Residence RMIT Union 1979 and Brunswick Work Co-op. 1983–85.

Exhibitions Ewing Gallery 1980; Geo. Paton Gallery 1982; RMIT Gallery 1981.

Bibliography *PCA Directory* 1988.

BLACKBURN, Vera UK

Born Sydney NSW 1911. Painter and printmaker.

Studies Sydney University and with Adelaide Perry in the 1920s; Westminster Art School, London 1934–35.

Exhibitions With Society of Artists exhibitions in Sydney 1934, 1936; Lives in UK.

Bibliography *A Survey of Australian Relief Prints 1900–1950*, Deutscher Galleries, Melbourne 1978.

BLACKER, Miriam NSW
Born Sydney NSW 1921. Printmaker.
Studies Lithography at Workshop Art Centre, Willoughby NSW 1967–71 and 1971–74;
Exhibits with Print Circle and Print Council of Australia shows.
Bibliography *Directory of Australian Printmakers 1976.*

BLACKSTOCK, Heather QLD
Painter and teacher.
Studies Associate Diploma in Creative Arts, Goulburn CAE 1978–81. Numerous summer
and winter schools and courses since 1965. Exhibiting member of RAS of NSW and
Watercolour Society, Brisbane.
Exhibitions Has shown widely in country areas since 1966 and won a number of prizes and
taught art part-time.

BLAKE, Kerry NSW
Born Bulli NSW 1959. Painter, printmaker.
Studies HAC–ESTC 1980–82.
Exhibitions Numerous group shows since 1982 and recently at AGNSW 1986, 87;
Blaxland Gallery 1987, 88; Nicholson St. Gallery 1987; Holdsworth Contemporary Gallery
1988; Rex Irwin – Faber Castell 1988; Eddie Glastra Gallery 1991.
Awards Goulburn Art Prize 1982; MBA Bicentennial Award 1988.
Represented IBM, Ord Minnett, and private and corporate collections.

BLAKE-LANE, Patricia Moyle QLD
Born Orange NSW 1925. Realist painter of landscapes and portraits.
Studies Shirley Bourne at Malvern Artists Society and privately with Alfred Calkeon;
Member of Royal Qld Art Society.
Exhibitions One-woman shows at Bank of Adelaide, Melbourne, 1973; Clive Parry
Galleries, Melbourne; Also shows with Verlie Just Town Gallery, Brisbane.
Awards VAS Melbourne; Malvern Artists Society.
Represented Artbank and institutional and private collections.

BLAXLAND, Barbara NSW
Born NSW 1934. Ceramic artist; Teacher.
Studies National Art School, Newcastle NSW; Newcastle College of Advanced Education,
Graduate Diploma in Art (ceramics) 1983; Contributes to Pottery in Australia Magazine.
Exhibitions One-woman shows at Cooks Hill Gallery, Newcastle 1972, 1984; Hayloft
Gallery Bathurst 1974; Group exhibitions, Newcastle City Art Gallery; Maitland City Art
Gallery; Pottery Society of Australia; Palazzo delle Marifestazioni — Accademia Italia,
Parma, Italy.
Awards 1980 'Academic of Italy with Gold Medal'; 1982 Diploma of Merit, from
Accademia Italia, Italy.
Represented Newcastle City Art Gallery; Private collections in Australia and overseas;
International Museum of Ceramics, Faenza Italy; Palazzo delle Manifestazioni Accedemia
Italia, Parma Italy.
Bibliography International *Who's Who in Art and Antiques*, Cambridge 1967.

BLENSDORF, Jan VIC
Born Melbourne Vic 1948. Painter, illustrator, weaver, soft sculptor, teacher.
Studies In UK and Europe 1972–76. With Mirka Mora 1977–78 and at Gippsland
Institute of Advanced Education 1979; Taught at Atlantic Art Centre and Gallery, Bruton,
Somerset UK and for the local education authority UK.

Exhibitions Atlantic Art Centre, Somerset UK; Dove Centre, Glastonbury UK 1975; Van Jager Gallery, Kew Vic 1978; Distelfink Gallery, Melbourne 1980; Profile Gallery, Melbourne 1981, 1982; Australian Galleries, Melbourne 1983.

Publications *Where Stars Grow*, a book for children by Jan Blensdorf, Oxford University Press, Melboure 1983.

BLIN, Rene QLD

Sculptor and teacher.

Studies Melbourne Teachers College 1960–63; State College 1973, 76–77. Overseas study in UK, Europe, USA 1968–72, 78–79. Has taught art widely since 1964.

Exhibitions Solo shows at Leveson Gallery, Melbourne 1981; Qld College of Art 1985; Centre Gallery, Gold Coast 1988; Noosa Regional Gallery 1991. Numerous group shows include Gryphon Gallery, Melbourne 1980, 82; Milburn Galleries 1982; QAG 1982; Noosa Regional 1983, 86, 88; Martin Gallery, Townsville 1984.

Represented Institutional and private collections in Australia and overseas.

BLIZZARD, Liz VIC

Born Murchison Vic. Expressionist-figurative painter in oil and acrylic.

Studies Prahran Technical College 1964–65; Ballarat CAE 1968–69.

Exhibitions One-woman show at Golden Age Gallery, Ballarat Vic 1982; Participated at Gallery 99, Princes Hill Gallery, Melbourne 1969 and Manuka Gallery, ACT 1969.

BLONSKI, Jeannette VIC

Painter photographer.

Exhibitions With Annette Fenelon, the A/A/A Show at National Gallery of Vic 1982.

Bibliography *Apt/Appropriate/Appropriations,* Lip, Issue No 7, 1982–83.

BOAG, Yvonne NSW

Born Glasgow Scotland 1954, arrived Australia 1964. Painter, printmaker, teacher.

Studies Graduated with Diploma of Fine Art (printmaking) from SA School of Art 1977; Overseas study tour 1983; part-time teacher at City Art Institute 1986–88 and Nepean CAE 1987–90; Artist-in-Residence, Aberdeen Art Gallery, Scotland 1989; Resident, Cité Internationale des Arts Studio, Paris, 1990; part-time lecturer, University of Sydney and Western Sydney 1991–.

Exhibitions Solo show at Golden Age Gallery, Ballarat 1982; Niagara Gallery, Melb. 1985, 87, 90; Tynte Gallery, Adelaide 1985; Works Gallery, Geelong 1986; Aberdeen Art Gallery, Scotland 1989; Gallery Tamura, Tokyo 1990; Tynte Gallery, Adelaide 1991; Numerous group shows since 1977 include AGSA 1981; ROAR Studios 1984; Moët & Chandon Touring Exhibition 1987; 70 Arden St. 1988; Galerie Ann Gregory 1988; Hill Smith Gallery 1990; Niagara Gallery 1990; Wagga Wagga Regional Gallery 1991.

Awards Cité Internationale des Arts Studio, Paris 1989; Aberdeen Art Gallery Studio 1988; Australia-Japan Foundation 1990.

Represented ANG; Artbank; institutional and private collections in Australia and overseas.

Bibliography *PCA Directory* 1988; *Artists & Galleries of Australia*, Max Germaine: Craftsman House 1990.

BOCKNER, Claire SA

Born London UK 1952. Photographer and horticulturalist.

Studies Arrived Australia 1982; Assoc. Dip. Arts (Photostudies); SACAE 1986–89; Member, RSASA and SA Centre for Photography.

Exhibitions Solo shows at Adelaide Botanic Gardens 1988; Living Arts Centre 1986; Art Zone 1987; Prospect Gallery 1990; Numerous group shows.

Represented Private collections around Australia.

BODDY, Janet R. VIC

Born Melbourne Vic 1935. Abstract painter in oil, acrylic, pastel, tempera; Printmaker, teacher.

Studies Informal; National Gallery School; Swinburne TC; Gordon Institute, Geelong; Senior art mistress, Morongo Presbyterian Girls School, Geelong for three years; Private teaching studio with Laurie Paul on the Gold Coast Qld for three years; Painting full-time since 1969.

Exhibitions Has had more than twenty solo shows since 1965 including Bartoni Gallery; Hawthorn City Art Gallery; Eltham Gallery, Vic; Strawberry Hill Gallery, Sydney; Bistro Gallery, Hobart; Design Art Centre and Gold Coast Art Gallery, Qld; Participated in numerous group shows and competitions and *New Generation Victorians* at Mornington Peninsula Art Gallery 1976. Roar II Gallery, Melb. 1985 also Eltham Art Awards 1986, 87, 88, 89; Diamond Valley Art Awards 1987.

Awards Bundaberg Art Society Watercolour 1969; Caltex Warana Contemporary 1969; University of Tas Union Contemporary (acquisitive) 1971; Royal Overseas League represented as Australian Prizewinner at Commonwealth Exhibition in London 1972; Doncaster Templestowe Contemporary 1974, Eltham Art Award 1989.

Represented Allegheny College, Meadville Pennsylvania; University of Oregon; University of Tas; Royal Overseas League, London; Private collections in Australia and overseas.

Bibliography *Encyclopedia of Australian Art*, Alan McCulloch: Hutchinson 1968; *Artists & Galleries of Australia*, Max Germaine: Craftsman House 1990.

BODEN, Anthea TAS

Born Hobart 1950. Semi-abstract painter in oil, gouache, silkscreen teacher.

Studies Hobart School of Art 1967; Obama Art Colony, Japan 1975; printmaking, Devonport Tech. College 1979. Study tour Japan, Europe, UK. 1975–76; Taught part-time Cottage School, Bellerive 1984. Sister of artist Richard Boden.

Exhibitions Cincinnatti, USA 1972; Salamanca Place Gallery, Hobart 1972; with Adam Rish, Secheron House. Hobart 1975; A & R Boden, The Studio, Hobart 1977–80. Numerous groups shows since 1971, including the Long Gallery, Hobart 1983.

Awards Uni. of Tas. Art Union Prize 1970.

Represented Private collections in USA, Japan and Aust.

Bibliography *Tasmanian Artists of the 20th Century*, Sue Backhouse 1988.

BODEY, Elisabeth VIC

Born Rockhampton, Qld 1953. Painter, printmaker.

Studies Uni. of Qld. — BA Fine Arts 1971–75; RMIT — BA Painting and Printmaking 1983–85.

Exhibitions Solo shows at Collective Gallery, Melb. 1985; Girgis & Klym Gallery, Melb. 1988; Realities 1989, 90; Group shows include Realities 1987; *A New Generation 1983–88*, ANG Canberra 1988; RMIT 1988; Standfield Gallery, Melb. 1988.

Awards RMIT Scholarship 1986; study tour to Europe 1987.

Commissions Marac Merchant Bank 1985.

Represented Institutional and private collections in UK, Europe, Australia.

BOISSEVAIN, Rhoda (Heathcote) WA

Born UK. Painter of portraits, children and flowers.

Studies Privately under Archibald and Amalie Colquhoun in Melbourne.

Exhibitions Mostly works on commission but exhibited in New Delhi India 1945 and her portrait of 'Pamela Geroff' was seen in the Helena Rubinstein Competition in 1961.

Awards Portrait Prize, New Delhi 1945; Second Prize, Helena Rubinstein 1960.

Represented Many private and institutional collections in WA.

BOKO, Eileen NT
Born NT. Aboriginal painter in acrylic from the Yuendumu area NW of Alice Springs NT.
Exhibitions Anima Gallery, Adelaide 1988.
Bibliography *Artlink* Autumn/Winter 1990.

BOLTON, Margo QLD
Born Abermain NSW 1914. Printmaker.
Studies Workshop Art Centre, Willoughby NSW with Sue Buckley.
Exhibitions Has exhibited with the Print Circle Group and the Print Council of Australia in Sydney and Brisbane.
Represented Private collections in Australia.
Bibliography *Directory of Australian Printmakers 1976.*

BOMBACH, Bonney NSW
Born Melbourne Vic 1945. Contemporary painter in oil, watercolour, pastels, collage, mixed media, sculptor, teacher.
Studies BA and Dip. Social Studies from Uni. of Melb. 1963–66 and overseas travel 1968–74. Sculpture at Camden Institute, London UK 1970–73. Dip. Art from PIT, Melb. 1975–77; taught art 1978–80; overseas study Europe, USA, India 1983; Conducted workshops and taught in NSW 1980–87.
Exhibitions Solo shows at Footscray Arts Centre 1978; Pinacotheca 1979; Mori Gallery, Sydney 1983; Lismore Reg. Gallery 1984; Reconnaissance, Melb. 1989; participated in numerous group shows since 1979 and recently at Cape Gallery, Byron Bay NSW 1985; Gold Coast Qld 1986, 87; Lismore Reg. Gallery 1988, 89.
Awards Tweed Festival 1982, 84; Fairymount Festival, Kyogle 1984, 88; Ispwich Purchase 1984; Byron Bay 1985, 86, 88; Caloundra 1986; Trinity College, Lismore 1987; Southern Cross, Ballina 1987; Grafton 1987 (shared) Southport 1987; Murwillumbah 1988; Kyogle 1988. VACB Project Grant 1988.
Represented Institutional and private collections in UK, Europe, USA, India and Australia.
Bibliography *Artists & Galleries of Australia*, Max Germaine: Craftsman House 1990.

BONDS, Mary Elizabeth NSW
Born Geraldton WA 1927. Painter and teacher.
Studies Adult Education classes WA 1959–68; National Art School, Sydney 1974; Diploma of Art from Alexander Mackie CAE 1975–77; Dip Ed from Sydney Teachers College 1978–80.
Exhibitions Solo show at Claude Hotchin Gallery, WA 1967; Participated Perth Society of Artists 1967; Festival of Perth 1968; Cremorne Gallery, Perth 1967; Arts Council, Sydney 1970; Beth Mayne Studio Gallery, Balmain Art Gallery, Waverley-Woollahra Arts Centre, Sydney 1981–82.
Awards Guild Art Prize for Drawing, University of WA 1966.
Represented Institutional and private collections in WA, SA, NSW and overseas.

BONHAM, Gaye VIC
Born Coburg Vic 1942. Traditional painter in pastel and watercolour.
Studies Industrial chemistry at RMIT with a hankering for art; Later studied under Ramon Horsfield and Jack Montgomery and painted with the Ferntree Gully Art Society for six years; Taught at Sherbrooke Art Society night classes in 1972; In recent years has been painting with Vic Artists Society.
Exhibitions First one-woman show at 'The Hut' Ferntree Gully in 1968 followed by the AMP Building, Melbourne; Halmaag, Abercrombie, The Masters, and Macbonyng Galleries Vic.

Awards Keilor Art Festival (three times); Sunbury Municipal Award (twice); Royal Melbourne Show; Camberwell Rotary Art Show and St Kevin's College, Toorak; More recent awards for watercolours include Hoechst Art Prize 1980–81–82; Frankston Festival 1980; Geelong Art Society 1980; Kilmore 1980–81; Woodend 1980; Williamstown Festival 1981–82; Kew Rotary 1982; Chelsea and Brighton Art Shows 1982; Whittlesea Shire Show 1982.

Represented Municipal, school and private collections.

BORCHARDT, Janet VIC

Born NZ 1916. Traditional painter in oil and watercolour.

Studies Hobart School of Arts under Jack Carington Smith 1960; CAE Melbourne 1965–66; Vic Artists Society 1969.

Exhibitions La Trobe University 1975; ANZ Bank, Melbourne 1977; VAS 1981.

Awards Has won over sixteen awards including Diamond Valley 1977, 1980; Woodend 1977, 1979; Ivanhoe 1977; Flinders 1980.

Represented La Trobe University; Artbank and private collections in Australia and overseas.

BOREHAM, Lorraine NSW

Born 1934. Painter and sculptor.

Studies Diploma of Art from East Sydney Technical College 1957; Overseas study tour 1967; Work in Mildura Arts Centre Collection.

Bibliography *Australian Sculptors,* Ken Scarlett, Nelson 1980.

BORGELT, Marion NSW

Born Nhill, Vic. 1954. Painter.

Studies South Australian School of Art, Diploma of painting 1973–76; Underdale College, Adelaide, Diploma of Education 1977; New York Studio School, Postgraduate studies, New York 1979–80; Travel France, Italy, London, New York, India 1985, 86; Artist/Tutor-in-Residence, Canberra School of Art 1986.

Exhibitions Solo shows at Wattle Park, Adelaide 1976; Bonython Galleries, Adelaide 1978; David Reid Gallery, Sydney 1981; Axiom Gallery, Melb. 1982; Roslyn Oxley9 Gallery, Sydney 1982, 83, 85, 86, 88; Christine Abrahams Gallery, Melb. 1984, 86, 89; Michael Milburn, Brisbane 1986, 88. Many group shows since 1975 include Parsons School of Design, New York 1979; New York Studio School Galleries 1979, 1980; Fourth Biennale of Sydney 1982; Florence, Italy 1983; Venice & Zagreb 1985; Australian Perspecta 1985; Sixth Indian Triennale, New Delhi 1986; AGNSW 1989; Moët & Chandon Touring Exhibition 1987, 88, 90.

Awards Channel 10 Artist's Award, Adelaide 1975; Harry S. Gill Award, South Australian School of Art 1976; Peter Brown Memorial Travelling Art Scholarship, New York Studio School, New York 1978; Dyason Award for Postgraduate Study in the United States, 1979; Muswellbrook Drawing Prize, 1983; VAB Grant 1984; Faber Castell Prize 1988.

Represented NGV; AGWA, AGNSW, New Parliament Houses Collection, ACT, Artbank, Muswellbrook Regional Art Gallery.

Bibliography *Artists & Galleries of Australia*, Max Germaine: Craftsman House 1990.

BORLASE, Nancy NSW

Born NZ, arrived Australia 1937; Painter and art critic.

Studies Canterbury College School of Art under Francis Shurrock (part-time); Life drawing and sculpture at East Sydney Technical College under Frank Medworth and Lynden Dadswell 1937–40; Also life drawing under Rah Fizelle and Grace Crowley; Joined the Contemporary Art Society, NSW branch 1939; Active committee member of CAS 1952–70; Study tours USA 1956, 1960; Europe 1956, 1969, 1972, 1973; China 1976 as

one of three art writers; Art critic, the *Bulletin,* Sydney 1973–75 and *Sydney Morning Herald* from 1975–81.

Exhibitions Solo shows at Barry Stern's 1962; von Bertouch Galleries, Newcastle 1963; Macquarie Galleries, Sydney 1960, 1966, 1969, 1972; Participated in 'Fifteen Australians', New Vision Gallery, London 1960; 'Survey One' and 'Survey Three', Blaxland Gallery 1961, 1963; 'Sydney Contemporary Painters', Arts Council of Australia, Qld division 1961; Newcastle City Art Gallery 1962; Solo show at Barry Stern Galleries, Sydney 1983. Woolloomooloo Gallery 1986.

Awards Mosman Art Prize, NSW 1961; Berrima Art Prize, NSW 1967 (equal First with David Aspden); AM 1987.

Represented ANG, AGSA, AGNSW, New England AG, Wollongong City AG, Wagga Wagga AG, Newcastle City AG, institutional and private collections in Aust. and overseas.

Bibliography *John Reed's New Painting 1952–62,* Longman's The Arts in Australia series; *Encyclopedia of Australian Art,* McCulloch; *Australian Painting 1788–1960,* Bernard Smith.

BOS, Rosemarie VIC
Born Germany 1929. Painter of Australian landscapes and wildlife in oil.
Studies Trained as a commercial artist in Germany.
Exhibitions Several solo shows at Alice House Gallery, Croydon Vic.

BOSCH, Lillian QLD
Born Florida USA 1924. Painter, printmaker, craftswoman.
Studies Extensive art study and travel in Europe and USA between 1943 and 1965 which included University of Tampa, Forida USA 1949, 1959; Yale School of Arts 1962; Penland Craft School 1965; Further travels Israel, USA, South Africa, Europe, West Indies 1975.
Exhibitions Solo shows at Florida 1955; New York 1965; London UK 1965; Design Arts Centre, Brisbane 1970; Macquarie Galleries, ACT 1971; Schubert Galleries 1988, 90; Participated in Captain Cook Show, Qld Art Gallery 1970; McInnes Gallery, Brisbane 1981; RQAS 1983, 87; Gold Coast Arts Centre 1988, 89.
Awards International Craft Award 1971; Gold Coast Award 1971; Qld Art Gallery purchased tapestry *Sunscape* 1973; Tapestry hung in Australian Pavilion at International Exhibition, Washington DC 1974.
Bibliography *The Artist Craftsmen of Australia* 1972; *A Homage to Women Artists in Queensland*: The Centre Gallery, 1988.

BOSCOTT-RIGGS, Hilary QLD
Born Qld. Installation artist.
Exhibitions Institute of Modern Art, Brisbane 1979–80; Art Projects, Melbourne 1980.
Bibliography *Six Brisbane Artists, Art and Australia,* Vol 18 No 4.

BOSTOCK, Euphemia NSW
Born Tweed Heads, NSW. Aboriginal painter, sculptor, designer, printmaker. One of the founders of the Boomalli Aboriginal Arts Co-operative, Sydney.
Exhibitions Australian Perspecta 1989 — Artspace Gallery; Performance Space; Tin Sheds Gallery, Boomalli Aboriginal Artists Co-op 1988; Paris, France 1987; Worawa College, Melb. 1987; Artspace, Sydney 1984.

BOSTOCK, Tracey Linn NSW
Born Brisbane Qld 1961. Painter.
Studies No formal art training, mostly self-taught. Joined Boomalli Aboriginal Artist Co-operative in 1989.
Exhibitions Eora Centre, Redfern 1984; Boomalli Gallery 1989 (3); Emu Plains Regional Gallery 1990; Fischer Library, Sydney University 1991.

Commissions Eco Paper Designs 1990; Kuri Productions, designs 1990.

BOT, G.W. ACT
Born Quetta, Pakistan 1954. Printmaker and painter.
Studies BA at ANU, Canberra, printmaking at Studio One, Canberra and in the UK and Paris. Has exhibited in Canberra, Wagga Wagga and Melbourne, Kingston Art Space Gallery 1987; Woden Library 1988 and Dorette's 1988 and recently at Bondi Pavilion 1989; Ben Grady Gallery ACT 1989; aGOG, Jan Jones, Bowral; Studio One and Canberra Festival 1990; Jan Taylor Gallery, Sydney; Berrima Art Society and Canberra Festival 1991.
Represented ANG, Canberra, regional galleries and collections in Europe, USA, Australia.

BOTTRELL, Fay NSW
Born NSW. Artist, textile designer and teacher.
Studies Studied design at East Sydney Technical College and later worked as a teacher at Mary White's Design School; Has had wide teaching experience in NSW and was one of the first craftspeople invited to make up the original Crafts Board.
Bibliography *Craft Australia* 1978/4.

BOURKE, Nanette VIC
Born Plymouth UK 1927. Printmaker.
Studies Julian Ashton School, Sydney 1966–71; Melb. CAE 1973–74.
Exhibitions Ararat Reg. Gallery 1987; VAS 1973–84; Malvern Artists Society 1972–88.
Bibliography *PCA Directory* 1988.

BOURNE, Shirley VIC
Born Brisbane Qld 1924. Realist painter and portraitist in oil mostly, some watercolour.
Studies National Gallery Art Schools, Melbourne; Worked as assistant in William Dargie's studio for some years; Has travelled and painted in UK, Europe, USA, Canada, Mexico and Guatemala; Taught at Malvern Artists' Society since 1965 and Victorian Artists' Society since 1966; Visiting tutor, Fremantle Arts Centre 1978; Member, Victorian Artists' Society, Twenty Melbourne Painters, Melbourne Society of Women Painters and Sculptors, Malvern Artists' Society and Soroptimist International of Deakin.
Exhibitions Has held six one-woman shows to date in Melbourne, Canberra and Adelaide; Regularly in Archibald Prize Competition and also McClelland Gallery, Vic; Shirley Bourne Retrospective 1979.
Awards Dora Wilson Travelling Scholarship, Cato Prize, Yorick Prize, Camberwell Rotary Prize, Dick Ovenden Memorial Prize and Mt Waverly Prize.
Represented Art Gallery of NSW (portrait of Roland Wakelin); Australian War Memorial (portraits Sister Vivian Bullwinkel, Sqd Ldr K. Murray, W011 K. Payne VC); Commonwealth Collection; Rockhampton Gallery Qld; Bendigo Gallery Vic; McClelland Gallery; Melbourne Grammar School; Numerous institutions and in private collections here in Australia and overseas.
Publications Series articles *Portrait Painting & Painting Flowers* in English magazine, *Artist*.
Bibliography *Artists & Galleries of Australia,* Max Germaine: Craftsman House 1990. *Australian Impressionist & Realist Artists,* Tom Roberts: Graphic Management Services, Melbourne 1990.

BOWDEN, Kerry QLD
Born Randwick NSW 1946. Painter and fashion designer.
Studies Privately with Anita Aarons; Founding member of Noosa Gallery Society and the Association of Artists.
Exhibitions Noosa Regional Art Gallery.
Awards OAM for services to the arts 1991.

BOYD, Amanda NSW
Born Sydney 1949. Painter in oil and watercolour. Eldest daughter of David and Hermia.
Studies Within the family circle in Australia, UK, France; painted in UK and France for
some time and had two exhibitions before returning to Australia.
Represented Institutional and private collections in UK, Europe, Australia.

BOYD, Cassandra NSW
Born Melbourne Vic 1956. Painter, works mostly in ink, crayon, wash and watercolour;
Third daughter of artists, David and Hermia Boyd.
Studies Has been deeply involved since childhood with drawing as her particular form of
visual expression; Has lived in France part-time since 1971. Studied under master etcher
Satish Sharma.
Exhibitions Her first one-woman show at von Bertouch Galleries, Newcastle in September
1977; followed by 1982, 84, 86, 88, 89, 90; Abercrombie Galleries, Melbourne 1980, 81;
Nicholson St. Galleries, Sydney 1984, 85; Wagner Gallery, Sydney 1990; Numerous group
shows in Europe and Australia.
Represented Private collections in Australia and overseas.

BOYD, Charlotte VIC
Born Melb. 1968. Sculptor, daughter of the late Guy Boyd.
Studies With the Boyd and Beck families.
Exhibitions Sandringham, Melb. 1984; Black Rock, Melb. 1985, 88; Elizabeth Rae
Gallery, Canberra and Townsville 1986; Manyung Gallery 1987; Schubert Gallery, Qld
1989; Holdsworth Galleries, Sydney 1989.

BOYD, Helen VIC
Born Moree NSW 1940. Science research worker, painter and teacher.
Studies For past twenty years has been involved in scientific research and teaching at univer-
sities in Australia and USA and has found time for painting during the last decade; Much of
her work is influenced by electron contour diagrams and similar patterns she encounters in
her scientific work; She returned to Australia in 1977 and held her first one-women show at
Gallery de Tastes, Melbourne in 1978. Giles St. Gallery and Solander Gallery, Canberra
1988.

BOYD, Hermia (Lloyd Jones) NSW
Born Sydney NSW 1931. Potter, ceramic sculptor, stage designer.
Studies Sculpture at East Sydney Technical School under Lyndon Dadswell 1945–47; After
this, she worked in the pottery partnership with her husband David; Concentrated on glass
paintings from 1964–68 and in 1970 the family, with three daughters, settled in the south
of France where she studied etching and worked on a series of bronze sculptures; Since 1973
she has worked on the themes of Sappho's poems illustrating them with etchings and draw-
ings; Also designed settings and costumes for Elizabethan Trust and Peter O'Shaugnessy's
productions in Australia and overseas.
Exhibitions 'Sappho of Lesbo' drawings, Wagner Gallery, Sydney and von Bertouch
Galleries, Newcastle 1978; Since 1950 has exhibited jointly with her husband in shows of
pottery and ceramics in Australia, UK and France at the following centres; Sydney 1948;
London 1951, 1953; St Paul-de-Vence, France 1952; Sydney and Melbourne 1955;
Melbourne, Brisbane and Adelaide 1956; Melbourne and Brisbane 1957; Sydney,
Melbourne and Brisbane 1958; Adelaide, Melbourne and Sydney 1959; Perth, Brisbane and
Melbourne 1960; Melbourne and Brisbane 1961; Colchester UK 1961; Her glass paintings
were exhibited in London and Australia 1964, 1968 and her bronze sculptures in London,
Sydney and Brisbane in 1971, 1972. Presently working on a series of painting in oil on can-
vas around a Daisy Bates theme.

Represented State Galleries of Vic, WA, Qld; Museum of Applied Art, Sydney; National Museum of Modern Art, Tokyo; Staffordshire Museum, UK.

Bibliography *The Art of David Boyd*, Nancy Benko, Hyde Park Press 1968; *The Pottery and Ceramics of David and Hermia Boyd,* John Vader, Mathews and Hutchinson 1977; *Australian Sculptors,* Ken Scarlett, Nelson 1980; *Artists & Galleries of Australia*, Max Germaine: Craftsman House 1990.

BOYD, Jane NSW

Born London 1953. Painter.

Studies L'Institut Francais de la Sorbonne; Camberwell School of Arts & Crafts, London, BA (Hons.) 1975. Taught at Gwent College of HE, Wales 1979–86.

Exhibitions Numerous shows in London, Wales, Europe and locally at Hogarth Gallery, Sydney 1986; Performance Space, Sydney 1988; Artspace, Sydney 1988 (multi-media installation).

BOYD, Lucinda NSW

Born London UK. 1954. Painter, second daughter of David and Hermia Boyd, settled in Aust. 1971. Works in the lower Hunter area with her two daughters Cressida and Jesamine painting landscapes mostly in pastel.

Exhibitions von Bertouch Galleries, Newcastle 1985, 89.

BOYD, Lucy VIC

Born Murrumbeena Vic 1916. Ceramic artist. See under Beck, Lucy.

BOYD, Lynne VIC

Born Melb. 1953. Painter. Printmaker.

Studies VCA, Melb. 1980–83, Postgraduate 1983–84.

Exhibitions Solo shows at 70 Arden Street Gallery 1986, 87; included in *A New Generation 1983–88* at ANG, Canberra 1988, Rex Irwin Gallery, Sydney 1988; MPAC, The Centre Gallery, Qld, Grafton Reg. Gallery 1988.

Awards BP Prize, Melbourne 1991.

Represented ANG, Artbank Regional Galleries institutional and private collections.

Bibliography Directory 1988.

BOYD, Mary UK

Born Melbourne Vic 1926. Painter and ceramic artist; Sister of Arthur, David and Guy; Married John Perceval 1944 and Sidney Nolan 1978.

BOYD, Polly VIC

Born Melbourne Vic 1946. Modern landscapist, mostly in oil; Daughter of Arthur and Yvonne Boyd.

Studies Went to live in London in 1959 with her parents and her brother Jamie and sister Lucy; Studied at Hornsey Art School, London; Has worked in Italy, Spain and the UK.

Exhibitions Her first one-woman show was at Andrew Ivanyi Galleries in Melbourne 1973 and her next two at von Bertouch Galleries, Newcastle NSW in 1975, 1978.

Represented National Gallery Lending Collection, Canberra; Private collections in Australia and overseas.

BOYER, Diana ACT

Born Buenos Aires Argentina 1948. Illustrator, printmaker.

Studies Botany at Nat. Uni. of Buenos Aires 1973.

Exhibitions PCA Show Canberra 1988.

Commissions Illustrations for *Flora of Australia*. Nat. Botanic Gardens illustrated leaflet.

Represented Artbank, Commonwealth Govt. Publications.
Bibliography *PCA Directory* 1988.

BOYLE, Jenni Matson VIC
Born Vic. Painter and stage designer.
Exhibitions One-woman show at Manyung Gallery, Mt Eliza Vic 1982 and participated in
Twenty Peninsula Artist at McClelland Gallery 1982.

BOYLE, Kathleen VIC
Born Melbourne Vic 1928. Figurative painter, some religious subjects in oil, watercolour,
acrylic, pastel, fabric overlay.
Studies National Gallery Art School 1952–57; Accademia Delle Belle Arti, Rome
1958–59; Travelled in Europe and lived in Ireland for a time 1958–60; Lecturer at Caulfield
Institute of Technology 1960–75; Studied Art Institute, San Francisco USA, graduated MA
1973–75; Travelled in UK, Europe and USA.
Exhibitions One-woman shows at MV *Oceania*, Lloyd Triestino 1960; 'Gallery A',
Melbourne 1961; Dominion Galleries, Sydney 1966; Princes Hill Gallery, Melbourne 1966;
Clive Parry Gallery, Melbourne 1975; Hawthorn City Art Gallery, Melbourne 1978;
Zanders Bond Gallery 1982; Participated in National Gallery of Vic, Flotto Lauro Prize
1957; Gallery A, 1961; Emerald Gallery 1961; Vic Artists Society 1962; Independent
Group Argus Gallery 1962; McClelland Inaugural Trust Exhibition 1965; Princes Hill
Gallery 1966; Melbourne University 1967; Toorak Presbyterian Church 1969; St John's
Croydon 1970; Wangaratta Gallery 1970; Australian Asian Association 1970; St Paul's
Cathedral, Melbourne 1972; Peninsula Drawing Prize 1973; San Francisco Art Institute
Spring Show 1975; Georges Invitation Prize Exhibition 1976; Horsham Art Gallery 1976;
Peninsula Drawing Prize 1977–79; Hawthorn City Art Gallery 1978, 1979, 1981; QAG
1982; MPAC 1983.
Awards Sara Levi Scholarship 1954; Gallery Society Award for Drawing 1956; National
Gallery School Travelling Scholarship, Second Prize 1956; Italian Government Scholarship
1958.
Represented St Bede's College, Mentone (mural); Private and institutional collections in
Australia and overseas.
Bibliography *Religious Art in Australia*, H.H. Knorr 1967; *Encyclopedia of Australian Art*,
McCulloch, Hutchinson, Melbourne 1977; *Artists & Galleries of Asutralia*, Max Germaine:
Craftsman House 1990.

BOYLE, Margery
Refer Fizgerald-Boyle, Margery.

BOYLE, Nikki VIC
Born Melbourne 1968. Painter.
Studies Victoria College, Prahran.
Exhibitions RMIT Gallery 1989; Victoria College Graduate Show 1989; Reflections
Gallery 1991.

BRACKEN, Georgina NSW
Born Sydney NSW 1954. Figurative painter of landscapes and portraits in oil pastel and
mixed media.
Studies Diploma and credit in painting and drawing from Julian Ashton Art School
1979–80; Sculpture with Tom Bass 1980; Brush painting in Hong Kong 1982–83; Study
tours to Europe 1974–75, 1977–78 and Indonesia 1981.
Exhibitions One-woman show Cutliffe Gallery, Sydney 1980; Participated at Cutliffe
Gallery 1981; Blaxland Galleries 1982; Coventry Gallery 1982; Solander Galleries, ACT 1983.

BRADFORD, Dorothy (Petras) QLD
Born Hobart 1920. Painter, portraitist, graphic artist.
Studies Hobart Tech. College 1936–45; East Sydney Tech. College 1946–48; Royal Academy School, London 1950–51; École des Beaux Arts, Paris 1952. Worked and studied in Italy for some time.
Awards Tas. Travelling Art Scholarship 1949.
Bibliography *Tasmanian Artists of the 20th Century,* Sue Backhouse 1988.

BRADLEY, Julie ACT
Born Sydney 1958. Painter, printmaker, teacher.
Studies St. George TC 1978. Dip. Visual Arts — Canberra S of A 1979–81; City Art Institute — Postgraduate in printmaking 1982; graduated Canberra S of A 1984; taught Canberra TAFE 1986–88.
Exhibitions Solo show at Manuka Gallery, Canberra 1984; group shows include Stadia Graphics Sydney 1980; Editions Gallery Melb. 1984.
Represented Institutional and private collections around Australia.

BRADY, Mary (Sister Margaret Mary OP) NSW
Born Tamworth NSW 1922. Painter in oil, mostly portraits.
Studies No formal training, mostly self-taught; High school art teacher and painter of land-scapes and portraits on commission.
Awards Hunters Hill NSW Landscape Prize (twice); Portia Geach Memorial Prize for Portraiture 1966, 1971, 1975.
Represented Private and institutional collections in Australia and overseas.

BRAHE, Marita (Ogburn) NSW
Born Sydney. Painter and teacher.
Studies North Sydney TC and at the John Ogburn Studio. Studied UK, Europe, USA 1979–80, 89; Taught art at Loreto Convent, Kirribilli for nine years and since 1983 at OLSH College, Kensington.
Exhibitions Annually at the Harrington Street Gallery since 1974.
Represented Institutional and private collections in UK, Europe, USA and Australia.

BRASH, Barbara VIC
Born Melbourne Vic. Painter and printmaker.
Studies National Gallery School, Melbourne and with George Bell; Printmaking at RMIT; Her screenprint 'Windmill' was commissioned for Print Council of Australia members print edition 1972.
Exhibitions Has held one-woman shows in Melbourne and Brisbane and her work was included in SE Asia Touring Exhibition 1962, 1971; Australian Print Survey 1963, 1964; Japan 1964; Smithsonian Institute, Washington USA 1966; Philadelphia Print Club, USA 1966; Third International Miniature Print Exhibition touring USA 1968, 1971; Pratt Benefit International Exhibition, New York 1969; India 1971, 1972; Poland 1972, 1973; New York 1973; 'Historical Survey of Printmaking in Australia 1812–1972' at Newcastle Gallery 1972; 'Artists' Artist', painting, National Gallery of Vic 1975; Tenth International Biennial Exhibition of Prints, Tokyo 1976; Western Pacific Print Biennale 1976; Selected Relief Prints (National Gallery of Vic) 1977; Contemporary Australian Prints (Perth, Fiji) 1977; Japan Print Association, Tokyo and 3rd Independents Exhibition of prints, Kanagawa, Japan 1977; Contemporary Australian Printmakers (book-launching exhib-tions, Sydney, Adelaide, Perth, Canberra 1977) 15 Australian Printmakers, Queensland Arts Council 1979; Contemporary Australian Printmakers, West Coast USA 1979, Sweden 1980; Department of Foreign Affairs, 1980; Touring Australian Prints Singapore 1981; Australian Printmakers 1945–1981 (McClelland, Vic 1982); The 2nd International

Miniature Print Exhibition, 'Space' Korea 1982, 88 Eastgate Gallery, Melb. 1989.
Awards Sara Levi Scholarships 1949; Warrnambool 1975; Gold Coast 1978; Stanthorpe 1980; Mornington Drawing Prize 1981. Included in 100 x 100 Print Folio 1988.
Represented National Collection, Canberra; State Galleries of Vic, WA, SA, Qld; Regional Galleries at La Trobe Valley, Warrnambool Vic, Newcastle NSW; University collections at Canberra, Melbourne, Monash Vic, Flinders SA; ICI, BHP and AMP buildings, Melbourne; Wagga Wagga Gallery.
Bibliography *Art and Australia,* Volume 1/4; *Directory of Australian Printmakers 1982, Encyclopedia of Australian Art,* McCulloch, Hutchinson, Melbourne 1977; *Alice 125*: Gryphon Gallery, University of Melbourne 1990; *Artists & Galleries of Australia*, Max Germaine: Craftsman House 1990.

BRASSIL, Joan NSW
Born Sydney 1919. Sculptor, painter, teacher, video.
Studies Sydney Teacher's College; East Sydney Technical College; Newcastle Technical College 1937–39; Power Institute of Fine Arts, Sydney University 1969–71; Postgraduate Diploma of Professional Art Studies; Alexander Mackie College of Advanced Education 1981; Ph.D., Creative Arts, University of Wollongong 1989–90.
Exhibitions Solo shows at Bonython Gallery, Sydney 1975; Sculpture Centre, Sydney 1976, 77, 78; Roslyn Oxley9 Gallery, Sydney 1982, 83, 84, 85, 86, 88; Wollongong City Art Gallery 1985. Group shows include First Australian Sculpture Triennale, Melb. 1981 and the second 1984; Italy 1983; Perspecta 1985, Art Gallery of NSW; Japan 1986; Sixth Sydney Biennale 1986; Roslyn Oxley9 Gallery 1987, 88; Powerhouse Museum 1988; First Draft 1988; Linz, Austria 1989; Fourth Australian Sculpture Triennial 1990.
Awards Mosman Prize 1973; VAB Grant 1978. Artist-in-Residence, Araluen, SA 1987. Installation-Powerhouse Museum, Sydney 1988; Aust. Emeritus Award 1988.
Represented Public collections such as Orange City and Armidale City Gallery, and in private collections in Australia and New Zealand.
Bibliography *Australian Sculptors,* Ken Scarlett, Nelson 1980. *Artists & Galleries of Australia*; Max Germaine: Craftsman House 1990.

BRASSINGTON, Pat TAS
Born Hobart 1942. Photographer.
Studies S of A, Hobart 1975–80, MFA 1983–85; Secretary Fine Arts Committee and programme co-ordinator 1981– .
Exhibitions ACP, Sydney 1987, 88; Chameleon Gallery 1986; Tas. S of A 1985; Participated Australian Perspecta 1989, AGNSW and many shows since 1975.
Bibliography *Tasmanian Artists of the 20th Century*: Sue Backhouse 1988.

BRAUND, Dorothy VIC
Born Melbourne Vic 1926. Painter, teacher, in oil and gouache.
Studies Diploma of Art from the National Gallery School of Vic under George Bell; Overseas study tours to Europe, UK 1951–52; Greece 1958; India, Turkey, Iran and Greece 1960–61; Greece 1965; Ceylon 1969; Saigon and the Philippines 1973; Taiwan 1976; Bali 1978; Art critic ABC Channel 2, 1964.
Exhibitions First exhibition was with Michael Shannon at Peter Bray Gallery, Melbourne 1952, followed by one-woman shows at the same gallery in 1955; Also at Brian Johnstone Gallery, Brisbane 1957; Argus Gallery, Melbourne 1960; Leveson Street Gallery, Melbourne 1962, 1964, 1967, 1970, 1976, 1977; Nundah Gallery, Canberra 1965; Clive Parry Galleries 1977; David Ellis Gallery, Melb. 1988.
Awards Albury Art Prize 1962; Colac Art Prize 1964; Bendigo Art Prize 1966; Muswellbrook Art Prize 1972.
Represented McClelland Gallery, Langwarrin; National Collection, Canberra; Bendigo

Art Gallery, Vic; Albury Art Gallery, NSW; Muswellbrook Art Gallery, NSW; National Gallery of Vic; Art Gallery of SA; Private collections in Australia and overseas.

BRAVERY, Janine NSW
Born Sydney. Contemporary painter in oil and watercolour, teacher.
Studies Nat. Art School, Sydney Diploma 1937–41. With Desiderius Orban 1942–43. Part-time with Douglas Dundas 1942–43. Taught at Nat. Art School 1947–53 and 1954–62 including two years at Newcastle Art College. Has taught at Ku-ring-gai Art Centre since 1980. Founder/President of Australian Society of Miniature Art 1985. President, Ku-ring-gai Art Society 1977–78.
Exhibitions Most recent solo shows at Holdsworth Gallery, Sydney 1980 and Spring Hill Gallery, Brisbane 1983. Many group shows since 1965. Won St Ives-Northern Suburbs Art Prize 1984. Bel Bello Gallery, Toronto Canada, 3rd. International Miniature Exhibition 1988.
Represented Private collections in UK, Europe, USA.
Bibliography *Artists & Galleries of Australia*, Max Germaine: Craftsman House 1990.

BRAVO, Jennian VIC
Born Melbourne 1953. Painter and sculptor.
Studies Gippsland IAE.
Exhibitions Solo show at Niagara Lane Galleries 1980, 83, 85; Melbourne City Square 1980; 70 Arden St. Galleries 1985; Group shows include Mildura Sculpture Triennial 1977; Hawthorn City Art Gallery 1979, 81; Gippsland 1979, 81; Victoria College 1982.
Bibliography *150 Women Artists*, Visual Arts Board/WAM, Melbourne 1988.

BREAKEY, Kate SA
Born Adelaide 1957. Photographer, teacher.
Studies SASA–Dip. Graphic Design 1978, BA Fine Art 1981; MA, Uni. of Texas, USA in progress 1988.
Exhibitions Solo shows at Developed Image, Adelaide 1983, 84; Photographers Gallery, Melb. 1984; Festival Theatre Foyer 1986, 87. Many group shows since 1981, including SASA Touring Show 1988.
Awards VAB Grant 1982; SA Govt. Grant 1987; Dept. of Arts Grant 1988.
Represented ANG, AGNSW, AGSA, NGV, Parliament House, Canberra, SA Law Courts, SACAE, Albury Regional Arts Centre, City of Toowoomba Art Gallery, Riddoch Gallery, SA.

BREEDON-WILLIAMS, Kay. See under Williams.

BREHENEY, Vivienne TAS
Born Launceston, 1949. Printmaker, teacher.
Studies School of Art, Hobart under Jack Carington Smith 1966–70. Study tour UK, Europe 1976. Printmaking teacher Devonport Tech. College, Tas. 1978 and initiated the Devonport Printmakers Workshop 1982. Studied at Kala Institute, California USA 1983; teaching at DTC 1988 – .
Exhibitions Solo shows at Salamanca Place Gallery, Hobart 1974; The Little Gallery, Devonport 1976; Harrington Street Gallery, Hobart 1981; Devonport Gallery and Art Centre 1982; Peelings Studio, Sydney 1984; The Cockatoo Gallery, Launceston 1984. Many joint and group shows since 1970.
Awards Burnie Coastal Art Group Prize 1981.
Represented Devonport and Burnie Regional Galleries; Hellyer College, Burnie; Hobart Tech. College; private collections in UK, Europe and USA and around Australia.
Bibliography *Tasmanian Artists of the 20th Century,* Sue Backhouse 1988.

BREILLAT, Ros NSW
Born Sydney NSW 1948. Modern painter and stained glass artist.
Studies North Sydney and East Sydney Technical Colleges.
Exhibitions Parker Gallery, Australian Heritage Galleries and Legacy House Gallery, Sydney.

BRETEL, Nan VIC
Painter of flower studies in acrylic.
Studies With the VAS, AGRA, Tuesday Painters Group and overseas.
Exhibitions Five Ways Gallery, Vic.

BRIANT, Irene (Beechey) TAS
Born Hobart 1934. Sculptor, teacher.
Studies Diploma of Fine Art, Tasmanian School of Art 1968–72; Diploma of Art Teaching, Tasmanian School of Art 1973; Bachelor of Fine Art, University of Tasmania 1982–83. Taught Tas. Educ. Dept. 1974–80; art tutor Elizabeth and Hobart Colleges 1980–86. Currently working in studios at Chameleon Co-operative, Hobart and teaching art at Rosny College, Hobart.
Exhibitions Solo show at Chameleon Gallery, Hobart 1986, and involved in ten group shows around Tasmania since 1982.
Awards VAB Grant 1986.
Bibliography *Tasmanian Artists of the 20th Century*, Sue Backhouse 1988.

BRIDGES, Trish ACT
Born Manly NSW 1930. Painter, sculptor, theatre designer.
Studies East Sydney Tech. College 1948; B.A. at the Australian National University, during which time she was head set painter and mask-maker for the Theatrum Classicum 1976–79; B.A. (Visual), majoring in Sculpture, at the Canberra School of Art, 1981–85. Teaches at the Canberra Art Workshop.
Exhibitions *Six Australian*, Qantas House, London 1980 and regular group shows since.
Awards Canberra Day Art Prize 1974; Queanbeyan City Art Prize 1972, 74, 81.
Represented Private and corporate collections in Australia and UK.

BRIDGLAND, Janet SA
Born Adelaide 1948. Painter, designer, teacher.
Studies SASA — Dip. FA (Painting) 1965–68; Ruth Tuck Art School. Taught at Ruth Tuck Art School and various TAFE Colleges 1966–85; designed costumes for major Australian theatre and ballet groups 1968–71.
Exhibitions Solo shows at Sydneham Gallery 1972, 73; Kensington Gallery 1985; Greenhill Galleries 1988; group shows Kensington 1983, 84, 86, Greenhill 1987, Adelaide Festival 1989.
Represented Institutional and private collections around Australia.
Bibliography *South Australian Women Artists:* Shirley Cameron Wilson 1988; *Australian Watercolour Painters*: Jean Campbell: Craftsman House 1989.

BRIMBLE, Patricia NT
Born 1947. Aboriginal painter in polymer paint on board.
Exhibited AGSA 1988.

BRISCOE, Kate NSW
Born UK 1944, arrived Australia 1968. Painter, printmaker, teacher.
Studies Portsmouth College of Art 1960–64; Leicester College of Art 1964–65; Teacher National Art School, Sydney NSW 1969–76; taught in UK 1965–68; After further

advancing her photo-etching techniques became a partner in the Miller Street Print Workshop, Sydney in 1978. Teaching part-time at City Art Institute and Director of Print Workshop Zero, Sydney 1982 – 90.

Exhibitions One-woman shows at Harnham Gallery, Salisbury UK 1968; Bonython Galleries, Sydney 1971; Hogarth, Sydney 1973, 1975, 1976; Art of Man, Sydney 1978; Bartoni, Melbourne 1978; Bloomfield Galleries, Sydney 1981; Robin Gibson 1984, 1985; BMG, Sydney 1988; Gallery Gabrielle Pizzi, Melb. 1988. Group exhibition, 'Group South', Southampton UK 1966, 1967; 'Graphics 72', Bonython Gallery, Sydney; Sydney Printmakers 1973, 1975, 1976; World Print Competition, San Francisco Museum of Art 1973; 'Boxes', Ewing Gallery, University of Melbourne, Georges Invitation Prize 1976; Print Award Exhibition, Perth 1976; Print Council of Australia Travelling Exhibition, Tokyo 1976; Sydney Printmakers 1978–79; Bloomfield Galleries 1981; *Survey '83* Commonwealth Bank, Sydney 1983; Ivan Dougherty 1984, 86; Heide, Melb. 1986; Hogarth, Sydney 1986; Blaxland 1987; Canberra Times Award 1987; UTS Union 1988; The Centre Gallery, Gold Coast 1989.

Awards Cathay Pacific Prize 1975; Cornelius Art Prize 1976; Wagga Wagga Purchase 1976; Maitland 1979. Gold Coast Purchase 1984; Maitland Purchase 1989.

Represented Wagga Wagga City Art Gallery; Newcastle Regional Gallery; Chartwell Trust, NZ; Townsville Teachers College Qld., Artbank. Institutional and private collections in UK, Europe, USA and Australia.

Bibliography *Artists & Galleries of Australia*, Max Germaine: Craftsman House 1990.

BRITTAIN, Dawn WA
Born 1943. Painter.
Studies Assoc. Dip. Visual Arts, Bunbury Institute 1987; has attended numerous workshops and summer schools.
Exhibitions Fine Arts Gallery 1981; Alexander Gallery 1984.
Awards Manjimup Art Prize 1973, 79, 80, 81, 82, 83; Margaret River Prize 1983.

BROOKER, Eileen TAS
Born Hobart 1922. Painter, potter, teacher.
Studies Hobart Tech. College under Jack Carington Smith and Lucien Dechaineux 1941–44; East Sydney Tech. under Douglas Dundas 1946. Taught at HTC 1944, 47–48 and Launceston and Hobart Schools 1949–50. Worked and studied at potteries in UK 1951–55. Taught art at Fahan School, Hobart 1955–65 and during this time set up The Montrose Pottery to work in stoneware. Head of art at Elizabeth College Hobart 1969–77. Study tour to UK, Europe, Ghana 1978. President, Tas. Potters Society 1979. Teaches art for Adult Education, Hobart. Many solo and group shows since 1969.
Awards VAB Grant 1975.
Represented Tas. Museum and Art Gallery and in many overseas collections.
Bibliography *Tasmanian Artists of the 20th Century*, Sue Backhouse 1988.

BROOKS, Ailsa VIC
Born 1956. Painter.
Studies RMIT.
Exhibition Solo show at The Art Gallery, Melb. 1988; Realities Gallery 1990.

BROOKS, Patricia Ann Lorraine SA
Born Adelaide 1933. Sculptor and teacher.
Studies Diploma in Fine Arts (sculpture), SA School of Arts 1969; Masters Diploma in Sculpture, National Gallery School of Vic 1972; Travelled Indonesia, Papua New Guinea, Micronesia 1973, Diploma of Design (ceramics) from SA CAE 1981; Study tour to UK and Europe 1982; Associate of the RSASA; Teaching for TAFE since 1978 and Fullarton Park

Community Centre since 1982.

Exhibitions Mildura Sculpture Triennial 1960; Cobar Centenary Show 1969; Solo shows at Lidums Gallery 1974.

Awards Harry Gill Memorial Prize 1949; Clarkson Memorial Prize 1950; RSASA Portrait Prize 1959.

Bibliography *Who's Who in the Commonwealth:* International Bibliographical Centre, Cambridge UK 1982.

BROPHY, Elizabeth QLD

Born Qld. Representational painter in oil and watercolour.

Studies East Sydney Technical College 1941–43; Presently studying and painting overseas. Married to Terence Brophy.

Exhibitions Rockhampton Art Gallery 1972; Gallery 1, Cairns 1973; Trinity Art Gallery, Cairns 1974; Qld Art Gallery 1974; Eight Bells Gallery, Surfers Paradise Qld 1976, 1978. Galleria Lucas, Portugal 1981; Galloway Galleries, Brisbane 1982; Particular Gallery, Portugal 1979, 1980, 1982; Galleria Venezuela, Estoril, Portugal 1982; Sheridan Gallery, Brisbane 1983.

Awards Atherton Art Society Prize, North Qld 1970; *Australian* newspaper and P&O Line Competition 1972; Mulgrave Shire Council Prize 1972.

Represented American Museum of Natural History, New York USA; Dept. of Agriculture, Canberra; Many private and institutional collections in Australia and overseas.

BROSE, Jill QLD

Born Qld 1938. Artist in natural fibres, sculptural and textured hanging.

Exhibitions Craft Council Gallery 1976; Joy Bowman Galleries, Brisbane 1982.

Represented Bardon Professional Development Centre, and private collections.

BROUE, Louise NSW

Born Canberra 1961. Printmaker.

Studies BA Visual Arts, City Art Institute, Sydney 1982; Grad. Dip. Art Studies 1986–87.

Exhibitions Sydney Printmakers 1984–90; Indiana Uni. USA; Holdsworth Galleries, Sydney 1986.

Represented ANG; Artbank; institutional and private collections.

Bibliography *PCA Directory* 1988.

BROWN, Aileen VIC

Born St. Arnaud, Vic. 1946. Prints, etchings, linocuts.

Studies Dip. Occ. Therapy, Perth WA.

Exhibitions Solo show at Woolloomooloo Gallery, Sydney

Bibiliography *150 Women Artists,* Visual Arts Board/WAM 1988

BROWN, Caroline Lillie SA

Born SA. Painter and printmaker.

Studies Mt Barker TAFE 1978–82. Exhibiting member of RSASA.

Exhibitions Solo shows at Hastings Street, Lombard and Butchers Hook Galleries; Numerous groups shows.

Awards Noarlunga Council 1982.

BROWN, Carolyn WA

Born WA. Representational painter, flower studies and landscapes.

Studies Technical Education Dept, Perth and privately with Rhoda Boissevain, Nell Langley and Joan Campbell. Member of Perth Society of Artists and WA Artists

Association. Guest painter La Salle College 1986 and America Cup Exhibition 1986 Observation City.

Exhibitions One-woman show at Sir Claude Hotchin Gallery, Albany 1982 and Bank of NSW 1980; Guest painter at Perth Society of Artists 1980, 1981, 1982. Gomboc Gallery, Perth 1985, 86, 89.

Represented Institutional and private collections in Australia and overseas.

BROWN, Jan ACT
Born Sydney 1922. Sculptor and teacher.

Studies Part-time evening student at East Sydney Technical College from time of leaving school until 1974, studying sculpture with Elizabeth Blaxland, Lyndon Dadswell and drawing with Dorothy Thornhill. Full-time student at Chelsea Polytechnic School of Art 1947–50. Studied sculpture with Henry Moore and Bernard Meadows. Awarded National Diploma in Design (sculpture) 1949; Part-time teacher, sculpture and drawing, at Canberra Technical College 1956–80, Senior Lecturer Foundation Studies and Open Art, Canberra School of Art, 1980–. Spent 10 years in England before returning to Australia, and has since revisited England, Europe and the Middle East. Works mainly in bronze or ciment fondu. Principal interest is in birds and animal forms.

Exhibitions Mixed exhibitions with London Group, Royal Academy, Royal Glasgow Institute of Fine Arts, Royal Society of British Artists (Open assembly); One-woman exhibitions Nundah Gallery, Canberra 1964–66; Australian Sculpture Gallery, Canberra 1968; Macquarie Galleries, Canberra 1974, 1978, Sydney 1976; Two-woman exhibition, Gallery Huntly, Canberra, 1980; Mixed Exhibitions Australian Sculpture Gallery, 1966; Mildura Sculpture Triennial 1967, 1982; Macquarie, Sydney 1973; Macquarie, Canberra 1974, 1976; Anna Simons Gallery, Canberra 1975; Canberra School of Art Staff Exhibition 1976, 1979, 1982; Susan Gillespie Galleries, Canberra 1977; Murray Crescent Galleries, Canberra 1979; Craft Council Gallery, Brisbane 1981. Solo show Gallery Huntly, Canberra 1985. Participated at Mildura Sculpture Triennial 1985, 88; Canberra School of Art Staff Shows 1986, 88; Gallery Huntly, Canberra 1987.

Commissions Hertford County Council, England; Captain Cook Memorial, Browning NSW; Kingsgrove Secondary School, NSW; Joint Staff College emblem, ACT; Yass Wool Award trophy; Commonwealth Gardens sculpture ACT (NCDC); Daramalan College chapels, ACT.

Represented Commonwealth Art Advisory Board; University House, ANU, ACT; Canberra College of Advanced Education; Canberra Technical College, (NCDC) Government House, Canberra; Artbank; New Parliament House, Canberra.

Bibliography *Australian Sculptors*, Ken Scarlett, Nelson 1980. *Drawing in Australia,* Janet McKenzie; Macmillian 1986; *Artists & Galleries of Australia*, Max Germaine: Craftsman House 1990.

BROWN, Julie NSW
Born Lismore NSW 1950. Painter and photographer.

Studies University of Qld 1969–71; Alexander Mackie CAE 1976.

Exhibitions *Disclosures,* Institute of Contemporary Art, Sydney 1982; Australian Perspecta 1983, Art Gallery of NSW; Roslyn Oxley9 Gallery 1983.

Bibliography *Catalogue of Australian Perspecta* 1983, Art Gallery of NSW.

BROWN, Lois VIC
Born Vic. Painter and printmaker.

Studies Ballarat IAE and Melb. State College.

Exhibitions Solo show of Gippsland landscapes and wildlife in watercolour at Wiregrass Gallery, Melb. 1989.

Awards Traralgon Art Festival 1987; Central Gippsland Hospital 1987; Berwick Rotary 1988; Warragul Rotary 1988; Gippsland-Parliament House, Canberra Acquisition 1988;

G.R. Smith Award, Brighton 1989.
Represented Institutional and private collections in Australia and overseas.

BROWN, Margaret NSW
Born Uralla NSW 1918. Traditional painter of Australian wildlife in watercolour, gouache, charcoal, works mostly on commissions.
Studies Correspondence course in drawing 1936; Night courses in painting and drawing 1970; Julian Ashton School 1975 and five years privately with Brian Blanchard FRAS. Exhibiting member of RAS of NSW and VAS.
Exhibitions Oxley Gallery, Tamworth 1978–79; Also Wildlife Art Society; Royal Qld Art Society; St George Art Society; Twenty two of her illustrations were included in publication *Atlas of Australian Birds.*

BROWN, Mitty Lee SRI LANKA
Born San Francisco 1922. Painter.
Studies East Sydney Technical College 1944–46; Has spent many years overseas including some time on the Greek Island of Cos; Presently living and painting near Trincomalee in Sri Lanka.
Biography *Present Day in Australia*, Ure Smith, Sydney 1945.

BROWN, Vita TAS
Born Vic. 1916. Painter, designer, teacher.
Studies Hobart School of Art under Jack Carington Smith 1962–65; East Sydney Tech. School 1968; London Polytechnic UK 1973. Has worked as a designer and commercial artist in Melb., taught with Education Dept. and Adult Education, Tas. Vice-President, CAS, Hobart 1972–73.
Exhibitions Solo shows include Salamanca Place Gallery 1973; Warehouse Gallery 1978; Louisville Resort, Orford, Tas 1982. Shows regularly with the Art Society of Tas. and numerous group shows.
Bibliography *Tasmanian Artists of the 20th Century,* Sue Backhouse 1988.

BROWNE, Mandy WA
Born Perth WA 1956. Painter in gouache, watercolour, collage. Printmaker and stage designer.
Studies Associateship in Fine Arts, WAIT 1976.
Exhibitions WAIT Invitation Show 1976; Undercroft Gallery, University of WA 1977.
Awards University of WA Undergraduates Guild Award 1976; TVW Channel 7 Young Artist Award 1976 (shared); Festival of Perth, poster, brochure and illustrations 1983.
Represented WAIT Collection; University of WA; Fremantle City Council.
Bibliography *Contemporary WA Painters and Printmakers*, Fremantle Arts Centre Press 1979.

BROWN-RRAP, Julie NSW
Born Lismore NSW 1950. Photographer, painter, installation and performance artist.
Studies BA, Uni. of Qld. 1969–71; ESTC 1974; Power Institute Uni. of Sydney 1975; City Art Institute 1976; Partner in freelance photography business 1979–84; ACP Sydney 1981–83; Meadowbank TC 1983–85; ESTC 1983–86; City Art Institute 1984–87; SCOTA 1985–87. Overseas study UK, Europe 1977–78, 82–83, 85, 86. Board member Artspace 1982–83 and ACP 1981–86.
Exhibitions Solo shows at ICA Sydney 1982; Roslyn Oxley9 Gallery 1983; Adelaide Festival 1983; George Paton Gallery, Melb. 1983; Artspace 1983, 86; Mori Gallery 1986, 87; ACP 1986. Group shows include Newcastle Reg. Gallery 1982; Zona Gallery, Florence, Italy 1983; *Australian Perspecta '83*, AGNSW; Tas. S of A 1984; AGWA 1985; Artspace 1985; International Theatre Festival, Copenhagen 1985; *Australian Perspecta '85*; ESTC and

ANG, Canberra 1985; George Paton Gallery 1986; ACCA, Melb. 1986; 6th Biennale of Sydney 1986; Edge to Edge, Japan 1988 Sighting Reference, Artspace, AGNSW and Monash Uni. 1987–88; Australian Bicentennial Perspecta 1988; Elsewhere, ICI Gallery London UK 1988.
Awards Lady Fairfax Award 1983; VAB-Besozzo, Italy 1982–83; VAB Grant 1984; Power Institute — Cité International des Arts Studio 1986.
Represented ANG, AGNSW, NGV, Institutional and private collections in UK, Europe, Australia.
Bibliography *Catalogue of Australian Bicentennial Perspecta,* AGNSW 1987; *Artists & Galleries of Australia*, Max Germaine: Craftsman House 1990.

BROWNSWORTH, Ann SA
Born Mareeba Qld 1950. Craftworker, jeweller, silversmith.
Studies Royal Melbourne Institute of Technology; Diploma of Gold and Silversmithing 1973; Tyler School of Art, Philadelphia USA; Study tour South America 1975 and UK, USA 1979.
Exhibitions Her work has been seen in many important shows in Australia and overseas since 1976.
Awards Diamond Valley Art Award, Vic 1982.
Represented Australian National Gallery; State Galleries in SA, Qld and NT and many Australian and overseas collections.
Bibliography *Craft Australia,* Summer 1980.

BRUCE, Janna NSW
Born Sydney NSW 1909. Painter mostly in watercolour and teacher.
Studies Westminster School of Art, London under Gertler and Meninsky 1936–38; Academie Ranson, Paris and under Dattilo Rubbo in Sydney. Lived in China 1948–51; Taught art for many years in Sydney including Abbotsleigh Girls School and Bissietta Art School. A member of the Australian Watercolour Institute for over thirty years where she still exhibits.
Represented Art Gallery of NSW; Manly Art Gallery and private collections around Australia and overseas.
Bibliography *Australian Watercolour Painter 1970–1980,* Jean Campbell, Rigby 1982.

BRUCH, Sandy NSW
Born Melb. 1952. Printmaker.
Studies Dip. Graphic Design, Prahran CAE 1975; Post Certif. ESTC 1981; Postgrad. City Art Institute 1986; Artist-in-Residence, Peacock Printmakers Aberdeen, Scotland 1984.
Exhibitions Numerous shows since 1982 include Hogarth Galleries 1982; Prouds 1983; Aberdeen Scotland 1984; Blaxland Gallery 1985, 87; Access Gallery 1986; 70 Arden St. Melb. 1988; Richard King 1988.
Bibliography *PCA Directory* 1988.

BRUCHHAUSER, Ida NSW
Born Sydney NSW. Painter of Australian wildflowers in oil and oil/pastel.
Studies Privately under Ross Doig (four years) and Joshua Smith (three years); Has been painting flowers for over twenty-eight years.
Exhibitions One-woman shows at Adelaide Festival of Arts 1964; Sydney Opera House 1973; OTC Gallery, Sydney 1979; CSR Centre, Melbourne 1970; Southport Qld 1982 and in other states; In recent years to 1991 has held solo shows at her Artarmon Studio, the latest in 1991; Participated in many group shows and at Royal Art Society of NSW shows; Her work was in the International Cultural Exhibition for United National in Sydney 1978; Her work was hung in the major exhibition surrounding the work of the late Ellis Rowan at the

S.H. Ervin Gallery 1991; For the past eight years her Australian wildflower illustrations have been used for the Royal Blind Society of NSW Christmas Cards.
Awards BEM for services to the arts 1981.
Represented United Nations Building, New York; Parliament House, Canberra; Admiralty House, Sydney; OTC Building, Washington DC; Girl Guides HQ, London UK; Stockmans Hall of Fame, Longreach Qld; Pharmaceutical Society of Great Britain, London UK; Many private collections in Australia and overseas.
Bibliography *Artists & Galleries of Australia*, Max Germaine: Craftsman House 1990.

BRUMBY, Angkaliya SA
Born c. 1941. Pitjantjatjara Aboriginal painter from Ernabella, SA.
Exhibitions Lauraine Diggins Fine Art, Melb. 1989.

BRUTON, Judith SA
Born Adelaide 1950. Printmaker, teacher.
Studies Dip. Ed. Art, SASA 1967–70; with Franz Kempf, SASA 1975–80; SACAE, B.Ed. 1977–79; Tas. Summer School 1981; Kala Institute, Berkley USA; Haystack School of Arts and Crafts, Maine, USA 1983. Studied Europe 1974–75, 80; USA 1983; Part-time lecturer in Printmaking and Drawing at Flinders University; North Adelaide School of Art, Kingston College and Hills College 1988–89; Member, Print Council of Australia; Currently lecturer in Printmaking & Design, University of SA.
Exhibitions Solo shows include CAS Gallery 1982; Limeburners Gallery 1985, 86; L'Unique Gallery 1987; Art Zone 1988; Greenhill Gallery 1991; Numerous group shows since 1981.
Awards VAB Grant to USA 1982.
Bibliography *PCA Directory* 1988.

BRUVERIS, Elvira VIC
Born Latvia 1922. Painter, sculptor, teacher.
Studies Latvian Academy of Arts, Riga; Cambridge Technical College UK 1947–49; University of Saskatoon, Canada 1959; Regina, Canada 1970. Member Vic Association of Sculptors, where she exhibits regularly.
Awards Saskatoon Sculpture Award, Canada 1964.
Bibliography *Latvian Artists in Australia*, Society of Latvian Artists ALMA 1979.

BRYAN, Carole VIC
Born Melbourne 1947. Painter, sculptor, teacher.
Studies Art & Craft Teachers Certificate 1965–68; Dip. Fine Arts (Sculpture), RMIT 1970–75; Dip. Fine Arts (Painting) PIT 1983–84.
Exhibitions Solo shows at Prahran College Gallery 1979; Cafe Nova, Townsville 1989; Numerous group shows since 1977 include Mildura Triennial 1978; La Trobe Biennial 1980; Christine Abrahams Gallery 1984; United Artists Gallery 1986; Gertrude St. Gallery 1987; Perc Tucker Regional Gallery, Townsville 1990.

BRYANS, Lina VIC
Born Hamburg Germany 1909, arrived Australia as a child.
Studies In Melbourne under William Frater and Mary Cockburn and later at La Grande Chaumière, Paris; Was represented in the exhibition of Australian art sponsored by the Carnegie Corporation which was shown at the Museum of Modern Art, New York and toured USA and Canada in 1941; In 1943 on the death of Ambrose Hallen she took over the old hotel he had brought at Darebin Vic and converted it into a studio-home where an artists' colony formed, which included William Frater, Ian Fairweather and Ada Plante; Lina Bryans is a member of the Melbourne Society of Women Painters and Sculptors and the

Independent Group. Exhibited at State Library of Vic. 1989.

Awards Crouch Prize in 1966.

Represented National Collection, Canberra; State Galleries of Vic, NSW, WA and Tas; Yale University Collection, USA.

Bibliography *Art and Australia*, Volume 4/2; *Art in Australia*, November 1938, June and August 1941; *Encyclopedia of Australian Art*, McCulloch 1977; Important Women Artists Gallery, Catalogue 1977; Article on Australian Art, *Studio*, London 1938; *Australian Women Artists 1840–1940*, Janine Burke, Greenhouse Publications 1980; *Lina Bryans*, Mary Eagle, *Art and Australia* Vol 21 No 2.

BRYANT, Angel C. NSW

Born Adelaide SA. Painter, designer, colour response consultant, lecturer, writer.

Studies SASA 1952; Interior Design and Colour, London UK 1958; Singapore 1982; USA 1984; Worked with Vogue Condenast, Elisabeth Arden and Holmeward Advertising in London UK 1958–60; has worked from own studio, Angel International, Sydney since 1970; Former National Vice-President of Society of Interior Design (Aust.)

Exhibitions Numerous at 12 Macleay St. Studio; Recent commissions include NSW Masonic Hospital, Dee Why Hotel, Society of Interior Designers, Sydney Building Information Centre, Jennings Constructions, STC, Jetcat Ferries, Wodonga High School and Christian Brothers High School, Balmain.

Represented Institutional, corporate and private bodies in Australia, UK, Europe and USA.

BUCHANAN, Meg ACT

Born 1949. Printmaker, sculptor, teacher.

Studies Diploma of Art and Education from Newcastle CAE 1968–71; Atelier 17, Paris under S.W. Hayter 1980; University of New York Colour Printmaking Studio 1981. Cofounder/Director, Studio One, Canberra ACT Visiting Artist, Gippsland Institute of Technology, Canberra School of Art and Toowoomba CAE 1983–86; Lecturer, part-time, Canberra School of Art 1984–88.

Exhibitions Solo shows at Stuart Gerstman, Melb. 1989; Goethe Institute, Canberra 1978; Arts Council 1984. Participated at Kingston Art Space Gallery 1985; Tia Gallery, Toowoomba Qld 1986; Ben Grady Gallery, Canberra 1986; City of Box Hill, Vic. 1987.

Represented ANG, institutional and private collections in UK, Europe, USA, Australia.

Bibliography *Directory of Australian Printmakers* 1988; *Artists & Galleries of Australia*, Max Germaine: Craftsman House 1990.

BUCHTER-ZELAZNE, Helen NSW

Painter in watercolour and mixed media.

Studies Worked as a commercial artist in London, Israel and Australia for some years. Member AWI.

Exhibitions Solo shows at Holdsworth Galleries 1990; Perth Galleries, WA 1990.

Awards Ku-ring-gai Art Prize 1986, 90.

BUCKLEY, Sarah ACT

Born Aust. 1966. Printmaker.

Studies BA Visual Arts, Canberra S of A 1984–88.

Exhibitions Glouster County College, USA 1987; Link Gallery Act; MPAC 1988.

Bibliography *PCA Directory* 1988.

BUCKLEY, Sue NSW

Born Perth WA 1911. Painter, mostly in oil; Printmaker and teacher.

Studies Painting with Desiderius Orban, Sydney; Took an interest in printmaking in 1956

and became a foundation member of Sydney Printmakers; Member of the Print Council of Australia and teaches lithography, woodcuts and painting at the Workship Art Centre, Willoughby NSW; As a special project from 1964–74, she conducted a school at the WAC for approximately 100 children and young people with emphasis on developing children's awareness through imaginatively planned programmes.

Exhibitions Australian Print Survey 1963, 1964; First International Triennale of Contemporary Woodcuts, Capri Italy 1969; Third International Graphic Biennale, Crawcow Poland 1970; Has exhibited annually with Sydney Printmakers since 1961; Retrospective exhibition 1960, 1970 comprised 57 prints in all media.

Awards Maitland Print Prize 1969; Shared Berrima Print Prize 1974.

Represented National Collection, Canberra; State Galleries of NSW and Qld; University of NSW; Museo Della Xilografia, Capri Italy; Private collections in Australia and overseas.

Bibliography *Art and Australia*, Volumes 3/2, 7/2 and 8/1; *Directory of Australian Printmakers* 1982; *Artists & Galleries of Australia*, Max Germaine: Craftsman House 1990.

BUCKNELL, Toni VIC
Born Launceston Tas 1938. Painter, printmaker, teacher.

Studies Vic. Artists Society 1969–72; Caulfield Institute of Technology 1973–75; Postgraduate Fellowship RMIT 1976. Overseas study tours 1975, 80. Taught at own Melb. studio 1977–.

Exhibitions Solo show at Standfield Gallery, Melbourne 1982; Exhibited with Print Council of Australia Student Shows at Royal College of Art, London 1974, and Australian Student Printmakers 1975, 1976; Participated in Henri Worland Memorial Art Prize Exhibition, Warrnambool Vic 1974, 1975; 'Seven Printmakers' at Beaumaris Vic 1975; Harrington Street Gallery, Hobart 1979, 1981; Print Council of Australia 1980–81; Prahran School of Art 1982. *Womens Art Forum,* Roar Studios, Melb. 1985.

Awards Crohill Art Prize 1987.

Represented Department of Foreign Affairs, Embassies and Consulates, Caulfield City Council, Family Law Court, SA; Private collections in Australia and overseas.

Bibliography *Directory of Australian Printmakers* 1982. *Tasmanian Artists of the 20th Century,* Sue Backhouse 1988; *Artists & Galleries of Australia*, Max Germaine: Craftsman House 1990.

BUDGEN, Beverley QLD
Born Brisbane Qld 1937. Contemporary painter in oil, acrylic, mixed media.

Studies Part-time student at Brisbane Technical College 1963–65 but mostly self-taught; Part-time lecturer in painting Qld College of Art 1977–; Painting tutor for Australian Flying Art School 1983–; Part-time art teacher, St Columban's College, Brisbane 1976; Tutor for painter and drawing, Qld Arts Council Seminars and Workshop 1978; Editor of the newsletter of the Qld Art Gallery Society 1975–77; Committee member of the Qld Art Gallery Society 1974–78; Art for Children, classes since 1972; Study tour to UK, Europe 1982.

Exhibitions One-woman shows at Design Arts Centre, Brisbane 1973; Martin Gallery, Townsville 1974; Italia Gallery, Brisbane 1975; Trinity Gallery, Cairns 1976; Martin Gallery, Townsville 1977; Linton Gallery, Toowoomba 1977; Martin Gallery, Townsville 1979; Town Gallery, Brisbane 1980; Point Dangar Gallery 1980; Qld College of Art 1982; Participated in 'Twelve Queensland Artists', Adelaide 1974; Darnell de Gruchy, Qld University 1974; 'Brisbane Painters Today', Institute of Modern Art, Brisbane 1976; This exhibition toured Qld 1976, 1977; Trustees Art Prize, Qld Art Gallery 1969–81; 'Wednesday Group', Brisbane 1967, 1969, 1971; Qld College of Art Tutors 1982.

Awards Brookfield Art Prize, still life 1965; Brookfield Art Prize, abstract 1969; Caltex-Warana, contemporary 1973; Royal National Association, Brisbane, contemporary landscape 1974; Royal National Association, Brisbane genre 1975; Royal National Association,

Brisbane, still life 1975; Caloundra Portrait Prize 1976; Charleville Open Art Award 1976; Labrador Open Art Award 1977; Murgon Open Art Award 1977; Rockhampton 1979, 1982; Beenleigh 1981; Hinchinbrook Shire 1982; Schonell-Redcliffe, Manly Centenary, Caltex Open, Ipswich Art Gallery 1982; Ipswich City Council, Hinchinbrook Shire Council.
Represented James Cook University, Townsville; Landsborough Shire Council Collection; Redlands Shire Collection; Private collections in Australia, UK and USA.

BUIST, Judith NSW
Born Sydney 1935. Printmaker.
Studies ESTC 1949–53; WAC, Willoughby 1979–85.
Exhibitions Southern Printmakers 1985; MPAC 1986; Dallas, Texas USA 1986–87.
Bibliography *PCA Directory* 1988.

BULL, Eliane NSW
Born Geneva, Switzerland of French father and Swiss mother. Flower and landscape painter.
Studies Lived Nice, France 1936–44. Married an Australian in London, arrived Sydney 1958; studied art at Julian Ashton Art School, Sydney.
Exhibition Solo show at Holdsworth Galleries, Sydney 1986, 89.

BULLUSS, Judith SA
Born Adelaide SA 1950. Painter, printmaker and teacher.
Studies Diploma of Art Teaching, South Australian School of Art 1967–70; Taught art in secondary schools 1971–73; Travelled across Asia and Europe; Taught in Treviso, Northern Italy 1974–75; Returned to teaching in South Australia 1976; Bachelor of Education (In Service) Adelaide CAE; Majored in printmaking; Worked with Peter Schulz and Barbara Hanrahan 1977–79; Travelled in Europe, visiting art galleries and print workshops, including ATELIER 17 in Paris 1980; Tasmanian Summer School, studied colour etching with Jorg Schmieser; Became Founding Member of CAS Print Workshop at Wayville SA; Set up Studio at Marino SA 1981; Attended Patricia Wilson Colour Viscosity Workshop; Taught etching at CAS Workshop 1983; Study tour to USA 1983.
Exhibitions Participated in CAS shows 1982–83 and at Fireworks Gallery, Hahndorf SA 1983.
Awards VAB Grant to study USA 1982.
Bibliography *Directory of Australian Printmakers* 1982.

BUNGEY, Nyorie SA
Born Adelaide SA 1938. Genre painter in most media; Printmaker and teacher.
Studies Girls Central Art School 1951–52; SA School of Arts and Crafts 1953–54, 62–68; Studied UK, Europe, USA 1963–64; Worked in commercial art and taught for the SA Dept of Education; Fellow of the Royal SA Society of Arts, and illustrator of several children's books.
Exhibitions Shows with the Royal SA Art Society and the Contemporary Art Society; Participated in the International Women's Year Exhibition, Adelaide 1975; Commissioned to paint the murals at the Children's Chapel, Maughan Church, Adelaide and at the Barmera Hotel; Solo show at Greenhill Galleries, Adelaide 1982; Newton Gallery 1988; Participated Adelaide week in Himeji, Japan 1989.
Represented Institutions and private collections in Australia and overseas.
Bibliography *Artists & Galleries of Australia*, Max Germaine: Craftsman House 1990.

BURCHILL, Janet NSW
Born Melb. 1955. Modern painter, photographer, film maker, sculptor.
Studies Sydney College of the Arts 1981–83 — BA Visual Arts.

Exhibitions Solo show at Yuill/Crowley Gallery, Sydney 1988; 200 Gertrude St, Melb. 1988; IMA, Brisbane 1987; Mori Gallery, Sydney 1987; Union St. Gallery 1986; Aust. Centre for Photography, Sydney 1989. Group shows include IMA 1984; Artspace, Sydney 1984–85; Charlottenborg Art Academy, Copenhagen 1985; Australian Perspecta '85, AGNSW; George Paton Gallery, Melb. 1986, 87; ACP, Sydney 1986; Mori at United Artists 1987; Ivan Dougherty, Sydney 1988. Collaborative work with Jennifer McCamley at Australian Perspecta 1989, AGNSW.
Represented NGV, institutional and private collections in UK, Europe, Australia.
Bibliography *Artists & Galleries of Australia*, Max Germaine: Craftsman House 1990.

BURGE, Elaine VIC
Born Charlton Vic 1929. Realist painter of landscapes and flowers.
Studies Drawing at Ballarat School of Mines 1946–47; RMIT 1948; Vic Artists Society 1969–72; Study tour of Central Australia 1983; Member, VAS, Australian Guild of Realist Artists, Sherbrooke Artist Society.
Exhibitions One-woman shows at Balmoral Galleries, Geelong 1974, 1976, 1978; AMP Towers Gallery 1978; Southland Gallery, Cheltenham 1980; The Palette Gallery, Healesville 1980, 1981, 1982, 1983.
Awards Sunbury Art Award 1978; Sir Arthur Streeton Award, Sherbrooke Art Society 1983.
Represented Vic Education Dept and many institutional and private collections.

BURGESS, Erica ACT
Born Salisbury UK 1957. Printmaker, photographyer, art conservator, arrived Aust. 1965.
Studies Hobart School of Art 1977–80. Studied Europe and the printmaking studio of the Uni. of Alberta, Canada 1981–82. Assistant to art conservator TMAG 1982–86; study tour UK Europe 1986. Studying for MFA at Canberra CAE 1987–.
Exhibitions Numerous group shows include Sixth Independants Exhibition of Prints, Yokohama, Japan 1980; PCA Touring Exhibition 1984.
Represented Devonport Art Gallery, Hobart SOA; Uni. of Alberta; private collections in Aust. and overseas.

BURGESS, Rosalind TAS
Born Hobart 1959. Printmaker, photographer.
Studies B. Fine Art, Uni. of Tas.
Exhibitions ACP, Sydney 1986; Salamanca Arts Festival 1987.
Bibliography *PCA Directory* 1988.

BURGESS, Ruth NSW
Born Sydney NSW 1932. Painter, printmaker, woodcuts and linocuts, teacher.
Studies Studied with D. Orban 1949; Mostly self-taught; Graduated from Sydney University in Arts-Music, involved with poetry and painting, going on to study Musical composition in Paris at the Paris Conservatoire; Three years with Sue Buckley studying the woodcut medium at Workshop Arts Centre, Willoughby; Member of The Nine Printmakers; The Print Council of Australia; Southern Creative Printmakers; World Print Council; Established print workshop 1980; Studied etching with Elizabeth Rooney 1983; Taught woodcuts at WAC School 1984–88. Working at Studio Camnitzer, Lucca, Italy and Studio Santa Reparata, Florence, Italy. 1987; Represented PCA in Harbin, China 1988–89. Guest lecturer, printmaking, Canberra S of A 1989; Fine Arts Academy, Hangu Print Workshop; Visiting lecturer, Central Arts Academy, Beijing 1990; Artist-in-Residence Zhejiang Academy of Fine Arts, Hangzhou, Tianjin 1990.
Exhibitions One-woman show at Workshop Art Centre 1980; Balmain Gallery 1984; Gates Gallery 1987; Painters Gallery 1989; Hangu Print Workshop, China 1990; Zhejiang

Academy of Fine Arts, China 1990. Participated at the Print Room 1980, 1981; von Bertouch Galleries, Newcastle 1980, 1981, 1982; Print Circle 1981, 1982; Nine Print-makers 1981–83; WAC 1982; Apmira Exhibition 1982; Intergrafik Triennale, Berlin 1984, 1987; Bois Pluriel, Evry France 1986; Xylon, Switzerland (touring) 1984; Seoul, Korea 1986; Gallery 460, Gosford, Bridge St. Gallery, Painters Gallery 1988, 89; von Bertouch Galleries Newcastle 1980–88; Blaxland Galleries — Print Circle 1983–88; Bloomfield Galleries 1985; PCA Melb. 1988; Gallery 460 Gosford 1988; Intergrafik, Berlin 1987; Sydney Printmakers 1990.
Represented State Parliament NSW, private and corporate collections; UK, Japan, USA, Italy, Beijing, Australia.
Bibliography *PCA Directory* 1988; *Artists & Galleries of Australia*, Max Germaine: Craftsman House 1990.

BURGLER, Joanna NSW
Born Canberra 1955. Painter, printmaker, teacher.
Studies Prahran TC, Melbourne 1975; Seven Hills C of A, Brisbane 1976; Dip. Art (Painting) Alexander Mackie CAE, Sydney 1977–79; studied in Europe 1982; painting and teaching art 1988–.
Exhibitions Solo show at Access Gallery 1991. Many group shows since 1979 include Blaxland Gallery 1980; Switzerland 1984; Collins St. Gallery, Melbourne 1990.
Awards Byron Bay NSW 1990.
Represented Institutional and private collections in UK, Europe and Australia.

BURKE, Geraldine VIC
Born Melbourne 1961. Painter, printmaker, teacher.
Studies BA Fine Arts RMIT; Dip. Ed. State College, Melbourne; Worked and studied in Papua New Guinea; Part-time teacher.
Exhibitions ROAR Studios 1985; RMIT 1985.
Bibliography *150 Women Artists*, Visual Arts Board/WAM, Melbourne 1988.

BURKE, Patricia VIC
Born Kew, Vic 1935. Painter.
Studies Watercolour at RMIT under Douglas Miller. Exhibiting member of VAS and Warrandyte Art Society. Solo show at Five Ways Gallery, Kalorama, Vic. 1987, 89, 91.
Awards Donvale Festival Award 1979. Painters acquired for collections of both Preston Municipal Council Vic and Waverley Municipal Council, Vic 1981.

BURKE, Peg SA
Born Melbourne 1918. Painter and potter.
Studies SASA 1957–61. Fellow, RSASA; Foundation member of Studio Potters Club of SA; Overseas study Mexico, New Zealand 1975; UK, Europe 1990.
Exhibitions Greenhill Galleries, Kensington Galleries; Lombard Gallery.
Awards RSASA Associates Prize.

BURNESS, Kate VIC
Born Sydney 1947. Painter, illustrator, writer.
Studies National Art School, Sydney. Has written and illustrated a number of childrens books. Her paintings of the Australian bush have been widely used for greeting cards.
Bibliography *Alice 125*, Gryphon Gallery: University of Melbourne 1990.

BURNS, Diana VIC
Born UK 1954. Printmaker.
Studies B. Ed. Arts & Crafts, Melb. CAE 1979.

Exhibitions Oculos Gallery 1984–88; Mini Print Biennale Connecticut USA 1987; John Szoke Gallery, New York 1987; Mini Prints to USA, Canada 1987–88; 70 Arden St. Melb. 1988; Sweet Jamaique Gallery Melb. 1989.
Bibliography *PCA Directory* 1988.

BURNS, Dorothy NSW
Born New Guinea. Weaver and ceramic artist.
Studied Dubbo Tech. College; Muswellbrook College of Technical and Further Education.
Exhibitions *Six Upper Hunter Ceramic Artists,* Muswellbrook Regional Gallery 1984. This exhibition, sponsored by the NSW Premier's Department, Cultural Division, and the Regional Galleries of NSW, toured NSW from September 1983 till June 1984. Solo Exhibition (with Bruce Rowland), Morpheth Gallery, 1985. Collectors' Choice, von Bertouch Galleries, 1983, 1984 and major solo show, 1986.
Awards Dubbo Show, 1978; Ceramic Award, Muswellbrook Art Exhibition, 1982: Ceramic Award, Muswellbrook Art Exhibition, 1983. Craft Board Grant 1984.

BURNS, Hilary VIC
Born Wonthaggi Vic 1942. Contemporary painter.
Studies Orban Studio, Sydney in the mid-1960s.
Exhibitions 'Ocker Funk' Exhibition touring Australian Regional Galleries 1976, 1977; 'Ocker Funk', Realities, Melbourne 1976; 'Watters at Pinacotheca', Pinacotheca, Melbourne and 'Women's Images of Women', Watters Gallery, Sydney 1977; Solo exhibitions, Watters Gallery, Sydney, Stairs Gallery, Wollongong and Earl's Gallery, Melbourne 1978; 'Some Recent Acquisitions of Australian Art' Exhibition organised by the Australian National Gallery 1979.
Represented National Gallery of Vic; ANU, Canberra; Newcastle Regional Art Gallery; Wollongong Art Gallery; Private and institutional collections.

BURRELL, Jane Lesley TAS
Born Hobart Tas 1951. Graphic artist and photographer.
Studies Diploma of Graphic Design from Tas School of Art 1969–71; Zoology Assistant 1972–73; Display Assistant 1974–75; Designer 1975–80; At the Tasmanian Museum and Art Gallery; Established own graphic arts firm 'Paperworks' in 1980; Member of Tasmanian Wilderness Society; Wildlife Artists Society of Australasia; Bird Observers Club of Tasmania; Crafts Council of Tasmania.
Exhibitions FIAP Foto Forum — Youth, Eislingen Germany 1973; Wildlife Artists Society of Australasia, Annual Exhibition 1980, 1981; Craft Council Gallery, Hobart 1986.
Publications Illustrations for 'Tasmanian Native Mammals' 1976–81 booklet and poster series. Published by the Tasmanian Museum & Art Gallery; Illustrations for 'A Guide to the Birds of Tasmania', M. Sharland, Drinkwater Publishing 1981; Catalogue designs for travelling art exhibitions, 'Australian Colonial Portraits' 1979; 'William Buelow Gould' 1980. Published by Australian Gallery Directors Council.
Awards Jaycees, 5 Outstanding Young Australians Award 1981; Tasmanian Division for work in chosen career.

BURROWES, Geraldine VIC
Born Vic. 1942. Sculptor.
Exhibitions Solo shows at Melbourne University Gallery 1982; Distelfink Gallery 1982; Craftsworks, Sydney 1982; The Centre Gallery, Gold Coast 1989. Group shows include Painters Gallery, Sydney 1982; Virginia Brier Gallery, San Francisco 1984; Gold Coast 1989; Fourth Australian Sculpture Triennial, Melbourne 1990.

BURROWS, Hilary NSW
Born London UK 1952, arrived Australia 1974. Semi-figurative painter of city landscapes.

Studies Art Certificate from Seaforth Technical College 1975–76; Diploma of Arts, Alexander Mackie CAE 1977–79; Postgraduate Diploma of Arts, Alexancer Mackie CAE 1981. Sydney TC — Certificate of Screen Printing 1984–85; study tour UK, Europe, USA 1985; taught Waverley-Woollahra Arts Centre 1985 –.

Exhibitions Solo shows at Painters Gallery 1984, 86; Access Gallery 1988, 89; participated Alexander Mackie Postgraduate Show 1981; Access Gallery 1986, 87, 89, 90. Numerous group shows since 1981 include Blaxland Gallery 1982, 83, 87.

Awards Pring Prize, Art Gallery of NSW 1982.

Represented Institutional and private collections in Australia and overseas.

BURROWS, Lola TAS

Born Longford, Tas. 1939. Painter, printmaker, teacher.

Studies Hobart School of Art 1957–59; 1982–84. Studied printmaking in USA 1981.

Exhibitions Major joint show with Janice Hunter, Chameleon Gallery, Hobart 1986; ArtHouse, Launceston 1990.

Bibliography *Tasmanian Artists of the 20th Century*, Sue Backhouse 1988.

BURSTON, Dawn NSW

Born Cessnock NSW 1932. Painter, printmaker and teacher.

Studies National Art School, Newcastle 1964–65; Sydney 1966–67; Art teacher at Newcastle Art School.

Exhibitions Included in the Print Council of Australia Print Prize Exhibition, shown in Australian galleries 1968, 1969; Singapore 1969; Also participated in the 'Printmaking in Australia 1812 to 1972' show at Newcastle City Gallery, NSW.

Represented Newcastle Regional Art Gallery and private collections.

BURSTOW, Elvie QLD

Born Toowoomba Qld 1933. Watercolour painter of landscapes and wildlife; Teacher.

Studies Privately with C.J. Mullinder (4 years), Mervyn Moriarty (2 years) and Ian Syme (1 year).

Exhibitions Linton Gallery; Bistro Gallery; Ikkina Gallery 1970–77.

Awards Gemini Watercolour Award 1972; Toowoomba open1973; Nerang watercolour 1973, 1977.

BUSH, Carlotta VIC

Born Bendigo Vic. Abstract painter, designer and gallery director.

Studies Art diploma, Bendigo Technical School; TV Direction, RMIT; Painter in contemporary abstract style; Studied London 1958–1960; 1960–1964 Director, Richardson-Cox Advertising Agency, Melbourne; Creative writer John Clemenger Advertising 1965–1972; Created Young Originals Gallery 1972.

BUSBY, Coralie NSW

Born Qld. Painter and printmaker.

Studies Flying Art School, Brisbane 1970–73; MacGregor Summer School 1975, 79, 81; ESTC 1986–89; WAC 1989.

Exhibitions Numerous solo shows since 1970 and recently at Allamanda Gallery, Bundaberg 1976, 81; Centre Gallery, Brisbane 1985; Bundaberg City Gallery 1986; Drummoyne Art Gallery 1989; Gallery Mark Julian, Sydney 1991. Numerous group shows since 1984 and recently at Blaxland Gallery 1989; Cell Block Gallery 1990; Coventry Gallery 1990.

Awards Qld. Eisteddford Art Prize 1970, 85; Bundaberg Sugar Company Acquisition 1980; Chippendale Award, Bundaberg 1981; Martin Hansen Memorial Award, Gladstone 1984.

Represented Institutional and private collections.

BUSHBY, Catherine
<div align="right">TAS</div>

Born Hobart 1949. Painter, stage designer.
Studies Hobart School of Art 1968–70; set designer and painter for Theatre Royal and Hobart Repertory Society.
Exhibitions Solo shows at Secheron House, Hobart 1972; Art Centre, Hobart 1973.
Awards Art Society Prize 1969; Lions Club Prize 1969.
Bibliography *Tasmanian Artists of the 20th Century*, Sue Backhouse 1988.

BUSSEY, Majorie
<div align="right">WA</div>

Born Bunbury WA 1937. Symbolist painter in oil and mixed media.
Studies RMIT, Associate Diploma (adv. Art) 1953–57; WAIT, Graduate Diploma in Education 1976–77.
Exhibitions Solo shows at Fire Station Gallery 1973; Quentin Gallery 1981, 1983; Participated at Darlington Festival 1977–78; *Survey 82* Travelling Exhibition, WA 1982 and Conventry Gallery, Sydney 1983.
Represented Institutional and private collections around Australia.

BUTLER, Jen
<div align="right">ACT</div>

Born Faversham UK 1945. Painter, designer, sculptor and teacher.
Studies Ravensbourne College of Art, Kent 1963–67 graduating with 1st Class Hons BA Fine Arts, Sculpture with Drawing; Lecturer in 3D design at London College of Fashion 1971–72; Lectured in sculpture and drawing at Wimbledon College of Art UK; Emigrated to Australia 1978; Part-time lecturer, life drawing, TCAE, Hobart 1978–79; Part-time lecturer, drawing and design, Secheron School of Weaving, Hobart 1978–80; Part-time lecturer in design, Reid TAFE, ACT 1981–; Part-time lecturer in drawing and design, Canberra College of Art 1982–.
Exhibitions Solo show at Solander Gallery ACT 1981; Bloomfield Galleries, Sydney 1983; Participated at Canberra College of Art and Bloomfield in 1981.
Represented Private collections in Sydney, Melbourne, Hobart and ACT.

BUTTERWORTH, Terri
<div align="right">NSW</div>

Born Sydney 1945. Abstract experssionist painter.
Studies Gymea Technical College, Sydney Lincoln Art Institute, Massachusetts USA; Seneca College, Ontario, Canada; Michigan City Art Institute, Indiana, USA; Santa Barbara City College, California, USA.
Exhibitions Four in USA 1979–83; Barrenjoey Art Gallery, Sydney 1984, 85; Mary Burchall Gallery 1986; Bridge St. Gallery 1987–88, 90; Blaxland Gallery 1988; Braemar Gallery 1988.
Awards Tri Kappa Purchase 1976; Santa Barbara Art Prize 1982, 83; Warringah Art Prize 1984; Mercantile Credit Prize 1984.
Represented Institutional and private collections in USA, Japan, Canada, Australia.

BUTTON, Loris
<div align="right">VIC</div>

Born Melb. 1951. Modern painter.
Studies PIT, Melb. 1975–79; Tas. School of Art. Hobart 1981–84.
Exhibitions Solo shows at *Anzart in Hobart,* 1983; Avago Gallery, Sydney 1983; Tas. School of Art, Hobart 1984; Rhumbarallas Gallery, Melb. 1985. Included in *A New Generation 1983–88* at ANG Canberra 1988.

BUXTON, Bertha
<div align="right">VIC</div>

Born France, arrived Australia 1939. Painter of landscapes in oil.

Studies With George Bell and at the National Gallery School, Melbourne; Returned to France in 1960, 1965, 1970 to study at the Academie de la Grande Chaumière under Professor Aujame and the Academie Julian with Mac Avoy, Pierre Jerome and Claude Schurr; Member of the Malvern Artists Society and the Victorian Artists Society and exhibits with both.
Represented Private collections in Australia, USA, the Philippines, NZ, Japan and France.

BYRNES, Mona NT
Born Hermannsburg Mission NT 1923. Painter, arts admininstrator, photographer.
Studies No formal art training but has been influenced by the late Margaret Preston, also Judy Cassab and other talented artists who have painted in her area. Study tour to UK, Europe 1976 and Asia 1979. Foundation and Hon. Life Member of Central Australian Art Society; member Alice Springs Art Foundation and Araluen Foundation.
Exhibitions Solo shows at Adelaide and Alice Springs 1979; retrospective show at Darwin Museum and Art Gallery 1983. Numerous group shows.
Awards Darwin Centenary Prize; NT Art Award 1982; Tennant Creek Award 1983; Awarded OAM in 1981 for services to the arts.
Represented Museum and Art Galleries of the Northern Territory; Northern Territory Government Collection; Australian Airlines Collection; Araluem Art Centre, Alice Springs; Law Courts, Alice Springs; Private collections USA, Germany, UK and Australia.
Bibliography *Artists & Galleries of Australia*, Max Germaine: Craftsman House 1990.

C

CADBY, Susan NSW
Born Melbourne Vic. Designer, painter and teacher.
Studies Diploma of Interior Design from East Sydney Technical College; Fine Arts Rice University, Houston USA; Colima College of Arts, Mexico; Returned to Australia 1975; Oomoto School of Traditional Japanese Arts, Kameska Japan 1978; Teaches at Waverley-Woollahra Art Centre and for watercolour workshops at University of NSW and Qld Arts Council.
Exhibitions Noella Byrne, solo shows 1980–81; 85; Hunter Taylor Gallery 1982, 87; James Brown Gallery, Mackay, Qld 1982; Engaged in fashion textile designing during 1988.
Represented Institutional and private collections in Australia, USA and Japan.

CADERET, Nona VIC
Born Vic. Tonal realist painter and teacher.
Studies Caulfield Institute of Technology; National Gallery School and with Shirley Bourne at the VAS; teaching at the Malvern Artists Society 1984–.
Awards Ringwood Rotary Art Show and Bendigo Rotary Art Show.

CADDEN, Judy NSW
Born NSW 1938. Realist painter in oil.
Studies Studied under Marjorie Penglase and Rex Newell 1973–78; Former member of Warringah and Ku-ring-gai Art Societies.
Exhibitions Caringbah, Dee Why and St Ives Galleries.
Represented Private collections in UK, Europe, Japan and Australia.

CADDY, Jo SA

Born 1914 in Washington State, USA. Grew up in Canada. Painter, portraitist, sculptural potter.

Studies Graduate in Fine Arts, Vancouver 1934; Lecturer, SASA 1957–63; University of Adelaide Adult Education Department and country lecture circuit 1960–64; Summer Schools 1961–63; Senior Art Lecturer Girton College now Pembroke 1967–68; Visiting Lecturer in Painting Glasgow School of Art, Scotland 1969; Established studio at Grove Hill 1970; Full-time freelance painting and ceramics from 1970; Lecturer, Adult Education, University of Adelaide and W.E.A. 1965–88; Seminars, Survival in the Arts, Prahran College of Advanced Education 1976; Art Reviewer, Antiques and Art. Fellow — RSASA, Secretary of Contemporary Arts Society, 1962; Study tours to Greece and North America 1965–66; South Africa 1966; East Africa 1968; New Caledonia and Timor 1968–69; The Himalayas 1977; UK, USSR, Turkey, Iran and Spain 1978; China 1978; Bali, India and Kashmir 1978; Indonesia, Java, 1980; Europe 1984; Saudi Arabia 1987.

Exhibitions Numerous solo shows since 1964 and in recent years Distelfink Gallery, Melb. 1982; Greenhill Galleries WA 1984; Reade Art 1988 and *Portraits Recent and Retrospective*, Royal South Australian Society of Arts 1988; Many group shows since 1960 and including Archibald Prize Travelling Exhibition to Nat. Gallery of Vic. and Orange Reg. Gallery 1987.

Awards Travelling Scholarship, Vancouver Art School, Canada 1964; Portia Geach Portrait Prize 1967; Kadina Portrait Prize, SA 1981.

Represented AG of SA; Lamu Museum, Kenya; Flinders University; SACAE; private collections in Aust. and overseas.

Bibliography McCullough, Alan, *Encyclopedia of Australian Art 1984*; Benko, Nancy, *Art and Artists of SA Adelaide 1969*; *Artists & Galleries of Australia*, Max Germaine: Craftsman House 1990.

CAHILL, Kathleen NSW

Born Aust. 1960. Painter.

Studies ESTC 1980; BA, Visual Arts, City Art Institute 1984; Grad. Dip. 1987.

Exhibitions RCA, London UK 1984; Blaxland Gallery, Sydney 1985, 86, 87; Ivan Dougherty Gallery 1987.

CALDER-BROOKE, Hazel Goddard VIC

Born Caulfield Vic. Traditional painter, portraitist and teacher.

Studies Diploma in Art from National Gallery School, Melbourne with scholarship for portrait painting; Foundation member of Beaumaris Art Group; Member Cheltenham Art Group and the VAS; Taught art at Clyde School, Woodend, Has exhibited over the years in the aforementioned groups and the Herald Art Show.

CALDOW, Sandy VIC

Born Lismore, Victoria 1961. Sculptor, ceramic artist, teacher.

Studies B. Ed. Arts & Crafts, Melbourne State College 1979–82. Studied and travelled in Asia 1987, 90; Has taught at Melbourne State College and Meat Market Centre; Art critic for *Geelong Advertiser* 1990–91.

Exhibitions Solo shows at Heathmere Gallery, Phillip Island 1988; Aviva Campbell Gallery, Melb. 1990. Numerous group shows include Qdos Gallery, Lorne 1989, 91; Geelong Regional Gallery 1990, 91; Wallace Bros. Gallery Castlemaine 1990.

Commissions Kostas Taverna, Lorne; Katmandu, Nepal; Sheraton Hotel, Nepal; Arts Council of Vic; Murals in schools.

Represented Institutional and private collections in Nepal, Indonesia and Australia.

CALKOEN, Yolande VIC

Born Oegaran Indonesia 1924. Painter in oil and watercolour; Teacher.

Studies Academy of Fine Arts, The Hague Holland; Exhibited with her husband Alfred Calkoen in Holland, UK and Australia; Special interests are portraits and mosaics.
Represented La Trobe University, Waverley Council Collection and private collections in UK, Europe and Australia.

CAMAMILE, Bev QLD
Born Qld 1940. Traditional painter.
Studies under private tutors.
Exhibitions Stevens Gallery, Brisbane 1983, 84, 85, 88, 89.
Represented Private collections in Australia and overseas.

CAMERON, Barbara NSW
Born Sanderstead UK, arrived Australia 1934. Naive painter.
Studies Royal Drawing Society, London 1919–20; Awarded Bronze Medal, special prize for drawing; Illustrator in black and white for the London Press in the 1920s; Studied oil painting with Justin O'Brien 1962–63.
Exhibitions One-woman shows at Frances Jones Studio, Sydney 1965; Yarn Market Association, Molong NSW 1976; Barry Stern Gallery, Sydney 1981; Gallery Art Naive, Melbourne 1983; Barry Stern 1984; Eddie Glastra Gallery 1986; participated in many joint shows in Sydney and Melbourne.
Publications Wrote and illustrated three children's books in the war years under the pen name of 'Toby Cameron', *The Magical Hat*, *Our Funny Mummy* and *Dora Dromedary, Detective*, Currawong Press; *Our Funny Mummy* is in the Dromkeen Collection of Children's Literature in Melbourne.
Represented Institutional and private collections in UK, USA and Australia.
Bibliography *Bibliography of Australian Children's Books*, Marcie Muir, André Deutsch, London Vol 1 1970; *Artists & Galleries of Australia*, Max Germaine: Craftsman House 1990.

CAMERON-BROWN, Alison WA
Born Harvey WA 1949. Painter in watercolour, pastels, tempera; Sculptor and teacher.
Studies Fine arts at WAIT, Perth majoring in Sculpture 1971–75; Lecturer in sculpture, Bunbury Technical College 1978–83.
Exhibitions Bunbury Arts Chambers 1978–79; Bunbury Purchase show 1980–82.
Represented Bunbury Civic Gallery WAIT Collection.

CAMERON-ROBERTS, Shirley NSW
Born Nyah West, Vic. 1942. Painter and portraitist.
Studies Graduated B.Comm. from University of Melbourne 1967. Victorian Artists Society 1978–81; with Wesley Penberthy, Ming McKay and Stephen May 1965–85; Willoughby Art Workshop 1988.
Exhibitions Solo show at Eaglehawke Galleries, Sydney 1990; numerous group shows since 1970 include Victorian Artists Society, Mosman and Artarmon Galleries.

CAMPBELL, Barbara ACT
Born Kansas City USA 1935. Painter and teacher.
Studies University of Colorado 1953–55; George Washington University 1957–58; New School and National Academy of Design, New York 1973–76; Lived in Lima, Peru; Canberra 1962–66; Rawalpindi, Pakistan 1967–69; Kuala Lumpur 1970–72; New York 1973–76; Canberra 1976–79; Vienna 1980–84; Visited Papua New Guinea 1985; Europe — Asia 1986; Member of the Board of Trustees, Women's Interart Centre, New York; Member of organising committee ACT I and II, Canberra, 1976–80; Lecturing at Canberra School of Art, 1984–.
Exhibitions Solo shows in Kuala Lumpur, Singapore and Europe since 1971 and at

Reconnaissance Gallery, Melb. 1987, Painters Gallery Sydney 1987, 88, 90; Numerous group shows since 1968 and Canberra S of A Staff Shows 1985–86; Kuala Lumpur 1968, 69; Susan Gillespie, Canberra 1977–78.

Represented ANU, Canberra Artbank; many institutions and private collections around the world and in Australia.

Bibliography *Artists & Galleries of Australia*, Max Germaine: Craftsman House 1990.

CAMPBELL, Cressida NSW

Born 1960. Painter, portraitist, printmaker, illustrator.

Studies ESTC 1978–79; Yoshida Hanga Academy, Tokyo 1980.

Exhibitions Solo shows at Hogarth Gallery, 1979, 81, 83; Mori Gallery 1985, 87; Griffith Uni, Brisbane 1986; numerous group shows include Aust. Perspecta 1985, AGNSW; Blaxland Galleries 1985, 86; 9th British Print Biennale, Bradford UK 1986; MPAC 1986; Ipswich Reg. Gallery 1986, 87; Warrnambool Reg. Gallery 1987; New England Reg. Gallery 1988; International Print Biennale, Cracou, Poland 1988; David Jones, Sydney 1988; Macquarie Galleries 1988; Penrith Reg. Gallery 1989; Rex Irwin 1988.

Awards QE Jubilee 1985; A in R, Griffith Uni. 1986; MPAC 1987; Henri Worland Print 1987; St. Gregorys Annual 1988; SMH Heritage 1988; VAB, Verdaccio Studio, Italy 1989; ACTA 1990.

Represented NGV, AGNSW, Artbank, institutional and private collections in UK, Europe, Australia.

CAMPBELL, Denise TAS

Born Hobart Tas 1952. Painter in oil, acrylic, mixed media and collage, printmaker, teacher.

Studies Launceston Technical College School of Art and Tas College of Advanced Education, Diploma of Fine Arts 1970–74; Glasgow School of Art, Scotland, Diploma of Postgraduate Studies 1974–75; Lithography course 1980–81 visiting colleges and workshops in England and Scotland; Part-time teacher at Launceston Technical College 1976; presently lecturer in Printmaking, Launceston College of TAFE; Fellow-in-Printmaking, Exeter College of Art and Design, Devon UK 1983–84.

Exhibitions One-woman show at Bowerbank Mill Gallery, Tas 1974; Launceston Studio, Tas 1975; Salamanca Place Gallery, Hobart 1976, 1978; Coughton Galleries, Hobart 1979–82; Ritchies Mill Art Centre, Launceston 1982; Handmark Gallery, Hobart 1984; Freeman Gallery 1987; Ritchies Mill Art Centre, Launceston 1989; Salamance Place Gallery and The Institute Gallery, Tas. State Institute of Technology, Launceston 1990. Group shows at Strathclyde University and Glasgow School of Arts, Scotland 1975; Work purchased for Tas Museum and Art Gallery, Tas Drawing Exhibition 1972; Artist-in-Residence, Queen Victoria Museum and Art Gallery, Launceston December 1975; Work selected for acquisition by Elwyn Lynn, Blue Gum Festival Exhibition; Paintings purchased by Tas Government Public Galleries; Tutor with adult education board 1976; Part-time lecturer in art theory, painting and visual exploration, Launceston Technical College School of Art 1976–78; Burnie Gallery 1980; Newcastle NSW 1981; Adelaide SA 1981; Salamanca Place Gallery 10th Anniversary 1982; Exeter Gallery, Devon UK 1984; Excelsior Gallery, Sydney 1985; Chameleon Gallery, Hobart 1986; 70 Arden St. Melb. 1988; QVMAG 1989; Freeman Gallery, Hobert 1990, 91.

Awards Tas Arts Council Grant for travel to Scotland, 1974–75; Tasmanian Drawing Prize 1975; Purity Art Prize 1979; Burnie AG 1980; Fellow-in-Printmaking, Exeter College UK 1983–84; TAAB Grant 1989; Goldfields Print Award 1989.

Commissions Fujii Keori, Japan 1981; Fricker Building, Hobart 1987; PCA 100 x 100 Print Portfolio 1988; Johnson Tile Project 1990.

Represented Tas Museum and Art Gallery; Tas government offices; Private collections Scotland, NSW, WA, Vic, Tas and Japan.

Bibliography *Directory of Australian Printmakers* 1982, 88; *Tasmanian Artists of the 20th*

Century, Sue Backhouse 1988; *Artists & Galleries of Australia*, Max Germaine: Craftsman House 1990.

CAMPBELL, Joan NSW
Born Aust. Potter, ceramic sculptor. Studied ceramics privately; foundation member of Crafts Council of Aust.
Exhibitions Faenza Ceramic Exhibition, Italy 1974; Carmen Dionyse International, Ghent, Belgium 1981.
Awards Caltex Award 1974; Roz Bower Memorial Award for services as Community Arts Developer 1986; MBE 1978.
Commissions Uni. of WA 1982; Orchard Hotel, Perth 1984; Williams Residence Sydney 1987; Fountain — St. Georges Building, Sydney 1988.
Represented ANG, NGV, QAG, QVMAG, TMAG, AGWA; V & A Museum, London UK; Powerhouse Museum, Sydney, institutional and private collections in UK, Europe, NZ, Australia.

CAMPBELL, Kay NSW
Born Bega NSW 1945. Painter and teacher.
Studies National Art School, Newcastle 1968–69 and National Art School East Sydney 1970–71. Awarded Diploma in Art (Education). Studied Newcastle University 1975–77, majoring in Classical Civilisation, awarded Bachelor of Arts Degree; Studied Newcastle College of Advanced Education 1979–80, awarded Diploma in Art; Studied Newcastle College of Advanced Education 1981, awarded Postgraduate Diploma in Painting; Studied Newcastle College of Advanced Education 1986 to convert Diploma in Art to degree status, awarded Bachelor of Arts (Visual Arts); Presently head teacher, Visual Arts at Northlakes High School, Newcastle.
Exhibitions Solo shows at von Bertouch Galleries, Newcastle 1985, 88; Numerous group shows with von Bertouch and Holdsworth Contemporary Galleries, Sydney 1987.
Awards Newcastle Region Artists Prize 1980, Maitland Tertiary Student Art Prize (joint winner) 1981, Newcastle Regional Artists Prize 1982.
Represented Institutional and private collections in Australia and overseas.

CANNEEL, Martine NSW
Born Brussels, Belgium 1936. Sculptor.
Studies Ecoledes Beaux-Arts, Brussels 1953; Sorbonne, Paris 1954–62.
Exhibitions Solo shows in Belgium 1972–78 and Hogarth 1982; Mori 1984; Included in Australian Sculpture Now, NGV 1985; Coventry Galleries 1988.
Bibliography *Catalogue of Second Australian Sculpture Triennial.*

CANNING, Criss VIC
Born Melb. Landscape painter, portraitist.
Studies Graphic art for one year at Swinburne TC, painting under private tutors.
Exhibitions Kalorama Gallery 1982; Melb. Art Exchange 1983–87, 90.
Awards Won prize in the A.M.E. Bale Awards 1985.
Represented Institutional and private collections in Australia and overseas.

CANNING, Gay SA
Born Sydney. Painter, printmaker, teacher.
Studies Dip. Art, Newcastle CAE 1979; Grad. Dip. Secondary Education 1981. Lecturer in Printmaking at Bendigo CAE 1989; presently teaching at St Aloysius College, Adelaide. Has exhibited widely.
Awards Printmaking Award, Burnie, Tas. 1989; BMG Fine Art Award, Adelaide 1991.

CAPELLE, Joanna WA
Born WA 1946. Figurative painter and illustrator. **Studies** Worked as a newspaper artist and a freelance illustrator in WA and overseas before beginning to paint in earnest in 1973. **Exhibitions** One-woman shows at Playhouse Theatre, Perth 1972; Churchill Gallery, Perth 1964, 1975, 1976; Shinju Matsuri Guest Artist, Broome WA 1977, 1979; The Courthouse, Broome WA 1978; Fremantle Arts Centre 1980; Greenhill Galleries, Perth 1981; Artist-in-Residence, Mundaring Arts Centre, WA 1982; Holdsworth Galleries, Sydney 1984; Participated at Cremorne Gallery, Perth 1965, 1966; Fremantle and Mundaring Arts Centres 1982–83.
Represented Public and private collections in UK, USA, Europe, Australia and NZ.
Bibliography *The Australian Artist* April 1985.

CAPSALIS, Helen VIC
Born Melb. 1965. Printmaker.
Studies BA Art and Crafts, Melb, CAE 1983–87.
Exhibitions 70 Arden St. Gallery 1988.
Commissions PCA 100 x 100 Print Portfolio 1988.
Bibliography *PCA Directory* 1988.

CAREY, Austral TAS
Born Kempsey NSW 1917. Painter, weaver.
Studies Hobart S of A 1966–68, and weaving and silversmithing workshops. Life member CAS.
Exhibitions Art Society of Tas. and CAS 1962–73. Salamanca Place Gallery 1976–78.
Bibliography *Tasmanian Artists of the 20th Century*, Sue Backhouse 1988.

CAREY WELLS, Penny TAS
Born Hobart 1950. Papermaker, sculptor, teacher.
Studies Hobart S of A 1967–70, MFA 1980–84. Taught with Tas. Ed. 1971–85; study tour Philippines 1982, 84; currently runs the Paper Mill at Hobart S of A.
Exhibitions Solo shows at Handmark Gallery, Hobart 1983, 85; numerous group shows including Beaver Gallery, Canberra 1985.
Bibliography *Tasmanian Artists of the 20th Century*, Sue Backhouse 1988.

CARLAND-SALIH, Trisha VIC
Born Geelong Vic 1954. Painter and printmaker.
Studies Diploma of Fine Arts under Jack Koskie at Gordon Institute of Technology, Geelong; Overseas study to UK and Europe 1971.
Exhibitions One-woman show Juniper Gallery, Melbourne 1975 and participated in Corio Shire Award 1973; F.E. Richardson Print Acquisitions 1974; Henri Worland Memorial Art Prize 1974, 1975; PCA Student Exhibition Royal College of Art, London 1974; Australian Student Printmakers, 1975; Ewing and George Paton Galleries, Melbourne University; Mornington Peninsula Art Centre 1980; Raya Gallery 1982; Gallery 10–12, Singapore 1983.
Bibliography *PCA Directory* 1988.

CARRINGTON, Sonya (Zakrzewska) VIC
Born Poland, arrived Australia 1949. Painter, illustrator, weaver, teacher.
Studies Institute in Plastic Art, Pozan, Poland. Technical Teachers College, Melbourne; taught at Syndal TC, Caulfield TC and Emily McPherson College.
Represented The Vatican Museum, Rome; University of Melbourne, institutional and private collections.
Bibliography *Alice 125*; Gryphon Gallery, University of Melbourne 1990.

CARROL, Linda QLD
Born London UK 1949. Painter, teacher, craftworker.
Studies Claremont TC, WA 1971–72; WAIT 1973–74; taught part-time at Uni. of Natal,
South Africa in the 1970's and exhibited in Durban and Capetown; Included at The Centre
Gallery, Gold Coast, Qld 1988.
Bibliography *A Homage to Women Artists in Queensland Past and Present*, The Centre Gallery
1988.

CARTAN, Leanne NSW
Born Kempsey NSW 1966. Painter and printmaker.
Studies ESTC 1985–87.
Exhibitions Blaxland Galleries 1987–88; Macquarie Galleries 1988, 90; Penrith Regional
Art Gallery 1989; Holdsworth Galleries 1991.
Awards Barry Stern Print Prize 1987.
Represented Institutional and private collections.

CARTER, Nanette VIC
Born Ivanhoe, Vic. 1954. Photographer.
Studies Dip. Art PIT also postgrad. Dip.
Exhibitions Solo show at Axiom Gallery, Melbourne 1981; Developed Image, Adelaide
1982; Barcelona, Spain 1982; Kyoto, Japan 1984; Numerous group shows.
Represented AGNSW; institutional and private collections around Australia and overseas.
Bibliography *150 Victorian Women Artists*, Visual Arts Board/WAM 1988.

CARTER, Ketha VIC
Born Melbourne Vic 1912. Printmaker and batik painter.
Studies Private drawing and painting lessons, Paris, France 1930; Working Men's College,
Melbourne under Amalie Field, Napier Waller and others 1932; Blackheath School of Art,
London 1933; Interior Design Course, RMTC, Melbourne 1959; Certificate of Art Course,
Brighton Technical College, Melbourne 1966; Worked as a free-lance textile designer 1964;
Studied screen-printing techniques 1965; Studied modern batik painting in Java Indonesia
1972; Foundation member of Society of Batik Artists, Melbourne 1980.
Exhibitions Participated in many shows since 1967 and in recent times batik painting at
East and West Art Gallery, Armadale, Melbourne 1977; Batik painting at Hawthorn City
Art Gallery 1978; Four shows of members work with the SBA.
Represented Private collections in UK, Java and Australia.

CARTER, Valerie QLD
Born 1964. Painter, graphic designer, illustrator.
Studies Dip. Graphic Design — Riverina CAE; Worked in advertising 1985; study tour
UK, Europe 1986; Committee member in charge of display at Noosa Reg. Gallery, Qld
1988–89.
Exhibitions Solo shows at Fairhill Gallery, Yandina, Qld 1987; The Art Gallery, Coolum,
Qld 1988; Holdsworth Galleries, Sydney 1989.
Commissions Commissioned to design and illustrate a set of works for Netanya Resort,
Noosa also the childrens book *The Nimbin* and the picture book *The Windmill in the Paddock*.
Represented Institutional and private collections in Australia and overseas.

CASBOLT, Leonie VIC
Born Melb. 1959. Painter, printmaker.
Studies B.Ed. — Melb. State College 1978–81; Postgraduate studies drawing/printmak-
ing, Gippsland IAE 1985.
Exhibitions Solo shows at Mori Gallery 1987; Holdsworth Contemporary Galleries 1988;

Group shows at Niagara 1979; Gryphon 1982, 83; MPAC 1983, 84; APC Travelling Show to Japan 1984.

Represented Regional Galleries, institutional and private collections in Australia and overseas.

CASEY, Karen VIC

Born Hobart 1956. Printmaker.

Studies Tas. S of A 1977.

Exhibitions Touring PCA show and Commonwealth Institute, London 1987–88; Aust. Perspecta — Artspace Sydney 1989.

Awards Visual Arts Fellowship 1988.

Commissions Northern Land Council Poster 1988.

Represented ANG; NGV; institutional and private collections.

Bibliography *PCA Directory* 1988; *A Myriad of Dreaming*, Malakoff Press 1989.

CASLEM, Sherryl Ann QLD

Born 1958. Painter, graphic artist.

Studies Graduated in Graphic Design from Perth TC, WA; also worked in London UK.

Exhibitions Solo shows at Territory Colours Gallery, Gold Coast, Qld 1989.

CASSAB, Judy NSW

Born Vienna Austria 1920 of Hungarian parents, arrived Australia 1951. Painter and portraitist.

Studies Prague and Budapest Art Academies; Married John Kampfner just before World War II and after difficult times and separation during the war years, the family arrived in Australia and settled in Sydney; She soon established a reputation as a painter of abstracts in oil and acrylic and a portraitist; She is one of the two women who have won the Archibald Prize; Trustee, Art Gallery of NSW 1980–1988.

Exhibitions Solo shows at Macquarie Galleries, Sydney 1953, 1955, 1961; Newcastle City Art Gallery 1959; Crane Kalman Gallery, London 1959; Argus Gallery, Melb. 1962; Rudy Komon Gallery, Sydney 1963, 1967, 1972, 1975, 1979, 1982; Georges Gallery, Melb. 1964; von Bertouch Galleries, Newcastle 1964, 1970, 1975, 1983, 1988; Skinner Gallery, Perth 1967, 1969, 1973; Studio White Gallery, Adelaide 1969; Reid Gallery, Brisbane 1973; South Yarra Gallery, Melb. 1976; New Art Centre, London 1978; Gallery One, Sydney 1979; Masterpieces Fine Art Gallery, Hobart 1980; Verlie Just Town Gallery, Brisbane 1980, 1984; Australian Embassy, Paris 1981; New Art Centre, London 1981; Greenhill Galleries, Perth 1982, Adelaide 1982; Solander Gallery, Canberra 1983; Holdsworth Galleries, Sydney 1985, 1987; Benalla Regional Gallery, Vic 1985; Hamilton Regional Gallery, Vic 1985; Caulfield Art Centre, Vic 1985; David Ellis Fine Art Gallery, Ballarat, Vic 1985; David Ellis, Melb. 1987, 89, 90; Portrait Exhibition: Artists and Friends, S.H. Ervin Gallery, Sydney 1988; von Bertouch Galleries 1988; Solander Gallery, ACT 1988; Brisbane City Gallery 1988; Nat. Library, Canberra 1988; Verlie Just Town Gallery, Bris. 1989; Fremantle Arts Centre 1990; Holdsworth Gallery 1990.

Awards Perth Prize 1955; Women's Weekly Prize 1955, 1956; Archibald Prize 1960, 1967; Helena Rubinstein Prize 1964, 1965; Charles Lloyd Jones Memorial Prize 1965, 1971, 1972, 1973; Awarded CBE for services to the arts 1969, and Officer of the Order of Australia 1988.

Commissions Portrait commissions include Sir Robert Helpmann and Dame Joan Sutherland for the Sydney Opera House; Queen Sirikit of Thailand for the Commonwealth Government; Princess Alexandra, P&O Lines Ltd for the ship RMS *Oriana* and HRH the Duke of Kent 1983.

Represented National Collection, Canberra; State Galleries of NSW, Vic, SA, Qld; Rugby Museum, UK; Nuffield Foundation, Oxford UK; Newcastle City Art Gallery; Tas Museum

and Art Gallery; Commonwealth Collection, Canberra; National Gallery of SA; Bendigo City Art Gallery Vic; National Gallery of Budapest; National Portrait Gallery, London; Private and institutional collections in Australia and overseas.

Bibliography *Masterpieces of Australian Painting*, James Gleeson 1969; *Modern Australian Painting 1960–70*, Kym Bonython 1970; *Encyclopedia of Australian Art*, McCulloch 1977; *Australian Painting 1788–1970*, Bernard Smith 1974; *Modern Australian Paintings 1970–75*, Kym Bonython 1974; *Judy Cassab*, Elwyn Lynn, McMillian 1984; *Judy Cassab, Artists and Friends*: Lou Klepac 1988; *Artists & Galleries of Australia*, Max Germaine: Craftsman House 1990.

CASTLES, Maree VIC
Born Young NSW 1950. Sculptor.
Studies Community College, San Francisco USA; In Melbourne with Frank Turtle; Study tour to South Africa.
Exhibitions Solo show at Wiregrass Gallery, Vic 1982, 88.

CAVALIERI, Angela VIC
Born 1962. Printmaker.
Studies BA Fine Arts VCA 1981–83.
Exhibitions Solo show at 200 Gertrude St 1986; group shows at Christine Abrahams 1984; Ben Grady Gallery, Canberra 1986.
Awards Potter Foundation, NGV Trustees 1981; Mitchell Endowment 1983; VAB Grant 1984, 86; Desiderius Orban Award 1985; Ministry of the Arts Grant 1985; Occupancy Paretaio Colleoli Studio, Italy.
Represented NGV, institutional and private collections.
Bibliography *PCA Directory* 1988.

CELTLAN, Sonya NSW
Born Kyogle, NSW 1944. Painter and teacher. Married to artist Francis Celtlan.
Studies ESTC 1962–64. Graduated, Sydney Teachers College 1965. Taught art at Belmont High School and Hunter Girls High School 1966–67; Taught in UK 1968–73. Awarded Postgraduate Diploma in Art and Special Education, Cambridge Institute of Education 1973 (UK); Lecturer, National Art School and Newcastle CAE 1973–83; Lecturer Education Centre, ANG 1983–86; Awarded M.Ed. (Hons) University of New England 1985; Lecturer, Newcastle CAE 1986; Education Officer, Newcastle Regional Art Gallery from 1987.
Exhibitions Solo shows at Newcastle Contemporary Gallery 1988; von Bertouch Galleries 1990. Numerous group shows since 1965.
Bibliography *Artists & Galleries of Australia*, Max Germaine: Craftsman House 1990.

CERNAK VIC
Born Aust. 1949 (Wendy) Painter and teacher.
Studies BA Fine Arts and History, Uni. of Qld. Tate Gallery, London, Founded Poets Union and Art workers Union in Brisbane and was the first community arts officer in Brisbane. Painter in Melb. for some years.
Exhibitions Solo shows include Terrace Gallery 1978; AFAS Gallery 1979; Young Masters 1980; Spring Hill 1980; Mori, Sydney 1981, 82; Numerous group shows.
Represented Institutional and private collections in UK, Europe, Australia.

CHAFFEY, Lesley TAS
Born Devonport Tas. 1948. Painter, printmaker, teacher.
Studies Dip. Art Teaching 1969; TTC 1971; Certificates in Sculpture and Printmaking 1987; BA Visual Arts 1990. Currently working part-time at Launceston College of TAFE; has taught in many Tasmanian schools since 1969.

Exhibitions Solo show at TAFE School Gallery 1989. Many group shows since 1972.

CHAFFEY, Pat NSW
Born Warwick, Qld. Landscape painter mostly in pastel.
Studies Tamworth TC and workshops and summer schools at Armidale University.
Exhibitions Goonoo Goonoo Road Gallery, Tamworth NSW
Awards Southern Cross Open.
Represented Insitutional and private collections around Australia and overseas.

CHANDLER, Lisa NSW
Born Sydney 1958. Painter and printmaker.
Studies Alexander Mackie CAE Dip Fine Art 1979.
Exhibitions The Wharf, Noosa Qld 1983; Market Rowe Gallery, Sydney 1983. Numerous group shows.
Awards Warringah Prize 1978.
Commissions Weswal Pottery, Tamworth 1978; Rios Complex, Noosa Qld 1980.

CHANDLER, Margaret (Peggy) TAS
Born Hobart 1923. Watercolour painter, teacher.
Studies Hobart TC under Jack Carington Smith and Lucien Dechaineux 1941–43, 44–45. Taught HTC 1947–49 and Tas. Ed. 1960–63. Overseas study tours China 1978, UK, Europe 1980, 85.
Exhibitions Saddlers Court Gallery 1987; regularly since 1944 with Tas. Group and Art Society of Tas.
Bibliography *Tasmanian Artists of the 20th Century*, Sue Backhouse 1988.

CHANDLER, Patricia VIC
Born Vic. 1939. Sculptor and ceramic artist.
Studies BA Fine Art (Sculpture) PIT Melb.
Exhibitions Solo show at Distelfink Gallery, Melb. 1985.

CHAPMAN, Annette NSW
Born Sydney 1959. Painter.
Studies Certificate, Hornsby TC 1979–80; Higher Certificate ESTC 1984.
Exhibitions Solo shows at Ten Taylor St. Gallery 1990; Access Gallery 1991; Group shows at Sydney Opera House 1980; ESTC Gallery 1985, 88.

CHAPMAN, Dora SA
Born Mt Barker SA 1911. Painter, printmaker and teacher.
Studies SA School of Arts; Worked and studied in UK and Europe for some years; On return to Adelaide lectured at SA School of Arts 1958–74; Married to artist James Cant; Fellow of the RSASA, member of the CAS; Won Melrose Prize for Art and has exhibited widely. Solo show BMG, Adelaide 1987.
Represented Australian National Gallery; Art Gallery of WA; Art Gallery of SA; Tas Art Gallery; Hamilton Art Gallery, Vic; University of Adelaide.
Bibliography *Directory of Australian Printmakers* 1976.

CHAPPELL, Christine VIC
Born Melbourne Vic 1950. Painter, sculptor and printmaker.
Studies Prahran Institute of Technology, Sculpture and Printmaking 1973–77; Diploma in Art and Design.
Exhibitions Solo shows at Ministry for the Arts, Melbourne 1979; Participated at Gryphon Gallery 1980; Warehouse Gallery 1977; Powell St Gallery 1978; Clive Parry Gallery 1978;

Mildura Arts Festival 1978; Intaglio Printmakers, London UK 1981; Standfield Gallery, Melb. 1987; Art Expo, New York, USA 1987; Westpac Gallery, Melb. 1987.
Commission Print Council Member Print 1981.
Represented Prahran CAE and private collections in UK and Australia.
Bibliography *Directory of Australian Printmakers* 1982, 88.

CHARLES, Rachel NT
Born c.1965 Coniston Station Central Australia, an Aboriginal painter in acrylic from the Napperby group.
Exhibitions Brisbane, Melb., Adelaide.

CHARLTON, Kathleen WA
Born UK 1923, arrived Australia 1949. Painter, printmaker and teacher.
Studies Diploma of Art Studies, Perth WA; Teaches for Education Dept of WA; Post diploma studies in Chinese art at Murdoch University.
Exhibitions North Perth 1976; Fremantle Arts Centre 1977; Printmakers Association of WA.
Awards Perth Print Award 1977.
Commissions Bridgetown Tourist Bureau Mural, WA.
Represented Perth Technical College and private collections in England, Channel Isles, Japan and Australia.
Bibliography *Directory of Australian Printmakers* 1982.

CHEO, Cecily NSW
Born Melb. 1951. Painter, printmaker.
Studies CIT, Melb. 1970–73; Brighton Polytechnic UK 1974; Uni. of New England 1982–83; SCOTA — BA Visual Arts 1984; Postgraduate Dip. 1985.
Exhibitions Solo shows at Bloomfield Galleries Sydney 1987, 89; BCAE, Kelvin Grove 1987; participated First Draft 1986; Albury Reg. Gallery 1988; Aust. Contemporary Art Fair, Melb. 1988.
Represented Institutional and private collections in UK, Europe, Australia.

CHESHIRE, Barbara QLD
Born Atherton Qld 1946. Painter.
Studies Dip. Fine Art, Townsville College of TAFE and with Fred Cress and Guy Warren.
Exhibitions Solo shows at Perc Tucker Reg. Gallery, Townsville 1987, Kirwin Library, Thuringowa 1987; Birch Carroll & Coyle Gallery, Townsville 1987; numerous group shows 1988, 89.
Awards Townsville 1985, 88; Pacific Festival 1987; Logan City 1988.

CHEUNG, Olwen NSW
Born 1943. Painter, printmaker, teacher.
Studies ESTC 1961–64; Taught art from 1965 including Hornsby Girls High School 1977–90. Completed M. Art Ed. degree at University of NSW 1990–91. Member of The Print Circle.
Exhibitions Kirribilli Centre 1987; WAC 1988, 89, 91.
Represented Institutional and private collections.

CHICK, Lorna VIC
Born Wangandary Vic 1922. Naive painter.
Studies Part-time Wangaratta Technical School 1964–65; First came to notice when her entry in the 1967 Fairley Art Award was Highly Commended; Her most ambitious work, a three-metre by one-metre canvas was acquired by the National Gallery, Canberra in 1976.

Represented Australian National Collection, Canberra; Shepparton Art Gallery; Wangaratta City Collection; Benalla Art Gallery and in private collections including that of Dr W. Orchard.

Bibliography *Australian Naive Painters*, Bianca McCullough, Hill of Content 1977.

CHORNEY, Mstyslava Joanna SA

Born Western Ukraine 1933, arrived Australia 1950. Sculptor, painter and teacher.

Studies Diploma of Art Teaching at SA School of Art and Adelaide Teachers College 1971; Lectures at the School of Arts and Crafts, Dept of Further Education, Adelaide; Part-time at the School of Graphics, CAE Adelaide; Member CAS and RSASA.

Exhibitions Has held eight solo shows since 1970; In recent times at Montrichard Gallery 1981; Centre Gallery, Dept of Education 1982.

Represented Vatican Museum, Italy and private collections in Australia and overseas.

CHRISTENSEN, Em VIC

Painter, illustrator.

Studies Under Ming McKay and Wes Penberthy. Member, CAS. Illustrates books and magazines.

Exhibitions Joan Gough Gallery 1984.

Awards CAS 1985, 86; Piccolo Spoleto Festival 1986; Capcon Convention 1987.

Represented Institutional and private collections in UK, Europe, Canada, NZ and Australia.

CHRISTOFF, Ludmila VIC

Born Istanbul Turkey 1948, arrived Australia 1970.

Studies College of Arts, Prague Czechoslovakia 1964–68; RMIT, Melbourne; Gold and silversmithing 1970–71; Printmaking, Caulfield Institute of Technology 1974–76; Burwood Teachers College 1976–77.

Exhibitions Spala Gallery, Prague 1966; Travelling exhibition to Poland 1967; Albert Loeb Gallery, Paris 1968; Drawing Biennale, Gallery Adriadne, Vienna 1969; Graphic Artists Fine Arts Prize, Lanes, Melbourne 1972; Group exhibition Cameron Galleries, Melbourne 1973; Monash University 1975; Clive Parry Galleries, Melbourne 1975; Caulfield Art Exhibition 1977.

Awards Young World Illustration Prize, Prague 1965; Slavoj Medal Design Prize, Prague 1967; Drawing Biennale, Vienna 1969; Caulfield City Council Prize 1977.

Represented College of Arts, Prague; Warsaw National Art Gallery; Young World Art Gallery, Prague; Albert Loeb Gallery, Paris; Gallery Adriadne, Vienna; Boston University, USA; Caulfield City Council Collection; AMP Print Collection.

CHURCH, Julia H. VIC

Born London UK 1959. Painter, printmaker.

Studies BA, ANU, Canberra 1977; Dip. Visual Arts, Canberra S of A 1979–81.

Exhibitions Numerous shows since 1979 include Bitumen River Gallery, ACT 1981, 83, 85; ANG 1982, 83, 85; Warsaw, Poland 1986; Finland and UK 1987; 70 Arden St. Melb. 1988.

Awards Artist-in-Residence Aust. Way of Life 1986 and Castlemaine TC 1987; VACB Travel Grant 1987.

Commissions PCA 100 x 100 Print Portfolio. Many poster commissions.

Represented ANG, AGNSW, AGSA, NGV, institutional and private collections in UK, Europe, Australia.

Bibliography *PCA Directory* 1988.

CHURCHER, Elizabeth Ann (Betty) ACT

Born Brisbane. Painter, art critic and teacher.

Studies Diploma in Painting and Drawing, North-East London Polytechnic; MA (First Class), Royal College of Art, London 1956; MA (Courtauld Institute of Fine Arts), University of London 1977; Her special area of study at Courtauld being English and American painting 1935–65; Taught in high schools; Lecturing in drawing and painting, Brisbane College of Art; Senior Lecturer in art and art history, Kelvin Grove CAE 1970–79; She joined Phillip Institute of Technology in 1979 and was appointed Head of the School of Art and Design in 1982. Qld consultant to the Visual Arts Board of the Australia Council 1974–76 and, at the same time, art critic for the *Australian* newspaper; Was a founding member of the Institute of Modern Art, Brisbane; She is a member of the following professional committees: International Art Critics Association; Australian Authors Association; Art Association of Australia; Chairperson of the Committee for the Domain Gallery, Centre for Contemporary Art, Melbourne; Member of the Board of Management of the Victorian Tapestry Workshop; Member of the Course Advisory Committee, Victorian College of the Arts, Melbourne; Chairperson, VAB of Australian Council 1983–88; Director of Art Gallery of WA 1987–89; Director of Australian National Gallery, Canberra from early 1990; Senior Vice-President of AICA 1991–.
Exhibitions Numerous shows over the years and latterly at The Centre Gallery, Gold Coast, Qld 1988.
Awards Princess of Wales Scholarship, Royal College of Art, London 1952; Received the Royal College of Art Drawing Prize and Travelling Scholarship 1956; *London Times* Senior award for an Information Book 1974.
Publications Author of *Understanding Art*, Rigby Ltd 1974.
Bibliography *A Homage to Women Artists in Queensland Past and Present*: The Centre Gallery, Qld 1988; *Artists & Galleries of Australia*, Max Germaine: Craftsman House 1990.

CICCARONE, Julia VIC
Born Melbourne 1967. Modern landscape painter.
Studies VCA Melbourne
Exhibitions VCA Gallery 1988; Centre Gallery, Surfers Paradise 1988. Included in the Moet & Chandon Touring Exhibition 1990.
Awards VA/CB Grant for residency of Verdaccio Studio, Italy 1991.

CILENTO, Margaret VIC
Born Sydney. Painter and illustrator.
Studies Central Technical College, Brisbane and Diploma in Fine Art (painting) from East Sydney Technical College 1945; Further studies in London, Paris and New York; Presently working in Melbourne.
Exhibitions Solo shows at Moreton Galleries, Brisbane 1951, 54; Macquarie Galleries, Sydney 1952, 53; Uni. of Qld Art Museum 1981; Garry Anderson Gallery, Sydney 1984; Many group shows since 1940 include New York 1949; Paris 1951; Macquarie Galleries, Sydney 1953; Redfern Gallery, London 1955 and annually with *The Half Dozen Group of Artists*, Qld.
Awards Wattle League Scholarship 1947.
Represented Qld Art Gallery and Institutional and private collections in Australia and overseas.
Bibliography *Australian Watercolour Painters 1780–1980*, Jean Campbell, Rigby 1982; *A Homage to Women Artists in Queensland Past and Present*, The Centre Gallery 1988; *Artists & Galleries of Australia*, Max Germaine: Craftsman House 1990.

CINANNI, Cathy WA
Born Perth WA 1963. Painter.
Studies WAIT Perth 1981–85.
Exhibitions Solo show at Beach Gallery, Northbridge WA 1987. Included in *A New*

Generation 1983–88 at ANG Canberra 1988.

CLARK, Ada NSW
Born NZ 1930. Expressionist landscape and flower painter in gouache, designer.
Studies Wellington Tech. School, NZ; Central School of Art, London UK; Numerous study tours to UK and Europe.
Exhibitions Solo shows at Architectural Gallery, Wellington 1955, 63; Chattertons Gallery, Sydney 1960; Willeston Gallery, Wellington 1960; Holdsworth Gallery, Sydney 1975; Orange Reg. Gallery 1979; Craft Council Gallery, Athens, Greece 1981; Lewers Memorial Gallery, Emu Plains 1984; Greek Centre, Sydney 1985; Beaver Galleries, Canberra 1987, 89, 91; Casey Galleries, Sydney 1988; Eaglehawke Galleries, Sydney 1991; Many group shows.
Awards Woollahra Bicentennial Art Prize 1988.
Represented Woollahra Municipal Council, corporate and private collections in Aust. and overseas.

CLARK, Bronwyn VIC
Born Box Hill Vic 1961. Printmaker, linocuts and woodcuts.
Studies Diploma of Art and Design (printmaking) from Prahran CAE, Vic 1980–82.
Exhibitions The Seal Club, Vic 1982 and in group shows touring Australia and Scotland 1983.
Awards Projects Gallery, Hamilton Vic 1982.

CLARK, Margaret Mary NSW
Born Brisbane Qld 1934. Painter of themes from nature in gouache, ink, pen and wash; Wife of artist, Donald Bruce Clark.
Studies Full-time interior design course and Diploma, Associate, RMIT 1950–54; Studied Perugia Italy 1958 at Universita per Stranieri; Studied ceramics under Molina Reddish from 1959; Worked as part-time tutor in art and craft workshop at teacher training dept Macquarie University; Painting a series of gardenscapes featuring cats and birds for Barry Stern Galleries.
Exhibitions Barry Stern Galleries, Sydney 1979; Gallery Art Naive, Melbourne 1982.
Represented Institutional and private collections in Australia and overseas.

CLARKE, Fran VIC
Born Vic. Potter.
Exhibitions Solo show at Golden Age Gallery, Ballarat Vic 1982; Participated at Profile Gallery, Melbourne 1980; Caulfield Arts Centre 1981; Mornington Peninsula Gallery 1982.
Represented Vic Ceramic Group Collection.

CLARKE, Gwen VIC
Born Orbost, Vic. 1938. Painter.
Studies Worked as trained nurse and midwife until 1967. Member of Hughesdale Art Group from 1965–78 and Australian Guild of Realist Artists from 1975.
Exhibitions Solo shows at Gallery Art Naive 1986, 87, 89; Australian Naive Galleries, Sydney 1989, 91.
Represented Institutional and private collections in UK, Canada, Australia.

CLARKE, Lynne NSW
Born Australia. Textile and fabric artist.
Studies Only daughter of the late Sir Russell Drysdale.
Exhibitions Solo shows at Holdsworth Galleries 1986; Australian Galleries, Sydney 1991.

CLARKE, Maree **VIC**
Born Swan Hill Vic 1961. Aboriginal jeweller, craftworker, photographer and teacher.
Exhibitions Numerous shows in Australia and overseas. Established the Aboriginal Arts &
Crafts Outlet for the Aboriginal Corporation in 1978.
Bibliography *Artlink* Autumn/Winter 1990.

CLARKE, May **QLD**
Born Toronto Canada 1920. Traditional landscapist and portrait painter in oil.
Studies Under Dorothy Pullen, Canadian artist; Member of Mackay Art Society; Former
member of One Hundred Artists Group, Toronto Canada; Member of Soroptimist
International, Mackay Qld.
Exhibitions At the former Brisbane Galleries and shows in Mackay, Townsville, Alice
Springs and the Gold Coast; Many galleries in Canada.
Awards Nerang Arts Festival, Qld 1977, 1978, 1979; Mackay Art Society 1977; State-wide
contest at Mackay for painting to present to sister-city Kailua-Kona Hawaii 1976; Many
Canadian awards; Portrait commissions include Prime Minister of Canada, Pierre Trudeau
and singer-actor, Burl Ives; Qld Arts Council 1979; Mackay TAA Award 1980, 1981, 1982;
Mackay Caltex 1981.
Represented Private and institutional collections in Australia, Canada, USA and South
Africa.

CLARKE, Pamela **TAS**
Born Hobart 1942. Painter mostly in watercolour.
Studies Hobart S of A 1960–61; Launceston S of A 1970–73.
Exhibitions Solo shows at Art Stretchers, Launceston 1975; Bowerbank Mill, Deloraine
1977; Tolarno Galleries, Melb. 1979, 81; Long Gallery, Hobart 1982; Salamanca Place
Gallery 1985; included NGV 1982 in National Bank Collection.
Represented Artbank, institutional and private collections around Australia.
Bibliography *Tasmanian Artists of the 20th Century*, Sue Backhouse 1988.

CLARKE, Robyn **NSW**
Born Sydney 1945. Craftworker, painter, teacher.
Studies ESTC, Graduating 1966; Alexander Mackie College 1967. Has taught art in
London, Melbourne and Sydney. Art critic for the Melbourne *Age* for some time.
Exhibitions Solo shows at Stuart Gerstman Gallery, Melbourne 1979; Holdsworth
Galleries, Sydney 1980; Group shows at Distelfink Gallery, Melbourne.
Represented Institutional and private collections in Australia and overseas.

CLEAR, Madeleine (Drenth) **WA**
Born Connecticut USA 1945. Painter, printmaker and teacher.
Studies Perth Technical College 1963–66 for Associateship in Fine Art and Diploma of
Graphic Design. Established a woodblock and screenprinting workshop for Aboriginals on
Bathurst Island 1968–74; Part-time lecturer at Technical Education Dept 1975, art lecturer
with TAFE 1975–90.
Exhibitions Solo shows at Greenhill Galleries, Perth 1981, 83, 87, 90; Alexander Galleries,
Perth 1985; Numerous group shows since 1966.
Awards Kalamunda Purchase 1982; Floreat Forum Award 1982; Burswood Resort 1988;
Bayswater Shire 1987; Perth College Acquisition 1989.
Represented Artbank, institutional, municipal and private collections in Australia.

CLEGG, Heather **SA**
Born Adelaide 1938. Potter, ceramic artist.

Studies BSc. — Uni. of Adelaide 1960; SASA, Adelaide 1969–71; studied in UK 1971; Fellow RSA Society of Arts, 1978, currently Vice-President. Member, SA Potters Guild and Craft Council.

Exhibitions Solo shows at Lombard St. Gallery 1974; Gallery de Graphic 1978; Hahndorf Academy 1980; Megaw & Hogg Gallery 1981; Jolly Frog Gallery, 1983; Bethany Gallery 1985; Kensington Gallery 1986; Tea Tree Gully 1987; Numerous group shows since 1974 include Reade Art 1986; Kintore Gallery 1988; Gorman House Arts Centre, Canberra 1989; joint show with Stephanie Schrapel 1989; Adelaide-Himeji, Japan Exhibition 1989; David Jones, Adelaide 1989; RSASA; Araluen Arts Centre, Alice Springs; Flinders University Art Museum and Christchurch NZ 1990; Shepparton Art Gallery Vic 1991.

Represented Municipal, institutional and private collections UK, USA and Australia.

Bibliography *Artists & Galleries of Australia*, Max Germaine: Craftsman House 1990.

CLEGG, Jeanette NSW

Born Aust. Modern landscape painter.

Studies With private tutors including Betty Morgan, Clifton Pugh, Andrew Sibley and Graeme Inson. Member of Peninsula Art Society.

Exhibitions Ocean Front Gallery, Sydney and at Manly Art Gallery with Peninsula Art Society.

CLELAND, Pam SA

Born Adelaide SA 1927. Painter, impasto done with palette knife oil on board.

Studies Under artists Jeff Smart, Gwen Barringer, Dorrit Black, Francis Roy Thompson, Ludwig Dutkiewicz and Jacqueline Hick from 1945–55; After graduating in law and being admitted to the SA Bar in 1957, had to give up painting due to pressure of legal work; Resumed painting in 1974 when she ceased to practise as a solicitor and practised only as a barrister.

Exhibitions First one-woman exhibition at Bonython Gallery, Adelaide; Also exhibited with the Hexagon Group at Whitechapel Gallery, London in the 1950s and at Royal SA Society of Arts in 1961.

CLEMENS, Charlotte Liley VIC

Born Vic. 1949. Painter, printmaker, muralist.

Studies Nat. Art School 1966; Melb. Uni. Fine Arts 1968; Dip. Painting 1970; UK, Europe, South America 1971–72; Zarapi Weaving Certificate, Mexico Uni, Mexico City 1974; Apprentice, Brunskill and Kingmans, London, UK 1974; Dip.Ed. Hawthorn State College 1978; taught art until 1986.

Exhibitions Solo show at Gallery 99, Melb. 1971; participated at Roar 2 Gallery 1986, 87; Solo, Stuart Gerstman 1990.

Awards Grace Joel Prize, and Nat. Gallery School Printmaking Prize 1968.

Represented Artbank and institutional and private collections in UK, Europe, USA, Japan, Australia.

CLEMENTS, Pam VIC

Born Vic 1948. Painter and teacher.

Studies TITC 1968; Taught 1969–72, 1976–77. B. Ed. (Art) from Victoria College 1981.

Exhibitions Solo shows at Design 3 1980; Hawthorn City Art Gallery 1982; Group shows include Eltham Gallery 1978; Origins Gallery 1980, 81; Gallery of Melbourne 1979, 89, 90.

Represented Institutional and private collections.

CLEMSON, Katie NSW

Born Temora NSW 1950. Painter, printmaker and teacher.

Studies Croydon College of Art, UK; Central School of Art, London graduating Bachelor of Arts (Hons) Fine Arts; Postgraduate art degree at Whitelands College, London 1977–78; Taught art at Eton College 1978 and printmaking at St Paul's Girls School 1979–81; Visiting lecturer at Central School of Art, London, Glasgow College of Art, Canterbury College of Art and Maidstone College of Art 1979–82; Member, Australian Print Council and edition of PMC magazine 1978–80.

Exhibitions One-woman shows at Dryden St, London 1978; J. Walter Thompson, New York 1979; Eton Drawing School 1981; Phoenix Gallery, UK 1981; Graffiti Gallery, London 1981–82; Blaxland Galleries 1987, 90; Participated in many group shows in UK since 1976 and recently Morley College, London 1983, and Bradford Biennale 1986; Blaxland Galleries 1989.

Awards Relief Print Prize Bradford UK 1986.

Represented Institutional and private collections in UK, Europe, USA, Canada and Australia.

Bibliography *Directory of Australian Printmakers 1988.*

CLEREHAN, Sonia (Cole) VIC
Born Melb. 1932. Painter, teacher.
Studies Nat. Gallery, London UK 1951; Victoria College, Prahran, Melb. 1973–77; Europe 1952, 87; USA, India, Russia 1968; tutor Adult Ed. and private schools 1977–82.
Exhibitions Roar Studios 1985; MPAC 1987; Ackland St. Gallery 1988; solo at CAS 1983; Ackland St. 1989.
Awards Art Papers 1982; CAS Prize 1984.
Represented Institutional and private collections in Australia and overseas.

CLIFF, Joyce NSW
Born Newcastle NSW 1927. Potter, ceramic artist and teacher.
Studies Newcastle CAE, completed four year part-time Ceramics Course; Taught for University of Newcastle Pastimes and Diversion Program 1973–75 and since then private classes.
Exhibitions von Bertouch Galleries 1979 and since 1971 with Newcastle Ceramic Group.

CLIFTON, Nancy VIC
Born Melbourne Vic 1907. Painter, printmaker and teacher.
Studies National Gallery School, Melbourne 1927–29; Worked as an illustrator for Melbourne newspapers in the early 1930s; RMIT for printmaking 1957–59; Art teacher at Ivanhoe Girls' Grammar School 1951–72; Study tours to UK, Europe and USA 1963, 1973, 1977, 1979–80.
Exhibitions One-woman shows at Gallery 99, Melbourne 1969; Flinders Gallery, Geelong 1974; Europa Gallery, Melbourne and Excelsior Hotel, Hong Kong 1975; Gallery de Tastes, Melbourne 1978; Niagara Galleries, Melbourne 1981–82; Prints and collage; Included in 'Melbourne Graphic Artists', Australian Gallery 1958; 'Melbourne Prints', Johnstone Gallery, Brisbane 1960; Vic Artists Society 1961; Argus Gallery and Gallery A 1962; CAS 1968; Third Andrew Fairly Prize 1969; 'Contemporary Graphic Art', Athenaeum Gallery 1971; Caltex Drawing Festival, Mornington 1973; Australian Watercolour Institute 1974–76; F.E. Richardson Award, Geelong Art Gallery 1976; 'Selected Relief Prints', National Gallery of Vic 1977; Group Exhibition Watercolours; Clive Parry Galleries, Beaumaris Vic; Shire of Flinders Art Purchase Awards Exhibition 1978; Mornington Peninsular Arts Centre Spring Festival of Drawing 1979; Mornington Prints; Womens Art Exhibition; Niagara Galleries, Melbourne 1980; Prints, Sweden 1981.
Awards Maitland Prize for Watercolour 1966, 1970.
Represented National Gallery of Vic; Newcastle Gallery, NSW; Geelong Art Gallery, La Trobe Valley Arts Centre; Private collections in Australia and overseas.

CLOSE, Yve NSW

Born 1930. Painter and portraitist.

Studies Julian Ashton School, ESTC, RAS of NSW and privately with Joshua Smith.

Exhibitions Joint shows with Joshua Smith at von Bertouch Galleries, Newcastle 1984, 86, 87, 90; Wagner Gallery, Sydney 1988.

Represented Aust. War Memorial, Canberra, regional galleries, institutional and private collections in UK, South Africa, USA and Australia.

CLOUSTON, Alison NSW

Born NZ 1957, arrived Aust. 1981. Sculptor, performance artist.

Studies Ilam School of Art, NZ 1979.

Exhibitions Solo shows at Mori Gallery 1986, 88; Jam Factory, Adelaide 1988; participated Sculpture Triennial, Melb. 1987; *A New Generation 1983–88* at the ANG Canberra 1988; Ray Hughes Gallery, Sydney 1991.

CLUTTERBUCK, Lucinda NSW

Born Hornsby NSW 1960. Painter, printmaker, animator, film maker.

Studies Les Beaux Arts d'Orleans, France 1979–81.

Exhibitions Several shows since 1978 and recently with her sister Victoria at Studio Alternburg, Sydney 1987. Produced film about the Tasmanian Tiger 1989.

Represented Institutuional and private collections in UK, Europe, Australia.

CLUTTERBUCK, Victoria NSW

Born UK 1952. Printmaker, potter, puppeteer.

Studies Shillito Design School, Sydney 1975–76. B. Visual Arts, Canberra S of A 1983–87.

Exhibitions Orleans La Source, France 1981; Canberra S of A 1987; Giles St. Gallery, Canberra 1987; Joint show with her sister Lucinda at Studio Altenburg 1987; and at Studio Altenburg 1988 and Braidwood Gallery 1989.

Represented Institutional and private collections in UK, Europe, Australia.

COALDRAKE, Alison (Murdoch) QLD

Born Waikerie SA 1927. Painter, printmaker, botanical illustrator in all media.

Studies Worked in the Botany Dept of University of Adelaide and studied art at the SA School of Arts (part-time); Married ecologist J.E. Coaldrake and moved to Qld 1951; Art classes with Melville Heysom 1955–56; Lived in America 1957–58; Studied with Roy Churcher and at vacation schools under Lawrence Daws and John Olsen 1960–67; Study tour to Japan 1973; North America, Europe and Thailand 1978; Further studies under Andrew Sibley, Fred Cress and at printmaking seminars 1980–82; Study tour to China 1983.

Exhibitions First solo show at Design Arts Centre, Brisbane 1973 followed by ten more up to Gallerie Baguette, Brisbane 1982, 84, 86, 88.

Represented Institutional and private collections in Australia and overseas.

COATS, Elizabeth VIC

Born Auckland NZ 1946, arrived Australia 1974. Non-figurative painter in acrylic, teacher.

Studies Diploma of Fine Arts Elam School of Fine Arts; University of Auckland NZ 1966–68; Diploma Education, Melbourne State College 1977; Visiting artist, Riverina College of Advanced Education, Wagga Wagga NSW November 1978; Member of Women's Art Forum, Melbourne; Study tour of Europe, USA 1981; Taught at ESTC 1987, 88, 89; SCOTA 1988, 89, 90.

Exhibitions One-woman shows at George Paton Gallery, Melbourne University Union, November 1977; Auckland Festival Exhibition, Gallery Data, Auckland NZ Easter 1978; Riverina College of Advanced Education, Wagga Wagga, November 1978; David Reid

Gallery, Sydney 1981; Avago, Sydney 1983; Garry Anderson Gallery, Sydney 1984, 85, 86, 87; Syme-Dodson Gallery, Sydney 1989, 90; Brooker Gallery, Wellington NZ; Participated in 'The Women's Show', Experimental Art Foundation, Adelaide, August 1977; 'Self Images', La Trobe University, Melbourne 1977; 'Lip Service', Melbourne 1977; 'The Map Show', George Paton Gallery, Melbourne University Union 1978; Coventry Gallery, Sydney 1981; Geelong Art Gallery 1981; Women's Arts Festival, Sydney 1982; Australian Perspecta 1983, Art Gallery of NSW; Powell St., Melb. 1984; Artspace 1983, 85; AGNSW 1985, 86, 87; Newcastle Reg. Gallery 1985; First Draft, Sydney 1988; Charles Nodrum, Melb. 1989; Tin Sheds Gallery 1989; AGNSW 1990; Heineken Village, Tokyo 1990; David Jones, Sydney 1990.
Awards VAB 1981, 83, 86, Tokyo Studio 87; Artists Fellowship 1990.
Represented AGNSW, Artbank, Regional Galleries, institutional and private collections in Australia and overseas.
Bibliography *Art and Australia*, Vol 18 No 4; Catalogue, *Australian Perspecta 1983*, Art Gallery of NSW; *Artists & Galleries of Australia*, Max Germaine: Craftsman House 1990.

COCHRANE, Grace NSW
Born NZ 1941. Photographer, teacher.
Studies Christchurch Teacher College and Canterbury Uni. 1961. Taught with NZ Ed. Dept. 1961–69, and Tas. Ed. Dept. 1972–77. Studied Tas. CAE, Hobart 1977; Hobart S of A 1979–83; MFA — Uni. of Tas. 1984–85; taught Hobart S of A 1985. Vice-President Crafts Council of Aust; member, Crafts Board Australia Council 1977–82; TAAB 1981–82; VAB 1984–85.
Exhibitions Solo shows ACP Sydney 1984; Chameleon Gallery, Hobart 1985. Many group shows since 1982 and recently ANG, Canberra 1986.
Represented ANG, institutional and private collections in Australia and overseas.

COCKATOO, Kitty (PULTARA) NT
Born c.1952. Aboriginal painter in acylic from Napperby Station, Central Australia.
Exhibitions Napperby Station, Alice Springs, Adelaide.

COCKS, Jane VIC
Born UK 1956. Painter.
Studies Dip. FA (Painting) – Prahran CAE; 1977–79 Dip. Postgraduate VCA, Melb. 1981–82. Taught part-time Victoria College, Prahran and VCA 1984–88; full-time lecturer Charles Sturt University 1988–91.
Exhibitions Hawthorn City Gallery 1979; VCA 1982; Keith and Elizabeth Murdoch Travelling Fellowship 1985; Solo shows at Realities, Melb. 1985, 88, 90; Studio 666, Paris 1986. Many group shows since 1979 and in recent times at Linden, Melbourne 1988, 89; RMIT 1988; Diamond Valley 1988; Realities 1989, 90; Deutscher Brunswick St. 1990; Albury Regional Gallery 1990; Charles Sturt University 1991.
Awards VAB Grant 1984; Keith & Elizabeth Murdoch Travelling Fellowship First Prize 1985; AGNSW Cité Internationale des Arts Studio, Paris 1985; VAB Studio Grant to Greene St. New York 1987.
Represented NGV and institutional and private collections around Australia and overseas.

COEN, Margaret Agnes NSW
Born Yass NSW 1909. Watercolourist of landscape and flower pieces; Married to the late Douglas Stewart, poet and playwright.
Studies Royal Art Society School, Sydney under Dattilo Rubbo, Sydney Long and Norman Lindsay; Travelled and studied in Europe in 1954; Fellow of the Royal Art Society of NSW; Honorary life Member of the Australian Watercolour Institute and the Royal Art Society.
Exhibitions In the joint New York exhibition by the Australian Watercolour Institute and

the American Watercolour Society 1975; Also with the Arthur Murch at Wagner Gallery, Sydney in 1977 and in the 'Women Painters' Exhibition at Artarmon Galleries, Sydney 1978; Included in the 'Women's Collection' to tour NZ in 1978; Solo shows at Wagner Gallery 1988, 89, 90; S.H. Ervin Gallery retrospective 1991.

Awards Goulburn 1964; Ryde 1966; Pring Prize 1968; Mercedes Benz RAS 1973.

Represented State Galleries of NSW and Qld; Newcastle NSW; Armidale Teachers College; Australian National Collection and National University Collection, Canberra; institutional and private collections in UK, Europe, USA, Japan, NZ, Australia.

Publications Illustrated three books *Land of Wonder* by Alex H. Chisholm; *The Seven Rivers* written by Douglas Stewart and *Garden Friends* written by Douglas Stewart.

Bibliography *Australian Watercolour Painters 1880–1980*, Jean Campbell, Rigby 1982; *Autobiography of My Mother* written by her daughter Meg Stewart; *Artists & Galleries of Australia*, Max Germaine: Craftsman House 1990

COGAN, Rosalie VIC
Born Holland 1948. Fibre and textile artist, painter.
Studies BA Fine Art — PIT Melb. 1984; Dip. Ed. — MCAE 1985.
Exhibitions Ararat Art Gallery 1983; Meat Market Craft Centre 1984, 85; ROAR Gallery 1988.
Represented Institutional and private collections around Australia.

COHEN, Barbara NSW
Born London UK 1939. Painter, sculptor, printmaker.
Studies Completed Art and Design Course at ESTC 1978–79 majoring in Printmaking.
Exhibitions Wagner Gallery, Holdsworth Galleries; Warwick Stokes Gallery and with Southern Printmakers.
Represented Institutional and private collections in Australia and overseas.

COHEN, Mieke NSW
Born Holland 1943. Painter, printmaker, teacher.
Studies ESTC and WAC, Sydney. Member, Sydney Printmakers, Print Circle, Aust. Society of Miniature Art. Has taught at WAC.
Exhibitions Regularly with Sydney Printmakers and widely including Cologne, Germany. Has won numerous awards in local competitions.
Represented Artbank and institutional and private collections in Australia and overseas.

COHEN, Yvonne Frankel VIC
Born Melbourne Vic. Painter of semi-abstract landscapes and themes.
Studies RMIT Melbourne; National Gallery and under George Bell.
Awards Won Vic Artists Society Spring Exhibition prize for oil painting 1958; Won Portland Prize 1968.
Represented Bendigo Teachers College Collection; Presently her time is divided between painting and lapidarial interests.

COHN, Anna NSW
Born Poland, arrived Australia 1947. Painter, sculptor, writer and art critic.
Studies Scholarship to Academie des Arts Modernes, Paris; Diploma Art Course, East Sydney Technical College and with Godfrey Miller and John Olsen; Sculpture under Lyndon Dadswell from 1961; Honorary Life Member of Society of Sculptors; Instrumental in establishing the Sculptors Centre, Sydney; CAS 1954–78; Committee Member 1977–78; The John Power Foundation for Fine Arts; Artworkers Union; International Art Critics Association 'AICA' (by invitation) since 1977; Member of the Council of the City of Sydney Advisory Committee for Monuments and Public Artworks.

Exhibitions First one-woman show, 'Masks and Figures', at the Sebert Gallery 1970 when Argyle Centre opened; Second, 'Shapes in the Sun', Bonython Gallery 1976; Third, 'Multiples', Wagner Gallery, Sydney 1977; Holdsworth Galleries, 1982; Sculpture Centre, Sydney 1983.

Awards 20 Sculpture Prizes (12 First Prizes), incl: Hunter's Hill Sculpture Prize 1967, 1969; Royal Easter Show Ceramic Sculpture Prize yearly 1968–73; City of Lismore Art Award 1982; Qantas-Bulletin 'Business Woman of the Year' Trophy Competition 1982–86.

Commissions 'Sentinel' 173 cm glazed ceramic sculpture, entrance to Shalom College, University of NSW. Crest and stationery for above, 1974; Qantas 'Business Woman of the Year' trophies 1982–86; Ceramic Wall Fountain, Law Faculty, University of NSW 1983; 'Healing' Metal Screen, Wolper Hospital, Woollahra 1983; Hebrew University, Jerusalem 1983; 'Torch of Learning' Award; Logo Letterhead, Cottage Community Centre, Campbelltown; Wall Sculpture, Ensemble Theatre, Milson's Point 1984; Monument to Raoul Wallenberg, Woollahra 1985; Ceramic Wall Fountain, University of NSW Symbolic Sculpture, Wolper Jewish Hospital, Woollahra 1986; Qantas-Bulletin 'Business Woman' Award repeat, 1987–1990; Logo and Letterhead for the Wolper Hospital 1987; New Qantas Trophy 1991; Austcare Bronze Mural 1991.

Represented AGNSW; QAG; Power Gallery for Contemporary Art; Shalom College Collection; Lismore Regional Art Gallery; Qantas; Sculpture Park, Gallery 460, Gosford; Uni. of Sydney; Darling Harbour, Sydney, institutional and private collections UK, Europe, USA, Israel Japan, Australia.

Bibliography *Modern Australian Sculpture*, Ron Rowe, Rigby 1977; *Australian Sculptors*, Ken Scarlett, Nelson 1980; *A Year in the Life of a Sculptor*, Sculptor's Bulletin, October 1982; *1983 Dictionary of International Biography*, Vol XVIII, (International Biographical Centre, Cambridge, England); *World Who's Who of Women*, 7th Edition, ditto; Women's Art Register, The Victorian Ministry for the Arts; *Encyclopedia of Australian Art*, Alan McCulloch: Hutchinson 1984; *Artists & Galleries of Australia*, Max Germaine: Craftsman House 1990.

COLE, Sonia VIC
Born Melbourne Vic. Contemporary painter in all media; Teacher.

Studies National Gallery School, Melbourne; Regent St Polytechnic, London UK; Diploma in Art and Design from Prahran CAE; Taught art at Melbourne School of Art Council of Adult Education and country workshops and private classes; Member of CAS Vic.

Exhibitions Solo show at CAS Gallery 1983 and in a number of group shows.

Awards Art Papers Acquisitive Award 1982.

COLE-ADAMS, Brigid VIC
Born Brisbane 1938. Painter, printmaker, illustrator.

Studies Etching, Islington Studio, London, UK, 1971; Printmaking, Camden Institute, London, UK, 1972–75; Diploma in Occupational Therapy, Queensland University, Brisbane 1960; B. Applied Science in Occupational Therapy, Lincoln Institute, Melbourne, 1980; B. Fine Arts, Corcoran School of Art, Washington DC, USA, 1984; Postgraduate Diploma in Sculpture, VCA, Melb. 1985.

Exhibitions Solo shows at Gallery 10, Washington DC, USA 1985; 70 Arden St. Gallery, Melb. 1989. Many group shows include Royal Academy, London 1975; MPAC 1976; Corcoran Gallery, Washington DC 1984; VCA Graduates, Melb. 1986; Linden and Westpac Galleries, Melb. 1987, 89.

Awards Corcoran School of Art, Washington DC 1984; Royal Jubilee of Queen Elizabeth II — screenprint selected as cover illustration, commemorative booklet on art in Adult Education Schools, London, UK, 1976; Has illustrated a number of books and contributed illustrations to *The Age*, Melb. and The Lincoln Institute, Melb.

COLECHIN, Be VIC
Born Tatura Vic 1919. Realist painter in watercolour and oil.

Studies Under Ethel M Richardson and later under Lance McNeill at Melbourne Realist School.
Exhibitions Solo shows in East Melbourne and Mt Gambier SA.
Commissions Rigby Ltd to illustrate *Mount Gambier Sketchbook* 1976 and *Shepparton Sketchbook* 1978.
Represented Benalla Regional Gallery; Civic and private collections in Australia, UK, Canada and Brazil.

COLEMAN, Constance VIC
Born Melbourne Vic 1903. Painter, printmaker and teacher.
Studies Mostly self-taught, she was a friend and close associate of painter-etcher Jessie Traill in the early 1930s, using her press on regular occasions; She earned many commissions for her bookplates and at a later stage became an art teacher with the Vic Education Dept; Now retired she is a full-time painter.
Exhibitions Retrospective show 1926–82 at Niagara Galleries, Melbourne 1982.
Awards Radio Station 3DB City of Melbourne Award 1982.
Publications *Bellbirds and other Poems* written and illustrated by Constance Coleman 1982.
Represented Australian National Gallery, ACT.
Bibliography *A Survey of Australian Relief Prints 1900–1950*, Deutscher Galleries, Melbourne 1978.

COLEMAN, Rosemary VIC
Born Melb. 1930. Paintings and collage.
Studies With Alfred Calkoen 1970–73 and at Deakin and Melb. Universities, Melb. Study tour to USA.
Exhibitions Solo shows at Young Originals Gallery 1974; Works Gallery, Geelong 1976, 84; Geelong College 1978; Niagara Galleries; Painters Gallery, Sydney; Swan Hill Regional Gallery 1986; Chameleon Gallery, Hobart; Artery Gallery, Geelong 1987; MCAG 1989, 91; Participated Geelong Art Gallery 1980, 83, 87; Tokyo, Japan 1982; Mt Gambier Reg. Gallery 1984; Blake Prize Travelling Show 1984; Warrnambool Regional Gallery 1986; Diamond Valley Gallery 1986; Artery Gallery 1987; Swan Hill Gallery 1987.
Represented Institutional and private collections USA, Japan, Hong Kong and Australia.

COLEMAN, Stella QLD
Born Shrewsbury UK. Painter in watercolour and acrylic.
Studies No formal art training, but studied under several tutors including Ruth Tuck and Tom Gleghorn; Member of Sunshine Coast Art Group and Royal SA Society of Arts.
Exhibitions Exhibits at Beta and Blue Marble Galleries, Qld.
Awards Weerama Prize for WC 1973; Mt Gambier WC Prize 1974, 1975, 1976.
Represented Private collections in UK, USA, Australia and PNG.

COLLIER, Robyn NSW
Born Sydney NSW 1949. Painter of landscapes, horses and wildlife in oil and watercolour.
Studies Under Alan Baker FRAS, and at the Royal Art Society of NSW; Member of the Wilderness Society.
Exhibitions One-woman show at Penrith NSW 1976; Also showed at Styles and Rainsford Galleries, NSW, and in a 'Father and Daughter' Exhibition with her father, Brian Baigent at Prouds Gallery, Sydney, July 1978. Recent shows at Styles 1981, 86; Collier 1982, 85, 87; Rainsford 1984; North Shore Gallery 1988; Danebury Gallery 1991.
Awards Penrith 1984, 85, 88; Blackheath Festival 1987.
Represented Institutional and private collections in Australia and overseas.

COLLIGAN, June SA
Born South Australia 1934. Painter and teacher.

Studies SASA 1963–67; Underdale CAE 1983; Fellow RSASA; has taught art since the early 1970's and at Whyalla College of TAFE 1980–82.
Exhibitions Solo shows at Yuriela Gallery, Hyde Park Gallery, Lombard Gallery and Whyalla College of TAFE. Many groups shows and regularly with RSASA.
Awards Murray Bridge 1974; Whyalla 1980, 81; Eyre Peninsula 1980; Barossa Purchase 1987; Campbelltown 1988, 90.
Represented Municipal, institutional and private collections.

COLLINGS, Vi NSW
Born Devonport Tas 1912. Painter and printmaker.
Studies Drawing with Joy Ewart and James Sharp 1960–64; Printmaking with Sue Buckley at Workshop Arts Centre, Willoughby NSW.
Exhibitions Included Sydney Printmakers 1970, 1973, 1975; Print Council of Australia 1970; Sydney Print Circle 1971, 1975; Printmakers exhibition, Sydney 1974; Cologne, W. Germany 1980.
Awards George Galton Print Prize, Maitland 1973; Lorraine Curtis Prize Boggabri, NSW 1977, 81.
Represented Dept of prints and drawings, Art Gallery of NSW; Regional Galleries and private collections.

COLLINGWOOD, Kerry TAS
Born Qld. Landscape painter in oil; Fashion designer and teacher.
Studies Chelsea, London UK 1965; Hobart S of A 1971; Tas. CAE 1972–75.
Exhibitions Many solo shows include Paddocks Gallery, Canterbury UK 1976; Saddlers Court, Richmond, Tas. 1978, 83; Southlands Gallery, Canberra 1979, 80; Richmond Gallery, Tas 1984, 85, 86, 87, 88; Freeman Gallery, Hobart 1989.

COLLINS, Bett VIC
Born Brighton Vic. Painter of lanscapes, horses and dogs in oil and watercolour and ceramic artist.
Studies Diploma in Commercial Art from Melbourne Technical College 1944–47; Specialises in paintings of horses and dogs; Member, Australian Guild of Realist Artists, VAS; Sherbrook Art Society..
Exhibitions Solo shows at Billilla Gallery, Brighton Vic 1977; Has also held her own canine art shows in Sydney; Joint show, Gallery 21, 1989.
Awards Brighton Vic Special Award 1980–81; Cobram Vic 1979, 1983; Bendigo Logo Design 1982. Maryborough 1984; Woodend 1988, 90; Cobram 1989, 90; Brighton 1990.
Represented Private collections in Malta, UK, USA and Australia.

COLLINS, Katrina NSW
Born Sydney 1958. Painter.
Studies BA — City Art Institute 1980, and Postgraduate Diploma 1983.
Exhibitions Solo shows at James Harvey Gallery, Sydney 1984; Gates Gallery 1986. Numerous group shows include Gates Gallery 1986, 87.
Represented Artbank, institutional and private collections.

COLLINS, Lucelle WA
Born WA. Impressionist painter of genre and portraitist in oil and watercolour.
Studies Perth Academy of Fine Arts and the Julian Ashton School, Sydney; Member of the Perth Society of Artists and Wanneroo Art Society; Exhibits at Mt Barket Art Gallery; Paints mostly on commission.
Represented University of WA; Parliament House, Perth and private collections in Australia and overseas.

COLLINS, Sue TAS

Born Sydney 1922. Paints miniatures and portraits.
Studies Hobart TC 1939; RMIT 1946–49 and with her mother Florence Rodway in Melb.
Paints on commission and exhibits with Art Society of Tas.

COLLOCOTT, Michelle Frances NSW

Born Sydney NSW 1945. Painter, sculptor and teacher. (Previously Martin Collocott to 15/9/89)
Studies Diploma of Secondary School Teaching, National Art School, Sydney 1960–66; Studied and painted in London and Europe 1968–70; Teaching part-time National Art School, Sydney 1970; Visiting lecturer, School of Art, Alexander Mackie College, Sydney 1975; Lecturer in art, Mitchell College of Advanced Education, Bathurst NSW 1977; Study Visit, May, New York City, NY, USA; Guest Lecture 'Contemporaries of the 60's', Painting and Sculpture at School of Art and Design Croydon College, London 1979; Teaching full-time, School of Art and Design TAFE, Wollongong NSW 1980; Visiting Lecturer, College of the Arts, Nepean CAE, NSW 1981; Teaching WAC, Sydney 1984, Ku-ring-gai Community Art Centre 1987.
Exhibitions One-person shows, Gallery A, Sydney and Melbourne 1967, 1968, 1969; Bonython Gallery, Sydney and Adelaide 1971, 1972, 1974; Australian Galleries, Melbourne 1972; Macquarie Galleries, Sydney 1974; von Bertouch Galleries, Newcastle 1977; Gallery Civic Centre, Orange NSW 1978; Mitchell Regional Art Gallery, Bathurst 1978; Qantas Gallery, London UK; Wollongong City Art Gallery 1981; Bloomfield Galleries, Sydney 1981–82, 87; Victor Mace Gallery, Brisbane 1983, 85; Painters Gallery, Sydney 1984; Charles Nodrum Gallery, Melb. 1986; Access Gallery 1987, 88; Holland Fine Art 1987; BMG Sydney 1988; Artlet, Sydney 1988, 89; Included in 'Wide Open' Exhibition, CAS Gallery, Sydney 1971; International Telephone and Telegraph Acquisitive Award, Australia, opening in Miami USA and travelling as an exhibition throughout USA; Invitation Ninth McCaughey Art Prize Exhibition, Melbourne 1974; 'Sculpturescape 1970–75', Coventry Gallery, Sydney 1976 and subsequent showings in Orange and Bathurst NSW 1976, 1978, 1982; NSW House, London UK 1982; Wagga Regional Gallery 1982; Penrith Reg. Gallery 1983; AGNSW 1983; Old Brewery Gallery, Wagga 1984; Access Gallery 1986; AGNSW 1986; Touring show Adelaide — Sydney 1988; ICA Gallery, London UK 1988; Commission — Centennial Park, Sydney, Design for dome 1988; Ku-ring-gai Bicentennial Gift Show 1988.
Awards ITT Acquisitive Award 1972; Wall hanging, International Grammar School, Sydney 1987; Uni. of Technology, Sydney Acquisition 1988; Uni. of Sydney Acquisition 1988.
Represented ANG; AGSA; Armidale City Art Collection; Wagga Wagga City Art Gallery; Mitchell Library, Photo Document, Sydney; Macquarie University Collection, NSW; Ku-ring-gai CAE Collection, NSW; Mitchell CAE, Bathurst NSW; Australia Council for the Arts Collection, NSW; IT and T Collection, New York; Rainier National Bank Collection, Seattle USA; BHP Collection, Melbourne; Commercial Bank of Australia Collection, Sydney; Ampol Australia Collection, Sydney.
Bibliography *Art and Australia*, Vols 8/3, 9/4 and 19/2; *Modern Australian Paintings 1970–75, Kym Bonython/Elwyn Lynn*, Rigby Ltd 1976; *Aspect, Art and Literature*, Vol 2/1 1976.

COLQUHOUN, Elizabeth VIC

Born Hampton Vic. Painter and teacher. Sister of Archibald Douglas Colquhoun. Taught for many years at Toorak College, Clyde MLC and her own studio. Member of Melbourne Society of Women Painters and Sculptors and the Twenty Melbourne Painters' Society. First of many one-woman shows at the Booklovers Gallery, Melbourne.
Represented Private collections in Australia and overseas. (Died 1989).

COLQUHOUN, Enid NSW
Born Sydney 1927. Watercolourist, etcher, teacher.
Studies Leeton TC; summer schools with Arthur Murch, Douglas Dundas, Sali Herman;
Julian Ashton School, RAS, Willoughby WAC, Hornsby TAE. Teaches at Colo Adult
Education Centre, Richmond NSW.
Exhibitions von Bertouch Galleries, Newcastle 1979; Qantas Gallery, London 1980;
Morpheth Gallery 1983, 85, 88; Asia Gallery, Hong Kong 1980; American Embassy,
Canberra 1982.
Awards Macquarie Towns acquisitive 1988.
Represented Institutional and private collections in Australia and overseas.

CONABERE, E.V. (Betty) VIC
Born Alexandra Vic 1929. Watercolourist; Specially interested in the conservation of
Australian native plants by illustration.
Studies RMIT Art School, Melbourne.
Exhibitions and Commissions National Herbarium of Vic for the Maud Gibson Trust, to
illustrate 50 Alpine plants 1965; Show of illustrations of wildflowers, including some of the
Herbarium Alpine drawings at Studio Nundah, Canberra 1967; Publishers, Thomas Nelson
Australia Pty Ltd to illustrate the book, *Wildflowers of South-Eastern Australia* 1968;
Commenced illustrations of poisonous plants and plants declared noxious, for the vermin
and noxious weeds board; Some of the Herbarium Alpine drawings shown in an exhibition of
Australian Botanical Illustrators at the Canberra Botanic Gardens 1973; Exhibited, as a
foundation member of the Society of Wildlife Artists, at the Windsor Hotel, Melbourne
1974; The Vic Ministry for the Arts purchased the 80 pages of original illustrations for
Wildflowers, and presented them to the La Trobe library, where some were displayed with
botanical books called *The Art of Botanical Illustration*; Show at Society of Wildlife Artists, at
the Vic Artists Society in Melbourne, Sale and Sydney 1975; Illustrations of noxious weeds
and poisonous plants were shown at the Murphy Street Gallery in Melbourne and subse-
quently at Vic Regional Galleries; Society of Wildlife Artists, at the VAS in Melbourne, Sale
and Sydney 1976; An illustration of Alpine plants owned by a private collector, printed in
card form, by the National Trust; Society of Wildlife Artists 1977; A second weed illustra-
tion was reproduced by the vermin and noxious weeds board 1978.

CONDELL, Dilys NSW
Born Newcastle NSW. Painter, sculptor, weaver.
Studies Claremont TC Perth WA; Prahran TC Melb.
Exhibitions First major show at Sculpture Centre, Sydney 1979 and recently at Breewood
Galleries, Katoomba 1988, 89.

CONDER, Pamela VIC
Born Melbourne Vic 1955. Painter in oil, watercolour and acrylic.
Studies No formal art training, but assisted in early years by her mother, botanical artist,
Lorrie Westaway-Conder. Study tours with Frankfurt Zoological Society to Africa 1980–83.
Exhibitions Solo shows at Emerald Gallery, Vic 1976; Young Originals Gallery, Melbourne
1977, 1978, 1979, 1981, 1982, 1983, 1985; Michel Gallery, Healesville Vic 1988;
Antwerp Belgium 1979; Frankfurt W. Germany 1980.
Awards Wildlife Society WC Award 1982. Illustrated the June Epstein book *Friends of
Burramys* which won the Zoological Society of NSW Book Medal. Also author and illustra-
tor of *Toad Forrest*.
Represented Private collections in UK, Europe, USA, Japan and Australasia.

CONLEY, Robyn NSW
Born Aust. Painter in mixed media, portraitist.

Studies Mitchell College, Bathurst; Macquarie Art School, Bathurst.

Exhibitions Solo shows at Marsden Galleries 1988, 89.

Awards Ryde 1988; Kinross Wolaroi Purchase 1989; Mosman 1990.

Commissions Orange Ex-Services Club 1984; Kinross Wolaroi School Portraits 1985; McDonalds, Bathurst 1989.

Represented Institutional and private collections in Australia and overseas.

CONNELL, Margaret V. VIC

Born Tasmania. Painter of wildflowers in watercolour and gouache.

Studies National Gallery School of Vic.

Exhibitions Solo show at Gasworks Gallery, Deniliquin 1980; And showed with Wildlife Art Society, Melbourne 1977–82.

Commission Chisholm College, La Trobe University, Melbourne to paint series of twenty wildflowers of the Mallee and Riverina areas for their collection 1981.

CONNOLLY, Helen NSW

Born Sydney 1956. Painter, sculptor, video artist.

Exhibitions Solo show at Roslyn Oxley9 Gallery, Sydney 1987.

CONNOR, Valma (Rastas) VIC

Born Lismore Vic 1948. Painter and printmaker.

Studies Diploma of Fine Art (printmaking) from Geelong Institute of Technology.

Exhibitions Print Council of Australia Show, Melbourne 1978.

Bibliography *Directory of Australian Printmakers* 1982, 88.

CONNORS, Anne VIC

Born Hobart Tas 1954. Painter and printmaker.

Studies Diploma of Fine Art (printmaking) from Tas College of Art 1973–75 and Bachelor of Arts Visual Arts 1978–79; VCA, Melb. 1981–82.

Exhibitions Many shows since 1979 include Sweden 1980; MPAC 1980, 82, 86; VCA Melb. 1985; Gryphon Gallery 1987; Chameleon Gallery, Hobart 1987; Warrnambool Reg. Gallery 1987; Horsham Reg. Gallery 1987; 70 Arden St. Melb. 1988.

Commissions PCA 100 x 100 Print Portfolio 1988.

Represented ANG, TMAG, Institutional and private collections.

Bibliography *PCA Directory* 1988.

CONNORS, Debra QLD

Born Maryborough, Qld 1959. Painter, printmaker, designer.

Studies Dip. Arts, University College of Southern Queensland 1989; worked as newspaper layout/graphic artist 1979–86.

Exhibitions Toowoomba Art Society 1989; Warrnambool Regional Gallery 1989; Ipswich Regional Gallery 1990; Logan City Council 1990; McWhirters Artspace 1991.

Awards Hugh Child Memorial Award 1989.

Represented Logan City Council Collection.

CONNORS, Sheryl. See under Parnell/Connors.

CONVEY, Sylvia ACT

Born Germany 1948, arrived Aust. 1949. Painter, teacher, illustrator, writer.

Studies BA (Hons) Canberra School of Art 1982–85; lectures at Canberra Institute of the Arts.

Exhibitions Has held fifteen solo shows since 1972 and latterly at Avant Gallery, Melb. 1976; Arts Council, Sydney 1977; Gallery Art Naive, Melb. 1980; Bitumen River Gallery,

Canberra 1986; Ben Grady Gallery, Canberra 1988. Numerous group shows include Gallery Huntly, Canberra 1982; Bitumen River Gallery 1984, 85, 86; Canberra Institute of Arts 1986, 88; Canberra Contemporary Art Space 1986, 87; Art Zone, Adelaide 1987; Ben Grady Gallery 1988.
Awards Albury Award 1978; Tallangatta Purchase 1980; Peter Stuyvesant Foundation 1986.
Represented ANG, Albury Reg. Gallery, institutional and private collections in Europe, USA, Australia.
Publications Illustrated *Days of Gold*, Tony Convey 1980. Co-author *Earth Skin Heart* and *Tall Tales*, Heart Press, Canberra 1987.
Bibliography *Artists & Galleries of Australia*, Max Germaine: Craftsman House 1990.

CONWAY, Shellie VIC
Born Melb. 1962. Printmaker.
Studies BA Fine Arts 1983–85.
Exhibitions 70 Arden St 1985, 86; MPAC 1986, 87; Artery Gallery, Geelong 1988.
Bibliography *PCA Directory* 1988.

COOKE, Jennie NSW
Born Christchurch NZ 1958. Painter and printmaker.
Studies Dip. Fine Arts (Printmaking), University of Canterbury NZ. Postgraduate teacher training at Christchurch Teachers College 1981; Overseas study 1980, 89.
Exhibitions Solo show at Gingko Gallery, Christchurch 1982; Participated at Warsaw and Cracow, Poland 1984; University of Florida USA 1986; WAC, Sydney 1990; Reflections Gallery, Melbourne 1991.
Represented Institutional and private collections in Australia and overseas.

COOK, Jill VIC
Born Melbourne Vic 1935. Painter of wildlife in watercolour; No formal art training.
Exhibitions One-woman shows at Leveson Street Galleries, Melbourne 1981–82 and group shows 1980–83. Lived and exhibited in New York 1965–69 and Vancouver Canada 1979–80.
Represented National Bank and APM Collections Melbourne and private collections in UK, USA, Europe and Australia.

COPELAND, Alexandra VIC
Born Melbourne 1947. Painter, illustrator, ceramic artist.
Studies Film and Television Production and Design at Swinburne TC.
Exhibitions Chicago, USA and Osaka, Japan 1990.
Publications *The Walrus and the Carpenter*: Warrandyte: Pig Productions 1970.
Bibliography *Alice 125*; Gryphon Gallery, University of Melbourne 1990.

CORDERO, Christine NSW
Born Chile. Painter, printmaker, teacher, arrived Aust. 1973.
Studies Uni. of Chile — BA (Hons) 1967; Universite de Bordeaux, France 1968; taught in Chile and Sydney 1966–86; Postgraduate studies Armidale NSW 1974; Mexico City 1978; studied printmaking at ESTC 1980–88; Post certificate in Printmaking 1988 and Painting 1989; Teaching printmaking at Waverley/Woollahra Art Centre 1990–.
Exhibitions Solo shows at Access Gallery, Sydney 1987, 88, 90; numerous group shows include ESTC 1988; Blaxland Gallery 1988; Toronto, Canada 1988; Seaways, Sydney 1989.
Awards Ryde 1987; Batik Assoc, 1983; Hunters Hill 1990.
Commissions PCA Print Portfolio 1988.
Represented Institutional and private collections in UK, Europe, Chile, Mexico, Australia.

Bibliography *PCA Directory* 1988.

CORNISH, Margaret NSW
Born NSW. Painter, designer and craftworker.
Studies National Art School, Sydney for three years; Also worked as an artist and designer in the commercial field.
Exhibitions Old Brewery Gallery, Wagga NSW 1986, 88, 89; many group shows, and commissioned paintings.
Awards Permanent Trustee Co Award for figurative painting at RAS Easter Show, Sydney 1981.
Represented Institutional and private collections in Australia and America.

COTSELL, Estelle NSW
Born NSW. Painter and teacher.
Studies National Art School, Sydney 1956–58; Diploma, Sydney Teachers College 1959; Overseas study tour 1972–73; Involved in teaching art in NSW from 1960–78; Recent years at the Armidale Technical College, when from 1974–78 she was also curator of art gallery and worked with Charles Reddington, Stanislaus Rapotec, John Olsen and David Tolley at University of New England and University of Qld; President, Armidale Art Society 1974–75; Curator of Armidale City Art Gallery 1974–78; Overseas travel 1978–79; Graphic designer at University of New England Printery 1979–83; Trustee of New England Regional Art Museum and teaches at UNE art appreciation course; Working in Indonesia 1983–84.
Exhibitions Has held over eighteen solo shows since 1966 and recently at Design Arts Centre and Armidale City Gallery 1975; Umberumberka Gallery, Armidale 1980, 1982; Recent group shows include von Bertouch Galleries, Newcastle 1981 and Tamworth and Armidale City Galleries 1982.
Awards Crittenden Landscape Prize 1964; Armidale Biennial Prize 1965, 1967.
Represented New England Regional Art Museum, University of New England; Private collections in USA and Australia.

COTTON, Judith USA
Born Broken Hill NSW 1941. Landscape painter, printmaker, teacher, writer.
Studies Uni. of Sydney; ESTC; Victoria Uni. NZ; New York Institute of Fine Art; Tokyo, Japan, Taught at Canberra TC 1967; wrote for *Vogue Australia* 1982.
Exhibitions Numerous solo shows since 1968 include Korea; Japan 1969; USA 1979; Wagner Gallery, Sydney 1980, 86, 87; David Jones' Gallery, Sydney 1982; Beadleston Gallery NY 1982, 85; Osuma Gallery, Washington DC 1985; NSW House London UK 1986. Many group shows in USA and at Solander Gallery, Canberra 1986.
Publications Illustrations for *Birds of Korea* 1969.
Represented Institutional and private collections in UK, USA, Australia.

COTTRELL, Linda VIC
Born Nairobi, Kenya 1956. Painter.
Studies VCA, Melbourne.
Exhibitions Solo shows at 70 Arden St. Gallery 1988; Judith Pugh Gallery 1990; Numerous group shows since 1986 include the Moet & Chandon Touring Exhibition 1990.

COULLING, Stella QLD
Born Miles Qld. Painter, florist and teacher.
Studies Gymea Technical College, Sydney; Teaches art at Caboolture Qld and was instrumental in forming the first Junior Group of the Australian Guild of Artists of which she is a life member; She is also a member of the Teachers' Guild in NSW and holds a Diploma in

Floristry.
Exhibitions Solo shows at Young Masters Gallery 1980; English Speaking Union Gallery 1980 and McDonnell and East Gallery 1984.
Represented Private collections in NSW, Qld and overseas.

COULTER, Dianne Marguerite VIC
Born Melbourne Vic 1948. Painter and sculptor.
Studies Commerical art at Swinburne Technical College, Melbourne 1965–66; Painting at Caulfield Technical College 1967; Travelled Australia and overseas 1968–73.
Bibliography *Australian Sculptors*, Ken Scarlett, Nelson 1980.

COULTIS, Cherry QLD
Born Laidley Qld 1930. Printmaker.
Studies Brisbane Technical College and later with printmaker David Rose, Sydney NSW; Exhibits with Artists Guild and Toowoomba Art Society where she is noted for her batik work.

COURTENAY, Gabrielle NSW
Born Aust. 1954. Sculptor, painter.
Studies B.Sc (Arch.) — Uni. of NSW 1970–73; Grad. Dip. Art Education — Sydney Teachers College 1976; Ceramics ESTC 1976–78; Julian Ashton School 1979. Postgraduate, Professional Art Studies, City Art Institute 1984–85.
Exhibitions Solo show at Hogarth Galleries, Sydney 1985; Participated CAS 1976–77; Ivan Dougherty 1984–85; AGWA 1985.

COURTIN, Polly VIC
Born East Melbourne Vic 1951. Expressionist painter of women, portraitist, teacher, oil, acrylic, pastel and chalk.
Studies Prahran CAE 1970–72; Gippsland CAE 1974–75 for Diploma of Art (visual arts); Tutor in drawing and painting at Prahran CAE, and visiting artist at Vic College of the Arts 1983.
Exhibitions Numerous solo and group shows since 1974, including Leveson Street Galleries 1977–78; Axiom Gallery 1980; Geelong Regional Gallery 1981; Victor Mace Gallery, Brisbane 1981; Vincent Gallery, Adelaide 1989.
Awards Drawing Prize, Mornington Regional Gallery 1981; VAB Grant 1980.
Represented Artbank, Gippsland CAE, and institutional collections in UK, USA and Australia.

COVENTRY, Virginia NSW
Born Melbourne Vic 1942. Painter, photographer, teacher.
Studies Royal Melbourne Institute of Technology, Melbourne 1960–64; Slade School of Fine Art, London 1967–68; La Trobe University, Melbourne (Educational, communication and media) 1973; Travelled to the UK and West Germany aided by a VAB Overseas Travel Grant 1977–78.
Exhibitions Solo shows at Experimental Art Foundation, Adelaide 1977; Art Projects, Melbourne 1979, 1980, 1981, 1982; IMA Brisbane 1980, 81, Watters Gallery, Sydney 1981, 86; Participated in a number of group shows since 1975 and recently *Photographs*, Ivan Dougherty Gallery, Sydney; *Biennale of Sydney*, European Dialogue, Art Gallery of NSW 1979; *Self-Portrait/Self-Image*, Vic College of the Arts, Melbourne; *Frame of Reference*, Ewing and George Paton Galleries, University of Melbourne 1980; *Australian Perspecta*, Art Gallery of NSW 1981; ICI Gallery, London UK 1982; Continuum, Tokyo 1983; Ivan Dougherty 1983; AGSA 1984; ANG Canberra 1986; First Draft Gallery, Sydney 1988.
Represented Australian National Gallery; National Gallery of Vic and private collections

in Australia and overseas.

Bibliography Catalogue of *Australian Perspecta 1981*; Art Gallery of NSW; *Artists & Galleries of Australia*, Max Germaine: Craftsman House 1990.

COWEN, Ruth VIC
Born Melbourne 1928. Visual poet and etcher on glass and mirror.
Bibliography *Alice 125:* Gryphon Gallery, University of Melbourne 1990.

COWLING, Margaret VIC
Born Perth WA 1941. Painter, teacher.
Studies Dip. Art RMIT 1957–60 with Murray Griffin, William Frater, Harold Freedman, and for a year in Florence, Italy; Worked as display artist and illustrator and taught art in Junior Technical Schools and presently at Malvern Artists Society and VAS, Member, Waverley Arts Society, VAS, Melb. Society of Women Painters and Sculptors, Secretary, Old Watercolour Society's Club (Aust.); Has exhibited annually since 1983.
Awards A.M.E. Bale Trust 1988.

COWLISHAW, Edith NSW
Born Adelaide SA. Printmaker and etcher of wild life.
Studies Graduated BSc, University of Sydney and worked as an industrial chemist; Studied painting and graphic art at Workshop Art Centre, Willoughby NSW with Sue Buckley, Elizabeth Rooney and Bela Ivanyi; Member of Sydney Printmakers since 1971, President 1984–87; Member of Print Council of Australia; Wildlife Artists of Australia 1978–83.
Exhibitions Solo shows at WAC 1971; Barry Stern 1978, 79, 82; Printmakers Gallery, Brisbane 1978, 79; Ottawa, Canada 1979; Gallery 460, Gosford 1982, 84; Maitland City Gallery 1983; Southport Art Gallery, Qld 1983; The Print Room, Sydney 1984, 86, 89; Shows at Sydney Printmakers and Print Circle, Freeman Gallery, Hobart 1988; Burns Kaldy Gallery, Newcastle 1989; Breewood Gallery, Katoomba 1990.
Awards Quirindi 1987; Gosford Print Prize 1987; Narrabri, Boggabri, Wellington and Sydney Royal Easter Show 1989.
Represented Regional Galleries and private collections in Australia and overseas.
Bibliography *PCA Directory* 1988; *Artists & Galleries of Australia*, Max Germaine: Craftsman House 1990.

CRAFOORD, Pam NSW
Born Sydney NSW 1936. Painter and printmaker.
Studies East Sydney Technical College and Workshop Art Centre, Willoughby NSW; Exhibits annually with Sydney Printmakers and Sydney Print Circle; Currently teaches painting and printmaking at WAC; Solo shows at Beth Hamilton Gallery, Sydney 1988.

CRAGGS, Joan VIC
Born Melbourne Vic 1927. Traditional, representational painter in oil, watercolour, mixed media.
Studies Mostly self-taught, studied for short time with E. Buckmaster and S. Bourne; Has exhibited widely and won many awards over forty years.

CRAIG, Fiona NSW
Born Sydney. Painter of Australian wildflowers in pastel and watercolour.
Studies ESTC, Meadowbank TC, Shillito Design School, Sydney.
Exhibitions Solo shows at Uni. of NSW 1979; Alexander Gallery, Wentworth Falls NSW 1980, 84, 85, 86; Holdsworth Galleries 1981, 83, 87; von Bertouch Galleries, Newcastle 1987, 88, 90; Greenhill Galleries SA and WA 1988; Holdsworth Galleries 1989.
Awards ABC Nat. Award 1966–72; Royal Easter Show, Sydney 1972; Blackheath

1970–83; Penrith 1969–72; Channel 7, Sydney 1968; 2SM Portrait 1970; Hawkesbury Shire 1985.

Commission twenty seven paintings for Regent Hotel, Sydney.

Represented Institutional and private collections in Australia.

CRAIG, Sybil VIC

Born Melbourne Vic 1901. Painter in oil and watercolour; Flowers, still-life, landscapes; Official war artist.

Studies Private with John Shirlow; National Gallery School, Melbourne under Bernard Hall and William McInnes 1924–31; Design, Melbourne Technical College under Robert Timmings 1935; Some study with Ian Bow at VAS 1950s and George Bell 1924.

Exhibitions One-woman shows at Athenaeum Gallery, Melbourne 1932 and Georges Gallery, Melbourne 1948; Important Women Artists, Melbourne 1978; Group shows with the New Melbourne Art Club from 1932; With the Melbourne Society of Women Painters from 1933; With the VAS from 1934–51; Associate member of the 'Twenty Melbourne Painters' from 1943–46; One of the 'Twenty Melbourne Painters' from 1947; Many other exhibitions in Vic and interstate; Held a show of watercolours with Ethel Carrick Fox and Jean P. Sutherland in 1940s.

Awards OAM for services to the arts 1981.

Represented Australian National War Memorial by a group of 80 works; National Gallery of Vic; Depts of Australian Paintings and Prints and Drawings; Australian National Gallery; Art Gallery of SA; Regional Galleries of Ballarat, Warrnambool and Shepparton.

Bibliography *A Survey of Australian Relief Prints 1900–50*, Deutscher Galleries, Melbourne 1978; Catalogue, Important Women Artists Gallery, Sybil Craig, Melbourne 1978; LIP, 78/79; *Australian Women Artists*, Janine Burke, 1840–1940, Greenhouse 1980.

CRAPP, Shirley NSW

Born NSW 1926. Painter and printmaker.

Studies Trained at Workshop Arts Centre, Willoughby NSW; Painting with Joy Ewart, etching with Elizabeth Rooney, silkscreen with Pam Crafoord, and woodcutting with Sue Buckley; Study tour to Japan 1983; Now works only in the printmaking media, often mixing the media; completed a limited edition (21 in edition) book of original prints and Haiku Poetry 1983.

Exhibitions One-woman show at Willoughby 1967, 88; The Print Room 1983; Cooks Hill Gallery, Newcastle 1981; Participated in Third International Biennale, Cracow Poland 1970; Premio Internazionale Biella 1971; International Exhibition of Graphic Art, Frenchen Germany 1972; Printed edition for IGAS, New York 1967.

Award Mosman Art Prize for Graphics 1967.

Represented Mosman, Armidale and Manly Galleries, NSW; Reserve Bank, Sydney.

Bibliography *Directory of Australian Printmakers* 1976, 88; *Artists & Galleries of Australia*, Max Germaine: Craftsman House 1990.

CRAWFORD, Kathie TAS

Born Hobart 1940. Photographer, teacher, designer.

Studies Hobart TC 1958–59; Hobart S of A 1973–76; overseas study 1979–82; taught at Rosny College 1984–86.

Exhibitions Solo shows at Drummond St Gallery, Melb. 1981; Fine Arts Gallery, Uni. of Tas. 1981, Numerous group shows since 1976.

Represented AGNSW, TMAG, QBMAG, Burnie AG.

Bibliography *Tasmanian Artists of the 20th Century*; Sue Backhouse, 1988.

CRAWFORD, Marian VIC

Born Melb. 1955. Printmaker.

Studies BA, Uni. of Melb. 1975–77; BA Fine Arts, VCA 1985–87.
Exhibitions VCA Gallery 1987; MPAC 1988; 70 Arden St. 1988; Judith Pugh Gallery 1991.
Bibliography *PCA Directory* 1988.

CREASER, Marlee NSW
Born Sydney NSW 1932. Painter and sculptor.
Studies Julian Ashton and Desiderius Orban Art Schools, Sydney 1950–52; Study tour of Europe 1952–53; Lived in Spain and painted in Europe and North Africa 1963–66; Taught Workshop Art Centre, Willoughby NSW 1974; Received Australian Council Special Grant 1975.
Exhibitions One-woman shows at Gallery A, Sydney 1972, 1974, 1975, 1978, 1980; Included in CAS 1972, 1973; 'Boxes Exhibition' Mildura Sculpture Triennial 1973; 'Sculpturescape', Ewing Gallery, Melbourne University 1974; Mildura Arts Centre 1975; 'Grids', sculptures space, Ewing Gallery, Melbourne University 1975; Biennale of Sydney, 'Recent International Forms in Art' 1976; Gallery A, Sydney 1977, 1982; Gryphon Gallery, Melbourne with Peter Corlett 1982; Australian Perspecta 1981, Art Gallery of NSW; Ivan Dougherty Gallery, Sydney 1982.
Represented Art Gallery of NSW; Mildura Sculpture Centre, Mildura; University of Sydney; Playboy Australia; Wollongong Region Art Gallery; Visual Arts Board of the Australia Council; Private collections throughout Australia.
Bibliography Catalogue, *Australian Perspecta* 1981, Vol 4; *Aspect*, Art and Literature, Interview pages 21–24 1976; *Lip*, transcript from ABC Radio interview pages 49–50 1977; *History and Development of Sculpture in Australia*, Graeme Sturgeon 1978; *Quadrant*, May 1979 'The Progress of Australian Sculpture' page 47; *Australian Sculptors*, Ken Scarlett, Nelson; Australian National Library Videotape collection 1979.

CREASY, Frances WA
Born Devon, England, arrived Australia 1968. Impressionist, abstract painter in oil, acrylic and mixed media.
Studies Studied under Laurie Knott; Member of Perth Society of Artists, CAS of WA, and Beverley Art Group.
Exhibitions Solo show in Perth 1974; Participated at Art Gallery of NSW 1972 and regularly in WA 1975–83.
Awards Murdoch University Purchase 1975; Williams Prize 1976; Beverley WA 1983; York WA 1983.
Represented Private collections in UK, Europe, USA and South Africa.

CREBER, Annette Scott QLD
Born Oakey Qld 1941. Traditional painter in oil and watercolour; Teacher.
Studies Mainly self-taught but some time under Rex Backhaus-Smith and Frederic Bates.
Exhibitions Group shows in Mackay.
Awards Mackay Champion Painting 1980, 1982. Mackay Rotary Vocational Service Award 1982; Mackay Electricity Board Calendar 1982.
Represented Institutional and private collections in Qld and NSW.

CREEDON, Irena VIC
Born 1945, arrived Australia 1950. Expressionist/realist painter and portraitist in oil and pastels.
Studies Diploma of Fine Art (painting) from Caulfield Institute of Technology 1975–77; Graduate Diploma in Fine Art (painting) from Vic College of the Arts 1979–80.
Exhibitions Participated in a number of group shows including the Keith and Elizabeth Murdoch Travelling Fellowship at Mornington Peninsula Arts Centre 1983.

Awards Hugh Ramsay Trustees Prize, National Gallery of Vic 1979.
Represented Institutional and private collections in Vic and NSW.

CRICKMORE, Joyce VIC
Born Melb. Naive and decorative artist. Started painting while working with handicapped
people as a craft instructor; study tours to UK, Europe.
Exhibitions Medici Gallery, London UK; Memorial Gallery, Barlarston UK; Libby
Edwards Galleries, Melb.; Naughton Studio, Sydney.
Represented Institutional and private collections in UK, Europe, Australia.

CRISP, Leeanne ACT
Born Adelaide SA 1950. Painter, printmaker, teacher.
Studies AFS Scholarship, USA 1968–69; SASA — Western Teachers College, Dip.
Painting, Printmaking, Teaching 1972; Part-time lecturer Canberra S of A 1975–80,
contract tutor 1980–89. Lived in London 1981–82; Has written and lectured about art
1975–89.
Exhibitions Solo shows at Solander Gallery, Canberra 1977; CAS Adelaide 1979; Garry
Anderson Gallery, Sydney 1983; Tynte Gallery, Adelaide 1986. Numerous group shows
since 1973.
Represented Institutional and private collections in USA and Australia.
Bibliography *Recent Art from SA*, CAS Adelaide 1975; International Women's Year 1975.

CROFT, Brenda NSW
Born Perth WA 1964. Aboriginal photographer; arts administrator.
Studies Canberra School of Arts 1982–83; Daramalan College, Canberra 1981; SCOTA
1985; Presently completing Dip. Gallery Management at University of Sydney, part-time;
Founding member of Boomalli Aboriginal Artists Co-op 1987; Full-time co-ordinator
1990–91.
Exhibitions Aboriginal Artists Gallery, Sydney 1986; Boomalli Aboriginal Artists Co-op.
1988; Albert Hall, Canberra 1988; Australian Perspecta-Artspace Gallery, Sydney 1989;
Tin Sheds Gallery 1988; Boomalli Aboriginal Artists Co-op 1989, 90; ANG 1989; Touring
show 'A Koori Perspecta' to NSW, SA and Vic 1990.
Represented ANG; State Library of NSW; Power Gallery, University of Sydney;
Institutional and private collections.
Bibliography *Artlink* Autumn/Winter 1990.

CROMB, Margaret Louise VIC
Born Aust. 1941. Watercolour painter and teacher.
Studies Nat. Gallery School; with Arthur Markham and David Taylor and in UK, Europe.
Exhibitions With VAS and AGRA.

CROMBIE, Peggy VIC
Born 1901, Painter.
Studies National Art School, Melb in the 1920s and with Geo Bell in the 1940s; Member of
the Embryo Group including Constance Stokes, Herbert McClintock and Eric Thorpe.
Exhibitions Showed with The New Melbourne Art Club in the 1930s. First solo show at
Jim Alexander Gallery, Melb. 1987.

CROOKE, Diana QLD
Born Thursday Island 1954. Painter and printmaker; Daughter of Ray Crooke.
Studies Little formal art training but has worked closely with Heinz and Evelyn Steinmann
on Cape York Peninsula.
Exhibitions Solo shows at Holdsworth Galleries, Sydney 1981; Upstairs Gallery, Cairns

1981–82; Cairns-Pacific International Hotel 1985; Holdsworth Gallery 1986; Showcase Gallery, Darwin 1987; Capricorn Gallery, Melb; von Bertouch Galleries Newcastle 1988 (joint); Participated at Philip Bacon Galleries, Brisbane and Tonnoir, Townsville Qld.
Represented Widely in private collections in Qld, NSW and Vic.

CROSS, Elizabeth VIC
Born Melb. 1943. Painter, printmaker, teacher, writer.
Studies Dip. Art, Painting and Printmaking, RMIT and graduate studies for Fellowship Dip. Art. Royal College of Art, London UK; La Trobe Uni., Melb.; British Museum. Has taught art widely and currently at PIT, Melb.
Exhibitions Crossley Gallery, Melb. 1969, 71; Ray Hughes Gallery, Brisbane 1981; Niagara Gallery, Melb. 1988; numerous groups shows in UK, Australia.
Awards Harold Wright Scholarship to British Museum.
Represented ANG; NGV; AGSA; AGWA; QAG; Artbank; Museum of Modern Art, New York; V & A Museum, London; institutional and private collections in UK, Europe, USA, Australia.
Bibliography Janet McKenzie, Drawing in Australia: Macmillan 1986; *Artists & Galleries of Australia*, Max Germaine: Craftsman House 1990.

CROSSING, Elisa ACT
Born Aust. 1964. Painter and teacher.
Studies Phillip College, Canberra 1981–82; Canberra CAE 1983; Canberra S of A., B. Visual Arts (Painting) 1983–86. Studied UK, Europe, USA 1988; Taught at Canberra Institute of the Arts 1990.
Exhibitions Canberra S of A 1986; Bitumen River Gallery 1986, 87; Ben Grady Gallery 1987; Canberra Contemporary Art Sapce 1989, 90.
Represented Institutional and private collections.

CROTHERS, Tanya NSW
Born Sydney NSW 1941. Painter, printmaker, craftworker, architect and teacher.
Studies Bachelor of Architecture, University of Sydney 1964; Diploma in Education, University of New England 1972; Studied Lithography and Etching, Willoughby Workshop Arts Centre 1969–71; Worked as an architect, Norway, London and Cambridge UK; Travelled around Britain, Europe, USA; Took part in a Design Seminar and Workshop sponsored by Det Danske Selskab 1965–68; Part-time printmaking, Yeovil CAE, UK 1973–74; Casual teacher, NSW Dept of Education 1975–76; Art/craft teacher, Christian Brothers, Lewisham 1977–79; Assistant administrator, Middle Harbour Recreation Centre 1979–80; Tutor in design, School of Architecture, University of Sydney 1980; Received a grant from Crafts Board, Australia Council towards compiling an art/craft manual for teachers 1981; Part-time tutor for various workshops: Dept of Education Inservice, Women and Arts etc 1981–82.
Exhibitions Six Young Artists, University of Sydney Gallery of Fine Arts 1960; Various group annual exhibitions: Sydney Printmakers, Nine Printmakers, Print Circle 1970–72; Winslow Group annual exhibition 1978–81; Print Council of Australia travelling exhibition 1980; International Graphic Exhibition Triennale, Frechen Germany 1980; Two-man exhibition, Printers Gallery, Brisbane 1980; Two-man exhibition, Harrington Street Gallery, Hobart 1980; Body Show, Hogarth Gallery, Sydney 1982; Has exhibited in Melb. and Sydney 1983–89; and Sydney Printmakers 1990.
Represented Private collections UK, Germany, France, Australia; NSW Parliament House; Reserve Bank; Qld Institute of Technology; Deakin University; Museum of Applied Arts and Sciences, NSW.

CRUZ, Maria NSW
Born Manila, Philippines 1957. Painter.

Studies University of Santo Tomas, Philippines 1976–78; ESTC 1980; SCOTA 1981–84; Kunstakademie Dusseldorf.
Exhibitions Solo shows at Artspace, Sydney 1986, 87; The Globe 1987; Canberra Institute of the Arts 1989; Mori Gallery, Sydney 1990. Numerous group shows since 1982 include Mori Gallery 1989, 91; Bitumen River Gallery, ACT 1990; IMA, Brisbane 1991; First Draft, Sydney 1991.
Represented Institutional and private collections in USA, Philippines and Australia.

CULIC, Milka VIC
Born Zagreb, Yugoslavia 1926, arrived Aust. 1960. Naive painter in fantasy realism.
Studies Under Jerolim Mise in Yugoslavia; Member of VAS, Melbourne Society of Women Painters and Sculptors; WAR.
Exhibitions Gallery Art Naive Melb. 1987, 88, 90 and many group shows.
Represented Private collections in Europe and Australia.

CULPEPER, Frances NSW
Born Harrogate UK 1922, arrived Australia 1966. Semi-abstract painter in oil.
Studies Leeds College of Art; Edinburgh College of Art; Stratford-on-Avon College of Drama, and later under Stanley Grimm for a short period; Study tour to Spain; After arrival in Qld, ran her own art school and conducted WEA classes in Julia Creek and Cloncurry.
Exhibitions National Society of Painters in Oils, UK 1959–63; Several one-woman shows in Sydney from 1968, Hahndorf Gallery, Adelaide 1972.
Represented Private collections Australia and overseas.

CUMING, Liz (Elizabeth) NSW
Born Sydney 1956. Painter, printmaker, teacher.
Studies Hornsby TAFE 1978–80; City Art Institute 1981–83; SACAE — Grad. Dip. 1984–86; M. Fine Arts, University of NSW 1990. Taught art at Sydney TAFE Colleges since 1984 and presently at University of NSW College of Fine Arts.
Exhibitions Solo shows at Bloomfield Galleries 1986, 88; Ivan Dougherty Gallery and Robin Gibson Gallery 1991; Numerous group shows since 1980 include City Art Institute 1983; Newcastle CAE 1984; Macquarie Uni. 1986; MPAC 1986; Bloomfield 1987.
Awards Elioth Gruner Memorial Prize for Painting, AGNSW 1989; Residency, Moya Dyring Studio, Paris 1990, AGNSW.
Represented Artbank, institutional and private collections.
Bibliography *PCA Directory* 1988; *Artists & Galleries of Australia*, Max Germaine: Craftsman House 1990.

CUMMINGS, Elisabeth NSW
Born Brisbane 1934. Painter, teacher, wife of artist James Barker.
Studies Nat. Art School, Sydney 1953–57; School of Vision, Salzburg, with Oskar Kokoschka 1961; lived in Europe 1961–68; taught art NAS 1969–74, City Art Institute 1975–87, TAFE 1975.
Exhibitions One-woman shows at Johnstone Gallery, Brisbane 1963, 1966; Darlinghurst Gallery, Sydney 1965; Design Arts Centre, Brisbane 1969, 1970, 1974; North Adelaide Galleries and Toorak Art Gallery, Melbourne with her husband 1967, 1969; Raffin Gallery, Orange 1973, 1975; Griffith Gallery, Canberra with James Barker 1975; Hayloft Gallery, Bathurst 1973, 1975; Ronlyn Gallery, Wollongong and Group shows in Sydney 1975; Blaxland Gallery, Sydney with James Barker and Tom Green and 'La Funambule' Gallery, Mulua Bay NSW 1978; Stairs Gallery, Wollongong 1982; Broadbeach Gallery, Qld 1982; Victor Mace Gallery, Brisbane 1982, 85, 88, 90; Mori Gallery 1982, 84, 87; Broadbeach Gallery, Qld. 1985; Painters Gallery, Sydney 1989.
Awards Le Gay Brereton Prize for Drawing 1957; NSW Travelling Art Scholarship 1958;

Gold Coast Art Prize Purchase 1971; Portia Geach Prize; Royal Easter Show, Sydney ('Human Image'); Cheltenham Art Prize 1972; Grafton Purchase Prize 1974; Drummoyne Prize 1976; Royal Easter Show, landscape and still-life; Lismore Purchase Prize; Fisher's Ghost Prize, Campbelltown NSW 1977, 1979; Gold Coast Purchase Prize 1978; Peter Stuyvesant Prize, Shoalhaven 1979; Gosford Purchase Prize 1979; Macquarie Towns 1981; Lane Cove 1982, 83; Mervyn Horton, Berrima 1984; Camden 1984, 87; Campbelltown Friends 1984; Faber Castell 1987; REIQ Bicentennial 1988; Gold Coast City 1989.
Represented ANG, AGNSW, QAG Regional Galleries, institutional and private collections, Australia and overseas.
Bibliography *A Homage to Women Artists in Queensland Past and Present*, Centre Gallery 1988; *Artists & Galleries of Australia*, Max Germaine: Craftsman House 1990.

CUMMINS, Cathy VIC
Born Ouyen, Vic 1958. Printmaker
Studies Melb. State College 1977–81; Gippsland IAE 1985–87.
Exhibitions Solo show at Leongatha Art Gallery, Vic, 1983; participated at Gryphon Gallery 1983; MPAC 1983–85; Warrnambool Reg. Gallery; PCA Gallery 1987; 70 Arden St. 1988.
Commissions PCA 100 x 100 Print Portfolio 1988.
Represented TMAG and institutional and private galleries around Australia.
Bibliography *PCA Directory* 1988.

CUPPAIDGE, Virginia USA
Born Brisbane Qld 1943. Painter and designer.
Studies Orban Art School, Sydney 1960–62; Mary White School of Art, Sydney 1963–65; Studio work under John Olsen, Stanislaus Rapotec, William Rose (painting), Robert Klippel (sculpture), Maria Gazzard (ceramics); Taught painting and drawing at Sydney Church of England Grammar School 1964–66; Fashion designer, Sydney 1966–69; Assistant at Max Hutchinson Gallery, New York 1969–70; Acting director of Richard Feigen Gallery, Chicago USA 1970–72; Artist-in-Residence, dept of fine arts, University of California, Berkeley USA 1975; Artist-in-Residence University of California 1984; Guest lecturer at Pratt Institute, New York State 1984–85; Visiting lecturer, Pratt Institute, New York; Teacher (painting) Manhattanville College, New York 1986.
Exhibitions First one-woman shows at Hungry Horse Gallery, Sydney 1961 and Brian Johnston Gallery, Brisbane 1962; Three-person show, Alladin Gallery, Sydney 1963; First one-woman show in the USA, A.M. Sachs Gallery, New York 1973; 'Women Choose Women' Show, New York Cultural Centre 1973; One-woman show, Gallery A, Sydney 1974, 1976, 1979; Three-person show, University Art Gallery, Berkeley 1975; One-woman show, Susan Caldwell Gallery, New York 1975; Three-person show with Clement Meadmore and Bud Hopkins, Lehman College, New York 1976; Susan Caldwell Gallery, New York 1970–78; 'Australian Women Artists' CAS, Paddington Town Hall, Sydney 1978; Solo shows at Gallery A, Sydney 1976, 1979, 1980, 1982, 1983; Bloomfield Galleries, Sydney 1985, 87; Michael Milburn, Brisbane 1985, 87; Stephen Rosenberg Gallery, New York 1986; Manhattanville College, New York 1986 (retro); Australian Galleries, Sydney 1991. Numerous group shows since 1973 and recently in the First Aust. Contemporary Art Fair, Melb. 1988.
Awards Macdowell Colony Fellowship 1975; CAPS Award for Painting 1975; Guggenheim Fellowship 1976.
Represented Neuberg Museum, Purchase, New York; Australian National Gallery; Chase Manhattan Bank; Whitney Communications Corporation; Philip Morris Collection; Clement Meadmore; State Galleries of NSW and Qld; Australian Embassy and Hammarskjold Plaza, New York; Private collections in the USA and Australia.
Bibliography *Artists & Galleries of Australia*, Max Germaine: Craftsman House 1990.

CURLEY, Maria NT
Aboriginal watercolour painter from Fregon, a Pitjantjatjara community associated with the Ernabella region around the SA/NT border.
Exhibitions Bloomfield Galleries, Sydney 1989.
Represented ANG; NTMAG; AGSA; Robert Holmes à Court Collection.

CURTIS, Anna QLD
Born Wangaratta, Vic. 1960. Painter, printmaker, teacher.
Studies Wangaratta College of TAFE 1978–79; Dip. Fine Art from Bendigo Institute 1981. Presently teacher and tutor at Mackay College of TAFE and for district art activities.
Exhibitions Solo at Jim Browns Gallery, Mackay 1984; Woollahra Print Workshop, Sydney 1985; Martin Gallery, Townsville 1988; Upstairs Gallery, Townsville 1989. Numerous group shows.
Awards Mackay Caltex 1984; Mackay 1984, 87, 88, 89; Suncorp-MOCA, Brisbane 1989.
Represented AGNSW, institutional and private collections in Australia and Japan.

CURTIS, Mary NSW
Born Sydney NSW. Semi-abstract painter and fabric designer.
Studies East Sydney Technical College and with Desiderius Orban School, Sydney; Designer at Silk and Textile Printers, Hobart Tas for seven years; Founder member of the CAS and member of Studio of Realist Art, Sydney.
Exhibitions Joint shows at Roseville Galleries, Sydney 1975, 1978; Solo show planned for 1985.

CURTIS, Sarah VIC
Born Melb. 1955. Allegorical painter.
Studies PIT Melb. 1975–78.
Exhibitions Solo shows at St. Martins Theatre 1983; Reconnaissance Gallery 1986–87–88 and included in *A New Generation 1983–88* at Aust. National Gallery, Canberra 1988 and Moët & Chandon Touring Exhibition 1988. Solo show at Realities, Melbourne 1990.

CURTIS, Sybil QLD
Born Canungra, Qld. 1943. Paintings and collage.
Studies B.Sc. — Uni of Qld 1962–67, self-taught artist.
Exhibitions Solo shows at Brisbane CAE 1983; Victor Mace Gallery 1986, 88; Participated at IMA, Brisbane 1983; Qld. Uni. Art Museum 1985; The Centre Gallery, Gold Coast 1988.
Awards Noosa Rotary 1980 Brisbane Caltex 1981; Redcliffe Award 1982.
Represented Brisbane CAE, Redcliffe City Council, private collections.
Bibliography *A Homage to Women Artists in Queensland, Past and Present*, The Centre Gallery 1988.

CURTIS, Vivienne Violet NSW
Born NSW 1926. Traditional painter.
Studies East Sydney Technical College under Douglas Dundas and G.K. Townshend.

D

DABRO, Vicki ACT
Born South Australia 1950. Painter, sculptor, ceramic jeweller; Married to sculptor Ante Dabro.

Studies Diploma of painting at East Sydney Technical College 1971; Part-time teacher at Canberra School of Art 1982–83.
Exhibitions *'Soft sculpture'* dolls in solo shows at Ray Hughes 1976 and Holdsworth 1981; Participated in Canberra School of Art Staff Exhibition 1982.

DABRON, Enid NSW
Born NSW. Painter.
Studies Sydney Teachers College 1940–41; ESTC 1945–49 and at Orban's Studio 1947–49.
Exhibitions Beth Hamilton Gallery, Sydney.

DABRON, Jacqueline Helene NSW
Born Springwood NSW 1943. Colourful expressionist painter of landscapes, still-life, portraits mostly in oil; Daughter of John H. Dabron and Jean Isherwood.
Studies East Sydney Technical College, National Art School 1966–69; Studied painting, diploma course and teacher conversion course in art at night; Received Diploma of Education (Art) 1969; Taught Cheltenham Girls High 1970–71, Sydney Boys High 1972; Full-time painter since 1974.
Exhibitions Joint shows with Jean Isherwood at Armidale City Gallery 1977; Primrose Lane Gallery, Cronulla 1978 and Tamworth City Gallery, NSW 1978.
Awards Gosford 1976, 1978; Lismore 1977; Muswellbrook 1977; Narrabri 1977, 1978; Nundle 1977; Dubbo 1978; Port Macquarie 1979.
Represented Municipal collections at Gosford, Lismore, Muswellbrook, Narrabri, Dubbo; Private collections in Australia and overseas.

DADE, Freya VIC
Born Sussex UK, arrived Australia 1958. Traditional painter in oil and watercolour.
Studies An honours student of the Royal Drawing Society, London; When aged sixteen she also won a major country award to study at the Royal Academy of Music, London; Member of the Victorian Artists Society, Melbourne, Women Sculptors and Painters, Guild of Realist Artists and Women's Art Forum of Vic; Has been painting full-time for the past eight years; Painted and managed a gallery in England 1979–81.
Exhibitions She has had a number of one-woman shows at Manyung Gallery, Mornington and also Gargoyle Gallery, Aspen Colorado and International Gallery, Oklahoma USA; Devon UK 1980; Benalla Regional Gallery 1982.
Publications Poems published in two anthologies, *Contemporary Poets* 1973 and *Twentieth Century Poets*, Regency Press, London.

DADOUR, Vivienne NSW
Born Sydney 1953. Painter, graphic designer, teacher.
Studies Dip. Graphic Design, National Art School 1972–74; Worked as graphic designer 1975–77; Graduated B.Ed., Alexander Mackie CAE 1978–80; Studied UK, Europe 1986; Taught art for NSW Dept. of Education 1983–89; Vice-president, Art Education Society of NSW 1988–89.
Exhibitions Solo shows at Willoughby Art Centre 1985; Annandale Studios 1986; Access Gallery 1989, 91.
Represented Corporate and private collections in USA and Australia.

DAHL, Astrid VIC
Born Bangkok Thailand 1944, arrived Australia 1954. Contemporary painter in oil, gouache, collage, charcoal; Teacher.
Studies Diploma of Art, RMIT 1964; Diploma of Education, Hawthorn Teacher's College 1972; Exhibiting member of VAS; B.Art Ed. from WACAE 1984.

Exhibitions One-woman shows at Vic Artists Society 1970; Munster Arms Gallery 1971; Joan Gough Studio Gallery 1974, 1976; Group shows at VAS Gallery 1964–68; Three Sisters Gallery 1968; Burton Street Gallery, Sydney 1972; Joan Gough Studio Gallery 1975; Swan Hill Regional Gallery 1975; Russell Davis Gallery, Melbourne 1978 (solo); Signature Gallery, Perth 1979 (solo); Hong Kong Arts Centre 1979; Caulfield Arts Centre 1980 (solo); Fine Arts Gallery, Perth 1981 (solo); Madang Country Club, New Guinea 1982; Kalamunda WA 1983 (solo); Sydney Cultural Council, NSW 1983; Further solo shows at Alexander Gallery, WA 1985; Gomboc Gallery 1986; Bay Gallery of Fine Art, Perth 1988; Gallery 97, Hong Kong 1989; Participated in the ACTA Touring Exhibition 1989.
Publications *Love* illustrated by Astrid Dahl, Artlook 1983.
Represented Hawthorn Teachers College; Rheem Australian Collections and private collections in Australia and overseas.

DAHL, Barbara (Lipscomb) NSW
Born Condobolin NSW 1933. Painter and teacher.
Studies Nat. Art School, Sydney 1950–53. Taught art for Ed. Dept. 1954–87.
Exhibitions Braemar Gallery, Springwood NSW 1988.
Awards Glenbrook Drawing Prize 1985.

DALEY, Pat QLD
Born Gympie Qld 1943. Genre painter in oil, chalk, watercolour and mixed media.
Studies Majored in Fine Arts at University of Qld and is an Associate of Trinity College, London University; Studied privately under John Molvig; Study tours to UK and Europe 1977–78 and 1980–81 with artist husband Tony Johnson.
Exhibitions One-woman show at Sheridan Gallery 1983; Also exhibits at Phoenix Gallery, Suffolk UK.
Represented Private collections in Australia, UK, Italy and Denmark.

DALGLEISH, Felicity Mary VIC
Born Melbourne 1940. Artist jeweller, silversmith, designer.
Studies RMIT, Dip. Art, Gold and Silversmithing 1982, Grad. Dip. Fine Arts 1986; Grad. Dip. Ed., Melb. CAE 1987.
Exhibitions Solo shows at Makers Mark Gallery, Melb. 1987, 89; Contemporary Jewellery Gallery, Sydney 1990. Has participated in many shows around Australia and internationally at Pforzheim, Germany 1985; Travelling museum show in Germany 1988–89; 2nd New Zealand Craft Biennale, Auckland 1989.
Represented Regional galleries, institutional and private collections in Australia and overseas.

DALLAS, Vera NSW
Born Kincardineshire Scotland. Expressionist painter in mixed media, ceramic artist, graphic designer, illustrator and teacher.
Studies Diploma, East Sydney Technical College 1965.
Exhibitions One-woman shows at Strawberry Hill Gallery, Sydney 1975; Munster Arms Gallery, Melbourne 1977.
Represented Private collections in Australia and overseas.

DALTON, Gabrielle NSW
Born Griffiths NSW 1953. Community and performance artist.
Studies Graduated BA Fine Arts (Hons), Sydney 1976.
Achievements Established TREE; Performance Art Group and with artist George Gittoes in 1978; **Performances** in a hectare of National Park at Wattamolla Beach include Wattamolla Fire Dream 1980; Echoes and Startides 1981, and The Unfound Land 1983.

DANCIGER, Alice NSW
Born Antwerp Belgium 1914. Painter in romantic expressionist to abstract styles in oil, watercolour, pen, charcoal and theatre; Textile designer.
Studies In Sydney under Dattilo Rubbo and in Paris 1935–38; Has lived overseas for periods since 1947; Returned to Sydney in 1972 after living in Rome for some years; Has designed many theatre sets including the *Kirsova Ballet* in Australia.
Exhibitions Her work was shown at the Salon des Tuileries, Paris 1935–38, and the Contemporary Art Society and the Society of Artists in Sydney; Solo shows in Rome 1950; Macquarie Galleries, Sydney 1951, 1973. Retro Show, Barry Stern 1986; Eddie Glastra 1988.
Represented Art Gallery of NSW; Many institutional and private collections in Australia and overseas.

DANIELS, Dolly, Nampijinpa NT
Born NT. Aboriginal painter in acrylic from the Yuendumu region, NW of Alice Springs NT.
Bibliography *Artlink* Autumn/Winter 1990.

d'ANNICK QLD
Born Belgium. Painter of flora and fauna in gouache.
Studies High School in Portugal; Art School in France. Lived in Brisbane for nine years after arrival in Australia. Presently living in Melbourne (1986).
Exhibition Solo show at The Manyung Gallery, Melb. 1986.
Represented Private and public collections in Belgium, Switzerland, France, Portugal, Finland, America and Australia.

DARK, Jann NSW
Born Qld 1956. Painter.
Studies Hornsby Tech. College 1977–79; ESTC 1983–85.
Exhibitions Solo show at Rex Irwin 1986 and included in *A New Generation 1983–88* at The Aust. National Gallery, Canberra 1988.

DARLING, Jennifer VIC
Born Melb. 1949. Painter.
Studies Nat. Gallery School 1968–71; Ass. Dip. Fine Arts.
Exhibitions Nat. Gallery School 1968; Monash Uni. Gallery 1975; Profile Gallery 1979; Drummond St. Gallery 1980; Chrysalis Gallery 1984.
Represented Institutional and private collections in Australia and overseas.

DARLING, Juliet VIC
Photographer, filmmaker, writer, painter.
Studies Canberra S of A 1975–76; Swinburne Film & TV School 1977–79. Produces films and writes plays; Worked on drawings and paintings 1988–89.
Exhibitions Arts Council Gallery, ACT 1982; Solo shows at Roslyn Oxley9 Gallery 1983, 84; Realities Gallery 1985, 89; Her film 'A Pair of ONE' was shown at Roslyn Oxley9 Gallery in 1988.
Represented UK. Europe, USA and Australia.

DA SILVER CURIEL, Sharon VIC
Born Melbourne Vic 1955. Painter and printmaker.
Studies Caulfield Institute of Technology 1974–77; Vic College of the Arts 1978–79; And with Dolf Reisner, UK 1981.
Exhibitions Participated in shows at VCA and CIT 1979.

Awards Arches-Rives Award, Melbourne 1978 and acquisitive prizes at Bayswater and Camberwell Vic 1981; Camberwell Travel Study Grant 1981.
Bibliography *Directory of Australian Printmakers* 1982.

DATTNER, Kay **VIC**
Born UK. Painter, illustrator and stage designer.
Studies Student Royal Academy Schools, London 1940 and was televised with the then president Sir Edwin Lutyens as the Academy's youngest exhibitor; Joined the forces, serving in UK and overseas and, when circumstances permitted, painted portraits and murals in various headquarters; Was later involved with the theatre, designing costumes for several productions, notably *La Boheme* in Cairo; After arriving in Australia she worked as a commercial artist designing wrapping papers and drawing covers for Georges' pamphlets and quarterly reviews; Amongst other commissions she illustrated *The Getting of Wisdom*; In the ensuing period she has increasingly moved to landscape, figure and portrait painting.
Represented Wiregrass Gallery, Eltham Vic and many private collections.

DAVEY, Jillian **NT**
Aboriginal watercolour painter of the Pitjantjatjara people in the Ernabella region which straddles the border area of SA/NT. Reported to be the sole remaining watercolourist in the area.
Exhibitions Bloomfield Galleries, Sydney 1989.
Represented ANG; NTMAG; AGSA; Robert Holmes à Court Collection.

DAVEY, Thyrza **SA**
Born Hahndorf SA 1931. Realist painter.
Studies Evening classes with Jeffrey Smart 1945. Full-time at Girls Central Art School, Adelaide 1946–50 under Sir Ivor Hele and Millwood Grey, followed by overseas study for one year, and another year of study in UK and Europe in 1980.
Exhibitions One-woman show at John Cooper's Eight Bells Gallery, Qld 1979 with further mixed shows there and at Newton Gallery, SA since moving to the Barossa Valley in 1980.
Awards Redcliffe Art Society, Qld 1963.
Publication *Waiting for May* written and illustrated by Thyrza Davey, Hodder & Stoughton 1983.
Represented Newman College, University of Melbourne; Redcliffe Art Gallery and private collections in Australia and overseas.

DAVIDSON, Barbara **NSW**
Born Sydney NSW 1928. Printmaking, lithography, wood and lino cuts; Member of Print Council of Australia.
Studies Diploma Art, East Sydney Technical College 1944–49; Workshop Art Centre, Willoughby 1964–70, 1978–79; Sir John Cass College, London UK 1968; Palo Alto Art Club, USA 1978; Camdem Arts Centre, London UK 1980; Chautauqua Institute, New York 1985.
Exhibitions Paintings WAC, Willoughby 1968; Printmaking, Old Bakery, Lane Cove 1978; Mixed Exhibitions, Germany 1980; NSW House, England 1982, 1983; Painters Gallery, Surrey Hills NSW 1983. Q Gallery, Sydney 1985; Marsden Gallery, Bathurst 1987; Penrith Reg. Gallery 1986; Toronto, Canada 1988; Woolloomooloo Gallery, Sydney 1988; 70 Arden St. Melb. 1988; Blaxland Gallery, Sydney 1990; Braemar Gallery 1990.
Awards Lane Cove Art Prize 1979; Drummoyne (Graphic Section) 1980; Boggabri 1981; Narrabri 1982, 1988; Acquisitive Warrnambool Vic 1973; Lismore 1977; Manly Art Gallery 1978; Muswellbrook 1979; Bathurst 1979; Mudgee 1980; Halsinglands Museum, Sweden 1980. Berrima 1987, Scone 1988; Mudgee 1988, 90; Hunters Hill 1989; Camden 1990; Liverpool 1990.

Represented Regional Galleries at Warrnambool, Lismore, Manly, Bathurst, Muswellbrook, Mudgee; Halsing Landsmuseum, Sweden; Private collections in Australia and overseas.

DAVIDSON, Diana NSW
Born Sydney. Printmaker and teacher.
Studies ESTC, Commonwealth Scholarship 1963–67; Chelsea College and Morely College and in Europe 1968–73. Established Whaling Road Studio, North Sydney 1978. Lecturer part-time ESTC 1978–87; City Art Institute 1985–88.
Exhibitions Solo shows at Realities, Melb. 1987; BMG, Sydney 1987; Blaxland Galleries, Sydney; Dempsters Gallery, Melb. 1988; Galaxy Gallery 1989.
Awards Nat. Art School Prize 1967.
Represented ANG, Artbank, institutional and private collections in UK, Europe, Australia.

DAVIDSON, Jo QLD
Born Oberon, NSW 1954. Painter.
Studies SA School of Art, Adelaide 1974–76; Studied in UK and Europe 1981–84.
Exhibitions Solo shows at CAS Gallery, Adelaide 1980; Ray Hughes Gallery, Brisbane 1981, 85; Gallery up Top, Rockhampton, Qld 1981. Recent group shows include Shell Gallery, Amsterdam 1983 with Stephen Killick; Adelaide Festival of Arts 1984; University of Queensland Art Museum 1985; Six Directions, Queensland Art Gallery 1985.

DAVIES, Dorothy Ada NSW
Born Doncaster Vic 1920. Painter and teacher.
Studies Echuca, Prahran and Caulfield Technical Colleges and Teachers College, Vic; Qualified as secondary school art teacher 1940; Attended portraiture classes at Royal Art Society, NSW 1967; Principal of Lyndon Art School, Epping NSW 1967–76; Also taught at the Wesley School for Seniors.
Awards Newcastle 1969; Campbelltown 1970; Blackheath 1974, 1977, Castle Hill 1975, 1978; Goulburn 1975; Parramatta 1976.
Represented Institutional and private collections in Australia.

DAVIES, Helen (Barnard) TAS
Born Launceston 1950. Painter and teacher.
Studies School of Art, Hobart 1968–70; Taught with the Tas. Education Department 1971–73; worked at the Barbican Craft Workshop, Plymouth UK 1973. Taught Launceston Technical College, Tas. 1977–79.
Exhibitions Solo shows at Something Good Gallery, North Hobart 1973 and Bowerbank Mill Gallery, Deloraine, Tas 1979. Group shows include 'Tasmanian Artists' Tasmania House, London UK 1979.
Bibliography *Tasmanian Artists of the 20th Century*, Sue Backhouse 1988.

DAVIES, Isabel VIC
Born Melbourne Vic. Painter and sculptor, assemblages and collage, multi-media.
Studies National Gallery School, Melbourne 1966–67; Travelled Europe 1977–8, 85.
Exhibitions Solo shows at Realities, Melbourne 1971, 1973; Holdsworth Galleries, Sydney 1971, 1973, 1976; Old Fire Station Gallery, Perth 1976; Stuart Gerstman Galleries, Melbourne 1977; Shepparton Art Gallery 1977; Powell St 1979; Christine Abrahams Gallery, Melb. 1987, 89, 91; Macquarie Galleries, Sydney 1988, 90, 91. Participated in Australian Galleries, Melbourne 1970; Darnell de Gruchy Invitation Exhibition, Brisbane 1974; 'Spring Festival of Drawing', Mornington Peninsula Arts Centre, Vic 1975; 'Women in Art', WA Institute of Technology, Perth 1975; 'The Money Show', Ewing and George

Paton Galleries, Melbourne University 1977; In 1977, 'Women's Postal Event', Institute of Contemporary Art, London; 'Women's Postal Event', Ewing Gallery, Melbourne University; 'The Women's Show', Experimental Art Foundation, Adelaide; 'Spring Festival of Drawing', Mornington Peninsula Art Centre; In 1978, 'Drawing 78', Stuart Gerstman Galleries, Melbourne; Caltex 'Master's Choice' Award, Royal SA Society of Arts Gallery, Adelaide; 'Eight Women Realists', Vic College of Arts Gallery, Melbourne; Seventh Sculpture Triennial, Mildura Arts Centre; 'The Map Show', Ewing Gallery, Melbourne University; Spring Festival of Drawing, Mornington Peninsula Art Centre 1979; Georges Invitation Art Prize, Georges Gallery 1980; Women's Art, Niagara Lane Galleries 1980; First Australian Sculpture Treinnial, La Trobe University 1981; 'Women's Art Forum' Exhibition, Hawthorn Galleries 1981; 'Ten Years', George Paton Gallery, Melbourne University 1981; 'Open Windows, Closed Doors', La Trobe University Gallery 1981; Women's Images, Prahran Gallery, Vic College 1982; Five Women Artists, Golden Age Gallery, Ballarat 1983; 'The Age of College' Holdsworth Contemporary Galleries, Sydney 1987; 10th Mildura Sculpture Triennial 1988; First Australian Contemporary Art Fair 1988; Vincent Art Gallery, Adelaide 1989; NGV 1989; QAG 1990; Painters Gallery, Sydney 1990; Macquarie Galleries 1991.

Represented ANG; NGV; Melbourne University; University of W.A.; State College of Victoria, Frankston; W.A. Institute of Technology; Shepparton Art Gallery; Mildura Arts Centre; Fremantle Arts Centre; Mt Lawley Teachers College, W.A.; La Trobe University, Melbourne; Artbank; Private Collections in Australia and overseas.

Bibliography *Art and Australia*, Vol 9/2, page 111; *Australian Sculptors*, Ken Scarlett, Nelson 1980; *Encyclopedia of Australian Art*, Alan McCulloch, 1984; *Artists & Galleries of Australia*, Max Germaine: Craftsman House 1990.

DAVIES, Susan Gael NSW
Born Sydney 1962. Painter in acrylic and pastel, designer.
Studies BA Visual Arts, Newcastle CAE 1984.
Exhibitions Newcastle CAE 1984; von Bertouch Galleries 1986, 89.
Represented Institutional and private collections in Australia and overseas.

DAVIS, Cecily NSW
Born Sydney. Figurative painter and portraitist, teacher, no formal art training. Teaches at Ku-ring-gai Community Arts Centre, Manly Evening College and North Balgowlah Community Centre. Solo shows in Sydney at Nicholson Street Gallery 1986 and Richard King Gallery 1988. Numerous group shows.

DAVIS, Jan NSW
Born Bairnsdale, Vic. 1954. Painter, printmaker, teacher.
Studies Dip. Art, PIT 1978–80, Postgrad. 1981.
Printmaking technician, VCA 1982–84; taught at Ballarat CAE 1985–87 and Northern Rivers CAE, Lismore NSW 1988. Committee member of PCA; Presently Lecturer in Printmaking and Head of 2D Studies at University of New England (Northern Rivers.).
Exhibitions Solo shows at Niagara Galleries 1988, 90; Roz McAllan Gallery, Brisbane 1989, 91; Participated numerous group shows since 1979 including Fremantle, Swan Hill. Warrnambool and Mornington Reg. Galleries 1983–87; Ballarat 1988; First Australian Contemporary Art Fair, Melb. 1988; PCA Gallery 1988; Watters Gallery, Jewish Museum of Australia, Linden Gallery, Niagara Galleries 1989; University of Tasmania, Araluen Arts Centre, NT, Geelong Art Gallery, Bathurst Regional Gallery 1990.
Represented Artbank, institutional and private collections.
Bibliography *PCA Directory* 1988; *New Art Three*, Nevill Drury: Craftsman House 1989.

DAVIS, Julia NSW
Born Vic 1957. Sculptor.

Studies Dip. Art & Design, Prahran College, Melbourne 1978.
Exhibitions Solo shows at Artspace, Sydney 1985; Irving Sculpture Gallery 1987; 70 Arden St. Gallery, Melbourne 1988. Group shows include Cell Block, Sydney 1983; Lewers Memorial and Penrith Regional Gallery 1986 and 10th Mildura Sculpture Triennial 1988; 70 Arden St. 1989; Judith Pugh Gallery 1990, 91; Manly Art Gallery, Sydney 1990.

DAVIS, M. Ryan NSW
Painter and printmaker.
Studies BA Uni. of Sydney; Brisbane Tech.; Warringah Print Workshop; RAS of NSW Diploma Course. Exhibits mostly with RAS.
Awards Teachers College Art Prize; RAS James R Jackson Award 1987; Willoughby Art Prize 1985.
Represented New MBF Building municipal, institutional and private collections in Australia and overseas.

DAVSON, Sharon NSW
Born Gatton, Qld 1954. Painter, sculptor, teacher.
Studies Brisbane C of A — Ass. Dip. Fine Art 1972–74; Kelvin Grove CAE — Dip. Teaching 1975; taught art in Brisbane 1975–80; travelled Aust. 1980–83. Specialises in large commissioned art works for public and corporate buildings. Foundation member 'Artists for Life Pty Ltd' 1991.
Exhibitions Solo shows at First Impression Gallery, Sydney 1985; Park Mall Studios Windsor, NSW 1989.
Awards RNAS Brisbane 1969; Toowoomba Royal Show 1971; Garden City Award 1975; Corinda Arts Festival, Brisbane 1978; Ian Fairweather Memorial Award and Aust. Theatre Work Award, Qld 1986.
Represented Many corporate institutional and private collections in Australia and at Buckingham Palace, London UK.

DAWES, Debra NSW
Born Goondiwindi, Qld 1955. Abstract painter.
Studies Art Certificate; Newcastle TAFE 1979; Diploma in Art; Newcastle College of Advanced Education 1980–82; Postgraduate Diploma in Painting Sydney College of the Arts 1984–85.
Exhibitions Solo shows at A-Weg Gallery, Groningen, Holland 1983; Union Street Gallery 1986; Mori Gallery, Sydney 1987, 88, 89; George Paton Gallery, Melb. 1988. Participated in numerous group shows since 1984 including Brisbane CAE Gallery 1986; Ray Hughes Gallery, Sydney 1987, and George Paton Gallery, Melb. 1987; Australian Perspecta 1989, AGNSW; Moet & Chandon Touring Exhibition 1989, 90.
Represented Institutional and private collections.
Bibliography *Artists & Galleries of Australia*, Max Germaine: Craftsman House 1990.

DAWES, Jenny VIC
Born Gladstone, Qld 1954. Landscape painter in oils, acrylic, watercolour.
Studies Under Lawrence Daws, Rex Backhaus-Smith and Bill Offord. Member, Ballarat Art Society. Shares as studio with Bill Offord.
Exhibitions Solo shows at Avocado Gallery, Buderim, Qld 1984 and Grafton House Gallery, Cairns, Qld 1987.
Awards Gympie, Qld 1st and Sunshine Coast Agricultural Qld 1st.

DAWSON, Gail QLD
Born Mungindi Qld 1957. Painter and teacher.
Studies Dip. Creative Arts (Visual), DDIAE, Toowoomba 1990. Artwork co-ordinator for

1990 Cabarlah Folk Festival. Currently employed at Toowoomba West Special School.
Exhibitions Downlands College Gallery 1989, 90; DDIAE Gallery 1989; McWhirters Artspace, Brisbane 1991.

DAWSON, Janet NSW
Born Sydney NSW 1935. Painter, printmaker, teacher, stage designer.
Studies National Gallery Art School, Melbourne 1951–56; Awarded National Gallery Travelling Scholarship and studied Slade School of Fine Art, London University 1957–58; Awarded Boise Scholarship London 1959; Studied graphic arts, lithography and etching, Atelier Patis, Paris and Anticoli Corrade, Italy. Her costume and set designs have featured in many notable stage shows around Australia over the years and she has also been very active with her book illustrations, prints and teaching. In 1980 she founded The Bugle Press with her husband Michael Boddy.
Exhibitions Held twelve solo shows at Gallery A, Sydney and exhibitions widely at Realities Gallery, Melb. and with prints at Ljubljana. Yugoslavia and the Victoria and Albert Museum, London. In recent times has shown at NSW House, London 1982; McClelland Gallery, Melb. 1982; Griffith Uni., Brisbane 1984; ANG, Canberra 1988; David Jones' Gallery, Sydney 1989; 312 Lennox Street, Melb. 1986, 88.
Awards Brisbane Art Gallery Trustees' Prize 1977; Mosman Art Prize 1979; Gold Coast Art Prize 1980; Print Council of Australia Invitation Print Exhibition 1981; George's Invitation Art Prize 1982; Camden Art Gallery Award 1983. VACB Grant 1985.
Represented ANG, AGSA, NGV, AGNSW, QAG, QVMAG, Ballarat Art Gallery, Vic; Commonwealth Loan Collection; Stedjelik Museum, Amsterdam; College of Advanced Education, Launceston Tas; Nursery Schools Teachers College, Sydney; Royal Melbourne Institute of Technology, Melbourne; National Capital Development Corporation, Canberra; General Motor Corporation, Australia; Mosman Municipal Council, Sydney; University of NSW, Sydney; Windsor Council, NSW; Macquarie University, Sydney; Gold Coast City Art Gallery, Qld; Bendigo Art Gallery, Vic.
Bibliography *Art and Australia* Vol 1/4, 2/4, 6/1 and 2, 8/4; *Australian Painting 1788–1970*, Bernard Smith, Oxford University Press 1971; *Modern Australian Paintings 1970–75*, Kym Bonython/ Elwyn Lynn, Rigby 1976; *Contemporary Australian Printmakers*, Frank Kamf, Landsdowne 1976; *Artists & Galleries of Australia*, Max Germaine: Craftsman House 1990.

DAWSON, Margaret L. VIC
Born Melbourne Vic 1945. Painter in oil and watercolour, landscapes and still life.
Studies Art, Methodist Ladies College, Melbourne and tutored by art teacher mother; Member Australian Guild of Realist Painters; Paints on commission by the Dept of Overseas Trade, Canberra.
Awards Won Lilydale Prize for Watercolour 1977.
Represented Overseas diplomatic offices.

DAWSON, Paula NSW
Born Brisbane 1954. Installations, holograms, sculptor.
Studies Higher Dip. Ed. State College, Vic., Graduated Fine Art RMIT., and BA from VCA. Was artist-in-residence or guest worker at Laboratoire de Physique et Optique, France; Telecom Research Laboratory, Melbourne; Applied Physics Department, RMIT; Presently lecturer at SCOTA, Sydney.
Exhibitions Solo shows at Gryphon Gallery 1977, 80; RMIT 1977, 79; Participated at Ewing Gallery 1974; Mildura Sculpturescape 1975; 'Continuum', Tokyo, Japan 1983; Film Museum, Frankfurt, W. Germany 1984; Tsukuba, Japan 1985; Qld. Museum, Brisbane 1986; Expotec, Montreal, Canada 1988; Australian Perspecta 1989, AGNSW.
Bibliography *150 Victorian Women Artists*, Visual Arts Board/WAM 1988.

DAY, Annie NSW
Born Sydney 1942. Painter, portraitist, photographer.
Studies Worked as apprentice in art studio from 1959 and studied in UK, Europe from 1969.
Awards Finalist in the Doug Moran National Portrait Prize 1990.

DAY, Elizabeth NSW
Born UK 1954. Paintings, installations.
Exhibitions Manly Art Gallery 1985; First Draft 1988; Artspace 1984, 86, 88; Performance Space 1984; Chameleon Gallery, Hobart 1985, 89; ACP 1988; Australian Perspecta 1989, AGNSW.

DEAN, Stephanie TAS
Born Launceston Tas 1936. Painter of Tas wildflowers in watercolour.
Exhibitions Exhibits in Tas and has published poster on Tas Mountain Plants and two sets of prints in folios on Tas Berries and Tas Wildflowers.

DEBENHAM, Pam NSW
Born Launceston, Tas. 1955. Printmaker.
Studies Meadowbank TC, Sydney 1975–76; SCOTA 1977–79 gaining Dip. Visual Arts and BA.
Exhibitions Many shows since 1979 and recently at Sydney Printmakers 1987; Blaxland Galleries 1987; 70 Arden St. Melb. 1988.
Awards Henri Worland Prize, MPAC Prize; Arches River Prize.
Commissions PCA 100 x 100 Print Portfolio 1988.
Bibliography *PCA Directory* 1988.

de COUVREUR, Genevieve NSW
Born Sydney 1958. Painter.
Studies ESTC 1975; UK, Europe 1976; Alexander Mackie CAE 1977–80, graduated Dip. Art; overseas study 1978, 81.
Exhibitions Solo shows at Greythorn Galleries, Vic. 1985, 89; Participated Philip Bacon 1985; Holdsworth Contemporary Galleries, Sydney 1985, 86; von Bertouch Galleries, Newcastle 1989.

de CRESPIGNY, Adele VIC
Born Melbourne Vic 1912. Painter of Australian flora and fauna in watercolour and coloured pencil.
Studies Art during school studies at Sacŕe Coeur Convent, Lille France and later at Melbourne National Gallery School under W.B. McInnes.
Exhibitions With Rogowskis Art Gallery, Colonial House Gallery and Chameleon Galleries, Melbourne but works mainly on commission.
Represented Private collections in England, France and Australia. (Died 1990).

DEERING, Yvonne VIC
Born Melb. 1951. Printmaker.
Studies BA (Hons.) Dip. Ed. Monash Uni. 1970–74; Dip. Art & Design CIT 1979–81.
Exhibitions Hawthorn City Gallery 1981; 70 Arden St. 1988.
Commissions PCA 100 x 100 Print Portfolio 1988.
Bibliography *PCA Directory* 1988.

DEGEUS, Marijke QLD
Born The Hague Holland 1917. Painter in oils; Ceramic artist and teacher.

Studies Academie Voor Beeldende Kunsten, The Hague; Escaped from Holland to Australia 1944; Went to Java to work as a nurse in the post war camps and later with the Education Dept 1945–47; Taught at Stuartholme, Brisbane and studied with Jon Molvig 1948; Lived and painted in the jungle in Sarawak Borneo 1966–67; Travelled Europe and Africa 1968; In recent years has been involved in ceramic sculpture.
Exhibitions One-woman shows at Finchley Galleries, Toowoomba 1963; Oefrer Gallery, Brisbane 1969; Reid Gallery, Brisbane 1972–74; Broadbeach Gallery, Qld 1976, 1979; Philip Bacon Galleries 1978; Nerang Qld 1980, 1982 (ceramics).
Awards Centenary Art Prize, Qld 1959; Dalby Art Prize 1964.
Represented Institutional and private collections in Europe, Indonesia and Australia.

de HAAS, Marion · NSW
Born Sydney 1953. Painter and teacher.
Studies Graduated BEd.; Uni. of Sydney 1976; Ku-ring-gai CAE — Grad. Dip. Teacher/Librarianship 1981; Art Certificate, Hornsby TAFE 1980–86; overseas study tours 1972, 78, 87; worked as teacher and/or librarian at various government schools 1977, 79, 82, 86, 88.
Exhibitions Solo show at North Sydney Contemporary Gallery 1988; participated Cell Block 1986; Balmain Loft, Anthony Field and Stadford Galleries, Sydney 1987.
Represented Institutional and private collections in UK, Europe, USA and Australia.

DELANEY, Jan · VIC
Born Vic. Painter, sculptor and potter.
Studies Pottery, sculpture at Bendigo School of Mines, Vic and painting under Dorothy Baker; Member, Victorian Artists Society and Contemporary Art Society, Melbourne, President 1987–89.
Exhibitions Malvern Art Society 1966; Herald Art Show 1967; CAS shows 1971, 1981; VAS Shows 1972, 1978; Royal Shows 1974, 1975; Solo show at Joan Gough Gallery, Melb. 1986; Alliance Francaise Gallery Melb. 1989.
Awards Frist Prize, Royal Shows 1974–75; Numurkah Shire 1989.
Represented Private collections in Australia, Germany, UK, USA, China.
Bibliography *Artists & Galleries of Australia*, Max Germaine: Craftsman House 1990.

de LANGE, Glenys · QLD
Born Brisbane Qld 1943. Naive painter in oil, acrylic and collage.
Studies Three years privately with Dutch traditional painter Alex Rotteveel at Toowoomba; One year each at Toowoomba Technical College and Darling Downs Institute of Fine Arts.
Exhibitions Solo shows at McInnes Gallereis, Brisbane 1981; Victor Mace Winter Show, Brisbane 1982; Eumundi Teahouse, Qld 1982.

DELL, Carol · TAS
Born Launceston, Tas 1952. Painter and teacher.
Studies Launceston School of Art 1972–74. Taught Launceston Technical College 1977.
Exhibitions Solo shows at Bowerbank Mill Gallery, Deloraine 1976; Devonport Gallery and Art Centre 1977; The Launceston Gallery 1980. Included in 'Twelve Tasmanians at Gillians Gallery', Adelaide 1982.
Awards VAB Grant 1977.
Represented QVMAG, Devonport Gallery and Art Centre, Artbank, TSIT, Launceston General Hospital.
Bibliography *Tasmanian Artists of the 20th Century*, Sue Backhouse: Pandani Press 1988.

DELLAL, Zerin · VIC
Born 1961. Printmaker.

Studies BA, Painting, RMIT 1980–83.
Exhibitions 70 Arden St. Melb. 1988.
Commissions PCA 100 x 100 Print Portfolio 1988.
Bibliography *PCA Directory* 1988.

DEL'MACE, Jill VIC
Born Grimsby UK 1947. Painter, portraitist, fashion designer.
Studies Basic training from her painter, art teacher, father. Worked as a fashion designer in San Francisco 1975.
Awards Finalist in the Doug Moran National Portrait Prize 1990.

DELRUE, Chantale TAS
Born Wevelgem, Belgium 1951. Painter, printmaker, muralist, teacher, arrived Australia 1974.
Studies Academie von Schone Kunsten, Heyst on den Berg, Belgium 1966–69; Colome Institut, Mechelen 1966–69; St Lucas Institute, Brussels 1969–73. Travelled through Asia 1973, and worked in Sydney 1975. Studied at the Escucla des Belles Artes, Guadalajara, Mexico 1976. Painted murals at Guadalajara, Mexico 1976; Oakland Community College, California 1976; and the Center for Independent Living, Berkeley, California 1977. Studied Oakland Community College, California 1977. Travelled through Latin America 1978 and worked as a printmaker at the Masareel Center, Kasterlee, Belgium 1979. Moved to Tasmania 1980. Studied at the Launceston Technical College and the School of Art, Launceston, graduating BA Fine Arts 1981–82. Worked as Artist-in-Residence, Warrnambool, Victoria for 3 months 1983; was artist in the community, Launceston 1984 working on 4 different mural projects; Launceston Gen Hosp 1985. Travelled to Europe and USA 1985; NSW, Qld & NT 1986. Lives with her sculptor husband Joris Everaerts.
Exhibitions Solo shows in Belgium 1973, 77, 79; Warrnambool Art Gallery, Vic. 1983; TSIT Launceston (ceramics) 1988; Devonport Gallery & Arts Centre 1989; Chameleon Gallery 1989; Cockatoo Gallery 1990; Numerous group shows since 1968 and joint show with her husband at Gabriel Gallery, Melb. 1983. Recent commissions include Mural for Ikeda Festival, Japan 1987 and Rainbow Serpent for the Bicentennial Exhibition, Launceston 1988.
Represented Warrnambool Regional Art Gallery, Tasmanian Development Authority, Footscray City Council Collection.
Bibliography *Tasmanian Artists of the 20th Century*, Sue Backhouse 1988.

de MAINE, Johanna QLD
Born Rotterdam Holland. Potter.
Studies Nelson and Colne CFE in UK majoring in ceramics 1974–75; Extensive travel in Asia; Set up De Maine Pottery in Qld with her husband in 1976.
Exhibtions One-woman shows at Tirano Gallery, Biloela Qld 1978–80; Gallery Up Tow 1979–80; Qld Potters Association 1980; Craft Council, Brisbane 1980; Mackay Harrison Galleries, Ballina NSW 1980–81. Margaret Francey Gallery, Brisbane 1988.
Awards Caloundra 1979; Marty Hansen Prize 1981; Stanthorpe 1982; Craft Board Grant 1981.
Represented Qld Art Gallery; Museum Applied Arts and Sciences; Caloundra Art Gallery; Gladstone Art Gallery; Stanthorpe Art Gallery; Brisbane College of Advanced Education.

de MESTRE, Tori VIC
Born Wollongong NSW 1951. Sculpture and textiles.
Studies National Art School, Sydney; Painting Diploma (studies discontinued) 1970–71; Melbourne State College; Diploma of Teaching Primary (Art & Craft) 1976–78. Has taught art at TAFE Colleges and Universities since 1983.

Exhibitions Solo shows at Calderwood NSW 1981 and Allegro Gallery NSW 1982; Jam Factory, Adelaide 1984. Numerous group and two-person shows 1979–83; Tamworth National Fibre 1984; Beaver Galleries, Canberra 1984; Meat Market Craft Centre, Melb. 1984, 85, 86; Ararat Regional Gallery 1986; 3rd Tapestry Biennial, Lausanne, Switzerland 1987; Gallery Handmade, Melb. 1987.
Represented Artbank; Arts Access Society; Institutions and private collections.

DENNIS, Margery NSW
Born Sydney NSW 1922. Naive painter of Australia landscapes, flowers and animals.
Studies First started painting in 1974 under Marion Farley; Member of Lane Cove Art Society.
Exhibitions Solo shows at Hobson Harding Gallery, Sydney 1976; Bloomfield Galleries, Sydney 1978, 79, 81, 83, 84, 86, 88; Cintra House Galleries, Brisbane 1984, 85, 87; Gallery Art Naive, Melb. 1979. Numerous group shows since 1975 including London UK 1982; Solander Galleries, Canberra 1988 and First Australian Contemporary Art Fair, Melb. 1988 with Bloomfield Galleries.
Awards Swan Hill Pioneer Award 1980.
Represented Commonwealth Artbank; Kensington Palace; Swan Hill Regional Gallery, Victoria; BHP; General Insurance Company Ltd., Australia; Private collections Australia, USA, UK.
Bibliography *Artists & Galleries of Australia*, Max Germaine: Craftsman Press 1990.

DENNIS, Rhonda J. VIC
Born Melbourne Vic 1930. Self-taught realist painter in oil and water colour of treefern gullies, waterbirds and wildlife; Member of Society of Wildlife Artists of Australasia (SWAA).
Exhibitions Paints mostly on commission; 1974 one-woman show Beethoven Gallery; 1975 invited artist International Women's Year Melbourne Exhibition; One-woman show Royal Bank Chambers.
Award 1981 Omeo Shire Art Prize.
Represented National Bank Collection, Interstate, UK, Europe and America private collections.

DENNIS, Telfer Anne TAS
Born SA. Semi-abstract painter of nature, mostly in oil.
Studies Friends School, Hobart; Hobart Technical School under Dorothy Stonor, Stephen Walker and Jack Carington Smith; Worked for some time as a commercial artist with the Hobart *Mercury*; Now married and living with her husband and family on a sheep property near Cressy Tas. Study tour to Europe 1979.
Exhibitions The Gallery, Carrick Tas 1968; Three-man show with Alan McIntyre and Geoff Tyson at Tas Tourist Bureau, Melbourne 1968; Salamanca Place Gallery, Hobart 1969, 1977; The Little Gallery, Devonport 1970; The Art Studio, Launceston 1971; Foscan Gallery, Hobart 1973, 1974; Southern Cross Hotel, Melbourne (opened by Sir William Dargie) 1975; Design Centre, Launceston Tas 1977, 1979, 1981, 1983, 1985; Coughton Galleries, Hobart 1980; Gillians Gallery, Adelaide 1982; Saddlers Court Gallery, Richmond Tas 1987. Numerous group shows since 1958.
Represented Artbank, QVMAG, TMAG and private collections.
Bibliography *Tasmania Artists of the 20th Century,* Sue Backhouse 1988.

DENSHAM, Lois VIC
Born Melbourne 1932. Textile artist, designer, teacher.
Studies Higher Dip. of Teaching in Textiles, Melbourne State College.
Exhibitions Solo shows at Distelfink 1981; Castlemaine Festival 1984; Koo Wee Rup Festival 1984, 85. Numerous group shows include Gryphon Gallery 1977; Castlemaine

Festival 1982; Meat Market Centre 1980–85; Ararat Miniatures Art Gallery 1981–83.
Publications *Soft Sculpture* with Maney Hammong and Noreen Landt.
Bibliography *150 Victoria Women Artists*, Visual Arts Board/WAM 1988.

DENT, Joan NSW
Born Qld 1924. Portrait painter and illustrator.
Studies Presbyterian Ladies College, Pymble and East Sydney Technical College; Fellow of
the Royal Art Society of NSW and Member of the Australian Watercolour Institute: Writes
articles and short stories, illustrates children's books and formerly worked freelance for the
Sydney Morning Herald, *Women's Mirror* and *NZ Mirror*.
Exhibitions Solo shows at Strawberry Hill Gallery and Wardrop Gallery, Sydney; and
Gallery 8, 1981; Gallery 460 and Wilena Gallery 1983; shared shows with daughter Anna
Neville at Q Gallery 1982; Pavan Gallery 1984; participates at Cape Gallery, Byron Bay
NSW. Included in the Peter Stuyvesant Travelling Exhibition 1975; Adelaide Festival and
group shows in Melbourne, Sydney and Brisbane.
Commissions Has been commissioned to paint portraits of many Sydney personalities
including two past presidents of the Journalists Club; Commissioned by the
Commonwealth Government to illustrate a book on the Barrier Reef for presentation to HM
the Queen.
Represented Private and institutional collection in Australia, UK and Italy.
Publications *The White Kangaroo* and *The Storm*, (Commonwealth Collection).
Bibliography *International Who's Who in Art and Antiques*, Melrose Press, Cambridge UK.
Australian Watercolour Painters 1780–1980, Jean Campbell: Rigby 1983.

de PETTRI, Ann VIC
Born Sandringham Vic 1947. Contemporary painter also interested in etching, lithography
and photography.
Studies Diploma of Art and Design (printmaking), Prahran College of Advanced Education
1978–81. Rusden State College 1983–.
Exhibitions Participated in shows at OZ Print Gallery 1978; Prahran CAE Gallery 1980;
Hawthorn City Art Gallery 1982; Projects Gallery, Hamilton Vic 1982; PIT Postgrad.
1985.
Awards Printmaking Award 1980; Prahran CAE.
Presented Private and institutional collections in Australia.

DERBYSHIRE, Nerelie WA
Born Gunnedah NSW 1920. Painter of wildflowers in oil, gouache and watercolour;
Teacher.
Studies Won scholarship to East Sydney Technical College, gained Diploma in Art (design
and crafts) 1943; As a student was influenced by Phyllis Shillito; Returned to painting after
many years raising a family and was fascinated by the wildflowers in the Esperance district of
WA; Works mostly on commissions from Australia and overseas and seldom has paintings to
exhibit; Last exhibition 'WA Artists 1974' was held at the WA Art Gallery for the Festival of
Perth; Next show planned for Esperance WA in 1983; Teacher at Esperance Technical
College since 1978; Member, Perth Society of Artists, Contemporary Art Society of WA and
Esperance Art Society.

DERRIN, Jean NSW
Born Balmain NSW 1904. Painter in oil and watercolour, teacher.
Studies With G.K. Townshend 1948–52. Member RASNSW; Life Member of Berrima
District Art Society. Teaches at her Bowral NSW studio.
Exhibitions First solo show at Moreton Galleries, Brisbane 1952; Grosvenor Galleries,
Sydney 1955, 57; Many solo and group shows since.

Represented Municipal, institutional and private collections.

de SALES, Doreen NSW
Born UK 1919, arrived Australia 1948. Traditional painter and teacher.
Studies Royal Academy, London; Joined Peter Panows Schools of Painting in Sydney as a teacher in 1955 and has continued with his students since his death.
Exhibitions Solo shows at Roseville Galleries, Sydney in 1970, 1978 and has participated in many group exhibitions.
Represented Private collections in Australia and overseas.

de STOOP, Christine NSW
Born Sydney NSW 1948. Self-taught painter of traditional landscapes and portraits in oil.
Director Hillcrest Gallery, Castle Hill NSW.
Award Castle Hill Prize 1976.
Represented Private collections in Australia and overseas.

de TELIGA, Sarah NSW
Born Sydney NSW 1957. Modern painter.
Studies East Sydney Technical College gaining Diploma of Fine Art 1972.
Exhibitions Solo shows held privately 1977 and at Mori Gallery, Sydney 1982, 88, 91.
Represented Artbank and private collections.

DEVAS, Patience NSW
Born England. Sculptor in all media.
Studies Chelsea School of Art, London 1948–49; Les Beaux Arts, Lausanne, Switzerland; Maidstone School of Art, UK; Paris Academy and Heatherly School of Art, London. Worked in South Africa in the late 1970's and arrived Australia 1978. Worked with Bim Hilder before opening her own studio. Member, Sculptors Society, Sydney.
Exhibitions Many overseas shows 1971–78 and in recent years at Holdsworth Gallery 1986, 87; Painters Gallery 1988; Holland Fine Art 1989; BMG, Sydney 1990.
Commissions Bronzes, London UK 1972, 73; WA Government Transport Commission 1982; Bronze, Sydney 1986; Six Murals for Bondi Pavilion, Sydney 1986; Bronze, Riyadh, Saudi Arabia 1987; Bronze, Government House, Canberra 1988.
Represented Governmental, institutional and private collections in UK, Europe, USA and Australia.

DEWAR, Rosemary WA
Born WA 1948. Painter.
Studies Dip. Fine Arts (Painting), Claremont S of A, Perth.
Exhibitions Solo shows at Miller Gallery 1981; Fremantle Arts Centre 1984; Matilda Bay Gallery 1987; Perth Galleries 1988, 90. Numerous group shows.
Awards Bunbury City Purchase 1986; Hospice Foundation 1988.
Represented Regional galleries, institutional and private collections.

DICKENSON, Audrey NSW
Born 1943. Printmaker.
Studies Nat. Gallery School, Melb. 1961–63; Uni. of California, Santa Barbara, USA 1973–75. Operated Tamarind Print Workshop in Sydney for some years.
Exhibitions Robin Gibson Gallery 1975; 70 Arden St. Melb. 1988.
Awards Dandenong, Vic 1965.
Commissions PCA 100 x 100 Print Portfolio 1988.
Bibliography PCA Directory 1988.

DILKES, Joan Marie WA
Born Perth WA 1929. Designer, weaver and textile artist.
Studies Diploma in Art Studies from Perth Technical College 1978; Diploma in Woven Textile Design from Harrogate College of the Arts, Yorkshire UK 1982; Distinction Licentiate, Society of Designer Craftsmen, UK 1982; Studied in UK, Europe 1982–83.
Exhibitions One-woman show at Old Courthouse Studio, Busselton WA 1983; Numerous group shows 1976–83.
Awards WA Arts Council Grant 1980.
Represented Corporate, institutional and private collections in UK, Europe and Australia.

DINHAM, Judith WA
Painter, photographer, teacher, writer.
Studies WAIT 1972–74, 78–80, Boston and New York, USA 1984; MA, University of WA 1986–89; Overseas study 1988, 89, 90.
Exhibitions Solo shows at Perth Galleries 1988; Fremantle Art Centre 1986; Many group shows since 1973 include Nedlands Gallery 1980; Undercroft Gallery 1987; Perth Galleries 1988, 90; Artlook Gallery 1990.
Awards Young Filmmakers 1978; Tresillian Drawing 1985; Albany drawing 1989. Has written numerous books and articles on art matters.
Represented Institutional and private collections in UK, Europe; USA and Australia.

DITCHAM, Diane, WA
Born Sydney 1946. Painter, ceramic artist, designer, teacher.
Studies Moved to Perth WA in 1973; Graduated Dip. Art Studies from Forrestfield TC 1981. Currently lecturer in Design at Forrestfield TC and teaches at Perth Modern School.
Exhibitions Solo shows at Stafford Studios 1989; Gomboc Gallery 1990; Numerous group shows since 1985.
Awards Studio 3AS 1983; Studio 4AS 1984; Maddington Homestead 1984; Melville City 1985 also commissions in UK 1986, 88, 89 and Perth WA 1989.
Represented Institutional and private collections.

DITCHBURN, Sylvia A. QLD
Born Allora, Qld. 1943. Figurative painter and printmaker, teacher.
Studies Townsville College of TAFE — Diploma of Fine Art 1984–87; Graduate Diploma of Museum Curatorship at James Cook University, Townsville, 1989; Currently completing M. Creative Arts Course. Previously studied Australian Flying Art School with Mervyn Moriarty; Vacation Schools with Bela Ivanyi, Ann Thomson, John Peart, John Davidson and Colin Lanceley; Tutor for Women's Workshop, Children's Workshops, TAFE and Artist in Schools Programme; Travelled extensively in Europe and Britain in 1980; Scenic Artist for Opera Sets and Programme Design, Innisfail; Director of Gallery 33, Innisfail Qld. 1981–84; Townsville TAFE — part-time painting teacher 1987–.
Exhibitions Solo shows at Paddington Gallery, Brisbane 1982; Gallery 33, Innisfail, The Northern Gallery, Townsville 1983; Queensland Country Life, Townsville; Christy Palmerston Gallery, Port Douglas; Perc Tucker, Regional Gallery 1986, 90; Christy Palmerston Gallery, Port Douglas 1987; Martin Gallery, Townsville 1987–88; Painters Gallery, Sydney 1990; Verlie Just Town Gallery 1991. Numerous group shows since 1981 include AWI show, Sydney 1983; AFAS Exhibition Memphis USA 1985; Capricorn Gallery, Melb. 1988; Linden Gallery 1989; Rockhampton Festival 1990.
Awards Over 30 awards for painting, watercolour, prints, drawing, and sculpture.
Represented Artbank, Suncorp, Shell Chemical, Townsville TAFE, Innisfail Art Society, Council Collections; Cairns, Hinchinbrook, Cardwell, private collections Australia and overseas.
Bibliography *Artists & Galleries of Australia*, Max Germaine: Craftsman House 1990.

DIXON, Beatrice (NUNGALA) NT

Born 1958. Aboriginal painter in acrylic from Napperby Station, Central Australia.
Exhibitions USA and around Australia. Meticulous painter who has diversified into orna-
mental fine art.

DIXON, Susan (PULTARRA) NT

Born c.1956. Aboriginal painter in acrylic from Napperby Station, Central Australia.
Exhibitions USA and around Australia.

DJUKULUL, Dorothy NT

Aboriginal bark painter, exhibited at S.H. Ervin Gallery, Sydney 1988.
Represented Robert Holmes à Court Collection.

DOCKING, Shay NSW

Born Warrnambool Vic 1928. Surrealist painter in oil, acrylic, pastel, watercolour; Married
to Gil Docking.
Studies Swinburne Technical College and National Gallery School, Melbourne; Lived in
NZ from 1965–71 and became very interested in images of the Pacific and volcanic South
Sea islands; Presently working on themes of the Angophora Eucalypts in Ku-ring-gai Chase
NSW and Australian volcanic landscapes.
Exhibitions Argus Gallery, Melbourne 1961, 1965; Blaxland Gallery, Sydney 1961, 1963;
Bonython Gallery 1962, 1974; Art Club Gallery, Canberra 1962; South Yarra Gallery,
Melbourne 1962; City Art Gallery, Mildura 1962; von Bertouch Galleries, Newcastle 1963,
1967, 1971; Johnstone Gallery, Brisbane 1964; Barry Lett Gallery, Auckland NZ 1967,
1969; Public Art Gallery, Palmerston North NZ 1967; Rudy Komon Gallery, Sydney 1968;
Public Art Gallery, Dunedin NZ (survey of ten years' work) 1968; Wairarapa Arts Centre,
Masterton NZ 1969; New Vision Gallery, Auckland NZ 1969; Victoria University,
Christchurch NZ 1970; Canterbury University, Christchurch NZ 1970; Victorian Arts
Festival 1975 (survey of two decades' work) shown at Vic regional galleries at Hamilton,
Warrnambool, Benella, Shepparton, La Trobe Valley, Sale; Also at St John's Cathedral,
Brisbane; Barry Stern Galleries, Sydney 1979; Participated in many important group exhi-
bitions in Australia, NZ and overseas including Australian Government Exhibition to SE
Asian countries 1962; Second International Young Artists Exhibition, Tokyo 1962;
'Australian Painting Today' Travelling Exhibition throughout Europe 1964, 1966; 'NZ
Painting', Expo 70, Japan 1970; 'Looking Back', National Gallery of Vic Travelling
Exhibition 1975; 'Landscape and Image', Australian Gallery Directors Council Exhibition
to Indonesia 1978; Barry Stern Gallery, Sydney 1979; Survey Exhibition, the 60s to the 80s;
Niagara Galleries, Melbourne 1983. Woolloomooloo Gallery, Sydney 1985; Regional
Galleries at Warrnambool, Bendigo and Swan Hill, Vic 1987; Broken Hill Art Gallery,
NSW 1988; S. H. Ervin Gallery, Sydney 1989; Kenthurst Gallery, NSW 1989; Manly Art
Gallery 1990; von Bertouch Galleries 1991.
Awards Maitland Prize (for local artist) 1959.
Represented National Collection, Canberra; State galleries of NSW, SA, WA, Qld;
Regional galleries at Hamilton, Warrnambool, Benalla, Shepparton, La Trobe Valley, Sale
Vic; Rockhampton Qld; NZ Public Galleries at Wellington, Auckland, Dunedin, Timaru,
Lower Hutt and Palmerston North; University of Melbourne Collection; Newcastle
University Collection; Bendigo Teachers' College Collection; Toorak Teachers' College
Collection; McRobertson Girls' High School, Melbourne; Trinity Grammar School
Collection, Sydney; Warrnambool College of Advanced Education Collection; St John's
Cathedral Collection, Brisbane; BHP Collection, Melbourne; IBM Collection, Sydney;
Fletcher Industries Collection, Auckland NZ; NZ Education Dept Collection.
Bibliography *Encyclopedia of Australian Art*, Alan McCulloch: Hutchinson 1968; *Art and
Australia*, Vol 13/2, *The Australian Landscape and Its Artists*, Elwyn Lynn, Bay Books 1977;

100 Masterpieces of Australian Landscape Painting, Susan Bruce/William Splatt, Rigby Ltd 1978; *Two Hundred Years of New Zealand Painting*, Gil Docking, Lansdowne Press 1971; *Landscape and Image*, Catalogue of Australian Gallery Directors Council Exhibition to Indonesia 1978; *Artists & Galleries of Australia*, Max Germaine: Craftsman House 1990; *Shay Docking Drawings*, Lou Klepac: Beagle Press 1989.

Publications *Shay Docking, The Landscape as Metaphor*, Shay Docking and Ursula Prunster, Reed, Sydney 1983.

DODD, Margaret **SA**

Born SA 1941. Sculptor and ceramic artist.

Studies Diploma of Art Teaching, SA School of Art 1962; Study tour of America 1965–68; University of California, Bachelor of Arts (Art) 1968; Lived and worked in Holland and travelled in UK, France and America 1974.

Exhibitions One-woman shows at Memorial Gallery, University of California 1968; Watters Gallery, Sydney 1971, 1981; Gallery 460, Gosford 1988. Participated in *Ceramics from Davis*, Museum West, San Francisco 1966; *Colour Pot, The Experience,* at Purdue, Rafayette Indiana 1967; Kingsley 43rd Annual, Sacramento, California 1968; *Sculpture,* Artists Contemporary Gallery, Sacramento, California 1968; *Harald Szeeman in Australia,* Bonython Gallery, Sydney 1971; Gallery One Eleven, Brisbane 1972; Chapman's Powell Street Gallery, Melbourne 1972, 1980; Llewelyn Gallery, Adelaide 1972; Crafts Council of Australia (travelling exhibition) 1973; Galerie Nova Spectra, den Haag, Nederland 1975; *The Road Show,* Shepparton Art Gallery 1976; *The Women's Show,* Adelaide 1977; *Mayfair Ceramics Award,* Craft Council Gallery, Sydney 1978; *Sculptural Works at Watters,* Watters Gallery, Sydney 1981; *Australian Perspecta 1983,* Art Gallery of NSW.

Bibliography *Nine Artist Potters,* Alison Littlemore, Murray Book Distributors, Sydney 1973; *Margaret Dodd talking with Julie Ewington,* Meredith Rogers, *Lip,* 1978/79; *Modern Australian Sculpture,* Ron Rowe, Rigby, Adelaide 1977; *Australian Sculptors,* Ken Scarlett, Melbourne 1980; *Art in the Making,* Linda Slutzkin, Art Gallery of NSW Travelling Art Exhibition 1979–80, Art Gallery of NSW 1979.

DODDS, Carolyn **QLD**

Born Aust. 1953. Printmaker.

Studies Colchester S of A, UK; Brighton Polytechnic of Art, UK.

Exhibitions Q'ld. C of A 1976; Mini Print International, Cadaques, Spain 1983–85.

Awards SGIO Prize 1983; Townsville Pacific 1986.

Bibliography PCA Directory 1988.

DOLINSKA, Pam **QLD**

Born London UK 1930, arrived Brisbane 1964. Figurative painter in oil, acrylic, pastel, watercolour.

Studies No formal art training; Privately under Mervyn Moriarty, Roy Churcher, Brian Seidal, John Firth-Smith and John Peart; Tutor at life classes at Eastaus Art School, Brisbane.

Exhibitions Macdonald and East Brisbane 1969, 1972; Biloela Art Gallery 1971; Young Australian Gallery, Brisbane 1972, 1973, 1974; Bakehouse Gallery, Mackay Qld 1974; Tia Gallery, Toowoomba Qld 1975; Twelfth Night Theatre Gallery, Brisbane 1975; Paul Bowker Gallery, Brisbane 1976; Wyoming Court Gallery, Orange NSW 1976; George's Upstairs Gallery, Brisbane 1977; Joan Dancey Broadbeach Gallery, Gold Coast 1978, 1980, 1981, 1982; Tia Gallery 1979, 1980, 1982; Gregory Terrace Gallery Brisbane 1980; Participated in shows at De Lisle Gallery, Montville; Gallery Uptop, Rockhampton Qld; Town Gallery, Brisbane; Studio Zero, Gold Coast; Ralph Martin Gallery, Townsville Qld; Samford Gallery, Brisbane; Nerang Gallery, Qld and Paddington Gallery, Brisbane.

Awards Lutwyche Art Expo 1976; Telegraph Home show 1977; Brookfield Show 1977; Beenleigh Rotary Club 1977; Westfield Art Prize (pottery) 1977; Caltex — Warana 1979.

Represented Qld Art Gallery and private collections in Australia and UK.

DONALDSON, Kim Janet VIC
Born Warragul Vic, 1956. Painter, teacher, designer.
Studies Melb. State College — B.Ed. 1975–78; PIT, Melb. – Grad Dip. Fine Art 1983.
Taught art in secondary schools 1979–82; lecturer, VCA, School of Drama 1987–. Guest
artist Uni. of Texas 1984, San Antonia Art Institute USA 1984; Moreland High School, Vic
1986; Footscray High School 1987. Member, Gertrude Street Studio Committee 1986–88.
Exhibitions Solo shows at 200 Gertrude St. 1986; 312 Lennox St. Gallery 1987, 89.
Included in Moet & Chandon Touring Exhibition 1988–89; Linden, St. Kilda 1988.
Awards Vic. Ministry of the Arts 1986; VAB Grant 1987.
Commissions Prints for Victorian Print Workshop and Myer Foundation project, 1986;
Painted tram for Transporting Art project, Ministry of Transport and Ministry for the Arts,
1987.
Represented Artbank, Myer Foundation and private collections around Australia.

DONECKER, Deborah QLD
Born Tamworth NSW 1954. Painter of figurative landscapes in acrylic, ink, charcoal and
wash.
Studies Diploma of Art at Alexander Mackie CAE 1978–80 (uncompleted); Worked as
graphic artist in Sydney 1970–75. Study tour to Indonesia. Painted in North Queensland
1981–83; painted in Melb. 1984–86, now painting full-time in Brisbane.
Exhibitions Solo shows at Roseville Galleries, Sydney 1982 and Weswel Gallery, Tamworth
NSW 1983; 86; Gallery Art Naive, Melbourne 1984, 86, 89; Hogarth Galleries, Sydney
1985; Naughton Naive Gallery, Sydney 1988.
Represented Artbank and institutional and private collections in Australia and overseas.

DORROUGH, Heather NSW
Born UK. Painter and textile artist.
Studies Eastbourne C of A. UK 1950–53; Interior design at Royal College of Art, UK
1950–53; City Art Institute, Sydney 1983–84.
Exhibitions Solo shows at Bonython Gallery, Sydney 1976; Robin Gibson 1979, 81; Crafts
Council 1982; Roslyn Oxley9 1985, 87; group shows include AGNSW 1975; Ivan
Dougherty 1983; Holdsworth Contemporary 1986; Roslyn Oxley9 1987; Lake Macquarie
Gallery 1987; Holdsworth Contemporary Galleries 1987.
Commissions Twelve embroidered panels for State Parliament House, Sydney, 1980;
Robert Garron Offices, Canberra 1984; IBM Ltd. 1985; Australian Embassy, Saudi Arabia
1985–86.
Awards Royal College of Art, London, Silver Medal 1956; Crafts Board Grants 1975, 78;
Commonwealth Postgraduate Award 1983–84; VACB, Residency Fellowship Grant to
studio in Italy.
Represented NGV, AGWA, institutional and private collections in UK, Europe,
Australia.

DOVE, Gladys M. WA
Born Guildford WA 1941. Painter, teacher, printmaker.
Studies Part-time 1958–61 James Street Technical College and 1973–76 Fremantle
Technical College; Diploma of Art Studies 1977; WA Institute of Technology 1977–79;
Bachelor of Arts (Fine arts) WAIT 1980; Teaching Fremantle Technical College and various
workshops 1983. Established printmaking studio at Fremantle College 1982–88.
Exhibitions Guild of Undergraduates 1978–79, Albany, Bunbury, Busselton and various
other mixed exhibitions, including Fremantle Art Centre 10th Anniversary 1982, Young
Originals Gallery, Greenhill Galleries, Gallery Australia, Bay Galleries, Art Co-ordinates,

Perth 1984–88; Beaver Galleries, Canberrra 1987–88.
Awards Albany Graphics 1980; Katanning Drawing 1981; Festival of Perth 1986.
Represented Institutional and private collections in Australia and USA.

DOVER, Imelda VIC
Born Melbourne 1959. Painter.
Studies Dip. Fine Art, VCA.
Exhibitions Solo shows at Iceberg Gallery 1983; George Paton Gallery 1984. Included in
the Keith & Elizabeth Murdoch Travelling Fellowship Exhibitions, VCA 1981, 83, 85.
Bibliography *150 Victorian Women Artists*, Visual Arts Board/WAM 1988.

DOWIE, Penny SA
Born SA, 1948. Painter; a niece of artist John Dowie.
Exhibitions Solo shows at Cricklewood Gallery, SA 1972; Adelaide Festival 1990.
Awards Her self-portrait won the first prize in the Doug Moran National Portrait Prize
competition 1988; Sir Hans Heysen Memorial Prize 1986. Has illustrated several books.
Bibliography *Alice 125*: Gryphon Gallery: University of Melbourne 1990.

DOWLER, Cynthia SA
Born Adelaide 1932. Painter, portraitist, teacher.
Studies SASA, Arts & Crafts Certificate 1980; North Adelaide School of Art, Associate Dip.
Fine Art 1986. Fellow of RSASA; Currently teaching portraiture for WEA.
Exhibitions Solo shows at Coppercrest Gallery 1968; Burke St. Gallery, Victor Harbor
1979. Regular group shows and with the RSASA.
Awards Scholarship to study at RSASA 1945–46; Many portrait commissions.
Represented Institutional and private collections around Australia.

DOWNIE, Beverley VIC
Born Melbourne Vic. Painter.
Studies TSTC Art/Craft 1961–63 Melbourne, Teachers' College Diploma of Art & Design
(CIT) 1972–75; Graduate Diploma of Art/Painting, (RMIT) 1977–79; Master of Arts,
Rosary Graduate School of Fine Arts, Villa Schifanoia, Forence Italy 1980–81.
Exhibitions Numerous shows since 1977 include Warehouse Gallery, Melbourne 1978;
Sydney Opera House 1980; Stanfield Gallery, Melbourne 1981; Villa Schifanoia, Florence
Italy 1981; Holdsworth Gallery, Sydney 1981; Prahran CAE 1982; Retrospective 1978–83
at Hawthorn City Art Gallery 1983.
Represented Private collections in UK, Italy and Australia.

DOYLE, Deanna NSW
Born Young NSW 1951. Painter in gouache and mixed media.
Studies National Art School, Newcastle and Newcastle Teachers' College gaining Diploma
in Art Education with honours; Secondary school teacher 1974 –.
Exhibitions Solo shows at Cottage Gallery, Newcastle 1973; East End Art, Sydney
1981–82 and *Collectors Choice* at von Bertouch Galleries, Newcastle 1981.
Represented Newcastle CAE and private collections in UK, USA and Australia.

DREDGE, Margaret VIC
Born Melbourne Vic 1928. Painter and etcher.
Studies No formal art training; Tutor in non-representational painting at Council of Adult
Education, Vic 1976; Engaged in etching using facilities of Bill Young Studio 1979–81.
Exhibitions Solo shows at Peter Burrowes Gallery 1964; Three Sisters Gallery 1964; Argus
Gallery 1965; Pinocotheca Gallery 1967 and Gryphon Gallery 1979.
Awards Shire of Flinders 1976; Tas Museum and Art Gallery Purchase Exhibition 1978;

Participated in CAS Shows, Melbourne 1961–69; Regional Galleries at Mildura, Geelong, Ballarat, Warrnambool and Gryphon Etchings Show 1982.
Represented Monash University; Commonwealth Banking Corporation; Shire of Flinders, Melbourne State College; Artbank; Tas Museum and Art Gallery.

DREW Judy VIC
Born Melb. 1951. Graphic artist and painter in oil and pastel. Worked in Bougainville Island, PNG 1976–85.
Awards Omega Prize, Melb. 1985.

DRUMMOND, Cathy VIC
Born Melb. 1962. Expressionsist painter.
Studies B. Fine Art, RMIT 1983; UK, Europe 1985.
Exhibitions Solo show at Niagara Galleries 1988; participated at The Age Gallery 1980; Ufitzi Gallery 1987; First Australian Contemporary Art Fair, Melb. 1988.
Represented Artbank institutional and private collections in Australia and overseas.

DRUMMOND, Rozalind VIC
Born Victoria 1955. Photographer.
Studies BA Fine Arts (Photography), Victoria College, Prahran Campus 1982–84. Post-Grad. Dip. Fine Arts VCA 1985.
Exhibitions Solo show at George Paton Gallery 1985; Participated at Clarence St. Lighthouse 1985; Ministry of the Arts Foyer Gallery 1985.
Bibliography *150 Victorian Women Artists*, Visual Arts Board/WAM 1988.

DRYSDALE, Pippin WA
Born Melb. 1943. Potter.
Studies Advanced Diploma Ceramics Perth Technical College 1979–81; Anderson Ranch, Colorado, USA 1982; Associate Potter, Clay Dimensions, San Diego, USA 1982; B.A. (Craft), Ceramics, Curtin University (WAIT) 1983–85.
Exhibitions Numerous shows since 1981 include National Ceramic Award Exhibition, Canberra 1986; Craft Expo Sydney 1987; Greenhill Galleries, Perth 1987; Fremantle Arts Centre, WA 1988; Handmark Gallery, Hobart 1988; Distelfink Gallery 1990.
Represented AGWA, QVMAG, WAIT (Curtin University), The Holmes á Court Collection, Jeff Minchim Collection, Department of Ministry For Trade – Japan.

DUGGAN, Barbara NSW
Born Stafford UK. Painter, stage designer and teacher. Arrived Australia 1953.
Studies Stafford College of Art; Birmingham College of Art; Central College of Art, London. Worked as a commercial artist with George Newnes Publishers, London for some years. Has taught art in NSW High Schools for twelve years. Past president of Bankstown Art Society.
Exhibitions Recent shows at Bondi Pavilion, Sydney and Burnbrae Vineyard, Mudgee 1989.

DUGUID, Elizabeth QLD
Born NSW, 1941. Figurative painter of landscapes and still life mostly in acrylic; teacher.
Studies Hobart Technical College under Jack Carington Smith, awarded Diploma of Art 1959–62; University of Tasmania, Certificate of Education 1962. Taught art in secondary schools in Tas. and NSW 1962–65; study tour to UK and Europe 1971. Attended vacation schools with Ross Davis 1972, Roy Churcher 1974, Andrew Sibley 1978, Rod Milgate 1989. In recent years has become involved in the design, organisation and presentation of community projects. Artist-in-Residence, the Albert Shire, Q. 1986.

Exhibitions Solo shows in Queensland at Boston Gallery 1980, 84, 85, 89; Gallerie Baguette 1981; Corbould Gallery 1985; Albert Shire Council 1986; Criffith University 1987; Cintra Gallery, Brisbane 1990. Numerous group shows include TMAG 1962; Alice Springs 1983, 85; Canberra Times Landscape Show 1985; Victor Mace Gallery 1988; The Centre Gallery, Gold Coast 1988.

Awards Ascot Prize 1975, 76, 88; Redcliffe Open 1978; SGIO; National Show 1980; Gold Coast City Prize 1981; Beenleigh Open 1982; Caloundra Drawing Ipswich Purchase; Bundaberg Prize, RQAS Prize, Karana Downs Prize, Caltex City Council 1983; Redlands Yurrara Prize 1984; Grumbacher Gold Medallion, RQAS 1984, 85; Toowoomba Purchase 1986; St. Albans Purchase 1987; Caloundra Open 1988; Bundaberg Prize 1988; REMM Purchase Prize 1989; Caloundra Drawing Prize 1989; Aberdare Purchase 1990; Redcliffe Open 1990.

Represented Bribie Island Ian Fairweather Memorial Gallery, Galton Mercury Art Gallery, Brisbane City Council Collection, Gold Coast City Council, Moreton Shire Council, Ipswich City Art Gallery, Anglican Grammar School, Brisbane; Queensland Club, BHP House, Albert Shire Council, Toowoomba Art Gallery, private collections in UK, Europe, Australia.

Bibliography *A Homage to Women Artists in Queensland Past and Present:* The Centre Gallery 1988; *Artists & Galleries of Australia*, Max Germaine: Craftman House 1990.

DUMBRELL, Lesley VIC

Born Melbourne Vic 1941. Abstract and colour painter; Married to sculptor, Lenton Parr.

Studies RMIT 1959–62; Artist-in-Residence, Monash University, Melbourne 1977.

Exhibitions One-woman shows at Bonython Art Gallery, Sydney 1969; Strines Gallery, Melbourne 1970; Powell Street Gallery, Melbourne 1973, 1976; Chandler Coventry Gallery, Sydney 1973; Ray Hughes Gallery, Brisbane 1974, 1977, 1981; Abraxas, Canberra 1976; 'Paintings and Studies 1967–77', Monash University, Melboutne 1977; Gallery A, Sydney 1978, 1980; Christine Abrahams Gallery, Melb, 1984, 85, 88, 89. Participated in 'Moravian International 74', Moravian College, Bethlehem USA 1974; 'A Room of One's Own', Ewing Gallery, Melbourne 1975; 'Women in Art', WA Institute of Technology, Perth 1975; Six Women Painters' Travelling Exhibition to Benalla, Ararat, Shepparton, Sale, Warrnambool Vic Regional Gallery 1976; 'Australian Colourists 77', WA Institute of Technology, Perth 1977; 'Some Recent Acquisitions of Australian Art', Australian National Gallery; Canberra Theatre Centre 1978; Australian Perspecta 1981, Art Gallery of NSW; *Ten Years*, Ewing Gallery, Melbourne University; *Survey of the Seventies*, Bendigo Art Gallery, Vic; Betty Cunningham Gallery, New York 1982 with John Firth Smith; *Geometric Extractions*, Wollongong Art Gallery, NSW 1982; *Women's Group*, Gallery A 1982; Australian National University Gallery, ACT 1982, 1983; National Gallery of Vic 1983; Art Gallery of NSW 1983; Australian Biennale 1988.

Awards Camden City Art Prize (purchased), NSW 1979; Georges Invitation Prize, Vic 1974, 1977, 1979; R.M. Ansett, Hamilton Art Award (purchased), Vic 1980.

Commissions Tapestry woven by Vic Tapestry Workshop for the High Courts, Canberra 1979; Tapestry woven by Vic Tapestry Workshop for the National Bank, Australia 1979; Tapestry design for Children's Theatre for the Australian National Gallery, Canberra 1980.

Represented ANG, AGNSW, AGWA, QAG, AGSA; Artbank; The University of WA; Monash University, Melbourne; Geelong Art Gallery, Vic; Hamilton Art Gallery, Vic; Vic Institute of Colleges, Melbourne; Sale Regional Arts Centre, Vic; Mt Gravatt College of Advanced Education, Brisbane; Kelvin Grove Teachers College, Brisbane; National Bank Collection, Australia; Private collections in Australia.

Bibliography *Catalogue of Australian Perspecta* 1981, Art Gallery of NSW; *Encyclopedia of Australian Art*, Allan McCulloch: Hutchinson 1984; *Artists & Galleries of Australia*, Max Germaine: Craftsman House 1990.

DUNN, Eunice VIC

Born Geelong, Vic. 1925. Painter and craftworker.

Studies Textile studies at RMIT.
Exhibitions Solo shows at Ferntree Gully Art Society 1960. Participated at Mornington Rotary 1985; St Kilda Arts Festival 1985.
Bibliography *150 Victorian Women Artists*, Visual Arts Board/WAM 1988.

DUNN, Valerie NSW
Born 1937. Printmaker.
Studies Gymea TC 1980; ESTC 1981; Mitchell CAE Workshop 1980.
Exhibitions Numerous shows since 1979 include Birkenhead Point, Sydney 1984–86; Barcelona, Spain 1984–87.
Awards Botany Festival 1980; Southern Cross 1981, 84, 85.
Bibliography *PCA Directory* 1988.

DUNSTAN, Edith NSW
Born Gladesville NSW 1916. Painter.
Studies Completed Fine Arts Course, University of Sydney 1975–76; Graduated BA, Macquarie University 1977–81; Overseas study in Europe and the East 1981.
Exhibitions Solo show at Garry Anderson Gallery 1991; Group shows at Macquarie University 1977–81; Garry Anderson Gallery 1989.

DURACK, Elizabeth WA
Born Perth WA 1916. Painter, graphic artist, writer and lecturer.
Studies Daughter of a well-known WA pioneering family; She grew up in the Kimberley district with her sister, authoress Mary Durack and lived at both Ivanhoe and Argyle cattle stations; Studied art whilst at Loreto Convent, Perth and later at Chelsea Polytechnic, London in 1937 where she gained her Diploma of Fine Arts; She has travelled extensively over the years and spent much time in studying the history and culture of the native people and their arts in many parts of the world including northern Australia, UK and Europe, North, Central and South Africa, China, Japan, New Guinea and SE Asia and a study of the American Indian sponsored by the Ford Foundation; Further studies at National Gallery, London; The Louvre, Paris and the Padro, Madrid 1966–68.
Exhibitions Held her first one-woman show at the Art Gallery of WA in 1946 and to date has had 46 solo shows throughout Australia; Recent ones being held at Solander Gallery, Canberra 1975; Prouds Gallery, Sydney 1976; Fine Art Gallery, Perth 1976 and at her own studio in Perth in 1977–78; Her retrospective exhibition was mounted by the Art gallery of WA in 1965; She participated at the World Trade Centre, New York 1979. A selection of her 'The Rim and Beyond' series was shown in Dublin and Galway, Ireland in September 1989 at the Australia — Ireland Conference.
Awards OBE 1966 for services to art and literature and CMG in 1982.
Commissions Murals at the University of WA, the Charles Gardiner Hospital, WA and the WA Tourist Bureau; Sets of drawings for the Australian Wool Bureau; BHP Ltd; The Australian Institute of Aboriginal Studies and WA Municipal Councils; Also assignments in Papua New Guinea for Dept of External Territories and at Bougainville Island for Conzinc Riotinto (Australia).
Represented ANG, AGNSW, AGSA, AGWA; The University of WA; Murdoch University; The WA Institute of Technology; The University of Texas, Austin, USA; Various mineral companies with collections in Melbourne, London and New York; The Australian Institute of Aboriginal Studies in Canberra and the Australian Wool Board in Melbourne possess a volume of her graphic material.
Bibliography *Face Value, Women in Papua New Guinea*, Ure Smith 1970; *The Australian Aboriginal Heritage*, Berndt and Phillips 1973; *Modern Australian Painting*, G. Dutton, Collins London 1966; *The Art of Elizabeth Durak*, Art Gallery of WA, Number 18, 1959; *Encyclopedia of Australian Art*, McCulloch, Hutchinson 1977; *Contemporary Western*

Australian Painters and Printmakers, Fremantle Arts Centre Press 1979; *The Art of Elizabeth Durack,* Angus & Robertson 1983; *The Australian Artist* Oct. 1988; *Artists & Galleries of Australia*, Max Germaine: Craftsman House 1990.

DURHAM, Kate VIC
Born Vic. Designer, illustrator, craftworker, jeweller.
Studies Dip. Fine Art from Chisholm IT 1978, Postgrad. Dip. from VCA 1980.
Exhibitions Many shows since 1980 include AGNSW 1981, 82; Distelfink Gallery 1982; Georges Gallery, Melbourne 1983, 86; Meat Market Craft Centre 1983, 84, 85; Christine Abrahams Gallery 1984; Craft Centre, Sydney and Jam Factory, Adelaide 1985; Victorian Regional Galleries 1985; Galerie Dusseldorf, Perth, Wollongong City Gallery and Edinburgh Arts Festival UK 1986; NGV 1987; Touring show to USA and at ANG, Canberra 1988; Victoria and Albert Museum, London 1989; Barry Sterns Exhibiting Gallery, Sydney 1989, 91.
Represented ANG; NGV; Institutional and private collections.

DURRE, Caroline VIC
Born England 1955 arrived Australia 1957. Painter, printmaker, teacher.
Studies Dip. Art, Preston IT 1973–75; Printmaking at Prahran CAE 1979; Photo-printmaking with Bea Maddock 1980; Grad. Dip. In Education, Hawthorn IE 1987.
Exhibitions Art Resource Collective, Yinnar, Vic. 1988, 89.
Represented La Trobe Valley Arts Centre and private collections.

DUTTON, Ninette SA
Born SA. Writer and enameller; Married to writer Geoffrey Dutton.
Studies Leeds School of Art, UK; Kansas State University, USA; Central School of Art, London UK.
Exhibition Gallery A, Sydney 1981, MORA Gallery, Melb. 1988.
Publication *The Beautiful Art of Enamelling,* Ninette Dutton.

DUXBURY, Lesley VIC
Born UK 1950, arrived Melb. 1983. Printmaker, teacher.
Studies Lancaster College of Art 1968–70; BA, Maidstone C of A, Kent 1970–73; Postgrad. Teachers Certif. 1973–74.
Exhibitions Numerous shows since 1972 include McLelland Gallery, Vic 1985; Albury Reg. Gallery 1987; 70 Arden St, Melb. 1988.
Commissions Essex UK 1974; Postal HQ, London 1978; PCA 100 x 100 Print Portfolio 1988.
Bibliography *PCA Directory* 1988.

DYKSTRA, Elly NSW
Born Dardrecht Holland 1939. Potter, ceramic artist and teacher.
Studies Art Academy of Rotterdam, ceramic sculptures and pottery 1972–76.
Exhibitions Solo shows at Macleay Harrison Gallery, Ballina NSW 1980–81; Lenora Charlton Gallery, Terranora 1981; Holdsworth Galleries, Sydney 1983.

DZELME, Dzidra (Mitchell) NSW
Born Germany. Contemporary painter and teacher.
Studies Sydney Technical College 1964; Newcastle National Art School graduating in 1967 with Diploma in Art (education); Lived in England 1970–76 and travelled extensively in Europe and North America, where she held two solo shows; Presently teaching secondary school art and exhibiting in group shows.
Bibliography *Latvian Artists in Australia*, Society of Latvian Artists in Australia 1979.

E

EADES, Lenore VIC
Born Melbourne Vic 1953. Sculptor; Works in bronze, silver, stone and marble also conté life drawings.
Studies Trained and guided technically by her father, Guy Boyd.
Exhibitions Von Bertouch Galleries, Newcastle NSW 1971, 1974, 1977; Australian Galleries, Melbourne 1973; David Dridan Galleries, Adelaide 1974; Collectors Gallery, Perth 1975; Desborough Galleries, Perth 1973; The Barn, Adelaide 1975; Billilla, historical Vic home 1977; Exhibition of conté life drawings, Salamanca Gallery, Hobart 1974; Kenneth John Sculpture Gallery, Melbourne 1978.
Bibliography *Australian Sculptors*, Ken Scarlett, Nelson 1980.

EAGER, Helen NSW
Born Sydney NSW 1952. Printmaker and painter, teacher.
Studies SA School of Arts, Adelaide 1972–75; Visual Arts Board Grant for study in Europe and USA 1980; Kala Institute, Berkley USA 1981–82; MA, City Art Institute; presently teaching at City Art Institute.
Exhibitions Solo shows at Watters Gallery, Sydney 1977, 79, 81, 83, 84, 86, 88, 89, 91; Pinacotheca Gallery, Melb. 1979; Michael Milburn Galleries, Brisbane 1984, 86, 88; Miller Gallery, Perth 1981; Avago Gallery, Sydney 1981; Anima Gallery, Adelaide 1987. Numerous group shows include Printmakers, Contemporary Art Society Gallery, Adelaide 1976; 'Outlines of Australian Printmaking', Ballarat Fine Art Gallery; 'Watters at Pinacotheca', Pinacotheca, Melb. 1977; Tokyo Print Bienale, Japan 1979; *Drawn and Quartered* (Australian Contemporary Paperworks) Art Gallery of SA, Adelaide 1980; *Contemporary Australian Drawings and Prints*, Art Gallery of NSW, Sydney 1980; *Works on Paper*, Watters Gallery, Sydney 1980; *Works from Kirktower House*, Peacock Printmakers Gallery, Aberdeen Scotland 1980; *Interiors*, Art Gallery of NSW Travelling Art Exhibition 1980–81; *21st Annual Sydney Printmakers Exhibition*, Blaxland Gallery, Sydney 1981; *Capital Permanent Award*, Geelong Art Gallery, Geelong; *Albury Purchase Award*, Albury Regional Arts Centre, Albury 1982; *Helen Eager, Pastels/Christine Simons — Acrylics on paper*, Watters Gallery, Sydney 1982; *Australian Perspecta 1983*, Art Gallery of NSW; NGV 1983; Benalla and Shepparton Galleries 1986; Tamworth City Gallery 1988; First Aust. Contemporary Art Fair, Melb. 1988; included in *A New Generation 1983–88* at the ANG Canberra 1988; Moët & Chandon Touring Exhibition 1987.
Represented Art Gallery of SA; Ballarat Fine Art Gallery; Art Gallery of NSW; Australian National Gallery; Newcastle Region Art Gallery; Tas College of Advanced Education; La Trobe Valley Arts Centre; National Gallery of Vic; Bathurst Region Art Gallery; Wollongong Art Gallery; NSW Parliament House; Albury Regional Art Centre.
Bibliography *Art in the Making*, Linda Slutzkin, Art Gallery of NSW Travelling Exhibition 1979–80; *Catalogue of Australian Perspecta 1983*; Art Gallery of NSW; *Artists & Galleries of Australia*, Max Germaine: Craftsman House 1990.

EAGLE, Rosemary VIC
Born Melb. 1949. Printmaker.
Studies Dip. Fine Art, RMIT. Ballarat CAE.
Exhibitions Swan Hill Gallery 1984; Ballarat CAS 1985; Mitchell College 1987; Borough Galleries 1988.
Awards Ballarat SA 1982; Buninyong Festival 1986; Hobsons Press 1986.
Bibliography *PCA Directory* 1988.

EASTAWAY, Lynne NSW
Born Sydney NSW 1949. Painter, printmaker, and teacher.
Studies Painting at National Art School, Sydney 1970–73; Art teacher 1974–78; Technical assistant in printmaking at New England Summer School, NSW 1975; Part-time lecturer (printmaking) at Alexander Mackie CAE, Sydney 1976; Worked with Michael Johnson with ten-week Saturday programme at Sydney College of the Arts 1977; Art teacher 1974–78; Study tour of UK and Europe 1979; Part-time teacher at East Sydney Technical College 1980–83.
Exhibitions 'Student Printmakers' Travelling Show 1972; Diploma Students, National Art School 1972; 'Nine Young Sydney Painters', Llewellyn Galleries, Dulwich SA 1973; Group show at Gallery A, Sydney 1975; Drawing show, Powell Street Gallery, Melbourne 1978; Solo show at Stephen Mori Gallery, Sydney and Axiom Gallery, Melbourne 1982; Two-man show CAS Gallery, Adelaide 1979; Solo show at DC Art, Sydney 1988, 89.
Awards Muswellbrook NSW Prize and Purchase 1974; Leichhardt NSW 1974; Drummoyne NSW 1977; Alice Prize (Purchase) 1977; VAB Grant 1982.
Represented Alexander Mackie College of Advanced Education; Muswellbrook Council Collection; Alice Springs Collection; National Gallery of Vic; Private collections in Australia and overseas.

EATON, Janenne ACT
Born Melbourne Vic 1950. Contemporary painter and teacher.
Studies Diploma of Art and Design, Caulfield Institute of Technology 1970; Teacher Vic Education Dept Technical Schools 1971–72; Study tour of Europe 1972–73; Lecturer, Perth Technical College WA; Worked in America 1979; BA Australian National University, ACT 1983; lecturer Canberra School of Art 1980–.
Exhibitions Solo shows at Lister Gallery, Perth 1977; Hogarth Gallery, Sydney 1980, 82; Pinacotheca Gallery, Melb. 1983, 86; Mori Gallery, Sydney 1984, 86; Milburn + Arté, Sydney 1988. Numerous group shows since 1982 include Nat. Gallery of Vic. 1983; Gallery Huntly, Canberra 1985; Australian Perspecta 85, AG of NSW; CAS Adelaide 1986; QCA Gallery, Brisbane and Ballarat Art Gallery, Vic. 1986.
Awards Paretaio Colleoli Award, Italy 1985.
Represented Uni. of WA; National Gallery of Vic.; ANU Canberra; Darwin Community College; Visual Arts Board, National Bank Collection, University of WA; Queen Vic Museum and Art Gallery, Tas; Private collections UK, USA and Australia.
Bibliography *Art and Australia*, Vol 18/1.

EBERHARD, Jo TAS
Born Vancouver, Canada 1943. Painter, teacher, arts administrator, arrived Australia 1949.
Studies Hobart S of A 1978–81; Uni. of Tas. 1982; overseas study 1975, 77, 80; Taught S of A and Adult Ed. Hobart 1976–85; Presently Executive Director, Crafts Council of Tasmania.
Exhibitions Solo shows at Geilston Bay 1983; Many group shows include Salamanca Arts Centre 1981, 84, 87, 88; Stanley, Tas. 1988. Upstairs Gallery, Hobart 1984.
Represented Institutional and private collections in UK, Europe, USA, South Africa, NZ, Australia.
Bibliography *Tasmanian Artists of the 20th Century*, Sue Backhouse 1988.

EBSWORTH, Andrea VIC
Born Melb. 1956. Ceramic artist, potter.
Studies Bendigo CAE 1977–79.
Exhibitions Solo show at Meat Market Centre, Melb. 1984. Group shows include Gryphon Gallery 1985.

EDGAR, Julie Elizabeth VIC
Born Melbourne 1951. Sculptor, painter, teacher.
Studies RMIT 1971–74; Dip. Fine Art from Chisholm IT 1976–77; BA (Hons) from
University of Melbourne 1981–85. Overseas study Japan 1971, 75, 89 and UK, Europe
1972, 75, 77, 79, 83, 89. Taught sculpture at Geohegan, Glenroy 1975.
Exhibitions Solo shows at Lyceum Club, Melbourne 1986, 90; Numerous group shows
since 1978 include University of Melbourne 1982; Kew Civic Centre 1983; VAS 1986, 88;
Blaxland Gallery 1988; MPAC 1990; The Womens Gallery 1990.
Represented Institutional and private collections in UK, Europe, Japan and Australia.

EDKINS, Cathleen SA
Born Aust. Traditional painter of the Australian landscape with emphasis on horses and
horsemen.
Studies In Melbourne under Septimus Power 1939–44.
Exhibitions Numerous solo shows at Kingston House Gallery, Adelaide and with the
Equestrian Society, London 1989.

EDMONDS, Fiona NSW
Born Sydney 1962. Painter, printmaker and teacher.
Studies City Art Institute 1980–83, graduated in Fine Arts. Has taught art at a number of
Sydney secondary schools and groups since 1984, also works with Warringah Printmakers.
Overseas study tours 1985, 87. Exhibited at City Art Institute 1982, 85, 86 and at North
Sydney Contemporary Gallery 1988.
Awards Warringah Art Prize 1984.
Represented Institutional and private collections in Australia UK and Europe.

EDWARDS, Annette VIC
Born UK 1952. Watercolour painter and printmaker.
Studies RMIT, Bachelor of Arts Fine Arts (painting) 1981; Graduate Diploma in
Printmaking 1982; Study tours to UK, Europe 1976 and UK, USA 1980.
Exhibitions RMIT Gallery 1981; Brents Gallery, Melbourne 1981; Print Council of
Australia 1981; Mornington Peninsula Gallery 1982; Darling Street Galleries, Sydney
1983. Solo shows at Powell Street Graphics 1986, 89; participated Uni. of Oregon, USA
1985; RMIT 1986; TAFE Toowoomba 1986; Albury Reg. Gallery 1986; MPAC 1986–88;
PCA, Melb. 1987.
Commissions PCA Member 1986; National Times Prints 1986.
Awards Johnson Rodda Prize 1979; Flinders Print Prize 1981.
Represented Institutional and private collections in UK, Europe, USA, Australia.
Bibliography *Directory of Australian Printmakers* 1982, 88.

EDWARDS, Elizabeth QLD
Born Buffalo USA 1957. Textile artist and lecturer.
Studies MA, Fine Arts, Uni. of Georgia, USA 1984; M. Fine Arts, candidate, Uni. of
Indiana USA 1982; B. Fine Arts, Miami Uni. USA 1982; Lecturer, Uni. of Tas. 1985–87;
DDIAE 1987–89; Kelvin Grove, Brisbane CAE 1989 to present.
Exhibitions Numerous shows in USA and recently at Uni. of Tas. 1986; DDIAE 1988; Uni.
of Wollongong 1988; Tamworth Reg. Gallery 1988; The Centre Gallery, Gold Coast 1988;
Toowoomba Reg. Gallery 1989; Qld, Crafts Council 1989; BCAE Gallery 1989.
Awards VAB 1986; Uni. of Tas. 1989; AC Design Arts Board 1986; studied UK, Europe
1988. Has conducted many workshops.
Represented Corporate, institutional and private collections in UK, Europe, USA,
Australia.

EDWARDS, Helen NSW
Born Katoomba NSW 1940. Painter, sculptor, printmaker and teacher.
Studies With Ross Doig for four years; Workshop Art Centre 1972–75 and 1980–; Now working mainly with experimental silkscreen/collage; Member of Board of Directors of WAC, World Print Council, and Print Council of Australia.
Exhibitions Solo show at Printers Gallery, Sydney 1982; Sydney Legacy Gallery 1987; Participated at Hogarth Galleries 1972; Roseville and Parramatta Galleries 1981; Chapman Gallery; Blaxland Gallery; Craft Council and WAC 1982; Guest artist, artist at Print Circle Gallery 1983; Chapman Gallery, Canberra 1982, 86; Willoughby WAC 1985, 88; Casey Gallery 1988; Sydney Printmakers 1990.
Represented Private collections in Australia, USA, Japan and Europe.

EDWARDS, Katy QLD
Born Qld. Naive painter, no formal art training.
Exhibitions Solo show at Androsson Gallery, Brisbane 1987.
Represented Private collections in USA and Australia.

EDWARDS, Margery NEW YORK
Born Newcastle NSW 1933. Abstract painter in oil and mixed media.
Studies BA Nursing with Honours, Sydney 1956; Private art tuition, Sydney 1961–68 with Dora Jarret, Rodney Milgate, Desiderius Orban; Brera Academy of Art, Milan Italy 1969; Morley College of Art, London 1970; Travelled and lived in the USA, UK, East Africa, Italy and Australia; Resident in NY 1959–60 and since 1974.
Exhibitions One-woman show at Macquarie Galleries, Sydney 1972, 1974; Pater Gallery, Milan 1972, 1974; Rawspace Gallery, Soho, New York 1978; Group includes von Bertouch Galleries, Newcastle and Holdsworth Galleries, Sydney 1988; Auction 393, New York, September 1976, 1977; James Yu Gallery, New York June 1977; Wooster Gallery, New York 1983; Gallery Gabrielle Pizzi, Melb. 1989.
Represented Private collections in Australia, UK, Italy, New York, Washington, Connecticut USA.
Bibliography Appreciations in catalogues, *Galleria Pater*, via Borgonuovo 10, Milan, October 1972 and September 1974, Elwyn Lynn (in English); Women's Artistic Liberation, *Australian*, Saturday 23rd February 1974, Sandra McGrath; Fine exhibitions, *Sun* (Sydney), 27th February 1974, John Henshaw; *Avanti* 78/225, 5th October 1974, Delfino, E. Mostre d'arte a Milano (in Italian); New York, 'It's a Collage', *Quadrant* Vol 22, pages 33–38 and cover, August 1978, Margery Edwards, Sydney; *Art and Australia*, Vol 21 No 3.

EDWARDS, Marie (Shaw) TAS
Born Stanley, Tas. 1925. Painter and teacher.
Studies Hobart Technical College 1959–60; School of Art, Hobart under Jack Carington Smith and Dorothy Stoner 1961, 63–67; summer school with John Olsen, Tas. 1969; School of Art, TCAE, Hobart 1971–73; Taught with Tas. Education Dept. 1974–75; overseas study tours 1973–74, 1976, 1980.
Exhibitions Numerous shows since 1972 include Festival of Drawing MPAC, Vic. 1973; Art Society of Tas.1973, 74; Blue Gum Festival of Tas. TMAG 1973, 75; Albury Art Gallery, NSW 1974; Salamanca Place Gallery, Hobart 1977.
Bibliography *Tasmanian Artists of the 20th Century*, Sue Backhouse 1988.

EDWARDS, Pene QLD
Born Brisbane. Painter and teacher.
Studies Brisbane IA 1981–85; Dip. Fine Art (Painting) 1986. Taught at Brisbane IA 1988 and South Brisbane TAFE 1988–90.
Exhibitions Solo shows at RQAS 1988, 89; McWhirters Artspace 1991. Numerous group

shows since 1982.

Awards Scholarship for Painting 1984; RQAS Contemporary Prize 1988; Nolan & Dolan Acquisitive, Mackay 1988; RQAS 1990; Mackay WC 1990; Cleveland 1990; Yurara 1990. Involved in the Muir Park Building Mural.

EDWARDS, Ruth NSW
Born Port Macquarie 1937. Painter and teacher.
Exhibitions Kenwick Galleries, Beecroft NSW and Oxley Gallery Tamworth NSW.
Awards Macquarie Traditional 1980; Walcha 1982; Wauchope Rotary 1989.

EGLITIS, Anna (Bramley) QLD
Born Fiji 1931. Painter, printmaker, teacher. Arrived Australia 1936.
Studies ESTC — Diploma of Fine Arts 1949–53 under Douglas Dundas. Five years study in UK, Europe and Middle East. Lecturer in art Goulburn CAE 1973–75; tutor WEA and Marian College 1975–80. Instructor, Cairns College of TAFE for Associate Diploma of Art course for Aborigine and Torres Strait Islanders since 1983. Awarded PCA 100 x 100 Print Portfolio Commission 1988.
Exhibitions Solo shows at Divola Galleries, Sydney 1973, 74; Raffins Gallery, Orange, NSW 1975; Solander Gallery, ACT 1975; Goulburn CAE 1978. Numerous joint and group shows since 1973 and recently at 70 Arden St. Melb. 1988.
Represented Canberra CAE, Goulburn Regional Gallery, institutional and private collections in Australia and overseas.

EGUCHI, Kazoko VIC
Born Fukuoka, Japan 1946. Painter and glass designer.
Studies Graduated from Kyoto City University of Arts. Chief designer for the Yamamura Glass Company for sixteen years, arrived Australia 1987.
Exhibitions Extensively in Australia, Japan and Europe.
Bibliography *Alice 125*; Gryphon Gallery; University of Melbourne 1990.

EIRTH, Merrin VIC
Born Benalla, Vic, 1957. Painter, weaver, teacher.
Studies Kelvin Grove CAE 1974–77; Prahran CAE, Dip. Art & Design 1978–79; VCA, Postgraduate Diploma 1979–81; Weaver at Victorian Tapestry Workshop 1981–82; Tutor at VCA 1984–85; Worked UK, Europe, USA 1988; Tutor in painting at Victoria College, Prahran 1989–91.
Exhibitions Solo shows at 200 Gertrude St. Gallery 1986; Realities Gallery 1987, 89, 90; Has participated in many group shows since 1977 and recently at Monash University 1987; PS 1 Studios, New York 1988; 200 Gertrude St. 1989; Wangaratta Regional Art Gallery 1990; Deutscher Brunswick St. Gallery 1990; NGV and Westpac Gallery 1991; University of Tasmania 1991.
Awards VACB grant for Vence Studio, France 1986; VACB grant for PS 1 Studios, New York 1987; Designed and painted tram for Transit Authority, Melbourne 1987.
Represented NGV, institutional and private collections in UK, Europe, USA and Australia.

EINFIELD, Maadi NSW
Born Newcastle NSW 1923. Painter, printmaker and weaver.
Studies John Ogburn 1964; Desiderius Orban and Rodney Milgate 1965–75; Japanese woodcut techniques at University of NSW with Hatsui Matsurami, weaving and spinning with Jutta Feddersen, etching at Willoughby Workshop with Elizabeth Rooney and Jenni Pollak, summer schools in sculpture with Ron Robertson Swan, patchwork design with Peter Travis and weaving with Mona Hessing 1975–82.

Exhibitions One-woman shows at Wagner Gallery 1978, 1981, 1983; Manyung Gallery 1983; Qld Arts Council 1985; Print Workshop, Woollahra NSW 1987; Menzies Holiday Inn, Sydney 1988; Eaglehawke Gallery 1990. Participated in many important group shows since 1966, including Australian stand, International Book Fair, Israel 1983; Japan 1986; Pennsylvania USA 1987; Bnai Brith Centre Sydney 1988; Print Workshop 1987; Barcelona, Spain, Toronto, Canada and Princeton USA 1989, 90; MPAC 1990.

Represented Many institutional and private collections in Australia, USA, UK, Norway and Israel.

Bibliography *PCA Directory* 1988; *Artists & Galleries of Australia*, Max Germaine: Craftsman House 1990.

ELHAY, Evelyn SA

Born Alexandria, Egypt 1916, arrived in Australia 1949; Ceramic and bronze sculptures based mainly on the human figure; Abstract and semi-abstract with some surrealist influences.

Studies SA School of Art, life drawing, life modelling, sculpture and painting; Main teachers John Dowie, Paul Beadle, Jackie Hick and Dora Chapman; Has taught in summer schools organised by the Worker's Educational Association; Presently teaching privately and at the SA Studio Potter's Club; Fellow of the Royal SA Society of Arts since 1966; Is an active member of the Committee and Selection Committee of the SA Studio Potter's Club.

Exhibitions Solo shows at City Cross Crafts, Adelaide 1969; Habitat Gallery, Adelaide 1970; Aldgate Crafts, Aldgate SA 1972; Xmas show Realities, Toorak Vic 1973; Bonython Gallery, Adelaide 1979, 1981; Shared exhibitions at Festival Exhibition, Greenhill Gallery, Adelaide 1974; Holdsworth Gallery, Sydney 1980.

Represented Extensively in private collections in Australia, Europe and South America.

ELLIOTT, Judi NSW

Born Australia 1934. Ceramic artist, potter, teacher, glass worker.

Studies Apprenticed to potter, Peter Fergusson, Hornsby, 1956–57; Set up own workshop at Sunnydale, Bethungra in 1958 where she continued to work until 1979; During this period she attended numerous schools and workshops conducted by several minor potters; Part-time teacher Cootamundra Technical College; During this period she also conducted numerous workshops for the Arts Council of Australia (NSW Branch); Study tour of England, France and Germany and attended an International Pottery School at Taggs Yard, London 1977; Part-time lecturer at Newcastle College of Advanced Education and School of Art and Design, Dept of Technical and Further Education, Newcastle 1979; She completed her Postgraduate Diploma in Professional Art Studies at Alexander Mackie College of Advanced Education, Sydney in 1980; Lecturer at First National Ceramic Conference, Sydney University 1978; Guest lecturer Newcastle College of Advanced Education 1979; Guest lecturer Newcastle Region Art Gallery, 1980; Visiting artist, Goulburn CAE 1983; completed Assoc. Dip (Glass) — Canberra S of A 1985; attended Pilchuck International Glass School, Seattle USA 1988.

Exhibitions One-woman shows at Helen West Galleries, Young NSW 1971; Raffins Gallery, Orange NSW 1975, 1976; Anna Simons Gallery, ACT 1975; Beaver Galleries, ACT 1976; von Bertouch Galleries, Newcastle 1976, 1981; Her Majesty's Theatre, Sydney 1978; Clive Parry Galleries, Melbourne 1978; Prouds Gallery, Sydney 1978; Potters Society 1979; von Bertouch Galleries 1981; Devise Gallery 1985; Holdsworth Gallery 1987; Access Gallery 1988, 91; Craft Council, ACT 1988, Beaver Gallery, ACT 1990. Many group shows since 1971 and recently at Meat Market Art Centre, Melb. 1987, 88, 89 and Kanazawa, Japan 1988.

Awards Henry Lawson Festival, Rural Bank 1971; Lamson Paragon Ceramic Award, 1977; Wagga Wagga 1978; Les Blakebrough Award, Crafts Council of the Australian Capital Territory 1978. VAB Grant to Pilchuck School, Seattle, USA 1988; Excellence Prize, Craft

Exhibition, Japan 1988; Commonwealth Bank, Brisbane, glass panels 1989; Foyer Installation, State Superannuation Board, Sydney 1990.

Represented Shepparton Art Gallery; Newcastle Region Art Gallery; Arts Victoria 78; Crafts Festival Collection; Penata Collection; Rockhampton Art Gallery, Qld; Artbank; NGV; QAG; ANU; New Parliament House, ACT.

ELLIOTT, Lucinda QLD
Born Brighton UK 1965. Painter and printmaker.
Studies Brighton Polytechnic UK 1981–82; Dip. Fine Art Qld., College of Art 1984–86.
Exhibitions Interface Gallery, Brisbane 1987; The Centre Gallery, Gold Coast 1988; Myer Centre, Brisbane 1989; QAG 1989.
Awards Joint winner of Melville Hayson Memorial Art Scholarship 1989. Artist for Queensland Bicentennial Art Spaces Project 1987–88.

ELLIOTT, Roberta NSW
Born NSW 1940. Figurative and abstract painter, teacher.
Studies Hornsby College of TAFE, Honours Art Certificate 1980–85; Paddington Art School 1984–86; Willoughby Art Workshop 1984–85. Taught life drawing at Woollahra Studio 1986.
Exhibitions Solo shows at Robb Street Gallery, Bairnsdale, Vic 1988; Access Gallery, Sydney 1989, 90. Numerous group shows since 1984 and a number of commissions to paint large Australian theme landscapes for corporations and institutions.
Represented Institutional and private collections in Australia USA, Sweden and Artbank.

ELLIS, E.N. UK
Born Sydney 1946. Jeweller, designer, printmaker.
Studies National Art School, Sydney 1963–66; John Ogburn Studio 1963–69; John Cass College, London 1972–74; Simon Brett, wood engraving 1981, 83. Works in London and has produced the book jackets and illustrations for many books since 1982.
Exhibitions Oxford Gallery 1984; Spelmans, New York 1985; Garden Gallery, Kew UK 1986; Seasons Gallery, Sydney 1986; Godfrey and Twatt, Harrogate UK 1987; Duncan Campbell, London 1988; Macquarie Galleries, Sydney 1988; Participated at Royal Academy 1984–88; Society of Wood Engravers and the Royal Society of Painter-Etcher Engravers, London 1984–88.
Represented Victoria and Albert Museum, Institutional and private collections in UK, USA and Australia.

ELLIS, Heather VIC
Born Mt Eliza Vic 1937. Realist painter, ceramic artist and sculptor.
Studies Studied art at night and in spare time, mostly self-taught; Member of Wildlife Art Society of Australia; Vic Ceramics Group and the Crafts Council of Vic.
Exhibitions Adam Galleries, Melbourne 1978; Walker Gallery, Hawthorn 1982; Shows regularly with the WAS of Australia at the VAS Gallery and with the Vic Ceramics Group at Caulfield Art Centre; Stagg Fair, Gippsland 1981–83; Eltham College 1981–83; Wildlife Gallery, Sydney 1985.
Awards Stagg Craft Award 1983; High relief bronze at Lauriston Girls School, Melbourne.
Represented Institutional and private collections in Australia and overseas.

ELLYARD, Heather Shain VIC
Born Boston USA 1939. Painter, teacher, writer.
Studies Graduated Bachelor of Science, Simmons College, Boston Mass 1957–61; School of the Boston Museum of Fine Arts 1961–63; Arrived Australia 1970; Taught part-time at Canberra School of Art 1973 and Canberra Art Workshop 1974; Art Reviewer ABC Radio,

Canberra 1974–76; Lived in Papua New Guinea 1976–78; Moved to Adelaide 1980; Chairperson SA Visual Arts Committee 1986; Appointed to board of Commonwealth Artbank 1985; lecturer, part-time in painting, SA CAE 1986–87; Lecturer, Victoria College (Prahran Campus) 1990–.

Exhibitions Solo shows at Macquarie Galleries, Canberra 1974; Abraxas Gallery ACT 1977; Roundspace, Adelaide 1981, 82, 83; BMG Adelaide 1985, 87, 88. Many group shows since 1973 include ANG Canberra 1979; 'Anzart' Hobart 1983; AGSA 1985; SACAE 1987; Solo show at Painters Gallery, Sydney 1989; Participated at Luba Bilu Gallery 1990 and ACAF, Melbourne 1990.

Awards Canberra Day Art Prize 1973; Canberra Art Club Prize 1974. Commissions for mural at Sculpture Garden ACT 1975, and at SA Museum, Adelaide 1988.

Represented Artbank; AGSA; Parliament House, Canberra, institutional and private collections in Australia and overseas.

ELMS, Georgina QLD
Born Melb. Ceramic artist and sculptor.

Studies Kelvin Grove CAE, Brisbane — ADVA majoring in ceramics 1978–81.

Exhibitions the Waterford Shop, Sydney and Victor Mace Gallery Brisbane 1986; Blaxland Gallery, Sydney 1990; Numerous group shows include Qld Art Gallery 1982 and with Qld Craft Council to Tokyo, Japan 1985; Blaxland Galleries 1990.

Awards Westfield Art Prize 1977; Qld Potters' 1978; Stanthorpe 1982; Qld Day Art, Qld Craft Award; Ceramic Award, Toowoomba 1985; Alice Craft Acquisition; Qld Craft Award; Grant — Crafts Board 1986.

Represented QAG, Stanthorpe Art Gallery, Toowoomba City Council, Crafts Council of Northern Territory, Brisbane Grammar School.

ELVINS, Elizabeth Patricia NT
Born Geelong Vic. Sculptor and three-dimensional painter.

Studies Gordon Institute of Technology, Geelong and later at RMIT under George Bell; Based in Alice Springs NT, she is interested in animal forms, particularly cats which were a feature of her one-man sculpture show in 1975; Her largest sculpture to date *Lord of the Dance* which was a commission for the Catholic Church.

Exhibition Her well-known show of thirty dioramas depicting Aboriginal legends was opened in 1970.

ELVY, Lee NSW
Born NSW 1919. Traditional painter in oil and watercolour.

Studies Under Ross Davis, Guy Warren, Frederic Bates; Royal Art Society of NSW under Allan Hansen; Also American 'Famous School' 1966; Resides Nowra NSW and was foundation member of Shoalhaven Art Society in 1963. Conducts regular art teaching group at her studio and teaches part-time for TAFE, Nowra.

Exhibitions Numerous shows over the years and recently at Ellimatta Gallery, Sydney 1983; Balmain Galleries 1983.

Awards Has won many awards in local competitions including Nowra 1974; Braidwood; Shoalhaven Shire Purchase and Raymond Terrace 1975; Shoalhaven Shire 1976, 1978, 1982; Goulburn 1978; Portland and Broken Hill Purchases 1980; Peter Stuyvesant-Shoalhaven Prize 1981; Nowra 1982; Shoalhaven Ceramics 1983.

Represented Municipal institutional and private collections around Australia and overseas.

ELY, Bonita VIC
Born Mildura Vic 1946. Sculptor, painter, teacher.

Studies Caulfield Technical College Painting 1965–66; Prahran School of Art Sculpture 1968–69; Graduated Diploma of Fine Arts (sculpture) later MA Fine Arts; Study tour of

Europe, UK, North Africa 1970–73 and New York 1973–75; St Martins Art School, London (part-time) 1970–71; Travelled and worked in Europe and USA 1981–82; Received special projects grants in 1977, 1978 from the Visual Arts Board for development of the Mount Feathertop Project; From August 1977 was part-time co-ordinator of a Schools Commission Innovations Programme Grant, the 'Women's Art Register Extension Project' involving research about women artists past and present for use in schools; In 1978 participated in the 'Artists in Schools' Programme funded jointly by the Community Arts Board, Visual Arts Board and Literature Board of the Australia Council.

Exhibitions Solo shows at West Street Gallery, Sydney 1979; Art Projects, Melb. 1979, 81; IMA Brisbane 1981; Adelaide Festival Centre 1982; Artspace, Sydney 1983; Performance Space, Sydney 1985; First Draft, Sydney 1986; Aust. Centre for Contemporary Art, Melb. 1988. A host of group shows since 1976 include Mildura Sculpture Triennial 1978; Nat. Gallery of Vic. 1980; 1st Australian Sculpture Triennial, Melb. 1981; Anzart NZ 1981; *Continuum*, Tokyo 1983; Charlottenberg Museum, Copenhagen 1985; *Perspecta 85*, AGNSW; Artspace, Sydney 1987.

Awards Henri Worland Memorial Prize 1979; Literature Grant Vic. Ministry for the Arts 1981; Kiffy Rubbo Memorial Award 1985.

Represented ANG Canberra, AGNSW, Uni. of NSW, Warrnambool Art Gallery, institutional and private collections in Australia and overseas.

Publication *A Profile of Australian Women Sculptors 1860–1960*, Anna Havana and Bonita Ely; *Murray-Murundi*, Experimental Art Foundation Project, Adelaide 1980; *Memoirs of a Dogwoman* 1986.

Bibliography *Australian Sculptors*, Ken Scarlett, Nelson 1980; *Catalogue Australian Perspecta* 1981, Art Gallery of NSW; *Australian Contemporary Drawing*, Arthur McIntyre: Boolarong Publications 1988; *Artists & Galleries of Australia*, Max Germaine: Craftsman House 1990.

ENDELMANIS, Vita TAS

Born Cesis Latvia 1933. Painter in acrylic, collage; Portraitist.

Studies Graduate, Austin Hospital Nurses's School, Melbourne Tas School of Arts (Fine Arts), Launceston and Devonport Technical College 1957–60, 63, 65. Overseas study tours to UK, Europe, USA, NZ 1960, 74, 75, 76, 77, 80, 82.

Exhibitions Held thirty two solo shows 1974–88 including Town Gallery, Brisbane 1977, 79, 81, 83, 85; Solander Gallery, Canberra 1978, 79; Royal Netherlands Embassy, Canberra 1982; von Bertouch Galleries, Newcastle 1975, 81; Devonport Gallery and Art Centre, Survey 1975–85; Freeman Gallery, Hobart 1987. Numerous group shows 1975–88.

Awards Lismore Art Gallery Prize Purchase 1978; Gold Coast City Art Prize Purchase 1980; Tasmanian Art Prize 1980; Alice Prize 1982; Stanthorpe Art Prize 1984.

Represented Queen Victoria Museum and Art Gallery, Tas; Burnie Art Gallery, Tas; Australian National University, Canberra and many institutional and private collections in Australia and overseas.

Bibliography *Ethnic Art Directory*, Australia Council, Community Arts Board 1981; *Latvian Artists in Australia*, Society of Latvian Artists 1980; *Artists & Galleries of Australia*, Max Germaine: Craftsman House 1990.

ENGELMAN, Joyce (Joy) NSW

Born Orange NSW 1949. Painter in oil and watercolour, paper worker.

Studies Orange Technical College 1958–65; Completed workshops with Frederic Bates and Adrian Brand 1981; Study tours of Central Australia, most areas during past ten years; Associate Diploma C.A. Mitchell CAE 1982–84.

Exhibitions Has held numerous solo shows in Bathurst, Orange and Wentworth Falls since 1980 and recently at Beaver Galleries Canberra 1989 and Holdsworth Galleries, Sydney 1989, 91; Coach House Gallery, Molong NSW 1990.

Awards Has won 14 Prizes at NSW country art shows since 1981.

Represented Private collections in Australia and overseas.

ENGLISH, Gail NSW
Born Sydney. Painter, printmaker, designer.
Studies ESTC 1958–61 and 1980 (p.t.) Studied and worked UK, Europe 1961–62; USA
1963–64; 65–66; Europe 1975.
Exhibitions Solo shows at Blaxland Galleries 1986, 87, 88, 90; Participated Strokes Print
Gallery 1982; Bridge St. Gallery 1984.
Commissions Sydney International Airport, VIP Lounge 1989.
Represented Institutional and private collections in UK, Europe, USA, Australia.

ENGLUND, Patricia NSW
Born NSW. Painter, potter, teacher; married to Ivan Englund.
Studies Julian Ashton School, former teacher at Wollongong TC; exhibits with her hus-
band.
Represented NGV; AGWA; institutional and private collections.
Bibliography *Australian Watercolour Painters*; Jean Campbell; Craftsman House 1989.

ERLICH, Esther VIC
Born Melbourne 1955. Painter, portraitist, illustrator, designer.
Studies Dip. Fine Art, Chisholm IT, Melbourne; Dip Ed. Victoria College (Painting &
Sculpture).
Awards Finalist, Doug Moran National Portrait Prize 1990.

ERNS, Ingrida SA
Born Russia 1919. Traditional painter in oil.
Studies Under Professors Z. Bilensteins and J.R. Tulbergs; Admitted to Berufsverband
Bildener Kunstler Society, Bavaria in 1945; Joined Adelaide Royal Art Society as associate
and later as a Fellow and served as council member for many years.
Exhibitions One-man shows at Miller Anderson Gallery, Adelaide 1969, 1973; Newton
Gallery, Adelaide 1974; White Studio 1975; Participates in the Royal Art Society and
Latvian annual exhibitions and the Contemporary Art Society. (Died 1989).

ESHRAGHI, Farimah (Ahdieh) VIC
Born Teheran, Iran. Painter, portraitist, lecturer. Arrived Australia 1987.
Studies Fine Arts College of Teheran 1968; University of Teheran, Fine Arts 1969; Fine
Arts Academy of Bologna 1972; University of Bologna 1974.
Exhibitions Solo shows since coming to Australia at Dandenong Art Centre, Vic 1989;
Doncaster Art Gallery 1989; Many group shows in Europe since 1973.
Represented Religious, municipal, institutional and private collections in Europe, South
America, USA and Australia.

EVANS, Gaye NSW
Born Sydney 1943. Sculptor, teacher.
Studies North Sydney TC with Bim Hilder 1970; Brookvale TC 1975; study tour to USA
1985; teaching at Ku-ring-gai Art Centre 1985–88; member, Sculptors Society, Sydney.
Exhibitions Sculptors Society 1978; own studio 1982; Centre Art Space, Chatswood 1983;
Woollahra Galleries 1984; Old Bakery Gallery 1985; Holdsworth Gallery 1986.
Commissions Channel 9 Business Sunday 1986; Sculpture Park, Gosford 1987; Ku-ring-
gai Bi-Centenary Park 1987, 88. Wisemans Ferry Sculpture 1988.
Represented Corporate institutional and private collections in UK and Australia.

EVANS, Joyce VIC

Born Melbourne 1929. Photographer, gallery director, teacher.

Studies University of Melbourne Dip. Social Studies 1965; BA (Fine Arts) 1972. Founder, director of Church Street Photographic Centre, Richmond Vic. 1976–82; Consultant to Deakin University 1986–87; Dept. of Aboriginal Affairs, Canberra 1987. Member Australian Institute of Professional Photographers.

Exhibitions Realities Gallery 1986; City of Waverley 1986; State Bank Centre, Melbourne 1990; Eltham Wiregrass Gallery 1990.

Awards Hasselblad Masters 1985; Print of the Year 1985.

Represented Institutional and private collections in Australia and overseas.

Bibliography *Who's Who of Australian Women* 1982.

EVANS, Kathleen Mae NSW

Born Bathurst NSW 1951. Traditional landscape painter, and sculptor.

Studies Under Dough Sealy in 1970s Hawkesbury Community Workshop with Kevin Oxley 1979. Sculpture under Frederic Chepeaux 1980. President, Macquarie Towns Arts Society 1986–87. Co-director of Windsor Attic Gallery.

Exhibitions Solo shows at Palette and Brush Gallery, Darwin 1973–74; Hesley Gallery, Orange 1974; Fine Art Gallery, Willoughby 1976. Numerous group shows.

Awards Bathurst 1977, 79, 84; Windsor Council Purchase 1979; Hawkesbury Show 1984.

Represented N.T. Museum and Art Gallery, Darwin and institutional and private collections in Australia and Overseas.

EVANS, Sally UK

Born Warwick Qld 1956. Painter in watercolour and interior designer in contemporary impressionistic style.

Studies Darling Downs Institute of Advanced Education, Toowoomba Qld; Private tuition for three years with Rex Backhouse-Smith 1976–79 and Inchbold School of Design, London1979.

Exhibitions Solo shows at Creative 92 Gallery, Toowoomba 1976, 1978, 1981; Peter Lewis Gallery, Taringa Qld 1976–77; Inverell Gallery, NSW 1979; Qld House, London 1980 and joint show at Spring Hill Gallery, Brisbane 1983.

Represented Qld House, London and in private collections in UK and Australia.

EVERINGHAM, Judy Ann NSW

Born Sydney NSW 1929. Traditional and experimental painter in oil, acrylic, watercolour, mostly landscapes and still-life.

Studies East Sydney Technical College 1947–50 under Joy Ewart, G.K. Townshend and Professor Maximilian Feuerring; Exhibiting member of Royal Art Society of NSW, Ku-ring-gai Art Society and Berrima District Art Society NSW; Paints on commission, seldom exhibits.

Represented Private collections in Australia and overseas.

EWERT, Christine VIC

Born Melb. 1957. Painter and musician.

Studies Degree, Fine Art, RMIT 1977–80, Grad. Dip. 1981. Worked in UK 1983–84.

Exhibitions Drummond St. Gallery 1982; Powell St. Gallery 1985, 87; included in Young Australians Touring Show 1987–90.

Represented ANG; Artbank; New Parliament House, Canberra.

EWING, Jennifer NSW

Born NSW 1938. Printmaker.

Studies Gymea College of TAFE; ESTC. Exhibits with Southern Printmakers.

Awards Southern Cross 1981, 82.
Bibliography *PCA Directory* 1988.

EYERS, Adele NSW
Born Sydney 1935. Painter and teacher.
Studies With private tutors. Member, CCAS and Hornsby Art Society.
Exhibitions Numerous solo shows since 1979 include Saints Gallery, Sydney 1985, 86;
Avoca Beach Gallery 1989.
Awards Mangrove Mountain 1979, 80; Central Coast Art Society 1985; Umina Rotary
1985; Singleton Drawing 1989; Cessnock Open 1989.
Represented Institutional and private collections in UK, Japan, USA, NZ, Australia.

F

FAERBER, Ruth NSW
Born Sydney NSW 1922. Painter, printmaker, paperworker, sculptor.
Studies Workshop Art Centre, Willoughby NSW, the Pratt Centre for Contemporary
Printmaking, NY; National Art School and Orban Studio, Sydney; Sydney University Fine
Arts; Pyramind Workshop, Washington USA. Participated International Art Critics
Convention, France 1982 and International Paper Congress, Kyoto Japan 1983; Part-time
teacher painting, drawing and printmaking and art critic Australian Jewish Times
1969–80.
Exhibitions Held 27 solo shows in Sydney, Melbourne, Canberra, Adelaide, New Zealand
and London 1964–86; Participated in many group shows over same period including
International Print Biennales, Bradford UK 1968, 1982; Australian Paperworks IPC '83,
Kyoto Japan; Paper and Paperworks, Wenniger Graphics, Boston USA 1983. Paperchase
Exhibition, Christchurch NZ 1984; Hobart School of Art 1984; New Papers Exhibition,
Devonport and Burnie, Tas 1985; First International Paper Biennale, Duren, West Germany
1986; Paper Conference Hobart 1987; Craft Council Travelling Show 1988; 70 Arden St.
Melb. 1988; BMG, Sydney 1989.
Awards: 1967: Scholarship, Pratt Centre, NY 1974: Commission, PCA Member Print
Edition (60). 1975: Exhibition Grant, VAB Australia Council. 1981: Travel Grant VAB;
Freight Grant, Qantas. 1983: Travel Grant, Aust-Japan Foundation. 1972–84: 23 painting
awards, 20 graphic awards. PCA 100 x 100 Print Portfolio 1988. Artist-in-Residence,
Bezalel Art Institute, Jerusalem 1987; Warringah Art Competition 1988; Invited Tutor —
Pyramid Paper Workshop; Washington DC. Australian representative art symposium and
exhibition — 'Use of Paper as Art Medium', Sweden. 2nd Prize Kulturakedemien
Harnosand, Sweden 1989; Japan and Mexico 1990.
Represented State Galleries of NSW, Vic, Qld, Sth Aust, Tas.: Queen Victoria Museum &
Art Gallery, Launceston; Print Council of Australia; Dept. of Education, Victoria; BHP;
Transfield; Artbank; Power Gallery, Sydney; Christchurch City Gallery, NZ; Thyssen-
Bornemisza International Collection; CBS Television, Los Angeles, USA; Leopold-Hoesch
Museum, Duren, West Germany.
Bibliography *PCA Directory* 1988; International *Who's Who in Art & Antiques*: Cambridge
UK; *Artists & Galleries of Australia*, Max Germaine: Craftsman House 1990.

FAIRSKYE, Merilyn NSW
Born Melbourne Vic 1950. Painter, photographer, muralist, installation artist and teacher.
Studies Diploma of Art at National Art School and Alexander Mackie CAE, Sydney

1970–75; Tutor at art workship, University of Sydney 1979–83 and part-time teacher at East Sydney Technical College.

Exhibitions Solo shows at AVAGO Gallery, Sydney 1980; Uni. of Sydney Art Workshop 1981, Filmmakers Cinema, Sydney 1982; Union Street Gallery, Sydney 1985; Roslyn Oxley9 Gallery Sydney 1985, 87, 88, 89, 91; Institute of Modern Art, Brisbane 1987; Chameleon Gallery, Hobart 1987; The Performance Space, Sydney 1987; ACCA Melb. 1987; group shows include Young Painters at Macquarie Galleries, Sydney 1976; Slide performance at Japan-Australia Centre 1981; 'Sexual Imagery in Art' Tas; School of Art Gallery, Hobart; 'The Easter Show' Filmmakers Cinema, Darlinghurst; Woolloomooloo Mural Project with Michiel Dolk, *Australian Perspecta* 1981 and 1985; ANZART, NZ 1985; *Trois Australiens,* Cité Internationale des Arts, Paris; *Inscriptions of Desire,* Studio 666, Paris; *Exposition Collectif,* Cité Internationale des Arts, Paris; *Kino Kapers: Contemporary Film by Australian Artists,* Australian National Gallery, ACT 1986; 'Chaos', Rolsyn Oxley9; Broken Hill Gallery; NGV; Praxis, Fremantle; Monash Uni.; Riddoch Gallery, Mt Gambier; CAC, Adelaide 1987; MOCA, Brisbane 1988.

Commissions Many murals with Michiel Dolk around Sydney 1979–84.

Awards Power Studio — Cité Internationale des Arts, Paris 1985; PSI Studio, New York — VAB Grant 1989–90.

Represented ANG, NGV, institutional and private collections in UK, Europe, USA, Australia.

Bibliography *Catalogue of Australian Perspecta* 1985, Art Gallery of NSW; *Artists & Galleries of Australia*, Max Germaine: Craftsman House 1990.

FARDOE, Linda WA
Born South London, UK. Painter and teacher.

Studies Wimbledon School of Art, UK 1964–66; Rheims, France 1967–68; Whitelands College, Putney, UK 1972–75; Dip. Fine Art, Claremont School of Art, WA 1983–84; Has taught part-time at Claremont School of Art and Perth TC.

Exhibitions Solo shows at Athene Gallery, Perth 1985; FTI, Fremantle 1987; Undercroft Gallery, University of WA 1989; Spiral Gallery, Fremantle 1990. Many group shows in UK and WA.

Represented Institutional and private collections in UK, Europe and Australia.

FARGHER, Barbara SA
Born South Kirkby UK 1932. Painter, stage designer and teacher.

Studies Bath Academy of Art, Corsham UK 1951–54; Teaching and designing in Sussex and Yorkshire before coming to Australia with her husband 1954–58, and on arrival set up her own workshop in SA; Study tour to UK, Europe 1981.

Exhibitions First one-woman show at Kensington Gallery 1982; Participated at Adelaide Fine Art and Graphics and Gallery de Graphic 1979; Showed at own workshop after 1981 overseas tour.

Represented Private collections in UK, Europe and Australia.

Bibliography *Australian Watercolour Painters*: Jean Campbell: Craftsman House 1989.

FARLY, Margaret NSW
Born NSW. Painter.

Studies Bachelor of Arts Fine Arts from Sydney University; Design and colour under Phyllis Shillito; A year of Postgraduate studies at St Martins School of Art, London UK.

Exhibitions First major one-woman show at Holdsworth Galleries, Sydney 1981.

Represented Institutional and private collections in UK and Australia.

FARMAN, Nola WA
Born 1939. Painter and teacher.

Studies Part-time at Perth Technical College 1959–61; Graduate in Fine Arts from College of Art, Ontario Canada 1962–66; Tutored in Sculpture and Drawing at Perth Technical College; Albany and University of WA Summer Schools 1967; Tutored in Sculpture at WAIT 1968; Part-time tutor at Perth Technical 1970–73 and at Fremantle Technical 1974; Part-time lecturing at WAIT 1978–82; Part-time tutoring at Balcatta High School Arts Access Workshops in various country centres 1980; Currently part-time tutoring Claremont Technical, Perth Technical, Kalamunda High School and WAIT; Invited to de Summer Schools at the University of WA and Esperance 1984.

Exhibitions One-woman shows at Old Fire Station Gallery, Perth 1971; Collectors Gallery, Perth 1977; Undercroft Gallery; University of WA 1978; Gallery 52 1980; Numerous group shows since 1968 and recently Queen Elizabeth Medical Centre 1978; Undercroft, WA Painters 1981; Galerie Dusseldorf Women's Show 1981; Praxis Gallery Women's Show 1981; Fremantle Art Gallery.

Represented VAB Collection; Crown Law Department; WAIT; University of WA; Claremont Teachers College; Art Gallery of WA; SGIO.

Bibliography *Contemporary Western Australian Painters and Printmakers,* Fremantle Arts Centre Press 1979.

FAULKNER, Alison NSW
Born Narrandera NSW 1918. Painter, mostly watercolour and teacher.
Studies Diploma student at East Sydney Technical College and with G.K. Townshend for 15 years. Worked in commercial art for some years; Fellow and past teacher at RAS of NSW and member of Bega Art Society.
Awards Caltex Prizes 1967, 1973, 1977; Royal Easter Show WC 1973; Fishers Ghost WC 1969, 1973; Castle Hill WC 1975.
Represented Municipal Collections at Cooma, Maitland, Tamworth and private collections.

FAULKNER, Claire VIC
Born Scone NSW. Painter, printmaker, teacher.
Studies Warrnambool IAE, Vic.
Exhibitions Solo shows at Splash Studios, Warrnambool 1989; Otway House Warrnambool 1989; Warrnambool Reg Gallery 1990. Group shows include Splash Studios 1988, 89; ROAR Studios, Melb. 1988, 89; Artery Gallery, Geelong 1989; Womens Gallery, Melb. 1989.

FAULKNER, Sarah VIC
Born Hobart 1959. Painter.
Studies RMIT 1977–78; Prahran CAE, Melb. 1980–81; Dip. Art and Design; Founding member of ROAR Studios 1982; Overseas study and travel, UK, Europe 1979, 83, 88; USA, South America 1988. Artist-in-Residence, Glenmorgan Boys Grammar School, Melbourne 1986.
Exhibitions Solo shows at Realities Gallery 1986, 88; Australian Galleries, Melbourne 1990; Included in *A New Generation 1983–88* at the Aust. National Gallery, Canberra 1988. Solo at Australian Galleries, Melb. 1990.
Awards VAB Grant for Greene St. Studio, New York, USA 1984; ANG, Canberra; Murals in restaurant 1986; Victoria Racing Club, commissioned painting 1989.
Represented NGV; ANG; Admiralty House, Sydney; Institutional and private collections around Australia.

FEDDERSEN, Jutta NSW
Born Germany, arrived Australia 1957. Weaver.
Studies Worked for Sturt Craft Workshops, Mittagong NSW; Teaching part-time at the

National Gallery Art School and Alexander Mackie College, Sydney 1962–67, 1977–80; Hunter IHE 1980. Gained her MA (Visual Arts) from CAI 1988; Since 1981 has been Lecturer/Co-ordinator in Studio Area Fibre Art Textiles in the Dept. of Fine Arts, School of Visual and Performing Art.

Exhibitions One-woman shows at Hungry Horse Gallery, Sydney 1967; Johnstone Gallery, Brisbane 1968; Bonython Gallery, Sydney 1970, 1972, 1975; Realities Gallery, Melbourne 1971, 1974, 1977; Victor Mace Gallery, Brisbane 1978; Group shows at World Craft Exhibition, Stuttgart Germany 1969; Art Gallery of NSW Travelling Exhibition 1971; Art Gallery of SA Wool Exhibition 1972; First German Tapestry Exhibition, Munich Germany 1978; Third Textile Triennale, Lodz Poland; Realities Gallery, Melbourne 1981; Linz Austria 1981; Roslyn Oxley, Sydney 1983; New England Reg. Gallery 1989; Coventry Gallery, Sydney 1989.

Awards Warringah Art Prize 1978; Diamond Valley 1981; Craft Board Grant 1982; VAB Grant of studio in Italy for three months 1982; Travelled and lectured in Japan, September 1982.

Commissions Sebel Town House Hotel, Sydney 1970; ANZ Bank, Darwin 1971; Casino, Hobart 1972; Sydney Opera House (Tapestry) 1973; Leonda Entertainment Centre and Doncaster Hotel, Melbourne 1974; Library, Sydney University 1975, Sydney North Shore Hospital and American Embassy, Canberra 1976; Century House and Export House, Sydney 1978; Wall hangings, Westmead Hospital 1980.

Represented National Gallery of Vic; Art Gallery of WA, McClelland Gallery, Vic; Ballarat Gallery, Vic; Carnation Milk Head Office, Chicago USA; Private collections in Australia, Germany and Poland; Qld Art Gallery.

Bibliography *Art and Australia,* Vol 11/3; *Sydney Opera House, the Works of Art,* Daniel Thomas; *Artists & Galleries of Australia*, Max Germaine: Craftsman House 1990.

FEHRING, Hilda SA
Born Eudunda SA 1920. Impressionist painter in oil.
Studies School of Arts and Crafts SA; Fellow of Royal SA Society of Arts.
Exhibitions Hahndorf Academy, Newton Gallery and Lidums Gallery, SA; Emerald Gallery, Vic.
Represented Paintings acquired by the late Sir Claude Hotchin for Perth Hospitals, University and Council Chambers; Also by Beneficial Finance Corp for their Tokyo and Singapore offices.

FELS, Carolyn VIC
Born Melb. 1941. Painter.
Studies Nat. Gallery School 1959–60; George Bell School 1961–62; BA, Uni. of Melb. 1979; B. Fine Arts, VCA 1986, Grad. Dip. 1987–88.
Exhibitions Solo shows at 13 Verity St. 1988; Coventry Gallery, Sydney 1989; participated in *A New Generation 1983–88*, ANG, Canberra 1988; The Centre Gallery, Gold Coast, Qld 1988; RMIT Gallery 1988; Uni. of Melb. Gallery 1989; Coventry Gallery, Sydney 1989; 13 Verity St. Gallery, Melbourne 1990.
Represented ANG, corporate and private collections in UK, Europe, USA, Australia.

FENELON, Annette VIC
Born Eire (Irish Republic). Painter and photographer.
Exhibitions With Jeannette Blonski, the A/A/A/ Show at National Gallery of Vic 1982.
Bibliography *Apt/Appropriate/Appropriations*, Lip Issue No. 7, 1982–83.

FENTON, Marny SA
Born Ararat, Vic. 1944. Painter, sculptor, teacher.
Studies Cordon IT 1960–62; West Dean College, Sussex UK 1989. Founding President of

Clunes Museum, Arts & History Centre, Vic. 1975–78; Teacher at TAFE Colleges, SA.

Exhibitions Solo shows at Clunes Town Hall 1974; Ballarat National Theatre 1975; Naracoorte Regional Gallery 1987, 91; Keith Institute Gallery 1985, 91. Numerous group shows.

Represented Institutional and private collections in UK and Australia.

FERGUSON, Anne NSW

Born Broken Hill NSW 1939. Semi-representational and abstract painter in pencil, ink and chalk, mostly landscapes; Sculptor.

Studies Julian Ashton School and CIG Welding Institute 1958–59; East Sydney Technical College 1967–70; Studied under Bim Hilder, formerly vice-president of Society of Sculptors; Overseas study tours 1965, 1970, 1973, 1976.

Exhibitions Solo shows at Bloomfield Galleries, Sydney 1984, 86; University of Wollongong 1988. Numerous group shows since 1976 include Irving Sculpture Gallery and Gallery A, Sydney 1982, 83; 2nd Aust. Sculpture Triennial, Melb. 1984; Crafts Centre, Sydney 1985; Adelaide Festival of Arts 1986; 3rd Australian Sculpture Triennial 1987; Mildura Sculpture Triennial 1988.

Awards Australian Artists Studio, Besozzo, Italy 1987.

Commissions Lindsay Robertson Memorial, Mosman, Sydney 1977; Steel and glass sculpture, Macquarie University, Sydney; David Jones Fashion Awards Musical Sculptures, Sydney 1978; Australian representative — Hagi International Sculpture Symposium, Hagi, Japan 1981; Yaddo Fellow, Saratoga Springs, USA 1983; Logo in cast bronze for the Children's Medical Research Foundation, Children's Hospital, Sydney 1985; Bronze gates for St. Peter's Church, Mosman, Sydney 1987; Marble finials for the staircases at Parliament House, Canberra, ACT; Black granite carving (in conjunction with sculptor Peter Corlett) for The Returned Soldier's League Memorial, Parliament House, Canberra, ACT 1988.

Represented University of NSW, Sydney, NSW; Macquarie University, Sydney, NSW; Pharmacia (NSW); Esso Australia; Brisbane City Hall Art Gallery and Museum, Brisbane, Qld; Parliament House, Canberra, ACT; Hagi Park, Hagi, Japan; Yaddo Fellow, USA; National Museum of Women in the Arts, Washington DC.

Bibliography *Art and Australia,* Vol.19, No.4 Winter 1982 'A Park Out of a Symposium', Anne Ferguson, pp.434–437 (illus.); *Artists & Galleries of Australia*, Max Germaine: Craftsman House 1990.

FERGUSON, Anne NSW

Born Maitland NSW 1959. Printmaker.

Studies B.Ed. Fine Art, Newcastle CAE 1977–81. Participated numerous group print shows.

Bibliography *PCA Directory* 1988.

FERGUSON, Marylyn NSW

Born Cooma NSW. Designer and painter in oil and watercolour.

Studies East Sydney Technical College 1956–57 under John Passmore and Peter Lavery; With Professor Bissietta, Sydney 1958–59; England and Scotland 1963–68.

Exhibitions Solo shows at Cooks Hill Galleries, Newcastle and in group shows in UK and Australia.

Represented Corporate and private collections in UK and Australia.

FERGUSON, Vivienne NSW

Born Sydney 1962. Painter.

Studies ESTC 1986–88.

Exhibitions Solo shows at King St. Gallery 1989; King St. on Buton Gallery 1991. Numerous group shows.

Awards Finalist, Capita Fine Art Grant 1988.
Represented Institutional and private collections.

FERMO, Suzanne (Samantha) QLD
Born N. Qld 1966. Painter of the underwater world of The Great Barrier Reef, Q.
Studies QCA hons. graduate 1986.
Exhibitions Solo shows at The Upstairs Gallery Cairns 1988 and Hang Ups Gallery, Bris. 1988. Numerous group shows include 'Public Imagery', Community Arts Centre, Brisbane 1987.
Represented Institutional and private collections in Australia, USA, Europe and Japan.

FERRAN, Anne NSW
Born Sydney 1949. Photography and installations.
Studies University of Sydney, Mitchell CAE, SCOTA gaining BA. Dip. Ed., BA (Visual Arts), PG Dip. (Visual Arts).
Exhibitions Solo shows at Performance Space, Sydney 1984, 86; ACCA, Melbourne 1987; Cité Internationale des Arts, Paris 1988; ACP, Sydney 1989; Street Level, Penrith 1989; Mori Gallery 1991. Numerous group shows include *Australian Perspecta* 1985; Developed Image, Adelaide 1986; First Draft, Sydney 1987; Australian Regional Galleries 1987; ANG 1988.
Awards VAB Grant 1985, 86; SCOTA Scholarship 1986; Power Studio, Paris 1987–88.
Represented Institutional and private collections in UK, Europe and Australia.

FERRIE, Cathie SA
Born New Zealand 1912. Contemporary painter and printmaker.
Studies National Art School Sydney 1934–35; Adelaide School of Fine Arts 1956–57; Julian Ashton School, Sydney and Desiderius Orban 1958–61; Foundation member of the Workshop Art Group, Willoughby where she studied with Joy Ewart, James Sharp and Sue Buckley.
Exhibitions One-woman show at Workshop Arts Centre 1968; Fullerton Park Community Centre Gallery 1978; Participated at WAC 1965; PCA 1969, 1971; Sydney Print Circle 1972–75; CAS Sydney and Adelaide 1976–83; RSASA from 1976; Adelaide Festival 1971, 1978.
Represented Warrnambool City Art Gallery, Vic and private collections.

FERRIER, Virginia QLD
Born Brisbane 1927. Painter mostly still life, photographer.
Studies Privately with Jon Molvig, Mervyn Moriarty. Irene Amos and BA, Uni. of Qld.
Exhibitions Solo shows at Victor Mace Fine Art 1985, 87, 89; Participated Painters Gallery, Sydney 1985; von Bertouch Galleries, Newcastle 1986; Stanthorpe Gallery 1988; Centre Gallery 1988.
Represented Institutional and private collections around Australia.

FERRIS, Judith SA
Born Adelaide 1957. Painter and teacher.
Studies Ruth Tuck Art School 1970–74; SASA 1975–79; Has taught at Ruth Tuck School since 1979.
Exhibitions Solo shows at 'Yarabee', Adelaide 1989, 91 and Kensington Gallery 1987. Numerous group shows include Kensington Gallery 1984, 87; Greenhill Galleries 1984, 86, 91; Festival Theatre Gallery 1987.
Represented Private collections in UK, Hong Kong, Australia.

FERSCH, Hellen VIC
Born Hamilton Vic. Painter.
Studies Margaret Dredge CAE 1977; Robin Schubert 1982–85; Merv Moriarty 1986.
Member CAS Vic. and Aust. Guild of Realist Artists.
Exhibitions CAS Gallery, Melb. 1985–86.
Represented Private collections in Australia, UK, Europe.

FIELD, Carmen Cazneaux NSW
Born Sydney NSW. Painter and printmaker.
Studies East Sydney Technical College 1929–32; Also with Dattilo Rubbo; Printmaking
with Sue Buckley at WAC, Willoughby NSW.
Exhibitions Joint showing, Brisbane 1979, also shows with *Print Circle, Sydney Printmakers*
and *Eight Graphic Artists.*
Represented Parliament House, Sydney and private collections in Australia and overseas.
Bibliography *Directory of Australian Printmakers* 1982.

FIELD, Jacqueline NSW
Born Sydney. Painter, sculptor.
Studies Uni. of NSW 1973; Nat. Art School, Canberra 1974–75; Alexander Mackie CAE,
Dip. Sculpture 1976–77, Dip. Visual Arts 1980–81.
Exhibitions Solo shows at Barry Stern Galleries 1980, 88, 89; joint show with Leonard
Matkevich 1989.
Represented Institutional and private collections in Australia and overseas.

FIELDING, Keely NSW
Born Sydney NSW 1967. Expressionist painter.
Studies Gymea Technical College 1986–87. Completed BA (Visual Arts) City Art Institute
1988.
Exhibitions Participated Arthaus 1987, 88; Ivan Dougherty 1989; BMG Adelaide and
Sydney 1989, 90.
Bibliography *New Art Four*: Craftsman House 1990.

FILIPPINI, Gabriella NSW
Born Florence, Italy. Sculptor and painter.
Studies Dip. Painting-Scuola D'Arte Di Porta Romana, Florence 1958–60; Scuola Del
Nudo — Accademia Di Belle Arti, Florence 1971. Studied sculpture and ceramics at ESTC
1981–83.
Exhibitions Solo shows at Chevron Hotel, Sydney 1975 (paintings); Irving Sculpture
Gallery 1985; Holdsworth Contemporary Galleries 1987. Numerous group shows include
Mildura Sculpture Triennials 1985, 88; WAC, Sydney 1987–88; Robb St. Gallery,
Bairnsdale Vic. 1988. Participated in many painting shows in Italy 1964–74.
Represented Artbank, institutional and private collections in Italy and Australia.

FILMER, Daphne B. SA
Born Lobethal SA 1924. Realist painter of landscapes in oil, acrylic and watercolour; Has
studied with WEA Country tutors.
Exhibitions With RSASA and Keith Art Group.
Awards Tintinara SA.
Represented Private collections in Australia and overseas.

FINCH, Helen USA
Born Sydney NSW. Painter and sculptor.
Studies Corcoran Gallery, Washington DC.

Exhibitions International Arts Exposition, Washington 1979; Holdsworth Gallery, Sydney 1980, 85.

FINEY, Mitzi NSW
Born Manly NSW 1930. Sculptor.
Studies National Art School Sydney, graduated Dip Sculpture 1952–57; Teaching artist, Workshop Arts Centre, Willoughby NSW; Sculpture, Mosaics, Design, Form Awareness, Musical Graphics 1962–73; Graduated History Music, Conservatorium Music, Sydney 1969–71; Cello study, Conservatorium Music, Sydney 1965–72; Lecturer 2-D, 3-D Design, Musical Graphics, College of Art, Brisbane 1974–76; was manager for her father, painter/sculptor George Finey; Summer schools – Frensham School, Mittagong 1972; Binna Burra Integrated Arts Project; Qld Dept Cultural Activities 1974; Weekend seminars — 'Adventures in Art' series, Dept Cultural Activities, Qld (sculpture) 1974; Australian Flying Art School Brisbane base, tutor painting 1974–76.
Exhibitions Teaching artists' annual shows, WAC, Willoughby 1962–73; One-woman show, sculpture, musical graphics, WAC, Willoughby 1972; Musical graphics, Roslyn Galleries, Sydney 1977.
Represented Collections in Sydney, Brisbane, Canada, Japan, USA, France and UK.

FIRTH, Nola VIC
Born Wangaratta, Vic. 1950. Weaver, textile artist.
Studies BA, Dip. Ed. University of Melbourne 1968–70 and Council of Adult Ed. 1979.
Exhibitions Solo show at Ishka Gallery Melb. 1980; Argyle Gallery, Sydney 1989; Participated Meat Market Centre 1984; Vic. Arts Centre 1985; Ararat Reg. Gallery 1983, 85; Beaver Galleries, Canberra 1986; Meat Market Centre, Melb. 1984, 87; Jam Factory, Adelaide 1987; Tamworth Regional Gallery 1988; Fibre III, touring show to Victorian Regional Galleries 1990; Jewish Museum of Aust. 1991.
Bibliography *Craft Australia* Spring 1984.

FISHER, Vanessa NSW
Born Cergourg Aboriginal Settlement, Qld.
Exhibitions Penrith Reg. Gallery 1983; Uni. of NSW 1984; Qld. Community Arts 1986; Karnijue Art Gallery, Brisbane 1987; Murri Community School, Brisbane 1988; *Aust. Perspecta* – Artspace Gallery, Sydney 1989.

FITZGERALD, Jennifer B. VIC
Born Melbourne Vic 1944. Realist painter in oil, watercolour, pastel and pen; Teacher.
Studies Studied in Melbourne under a number of tutors; Member, VAS and tutor at Warringal Gallery.
Exhibitions Solo shows at Warringal Gallery, Melbourne 1980, 1982.
Represented Private collections in UK, Europe, Australia.

FITZGERALD, Margery VIC
Born Melbourne 1934. Expressionist painter in oil.
Studies BA (Fine Arts) from RMIT.
Exhibitions Periodically since 1970.
Bibliography *Alice 125*, Gryphon Gallery; University of Melbourne 1990.

FITZGERALD, Mirabel NSW
Born London UK 1945. Painter and printmaker.
Studies NDD Byam Shaw School, London; Workshop Arts Centre, Willoughby NSW; Atelier 17 — working Cité des Arts, Paris; Lecturer in printmaking at Sydney College of the Arts, Sydney University.

Exhibitions Has held three one-woman shows in Sydney and Canberra since 1971 and participated in group shows with Sydney Printmakers; Her work was included in residents' exhibition Cité des Arts and Prix de Graveur (Rank Xerox Exhibition) Paris 1973; King St. on Burton Gallery 1990; Blaxland Galleries 1991.

Represented Institutional and private collections in UK, Europe and Australia.

FITZGERALD-BOYLE, Margery VIC
Painter and teacher.

Studies Mainly self-taught with brief periods of study with Melbourne Artists Vivienne Thorrowgood and Shirley Bourne. Formerly a painter in oils of colourful landscapes executed with the knife. In 1979 changed to a brush technique, concentrating on figure and portraits in oils, watercolour and pastel; Teaches with Mentone Art Group and VAS.

Exhibitions A regular exhibitor at Vic Artists Society (VAS) shows since 1973, she held her first one-woman show at Munster Arms Gallery, Melbourne in 1977–78.

Awards Cheltenham Art Prize 1972; Best oil at Mornington 1977; Melbourne City Council Prize at VAS 1975; St Kevins College, Toorak Show, First Prize 1978, Brighton City 1978; Mordialloc 1980–81.

Represented Artbank and private collections in Australia and overseas.

FITZPATRICK, Dawn NSW
Born Sydney NSW. Artist in cloth and appliqué.

Studies Three years at SA School of Arts and Crafts (GCAS).

Exhibitions Hogarth Gallery, Sydney 1980–82.

Represented Parliament House, Sydney; Drama Festival Hall, ACT; Australian Film Commission and institutions and collections in Australia and USA.

FLAXMAN, Mollie NSW
Born Sydney NSW. Watercolourist.

Studies East Sydney Technical College, Royal Art Society and later under G.K. Townshend; Fellow of the Royal Art Society of NSW. Member AWI; painted in India 1978; UK 1980, 83.

Exhibitions One-man shows, Moreton Gallery, Brisbane 1954; Town Gallery, Brisbane 1975; Art Lover's Gallery, Sydney 1962; Barbazon, Mosman 1976; Green Glades, Melbourne 1949; Hesley, Canberra 1977; Participated in AWI to New York 1976 and to NZ 1975, 77–78, also with Cheltenham Art Group UK and the RAS of NSW.

Awards Concord 1955; Albury 1955; Goulburn 1956, 1957, 1960; Bega Caltex 1964, 1971; North Shore Historical Society 1960; Northside Festival 1963; Cheltenham HSP&C 1969; Ryde 1968, 1971; RAS Mercedes Benz 1975.

Represented Art Gallery of NSW; National Art Collection, Canberra; Bega Collection, NSW; Geraldton and Northam Collections, WA; Private collections in UK, USA and Tokyo.

FLETCHER, Elizabeth (Betty) NSW
Born Warren NSW 1930. Painter, sculptor, designer.

Studies Orban Studios 1948–56, 65–86; Sydney TC 1948–49; Diploma, Sydney Conservatorium of Music 1972–75.

Exhibitions Solo shows at Dominion Galleries 1964, and Fazzles Gallery, North Sydney 1982.

Awards Woollahra Art Centre Scholarship 1954.

Represented Institutional and private collections in Australia and overseas.

FLETCHER, Jennifer VIC
Born Inverell NSW 1947. Printmaker, papermaker.

Studies BA Fine Arts, Chisholm IT, Melb. works at Pindari Print Workshop.
Exhibitions Numerous shows since 1977 include PCA 1987; Bridge St. Gallery, Sydney 1988. Impressions Gallery, Melb. 1988.
Awards St. Margarets, Melb. 1987, 88.
Represented Artbank, private collections in USA, Hong Kong, Australia.

FLOCKART, Audrey TAS
Born Melb. 1931. Painter and teacher.
Studies Hobart Tech. School under Jack Carington Smith 1958–61; Slade School, London 1962–64. Taught art at Hobart School of Art 1965–69. Friends School 1968–69. With Tas. Film Unit 1974–78 and Nat. Parks and Wildlife 1978–85. Overseas study tours 1962–64, 1970, 80, 82.
Exhibitions Solo shows Art Boutique 1966; Carmyle 1968; Don Carmillo 1969; Hobart Teachers College 1969; Uni. of Tas. 1971; Salamanca Place 1972. Numerous groups shows 1959–1976.
Awards Tas. Open Art Prize 1968.
Represented Uni. of Tas. and private collections.
Bibliography *Tasmanian Artists of the 20th Century,* Sue Backhouse 1988.

FLØISTAD, Lise NSW
Born Calcutta, India 1956. Painter, sculptor, weaver, teacher.
Studies Gamlebyen Folkehøy Skole, Fredrikstad, Norway 1974–75; Risør Husflid Skole, Risør, Norway 1975–76; Seterglentan, Insjon, Sweden 1976; B.F.A. (Hon) Textiles, Rhode Island School of Design, Providence, Rhode Island, USA 1978–82; M.A. (Visual Arts) Sculpture, Sydney College of the Arts, Australia 1984–86. Teaching appointments include Spain 1977; India 1982; Rhode Island USA 1982; ESTC, Sydney 1983, 87, 88; CAI Sydney 1984–85, 87, 88; Canberra School of Art 1986; Hornsby College of TAFE 1987.
Exhibitions Solo shows include Rhode Island USA 1982; Penrith Regional Gallery 1984; Coventry Gallery, Sydney, Tyholem Gallery, Norway, Power Gallery, Uni. of Sydney 1986; Macquarie Galleries, Sydney 1987, 88; AVAGO, Sydney University 1988. Kunstlerhaus Bethanien, Berlin 1990; Palma de Mallorca, Spain 1991. Group shows at New York 1982; Coventry Gallery, Sydney 1984, 86, 87; *Australia Perspecta* 1985; 9th Mildura Sculpture Triennial 1985; Macquarie Galleries, 1988; Berlin, Germany 1991.
Awards The Textron Award, U.S.A. 1982; Commonwealth Postgraduate Award 1985; Project Grant, Visual Art and Crafts Board 1987; The Blake Prize 1988; VA/CB Grant, Kunstlerhaus Bethanien Studio, Berlin 1989.
Represented Artbank, and corporate and institutional collections in Australia, USA and Europe.
Bibliography *New Art Two:* Craftsmans Press 1988.

FLOOD, Patricia ACT
Born Melb. 1919. Painter, began painting in Canberra 1963. Studied Japan 1971, UK 1972–73; Nepal 1985.
Exhibition Many solo shows since 1964 include Centre Gallery 1973; Solander Gallery 1973, 74, 77, 79, 81, 87; Holdsworth Galleries, Sydney 1976, 89; Manuka Gallery 1984; Sheraton Hotel, Nepal 1985; First Aust. Contemporary Art Fair, Melb. 1988. Numerous groups shows.
Awards Orange Esso 1969; Gold Coast 1970; George Crouch 1971.
Represented Institutional and private collections in UK, Europe, USA, South America, Japan, Korea, Australia.

FLOREAN, Natasha NSW
Born Czechoslovakia. Woodcuts, linocuts, screenprints, etching.

Studies Graduated Bachelor of Arts (fine arts), Sydney University 1976; Studied Printmaking at Scuola di Alberto Marconi, Rome Italy 1978; Finished Post Certificate Studies (printmaking), East Sydney Technical College 1981; Overseas study tour 1983.

Exhibitions Solo shows at East End Art 1982; University of NSW, Senior Common Room Club 1982; Robin Gibson Gallery 1983; Cylinder House, London 1984; NSW House, London 1987; Sydney Opera House 1988; Eddie Glastra Gallery, Sydney 1988; Participated at Barry Stern Print Award, East Sydney Technical College; East West Art, Cabo Frio International Print Biennial, Rio Brazil 1982; New London Theatre UK and Bienale of Graphic Art, Heidleberg, W. Germany 1984; Leighton House, London; Tokyo; IJAC, New York; NSW House, London; Mermaid Gallery, London 1985; British Print Bienale 1986; International Print Bienales at Taipei China and Cracow, Poland 1987; Holdsworth Gallery 1987; Theatre Royal — Les Miserables, Sydney 1988.

Awards Schonbrun Intergraphik Award 1981.

Represented Diplomatic, institutional and corporate collections in UK, Europe, USA, Japan, Australia.

Bibliography *Directory of Australian Printmakers* 1982; *Artists & Galleries of Australia*, Max Germaine: Craftsman House 1990.

FLOYD, Linda VIC

Born Melbourne Vic 1929. Surrealist painter in watercolour, gouache and oil.

Studies Under Joan Gough for painting; Ming McKay for drawing and Douglas Millar for watercolour. Member, VAS since 1974 and CAS since 1979; Treasurer 1983–85.

Exhibitions Solo show at Joan Gough Gallery 1983; Mornington Art Gallery 1979. Joint shows include Victorian Artist's Society 1974–86; Contemporary Art Society 1979–86; National Contemporary Art Society Exhibition, Perth, 1986; Mornington Regional Gallery, 1984–86; The 'Alice' Prize Exhibition, 1983–85, 87; Swan Hill Pioneer Print Exhibition, 1984; Jennifer Tegel Gallery, San Francisco 1985.

Represented Geo Patterson Collection, Melbourne and private collections.

FLOYED, Janet NSW

Born Hobart 1952. Photographer, teacher, curator.

Studies Hobart School of Art 1971–73; 76. Teaching Education Dept. 1974–75; 77–78. Overseas study 1973–74; 77 – 78. With *The Examiner* Launceston 1978–79; Curator of Craft at QVMAG 1981–85. Living in Europe 1987.

Bibliography *Tas. Artists of the 20th Century;* Sue Backhouse, 1988.

FLUGGE, Anne WA

Born WA. Self-taught watercolour painter.

Exhibitions Watercolour Society of WA; WA Society of Arts and Crafts; Katanning Art Society.

Awards WAS Prize 1980, 83.

Bibliography *Australian Watercolour Painters*: Jean Campbell: Craftsman House 1989.

FLYNN, Joanna WA

Born WA 1959. Painter and printmaker.

Exhibitions ArtHouse, Launceston 1990.

FOA, Angy (Dalton) ACT

Born UK 1927. Realist painter in oil and watercolour.

Studies Part-time student at Ruskin School of Art, Oxford UK 1942–43; Slade School, London 1944–45, and Canberra Technical College, ACT 1970–72.

Exhibitions Solo shows at Braidwood UK 1974; Canberra ACT 1977, and London UK 1981; Participated in many group shows in Australia and overseas.

Awards Harden Murrumbourough Prize 1977.
Represented Private collections UK, USA, Europe, Canada, Malta and Australia.

FOARD, Patsy VIC
Born Bairnsdale Vic 1935. Abstract expressionsist painter in acrylic.
Studies Diploma of Art, RMIT 1953–58; Teacher, Caulfield Art Centre, Melbourne 1960–64; East Sydney Technical College (part-time) 1968–69; SA School of Arts (part-time) 1970; Prahran College of Advanced Education 1971–78; Studying for Master of Fine Arts Degree at University of Hawaii USA 1978–80.
Exhibitions First one-woman show at Gallerie D'Arte Moderna, Florence Italy 1959, followed by solo shows at Commonwealth Institute, London 1959; Vic Artists Society, Melbourne 1961; Carmyle Gallery, Melbourne 1966; Toorak Gallery, Melbourne 1974; Hawthorn City Art Gallery 1977; Honolulu Hawaii 1979; Many group shows since 1958 in Europe, USA and Australia which included Gallerie D'Arte Moderna, Florence Italy; Emerald Gallery, Melbourne 1961; Eastside Gallery 1962; Leveson Street Gallery 1963; Argus Gallery 1963; Warehouse Gallery 1972; Women's Art Forum 1977.
Represented Private collections in Australia, UK, Europe and USA.

FOGARTY, Catherine NSW
Born Australia. Ceramic artist.
Studies University of NSW, College of Fine Arts.
Exhibitions Ivan Dougherty Gallery 1990.
Awards Inaugural Telecom Fine Art Scholarship in 1990.

FOGWELL, Dianne ACT
Born Lismore NSW 1958. Painter, printmaker and teacher.
Studies Wollongong School of Art and Design 1975–76; Riverina College of Advanced Education, Wagga Wagga 1978–79; Graduated Canberra School of Art, Diploma Visual Art 1980; Studio Assistant, Printmaking Workshop, Canberra School of Art 1981–82; Lecturer (P/T) Etching, Drawing, and Foundation, Canberra School of Art 1981–83; Established 'Studio-One' (Etching and Drawing Workshop) in conjunction with Meg Buchanan 1983; Carried out commissions for ANU, Canberra in 1981–82, 85.
Exhibitions Solo shows at Arts Council Gallery, Canberra 1984; Solander Gallery, Canberra 1987; Libby Edwards Gallery, Melb. 1988; Giles Street Gallery, Canberra 1988; Robb Street Gallery, Bairnsdale, Vic 1989. A host of group shows include Print Council Travelling Exhibition 1978; Link Gallery, Canberra; Contemporary Arts Society, Adelaide 1980; Gallery Huntley, Canberra 1981; Staff Show, Canberra School of Art Gallery; First Annual Invitation Exhibition, Wagga Wagga; Super Doreen Show, Arts Council Gallery, Canberra 1982. Arts Space Gallery, Canberra 1984, 85; Tenants Arts Council Gallery, Canberra. 'Australian Printmakers' Australian National University Drill Hall; 'Time and Place' Staff Show CAS Gallery 1986, 87; Libby Edwards Gallery, Melb.; Robb Street Gallery, Bairnsdale; Ben Grady Gallery, ACT; Kensington Gallery, Adelaide 1988.
Represented ANU, Canberra and institutional collections around Australia and overseas.
Bibliography *Artists & Galleries of Australia*, Max Germaine: Craftsman House 1990.

FOLETTA, Louise VIC
Born Melbourne Vic 1945. Modern landscape painter mostly in watercolour.
Studies Studied painting RMIT and Caulfield Institute 1963–68; Travelled extensively throughout South East Asia, Europe and America 1969–72; Studied watercolour with Kaji Aso in Boston USA 1971–72; Teaching watercolour with CAE, Melbourne 1973–83; Conducted summer workshops and weekend workshop at Buxton, Vic 1975–83; Vice-President Contemporary Art Society 1975–81 and President 1982–84.
Exhibitions Private showings, UK, USA; One-woman show, Studio Gallery, Kew 1974;

'Spectrum Show', Studio Gallery, South Yarra 1977; CAE Gallery, Melbourne 1981; Atelier Gallery, Benalla 1982; Stringybark Gallery, Euroa 1985; World Trade Centre 1986; many group shows since 1973.

Awards Dandenong Festival 1967; Wirranda, Marysville 1977; Beaumaris Art Prize 1977; Flinders Art Show 1977; Swan Hill Art Show 1977; Kyabram and Tallangatta 1981; Bright 1983; Burke Hall Acquisitive 1986; Birchip 1987.

Commissions Painted the background for Forestry Commission animated film *Too Beautiful to Burn.* Murals for Malvern City Square Project 1989.

Represented Institutional and private collections in Australia and overseas.

FOLEY, Fiona NSW

Born Aust. 1964. Aboriginal painter and printmaker.

Studies ESTC 1982–83; visiting student to St. Martins S of A, London UK 1983; B. Visual Arts, SCOTA 1984–86; Dip. Ed. Sydney Uni. and Sydney IE 1987. Numerous study grants; Artist-in-Residence at Griffiths University, Brisbane and Maningrida NT during 1988 and at Cleveland St. Extensive Language Centre, Sydney 1990.

Exhibitions Solo show at Roslyn Oxley9 Gallery 1988, 89, 91; group shows include Artspace Gallery 1984; Aboriginal Artists Gallery Melb. and Sydney 1985; Willoughby WAC 1986; PCA, Melb. and Sydney 1985; Willoughby WAC 1986; PCA, Melb. 1987; Boomalli Co-op., Sydney 1987; Craft Centre Gallery, Sydney 1988, AGSA 1988. *Aust. Perspecta* — Artspace Gallery, Sydney 1989.

Represented ANG, AGNSW, Artbank, Australian Museum, institutional and private collections.

FONTAINE, Victoria QLD

Born UK. Painter and portraitist in oil and pastel.

Studies Folkestone School of Art and Brighton Art College graduating with Bachelor of Arts in Fine Arts; Member of Chelsea Arts Club, London.

Exhibitions Holdsworth Gallery, Sydney; Tom Silver and Moorabbin Galleries, Melbourne; Newton Gallery, Adelaide; MacInnes Gallery, Brisbane and John Cooper Eight Bells Gallery, Surfers Paradise Qld; In earlier times showed at Royal Society of Portrait Painters, London and in Jersey, Munich and Washington, DC.

Commissions Her sitters include many important figures in UK, USA and Europe and locally The Hon and Senator Joh and Florence Bjelke-Petersen; Irvin Rockman, Jackie Macdonald and Greg Chappell.

FOOT, Maxienne VIC

Born Carton Vic 1948. Painter and printmaker.

Studies Diploma in Fine Arts from Caulfield Institute of Technology 1973–76; Graduate Diploma in Fine Arts from Vic College of the Arts 1977–78; Santa Reparate Studio, Italy 1981.

Exhibitions Solo shows at Susan Gillespie Gallery, ACT 1979; Pinocotheca Gallery, Melbourne 1982; William Mora Gallery 1988; Participated in group shows in UK, Europe, Japan and Australia.

Awards K & E Murdoch Travel Fellowship 1981; Henry Worland Memorial Acquisition 1976.

Represented Warrnambool Art Gallery; Vic College of the Arts, and institutional and private collections in UK, Europe and Australia.

Bibliography *Directory of Australian Printmakers* 1982.

FORBES, Dorothy Marie QLD

Born Qld. Graphic artist and gallery director.

Studies Qld Art Gallery School; Brisbane Technical College; Director, Bakehouse Art

Gallery, Forbes Art Gallery Mackay, Q.
Exhibitions Martin Gallery, Townsville and Mackay City Library.
Awards Townsville Drawing Prize.

FORBES, Sheila Marjorie NSW
Born Sydney 1919. Traditional painter in oil.
Studies Special School for the Deaf at Bournemouth UK 1927–31; SCEGGS, Sydney
1934–37; ESTC 1937–41 and with Jerrold Nathan, Royal Academy, London; Gordon
Marwood and Allan Hansen, Sydney.
Exhibitions Regularly with the RASNSW.
Awards Numerous awards over the years include Goondiwindi, Avoca; St. Ives; Deniliquin
and the North Shore Art Society.
Represented Private and institutional collections in UK, Canada and Australia.

FORBES-WOODGATE, Claudia NSW
Born Melbourne Vic. Traditional to impressionist painter in oil, watercolour and pastel.
Studies Privately tutored in SA; In Sydney under John Godson, Henry Edgecombe, G.K.
Townshend and George Duncan; World study tours UK, Ireland, Scotland, Europe, USA,
Turkey, China 1971, 1976; Treasurer, Australian Watercolour Institute since 1976;
Assistant teacher, Townshend Group for some years; Sporadic tutoring and lecturing at
Australian Watercolour Institute; Adult education and private; Fellow, Royal Art Society of
NSW; Member Ku-ring-gai Art Society.
Exhibitions With Australian and American Watercolour Institutes, National Gallery, New
York 1976; Australian Watercolour Institute exhibition to NZ State Galleries 1977, 1978;
Mostly group exhibitions such as Royal Agricultural Society, Royal Art Society, Australian
Watercolour Institute and Ku-ring-gai Art Society; In major annual Prizes such as Wynne,
Archibald, Portia Geach and various municipal council exhibitions in city, country and
interstate. Gallery Lynch 1988; Beth Mayne Gallery 1989.
Awards Mosman 1953; Taree Municipal Council 1960, 1962, 1963, 1964; Goulburn
Municipal Council 1964; Royal Agricultural Society 1966, 1967, 1974; Northside Arts
Festival Grace Prize 1973; Campbelltown Municipal Council 1972; Killara 1972; Royal
Prince Aflred Yacht Club Awards 1975, 1976, 1977; Australian Opera Audition Awards
1977; Ku-ring-gai Council 1978.
Represented Taree Municipal Council Collection (four); Goulburn Municipal Collection;
Royal Art Society Fellows Collection; Private collections throughout Australia, UK,
Scotland, USA, Turkey, NZ and Japan; Three works acquired by actor, Vincent Price for
Sears-Roebuck Collection which toured USA in 1966.

FORD, Elizabeth WA
Born WA 1941. Abstract painter and teacher.
Studies Claremont Teachers College, Perth 1959–61; Associateship in Art Teaching from
WAIT 1971. Accepted a Postgraduate studio attachment to study for the spring term at the
Royal College of Art, London UK 1987–88. Prior to that was a senior lecturer at WACAE,
Perth, a position she still holds.
Exhibitions One-woman shows at Cremorne Art Gallery 1972; Old Fire Station Gallery
1974; Gallery 52, Perth 1979–80; Fremantle Arts Centre 1981, 86, 87; Miller Gallery
1984; Perth Galleries 1989. Participated in Blake Prize, Art Gallery of NSW and Perth
Drawing Prize 1973–75 and over thirty group shows since 1972.
Awards Albany Art Prize 1973; Bunbury Purchase 1975, 1977; Stirling Prize 1977;
Pegasus Art Award 1982.
Represented Many institutional and private collections in WA and NSW.
Bibliography *Contemporary WA Painters and Printmakers,* Fremantle Art Centre Press 1979.

FORD, Sue VIC

Born Melbourne Vic 1943. Painter, photographer, film maker.

Studies RMIT 1961; Completed two years postgraduate at VCA 1975; Worked in own studio from 1962.

Exhibitions Solo shows include Hawthorn City Art Gallery 1971; NGV 1974, 88; ACP, Sydney 1975; AGNSW 1982; Christine Abrahams 1982; Watters Gallery 1984; MCAG 1989; ANG 1989. Participated in many group shows since 1974 including Sydney Biennale, AGNSW 1982; *Continuum 83*, Tokyo 1983; ANG 1983, 87, 88; ACCA, Melbourne and touring 1987; The Performance Space, Sydney 1988.

Awards Ilford Photography Scholarship 1973; VCA Fellowship 1987.

Bibliography Catalogue of *Biennale of Sydney* 1982, AGNSW.

FORSTER, Josephine QLD

Born Brisbane Qld. Semi-abstract painter using mixed media, printmaker.

Studies Brisbane Technical College under Melville Hayson; Later with Roy Churcher and Mervyn Moriarty at the Australian Flying Art School, and with Bela Ivanyi and Andrew Sibley; Board member of Qld Arts Council 1973–76; Committee member of Qld Federation of Art and Craft Societies: member of CAS, Qld when in operation; Member of the Institute of Modern Art, Brisbane.

Exhibitions First one-women show at Australian Flying Art School Gallery, Brisbane 1977; Martin Gallery, Townsville 1981, 86; Christy Palmerston Gallery 1987. Has shown in numerous exhibitions in Qld and interstate including Eight Bells Gallery, Surfers Paradise Qld 1977, 1979; Design Art Centre, Brisbane 1977, 1978 and Holdsworth Gallery, Sydney 1979; Batik show with Gladys Cooney at Martin Gallery, Townsville 1978; Pratt Institute, New York 1985; PCA Melb. 1988; 70 Arden Street Gallery, Melb. and Beaver Gallery, Canberra 1988.

Awards Has won a number of prizes in Qld art competitions since 1966.

Represented Artbank and institutional and private collections in Australia and overseas.

FORSYTH, Christine TAS

Born Hobart Tas 1949. Realist painter, printmaker, teacher.

Studies School of Art, Hobart 1967–69; City and Guilds School of Art, London 1974; City of London Polytechnic 1975–76; taught for Tas. Education Dept. 1978–80; worked as graphic designer 1978–83. Worked and studied NZ 1971–72, Japan 1972–73, England 1974, Asia 1976–77.

Exhibitions Solo shows at Salamanca Place Gallery, Hobart 1976–77; Coughtons Gallery, Hobart 1978, 1982; Adelaide Fine Arts and Graphics 1979; Harrington Street Gallery, Hobart 1980; The Field Workshop, Melb. 1982; Handmark Gallery, Hobart 1984, 85; Numerous joint and group shows include PCA show to Sweden 1980–81; Chameleon Gallery, Hobart 1984, 85; Australian Print Show to USA 1985–86.

Awards Member print for PCA 1979, 84 and Ministers Award for Excellence 1984.

Represented TMAG, QVMAG and many institutional and private collections in Australia, NZ, Japan, UK, Europe.

Bibliography *Tasmanian Artists of the 20th Century*, Sue Backhouse 1988.

FORSYTH, Margaret TAS

Born Hobart 1918. Painter.

Studies Uni. of Tas. 1936–38; with George Davis and Harry Buckie 1960–62; Hobart School of Art under Jack Carington Smith 1963–65.

Exhibitions Numerous solo shows since 1969 include Artists Studio, Bellerive, Tas. 1974, 76, 78, 79; Hibiscus Gallery 1979; Uni. of Tas. Gallery 1981. Participating at Art Society of Tas. since 1962 and Palette Gallery, Hobart 1980, 81.

Represented Institutional and private collections in Australia and overseas.

Bibliography *Tasmanian Artists of the 20th Century,* Sue Backhouse, 1988.

FORTHUN, Louise VIC
Born Port Macquarie NSW 1959. Painter.
Exhibitions Solo shows at Pinacotheca Gallery 1985; George Paton Gallery 1987; Tolarno Galleries 1990. Numerous group shows since 1985 include Moët & Chandon Touring Exhibition both 1989 and 1990.

FOSTER, Una NSW
Born Sydney NSW 1912. Painter, survey draughtsman and printmaker.
Studies Diploma, East Sydney Technical College 1934; Textile design at Central School of Arts and Crafts, London 1950–51; Worked for many years as survey draughtsman; Forestry Commission of NSW 1936–48; Teaching Art & Crafts at Occupational Therapy Training Centre 1949; Cumberland Country Council 1952–67, Mosman Municipal Council 1967–71 as Survey Draftsman; Teaching Serigraphy at Workshop Arts Centre, Willoughby 1976–1980; Overseas study tours 1982, 90. Member WAC; Sydney Printmakers; Nine Printmakers.
Exhibitions Solo show at Printers Gallery, Sydney 1981; Beth Hamilton Galleries 1987; Burrangong Gallery 1987; Braemar Gallery 1989; Participated Sydney Printmakers since 1971; Print Circle since 1974, PCA show to Sweden 1980. Printmakers of NSW to London, Edinburgh and on tour 1982–83. Beth Hamilton Gallery 1987, 88.
Awards Henri Worland Prize, Warrnambool 1973; Reserve Bank Purchase 1976; Townsville Festival Purchase 1978; Boggabri 1978, 1979, 1982; Maitland 1979; Lane Cove 1980; Camden 1982; Nundle 1982; Grenfell 1984; Moree 1984; Boggabri 1984, 88; Young 1987; Gunnedah 1988.
Represented Regional Galleries at Warrnambool, Townsville, Maitland, Lane Cove Council, Reserve Bank and private collections in Australia and overseas.
Bibliography *Directory of Australian Printmakers* 1982; *Encyclopedia of Australian Art*, Alan McCulloch: Hutchinson 1968; *Artists & Galleries of Australia*, Max Germaine: Craftsman House 1990.

FOWLER-SMITH, Louise NSW
Born Sydney. Painter, printmaker, teacher.
Studies City of London Polytechnic 1977; Dip. Art and Art Ed., Alexander Mackie CAE 1978; Grad. Dip. Professional Art Studies, CAI 1981 and BA 1983; MFA (Visual Arts) University of California, USA. Has taught art in a number of art institutes and universities in Australia and USA since 1978; Presently lecturer in painting and drawing, College of Fine Arts, University of NSW.
Exhibitions Solo shows at Holdsworth Galleries 1982, 88; Ucen Gallery, Santa Barbara USA 1985; Many group shows since 1978 and recently at Galerie Des Femmes, Paris 1985; The Painters Gallery, Sydney 1990; The Works Gallery 1988; Artspace 1989.
Awards Five grants from University of California 1983–84.
Represented Institutional and private collections in USA and Australia.
Bibliography *Contemporary Australian Collage and It's Origins*, Arthur McIntyre: Craftsman House 1990.

FRANCIS, Elizabeth VIC
Born Aust. Impressionist painter of Australian landscapes; member of VAS and AGRA.
Exhibitions Five Ways Galleries, Vic. 1989.

FRANCIS, Iris WA
Born Fremantle WA 1913. Representational painter in watercolour and oil; Teacher.
Studies SA School of Arts; Diploma, Perth Technical College; Member, Perth Society of

Artists and exhibits annually with them, and with group of three painters; Also paints theatre murals; Taught at Perth Technical College 1935–47 plus technical extension classes.
Represented Sir Claude Hotchin Collection and private collections in WA.

FRANCIS, Ruth QLD
Born Qld. Fabric designer and painter, teacher.
Studies Australian Flying Art School and Central West Qld. Creative Arts Association. Conducts children's art classes.
Exhibitions Gallery Baguette 1981, and numerous institutional group shows since 1969.
Awards Barcoo Shire 1978; Longreach Shire 1978 and numerous prizes in Central West Qld 1972–80.

FRANCIS-JOHNSON, Toni NSW
Painter and teacher.
Studies Dip. Painting from ESTC and later taught at ESTC. Member, Ku-ring-gai Art Society.
Exhibitions Society of Artists; Terry Clune Galleries; Blaxland Gallery; Ku-ring-gai Art Society.
Awards Kempsey 1990; Oyster Festival 1989; Scone Open 1990.
Represented Institutional and private collections.

FRANCOMBE, Nell TAS
Born Tas 1906. Realist painter in oil and watercolour of Tas landscapes and native flowers, teacher.
Studies Philip Smith Teachers Training School and Uni. of Tas. Hobart. Studied under Isobel Oldham, Hobart and Max Meldrum, Melb. and design and crafts at Melb. Tech. College. Taught with the Tas. Education Dept. for many years and held an annual solo show in Hobart with occasional shows elsewhere.
Represented Private collections in UK, Scotland, France, USA, South Africa and all Australian states.
Bibliography *Tasmanian Artists of the 20th Century*, Sue Backhouse 1988.

FRANKEL, Annette Barrette VIC
Born Pakenham Vic 1929. Painter of historical subjects in oil; Portraitist and teacher.
Studies National Gallery School, Melbourne 1948–52; Under George Bell 1953; Certificate of Art Course, RMIT 1957–58 under Lindsay Edwards; Founded Eastside Gallery, Jolimont Vic 1960; Established Carmyle Art Gallery, Toorak Vic in association with artist Patsy Foard 1961; Director Eltham Art Show 1967; Art teacher at St Columbus Ladies College, Essendon Vic 1974–75; Study tour to Europe 1977.
Exhibitions Shepparton and Benalla Regional Galleries, Vic 1970–71; Adelaide Festival of Arts 1972; Rigby's Gallery, Adelaide 1973; Bartoni Gallery, Melbourne 1975; Myer's Gallery, Melbourne 1976; Retrospective exhibition, Illawarra, Toorak, Vic 1978.
Represented Shepparton Regional Gallery and private and institutional collections in Australia, New Zealand and overseas.

FRANKLIN, Annie NSW
Born Coffs Harbour NSW 1962.,
Illustrator, graphic artist, printmaker, teacher.
Studies Riverina-Murray IHE, Dip. Applied Art-Printmaking. Illustrator for *Canberra Times* 1988; Printmaking tutor, NT University 1989; Designer/illustrator for Community Aid Abroad and arts co-ordinator for Yokikini Women's Centre, Melville Island 1990.
Exhibitions Solo shows at Dorettes Bistro 1987, 88; Canberra Contemporary Art Space 1988; Darwin 1989; Punch Gallery, Sydney 1990; aGOG, Canberra 1990. Numerous group

shows include Wagga Wagga Regional Gallery 1983; Blaxland Gallery 1983; Canberra Contemporary Art Space 1987; North Sydney Contemporary Gallery 1988; MPAC and Fremantle Print Exhibitions 1990.

Awards Padua, ACT 1984; Champagnat, Canberra 1985; Queanbeyan 1987. Arts Development Board Grant 1988.

Represented ANG, Wagga Wagga Regional Gallery, Regional Galleries, institutional and private collections around Australia.

FRAPPELL, Joan QLD
Born Sydney 1928. Painter, jewellery designer.
Studies ESTC 1944 and in Queensland with private tutors.
Exhibitions Solo shows at Boston Gallery, Brisbane 1981, 82; participated in National Womens Art Award at The Centre Gallery, Gold Coast 1988.
Represented Kelvin Grove CAE and institutional and private collections in USA and Australia.

FRASER, Mary Mehetabel QLD
Born Brisbane Qld. Painter and sculptor.
Studies Brisbane Technical College 1951; South-West Essex School of Art, UK 1952–55; Royal Academy School, London 1955–58. Theological studies in Sydney 1963–66; Study tours to Europe and Middle East 1965–67. Completed a number of commissions for both metal and terracotta sculptures for buildings in Brisbane during the 1970s.
Bibliography *Australian Sculptors,* Ken Scarlett, Nelson 1980.

FRECKER, Rachael NSW
Born Sydney NSW 1949. Weaver of tapestry and rugs.
Studies Mary White School of Art, Sydney 1967–70, and apprenticed with Margaret Grafton 1970–72.
Exhibitions Solo show at Armstrong Gallery, Morpheth NSW 1980; Participated many group shows since 1975 and recently Newcastle Regional Art Gallery 1980 and Ararat Regional Gallery; Vic 1982.
Awards Crafts Board of Australia Grant 1974.
Commissions Katoomba District Hospital (with Margaret Grafton); Newcastle Gallery Society.
Represented Crafts Board of Australia; Regional Galleries at Stanthorpe, Tamworth and Ararat; Dalgety Ltd Collection and private collections.

FREEMAN, Di NSW
Born Aust. Woodcuts, lithography and sculpture.
Studies Chatswood Evening College and at the WAC. Member of PCA and The Print Circle, Sydney.
Exhibitions WAC 1982; PCA International Travelling Exhibition 1984–86 and regularly with The Print Circle.
Represented Institutional and private collections in UK, Europe, USA and Australia.

FREEMAN, Emma QLD
Born Port Kembla NSW 1922. Painter and sculptor.
Studies Art Training Institute, Melb. 1954–56. Numerous schools and workshops in Qld. NZ 1975–76; Noumea 1980; Canada 1985.
Exhibitions Solo show at Noosa Heads Gallery 1965; Painters Gallery, Sydney 1990; Recent group shows at Noosa Reg. Gallery 1988–89.
Awards Sandgate 1972.
Represented Institutional and private galleries in UK, Europe, USA, Canada, Noumea

and Australia.

FREEMAN, Monica ACT
Born UK 1922. Painter and sculptor.
Studies Cambridge School of Art UK; Commercial School of Art, London and Diploma in Art (sculpture) from Canberra School of Art.
Exhibitions Solo show at Macquarie Galleries 1975 and several group exhibitions.
Represented ANU, Canberra; Canberra CAE, and private collections in UK, USA, Japan and Australia.

FREIRE, Di NSW
Born Mendoza, Argentina 1954. Sculptor, arrived Aust. July 1988.
Studies Self taught sculptor and bronze founder; taught at Liceu de Artes e Officios, San Paulo 1985–86.
Exhibitions Forty shows in south America and Japan since 1980; first solo show in Aust. at Holdsworth Galleries 1989.

FREITAG, Helen (Bridley) TAS
Born Launceston 1936. Painter, music teacher.
Studies Launceston Tech. College 1964; TCAE School of Art, Launceston 1971–73, 75. European study tour 1978–79.
Exhibitions Solo show at Art Stretchers Gallery, Launceston 1976. Numerous group shows.
Bibliography *Tasmanian Artists of the 20th Century,* Sue Backhouse 1988.

FREITAG, Karla WA
Born Launceston 1959. Painter, sculptor, printmaker.
Studies L'ceston School of Art 1977–78; L'ceston Tech College 1979; Claremont Art School, Perth WA 1980–81.
Exhibitions Two artists, Claremont 1981.
Represented AGWA, QVMAG.
Bibliography *Tasmanian Artists of the 20th Century,* Sue Backhouse 1988.

FRENCH, Elizabeth (Liz) SA
Born London UK 1925. Painter, textile, designer, printmaker, teacher.
Studies Wimbledon School of Art, London 1941–44 and Royal College of Art 1944–47; Diploma of Associateship, Royal College of Art (ARCA) London 1947; Fellow, Royal SA Society of Arts; SASA 1969; North Adelaide S of A 1986; Taught UK, Tas. and SA 1947–81; Involved with Print Council of Australia; Council member and Hon. Sec. of Contemporary Art Centre, Adelaide 1986, 87; moved to Melb. 1987; papermaking and printmaking for next exhibition 1987–88.
Exhibitions Numerous one-woman and group shows and her work was included in a travelling exhibition at the Victoria and Albert Museum, London. Retrospective exhibition at Kensington Gallery, Adelaide 1982. Included in SA artists slide show at Adelaide Festival of Arts 1982. Solo show at Greenhill Galleries Adelaide 1987; Blaxland Gallery, Melbourne 1990 and won Brighton Art Prize, SA 1987. Recent shows at Papermakers of Victoria 1989 and in 1990 at Meat Market Craft Centre; Metro Arts, Brisbane; Alice Springs and Darwin; Tamworth National Fibre Exhibition; MPAC; Craft Council of Vic.
Represented Private collections in Australia, Japan and UK including V&A Museum, London UK.
Publications *Macrame,* Elizabeth French and S.E. Schrapel, Rigby Ltd; *Batik and Fabric Printing,* Elizabeth French and S.E. Schrapel, Rigby Ltd.
Bibliography *Directory of Australian Printmakers* 1982; *The World Who's Who of Women* 1982; *Artists & Galleries of Australia,* Max Germaine: Craftsman House 1990.

FRENCH, Joy VIC
Born Melbourne Vic 1917. Graphic artists, printmaking and drawing.
Studies RMIT and George Bell School; Exhibiting member of the Vic Artists Society for thirty years.
Exhibitions Retro show 1962–82 at Niagara Galleries, Melb. 1982. Group shows include travelling show of Australian paintings to Port Moresby 1966; Mornington Regional Gallery Festival of Drawing 1973, 1975, 1977, 1979; VAS Show at Horsham Regional Gallery; Bendigo Regional Gallery, 'Women Artists' Show 1975; Niagara Lane Gallery, Melbourne 1980, 85; Annually at VAS.
Awards Herald Prize for Figure Drawing (VAS) 1948; Albury Graphics Prize 1960; VAS Watercolour Prize 1970, 1971; Special Exhibition Prize, VAS 1972.
Represented National Gallery of Vic; Regional Galleries at Albury an La Trobe Valley; City of Heidelberg Collections and private collections.

FRIEND, Priscilla VIC
Born UK. Naive painter.
Exhibitions One-woman shows at Gallery Art Naive, Melbourne 1982 and Verlie Just Town Gallery, Brisbane 1983.

FRITH, Elizabeth QLD
Born Qld. 1943. Painter.
Studies ESTC.
Exhibitions Solo shows include Macquarie Galleries 1973; Eumumdi Galleries 1980; Michael Milburn 1981; Holdsworth Galleries 1987, 89, 91. Many group shows since 1972 include QAG 1973; Philip Bacon 1979; Noosa Regional Gallery 1986, 88, 89; Centre Gallery, Gold Coast 1988; Schubert Galleries 1988; Libby Edwards Gallery, Melbourne 1990.
Represented Institutional and private collections around Australia.

FROST, Ruth TAS
Born Sydney 1957. Photographer, designer.
Studies School of Art, Hobart 1981–84, 86–8 gaining M. Fine Arts.
Exhibitions With Anne McDonald at Chameleon Gallery, Hobart 1984; numerous group shows include Craft Council, Sydney 1982; Aust. Centre for Photography, Sydney 1985; CAS of SA Gallery, Adelaide 1987; Uni of Tas and Chameleon Galleries, Hobart 1987.
Commissions Waverley Woollen Mills, Launceston 1984; Blackmans Bay Primary School 1986.
Represented QVMAG, Devonport AG; Uni of Tas.
Bibliography *Tasmanian Artists of the 20th Century*, Sue Backhouse 1988.

FRUTOS, Gabriela NSW
Born Uruguay 1964. Colorful abstract painter.
Studies B. Visual and Performing Arts, School of Creative Arts: University of Wollongong 1983–86; Dip. Ed. 1987.
Exhibitions Solo shows at Wollongong City Council 1987; Coventry Gallery 1990. A number of group shows at University of Wollongong and Coventry Gallery since 1984.
Commissions City of Wollongong Mosaic 1988.

FRY, Trudi VIC
Born NSW. Ceramic Artist.
Studies Completely self-taught, she is a creator of large bowls, pottery figures, fountains, cascades and waterfalls; Her work has been shown at the Halmag Galleries, Melbourne and Adelaide and at the Adelaide Festival of Arts.

Represented Qantas in overseas air terminals; Melbourne University Halls of Residence; Northcote Municipal offices; MLC Building, Melbourne and Adelaide and at the Adelaide Festival of Arts.

FRYSTEEN, Nell QLD
Born Victoria. Painter, printmaker, teacher.
Studies Caulfield IT, printmaking and sculpture; Teacher training at Toorak Technical College 1969. Taught art 1970–77 and gained Assoc. Dip. (Painting). Worked in USA 1980–86 where she exhibited and illustrated children's books for Collins Dove and won several awards.
Exhibitions Blue Marble Gallery, Buderim 1989, 90.
Awards Broken Hill WC 1981; Noosa Rotary WC 1988 and a number in USA.

FULLARTON, Nan VIC
Born Melbourne 1913. Painter, illustrator, cartoonist and ballet costume designer.
Studies Sydney Technical College 1930. Her comic strip 'Alice' appeared in the *Sunday Herald*, Sydney in the late 1940s. Has illustrated many children's books; Presently designing ballet costumes.
Bibliography *Alice 125*, Gryphon Gallery: University of Melbourne 1990.

FULLER, Merran (Francis) TAS
Born Sydney 1954. Printmaker.
Studies Swinburne COT, Melb. 1970; RMIT 1979; Victoria College, Prahran 1980–82.
Exhibitions Art Projects Hamilton, Vic 1982; PCA Student Printmakers touring Scotland UK and Australian States 1982–83; Chameleon Gallery, Hobart 1984.
Represented TMAG and private collections.

FUREY, Anita VIC
Born Aust. 1947. Painter, married to artist Daniel Moynihan.
Studies RMIT 1967–71.
Exhibitions Solo shows at Powell St. Gallery, Melbourne 1971, 75. Has not exhibited for over ten years; Still represented by Powell St. Gallery.

FUSSELL, Frances (Arent) NSW
Born Holland 1947. Painter, weaver, teacher.
Studies ESTC 1963–67 gaining Dip. Fine Art. Teaches art at High Schools.
Exhibitions Solo shows at Morpeth Gallery 1988; Casey Gallery 1989; von Bertouch Galleries 1991. Numerous group shows.
Awards Singleton 1987; Weston 1987, 89. 90, 91; Raymond Terrace 1988, 89; Cessnock 1983, 90.
Represented Institutional and private collections in UK, Europe and Australia.

G

GAAFAR, Amahal VIC
Born Omdurman, Sudan Africa 1947. Contemporary painter in oil, acrylic and watercolour.
Studies Diploma of Fine and Applied Art, Khartoum 1971; Diploma of Primary Teaching, Toowoomba Institute of Advanced Education, Qld.
Exhibitions One-woman show at East and West Art, Melbourne 1981; Participated in Ethnic Arts and Crafts Cooperative Exhibition, Sydney 1979; 'Image of the Sudan & Other

Countries' a joint exhibition with her husband in 'Art of Man' Gallery, Sydney 1979; Artists in the community DDIAE, Toowoomba 1979–80; Ethnic Arts and Crafts Exhibition, Sydney 1980.
Represented Private collections in Australia and overseas.

GADSBY, Doreen NSW
Born NSW 1926. Impressionist painter in oil, watercolour and pastel; Recently married to artist John Coburn.
Studies East Sydney Technical College 1941–43 and later with George Lawrence and John Santry; Lived in Canada 1971–80.
Exhibitions Solo shows at Barry Stern Gallery 1963, 88; in Ottawa 1975, 1977, 1979 and Prouds Gallery, Sydney 1980; Bowral 1982.
Awards Wentworth Art Prize; W.D. & H.O. Wills Award.
Represented Institutional and private collections in Australia and overseas.

GAHA, Adrienne NSW
Born Sydney 1960. Painter, performance artist.
Studies ESTC 1979–82; BA Visual Arts, SCOTA 1984–85.
Exhibitions Solo show at Mori Gallery 1986, 90; Participated Art Unit 1983, 84; SCOTA 1984; *Perspecta* '85, AGNSW; Tas S of A 1985; Koln, West Germany 1985; ACP Sydney 1986; Penrith Reg. Gallery 1986; NGV 1987.
Represented NGV, institutional and private collections in UK, Europe, Australia.

GALALEDBA, Dorothy NT
Born Central Arnhem Land c.1967. Aboriginal painter in ochre on bark, weaver and basket-maker from the Maningrida Community NT.
Exhibitions Hogarth Galleries 1989; Tandanya Aboriginal Cultural Centre, Adelaide 1990; Deutscher Gallery 1990.
Represented ANG; Institutional and private collections.
Bibliography *Art and Australia* 28/3.

GALE, Adrienne NSW
Born Sydney 1937. Figurative painter in oil, pastel and gouache.
Studies ESTC 1953–56; RQAS 1975; Qld C of A; Dip. Fine Art 1983; BA, Uni. of Qld. 1989.
Exhibitions Solo shows at Boston Gallery 1984. Galerie Bagnette 1986–88.
Awards Caltex Warana 1983; Caltex Brisbane 1984; Wide Bay — Maryborough 1984; Hinchinbrook, Ingham Rotary, City of Rockhampton and Redcliffe Council 1984; Noosa and Hinchinbrook 1985; Esk Heritage 1986; Bundaberg Purchase 1987; QAG Purchase 1987.
Represented Municipal and institutional collections in Australia and overseas.

GALL-BUCHER, Ruth TAS
Born Hobart 1957. Painter.
Studies School of Art, Hobart 1975–77, 82; M. Fine Arts, Uni. of Tas. School of Art 1983–85. Painted in NZ 1985; Artist-in-Residence CSIRO, Hobart 1986.
Exhibitions Solo show at CSIRO 1986; group shows include ANZART, NZ 1985; Rhumbarallas Gallery, Melb 1985; Chameleon Gallery, Hobart 1985.
Represented CSIRO Collection.
Bibliography *Tasmanian Artists of the 20th Century,* Sue Backhouse: Pandani Press 1988.

GANF, Rosemary Woodford SA
Born Dorset UK 1949. Watercolour painter of Australian wildlife.

Studies Short period at art school in England but mostly self-taught; Painted at Queen Elizabeth National Park, Uganda 1969–71; UK, Europe 1972–74.
Exhibitions Tryon Galleries, Nairobi 1971, 1974; Australian Galleries, Melbourne 1976, 1979, 1984.
Represented Collections in UK, Europe, USA, East Africa and Australia.
Publications *The Marsupials of Australia* Lansdowne Press, Vol I 1979; Vol II 1984.

GARDE, Judith VIC
Born Melbourne 1947. Painter.
Studies Burwood State College 1977; Syndal TC 1978–81; Wonthaggi TAFE 1988–89; Malvern Artists Society with Shirley Bourne 1988–89.
Awards Woodend 1980; Yallourn North 1987.

GARDINER, Anne QLD
Born Tamworth NSW 1925. Painter and teacher.
Studies Co-owner and director of Tia Galleries, Toowoomba; Life member and secretary of the Toowoomba Art Society since 1966; Tutored classes and judged art competitions in northern NSW and southern Qld for many years.
Awards Kenneth McQueen Watercolour Prize, RNA Toowoomba 1976; St Alban's Southport, Religious Prize 1980.

GARDINER, Susan Anne QLD
Born Tara Qld 1955. Painter; Daughter of Fred and Anne Gardiner.
Studies Darling Downs Institute of Advanced Education; Assistant director, Tia Galleries, Toowoomba.
Awards Bailie Henderson $200 Open Art Award (shared) 1977; Toowoomba Caltex Award 1978; Toowoomba Art Society Open Art Award 1976; RNA Award 1975; Caboolture Centenary Art Prizes (two) 1979; St Peter's Caboolture Art Prize 1981, 1982.
Represented Toowoomba City Art Gallery and private collections in Australia and overseas.

GARLICK, Rosa VIC
Born Daylesford Vic 1914. Semi-abstract painter and printmaker.
Studies RMIT and National Gallery Art School.
Exhibitions Leveson Street Gallery 1958; Toorak Gallery 1964; Hawthorn City Gallery 1977; Lyceum Club 1979; Prints at Vic Arts Council, Travelling Exhibition 1974–75; CAS, Vic and Women' International Year Shows; Geelong and Shepparton Regional Galleries. Many PCA annual and travelling shows.
Awards Dean's Prize 1967; Inez Hutchinson Prize 1970 (shared); Hanover Holdings Prize 1974.
Represented La Trobe Valley Gallery; Vilnis University, Lithuania; State College of Vic and private collections.
Bibliography *Directory of Australian Printmakers* 1982.

GARNER, Olga Claire (Aggio) UK
Born Australia. Painter, mostly landscapes.
Studies National Art School, Sydney 1975 and taught for some time at the Adult Education Centre, both in Sydney and Gibralter. Travelled Europe and Asia 1968. Made life member of Wollongong Traditional Art Society 1976 before leaving for Europe.
Exhibitions Wollongong 1973; Gibralter 1977; London 1978; Mountbatten Gallery, Portsmouth 1979; Qantas Gallery, London 1980; Bournemouth Gallery, UK 1981; Beta Gallery, Qld 1981; New York 1982; Sheridan Gallery, Brisbane 1982.
Awards Noosa Qld; Port Macquarie NSW; Merbein Vic; Caloundra Qld.

Represented HM Queen Elizabeth II and Prince and Princess of Wales Collections; Wollongong Art Gallery; Australia War Memorial, ACT; And institutional and private collections in Australia and UK.

GARRAN-BROWN, E. (Peg) NSW
Born Brisbane Qld. Traditional painter in oil of landscapes, seascapes, wildlife, portraits.
Studies For Six years with A. Dattilo Rubbo. Member Ku-ring-gai Art Society, Fellow, RAS of NSW.
Exhibitions Shows at the Royal Art Society and regularly in Royal Easter Show, Archibald, Wynne Sulman, and Portia Geach competitions.
Awards Hunters Hill 1969; Hawkesbury Agricultural Association Open Award 1967, 1968, 1969; City of Parramatta Award 1973, 1974; Southern Cross Award 1982, 1985; Berimba 1984; Tumut 1985; Young Cherry Festival 1985, 1986; Boggabri 1985; Coffs Harbour 1985; Mudgee APEC 1985; Condoblin 1985; Portland Purchase, 1985, 1986, 1989; Quirindi 1986; Grenfell Henry Lawson 1986; Kogarah 1988; Scone 1986, 1988; Royal Easter Show 1983, 1985, 1986, 1988.
Represented Private collections in Vic, NSW, Qld and overseas.
Bibliography *Artists & Galleries of Australia*, Max Germaine: Craftsman House 1990.

GARRETT, Nola VIC
Born Box Hill Vic 1939. Self-taught painter in oils of Australian landscapes and flower studies.
Exhibitions Solo shows at The Homestead Gallery, East Doncaster, Vic 1976, 1978, 1980, 1983.
Awards Myrtleford 1979.
Represented Private collections in UK, Europe, USA and Australia.

GASCOIGNE, Rosalie ACT
Born Auckland NZ 1917. Assemblages, sculpture; No formal art training.
Exhibitions Macquarie Galleries, ACT 1974; Gallery A, Sydney 1976; Institute of Modern Art, Brisbane 1977; Survey 2, National Gallery of Vic 1978; Ray Hughes Gallery, Brisbane 1979; Pinacotheca Gallery, Melbourne 1981, 88; Roslyn Oxley9, Sydney 1989. Participated in numerous group shows since 1975 including Australian Sculpture Triennial, Melb 1981, 87; *Australian Perspecta*, 'Ten by Ten' 200 Gertrude Street Gallery, Melb. 1988; Aust. Biennale 1988 at AG of NSW and NGV, Melb.; AGSA 1988; Malmo, Sweden 1989.
Represented Australian National Gallery; Art Gallery of NSW; National Gallery of Vic; Philip Morris Collection; Canberra College of Advanced Education; Regional Galleries at Launceston, Shepparton and Newcastle.
Bibliography *Catalogue of Australian Perspecta* 1981; Art Gallery of NSW; *Australian Sculptors*, Ken Scarlett, Nelson 1980. *Catalogue of Australian Bienale* 1988: AGNSW, Sydney; *Artists & Galleries of Australia*, Max Germaine: Craftsman House 1990.

GASKELL, Tessie May SA
Born Paddington, NSW. Painter, illustrator, printmaker and teacher.
Studies Diploma in Commercial Art and Fashion Illustrating; Prolific painter in a variety of media; Teacher, adult education classes in SA; Member of CAS and Royal SA Society of Artists. Attended Goolwa Summer School of Arts 1975, 1976, 1977. Member RSASA and Keith Art Group.
Exhibitions Solo shows at Meningie 1978 and Gaskells Art Gallery, Keith 1981; Participated Swan Hill Gallery Printmakers 1982.
Represented Private collections in Australia and overseas.

GAUVIN, Dorothy QLD
Born Winton, Qld 1942. Genre painter.

Studies Art Training Institute, Melb 1954–57; Night studies, Technical College, Toowoomba 1958–60; David Fowler, Nan Paterson, Brisbane 1970–72; study tour of Art Museums, Europe 1984.

Exhibitions Solo shows at New Central Galleries, Brisbane 1978, 81; Raintrees Gallery, Cairns 1980; Emerson Galleries, Brisbane 1982; Participated *Australian Artists Abroad Expo*, in San Frascisco, Los Angeles and La Jolla, USA 1987.

Awards Open Portrait, Toowoomba Art Society 1956; Traditional, Garden City Art Prize, Brisbane 1977; *People in Pubs,* Castlemaine Perkins, Brisbane 1982.

Publications *Banjo Paterson's People* (Volume 1) Angus & Robertson 1987.

GAVAN, Jane NSW

Born Sydney 1962. Glass sculptor, designer, printmaker.

Studies BA Fine Art, Uni. of Sydney 1988; BA Visual Arts, SCOTA 1986–88; Grad. Dip Gallery Management, City Art Institute 1989; Member, Board of Directors Craft Council of NSW 1987 –. Established studio for ongoing glass sculpture and design work at Balmain NSW 1989. Studied UK, Europe, USA 1984–85.

Exhibitions SCOTA Gallery 1986, 87; Kelly St. Kolektiv 1987.

Awards ANZ Glass Prize, First Category 1988.

GAY, Leoni VIC

Born Melbourne Vic 1946. Graphic artist and painter in gouache — surrealist style.

Studies Graphics, Swinburne Technical College; Television graphics GTV9 1965, AMV 4 1966; Art Editor, *Haymarket Press*, London UK 1968–69; *Sunday Press*, Melbourne 1973–77; *Sun-News Pictorial*, Melbourne 1977–78; Hon Secretary of CAS, Melbourne 1976–78; Designer for publication, *Lake Pedder — The Alps at the Crossroads*.

Exhibitions Studio group, VAS 1970; Old Ruytonians Exhibition, Studio Gallery 1978; CAS 1975–82.

Represented Many institutional and private collections in Australia and overseas.

GAZZARD, Marea NSW

Born Sydney NSW 1928. Sculptor, teacher.

Studies Ceramics, National Art School, Sydney; Then, Central School of Arts and Crafts, London 1955–59; Travelled in Europe; Lived in Montreal Quebec 1955–60; Travelled east coast of USA; Returned to Sydney 1960; Elected member of the International Academy of Ceramics, Ariana Museum, Geneva 1971; Invited participant in ceramic seminar at World Crafts Council Conference in Mexico 1976; Guest artist, Haystack Mountain School of Crafts, Deer Isle, Maine USA 1976; Awarded First Crafts Council of Australia Award 1977; First elected President of the World Crafts Council (based in New York); Trustee of the Powerhouse Museum, Sydney; Lecturer at the Renwick Museum in Washington DC, USA; Lecturer at the Central School of Art and Design in London; Visiting Lecturer at the City Art Institute, Sydney.

Exhibitions One-woman shows at Westmount Gallery, Montreal Quebec 1960; Hungry Horse Gallery, Sydney 1963; Johnstone Gallery, Brisbane 1965, 1967; Gallery A, Sydney 1966, 1969; South Yarra Gallery, Melbourne 1970; 'Clay Plus Fibre' Invitation Exhibition with Mona Hessing at the National Gallery of Vic 1973; 'Clay Plus Fibre', Bonython Gallery 1973; Coventry Gallery, Sydney 1979, 87, 90. Participated in exhibition, von Bertouch Galleries, Newcastle 1963; Group Seven, Hungry Horse Art Gallery 1964; 'Art in Ceramics', Adelaide Festival 1964; 'Spirit of Sixty-Six' (Kaldor) with Jordan, Reinhardt and Kitching 1966; Art Gallery of SA, Adelaide Festival 1968; Guest exhibitor with Milton Moon, Auckland War Memorial Museum, NZ 1969; Mildura Sculpture Triennial 1967, 1970; 'Craft 70s', Art Gallery of NSW Travelling Exhibition 1972; Citta' di Faenza 32nd Internationale della Ceramica D'arte Contemporanae 1974; 'Australian Ceramics' sponsored by Crafts Broad, Australia Council 1974, 1976; 'Clay' sponsored by Crafts Board,

Australia Council, touring USA 1978, 1979; Citta' di Faenza 38th Concorso Internazionale della Ceramica d'Arte Contemporanae 1980; Ceramics Exhibition at Ivan Dougherty Gallery, Sydney 1981; Coventry Gallery (with Bridget Riley and Inge King) 1982; Selected to exhibit work with Sidney Nolan in Mexico City on the occasion of the UNESCO Conference on World Cultural Policies 1982; Ian Potter Foundation Sculpture Commission 1982–83 NGV; AGWA 1985; Tsukuba Expo, Japan 1985.

Awards Member of the Order of Australia, (A.M.) 1979; Awarded Senior Fellowship by the Crafts Board Australia Council 1980; Elected President World Crafts Council at the 9th General Assembly in Vienna 1980; Frequent travel as President of the World Crafts Council in Asia, Europe and North America; Sponsored by the Dept of Foreign Affairs, and the Crafts Board of the Australia Council 1981–; Member, the Australian delegation to the UNESCO Conference on World Cultural Policies in Mexico City 1982; Appointed a Member, the Australian National Commission of UNESCO 1982; Appointed Member of the Trust of the Museum of Applied Arts and Science 1982; January, Guest Lecturer, Central School of Art and Design, London 1983; Residency of the Denise Hickey Studio, Cité Internationale des Arts, Paris 1988; Australian Creative Fellowship 1990–93. Bronze commissions for New Parliament House, Canberra 1988.

Represented ANG, AGNSW, NGV, AGSA, AGWA, institutional and private collections in UK, Europe, USA, Hong Kong and Australia.

Bibliography *Encyclopedia of Australian Art,* Alan McCulloch: Hutchinson 1984; *Artists & Galleries of Australia*, Max Germaine: Craftsman House 1990.

GEIER, Helen ACT
Born Sydney NSW 1946. Painter, printmaker and teacher.
Studies National Art School, Sydney 1966–68; Alexander Mackie Teachers College, Sydney 1969; Postgraduate studies at St Martin's School of Art, London 1973; Teaching art in London 1970–73; Lecturer in painting Prahran CAE Melbourne 1974–80; Gloucestershire School of Art and Design, Cheltenham UK 1979; Lecturer in painting and drawing, Canberra School of Art, ACT 1981–85; Painting Workshop (full-time) 1986 –.
Exhibitions Solo shows at Bonython Gallery, Sydney 1974; Rex Irwin Gallery, Sydney 1976; Huntly Gallery, Canberra 1977, 81; Powell Street Gallery, Melb 1978; Axiom Gallery, Melb 1980, 82; Solander Gallery, Canberra 1984; Christine Abrahams Gallery, Melb 1985; Michael Milburn Gallery, Brisbane 1985; Coventry Gallery, Sydney 1986; Anima Gallery, Adelaide 1987. A host of group shows since 1972 include St. Martin's, London 1972; Postgraduate Exhibition, Staff and Students; Sussex University, UK 1973; Macquarie Gallery, Sydney; Huntly Gallery, Canberra; 'Twelve Lithographers', National Gallery of Victoria 1975; South Pacific Biennale (Travelling) 1976; Tokyo Print Exhibition (Travelling) 1976; 'Aspects of Love', Realities Gallery, Melb 1977; Works on Paper, Art Gallery of South Australia 1980; 'The Braidwood Show', Goulburn Regional Gallery, NSW 1986; 'Time and Place', Canberra School of Art, ACT 1986; Faber Castell Prize for Drawing Exhibition; Rex Irwin Gallery, Sydney 1986. Her work was included in *A New Generation 1983–88* at the ANG Canberra 1988.
Awards National Art Award, Canberra Times, ACT 1982; Matarra Festival of Newcastle; Peter Sparks Memorial Prize, NSW 1986.
Represented ANG; NGV; RMIT; Artbank; Coventry Collection; Canberra College of Advanced Education, ACT; St. Edmund's College Collection, Victoria; Parliament House Collection, ACT; Warrnambool Art Gallery, Victoria; Ballarat Art Gallery, Victoria; Newcastle Art Gallery, NSW.
Bibliography *Directory of Australian Printmakers* 1988.

GEMMELL, Nancy SA
Born Adelaide SA 1917. Traditional painter in oil and watercolour.
Studies SA School of Arts; Fellow, Royal SA Society of Arts; Historical research for National

Trust; Paints wildflowers for conservation bodies; Illustrated book *Gum Trees in South Australia,* for publication in 1979.

GENOFF, Karen **SA**
Born Adelaide 1958. Sculptures, collage.
Studies Adelaide CAE 1976–79.
Exhibitions AGSA 1982–83; CAS, Adelaide 1983; Adelaide Festival 1984. Participated Second Aust. Sculpture Triennial, NGV 1985.
Commissions Modbury Hosptital Sculpture, SA 1988.

GEORGESON, Valerie **SA**
Born Adelaide. Painter and printmaker.
Studies North Adelaide S of A — Dip. Painting and Printmaking 1985; Fellow of RSASA 1988.
Exhibitions Numerous shows since 1983 include RSASA Gallery 1984, 85, 88; Tynte Gallery 1987; Tessha's Gallery 1985; Domani Gallery 1986.
Represented Institutional and private collections in Australia and Switzerland.

GEORGIOU, Suzanne **SA**
Born Melbourne 1935. Semi abstract painter, designer, teacher.
Studies Mostly self taught. Studied design with Lyn Todd for two years. Fellow, RSASA; President of Adelaide Art Society; Teaches adult art classes.
Exhibitions Solo shows at Mount Torrens 1986; Lombard Gallery 1987; Regular group shows with RSASA and Adelaide Art Society and at Himeji, Japan 1989.
Awards Tea Tree Gully WC Prize 1989.
Represented Institutional and private collections in Australia and overseas.

GERBER, Fay Diane **VIC**
Born Melbourne Vic 1925. Ceramic artist, sculptor and jeweller, semi-abstract and realist in all media.
Studies RMIT studying under Stan Hammond, George Allan and Victor Greenhalgh. Further studies part-time at Caulfield Institute of Technology 1944–47; Diploma course in Cermaics, including Metalwork, at Royal Melbourne Institute of Technology 1968–71; Jewellery Design at Collingwood College of Technology and Further Education 1977 –.
Exhibitions Annually with Association of Sculptors of Vic; Participated in group exhibitions, Springfield Art Show, and Flinders Art Show; Exhibited with S. Hammond, A. Harbott, and A. Patience at Russell Davis Gallery, Armadale Vic 1981; In 1975, Stoneware pot exhibited in 'Crafts Victoria '75' at National Gallery of Vic and thence to Regional Galleries for remainder of year.
Represented Private collections in Australia, Belgium, and Holland.

GEYL, Virginia **NSW**
Born Eindhoven Holland 1917. Figurative painter in acyrlic.
Studies Newcastle Technical College, NSW.
Exhibitions von Bertouch Galleries, Newcastle NSW 1968, 1979, 1974, 1977, 1980, 1983, 1986, 1989; Bonython Gallery, Adelaide 1971; Galerie Het Kunstcentrum, The Hague Holland 1972, 1975 (solos); Armstrong Gallery, Morpeth NSW 1979, 1981, 1988.
Awards Two prizes at Technical College and the Mattara Festival Prize, Newcastle NSW.
Represented University of Newcastle and private collections in Australia and Europe.

GIBBS, Audrey **QLD**
Born Maryborough Qld 1921. Painter.
Studies ESTC; Brisbane Tech. College with Melville Hayson; Seven Hills C of A 1978.

Study tour to Russia and China 1987.
Exhibitions MacDonnel and East Ipswich 1971; Ardrossan Gallery, Brisbane 1986, 88.
Awards Brisbane Royal Show 1979, 82, 87; Faber-Castell Drawing Prize 1983; Warana-Caltex, Speld Art, RQAS; Corinda Art Show, SGIO Purchase 1984.
Represented Various public institutions in Brisbane, and private collections in Australia.

GIBBS, Denyse VIC
Born Melbourne Vic 1949. Painter and printmaker concerned with the synthesis of Art and Science.
Studies Melbourne University Vic College of the Art — Postgraduate Diploma 1973; Lived London UK 1974–75; Studied in Rome 1975–76; Lived in Jeddah Saudi Arabia 1978–82.
Exhibitions Solo shows at Tolarno Galleries, Melbourne 1972 and 1978; British Museum, London 1977; A Selection of Prints entitled 'An Aesthetic Approach to Entomology'; Commonwealth Gallery, London 1978, Prints and Drawings; Participated at Jeddah Expo Centre 1979; *Australian Perspecta* 1983; Art Gallery of NSW.
Awards VAB Grants 1973, 1975 and Myer Foundation Grant 1973, 1975.
Publications 'Artworks based on Entomology' by Denyse Gibbs; 'Leonardo' Art/Science International publication 1977.
Bibliography *Catalogue of Australian Perspecta* 1983; Art Gallery of NSW.
Represented National Collection, Canberra; National Gallery of Vic; Ballarat Art Gallery; Philip Morris and Artbank collection; Private collections in Australia, New York, London, Rome, South America, Japan and The Kingdom of Saudi Arabia.

GIBNEY, Jennifer VIC
Born Melb 1955. Painter, ceramic artist, stained glass designer.
Studies Prahran CAE, majored in drawing and printmaking.
Exhibitions Solo shows at Kay Craddock Bookshop Gallery, Melb. 1978–82, 86. Commissioned to design and execute stained glass windows based on Kenneth Graeme's 'The Wind in the Willows'.
Represented at Melb. Art Exchange.

GIBSON, Iris NSW
Born Aust. Flower painter.
Studies With G.K. Townshend, and later at RAS with F. Bates, A. Hansen, A. Murch. Has exhibited with the RAS, AWI and Ku-ring-gai Art Society.

GIBSON, Margaret (Shannon) NSW
Born Sydney. Painter in watercolour and oil.
Studies With private tutors and member of AWI for some years.
Awards Pring Watercolour Prize 1972.
Bibliography *Australian Watercolour Painters*: Jean Campbell: Craftsman House 1989.

GIBSON, Mary QLD
Born Narrandera NSW 1921. Painter of landscapes, flowers and animals in oil and pastel.
Studies Attended adult education classes and technical school seminars but mostly self-taught; Secretary of the Burdekin Art Society, Qld; Exhibits at Vanda Art Gallery, Ayr and Margarite Gallery, Townsville.
Awards Ayr Qld 1975; Bowen Qld 1975.
Represented Private collections in Australia and overseas.

GIBSON, Norma NSW
Born Sydney NSW. Impressionist, painter and portraitist in all media.
Studies Hornsby Technical College Art School (part-time) 1974–80. Selected to attend

International Art Workshop — New Zealand 1991.

Exhibitions Major solo shows at Access Gallery, Sydney 1988, 91: Many group shows since 1978 and recently at Gallery 460, Gosford 1984–88; Access Gallery 1986–88; Lochiel House Gallery 1987, 88.

Awards Has won over 36 prizes since 1977 and most recently at Hornsby 1986, 87; Fairfield 1986, 87, 88; Southern Cross 1988; Dubbo Council and Warringah Prize 1987; Willoughby Council 1989.

Represented Municipal, institutional and private collections in UK, Europe, Hong Kong, Australia.

Bibliography *Artists & Galleries of Australia*, Max Germaine: Craftsman House 1990.

GILES, Celia
NSW

Born UK 1953. Contemporary, abstract painter in oil and acrylic.

Studies Diploma, Fine Arts (painting), SA School of Art.

Exhibitions One-woman show at Gallery A, Sydney; Participated in group show, Gallery A 1974; With Garry Nichols and Angus Nivison, Gallery A 1978; 'Australian Women Artists', Paddington Town Hall NSW 1978; Contemporary Art to Indonesia, 'Landscape and Image' 1978; 'Gallery A Artists', Warehouse Gallery, Melbourne 1978.

Awards and Exhibitions Master Diploma 1973 and also Australia Arts Council Travelling Scholarship and Myer Foundaton Grant; Lived in London 1974–75; Awarded the same scholarship and grant again in 1975 and studied in Rome 1975–76; Potter Foundation Grant 1976 and returned to London; 'an Aesthetic Approach to Entomology' Exhibition, British Museum Natural History 1977; Publication, *Art Works Based on Entomology, Leonardo,* international science magazine, December 1977; Awarded Assistance Grant from Australian High Commission, London 1977; 'Prints and Drawings' Exhibition, Commonwealth Art Gallery, London January 1978; One-woman shows at Tolarno Galleries, Melbourne 1972, 1978.

Represented National Collection, Canberra; National Gallery of Vic; Private collections in Australia, New York, Rome, London.

GILES, Kerry (Kurwingie)
SA

Born Waikerie SA. Aboriginal painter, printmaker, ceramic artist and teacher.

Studies Her natural talents for art and craft were developed when a student at Katherine Homemakers NT in 1980.

Exhibitions AGSA and in New York 1988.

Awards SA Aboriginal of the Year 1986. Artist-in-Residence, Flinders University 1988; Participated in the SA Departments of the Arts Port Lincoln Aboriginal Organisation Mural.

Bibliography *Artlink* Autumn/Winter 1990.

GILES, Patricia
TAS

Born Hobart Tas 1932. Traditional painter of bush subjects, landscapes, mosses and lichens in oil and watercolour.

Studies Hobart Technical College; Tas School of Art, Diploma of Fine Arts under Jack Carington Smith; A life member of the Art Society of Tas and a member of the Australian Watercolour Institute, Sydney. Co-director, Lloyd Jones Gallery and taught Adult Ed. art 1960–65; Graduated Dip. Fine Art, Hobart S of A 1963–67. Taught Fahan School 1965; and Hobart S of A 1965–72.

Exhibitions Has held over thirty solo and joint shows since 1956 and in later years at Coughton Galleries and Handmark Gallery, Hobart and the Salamanca Place Gallery 1979–86. Participated widely in group shows from 1956 and in later years at TMAG 1956, 61, 63, 68, 73–76; Uni. of Tas. 1976, 78, 79; Burnie AG 1980; Art Centre Gallery 1980; Salamanca Place Gallery 1982; Freeman Gallery 1986.

Awards Purchased twice for Tas Museum and Art Gallery 1972; 1973 (watercolour); Devonport Dahlia Festival Watercolour Award; Visual Arts Board Purchase 1978.
Publications Her paintings of Coles Bay, Tas were used in a book of poems by James McAuley as a separate expression of the place the book is about, *A World of Its Own,* Canberra University Press.
Represented ANG; TMAG; QVMAG; Ballarat AG; Hamilton AG; Artbank, institutional and private collections in Australia and overseas.
Bibliography *Encyclopedia of Australian Art,* Alan McCulloch: Hutchinson 1984; *Australian Watercolour Painters 1780–1980,* Jean Campbell: Rigby 1983; *Tasmanian Artists of the 20th Century*, Sue Backhouse: Pandani 1988; *Artists & Galleries of Australia*, Max Germaine: Craftsman House 1990.

GILL, Susan VIC
Born Melb. 1954. Painter.
Studies Dip. FA and Graphic Design from Swinburn IT 1975–77; Dip. Fine Art, VCA 1978–81; Postgraduate Dip. Professional Art Studies, City Art Institute, Sydney 1987.
Exhibitions Solo show at St. Martins Gallery, Melb. 1985; Access Gallery, Sydney 1990, 91. Participated at Hawthorn City Gallery and ROAR Studios 1981; Ivan Dougherty Gallery 1987; The Works Gallery 1990.

GINGINGARA, Doris WA
Born Arnhem Land NT 1946. Talented Aboriginal painter and illustrator presently working in an outback mining town in WA.
Exhibitions Blaxland Gallery, Sydney 1990.
Bibliography *Alice 125*, Gryphon Gallery: University of Melbourne 1990; *Artlink* Autumn/Winter 1990.

GIRSCH, Irene QLD
Born Cairns, Qld 1963. Printmaker.
Studies Dip. Art, Qld. C of A.
Exhibitions Six Qld. Printmakers exchange show to Holland 1984.
Commissions Qld. C of A Print Portfolio 1987.
Bibliography *PCA Directory* 1988.

GITTOES, Joyce NSW
Born NSW. Ceramic sculptor, painter, teacher.
Studies St. George T.C.; teaches in her own studio.
Exhibitions Regularly at Barry Stern Galleries; NTMAG 1987; Jan Taylor Gallery 1991.
Awards Mural, Police H.Q., Darwin.
Represented Institutional and private collections in Australia and overseas.

GLASER-HINDER, April NSW
Born Sydney NSW 1928. Contemporary painter, sculptor and film maker.
Studies Diploma, National Art School 1967–71; Diploma in Art Education, Sydney Teachers College 1974; Presently working in Switzerland.
Exhibitions One-woman show 'Steel Ribbon Sculptures' 1977; Mixed shows painting and sculpture 1971, 1972, 1973; 'Soft Sculpture Hangings', Gallery A, Sydney 1976; Trudel House, Baden Switzerland 1979; Gallery Steinfels, Zurich 1981; Irving Sculpture Gallery, Sydney 1983; Painters Gallery, Sydney 1983; Bloomfield Galleries, Sydney 1991.
Represented Municipal Gallery, Lenbach House, Munich and the Transfield Collection; Private collections in UK, Europe and Australia.
Bibliography *Architecture Australia,* August-September 1976; *New Directions in Australian Sculpture; Art International* Vol 21/4 July 1977 *Steel Ribbon Sculpture,* August 1977; *Australian*

Sculptors, Ken Scarlett, Nelson 1980.

GLAZEBROOK, Clare QLD
Born Brisbane Qld 1924. Traditional painter in watercolour, line and wash.
Studies Part-time at Art Branch, Brisbane Technical College, and later studied Art History
and Appreciation with Dr Gertrude Langer and Life Drawing under the late Melville
Haysom; Member of Art Staff of the Kelvin Grove Teachers' College 1942–48; Current
member of the Half-Dozen Group of Artists.
Exhibitions McInnes Galleries, Brisbane; Sheridan Gallery; Qld National Gallery and
annually with the Half-Dozen Group of Artists; Solo Exhibition 1980 with the New Central
Galleries, Brisbane; Collaborated to illustrate the book 'Spring Hill Re-Sprung', 1980 –
(text by Jack Murphy).
Represented In private collections in Australia and overseas.

GLEESON, Betty NSW
Born Yeoval NSW 1944. Paintings, assemblages.
Exhibitions Solo shows at Watters Gallery 1984, 91; Muswellbrook Regional Gallery
Retrospective 1988; Muralla Gallery 1991. Numerous group shows since 1980.
Represented Municipal, institutional and private collections.

GLENN, Eve VIC
Born Aust. 1944. Painter muralist, community artist.
Studies Dip. FA – RMIT; TTTC Works as scenic artist for TV.
Exhibitions Gallery A, Chevron Gallery, La Trobe Gallery, Melb.

GLOVER, Cate (Whitehead) VIC
Born Stawell, Vic 1955. Painter, sculptor.
Studies Ballarat CAE, B. Fine Arts 1986–88. Member, Wildlife Art Society of Aust.
Exhibitions Horsham and Ararat Reg. Galleries, Mildura Art Centre and with WASA.
Represented Institutional and private collections in Australia and overseas.

GLOVER, Eileen VIC
Born Stawell, Vic 1924. Painter, teacher. Member, Ballarat Society of Artists.
Exhibitions Tas. Tourist Bureau, Melb. 1965. Horsham Reg. Gallery 1976, 80; Ararat Reg.
Gallery 1985; Mountain Grand Gallery, Halls Gap, Vic 1988; Warrnambool Regional
Gallery and Caulfield Arts Complex 1989; Gallery 449, Ballarat 1990.
Awards Warracknabeal Pioneer Museum painting 1977, 88; Stawell Rotary 1979.
Represented Corporate, institutional and private collections in Australia and overseas.

GLOVER, Joy NSW
Born NSW. Painter and sculptor.
Studies New York and Westchester County 1955, 56 and 1967, 69. RAS Sculpture Centre
and Willoughby Art Centre, Sydney.
Exhibitions Solo show at Sculpture Society, Sydney 1973 and participated in many groups
and exhibitions since 1962. Exhibiting member of Ku-ring-gai Art Society.
Represented Institutional and private collections in Australia and UK, USA and Asia.

GLOVER, Virginia (Carroll) NSW
Born Sydney 1946. Painter, designer, architect.
Studies With Desiderius Orban, John Ogburn, Stanislav Rapotec and John Olsen
1960–63; Graduated B. Arch. (Hons.) University of Sydney 1963–67. M. Environmental
Design from Yale University, New Haven USA 1969–71. Worked UK, Europe, Asia
1973–75; Established Carroll & Carroll, Architects in Sydney 1981.

Exhibitions Solo show at Blaxland Galleries, Sydney 1990; Numerous group shows since the 1970's recently at BMG Fine Art, Sydney 1990 and various Environmental Colour Installations in Sydney from 1985.
Awards Fulbright Travelling Scholarship to USA 1969.
Represented Corporate, institutional and private collections in UK, Europe, USA, Asia and Australia.

GLYNN, Anna NSW
Born Melb. 1958. Painter, sculptor, textile airbrusher, teacher.
Studies B.Ed. from Melb. CAE majoring in painting and sculpture 1979. Part-time tutor at Uni. of NSW 1986 and Penrith Regional Gallery 1986.
Exhibitions Solo show at Gates Gallery, Sydney 1987, participated at Hawthorn City Gallery, Melb. 1979; Thomastown Gallery and Factotum Gallery 1984; Sydney Textile Museum 1985; Balmain Galleries and Kake Gallery, Sydney 1985; New Designer Gallery and Lewers Bequest and Penrith Regional Gallery 1986; NSW Crafts Council 1986; Beaver Gallery, Canberra; Painters Gallery, Sydney; Tamworth National Fibre Exhibition 1988; Narek Galleries, ACT 1991; Pacific Design Centre, Los Angeles 1988.
Awards and Commissions NSW Crafts Council 1986; Award of Merit in the Australian Textile Art Prize 1979; Jennings Industries 1989; Paintings for Oceanic International Hotel.
Represented Corporate and private collections around Australia and overseas.

GODDARD, Gloria SA
Born SA 1942. Painter, textile artist, teacher.
Studies Dip. Teaching, Adelaide Teachers College 1958–60; SASA 1971–72; Sturt CAE 1972. Overseas study UK, Europe 1970, 76, 88; NZ 1982; taught at TAFE Colleges 1972–88.
Exhibitions Solo show at Greenhill Galleries 1975; participated at Tamworth 1980, 82; Ararat 1981, 83; Jam Factory 1980; North Adelaide S of A Gallery 1984, 85, 86.
Awards Jam Factory Acquisition 1980; Ararat 1981; Australia Tour 1983, 86.
Commissions Old Sydney Parkroyal 1987; Pier Hotel, Cairns 1988; The Terrace 1989.
Represented Institutional and private collections in UK, Europe, USA, Australia.

GODDARD, Inta WA
Born Latvia, arrived Australia 1949. Painter.
Studies Westminster College of Art, London 1969–70; First year, Dip. Fine Art, Claremont School of Art, Perth WA 1974; BA Fine Art, Curtin University 1977; Informal studies, Bath Academy of Art, UK 1979–80.
Exhibitions Solo shows at Gomboc Gallery, Perth 1984; Delaney Galleries, Perth 1990. Numerous group shows around Australia and UK.
Awards Curtin University 1976; York Fair, WA (Sculpture) 1977; Merredin Art Society 1978, 81; Bunbury City 1983; Manjimup Art Society 1984.
Represented Artbank, institutional and private collections in UK and Australia.

GODDEN, Christine NSW
Born Sydney NSW 1947. Photographer and teacher.
Studies Fine Arts and Architecture, Melbourne University 1964–66; Travelled in Europe, Asia and USA 1970–71; Photography at San Francisco Art Institute, California 1973; Graduated Bachelor of Fine Arts, San Francisco Art Institute and commenced studying with Nathan and Joan Lyons at the Visual Studies Workshop, Rochester New York 1974; Director of the Australian Centre for Photography 1978–83; Consultant curator, CSR Photography Project; studying architecture 1989 –.
Exhibitions 'Women working' at Advocates for Women, San Francisco Art Institute 1974;

'Women', State University of New York at Buffalo Visual Studies Workshop, Rochester 1975; Rochester Institute of Technology; George Paton Gallery, University of Melbourne; Australian Centre for Photography, Melbourne 1976.

GOFF, Patricia — WA
Born England UK 1931. Painter, printmaker, teacher.
Studies Dip. Fine Arts, Canterbury University NZ 1965–69; Assoc. Fine Arts (Painting), WAIT 1970–73; BA Fine Arts, WAIT 1980–82. Has lectured in Fine art at numerous technical colleges and workshops in Perth since 1973.
Exhibitions Solo shows at Undercroft Gallery 1983; Mt Lawley CAE 1984; Editions Gallery 1984; Fremantle Arts Centre 1985; Guildford Village 1989; Ricks Gallery 1990; Golden Mile Space 1990; New Collectables Gallery 1991. Over sixty group shows since 1971.
Represented Institutional and private collections in UK, Europe, South Africa and Australia.

GOLD, Margaret — VIC
Born Melb. 1944. Sculptor.
Studies VCA, Melb. 1982–84.
Exhibitions Solo shows at Manyung Gallery 1976; Craft Centre 1978; participated at Orleans House, London UK 1980; World Trade Centre, Melb. 1985; Festival of Perth and AGWA 1985; Judith Pugh Gallery, Melbourne with Georgina Hilditch 1990.

GOLDBERG, Jean — VIC
Born Melb. 1927. Embroiderer, textile artist, teacher.
Studies George Bell School.
Exhibitions Tamworth National Fibre Exhibition 1982, 84.
Bibliography *Alice 125*, Gryphon Gallery: University of Melbourne 1988.

GOLSKI, Kathy — NSW
Born Sydney NSW 1941. Figurative painter in oil, watercolour, gouache, pen and ink; Portraitist and teacher.
Studies Degree in Fine Arts from University of Sydney and at Goldsmith College, London, and UK; Lived in Papua-New Guinea with anthropologist husband 1981–83.
Exhibitions Has held one-woman shows in Canberra, Sydney and Melbourne since 1974 and Canberra Theatre Centre 1979, Solander Gallery 1984, The Collins St. Gallery 1988; Sussex Gallery, Sydney 1990; Capricorn Gallery, Melb. 1991.
Represented Royal College of Surgeons, London and institutional and private collections in UK, Europe, USA and Australia.

GOMME, Babette — NSW
Born NSW. Sculptor, painter, teacher.
Studies ESTC under Douglas Dundas, Arthur Murch, Geoff Townshend, Dorothy Thornhill, Lyndon Dadswell. Member, Society of Sculptors, Sydney.
Exhibitions Solo exhibitions at Woolloomooloo Gallery 1985 and Painters Gallery 1988.
Awards Taree 1984, 86; Port Macquarie 1986; Wauchope 1988; Kempsey 1988, 90.
Represented Municipal, institutional and private collections.

GOODALL, Margot — NSW
Born Fiji 1937. Printmaker.
Studies Printmaking at the Workshop Art Centre, Willoughby NSW under Sue Buckley, Bela Ivanyi and George Braker; Regular exhibitor with Sydney Printmakers and the Print Circle; Participated in Print Council of Australia shows in 1969, 1971 and graphic shows at

Mosman NSW and Shepparton Vic.
Represented Shepparton Regional Gallery, Vic.
Bibliography *Directory of Australian Printmakers* 1976.

GOODING, Yvonne NSW
Born Bendigo Vic 1926. Printmaker.
Studies Printmaking at Workshop Art Centre, Willoughby NSW from 1964.
Exhibitions With Sydney Printmakers and Print Council of Australia, Print Circle; Held
one-woman show at University of NSW 1975.
Awards Print prizes at Currabubula NSW 1970 and Tamworth NSW 1970.
Represented Art Gallery of NSW; Regional Galleries at Tamworth and Bathurst NSW;
Private collections around Australia.
Bibliography *Directory of Australian Printmakers* 1976.

GOODWIN, Alison SA
Born Broken Hill NSW 1953. Printmaker, teacher.
Studies Dip. Fine Art, Torrens CAE 1977, Postgrad. 1978; Postgrad. Fine Art SACAE
1982. Worked in UK 1988; lecturer Printmaking and Design at North Adelaide S of A
1984–89. Printmaker-in-Residence Aberfoyle Park High 1986; Gepps Cross Girls 1985;
Fremont High 1983.
Exhibitions Numerous shows since 1977 and recently at Anima Gallery 1983, 84; Gillians
Gallery 1984; Kensington Gallery 1986; BMG and CAC, Adelaide 1987.
Commissions Sheraton Hotel Complex 1985, 86.
Represented ANG, AGSA, New Parliament House, ACT private collections in UK,
Europe, Australia.
Bibliography *PCA Directory* 1988.

GORDON, Kay SA
Born 1910. Photographer, designer, painter, sculptor.
Studies Chelsea School of Art & Design and St. Martins College of Art, London. Agfa-
Gervart Audio-Visual Summer Schools; SACAE 1986; Fellow, RSASA; Associate of The
Royal Photographic Society, Adelaide.
Exhibitions Solo show at Iran-America Cultural Society, Teheran. Regularly with RSASA.
Awards Northern Telegraph Art Prize 1925; Lancashire UK 1928, 56.
Represented Institutional and private collections in Australia and overseas.

GORDON, Maureen SA
Born Nottingham UK 1945. Sculptor, painter, portraitist.
Studies Nottingham School of Art & Craft 1963–64; St. Martins School of Art, London
1964–67. Came to Australia in 1969 with her Adelaide born artist husband Jeremy Gordon.
Exhibitions Arts Laboratory, London 1968, 78; The Womens Art Show, Adelaide 1977;
Mildura Sculpture Triennial 1973; Adelaide Festival 1980; Tynte Gallery, Adelaide 1987.
Represented Institutional and private collections in UK, Europe and Australia.

GORDON, Robyn NSW
Born Sydney NSW 1943. Craftsperson, sculptor, teacher.
Studies Special Art Diploma, National Art School, Sydney and Sydney Teacher's College
1960–63; Diploma of Art Education, Alexander Mackie CAE 1976; Diploma of
Professional Art, City Art Institute 1981. Lived in India and Europe and Middle East,
1966–69. Travelled to Japan, South-East Asia and Greece between 1970 to 1984, and USA
in 1986. Secondary school teaching Sydney 1964–65, 70–79, London UK 1966–69; Part-
time lecturer City Art Institute 1982–83; Member of Australian Government, Department
of Education and Youth Affairs Task force on Education and the Arts 1983–84; Member of

National Reference Group for the (Commonwealth Schools Commission/ Australian Bicentennial Authority's) Bicentennial Australian Studies Schools Project 1985–87.

Exhibitions Solo shows at Macquarie Galleries, Sydney 1981, 82, 84, 85, 86; Fremantle Art Gallery 1983; BMG, Adelaide 1983, 86; Tas. Touring Show 1985; Neiman Marcus, Dallas USA 1986; 'Reef Daydream' – Permanent Installation Marine Wonderland, Townsville 1987; 'On the Edge', New England Regional Art Museum, Armidale, Perc Tucker Gallery, Townsville, Macquarie Galleries, Sydney 1988. Has participated in a host of important group shows since 1980 including 'Art Clothes', Group Show, Art Gallery of NSW 1980; 'Fancy Goods', Ralph Turner's Private Collection of Popular Jewellery, touring England, Scotland, Wales 1981; Crafts Council Centre Sydney 1982; Meat Market Centre Melb. 1983–84; NTMAS, 1983; 'Aspects of Australian Craft' Powerhouse Museum, Sydney 1983–84; Aralven Arts Centre, Alice Springs 1985; AGWA 1985; *Australian Perspecta* '85; Perc Tucker Reg. Gallery, Townsville; Fremantle Art Centre, WA; Contemporary Jewellery Gallery, Sydney 1987; AGNSW then touring Regional Galleries 1988.

Awards Ararat Gallery Miniature Textiles Acquisitions 1981; Batman Prize, Launceston 1983; Northern Territory Craft Prize, Darwin 1984; Alice Craft Acquisition, Araluen 1985; Broadley Ford Graphics Award, Cairns 1987; Crafts Board Grant 1982, 87.

Commission – Sculptural Installation for the Great Barrier Reef Marine Park Authority's Reef Wonderland Commission – design for one side of Pantechnican for Australian Bicentennary travelling exhibition 1987.

Represented ANG, AGSA, QVMAG, NTMAG, AGWA; Regional Galleries, institutional and private collections in Aust. and overseas.

Bibliography *Australian Perspecta* '85 – catalogue, Ursual Prunster and Niel Brown, 1985; *Art & Australia,* Vol. 24, No.2, Summer 1986; *PCA Directory* 1988; *Artists & Galleries of Australia*, Max Germaine: Craftsman House 1990.

GORE, Jennifer Anne (Jenny) nee BURDEN SA
Born Adelaide SA 1937. Artist in enamels, and teacher.

Studies Part-time art training at SA School of Art whilst working at Griftin Press as a commercial artist 1954–59; Studied various crafts at WEA 1972 and enamelling self-taught 1973. Craft certificate course in silver jewellery and photography 1975–77 also attended a number of workshops and summer schools 1975–77; Tutor in enamelling at Mitcham Village Arts and Crafts 1975–79 and DFE School 1978–79. Fellow of RSASA 1980; Member, Craft Council SA 1973–90; Worked and studied overseas in UK, Europe, India and USA 1983, 84, 87, 90.

Exhibitions Solo shows at Beaver Galleries, ACT 1980 and 1983; Studio 20, Blackwood SA 1984, 86; Retrospective at Wangaratta, Vic. 1987. Many group shows since 1975 including David Driden Gallery, Clarendon SA 1982 and Berrima Galleries, NSW 1983; Meat Market Centre, Melbourne 1985; Prouds Gallery, Sydney 1986; Tokyo 1987; West Germany 1987; USA 1987; Craft Council, Sydney 1988; David Jones, Adelaide 1989, 90; France 1990; David Jones, Sydney 1991.

Awards RSASA Craft Award 1979–80; Salisbury Acquisitive Prize 1982; Advisory Committee Grant, SA; Many commissions for wall panels and coats of arms since 1978.

Represented Artbank, Salisbury City Council and private collections in Australia and USA.

GORMON, Lynne NSW
Born Quirindi NSW 1946. Painter of Australiana in oil.

Studies Sydney Teachers College.

Exhibitions Solo show at Vivian Gallery, Sydney 1977, group shows at Geo Styles, Van Dorff and Saints Galleries.

Awards Oyster Bay 1979; Sutherland Shire Acquisitive 1982.

Represented Sutherland Shire Council, De La Salle College and private collections.

GORRING, Jackie NSW
Born Maitland NSW 1953. Printmaker.
Studies BA Visual Arts, Newcastle CAE 1972–76.
Exhibitions Berkeley USA 1986; Goulburn and Maitland Reg. Galleries 1988; Canberra Contemporary Art Gallery 1988.
Bibliography *PCA Directory* 1988.

GORTER, Kirsty VIC
Born Vic. Paintings, textiles and craftworker, noted for her 2D images of painting and textiles.
Exhibitions Meat Market Craft Centre-Blackwood Street Gallery Melb. 1988.

GOSBELL, Robyn NSW
Born Sydney 1943. Genre painter in oil, acrylic, watercolour pastel.
Studies Gymea T.C.
Exhibitions Solo show at von Dorft Gallery 1987.
Awards Figurative Painting Prize, Sydney Royal Easter Show 1988.

GOTTLIEB, Julie NSW
Born Brisbane. Medical practitioner and painter.
Studies MB.BS. Uni. of NSW 1974–79. ESTC 1976–80; Nice Academy of Art, France 1982.
Exhibitions Nice 1982; Holdsworth Gallery, Sydney 1988.

GOUGH, Joan VIC
Born England 1918, arrived Australia 1921. Painter and teacher.
Studies Diploma of Art and Diploma of Applied Art, Hobart Technical College, Tas; Diploma of Education, University of Tas; Fine Arts A, University of Melbourne; Advanced Diploma of Education, Mercer House, Melbourne; Studied under Archibald Colquhoun 1948; National Gallery School 1959; Council member, Royal Tas Art Society 1942–44; Member, Vic Artists' Society 1945–68; Committee member, VAS 1946–48; Member, Contemporary Art Society, Vic 1970–78; Vice-president, CAS 1972; President, CAS 1973–78; Owner-director, Studio Gallery, Punt Road, South Yarra 1974 –. Member, Ministry for the Arts, Visual Arts Committee 1987–88.
Exhibitions OBM's Hobart Tas 1938; Studio Exhibitions, Tas 1939, 1942, 1945; Cascade Gardens, Tas 1939; Group show, Royal Tas Art Society, 1939, 1941, 1942, 1943; Teachers' College, Tas 1943; Studio, Burwood East, 1955, 1958, 1963; Colac Arts Festival 1968, 1969; Studio group show, VAS 1970; Studio, Warrandyte 1972; Studio Gallery, Kew 1973, 1974; Studio Gallery, South Yarra 1975, 1976, 1977, 1978; Group show, Vic Art Society 1945, 1958, 1968; CAS show, Windsor Gallery, 1970; CAS, Hawthorn Gallery, 1972; CAS, Forest Hill Festival 1974, 1975; CAS, Perth 1974; CAS, Women's Exhibition 1975; CAS, Studio Gallery, 1976–89; Jennifer Tegel Gallery, San Francisco, 1985; Major retro show at CAS Gallery 1985; Assemblages at McClelland Gallery, Melbourne 1990.
Awards Rotary Exhibition Prizes 1935, 1936, 1937; Under the patronage of the late Sir Ernest and Lady Clarke, Governor of Tas 1939, 1940; Exhibit Acquisition by Dr Pearson, Curator, Tas Museum and Art Gallery 1943; CAS Prize 1983, 88.
Publications *Carrion Flower Writ.* Nosukumo, Industrat Vol.2 Illustration; *Points in Time –* Berold, Dixon and Strugnell, Publisher Coghill, 1985. Reprinted 1986. Illustrations.
Represented Private collections in Australia, UK and the USA.
Bibliography *Artists & Galleries of Australia*, Max Germaine: Craftsman House 1990.

GOUGH, Rowena VIC
Born Maryborough Vic 1958. Silversmith and designer.

Studies Dip. Art/Design, RMIT 1978; B.Ed. Melb. State College 1980.
Exhibitions Aust. Jewellery Touring Show 1979; West Germany 1980; Tim Standfield Gallery 1981; Jewellery Touring Show to UK, Europe 1982.
Represented ANG, NGV, AGWA, QVMAG, Powerhouse Museum, Sydney. Private collections Australia and overseas.

GOUGH, Vanessa VIC
Born Melbourne Vic 1950. Ceramic artist.
Studies Diploma, Fine Arts (ceramics), RMIT: Diploma of Education, Mercer House, Melbourne; Member of Ceramic Group, Vic and editor of newsletter; Member of CAS, Melbourne 1971–83.
Exhibitions Colac Arts Festival 1968, 1969; VAS Studio Group 1970; Deepdene Art Show 1972; Elizabeth Street Art Show 1972; CAS, Women's Show, Melbourne 1974–83; One-woman show, Studio Gallery, South Yarra 1977; VCG Annual Exhibition, Melbourne 1978; ORE Studio Gallery, South Yarra 1978; Studio Gallery 1983.
Awards Kelvin Award for pottery, RMIT 1971; Canberra Travelling Art Show Award 1963.
Represented Private collections in USA, Manila, South Africa and Australia.

GOWER, Elizabeth VIC
Born Adelaide SA 1952. Painter in oil, mixed media, collage; Teacher.
Studies Prahran College of Advanced Education 1970–73, Mercer House Teachers College 1974. Taught Prahran High School 1975–77. Studied Paris 1980; Paretaio, Italy 1983. Lecturer VCA 1978–84; lecturer; Uni. of Tas. – Centre for the Arts 1985–86; Head of Painting VCA 1987 –.
Exhibitions One-woman shows – Hawthorn City Art Gallery 1975; Institute of Contemporary Art, Sydney 1976; George Paton Gallery, Melbourne University 1976 and Powell Street Gallery, Melbourne 1977; Axiom Gallery, Melbourne 1980, 1982; Coventry Gallery, Sydney 1981; Institute of Modern Art, Brisbane 1982; Christine Abrahams Gallery, Melbourne 1983, 84; 312 Lennox St. Gallery 1987, 89; Bellas Gallery Brisbane 1988, 89. Group shows — Powell Street Gallery 1975; WA Institute of Technology, Perth 1975; Institute of Modern Art, Brisbane 1976; John McCaughey Memorial Art Prize, National Gallery of Vic (Melbourne); 3rd Biennale of Sydney, Art Gallery of NSW (Sydney); 'Aspects of the Biennale of Sydney' Pitspace (Melbourne); 'Three Artists' Powell Street Gallery (Melbourne) 1979; 'Drawn and Quartered: Australian Contemporary Paperworks' Art Gallery of SA (Adelaide Festival Exhibition) 1980; Art Gallery of NSW (Sydney) 1981; '10 Years' Ewing and George Paton Gallery (Melbourne) 1981; *Australian Perspecta* 1981; National Gallery of Vic, John McCaughey Prize 1983; *Aust. Perspecta* '85; Fine Arts Gallery, Hobart; Venice, Italy and Belgrade, Yugoslavia 1985. Ray Hughes, Sydney 1986; NGV; Holdsworth Contemporary Galleries; MCA, Brisbane; Power Institute, Sydney; Jam Factory, Adelaide; Arts Council, Canberra 1987. AGNSW, Westpac, Melb., AGWA, Qld. AG 1988. *Ten by Ten* 200 Gertrude St. Gallery 1988; Moët & Chandon Touring Exhibition 1988.
Awards Lynch Prize for painting 1973; Overseas Travel Grant, Visual Arts Board, Australia Council — travelled to New York, London, Europe etc 1977, 1978; Special Projects Grant, Visual Arts Board, Australia Council 1978; Alliance Francaise Art Fellowship — study in Paris 1980. Artist-in-Residence, Paretaio, Italy 1983, 84.
Represented ANG, NGV, AGSA, Artbank, Regional Galleries, institutional and private collections in Aust. and overseas.
Bibliography *Encyclopedia of Australian Art,* Alan McCulloch: Hutchinson 1984; *Artists & Galleries of Australia*, Max Germaine: Craftsman House 1990.

GRACE, Helen NSW
Born Warrnambool, Vic. 1949. Photographer, film maker.

Exhibitions Solo shows at Australian Centre for Photography 1983; Mori Gallery 1989. Many group shows since 1977 include Ewing and George Paton Galleries, Melbourne 1981; Experimental Art Foundation, Adelaide 1977, 82; Musee d'Art Moderne de la Ville de la Paris 1983; Guggenheim Museum, New York 1985; Union St. Gallery, Sydney 1988; ANG-Univesrity Drill Hall 1989.
Awards Sydney International Film Festival; American Film Festival, New York 1983.
Represented ANG, institutional and gallery collections in UK, Europe, USA and Australia.

GRAHAM, Anne NSW
Born England 1949. Sculptures, paintings, performance, installations.
Studies Manchester Polytechnic: Dip.Ed., painting 1969; Royal College of Art: MA 1973; WA Institute of Technology: Grad. Dip.Ed 1983; University of New England: Enrolled B.Soc.Sci 1988.
Exhibitions Solo shows at Praxis, Fremantle, WA 1986; Darklight Photography Gallery, WA 1983; Museum of Western Australia, Installation 1984; Australian Centre for Photography, Sydney 1984; AVAGO, Sydney 1985; Roslyn Oxley9, Sydney 1988. Numerous group shows since 1973 include RCA and Cockpit Galleries, London UK 1973–74; Lewers Bequest Gallery, Penrith NSW 1985; *Australian Perspecta '85*, AGNSW; *The Biennale of Sydney* 1986; Chameleon Gallery, Hobart 1986; *Third Australian Sculpture Triennial,* NGV 1987.
Awards Sanderson Travel Scholarship, UK 1974–75; West Australian Arts Council Grant 1976; Visual Arts Board Grant for Metropolitan Remand Centre 1982.
Represented Western Australia Library; Perth Technical College, Western Australia; West Australian Institute of Technology, Perth; University of Western Australia, Perth; Parliament House Collection, Canberra; Transfield Corporation, NSW; Private Collections UK and Australia.
Bibliography *Artists & Galleries of Australia*, Max Germaine: Craftsman House 1990.

GRAHAM, Anne VIC
Born Vienna 1925. Painter and sculptor.
Studies Vienna under Professor Cizek 1932–35; Melbourne Technical College 1939–42; National Gallery Art School 1948–49; George Bell School 1951–53; In Italy under Emilio Greco and Oskar Kokoschka 1959; Museo di Capodimonte Restoration Depts and Uffizi Gallery; Vic Archaeological Survey; Lectured Melbourne University School of Architecture on composition and design, art techniques allied to architecture, creative arts for children 1961–66; Melbourne *Age*, series during 1950s; Publishing commissions for Heinemann, Cheshire and National Gallery Society; Artist attached University of Sydney archaeological survey on Greek island of Andros 1970; Artist to La Trobe University pre-history dept; Member CAS Vic; Founding member of 'Essentialists' and 'Figuratives Now' groups; Council of National Gallery Society 1965–67. Member of WAR.
Exhibitions One-woman show at Casa Della Asta, Naples Italy 1959; Leveson Street Gallery, Melbourne 1966; Australian Galleries, Melbourne 1966; Argus Gallery, Melbourne 1966; Cox Foys Gallery, Adelaide 1966; Johnstone Gallery, Brisbane 1966, 1969; Macquarie Galleries, Sydney 1967, 1971; Toorak Art Gallery, Melbourne 1969, 1970; John Leach Gallery, Auckland 1970; Lidums Art Gallery, Adelaide 1970; Gallery Petit, London 1971; Max Bollag Gallery, Zurich 1972; Holdsworth Galleries, Sydney 1972; Manyung Gallery, Vic 1974, 1975, 1977; Sidenham Galleries, Adelaide 1976; Collectors Gallery, Perth 1976; Murphy Street Print Room, Melbourne 1976; Hogarth Gallery, Sydney 1976; Anna Simon Gallery, Canberra 1976; Town Gallery, Brisbane 1976, 1978; Shepparton Art Gallery, 1976; David Sumner Gallery, Adelaide 1977; Saddler's Court Gallery, Richmond, Tas 1977; Town Gallery, Brisbane 1978; Art of Man Gallery, Sydney 1980; Qantas Gallery, London UK 1979; Retrospective show, Georges Gallery, Melbourne 1982; Barry Stern,

Sydney 1982; Benalla and McClelland Regional Galleries 1983; Adelaide Festival, Greenhill Gallery 1984; Touring show to Vienna, Zurich and Munich 1984; Solander Gallery, Canberra 1985; Town Galleries, Brisbane 1987; Barry Stern Galleries, Sydney 1988; McClelland Gallery Melb. and touring Vic. Reg. Galleries 1990–91; Japan 1991.

Awards Springbrook Art Prize (painting) 1966; *Australian* newspaper Drawing Prize 1970; Jacaranda Art Prize (drawing) 1976; Carlo Levi Art Prize (painting) 1976; La Trobe Valley Acquisitive Prize (painting) 1976; Italian Government Travelling Scholarship 1959; Adelaide Festival *Porgy and Bess* programme design; Art films *Day Dream*, Nigel Buesst 1966; *Sundaze* State Film Centre 1967; *Impressions of Greece* (drawings) 1971; *The Little Theme*, State Film Centre 1968; *Anne Graham*, Brian Adams, ABC-TV 'Art in Perspective' 1978; Her painting *Children Playing* selected by UNICEF for use on greeting cards for the International Year of the Child 1979; Melbourne International Centenary Exhibition 1980.

Represented Benalla Reg Gallery; Collections of Melbourne and La Trobe Universities; State Galleries of Vic, WA, Qld; Dunedin and Auckland NZ; Regional Galleries, Shepparton, La Trobe Valley Vic; Private collections in Australia and overseas; Fountain, Southern Cross Hotel courtyard, Melbourne; Fountain, Park Towers, First Floor, Sprint Street, Melbourne; Four relief murals, Seventh Day Adventist Sanitarium, Sydney; Two glass mosaic freizes, Roman Catholic Cathedral, Bendigo Vic; Glass mosiac mural, Red Tulip Factory, High Street, Prahran Vic; Glass mosaic mural, St Peter's Church, Box Hill Vic.

Bibliography *Who's Who of Australian Women* 1982. *Encyclopedia of Australian Art*, McCulloch, Hutchinson 1977; *Paintings by Anne Graham*, Ronald Greenaway, Aldine Press 1969; *Australian Naives*, Bianca McCulloch, Collins 1977; *Twentieth Century British Naive and Primitive Artists*, Lister and Williams, Astragal 1977. *An Essential Vision, The Art of Anne Graham* by Joan Ackland, Greenhouse Publications 1988; *The World Encyclopedia of Naive Art*, Frederick Muller 1988; *Artists & Galleries of Australia*, Max Germaine: Craftsman House 1990.

GRAHAM, Beverley (Knox) VIC
Born Melbourne Vic 1932. Painter of wildflowers in watercolour, gouach, pen and ink.
Studies RMIT 1949–51; Commerical fabric designer 1951–56; Melbourne CAE, sculpture and ceramics 1969, painting 1970–73; Commercial artist 1960–65 and 1968–70; Now specialises in painting Australian flora; exhibition director of the Wildlife Art Society of Australia 1982–84.
Exhibitions Solo show at Corowa Golf Club 1976; Participated at Mornington Peninsula -Arts Centre 1978–79; Annually since 1978 at Wildlife Art Society and at many other shows including *Flowers and Gardens,* The Mall Gallery, London UK 1984; *Australian Decorative Arts 1900–1985;* ANG Canberra 1988–89; Many commissions for wildflower paintings.
Represented ANG, Artbank, corporate institutional and private collections in Aust. and overseas.

GRANITES, Alma Nungarrayi NT
Born 1955. Aboriginal painter in acrylic from Yuendumu, Central Australia. Warlpiri language group.
Represented SA Museum.

GRANITES, Dolly NT
Aboriginal painter in acrylic from the Yuendumu area of Central Australia.
Exhibitions New York 1988 group show.

GRANITES, Judy Nampijinpa NT
Born 1934. Aboriginal painter in polymer paint on canvas from Yuendumu, Central Australia. Warlpiri language group. Her paintings are large and colourful and she is some-

times assisted by other women painters in the Papunya area.
Exhibitions ANG, Canberra 1989.
Represented ANG.
Bibliography *Windows on the Dreaming,* ANG 1989.

GRAY, Alexandra NSW
Born 1950. Printmaker.
Studies Waverley-Woollahra Arts Centre 1986; ESTC, Nat Art School 1988.
Exhibitions ESTC Cell Block 1988; Bridge St. Galleries 1988.
Bibliography *PCA Directory* 1988.

GRAY, Dorothy (Sister Dorothy) VIC
Born Swan Hill Vic 1920. Naive painter and teacher.
Studies Early art studies at Genazzano Convent, Kew Vic where, while still a student, she decided to enter the convent and make teaching her life; She taught art for many years and was moved to the Stella Maris Convent at Frankston Vic in 1972 where she joined the Peninsula Art Group; She was awarded her Diploma of Fine Arts (painting) at the Caulfield Institute of Technology in 1975 and she won the competition for the Mornington Art Prize in 1976.
Bibliography *Australian Naive Painters,* Bianca McCullough, Hill of Content, Melbourne 1977.

GRAY, Jean VIC
Born Melbourne Vic 1927. Realist painter in all mediums; Teacher.
Studies Diploma of Graphics from Swinburne Technical College 1947–50; RMIT 1951 and graduate course at Glasgow School of Arts UK. Taught at Council of Adult Education, Geelong Grammar School, and VAS; Overseas travel to UK 1981; Member of VAS, Melbourne Society of Women Painters and Sculptors, and the Old Watercolour Club; Has held many exhibitions since 1965.
Awards Mordialloc Acquisitive Prize 1982; Bright 1982; Tallangatta 1982.
Represented Benalla Regional Gallery, Geelong Grammar School; Collections in UK, USA and around Australia.

GRAY, Norma NSW
Watercolour painter.
Studies Dip. Art, Sculpture, Nat. Art School and later at TAFE.
Exhibitions Solo shows at Old Brewery Gallery Wagga 1984, 85, 87, 89; Wilena Gallery, Sydney 1988; Artarmon Galleries 1988.
Awards Hawkesbury Shire 1984; Fishers Ghost 1984; Hurstville Council 1985, 86, 89.
Represented Municipal institutional, private collections in Australia and overseas.

GREEN, Anne QLD
Born Qld. Traditional painter in oil, ink, pencil, charcoal and teacher.
Exhibitions First one-woman show at Rockhampton Civic Art Gallery 1971 and recent one-woman shows at McInnes Galleries, Brisbane in May 1978, 1979; Gallery Creative, Toowoomba 1979; New Central Gallery, Brisbane 1980; Galloway Galleries 1982; Greythorn Galleries, Melbourne 1982.
Awards Joint First Prize for her two entries, Rockhampton Art Prize 1974 (Judge Sir William Dargie); Cloncurry Art Prize 1975; Visual Arts Board Grant to attend fine arts seminar in Perth 1973.
Publications *Not To Be Trusted,* Boolarong Press, Brisbane 1979; Also *Drawn to the Coast 1982* and *In Trust* 1982 by same publisher.

GREEN, Denise NEW YORK
Born Melbourne Vic 1946, lives New York USA. Modern painter.
Studies The Sorbonne, Paris 1969; Master of Fine Arts from Hunter College, New York.
Exhibitions Ray Hughes Gallery, Brisbane; Hogarth Galleries, Sydney; Whitney Museum of Art, and Art Resources Centre, New York 1975; RMIT and Institute of Modern Art, Brisbane 1977; Max Protech Gallery, New York 1976, 1978, 1980; Franklin Furnace, New York, performance with Elizabeth Sacre 1981; Belgium 1982, 84, 86; Axiom Gallery, Melb. 1982; Gallery A, Sydney 1982, 83; Christine Abrahams, Melb. 1983, 85, 86, 87, 88, 89. USA 1982, 85, 86, 87, 88; Roslyn Oxley9 Gallery Sydney 1985, 86, 88, 89; Uni. of Melb. retro 1988. Participated in many important group shows in American and Australia since 1972 and recently at *Australian Perspecta 1981* at the Art Gallery of NSW, and Women's Group Show at Gallery A, Sydney 1982 and a further forty eight group shows in Australia and overseas until the end of 1989.
Represented ANG, AGNSW, QAG, NGV, many corporate, institutional and private collections in UK, Europe, USA, India, Australia.
Bibliography *Catalogue of Australian Perspecta 1981,* Art Gallery of NSW; *Art International* September 1979, Elwyn Lynn; *Artists & Galleries of Australia*, Max Germaine: Craftsman House 1990.

GREEN, Janina VIC
Born Essen, Germany 1944. Printmaker, photographer, writer.
Studies Victoria College, Prahran. Diploma FA at RMIT. University of Melb. Co-producer of documentary films and videos on class and social issues. Currently art reviewer for *The Melbourne Times.*
Exhibitions Artists Space, Melb. 1986; Aust. Centre for Photography, Sydney 1987; Artists Space, Melb. 1988; participated in *Australian Photography 1978–88,* ANU Canberra 1988; ACCA, Melb. 1988.
Represented ANG Canberra, NGV, Griffiths University, Waverley City Gallery.

GREEN, Kaye L. VIC
Born Ulverstone, Tas 1953. Painter, printmaker, teacher.
Studies Graduated Bachelor of Arts from School of Art, Hobart Tas 1973–76, and Master of Arts from University of New Mexico USA 1979–81. Taught Dept. of Ed. Tasmania 1977–79 and Uni. of New Mexico 1980–81; Uni. of Tas. Summer School 1982; VCA, Melb. 1982. Worked at Tamarind Institute of Lithography USA 1980–81; senior tutor in printmaking at Gippsland IAE Vic. 1982 –.
Exhibitions Solo shows at Umeda Art Gallery, Osaka, Japan; Powell St Graphics 1984, 86, 88, 90; Griffith University, Brisbane 1984; Sale Regional Arts Centre 1985; Powell St. Graphics 1986; Roz MacAllan Gallery, Brisbane 1987; Grafiris, Helsinki, Finland and La Trobe Valley Arts Centre 1988. Numerous group shows include Uni. of New Mexico Travelling Show 1980; Tamarind Lithography Show, USA 1980; PCA Travelling Show, Vic 1984; '150 Women Artists', Melb 1985; MPAC 1987; Ipswich Regional Gallery 1987.
Awards Tas Council VAB 1977; Ford Foundation Grant USA 1978; VAB Grant 1982; Artist-in-Residence, VAB and Griffith University 1984; Griffith University Print Edition 1984, 87; Print Council Member Print 1987.
Represented School of Art, Hobart; Burnie Art Gallery; Devonport Art Gallery; Visual Arts Board, (Tasmania Council); University of New Mexico, Fine Arts Museum, USA; Tamarind Institute, USA; Umeda Art Gallery, Osaka, Japan; Tokyo Sculpture Centre, Japan; La Trobe Valley Art Foundation, Vic.
Bibliography *PCA Directory* 1988.

GREEN, Sue NSW
Born Melbourne 1939. Painter of traditional landscapes in oil.

Studies Under Walter Chandler and Garret Kingsley; Member of St George Art Society since 1966.
Exhibitions Solo shows at Von Dorff Gallery, Sydney 1978, 1979, 1980, also shows at Saints Gallery, Geo Styles Gallery, Boyd Gallery, Camden NSW.
Awards Oyster Bay Traditional 1980.
Represented Institutional and private collections in Australia and overseas.

GREENHALGH, Audrey Edith WA
Born Ravensthorpe WA 1903. Painter of landscapes and seacapes in oil and watercolour.
Studies Self-taught with encouragement from Robert Campbell and James Cook; Life member and many times vice-president of the Perth Society of Artists; Foundation committee member of the Royal Agricultural Society Art Purchase Prize.
Exhibitions Claude Hotchin Gallery 1951, 1959; Newspaper House 1953; Cremorne Gallery 1970, 1973; Retrospective exhibition at Fremantle City Art Gallery 1983. Included AGWA 1987.
Awards Kwinana Shire Prize 1964.
Represented Albany Regional Hospital Collection; Art Gallery of WA; Sir Charles Gairdner Hospital Collection; City of Fremantle Collection; Hawks Hill Gallery Collection; King Edward Hospital Collection; Parliament House Collection; Parmelia Hotel Collection; Ravensthorpe Junior High School; Royal Perth Hospital Collection; Numerous country shire collections; Many private collections in WA, SA, Vic, USA, UK and Singapore.

GREENHILL, Anne WA
Born Perth WA 1941. Abstract sculpture and drawing in mixed media.
Studies Claremont School of Art, WA.
Exhibitions Quentin Gallery, Perth 1982 and Claremont School of Art 1982.
Represented Claremont School of Art, WA; Education Department, WA; Rural and Industries Bank, WA; Private collections in Australia.

GREENWOOD, Ann VIC
Born UK 1939. Weaver, textile artist, teacher.
Studies Swinburne IT and trained as a primary school teacher. Since 1969 has been involved with classes for Council of Adult Education, including the establishment of a weaver's workshop and classes in primitive weaving; Taught extensively for craft organisations and educational establishments in Melbourne, Vic and interstate; Lectured at SCV, Melbourne in 1975, 1976 part-time; Led a group of craft-oriented people to South America visiting many museums' weaving centres 1974–75; Visited Peru and Navajo centres in New Mexico and Arizona 1977–78; In-depth tour of Peru 1978–79; Awarded a maintenance grant by Craft Board 1975; Second grant to finance exhibition 'Woman' 1977; Conducted workshops Bali and Lombok 1988; Wool Technologist for the Australian Government in Bhutan 1990; Workshops in NZ 1991. Tutor in Textiles, East Gippsland College of TAFE 1986–89. Lives in Gippsland, Vic.
Exhibitions Hawthorn City Art Gallery, rugs and hangings; Queen Victoria Art Gallery, Launceston 1973; Narek Galleries, Canberra; Dennis Croneen Galleries, Melbourne 1974; Distelfink Gallery 1975, 77, 79; Narek Galleries 1978, 82, 83; Imago Gallery 1977; RMIT Gallery 1978; Old Bakery Gallery, Sydney 1979; CAC, Melbourne 1980; Australian Wool Corporation 1981; Bowerbank Mill, Tas. 1981; Ararat Art Gallery 1981; Gryphon Gallery 1983; Gallery Indigenous 1985; Sale Regional Arts Centre 1987; Raya Gallery 1988; International School of Weaving, Picton NZ 1991. Represented at Expo 74, Spokane Washington 1974; Distelfink Gallery, Melbourne; 'Crafts Alive' 1975; 'Crafts Victoria' 1975; Narek group exhibition, Canberra; 'Woolworks' Group Exhibition, Ararat Gallery 1975; Miniatures Exhibition, Distelfink 1976; Distelfink, Melbourne June 1977; 'Imago',

Melbourne October 1977; Group rug exhibition, Distelfink, Melbourne August 1977; Narek, Canberra; RMIT, Melbourne 1978; 'Australian Weavers in Wool', Royal Show Awards 1978; Meat Market Centre 1980; Australian Craftworks, Sydney 1981; Australian Crafts 1982; Gallery Indigenous 1984; MPAC 1985; QVMAG 1986; Sale Regional Gallery 1987.

Commissions In recent years has completed many commissions for wall hangings and stage curtains for municipalities in ACT and Victoria including the Victorian Arts Centre.

Represented Circulating collection, National Gallery of Vic; State College of Vic, Coburg; Canberra College of Advanced Education; Ararat Art Gallery; Arts Victoria 1978 Collection; Private collection in Australia and overseas.

GREGAN, Kerry TAS

Born Sydney NSW 1950. Contemporary painter in oil and acrylic.

Studies National Art School, Sydney 1968–71; Travelled New Guinea; New York USA 1981–82.

Exhibitions Solo shows at Robin Gibson Gallery, Sydney 1977; Collectors Gallery, Perth 1977; Philip Bacon Galleries, Brisbane 1978; David Jones Gallery 1979; Gallery A, Sydney 1982; Realities Gallery Melb. 1983, 85; Garry Anderson Gallery, Sydney 1984, 1985; Peter Crocker Gallery, Sydney 1985; Salamanca Place Gallery, Hobart 1986. Numorous group shows since 1974 include Robin Gibson Gallery, Sydney 1977, 79; Bonython Gallery, Adelaide 1977; David Jones Gallery, Sydney 1980, 83; Bloomfield Galleries, Sydney 1983; Warwick Arts Trust, London UK 1985; Gary Anderson Gallery Sydney 1986, 89.

Represented Visual Arts Board, Australia Council; Philip Morris Collection; Bendigo Art Gallery; CBA Collection; Milperra College of Advanced Education; AGNSW; Parliament House, Canberra; Artbank and private collections.

Bibliography *Modern Australian Painting 1975–80,* Kym Bonython, Adelaide, Rigby 1981.

GREGORY, Joan M. QLD

Born Qld. Painter, textile worker, teacher.

Studies Part-time study Central Technical College, Art Dept., with tutors C.G. Gibbs and Melville Haysom; Australia Council Vacation Schools with John Rigby and Andrew Sibley; Diploma of Fine Art, Brisbane College of Art; Graduate Diploma of Teaching, Brisbane College of Advanced Education, Kelvin Grove Campus; Associate Diploma in Visual Arts (Textiles), Brisbane College of Advanced Education, Kelvin Grove Campus.

Exhibitions Solo show at Chernside Gallery, Brisbane and Dawson Gallery, Gatton, Qld; participates at Design Arts Centre, RQAS and Half Dozen Group.

Awards Shell-Mareeba 1977; Quota Prize 1985; Redlands Prize 1985 (shared).

Represented Institutional and private collections in Australia and overseas.

GREGORY, Nina VIC

Born Yugoslavia, arrived Australia 1959. Naive artist.

Studies Studied painting and dramatic art in France. Over a period of some years appeared in many television shows including Homicide, Division 4, Hunter, The Box and Matlock Police; Now painting full-time.

Exhibitions Solo show at Australian Galleries, Melbourne 1980.

GREY, Victoria TAS

Born England 1954. Printmaker and teacher.

Studies Hobart School of Art 1975–78, and taught wide Education Dept. 1979–81. Completed Uni. of Tas. Librarians Course 1983 and works as teacher and librarian.

Exhibitions Harrington St. Gallery 1978; Uni. of Tas. 1980; Chameleon Gallery, Hobart 1985.

Bibliography *Tasmanian Artists of the 20th Century*, Sue Backhouse, 1988.

GREY-SMITH, Helen WA
Born Coonoor South India 1916. Painter in acrylic, collage; Textile designer and printmaker; Married artist Guy Grey-Smith in 1939.
Studies London School of Design 1936–39; Hammersmith School of Art, London 1953–54; Commenced textile design/painting in WA in 1954 and exhibited annually in Perth in conjunction with her husband until his death in 1981.
Exhibitions Collage, Perth 1968, 1970 and acrylic paintings 1970, 1972, 1974, 1976; Blaxland Gallery, Sydney 1960; Bonython Gallery, Adelaide 1961; John Gild Gallery, Perth 1968; Old Fire Station Gallery, Perth 1972, 1974, 1976; University of WA, Undercroft Gallery 1979, Delaney Gallery, Perth 1989.
Represented Silkscreen curtains at Perth City Council House; University of WA; Reserve Bank, Canberra; Serigraphs at Qld Art Gallery; Art Gallery of NSW; National Collection, Canberra; Newcastle Art Gallery; Paintings at University of WA; WA Institute of Technology; Fremantle Art Centre.

GRIEVES, Lesley A. WA
Born Perth 1952. Printmaker.
Studies Assoc. Dip. WAIT 1970–72; Dip. Printmaking Perth TC 1980–86.
Exhibitions Gomboc Gallery 1984.
Bibliography *PCA Directory* 1988.

GRIFFIN, Carole NSW
Painter, sculptor, printmaker, teacher.
Studies Dip. Painting & Drawing, National Art School 1963; Dip. Ed., Sydney Teachers College 1964; Sculpture, National Art School 1968. Etching & Painting, ESTC 1976, 77, 81. Taught art at ESTC and Meadowbank College of TAFE 1982–88, and at National Art School, Sydney 1988–90.
Exhibitions Solo shows at Holdsworth Galleries 1988, 90; Many group shows since 1963.
Represented Institutional and private collections.

GRIFFIN, Julia NSW
Born Port Moresby, PNG 1958.
Studies Degree, Visual Arts, SCOTA 1977–79; Postgrad. at Central School of Arts, London 1981; Degree Conversion of Visual Arts — SCOTA 1982.
Exhibitions Solo shows at Coventry Gallery, Sydney and Cintra Gallery, Brisbane 1988, 90. Participated at Blaxland Galleries 1986, 87, 88; Westwal Gallery, Tamworth 1987; Coventry Gallery 1988, 89, 90.
Bibliography *PCA Directory* 1988.
Represented Artbank; Institutional and private collections.

GRIFFITHS, Katherine VIC
Born Launceston, Tas. 1962. Ceramic sculptor, designer.
Studies Chisholm IT, Melb — Degree in Ceramic Design 1984.
Exhibitions Travelling Show to UK 1983–84; Darwin 1984; Vic Ceramic Group and Ballarat Reg. Gallery 1984.

GRIFFITH, Pamela Ann NSW
Born Sydney NSW 1943, Painter, printamker, teacher and writer.
Studies National Art School and Sydney Teachers College 1961–64 and graduated with Art IV prize; Diploma of Art Education, Alexander Mackie College 1977; Bachelor of Art Education, Sydney College of Advanced Education 1983; Past Secretary of Art Teachers

Association; Past member of Department of Education Art Syllabus Committee; Past President and foundation member of Southern Printmakers Association; Taught in secondary schools, Technical Colleges, Colleges of Advanced Education, for the Arts Council of NSW, and for the Department of Education Inservice Training programme and the Art Teachers Association; lecturer in Art, Sydney Institute of Education; Fourteen months in Europe 1972–73, including workshop experience in England, Germany and Israel; Eight weeks study tour of Europe 1981–82; Established the Griffith Studio and Graphic Workshop in 1974; Employs Graduate Art Students and prints established artist's work; winner of Rotary International Vocational Service Award 1982. Studied Maritime Museum, Paris 1987.

Exhibitions Recent One Woman Exhibitions include, Young Masters Gallery, Brisbane, 1981; Barry Stern Gallery 1981, 82, 84, 86, 88, 89; Old Brewery Gallery, Wagga 1981, 84, 85, 86, 89; Gates Gallery Sydney 1985; Graphic Art Gallery 1988; Gould Gallery, Melb. 1987; Painters Gallery 1990; Recent group exhibitions include, Sydney Print Survey 1979; Sydney Printmakers 21st Annual Exhibition, Invited Artist 1981; Printmakers of NSW, touring Great Britain 1982; Sydney Womens Festival, Bloomfield Galleries with the Southern Creative Printmakers 1982; International Printmakers, Baguette Gallery, Qld 1982; Crates Gallery 1985, 86.

Commissions Woodcut for Friends of the Earth 1979; Etchings 2 editions 1980 for Syrinx Research; Etchings 'Protected Shells of Queensland' 3 editions 1981 for Syrinx Research; Etching 'Ulysses Butterfly' 1 edition Studio Graphics Gallery 1982; Etching 'Syrinx and Pan' 1 edition Syrinx Research 1982; Etchings 'Birds of Woollahra' suite of 6 editions Southern Cross Books, Artist Blake Twigden 1982; Etchings, 2 editions, Southern Cross Books, Artists Pixie O'Harris, 1982. Braybon Ward Collection 1985. Comalco etchings 1987–88; Qantas etching 1988; Ascraft Fabrics and Marrickville Council 1988.

Represented Wollongong Regional Art Gallery; Bathurst Regional Art Gallery; Art Gallery of NSW Parliament House Collection; Museum of Applied Arts and Sciences, Sydney; Sydney Institute of Education; National Gallery, Canberra; University of NSW; Regent Hotel, Sydney; Centre Point, Sydney; Significant private collections throughout the world.

Bibliography *PCA Directory* 1988; *The Australian Artist* Oct. 1988; *Artists & Galleries of Australia*, Max Germaine: Craftsman House 1990.

GRIGGS, Mary-Jane NSW
Born Sydney 1955. Painter, illustrator, teacher.

Studies BA (Fine Arts), University of Sydney 1974–77; Dip. Ed. Sydney Teachers College 1978; Overseas study in UK, Europe, Thailand, New Zealand 1983–84; ESTC (Painting) 1986–87; Taught art intermittently 1978–88; Lecturer, Charles Sturt University, Albury 1989; Lecturer, Albury College of TAFE 1989.

Exhibitions Solo shows at Cellblock Theatre, Sydney 1989; Access Gallery 1990; Many group shows since 1977.

Commissions Sydney Teachers College 1978; Australian Hereford Society 1986; Darling Harbour Training Services 1989.

Represented Institutional and private collections around Australia.

GROBLICKA, Lidia SA
Born Poland 1933, arrived Australia 1965. Naive and surrealistic artist in oil, woodcut, linocut, embroidery.

Studies Graduated from the Academy of Fine Arts, Cracaw, Poland 1951–57; Moved to London to further her studies; Exhibits as a fellow of the Royal SA Society of Arts; Member, Contemporary Art Society and the Print Council of Australia, also with the Sydenham Gallery, Adelaide and Australian Galleries, Melbourne.

Represented Fremantle Arts Centre, Warrnambool Art Gallery, Artbank, Flinders

University and institutional and private collections in UK, Europe and Australia.
Bibliography *Directory of Australian Printmakers 1976; Australian Naive Painters,* Bianca McCullough, Hill of Content, Melbourne 1978; Ethnic Art Directory — Australia Council 1981; *Artists & Galleries of Australia*, Max Germaine: Craftsman House 1990.

GROSMAN, Barbara VIC
Born Georgia USSR 1943, arrived Australia 1958. Figurative painter in oil, acrylic, gouache, watercolour; Lived Lodz Poland 1954–58.
Studies Swinburne Technical College Melbourne, Diploma of Advertising and Graphic Design 1960–64; Painting lecturer, Prahran College of Advanced Education 1975; Artist-in-Residence, Vic College of the Arts 1978; Caulfield Institute of Technology 1982; Community Education RMIT 1982.
Exhibitions One-woman show at Osborn and Polak Gallery, Melbourne 1971; Chapman Powell Street Gallery, Melbourne 1974; Powell Street Gallery, watercolours and gouaches 1975; Participated in Corio Prize Exhibition, Geelong Art Gallery 1969; Sale Prize Exhibition, Sale Art Gallery 1969; Inez Hutchinson Prize Exhibition, Beaumaris Art Gallery 1970; 'Four Women Painters', Mornington Peninsula Arts Centre, Vic 1972; Georges Invitation Art Prize, Melbourne 1973; Group exhibition, Macquarie Galleries, Canberra 1974; 'Prahran Painters', Melbourne University Gallery 1975; 'Eight Women Realists' Exhibition of Vic College of the Arts Gallery 1978; Spring Festival of Drawing, Mornington Peninsula Art Gallery 1979–81; MPAC 10th Anniversary 1982; 'Australian Art of the Last Ten Years' Canberra 1982.
Represented Monash University Collection; ICI Collection; Philip Morris Collection; Private collections and Vic College of the Arts.

GROUNDS, Joan Dickson NSW
Born Atlanta USA 1939. Sculptor, creamic and performance artist, teacher.
Studies Bachelor of Arts, Newcomb College, New Orleans USA 1962; Master of Arts (sculpture) Berkeley University, California USA 1966; Part-time instructor at East Sydney Technical College; Sculpture 1969; Ceramics 1969–72; Interior Design 1972. Ceramics instructor at The Woolley Centre, Glebe NSW 1973–74; Part-time instructor Sydney Teachers College 1974; Resident artist at Sydney University Workshop 1975–76; Part-time lecturer Adult Education, Sydney University 1975; Visited France and participated in Paris Biennale 1977.
Exhibitions Has exhibited ceramic sculptures and been involved in performance shows since 1972 which include Mildura Sculpture Treinnial 1973; Toronto Canada 1974; London Film Festival 1975; W. German Film Festival 1977; Jam Factory, Adelaide 1977, 85; 3rd Biennale of Sydney 1978; ANU Canberra and Ewing Gallery, Uni of Melb. 1980; Canberra S of A 1982; Artspace, Sydney 1983; Forti Studio, New York 1984; *Perspecta* '85, AGNSW; Performance Space, Sydney 1986, 87, 88; *Australian Perspecta* 1989, AGNSW; Fourth Australian Sculpture Triennial 1990.
Awards Film Grant 1975; Philip Morris Film Award 1976 (shared) VAB Travel Grant 1981. VAB Grant 1987; Theatre Board Grant 1988.
Represented Australian National Gallery and institutional and private collections in USA, West Africa, UK, Europe and Australia.
Bibliography *Catalogue of Sydney Bienniale* 1979; *Australian Sculptors,* Ken Scarlett, Nelson 1980; *Artists & Galleries of Australia*, Max Germaine: Craftsman House 1990.

GROUNDS, Sue VIC
Born Melb. 1949. Painter, teacher.
Studies Nat. Art School — Dip. Art and Design. Hawthorn Teachers College.
Exhibitions Adelaide Festival Centre 1984; Meat Market Centre 1984; Crafts Council Sydney 1985; Albury Reg. Gallery 1985; Araluen Centre, NT 1985.

GROVE, Hélène QLD

Contemporary painter; qualified as a doctor of medicine in 1970 and practised until 1983, now full-time painter. No formal art training.

Exhibitions Solo shows at Michael Charles Gallery 1986; Galerie Baguette 1987; Bundaberg Art Gallery 1988; Prouds Gallery, Sydney 1988; Queensland House, London, 1989; Schubert Gallery 1989; Casey Kingman Gallery 1989.

Awards Mackay Caltex 1981; Tooheys Paint-a-Pub 1981; Rockhampton Caltex 1983; Mackay Portrait 1984 FourX Paint-a-Pub 1984; Bundaberg Harvest Festival WC 1984; Maryborough Open 1985; Biggenden Open 1985; Noosa Drawing and Acrylic 1985; Faber Castell (amateur) 1985; Suncorp 1987; Noosa Open (shared) 1987; Cloncurry Open 1987; Master Builders NSW WC 1988.

Represented Institutional, municipal and private collections in NSW and Qld.

GROVES, Helga NSW

Born Ayr, Queensland 1961. Abstract painter.

Studies Graduated SCOTA 1988.

Exhibitions SCOTA Gallery 1988; First Draft Gallery, Sydney 1988; Included in the Moët & Chandon Touring Exhibition 1989.

GROVES, Ruth VIC

Born Melbourne Vic 1951. Painter and printmaker.

Studies SA School of Arts; Santa Reperata Printmaking Studio, Florence, Italy and Vic College of the Arts, Melbourne; Worked for over five months for Bea Maddock on commission for High Court, ACT 1980.

Exhibitions Solo shows at Port Melbourne Gallery 1978 and Gippsland IAE 1980; Participated in many groups shows including Installation 601/4 Broderick, San Francisco USA 1977–78; Powell Street Gallery New Artists 1979; Ballarat Fine Art Gallery 1979; Gippsland IAE 1979–80; McCaughey Prize — National Gallery of Vic 1981 and VCA 1981.

Awards CUB Scholarship 1978; National Gallery Society Scholarship, Vic 1979; Arches Rives Prize 1979.

Represented National Gallery of Vic, Vic College of the Arts, Ballarat Fine Arts Gallery, and private collection in UK, Europe and Australia.

Bibliography *Directory of Australian Printmakers* 1982; National Gallery of Vic, Bulletin October 1979.

GRUBITS, Christine SA

Born Adelaide 1959. Painter, illustrator, teacher.

Studies Dip T. B.Ed. Adelaide CAE; studied UK, Europe 1983, 86; SE Asia 1988. Presently Art Co-ordinator at St. Pauls College, Adelaide.

Exhibitions Die Galerie Tanunda and CAS Print Workshop 1986; Greenhill Galleries 1987, 88, 89; Melb. Art Exchange 1989; Jarmans Gallery, Melb. 1989.

Represented Institutional and private collections in UK, Europe, SE Asia, Australia.

GRUZDEFF, Leeka (Kraucevicuite) NSW

Born Lithuania 1939. Romantic impressionist painter in oil and pastel.

Studies East Sydney Technical School 1956–59; Worked as commercial artist for some years.

Exhibitions Two solo shows at Repin Gallery, Strathfield 1977, 1980; Group show at Woollahra Gallery 1982.

Awards Has won eighteen awards since 1976 and recently Drummoyne Portrait Prize 1982; Mackay Qld Drawing Prize 1982 and Bankstown Council Art Award 1982.

Represented Institutional and private collections in NSW and Qld.

GUDE, Gilda VIC

Born Ballarat Vic 1918. Painter of figure pieces and flower studies in oil and watercolour; Teacher; Sister of Nornie Gude.

Studies Ballarat School of Mines and George Bell School; Lecturers in art at the RMIT 1961.
Awards Won Drawing Prize at Royal Art Society, Melbourne 1952.
Represented National Gallery of Vic.

GUDE, Nornie (Eleanor Scott Pendlebury) VIC

Born Ballarat Vic 1915. Painter, portriatist in watercolour; Wife of artist, Laurence Scott Pendlebury; sister of Gilda Gude.

Studies Ballarat School of Mines, five years; Melbourne National Gallery School, five years; Overseas study tour 1958.
Exhibitions Velazquez Gallery 1944, Georges Gallery 1945, Vic Artists Society 1960, Windeyer Gallery 1974, Moreton Gallery 1960, Greythorn Gallery 1981, Leveson Gallery 1983.
Awards Prizes for watercolours, F.R. Richardson, Geelong 1948, 1952; Bendigo 1950; Perth Art Gallery 1953; Dunlop 1955; Crouch 1957, 1959; Voss Smith 1958; E.T. Cato 1959; Albury 1952; Robin Hood 1959; Pring Prize 1970; Rotary Art Prize 1979; Winner, Doug Moran Naval Prize 1988; Finalist, Doug Moran National Portrait Prize 1990.
Represented National Gallery of Vic; Regional Galleries at Albury, Bendigo, Geelong, Castlemaine, Ballarat and institutional and private collections.
Bibliography *Encyclopedia of Australian Art*, McCulloch, Hutchinson 1977; *Artists & Galleries of Australia*, Max Germaine: Craftsman House 1990; *Australian Impressionist & Realist Painters*, Tom Roberts: Graphic Management Services, Melbourne 1990.

GUEST, Betty SA

Watercolour painter. Studied with Ruth Tuck and private tutors. Fellow RSASA.
Awards Gwen Barringer Watercolour Prize 1963.
Bibliography *Australian Watercolour Painters*; Jean Campbell; Craftsman House 1989.

GUNN, Grazia ACT

Born Cairo Egypt 1937. Art historian and curator. Assistant curator, Melbourne University Gallery. Worked on the University's collections and in particular on the Leonhard Adam Ethnological collection 1971–73; Project Officer, International and Australian touring exhibitions, Visual Arts Board, Australia Council 1973–74; Curator, Monash University art collection and exhibition gallery 1974–79; Member of the Academic Committee in art and design, Vic Institute of Colleges 1976–77; Member of the selection committee for the Visual Arts Board, Australia Council, Art Purchases Programme 1977–78; Member of the Royal Australian Institute of Architects jury for the 1979 Architectural awards 1979; Assistant Curator, Australian National Gallery 1980; Acting Curator, Contemporary Art, Australian National Gallery 1982–83; Prolific writer of art articles, catalogues and books. Appointed director of Australian Centre for Contemporary Art, Melb. 1989.

GUNNER, Michelle NSW

Born Cessnock NSW 1944. Mostly self-taught painter of traditional Australian landscapes in oil, watercolour, acrylic, gouache and portraitist.
Exhibitions Solo shows at The Hills Gallery, Sydney 1981–82 and Kenneth Jones Gallery 1981, also shows at the North Shore Gallery, the Saints Gallery and the Pokolbin Gallery, Wollombi NSW.

GURNEY, Junee VIC

Born Bondi, NSW 1908. Sculptor. Founding member of Brighton Art Society and member of Association of Sculptors, Vic; Exhibits with the Association and at Manyung Gallery, Mt

Eliza and Colonial Gallery, Brighton.

GUTHRIE, Beryl NSW
Born Manly, NSW 1929. Traditional painter in oil and watercolour.
Studies East Sydney Technical College under William Dobell and G.K. Townshend.
Exhibitions One-woman shows at Saints Gallery 1977 and Everglades Gallery, Port Macquarie 1979; Group shows at Saints Gallery 1980–83; And Geo Styles Gallery.
Awards Blackheath Landscape Prize 1971.
Represented Private collections in Japan, Hong Kong, Germany, UK, USA and Australia.

GUY, Monica QLD
Born Palmerston NZ. Traditional painter in oils and watercolour.
Studied privately with a number of tutors; Foundation member of the Sunshine Coast Art Group.
Awards Maroochy Shire Acquisition 1978; Nambour Watercolour 1977; CWA Prize 1964; SQAF 1989.
Represented Parliament House, Brisbane and private collections in Australia and overseas.

GUY-VILLON, Meredith SA
Born Adelaide 1952. Painter of metamorphic landscapes.
Studies Adelaide Hills College of TAFE, North Adelaide School of Art 1984–87; SACAE 1989–.
Exhibitions North Adelaide S of A 1986; Gold Coast City 1987; BMG, Adelaide 1989.
Bibliography *New Art Four*: Craftsman House 1990.

H

HAASZ, Genevieve Lynette NSW
Born Toowoomba, Qld. 1945. Painter, teacher, sculptor.
Studies B.Sc. — Uni. of Melb. 1963–65; Dip. Art & Design — Prahran CAE 1977–80; Grad. Dip. Ed., Melb. CAE 1983; presently lecturer, painting and drawing Northern Rivers CAE, NSW 1988–
Exhibitions Solo shows at Christine Abrahams 1983; Painters Gallery 1985; Niagara Galleries 1985, 86; William Hamilton, Melb. 1986; Peter Gant 1988; King St. Gallery, Sydney 1989. Numerous group shows include Vic. Arts Centre 1985; Lismore Reg. Gallery 1988; Peter Gant Gallery 1988.
Commissions Bronze — Village Market, Laverton, Vic. 1987.
Represented Footscray City Council, institutional and private collections.

HACKETT, Gwenda SA
Born Brighton SA 1924. Painter in oil and watercolour.
Studies Fellow of RSASA.
Exhibitions Lombard Gallery 1986; High St. Kensington 1988; Christchurch NZ 1990 and regularly with RSASA.
Represented Private collections in UK and Australia.

HACKETT, Shaaron VIC
Born Melb. 1947. Painter.
Studies Frankston TC 1976; RMIT 1977; Bendigo CAE 1988–90; Member, Beaumaris Art Group.

Exhibitions Numerous shows since 1984 and recently at Ackland St. Gallery 1987, 88; Gallery Carlsruhe 1988; Greenfrog Gallery 1988.

HADDY, Barbara WA
Born Aust. 1948. Printmaker.
Studies WAIT; Uni. of Oregon, USA.
Awards Albany 1974; Manjimup 1979, 83; Tresillian 1983.
Represented AGWA, institutuional and private collections.
Bibliography *PCA Directory* 1988.

HADLAND, Rose Lilian SA
Born Taston UK 1915. Painter, teacher and sculptor; Member RSASA and Elizabeth Art Society. Teacher of painting at Elizabeth Technical School 1974–78.
Bibliography *Who's Who in the Commonwealth*, Cambridge, UK 1982.

HAGGATH, Helen NSW
Born NSW. Painter, musician and teacher.
Studies Associate Diploma of Art (painting) RMIT 1966; Secondary Teachers College, Melbourne — ACTT, 1968; Jazz Studies, NSW Conservatorium 1970–75; Graduate Diploma in Education (Jones Medal), Sydney Teachers' College 1976; Toured Europe 1977; Graduate Diploma in Professional Art Studies, Alexander Mackie CAE 1982; Currently studying towards Master of Arts, City Art Institute 1982–; A director of the Australian Jazz Foundation 1982.
Exhibitions One-woman show at Mori Gallery, Sydney 1982; Holdsworth Contemporary Gallery 1988; Wagner Gallery 1991. Participated at Ivan Dougherty Gallery 1980; Wollongong City Art Gallery 1980; Mori Gallery 1982; Holdsworth Contp. Gallery 1988.
Awards Carlton Art Prize 1968; NSW Government Grant 1979.
Represented Artbank and private collection in UK, Europe and Australia.

HAGINIKITAS, Mary (Connell) QLD
Born Wilcannia NSW 1950. Sculptor and painter of wilderness and aboriginal themes, illustrator.
Exhibitions Gallery Art Naive, Melb. 1984; Rainsford Gallery, Sydney 1984, 87, 88; Upstairs Gallery, Cairns 1984, 85, 86; BMG Adelaide 1984; Cintra House, Brisbane 1985, 86; Solander Gallery, Canberra 1985; Holdsworth Gallery, Sydney 1985, 88. Included in Aust. Art Expo 1985 touring show to USA.
Commissions Has illustrated jointly with artist Percy Trezise three children's books, *Platypus and Kookaburra, Black Duck and Water Rat* and *The Last of His Tribe*, published by William Collins 1987, 88, 89. Has produced numerous murals and paintings for tourist establishments around Cairns, Qld.
Represented Corporate institutional and private collections in USA and Australia.

HAIN, Rosemary NSW
Born Sydney 1931. Painter, married to artist John Beeman.
Studies Diploma Course at ESTC by scholarship 1947–51. Art Commissions from Department of Fisheries NSW, the Australian Museum and The Australian Museum Society and has exhibited in Sydney and a number of large country centre.
Awards for drawing — Taree and Currabubula.
Represented Institutional and private collections in Australia and overseas.

HALE, Vivienne TAS
Born Hobart 1955. Photographer and teacher.
Studies Uni. of Tas. 1973; Hobart School of Art 1974–77; taught with Tas. Ed. Dept.

1978–80, 1984–85 and since 1987. Overseas study tours 1977, 81–83, 86.
Exhibitions Warehouse Gallery, Hobart 1977; *China, A Selection of Photographs*, QVMAG; Uni. of Tas. toured Vic., NSW, NT 1978–79; Aust Centre for Photography, Sydney 1978, 80; Photographers Gallery, Melb 1978; Biennale of Sydney 1979; Long Gallery, Hobart 1984.
Represented TMAG, QVMAG and The Philip Morris Collection ANG, Canberra.
Bibliography *Tasmanian Artists of the 20th Century*, Sue Backhouse 1988.

HALL, Anne VIC
Born Melb. 1945. Painter.
Studies RMIT 1960–63.
Exhibitions From 1967 in Melb., Sydney, Adelaide and at MPAC 1979 when her work was acquired. Her work and career were influenced by John Perceval whose portrait she painted in 1976.
Bibliography *Encyclopedia of Australian Art*: Alan McCulloch, Hutchinson 1984.

HALL, Fiona VIC
Born Sydney NSW 1953. Painter and photographer.
Studies National Art School, Sydney 1972–75; MFA in Photography from Visual Studies Workshop, Rochester, New York 1979–82; working in New York, 1982–
Exhibitions One-woman show at Creative Camera Gallery, London UK 1977; Galeria Fotographica Nadar, Pisa Italy; Church Street Photography Centre, Melbourne 1978; Australian Centre for Photography, Sydney 1980, 1982; Participated at National Gallery of Vic 1975; *Australian Perspecta* 1981; DBR Gallery, Cleveland Ohio USA 1981; Art Gallery of NSW 1981; Biennale of Sydney 1982; *What is this thing called Science?* Melb. Uni Gallery 1987; Aust. Centre for Photography, Sydney 1989, 90; ACCA, Melb. 1989.
Represented AGNSW, institutional and private collections in Australia, UK, Europe, USA.
Bibliography *The Art of Fiona Hall*, A and A 25/2; *Catalogue of Australian Perspecta* 1981 and *Biennale of Sydney* 1982, Art Gallery of NSW.

HALL, June VIC
Born Geelong Vic 1925. Painter, printmaker, teacher.
Studies Gordon Institute of Technology, Geelong, Diploma of Fine Arts (painting) 1971–74; Post-diploma study and assisted in printmaking department 1975; Taught art 1976 and continued studies for Diploma of Education at Melbourne State College 1977. Taught at Gordon Technical College from 1978.
Exhibitions Participated at major shows at Geelong Art Gallery 1974, 1975, 1977; The Age Gallery 1975; Mornington Peninsula Art Centre 1974; Brim Brim Gallery, Queenscliff Vic 1982; Aspen Gallery, Melbourne 1983.
Represented Deakin and University and private collections in Vic and NSW.

HALL, Mary NSW
Born UK. Designer and mosaic artist.
Studies Workshop Arts Centre, Sydney.
Exhibitions Blaxland Galleries 1980; Giles St. Gallery, Canberra 1987, also at Painters Gallery and the WAC.
Awards Blake Prize 1984.
Commissions Many works include Forecourt, Chevalier College, Bowral; Floor of Australian Hellenic Memorial, Canberra and Hawkesbury Agricultural College Centenary.

HALL, Rita SA
Born Holland 1947. Painter, printmaker and teacher.

Studies SA School of Art, Diploma of Teaching/Art 1966–68, and advanced Diploma Teaching/Art 1975; Taught art at Whyalla SA 1969–74; Currently part-time lecturer in art with the SA Dept of Further Education.

Exhibitions One-woman shows at Algate Crafts 1969, 1972; Katherine NT Arts Council 1973; Yuraillia Galleries, SA 1976; Naracoorte Regional Gallery and Adelaide Fine Arts Graphics 1977; Participated in Print Council of Australia Travelling Exhibition 1976; Channel 10, Young Artists Award 1976; CAS members exhibitions 1974, 1977; Fremantle Print Prize Show 1977; Whyalla Art Teachers 1970, 1974; Freeman Gallery, Hobart 1988.

Awards Alice Prize (Purchase) 1978; Whyalla Art Prize (Second).

Represented Art Gallery of SA; Alice Springs Art Foundation; CAS Collection; Institutional and private collections in Australia and overseas.

HALLANDAL, Pam VIC

Born Melbourne Vic 1929. Sculptor in wood and ceramics; Draughtsman, teacher.

Studies Fellowship Diploma in Fine Art (sculpture) RMIT 1951; Central School of Arts and Crafts, London 1955–56. Has travelled extensively in UK, Europe and USA, lecturer in charge of drawing at Prahran Art School, Vic College 1970–.

Exhibitions National Gallery of Vic 1951; Olympic Games Show 1956; Hobart Gallery and Mildura Sculpture Centre 1972, 1974; One-woman show at Pinocotheca Gallery, Melbourne 1982; Stuart Gerstman, Melbourne 1989.

Represented National Gallery of Vic; Heidi Park Gallery; Mornington Peninsula Art Centre, Vic Education Dept and private collections in Australia and overseas.

Bibliography *Australian Sculptors*, Ken Scarlett, Nelson 1980; *Encyclopedia of Australian Art*, Alan McCulloch: Hutchinson 1968; *Artists & Galleries of Australia*, Max Germaine: Craftsman House 1990.

HALLINAN, Michelle VIC

Born Vic. 1963. Printmaker.

Studies BA, WIAE, Vic. 1984; Assoc. Dip., Canberra IA 1988.

Exhibitions Erwin Faisst Gallery, Warrnambool 1985; New Harmony Gallery, Indiana USA 1986; Canberra Theatre Centre and Mitchell College, Bathurst 1988.

Bibliography *PCA Directory* 1988.

HALPERN, Deborah VIC

Born Melbourne Vic 1957. Ceramic sculptor.

Studies Potters Cottage School and in the workshop of her father, Artek Halpern. CIT, Melb. 1979.

Exhibitions One-woman show at Potters Cottage Gallery 1978 and 'Sixteen Artists' Exhibition, Eltham Vic 1978; Meat Market Craft Centre 1981; Blackwood Street Gallery, Melb. 1981; Rosie's Gallery, Melb. 1983; Christine Abrahams Gallery, Melb. 1985, 87, 89; Participated at Manly Art Gallery, Sydney 1985; *A New Generation 1983–88* at ANG, Canberra 1988; Irving Sculpture Gallery, Sydney 1988.

Commission Bicentennial sculpture for Nat. Gallery of Vic. 1988, 'Angel'.

Awards Craft Board Grant 1981; Artist-in-Residence for Artists in Schools programme 1982.

Represented Melbourne State College and institutional and private collections in Australia and overseas.

Bibliography *Artists & Galleries of Australia*, Max Germaine: Craftsman House 1990.

HALPERN, Sylvia VIC

Born Kobe Japan 1919. Ceramic artist; Wife of the late painter and potter, Stanislaw Halpern.

Studies RMIT 1944–45.

Exhibitions One-woman show, Potters Cottage Gallery 1971; Joint show, Potters Cottage 1978; Participated Royal SA Society of Arts 1964; Geelong Art Gallery 1972; Bendigo Pottery Award 1973; Caltex Ceramic Award shows 1974, 1975; Benalla Art Gallery 1974; Croydon Arts Council; Mayfair Ceramic Award 1976.

Awards Ceramic Association of Vic, Earthenware Prize 1973; Bendigo Pottery Award, Hon mention, Open Pottery 1973.

Represented State College of Vic, Kew; Ewing Gallery, Melbourne University Union; Shepparton Art Gallery; Croydon Civic Centre.

HALSALL, Pauline Grace QLD

Born Ballarat Vic. Contemporary painter and teacher.

Studies RMIT Diploma of Art & Design 1964; Worked in Interior Design for 10 years; University of Qld, Bachelor of Arts (fine arts) 1981; Advanced painting studies with Irene Amos at Brisbane Art School 1982; Studied art in Paris with University of Flinders group at the International Study Centre, Sèvres, Paris, 1983; Organises annual Festival of Modern Arts on the Sunshine Coast, also Creative Art Classes for children and teaching for TAFE College courses for Unemployed Youth, (creative arts). Co-founder, Society of Modern Art, Sunshine Coast; Member, Queensland Institute of Modern Art. Has won many awards and recently in France 1990.

Exhibitions Kawana, Qld 1980; University of Qld Club 1981; Gregory Terrace Gallery, Brisbane 1982; Towen Mount Gallery, Qld 1983; Institute of Modern Art, Brisbane 1983; Qld Art Gallery 1982; Buderim Gallery 1984; Towen Mount Gallery 1985; Maroochy Civic Centre 1986; Expo '88, Brisbane; Blue Marble Gallery, Buderim Qld 1990.

Represented Institutional and private collections in Australia and overseas.

HAMBLY, Marian ACT

Printmaker.

Exhibitions Bitumen River Gallery 1987. Ben Grady Gallery 1988.

Bibliography *PCA Directory* 1988.

HAMILTON, Beth NSW

Born Newcastle NSW. Watercolourist, printmaker, teacher, stage designer.

Studies ESTC 1943–49; Diploma in Art Illustration. Additional course in Ancient Art part-time at Sydney Uni. Study tour England and Europe 1950–52. Attended School of Printing and Graphic Arts, Fleet St. London. Illustrator on English *Woman's Journal* 1952. After returning to Sydney in 1952, employed as illustrator on *Woman's Day* magazine and *Herald* Newspapers 1953–60. Theatre sets for Independent Theatre 1953. Freelance artwork. Art Teacher at Pittwater House Grammar School 1970–78. Art History Teacher Seaforth Technical College 1981–82. Co-director Printers Gallery, Crows Nest 1979–84. Exhibiting member Peninsula Art Society and Royal Art Society. Study tour of China 1985. Japan 1983, 1985, 1986. USA 1987. Painting trip to the Kimberley area West. Aust. 1988 and 89. Various group exhibitions. Currently Director, Beth Hamilton Galleries, Northbridge NSW.

Awards Scone, Boggabri, Cheltenham, Campbelltown, 1981–82. Warringah 1988.

Represented Institutional and private collection in Aust. and overseas.

HAMILTON, Jennifer QLD

Born Qld. 1959. Printmaker.

Studies Darling Downs IAE 1978–79; Tas. S of A 1982–84; SASA 1985–86.

Exhibitions Indiana Uni. USA 1986; SA Dept. Arts 1988.

Bibliography *PCA Directory* 1988.

HAMILTON, Sue NSW
Born Sydney 1946. Landscape painter and teacher.
Studies Attended University of Sydney and Sydney Teachers College and studied under private tutors.
Exhibitions Solo shows at Forbes Regional Gallery 1990; Eaglehawke Galleries 1991.
Awards Has won over twenty prizes at NSW country art shows since 1985.
Represented Institutional and private collections in Australia, Japan, Filand, Thailand, USSR.

HAMLYN, Rhonda NSW
Born Sydney NSW 1944. Contemporary painter, printmaker.
Studies Full-time diploma student at East Sydney Technical College; Held a Bursary and Scholarships, gained Credit Diploma for painting 1964.
Exhibitions Group show, Watters Gallery, Sydney 1965; 'Stefana Ambioziah, Rhonda Hamlyn', Watters Gallery, Sydney 1967; La Trobe Valley Purchase Awards, La Trobe Valley Arts Centre, Vic 1974; Perth Prize for Drawing, WA Art Gallery 1975; Exhibition of drawings and sets, series, sequences, Watters Gallery, Sydney 1977, 1983; Drawing, prints, works on paper, Art Gallery of NSW 1980, 1983, 1985; Watters Gallery 1984, 87; Penrith Reg. Gallery 1985; First Aust. Contemporary Art Fair, Melb. 1988; Showed rugs with Susannah Hamlyn at Watters Gallery 1989.
Represented National Collection, Canberra; Art Gallery of NSW; National Gallery of Vic; Fremantle Art Gallery; Private collections in Australia and overseas.

HAMPEL, Suzanne VIC
Born Melbourne 1944. Photographer and film maker.
Studies Studied Fine Arts at University of Melbourne and Art & Design at Prahran College.
Exhibitions Warehouse Gallery 1976; Realities Gallery 1977, 78; Monash University 1982; Developed Image, Adelaide 1982.
Bibliography *150 Victorian Women Artists*, Visual Arts Board/WAM 1988.

HAMPSON, Catharina QLD
Born Amsterdam 1936, arrived Australia 1959. Sculptor.
Studies Brisbane TC and frequently in Europe since 1980. Member of Society of Sculptors (Qld), President 1987–88.
Exhibitions St Johns Cathedral, Brisbane 1983, 89; Half Dozen Group 1984; Society of Sculptors 1985; Boston Gallery 1990– .
Commissions Bronze at Barrister Chambers, Brisbane 1986; Celtic Cross, St. Joseph College 1987 and further edition of miniatures 1989.

HANLEY, Joy NSW
Born Sydney NSW 1917. Traditional painter, mostly in oil.
Studies RAS of NSW and Cannon Studio, Epping under several tutors.
Exhibitions North Shore, Saints, Kenwick and St Georges Terrace Galleries, Sydney.
Awards Orange Blossom 1973, 1977; Castle Hill 1980; Mudgee 1980; RMA Cannon Award 1980.
Represented collections in USA, Japan, Canada, UK, Singapore and Australia.

HANN, Marjorie (Fisher) SA
Born Adelaide 1916. Painter, illustrator, cartoonist, teacher.
Studies SASA 1933–37; worked in commercial art for 25 years. Studied History of Art at SASA 1966–68. Overseas study tours to UK, Europe 1976, 79. Has taught at Kensington College of TAFE, Adelaide Art Society and RSASA. Hon. Life Member RSASA. Her cartoons appeared in several newspapers; Taught art at RSASA, TAFE Colleges and The

Adelaide Art Society.

Exhibitions Solo shows at Kintore Gallery 1976, 79, and at Lombard Gallery, Miller Anderson Gallery and the RSASA.

Awards OAM for services to the arts 1988.

Represented Institutional and private collections in UK, Europe, Australia.

Bibliography *Alice 125*, Gryphon Gallery: University of Melbourne 1990.

HANRAHAN, Barbara SA

Born Adelaide SA 1939. Figurative painter, printmaker, teacher and writer, Has written twelve novels since 1973.

Studies SA School of Art 1957–63; Central School of Art, London 1963–66; Lectured in art at Western Teachers College, Adelaide, SA School of Art; Salisbury College of Advanced Education; Torrens CAE, Adelaide; Falmouth School of Art, Cornwall; Portsmouth College of Art; Member of Printmakers Council of Great Britain; Has written thirteen novels.

Exhibitions One-woman shows at Contemporary Art Society of SA 1964, 1975; Bonython Gallery, Adelaide 1966, 1969, 1971, 1977; Bonython Gallery, Sydney 1968, 1971, 1975; Compendium 2, London 1969; Galleria Vaccarino, Florence Italy 1970; Clytie Jessop Gallery, London 1971; Ray Hughes Gallery, Brisbane 1976; Fremantle Arts Centre, WA and Macquarie Galleries, Canberra and Sydney 1977; Fremantle Arts 1978; von Bertouch Galleries, Newcastle 1980; University of Qld 1980; Grahame Gallery, Brisbane 1988; Powell St. Graphics, Melb. 1989; aGOG Gallery ACT 1989; Grahame Galleries, Brisbane 1990. Participated in 'Young Contemporaries', London; 'Australian Artists', Tokyo 1964; Mornington Peninsula Print Prize (purchased) 1974; 'Australian Artists in England', Commonwealth Institute, London 1974; Print Council of Australia 'Six-by-Four Australian, New Zealand Printmakers' 1975; In 1976, Fifth British International Print Biennale, Bradford; International Biella Prize for Prints, Italy; Western Pacific Print Biennale, Melbourne; Pederson Prize for Printmaking, Qld Art Gallery (purchased); Print Council of Australia exhibitions, Art Gallery of WA, Japan Print Association, Tokyo and Fiji Arts Council 1977; PCA Exhibitions; East and West Coasts, USA 1979; Henri Worland Memorial Print Award, Warrnambool Art Gallery (purchased) 1980; 'Graven Images in the Promised Land', Art Gallery of SA 1981; SA Paper Works, Art Gallery of SA 1981; MPAC Prints Exhibition (purchased) 1981; Henri Worland Memorial Print Award (purchased) 1982; Tynte Gallery, Adelaide 1983; Toronto, Canada 1983; QAG 1987.

Awards Etching *Heroine* commissioned for PCA member print edition 1974; Henri Worland Print Award 1980, 1982; MPAC Print (purchased) 1981; PCA Print Edition 1987; Brindabella Press engravings 1984; Adelaide City Council 1987; ANG Bicentennial Print Folio 1988.

Achievements A novelist as well as a printmaker, her books are: *The Scent of Eucalyptus*, 1973; *Sea-Green*, 1974; *The Albatross Muff*, 1977 — published by Chatto and Windus, London and *Where the Queens all Stayed*, 1978; *The Peach Groves*, 1979; *The Frangipani Gardens*, 1980; *Dove*, 1982 — published by University of Qld Press.

Represented ANG, AGSA, AGNSW, AGWA, QAG, Regional Galleries, institutional and private collections in UK, Europe, NZ and Australia.

Bibliography *PCA Directory* 1988; *Barbara Hanrahan, Printmaker*, Alison Carroll: The Wakefield Press, Adelaide 1988; *Artists & Galleries of Australia*, Max Germaine: Craftsman House 1990.

HANRAHAN, Jean NSW

Born Melbourne Vic. Painter, printmaker, and teacher.

Studies Workshop Arts Centre, Willoughby NSW, where she teaches lithography.

Exhibitions Print Circle and Eight Graphic Artists, Sydney; Print Circle Show, Cologne W Germany 1980; Painters Gallery 1982; Manly Art Gallery 1984, 85; Willoughby WAC 1984, 85; Print Circle 1988.

Represented Private collections in Australia and overseas.
Bibliography *PCA Directory* 1988.

HANSEN, Birgitte **NSW**
Regional realist painter and printmaker. Lives and paints at Carrington NSW near steel-maker BHP.
Exhibitions Solo show at Holdsworth Galleries, Sydney 1982.
Bibliography *Australian Painting 1788–1990*, Bernard Smith: OUP 1991.

HANSEN, Frances **NSW**
Born New Zealand 1962. Expressionist painter.
Studies BA (Visual Arts) City Art Institute 1986–88.
Exhibitions Participated Concourse Gallery, Dublin 1989; BMG Fine Art, Sydney 1989.
Bibliography *New Art Four*: Craftsman House 1990.

HARDING, Joy **WA**
Born Christchurch NZ 1926. Impressionist painter.
Studies Commercial art at Perth Technical College, WA under P. Ivor Hunt; Later in Melbourne under George Bell, Henk Guth and at the VAS.
Exhibitions Commonwealth and State Banks in Vic 1967–68; Derek Hunt Gallery, Perth 1970; Gilt Helmet Gallery, Perth 1971; Signature Gallery 1979; Cremorne Gallery 1979; Westralian Artists Gallery 1980–81.
Awards City of Stirling 1973; Royal Agricultural Society 1974, 1975; Bunbury Art Prize 1975; Harvey Art Prize 1975; Beverley Award 1977; Brunswick Agricultural Peters Award 1982; Artist-in-Residence Floreat Arts Centre 1977–80; Muresk biennial seminars 1977–80.
Represented New York Graphics, USA; Aldebert Construction Company, Paris; Pleissy Electronics, UK; Commercial Bank head office, Perth; US Consulate, Washington DC; Nebraska Education Authority, USA.

HARDMAN, Marion **NSW**
Born Hobart Tas 1951. Photographer and teacher.
Studies Graduated, Tas School of Art 1973; Lecturer in photography at Tas School of Art 1978–; Uni. of Tech., Sydney — Grad. Dip. Communications 1987. Study tours China 1977; UK, Europe 1979–80, 83; Teaching photography at the Hamilton College of TAFE 1990–, after some years at The Australian Centre for Photography, Sydney.
Exhibitions Has held eight solo shows since 1975 including Macquarie Galleries, Sydney 1980, 1981, 1982; Participated in numerous group shows including China, toured four states and NT for the AGDC 1978–79; Tutors Show, Tas School of Art, Hobart, Tas 1980; *Australian Perspecta*, Art Gallery of NSW; Reconstructed Vision, Art Gallery of NSW; Land Rites, Vic College for the Arts 1981; Newcastle Reg. Gallery 1982; Musée d'Art Moderne, Paris 1983; ANG, Canberra and AGNSW 1983; Stucki Museum, Poland 1984; AGNSW 1984, 86; ACP, Sydney 1984; touring show to Uni. of Tas., Developed Image, Adelaide and Uni. of Missouri USA 1985; NCV, Albury Reg. Gallery 1986.
Awards VAB Grants 1975, 80, 82, TAAB Grant 1980, Uni. of Tas. Grants 1982, 84.
Bibliography *New Visions of Australia*, Gary Catalano, London Magazine November–December 1980; *Catalogue of Australian Perspecta* 1981, Art Gallery of NSW.
Represented National Gallery of Vic; Art Gallery of NSW; Tas Museum and Art Gallery; Burnie Art Gallery; Artbank; High Court of Australia; Philip Morris Collection; Visual Arts Board Art Purchase Program; University of Tas; Polaroid; Swinburne Institute; Rusden College; Bibliotheque Nationale.

HARRINGTON-CORMACK, Robyn Janet
(Williams) NSW
Born Sydney NSW 1952. Painter of fine porcelain, also paints in oil and acrylic.
Studies Meadowbank Technical College 1970–73 and under Wanda-Ellen Hurcombe.
Exhibitions Porcelain art only; David Jones Annual Exhibition 1976, 1977, 1978; Grace
Bros Gallery 1978–81; Hunters Hill NSW Art Society 1981; Various local Art Exhibitions
in NSW.
Awards Royal Easter Show, Sydney 1981 — Porcelain Art; Open competition — First,
Second and Third.
Commissions Australia wide and overseas (principally the UK.)

HARRIS, Ann SA
Born Ulverstone Tas. 1957. Photographer, teacher.
Studies Hobart School of Art 1976–79; TMAG 1980–81; MFA School of Art, Hobart 1982
where she taught in 1982.
Exhibitions School of Art, Hobart and QVMAG 1980; Long Gallery, Hobart 1983, 84.
Bibliography *Tasmanian Artist of the 20th Century*, Sue Backhouse 1988.

HARRIS, Joanna VIC
Born Melbourne 1950. Photographer.
Studies Dip. Teaching, Melbourne CAE. Dip. Art & Design, Prahran CAE 1981.
Exhibitions Horsham Regional Gallery 1980; Prahran College Gallery 1981; WAM Group
Show 1983, 85.
Bibliography *150 Victorian Women Artists*, Visual Arts Board/WAM 1988.

HARRIS, Maisie VIC
Born Vic. Weaver.
Studies Spinning and weaving at PLC, Melbourne 1940; Full-time from 1967.
Represented Regional Galleries at Stanthorpe Qld and Dubbo NSW.

HARRIS, Nan VIC
Born Korumburra Vic 1910. Painter of wildflowers in watercolour. Studied with tutors privately.
Exhibitions AMP Square, Melbourne 1978; Dromana Vic 1976, 1982.
Represented Private collections in Japan, Canada, UK and Australia.

HARRIS, Pamela SA
Born Broken Hill NSW 1946. Painter, printmaker and teacher.
Studies Graduated in Fine Arts (painting) from SA School of Arts 1977. Postgrad. Uni. of
Tas. 1981.
Awards Australian prints selected by Print Council of Australia for Vic High Schools 1981.
Broken Hill Centenary 1982; VAB Grant 1983; PCA Print Edition 1986.
Exhibitions Anzart NZ 1985; Jam Factory, Adelaide 1985; *Aust. Perspecta* 1985, AGNSW;
Adelaide Festival 1986, 88.
Represented ANG, AGSA, AGWA, Artbank, Regional Galleries, institutional and private collections in Australia.
Bibliography *PCA Directory* 1988.

HARRIS, Suzan VIC
Born Brisbane Qld 1955. Printmaker of innovative wildlife art.
Studies Printmaking at the State College of Vic 1974–77 under Hertha Kluge-Pott and
RMIT 1978; Study tours Canada and USA 1975; Europe and Scandinavia 1976–77, India
and Nepal 1978.

Exhibitions From 1976–80 exhibited at PCA Australian Wildlife Show; Royal Art Society Gallery; Richmond Hill Press Gallery; Gaston Renard Gallery; Impressions Print Galleries; Gryphon Gallery, Sale Regional Gallery Vic; Qld Art Gallery; Warrnambool Regional Gallery; Susan Gillespie Gallery, ACT; Australian Prints to Sweden 1980.
Represented Private collections in Australia, UK, Switzerland, Norway, Sweden and Canada.
Bibliography *Directory of Australian Printmakers* 1982.

HARRISON, Gail NSW
Born Australia. Contemporary painter in acrylic and pastel.
Studies Art certificate from Kogarah Technical College; Diploma in Art, Alexander Mackie CAE 1976–80; Postgraduate studies 1981.
Exhibitions Seymour Centre 1981, 1983; Antares Gallery, Sydney 1983.
Represented Kinross and other private collections.

HARRISON, Lyn NSW
Born Sydney 1951. Painter.
Studies Meadowbank College of TAFE 1968–69; Penrith College of TAFE 1981–82.
Exhibitions Solo shows at Wentworth Falls School of Arts 1988, 89; BMG Galleries, Sydney 1989; Numerous group shows since 1985.
Awards Atelier National Art Prize 1987; Macquarie Towns-Caltex 1988; Blue Mountains Arts Council 1990.
Represented Municipal and private collections.

HARRISON, Wendy R. VIC
Born Ballarat Vic. Painter and printmaker, a niece of the late Lloyd Rees.
Studies Caulfield Technical College, National Gallery School, Melb. and with Malcolm Cameron and Brian Gilligan. Study tour to China 1982; Member, VAS; The Old Watercolour Society, (Aust.).
Exhibitions First solo show in Melb 1977 and recently at Five Ways Galleries, Kalorama, Vic. Regularly with VAS and OWS.

HARRISON, Yvonne Jeanette QLD
Born Murwillumbah Qld 1942. Abstract sculptor in most media.
Studies Privately with tutors and at seminars at Qld Institute of Technology and Brisbane Society of Sculptors.
Exhibitions Victor Mace Gallery, Cintra House, John Coopers Eight Bells, Design Art Centre and annually with Gold Coast and Brisbane Sculptors Societies since 1974.
Awards Beenleigh Rotary 1977, 1979, 1981, 1983; Indooroopilly 1975; Caloundra 1977, 1980; Chermside 1978; Gold Coast 1982.
Represented Institutional and private collections in NSW and Qld.

HARRISON-WILLIAMS, Shaz TAS
Born Sydney 1947. Printmaker.
Studies Hobart School of Art 1973–76, 76–78.
Exhibitions PCA Student Prints touring Australia and France 1975; Blue Gum Festival, TMAG 1976, 77; Burnie Art Gallery 1978.
Represented TMAG, QVMAG and private collections.
Bibliography *Tasmanian Artists of the 20th Century*, Sue Backhouse 1988.

HARRY, Pat (Carr) ACT
Born Sydney NSW 1931. Abstract painter in acrylic; Teacher.
Studies Part-time painting Wollongong Technical College 1960–66; Taught art, St. Paul's

College, Bellambi 1965–66; Illawarra Grammar School, Wollongong 1972–73; Part-time teacher, Canberra Technical College 1974; Full-time painting teacher, Daramalan College, Canberra 1974; Appointed full-time teacher, NSW Department of Technical and Further Education, Canberra 1975; Travelled to England, Europe 1977–78; Appointed Lecturer in Painting, Canberra School of Art 1977; Travelled to USA 1982–83, 87; UK, Europe 1985.

Exhibitions Ronlyn Gallery, Wollongong 1971; Liddums Gallery, Adelaide 1971; Ronlyn Gallery, Wollongong 1972; Hogarth Gallery, Sydney 1974, 1975; Wollongong University College 1976; Roslyn Oxley Gallery, Sydney 1983; Christine Abrahams, Melb. 1984; Irving Sculpture Gallery 1985; Arts Council, Canberra 1985; Solander Gallery, Canberra 1986; DC Art, Sydney 1988; Participated at Anna Symons Gallery, Canberra 1975; Hogarth Gallery, Sydney 1975; Canberra School of Art 1979, 1982, 1986, 1988; Ben Grady Gallery, Canberra 1989.

Publications Art International 1982 Vol XXV/3–4 March–April, Letter from Australia; *Art and Australia*, Autumn 1986 and 1987.

Represented Institutional and private collections in UK, Europe, USA, Australia and Artbank.

HART, Eleanor Sarah VIC
Born Melbourne Vic 1946. Printmaker and educationalist.

Studies Caulfield Institute of Technology, Diploma of Art and Design (printmaking major) 1974; Royal Melbourne Institute of Technology, Fellowship Diploma Fine Art (printmaking) 1975; State College, Hawthorn, Diploma of Education 1976; Travel to UK and Europe 1981.

Exhibitions Solo shows at Hawthorn City Gallery 1975–77, Toorak Gallery 1976; Realities Gallery 1981; Excelsior Gallery 1985. Participated in many local and overseas print shows.

Awards Appointed Australian correspondent for the World Print Council, New York 1981; Awarded Moya Dyring Award for three months at Paris Studio Cité International 1983.

Represented USA Consulate, Melbourne; Warrnambool Art Gallery; Education Dept of Vic; Private collections in Australia, USA and Mexico.

Bibliography *Directory of Australian Printmakers* 1982.

HART, Trish VIC
Born Perth, WA 1956. Painter, illustrator and printmaker, mainly Australian wildlife.

Studies Diploma Art and Design, Caulfield Institute of Technology 1977. Went freelance in 1981 illustrating calendars on Australian wildlife for World Wildlife Fund, then Valentine Sands, 1982–1990; illustrated childrens books for publishers Angus & Robertson, *Matilda Goodbucket* and *Rungawilla Ranger*; member of ANARE 1987–88 Summer Program to Macquarie Island, Heard Island, and Davis Base, Antarctica by the Australian Antarctic Division, to record wildlife for 1990 Calendar, exhibition material and set of stamps on Australian Antarctic Territory — commissioned by Australia Post. Illustrated poster for Fisheries and Wildlife on the Mountain Pygmy Possum; also Shell Road Map covers using State Flora and Fauna emblems; started print making in 1987.

Exhibitions Russell Davis gallery Melbourne 1981; Waverley City Gallery, Melb. 1987; Antarctic Exhibition, Handmark Gallery, Hobart 1988; Five Ways Gallery, Kalorama 1989, 91.

Awards Wildlife Artists Society of Australasia — Drawing Award, 1985–1986–1987; First Prize, Victorian Artists Society, Spring Exhibition, 1987.

Represented Private collections in Australia, USA, England, Denmark, Sweden and Yugoslavia, also in Osaka, Chamber of Commerce Japan.

Bibliography *Design World* (Australia) first edition 1983.

HARVEY, Joy NSW
Born Sydney Australia. Contemporary painter in oil and gouache.

Studies Hornsby College of TAFE 1980–83; Adelaide Art School 1961–62.
Exhibitions Solo shows at Holgate Studio 1977–85; Toowoon Bay Gallery 1988; Seaview Gallery, Whitebridge NSW 1989. Numerous group shows, including Styles, Prouds and Gallery 460, Gosford 1985–88.
Awards Darwin Show, Hawkesbury Show, Wyong Festival, Gosford Festival.
Represented Institutional and private collections in Aust., UK, Norway, Germany, Canada.

HASPEL, Hanna VIC
Born Vienna Austria 1920, arrived Australia 1938. Tapestries and wool paintings.
Studies Art and Craft Academy, Vienna, Fashion design, Paris; Ecole de Beaux-arts; On arrival in Australia worked as a Fashion-artist on Melbourne newspapers and for the Fashion-trade; Has now fully developed her techniques of designing and executing her unique Wool-paintings; Her figurative designs are on large Hessian frames, using yarns and wools, depicting Polynesian and biblical themes; Her abstracts are executed on canvas, using gros-point stitching; She is experimenting also with a new medium, i.e. handstitched appliques in felt.
Exhibitions Craft Centre, South Yarra, Vic; Balmoral Galleries, Geelong Vic; International Originals, Collingwood, Vic; Manyung Gallery, Mount Eliza Vic; Australian Wool Corporation, Parkville Vic 1978; Distelfink Gallery, Hawthorn, Vic 1978; Paul Rigby (Signature) Gallery, Nedlands, Perth, 1979; Blaxland Gallery, Sydney 1981; Griffin Gallery, Canberra 1981.
Represented The Wool-House, Parkville, Vic; Private collections in Melbourne, Sydney, Perth, Canberra, UK, France, Italy, and Israel.

HASTIE, Kaye Maureen QLD
Born 1955. Graphic artist.
Studies Graduated, Perth TC 1976.
Exhibitions Solo show at Territory Colours Gallery, Gold Coast 1989.

HATCHES, Nyukana NT
Aboriginal watercolour painter from Fregon a Pitjabtjatjara community associated with the Ernabella region around the SA/NT border.
Exhibitions Bloomfield Galleries, Sydney 1989.
Represented ANG; NTMAG; AGSA; Robert Homes à Court Collection.

HATTAM, Katherine VIC
Born Melb. 1950. Painter.
Studies Bachelor of Arts, (Hons) Melb. University.
Exhibitions Ewing and George Paton Galleries, Melb; Susan Gillespie Gallery, Canberra; Brackenlea Gallery, Mt. Gambier 1978; Drummond St. Gallery, Melb 1982; Tynte Gallery, Adelaide 1984; 70 Arden Street, Melb.; Amina Gallery, Adelaide 1987; Warrnambool Art Gallery; William Mora Galleries, Melb. 1988. Participated Tynte Gallery, Adelaide 1984; Group Drawing Show, 70 Arden St. Melb.; 200 Gertrude Street, Melb 1986.
Awards Mornington Peninsula Arts Centre Spring Fesitval of Drawing 1986; Box Hill Drawing Prize 1987.
Represented ANG, NGV, MPAC, Artbank, Box Hill City Collection, Hamilton Art Gallery, Warrnambool Art Gallery, Queen Victoria Hospital Collection, Private collections.

HATTON, Beth NSW
Born Canada. Weaver.
Studies Postgraduate Diploma in Professional Art Studies, City Art Institute, Sydney 1982.

Exhibitions Solo show at Beaver Galleries, Canberra 1988.
Awards Craft Council of NSW Merit Award 1979.
Represented State galleries in Perth and Brisbane, Powerhouse Museum, Sydney.
Bibliography *Craft Arts*, Sept/Nov 1988.

HAVEKES, Ineke NSW
Born Aust. 1965. Painter.
Studies Hornsby TC 1985; Grad. Dip. City Art Institute 1989.
Exhibitions Galaxy Gallery, First Draft Gallery, Sydney 1989.

HAVYATT, Phoebe L. NSW
Born Melbourne 1951. Sculptor in mixed media.
Studies BA (Visual Arts), UNE, Lismore 1986–89.
Exhibitions Solo shows at Portia's Place, Lismore 1990; Cafe Bohemia Gallery, Lismore
1991. Numerous group shows since 1987 include Lismore Regional Gallery 1986, 87, 88,
89; Tamworth City Gallery 1990.
Awards University of New England Studio Sculpture Prize 1989.

HAWKES, Gay NSW
Born Burnie, Tas. 1942. Figurative sculptor, painter, woodworker, teacher.
Studies Uni. of Tas. 1960–62; Tas. S of A, Hobart 1979–80 — Associate Dip.;
Woodworking Summer School 1981, 82; Woodskills Course, S of A 1982–83; Artist-in-
Residence Wesley College, Melb. 1984 and Swan Hill, Vic. 1985; taught Tas 1963–75;
England 1966; Canada 1967; PIT, Melb. 1986; Trondheim, Norway 1988.
Exhibitions Solo shows at Adelaide Festival Centre 1983; Ray Hughes Gallery, Sydney
1985; Gallery Gabrielle Pizzi and Lennox Street Gallery, Melb 1988. Her work was also
included in *A New Generation 1983–88* at the ANG, Canberra 1988 and many group shows
since 1981. Solo show at Australian Galleries, Melb. 1989.
Awards VACB Grants 1982, 88.
Represented ANG, AGSA, MCA, Brisbane, New Parliament House, Canberra, Artbank,
institutional and private collections in UK, Europe, Canada, USA and Australia.

HAWKES, Ponch VIC
Born Melbourne 1946. Photographer, journalist and writer whose work appears in many
Australian newspapers.
Exhibitions Solo shows at Brummel's Gallery, Melbourne 1976; NGV 1989. Numerous
group shows since 1974 include VCA Gallery 1980; La Trobe University Gallery 1981;
Watters Gallery, Sydney 1981; Monash University Gallery and Developed Image Gallery,
Adelaide 1982; Perc Tucker Gallery, Townsville and Artspace, Sydney 1983; ANG,
Canberra 1984, 86, 88; ACCA, Melbourne 1988.
Bibliography *Shades of Light, Photography and Australia*: ANG and Collins, Sydney 1988;
Field of Vision: Janine Burke: Viking-Penguin 1990.
Represented ANG, Canberra and institutional collections.

HAWKINS, Mabel K. NSW
Born Dunolly Vic, circa 1900. Painter.
Studies With D. Orban, for eight years and under Conrad Kickert in Paris. Member and
publicity officer for CAS for some years. Held many exhibitions around Australia. Lives
Sydney.

HAWKINS-KOOZNETZOFF, Ludmela NT
Born Biloela Qld 1941. Painter, printmaker and teacher.
Studies College of Art, Brisbane; Atelier Franck, Pairs; SA College of Arts gaining Bachelor

of Arts Fine Arts and Diploma of Education; Presently head of Dept of Creative and Fine Arts at Community College of Central Australia, Alice Springs.
Exhibitions One-woman shows in Brisbane 1977 and Adelaide 1979; Many group shows including Alice Springs 1977, 1979; Broken Hill 1978, 1979; Students of Paul Franck, Paris 1978; SASA Gallery, Adelaide 1979; And CAS Gallery, Adelaide 1979.
Awards The Alice Prize 1979; Broken Hill 1979.
Represented Alice Springs, Broken Hill and Caltex NT Collections and private collections in Australia and UK, Europe.
Bibliography *Directory of Australian Printmakers* 1982.

HAWTHORN, Barbara WA
Born WA 1948. Painter and printmaker.
Studies WA Institute of Technology and University of Oregon, USA 1975–76; Summer School at Tas School of Art 1981.
Exhibitions Held one-woman shows at Perth 1974, 1978, 1980 and participated in Printmakers shows 1976–81 and at Galerie Dusseldorf 1981.
Awards Albany Council (painting) 1974; Manjimup Print Prize 1979.
Represented Art Gallery of WA and institutional and private collections in WA, NSW and USA.

HAWTHORN, Shirley Yvonne VIC
Born Melbourne Vic 1919. Painter and sculptor.
Studies RMIT in the late 1930s. No further studies until 1952 in Japan, when she studied with a Japanese artist in Yokohama; It was not until 1973 she began sculpture when she joined Robert Langley's classes and from that time she has been concentrating solely on sculpture; Member of the Association of Sculptors, Vic; The Melbourne Society of Women Painters and a Fellow of the Royal Society of Arts, London.
Exhibitions Kew 1976; Manyung Gallery, Mt Eliza, Vic 1979, 1982.
Represented Private collections in Australia and Singapore.

HAXTON, Elaine (Hood) NSW
Born Melbourne Vic 1909. Painter, theatre designer, printmaker, illustrator of children's books.
Studies East Sydney Technical College under Rayner Hoff; Worked as a fashion artist in a Sydney dept store for some time, then went to UK to study at the London studio of Scottish painter, Iain McNab and stayed for eight years; Returned to Australia in 1939 via USA and Mexico and became known for her colourful murals; She designed ballet costumes and theatre sets for the government in Dutch New Guinea in 1945; Revisited USA and UK 1946–48 and for a time studied theatre design at the New School, New York; Formerly member of the NSW Society of Artists and the Contemporary Art Society; As a printmaker she studied at the Workshop Art Centre, Willoughby NSW, William Hayter Atelier, Paris and at Kyoto Japan.
Exhibitions One-woman shows in Sydney 1967, 1975; Perth 1967; Brisbane 1967; Melbourne 1968; Stadia Graphics, Sydney 1983; Greenhill Galleries, Perth 1983; Holdsworth Galleries, Sydney 1984; Eddie Glastra Galleries, Sydney 1988. Her prints were included in Second British International Print Biennale 1970, and in shows in Rome 1969, Madrid 1970, Prague 1970; Still a regular exhibitor with Sydney Printmakers and was included in the First and Second Triennale of Contemporary Xylography at Carpi Italy 1969, 1972; Her retrospective show of 100 prints was held at Queen Victoria Museum and Art Gallery, Launceston Tas in 1982 and is presently travelling in Australia; Solo show at David Jones Gallery, Sydney 1984.
Awards Sulman Prize for mural Le Coq d'Or Restaurant, Sydney 1943; Crouch Prize 1946.
Represented Metropolitan Museum of Art, New York; National Collection, Canberra; All

State Galleries; Regional Galleries at Geelong, Newcastle, Ballarat, Bendigo; Many private and institutional collections in Australia and overseas.
Bibliography *Australian Painting 1788–1970*, Bernard Smith, Oxford University Press 1974; *Directory of Australian Printmakers 1976; Present Day Art in Australia*, Ure Smith, Sydney 1945; *Artists & Galleries of Australia*, Max Germaine: Craftsman House 1990.

HAYDON, Ingrid NSW
Painter, designer, teacher.
Studies Scholarship, ESTC 1961–62; freelance designer of textiles 1963–66; studied UK 1966; Heatherley School of Art, London UK 1967–68, taught UK 1968; studied batik in Sydney 1969–70; worked UK 1978–80. Completed BA Visual Art, City Art Institute 1982–84; part-time teaching Hornsby College of TAFE 1985–90.
Exhibitions Access Gallery 1987, 88, 89, 90. Numerous group shows since 1970 include Heals, London UK 1978; Old Bakery Gallery 1985; Delmar Gallery 1988; Blaxland Gallery, Sydney 1986, 87, 88, 89.
Awards Willoughby Drawing Prize 1985, 86. Commissioned Wall Hangings, Saudi Arabia 1979.
Represented Institutional and private collections in UK, Europe, Australia.

HAYMAN, Karen VIC
Born Melb. 1959. Painter.
Studies PIT, Melb. 1980–82.
Exhibitions Solo show at William Mora Gallery, Melb. 1988. Her work was included in *A New Generation 1983–88* at the ANG Canberra 1988.

HAYS, Bette (nee PASSMORE) QLD
Born Sydney NSW 1922. Painter of landscapes and figure compositions in oil; Teacher.
Studies East Sydney Technical College 1938; Studies interrupted by four years in the WAAAF; Returned to diploma course after discharge under CRTS; Instructors were Frank Norton, Douglas Dundas, Jean Bellette, Alfred Cook and Roland Wakelin; Also studied sculpture with Lyndon Dadswell and Frank Lumb; Lived in Papua New Guinea 1950–59; Taught at Townsville Grammar School, North Qld 1964–71.
Exhibitions Halmaag Galleries, Melbourne 1971, 1972, 1976, 1977 and Adelaide 1973, 1978; Qantas Gallery, London 1974; Barry's Art Gallery, Brisbane 1977; Cintra House 1979–81; Holdsworth Galleries, Sydney 1980, 1982, 1988.
Award Townsville Art Prize 1965.
Commissions Large mural at Blue Room of the Hotel Cecil, Lae New Guinea; Designed set of four stamps for Papua New Guinea, *The Dancers* Christmas Issue 1971.
Represented Collections at Olympic House, Sydney; ANZ Banking Company, London and Brisbane; Commonwealth Bank, London; Qantas Overseas Terminals; Dalgety Australia Ltd; International Harvester Corp; Minet Australia Ltd; Reserve Bank of Australia; Carlton and United Brewery; Townsville City Council; Bristol Paints; Wool Commission; Wheat Board; Many private collections in Australia and overseas.

HAYTHORNWAITE, Lee WA
Born Perth WA. Figurative painter in oil, acrylic; Sculptor and teacher.
Studies Institute of Technology, Perth WA; Vancouver School of Arts, British Columbia Canada.
Exhibitions Sydney 1974 and Perth 1977; Lecturer, Experimental School of Arts, Perth; Commissioned to paint 83-foot (25.3 metre) mural *Feast of Purim* for the Jewish Synagogue in Vancouver, whilst lecturer at School of Arts there. Recent shows at Fire Station Gallery 1981; Perth Concert Hall 1989.

Represented Mt Lawley School of Advanced Education, WA; Max McCreedy Collection, Melbourne.

HEADLAM, Kristen VIC
Born Launceston, Tas. 1953. Expressionist painter.
Studies Uni of Melbourne 1972–76; VCA 1980–81.
Exhibitions Solo shows at Nielsen Hayes Library, Bangkok 1984; Cockatoo Gallery, Launceston 1988; Charles Nodrum Gallery, Melbourne 1989, 91. Group shows include Tricycle Arts Complex, London UK 1982; Bicentennial Touring Exhibition, Melbourne, Sydney, Adelaide 1988; Geelong Regional Art Gallery 1989, 90.

HEALY, Beryl May VIC
Born Glenthompson, Vic 1927. Post-impressionist painter in oil and pastel, and portraitist.
Studies VAS under William Frater 1969; Member, VAS and Women Painters and Sculptors.
Exhibitions Solo shows Melbourne 1981–82 and VAS exhibitions.
Awards Lord Mayors $1500 Acquisitive Prize 1982.
Represented Melbourne City Council and private collections in Australia and overseas.

HEALY-WILLS, Eleanor VIC
Born Melb. 1942. Painter, muralist, printmaker.
Studies Nat. Gallery School; CIT and Box Hill TAFE.
Exhibitions Falls Creek 1976; Realities 1980; Golden Age Gallery, Ballarat 1984.
Awards Bright Festival, Vic 1981.
Represented Institutional and private collections in Aust. and overseas.

HEARMAN, Louise VIC
Born Melb. 1963. Paintings and installations.
Studies VCA Melb. 1982–84.
Exhibitions Solo shows at own studio, Melb. 1985 and Mori Gallery, Sydney 1988. Her work was included in *A New Generation 1983–88* at the ANG, Canberra 1988. Solo show at City Gallery, Melb. 1989 and at Realities Gallery 1991. She was also included in the Moët & Chandon Touring Exhibition 1988, 89.

HEATH, Barbara QLD
Born Sydney 1954. Silversmith and jewellery designer.
Studies RMIT and served apprenticeship with Laslo Puzar.
Exhibitions Solo show at Roz MacAllan Gallery, Brisbane 1987. Numerous group shows.
Awards Westpac Craft Award, Brisbane 1983; VACB Grant 1986, 87.
Represented QVMAG, corporate and private collections.
Bibliography *A Homage to Women Artists in Queensland*: The Centre Gallery 1988.

HEATH, Diana QLD
Born Scotland UK 1937. Painter, printmaker.
Studies West of England Academy 1958–59; Gaining Associate Diploma in Visual Arts (graphics) 1980; Kelvin Grove CAE, Brisbane.
Exhibitions Kelvin Grove CAE Gallery, Brisbane; Part of her working time is devoted to her hobby of producing embossed books of poems for blind readers which are available at Braille House, Brisbane Qld. Participated at Uni. of Qld. Staff Show 1988; Kelvin Grove CAE 1980; Crafts Council 1983.
Bibliography *PCA Directory* 1988.
Represented Private collections UK, USA and Australia.

HEATHER, Madeleine L. NSW
Born Sydney NSW. Potter, ceramic artist and weaver.
Studies St Georges Technical College and graduate of ceramics dept of National Art School, Sydney 1969; Teacher in charge, Lithgow Technical College (ceramics) 1979.
Awards Royal Easter Show, Sydney; Orange (Purchase) 1975, 1977.
Represented Orange Regional Gallery and private collections.

HEATHWOOD, Margaret NSW
Born Sydney 1964. Paintings and collage.
Studies Art Certificate, Gymea TAFE 1983; BA Visual Arts, City Art Institute 1984–86; Grad. Dip. 1987–88. Overseas study 1989.
Exhibitions Solo shows at City Art Institute Gallery 1987; Arthaus, Sydney 1988.

HEDLEY, Helen VIC
Born Melbourne Vic 1942. Printmaker and teacher.
Studies Graduated Bachelor of Education, Arts and Crafts from State College of Vic 1976–79.
Exhibitions Oz Gallery, Melbourne 1978–79; Chameleon Gallery, Sydney 1979; Harrington Street Gallery, Hobart 1980.
Represented Institutional and private collections in USA and Australia and overseas.
Bibliography *Directory of Australian Printmakers* 1982, 88.

HEGARTY, Elizabeth Muriel NSW
Born 1893. Traditional painter mostly in watercolour; Teacher. Numerous group shows; Two one-woman shows over the years; Now living at Mowell Village, Castle Hill NSW.
Awards Watercolour awards at Yass, Goulburn and Wollongong NSW.
Bibliography *International Who's Who in Art and Antiques*, Cambridge 1976.

HEGGE, Marit QLD
Born Australia. Painter and arts administrator.
Studies Diploma in Art from Alexander Mackie CAE 1975. Awarded NSW Art Gallery Travelling Scholarship 1976; Studied in Europe and Asia; Held solo shows in Brisbane and participated Art Gallery of NSW. Presently Community Arts Officer at the Government funded Brisbane Community Arts Centre.

HEIDENREICH, Judith SA
Born Mannum SA 1936. Painter of still-life and religious subjects.
Studies SA School of Art, gaining Diploma in Fine Art (painting) 1960–63; Fellow of the RSASA; Member of the CAS; Overseas study tour 1969; In 1977 she, her husband and children and two other families formed Manoah Christian Community, being led to restore the burnt-out shell of what was once a grand old building built by Sir Josiah Symon while engaged in final drafting of the Australian Constitution in 1898. Manoah is located at Upper Sturt SA.
Exhibitions One-woman shows at Perth Arts Festival 1968; Adelaide Festival of Arts 1968, 1972, 1974; Lidums Gallery 1970; Kuala Lumpar 1970; Die Gallery, Tanunda SA 1972, 1974; Munster Arms Gallery, Melbourne 1975; Many group shows over the years and recently RSASA Fellows 1982; Queens College, Cambridge UK 1982; Bonython Gallery, Adelaide 1982.
Awards Olive Dutton Prize 1962; RSASA Still-life 1964.
Represented Naracoorte Art Gallery, SA; Brera Museum, Milan Italy; Institutional and private collections in Australia, USA, UK, Europe and NZ.
Bibliography *Who's Who in the Commonwealth*, Cambridge UK 1983.

HEILPERN, Louise NSW
Born Sydney 1962. Painter.
Studies BA Visual Arts, University of NSW 1981–83; Dip. Ed., Sydney Teachers College 1986.
Exhibitions Solo shows at Mori Gallery 1986, 88, 89, 90. Numerous group shows include Blaxland Gallery 1984; Ivan Dougherty Gallery 1984; Australian Centre for Photography 1988; Sylvester Studios 1988; Mori Gallery 1990, 91; IMA, Brisbane 1991; Umbrella Studio, Townsville 1991.
Awards Desiderius Orban Youth Art Award 1987.
Represented Institutional and private collections.

HEINER, Ruth QLD
Born Goomeri Qld. Painter of genre subjects.
Studies Completed a commercial art course.
Exhibitions Park Road Gallery, Brisbane; Upstairs Gallery, Cairns and Blue Marble Gallery, Buderim, Qld.
Awards Castlemaine-Perkins 'Pubs in a Landscape' Prize 1983.

HEINT, Raelene SA
Born Adelaide SA 1946. Abstract expressionist painter mostly in oil, mostly self-taught; Member of the CAS and RSASA.
Exhibitions Tee Tree Gully Gallery 1978; Strathalbyn Art Centre 1979; Leabrook Gallery 1983. Solo studio shows 1984, 88. Numerous group shows since 1981.
Awards Adelaide Oil Refinery Prize 1989. Murray Bridge District Prize 1989.
Represented Institutional and private collections in Aust. and overseas.

HELLARD, Kate VIC
Born Melbourne Vic. Painter, illustrator and teacher.
Studies Worked as an illustrator for nine years with the Melbourne *Herald*; Member of Vic Artists' Society and Beaumaris Art Group; Also tutor with the Council of Education; Held several exhibitions of her landscape paintings including Juniper Gallery, Melbourne 1977, Wiregrass Gallery, Melb 1988; Overseas study tour UK, Europe 1987.

HELY, Patsy NSW
Born Sydney 1946. Ceramic artist and teacher.
Studies ESTC 1976–77 and postgraduate 1979. Sydney University Art Workshop 1980–83; Newcastle CAE 1985; City Art Institute 1985–88; Full-time lecturer in Ceramics at UNE-NR 1989– ; Artist-in-Residence, Victorian Tapestry Workshop 1988.
Exhibitions Solo shows at Seasons Gallery 1982; Mori Gallery 1983; Garry Anderson Gallery 1988, 90. Numerous group shows include Distelfink Gallery, Shepparton Regional Gallery, QVMAG, Launceston, Manly Art Gallery.
Awards Mayfair Ceramics Award 1984; VACB Grants 1984, 85, 89; Commissions include Bondi Pavilion Murals 1984, 85; Bicentennial Authority Installation 1987; Darling Harbour Mural 1987.
Represented AGWA, AGSA; Regional Galleries at Bathurst, Townsville, Rockhampton and Manly; New Parliament House Collections, Canberra.

HENDERSON, Jill VIC
Born Vic. 1939. Painter of landscapes and horses; studied with Cheltenham Art Group, Vic; Member AGRA; Director of Akoonah Gallery, Berwick, Vic.
Exhibitions Solo shows since 1977 include Shilolodge Gallery Narre Warren Vic. 1983, 84; Mulgrave Gallery 1985; Ki-Ba-Be Gallery, Merimbula NSW 1985, 86, 87; Berwick City Hall, Vic. 1988; Old Cheese Factory, Berwick 1988.

Awards Merimbula 1984, 85; Berwick 1978; 'Artist of the Year', McClelland Guild of Artists 1987.

Represented Institutional and private collections in UK, Europe, USA, Canada, Asia, Australia.

HENDERSON, Joy NSW
Born Perth WA 1957. Sculptor.

Studies BA, Murdoch Uni, Perth 1976–80; Dip FA Claremont S of A, Perth 1980–82; Dip. Ed., Sydney CAE; Post Certificate Sculpture, ESTC 1986; Study tour UK, Europe 1986.

Exhibitions Solo show at Access Gallery, Sydney 1988, 89; Numerous group shows since 1982 include Gomboc Gallery, WA 1984, 88; Editions Gallery, Fremantle 1984; Claremont S of A 1984; Access, Sydney 1987, 89.

Awards South Perth Heritage 1981; WA Arts Council Grant 1983. Commissions include Feature Film — 'Birdsville; Glenrowan/Ned Kelly Tourist Exhibition, Status Marketing, Laserlight Expressions.

Represented Represented in Robert Holmes à Court Collection, Alan Burns Collection and numerous private collections throughout Australia and UK.

HENDERSON, Wendi VIC
Born Melbourne 1949. Painter, printmaker, sculptor.

Studies Swinburne Institute in the late 1960s.

Exhibitions Solo show at Eltham-Wiregrass Gallery 1990; Numerous group shows since 1983.

Awards Wildlife Art Society of Australasia Prize 1989.

HENDY, Sandra NSW
Born NSW. Watercolour painter and teacher; Exhibiting member of the RAS of NSW and the Ku-ring-gai Art Society; Also shows at the Bentinck Galleries, Ballina NSW.

HENRIKSEN, Kari VIC
Painter.

Studies RMIT, Dip. Fine Art 1972–74; Fellowship Dip. 1975. Study tour UK, Europe, South America 1976; Japan 1988.

Exhibitions Reflections Gallery, Melb. 1985; Beaver Galleries, Canberra 1986; Eltham Gallery, Melb. 1987; Capricorn Gallery 1988. Numerous group shows include ROAR Studios 1986; Toronto, Canada 1988.

Represented Institutional and private collections in UK, Europe, Japan, South America, Australia.

HENSHAW, Judy VIC
Born Coleraine Vic 1936. Traditional painter in oil and watercolour.

Studies Night classes at Bendigo School of Mines; National Gallery School 1955–59 and various private tutors.

Exhibitions Solo shows at AMP Gallery, Melbourne 1977, 1978.

Awards Bendigo Art Gallery Students 1954; Heidelberg Artists Society 1976.

Represented Institutional and private collections in USA, Canada, Japan and Australasia.

HEPBURN, Lorraine (Merrony) NSW
Born Aust. 1938. Sculptor.

Studies Bachelor of Visual Arts, Sydney College of the Arts, Sculpture Major 1978–80; Postgraduate Diploma, Professional Art Studies, City Art Institute/Alexander Mackie Institute, Sydney, Sculpture Major 1981; MA (Honours) Candidate, University of New South Wales 1986–87. One of 40 participants in the International Symposium 'Metal Plus

Textiles Equals?' in Zurich, Switzerland 1980; overseas study tours 1973, 78, 80, 82, 85. President and Vice-President of the Crafts Council of The ACT. Delegate to the Crafts Council of Australia. 1976–77.

Exhibitions One-woman shows at First-Anna Simmons Gallery, Canberra 1973; Experimental Art Foundation, Adelaide 1978; Art Empire Industry, Sydney 1980; The Adelaide Festival Centre Trust commissioned 'The Quilt and Sheet Show!' for the Festival Centre Gallery in 1981; This became a touring installation which toured Australia; Group shows include *Australia 1970 Onwards* including Australian Sculpture Triennial, Melbourne 1981; UK 1982; Italy 1983; Irving Sculpture Gallery 1983, 1984, 1985; Giles Street Gallery, Canberra 1986; Painters Gallery 1987, 89. Group shows include 1st Australian Sculpture Triennial 1981; CAS, Adelaide 1982; Zona Art Space, Florence, Italy 1983; Meat Market Centre, Melb. 1984; 'Sculpture '85', World Trade Centre, Melb. 1985; Glass Artists Gallery 1985; Irving Sculpture Gallery 1986, 87; Regional Galleries at Lake Macquarie and Goulburn; Jam Factory, Adelaide 1987.

Awards Australia Council Grants 1973–74 and 1982; Australia-Japan Foundation Travel grant to Japan 1978; Selected one of 40 for International Symposium and 8-day workshop on Metals and Textiles, Zurich Switzerland; One of 100 special student grants at WCC Conference, Vienna 1980.

Represented Corporate and private collections in UK, Europe and Australia.

Bibliography *Who's Who in Australian Women*, Methuen 1982; LIP — Women in the Visual and Performing Arts 1981–82; Craft Australia 1980(3) 1981(4) 1982(1); Art Network 1981/3 1982/1.

HEPPER, Judy NSW

Born NSW 1928. Modern figurative painter in oil and acrylic.

Studies Melbourne Technical College 1954; Julian Ashton School, Sydney 1955; East Sydney Technical College 1956–59; Newcastle TC 1982–85.

Exhibitions von Bertouch Galleries, Newcastle 1965, 86, 91; Bonython Gallery, Adelaide.

Represented Maitland and Newcastle City Galleries; Private collections in Australia and overseas.

HEPWORTH, Anne (Creed) WA

Born WA 1915. Painter and teacher.

Studies Perth TC; Fremantle TC; Member and past president of Perth Society of Artists; member, CAS, taught at YMCA, Melville.

Exhibitions Solo shows at Boans Gallery, The Patch Theatre and Collections Gallery 1975.

HERBERT, Diana Lipson NSW

Born Sydney 1943. Painter and teacher.

Studies BA Fine Arts (Hons) University of Sydney 1981; Dip. Ed. Sydney Teachers College 1982; Certificate of Art & Design ESTC 1990.

Exhibitions Woolooware House Gallery 1990; ESTC Gallery 1990.

HERBERT, Nancy Flora (Woods) NSW

Born Tamworth NSW. Painter of animals and fantasy in oil.

Studies Gymea College of TAFE and with private tutors.

Exhibitions Woolooware House Gallery 1990; Southern Cross Art Exhibition, Caringbah NSW 1990.

HESSING, Mona NSW

Born Sydney NSW 1934. Weaver.

Studies Completed Diploma Design Course at National Art School, Sydney; Worked as a design consultant from 1953–65 and also taught art; Study tour to India 1967.

Exhibitions First at Bonython Gallery, Sydney in 1971; Was invited to participated in textile seminar at the World Craft Council, Dublin Conference 1970; Joint exhibition with Marea Gazzard at National Gallery of Vic 1972.

Commissions Wall tapestry for Indian magazine *Design*, New Delhi 1967; Tapestry for Wentworth Memorial Church, Vaucluse; Wall tapestry for Menzies Hotel, Sydney; Wall hangings for Basser College and Clancy Auditorium, University of NSW.

Represented National Collection, Canberra; National Gallery of Vic; Private collections in Australia and overseas.

Bibliography *Art and Australia*, Vols 9/2 and 3.

HESSING, Perle UK

Born Zaleszcyki Poland 1908. Naive painter; Mother of Leonard Hessing.

Studies Lived in Australia for twenty-two years and encouraged by her son, took up painting in the 1960s.

Exhibitions Had numerous shows in Australia; Now lives in UK and exhibits at the Portal Gallery, London and illustrates books.

Bibliography *Australian Naive Painters*, Bianca McCullough, Hill of Content, Melbourne 1977; *Who's Who in the Commonwealth*, Cambridge UK 1982.

HEY, Ros TAS

Born Launceston, Tas 1945. Printmaker and teacher.

Studies Hobart S of A 1963–65, 77–80. Taught Tas. Ed. Dept. 1966–68; Adult Education 1978–80; Dominic College 1981–86.

Exhibitions Solo shows at Harrington Street Gallery 1979, 80; Japan 1980–81; Prints in Victorian Schools 1981; Poster Show UK 1981.

Bibliography *Tasmanian Artists of the 20th Century*, Sue Backhouse: Pandani Press 1988.

HEYSEN, Nora NSW

Born Hahndorf SA 1911. Traditional painter of flowers, still-life, portraits mostly in oil, some watercolour; Daughter of Sir Hans Heysen.

Studies Adelaide School of Fine Arts under Millward Grey; Central School of Arts and Crafts, London under James Grant and Bernard Meninsky; Also some sculpture under Alfred Turner and Skeaping, and the Byam Shaw School of Art, London; Served as an official war artist in New Guinea with the three services 1944–46; Presently drawing and painting portraits in Sydney.

Exhibitions First one-woman show, SA Society of Arts 1933; Then followed by others at Hahndorf Gallery, SA 1952; Moreton Galleries, Brisbane 1954; John Martin Gallery, Adelaide 1957; Millicent Masonic Hall, SA 1963; North Adelaide Gallery 1967; Retrospective shows at Clarendon Gallery, SA 1984, von Bertouch Galleries, Newcastle 1986 and S.H. Ervin Gallery, Sydney 1989.

Awards Melrose Prize SA; L.J. Harvey Drawing Prize, Qld (twice); Archibald Prize 1938.

Represented Australian National Gallery, Canberra; the Art Gallery of New South Wales; the Queensland Art Gallery, the National War Museum, Canberra; the Art Gallery of South Australia; The Newcastle Region Art Gallery; Ballarat Fine Art Gallery; Hamilton Art Gallery and New England Art Museum (formerly the Howard Hinton Collection of the Armidale Teachers' College).

Bibliography *Artists & Galleries of Australia*, Max Germaine: Craftsman House 1990.

HICK, Jacqueline QLD

Born Adelaide SA 1919. Figurative painter in oil.

Studies SA School of Art; Central School of Art, London; Academie Montmarte, Paris; Foundation member of CAS, Adelaide; Fellow of Royal SA Society of Arts; Served as trustee on board of Art Gallery of SA 1968–76.

Exhibitions Since 1940 has shows in many group and one-woman shows in all states, UK, California USA; 'Australian Painting', Corcoran Gallery, USA 1966; De Hedendaagse Schildur Kunst in Australia 1964; Commonwealth Art Today 1962–63; Solo shows at Victor Mace Gallery, Brisbane 1981, 1982; Greythorn Galleries Melb. 1988, 89.
Awards Dunlop 1955–56; Melrose 1958; Cornell and Adelaide Arts Caltex 1960; Maude Vizard-Wholohan 1962–64.
Represented Australian National Gallery, Canberra; All state galleries; London Guild Hall; Mertz Collection, USA; Raymond Burr Collection, USA; Many provincial and university collections.
Bibliography *Modern Australian Painting 1970–75*, Kym Bonython/Elwyn Lynn, Rigby 1976; *Australian Painting 1788–1970*, Bernard Smith, Oxford University Press 1974; *Art and Australia* Vols 1/4, 2/2, 4/2; *Artists & Galleries of Australia*, Max Germaine: Craftsman House 1990.

HICKS, Bobbi NSW
Born NZ.
Studies Dattilo Rubbo Studio, Sydney.
Exhibitions David Jones Gallery, Sydney 1978, 82; Palm Beach Studio 1991.

HIDER, Anne SA
Born Adelaide SA 1938. Sculptor.
Studies Variety of art classes but mainly self-taught; Fellow, Royal SA Society of Arts; One-woman shows in 1971, 1973, 1977; Two-woman show 1969; Commissioned by SA Institute of Teachers in 1973 to erect a 4-by-2.5-metre steel and glass mural; SAFCOL 1.25-metre sculpture of emblem 1976; Part-time lecturer at SA Dept of Further Education 1978–.

HIGGINBOTHAM, Julie VIC
Born Melbourne Vic 1953. Printmaker and photographer.
Studies Prahran CAE 1970–74; Preston Institute 1977; Phillip Institute 1981–82; Co-director of Iceberg Gallery, Melbourne; Study tour to UK, Europe 1983.
Exhibitions Solo shows at Faraday Gallery 1975; Iceberg Gallery 1982; Bitumen River Gallery, ACT 1983; Garry Anderson Gallery, Sydney 1988; Seamans Mission Gallery, Melb. 1989; Linden Gallery, Melb. 1989; Participated in many group shows since 1975 including Student Printmakers to UK and Europe 1977 and Contemporary Australian Printmakers to USA and Canada 1984.
Represented Institutional and private collections in Australia and overseas.

HIGSON, Shayne NSW
Born Sydney 1960. Painter, designer, photographer.
Studies ESTC 1978–80; City Art Institute 1980–83.
Exhibitions Solo shows Avago Gallery, Sydney 1981, 82, 85; Mori Gallery 1987; Realities Gallery, Melbourne 1987, 90; Michael Milburn Gallery, Brisbane 1987, 89; aGOG Gallery, Canberra 1990; Roslyn Oxley9 Gallery, Sydney 1990. Many group shows since 1982 include Anzart, Auckland 1985; Biennale Des Friedens, Hamburg, Germany 1986; Intergrafik '87, Berlin 1987; Tin Sheds Gallery 1988, 89; Garry Anderson Gallery 1988; The Centre Gallery, Gold Coast 1988; Roslyn Oxley9 Gallery 1988; Milburn + Arte, Brisbane 1988; Linden Gallery, Melbourne; Pailou Centre, Sydney; Artspace, Sydney and Ivan Dougherty Gallery 1989; The Painters Gallery, Sydney 1990.
Represented ANG; MCA, Brisbane; Griffiths University; SCAE; Institutional and private collections in Australia and overseas.

HILDA NT
Born c.1941. Aboriginal acrylic painter from the Yuendumu region of Central Australia.

Warlpiri language group.
Represented Art Gallery of SA.

HILDEBRANDT, Johanna NSW
Born Bavaria 1950. Naive painter.
Exhibitions Rainsford Gallery, Sydney 1983, 85, 87, 88; Prouds Gallery, Sydney 1983, 85, 86; Gallery Art Naive, Melb. 1984, 86, 87, 88; Town Gallery, Brisbane 1984; Naughton Studios, Sydney 1987, 88; Musée d' Art Naif, Paris 1990; Queensland House, London 1989, (Australian Arts Week).
Represented Institutional and private collections in UK, Europe, Australia.

HILDITCH, Georgina VIC
Born Vic. 1963. Sculptor.
Studies Graduate VCA 1983–85.
Exhibitions Solo shows at 70 Arden St. Gallery 1986, 88. Since 1982 has participated in twenty-five group shows in Melbourne, Launceston, Geelong, Aberdeen UK, Perth, Castlemaine, Grafton NSW and most recently at Judith Pugh Gallery and the Fourth Australian Sculpture Triennial 1990.

HILL, Christine NSW
Born Kent England 1948. Realist painter of landscapes and seascapes; No formal art training, founding member of Peninsula Art Society, NSW; Exhibits at Clareville Gallery, NSW.
Awards Peter Campbell Art Award 1979.
Represented Private collections in Australia and overseas.

HILL, Daisy (Boissevain) WA
Born Greenmount WA. Painter and designer; Daughter of William and Rhoda Boissevain.
Studies Her art education has mostly been within the family circle; Study tour to Europe and UK 1978–79; Known in WA for her decorating and gold leaf work on ceramics, mostly native flora and fauna designs.
Represented Many private collections in Australia and SE Asia.

HILL, Jean M. VIC
Born Ulverstone Tas 1916. Traditional painter in watercolour, pastel, pencil, some oil.
Studies Three years at Ballarat School of Mines as a commercial artist 1936–39; Worked in Melbourne at transfer design, fashion work, package design before moving to Horsham Vic, where her husband conducted a printing and stationery business; Took up sketching and painting in 1965; Joined Horsham Gallery Art Group.
Exhibitions 'Three Women Artists', Horsham Gallery; Annual exhibitions of group held in Regional Gallery Rotary Art Shows in Camberwell, Hamilton, Horsham, Stawell; Apex Shows in Ararat, Ballarat, Portland, Colac, Merbein, Mt Gambier, Swan Hill, Alice Springs, Sydney Easter Show.
Awards Horsham Rotary Art Show.
Represented Horsham Art Gallery; Private collections in Australia and overseas.

HILL, Marjorie TAS
Born Wellington NZ 1919. Abstract painter.
Studies School of Art, Hobart under Jack Carington Smith; Gained Diploma of Fine Art 1966; Studied at summer schools under Syd Ball, John Olsen (three times), Michael Shannon (twice), Robert Grieve, Clifton Pugh and M. D'Hauterive in Paris; Director of the Salamanca Place Gallery, Hobart Tas. until 1986.
Exhibitions One-woman show, Launceston and two-woman in Hobart 1978.

HILL, Maree Jennifer NSW
Born Sydney NSW 1958. Artist and architect.
Studies NSW Institute of Technology 1976–78, 1980–82, graduated 1983; Professional Training — Public Works Dept, Sydney 1976–82; Visiting tutor, Sydney College of the Arts 1982.
Exhibitions Fourth Biennale of Sydney with Gary O'Reilly and Richard Terry at the Italian Cultural Institute, *Architectural Projects — Palladian Regemsis*; Executed projects — Arcadia Public School, Arcardia NSW, for PWD 1980; Manns Road Special Purposes School for PWD at Gosford NSW 1981; Malouf House, Concord NSW 1981; NSW Permanent Building Society Housing Competition with Gary O'Reilly, Bojahra House 1982.

HILL, Robyn USA
Born Sydney. Painter, designer, illustrator.
Studies Graduated from National Art School, East Sydney after five years plus postgraduate work in ceramics. Currently working for a subsidiary of American Greetings Corportion.
Represented Diplomatic, institutional and private collections in UK, USA and Australia.

HILLARD, Merris VIC
Born Sydney 1949, Printmaker, photographer, teacher, portraitist.
Studies RMIT and Prahran CAE. Worked at Royal Women's Hospital as Medical Artist/Photographer 1973. Teaches painting in own studio and various centres.
Exhibitions Solo shows at Statewide Building Society, Melb. 1984 and Wyreens Gallery, Melb. 1987. Participated in Mornington Peninsula Print Prize 1974, 1975, 1982; Geelong Print Prize 1974; Minnie Crouch Exhibition, Ballarat Fine Art Gallery 1975; Perth Print Prize 1977; Westmead Hospital 1979; Blake Prize 1981; Western Pacific Print Biennale 1977; West German Embassy, London UK 1987.
Represented Private collections in Vic, SA and NSW.
Bibliography *Directory of Australian Printmakers* 1989.

HILLCOAT, Pat VIC
Born Qld. Paintings and collage.
Studies Dundas Valley School of Art, Ontario, Canada; Creative Arts Workshop, Newhaven, USA.
Exhibitions Solo shows at Judith Pugh Gallery 1985; participated at Prahran Gallery, Vic. College, Melb. 1982; 70 Arden St. 1986.
Bibliography *150 Victorian Women Artists*, Visual Arts Board/WAM 1988.

HILLER, Christine Mary TAS
Born Hobart Tas 1948. Painter, portraitist and teacher.
Studies Completed the Teachers' Diploma of Art at The Tas School of Art 1966–68; Art teacher at Burnie High School 1969–72.
Exhibitions Rialto Gallery, Burnie Tas 1982; Fine Arts Gallery, University of Tas 1983. Masterpiece Gallery, Hobart 1985; Freeman Gallery, Hobart and Joyces Gallery, Burnie 1988; Artarmon Galleries, Sydney 1989. Has been hung in the Archibald Prize and the Portia Geach Prize on several occasions.
Awards Tas. Resident Artist 1979; Portia Geach Portrait Prize 1987.
Represented TMAG, QVMAG, Artbank, Burnie and Devonport Art Galleries and private collections around Australia.
Bibliography *Tasmanian Artists of the 20th Century*, Sue Backhouse 1988.

HILLS, Noela QLD
Born Brisbane Qld 1954. Painter in watercolour and pencil, Printmaker.
Studies Graphic Design at the Brisbane College of Art, followed by Postgraduate study at

the Central School of Art and Design, London, to obtain a Dip.Art, majoring in printmaking. After completing studies, travelled in Europe and maintained a studio in London. Returned to Australia in 1978, living and working at 'Eryldene' in Sydney for a year, before returning to Brisbane, travelling regularly to London, Italy and USA. Has taught drawing and printmaking at the Brisbane College of Art and the Kelvin Grove CAE and in 1985 ran a drawing workshop series at the Queensland Art Gallery.

Exhibitions Solo shows at Victor Mace Gallery, Brisbane 1979, 81, 82, 84, 85; Robin Gibson Gallery, Sydney 1979, 81, 84; Thumb Gallery, London UK 1980, 82; Cooks Hill Galleries, Newcastle 1983; Solander Gallery, Canberra 1985.

Awards and Commissions Caltex City of Brisbane Art Award 1981; Limited edition print for the National Trust of Queensland 1982; *Saturday Morning* children's book, published by Jacaranda Wiley; *Wild and Woolly* children's book, published by Lothian Publishing Company 1983; *Prisoner of the Mulligrubs*, published by Collins Books Ltd. 1985; Freelance illustrator for *The Age* (Melb.), *Sydney Morning Herald* (Sydney), *The Sunday Times* (London), Penguin Books Ltd. and University of Queensland Press.

Represented Queensland Art Gallery, Darling Downs Institute of Advanced Education; State Library of Queensland; Artbank.

HILTON, Juliana Louise (Keats) VIC
Born Seymour, Vic. 1940. Figurative painter, printmaker.
Studies Melbourne and Prahran Technical Colleges and Melbourne University 1958–60; Printmaking at Bendigo CAE 1982.
Exhibitions Solo shows at the Leveson Gallery, Melb. 1966, 73, 74, 78; Gallery Art Naive, Melb. 1981; David Ellis Fine Art 1987, 89.
Awards Bacchus Marsh Watercolour 1974; Pioneer Award, Swan Hill (oil painting) 1979; Mornington watercolour 1980; Pioneer Award, Swan Hill (watercolour) 1981; Maryborough (watercolour) 1982.
Represented Australian Commonwealth Collection; Swan Hill Regional Gallery; Institutional and private collections, Australia and overseas.

HINDER, Margel Ina Harris NSW
Born Brooklyn New York 1906. Sculptor, designer and teacher.
Studies School of Fine Arts, Buffalo New York; Albright Art Gallery under Florence J. Bach; Studied at School of Museum of Fine Arts, Boston under Charles Crafley and Frederick Allan 1926–29; Married Frank Hinder 1930; Attended occasional classes at Child-Walker School of Fine Arts, Boston under Frank Hinder and Howard Giles as visiting teacher 1930–34; Cook and chaperone at art colony in New Hampshire, Frank Hinder being a co-founder and instructor; Lived according to Plato's theories 1932; Summer school under Emil Bisttram, Taos New Mexico; Australia 1933–34; Managed Grosvenor Galleries with Frank Hinder 1938; Worked with Frank Hinder in camouflage section, Dept of Home Security during war, making models of aircraft and ships now in Australian War Memorial, Canberra 1939–44; Taught sculpture part-time at National Art School, Sydney 1949–50; Freelance sculptor in association at times with Frank Hinder since 1964.
Exhibitions Mixed shows at David Jones' Art Gallery, Sydney 1939, 1948, 1949; Pinkerton Memorial Sculptural Competition, Ballarat 1949; '110 Years of Australian Art', Farmer's Blaxland Gallery, Sydney September 1950; 'The Unknown Political Prisoner', International Sculpture Competition sponsored by Institute of Contemporary Arts, Tate Gallery, London; Retrospective exhibition of Australian Painting, Art Gallery of NSW, 25th September–25th October 1953; Arts Festival of the Olympic Games, National Gallery of Vic 1956; Civic Park Fountain Competition, Newcastle City Art Gallery 1961; Second International Sculpture Show, Paris 1961; Exhibition of models and designs of sculpture and decorative features, Reserve Bank of Australia, Sydney and 'New Influences' Exhibition, Newcastle City Art Gallery 1962; 'Recent Australian Sculpture'; toured Australian State

Galleries, Canberra and Newcastle 1964–65; Also exhibited regularly in CAS shows, Mildura Sculpture Competitions, Art Gallery of NSW Acquisitions; Retrospective shows with Frank Hinder at Newcastle Art Gallery 1973; Gallery A 1980, 83; Bathurst Reg. Gallery 1983; Bloomfield Galleries 1987; Carrick Hill, Adelaide 1986; First Aust. Contemporary Art Fair, Melb. 1988.

Awards Cary Prize for Sculpture USA 1925; Special Prize with Frank Hinder for Water Board Sculpture, Sydney 1939; CAS Madach Prize 1955; CAS Clint Prize 1957; Sculpture Design Competition, Anzac House, Sydney 1959; Civic Park Fountain Competition, Newcastle 1961; Blake Prize for Sculpture 1961; Reserve Bank Sculpture Design Competition 1962; VAB Grants 1974, 1979; Awarded Australia Medal 1979.

Commissions Abstract sculpture for Western Assurance Company, Sydney 1959; Wall sculpture for Carlton-Rex Hotel, Sydney 1960; Wall sculpture for Canberra-Rex Hotel, Canberra 1960; *Revolving Sphere*, Monaro Mall, Civic Centre, Canberra 1963; Free-standing sculpture, Reserve Bank of Australia, Sydney 1964; Captain James Cook Memorial Fountain, Civic Park, Newcastle 1966; Sculptural form, Woden Town Square, Canberra 1972; Free-standing sculpture, Telecommunications Building, Adelaide 1973; Sculpture fountain, Northpoint Building 1975; Turner Fountain, Sydney Teachers College 1977; Centre for Performing Arts, Geelong, Vic 1981; Deakin University 1981; Denis Winston Memorial Park, Sydney 1981; Reconstruction at Western Assurance Building, Sydney 1983; Robert Quentin Memorial Garden, Sydney 1985–88.

Represented Art Gallery of NSW; Newcastle City Art Gallery; Qld Art Gallery; Many institutional and private collections in Australia and overseas.

Bibliography *Who's Who in Australia* 1977; *Encyclopedia of Australian Art*, McCulloch, Melbourne 1977; 'Sculpture in Australia Since 1945', L. Parr, *Art and Australia*, Sydney Vol 1/1 May 1963, pages 20–25; *Australian Sculptors*, Ken Scarlett, Nelson 1980; *Frank and Margel Hinder Retrospective Catalogue*, Art Gallery of NSW 1980; *Art and Australia*, Vol 18 No 2; *Artists & Galleries of Australia*, Max Germaine: Craftsman House 1990.

HINGERTY, Michelle NSW
Born Sydney 1962. Painter, printmaker, teacher.
Studies B. Fine Arts, Uni. of Sydney; Dip. Ed., Sydney IE; worked at Griffith Studio and Graphic Workshop; studied under John Hingerty.
Commissions Syrinx Research-Portfolio of Lord Howe Island Etchings; Illustration for limited edition Poemes by Reine Lefebre-Legaye which won Bronze Medal, Nat. Print Awards 1985.

HINTON, Betty QLD
Born Gin Gin Qld 1935. Self-taught traditional painter in gouache, mostly wildflowers of tropical Qld.
Exhibitions One-woman shows at Innisfail Qld and ANZ Banks at Brisbane, Sydney and Melbourne 1978; Also shows at her own Floravilla Galleries at South Johnstone Qld; Age Gallery, Melbourne, November 1978.
Award Atherton Traditional Painting Award 1976.
Commissions In 1978, Valentine Publishing Company commissioned twelve paintings for a wildflower calendar for 1979 and two paintings for greeting cards; In 1979, Peer Productions commissioned thirteen paintings for a tropical wildflower calendar for 1981; She was also invited to produce a 40-painting display exhibition of the wildflowers of the Cape York Peninsula Wilderness displayed at the Second World Wilderness Congress, Cairns 1980.
Represented Many institutional and private collections in Australia and overseas.

HINWOOD, Rhyl Kingston QLD
Born Brisbane Qld 1940. Painter, sculptor and teacher.

Studies Six years as display artist at Qld Natural History Museum; Studied sculpture at Qld Technical College and with visiting interstate and overseas tutors, Has taught sculpture at Government and private schools and workshops; Attended Kyoto Japan, World Craft Conference 1978; Spent two years as workshop convenor for Crafts Council of Qld; Works in liaison with husband Bob.

Exhibitions Crafts Council of Qld; Design Arts Centre; Victor Mace Gallery; Holdsworth Gallery and Sculpture Centre, Sydney; Solo show at Qld Performing Arts Centre 1990.

Commissions Ongoing grotesque portraits for University of Qld; Lennons Plaza; Marcellin College; St Michaels Roman Catholic Church, Brisbane; Korea/Malaya/Borneo War Memorial Bronze, Anzac Square, Brisbane; Coat of Arms, New Parliament House, Canberra; Mural, Qld Agricultural College and many others.

Awards Bundaberg 1967; Warana Caltex 1972, 75; Caloundra 1973; Sandgate 1974; Garden City 1973, 75; Appointed University of Qld sculptor; Churchill Fellowship 1986; National Trust Listing — University of Qld 1990.

Represented Municipal, Governmental and institutional collections in Australia and overseas.

HIRSH, Libby Pilkington VIC

Born Melbourne Vic 1951. Painter of animals and wildlife; Printmaker and teacher.

Studies Melbourne State College; Art teacher and artist advisor at Melbourne Zoological Gardens from 1973; Member and regular exhibitor with the Society of Wildlife Artists of Australasia. Has taught art at a number of High and private schools in Melbourne and acted as workshop leader for the National Gallery Society of Victoria.

Exhibitions Coolart 1984, 87, 88, 89; Richard Weatherly Gallery 1985, 86, 87; Australian Impressions Gallery 1988; Libby Edwards Gallery 1990. Since 1976 has shown over seven times with the Wildlife Art Society of Australasia at the VAS Gallery, Melbourne.

Commissions Healesville Sanctuary Calendar 1987; Illustrations for Safcol Wildlife Fund 1988.

Represented Collections of Melbourne Zoological Gardens; Sir Rohan Delacombe; Many institutional and private collections in Australia and overseas.

Bibliography *Directory of Australian Printmakers* 1976.

HIRST, Joy SA

Born Melbourne Vic 1945. Sculptor in stone and wood.

Studies Swinburne Technical College Art School and RMIT.

Exhibitions The first showing of her sculptures was at the Anima Gallery, Adelaide in May 1984 jointly with her brother painter Barry Skinner.

HJORTH, Noela SA

Born Melbourne Vic 1940. Painter, printmaker and sculptor.

Studies Prahran Institute of Technology and RMIT, Melbourne 1958–62; Chelsea School of Art, London 1969–71; Lectured part-time at Caulfield Institute of Technology 1973–74; In charge of printmaking at Box Hill Technical College 1975–78; Vice-president of the Print Council of Australia 1976; Founder member and co-ordinator of the Vic Printmakers Group and Workshop 1976–79; Since returning to Melbourne from London in 1972, she established her own etching studio; Artist-in-Residence, Riverina CAE 1980 and part-time lecturer 1981; Painting at Clarendon SA 1982–83; Study tour to UK, Europe, USA 1983.

Exhibitions One-woman shows at The Gallery, Hornsey UK 1970; Gallery 273, Whitechapel, London 1970; Battersea District Library, London 1971; Warehouse Gallery, Melbourne 1972; Swan Hill Regional Gallery, Vic 1973; Victor Mace Gallery, Brisbane 1977; Solander Gallery, Canberra 1978; Robin Gibson, Sydney 1978; Salamanca Place Gallery, Tas 1979; Burnie Art Gallery 1979; Greenhill Gallery, Adelaide 1979; Fremantle Arts Centre 1979; Powell Street Gallery, Melbourne 1980; Riverina CAE 1980; Silpakorn

University, Thailand 1980; Hawthorn City Art Gallery 1980; Wagga Wagga Gallery 1981; Kalamunda Gallery, Perth 1982; Tynte Gallery, Adelaide 1982; Hogarth Galleries, Sydney 1983; Solander Gallery, Canberra 1984; Greenhill Galleries, Adelaide 1987, 88; Museums and Art Galleries of the Northern Territory, Darwin 1988; Holdsworth Galleries, Sydney 1989. Group shows at Leveson Street Gallery, Hawthorn City Gallery, Melbourne and Morley Art Gallery, London 1970; South London Art Gallery, London 1971; In 1978, 'Australian Printmakers', Impressions Gallery, Melbourne; 'Melbourne Printmakers', Bookshelf Gallery, Melbourne; Print Council of Australia, travelling exhibitions including the 1977 Japan Print Association 45th Exhibition; Vic Printmakers Workshop Travelling Exhibition, CAS Adelaide; Susan Gillespie Galleries, Canberra; Naracoote Regional Gallery, SA Brisbane; Civic Centre Galleries, Dusseldorf, Perth; Blackfriars Gallery, Sydney; Caulfield Arts Centre; 'Fifteen Australian Printmakers', Qld Arts Council 1978–80; Festival of Perth 1982 with John Olsen.

Represented ANG, Canberra; AGNSW; NG of Vic.; AGSA; AGWA; TMAG; NTMAG; Swan Hill Regional Gallery; Burnie Regional Gallery, Tas; Stanthorpe Regional Gallery, Qld; Wagga Wagga Regional Gallery; La Trobe Valley Arts Centre; Riverina College — WAIT; Box Hill Technical College; Aquinas College, Ballarat; Yarra Valley Church of England School; St Michael's, London; The Melbourne Clinic; Parmelia Collection WA; Gainsborough Collection, London and other private and public collections.

Bibliography *Directory of Australian Printmakers 1976; Who's Who in Australian Women*, Methuen 1981.

Publications *Fantasy of Flight*, a portfolio of 20 etchings to accompany selected verses from 37 poems, Deluxe Editions 1981; Monograph *Noela Hjorth*, Granroft Press 1984; *Journey of a Fire Goddess*, Craftsman Press 1989; *Encyclopedia of Australian Art*, Alan McCulloch: Hutchinson 1984; *Artists & Galleries of Australia*, Max Germaine: Craftsman House 1990.

HOBART, June VIC
Born Melbourne Vic. Painter and teacher.
Studies Under A.D. Colquhoun, Melbourne and in UK, Europe 1952–53; Member of VAS; Society of Women Painters and Sculptors; Hon Secretary of the Twenty Melbourne Painters Society; Teaches art privately.
Exhibitions First one-woman show at Georges Gallery, Melbourne 1951.
Represented Private collections in Australia and overseas.

HOBBS, Marie Louise WA
Born SA 1933. Painter.
Studies Southampton School of Art, UK 1973; Claremont Technical College, WA 1974 and Byam Shaw School, London 1981.
Exhibitions The Old Fire Station Gallery 1974, 1976; Undercroft Gallery, University of WA 1978; Bonython Gallery, SA 1979; Fremantle Art Gallery (Review Exhibition) 1980; Critics Choice, Festival of Perth Exhibition, Art Gallery of WA; Claremont School of Art 1982; Delaney Gallery, Perth 1988; AG of WA 1988.
Represented The Rural and Industries Bank of WA; The Queen Elizabeth II Medical Centre; National Gallery of Vic; The University of WA; Christchurch Grammar School; Art Gallery of WA; IBM; SGIO; Claremont Teachers College; Scotch College; Wesley College and private collections.

HOCHMAN, Anita NSW
Born Sydney 1953. Painter and teacher.
Studies BA Fine Arts/Government, Sydney University 1973; Dip. Ed. Art, Sydney Teachers College 1974; BA Visual Arts/Painting, NRCAE 1988; Presently studying for MFA at University of NSW. Has taught art since 1975 and presently Lecturer, Art Theory and Painting at University of New England, Northern Rivers.

Exhibitions Numerous shows include Wagga Regional Gallery 1985; Lismore Regional Gallery 1986, 87, 88, 90; Tweed River Regional Gallery 1989.

Awards NRCAE Prize for Painting 1988.

Represented Institutional and private collections.

HOFFIE, Patricia E.N. (Pat) QLD

Born Edinburgh, Scotland 1953. Painter, teacher, writer.

Studies Kelvin Grove College of Advanced Education, Diploma of Teaching (Secondary Art) 1971–73; Queensland College of Art, Diploma in Fine Art 1974–75; University of Queensland, completed Twentieth Century Literature and Third World Literature 1976; M. Creative Arts, Wollongong 1986; Secondary teacher Qld Education Dept 1974–77; instructor, Qld College of Art 1979–85, senior lecturer from 1985; instructor AFAS 1984–85 and author of their correspondence courses; NAVA Qld Board member 1988; Artist-in-Residence Qld Art Gallery 1988; VACB Grants Committee co-opted Qld member 1988. Overseas study tours 1974, 78–79, 80, 81, 84, 85, 86, 87. Artist-in-Residence, Kelvin Grove CAE 1989.

Exhibitions Cellars Gallery 1975; Kelvin Grove CAE 1976; Design Arts Centre 1977; Kelvin Grove CAE 1981; Independent Artists Exhibition, Melbourne 1982; Baguette Gallery, Qld 1983; Drawing Exhibition, Noosa Civic Centre 1983; Wollongong Uni. Gallery 1986; Roz MacAllan Gallery, Brisbane 1987, 88; Coventry Gallery, Sydney 1988, 89, 90; Qld Art Gallery 1988. Many group shows since 1982 include Qld Art Gallery, Trustees Exhibition 1981–83; A Survey of 80 Painters, Qld Uni. Art Museum 1985; Moet and Chandon Touring Exhibition 1986–87; ARX Festival, Perth WA 1987; Praxis Galleries, Fremantle WA 1987; Coventry Galleries, Sydney 1988; *Australian Perspecta* 1989, AGNSW.

Awards Has won many prizes since 1973 and in recent years L.J. Harvey Drawing Purchase 1980; Redcliffe Art Prize 1981; Caloundra Art Prize 1984; Gold Coast Art Prize 1984; Ipswich Art Gallery Purchase 1984; Caloundra Art Prize 1986; Moet and Chandon Travelling Exhibition 1986.

Represented QAG, Civic collections at Gold Coast, Ipswich, Stanthorpe, Redcliffe, Bribie Island, Caloundra, institutional and private collections Aust. and overseas.

Bibliography *A Homage to Women Painters in Queensland, Past and Present*, The Centre Gallery 1988.

HOGAN, Susan NSW

Born UK 1961. Painter, teacher, art therapist.

Studies BA (Hons) Edinburgh College of Art 1981–84; Postgradute Dip. Art Therapy Hertfordshire College of Art and Design 1984–85; Edinburgh University 1985–86; Leeds University 1987; M. Arts Administration, City University, London 1988–89; Ph.D. student at Dept. of Fine Art, Sydney University 1990– ; Has been closely involved in art, art therapy and teaching in UK, Europe and Australia since 1981, currently teaching Art Theory at the National Art School, East Sydney. Many memberships include Australian National Art Therapy Association; Institute of Arts Administrators, Australia; Institute of Contemporary Art, London; The British Association of Art Therapists.

Exhibitions Solo show at Artlet, Sydney 1991; Numerous group shows since 1983 include Scottish Royal Academy 1983; Edinburgh 1985, 86, 87, 88; University of Technology, Sydney 1990; Foundry Galleries, Sydney 1990; Artlet Sydney 1991.

Represented Institutional and private collections in UK, Europe and Australia.

HOLDERNESS, Gail VIC

Born Australia 1953. Printmaker.

Studies Diploma of Art and Design, Caulfield Institute of Technology; Fellowship of Printmaking, RMIT.

Awards Mornington Peninsula Print Prize (purchase) 1974; Kew Hospital Art Prize.
Represented Mornington Peninsula Arts Centre, Vic; Kew Hospital, Vic and private collections.
Bibliography *Directory of Australian Printmakers* 1976.

HOLDING, Judith VIC
Born Bendigo, Vic 1945. Paintings and assemblages.
Studies Dip. FA, Chisholm IT, Vic.
Exhibitions Solo shows at Solander Gallery, Canberra 1983; NTMAG, Darwin 1984.

HOLLIE QLD
Born Brisbane 1958. Paintings and installations.
Exhibitions Solo shows at One Flat Gallery, Brisbane 1982; 'A Room', Brisbane 1984; IMA, Brisbane 1985; Michael Milburn Galleries, Brisbane 1987, 88, 89; Included in *A New Generation 1983–88* at the ANG Canberra 1988 and the DDIAE Touring Show to China 1988; and numerous other shows since 1982 including the Moët & Chandon Touring Exhibition 1990.
Awards Moët & Chandon Fellowship 1990.
Represented ANG; QAG; Institutional and private collections.
Bibliography *A Homage to Women Artists in Queensland*, The Centre Gallery 1988.

HOLLISTER, Virginia NSW
Born Atlanta USA 1952. Ceramic sculptor.
Studies BA with Academic Honors, Beloit College, Wisconsin 1970–74; Ceramic Certificate, ESTC, Sydney 1975–76.
Exhibitions Ivan Dougherty Gallery 1981, 88; Breewood Gallery 1988; EMR, Gallery 1988.

HOLMES, Dorothy R. WA
Born South Perth, WA 1939; Semi-abstract painter in oil, charcoal, watercolour, pastel; Printmaker, sculptor, teacher.
Studies Diploma in both Art Studies and Art from the Claremont Technical College, WA 1978; Founder and past president Rossmoyne Arts Group, Canning Music Society, Canning Players, and Yalgaru Artists; Also instigated the building of the Canning Cultural Centre; Teacher of music and the history of art; Trained nursing sister; Member of Perth Society of Artists.
Exhibitions Fremantle Art Centre; Art Gallery of WA (sculptures); Waterways Art Gallery; CAS and Perth Society of Artists; Perth Concert Hall Invitation and several one-woman shows.
Awards Canning Art Award (five prizes) 1972–78; Three first prizes in country competitions and Rotary Award 1974 for arts and crafts service to the community.
Represented Many private and institutional collections in WA.

HOLT, Karen Milenka (Lenka) VIC
Born Kent UK 1964. Painter, printmaker, sculptor, teacher.
Studies B. Ed. (Arts & Crafts) Melbourne CAE 1983–86. Studied UK, Europe 1972, 75, 77, 88. Currently teaching at Syndal Secondary College.
Exhibitions MCAE 1986; ROAR 2 Studios 1987; Ufitzi Gallery 1988; Linden Gallery 1989; Gallery Surreal, Toorak 1991. Has carried out a number of commissions for murals in business premises around Melbourne.

HOLT, Norma NSW
Born Adelaide 1936. Figurative painter.

Studies SASA to 1958; with private tutors in Canberra 1965–68; Member, SASA 1959; Perth Society of Artists 1970; studied in UK 1981.
Exhibitions Solo shows in Canberra and permanent show at Studio Gallery at Batemans Bay, NSW.

HONEY, Elizabeth VIC
Born Wonthaggi, Vic. 1947. Illustrator and author of children's books.
Studies Graduated with Diploma in Film and Television Sciences.
Exhibitions Melbourne Concert Hall.
Awards Series of 'Aussie Kids' stamps for Australia Post.
Bibliography *Alice 125*, Gryphon Gallery: University of Melbourne 1990.

HONYBUN, Elizabeth VIC
Born Wangaratta Vic 1953. Sculptor and painter.
Studies Wangaratta Technical College 1971; Diploma of Art and Design (fine arts) from Gordon Institute of Technology, Geelong 1972–74.
Bibliography *Australian Sculptors*, Ken Scarlett, Nelson 1980.

HOOK, Jo Anne QLD
Born Vic. Painter, illustrator, graphic designer of bird and marine life of the Great Barrier Reef.
Exhibitions Her work was included in Australian Art Expo '85 to USA and at Upstairs Gallery, Cairns 1987; Jo Anne Hook Editions Galleries, Cairns; Marina Mirage Gallery, Surfers Paradise.
Awards Nat. Silver Poster Award 1980.
Represented Corporate, institutional and private collections in Aust. and overseas.

HOOPER, Iris Lynette NSW
Born Sydney NSW 1938. Abstract painter, printmaker and teacher.
Studies National Art School, East Sydney and Sydney Teachers College 1956–61, graduating with Art Diploma in Illustration and Diploma of Education; Taught art in NSW High schools until 1976; Appointed teacher of art, design and screen printing at Goulburn Technical College 1977; Argyle College of Technical and Further Education in 1979.
Exhibitions Exhibits in Australia and overseas and is represented in Australia and several countries.

HOPEWELL, Jennifer WA
Born WA 1960. Painter.
Studies BA Fine Art, Curtin Uni. WA 1978–81.
Exhibitions Editions Gallery, Fremantle 1984; Tressillian Gallery, Nedlands 1986, 87; Fremantle Art Gallery 1988; Silver St. Studio 1988. Numerous group shows.
Awards Young Artists 1983; Tressillian 1985.
Represented AGWA, institutional and private collections.

HORTON, Ede VIC
Born Sydney 1952. Glass artist and teacher.
Studies Sydney Kindergarten TC gaining Dip. Ed.
Exhibitions Solo shows at Distelfink Gallery 1984; Beaver Galleries ACT 1984; The Craft Centre, Melbourne 1982; Profile Gallery 1982. Numerous group and touring shows.
Bibliography *150 Victorian Women Artists*, Visual Arts Board/WAM 1988; *Stained Glass of Australia*, Jenny Zimmer: OUP 1984.

HORWITZ, Tess NSW
Born Sydney 1952. Painter.

Exhibitions Solo shows at Avago Gallery 1986; First Draft Gallery 1987. Numerous group shows since 1983 include Mori Gallery 1985; Artspace 1985, 86; Penrith Regional Gallery 1986; Performance Space 1987; Moët & Chandon Touring Exhibition 1988.

HOSKING, Eve QLD
Born Perth WA. Traditional painter and portraitist in oil, watercolour.
Studies Perth Technical College, WA; Worked in commercial art and as a draughtsman for many years; Studied privately with Max Meldrum and life classes at Melbourne Technical College; Member, Royal Qld Art Society; Paints on commission and enters periodical group shows and competitions.

HOUSTEIN, Pam NSW
Born Melbourne Vic 1942. Semi-abstract painter in Liquitex.
Studies The Friends School, Hobart and at Hobart Technical College under Jack Carington Smith, Dorothy Stonor and Rosamund McCulloch; Moved to Sydney and attended East Sydney Technical College 1962, graduated 1964; Graduated Diploma of Education, Sydney University 1975; Part-time lecturer, Canberra Technical College 1967, 1968, 1969; Part-time Ottawa School of Art, Canada 1970; Part-time lecturer, Canberra CAE (teacher training) and guest lecturer (teacher training); Australian National University 1974; Part-time illustrator at Correspondence School 1978; Attended course in children's book design at Kuring-gai College 1978.
Exhibitions One-woman shows at Canberra Theatre Centre 1971, 1973; Hunters Hill Gallery 1975; Holdsworth Gallery 1976; Exhibited in many group shows since 1962 including a number of Archibald Prize competitions.
Awards Mercury Design Competition, Hobart 1961; Mirror-Waratah Drawing Prize (18–22 years) 1962; City of Ottawa Painting Prize, Canada 1970; Deaking Portrait Prize 1973.
Represented Private collections in Australia, Europe, North America.

HOUSTON, Bunty TAS
Born london UK 1915. Painter, printmaker, teacher.
Studies By correspondence with ESTC and Adult Education with George Davis, Hobart 1967–69; Hobart S of A 1969–74; printmaking 1975–76. Taught for AEB, Hobart 1974–82. Overseas study tour to UK, Europe, Africa 1979–80. Still teaching for AEB.
Exhibitions Solo shows at Gallery One, Hobart 1977; Coughton Galleries, Hobart 1979, 83; Design Centre, Launceston 1980; Devonport GAC 1985. Group shows since 1973, include Blue Gum Festival, TMAG 1975, 76; Chameleon Gallery 1985.
Awards Salamanca Centre Drawing Prize 1985.
Represented TMAG, Media Centre, Hobart, Burnie AG, private collections.
Bibliography *Tasmanian Painters of the 20th Century*, Sue Backhouse 1988.

HOWARD, Lenore Beverley QLD
Born Cairns 1955. Painter, photo-journalist, teacher.
Studies Brisbane College of Art 1974–75; ADFA 1976; overseas study tour to UK, Europe 1978–79; teachers art at Tableland and Cairns TAFE Colleges.
Exhibitions Solo shows at Raintrees Art Gallery, Cairns 1980; Grafton House Galleries; numerous group shows and her work is represented at Painters Gallery, Sydney and Solander Gallery, Canberra.
Awards Mareeba 1978, 80, 83; Atherton 1980, 83, 88; Cairns Art Society 1985, 88.
Represented Institutional and private collections in UK, Europe and Australia.

HOWARD, Melanie SA
Born UK 1952, arrived Australia 1958. Painter.

Studies SACAE, Adelaide 1983–85.
Exhibitions Solo show at Adelaide Festival Centre 1983, 86, 88; CAC, Adelaide 1986, 89; ANG, Canberra 1986 and *A New Generation 1983–88* in 1988; Anima Gallery, Adelaide 1989.
Represented ANG, Artbank and private collections.

HOWARD, Susan NSW
Born Sydney 1956. Modern painter and portraitist.
Studies Julian Ashton's and Seaforth Technical College 1975; Graduated Diploma in Art, Alexander Mackie College of Advanced Ed. 1978; Travelled Japan, Europe and Kenya 1984; Diploma of Teaching, Sydney Institute of Education 1986; Lived and painted commissioned series in Hong Kong 1987.
Exhibitions Solo shows at Hogarth Galleries, Sydney 1981, 82, 83, 85; 97 Gallery, Hong Kong 1988; Access Gallery 1989.
Awards Portia Geach Prize 1981; Warringah Art Prize 1981, Manly Daily 1982.
Represented Institutional and private collections in Australia, UK, Europe, Hong Kong.

HOWARD, Susan Patricia NSW
Born Benalla Vic 1958. Painter, printmaker and teacher.
Studies Diploma in Applied Arts & Printmaking from Riverina CAE.
Exhibitions Solo show at Riverina CAE 1981. Participated Toowoomba and Canberra 1980; PCA Students 1981; Editions Gallery, Melbourne 1981.
Represented Wagga Regional Art Gallery and private collections.
Bibliography *Craft Australia*, Autumn 1980.

HOWE, May SA
Born Torrensville SA 1911. Painter and teacher.
Studies Walter Wotzke Hahndorf Academy 1959–65; With Ruth Tuck 1962–75; Taught for SA Dept of Education 1966–75, and Country Women's Association 1968–74; Assoc. RSASA 1981.
Exhibitions Hahndorf Gallery 1965; Adelaide Festival 1972, 80; Melbourne 1979; Lombard Gallery, Adelaide 1982, 85.
Awards Royal A Show 1963; E. McArthur Pottery Scholarship 1967; Weerama Festival 1972; Goolwa 1986; Rotary 1988.
Represented Strathalbyn Municipal Council; Institutional and private collections in Australia and overseas.
Bibliography *Who's Who in the Commonwealth*, Cambridge UK 1982, 84.

HOWIE, Daphne NSW
Born Australia 1932. Landscape and genre painter in most media.
Studies Dattilo Rubbo/Bisietta School, Sydney 1949–54; High Holborn Art School, London UK 1955; Ontario College of Art, Canada 1960; BA, Dip. Ed. (Fine Arts) University of Sydney 1978–82.
Exhibitions Solo shows at Southam Creative Gallery, Toronto 1962; Saints Gallery, Sydney 1971; University of NSW 1973; The Civic Centre, Sutherland NSW 1975; Hogarth Gallery 1988.
Awards John Gero Art Prize, Macquarie University 1973; Southern Cross Landscape 1975.

HOWLETT, Leonara NSW
Born Sydney 1940. Painter.
Studies Scholarship to ESTC 1956–60. Study tours UK, Europe, 1967–70, Mexico 1975, India 1978.
Exhibitions Solo shows include Barry Stern 1962; Holdsworth 1976; Mori 1981; James

Harvey 1982; Woolloomooloo 1985, 88. Numerous group shows since 1959.
Represented Institutional and private collections in UK, Europe, USA, India, Australia.

HUBER, Chris NSW
Born Izmit Turkey 1936 of Austrian parents; Returned to Austria 1940, arrived Australia 1955. Self-taught painter of traditional landscapes in oil, and Hawkesbury Community Workshop; Member of the Royal Art Society, Sydney.
Exhibitions Cocks Gallery, Mosman 1974, 1975; Saints Gallery, Carlton NSW 1977; Strawberry Hill Gallery 1978; Manyung Gallery, Mt Eliza Vic 1978–79; Young Masters, Brisbane 1980, 82; Prouds Gallery, Sydney 1982, 84; Barry Stern Galleries 1986, 87, 88; Eddie Glastra Gallery, Sydney 1988.
Awards Nundle Landscape 1978; Drummoyne 1978; Blacktown Purchase 1983; Blacktown Open 1983.
Represented Institutional and private collections in Australia and overseas.

HUDSON, Helen NSW
Born Sydney 1938. Painter and teacher.
Studies National Art School, Sydney; RASNSW. Associate of RASNSW; Member, Australian Society of Miniature Art and Pastel Society of NSW.
Exhibitions Hesley Gallery, ACT; Golden Helmet Gallery; Noella Byrne Gallery; Okamoto Gallery.
Represented Institutional and private collections.

HUGHES, Glen (Marde) WA
Born Sydney 1945. Painter, printmaker, sculptor.
Studies East Sydney Technical College 1960–64 part-time; Julian Ashton's 1965 part-time; Kelvin Grove Teachers' College 1973; East Sydney Technical College 1980; Study tour PNG and South East Asia 1976–78; Perth TC 1985.
Exhibitions Solo shows at Lord Howe Island 1970; Papua New Guinea 1976; World Trade Centre WA 1982; New Collectables Gallery 1987; Greenhill Galleries, Perth 1990 and Adelaide 1991. Has participated in many group shows since 1974 including Commonwealth Bank, Sydney 1980; Festival of Perth 1987 and Artemis Inaugural Show 1988; New Collectables Gallery 1990; Greenhill Galleries, Perth 1990 and Adelaide 1991; Fremantle Arts Centre 1991.
Awards Mirror Waratah NSW 1960; Grace International NSW 1972; Community Arts Grant 1975; Commission, Exmouth WA 1988; Sutherland Shire Acquisitive NSW 1988; Exmouth Acquisition 1988; Perth College Acquisition 1990.
Represented Corporate and municipal collections in Australia and overseas.
Bibliography *Artists & Galleries of Australia*, Max Germaine: Craftsman House 1990.

HUGHSTON, Edith (Moore) VIC
Born Broken Hill NSW 1905. Painter, sculptor, printmaker and teacher.
Studies Melbourne National Art School 1926–29; Taught at St Hilda's College, Southport Qld 1929–32; Chelsea Polytechnic, London UK under Henry Moore 1933; Taught at 'Koornong' Warrandyte and Toorak College 1935; Foundation member of Plastic Group and committee member of CAS 1939–40.
Exhibitions The Plastic Group 1936–39; CAS 1939–40; Society of Women Painters & Sculptors 1939–45.
Awards La Trobe Valley Arts Centre Prizes 1972, 1973.
Represented La Trobe Valley Regional Gallery and private collections.
Bibliography *The Development of Australian Sculpture 1788–1975*, Graeme Sturgeon, Thames & Hudson 1978; The catalogue of the Campbell Hughston Collection, La Trobe Valley Arts Centre, Morwell Vic 1974.

HULSCHER, Vera NSW

Born China 1932, arrived Australia 1951. Graphic artist, designer and traditional painter of landscapes in oil and acrylic; Portraitist.

Studies Tientsin Art School, China; St George Technical College and Gymea Technical College completing art certificate course; Paints on commission; Study tour to UK, Europe 1982.

Exhibitions RSL Building Society, Caringbah 1982; Commonwealth Bank, Sydney 1983; Woolloomooloo Gallery 1985; Access Gallery 1988.

Awards Rockdale Award and Ramsgate Art Prize, NSW.

HUMBLE, Brenda NSW

Born Brisbane Qld 1933. painter, portraitist teacher.

Studies Diploma in painting, ESTC 1960. Taught art 1969; Silver jewellery course 1972; Studied sculpture; Appointed Community Development Officer for City of Sydney 1975; overseas study 1981.

Exhibitions Solo shows at Woollahra 1974, Bondi Pavilion 1980, 1981; James Harvey Gallery 1982 and retrospective 1983; Clareville Gallery 1984; Woolloomooloo Gallery 1986; Access Gallery, Sydney 1988, 89, 90; Many group shows since 1960 include BMG Adelaide 1983; Woolloomooloo Gallery 1985, 87; Access Gallery 1986, 87, 88, 89, 90.

Awards South Sydney Prize 1976–78, 80; Arthur Phillip Cumberland Award 1981; Portia Geach Portrait Prize 1982.

Represented Artbank, University of NSW and numerous private and corporate collections in Australia, Canada, Japan, UK and USA.

HUMBLE, Joan TAS

Born Birmingham UK 1938. Traditional landscape painter and teacher.

Studies Adult Education, London 1972; Adult Education, Hobart, Tasmania 1973–75; Decordova Art College, Lincoln, Massachusetts 1979; Mainly self-taught.

Exhibitions Several solo shows in Hobart since 1976 including ANZ Bank 1980, 81; Tas. Permanent Building Society 1985; Joyce's Gallery, Burnie 1988. Group shows include Kennedy Library, Boston USA 1979; Portman Hotel, London, UK 1986; Aust. International Art Fair, Sydney 1988; Aust. Bicentennial Exhibition, London UK 1988.

Awards Tourist award, Kingborough Council 1976; Oliebolen Festival, Popular choice award every time entered, 1976–78, 80, 81 (Tas.); First Prize Acton Art Society, Massachusetts 1979; Three paintings commissioned by the Forestry Commission, Hobart 1990.

Represented University of London Australian Studies Centre; Forestry Commission, Hobart; Kingborough Council Chambers; Launceston Casino, Tasmania; Headquarters, ANZ Bank, Hobart; Private collections around Australia, New England, USA, London and Canada.

HUMPHREY, Shirley Moyle NSW

Born Sydney NSW 1928. Painter of genre and the human image mostly in oil.

Studies East Sydney Technical College, part-time 1956–59.

Exhibitions Solo shows at The Barn Door Gallery, Tinonee NSW.

Awards Taree Open Award 1972.

Represented Institutional and private collections in Australia and USA.

HUNDLEBY, Cynthia NSW

Born Auckland NZ 1936. Watercolour painter, designer, portraitist.

Studies London Polytechnic 1961; Meadowbank TC 1980; Worked as fashion artist in London for two years; Studied portraiture with Joshua Smith. Exhibiting member, RASNSW; Teaches at Ku-ring-gai Art Society.

Exhibitions Solo show at Ku-ring-gai Art Society 1989; Many group shows include St. Georges Terrace Gallery 1983; St. Ives Gallery 1984; Royal Sydney Show 1990; AWI 1990; RASNSW 1991.
Represented Institutional and private collections in Australia and overseas.

HUNT, Deirdre VIC
Born Melbourne Vic 1939. Wildlife painter; Has held four solo shows since 1973; Member of the Wildlife Art Society of Australia; Her studies of Australian birds have appeared on limited editions of Westminster porcelain.
Studies Swinburne Technical College.

HUNT, Diana NSW
Born London UK, arrived Australia 1950. Sculptor, painter.
Studies Southern School of Art, Essex and St Martins Art School, London UK; Later at East Sydney Technical College under Lyndon Dadswell 1963–67; Was a member of the Society of Sculptors and the CAS.
Exhibitions Solo shows include Barry Stern 1965; Seberts Gallery 1972; Fantasia Gallery, Canberra 1973; Kings Cross Library 1976; Cooks Hill Gallery 1980; Holdsworth Galleries 1986, 89.
Commissions Completed a number of works in NSW between 1966–1977, including wood sculpture, University of NSW; Fountain and sculpture, Moore Park, Sydney; Sir Lionel Lindsay Memorial, Wahroonga Park; Pioneer Women Memorial, Griffith NSW; Portrait, Sir Robert Helpmann, Sydney Opera House 1981; Portrait, Sir William Dobell 1987.
Represented Manly Regional Art Gallery and institutional collections.
Bibliography *Australian Sculptors*, Ken Scarlett, Nelson 1980.

HUNTER, Inga NSW
Born UK. Mixed media, collage, assemblages, teacher.
Studies BA, University of Sydney; Lecturer in fibre, SCOTA 1981, CAI 1981–84, University of NSW 1975–84. Founder, Batik and Surface Design Association of Aust; Writes for a number of technical magazines.
Exhibitions Numerous major shows since 1975 and recently at Beaver Gallery, Canberra 1989 and Breewood Gallery, Katoomba 1991. Group shows since 1985 include Tamworth Regional Gallery; Crafts Council of ACT; Balmain Gallery; Ararat Regional Gallery and QVMAG, Launceston. Represented by Blaxland Gallery.
Represented ANG; QAG; NTMAG; Powerhouse Museum, Sydney; Institutional and private collections around Australia and overseas.

HUNTER, Janice TAS
Born Grafton, NSW 1943. Printmaker, doll maker, teacher.
Studies BFA, Fine Art, Tas. School of Art 1980; MFA 1983. Lived New Guinea 1964–74. Has taught with Tas. Education Dept. since 1984. HTC 1987–.
Exhibitions Solo shows at Bowerbank Mill, Deloraine, Tas. 1981; Uni. of Tas. 1981; Avago Gallery, Sydney 1983; Bibra Gallery, Melb. 1984; Roz MacAllen Gallery, Brisbane 1987. Numerous group shows since 1980 include Paton Gallery, Uni. of Melb. 1980; Student Printmakers Touring Show 1981, 82, 83, 85; Women and Arts Festival, Sydney 1982; *Australian Perspecta* '85, AGNSW; Chameleon Gallery, Hobart 1986.
Represented Devonport AG; Parliament House, Canberra; Artbank; TAAB; Uni. of Tas. and private collections in Australia and overseas.
Bibliography *Tasmanian Artists of the 20th Century*, Sue Backhouse, Pandani Press 1988.

HUNTLEY, Ida VIC
Born Melbourne Vic 1954. Potter.

Studies Prahran Institute of Technology. Numerous exhibitions including a joint show with Tom Huntly and included in Twenty Peninsula Artists at McClelland Gallery, Langwarrin Vic 1982.

HUPPERT, Erika VIC
Born Vienna Austria. Painter in oil and acrylic; Teacher.
Studies Fine arts course RMIT; Worked for some years as costume and stage set designer for Garnet Carroll and J.C. Williamson Theatres in Melbourne; teaching adult classes until 1987.
Exhibitions Regular one-woman shows at Toorak Gallery and Vic Artists Society Gallery, Melbourne; Participated in many group shows including Contemporary Art Society, Age Gallery, Athenaeum Gallery, Recently Prahran Art Festival and Robert Douglas Gallery 1983; Annually at VAS Gallery.
Represented Melbourne Stock Exchange and many boardrooms, institutional and private collections in Australia and overseas.

HURCOMBE, Wanda Ellen NSW
Born Burwood NSW. Painter in watercolour, oil and crayon; Porcelain artist and teacher.
Studies With David Rabb 1955–57; Ross Doig 1958–61; Julian Ashton School 1963; June Kaye 1973 and Helen Watkins 1976; Taught art at Scots College 1955–57; Has taught porcelain painting since 1974.
Exhibitions Porcelain painting demonstrations at David Jones stores 1973–79 and Grace Bros 1978–79; ANZ Bank, Sydney 1978, 1979; Also in Vic and WA.
Represented Her work has gone to UK, Europe, USA, Jamaica and Australasia.

HURST, Jeanelle QLD
Born Brisbane 1957. Painter, performance artist, teacher.
Studies Qld College of Art 1979–81. Has participated widely in art activities in Brisbane since 1982.
Exhibitions Many shows since 1982 include IMA, Brisbane 1984, 85; Qld University Art Museum 1985; Gladstone Civic Art Gallery 1985; Praxis, Fremantle 1986; CAC, Melbourne 1986; Chameleon, Hobart 1986; Jam Factory, Adelaide 1986; Qld College of Art and IMA 1986; CAS, Brisbane 1987; Axis Art Project, New York 1988; The Centre Gallery, Gold Coast 1988.
Awards VA/CB 1982, 86, 87.
Represented ANG; Institutional and private collections in UK, Europe and Ausralia.
Bibliography *A Homage to Women Artists in Queensland, Past and Present*, The Centre Gallery 1988.

HUTCH, Denise NSW
Painter and printmaker.
Studies Paddington Centre of Photography 1982; FA Certif. — ESTC 1985–87; Study tour UK, Europe, Middle East, USA, Asia 1980–83.
Exhibitions Solo shows at North Sydney Contemporary Gallery 1988; Access Gallery 1989, 90; Participated Barry Stern 1986–87; Bondi Pavilion 1988.
Represented Institutional and private collections in Australia and overseas.

HUTCHESON, Margot NSW
Born London UK 1952. Painter.
Studies St. Martins School, London 1970–71; arrived Aust. 1974.
Exhibitions Solo shows at Watters Gallery 1981, 83, 85, 87, 89; participated at Albury

Reg. Gallery 1983. First Aust. Contemporary Art Fair, Melb. 1988; Max Watters Collection at Muswellbrook Gallery 1988.
Represented NGV, Artbank, institutional and private collections in UK, Europe, Australia.

HUTTON, Joy QLD
Born Tas 1921. Painter and printmaker.
Studies Painting with Roy Churcher, Brisbane 1956 and printmaking at Uni. of Qld Summer School with David Rose 1971.
Exhibitions Solo shows at Reid Gallery, Hobart 1971; Design Arts Centre, Launceston; 1972, 74; Town Gallery, Brisbane 1979; Editions Galleries, Melb. 1980, 81. Group shows include TMAG 1969; PCA Touring Shows 1977, 78, 80, 82; Qld Arts Council 1978, 80.
Awards Caufield Print Prize 1978; RNA Print Prize and Gold Coast Purchase 1977, 80.
Represented Qld Art Gallery, Artbank and institutional and private collections around Australia and overseas.

HUTTON, Judith Louise QLD
Born Brisbane Qld 1953. Painter and printmaker.
Studies With Mervyn Moriarty 1967; Brisbane Art College 1972; Overseas study tour 1973; Vacation schools 1974, 1975, 1978.
Exhibitions One-woman show at Taringa Gallery, Brisbane 1977.
Awards SGIO Award 1981.
Represented Qld Art Gallery and private collections.

HUTTON, Marie NT
Figurative painter.
Studies BA (Fine Arts), Darwin IT 1988.
Exhibitions Solo shows at Holdsworth Galleries, Sydney and The Showcase Gallery, Darwin in 1990; Group shows include Osaka, Japan 1986; Casuarina Town Square NT 1986, 87; NTMAS, Darwin 1988.
Commissions Three paintings for Nicron Resources, Sydney 1989.
Represented Institutional and private collections in Japan and Australia.

HYAM, Joyce QLD
Born Brisbane Qld 1923. Painter, illustrator, printmaker, embroiderer and teacher.
Studies Central Technical College and College of Art, Brisbane; Waki Zollner Art School and Volkhochscule Munich 1968; Return study tours to UK and Europe 1970, 1975 and Japan 1972, Taiwan 1982; Lectures in interior decorating, art, and art and craft for sundry institutions; Part-time lecturer at the College of Art, Brisbane from 1962 to 1982.
Exhibitions Solo shows in Brisbane 1974, 1975, 1980.
Represented Private and institutional collections in Australia, Japan, UK, Europe and Taiwan.
Publications Author and Illustrator of *Interior Decoration for Australian Homes*, Jacaranda Press 1972.

HYDE, Jacqueline NSW
Born Sydney 1950. Painter.
Studies ESTC 1969–71.
Exhibitions Solo shows at Studio 666, Paris, France 1987; Mori Gallery, Sydney 1988; her work was included in *A New Generation 1983–88* at the ANG, Canberra 1988.

I

IGGULDEN, Annette VIC
Born London UK 1942. Painter.
Studies Australian Flying Art School and with private tutors 1973–81; BA from VCA, Melbourne 1984–86; Extensive overseas travel.
Exhibitions Boston Gallery, Brisbane 1981; Gallery Baguette 1982; University of Brisbane 1990; Judith Pugh Gallery, Melbourne 1990. Many group shows since 1976.
Represented Artbank, institutional and private collections around Australia and overseas.

INDYK, Itka NSW
Born Poland. Modern painter in all media; Teacher.
Studies Wellington Technical College, NZ; Canterbury University, Christchurch NZ; New York State University, USA 1949–51, and under Clem Millward at Hornsby Technical College 1975–79 for art certificate.
Exhibitions Solo shows at Mavis Chapman Gallery; Roseville Gallery and Royal Art Society; Numerous group shows.
Awards Kogarah, Ryde and Ku-ring-gai.
Represented Private collections in USA, South Africa, Australia and NZ.

INGEVICS, Muriel QLD
Born Monto Qld 1935. Painter, printmaker and craftworker.
Studies John Collins York Gallery, Ottawa Canada.
Exhibitions Solo shows at Ottawa and Hawkesbury Ontario 1978; Canberra ACT 1979.
Represented Private collections in USA, Canada, Europe, Egypt, Sri Lanka and Australia.
Bibliography *Directory of Australian Printmakers* 1982.

IRVING, Julie VIC
Born Melbourne Vic 1953. Painter in acrylic and collage.
Studies Association Diploma of Art, National Gallery School of Vic 1971–73; Graduate Diploma of Art, Vic College of the Arts 1973–75.
Exhibitions One-woman show at Abraxas Gallery, Canberra 1976; Group shows 'A Room of One's Own', three artists, Ewing Gallery, University of Melbourne 1973; Pinacotheca Gallery, Melbourne 1974; 'Nine Artists', graduate exhibition, Vic College of the Arts 1975; 'Drawing — Some Definitions', Ewing Gallery, University of Melbourne 1976; 'Artists' Choice', Warehouse Galleries, Melbourne 1977; Realities Gallery 1989.
Represented Australia Council and Peter Stuyvesant Collections.

IRVING, Pamela VIC
Born Aust. Ceramic sculptor, teacher, writer.
Studies B. Ed. Arts & Crafts, Melb. CAE 1979–82; MA 1984–88. Lectured part-time at Melb. CAE 1985, 86, 87; RMIT 1987, 88; CIT 1987; Chisholm IT 1988. Art critic for *Geelong Advertiser* 1986–88.
Exhibitions Many shows since 1981, include Gryphon Gallery 1981, 82, 87; Profile Gallery 1983, 84, 85; Meat Market Centre 1985, 88; RMIT 1985, 88; Holdsworth Galleries, Sydney 1985, 86, 88; Castlemaine Reg. Gallery 1986; Geelong Art Gallery 1987; Distelfink Gallery 1987; Deakin Uni. Gallery 1987; Touring show to Canada/North America 1988.
Awards Kamel Award 1981; City of Box Hill 1985; Footscray Municipal 1985; Artists in Schools 1987, 88; VACB Grant 1988.
Represented Institutional and private collections in UK, Europe, USA, Canada, Australia.

Bibliography *Pottery in Australia* Vol. 26 Nos. 1 & 4.

ISHERWOOD, Jean de Courtenay NSW
Born Sydney NSW 1911. Traditional painter in oil and watercolour; Portriatist and print-maker.
Studies National Art School on scholarship 1926–28; further five years with Dattilo Rubbo at RAS of NSW; Member, AWI 1948; taught at NAS 1961–74; Member RAS of NSW since 1976, Fellow from 1982.
Exhibitions Many solo shows since 1946 and recently at Artarmon Galleries 1986, 88, 89, 90.
Awards Has won over seventy first prizes in local and country competitions since 1950.
Represented ANG; AGNSW; institutional and private collections.
Bibliography *Australian Watercolour Painters 1780–1980*; Jean Campbell 1983.

J

JACKMAN, Hilary VIC
Born Melbourne Vic 1943. Painter of landscapes, seascapes, still-life, nudes and portraits in oil pastel and ink.
Studies Private tuition Ian Hassall 1957–58; RMIT 1960–64, drawing under Harold Freedman and Murray Griffin and painting under Jock Frater; Worked as an illustrator for 10 years before joining the 'Seven Painters' formed in 1971. Worked at Vic. State Studio 1976–77; Overseas study Europe 1968, 69, 80, 85; Philippines 1975.
Exhibitions Seven painters group shows at VAS Melbourne 1973–77, at David Sumner Gallery, Adelaide 1976, 1977; Eltham Community Centre 1980; Two-man show Stringybark Gallery, Melbourne 1975; 'Victorian Women' show Bartoni Gallery, Melbourne 1976; Solo shows Eltham Gallery, Melbourne 1978, 82, 83; Eltham Community Centre 1980, 84–87; Aust. Impressions Gallery, Melb. 1989.
Awards John Storey Jr, Memorial Scholarship 1963–64, Tom Roberts Award 1974, Mt Waverly Award 1974, Special Awards Diamond Valley 1975, Camberwell 1976, 1977; Kew Prize Kew Awards 1979; Eltham Prize; Travelling Scholarship 1980. Alice Bale Travelling Scholarship 1985.
Represented Shire collections Eltham, Kew and Diamond Valley; Private collections Australia, UK and USA.

JACKSON, Jo-ellen VIC
Born Melb. 1956. Painter.
Studies Caulfield IT, Melb. 1972–73; Universidad de Quito, Ecuador 1980–81; Tas. CAE, Launceston 1982–85.
Exhibitions William Mora Galleries, Melb. 1987 and her work was included in *A New Generation 1983–88* at ANG, Canberra 1988.

JAHNSONS, Silvia NSW
Born Australia 1950. Painter, stage designer, teacher.
Studies Bachelor of Arts, Fine Arts and Diploma of Education from University of Sydney 1971–75; Taught at high schools and went to London UK 1977 as a stage designer, also as a photographer; Designed costumes and sets for Royal College of Arts, London, production 1978; Designs for Nimrod and other Australian theatres.
Exhibitions First one-woman show at Watters Gallery, Sydney 1977; Participated with Mike Mullins in performance *New Blood* at Australian and British Stage Design Show at

Adelaide Festival Centre 1982.

Commissions Designed the sixty-five costumes for the international touring show 'Alice' by Lindsay Kemp. It has already visited UK, Spain, Italy, Japan, Israel and Mexico and still touring.

Represented Institutional and private collections in Australia and overseas.

Bibliography *Alice 125*, Gryphon Gallery: University of Melbourne 1990.

JAKSIC-BERGER, Mimi NSW

Born Pomazatin Serbia 1936, arrived Australia 1959. Lyrical abstractionist painter mostly watercolour; Teacher and designer; Married Dr George M. Berger 1970. Studied full-time at Technical Institute, Pec (Petch) and participated during the summer-recesses in fresco restorations at Petchka Patriarchia and churches at Neresi, Orchid and Liplyan, employed by the institute for the Preservation of Historical and Cultural Monuments, Belgrade 1951–56; Diploma as Painter and Art Teacher. Taught in Belgrade. Worked at Art Department of Kekez, Novisad. Had poems published 1956–58. Her painting *Coral Sea Fantasy* was published in the American Watercolour Society Catalogue of 1975; Member of the Australian Watercolour Institute.

Exhibitions First at the 'Young Contemporaries' Exhibitions at the Blaxland Gallery, Sydney 1967; One-woman shows at the Barefoot and Sebert Galleries, Sydney 1970, 1973; Reid Gallery, Brisbane 1972; Bloomfield Gallery and Hunter Douglas Design Centre, Sydney 1973; Solander Galleries, Canberra 1974; Lidums Gallery, Adelaide 1976; Bartoni Gallery, Melbourne 1978; Bonython Gallery, Sydney 1976; Lincoln Centre, New York 1980; Wagner Gallery, Sydney 1979, 81, 82, 84; Mimi's Gallery, Sydney 1991. Many group shows since 1970 including Blaxland Gallery, Sydney 1982, 85 and Columbia University Gallery, New York 1984.

Awards 147 Art Prizes throughout Australia since 1967.

Represented Regional Galleries and institutional and private collections in UK, Europe, USA and Australia.

Bibliography *Australian Watercolour Painters,* Jean Campbell: Rigby 1983. *Modern Australian Painting* 1970–75, Kym Bonython/Elwyn Lynn, Rigby 1976; *Artists & Galleries of Australia*, Max Germaine: Craftsman House 1990.

JAMES, Catherine NSW

Born England. Painter, designer, sculptor.

Studies Julian Ashton School under Richard Ashton and Brian Blanchard.

Exhibitions Solo shows at Artlook Gallery, Sydney 1989, 90.

Represented Institutional and private collections.

JAMES, Christine NSW

Born Casino, NSW 1953. Painter.

Studies Qld College of Art 1971–72, 1982–86. India 1977.

Exhibitions Solo show at Casey Galleries, Sydney 1988.

JANAVICIUS, Jolanta NSW

Born Lithuania 1929. Sculptor, ceramic artist, teacher.

Studies L'Ecole des Arts et Metiers, Freiburg 1947; ESTC 1950–51 and 1966–70; Adult Education studies in fine arts at University of Sydney 1980–82; Since 1974 has had her own studio and taught ceramics at Mulawa Prison and Lane Cove Community Centre.

Exhibitions Has held twenty solo shows since 1970 and recently at BMG, Adelaide 1982; The Sculpture Centre, Sydney 1983; Manuka Gallery, Canberra 1984; Bloomfield Galleries 1986, 89; Craft Centre, Melbourne 1987. Numerous local and overseas group shows include Valauris, France 1970; Faenza, Italy 1972, 76; London 1979, 80; Nepal 1984.

Awards Royal Easter Show Ceramics 1986; Warringah Art Prize 1986.

Represented AGSA, Artbank, institutional and private collections around Australia and in many overseas countries.

JARRET, Dora NSW
Born Sydney NSW 1895. Painter of landscapes, old houses and portraits in oil and watercolour; Teacher.
Studies Dattilo Rubbo Art School, Sydney; Colarocsi and Andre L'hote, Paris; Member of Australian Watercolour Institute since 1940.
Exhibitions First one-woman show in Brisbane 1929; Regular participant in group and Australian Watercolour Institute shows.
Represented Art Gallery of NSW; Newcastle City Art Gallery; Howard Hinton Collection, Armidale NSW.

JARVIS, Katherine (Stephen) WA
Born Peterhead Scotland 1910, arrived Australia 1930. Semi-abstract painter in oil, acrylic, watercolour.
Studies Diploma of Art, Gray's School of Art, Aberdeen Scotland 1930 and Central School of Art, London. Member, Perth Society of Artists. Formerly Art teacher with WA Dept of Education and with Adult Education classes; Was member of WA Society of Artists, Perth and one time vice-president.
Exhibitions A number of three-man shows at Newspaper House Gallery, Perth and the Claude Hotchin Gallery, with Iris Francis and the late Allan Cook; A two-man show with George Lazlo at the Cremorne Gallery, Perth.
Awards Dunlop Watercolour Prize 1953; Claude Hotchin Watercolour Prize 1953, 1955.
Represented Art Gallery of WA and in country galleries and private collections.

JARVIS, Sue VIC
Born Dandenong, Vic 1949. Impressionist painter in oil and watercolour.
Studies Caulfield Technical College and Melbourne State College 1967–71; Study of Art and Craft of NZ; Sponsored by the ANZ Bank and Young Farmers Movement of Vic 1973; Art-Craft Consultant with the Ballarat Region of the Education Dept 1978–80; Inaugurated and ran Life Drawing Group at the Ballarat Fine Art Gallery 1974–79; Taught Impressionist Painting Class, Monash University 1982. Member, CAS, Melb.
Exhibitions Solo shows at ANZ Bank, 388 Collins St, Melbourne 1974; Chameleon Gallery, Mt Eliza 1976; Ballarat, Skipton Street Methodist Church 1977; Swan Hill Regional Gallery 1979; Ballarat Community Education Centre 1980; Old Bank Gallery, Buninyoung 1981; Vic Artists' Society 1982; Eltham Gallery, Vic 1983; State College of Vic, Burwood Campus 1985 (retro); Woolloomooloo Gallery Sydney 1986; Sale Reg. Gallery, Carmen Powell Gallery , Dandenong 1987; James Starkey Galleries, Beverley, UK 1988; Wiregrass Gallery 1989.
Awards Dandenong Festival of Music and Art for Youth; Young Artists' Award, Oils, Acrylics 1972, 1973, 1974; Watercolour Award 1972, 1973; City of Dandenong District Art Award 1974, 1975; Dandenong Centenary Art Award 1973; Shire of Buninyong Art Award 1980; Ballarat YMCA Vynol Paints Award 1980; Shire of Buninyong Acquisitive Prize 1981; Foster Watercolour Award 1981; Maryborough Golden Wattle Festival 1982. Barossa Valley, Noble Park Rotary 1985; Pakenham 1985, 86, 88; Warragul Rotary 1985, 86; Pakenham, Vic.; St. Francis Xavier, Berwick Rotary, Bacchus Marsh Rotary 1989.
Represented Private collections throughout Australia, UK, Germany, NZ and India; Cities of Dandenong, Maryborough, Shires of Ripon, South Gippsland, Buninyong. Pakenham Gisborne.
Bibliography *Artists & Galleries of Australia*, Max Germaine: Craftsman House 1990.

JASULAITIS, Margaret VIC
Born Melbourne Vic 1936. Painter, sculptor, craftworker and teacher.

Studies Certificate of Art, RMIT 1955; Diploma of Art and Graduate Diploma of Art, RMIT 1975–76; Diploma of Education, MSC 1977.
Exhibitions The Craft Centre, Melbourne 1978; Macquarie Galleries, Sydney 1981–82; Makers Mark Gallery, Melbourne 1982; Participated in many group shows since 1974 and recently 'Australian Jewellery', Australia Council, England, Scotland, Germany, Austria and Denmark 1982; 'Skin Sculpture', City Art Gallery, Wellington NZ 1982; 'Cameleons and Ostriches: Ritual Bibs and other Works', Macquarie Galleries, Sydney 1982.
Represented Institutional and private collections in Australia and overseas.

JAUGIETIS, Aina-Regina SA
Born Latvia 1923, arrived Australia 1949. Painter, teacher and sculptor.
Studies Ceramics and sculpture at SA School of Arts, where she is now a lecturer; Member of RSASA and CAS.
Exhibitions Mildura Sculpture Centre 1961, 1964, 1967, 1968.
Awards Clarkson Memorial Sculpture Prize, SA 1958.
Represented Institutional and private collections around Australia.
Bibliography *Latvian Artists in Australia,* Society of Latvian Artists, ALMA 1979.

JAUNCEY-PRIOR, Gladys VIC
Born Herefordshire, UK. Arrived in Australia 1924. Traditional realist painter of landscapes, still life and portraits.
Studies Following early retirement from a career in Nursing Education studied art at the VAS, overseas and with private tutors in Melb. Member, VAS and AGRA.
Exhibitions Solo shows at Swan Hill Arts Centre 1983. North Balwyn 1983–88; Victoria Franck Gallery 1984; Sherbrooke Art Centre 1986; Serendipity Gallery 1988; Sha's Gallery 1988; Walpole WA 1988.
Awards Sherbrooke 1982, 83; Kyabram Rotary WC 1984; Royal Melb. Show 1984; Traralgon 1987; Altona Rotary 1988.
Represented Institutional and private collections in UK, Europe, USA, Australia.

JAY, Virginia SA
Born SA. Painter and teacher.
Studies SA School of Art and gained Diploma of Fine Art (painting); Taught at secondary and tertiary levels for some years; Lecturer at SA School of Art, Torrens CAE; Overseas study tour UK, Europe in 1972.
Exhibitions 'Young Adelaide Artists', Bonython Gallery, Adelaide and Transfield, Sydney 1968; One-woman shows at Skillion Gallery, SA 1969; Bonython Gallery, Sydney 1970, 1974, Adelaide 1972; Participated Georges Invitation, Melbourne 1970, Tas Art Gallery 1970, 1974; State Gallery, Vic 1971; CAS Adelaide Festival 1972; Gallery A, Melbourne 1973; Llewellyn Gallery, Adelaide 1973; Designs sets for Adelaide University AUDS productions.
Represented National Collection, Canberra; State Galleries of Qld, WA and Tas; Castlemaine, Ballarat, Geelong, Shepparton Galleries and private collections.

JENEID, Liz NSW
Born Sydney 1936. Weaver, textile artist, teacher.
Studies Shillito Design School, Sydney; MCA, School of Creative Arts, Uni. of Wollongong. Currently, lecturer in textiles at School of Creative Arts, Uni. of Wollongong.
Exhibitions Numerous shows include Distelfink, Melb.; Beaver Gallery, Canberra; Wollongong City Gallery; Craft Council Gallery, Sydney.
Represented Powerhouse Museum, QAG; Craft Council of NSW; Uni. of Wollongong.

JENSEN, Eula QLD
Born Cairns. Landscape painter, mostly watercolour and teacher. Studied under the late Ted

Creasy; Teaches Adult Education classes.
Exhibitions The Upstairs Gallery, Cairns and The Tradewinds Outrigger Convention Centre.
Awards Ingham Art Society Watercolour 1982; Innisfail Art Society 1981, 82, 83.

JENUARRIE QLD
Born Rockhampton 1944. Painter, ceramic artist, printmaker.
Studies Completed Fine Arts course at Cairns TAFE 1986.
Exhibitions Solo show at Dabbels on Days, Brisbane 1986; group shows include Armadale Vic 1987; QAG 1987, 88; PCA Melb. Touring Show 1987–88.
Represented ANG, Canberra; NG of Vic., Qld. AG; Qld. and SA State Museums.
Awards Lillian Pedersen Memorial Prize for Printmaking 1988.
Bibliography *A Homage to Women Artists in Queensland*: The Centre Gallery 1988.

JENYNS, Josephine QLD
Born 1905 Brisbane Qld. Traditional painter of flowers and landscapes.
Studies Brisbane Central Technical School 1923 and privately with Dora Birkbeck; Later with William Bustard 1962 and Hubert Jarvis and vacation school 1966; Member RQAS.
Awards Royal National Association of Qld, Jubilee Show 1925; First Prize Still-Life, Royal Show 1927; First Prize Flowers, Enoggera Annual Show 1925.
Represented Private collections in England, Munich, Hong Kong, NZ and Australia.

JENYNS, Lorraine VIC
Born Melb. 1945, Ceramic sculptor and painter.
Studies CIT, RMIT, Melb. Teachers College 1963–65.
Exhibitions Solo shows at Chapman Powell Gallery 1973; Watters Gallery, Sydney 1975, 86; AGSA 1977–78; 312 Lennox St. Gallery 1987. Joint show with Bob Jenyns, Watters Gallery and Vic. Reg. Galleries 1976–77. A host of group shows since 1971 including Mildura Sculpture Triennial 1975, 78; *Australian Perspecta* '81, AGNSW; First Australian Sculpture Triennial, Melb. 1981; Ceramics show to USA, Canada, NZ 1981; Meat Market Craft Centre 1983, 84; Fine Arts Gallery, Uni. of Tas 1985; ANG Canberra 1985–86; *The Great Australian Art Exhibition* 1788–1988 touring 1988. First Aust. Contemporary Art Fair, Melb. 1988. Max Watters Collection at Muswellbrook Art Gallery 1988. Ivan Dougherty Gallery Touring 1988.
Awards Caltex Ceramic Sculpture Prize and Crafts Board Grant for Exhibition of Ceramic Sculpture 1974. Research Grant, University of Tasmania 1985–86.
Commissions Royal Hobart Hospital 1986.
Represented Australian National Gallery; Ballarat Fine Art Gallery; National Gallery of Vic; Art Gallery of SA; Shepparton Art Gallery; Ararat Art Gallery; La Trobe Valley Arts Centre; Melbourne State College; Queen Victoria Museum and Art Gallery, Launceston; The Art Gallery of WA; New Parliament House Canberra; Artbank, Regional Galleries, many institutional and private collections in Aust. and overseas.
Bibliography 'The New Ceramics', *Art & Australia*, Barrie Reid, Vol 10 No 4, April 1973; *Modern Australian Sculpture,* Ron Rowe, Rigby 1977; *Australian Sculptors,* Ken Scarlett, Nelson 1980; *Artists & Galleries of Australia*, Max Germaine: Craftsman House 1990.

JESSOP, Clytie (Lloyd Jones) NSW
Born Sydney NSW 1929. Expressionist painter mostly in oil; Gallery director; Sister of Hermia Boyd.
Studies East Sydney Technical College; Chelsea Polytechnic, London; Director of Clytie Jessop Gallery, London 1965–73, which specialised in the work of Australian contemporary painters; Director of the National Trust S.H. Ervin Museum and Art Gallery, Sydney 1978–81.

Exhibitions Dominion and Argus Galleries, Melbourne 1963.
Bibliography *The Art of David Boyd*, Nancy Benko, Lidums, Adelaide 1973; *The Pottery and Ceramics of David and Hermia Boyd,* John Vader, Mathews and Hutchinson, Sydney 1977.

JETNIKOV, Marina QLD
Born Qld 1957. Printmaker.
Studies Assoc. Dip. Kelvin Grove CAE 1986–87.
Exhibitions Carawah Gallery, Brisbane 1987; 70 Arden St., Melb. 1988.
Commissions PCA 100 x100 Print Portfolio 1988.
Bibliography *PCA Directory* 1988.

JOANNOU, Pollyxenia NSW
Born Sydney NSW 1953. Painter.
Studies East Sydney Technical College 1978–79; Alexander Mackie CAE 1980–82; Won 1982 NSW Travelling Art Scholarship.
Exhibitions Solo show, 'Butchers Exhibit', Sydney 1983; Participated in 'Fresh Blood' Travelling **Exhibition** 1983 also at Commonwealth Bank 1981; Art Gallery of NSW, Sulman 1982; Ivan Dougherty 1983. Fourteen Roses Gallery Sydney 1988.
Represented Institutional and private collections.

JOHNS, Gail NSW
Born Wollongong NSW 1954. Traditional painter in mixed media and printmaker.
Studies Newcastle Technical College Art School and College of Advanced Education first as a teacher trainee, then as a diploma student, graduating with a Diploma of Art. In 1985 she became a part-time teacher of painting and drawing at the School of Art and Design, College of TAFE, Newcastle. Currently teaching part-time at the School of Art at Meadowbank College of Technical and Further Education as well as one day a week at the School of Art and Design, Newcastle College of TAFE.
Exhibitions Four of Gail John's five exhibitions have been held at von Bertouch Galleries Newcastle: July 1978, October 1980, March 1986 and July 1988; and one at The Bloomfield Galleries Sydney: November 1979. During 1987 she participated in group exhibitions at the Contemporary Gallery Newcastle and the Holdsworth Contemporary Galleries Sydney.
Represented Institutional and private collections in Australia and overseas.

JOHNSON, Heather NSW
Born Sydney NSW. Fibre craftswoman specialising in knotted sculptures; Teacher, writer.
Studies Georgian College, Toronto Canada 1972–74; Various workshops 1974–84; Craft Council of NSW 1980; Uni. of Sydney Fine Arts — BA (Hons) 1986, MA (Hons) 1989.
Exhibitions Solo shows in Ontario, Canada 1971, 72; Crafts Council NSW 1975; Many group shows including Craft Council Biennials 1977, 79.
Awards Many in Canada and locally include Dubbo 1977, 78; Wyong 1978, 79; Campbelltown 1979.
Represented Institution, corporate and private collections in NSW, Victoria and Canada.
Publications *Roy de Maistre. The Australian Years 1894–1930,* Craftsman's Press, 1988; Numerous magazine articles on fine art and craft.

JOHNSON, Jean NSW
Born WA. Painter in oil, watercolour, egg tempera; Printmaker.
Studies Attended life classes in NSW, Vic and WA.
Exhibitions Her work has appeared in shows at state and commercial galleries and in Wynne, Blake and Australia Print Council exhibitions, also in Print Prize 1967 and University of Tas Print Prize 1968, Singapore 1982.

Bibliography *Directory of Australian Printmakers* 1988.

Publications Her pen and ink and wash drawings illustrate the book, *Requiem for Woolloomooloo*, published by Hodder & Stoughton.

JOHNSON, Merryle VIC

Born Melbourne Vic 1949. Painter, photographer and teacher.

Studies Graduated Dipolma of Fine Arts (painting) RMIT 1969; Commenced work as a commercial photographer; Began lecturing in fine arts at Bendigo College of Advanced Education from 1972; Currently part-time lecturer in photography, Australian College of Photography, Melbourne.

Exhibitions First one-woman show at Abraxas Gallery, Canberra 1976; NGV 1977, 83; Benalla and Bendigo Regional Galleries 1978; Museum of Modern Art, Oxford UK 1980; Castlemaine Art Gallery 1981; La Trobe Valley Arts Centre 1984; Christine Abrahams Gallery, Melb 1985; State Library, Vic. 1986; Centre Eye Gallery, Calgary, Canada 1988. Participated, National Gallery of Vic; Australian Centre for Photography, Sydney; Festival of Sydney; Abraxas Gallery, Sydney 1977; Work selected for exhibition of contemporary Australian photographers for Philip Morris collection at Adelaide Festival of Arts 1978; Since then included in many group shows including Monash University 1982; Albury Regional Gallery 1983, 86; NGV 1984, 86; Australian Centre for Photography 1984; AGNSW 1984, 85, 86, 88; ANG 1985, 87; Ballarat Regional Gallery 1986; Blaxland Gallery, Melbourne 1989.

Awards VAB 1988.

Represented ANG; NGV; AGNSW; Regional galleries and private collections.

JOHNSON, Molly NSW

Born Adelaide SA. Painter of landscapes, portraits, native peoples, in oil and pastel; Teacher.

Studies Swinburne Technical College, Melbourne; Canterbury College of Art, NZ and with Archibald Colquhoun in Melbourne; Conducted summer school at Port Moresby, Papua New Guinea 1963; Studied and painted in the UK, Europe, USA, Canada 1974–77; Fellow of Royal Art Society of NSW.

Exhibitions One-woman shows at David Jones' and Anthony Hordern Galleries, Sydney 1954; Also at Turramurra NSW, Moreton Galleries, Brisbane, Port Moresby Gallery, Parliament House, Canberra (New Guinea paintings); Hilton Art Gallery 1984; Participated in Matthew Flinders, 'Artists in England' Exhibition, Leicestershire UK 1976; Barbizon Gallery, Sydney 1983; Qantas International Centre, Sydney 1982; Tininburra Gallery, Tamworth, 1985; With Garren-Brown and Joanne Thew at RASNSW 1987, 90.

Awards Drummoyne and Blue Mountains 1962; Taree NSW; 'On Broadway Portrait Prize' 1982. Hawkesbury Shire 1981, 88 Macquarie Towns Purchase 1988.

Represented Collections in Europe, USA, Canada, New Guinea and Australia.

JOHNSTON, Diana WA

Born UK 1940. Modern landscapist.

Studies Educated and studied art in UK and Switzerland; Lived in Rhodesia for some years before coming to WA.

Exhibitions Has held several one-woman shows at Lister Gallery, Perth 1973, 1978 and participated in many group shows and competitions.

Awards Mundaring Art Prize, $500 1972; WA 'Artists of the Year' Award 1972; Spinifex Prize, $750 1973; Spinifex Prize $750 1974; Also second entry acquired.

Represented Rhodes National Gallery, Salisbury Rhodesia; Art Gallery of WA; University of WA (Currie Hall); Murdoch University, WA; Graylands Teachers College, WA; Perth College, WA; Premiers Department, WA; Family Law Courts of WA; Royal Perth Hospital; West Rail, WA; Rural and Industries Bank; CRA Ltd; Hamersley Iron Ltd; Australian Controls Ltd; Alcoa Australia Ltd; Alcoa USA; Royal College of Surgeons, Canada; Anglo

American Ltd, Johannesburg and London; Also many other private collections in USA, Canada, Japan, South Africa, Hong Kong, UK and Australia.

JOHNSTON, Jennene NSW
Born NSW 1971. Contemporary painter.
Studies Blacktown Girls High School, Sydney.
Awards *The Australian* 1988 National Art Award for Secondary Students.

JOHNSTON, Norma NSW
Born Narrabri NSW 1981. Porcelain painter and teacher.
Studies Diploma from School of Porcelain Art under Danish tutor Celia Larsen; Later at workshops in USA, and Spain; Member of International Porcelain Art Teachers Association, Dallas USA.
Exhibitions David Jones, Sydney 1976–80; Menzies Hotel 1979; Kenwick and Burning Log Galleries, Sydney.
Represented Many private collections in Australia and overseas.

JOHNSTON, Pam NT
Painter and printmaker.
Exhibitions Solo shows at Kelly Street Kolektiv 1987; Boomalli Aboriginal Artists Co-op. Gallery 1988, 89; Balmain Loft 1988; Works Gallery, City Art Institute 1988; *Aust. Perspecta* — Artspace Gallery, Sydney 1989. Numerous group shows since 1986.

JOHNSTON, Patricia M. NSW
Born Sydney 1932. Painter of landscapes, flowers, portraits in oil and watercolour.
Studies BA University of Sydney 1952; Diploma of RAS of NSW 1987; Exhibiting member 1978– .
Exhibitions Solo show in California USA 1977 and five joint shows in Sydney in recent years; Willandra Gallery 1990.
Awards Camden Municipal Art Festival Open 1980; Macarthur Art Prize (shared) 1980; CRT Farmers Annual Merit Award 1982; Ryde Art Award 1983; Fishers Ghost Art Festival Local Section 1980, 1981, 1985; Stonequarry Festival 1980, 1981, 1984, 1985; C.W.A. Ampol Gold Medal 1985, 1986.
Represented Municipal collections of Camden, Campbelltown, Fairfield, Ryde and Sutherland. Private collections in Australia, New Zealand, USA, Canada and Europe.

JOHNSTONE, Ingrid NSW
Born Hamburg, W. Germany 1941. Painter, printmaker, teacher.
Studies ESTC, City, Art Institure, Hornsby TAFE 1976–83 gaining Grad. Dip. Professional Art Studies. Overseas study 1986, 88, 89. Teaching at Ku-ring-gai Art Centre 1988–91. Member, Sydney Printmakers, Print Circle, Southern Printmakers, PCA.
Exhibitions Bloomfield Galleries 1981; Q Gallery 1982, 85; Ivan Dougherty Gallery 1983; Fremantle Arts Centre 1983; Blaxland Galleries 1985, 89; CAS Adelaide 1985; Excelsior Gallery, Sydney 1986; Sydney Printmakers 1986–90; Braemar Gallery 1990.
Awards Hunters Hill 1980, 81, 85, 86.
Represented Artbank, institutional and private collections.
Bibliography *PCA Directory* 1988.

JOHNSTONE, Ruth VIC
Born Hamilton Vic 1955. Painter, printmaker and teacher.
Studies Diploma of Fine Art, Warrnambool Institute of Advanced Education 1974, 1976–79; Two month study tour of European galleries 1979; Lecturer in printmaking and drawing, Warrnambool Institute of Advanced Education (part time) 1980–; Postgraduate

studies in Printmaking, Royal Melbourne Institute of Technology 1981–82.

Exhibition Solo shows at Powell St. Graphics 1984, 86, 88, 91. Participated at Warrnambool Art Gallery 1981, 1982, 1983; Heide Gallery 1982; Swan Hill Gallery 1982; Mornington Peninsula Art Centre 1982; PCA to Japan 1984; ACCA, Melb. 1985; RMIT 1986; Ivan Dougherty, Sydney 1986; Canberra S of A 1986; Wollongong City Gallery 1986; Gryphon Gallery 1986, 87; ANG, 1987, 89; Chameleon Gallery, Hobart 1987; 70 Arden St. Gallery 1988; NGV 1989; Westpac Gallery 1990. Regional galleries in SA, Vic., Qld, NSW and ACT 1990–91.

Awards Warrnambool 1981, Mornington 1982, 86; Diamond Valley 1983; Hamilton AG 1984; Ispwich City Council 1987; Fremantle Print Award 1986; Residency, Besozzo Studio, Italy 1990.

Commissions Myer Foundation 1986 and PCA Member Print 1986; Vic Print Workshop 1987; PCA Print Portfolio 1988.

Represented ANG, Artbank Regional Galleries, institutional and private collections.

Bibliography *PCA Directory* 1988; *Artists & Galleries of Australia*, Max Germaine: Craftsman House 1990.

JONES, Dee SA

Born SA 1933. Paints colourful and vivacious representations of genre subjects.

Studies Fine Arts Flinders University Adelaide 1975 (Equal top distinction 1st year).

Exhibitions Solo shows at Robert Bolton Gallery 1968; Lidums Gallery 1971; Macquarie Galleries, ACT 1972; Llewelyn Galleries 1973; Greenhill Galleries 1977; Bonython Galleries 1980, 1983, 1988; Philip Bacon Galleries, Brisbane 1981, 1982, 1984, 1986; Included in 'Landscape and Image' show to Indonesia 1978 and others in Vic, NSW, SA and Darwin 1974–80. 'The John McCaughey Memorial Art Prize' exhibition, NGV 1981; 'Contemporary South Australian Painting', AGSA 1986.

Commissions Portrait of Henri Bastin which featured on cover of book *One Continuous Picnic*, Michael Symonds, Duck Press 1982.

Represented Art Gallery of SA, The Alice Springs Art Foundation, NT; The Barossa Valley Collection, SA; BHP Collection; Toowoomba College of Advanced Education Collection, Qld; Hartley College of Advanced Education, SA.

Bibliography Catalogue, *Landscape and Image,* Australian Gallery Directors Council Travelling Exhibition to Indonesia 1978.

JONES, Elspeth NSW

Studies Dip. Fine Art, Caulfield IT 1976–80; France 1982.

Exhibitions Solo shows at Artlook Gallery, Sydney 1988, 89.

Commissions Six murals, San Torini, Greece 1983.

Represented Institutional and private collections in Australia and overseas.

JONES, Frances NSW

Born Sydney NSW 1923. Naive painter, and textile designer.

Studies East Sydney Technical College and Julian Ashton School 1940–45; Sister of flower painter Paul Jones.

Exhibitions Joint naive painters, Macquarie Gallery, Canberra 1964 and one-man show 1966; Mixed show Macquarie Gallery, Sydney 1968; Anna Simons Gallery, Canberra 1970, 1972; Prouds Art Gallery, Sydney; One-man show 1971; Mixed 1976; One-man show, Philip Bacon Gallery, Brisbane 1977; Joint naive Barry Stern, Sydney and Susan Gillespie Galleries, Canberra 1978; Solo at Barry Stern 1981; Gallery Art Naive, Melb. 1981, 83, 86; Eddie Glastra Gallery, Sydney 1986, 88, 90. Joint retrospective with Anne Graham Benalla and McClelland Galleries, Vic 1983.

Represented Artbank, Canberra CAE and private collections.

JONES, Glenda NSW
Born Kyneton, Vic. 1944. Painter, printmaker.
Studies Caulfield College of TAFE (Printmaking) 1966; Dip. Art & Design (Printmaking) Prahran College of TAFE 1976.
Exhibitions Hung in Archibald Prize, AGNSW 1991.
Commissions Murals for Leichhardt Council NSW 1984, Birchgrove Public School 1985 and Bill Evans Autoport 1988, 89.

JONES, Heather WA
Born Sydney NSW 1941. Painter in watercolour, oils, pastels and mixed media.
Studies Self taught.
Exhibitions Churchill Gallery, WA 1978; Hawkes Hill Gallery, WA 1980; Ric's Gallery, WA 1981; Waterways Gallery, WA 1983.
Awards WA Society of Artists prize 1977; Wanneroo Shire Art Prize 1979; Stirling City Art Prize 1980; Watercolour Society of WA, Inaugural Art Award 1981; Floreat Rotary Art Award 1982; Sabemo Art Award 1982.
Represented Royal Perth Hospital, King Edward Memorial Hospital, Wanneroo and Stirling City art collections; Private collections in Australia and overseas.

JONES, Lyndal VIC
Born Sydney NSW 1949. Performance and video artist.
Studies Bachelor of Arts and Diploma of Education from Monash University, Melbourne 1968–72; Presently lecturer at School of Drama, Vic College of the arts.
Exhibitions Solo shows at La Mama Theatre, Melbourne 1977–79; George Paton Gallery, Melbourne 1979, 1980, 1981; University Gallery, University of Melbourne 1979; 110 Chambers Street, New York 1980; Institute of Modern Art, Brisbane 1988; Performance Space, Sydney 1988. Participated in Festival of Sydney, Sydney Town Hall 1978; Third Biennale of Sydney, 1979; Act 2, Australian National University, Canberra 1980; First Australian Sculpture Triennial, La Trobe University, Melbourne 1981; Fourth Biennale of Sydney, Cell Block Theatre, Sydney 1982; Art in the Age of Mechanical Reproduction, George Paton Gallery, Melbourne 1982; Act 3, Canberra School of Art Gallery, Canberra 1982; *Australian Perspecta* 1983, Art Gallery of NSW 1983; Image '83, Melbourne 1983; Continuum '83, Plan B, Tokyo, Japan 1983. Anzus in Edinburgh 1984.
Awards Theatre Board, Australia Council 1976, 1979, 1980; VAB, Kitty Rubbo Memorial Fellowship 1983.
Bibliography *Art and Australia,* Vol 19 No 4 'The Melbourne Scene', *Catalogue of Australian Perspecta* 1983.

JONES, Madeleine Scott NSW
Born Kent UK. Designer and potter.
Studies Camberwell School of Art, London and taught there for a year after gaining her diploma; Later she freelanced in Brazil and from 1951–59 taught design in relation to pottery at Portsmouth College of Art, UK; Arrived Australia in 1959 and in 1961 became teacher in charge of the newly formed pottery section at Newcastle Technical College, National Art School.
Exhibitions Her first one-woman show was at the von Bertouch Galleries, Newcastle in August 1977; Prior to this she had participated in numerous group shows including International Women's Year, Newcastle Artist 1975; Potters of NSW Regional Survey 11, 1961; Australian Pottery 1970; Hunter Valley Pottery 1971, Newcastle City Art Gallery.

JONES, Mary SA
Born Semaphore SA 1916. Potter and teacher.
Studies SASA and with private tutors.

Exhibitions Solo show at Coach House Gallery, Adelaide; Regular shows with RSASA and the Studio Potters Club; Adelaide Festival 1990; Christchurch NZ 1990.

JONES, Nola NSW
Born Adelaide 1938. Painter, fibre and textile artist, theatrical designer.
Studies SASA 1960–63; Central School of Arts & Crafts, London 1964; Also worked in New York and West Berlin.
Exhibitions Solo shows at Solander Gallery 1980, 86; Hogarth Gallery 1983, 85; Ararat Regional Gallery 1986; BMG Fine Art, Sydney 1987, 89.
Awards VAB Grants 1980, 83, 86.
Represented AGWA, AGMNT, Artbank, many institutional and private collections.
Bibliography *New Art Four*: Craftsman House 1990.

JONES, Sue NSW
Born Sydney 1942. Potter and teacher.
Studies Dip Medical Laboratory Technology, Sydney 1964; Dip Studio Pottery, Harrow School of Art, UK 1971; Part-time lecturer in Ceramics, Harrow School of Art and Southend-on-Sea School of Art 1972; Returned to Australia 1978 to set up present workshop. Member, Newcastle Studio Potters and Potters Society of Australia.
Exhibitions Solo shows at Armstrong Gallery, Morpheth 1980; Cooks Hill Gallery 1981, 84; von Bertouch Galleries 1990. Many group shows overseas and around Australia.
Awards University of Newcastle 1983.
Represented Reading Museum UK, institutional and private collections.

JORDAN, Valerie SA
Born Mytholmroyd, West Yorkshire UK. Printmaker, watercolourist and teacher.
Studies Newcastle-upon-Tyne College of Art 1964–65; Coventry College of Art and Design, Bachelor of Arts Graphic Design 1965–69; Central School of Art, London; HDD Illustration 1970–71; Taught young children for two years and then obtained a diploma in teaching at Leeds College of Education before arriving in Australia 1974; Presently teaching art full-time at Westminster School, SA.
Awards Royal SA Society of Arts — Prize for screenprint.
Represented Private galleries in Australia, NZ and UK; Alice Springs Art Foundation; Barossa Valley Art Collection; Parliament House, Sydney; Adelaide College of the Arts and Education; Westminster School Art Collection; Private collections in Australia and overseas.
Exhibitions Lombard Gallery, SA 1977, 1979 and 1981; Numerous group shows throughout Australia, NZ and UK from 1977 onwards.
Bibliography *Directory of Australian Printmakers* 1982.

JORGENSEN, Jan QLD
Born Brisbane Qld 1942. Representational wild-life artist in watercolour, pastel, gouache and oil.
Studies Won an art scholarship to Brisbane Central Technical College of Art and studied under Melville Haysom; A period as a commercial artist on the 'Daily Sun', then as a freelance artist was followed by painting studies at Eastaus Art School, Brisbane 1979–80, and an Associate Diploma of Visual Arts at Brisbane College of Advanced Education, Kelvin Grove 1983–87; founded the Queensland Wildlife Artists Society with sculptor Janna Pameijer in 1983 and was president of QWAS from 1983–88; member of Royal Qld. Art Society and the Wildlife Artists Society of Australasia, Director, Ardrossan Gallery, Brisbane, and established River House Galleries 1989.
Exhibitions Solo shows at Findhorn Gallery, Brisbane 1979; Downs Gallery, Toowoomba 1980; McInnes Gallery, Brisbane 1981 and Young Masters Gallery 1983; Group shows

include Paddington Gallery 1979; Downs Gallery, Toowoomba 1981; Galerie Baguette, 1982; Southlands Gallery, Canberra 1984 and annually with RQAS, AWS and QWAS.
Awards Suncorp 1987.
Represented Institutional and private collections in Sydney, Melbourne, Brisbane, London and Copenhagen.

JOSÉ, Ellen VIC
Born Qld. 1951. Printmaker, illustrator.
Studies Seven Hills CAE, Brisbane 1976; Dip. Fine Art, PIT, Melb. 1978; Dip.Ed. Melb. CAE 1979. Studied overseas 1981, 82, 88.
Exhibitions Aboriginal Artists Gallery, Melb. 1987; PCA Touring Show Aust. and UK 1987–88; 70 Arden St. 1988; *Australian Perspecta* 1989, AGNSW.
Awards Aboriginal Arts Board Grant 1987.
Commissions Philips Industries 1987; PCA Print and Portfolio 1988.
Represented ANG, NGV, Holmes à Court Collection.
Bibliography *PCA Directory* 1988; *A Myriad of Dreaming*, Malakoff Press 1989.

JOSEPH, Fay NSW
Born Sydney NSW 1939. Traditional painter of genre in oil and watercolour; Portraitist.
Studies Privately with Roland Peters, otherwise self-taught; Portrait painting at Bankstown Technical School.
Exhibitions One-woman shows at Saints Gallery, Sydney 1976, 1978, 1981; Noella Byrne Gallery 1980, 1982, 1989; Everglades Gallery; Port Macquarie 1980; Vivian Gallery 1977; Wyoming Court, Orange 1976, 1978; Marsden Gallery, Bathurst 1979; Golden Helmet Gallery 1982 (shared).
Awards Kogarah 1973; Oyster Bay 1973; Southern Cross 1973, 1975; Oyster Bay (shared) 1974; Ramsgate 1975.
Represented Private collections in Australia and overseas.

JOSEPH, Frances NSW
Born Auckland NZ 1954. Sculptor and teacher.
Studies Hobart S of A 1975–78. Tutor in sculpture SCOTA Sydney 1980–.
Exhibitions Solo show at Watters Gallery, Sydney 1980. Numerous group shows since 1977.
Bibliography *Tasmanian Artists of the 20th Century,* Sue Backhouse 1988.

JOYCE, Ena NSW
Born Sydney NSW 1926. Figurative painter and portraitist in pastel, gouache and oil.
Studies National Art School, East Sydney on a scholarship 1940–46; Diploma of Arts (Hons) 1946; Awarded NSW Traveling Art Scholarship 1946; Travelled UK and Europe for three years; Studied at London School of Arts and Crafts under Bernard Meninsky; Graduated Dip. Art (Hons.); Art mistress, Ballarat Grammar School and Melbourne Girls Grammar School 1953–58; Study tour to UK and Europe 1972–73, 1980; 1987–88; Member of AWI.
Exhibitions One-woman shows, Macquarie Galleries, Sydney 1946, 1975, 1976, 1977, 1979; Painters Gallery, Sydney 1983, 1985, 1987, 89, 90; von Bertouch Galleries, Newcastle 1984; Beth Hamilton Galleries, Sydney 1988; AWI 1981; Also participated in group shows in Melbourne and Sydney between 1956–88.
Awards Scholarship to National Art School 1940; NSW Travelling Art Scholarship 1946; Portia Geach Award 1977; Drummoyne Prize 1977; Lane Cove.
Represented AGNSW, NGV, AGWA, TMAG, Artbank, Regional Galleries, institutional and private collections.
Bibliography *Artists & Galleries of Australia*, Max Germaine: Craftsman House 1990.

JUBELIN, Narelle NSW
Born Sydney 1960. Painter, weaver, designer.
Studies Alexander Mackie CAE, Sydney 1979–82; CAI, Sydney 1983.
Exhibitions Solo shows at Plan Z Gallery, Sydney 1985; Mori Gallery, Sydney 1986, 88;
AVAGO Gallery, Sydney 1986; NSWIT Gallery 1987; First Draft, Sydney 1987 (toured to
Canberra Contemporary Art Space). Her work was also included in *A New Generation
1983–88* at the ANG Canberra 1988 and at Geo. Paton Gallery, Melb. and Uni. of Tas
Gallery 1989 also at *Australian Perspecta* 1989, AGNSW; Ivan Dougherty Gallery 1989; Tin
Sheds Gallery 1989; Kunstmesse, Frankfurt 1990; Canberra C of A 1990; Artists Space,
New York 1990; Spoleto Festival, USA 1991; Chicago International Art Exposition 1991.
Represented Institutional and private collections in UK, Europe, USA and Australia.

JUDELL, Anne NSW
Born Melbourne Vic 1942. Painter and designer; Married to artist Fred Cress.
Studies Diploma in Graphic Design from RMIT 1958–62; Freelance designer 1963–74;
Travel in UK, Europe and USA 1965–66 and 1974; New York State University 1979–80.
Exhibitions Manyung Gallery, Melbourne 1976; Clive Parry Gallery, Melbourne 1976;
Barry Stern Gallery, Sydney 1977, 1978, 1982, 1984. Blackheath Festival 1983; Solander
Gallery, Canberra 1985; Christine Adams Gallery, Melb. 1986; Macquarie Galleries, Sydney
1986, 88. Group show Macquarie Galleries 1988.
Represented AGNSW, Artbank, New Parliament House, Canberra Regional Galleries,
institutional and private collections in UK, Europe, USA, Australia.

JULIUS, Ruth NSW
Born Sydney NSW. Modern painter and printmaker; Daughter of Harry Julius, the cartoon-
ist.
Studies Won Scholarship to East Sydney Technical College and studied at Workshop Arts
Centre, Willoughby NSW with Bela Ivanyi and Sue Buckley.
Exhibitions First one-woman show at Mavis Chapman Gallery, Sydney, followed by a num-
ber of solo shows at Beth Mayne Studio 1980; Cooks Hill Gallery, Newcastle 1981, 84;
Findhorn Gallery, Brisbane 1982, and group exhibitions gaining five First Prizes for paint-
ings and prints; Exhibits annually with Nine Printmakers Group.
Awards Selected for UNICEF Greeting Card 1988, 90.
Represented Parliament House, Sydney, numerous institutional and private collections in
UK, USA, Australia.
Bibliography *Directory of Australian Printmakers 1988.*

JUPP, Mary Helen VIC
Born Vic 1941. Painter of romantic, impressionist landscapes, mostly in oil.
Awards Eltham WC Award 1975.
Represented Private collections in UK, Europe, USA and Australia.

JUSKOVIC, Hana NSW
Born Prague Czechoslovakia, arrived Australia 1949. Painter in oil.
Studies Art Academy of Prague; Has exhibited in many group shows in Sydney and country
areas and won awards at Tumut and other centres; Her non-abstract figure compositions
often feature musicians and orchestras; She works in oil and also paints Australian native
flowers and landscapes.
Represented Beth Mayne Studio Shop, Sydney where she held a one-woman show in 1980.
Since then to 1989 has sold privately and painted on commission.

JUST, Jeraldene QLD
Born Brisbane Qld 1944. Illustrator and printmaker; Daughter of artist Verlie Just.

Studies Art at University of Qld and became interested in printmaking because of the availability of a platen-style Shapcott Press; Worked as a freelance illustrator and for Angus & Robertson; Exhibits in most major Qld exhibitions and festivals; Included, Qld Art Gallery 1975 Narvey Prize; Newling School Exhibition, Armidale NSW.
Represented Town Gallery, Brisbane.
Bibliography *Directory of Australian Printmakers* 1976.

JUST, Verlie QLD
Born Toowoomba, Qld. Painter, jeweller, silversmith, gallery director.
Studies Brisbane Central Technical College, four years full-time art course; Founder-president, Crafts Association, Qld and founder-member, Crafts Council of Australia 1970; Established the Town Gallery, Brisbane 1973. Overseas study tour 1989.
Exhibitions Solo shows at Moreton Galleries 1963, 65, 66; Barry Stern Sydney 1965, 66, 68; Design Arts Centre, Brisbane 1967, 69. Numerous group shows since 1963 including AGNSW Travelling Show 1972.
Award Scholarship to study in USA for five months 1969.
Represented ANG, QAG, institutional and private collections in UK, Europe, USA, Australia.
Bibliography *Artist-Craftsmen in Australia*, Fay Bottrell; *Crafts 70s*, Art Gallery of NSW; *Art and Australia*, Vol 9/4. *A Homage to Women Artists in Queensland — Past and Present*, The Centre Gallery Catalogue 1988; *Artists & Galleries of Australia*, Max Germaine: Craftsman House 1990.

K

KADELL, Wendy E. QLD
Born Sydney 1933. Painter.
Studies ESTC, worked as commercial artist until 1985.
Exhibitions Dabbles on Days Gallery 1987; Red Hill Gallery 1988; Corbould Gallery 1988.
Awards Redland Bay 1988.
Represented Institutional and private collections in Aust. and overseas.

KAHANS, Jill VIC
Born UK 1938. Musician and painter.
Studies North Sydney Art Centre, mostly self-taught.
Exhibitions Solo show at Pinocotheca Gallery, Melb. 1985, participates at Gallery Art Naive, Melb.
Represented Private collections in Sydney and Melb.

KANEPS, Janis SA
Born Riga, Latvia 1927. Arrived Aust. 1948. Self-taught painter. Study tour to Europe 1983.
Exhibitions First solo show at Young Painters Gallery, Sydney 1963; Participated in Helena Rubinstein Portrait Prize Touring Show 1964.
Awards Blackheath NSW 1973; Lithgow 1975; Sellicks, Adelaide 1984.
Represented Institutional and private collections in Europe and Australia.

KARADADA, Lilly WA
Aboriginal painter, mostly ochre on canvas from the Kalumburu area of the Kimberleys.

Sister of Louis.
Exhibitions First solo show at Gallery Gabrielle Pizzi, Melbourne 1990.

KARADADA, Rosie WA
Aboriginal painter, mostly ochre on canvas from the Kalumburu area of the Kimberleys.
Sister of Louis.
Exhibitions First solo show at Gallery Gabrielle Pizzi, Melbourne 1990.

KARGULEWICZ, Monica VIC
Born Melbourne 1961. Painter and printmaker.
Studies BA Fine Arts, Chisholm IT 1985; Grad. Dip. Education, Victoria College Rusden
Campus 1990. Works as freelance sketch artists part-time at the Melbourne courts.
Exhibitions Chrysalia Gallery 1984; MPAC 1984, 90; Anvil Gallery, Kergunyah 1987, 88;
The Brighton Gallery 1988; BWA Piwnice Gallery, Kielce, Poland 1989; State Bank
Galleria 1989; 'Churchie' Exhibition, Brisbane 1990; The Anvil Gallery 1990.
Represented Institutional and private collections in Australia and Poland.

KARP, Lauren NSW
Born Johannesburg, South Africa 1961. Painter and teacher.
Studies Johannesburg School of Art 1979–80; BA Art Education, City Art Institute
1981–85; Taught art 1985; Postgrad. Dip (Painting) CAI 1986–87; Overseas travel and
study UK, Europe 1978, USA, Canada 1988–90.
Exhibitions Solo shows at Reflections Gallery, Melbourne 1989, 90; Access Gallery 1991.
Numerous group shows since 1984 include Ivan Dougherty 1985, 86; Blaxland Gallery
1986; Cooper Gallery 1987; The Works Gallery 1987; BMG Fine Art, Sydney 1990;
Reflections Gallery, Melbourne 1990.
Awards Hobson National Student Art Award (Mixed Media) 1987.
Represented Artbank, institutional, corporate and private collections around Australia.

KARPIN, Alexandra NSW
Born Sydney 1957. Printmaker
Studies BA, Uni. of NSW; BA Visual Arts, City Art Institute 1980–82.
Exhibitions Solo shows at Hogarth Galleries 1986. Participated Warrnambool, Swan Hill
and Maitland Reg. Galleries 1982; Ivan Dougherty 1983; Blaxland Galleries 1983, 84, 85,
86, 87, 90; MPAC 1984; Bloomfield Galleries 1985; Hogarth Galleries 1986.
Awards Moya Dyring Cité Internationale des Arts Studio, Paris 1988.
Bibliography *PCA Directory* 1988.

KAY, Hanna NSW
Born Tel-Aviv, Israel 1947. Expressionist painter.
Studies In Tel-Aviv and later at the Academy of Fine Art, Vienna 1971. Arrived Australia
1989.
Exhibitions Since 1974 has had many solo and group shows around Europe and USA
including BMG Fine Art, Sydney 1990.
Bibliography *New Art Four*: Craftsman House 1990.

KAY, Kathleen Ann NSW
Born Sydney 1946. Painter and teacher; Landscape, still life, all media.
Studies Tamworth TC, NSW, 1966; Melb. with Ernie Trembath 1979–81 and Dot McVay
1981. Member VAS.
Exhibitions Melb. 1981; Albury 1983. Teachers at her own studio in Albury. Has won
numerous prizes in NSW country art shows.
Represented Private and institutional collections in UK, USA and Australia.

KAY, Pandora VIC

Born Melbourne Vic 1958. Printmaker, craftworker, administrator.

Studies Gained Bachelor of Education in Arts and Crafts from State College of Vic 1976–79; Presently studying Postgraduate Business administration (arts) at SA Institute of Technology, and is administrative assistant at PCA, Melbourne.

Exhibitions Participated in 'Just Paper Competition' Melbourne 1979; Printmaking 1977–80; State College Final Year Students 1980.

Represented Rockhampton CAE and private collections around Australia.

KAYE, Maria VIC

Born Warsaw Poland 1925. Contemporary expressionsist painter in oil and watercolour; Printmaker.

Studies At VAS and CAS under Joan Gough 1981–82; Member CAS and VAS.

Exhibitions Solo show at Studio Gallery, Melbourne 1983; Participated in many shows at VAS and CAS since 1978.

Represented Private collections in Europe and Australia.

KAZEPIS, Helena VIC

Born Sydney 1956. Painter.

Studies Tas. IT, Launceston 1981–84; Postgrad. at Chisholm IT, Melb. 1986.

Exhibitions Solo shows at Prism Gallery, Perth 1987; Christine Abrahams Melb. 1989; Group shows at Chameleon Hobart 1984, 85; QVMAG 1984; La Trobe Valley Arts Centre 1988; Christine Abrahams 1988.

Represented Institutional and private collections.

KEAN, Roslyn ACT

Born Sydney 1953. Painter, printmaker, teacher.

Studies Nat. Art School, Sydney 1971–72; Shillito Design School 1973–75; Slade School Uni. of London, UK 1976, 78 also tutor 1978–79 and research assistant 1981–82; London College of Printing 1982; Research graduate at Tokyo National University of Fine Arts 1985–87. Lecturer, Shillito Design School 1976; Byam Shaw School of Fine Art, London UK 1978–80; Strathfield School of Textiles, Sydney 1980; St. George T.C. Sydney 1980, 84, 85; City Art Institute, Meadowbank TC, Sydney 1983; City Art Institute and Gymea TC 1984–85. Visiting artist to Canberra Institute of the Arts 1987; Full-time lecturer 1988 –.

Exhibitions A host of shows since 1975 include NSW House, London 1979, 80; Angela Flowers Gallery, Minsky's Gallery and Anthony Dawson Gallery, London 1982; White Art Gallery, Tokyo 1983; Hogarth Gallery, Sydney 1983, 84, 85; Allegro Gallery, Sydney 1985, 88; Michael Milburn Gallery, Brisbane 1986; Lyubljana Print Exhibition Yugoslavia 1987; Katutoya Gallery, Tokyo 1988; Angela Flowers Gallery, London 1988; North Sydney Contemporary Gallery 1988.

Awards Japanese Government 'Monbusho' Research Scholarship.

Represented Widely in corporate, institutional and private collections in UK, Europe, Japan and Australia.

KEATINGE, Jessie NSW

Born Brisbane Qld. Figurative painter of still-life, landscapes and collage; Sculptor.

Studies In Sydney with Roland Wakelin, D. Orban, Andrew Sibley and sculpture at the National Art School; Further study in London and Italy.

Exhibitions Solo exhibition of collage at Frances Jones' Gallery; Paintings and sculptures in mixed exhibitions in city and country areas, and at Beth Mayne Studio.

Represented Private collections in UK, Europe, USA, Australia.

KEATS, Juliana see under HILTON, Juliana

KEDEM, Rimona VIC
Born Israel 1937, arrived Aust. 1967. Expressionist painter, stained glass designer.
Studies Avni Art Academy, Tel Aviv 1955–58, Art Academy, Mexico 1962–65; BA, Flinders Uni.; BA and Dip. Ed., La Trobe Uni. Melb.; MA, Melb. Uni. 1980–83; 1984–85.
Exhibitions Solo shows at Nat. Art Museum, Mexico City 1972; Rudy Komon Gallery, Sydney 1967; Powell St. Gallery, Melb. 1969; Macquarie Galleries, Sydney 1970; Mexico 1971, 72, 74; Lidums Gallery, Adelaide 1973; Munster Arms Gallery 1975; Niagara Gallery 1986; Israel 1988; Portsea Gallery 1989; Greenhill Galleries, Adelaide 1990; Eltham Wiregrass Gallery 1990. Numerous group shows since 1967 including Vorparl Galleries, San Francisco and New York 1964–84.
Awards Flinders University Scholarship 1976; Art Education Award 1980–81; Artist-in-Residence, Vic. Education Dept. 1983; Many commissions for stained glass windows and murals.
Represented NGV, Nat. Museum, Mexico, institutional and private collections Israel, USA, Australia.

KEELING, Dorothea TAS
Born Strahan Tas. 1907. Painter.
Studies ESTC 1928; Nat. Gallery School, Melb. 1929–32.
Exhibitions Solo shows at QVMAG Launceston 1944; Assembly Hall, Melb. 1945–46; Numerous group shows since 1925 including Launceston Art Society 1925–36; 'The Launceston Art Society in Retrospect' 1891–1983, 1983.
Bibliography *Tasmanian Artists of the 20th Century,* Sue Backhouse 1988.

KEELING, Mandy NSW
Born NSW 1947. Figurative painter.
Studies ESTC, Willoughby Arts Centre (part-time)
Exhibitions Solo show at Legacy House Gallery, Sydney 1986; Group shows at Bathurst Regional Gallery and Mosman Gallery, Sydney 1986, 87.

KEENE, Shirley SA
Born Adelaide 1924. Representational painter.
Studies Girls Central Art School, Adelaide 1938–44; SASA 1945–51; Lived and worked in UK 1951–84.
Exhibitions Solo shows at RSASA Gallery 1946; John Martin's Gallery, Adelaide 1947; Regularly with the CAS and RSASA; Recently in 'Adelaide Angries', AGSA 1989.

KEESE, Enid Ratnam NSW
Born Penang, Malaya. Painter, printmaker, teacher.
Studies RMIT, Dip. FA (Sculpture) 1970–74; BA English History and Teachers Diploma Malaya Technical College. Taught printmaking Nepean CAE NSW 1981–83 and English and History in NSW High Schools 1984–85; Currently teaching sculpture part-time Penrith TAFE.
Exhibitions Blackfriars Gallery, Sydney 1981; Wagner Gallery, Sydney 1984, 85, 87; Group shows include PCA shows to Korea and Sweden; MPAC Vic. 1987.
Awards Bowral–Mittagong Rotary 1988; Mosman Print and Drawing 1988.
Represented Institutational and private collections in Australia and overseas.
Bibliography *Directory of Australian Printmakers* 1988.

KEHOE-ELLISON, Elspeth QLD
Born Australia. Colourful painter of northern Qld scenes; Wife of Chuck Kehoe.
Exhibitions Numerous in Vic and NSW and recently at the Wilderness Exhibition at the Upstairs Gallery, Cairns 1983 with Heather Bell and Evelyn Steinmann.

KEIGHTLEY, Maria-Rosa VIC
Born Madrid Spain, arrived Australia 1972. Painter in the modern European style.
Studies Graduated in Economics in 1955 and from the Madrid Conservatorium 1956 and gained her Diploma in Journalism in 1957; Studies painting under Anthony Duke in Nottingham UK 1960.
Exhibitions Juniper Gallery, Melbourne 1977.

KELLER, Kay Singleton NSW
Painter in oil and pastel.
Studies ESTC in the 1960's. Member, The Pastellist Society of Australia. Worked in Paris with the French Pastellist Society 1988–90.
Exhibitions Solo show at Nino Tucci Gallery, Gold Coast 1990. Participated Wayford Gallery 1987; Australian Pastel Society 1988; Centre Gallery, Gold Coast 1989; McWhirters Artspace, Brisbane 1989; Punch Gallery, Sydney 1990.

KELLETT, Jane VIC
Born Tongala Vic 1954. Naive painter.
Studies Diploma of Art from Preston Institute of Technology 1978.
Exhibitions First one-woman show at Australian Galleries, Melbourne 1980.

KELLY, Cheryl TAS
Born Melb. 1955. Landscape and portrait painter, commercial artist.
Exhibitions Richmond Galleries and Hythe Gallery, Tas.
Awards Combined Rural Traders Art Prize, Qld 1983.
Represented Institutional and private collections around Australia.

KELLY, June QLD
Born Northgate Qld. Illustrator and painter of genre subjects and flowers in watercolour.
Studies With Stan Hobday and under Chinese painter Ho Khay Bemg whilst living in Penang. She has illustrated and published a number of books in the 'Sketchbook' and 'Brisbane is a Garden' series.
Exhibitions Downes Gallery, Toowoomba; Solander Gallery, ACT and in recent times with Blue Marble Gallery, Buderim, Qld.
Represented Municipal, institutional and private collections in Australia and overseas.

KELLY, Wendy VIC
Born Vic. Painter, teacher.
Studies Diploma of Art and Design/Fine Art. Caulfield Institute of Technology (Chisholm Institute) 1978. Study tour to UK, Europe, USA 1987. Current member of Moorabbin City Council Arts Advisory Committee 1987; Teacher, short courses in painting and drawing — Holmesglen TAFE; Interim Committee, Womens Art Register, Melb. 1988.
Exhibitions Solo shows at Hawthorn City Art Gallery, 1981; Pinacotheca 1985; Chisholm College, La Trobe University 1985; Judith Pugh Gallery 1990. Numerous group shows since 1981 include Power Gallery of Contemporary Art; ACT Arts Council Gallery; Shepparton Art Gallery; Experimental Art Foundation, Adelaide 1987; MPAC 1989; Judith Pugh Gallery 1990.
Commission 1981 Chisholm College, La Trobe University.
Represented Swan Hill Regional Art Gallery; La Trobe University; Chisholm College, La Trobe University; Private collections.

KEMARRE, Gladys NT
Aboriginal painter in acrylic on canvas from the Utopia Station region of Central Australia about 240 kms NE of Alice Springs.

Exhibitions Bloomfield Galleries, Sydney 1989.
Represented ANG; NTMAG: AGSA; Robert Holmes à Court Collection.

KEMP, Bronwyn NSW
Born Australia. Ceramic sculptor.
Exhibitions One-woman show at Market Row Gallery, Sydney 1982.

KEMP, Maud (Cannon) NSW
Born Sydney, NSW. Painter in oil, acrylic and gouache.
Studies National Art School, East Sydney.
Exhibitions Solo shows at Ashton Gallery, North Sydney 1967 and Australia Square 1967.
Shows with the Peninsula Art Society, Sydney of which she was Inaugural President.
Founding Editor of Australian Artist Magazine since its inception in 1984. Included in
'Warringah Book' 1988.
Represented in collections in Australia and overseas.

KENNEDY, Lucy NT
Born c.1926. Aboriginal acrylic painter from the Yuendumu region of Central Australia.
Warlpiri language group.
Represented Art Gallery of SA.

KENNEDY, Sheridan QLD
Born Winton, Qld 1964. Silversmith, sculptor, designer.
Studies Qld C of A 1982–84; BA 1987; Awarded a crafts traineeship from the Crafts Board
to work with Barbara Heath 1986.
Exhibitions Solo shows at Qld. Art Gallery and Roz MacAllan Gallery 1987. Several group
shows include Makers Mark, Melb. 1987 and 'Axis File', Brisbane, London, New York
1988.
Bibliography *A Homage to Women Artists in Queensland:* The Centre Gallery 1988.

KENYON, Therese NSW
Born Sydney 1948. Printmaker.
Studies ESTC 1964–66; Dip. Art Alexander Mackie CAE; 1974–78; MA, City Art
Institute 1988; Studied USA 1973–74, 83–84.
Exhibitions Solo shows at Macquarie Galleries 1973; Armstrong Gallery, Morpheth 1979,
82; CAS, Adelaide 1982; Ivan Dougherty 1982; Newcastle Reg. Gallery 1983; Many group
shows since 1976 and in recent times Holdsworth Galleries 1986, 87; Kala Institute,
Berkeley, California 1986–87; Tin Sheds Gallery, Uni. of Sydney 1988; Newcastle
Contemporary Gallery 1991.
Awards VAB Residency Grants 1980, 84.
Commissions Belvoir St. Theatre Club 1985.
Bibliography *PCA Directory* 1988.

KERR, Millie WA
Born Boulder WA 1908. Impressionist painter in oil and sometimes watercolour.
Studies Evening classes at technical college and summer schools; Member of Perth Society
of Artists and Esperance Society of Artists; Taught painting and drawing at Esperance
Technical College for ten years; Mostly paints local landscapes and portraits on commission.
Exhibitions First one-woman show at Kalgoorlie WA; Many group shows with Perth
Society of Artists and winner of a number of shire and local awards.

KERSWELL, Kathryn QLD
Born Brisbane 1954. Printmaker.

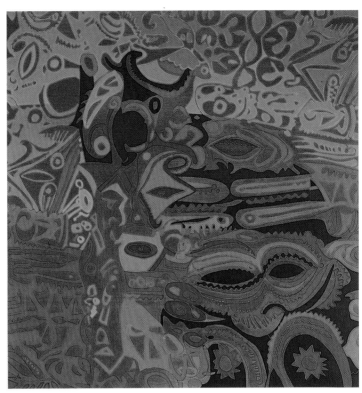

Veda Arrowsmith *Creation – the Fifth Day*
Acrylic on board, 92 x 122 cm
Collection: St John's Chapel, St John's College, University of Queensland

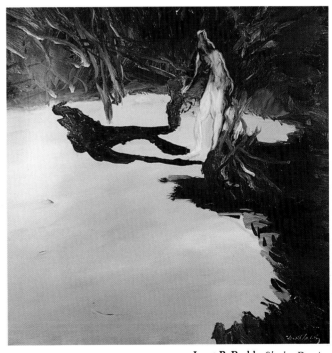

Janet R. Boddy *Shadow Dressing*
Oil on hardboard, 122 x 122 cm
Private Collection

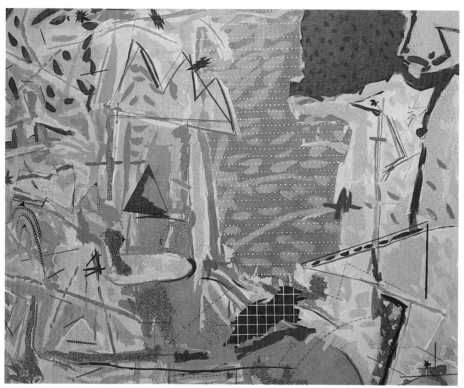

Denise Campbell *Ground Plan with Defences*
Oil on linen, 137 x 167 cm
Private Collection

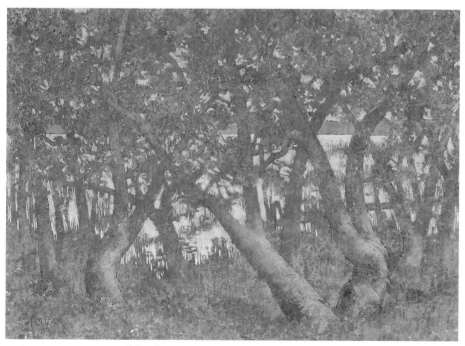

Madeleine Clear *Last View of the Lake*
Mixed media on paper, 69 x 103 cm
Private Collection

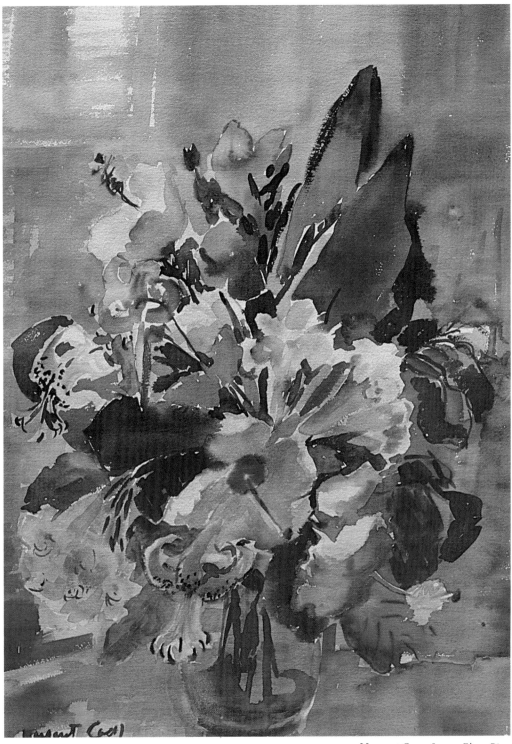

Margaret Coen *Summer Flower Piece*
Watercolour, 45 x 75 cm
Photo: Lorna Rose
Collection: Meg Stewart

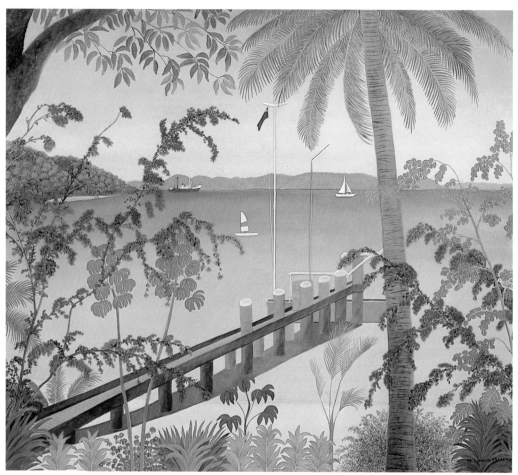

Margery Dennis *Orpheus, Queensland*
Oil on board, 90.2 x 105.4 cm
Private Collection

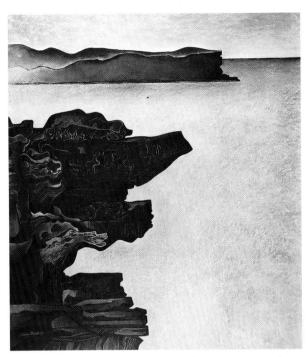

Shay Docking *Entrance to Harbour 1*
Pastel and acrylic on paper on hardboard, 139 x 122 cm
Private Collection

Maadi Einfeld *Kakadu*
Monoprint, 67 x 48 cm
Possession of the artist

Dorothy Gauvin *Australia Past and Future*
Oil on linen, 91.5 x 122 cm
Private Collection

Marea Gazzard *The Head* Bronze (Group of Five)
136-172 x 18-30 x 12-20 cm
Photo: Paul Green
Courtesy: Coventry Gallery

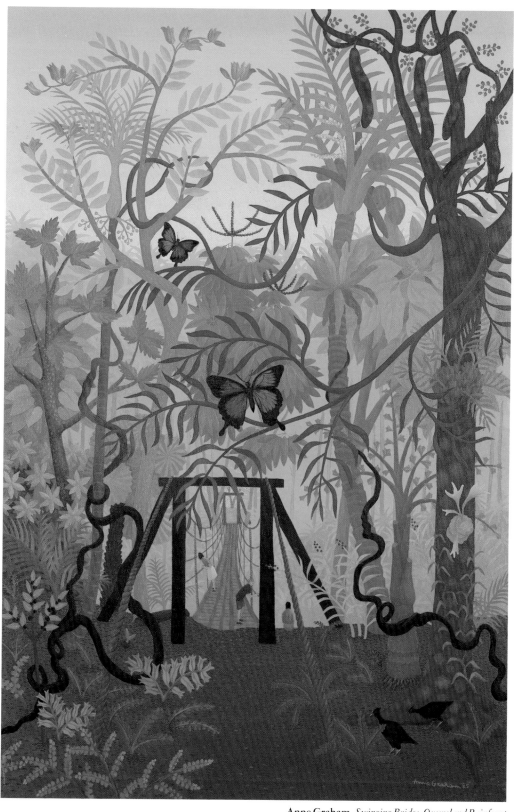

Anne Graham *Swinging Bridge, Queensland Rainforest*
Oil on canvas, 90 x 60 cm
Collection: Australian Airlines

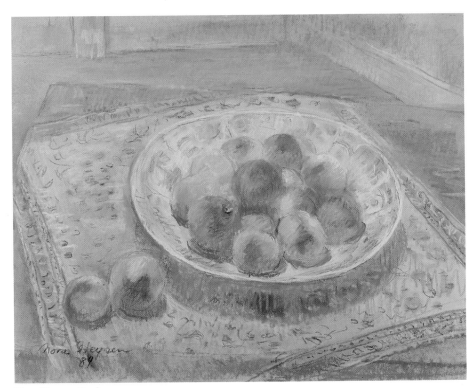

Nora Heysen *Peaches*
Pastel, 50 x 65 cm
Private Collection

Noela Hjorth *Dancing Sacred Cow*
Mixed media on paper, 90 x 110 cm
Possession of the artist

Mimi Jaksic-Berger *Silver Light*
Oil on canvas, 178 x 178 cm
Collection: The Museum of Contemporary Art, Skopje, Yugoslavia

Ena Joyce *Afternoon Tea*
Oil on canvas, 60 x 90 cm
Private collection

Wendy Kelly *Foundation 2*
Oil on board, 122 x 183 cm
Private Collection

Ursula Laverty *The Railway Station at Bourke*
Oil on canvas, 75 x 105 cm
Private Collection

Sandra Leveson *Pale Gates of Sunrise*
Acrylic on linen, 195 x 195 cm
Private Collection

Elaine Namatjira *The Twin Gums Near Burt's Bluff N.T.*
Watercolour, 36 x 48 cm
Private Collection

Pansy Napangati *Women's Dreaming at Kampurarrpa*
Acrylic on canvas, 182 x 139 cm
Courtesy: Gallery Gabrielle Pizzi

Susan Norrie *Untitled*
Wood veneer and oil on canvas, 80 x 134 cm
Private Collection, USA

Stephanie Schrapel *Eroding Sands, Joulni*
Cibachrome photograph
Possession of the artist

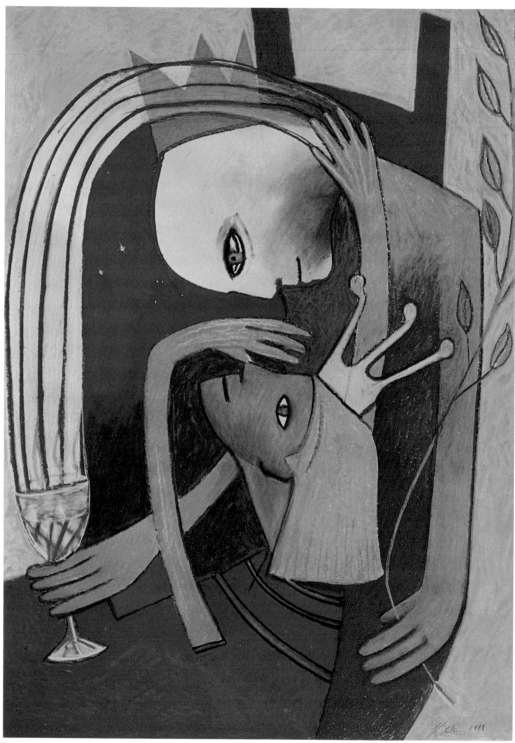

Kerry Stokes *Lovers*
Pastel, 76 x 54 cm
Private Collection

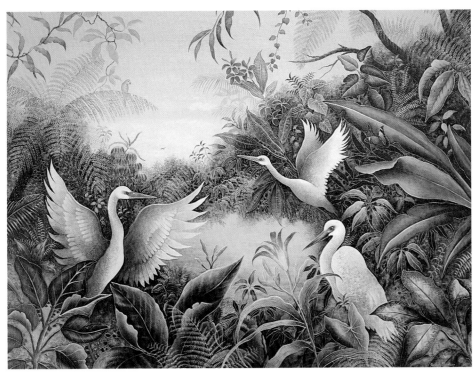

Evelyn Steinmann *Egret Lagoon*
Acrylic on canvas, 55 x 74 cm
Possession of the artist

Ann Thomson *Renegade*
Oil on linen, 178 x 117 cm
Collection: Chandler Coventry Esq.
Photo: Paul Green
Courtesy of Coventry Gallery

Jenny Watson *Flowers*
Oil, Indian pigment and haberdashery on Belgian linen
184 x 295 cm
Private Collection

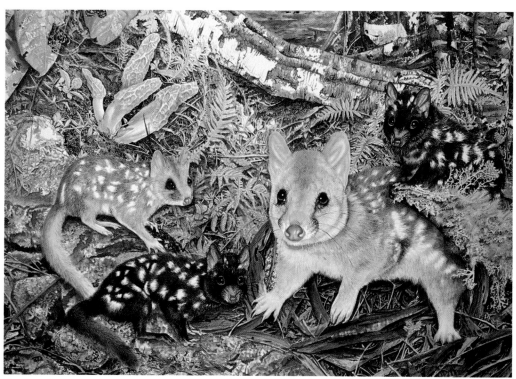

Kay Breedon Williams *'Coming Out', Quolls (Native Cats) in rainforest*
Acrylic on Fabriano, 55 x 75 cm
Possession of the artist

Studies Dip. Art, Qld. C of A.
Exhibitions QAG 1982; Jan van Eyck Akadamie, Holland 1984; Spring Hill Gallery 1984; John Bunston Galleries 1985; Cadaques, Spain 1986; Burdekin Cultural Centre 1987.
Awards SGIO 1985.
Bibliography *PCA Directory* 1988.

KETT, Norma VIC
Born Vic. Traditional painter of Australian landscapes who sells from her own studios at Porepunkah and Melbourne Vic.

KEVIN, Anniko QLD
Born Aust. 1969. Painter, portraitist.
Studies BA, Uni. of Qld.
Exhibitions Solo shows at Q Gallery, Sydney 1985, 86 and included at RQAS 1988 show Brisbane and the 'Q' Gallery, Jupiter Hall, Sydney 1989.

KEIRNAN, Leslie NSW
Born Scotland. Traditional painter of landscapes and genre subjects in watercolour.
Studies Upper Regent St. Polytechnic and St. Martins School, London UK. Exhibiting member of the RASNSW.
Exhibitions Solo show at Gallery Wall, Edgecliff and participates in RASNSW shows.
Represented Institutional and private collections in UK and Australia.

KILDERRY, Diane VIC
Born Melb. 1941. Printmaker.
Studies BA Fine Art PIT, Melb. 1986.
Exhibitions 70 Arden St. 1985, 88; ROAR Studios 1986, 87, 88; Swan Hill Reg. Gallery 1987; 200 Gertrude St. Melb. 1988; Oculos Gallery 1988.
Commissions PCA 100 x 100 Print Portfolio 1988.
Bibliography *PCA Directory* 1988.

KINDNESS, Irene CANADA
Born Djakarta Indonesia 1940. Figurative painter working in oil, watercolour and stained glass.
Studies Central Technical Art School, Brisbane, Australia 1963–66; Barrier Reef Underwater Study, Australia, 1965; Tours — England, Switzerland, Italy, France, Spain, Holland, 1972; Canada, USA 1979, 1980; Australia and India, 1983; Outback Queensland Desert, Australia, 1974–76; Stained Glass, Brisbane, Australia, 1976; Sheridan College School of Crafts and Design, Oakville, Canada 1980–83; Glass Studio Major, 1983.
Exhibitions Old Fire Station Gallery, Perth 1969; Group exhibition, Hogarth Galleries, Sydney 1975, 1976; Fantasia Galleries, Canberra 1976; In Brisbane at the Beak Gow Galleries 1969; Design Arts Centre 1970, 1971, 1973; Philip Bacon Galleries 1975 and Galleries du Paddington 1978; Martin Gallery, Townsville 1976, 1978; Linton Gallery, Toowoomba 1975, 1977; Leaded glass with Sculpture Society, Philip Bacon Galleries 1978; Burlington Annual Open Juried Show, Canada 1980, 1981; 1981 Colour and Form Open Juried Show, Toronto 1981; Kitchener-Waterloo Art Gallery (art forms) 1982; CKOC Show, Hamilton Art Gallery 1981; Verre d'Art, Montreal 1981; Art Expo, New York, (Venturgraph International) 1982; Community Gallery, Harbourfront, Toronto 1983; Art Expo, New York 1982–85; Several shows in Toronto, Ottawa and New York to 1989.
Awards Warana 1970, 1976; Goondiwindi 1972; Cairns Contemporary 1974; Tweed 1976; Bundaberg Drawing 1978; Townsville Open 1978.
Represented Toowoomba City Collection; Permanent Building Society Collection; Caltex Collection; Caloundra Festival Committee Collection (leather sculpture). Private

Collections: Australia, USA, Canada.

KING, Barbara WA
Born Goomalling WA. Painter and sculptor.
Studies Claremont S of A, Perth WA. Member, Perth Society of Artists.
Exhibitions Wongan Hills 1979; Fremantle 1983, 87.
Awards Wongan Hills Landscape 1968.
Represented Parliament House WA and private collections.

KING, Inge VIC
Born Berlin West Germany 1918. Scultor in metal, welding and fabricating steel, bronze
and aluminium.
Studies Trained in Germany and UK in the classical tradition of carving in wood and stone;
Studied and exhibited in Europe and USA; Married artist, Grahame King and settled in
Melbourne in 1951.
Exhibitions One-woman shows at London Gallery, Brook Street, London 1949; Powell
Street Gallery, Melbourne 1969, 1973; Realities Gallery, Melbourne 1977; Coventry
Gallery , Sydney 1978; Victor Mace Gallery, Brisbane 1978; Realities Gallery, Melb. 1980,
85; Melb. Uni. Gallery 1982; BMG Adelaide 1985 and Sydney 1987; Australian Galleries,
Melb. 1988; Retro show of works on paper 1979–89, Australian Galleries 1989. Since 1952
has participated in over eighty group shows in Australia and overseas and in later years at 15
Years Retrospective Exhibition with Grahame King — Travelling State and Regional
Galleries 1975–76; 1st Sculpture Triennial, La Trobe University, Melb. 1981; 2nd
Sculpture Triennial, National Gallery of Victoria, Melb. 1984; 3rd Sculpture Triennial,
Heide Park & Art Gallery, Vic 1987.
Awards Eltham Art Prize 1965, 1967; Adelaide Festival Prize 1968; British Council Travel
Grant 1969; Dyason Education Grant 1969; AO for services to the arts 1984; Adelaide
Festival Prize 1968; British Council Travel Grant 1969; Dyason Education Grant 1969;
Visual Arts Board Grant for International Sculpture Conference, Washington 1980; Alice
Springs Prize 1984; Royal Blind Society Sculpture Award, Sydney 1987; ICI House,
Melbourne 1989.
Commissions Many important commissions include *Mobile* by the *Herald* for the first
Herald Outdoor Exhibition 1953; *Dewdrop Fountain*, Fitzroy Gardens, Melbourne 1959;
Fountain for Norman Bros, Fitzroy 1965; Wall sculpture for foyer, BHP Laboratories, Vic
1968; Fountain (black steel and colour), Civic Centre, Wodonga Vic 1971; Sir Fred Schonell
Memorial Fountain (fabricated bronze) University of Qld, St Lucia 1972; *Balance of Steel
Forms*, sculpture for directors' floor at BHP House, William Street, Vic 1972; RAAF
Memorial, Canberra ACT 1973; *Forward Surge*, still in construction at Vic Arts Centre plaza
1974; *Upward Surge*, Institute of Early Childhood Development, State College of Vic
1974–75; Moat Theatre Sculpture, La Trobe University 1975; *Black Sun II*, Australian
National University, Canberra 1975. Lawn of Univeristy House, Canberra; Woden Valley
Hospital, Courtyard 3, ACT; University of Melbourne, Union Lawn, Parkville, Victoria;
State Bank, Victoria.
Represented ANG, NGV, QAG, TMAG, NTMAG; many Regional Galleries; institution-
al and private collections in UK, Europe, USA and Australia.
Bibliography *Art and Australia,* Vols 1/1, 2/2, 4/2; *Sculpture, the Arts in Australia,* Lenton
Parr, Longmans, Sydney 1961; *Australian Sculptors,* Ken Scarlett, Nelson 1980; *Artists &
Galleries of Australia*, Max Germaine: Craftsman House 1990.

KING, Jan NSW
Born Cunnamulla Qld 1945. Sculptor and teacher.
Studies Academia di Belli Arti, Perugia Italy 1970; National Art School; Alexander Mackie
CAE; Diploma of Fine Art; Major in sculpture 1971–75; New York Studio School, New

York, Sculpture 1979; Overseas travel to Asia, UK, Europe 1967–71; UK, Europe, USA 1979–80; Teaching sculpture at ESTC and TAFE 1978–88. Completed BA (Visual), City Arts Institute 1985.

Exhibitions Solo shows at Art of Man Gallery, Sydney 1979 and Irving Sculpture Gallery 1982, 84, 89. Group at Young Sydney Sculptors, Sculpture Centre, Sydney 1976; Selected Exhibition VAB/SCC, Martin Place, Sydney 1976; Studio School Sculpture, New York Studio School, New York 1979; Survey of Sculpture, East Sydney Technical College, Sydney 1979; Table Sculpture, Irving Sculpture Gallery, Sydney 1982; Mildura Sculpture Triennial 1982; Abstract Australian Sculpture from 1970, The Irving Sculpture Gallery, Sydney 1982; Eight Sculptors, Penrith Regional Gallery, NSW 1982; Women Sculptors, Irving Sculpture Gallery, Sydney 1982; Second Aust. Sculpture Triennial, NGV 1984; 9th Mildura Sculpture Triennial 1985; First Draft, Sydney 1986; Qld. AG and Museum of Modern Art, Saitama, Japan 1987; Third Aust. Sculpture Triennial 1987; City Art Institute 1987; NSW Uni. of Tech. 1987; Sculpture Park 88, Gosford 1988.

Awards VAB New York Studio 1979; VAB Grant 1981, 83.

Represented Institutional and private collections UK, Europe, USA, Australia.

Bibliography *Artists & Galleries of Australia*, Max Germaine: Craftsman House 1990.

KING, Jean
NSW

Born Sydney NSW. Painter, sculptor and teacher.

Studies East Sydney Technical College 1946–55 and 1965–70.

Exhibitions Dural Galleries, Sydney 1981.

Awards Readers Digest Drawing Prize 1968; Waratah Sculpture Prize 1969; Has taught at Hornsby, Meadowbank and Gymea Technical Colleges.

Represented Readers Digest and ESTC Collections and private collections.

KING, Pamela
QLD

Born Qld. Painter and writer.

Studies Diploma of Creative Arts, Darling Downs Institute of Advanced Education 1975; Bachelor of Arts, University of Queensland 1976; Bachelor of Letters, University of New England, 1980; Art reviewer for *The Chronicle,* Toowoomba and regional art reviewer for *The Courier-Mail*, Brisbane.

Publications Durack, N and King, Pamela: *Downs Artists: A Changing Landscape* (Toowoomba, Darling Downs Institute Press, 1985)

Exhibitions Solo show at The Downs Gallery Toowoomba, 1977.

Represented Private and public collections NSW and QLD.

KINGSTON, Amie (Challen)
NSW

Born Tas 1908 Painter, teacher and stage designer.

Studies Hobart Technical College 1928–31 under Mildred Lovett, who inspired in her an interest in simple shapes and forms; Studied at Julian Ashton Art School from 1932 and part of 1933; She was particularly impressed by Thea Proctor's teaching ('filling the space') and when Miss Proctor left the school, she continued to have private lessons from her; Returned to the Hobart Technical College and taught geometric drawing for design and some linocutting 1933; Studied at the Westminster Art School under Bernard Meninsky and at the Slade School, London where she studied stage design under Vladimir Polunin, who had been a designer with the Diaghilev Company 1937–40; After her return to Australia she settled in Sydney and was associated as a designer, with the Helene Kirsova Ballet Company in the early 1940s; She designed decor and costumes for *Hansel and Gretel*, *Peter and the Wolf*, and *Harlequin*; Peter Bellew, art critic and editor of *Art in Australia 1939–42*, wrote of *Harlequin* that 'Amie Kingston's simple and truly creative decor ... established her as an outstanding theatrical designer ...'; Other designers with the company were Loudon Sainthill, Wolfgang Cardamatis and Alice Danciger; Display artist at 'Farmers' (now Myer) stores in Sydney for

many years; Taught art and design with the NSW correspondence schools 1959–76.

Exhibitions Many shows since 1929 include Macquarie Galleries 1936, 40, 55, 57, 61; Slade School, London 1938; AGNSW 1947, 82; IWA Gallery Melb. 1978. Presently showing linocuts and drawings at Wooloomooloo Gallery, Sydney.

Represented ANG, AGNSW, institutional and private collections in UK, Europe, Australia.

Bibliography *Australian Watercolour Painters 1970–80;* Jean Campbell 1983. *Tasmanian Artists of the 20th Century;* Sue Backhouse 1988; *Artists & Galleries of Australia,* Max Germaine: Craftsman House 1990.

KINGSTON, Daphne NSW

Born Sydney NSW 1928. Traditional and historical painter in oil, pastel, pencil, pen and wash, gold leaf, stained glass.

Studies Julian Ashton School, Sydney 1969–76 and privately under Brian Blanchard 1973–77; Member of Hurstville and Kogarah Historical Societies; Has been involved in a study of the Hawkesbury River area with WEA and University of Sydney for years; Study tour to UK, Europe 1982, 80, 88.

Exhibitions Notable solo show of historical paintings, drawing and photographs at ANZ Exhibition Centre, Sydney 1981; Also shows regularly at University of Sydney, Scots College and Opera House Trust; She illustrated the book *The Hillsides Dew Pearled* by Dorothy Coleman, on the Kangaroo Valley district 1976 and *The Changing Hawskesbury,* published in 1979; *History of Kogarah Municipality,* 1985; *Early Slab Buildings of the Sydney Region* 1985; *Sydney's Hidden Charms* 1987, all by Kangaroo Press.

Represented P&O Ltd Collection; Mitchell Library and institutional and private collections in Australia, Japan, USA and Canada.

KINNY, Shirley NSW

Born Orange NSW. Painter in oil, watercolour, pastel and ink.

Studies Private tutors and at Muswellborok and Lithgow Technical Colleges.

Exhibitions Muswellbrook Arts Centre.

Awards Newcastle 1971; Cowra 1973.

Represented Muswellbrook Arts Centre and private collections in Australia and overseas.

Bibliography *Australian Watercolour Painters,* Jean Campbell, Craftsman Press 1989.

KIRKBY, Mary NSW

Born Australia 1926. Painter in oil and watercolour; Teacher.

Studies East Sydney Technical College 1940–43; Hurstville and Sutherland Evening Colleges 1954–57; Gymea Technical College 1975; Painted around Australia 1976, and has taught art since then; Past president and secretary of St George Art Society, and member of Sutherland and Ryde Art Societies and the RAS of NSW; Also interested in marquetry and jewellery.

Awards Campbelltown 1963–64; Oyster Bay 1975, 1976, 1982; Wollongong 1964; Blackheath 1974; Dubbo 1972; Ryde 1977; Cronulla 1980; Bonnet Bay 1980; Gosford 1972; Grace Bros 1969; Paint-a-Pub 1977; Marquetry 1978–79; Royal Easter Show (marquetry) 1974, 1975, 1980.

Represented Toastmistress House, Anaheim USA, and private collections in Australia and overseas.

KITCHENER, Jenny NSW

Born Sydey 1955. Printmaker.

Studies Dip. Visual Arts, SCOTA 1977–79.

Exhibitions MPAC 1982; Seasons Gallery, Sydney 1986–87.

Awards Arches Rives Prize 1978; Kyogle Fairymount 1982.

Bibliography *PCA Directory* 1988.

KITTELTY, Robyn VIC
Born Geelong Vic 1943; Impressionist/ expressionist in oils, watercolour, pastels and pen and wash. Teacher.
Studies Ringwood Tech. College, Melb. Teacher for CAE Country Education Project in many provincial areas. Founding President, Ballarat Society of Artists.
Exhibitions Has had 15 solo exhibitions, including La Scala, Ballarat, Old Bank Gallery, Buninyong, Eureka Gallery and Robyn Kittelty Gallery.
Awards Ballarat, Horsham, Geelong, Portland, 'Gnarput' Skipton, Ballan.
Represented Institutional and private collections Australia and overseas.

KJAR, Barbie TAS
Born Burnie 1957. Printmaker.
Studies BA Fine Art, Tas S of A; University of Tasmania 1987 following B. Ed. 1975.
Exhibitions Salamanca Place Gallery 1986, 87, 89, 90; Glyde Gallery, Perth 1991; Numerous group shows include Chameleon Gallery 1984, 87, 88; Devonport Art Gallery 1988; Gallery Cimitiere 1990; MPAC 1990; Entrepot, Hobart 1990; Gallery Two, Launceston 1991.
Awards Artist-in-Residence Kala Institute, San Francisco 1988.
Bibliography *PCA Directory* 1988.

KLEIN, Deborah VIC
Born Melb. 1951, lived London UK 1973–80. Painter and printmaker, especially wood block.
Studies BA (Hons.) Chisholm IT, Melb. 1984; Grad. Dip., Gippsland IAE; Administrative assistant PCA, Melb. 1985–87.
Exhibitions Solo shows at Tynte Gallery, Adelaide 1987; Port Jackson Press Gallery Melb. 1988; Numerous group shows include MPAC 1984, 86; Edinburgh School of Art, Scotland 1985; Print Biennial, Taiwan 1986; Fremantle and Warrnambool Print Shows 1987.
Awards Arches River 1984; PCA Edition 1986.
Represented Institutional and private collections in UK, Europe, Taiwan, Australia.
Bibliography *Alice 125*, Gryphon Gallery: University of Melbourne 1990.

KLEIN, Susie NSW
Born Sydney NSW. Painter and weaver.
Studies National Art School, Sydney 1954–57; Taught art at several high schools for a time before travelling extensively in Europe and USA; Became interested in weaving and completed the extension course for Diploma of Art Education in Weaving at the Alexander Mackie College of Art in 1976; She has experimented for several years with new techniques and dyes all her own materials and spins her own fleece; Her first one-woman show was at the Wagner Gallery, Sydney in February 1978.

KLETTENBERG, Anna-Lisa NSW
Born Kisa, Sweden. Painter, teacher.
Studies ESTC and Alexander Mackie College, taught at Normanhurst Boys High School.
Exhibitions Ararat Regional Gallery 1983; Holdsworth Galleries 1984, 86, 89.
Represented Institutional and private collections.

KLIMEK, Dorothy NSW
Born Poland. Painter and teacher.
Studies Alexander Mackie CAE, Graphic Design 1972–76; Dip. Fine Arts (Painting) 1979. Has taught at TAFE Colleges at Seaforth and Penrith, currently at Meadowbank.

Exhibitions Solo show at Wooloomooloo Gallery 1984; Group shows with The Polish Cultural Society and at Gosfrod three times.
Represented Institutional and private collections in Europe and Australia.

KLUGE-POTT, Hertha VIC
Born Berlin Germany 1934, arrived Australia 1959. Printmaker and teacher.
Studies Braunschweig and Berlin Academy of Art 1953–58; RMIT 1960–63; Further studies in Europe 1964–65, and 1974–75; Senior lecturer in charge of printmaking at RMIT.
Exhibitions One-woman shows in Melbourne 1972, 1982; Canberra 1978; Brisbane 1981; Stuart Gerstman Gallery 1982; Works Gallery, Geelong 1985; Powell St. Graphics 1987, 1990. Participated in many group shows and all PCA exhibitions including Cracow, Poland 1972–76; 'Images' show to India 1972; 'Australian Etchings' to all state galleries 1978; 'Twelve' Australian Printmakers ' to UK and Europe 1982–83; Gerstman Galleries 1983; PCA Show to Japan 1984; MPAC 1984; Uni. of Oregon USA 1985; Brooks Museum, USA 1985; PCA Gallery 1988; MPAC 1984, 1985, 1988, 1990; Warrnambool Art Gallery 1987, 89; Lodz, Poland 1989, 90.
Awards F.E. Richardson Prize 1966; Henri Worland Prize 1981, 87; MPAC 1982, 84; Yarra Valley 1982, 87; PCA Patron Print Edition 1969, 88.
Represented ANG, NGV, AGNSW, QAG, Regional Galleries, institutional galleries and private collections and Artbank.
Bibliography *PCA Directory* 1988; *Encyclopedia of Australian Art*, Alan McCulloch: Hutchinson 1968; *Artists & Galleries of Australia*, Max Germaine: Craftsman House 1990.

KNGWARREYE, Emily NT
Aboriginal artist from the Utopia region NE of Alice Springs. Paints mostly in acrylic on linen.
Exhibitions Many shows since 1980 and in recent years at Craft Council, Canberra, Bundaburg Gallery and Araluen Arts Centre NT 1986; Fremantle Arts Centre, NTMAS, Yirrkala Community Centre, Jogyakarta Fine Art Academy, Indonesia, Craft Council, Sydney and Araluen Arts Centre 1987; Austral Gallery, St. Louis USA, Utopia Art, Sydney and Queensland Museum 1988; Orange Regional Gallery 1989; S.H. Erwin Gallery, Sydney 1989; NTMAS 1989; Coventry Gallery, Sydney 1989, 90.
Represented ANG; NGV; Araluen Arts Centre; Coventry Collection.

KNIGHT, Winifred TAS
Born Devonport 1921. Painter and teacher.
Studies Hobart TC 1938–42; Summer schools under John Olsen, Clifton Pugh, John Firth Smith and Jan Serbergs. Taught with TE Dept. 1943–46, 1960–76; Tas. Teachers Certificate from University of Tas. 1964.
Exhibitions Solo show at Salamanca Place Gallery 1980; Burnie Art Group 1987; Lady Franklin Gallery, Hobart 1989. Group shows include Tas. Group of Painters 1941, 46, 59, 61; Velasquez Gallery, Melb. 1946; Long Gallery, Hobart 1985.
Awards Salamanca Arts Centre WC Prize 1985; Advocate Award 1986.
Represented Artbank AEB and private collections.
Bibliography *Tasmanian Artists of the 20th Century*, Sue Backhouse: Pandani Press 1988.

KNOX, Jean VIC
Born Melb. 1926. Figurative painter.
Studies BA Dip. Social Studies, Uni. of Melb.; Studied art with Frank Werther, Erica McGilchrist and Adult Education.
Exhibitions Solo shows at Gallery 99 1968; Niagara Galleries 1983, 85; Geelong Art Gallery 1988; Participated MPAC 1979, 81, 83, 89, 90; Warrnambool Regional Gallery

1982.
Represented La Trobe Uni.; Artbank; MPAC and private collections.
Bibliography *Encyclopedia of Australia Art*, Alan McCulloch: Hutchinson 1968; *Artists & Galleries of Australia*, Max Germaine: Craftsman House 1990.

KOBIELA-HORN, J. Rosanna ACT
Born Cieszyn Poland 1953. Painter and printmaker.
Studies Master of Fine Arts from Academy of Fine Arts, Cracow.
Exhibitions Solo shows in Chorzow Poland 1978; Antwerp Belgium 1978; Participated in Katowice Poland 1979; Genk Belgium 1979; Mornington Peninsula Art Gallery 1978 and Sydney 1978, 1979, 1980.
Represented Private collections in UK, Europe and Australia.
Bibliography *Directory of Australian Printmakers* 1982.

KOBOR, Michaela NSW
Born Jerusalem 1964. Printmaker.
Studies BA Visual Arts, City Art Institute and Grad. Dip. later 1983–86. B. Art Ed. 1986–88; Art teaching 1988–90; Community Artist Screenprinter, Garage Graphix Community Arts 1991. Member, PCA Sydney Printmakers and International Graphic Arts USA.
Exhibitions Hogarth Galleries 1987; Holdsworth Galleries 1989; Group shows include Blaxland Galleries and Fremantle Art Centre.
Bibliography *PCA Directory* 1988.

KOOZNETZOFF-HAWKINS, Ludmela NT
Born Biloela Qld 1941. Painter, printmaker and teacher.
Studies Associate Diploma of Fine Art, College of Art, Brisbane Queensland 1977; Certificate D'enseigner la Gravure, Atelier Franck, Paris France 1978; Bachelor of Arts (fine arts) Adelaide College of Arts and Education 1980; Graduate Diploma of Education, Adelaide College of Arts and Education 1981; In 1980 was appointed head of the newly created Dept of Creative and Applied Art, Community College of Central Australia; Alice Springs, UK, Europe study tour 1977–78.
Exhibitions One-woman shows include Georges Gallery, Brisbane 1977; Adelaide Fine Arts and Graphics 1978; Hawthorn City Art Gallery, Melbourne 1979; Alice Springs 1982; Participated in many PCA and other group shows since 1959 including Port Moresby 1965; Tokyo 1976; Farnham UK 1976; Paris 1978.
Awards Caltex, Vic 1959; Brisbane College of Art 1975–76; Bathurst 1978–79; Alice Prize 1979, 1982; Broken Hill 1979; Tweed Heads 1980; Blackwater Prize 1980; Caltex NT 1982.
Represented Business and private collections in France, Malta, Australia, New Guinea, New Zealand; Broken Hill Art Gallery, Bathurst Art Gallery; The Alice Prize Collection, Alice Springs; Tennant Creek Art Award Collection.

KOSHLAND, Phyllis NSW
Born Chicago USA 1949. Sculptor arrived Australia 1975.
Studied BA Radcliffe College; Studied at The School of the Museum of Fine Arts at Boston Night School 1972; In USA and Europe and Jean Francois Atelier, Paris 1983.
Exhibitions Sculpture Centre, Mavis Chapman Gallery and Holdsworth Galleries, Sydney 1975–79; Solo shows at Robin Gibson Gallery, Sydney 1983, 86, 89.
Represented Institutional and private collections in Australia and overseas.

KOSKA, Rebeka VIC
Born Yugoslavia 1964. Printmaker.

Studies VCA, Melb. 1983.
Exhibitions NGV 1983; ROAR Studios 1987; PCA Gallery 1988.
Represented ANG, private collections.
Bibliography *PCA Directory* 1988.

KOSTOGLOU, Helen SA
Born Adelaide SA 1935. Expressionist and abstract painter in oil and acrylic.
Studies No formal art training other than adult education classes under Anton Hotzner
since 1965; Studies and exhibits with the Contemporary Art Society of SA and the Royal SA
Society of Artists; Lived in Melbourne 1972–78 and worked and exhibited with the Vic
Artists Society and Beaumaris Art Group; Had solo show at Juniper Gallery, Melbourne
1977.

KOZIC, Maria VIC
Born Melbourne Vic 1957. Painter, printmaker, sculptor, film maker.
Studies Preston Institute of Technology 1977–80; Phillip Institute of Technology 1980.
Exhibitions One-woman shows at Clifton Hill Music Centre, Melbourne 1978; Oz Print
Gallery 1979; George Paton Gallery, University of Melbourne 1981; Roslyn Oxley Gallery,
Sydney 1984, 86, 87, 88, 89; Reconnaissance Gallery, Melbourne 1982; Tas S of A Hobart
1983; Tolarno Galleries, Melb. 1984, 88; Artspace 1985. Participated in numerous group
shows since 1978 and recently Biennale of Sydney 1982 and *Australian Perspecta* 1983; Art
Gallery of NSW; ANG, Canberra, Galerie Brederberg, Amsterdam, Nat. Gallery of Vic.
1983; ACCA, Melb., AGWA 1985; Venice Biennale 1987 'Sighting Reference' Artspace
and AGNSW 1987; Heide Museum and Art, Gallery, Melb 1988; 'Chaos' Roslyn Oxley9
Gallery 1987; Moët & Chandon Touring Exhibition 1989; 200 Gertrude St. Gallery 1989;
Bicentennial Print Folio Touring Exhibition to ANG and State galleries 1989.
Commissions Christmas tree — National Gallery of Victoria, 1984; The Bicentennial
Print Folio 1988.
Represented The Mitchell Endowment, National Gallery of Victoria; Philip Morris Arts
Grant, Australian National Gallery; Australian National Gallery Collection; Artbank;
Private Collections.
Bibliography *Catalogues of Sydney Biennale* 1982 and *Australian Perspecta 1983,* Art Gallery
of NSW. 'Pages from Maria Kozic's Book': Danielle Duval 1988; *Artists & Galleries of
Australia*, Max Germaine: Craftsman House 1990.

KREUTZMANN, Yvonne QLD
Born Wynnum, Qld 1914. Painter.
Studies Brisbane Technical College; Hobdays Art Studio, Brisbane.
Exhibitions RQAS shows 1957–81; Newcastle, Grafton, Lismore.
Represented Private collections in Australia and overseas.

KRIVITSKY, Margarita VIC
Born Odessa USSR, arrived Australia 1988. Painter and teacher.
Studies State College of Arts, Odessa and at Teachers College for eight years.
Exhibitions Solo shows Moscow and Leningrad; Design Station and Reflections Galleries,
Melbourne. Group show NGV 1991.
Represented Europe, USSR and Australia.

KROPPER, Jean NSW
Born Boston, Mass., USA. Printmaker, papermaker, graphic designer.
Studies Aix en Provence, France 1980; Graduated BA Fine Arts from University of
Vermont, Burlington USA 1982. Studied printmaking at Ku-ring-gai Art Centre with
Ingrid Johnstone and Ruth Burgess.

Exhibitions Gleneon Craft Fair; Represented at Blaxland, Pochoir and Picture Show Galleries, Sydney.

KRUGER, Elizabeth — ACT

Born Noumea, New Caledonia 1955. Painter, printmaker, teacher, craftworker.
Studies Canberra School of Art where she is currently part-time lecturer in printmaking.
Exhibitions Solo shows at Craft Council, ACT 1978 (quilts); Craft Council Gallery, Sydney 1979; Giles Street Gallery, ACT 1988; Numerous group shows since 1973.
Awards Moët & Chandon Art Fellowship 1989.

KUBBOS, Eva — NSW

Born Luthuania 1928, arrived Australia 1952. Abstract expressionist painter in watercolour, gouache, oil and pencil; Graphic artist.
Studies Hochschule fur Angestande Kunst, Berlin 1946–51; After arrival in 1952 studied at RMIT and Swinburne Technical College and worked in the commercial advertising field until she moved to Sydney in 1960; Foundation member of Sydney Printmakers, and a member of the Australian Watercolour Institute.
Exhibitions One-woman shows at Sydney 1962; Newcastle 1964; Adelaide 1968 and Canberra 1969; Tia Gallery, Toowoomba, Qld 1981; The Masterpiece Gallery, Hobart 1981; Niagara Gallery, Melbourne 1984; Participated in Third International Print Biennale, Tokyo 1962; South-East Asia Travelling Exhibition 1962; South London Gallery 1962; Contemporary Drawing Exhibition, Newcastle 1965; International Young Painters' Exhibition, Tokyo 1969; Many group and competition showings; Her painting *Dark Summer* was included in the 'Australian Painters' Exhibition (Mertz Collection) at the Corcoran Gallery, Washington DC USA 1967; Abstract Expressionism in Sydney 1956–64; Ivon Dougherty Gallery 1980; Lithuanian Artists of the free world, Ciurlionis Art Gallery, Chicago, Illinois USA 1983; Watercolour Travelling show, Australia 1983. Delmar Gallery, Sydney 1987.
Award Mirror-Waratah Contemporary Watercolour 1963; Armidale Watercolour Prize 1963; Wynne Watercolour Prize 1963, 1970, 1971; Maitland 1964; Rockdale 1964, 1965; Mosman 1964, 1966; Wollongong 1964, 1965; Lithuanian Arts Festival, Melbourne 1964; Ryde 1965; Robin Hood 1965; Hunters Hill 1966; Pring Prize for Watercolour 1970, 1971, 1974, 1975, 1977, 1979, 1981, 1983; Trustees Watercolour Prize, Art Gallery of NSW 1963, 1970, 1971, 1981.
Represented National Collection, Canberra; Mertz Collection; State Galleries of NSW, Vic, WA; Newcastle and Armidale Galleries; National Gallery, Kuala Lumpur; Many Australian and overseas collections including National Art Gallery, Vilnius Lithuania 1980; Tas Art Gallery and Museum; Ciurlionis Art Gallery, Chicago USA 1983.
Bibliography *The Australian Painters 1964–1966*, Griffin Press, Adelaide 1966; *Australian Painting 1788–1970*, Bernard Smith, Oxford University Press 1974; *Encyclopedia of Australian Art*, McCulloch, Hutchinson 1977; *Elwyn Lynn — Drawing*, Australian Art Series, Longmans, Melbourne 1963; *Australian Watercolour Painters 1780–1980*, Jean Campbell, Rigby 1983; *Artists & Galleries of Australia*, Max Germaine: Craftsman House 1990.

KUCZYNSKA, Maria — NSW

Born Poland 1948. Sculptor, teacher, arrived Aust. 1982.
Studies Academy of Fine Art, Gdansk, Poland, MA Graduated with specialisation in Sculpture for Architecture 1965–71; Jury panel member, Faenza International Ceramic Competition — Italy 1980; Member of International Academy of Ceramics — Geneva, Switzerland 1985. Artist-in-Residence Canberra S of A 1982 and WACAE, Perth 1983.
Exhibitions Numerous solo shows since 1979 include Faenza, Italy 1980; Scheider Gallery, Freiburg, West Germany 1982; Individual travelling exhibition of sculpture in ceramic —

Canberra, Sydney, Perth, Adelaide, Geelong, Mornington 1982–83; Dusseldorf Gallery, Perth; Cooks Hill Gallery, Newcastle, NSW 1983; Christchurch Art Festival, NZ 1984; Macquarie Galleries, Sydney 1986, 88; Christine Abrahams Gallery, Melb. 1986, 88; Grosser Bachem Galeries, Cologne — 1986; Numerous group shows — Europe 1981 –86 and recently at The Fourth Australian Sculpture Triennial, Melbourne 1990.
Awards Many medals and prizes in Europe since 1971 including the Gold Medal at Faenza, Italy in 1978 and the Grant Prize in 1979 and scholarships to Heusden, The Netherlands and Kecskemet, Hungary.
Represented NGV, AGWA, Auckland Museum NZ, WACAE, Canberra S of A, Museum of International Ceramics, Faenza, Museum de Bellerive, Geneva and many institutional and private collections in UK, Europe and Australia.

KULYURU, Angkuna NT
Aboriginal batik painter of the Pitjantjatjara people in the Ernabella region which straddles the SA/NT border area. Has studied in Japan and Indonesia.
Exhibitions Bloomfield Galleries, Sydney 1989.
Represented ANG; NTMAG; NGV; AGSA; Robert Holmes à Court Collection.

KUYATA, Yipati NT
Aboriginal batik painter of the Pitjantjatjara people from the Ernabella region which straddles the SA/NT border. Has studied in Japan and Indonesia.
Exhibitions Bloomfield Galleries, Sydney 1989; Lauraine Diggins Fine Art 1989.
Represented ANG; NTMAG; NGV; AGSA; Robert Holmes à Court collection.

KY, Carmen NSW
Born Cowra NSW 1946. Printmaker.
Studies ESTC 1961–66; Grad. Dip. City Art Institute 1983; Assoc. Dip., Canberra S of A 1988. Studied Europe, S.E. Asia 1977; Asia 1985; UK, Europe 1986.
Exhibitions Blaxland Galleries 1966–70, 84, 85, 86, 88, 90; Ivan Dougherty 1983, 86; Solo at Gallery A 1968; Old Fire Station, WA 1969; Bonython 1974.
Awards Ashfield 1968, 69; Ryde 1970; Campbelltown 1973.
Bibliography *PCA Directory* 1988.

L

LABSON, Violet Chin-Ai VIC
Born Melbourne Vic 1918. Chinese brushpainting and western impressionism.
Studies Bachelor of Arts French and Latin, University of Melbourne 1942; Bachelor of Arts, Stanford University of California, USA in Chinese; Chinese painting under Roland Chan, Hong Kong and line drawing under John Yule.
Exhibitions Geelong Art Gallery, East and West Art, Melbourne 1977, 1978.
Awards Caltex-La Trobe Valley 1974.
Represented La Trobe Valley Arts Centre and private collections in Australia and overseas.

LACIS, Astra NSW
Born Riga Latvia. Painter, illustrator and graphic artist.
Studies Diploma, Hons from East Sydney Technical College 1959; Works as a freelance artist and illustrator of children's books; Has held several one-woman shows at Latvian Community Hall, Sydney.

Represented Illustrations in *Lexel and the Lion Party*, Christobel Mattingby and twenty other books.

LADY NT
Born c.1933. Aboriginal acrylic painter from the Yuendumu region of Central Australia. Warlpiri language group.
Represented Art Gallery of SA.

LAMAS, Marguerita QLD
Born Chile. Painter.
Studies University of Chile, School of Fine Arts 1942–46.
Exhibitions Chile; Los Angeles, USA; Woollahra Galleries, Sydney; Nino Tucci Gallery, Brisbane.

LAMB, Robyn TAS
Born Melb. 1943. Painter, teacher.
Studies Launceston Teachers College 1961–62; Burnie TC 1975–78.
Exhibitions Solo show at Devonport Gallery and Art Centre 1983. Several group shows.
Bibliography *Tasmanian Painters of the 20th Century*, Sue Backhouse 1988.

LAMING, Amanda VIC
Born Melb. 1955. Painter.
Studies RMIT 1973; VCA, Dip. FA 1974–77, Postgraduate Dip. 1979–81.
Exhibitions Solo show Uni. of Melb.; George Paton Gallery 1982; group shows at MPAC and NGV 1984.
Represented NGV, MPAC, institutional and private collections.

LANCASTER, Helen NSW
Born NSW. Painter, textile and fibre artist.
Studies ESTC 1954–57 and the STC. Has taught at High and Technical Schools, most recently at St. George CAE.
Exhibitions Solo shows at Camelion Gallery, Mosman 1980; Penrith Regional Gallery 1982; Group shows include Hogarth Gallery 1987; Penrith Regional Gallery 1987; Gryphon Gallery, Melbourne 1987.
Represented Commonwealth Bank in Sydney and Brisbane; Institutional and private collections in UK, Europe and Australia.

LANDER, Jane NSW
Born Melb. 1957. Painter.
Studies Warrnambool IAE — Diploma FA 1979; Postgraduate Diploma (Printmaking) Newcastle CAE 1981.
Exhibitions Solo shows at Cafe Gritz, Newcastle 1985; Holdsworth Contemporary Galleries, Sydney 1986; Lake Macquarie Gallery 1987, 88; group shows include Newcastle CAE 1981; Lake Macquarie Gallery 1982, 86, 87, 88; Newcastle Regional AG 1984, 88; BMG, Sydney 1989; AGNSW 1990; BMG, Adelaide 1991.
Awards Maitland Student Art Prize (joint) 1981. Private commission, Paraburdoo WA.
Represented Municipal and private collections.

LANDT, Karen VIC
Photographer, printmaker, craftworker.
Studies RMIT BA (Photography) 1982 and graduate diploma, FA 1984. Papermaking, etching, lead lighting with Anthony Sydnicas 1984.
Exhibitions Solo show at Joan Gough CAS Gallery, Melb. 1984.

Represented Institutional and private collections around Australia.

LANDVOGT, Margaret VIC

Born Cornwell UK 1930. Landscape painter, teacher, arrived Australia 1948.
Studies Plymouth School of Art UK; RMIT, Chisholm and Victoria Colleges, Melb. —
Diploma, Painting and Drawing, Regional Art/Craft Consultant to Vic. Ed. Dept. 1976.
Overseas study 1979, 81; head of art at PLC, Melb. 1982–85. Now paints full-time.
Exhibitions Solo shows at Profile Gallery, Melb. 1984; Ufitzi Galleries 1987; AMP Square
1988; Waverley City Gallery 1985, 86, 88.
Awards Rotary Drawing 1986; Mulgrave Prize 1988.
Represented Institutional and private collections in UK, Europe and Australia.

LANE, Judy NSW

Born Sydney 1942. Painter and teacher.
Studies Dip. Fine Art, Julian Ashton School, Sydney; Study tours to UK, Europe also to
China in 1982. Artist-in-Residence, Festival of Mosman 1983, 85; taught at Julian Ashton
School and later opened her own school at Mosman. Study tour to UK, Europe 1989.
Member, Pastel Society of NSW.
Exhibitions Most recent solo shows at Artstok Gallery, Sydney 1988 and Access Gallery
1989, 90.
Represented Institutional and private collections in UK, Europe, USA, China, Japan,
Australia.

LANG, Marie VIC

Born Melbourne Vic. Landscape painter.
Studies National Gallery Art School and privately with Sir William Dargie; Diploma of Art
from Prahran CAE 1973–76; Study tour to Central Australia 1982.
Exhibitions One-woman show at Russell David Gallery, Vic 1983; Participated at
Warehouse, Ackland St and Important Women Artists Galleries and Swan Hill Gallery.
Represented Private collections throughout Australia.

LANGAN, Margaret Adele NSW

Born Sydney NSW 1934. Abstract expressionist painter, sculpture, theatre design, photog-
rapher and printmaker.
Studies School of Art and Design Sydney; Currently recording and photographing
Archaeological Art Sites, NSW in consultation with Parks and Wildlife.
Exhibitions Participated in group exhibitions with Southern Printmakers Association
(Founding Committee Member); Current exhibition — photographs and etchings,
Administrative Centre at Audley, Royal National Park; Group Show, Studio 67 at Cronulla
1979.
Awards Printmaking — St George and Sutherland Shire 1980; The Dennis Porter Award
1979; Sculpture — Port Hacking Potters' 11th Anniversary, Grace Bros. Broadway,
Ceramic Sculpture; Gymea Technical College Award 1979; Photography — Botany
Municipal Council Award 1978; Glen Galleries 1985.
Represented Private and institutional collections, South Africa, USA, West Germany, UK.
Bibliography *Directory of Australian Printmakers* 1982, 88.

LANGDON, Anne SA

Born Hamilton, Vic. 1950. Painter and printmaker.
Studies BA, Dip. Ed. Monash Uni. Dip. Fine Art, Bendigo CAE.
Exhibitions Numerous shows in recent years include Wallace Bros., Castlemaine, Vic.
1986, 88, 90; MPAC 1986, 88; Bridge St. Gallery, Sydney 1988; Print Show touring Spain
1987–88; touring show to USA 1988–89; Toronto, Canada 1988; Castlemaine Regional

Gallery 1989; Jarman Gallery 1989; Artspace, Bendigo 1989; Wiregrass-Eltham Gallery 1990; Tynte Gallery, Adelaide 1990; Bendigo Regional Gallery 1990; Spain Touring 1987–88; USA 1988, 89; Canada 1989; Korea 1990.
Represented Institutional and private collections in UK, Europe, USA, Australia.
Bibliography *PCA Directory* 1988.

LANGDON, Molly Nampijinpa NT
Aboriginal painter in acrylic on canvas from the Yuendumu area of Central Australia. Warlpiri language group.
Represented SA Museum.

LANGE, Eleonore NSW
Born Germany 1893. Sculptor writer and lecturer.
Studies At the Kunstgewebeschule, Frankfurt-on-Main under Karl Stock and Professor Hans Cornelius; Taught in Germany and for a short time on the island of Qualto off Papau New Guinea before settling in Sydney in 1930; Lectured and taught at the Art Gallery of NSW; The Contemporary Art Society, Rah Fizelle's studio, wrote articles for *Art in Australia* and played an important part in the art life of Sydney until 1949 when she joined the staff of Frensham School, Mittagong NSW as art mistress where she remained until 1954.
Commissions 1930 Medallion for Holy Trinity Church, Erskineville NSW; 1934 Preliminary work on memorial to Dr Duffield of Canberra, not proceeded with; Maquette at Frensham School; 1935 Christmas Crib for St James Church, Sydney; 1936 Stone figure for Special School, Glenfield NSW; 1937 Sydney Teachers College carved wood relief as memorial to H.W. Hamilton.
Bibliography *The Development of Australian Sculpture 1788–1975*, Graeme Sturgeon, Thames and Hudson 1978; *Australian Sculptors*, Ken Scarlett, Nelson 1980; *Art and Australia*, Vols 2/4, 3/1 and 2, 5/4, 6/1.
(Died August 1990)

LANGE, Paula QLD
Born Stanthorpe Qld 1953. Painter, printmaker and teacher.
Studies Kelvin Grove CAE.
Exhibitions Solo shows at Bundaberg Qld and Terrace Galleries, Brisbane; Teaches art at private schools.

LANGLEY, Betty Jacqueline VIC
Born Hawthorn Vic 1925. Painter and printmaker, all media.
Studies Swinburne Technical College 1942–45.
Exhibitions Many shows since 1966 including VAS and Society of Women Painters and Sculptors.
Represented Collections in Australia and UK.

LANGLEY, Jean VIC
Born Melbourne Vic 1926. Landscapes and flower paintings in oil and watercolour.
Studies National Gallery School, Melbourne for a short time, otherwise self-taught.
Exhibitions Exhibited with her brother, sculptor Robert Langley, Museum of Modern Art and at Gallery 99, Melbourne; One-woman show of flower paintings from her book at Tolarno Galleries, Melbourne; Also showed landscapes at Russell Davis Gallery; Drawings at Mornington Arts Centre and participated in a group show at von Bertouch Galleries, Newcastle NSW.
Represented National Bank Collection; Institutional and private collections in Australia and overseas.
Publications *Australian Bush Flowers*, Lansdowne Press 1971; Originals of the illustrations

in this book were purchased by the National Bank of Australia; *To A Blue Flower*, Flower Press, Melbourne 1983.

LANGLEY, Nancy WA
Born Melb. 1928; Painter, graphic artist, teacher.
Studies Commercial art under William Dargie at Caulfield TC; Nat. Gallery School, Melb.; Nat. Gallery Diploma at Uni. of Melb. 1965. Lectured at Perth TC, WA and technical education for twenty years.
Awards Stirling Art Prize 1978, 85.
Publications Author of TAFE textbook *Oil Painting for Pleasure* 1984.

LANGSFORD, Beryl Frances WA
Born Albany WA 1915. Representational painter in oils and with bark.
Studies Oil painting with Henry Froudist, Alan Baker and Laurie Knott at adult education schools.
Exhibitions Special annual 'Wildflowers of WA' Show in Kings Park, Perth each year 1970–78; Bark paintings at Cottesloe Civic Centre, WA 1970, 1971, 1976, 1977, 1978; Exmouth Shire Hall, WA 1978; Inaugural president of Australian Art in Bark Association.

LANGSHAW, Yvonne NSW
Born Sydney. Painter and teacher.
Studies ESTC and Chatswood Evening College. Currently teaching painting at the Willandra Art Centre. Exhibiting member of Ku-ring-gai, Ryde and Peninsula Art Societies.
Exhibitions Major solo show at North Sydney Contemporary Gallery 1990. Numerous group shows include Gallery 8; Gallery 680 and Willandra Art Centre.
Awards Has won twenty prizes in local art competitions since 1968 and most recently the Ku-ring-gai Art Society Silver Jubille Award 1990.
Represented Institutional and private collections.

LANKAU-KUBITZ, Sigrid VIC
Born Koenigsberg Germany 1939. Painter, sculptor and printmaker.
Studies Darmstadt 1959–61 and Academy of Fine Art, Karlsruhe W Germany 1966–67. Night classes in printmaking at Monash University, 1979; VPW Printmaking at the Meat Market Craft Centre 1982; Monash University — weekend Paper making course, Melb. 1983; Prahran CAE, Bronze casting course, 1983; opened her own studio in Melb. 1983.
Exhibitions Solo shows include Distelfink Gallery, Melbourne 1978; Hawthorn City Art Gallery 1979, 1980; Solander Gallery, ACT 1980; Mentone Galleries, Melbourne 1981; Four solo shows in West Germany 1982–83; 'Sherton' Melb. 1985; Waverley City Gallery 1986. Has participated in many print shows around the world since 1983 and recently at Mini Print International, Spain 1987; SC World Fair, Kyushu, Japan 1988; Korea 1986, 88; Print Show touring UK 1987, 88; Spain 1988; USA 1989.
Commissions Trophy and Medallion for Walter Schauble Ethnic Broadcasting Foundation as awards for the Pursuit of Excellence in ethnic broadcasting 1987.
Represented Institutional and private collections in Europe, USA and Australia.
Publications *Adventure Into New Art Techniques and Paper Making* (Gum and Paper Bark Trees), S. Lankau-Kubitz, 1985.

LARKINS, Catherine VIC
Born Victoria 1953. Painter, sculptor, teacher.
Studies Dip. Visual Arts, Gippsland IAE 1972–75; Dip. Ed., Hawthorn State College 1975. Currently lecturer in Painting and Sculpture at East Gippsland Community College.
Exhibitions Solo show of Sculpture, Switchback Gallery, Gippsland IAE 1989. Group

shows include Robb St. Gallery, Bairnsdale and Blaxland Gallery, Melbourne 1990.

LARSEN, Lidija D. WA
Born Riga 1925. Painter, ceramic artist.
Studies Painting, sculpture and graphic art at the Royal Academy of Fine Arts, Copenhagen, Denmark 1951–55. Between 1945 and 1951 she worked in ceramic workshops in Copenhagen and at Fernand Léger's Art School, France. Art studies in France and Italy working as painter and ceramist 1956–62.
Exhibitions Solo show at Galerie Dusseldorf, Perth 1988. Many group shows in Europe and USA to 1984 and at First Aust. Contemporary Art Fair, Melb. 1988.
Represented AGWA; Danish museums and State Art Foundations; The National Bank and Tuborg Art Associations; collections and private Foundations in Germany, USA, Canada, Belgium, France, Scandinavia, Australia.

LATIMER, Rachel VIC
Born Lilydale, Vic. Painter, teacher.
Studies With Karlis Mednis 1962–69 and Louis Kahan 1969–71. Diploma course under Lance McNeill 1975–78. Member, VAS and Aust. Guild of Realist Artists. Teaches at her Melb. studio.
Exhibitions Solo show at Greenfrog Gallery, Melb. 1987.

LATTER, Anne NSW
Born Sydney 1950. Painter, teacher.
Studies Sydney Teachers College 1969–70; under Fred Goss 1982; Judith White Art Centre 1983–87, where she taught 1987–88. Currently conducting watercolour classes at Mona Vale.
Exhibitions Solo shows at Access Gallery, Glebe 1987, 88, 89. Numerous group shows.
Awards Judith White Caran D'Ache Award 1985, 86.
Represented Institutional and private collections in Australia and overseas.

LAUK, Eha WA
Born Estonia 1920. Landscapist in oil and watercolour.
Studies Claremont Technical School, WA.
Exhibitions International Drawing Exhibition at the Art Gallery of WA; Charles Hamilton Memorial Exhibition 1972; Annually at the Royal Agricultural Show, Perth where she has been a consistent prize winner.

LAURENCE, Janet NSW
Born 1949. Painter in oil, watercolour, collage, installations.
Studies Sydney University 1968–71; Academy of Fine Arts, Perugia Italy 1972–74; New York Studio School, NYC and Artist-in-Residence Bennington College, Vermont 1980; Postgraduate Studies at Alexander Mackie CAE 1981; Assistant for Craft Council's Project of Sheila Hick's installation 1982; New York Studio School, USA 1980; MA Fine Arts, University of NSW 1989–91.
Exhibitions Stephen Mori, Sydney 1979, 1981; ICA, Central St 1981; Brisbane College of Art Gallery 1982, Roslyn Oxley Gallery, Sydney 1982; Perc Tucker Regional Gallery, Qld 1982; Adelaide Festival Centre 1982; Uni. of Melb. 1983; Avago Gallery, Sydney 1984; Artspace, Sydney 1985; United Artists, Melb. 1985; City Gallery 1989; Garry Anderson, Sydney 1985, 87, 89; Wollongong Regional 1986; Greenhill, Adelaide, Canberra School of Art, King St. Studios, Sydney 1988; Milburn + Arte, Brisbane 1989; Lunami Gallery, Tokyo 1990; City Gallery, Melb. 1990; Seibu Gallery, Tokyo 1991; Numerous group shows since 1982 include Florence, Italy 1982, 83; *26 Characters*, Adelaide Festival Exhibition; *Surface & Image*, Crafts Council Gallery, NSW and Lewers Regional Gallery, Penrith; *Australian*

Images, Mixed Media Travelling Exhibition 1984; *Contemporary Australian Art*, Warwick Arts Trust, London, UK; *Isol-Australia*, Venice, Italy; *Australiana*, Belgrade, Yugoslavia; *Perspecta*, Survey of Contemporary Australian Art, Art Gallery of NSW 1985; *Oz Drawing Now*, Holdsworth Contemporary Galleries, Sydney 1986; First Draft Gallery, Sydney 1986; New York 1986; Holdsworth Galleries 1986; Milan Art Fair, Italy 1987; Ben Grady Gallery, ACT 1987; ANG 1988; Coventry Gallery 1988; Beach Gallery, Perth 1989; Tokyo 1990; Linden Gallery 1990; Deutscher Brunswick Gallery 1990; Tokyo 1990; AGNSW and touring regional galleries 1990–91.

Awards VAB Travel Grant VAB Studio Paretaio, Italy; Gold Coast Purchase, Qld; Women in Arts Painting Prize, Sydney 1982; Campbelltown NSW Drawing Purchase 1984; Camden NSW Painting Purchase 1985; Woollahra-Waverley Art Prize; VAB Project Grant 1986; Lake Macquarie Prize 1988; Pring Prize 1987; Newcastle Acquisitive 1988; VA/CB Tokyo Studio 1988; VA/CB Development Grant 1989.

Represented Parliament House Collection, Canberra, the Australian National Gallery Collection, the Faber-Castell Collection and in several regional gallery collections; Institutional and private collections in USA, UK, Europe, Japan and Australia.

Bibliography *Australian Contemporary Drawing*, Arthur McIntyre, Boolarong Press 1988; *Art and Australia* 26/4.

LAVERTY, Ursula A. NSW

Born London UK 1930, arrived Australia 1949. Painter and printmaker; Wife of Peter Laverty.

Studies Winchester School of Art, UK and National Art School, Sydney; ASTC; Foundation and Life Member, Sydney Printmakers.

Exhibitions Joint show with Peter Laverty, Canberra 1959 and von Bertouch Galleries, Newcastle 1963; Maitland 1982; One-woman shows at Design Arts Centre, Brisbane 1968; Macquarie Galleries, Sydney 1969; Arts Council Gallery and Workshop Arts Centre, Sydney 1973; Design Arts Centre, Brisbane; Robin Gibson Galleries, Sydney 1978; Regular exhibitor Sydney Printmakers; Represented in Print Survey, Sydney 1980 and Printmakers of NSW in London UK 1982. Solo show at Artarmon Galleries 1987, 90.

Awards Mosman Drawing Prize 1957; Journalists Club Award, Graphic Section, 1959 Ryde (mixed media) 1978; George Galton Print Prize 1980.

Represented Art Gallery of NSW; National Gallery of Vic; Newcastle Region Art Gallery; Bendigo and Manly Art Galleries; Reserve Bank, QAG, institutional and private collections around Australia and overseas.

Bibliography *Encyclopedia of Australian Art*, McCulloch, Hutchinson 1977; *Australian Printmakers*, Kempf; *Directory of Australian Printmakers 1976*; *Art and Australia*, Vol 19 No 4; *Who's Who in Australia and the Far East*: IBC Cambridge; *Artists & Galleries of Australia*, Max Germaine: Craftsman House 1990.

LAWRENCE, Christine SA

Born Adelaide 1951. Painter and teacher.

Studies Advanced Dip. Secondary Teaching/Fine Art, SASA and Torrens CAE 1969–72. Taught art 1973–84.

Exhibitions Solo shows at Avenel Bee 1977; CASSA 1981; Greenhill Galleries Adelaide and Perth 1988. Many group shows since 1979 and recently at Greenhill Galleries 1986, 89, 90; Barry Newton Gallery 1990.

Represented NGV, Artbank; Diplomatic, institutional and private collections in UK, Europe and Australia.

LAWRENCE, Patricia NSW

Born Aust. 1930. Sculptor.

Studies B. Sc. University of Adelaide; Art Institute of New Brunswick USA; Case Western

Reserves University, Cleveland USA 1983–84 followed by two years at the Tom Bass Sculpture School, Sydney. Sculpture Center Studios, Manhattan USA 1987–88 and on return studied for a time at The Julian Ashton School.
Exhibitions Tom Bass School 1984; Sculpture Center Studios, New York 1988; Julian Ashton School 1989; Sculptors Society, Sydney 1990; Robin Gibson Gallery 1990.
Represented Wilfrid Laurier University, Ontario, Canada; Institutional and private collections in Australia and overseas.

LAWS, Judith QLD
Born Charters Towers Qld. Painter, printmaker.
Studies With Rex Backhaus Smith and the Flying Art School under Mervyn Moriarty. Study tour to UK, Europe, USA, Egypt 1987.
Exhibitions Solo shows at Linton Gallery, Toowoomba 1979, 81; Tia Gallery 1980, 84; Blue Goose Gallery, Gosford 1980, 82; Holdsworth Galleries, Sydney 1984, 86, 89; Ulmarra Galleries NSW 1984; Schubert Gallery, Qld 1985, 87, 89; Grafton House Galleries, Cairns 1987; Solander Galleries, Canberra 1989; Adrian Slinger Galleries, Brisbane 1989 and a host of group shows since 1979.
Awards Toowoomba 1978, 1979, 1980; Warwick 1979; Ascot 1980; Caltex 1980.
Represented Parliament House, Brisbane; Toowoomba City Collection and private collections in Australia and overseas.

LAWSON, Rosalind VIC
Born Ballarat, Vic. 1948. Painter.
Studies Uni. of Melb. Dip. Phy. Ed.; RMIT, Dip.FA; Melb. College TSTC.
Exhibitions Solo show at Dunlaoghaire Gallery, Ireland 1979; MPAC 1981; Gallery Max Honisberg 1987.
Represented MPAC, institutional and private collections in UK, Ireland, Australia.

LEA, Nerissa QLD
Printmaker, film maker. Artist-in-Residence, Qld. Film and Drama Centre, Griffith University, Bribane 1985. Solo show at Pinacotheca Gallery, Melb. 1988.

LEARMONTH, Anne VIC
Born Melb. 1934. Designer, textile artist, weavings.
Studies Uni. of Auckland NZ.
Exhibitions Solo shows at Clive Parry Gallery, Melb; Narek Gallery, ACT; Eltham Gallery.
Represented Municipal, corporate and private collections in Australia and NZ.

LECKIE, Louise QLD
Born Murtoa, Vic 1960. Painter, printmaker.
Studies Brisbane College of TAFE and private tutors.
Exhibitions Solo shows at Broadbeach Gallery, Qld 1981, 85; group shows at Nerang Gallery and The Centre Gallery, Qld 1982–88.
Awards Miami Gold Coast 1985; St Albans Prize G.C. 1986, 87; St. Kevins G.C. 1987.
Bibliography *A Homage to Women Artists in Queensland Past and Present*, The Centre Gallery 1988.

LEE, Eileen Farmer NSW
Born Newcastle NSW 1919. Impressionist landscape and portrait painter in watercolour and oil.
Studies WA Academy of Fine Arts 1959–63; Portraiture with the late Hayward Veal; Overseas study tours 1975, 1977, 1978.
Exhibitions Numerous solo shows since 1969 including von Bertouch Galleries, Newcastle

1982, 90 and Morpeth Gallery, NSW 1978, 1979, 1980, 1981, 1983, 1984, 1986, 1987, 1989; Group shows since 1969 include von Bertouch 1982 and Newcastle University 1982. Won Raymond Terrace WC Prize 1987.

Represented Private collections in Australia, Canada, United Kingdom, Greece, the Sir Claude Hotchin Collections, Perth, Mt Newman Mining Coy, Perth ELMA, Newcastle and University of Newcastle.

LEE, Fran VIC
Born 1964. Printmaker.
Studies Fine Art, PIT 1982–84; Dip Ed. Bendigo CAE 1985.
Exhibitions York St. Gallery, Melb. 1988.
Bibliography *PCA Directory* 1988.

LEE, Heather QLD
Born Australia 1928. Representational painter in oil.
Studies Studied for seven years under the late Frank De Silva; President RQAS Gold Coast Branch; Consistent exhibitor at RQAS and award shows.
Awards Ascot; Westfield and RQAS, Gold Coast.
Represented Private and corporate collections in Qld, NSW and overseas.

LEE, Hyunmee NSW
Born Seoul, Korea 1961. Abstract painter, arrived Australia 1985.
Studies Seoul High School of Music and Art 1977–80; Hong-lk University, Seoul 1981–85 gaining BA; Grad. Dip. (Visual Arts) SCOTA 1989; Currently studying for MA.
Exhibitions Fifteen in Korea and at BMG, Sydney 1989.
Bibliography *New Art Four*: Craftsman House 1990.

LEE, Lindy NSW
Born Brisbane 1954. Painter, teacher, writer.
Studies Kelvin Grove CAE Brisbane 1973–75; Uni. Calgary, Canada 1978; Universita per Stranieri, Perugia, Italy 1978; Chelsea School of Art, London 1979–80; SCOTA Sydney 1981–84. Formerly editor 'On the Beach' magazine. Part-time teacher at SCOTA where she graduated BA and Postgraduate Diploma (Painting). Board member of Artspace.
Exhibitions Solo shows at Union Street Gallery, Sydney 1985; Roslyn Oxley9 Gallery, Sydney 1986, 87, 88, 90; Reconnaissance Gallery, Melb. 1986; 13 Verity Street Gallery, Melb. 1988, 90; Bellas Gallery, Brisbane 1990. A host of group shows since 1982 include *Australian Perspecta* 1985, AGNSW; The 6th Biennale of Sydney 1986; Philip Morris Purchases, ANG, Canberra 1986; Moët & Chandon Touring Show 1987; *Young Australians* NG of Vic. 1987; Edge to Edge, Japan tour 1988; DDIAE touring show to China 1988 and her work was included in *A New Generation 1983–88* at the ANG, Canberra 1988; Bradford Print Biennale UK 1988; RMIT Gallery, Melb 1988; Roslyn Oxley9 Gallery 1988, 90; Artspace 1988; State Museum of Beijing, China 1988–89; ANG and Geelong Regional Gallery 1989; Artists Space, New York, Ivan Dougherty Gallery, Linden Gallery and Deutscher Brunswick St. 1990; Christopher Leonard Gallery, New York, 200 Gertrude St. Gallery, Chameleon Gallery, Hobart, Canberra Contemporary Artspace, Jam Factory, Adelaide, Artspace, Sydney and Perth Contemporary Artspace 1991. Performance at VCA 1989.
Represented AGNSW, ANG, NGV, institutional and private collections.
Bibliography *Catalogue of Australian Perspecta 1985*, AGNSW; *Artists & Galleries of Australia*, Max Germaine: Craftsman House 1990.

LEE, Lorraine NSW
Born 1951. Ceramic artist, teacher.

Studies Art Teachers Diploma, Tasmanian School of Art 1970–72; High School Art Teacher 1973–76; One year study leave overseas travel — SE Asia, Japan, Europe, India 1975; Bachelor of Arts, Tasmanian College of Advanced Education 1977; Potter for the Jam Factory Workshops, Adelaide 1979–80; Tutor in ceramics, Tasmanian School of Art, University of Tasmania 1981–84; MA (Visual arts) Ceramics, Sydney College of the Arts 1984–87; Taught art in Tasmanian schools 1973–77; Jam Factory, Adelaide 1980. Tutor in Ceramics, University of Tasmania 1981–84; Part-time lecturer in ceramics, Nepean CAE 1985; Randwick TAFE 1985; SCOTA 1984–89; Tin Sheds Workshop, University of Sydney 1987–90; National Art School 1988–90; University of NSW, College of Fine Arts 1990–91; Co-ordinator in Ceramics, Tin Sheds Workshop 1991.

Exhibitions Solo shows at Uni. of Tas. 1980; Jam Factory, Adelaide and Craft Centre, Melb. 1981; Upstairs Gallery, SCOTA 1987; Macquarie Galleries 1987, 90; Ros MacAllan Galleries, Brisbane 1988. Group shows include Distelfink, Melb. 1985; Lewers Bequest 1986; Canberra S of A 1986, 90; Irving Sculpture Gallery 1986, 88; Meat Market Centre, Melb. 1987; Manly Art Gallery 1987; First Draft Gallery 1988; Craft Council, Sydney 1989; Centre for the Arts Gallery, University of Tasmania 1990.

Awards Tasmanian Arts Advisory Board Scholarship, Batman Craft Purchase Award 1978; Lismore Art Award 1982; University of Tasmania Research Award; Batman Craft Purchase 1983; Commonwealth Postgraduate Award 1984.

Represented Artbank; AGWA; Uni. of Tas.; Aust. Embassy, Bangkok; QVMAG; Devonport Gallery; corporate, institutional and private collections in Australia and overseas.

LEE, Pam NSW
Born 1948. Genre painter in watercolour, pen and wash.
Studies Qualified as an architectural draftswoman, started painting in 1979.
Exhibitions Legacy House Art Gallery, Sydney; Stockmans Hall of Fame, Qld. Commissioned to paint a series of pictures of historical houses in the Hills district for the Baulkham Hills Council; Show at The North Shore Gallery, Sydney.

LEES, Margaret VIC
Born Melb. 1936. Painter, illustrator, printmaker, teacher.
Studies RMIT and at Prahran Technical College as a secondary school art teacher; Has taught at a number of Melbourne high schools for the Vic Dept of Education in 1973 and has since illustrated seven children's books, one of which received a commendation from the Australian Children's Book Council.
Exhibitions Joint show, Melbourne 1974 followed by one-woman shows at Russell Davis Gallery, Melbourne 1977, 1978; Melb. Art Exchange 1988.
Bibliography *PCA Directory* 1988.

LEES, Robyn WA
Born 1949. Ceramic artist, craftworker, teacher.
Studies BA Visual Arts, Edith Cowan University, Perth 1988–90; B. Ed. WACAE 1983–85; Art/Craft Teachers Certificate, Melbourne Teachers College 1970.
Exhibitions Cheshire Ryder Exhibition 1989; Craft Council 1989; Perth Ceramic Group 1989; Indonesian Ceramic Touring Show 1990; Perth Craft Award 1990; Joondalup Development Corp. 1990; WACAE Graduates 1990.
Represented Institutional and private collections.

LEES, Shivalee VIC
Born Bangkok 1957. Painter, illustrator.
Studies Studied Creative Design at Prahran College, also has a B. Business Studies.
Exhibitions Bangkok.

Bibliography *Alice 125*, Gryphon Gallery, University of Melbourne.

LEHMAN, Penny NSW
Born Adelaide 1953. Figurative painter.
Studies South Australian School of Art, Awarded Diploma in Painting 1974. Moved to Sydney, 1975.
Exhibitions Solo shows at Works on Paper Gallery, Sydney 1978; Coventry Gallery, Sydney 1980; Ray Hughes Gallery, Brisbane 1981; Garry Anderson Gallery 1984; group and joint shows include Ray Hughes Gallery, Brisbane 1978; Wollongong City Art Gallery 1982; CAS, Adelaide 1985; Holdsworth Contemporary Sydney 1986; First Draft, Sydney 1986.
Awards VAB-Alliance Francaise Fellowship 1986.
Represented ANG, Canberra and institutional and private collections.
Bibliography *Australian Contemporary Drawing*, Arthur McIntyre, Boolarong Press 1988.

LEITCH-HARRIS, Gwen SA
Born Burnie, Tas. 1931. Painter, teacher.
Studies Hobart TC under Jack Carington Smith and Dorothy Stonor 1950–52. Central School of Arts and Crafts London 1954. Lived Cornwell UK for 12 years; taught HTC 1953 and SACAE 1974.
Exhibitions Solo shows at Salamanca Place Gallery 1984 and Handmark Gallery 1987 (Hobart). Group shows in UK and Adelaide.
Award Tas. Travelling Art Scholarship 1953.
Bibliography *Tasmanian Artists of the 20th Century*, Sue Backhouse 1988.

LEMPRIERE, Helen NSW
Born Melbourne Vic. Painter, mostly of the mythology and mystique of the Australian Aborigines in mixed media.
Studies Studied in Melbourne under Archibald Colquhoun and Justus Jorgensen during the 1930s. Moved to Paris in 1950 to study at the studio of Fernand Leger where over the next few years she developed her own style, greatly influenced by Dutch painter Fred Klein; She is a great-grand-daughter of Thomas James Lempriere who settled in Hobart in 1822 as Assistant Commissary-General and who was an artist of considerable skill. Through her mother she is a niece of the late Dame Nellie Melba.
Exhibitions Exhibited with many salons and groups in Paris, Milan, The Hague and London between 1953–66; Has held over twenty one-woman shows including Galerie Palmes, Paris 1954–55; Chase Gallery, New York 1958–60; Leicester Galleries, London 1965; David Jones Gallery, Sydney 1966, 1969, 1973.
Represented The Art Gallery of NSW, Sydney; Qld Art Gallery, Brisbane; Tel Aviv Museum, Israel; Museum Ein-Harod, Israel; Washington County Museum, Hagerstown, Maryland USA; Phoenix Museum of Fine Arts, Athens, Georgia USA; Long Beach Museum of Art, California USA; Miami Museum of Modern Art, Florida USA and in many private collections in France, England, Holland, Germany, the USA and Australia.

LESLIE, Barbra SA
Born Adelaide. Painter and teacher.
Studies SASA 1958–61; Tertiary teacher 1971–67; TAFE lecturer 1967–80. Fellow, RSASA 1984.
Exhibitions Solo show at Hahndorf Gallery 1965; Miller Anderson Gallery 1975, 80, 83; Jolly Sailor Gallery 1981, 82; Hahndorf Academy 1975, 80, 83; Studio Z 1987, 88. Numerous group shows since 1975 include RSASA 1984, 90; SA Arts Council Touring Show 1986; Adelaide Festival Centre 1986; Sydney Opera House 1988.
Awards Stirling 1982; Dragzn Miljznovic Award 1982; Sellicks WC 1984; Master Builders WC 1988.

Represented Institutional and private collections in Australia and overseas.

LESLIE, Donna VIC
Born Warren NSW 1963. Aboriginal painter in watercolour of the Gamileroi tribe.
Studies Graduated in Fine Arts (Painting) from Chisholm IT and Dip. Ed. from Melbourne CAE 1986. Member of Koori Arts Group, Melbourne.
Exhibitions Mildura Regional Gallery and was included in the touring show 'Womens Dreaming' to Regional Galleries 1988–89.
Awards VACB Grant 1987.
Bibliography *Artlink* Autumn/Winter 1990.

LESTER, Kerrie NSW
Born Sydney NSW 1953. Paintings and arrangements.
Studies National Art School, Sydney 1971–74; Alexander CAE 1975.
Exhibitions Solo shows at Hogarth Galleries 1976, 1977, 1978, 1979; Macquarie Galleries 1981–85, 87, 88. Participated in many group shows since 1975 including Museum of Modern Art, San Francisco 1978; Biennale of Sydney 1979; Australian Embassy, Paris 1979; *Australian Perspecta* 1981; Ivan Dougherty Gallery 1981; AGNSW 1982; Wollongong City Gallery 1982; Macquarie Galleries 1982, 85; Broken Hill Gallery 1985; Lewers Bequest and Penrith Gallery 1986; City Art Institute 1987; Holdsworth Contemporary 1987.
Awards VAB Grants 1977, 1979; Overseas travel grant and Georges Art Prize 1978; State Bank of New South Wales 1986.
Represented Georges Collection, Melbourne; Philip Morris Collection; Dusseldorf Collection; Justice Elizabeth Evatt Collection; Horsham and Wollongong Galleries and private collections in Australia and overseas.
Bibliography *Catalogue of Sydney Biennale* 1979 and *Australian Perspecta* 1981, Art Gallery of NSW; *Art and Australia*, Vol 17 No 2; *Modern Australian Painting 1975–1980*, Kym Bonython, Rigby 1980; *Artists & Galleries of Australia*, Max Germaine: Craftsman House 1990.

L'ESTRANGE, Sally VIC
Born Brisbane Qld 1953. Modern painter in oil and gouache.
Studies Kelvin Grove CAE 1970–73; Camberwell College, London UK 1975–76; Vic College of the Arts 1977–78.
Exhibitions One-woman shows at North Brisbane CAE 1979, 1980; Ray Hughes Gallery 1981, 88; Participated at Kelvin Grove CAE, *Women Artists* 1980; Pinacotheca Gallery, Melbourne 1981; Tucker Regional Gallery, Townsville 1981; *Australian Perspecta* 1983.
Bibliography *Catalogue of Australian Perspecta 1983*, Art Gallery of NSW.

LESZCZYNSKI, Elizabeth VIC
Born Toronto, Canada 1950. Painter.
Studies Three Schools of Art, Toronto, Ontario 1971–72; York University, Visual Arts, Toronto, Ontario 1972–73; University of Toronto, Ontario 1973–74.
Exhibitions Numerous solo shows in Canada and at Realities Gallery, Melb. 1986, 87. Many group shows in Canada since 1976 and Realities 1983, 84, 85; Painters Gallery, Sydney 1985.
Represented Institutional and private collections in UK, Europe, Canada, USA, Australia.

LETCHER, Joan VIC
Born Melbourne Vic 1955. Painter.
Studies Prahran Institute of Technology 1980–82, Dip. fine Art.
Exhibitions Powell Street Gallery 1981; Hawthorn City Gallery 1983; St Kilda Festival 1982. 13 Verity St. Gallery 1987, 89. Her work was included in *A New Generation 1983–88*

at the ANG, Canberra 1988; RMIT Gallery 1988; Ivan Dougherty Gallery 1988; The Centre Gallery, Gold Coast, Qld 1988; Moët & Chandon Touring Show, NGV 1989.
Represented ANG, Canberra, private collections.

LETHBORG, Keryn TAS
Born Launceston 1952. Printmaker.
Studies Hobart S of A 1972, 73, 77; Winner PCA Student Printmaker Award 1973.

LEVESON, Sandra NSW
Born Melb. 1944. Painter, printmaker, teacher.
Studies Caulfield Institute of Technology 1959–63; Graphic Designer with Les Mason 1963, 64; Taught printmaking, Brighton Technical College 1965; Twelve months study overseas, UK, Europe and New York 1974, 77, 79, 80. Senior lecturer in Printmaking, Prahran CAE 1972–82.
Exhibitions Solo shows include Pinacotheca Gallery, Melb. 1968; Holdsworth Gallery, Sydney 1972; Bonython Gallery, Sydney 1976; Realities Gallery, Melb. 1976, 82; Texas and Oklahoma, USA 1978, 79, 80, 83, 85; Rome and Paris 1980; Gallery 52, Perth 1981, 84; Macquarie Galleries, Sydney 1985, 87, 89; Retrospective at University of Melbourne 1977; Coventry Gallery, Sydney 1977; Mayor Rowan Gallery, London UK 1990. Participated in forty group shows in state, regional and commercial galleries from 1965–88 also some overseas and in recent years at Gallery 52, Perth 1983, 86, 87; Solander Gallery, Canberra 1990.
Awards Corio Painting Prize, Geelong Art Gallery 1971; 'Alice' Painting Prize; Trustees Award, Queensland Art Gallery 1972; Purchase Award from 19th Trustees Award, Tasmanian Art Gallery 1975; Patron Print for Australian Print Council; South Pacific Print Biennale; Commission to paint Melbourne Tram, Visual Arts Board 1978; '5 Australian artists', commission for Print folio, Ministry for the Arts, Vic. 1979; Invitation to McCaughey Prize, NGV 1979; Darling Harbour Proejct 1988; Kakadu-Darwin Art Gallery Field Trip 1990.
Represented ANG, Canberra, AGNSW, QAG, AGSA, TMAG, NTMAG. Most regional galleries in Victoria and New South Wales. Corporate, institutional and private collections throughout Australia, UK, Germany, USA and Asia.
Bibliography *Encyclopedia of Australian Art*, Alan McCulloch: Hutchinson 1968; *Artists & Galleries of Australia*, Max Germaine: Craftsman House 1990.

LEWAY, Susan QLD
Born Brisbane 1962. Photographic artist.
Exhibitions Solo show at Imagery Gallery, Brisbane 1990; Archerfield Aerodrome 1991. Participated at Kooralbyn International Art Show 1990. Conducted workshops at Photographers Gallery 1990 and QAG 1991.

LEWERS, Darani (Larsen) NSW
Born Sydney NSW 1936. Silversmith and teacher.
Studies East Sydney Technical College 1957; Estonian Master Jeweller, Sydney 1958; Helge Larsens workshop, Copenhagen 1959; Chairperson, Crafts Board, Australia Council 1976–80; Part-time lecturer City Art Institute 1980; Trustee of Museum of Applied Arts and Sciences 1981; Member, Management Committee of Lewers Bequest, Penrith Art Gallery 1981; Appointed member general division of Order of Australia 1982; Member of Artworks Advisory Committee, Parliament House Construction Authority 1982–86.
Exhibitions Many solo and group shows in Australia and jointly with her husband Helge Larsen in UK, Europe, Japan, and Australia including the 1986–88 retrospective touring show organised by NGV and including AGWA and the Jam Factory, Adelaide. Irving Gallery, Sydney 1989.
Awards Many awards and commissions in her own right and jointly and most recently the

Ceremonial Mace for the Uni. of Technology, Sydney 1989.
Represented ANG, Canberra, state galleries, regional galleries, museums and institutional collections in UK, Europe, Japan, Canada, Australia.
Bibliography *Art and Australia*, Vol 18 No 4; *Artists & Galleries of Australia*, Max Germaine: Craftsman House 1990.

LEWINGTON, Roma NSW
Born Scone NSW. Painter in oil and watercolour; Printmaker and teacher.
Studies Graeme Inson School, Royal Art Society of NSW under Joshua Smith and Arthur Murch; Orban Studio and Workshop Arts Centre, Willougby NSW (lithography and etching); Four overseas study tours between 1972–85; Worked with Californian watercolourists in USA, painted in UK, Europe and Greece; and all Aust. states including the Kimberley region and Arnhem land. On the teaching panel at Workshop Art Centre, Sydney; Fellow of the Royal Art Society of NSW.
Exhibitions Solo shows at Little Gallery, Chatswood 1978; Mavis Chapman 1979, Salamanca Place Gallery, Hobart 1981; 'Q' Gallery Hunters Hill 1985; Seven Group Shows including two-man show at Workshop Arts Centre (Pastels and Lithographs) 1987.
Awards Wyong, 1981; Scone Print Prize 1983.
Represented Institutional and private collections in Australia and overseas.
Bibliography *Directory of Australian Printmakers* 1982, 1988; *Artists & Galleries of Australia*, Max Germaine: Craftsman House 1990.

LEWIS, Brenda QLD
Born Brisbane 1924. Painter, designer, teacher.
Studies Chelsea School of Art, London UK 1948–53. Weekend schools with well known artists in Qld.
Exhibitions Ten solo shows since 1973 including Brisbane City Hall 1981; Hamstead Community Centre, London UK 1986. Her work was included in *Women Artists of Australia* at Fryer Library, Uni. of Qld 1978; and The Centre Gallery, Gold Coast 1987.
Represented Institutional, trade unions and private collections in UK and Australia.

LEWIS, Joni NSW
Born Sydney NSW 1916. Printmaker.
Studies East Sydney Technical College and Rah Fizelle Studio; Workshop Arts Centre, Willoughby NSW 1971–73.
Exhibitions Held solo show at Shellharbour NSW 1974 and has participated in Print Circle exhibitions since 1972.
Represented Esanda Collection, Sydney and private collections in Australia and overseas.
Bibliography *Directory of Australian Printmakers* 1976.

LEWIS, Naomi NSW
Born Sydney 1930. Painter, portraitist.
Studies As a girl at the Dattilo Rubbo Studio; John Ogburn Studio 1960–67; UK, Europe 1967; With John Olsen, Michael Kmit, Ross Davis and Tony Tozer 1969–70.
Exhibitions Joint show with Susan Hamilton at Eaglehawke Galleries, Sydney 1991; Has participated in many group shows since 1964.
Awards Woollahra Bicentennial Art Prize 1988; Waverley Art Prize 1988.
Represented Institutional and private collections in UK, Europe, USA and Australia.

LEWITZKA, Lorraine SA
Born Adelaide 1952. Painter and fashion artist.
Studies SASA and with private tutors 1985–86, 88. Fellow, RSASA 1988; Workshops in USA and Slade School of Art, London 1990.

Awards Victor Harbor Rotary 1990, 91.

LICHA, Barbara NSW
Born Poland 1957. Printmaker.
Studies Academy of Fine Arts, Wroclaw, Poland; BA Visual Arts, City Art Institute 1985–88, Grad. Dip. Fine Art 1989.
Exhibitions Holdsworth Galleries 1984; Ellimatta Galleries, Sydney 1983; Arthouse, Sydney 1985–86; Vic. Print Workshop 1987; Access Gallery 1989, 90, 91; Reflections Gallery, Melbourne 1991. Numerous group shows include Wroclaw, Poland 1989; Lublin, Poland 1989; Ivan Dougherty Gallery 1988; MPAC 1988; Second Australian Contemporary Art Fair 1990.
Bibliography *PCA Directory* 1988.

LIEL-BROWN, Deborah NSW
Born NSW 1957. Painter.
Studies Gymea TC, Art Diploma 1974; Kogarah TC 1975; Alexander Mackie CAE, Diploma 1979; City Art Institute, B. Fine Arts 1985. Studied UK, Europe, Asia 1984.
Exhibitions Solo shows at Nidus Gallery 1986; Cooper Gallery 1987; Wiregrass Gallery, Melb. 1987; Holdsworth Contemporary Galleries 1988. Group shows at Nidus and Cooper Galleries 1987.
Awards Rockdale Art Prize 1974.
Represented Institutional and private collections in Australia and overseas.

LIGHTFOOT, Phillipa WA
Born Brunswick Junction 1944. Printmaker.
Studies Dip. Art & Design, Perth TC 1962–65; Sir John Cass College, London UK 1980; BA Fine Art, Curtin Uni. 1981–82; Relief Process Workshop, Akiro Kurasaki 1983.
Exhibitions Many shows since 1965 and in recent times at Galerie Dusseldorf 1984; MPAC 1984; Undercroft Gallery 1986; Perth TC Staff Show 1986; Puritan Man Gallery 1987; AGWA 1988.
Awards Westfarmers Open 1964; Perth Prize 1965; Nat. Book Design 1971; Japan, USA 1984.
Represented AGWA, institutional and private collections.
Bibliography *PCA Directory* 1988.

LIIBUS, Vaike (Lakeman) NSW
Born Estonia and came to Australia as a child. Figurative painter and portraitist.
Studies National Art School, Max Meldrum School and Julian Ashton School, Sydney; Associate of RAS of NSW; Member of CAS.
Exhibitions One-woman shows at Holdsworth Galleries 1976 and Gallery Danielli, Toronto Canada 1978. Participated in numerous group shows including Luxembourg 1978 and International Women's Exhibition, Paris 1978, 1979, 1980.
Awards Phillip Musket Landscape Prize, Portia Geach 1969, Australian Fabric Design Award, Estonian Art Prize (Australia 1973), Wollongong Abstract Prize, Royal Easter Show Abstract Prize.
Represented The Mertz Collection USA and many portraits and paintings in schools, colleges, institutions in UK, USA, Europe, Canada and Australia.

LIKIC, Jean QLD
Born France 1934, arrived Australia 1959. Painter and sculptor.
Studies Zagreb Art School, Yugoslavia; Shared sculpture award at Mildura Sculpture Centre 1961.
Bibliography *Australian Sculptors*, Ken Scarlett, Nelson 1980.

LILLAS, Norah TAS
Born Hobart 1920. Painter, teacher.
Studies Philip Smith Teachers College, Hobart 1941–42; HTC under Jack Carington Smith, Lucien Deschaineux, Dorothy Stonor 1942–43; Devonport TC 1966–68; Burnie TC 1980–82; John Olsen Summer Schools 1974–75. Taught with Tas. Ed. Dept. 1943–45; St. Brendan Shaw College, Devonport 1971–76.
Exhibitions Burnie AG and Penguin Town Hall 1982; Coastal Art Group 1978 on.
Awards Zeehan Centenary Acquisitive Prize 1982.
Bibliography *Tasmanian Artists of the 20th Century*, Sue Backhouse 1988.

LILLECRAPP-FULLER, Helen QLD
Born Adelaide SA 1949. Painter in mixed media, collage, photography, assemblage, teacher.
Studies SA School of Art 1967–68; Western Teachers College; Diploma in Secondary Art Teaching 1969–71; Torrens College of Advanced Education; Diploma in Fine Art (painting) 1977–78. Extensive overseas study tours; Taught part-time at Brisbane CAE since 1980; currently tutor in painting and drawing at Kelvin Grove CAE.
Awards SAS 10 Young Artists 1977; VAB Grant 1981; Qld Gallery Trustees 1982; Artist-in-Residence North Brisbane CAE 1982.
Exhibitions One-woman shows Ray Hughes Gallery 1979, 1981, 1982, 1984, 1986; Anima Gallery, Adelaide 1986; Ray Hughes Gallery, Sydney 1987; Numerous group shows since 1977 include Pinacotheca Gallery, Melbourne 1981; Art Gallery of SA 1981, 1982; Qld Art Gallery 1982; Qld University, Art Museum 1982; *Australian Perspecta* 1983. Her work was included in *A New Generation 1983–88* at the ANG, Canberra 1988.
Represented Qld University Art Museum; Griffith University, Qld; National Gallery of Vic; Brisbane College of Advanced Education; Art Gallery of SA; SA College of Arts and Education; Visual Arts Board of the Australian Council; Qld Art Gallery, Artbank; NGV; Parliament House, Canberra and institutional and private collections in UK, Europe, Israel, Asia and Australia.
Bibliography *Art and Australia*, Vol 18 No 4; *Catalogue of Australian Perspecta* 1983, Art Gallery of NSW; *A Homage to Women Artists in Queensland Past & Present*, The Centre Gallery 1988.

LINCOLN, Nanette TAS
Born Lindisfarne, Tas. 1928. Painter, teacher.
Studies Hobart TC under Jack Carington Smith 1945–49, and taught with Tas. Ed. Dept. for twenty years.
Exhibitions Rosamond McCulloch's Studio, Hobart 1973; Art Centre Gallery 1981; with Tas. Group of Painters and CAS 1956–73.
Bibliography *Tasmanian Artists of the 20th Century*, Sue Backhouse 1988.

LINDSAY, Elizabeth VIC
Born Vic. Textile artist and designer.
Exhibitions Solo shows at Beaver Galleries, Canberra 1988; Ararat Regional Gallery 1984; Orange Regional Gallery 1988. Participated Ararat Biennial Touring Exhibition 1981, 83, 85, 87; Meat Market Centre, Melb. 1987.
Represented Institutional and private collections.

LING, Helen VIC
Born Melb. 1940. Printmaker.
Studies RMIT 1978–83.
Exhibitions RMIT; MPAC, PCA Warrnambool Reg. Gallery 1979–87.
Bibliography *PCA Directory* 1988.

LIROSI, Sarina VIC
Born Aust. 1961. Sculptor, ceramic artist.
Studies BA, Arts and Crafts 1983.
Exhibitions Solo at Devise Gallery 1985 and participated at Gryphon Gallery, Melb. State College 1983.
Represented Institutional and private collections.

LITCHFIELD, Marcia L. NSW
Born Sydney 1939. Painter of flowers, birds and animals.
Studies Meadowbank and Hornsby TCs, private tutors. Co-proprietor of Saratoga Studios, NSW.
Awards Quirindi NSW 1985; Gunnedah 1986; Goulburn Lilac 1986; Shoalhaven 1987.

LITTLE, Jennifer NSW
Born Aust. 1954. Painter.
Studies Julian Ashton School Dip. 1983; BA Visual Arts, City Art Institute 1984–86; Grad. Dip Prof. Art Studies, 1987.
Exhibitions Arthaus 1985; City Art Institute and Ivan Dougherty Galleries 1987; Blake Prize Touring Show 1987–88.

LITTLEJOHN, Vivienne NSW
Born Tas. 1948. Painter, printmaker, teacher.
Studies PIT, Melb 1967–69; Secondary art teacher, Tasmania 1970–72; Travelled and worked in Europe 1973–74; Alexander Mackie CAE Sydney, Diploma of Art 1975–76; Lived and worked for four months in Luxor, Egypt 1984; Teacher in printmaking, Sydney 1986–88; VAB Grant 1985.
Exhibitions Hargraves Gallery, Sydney 1982; Painters Gallery, Sydney 1983; Powell Street Graphics, Melb. 1984, 88; Macquarie Galleries, Sydney 1987, 90; Warrnambool Art Gallery, Vic 1983–84; MPAC 1984–86; Slovenj Gradec, Yugoslavia 1985; British International Print Biennale, Bradford, UK 1986, 88; PCA Gallery, Melb. 1988.
Represented ANG, NGV, QAG, AGNSW, La Trobe Valley and Warrnambool Reg. Galleries, MPAC institutional and private collections in UK, Europe, Australia.

LIU-ZALOGA, Anna NSW
Born Harbin, China. Painter, teacher, arrived Aust. c.1984.
Studies Surikov Art Institute, Moscow. Taught art at Beijing Institute for thirty years. Has written seven books about Russian artists. Member, Chinese Artists Association, RAS of NSW.
Exhibitions Solo show at Holdsworth Galleries 1989.

LIVINGSTONE, Fiona NSW
Born Sydney 1963. Painter, teacher.
Studies BA, SCOTA 1982–84; Grad. Dip. Ed. 1986. Grad. Dip. Visual Arts 1985–87.
Exhibitions SCOTA Gallery 1983, 84; Artspace 1985; Berrima Art Society, 338 Gallery 1988; EMR Gallery 1988, 89.

LLEWELYN, Clare QLD
Born Brisbane 1945. Sculptor in metal, teacher.
Studies Central TC, Brisbane; and with David Wilson at vacation school 1974; tutors in sculpture at Kelvin Grove CAE.
Exhibitions Solo shows at Irving Sculpture Gallery Sydney 1983, 87.
Represented Institutional and private collections in NSW and Qld.

LLOYD, Muriel **VIC**

Born Yorktown SA 1913. Painter and illustrator in oil, watercolour, pastel, pen and wash; Teacher.

Studies Awarded scholarship to Adelaide School of Art 1936; Recommended from Adelaide School of Art for apprenticeship in stained glass with Clarkson Ltd, Adelaide 1937; Enlisted with Australian Women's Auxilliary Air Force as a draughtswoman for three and a half years; Whilst at Vic barracks, Melbourne attended life class at Melbourne Art Gallery for three years 1942–45; Rehabilitation studies at RMIT for the diploma course in fine arts 1946; Attended life class in London 1950–51; Art teacher, Prahran Technical School, Vic 1946; Art Directorship with Lush Studios, Adelaide 1948–49; Artist-in-charge, packaging design studio, Cadbury's Cadby Hall, London 1950–51; Artist at Long Range Weapons Establishment, Salisbury SA 1953; Staff artist with Webb, Roberts, McMelland advertising firm, Adelaide 1954; Technical illustrator with Ferranti, computer assembly, London 1955; Technical illustrator, Elliott Brothers Ltd, London 1956; Artist-in-charge, packaging design, Cadbury's, Claremont Tas 1962; Appointed chief artist with Fiji *Times*, Suva 1968; Appointed secretary/treasurer with Mildura Tourist Association 1972.

Exhibitions One-woman shows at Hammersmith, London; Yorktown and Minlaton SA.

Awards Scholarship to Adelaide School of Art 1936; Awarded Open Section Trophy, Mildura (oils) 1978.

Commissions and Achievements Oils on fabric for Ecclesiastical Heraldry, professional banners both in Australia and London; Whilst with long range weapons, was commissioned to design and produce a mural depicting story of rocketry 1953; Completely financed and conducted a goodwill project between Australia and South Pacific Islands in the form of projecting the life and customs of the various islands and their peoples, historically and geographically in Australia and the reverse, of Australia in the islands, by way of a series of films and sound recordings.

Represented Long Range Weapons Establishment, Salisbury SA; Many institutional and private collections in Australia and overseas.

LOCK, Margaret **QLD**

Born Hamilton, Ontario Canada 1950, arrived Australia 1974. Painter and printmaker.

Studies Bachelor of Arts (hons) McMaster University, Hamilton 1972; Diploma in Visual Communication, Goldsmiths' College, University of London, UK 1978; Part-time instructor (printmaking), College of Art, Seven Hills, Brisbane 1975–76; Part-time lecturer (printmaking), Kelvin Grove CAE, Brisbane 1977; Full-time lecturer 1978–79.

Exhibitions Solo shows at Verlie Just Town Gallery, Brisbane 1979, 1981 and Ulmarra Galleries, Qld.

Represented Australian National Library, Canberra; State Library of NSW, Sydney; State Library of Qld, Brisbane; University Library, Cambridge; Pierpont Morgan Library, New York; William Andrews Clark Memorial Library, Los Angeles; Private collections.

Bibliography *PCA Directory* 1988.

LODER, Margaret **NSW**

Born Marrickville NSW 1922. Semi-abstract painter of landscapes and portraitist, mostly in oil.

Studies With Dattilo Rubbo.

Exhibitions One-woman shows at von Dorff Galleries and Saints Gallery, Sydney; 70 Arden St. Melb. 1985.

Awards Bankstown, three paintings purchased and winner of the 'Woman of the Year in Art' Award 1975; Many portrait commissions.

Represented Bankstown Municipal Collection and private collections in Australia and overseas.

LODGE, Annette L. NSW
Born NSW 1954. Painter, printmaker, theatre designer and teacher.
Studies Perth Technical College graphic design 1972; WAIT Associateship in Fine Art
1974; Perth Technical College, Printmaking 1977–78; The Banff Centre School of Fine
Arts, Canada 1979. Overseas study Malaysia 1971–73; NZ 1975; Pacific Islands 1976;
Canada 1977–80; Mexico and Canada 1981; Since 1975 has taught art around Australia and
in Canada and in recent times has been involved in Australian television as art director and
co-producer.
Exhibitions Regular shows since 1973; Seven in Canada 1978–80 and recently one-woman
show at East End Art, Sydney 1982, 1983 and Banff Centre of Fine Arts, Canada 1983.
Sydney Artists' Co-operative, Antares Gallery, Sydney 1982; Hogarth Gallery, Sydney
1985, 88; Undercroft Gallery, Uni of WA, 1986; numerous travelling shows in Canada
1978–83.
Awards The Guild of Undergraduates Painting Prize; Annual Painting Prize, sponsored by
University of WA 1973; Overseas Study/Research Grant; WA Arts Council 1978; Tuition
Scholarship; The Banff Cenre of Fine Art 1979; Commissioned Painting for The Banff
Centre 1979.
Represented The West Australian Child Care College, Perth; The Banff Centre School of
Fine Arts, Banff, Canada; Art Forum Limited, Calgary, Canada; Pan Canadian Petroleum
Corporation, Calgary; Bumper Development Corporation, Calgary; Richard Eagan
Collection, New York City; Shell Collection.

LODGE, Gillian Munro VIC
Born Melb. 1937. Naive painter.
Exhibitions Solo shows at Gallery Art Naive, Melb. 1985, 86, 87; Libby Edwards Galleries
1988; participated in group shows at above galleries 1985–89.

LOFTS, Amy NSW
Born Sydney NSW 1907. Impressionist and traditional painter and teacher.
Studies East Sydney Technical College; Exhibits on occasions at Roseville Galleries, Sydney.
Represented Many private collections in Australia and overseas.

LOHSE, Kate NSW
Born Crookwell NSW 1948. Painter and etcher.
Exhibitions One-woman shows at Mori Gallery, Sydney 1980, 1982; Participated at
Wentworth Falls 1981; Mori 1982; Woollahra 1982 and *Australian Perspecta* 1983; Heide
Park and Gallery, Melb. 1985.
Represented Artbank, National Gallery of Qld and private collections.
Bibliography *Catalogue of Australian Perspecta* 1983; Art Gallery of NSW; *What Katie Does*,
Susan Westwood, Vogue Australia October 1980.

LONG, Helen D'Olyly VIC
Born Perth WA 1946. Painter and designer.
Studies Perth Technical College, WA.
Exhibitions Exhibits annually at Springfield Art Show, Geelong and is noted for her textile
designs of jungle animals in exotic designs.

LONG, Riva VIC
Born Melb. 1956; Photographer.
Studies B.Ed., Media and Librarianship.
Exhibitions Solo show of 'Photomontage' at Images Gallery 1984; participated St. Kilda
Arts Festival 1984; Rhumbarallas 1985.
Represented Corporate and private collections.

LONGLEY, Dianne SA
Born Sydney NSW 1957. Painter and printmaker.
Studies Diploma in Art, Newcastle CAE, NSW 1975–78; Moved to Adelaide 1979;
Member CAS from 1981. Part-time lecturer, SASA 1985–87, North Adelaide S of A and
Noarlunga College of TAFE 1988. Full-time lecturer, Printmaking, Hunter IHE 1989– .
Exhibitions Solo shows at Adelaide Fine Art Gallery 1982 and Anima Graphics 1983, 84,
88; Aberdeen Gallery, Scotland UK 1985; Springton Gallery, SA 1986; New Collectables
Gallery, Fremantle 1988. Many group shows since 1978 including RSASA, Adelaide 1982;
Fremantle WA 1982; Warrnambool, Vic 1982, 87; CAS Gallery, Adelaide 1983, 84; Seoul,
Korea 1983, 88; Japan 1984; Cadaques, Spain 1984; PCA Prints to USA 1985; AGSA
1985, 88; Lodz, Poland 1985; Toronto, Canada 1986, 88; College Gallery, University of
California, USA; Greenhill Galleries, Adelaide 1990.
Awards SA Government Grant for limited edition book 1979, Acquisitive Prize at Korean
Print Show. VAB Grants 1984, 88; Box Hill Acquisitive 1987; VA/CB Grant for Tokyo
Studio 1989.
Commissions SA Government book 1979; PCA Print 1984; SA Film Library 1986; PCA
100 x 100 Print Portfolio 1988.
Represented Art Gallery of SA; Mitchell Library, Sydney, Flinders University;
Warrnambool Art Gallery, Korea Miniature Collection and private collections around
Australia and overseas.
Bibliography *PCA Directory* 1988.

LOONEY, Margarette NSW
Born Melb. Painter, teacher.
Studies Diploma FA, Gymea College of TAFE 1982. Currently teaching at Caringbah.
Awards Oyster Bay Festival 1981, 84; Noosa, Qld. 1982.

LORD, Anne QLD
Born Townsville, Qld 1953. Painter, printmaker, teacher.
Studies Eastaus Flying Art School 1972–1973; East Sydney Technical College 1974;
Alexander Mackie CAE 1975–1977; Sydney Teachers College 1978; Teaching at Townsville
College of TAFE 1979–87.
Exhibitions Solo shows at Holdsworth Contemporary Galleries, Sydney 1986, 88.
Burdekin Cultural Complex, Qld. 1987; Verlie Just Town Gallery, Brisbane 1991. Has par-
ticipated in a host of group shows around Australia since 1974 including; QAC 1983; Perc
Tucker Reg. Gallery 1984–85; Ralph Martin Gallery 1985; Hang Ups Gallery, Brisbane
1985.
Awards Has won over twenty awards since 1972, most notable first prizes at Cloncurry
1973, 84, 85; Julia Creek 1978; Townsville Pacific Festival 1983; M. Murray Award 1984;
Ernest Henry Memorial 1984; Townsville Art Society 1986; Mackay Art Society 1986;
Caltex-Artists and Art 1987. Fletcher Jones Memorial 1988.
Represented Parliament House, Brisbane; James Cook University, Townsville; Perc Tucker
Regional Gallery, Townsville; BHP Collection, Artbank; Private Collections in Australia
and Overseas.
Bibliography *PCA Directory* 1988; *Artists & Galleries of Australia*, Max Germaine:
Craftsman House 1990.

LORD, Lorna VIC
Born Melbourne Vic 1925. Traditional representational painter in watercolour and porce-
lain; Studied privately with Eric Brittain.
Exhibitions AMP Gallery, Melbourne 1976, 1978, 1980, 1981; Windeyer Gallery 1979;
Balmoral Gallery 1980; Gallery 333 1982, Auburn Gallery 1982.
Awards WE Cole Award, Flinders 1977.

Represented Institutional and private collections in Australia and overseas.

LORD, Pauline QLD
Born Colchester UK. Traditional painter of marine subjects in watercolour and oil.
Studies Colchester Art School for four years and under Cor Vissor, Dutch official marine war artist and portraitist to Queen Wilhelmina and members of the Dutch Royal Family; Founder member of the Dedham Art Club (Constable Country) member of Suffolk Art Society; She has lived and painted in Qld since 1970 and is a member of the Royal Qld Art Society; Has held one-woman shows at McInnes Gallery, Brisbane in 1973, 1976, Sheridan Gallery, Brisbane 1983; Gallery Six, Mona Vale NSW 1983.
Represented Private collections in UK and Australia.

LORRAINE, Judy VIC
Born Bendigo, Vic 1928. Ceramic artist and architect.
Studies Dip. Arch. Artist-in-Residence, Benalla, Vic 1985.
Exhibitions Solo shows at Narek Galleries, ACT, Playhouse Gallery, Adelaide Shepparton Reg. Gallery; Crafts Council, Hobart.
Commissions Lake Benalla Bicentenary Ceramic Mural 1988.
Represented NGV, municipal and private collections.

LOTZOF, June NSW
Born Johannesburg South Africa 1927. Painter, printmaker and teacher.
Studies Natal School of Art 1944; Publicity artist for MGM, Durban 1945–46; Travelled USA, Europe 1950; Designed stage sets and costumes 1954–60; Arrived Australia 1960; Art certificate from Meadowbank Technical School; Association Diploma in Visual and Performing Arts (printmaking) from Nepean CAE. Studied UK, Europe, USA 1984–86.
Exhibitions Solo show at East-West Airlines Terminal, Sydney 1983; Norfolk Island 1983; Crete 1985; The Greek Centre, Sydney 1986. Participated Lennox Gallery, Parramatta, Penrith Regional Gallery and Balmain Gallery 1981; Lismore Regional Gallery; St Georges Terrace Gallery and Willandra Gallery 1982.
Awards Portland Purchase Prize 1982.
Represented Private collections in South Africa, USA and Australia.

LOUPEKINE, Jill VIC
Born Melb. 1943. Printmaker.
Studies RMIT; Prahran TC; Uni. of Melb. 1962–64; Sir John Cass School of Art, London 1971; Asachi Cultural Centre, Nagoya, Japan 1976.
Exhibitions Nairobi, E. Africa 1978; Japan and Korea 1982–84; Rio de Janeiro, Brazil 1983; PCA Touring Show, Australia 1984–86.
Bibliography *PCA Directory* 1988.

LOVE, Julie NSW
Born NSW 1950. Contemporary painter in watercolour and ink.
Studies East Sydney Technical College; Overseas study tour to Asia, Europe, USA and Canada 1972–74; Has worked as an artist in UK, Canada and Sydney including the art dept at Macquarie University.
Exhibitions Held one-woman show of her first series 'Early Settlers' at Holdsworth Gallery, Sydney April 1977 and the second series at the same gallery in May 1978.

LOVELL, Helena TAS
Born Aust. 1936. Printmaker.
Studies Nat. Diploma Birmingham College of Art, UK 1957; Art Teachers Dip and Dip Ed. 1958.

Exhibitions Strickland Gallery, Hobart 1986, 87; Burnie AG 1987; Colonial Gallery, Evandale; Oculos Gallery, Melb. 1988; 70 Arden St. Melb. 1988.
Awards Boland WC Prize 1987.
Commissions PCA 100 x 100 Print Portfolio 1988.
Bibliography *PCA Directory* 1988.

LOVELL, Valerie VIC
Born SA 1951. Painter.
Studies SACAE, Fine Arts 1969–71; Deakin Ini. BA Humanities 1985–88.
Exhibitions Studio 20 1979; Jam Factory 1981; Barry Newton Gallery 1982; Limeburners Gallery 1983; Sweet Jamaique Gallery, Melb. 1989.

LOW, Helen NSW
Born Hobart. Painter in watercolour.
Exhibitions Numerous solo shows since 1972 include Art Centre Gallery, Hobart 1980, 81; participated Launceston Art Society 1971–80; TMAG 1973, 77; Art Society of Tas. 1978, 79; Salamanca Place Gallery, Hobart 1978. Presently shows with Boronia Gallery, Sydney.
Represented Institutional and private collections around Australia.

LOWE, Ruth NSW
Born Berlin, Germany 1923, arrived Australia 1938. Painter in oil and acrylic; Portraitist.
Studies East Sydney Technical College 1959–60 with the late Joy Ewart 1960–64 and with Professor Maximilian Fuerring 1966–68; Taught for Drummoyne Art Society; Dept of Corrective Services; Willoughby Workshop and privately.
Exhibitions Willoughby Workshop Arts Centre 1964; Woollahra Gallery 1973; Art of Man Gallery 1978; Bloomfield Gallery 1981, 1984; Gallery 460, Green Point 1981.
Awards Robin Hood 1973; Hunters Hill 1977; Drummoyne 1978; Roseville 1978; Cowra 1979; Grafton 1981.
Represented Grafton and Cowra Regional Galleries and private collections in USA and Australia.

LUCAS, Beryl VIC
Born Melbourne Vic 1926.
Studies Swinburne Technical College for four years followed by a career in textile designing, fabric painting and freelance art work; Later studied under Ramon Horsfield, Lance McNeill and David Moore for seven years; Member, Vic Artists' Society, Australia Guild of Realist Artists and the Sherbrooke Art Society.
Exhibitions Regular exhibitor in Vic competitions and Art Society shows.
Awards City of Frankston $1,000 Landscape Award 1978; Jack Montgomery Award 1978 and several minor awards.
Represented Frankston City Council Collection and in many private collections throughout Vic.

LUCE, Ilze NSW
Born Germany 1944. Painter, printmaker and potter.
Studies East Sydney Technical College 1963–66, gained Diploma of Art.
Exhibitions One-man show, Holdsworth Galleries, Sydney 1975; Regular exhibitor, Sydney Latvian House art shows.

LUDERS, Muriel NSW
Born Gundagai NSW. Naive painter in oil; Self-taught.
Exhibitions First success was at the Tumut Art Show, NSW when she was discovered by

Daniel Thomas; Solo shows at La Perouse Gallery, Canberra 1977, 1979 and in Brisbane.
Awards Tumut NSW 1962; Civic Permanent Art Award, Canberra (highly commended) 1978.
Represented Art Gallery of NSW; National Gallery, Canberra; Carnegie Collection, Vic; Private collections in Australia and overseas.
Bibliography *Australian Naive Painters,* Bianca McCullough, Hill of Content, Melbourne 1977.

LUI-ZALOGA, Anna NSW
Born Harbin, China, arrived Aust. 1984. Painter and teacher.
Studies Surikov Art Institute, Moscow. Taught art in Beijing, China for over thirty years. Member RAS of NSW and Chinese Artists Association. Has written seven books about Russian and artists.
Exhibitions Solo show at Holdsworth Galleries 1989.

LUMSDEN, Carol M. NSW
Born Toronto Canada 1945. Painter, illustrator, teacher, printmaker.
Studies Alberta College of Art, Calgary Canada 1966–70; Diploma of Fine Art, University of Calgary; Bachelor of Education 1972–74; Tas College of Advanced Education, Hobart; Bachelor of Arts (visual) 1976–77; Taught art in Australia 1974–82; Worked as background artist for series of animated Dickens stories. Teaches art at Eora Centre for Dept. of TAFE 1984 –.
Exhibitions Numerous shows in Canada and Australia since 1971 and latterly solo shows at Antique Gallery and XX Gallery, Sydney 1982, Chelsea and Seaways Galleries, Sydney 1989; participated at Mary Burchill 1986; Etchers Gallery 1987; Beth Mayne 1988–89.
Awards Edmonton Canada 1969 and Tas Arts Board Scholarship 1979.
Represented Institutional and private collections in Canada and Australia.

LUPO, Nada VIC
Born Myrtleford, Vic 1964. Painter and printmaker.
Studies Wangaratta College of TAFE and graduated in Applied Arts, Painting and Printmaking from Riverina CAE 1983–84.
Exhibitions Veritas Galleries, Eldorado, Vic. 1990 (solo); Wangaratta College of TAFE Gallery 1989; Watermark Gallery, Melbourne 1989; Disposals Art Space, Wagga 1988 (solo); Scribbles Cafe, Wagga 1987 (solo); French Tavern Gallery, Wagga 1987 (solo).

LYNN, Victoria NSW
Born Sydney 1963. Modern watercolour painter and curator.
Studies Sydney Girls HC art classes; BA (Hons.) Fine Art, Uni. of Sydney; Postgraduate Diploma in Gallery Management. Worked UK, Europe 1972, 74, 78, 80, 88–89; Israel, Cairo, Athens 1988–89. Assistant curator, Contemporary Art at AGNSW 1987– ; Studied and worked Europe, USA 1990. Curator, *Australian Perspecta* 1991.
Exhibitions Group shows at AGNSW 1980, 81, 82; NSW Touring Show 1980–81; Uni. of NSW 1987.
Publications Articles and catalogues include Bradford Print Biennale, UK 1987–88; *Australian Perspecta '89.*
Represented Institutional and private collections in UK, Europe, USA, Australia.
Bibliography *Artists & Galleries of Australia*, Max Germaine: Craftsman House 1990.

M

McALEER, Olive NSW
Traditional painter of landscapes, portraits and still life in oil and watercolour.
Studies Fourteen years with the RASNSW, awarded Diploma of Art 1986.
Exhibitions Regularly with the RASNSW and at Willandra Gallery 1990.
Awards Numerous prizes in the Camden-Campbelltown region in recent years.
Represented Campbelltown Regional Art Gallery.

McALEER, Robyn WA
Born Melb. 1945. Textile artist, designer
Studies Dip. Fine Art, Claremont TC, Perth 1978–80; BA Craft (Textile) 1983–85.
Exhibitions Numerous shows since 1979 include Undercroft Gallery 1979; WAIT Gallery
1985; Distelfink Gallery, Melb. 1986; Commonwealth Textile Exhibition, Edinburgh,
Scotland 1986; Craft Expo, Sydney 1986; Dallas, USA 1986; Craft Expo, Melb. 1987;
AGNSW 1988; Fremantle Arts Centre 1989.
Awards Hoechst Textile Award 1985; Craft Expo 1986; Craft Board Grant 1986.
Represented Institutional and private collections.

McALLISTER, Prue WA
Born Cottesloe WA 1926. Painter in oil, watercolour, charcoal, ink; Teacher.
Studies Perth Technical College, part-time; Travelled in Europe and UK 1951–53 includ-
ing study at Maidstone School of Art; Resumed studies in WA for 8 years with the late
Henry Froudist; After his death in 1968 studied sculpture at Fremantle Technical College
then completed Fine Art Diploma Course at Claremont School of Art; Teacher in drawing,
oil painting and watercolour at Applecross Technical School and Atwell House, Melville;
Member of Perth Society of Artists and Contemporary Art Society, WA Branch.
Exhibitions Solo shows at Fremantle Art Centre 1982; Glyde Gallery 1985, Many group
shows since 1967 include Cremorne Gallery 1978–81; Fine Arts Gallery 1982; Regularly
with Perth Society of Artists and CAS.
Awards Many prizes since 1972 and recently Albany Graphics 1985; Geraldton WC 1985,
88; Bunbury Purchase 1986; Mining Industry WC 1988; South Perth Bicentennial WC
1988.
Represented Institutional and private collections in UK, Europe, USA and Australia.

McALPINE, Fiona QLD
Born Brisbane 1965. Printmaker.
Studies Dip. Art, BA, Qld. C of A. Exhibited Rockhampton 1986, 88.
Commissions PCA Member Print Edition 1987.
Bibliography. *PCA Directory* 1988.

MACARTHUR, Bridgette NSW
Born Australia. Sculptor, teacher, painter.
Studies MA Fine Arts, Hartford Art school, Uni. of Hartford, Connecticut USA, 1981. BA
(Hons) Wimbledon School of Art, London UK 1977; Part-time lecturer SCOTA.
Exhibitions Solo show at Irving Sculpture Gallery, Sydney 1983; Group shows include Art
Unit, Sydney 1983; Irving Sculpture Gallery 1984; Serpentine Gallery, London 1980.
Represented Institutional and private collections in UK, Europe, USA, Australia.

McARTHUR, Elaine QLD
Born Rockhampton Qld 1947. Painter in oil and watercolour, graphic artist; Botanical illus-

trator, no formal art training.

Exhibitions Solo shows at Mt Hagen Papua New Guinea 1975; McInnes Gallery, Brisbane 1978. Cintra House Galleries 1980.

Represented Private collections in Papua New Guinea, Australia, UK and Europe.

Bibliography *A Homage to Women Artists in Queensland, Past and Present:* The Centre Gallery 1988.

McARTHUR, Kathleen QLD

Born Qld. Self-taught painter of Australian wildflowers; Started painting wildflowers by chance about 1950; Her first book of wildflowers came out to coincide with the Qld Centenary 1959; Her book *The Bush in Bloom*, Kangaroo Press, Sydney 1981.

Exhibitions Recent shows at Montville Art Gallery and the Rainbird Art Gallery, Montville, Qld. 1989–91.

McAULEY, Nita NSW

Born NSW. Equine painter, teacher.

Studies Julian Ashton school and with Professor Bissietta. Teaches with TAFE at Cowra, Grenfell and Young. Has travelled extensively studying the various breeds of horses, and has won a National Grand Prix Dressage Title. Paints mostly on commission.

Represented Club and private collections in UK, Europe, USA and Australia.

McAULEY, Norma (Abernethy) TAS

Born Sydney 1919. Painter, teacher, jeweller, metalworker.

Studies Sydney Teachers College; Paris American Academy, Paris, 1978; Adult Education, Tas., since 1976; President, Art Society of Tas. 1986–91.

Exhibitions Gallery One and Salamanca Place Gallery, Hobart 1977, 78 and annually with the Art Society of Tas. Further solo shows at Saddlers Court Gallery 1988; Lady Franklin Museum 1991.

Bibliography *Tasmanian Artists of the 20th Century,* Sue Backhouse 1988.

McBRIDE, Janice Ann VIC

Born Melbourne Vic 1938. Painter, theatre designer, muralist and teacher.

Studies Certificate of Art, Caulfield Technical College 1955–58; Painting, life drawing, screen printing, RMIT 1959–61; Art teacher for the Mitcham Arts Association, adult classes 1966–73.

Exhibitions Has exhibited in over 40 one-woman and group shows around Vic, ACT and Alice Springs since 1956; Recent shows include Eltham Gallery, Vic 1979, 1982, 1983 (solo); Participated Occulous Gallery 1980, 1981 and St Kilda Festival 1983.

Awards Dandenong Youth Festival, first prize 1954; Diamond Vallery Art Awards, Acquired 1977; Inez Hutchinson, Clive Parry Galleries highly commended 1977; Australia Council Grant for 'The Gardner Puppet Theatre' re-design of the kindergarten programme, reversable sets and props to the design and rendering of 'the Silver Pot' secondary school programme and 'Papalluga' secondary school programme, sets and props 1976, 1977.

Commissions Mural commissions for TAA are in fibreglass and perspex at AMP Building, Melbourne, Philip House, Sydney and both Tullamarine and Sydney International Airports; Theatre commissions include three for the Avenue Players, Blackburn; *Calling Dr Luke* (musical), the design of sets, costume, programme and record cover (drawing) 1968; *Cyclone,* programme and record cover, pen and ink drawing 1971; Rock opera *Paul*, polystyrene sculptural set, design costumes, programme and record cover for the seasons at Camberwell Civic Centre and the Memorial Theatre Ballarat Begonia Festival 1974; Rock opera *Paul*, re-designed set, the Great Hall, Sydney Opera House 1974; Gardner Puppet Theatre 1979, 1981, 1982, 1983 kindergarten programme sets and props; 'Under Shark Bay' puppets, sets, props (secondary school programmes), St Gerards Church, Warrandye, design nine panels

leadlight windows.

Represented Diamond Valley Council Chambers, Vic; World Record Club Collection; Private collections in Australia and overseas.

Bibliography *Art Techniques for Students,* Max Dimmack, Macmillan, Australia 1969.

MacCALLUM, Polly NSW
Born UK. Sculpture and collage.

Studies Willesden Art School and The Royal Academy of Music, UK; Dip. Art, Alexander Mackie CAE 1970; MA Visual Arts, City Art Institute 1986; Studied UK Europe 1980, 83.

Exhibitions Holdsworth Gallery 1980; Festival of Perth 1983; Coventry Gallery 1985, 88, 90; Wollongong City Gallery 1986; Group shows include Ivan Dougherty 1979; Garry Anderson 1982, 84; Coventry Gallery 1986, 87, 88; Holdsworth Contemporary Gallery 1987; Mildura Sculpture Triennial 1988; Coventry Gallery 1988; Painters Gallery 1990.

Awards VAB-Besozzo Studio, Italy 1983.

Represented Wollongong, Mildura and Fremantle Regional Galleries, institutional and private collections in UK and Europe.

Bibliography *Artists & Galleries of Australia*, Max Germaine: Craftsman House 1990. *New Art Five*, Nevill Drury: Craftsman House 1991.

McCAMBRIDGE, Jo NSW
Born Hobart 1953. Painter.

Studies BA Visual Arts, SCOTA 1982–83, Postgraduate City Arts Institute 1984. Co-ordinator, First Draft Gallery, Sydney 1988–89.

Exhibitions Solo shows at Cafe Gritz, Newcastle 1986; Painters Gallery, Sydney 1987; CAE, Brisbane 1988; First Draft, Sydney 1988. Group shows include First Draft and EMR Gallery 1988; Artspace 1989.

Represented Institutional and private collections.

McCAMLEY, Jennifer NSW
Born Brisbane 1957. Paintings, installations.

Exhibitions Collaborative works with Janet Burchill include Artspace, Sydney 1985; ACP 1986; Cité Internationale des Arts, Paris 1988; Mori Gallery 1987, 89, 91; *Australian Perspecta* 1989, AGNSW.

McCARTHY, Christine SA
Born Adelaide 1952. Painter, printmaker, teacher.

Studies SASA, Diploma FA (painting) 1976; Diploma of Teaching 1977. Taught with Education Department, 1978–81; Teacher with Ruth Tuck School since 1981.

Exhibitions Kensington Gallery, May 1984, 85; Adelaide Hilton Hotel 1986; St. Ives Gallery, Sydney 1986; Adelaide Festival Theatre 1987; Greenhill Gallery, Perth 1987; Royal Botanic Gardens, Sydney, 1988; Greenhill Gallery, Adelaide 1989

Represented Artbank, Canberra, Government Departments, institutional and private collections around Australia.

McCARTHY, Kate NSW
Born Sydney 1952. Painter, printmaker, sculptor.

Studies Northern Rivers CAE 1986; BA Visual Arts, University of New England and Northern Rivers 1990.

Exhibitions Solo shows at Gold Coast City Art Gallery 1990; Access Contemporary Art Space, Lismore 1990. Numerous group shows.

Awards UNENR Printmaking Prize 1988.

Represented Institutional and private collections.

McCLYMONT, Sally QLD

Born Rockhampton Qld 1960. Painter of the northern Australian scene in oil, watercolour, pen and wash and ink in a loose impressionist style, self taught.

Exhibitions Held an annual one-woman show at McInnes Gallery, Brisbane since 1974 and Sheridan Gallery from 1982; Participated in the 13th Grand Prix International d'Art Contemporain, Monte Carlo 1979.

Represented Qld State Gallery (painting purchased from her first exhibition when aged 13 years); Museé Nationale Monaco; Private collections in the UK, Ireland, America, Australia, NZ and Tas.

McCOLL, Mitzi NSW

Born Vienna, arrived Australia 1938. Sculptor and teacher.

Studies Under Lyndon Dadswell at the East Sydney Technical College 1953–60; She worked with Douglas Annard as an assistant on the mural sculptures in the P & O Building in Hunter St, Sydney, and the glass sculpture outside the CSR Building in O'Connell Street and also with him in Malaysia; She also worked with Margo Lewers to create the bronze mural designed by her late husband, Gerald Lewers, just before his death, for submission to the Reserve Bank, Martin Place, Sydney Competition; (This work is now in the Reserve Bank, Canberra); She taught sculpture at East Sydney Technical College (1969–72) and at Meadowbank Technical College (until 1976); In 1972 she began teaching at the Sculpture Centre, Sydney, becoming Head Teacher in 1976 and also Chief Administrator in 1980; She also teaches at summer schools and evening classes for the Dept. of Adult Education; Member of the Society of Sculptors since 1963. Presently teaching at her own studio at Northbridge, NSW.

Exhibitions and Commissions Solo show at Murray Crescent Galleries, ACT 1980, and the Sculpture Centre, Sydney 1979; Group shows with the Society of Sculptors; In 1980 she completed a commission by the Merchant Guild of Wollongong for a sandstone sculpture in two parts which stands in the Art Gallery Park in that city. Gallery 460, Gosford Bicentennial Sculpture Park 1988.

Represented Commonwealth Government Collection, Canberra, and in private collections in Australia, USA and Mexico; Sculpture in steel for Fairfield Girls High (commissioned) 1979.

Bibliography *Art and Australia,* Vol 19 No 3; *Australian Sculptors*, Ken Scarlett, Nelson 1980.

McCONCHIE, Judy ACT

Born Melbourne Vic 1938. Painter, gallery director and teacher.

Studies RMIT; Canberra Technical College and Canberra School of Art; Director of Hesley Gallery, ACT. Overseas study in NZ 1980, Asia 1981, UK, Europe 1985, 86, 88.

Exhibitions Solo shows at Ginninderra Village, ACT 1975; Galeria Tapande, ACT 1978, 1980; Hesley Gallery 1983, 84, 85; Merimbula Gallery 1986, 87; Hesley Gallery 1986, 88; Participated in numerous group shows, Canberra, Melbourne, Sydney and NZ.

Awards Numerous prizes since 1981 including first at Queanbeyan 1981; Royal Canberra Show 1983, 84, 85, 86, 87; Hawker Art Show 1984; Wanniassa Art Show 1987; Hackett Art Show 1987; Queanbeyan Lions 1988; Padua 1988.

Represented Institutional and private collections in UK, Europe, Singapore, Egypt and Australia.

McCORMACK, Carol QLD

Born Qld. Modern landscape painter.

Studies Member AFAS since 1972 under Mervyn Moriarty, Bela Ivanyi. Foundation member of Glenmorgan Art Group.

Exhibitions Solo shows at Toowoomba 1984 and Ardrossan Gallery, Brisbane 1985, 86, 87.

Represented Institutional and private collections in Australia and overseas.

McCORMACK, Christine SA
Born Adelaide 1953, Printmaker.
Studies Dip. Fine Art, SASA.
Exhibitions Art Zone Gallery, Adelaide 1988.
Represented AGSA, institutional and private collections.
Bibliography *PCA Directory* 1988.

McCORQUODALE, Suzanne TAS
Born Hobart Tas 1959. Printmaker, teacher.
Studies Bachelor of Art (Fine Arts) from Tas School of Art. 1978–81. Helped set up the
Jabberwock Paper Mill in Hobart; Taught at Bellerine Community Art Centre, Rosny
College, and the School of Art.
Exhibitions Harrington Street and Tas School of Art 1979, 1980.
Publications *Comparative Study of Australian, American and European Workshops*, Art
Network 3 and 4 with Leilani Weedon.
Bibliography *Tasmanian Artists of the 20th Century*, Sue Backhouse 1988.

McCORMACK, Christine SA
Born Adelaide SA 1953. Printmaker.
Studies Torrens College of Advanced Education and SA School of Arts.
Exhibitions Included in PCA Student Printmakers 1972; 'Arts and the Creative Woman'
1975; Artzone, Adelaide 1988.
Awards Ethel Barringer Memorial Prize for Printmaking 1973.
Represented Flinders University Collection.
Bibliography *Directory of Australian Printmakers* 1976.

McCOWN, Dana QLD
Born USA. Craftworker.
Studies Graduated Bachelor of Arts in Art Education, University of Wisconsin USA;
Studied weaving under Louise Percival.
Exhibitions Townsville Art Gallery 1973; Bakehouse Gallery, Mackay 1974; Gallery
TACA 1975, also Seiberts Gallery, Sydney; Distlefink, Melbourne and Craft Association
shows throughout Queensland.
Awards Townsville Pacific Festival, batik and jewellery sections.
Represented Stanthorpe Art Gallery, Qld.

McDERMOTT, Anne VIC
Born Australia 1960. Printmaker.
Studies BA Fine Art, Warrnambool IAE.
Exhibitions MPAC 1986; Gryphon Gallery 1986.
Awards Henri Worland Memorial 1981, 82.
Represented Warrnambool Regional Gallery.
Bibliography *PCA Directory* 1988.

McDONALD, Alina VIC
Born Ballarat, Vic. 1947. Painter.
Exhibitions Performance Space, Sydney 1985; Girgis & Klym Gallery, Melb. 1987, 88, 90.
Numerous group shows include Mori Gallery and Artspace, Sydney 1985; 200 Gertrude St.
Gallery 1986; ANG 1989; ACCA, Melb. 1989; San Diego State University, USA 1989;
University of California 1990; Woodland Pattern Gallery Milwaukee, USA 1990; Linden
Gallery, Melb. 1991; International Shadow Proejct, USA 1991.

Represented ANG; NGV; Institutional and private collections in USA and Australia.

MacDONALD, Anne TAS
Born Launceston 1960. Printmaker, photographer, teacher.
Studies Tas. S of A, BA 1981; MA, 1983. Tutor in photography, Tas. S of A 1984; Chameleon Gallery, Hobart administrator 1985; Assistant director 1987. Tutor in photography, Centre for the Arts, Hobart 1988–90, lecturer 1990–91.
Exhibitions Solo shows at Tas. S of A 1983; George Paton, Uni. of Melb. and Chameleon Gallery, Hobart 1986. First Draft, Sydney, Roz MacAllan, Brisbane 1987; Roslyn Oxley9 and CAC, Adelaide 1988, 91. Numerous group shows since 1983 include ANG, Canberra 1985, 87; *Australian Perspecta* 1985; Adelaide Festival, ACCA, Melb. 1986; Holdsworth Contemporary Gallery, Macquarie Galleries, Sydney and Uni. of Tas. 1987; George Paton Gallery 1988; ANG 1988; Roslyn Oxley9 Gallery 1988; ACCA, Melbourne 1989; Roz MacAllan Gallery, Brisbane 1989; AGSA 1990; ANG 1991; Chameleon Gallery, Hobart 19881.
Awards VAB Grants 1985, 88; TAAB Grant 1987; VA/CB Paris Studio Grant 1990.
Represented ANG, AGSA, Tasmanian Arts Advisory Board, Museum of Contemporary Art, Brisbane, University of Tasmania, Artbank.
Bibliography *Tasmanian Artists of the 20th Century*, Sue Backhouse, 1988.

MACDONALD, Fiona VIC
Born Melb. 1955. Paintings, collage, photolithographs.
Studies VCA, Melb and Postgraduate 1987.
Exhibitions Solo shows at George Paton Gallery 1985; ACP, Sydney, IMA, Brisbane and 200 Gertrude St. Melb. 1988; Group shows at IMA, Brisbane 1985; ACP, Sydney 1986; Linden, Melb. 1987; Chameleon Gallery, Hobart; George Paton Gallery, Melb. and Melb. Uni. Gallery 1988; *Australian Perspecta 1989*, AGNSW. Solo at Elizabeth Bay House, Sydney 1990.
Bibliography Catalogue of *Australian Perspecta 1989*, AGNSW.

MACDONALD, Fiona NSW
Born Rockhampton, Qld, 1956. Painter.
Studies BA, Fine Art, SASA Adelaide 1979; Assoc. Dip. Fine Art, Brisbane C of A 1976.
Exhibitions Solo shows at Mori Gallery 1983, 84, 86, 87, 88; Studio 666, Paris 1987; Group shows include Seattle, USA 1984; Uni of Tas. 1985; Uni. of Qld. Art Museum 1985. *Australian Perspecta* 1985, AGNSW; Mori Gallery 1985, 86, 87, 88, 90; Ballarat Reg. Gallery 1986; IMA, Brisbane 1986; 200 Gertrude St. Melb. 1986, 87; Chameleon, Hobart 1986; Jam Factory, Adelaide 1987; Macquarie Galleries 1987, Holdsworth Contemporary Galleries 1987; *A New Generation 1983–88*, ANG, Canberra 1988; Flaxman Gallery, London 1988; First Draft West, Sydney 1990; Heide Gallery, Melbourne 1990; Chicago International Art Exposition 1991.
Represented ANG, Artbank, AGWA, institutional and private collections in UK, Europe and Australia.

MACDONALD, Heather Joan NSW
Born Adelaide SA 1934. Traditional painter of landscapes and portraits.
Studies Portrait painting under Jerold Nathan (Fellow of the Royal Academy, London); Landscape painting under Kenneth Green and Graeme Inson at Royal Art Society of NSW; Associate, RASNSW; Exhibiting member, Ku-ring-gai Art Society and Peninsula Art Society.
Exhibitions Roseville Galleries, Sydney; Ku-ring-gai Art Society and Royal Art Society of NSW.
Awards Ku-ring-gai Art Society Silver Jubilee Prize 1990.

Represented Private collections in Australia and overseas.

McDONALD, Kim
VIC

Born Vic. 1961. Printmaker,

Studies BA Fine Art (Hons) CIT 1984, Postgraduate VCA 1986.

Exhibitions Numerous shows since 1983 and recently at 70 Arden St.; Albury Reg. Gallery and Grafton Reg. Gallery 1988.

Awards Artist-in-Residence, Camberwell Grammar School, Vic. 1985; VCA Scholarship 1986; Entry to Emily Carr School of Art, Vancouver Uni. Canada.

Commissions designed Meeniyan Mural, Vic. 1984.

Bibliography *PCA Directory* 1988.

McDONALD, Stephanie
VIC

Born Armidale NSW 1960. Painter.

Studies Brisbane C of A 1978–79; School of Art, Uni. of Tas. 1980–81. Founding member and secretary of Chameleon Inc. Hobart.

Exhibitions Uni. of Tas. School of Art Gallery 1980, 81; Crafts Council Gallery, Hobart 1982; Chameleon Gallery, inaugural 1982 and also in 1983; Long Gallery, Hobart 1982.

Bibliography *Tasmanian Artists of the 20th Century,* Sue Backhouse 1988.

MACDOUGALL, Angela
VIC

Born Melbourne 1965. Sculptor.

Studies BA (Sculpture) RMIT 1987–89.

Exhibitions Solo show at Access Gallery, Sydney 1991; Group shows at RMIT Gallery 1989; Access Gallery 1990.

Represented Artbank, institutional and private collections.

McDOUGALL, Sue
VIC

Born Melb. 1919. Painter.

Studies RMIT 1937; With George Bell 1959. President CAS Melb. 1980–82. Member Beaumaris Art Group 1954–79. Overseas study UK, Europe 1974, 77.

Exhibitions Solo shows at CAS 1965; Leveson St. Gallery 1971; Joan Gough Studio Gallery 1985; Artists Space 1986. Numerous group shows since 1963. Solo show at Eclectic Easel Melb. 1989.

Awards Isobel de Soyres Award 1974; Repatriation Prize 1982; CAS Prize 1985. MPAC Drawing (acquired) 1983.

Represented MPAC, institutional and private collections in Australia and overseas.

McELHINNEY, Myra
VIC

Born Yugoslavia 1953, arrived Australia 1967.

Studies Diploma course at Lance McNeill Realist Art School 1975–78 and with private tutors.

Exhibitions Young Masters Gallery, Melbourne 1980, 1981; Russell Davis Gallery 1980, 1981; Jorgensen Gallery 1981, 1982; Eltham Gallery 1983.

Represented Private collections in Australia and overseas.

McEVOY, Marga
VIC

Born Braunschweig Germany 1946. Ceramic artist and teacher.

Studies Diploma FA (pottery), Bendigo CAE 1963–67; Taught at Caulfield Technical School 1968; Studied at Winifred West Schools, Mittagong NSW 1969–71; Built own workshop and gallery, Bendigo 1972; Full-time lecturer, Bendigo CAE in ceramics 1974.

Exhibitions and Awards Bendigo Institute of Technology, College prize 1964, 1967; Wodezki prize 1964; Citizenship Prize and President of SRC; Dux of Vic Diploma in

Ceramics 1967; Exhibited 'Sturtshop', Mittagong and Australian Potters Workshop, Sydney 1970; Berrima Galleries, NSW and 'Sturtshop', Mittagong 1971; One-woman show, Helen West Gallery, Young NSW and Ewing Gallery, University of Melbourne 1972; One-woman show, Macquarie Galleries, Canberra 1974; Eaglehawk Pottery First Prize 1975; Judge for Shepparton Art and Craft Exhibitions 1974, 1975; Australian Arts Council Grant for workshop equipment 1975; Bendigo Pottery Award Exhibition 1976; Six months study grant of ceramics, Japan, USA, Canada and UK 1978; One-woman show, Aspen Colorado USA 1978.
Represented Private and gallery collections in Australia, Japan and USA.

MACFARLANE, Pamela ACT
Born Dunedin NZ 1926. Painter and printmaker, teacher.
Studies MA in Zoology, Otago Uni. NZ 1943–48; Dunedin School of Art 1938–46; With Melville Haysom, Brisbane TC 1950–51. Art Students League, New York 1952–58; Pratt Graphics Workshop, New York 1958–59; Lecturer in printmaking at SA School of Arts, Adelaide 1976–80.
Exhibitions Has held 14 solo shows in Australia and NZ since 1954 and recently at ANU Gallery, Canberra 1986; Participated in Australian Graphics, Poland 1972–73; Australian Prints, New York 1973; Travelling print shows to Poland and USA 1979–80.
Represented ANG; Qld AG; AGSA; TMAG; Wellington AG; Dunedin Art Gallery, NZ; Bruce Hall Collection; Australian National Univesity, Canberra and private collections in Australia, Canada, UK, Japan, NZ and USA.
Bibliography *Directory of Australian Printmakers*, 1982; *A Homage to Women Artists in Queensland:* The Centre Gallery 1988.

McGAIN, Wendy (Harrison) NSW
Born Melbourne Vic 1939. Expressionist landscape painter and teacher.
Studies Diploma in Fine Art (painting), RMIT; Art teacher at PLC Geelong, Vic for 12 months.
Exhibitions Tas Tourist Bureau Gallery, Melbourne 1961; 39 Steps Gallery, Melbourne (shared) 1970; Six Home Studio Exhibitions, St Andrews, Vic 1973–76; Stringybark Galleries, Eltham Vic (shared) 1975; Eltham Galleries, Vic 1977; Wiregrass Galleries, Eltham Vic 1978; Drawing Exhibitions, Claremont Studios, Castlemaine Vic (shared) 1979; Mackay-Harrison Galleries, Ballina NSW (shared) 1980; Ulmarra Galleries, represented in Group Exhibition 1981.
Awards Kyogle Art Festival, NSW 1979, 1980; Southern Cross Festival, Ballina NSW 1981.
Represented In private collections, Vic, SA, NSW.

McGILCHRIST, Erica VIC
Born Mt Gambier SA 1926. Semi-abstract painter in oil and acrylic; Designer, art teacher and lecturer.
Studies SA School of Arts and Crafts, part-time 1936 (aged 10) to 1946; Adelaide Teachers College, Art Teachers' Certificate 1945–46; Melbourne Technical College (now RMIT), part-time 1952–55; Akademie der bildenden Künste (Academy of Fine Arts), postgraduate, Munich 1960–61; Co-ordinator, Womens Art Register 1978–87.
Exhibitions Over forty solo shows since 1951 including Munich 1960, 63, Qantas Gallery, London 1963; Naples 1978 and in recent times at Monash Uni. Melb. 1980; Caulfield Arts Centre 1986; and a Bicentennial Project Retrospective 1951–88, at Springvale Public Library Vic 1988; Victorian Womens Trust Gallery 1991. Has participated in a host of important shows in UK, Europe and Australia since 1950 and recently at NGV 1979; QAG 1979; Golden Age Gallery, Ballarat Vic 1983; Meat Market Centre, Melb. 1988; Subject of a 30 minute video documentary by Ugo Mantelli 1988.

Awards John White Landscape Prize (student award, Adelaide School of Arts and Crafts) circa 1944; Adelaide *Advertiser* Prize for Contemporary Art, shared with Wladislaw Dutkiewicz 1956; Helena Rubinstein Mural Prize, mural installed Women's University College, Melbourne 1958; Postgraduate scholarship from German Academic Exchange Service, taken up at Akademie der bildenden Künste (Academy of Fine Arts), Munich 1960, 1961; Grant from Dyason Bequest, Art Gallery of NSW 1961; Grant from German Academic Exchange Service for solo exhibition at Galerie Gurlitt, Munich 1963; Visual Arts Board Grant 1973; Caltex Art Award 1978; Has been responsible since 1973 for many cover designs and illustrations in Australian and overseas publications, ballet sets and costumes for Ballet Victoria and Australian ballet and postage stamp designs for Australia Post; Decorated tram for Vic; Ministry for the Arts 1979; VAB Grant 1981, and grants from Vic Ministry for the Arts, ACTU, VAB, Myer Foundation and Reichstein Foundation for Womens Art Register activities 1978–87.

Represented ANG, NGV, AGNSW, institutional and private collections in UK, Europe, Israel and Australia.

Bibliography *Art and Australia,* Vols 2/3 and 5/1; *Australian Painting 1788–1970,* Bernard Smith, Oxford University Press 1974; *Encyclopedia of Australian Art,* McCulloch, Hutchinson 1977; *Who's Who of Australian Women,* Lofthouse and Smith, Methuen Australia 1982.

McGILLIVRAY, Sally TAS
Born Hobart 1964. Ceramic artist.
Studies BFA, Uni. of Tas. S of A 1982–85; Hon. research associate 1986–87.
Exhibitions Solo show at Handmark Gallery, Hobart 1987. Participated at Crafts Council Gallery 1986; Devonport Craft Acquisition 1986; Uni. of Tas. 1986; Beaver Gallery, Canberra 1987.
Awards Crafts Board 1986; Designer-Makers Co-op. 1987; Ed. Dept. Commission 1987.
Represented Devonport GAC; TMAG; Uni. of Tas.

McGOWAN, Maidie (MacWhirter) VIC
Born England, 1906, arrived Melbourne 1920. Painter in oils.
Studies National Gallery School under W.B. McInnes, 1920s; George Bell School 1935–1938; Foundation member of The New Group at the Athenaeum Gallery 1937, and the CAS and Melbourne Contemporary Artists. Past President of Melbourne Society of Women Painters and Sculptors.
Exhibitions One Woman exhibits at VAS 1974; Clive Parry Galleries 1978; Mornington Gallery 1987, with Justin Gill and Guelda Pyke, AFFA Gallery, Bendigo 1988, 89; Group shows at VAS 1939, 1960–65; David Jones' Gallery 1945; McClelland Gallery (Frankston), 1981, 1982; Georges 1981; Avant Gallery 1982; AFFA Gallery, Bendigo 1986, 1987; Holland Fine Art Sydney 1987; Quasions Mornington Gallery 1991.
Represented McClelland Gallery, private collections in Australia and overseas.

McGRATH, Marilyn NSW
Born Sydney NSW 1939. Sculptor and teacher.
Studies Newcastle Technical College Art School 1958–60; Studied Sculpture at National Art School, East Sydney 1960–62; Teacher at National Art School, Newcastle 1970–74; Teacher at School of Art and Design, Newcastle Technical College 1977–79; World study tour 1976–77; Project Fellowship to study sculpture in New York; AGNSW occupancy of Cité Internationale des Artes, Paris 1988. Lecturer, Seaforth College of TAFE 1980–89.
Exhibitions Solo shows at Bonython Gallery, Sydney 1975 and Adelaide 1980; von Bertouch Galleries, Newcastle 1979, 80; Numerous group shows including Society of Sculptors, Sydney 1972; von Bertouch Galleries 1973, 88, 90; Bonython Gallery 1974; Robin Gibson Gallery 1981, 88, 89; Manly Art Gallery 1983; AGNSW 1985.

Commissions Newton-John Award, University of Newcastle 1977; BHP bronze sculpture gift to City of Newcastle.
Represented Art Gallery of NSW; City and University of Newcastle and institutional and private collections in Australia and overseas and Qld Art Gallery.

McGREGOR, Charmian NSW
Born Toowoomba Qld 1914. Traditional painter in oil, mostly flower subjects.
Studies Under Albert Rydge, Peter Panow and Molly Flaxman, Royal Art Society, Sydney; Exhibits regularly with the society of which she is an associate, and paints on commission.
Represented Private collections in Australia, UK, USA, and Japan.

McGUIGAN, Nancye NSW
Born NSW 1943. Traditional painter.
Studies With Jock Lumsden and Betty Morgan 1972; Weekend workshops with Reg Campbell and Robert Wilson 1984, 85, 86, mostly self-taught.
Exhibitions Solo shows at own gallery at Leura NSW 1972–90. Numerous group shows.
Awards Many awards in local competitions since 1972, and her work has been reproduced in two series of limited edition prints.
Represented Diplomatic, institutional, private collections in UK, Europe, USA, Japan, Canada, NZ and Australia.

McGURGAN, Elizabeth Ruth NSW
Born NSW. Painter and teacher.
Studies Dip FA and Dip Ed. Canberra S of A. 1969–76; Double major in FA from ANU, Canberra 1985, also has a graduate diploma in Community Counselling.
Exhibitions Solo show at Ariel Bookshop, Sydney, participated at Cooks Hill Gallery, Newcastle, Access Gallery, Sydney and in Canberra 1987.
Represented Government offices, institutional and private collections.

McINERNEY, Sally NSW
Born Sydney NSW 1946.
Studies No formal art training; Studied etching techniques at Workshop Art Centre, Willoughby NSW 1973–74; Works as freelance journalist; Editor of *The Confessions of William James Chidley*, Qld University Press 1977.
Exhibitions Macquarie Galleries, Sydney 1974; Collections Gallery, Perth; Prouds Gallery, Sydney 1977.
Represented Private collections in Australia and overseas.

McINTYRE, Jocelyn TAS
Born Tas 1943. Semi-traditional painter of still-life and interiors in oil and watercolour, teacher. Married to artist Alan McIntyre.
Studies Uni. of Tas. 1960–61; Launceston TC 1966–71; Launceston Teachers College 1971–72; Associate Diploma, Ceramics, LTC 1981. Taught Sacred Heart College 1971–79 and part-time at LTC 1976–79. Overseas study tour 1981.
Exhibitions One-woman show, Bowerbank Mill Gallery, Deloraine Tas and jointly with husband at Greenhill Galleries, Adelaide 1977–78, 84; Ritchies Mill Gallery 1989; With Launceston Art Society 1969–79; TMAG 1970; Young Originals, Melb. 1978.
Represented Artbank, Uni. of Tas., institutional and private collections.
Bibliography *Tasmanian Artists of the 20th Century*, Sue Backhouse 1988.

McKAY, Barbara USA
Born Sydney 1940. Painter, printmaker, teacher.
Studies Diploma FA–Nat. Art School, Sydney 1956–60; Director Workshop Arts Centre,

Sydney 1984–85. Overseas study in UK, Europe, USA 1961–63, 75, 76, 80–83, 85; Presently working in New York.

Exhibitions Solo shows at WAC, Willoughby 1971; Arts Council 1973; Hogarth Gallery 1975, 76, 77, 79, 80; Rudy Komon 1983; Studio 1984; Painters Gallery, Sydney 1985, 87, 89. Numerous group shows since 1974.

Represented Bathurst Regional Art Gallery; Wollongong City Art Gallery; Australian Council for the Arts; Australian National University, Canberra; Private collections in Australia, Europe and USA.

MACKAY, Brenda SA
Born Melbourne Vic 1950. Textured tapestry sculptures in natural fibres.
Studies Marleston School of Wool and Textiles SA 1974–75; The Rocks Weaving School, NSW 1977; School of Art & Crafts, SA under Therese Stacher 1983.
Exhibitions The Rocks Weaving Gallery 1977–78; Strawberry Hill Gallery, Sydney 1980; The Meat Market Craft Centre, Melbourne 1981; Finchley Galleries, SA 1983.

MACKAY, Ming VIC
Born Torquay UK 1918. Realist-expressionist painter in mixed media, pastel, oil; Teacher, portraitist.
Studies St Martins School of Art, London; Central School of Arts and Crafts, London under Bernard Meninsky; Diploma, Royal Drawing Society; Member, Society of Graphic and Industrial Artists, Federation of British Artists and Realist Artists; Taught at Barret Square Technical College, Chelsea School of Art, and Central School of Arts, London. Since arrival in Australia has taught at SA School of Arts; Presently teaching life drawing and painting at the Vic Artists Society and working as freelance artist and consultant; Served for five years in army intelligence unit during World War II, and she has periodically talked on art on ABC radio and television; Resident artist for Dept of Education Scheme 1981; Artist-in-Residence, CamberwellC of E Girls Grammar School 1982; Participating artist in Artbank at VAS Melbourne 1982. Member, CAS, Cosmopolitan Group, Melb.; Chelsea Arts Club, London; Fellow, VAS, Melb.; Co-founder, Pastel Society of Vic. 1987.
Exhibitions Many solo and group shows in Melb., Adelaide and Sydney over the years and recently at the International Exhibition of Pastellists at Lille, France 1987.
Awards VAS Portrait; CAS Drawing 1983.
Represented Private collections in Australia, UK, Brazil, USA, Denmark and France.

McKAY, Irene Betty SA
Born Port Augusta SA 1926. Painter and portraitist.
Studies SA School of Art 1968; Drawing under Mervyn Smith 1969; Painting and portraiture under William Davey and Ingrid Erns 1965–70; Fellow of RSASA.
Exhibitions One-woman shows at Copper Crest and Newton Galleries, Adelaide.
Represented Corporate and private collections in SA.
Bibliography *Who's Who in the Commonwealth,* Cambridge UK 1982.

McKENZIE, Laurel VIC
Born Geelong 1948. Painter, printmaker and teacher.
Studies 1967–69 Prahran College of Technology 1967–69; Royal Melbourne Institute of Technology 1970; Graduated Diploma of Fine Art (printmaking) 1970; State College of Vic, Hawthorn 1972; Trained Techncial Teachers Certificate 1972; Grad. Dip. Visual Arts, Gippsland IAE 1985–86; Co-ordinator of Printmaking, Box Hill College of Technical and Further Education 1973.
Exhibitions Solo shows at Miscellany Gallery, Melbourne 1969 and Hawthorn City Art Gallery 1979; Robin Gibson Gallery, Sydney 1983; Bolitho Gallery, Canberra 1983. Group shows include Tynte Gallery, Adelaide 1981; Intaglio Gallery, London UK 1982; Sweden

and Germany 1980; Paris and Doudon France 1981; Japan 1981; Switzerland 1982; Swan Hill Vic 1982; Qld Art Gallery 1982; W. Germany 1980–83; Cité Internationale des Artes Studio, Paris 1981; Cabo Frio Print Biennale, Brazil 1982; Aust. Prints to USA West Coast 1984; Krakow, Poland 1984; Aichi Prefecture, Japan 1984.
Represented Artbank, regional galleries, institutional and private collections in UK, Europe, USA, Brazil, Australia.
Awards Moya Dyring Studio, Paris 1981.
Commissions PCA 100 x 100 Print Portfolio 1988.
Bibliography *PCA Directory* 1988.

McKEOWN, Jean NSW
Born Sydney NSW. Painter of Australian wild flowers.
Studies After completing her art course at East Sydney Technical College, worked as a commercial artist for some time; Later attended Peter Panow's School of Painting for five years.
Exhibitions Has held two one-woman shows and participated in many groups at Roseville Galleries, Sydney 1968–79.
Represented Widely in private collections.

McKIE, Helen VIC
Born Coburg, Vic. Traditional realist painter of old buildings, mainly self-taught; Member VAS, Old Watercolour Club; Director of the Brighton Gallery.
Exhibitions Solo shows at ANZ Bank Gallery, Melbourne 1975 and Balmoral Galleries, Geelong 1977.
Represented Private collections in Australia and overseas.

MACKINNON, Katherine VIC
Born Melbourne, Vic 1950. Figurative artist in black and white, pencil, charcoal; Mostly self-taught.
Exhibitions One-woman show at Ewing and Paton Galleries, Melbourne University 1978; Susan Gillespie Galleries, ACT 1978; Brackenlea Gallery, SA 1978.
Represented Hamilton Regional Art Gallery, Vic.

MACKINNON, Leah NSW
Born Canberra 1943. Painter and teacher.
Studies Canberra TC 1962–69; Canberra S of A 1973–76; Lecturer CAE, Canberra 1975–77; Artist-in-Residence, Uni. of Armidale 1979–80; Lecturer at SCOTA 1985–87; Head of Painting, SCOTA 1988; Lecturer, Armidale College of TAFE 1989 –.
Exhibitions Numerous solo and group shows include Georges, Melb. 1976; ICA, Sydney 1976; West St., Sydney 1975; Solander, Canberra 1975; MPAC 1977; Powell St. 1977; Coventry, Sydney 1980; Armidale Reg. 1980; Tamworth Reg. 1982; Paton Gallery, Uni. of Melb. 1987; Artspace, Sydney 1987; Power Institute 1987; First Draft, Sydney 1988, 89; David Jones' Gallery, Sydney 1990.
Represented Institutional and private collections in Australia and overseas.
Bibliography *Encyclopedia of Australian Art*, Alan McCulloch, Hutchinson 1984.

McKINNON, Robyn TAS
Born Brisbane 1953. Painter, teacher, sculptor.
Studies Kelvin Grove TC Brisbane 1969–71; Seven Hills Art College, Diploma FA 1970–75; Launceston TC, Postgraduate 1981; Studied Visual Languages, Deakin Uni. 1987; Overseas study 1975–77; Taught Launceston, Tas 1972–74, 82–84, 88– ; Townsville Qld 1978–79; Deakin Uni. Vic 1986–88.
Exhibitions Solo show at Cockatoo Gallery, Launceston 1984, 88; Upstairs Gallery, Hobart 1988; Design Centre, Launceston 1989; Numerous group shows include Long Gallery,

Hobart 1983; Powell Street Gallery, Melb. 1982; Cockatoo Gallery 1986, 87, 88, 89; Fine Arts Gallery, University of Hobart 1988; Centre for the Arts Gallery, Hobart 1988; ACTA Touring Exhibition 1988; Design Centre and Gallery Cimitiere 1989; SA Biennale of Australian Art 1990.
Awards VAB Grant 1982, 85; TAAB Commission 1987; Manly-Warringah Prize NSW 1983.
Represented Institutional and private collections.

McKINNON-KIDD, Marianne NSW
Born Sydney 1948. Painter and portraitist.
Studies National Art School, East Sydney and Newcastle 1965–68; University of Newcastle 1990.
Exhibitions Solo shows at Armstrong Gallery 1983; Architect's Snell 1988. Group shows include von Bertouch Galleries 1979, 86, 87; Cooks Hill Gallery 1984; Lake Macquarie City Art Gallery 1986, 90; Crowtrap Studio 1986, 87, 88.
Commissions Has completed many commissions for portraits and murals.
Represented Institutional and private collections in Australia and overseas.

McLEAN, Bridgid NSW
Born NSW 1946. Painter and sculptor.
Studies Association of the Sydney Technical College on completion of the diploma course in painting 1968; Travelled USA, Europe and India 1970; Travelled Japan and the USA 1977.
Exhibitions Solo show, Watters Gallery, Sydney 1973; 'Woman in Art', mixed show at WA Institute of Technology, Perth 1975; 'Ocker Funk' Exhibition touring Australian regional galleries 1976, 1977; Solo show, paintings and sculptures, Watters Gallery and 'Ocker Funk', Realities Gallery, Melbourne 1976; Exhibition, Contemporary Art Society, SA, 'Watters at Pinacotheca', Pinacotheca, Melbourne and 'From the Funk Tradition', Watters Gallery, Sydney 1977, 1980, 1982, 1983; Penrith Reg. Gallery 1984–85; First Aust. Contemporary Art Fair, Melb. 1988; Max Watters Collection at Muswellbrook Gallery 1988; MCA, Brisbane 1988.
Awards Cowra Art Group First Prize Fiat Award 1969, Open Award 1970, 1971; North Side Arts Festival Second Open Section 1971.
Represented Australian National Gallery; Philip Morris Arts Grant; Visual Arts Board Collection; Rheem Australia Limited; Bathurst Municipal Collection; Muswellbrook Reg. Gallery; MCA, Brisbane; Private collections.

McLELLAN, Margaret (Spratt) NSW
Born Perth WA 1932. Painter, printmaker and teacher.
Studies Newcastle Technical College 1954–57; Graduated with painting diploma ASTC (hons) from National Art School, Sydney 1958–62; Taught at National Art School 1963–74; Study tour to UK, Europe 1972–73; Studied etching at Alexander Mackie CAE 1974 and taught there 1975–80; Lecturer at City Art Institute, Sydney CAE 1981–83; Set up print workshop in Redfern opened in 1984.
Exhibitions One-woman print shows at Macquarie Galleries, Sydney 1967, 1969, 1971 and Canberra 1979; Bonython Galleries, Sydney 1973; Cooks Hill Gallery, Newcastle 1973; Many group shows since 1965 and more recently East Sydney Technical College 1980, 1983; NSW House, London UK 1982; Regional galleries touring show, NSW 1983; Sydney Printmakers 1990.
Awards Hunters Hill 1968; Ashfield 1973; Gosford WC 1973; Tamworth WC 1974; Berrima WC 1974 (shared).
Represented Craft Council of NSW, Collection; The Foreign Affairs Dept, Canberra; State Government Collections; Monash University, Melbourne; Alexander Mackie College Collection; Canberra College of Advanced Education; IBM Collection, Sydney; Various

schools and private collections in Australia and overseas.
Bibliography *Directory of Australian Printmakers* 1976.

McLOUGHLAN, Tess VIC
Born Sealake Vic 1949. Contemporary painter in most media, teacher.
Studies Mercy Teachers College, Ascot Vale, Vic 1968–69; Melbourne University 1974–77; City Literature Institute, Covent Garden, London 1978–79; Private student of H. Tucker, London. Member, VAS and CAS, Melb. Taught for Vic. Government 1974–84.
Exhibitions Berriwillock and Culgoa Vic, Annual Exhibitions 1980–82; Contemporary Artists Society 1983; Group Exhibitions: Young Originals Gallery, Punt Rd, Windsor 1981–82; Contemporary Art Society 1981–82; Vic Artists Society 1981–82. Solo shows at Joan Gough Studio 1983 and Eastern Beach Gallery, Geelong 1986. Numerous group shows with VAS, CAS, Young Originals, Artists Proof Gallery.
Represented Institutional and private collections in Australia and overseas.

McMAHON, Bettina NSW
Born Sydney NSW 1930. Painter, printmaker and teacher.
Studies Julian Ashton School of Fine Arts (received Diploma 1949) National Art School, Sydney; Morley College, England 1972; Goldsmith College, London University (completed advanced etching course) 1972; Travelled and lived overseas for three years 1971–73; Teacher of etching at Workshop Arts Centre, Willoughby 1976–80 and Roseville Community Centre, 1981; Selected member of Australian Print Council 1976; Member of Sydney Printmakers and of Print Circle Group.
Exhibitions Solo shows at Dominion Gallery, Sydney 1968; Mosman Gallery 1973; Langsam Gallery, Melbourne 1974; Barry Stern Galleries 1978, 1982, 1984; Susan Gillespie Gallery, ACT 1978; Cooks Hill Gallery 1979; Chapman Gallery, ACT 1982; Tynte Gallery, Adelaide 1982; Barry Stern Sydney 1984; Barry Stern, Sydney 1988; Numerous group shows since 1968 include Sweden 1980; Cologne Germany 1980; London and Edinburgh 1982; Frenchen Germany 1980, 1983. Printmakers, London 1981, 83; Edinburgh Festival 1982; St. Louis USA 1987; Sydney Printmakers 1990.
Awards Commissioned to do Member Print for Print Council of Australia in 1981; Allocated Art Gallery of NSW; Moya Dyring Studio at the Cité Internationale des Arts, Paris, July 1982; Painting and print prizes include Bathurst 1963; Ryde 1967; Portia Geach 1968; Hunters Hill 1970; Drummoyne 1972, 1978, 1983, 1985; Bathurst 1979; Narrabri 1979; Gosford 1979; Mosman Print Prize 1983; Gosford Print 1985; Alice Springs 1985; Drummoyne 1985; Currabubula 1989; Residency, Cité des Artes Studio, Paris 1987.
Represented Australian National Gallery; Art Gallery of NSW; Bathurst Art Gallery; Newcastle City Gallery; Parliament House; Public Works State Block; University of NSW; Westmead Hospital; Fiat; First National Bank of Chicago; Notable private collections in Australia, America, England, Germany, Sweden and Spain and Cité Internationale des Arts, Paris.
Bibliography *Directory of Australian Printmakers* 1982, 88; *Artists & Galleries of Australia*, Max Germaine: Craftsman House 1990.

McMAHON, Marie NSW
Born Melbourne Vic 1953. Painter, printmaker and enamellist, teacher.
Studies East Sydney Technical College and Craft Board Traineeship 1974–75, 86. Worked and taught in various places since 1976 including Bathurst Island NT 1980, 1988–89; Printmaking Department, ESTC 1981–86; California, USA Workshop 1978.
Exhibitions Held joint exhibition with Vivienne Binns, 'Portraits of Women', shown at Universities of Melbourne and Sydney; Bondi Pavilion 1985; AGNSW 1985, 86; Artspace, Sydney, 1986; ANG Touring Show 1988; Bicentennial Print Portfolio 1988; aGOG, ACT 1989 (Solo); Tin Sheds Gallery 1991 (Solo); Warrnambool Art Gallery 1989; QAG 1990.

Awards and Commissions NSW Women and Arts Fellowship 1989; Australian Advertising Industry, Community Service Poster 1989; PCA Member Print 1989; Henri Worland Acquisitive 1989.
Represented ANG; AGNSW; Regional and institutional collections.
Bibliography *PCA Directory* 1988.

McMANUS, Barbara VIC
Born Melb. Painter, teacher.
Studies Under private tutors in Melb. Exhibiting members VAS, Waverley Arts Society, Melb.; Womens Painters; Sculptors Society and AGRA. Writes about art and teaches at many workshops. Overseas study tour 1987.
Exhibitions Solo shows at Five Ways Galleries, Kalorama Vic. 1984, 86, 88, 90; Numerous group shows since 1977.
Awards Many prizes include The Alice Bale Overseas Travel Scholarship 1986 to Europe; Finalist, Doug Moran Portrait Prize 1990.
Represented Waverley Municipal Council Vic. and institutional and private collections in Australia, UK and Europe.

McMASTER, Anne VIC
Born Melb. 1959. Printmaker.
Studies Warrnambool, IAE.
Exhibitions Artery Gallery, Geelong, Powell St. Graphics 1987; Warrnambool Reg. Gallery; 70 Arden St. Melb. 1988.
Commissions PCA 100 x 100 Print Portfolio
Bibliography *PCA Directory* 1988.

McMENOMY, Kay NSW
Born Melb. 1943. Painter and teacher.
Studies Swinburne TC, Dip. Advertising/Design 1963; Teacher Training 1964; Taught Melb. CAE 1966; Study tour USA 1977; Chischolm IT, Dip. FA 1982; Painted in UK 1983; Teaching in Sydney 1986 –.
Exhibitions Solo shows at Access Gallery 1987, 89; Group shows in Melb. and Sydney 1983–88.
Represented UK, Europe, Thailand and Australia.

MACMICHAEL, Susanne SA
Born SA. Fabric and collage artist, naive painter.
Exhibitions Solo shows at Anvil Gallery, Kiewa, Vic; Eddie Glastra Gallery, Sydney; Gallery Art Naive, Melb.; Participated Greenhill and Elders Galleries, Adelaide; Howard St, Gallery, Perth; Georges Gallery, Melb.
Represented Institutional and private collections around Australia.

McNAMARA, Margaret VIC
Born Melb. 1956. Printmaker.
Studies Prahran CAE 1976; Dip. Fine Art (Printmaking) RMIT 1976–78.
Exhibitions ROAR Studios 1981.
Bibliography *PCA Directory* 1988.

McNAMARRA, Bonnie Tjapanangka NT
Born c. 1947 at Nilpy west of Yuendumu NT. Aboriginal painter of the Napperby group, Central Australia.
Exhibitions USA, Australian capital cities.

McNAMEE, Holly **SA**
Born Boggabri NSW 1948. Painter.
Exhibitions Solo show at Anima Gallery, Adelaide 1985, 87; Her work was included in *A New Generation 1983–88* at the ANG, Canberra 1988.

McNEIL, Margaret (Madge)
See under Walker.

McNEILAGE, Moonyeen **VIC**
Born Melbourne Vic 1935. Painter, printmaker, fabric and macrame artist and teacher.
Studies Caulfield Institute of Technology and RMIT 1950–54; Worked with Arthur Boyd as a ceramic artist and a freelance illustrator 1955–58; Editor, Vic Craft News.
Exhibitions Has had five one-woman shows and participated in many group shows including 'Six Women Artists', Vic Ministry of the Arts show to all regional galleries in Vic; Competitions at Benalla, Geelong, Warrnambool and Caulfield Art Centre, where she won five awards for watercolour and drawing.
Represented Three state college collections and private collections in Australia and overseas.

McPHEE, Dora **VIC**
Born Melbourne 1953. Painter and teacher.
Studies Grad. Dip. Fine Arts, VCA 1986–87. BA (Fine Art Painting) Victoria College, Prahran Campus 1983–85. B.Sc. (Hons), Monash University 1972–76; Part-time studies in Arts and Anatomy at University of Melbourne still in progress. Also occupied with part-time art teaching and laboratory work for cancer research.
Exhibitions Solo show at George Paton Gallery 1988; Group shows include Victoria College, Prahran 1985; Chameleon Gallery, Hobart, George Paton Gallery and MOCA, Brisbane 1987; 200 Gertrude St. 1988; Judith Pugh Gallery and New Norcia Gallery, Perth 1990.
Represented Institutional and private collections in Australia and overseas.

MACQUEEN, Mary **VIC**
Born Melbourne Vic 1912. Painter, printmaker and teacher.
Studies Drawing with George Bell 1946–47 and printmaking at RMIT 1957–58.
Exhibitions One-woman shows, Kozminski Gallery, Melbourne 1945; Georges Gallery, Melbourne, 1948, 1950; Leveson Street Gallery, Melbourne 1964; Design Art Centre, Brisbane 1967, 1969, 1974; Crossley Gallery, Melbourne 1967, 1969, 1971; Macquarie Gallery, Sydney 1970; Powell Street Gallery, Melbourne 1973, 1983; Ray Hughes Gallery Brisbane 1977, 1979, 1981, 1982; Tynte Galleries, Adelaide 1983, 86; Powell Street Gallery 1985; Museum of Contemporary Art, Brisbane 1988; Charles Nodrum Gallery, Melb. 1986, 89; Survey of painting and collage 1968–1988 at the Powell Street Gallery 1988; Partipicated in Australian Print Survey 1963, 1964; 'Australian Prints Today' Smithsonian Institute, Washington USA 1966; 'Imprint', SE Asia 1970; 'Contemporary Australian Prints', NZ 1971; 'Images', India and Hong Kong 1971, 1972; Pratt Centre, New York USA 1974; 'Recent Drawings', National Gallery, Melbourne 1975; 'Twelve Australian Lithographers', National Gallery, Melbourne 1975–76; Western Pacific Print Biennial 1977; Japan Print Association Exhibition, Tokyo 1977; 'Contemporary Nude Drawing', Stuart Gerstman Galleries, Melbourne 1977; 'Contemporary Australian Prints', Perth, Fiji 1977; Drawings 78, Stuart Gerstman Galleries, Melbourne 1978; Geelong and Benalla Galleries and Monash University 1981; Art Gallery of NSW, Project 39, 1982 and *Perspecta* 1983.
Awards Vic Artists Society Drawing Prize 1957; Portland Drawing Prize 1964; Caltex Festival of Drawing, Mornington Peninsula Arts Centre 1973; Ronald Awards, La Trobe

Valley Arts Centre 1973; Henry Worland Print Prize, Warrnambool Art Gallery 1973; Maitland Print Prize 1974; F.E. Richardson Water Colour Award, Geelong Art Gallery 1976; Her lithograph *Africa Puzzle* was commissioned for PCA member print edition 1975; Mornington Peninsula Print Award 1980; A. & L. Pederson Drawing Prize, Qld 1982; PCA Print Awards 1983.
Commission Tapestries VCA Melb. 1984.
Represented National Gallery, Canberra; State Galleries of WA, SA, Vic, NSW, Qld; Regional Galleries in Geelong, Shepparton, Bendigo, Warrnambool, Mornington Peninsula Arts Centre, La Trobe Valley Arts Centre; Newcastle City Art Gallery; Artbank; Visual Arts Board; La Trobe University; Melbourne University; Flinders University; Griffiths University, Qld and private collections.
Bibliography *Directory of Australian Printmakers* 1976; *Encyclopedia of Australian Art,* McCulloch, Hutchinson 1977; *Catalogue of Australian Perspecta* 1983, Art Gallery of NSW.

McRAE, Dora (Taite) VIC
Born Vic 1908. Painter in oil of landscapes, portraits and still-life.
Studies Prahran Technical College and Heatherley's, London UK.
Exhibitions Numerous solo shows include Park Galleries, Melbourne 1945.
Represented Universities of WA and Melbourne; Bishopcourt, Melbourne and many private collections.

McRAE, Hazel WA
Born Sydney NSW. Landscape painter.
Studies Wollongong TAFE 1970–71.
Exhibitions Has shown in NSW and WA and recently at Juanita Gallery, Austinmer NSW 1989.
Awards Wollongong 1970, 71.
Represented Institutional and private collections in UK, Europe, USA and Australia.

McTAGGART, Josephine QLD
Born Wales, UK, arrived Aust. 1968. Painter, stage and theatrical designer.
Studies Aust. Flying Arts School. Has worked with Australian Opera Company, The Arts Council and Qld. Cultural Activities.
Exhibitions Solo shows at Ardrossan Gallery, Brisbane 1988.
Awards Atelier Acrylic Prize 1988.
Represented Institutional and private collections in UK, Europe, USA, NZ and Australia.

MACEY, Barbara VIC
Born Launceston, Tas. Textile artist, designer, quiltmaker.
Studies BA, Dip.Ed, Uni. of Tas.
Exhibitions Solo show at Distelfink Gallery, Melb 1983, 85; Participated Meat Market Centre 1981–85; Wollongong Reg. Gallery 1984; Crafts Council, Canberra 1984; Touring quilt show to USA, Japan 1985.
Represented AGWA, QAG, Artbank, municipal and institutional collections.

MADDIGAN, Gayle VIC
Born Mildura 1957. Aboriginal photographer, teacher and painter in acrylic, a descendant of the Wamba Wamba and Warraguya tribes.
Exhibitions Numerous solo and group shows and was included in the 'Women's Dreaming' Exhibition touring to many Regional Galleries.
Bibliography *Artlink* Autumn/Winter 1990.

MADDISON, Ruth VIC
Born Melb. 1945. Photographer.
Exhibitions Solo shows at Ewing Gallery, Uni. of Melb. 1979; ACP Sydney 1980; Watters
Gallery, Sydney 1983; Participated at NGV 1980; Monash Uni. 1982; Developed Image
Gallery, Adelaide 1982; Artspace, Sydney 1983; ANG, Canberra 1984.
Represented ANG, NGV, institutional and private collections in Australia and overseas.

MADDOCK, Bea VIC-TAS
Born Hobart Tas 1934. Painter, printmaker and teacher.
Studies Hobart Technical College 1952–56; Slade School, London 1959–62; Travelled and
studied in Europe 1959–62; Lecturer, Launceston Teachers College 1962; Lecturer,
Launceston Technical College 1965–69; Lecturer in printmaking, National Gallery School,
Melbourne 1970–73; Senior lecturer in printmaking, Vic College of the Arts 1974–82;
Acting Dean 1979–80; Creative Arts Fellow, Australian National University, Canberra
1976; Artist-in-Residence, Alberta University, Canada 1978; Artist-in-Residence, Sydney
College for the Arts 1979; Part-time lecturer Bendigo CAE and formed Access Studio,
Macedon Vic 1982; Head of School of Art, Tas CAE 1983–84. Member, Council of the
ANG, Canberra 1985–; Visited Antarctica through the 'Artists in Antarctica Programme'
1986.
Exhibitions Since 1964 has held over thirty solo shows around Australia and recently at
Stuart Gerstman Galleries, Melb. 1988. Participated widely in International prints exhibi-
tions including Smithsonian Institute, Washington DC 1966; NZ 1971; S.E. Asia 1971;
India 1971, 77; Yugoslavia 1976, 77, 78; New York 1971, 72; Poland 1971, 72, 74, 76;
Victoria and Albert Museum, London 1972; Norway 1972; USA 1973, 76; Tokyo 1974; W.
Germany 1976; E. Germany 1977; Canada 1978 and more recently at 'Junij' Exhibition,
Ljubljana Yugoslavia; Commonwealth Print Portfolio Exhibition, Edmonton Canada;
'Seven Printmakers', TCAE, Hobart, Tas 1978; Gallery A, Sydney 1980; *Australian Perspecta*
1981, Art Gallery of NSW; Bendigo Art Gallery 1981; 'Cool Contemporary Art', Australian
National University, ACT 1983; 'Bea Maddock Prints 1960–82', toured NZ 1982–83;
'Recent Australian Painting'; A survey 1970–83, AGSA 1983; 'In Sequence' Hobart SOA
1985; ANG Prints 1985; Budapest 1985; Bradford UK 1986; Kyoto, Japan 1986; 200
Gertrude St. Melb. 1987; QVMAG 1987; ANZ Touring Show 1987–88; Antarctic Group
Newcastle Reg. Gallery and TMAG 1988.
Awards and Commissions Tas Drawing Prize 1968; F.E. Richardson Print Prize, Geelong
1969; VAB Grant 1973; International Print Biennale, Cracow, Poland 1974; Commission,
Print Council of Australia, Members Print 1974; Creative Arts Fellowship, Australian
National University 1976; Commission, Visual Arts Board, ten prints for Seventh
International Contemporary Art Exhibition, New Delhi India 1977; Commission,
Commonwealth Games Print Portfolio, University of Alberta, Canada 1977; VAB High
Court, ACT 1979; Alice Prize 1979; Qld Art Gallery Purchase Prize 1982. Greta Horte por-
trait 1986; ANG-ANZ painting 1987; New Parliament House posters ACT 1988; AM
1991.
Represented Museum of Modern Art, New York; ANG; NGV; TMAG; AGSA; QAG;
QVMAG; Regional Galleries; Institutional and private collections in UK, Europe, USA,
Canada, Tokyo, India and Australia.
Bibliography *Encyclopedia of Australian Art*, Alan McCulloch: Hutchinson 1984; *PCA
Directory* 1988; Catalogue of *Australian Perspecta 1981*: AGNSW.

MADIGAN, Rosemary NSW
Born Glenelg SA 1926. Sculptor, painter and teacher.
Studies Diploma in Sculpture, East Sydney Technical College 1948; Study tour to Europe,
UK and India 1950–53; Sir John Cass College, London 1952; Taught at SASA 1964; ESTC
1964; Mary White Art School 1964; Sculpture Centre 1975–79 and ESTC since 1973.

Exhibitions Gallery A, Sydney 1964, 1974; Sculpture Centre, Sydney 1976, 1977; Genesis Exhibition Part Two, Sydney 1978; Rudy Komon 1980–83 (solo); Participated David Jones' Gallery 1980; Queen Street Gallery 1980; Art Gallery of SA 1981; Macquarie University 1982; ESTC Staff Show 1982; Garry Anderson Gallery 1982, 1983, 1986, 1989; David Jones' Gallery, Sydney 1985; Second Australian Sculpture Triennial, NGV, 1984.
Awards NSW Travelling Art Scholarship 1950; Visual Arts Board Grant 1976.
Represented National Collection, Canberra; Art Gallery of NSW; Rockhampton Art Gallery, Qld; Avon Collection, New York; Private collections in Australia; New York and London.
Bibliography *Larousse Encyclopedia of Art, Australian Sculptors*, Ken Scarlett, Nelson 1980.

MAGILTON, Alison VIC
Born Vic. Artist and Weaver.
Studies Diploma of Art (sculpture); Tutor in weaving for CAE, Melbourne and Artist-in-Residence, Melbourne College of Textiles 1981.
Exhibitions Numerous one-woman shows include Craft Centre, Melbourne 1976, 1979; Distelfink Gallery, Melbourne 1977; Design Centre, Launceston 1980; Footscray Community Arts Centre 1982; Recent group shows include Hawthorn City Gallery 1980; Meat Market Craft Centre 1981; Gryphon Gallery 1983.
Represented Sale Regional Arts Centre; State College, Burwood, Vic; Australian War Memorial, Canberra; Qld Art Gallery; City of Footscray and institutional and private collections in Australia and overseas.

MAHOOD, Marguerite Dr VIC
Born Melbourne Vic 1901. Painter, potter, printmaker and art historian.
Studies Painting at National Gallery School, Melbourne; Ceramics, RMIT; Dr Mahood established herself as a fine graphic artist and watercolourist in the 1920s; Lectured on design in the early days of radio and wrote articles for the *Listerner-in* and its Sydney counterpart *Radio*; After a very successful career as a potter from 1931–50 she turned to academic life, gaining her Master of Arts and Doctor of Philosophy in history; Her thesis was on Australian political cartoons of the late 1800s; Presently working on another book which she expects to be a satirical view on the development of Melbourne social and political life as seen by cartoons.
Bibliography Catalogue, *The Printmakers*, Important Women Artists Gallery, Melbourne 1977.
(Died 1989)

MAIS, Hilarie NSW
Born Leeds, UK 1952. Painter, sculptor.
Studies Bradford School of Art 1970–71; BA Hons, Winchester School of Art 1971–74; Slade Higher Diploma, Boise Scholar, Slade School of Fine Art 1975–77; Fellowship New York Studio School 1977–78; Visiting Artist, SUNY., Purchase, NY. 1980–81; Resident in New York 1977–81; Resident in Sydney 1981 –.
Exhibitions Solo shows at Cuningham Ward, New York 1977–79; Billiard Room Gallery, Boston 1979; Betty Cuningham, New York 1981; Christine Abrahams Gallery, Melb 1986, 89; Roslyn Oxley9 Gallery, Sydney 1984, 87, 88, 90; Centre for the Arts, Hobart 1990; CAC, Adelaide 1990; Christopher Leonard Gallery, New York 1991. A host of group shows since 1974 include *Biennale of Sydney* 1982, 86, 88; *Aust. Sculpture Triennial* 1984, 87, NGV; *Perspecta* 1985, AGNSW and touring exhibition; *Recent Acquisitions of Contemporary Australian Art*, ANG Canberra; Crescent Gallery Dallas USA 1987; ACCA, Melb 1988; AGNSW 1989; Roslyn Oxley9 1990.
Awards Hampshire Travel Award, UK 1973; Boise Scholarship, UK 1977; HFC Award, USA 1977; VACB Artist Grant 1977, 87.

Represented ANG, AGNSW; NGV; Artbank; Slade School, London UK; New Parliament House, Canberra, institutional and corporate collections in Australia and overseas.
Bibliography *Catalogue of Australian Bicentennial Biennale* AGNSW 1988; *Contemporary Australian Sculpture*, Graeme Sturgeon: Craftsman House 1991; *Artists & Galleries of Australia*, Max Germaine: Craftsman House 1990.

MALBUNKA, Helen
NT

Aboriginal painter in acrylic on canvas from the Hermannsburg region of Central Australia.
Exhibitions Bloomfield Galleries, Sydney 1989.

MALET, Mary-Jane
WA

Born Chargot UK 1938. Painter and portraitist.
Studies Somerset College of Art 1955–56; Ruskin School of drawing and fine arts, Oxford; National Diploma of Design 1957–60; Diploma of Fine Arts, Oxford University.
Exhibitions Hartron House, Somerset UK 1966; Chargot House, Somerset UK 1968; Hendford House, WA 1969; Collectors Gallery and Fine Arts Gallery, Perth WA 1975, 1978.
Commissions Portraits Admiral Turl, Mrs Turl 1963; Captain Peter Hibbert; Royal Irish Hussars; Captain Barry DeMorgan; Mrs O'Connel, Malta 1964; High Sheriff of Somerset 1961; Horses for Mrs Hankies; Colonel Mitford Slades; Basil Mavroleaus; Hon Mrs Kidd; Major and Mrs Enderby; John Lindley; Horlicks Factories; Mrs John Morris; Bishop McDonald; Mr and Mrs Norman.
Represented New English Art Club, London and overseas private collections.

MALLINSON, Beryl Goldsteen
NSW

Born NSW 1916. Landscape painter in oil and watercolour.
Studies Julian Ashton School, Sydney 1931–36 under Julian Ashton, Henry Gibbons, Adelaide Perry, Thea Proctor and John Passmore; Freelance artist 1936–42; Foundation member of Parramatta Art Society and Ryde Art Society; Associate of Royal Art Society, NSW.
Exhibitions Regular exhibitor in RAS and other annual shows in Melbourne and Sydney.
Awards First Prize Waratah Festival 1960, 1963; Royal Sydney Show Watercolour 1965, Campbelltown 1964, 1965; Penrith 1975; Parramatta 1972, 1975.
Represented Institutional and private collections in Australia and overseas.
Bibliography *Who's Who in the Commonwealth*, Cambridge 1982.

MALONE, Penny
TAS

Born Hobart 1956. Photographer, printmaker, teacher.
Studies Hobart S of A 1974–77; Sydney, Brisbane 1979–80; Teaches with Tas. Ed. Dept.
Exhibitions Blue Gum Festival, TMAG 1977; Warehouse Gallery, Hobart 1977; ACP, Sydney 1978; Chamber Gallery, Hobart 1985.
Represented ANG; TMAG; and private collections around Australia.

MALONEY, Betty
NSW

Born Colac Vic. Botanical artist and illustrator.
Studies RMIT 1943–44.
Exhibitions Joint shows with her sister Jean Walker at Castlecrag Gallery and Strawberry Hill Gallery.
Publications Illustrations for Vincent Serventys *Plant Life in Australia*; *Palms*, Alec Blombery and Tony Rodd and the limited edition *Proteaceae of the Sydney Region* with text by Alec Blombery; With her sister Jean Walker she wrote and illustrated *Designing Australian Bush Gardens, More about Bush Gardens* and *All about Bush Gardens*.

MALSEED, Nancy VIC
Born Vic 1913. Semi-abstract painter in oil, watercolour and etching; No formal art training.
Exhibitions Retrospective show at City of Hamilton Art Gallery, Vic 1981.
Awards Won Portland Award twice and two of her etchings were presented by Hamilton Gallery, Vic to Hamilton Gallery, NZ.
Represented Hamilton and Portland Regional Galleries, Vic; Hamilton Gallery, NZ; Carnegie Collections, Vic and many private collections.

MANGAN, Dianne VIC
Born Melbourne Vic 1951. Ceramic artist.
Studies Caulfield Institute of Technology 1977; Now working at her own studio in NE Vic.
Exhibitions Caulfield Arts Centre 1977; Mornington Regional Arts Centre 1978; Walker Ceramics Gallery 1981; Golden Age Gallery, Ballarat 1982.

MANGOS, Simone NSW
Born Sydney 1960. Sculptures and installations, teacher.
Studies Alexander Mackie CAE, Sydney Conservatorium of Music; Teachers part-time at Uni. of Sydney.
Exhibitions Solo shows at Bondi Pavilion 1982; Union Street Gallery 1985; Performance Space and Roslyn Oxley9 Gallery, Sydney 1986, 88; Participated *The Australian Bicentennial Perspecta*, AGNSW 1988.
Awards VAB Desiderious Orban Youth Art Award 1985.
Represented AGNSW.
Bibliography *Catalogue of The Aust. Bicentennial Perspecta* 1988.

MANLEY, Elizabeth SA
Born Adelaide SA 1927. Semi-abstract painter in oil.
Studies SA School of Art; Fellow of the Royal Society of Arts, London; Fellow and president of the Royal SA Society of Arts; Elected first woman president since its inception, October 1974; Editor of *Kalori*, quarterly journal of the RSASA for some years; Director of International Women's Year Exhibition 1975, 'Art and the Creative Women'; 'Master's Choice' Exhibitions 1976, 1978; Fellow of the Australian Institute of Management; Member of Zonta International; President of the Advertising Marketing International Network, Pacific Zone; Winner of the Bulletin–Veuve Clicquot 'Business Woman of the Year' Award 1979; OBE for services to the arts 1982.
Exhibitions Numerous solo and group shows in Adelaide and the RSASA.
Represented Institutional and private collections in Australia and overseas.

MANN, Anne Saunders NSW
Born Edinburgh, Scotland 1955. Printmaker, teacher.
Studies BA, Printmaking, Jordanstone C of A, Dundee 1973–77; Lecturer, University of South Queensland 1977–81; Charles Sturt University, Wagga Wagga 1981–83; Ballarat University College, Vic. 1987–90. Member, Print Council of Australia; Chartered Society of Designers.
Exhibitions Include Aberdeen 1975, 77; Glasgow and Dundee 1976; Robin Gibson Gallery 1978; Wagga City Gallery 1982; Gold Coast City Gallery Qld 1982; Compass Gallery, Glasgow 1984; Eden Court Gallery, Inverness 1985; Upstairs Gallery 1987; Old Brewery Gallery 1988; Ballarat Fine Art Gallery 1989.
Bibliography *PCA Directory* 1988; *Artists & Galleries of Australia*, Max Germaine: Craftsman House 1990.

MANN, Gillian ACT
Born 1939. Printmaker.

Studies Lancaster, C of A UK 1961–63; Dip AO, Leicester C of A UK 1963–67; Postgraduate at Hornsey C of A, London 1967–68.
Exhibitions Numerous shows since 1970 and in recent years Poland, Italy, Tokyo, MPAC and Canberra S of A 1987; Hobart, PCA, Melb. and 70 Arden St. Melb. 1988; Jan Taylor Gallery, Sydney 1991.
Awards Commonwealth Travel 1985; Italy Study 1987; PCA Print Edition 1985; 100 x 100 Print Porfolio 1988; Blake Prize 1990.
Represented ANG, Institutional and private collections in UK, Europe and Australia.
Bibliography *PCA Directory* 1988.

MANNALL, Sally A. ACT
Born 1964. Printmaker.
Studies BA Visual Arts, Canberra S of A 1983–87.
Exhibitions Warrnambool Reg. Gallery, Vic 1987; Canberra Contemporary Art Space 1988; 200 Gertrude St. Fitzroy, Melb. 1988.
Bibliography *PCA Directory* 1988.

MANSFIELD, Janet NSW
Born 1934 NSW. Potter and writer.
Studies Ceramics at National Art School ESTC, 1964, 65; Invited participant in international symposia; Lecturer at national and international conferences and workshops; Author of several books on ceramics including *A Collector's Guide to Modern Australian Ceramics*, Craftsman House 1988 and *Salt-Glaze Ceramics: An International Perspective*, Craftsman House, 1991; Editor of *Pottery in Australia*, 1976–1990; Editor and publisher of *Ceramics: Art and Perception* since 1990. Exhibiting member of the Potters' Society of Australia since 1968. Past President of Ceramic Study Group, Crafts Council of NSW, Potters' Society of Australia. Member Art Advisory boards in art colleges in Australia. Titular member of International Academy of Ceramics from 1982.
Exhibitions Thirty solo exhibitions in Australia, Japan, NZ since 1968. Major invitational national and international group exhibitions.
Awards 1990 Australia Council Emeritus Award for Art; Order of Australia Medal, 1987; Australian Ceramic Society Award for Ceramic Design, 1986. VACB and Australia-Japan Foundation grants for study and travel.
Represented National and state galleries, many regional galleries, city and college collections in Australia; Public collections in USA, Hungary, Japan, UK and NZ.
Bibliography Articles and photographs of work have appeared in most ceramics and craft-related magazines and in many books on ceramics throughout the world.

MANTZARIS, Diane SA
Born Melb. 1962. Painter and printmaker.
Studies BA Fine Art (Painting) RMIT 1979–82.
Exhibitions Solo shows at 200 Gertrude St. Contemporary Art Space Gallery, Fitzroy 1987; Participated at RMIT Graduates 1983; Linden House 1987; Warrnambool Art Gallery (Print acquired) 1988; Fremantle Art Gallery Print Award Show 1988; SASA Gallery 1988 with Banduk Marika and Kate Breakey touring nationally to Regional Galleries; *The First International Symposium of Electronic Art,* Utrecht, The Netherlands 1988; Warrnambool Reg. Gallery, Vic 1988.
Awards VACB Grant 1986 and residency of Tokyo Studio 1987; Vic Ministry for Arts – Summer School, Adelaide 1989.
Represented Warrnambool AG: St Kilda Council; RMIT and collections in Australia and Japan.

MANWARING, Wendy (Slade) NSW
Born Sydney NSW 1936. Silver and goldsmith and jeweller.

Studies Bachelor of Arts, University of Sydney 1956; Overseas travel 1957, 1971; Worked at Australian Museum for two years; Chatswood Evening College 1967; W. Van Heeckeren School, Sydney 1969–76; Partner in Argyle Silversmith, Sydney 1972–76; Currently teaching at Loreto Convent, Sydney and privately.

Exhibitions Beaver Galleries, ACT 1977, 1983; Qld Craft Council 1978; Art of Man Gallery 1978; Gallery 62, Newcastle 1978 and numerous group shows including Australian collection of contemporary jewellery touring Europe 1982–83.

Awards Warringah Craft Prize 1977; Craft Board Grant 1976; Sculptures for 1982–85; *Australian House and Garden* Interior design awards 1981; W.B. Lawrence, Gold Presentation Tablet.

Represented Qld Art Gallery; Talbot and Jenepher Wilson Collection, Qld.

MANZIE, Betty QLD

Born Vic 1919. Watercolour painter, potter, teacher.

Studies CIT 1963; Dip Art from RMIT 1970; Alburn Teachers College and for some time in UK, Europe. Member of RQAS and Watercolour Society of Qld.

Bibliography *Australian Watercolour Painters,* Jean Campbell: Craftsman House 1989.

MARCH, Rhonda Pauline NSW

Born Balaklava SA, 1934. Painter of genre subjects, mostly self-taught, owner of Rhonda's Gallery, Glen Innes, NSW.

Exhibitions Numerous shows including Parmenter Gallery, Walcha; Pioneer Gallery, Tamworth; Kimberley Gallery, Brisbane.

Awards Many prizes since 1976 and recently at Glen Innes 1980, 81, 82; Gunnedah 1987; Goondiwindi 1986, 87; Miles 1986; St George 1986; Quirindi 1987.

Represented Institutional and private collections.

MARCUS, Donna NSW

Born Darlinghurst NSW 1960. Painter, sculptor, teacher.

Studies Hobart S of A 1977–80; City Art Institute, Sydney; MFA 1985–86. Taught with Tas. Ed. Dept. 1981–82. VAB Grant 1982.

Exhibitions Solo shows at Painters Gallery 1985; Bondi Pavilion 1988; DC Art 1988. Group shows since 1980 include Long Gallery, Hobart 1982; Artspace, Sydney 1983, 84; Avago, Sydney 1985; Hobart S of A 1985.

Represented Institutional and private collections in Australia and overseas.

MARI, Ricia NSW

Born Sydney. Painter, teacher.

Studies Dip. Painting, ESTC 1967–71; Dip. Ed., Sydney Teachers College 1972; Secondary school teacher 1973–80.

Exhibitions Solo shows at Milsons Point Studio 1984, 85; Corinne Timsit Gallery, Paris 1985, 86; Guild Gallery, London 1987; Chateau Bullecom, Belgium 1987, 88; Group shows at Djuric Gallery, Sydney 1990; Galerie des Arts, Sydney 1991.

Awards Has won a number of European art awards.

Represented Institutional and private collections in Australia and overseas.

MARIKA, Banduk NT

Born Arnhem Land NT. Aboriginal painter, printmaker and arts administrator from Yirrkala, NE Arnhem Land NT.

Studies Was taught drawing and printmaking by her father and brother, both important artists. Has been Artist-in-Residence at Flinders University, Canberra College of the Arts and at the Australian National Gallery of which she is a council member. Manager, Buku Larrngay Arts & Craft Shop at Yirrkala from 1988.

Exhibitions NTMAS, Darwin, ANG and widely around Australia and overseas.
Bibliography *Artlink*, Autumn/Winter 1990.

MARKS, Joan (Yonge) VIC
Born Pakenham Vic. 1914. Painter and portraitist.
Studies With George Bell 1934.
Bibliography *Alice 125*, Gryphon Gallery/University of Melbourne 1990.

MARKS, Rae VIC
Born Vic 1945. Realist painter in oil, acrylic and watercolour, illustrator.
Studies Diploma of Art at Swinburne Institute of Technology.
Exhibitions Solo shows at Avant Gallery, Melbourne 1973; George Paton Gallery, Melbourne; University Union 1977; Australian Galleries, Melbourne 1977, 1981, 1983, 1986; Gallery Art Naive, Melb. 1989; Participated in 'Six Women's Painters' at Regional Galleries in Vic 1976 and 'Eight Women Realists', Vic College of the Arts Gallery 1978; 'Self Portrait-Self Image' travelling exhibition 1980; Geo Paton Gallery 1981; Linden Gallery 1989.
Bibliography *Australian Naive Painters*, Bianca McCullough, Hill of Content, Melbourne 1977.

MARLOWE, Karen TAS
Born Tas. Painter in all media.
Studies PhD in English Literature, Uni. of Tas. 1983; A self-taught artist.
Exhibitions Solo shows at Salamanca Place Gallery 1983; Colonial Gallery, Evandale 1982, 87. Participated McClelland Gallery, Melb. 1983 and Alice Bale Award 1987. Won open award at Circular Head 1985,
Bibliography *Tasmanian Artists of the 20th Century*, Sue Backhouse, 1988.

MARON, Dalia NSW
Born Germany 1946. Sculptor, painter, teacher, arrived Aust. 1949.
Studies ESTC 1965–69 – Diploma FA. Taught at ESTC 1970. Study tour to Japan, China 1983, 85. Worked Jabberwock Paper Mill, Tas 1985.
Exhibitions Solo shows at Penrith Reg. Gallery 1983 and Robin Gibson Gallery 1986; Numerous group shows.
Represented Institutional and private collections in Australia, Japan and China.

MARRINON, Linda VIC
Born Melbourne Vic 1959. Painter.
Studies Vic College of the Arts 1979–81, Dip. Fine Art (Painting). Degree Conversion 1982.
Exhibitions Solo shows at George Paton; Uni. of Melb. Gallery 1983; Tolarno Galleries, Melb. 1986, 89; Roslyn Oxley9 Gallery Sydney 1987, 91; Group shows include *Perspecta '83*, AGNSW; NGV and AGWA 1984; Edinburgh College of Art, Scotland, ANZART 1984; ACCA, Melb. 1985; Uni. of Melb. 1986; Chaos, Roslyn Oxley9 1987; Moët & Chandon Touring Exhibition 1988; Roslyn Oxley9 1988; Manly Art Gallery 1989; 200 Gertrude St. Melbourne 1989; SACCA 1990; Monash University Gallery 1990; Cannibal Pierce Gallerie Australienne, Paris 1990.
Represented ANG; NGV; AGSA; Institutional and private collections in Australia and overseas.
Bibliography *Catalogue of Australian Perspecta* 1983, Art Gallery of NSW; *Art and Text*, No 8, Summer 1982.

MARSH, Anne SA
Born London UK 1956, arrived Australia 1968. Painter, sculptor and performance artist.

Studies Torrens CAE gaining Bachelor of Arts, fine art (sculpture) 1975–78.

Exhibitions Solo shows include Women's Art Movement, Adelaide 1979; Roundspace Gallery 1980; Group shows include The Women's Show, Experimental Art Foundation, Adelaide 1977; Young Artists Show, Festival Centre, Adelaide 1978; The Union Show, University Gallery, Adelaide; Recent Women's Performance Art, Women's Art Movement, Adelaide 1979; Contemporary Australian Artists, touring USA 1979–80; Anne Marsh Performance Art Documentation, The Bakery, Adelaide; Women at Work, Ewing and George Paton, Melbourne 1980; Grand Dieu!, Cairn Paris; Australian Women Artists Documentation, San Francisco Women's Building 1981; Biennale of Sydney 1982.

Bibliography *Catalogue of the Biennale* of Sydney 1982, Art Gallery of NSW.

MARSHALL, Helen NSW

Born Bellarena Northern Ireland 1918, arrived Australia 1935. Figurative, symbolic painter in oil, gouache, watercolour, collage, applique; Ceramic artist.

Studies Worked in ceramics with Stasha Halpern 1946; Started working as a full-time painter 1947; Studied with George Bell, Melbourne; Exhibited Vic Arts Society 1948; Returned to Europe, married to Phillip Martin with whom she worked in London, Italy, Paris, Ireland and Spain 1950; Journey to India travelling, working in Pondicherry 1962; Revisited Australia staying two years working and exhibiting 1968; Returned to Italy, settling in Bellaggio Italy; Worked in Paris and Brittany 1971; Returned to Australia 1979.

Exhibitions Many solo shows since 1951 and recently Holdsworth Galleries, Sydney 1969, 1977; Art of Man Gallery, Sydney 1980; Galerie Gammel Strand, Copenhagen 1980; Numerous group shows in Europe and Australia since 1948; and recently at Coventry, Sydney 1982, 91 and Richard King Gallery 1987.

Represented NGV, institutional and private collections in UK, Europe, India and Australia.

MARSHALL, Jennifer NSW

Born Adelaide 1944. Printmaker, teacher.

Studies Dip. Fine Art SASA 1959–62; Postgrad. 1963; BA (Hons) Uni. of Sydney 1976. Overseas study 1974–75, 78, 84.

Exhibitions Numerous solo shows since 1961 include Stadia Graphics, Sydney 1982, 86. Powell St. Graphics, Melb. 1986, 88; BMG, Sydney 1987; Glasgow UK and Jaroslay, Poland 1988; Many group shows 1961–89 and solo show at Realities, Melbourne 1990.

Awards Power Studio, Paris 1974–75; VAB Grant 1977; Artist-in-Residence, Riverina CAE 1977; British Council, London 1983; Moya Dyring Studio, Paris 1987.

Represented ANG, AGNSW, AGSA, Artbank, Regional Galleries, institutional and private collections in UK, Europe and Australia.

Bibliography *PCA Directory* 1988.

MARSTON, Suzie NSW

Born Sydney 1952. Modern painter, teacher.

Studies Wollongong TC 1982; Mostly self-taught; Taught Illawarra Grammar School, Wollongong and studied in India 1981–83; Awarded Power Studio, Cité Internationale des Artes, Paris 1984; Taught Canberra Art Workshop 1984; Taught Canberra S of A 1985–86.

Exhibitions Solo shows at Watters Gallery, Sydney 1982, 83, 85, 87, 89; Pinacotheca, Melb. 1983; Wollongong Reg. Gallery 1983; Chapman, Canberra 1984; Numerous group shows include Ballarat FA Gallery 1984 and Cité Internationale des Artes, Paris 1985; Penrith Reg. Gallery 1984–85; ANG, Canberra 1987; Newcastle and Tamworth Reg. Galleries 1988; First Aust. Contemporary Art Fair, Melb. 1988.

Awards Co-winner of Blake Prize 1982; Power Studio 1984.

Represented ANG, NGV, Regional Galleries and institutional and private collections in UK, Europe and Australia.

MARTIN, Beryl SA
Born Lancashire, UK 1925. Painter, writer, teacher.
Studies Private tutors 1960–66; Uni. of California 1966; London Polytechnic 1972;
Teaches watercolour, batik at Mitcham Village Art and Craft Centre 1974–84–.
Exhibitions Many solo shows since 1968 and in recent times Adelaide Festival 1984, 86;
Giles St. Gallery, Canberra 1986, 88; Cintra Galleries, Brisbane 1988; Robert Steele
Gallery, Adelaide 1989; Numerous group shows since 1980 include Parap Gallery, Darwin
1987; Art Mart, Alice Springs 1987.
Represented BP Adelaide; ANU Canberra; M. Veigli Investments; Co-operative Building
Society, Adelaide, plus many private collections in Australia, USA, UK and Europe.

MARTIN, Elizabeth NSW
Born UK. Painter, sculptor and printmaker.
Studies Westminster Technical College and Chelsea Polytechnic; Her interest in ceramics
started with Madeleine Scott Jones' classes at Newcastle Technical College in the early
1960s; Her first full-time job was layout and lettering artist for technical and trade papers;
Prior to that she had designed posters, folders and book jackets professionally; Lived at
Newcastle for many years; Part-time teacher of Newcastle Technical College and Paul
Beadle's only assistant when he was appointed head teacher of the School of Art in 1954; As
well as being a ceramicist, she is a painter and printmaker (linocuts); Designed stage sets for
many local play productions; *Playboy of the Western World*, *Waltz of the Toreadors*, *Murder in the
Cathedral*, *Twelfth Night*; Also puppeteer, having given puppet shows on television and pri-
vately; Painted murals for the Royal Newcastle Hospital Children's Ward and Stockton
Hospital.
Exhibitions One-woman shows at von Bertouch Galleries, Newcastle 1975, 1978, 1982,
1988; Morpeth Galleries 1979, 1982, 1983.
Awards Won First Prize in the Newcastle Show art section 1964 and was awarded the
Bradford Mills Prize for Painting at the Maitland Art show in 1966; First Newton John
Award presented was an Elizabeth Martin terracotta sculpture in 1975.
Represented Newcastle Region Art Gallery Collection and the Maitland City Art Gallery.
(Died 1989)

MARTIN, Florence O'SEAS
Born Ballarat, Vic. Painter and stage designer.
Studies With Archibald Colquhoun, Melbourne; American Art School, New York; Theatre
design with Sergei Soudeikine; Designed costumes and decor for Col Basil's; Ballet Russe
(Igor Schwezoff's *Lutte Eternelle*); Borovansky's Australian Ballet Company; Theatre
Company, Melbourne; Teatro Municipal Ballet, Rio de Janeiro; Grant Mouradoff Ballet
Company, New York; Became a member of the United Scenic Artists of America.
Exhibitions One-woman shows at the George Binet Gallery, New York 1950; Princeton
University 1950; Trafford Gallery, London 1955; Brummel Gallery, Melbourne 1957;
Arthur Jeffress Gallery, London 1962; Argus Gallery, Melbourne 1963; Judith Garden
Gallery, New York 1964; Mercury Gallery, London 1966; South Yarra Gallery, Melbourne
1967; Macquarie Gallery, Sydney 1974; Mized shows at the Redfern Gallery, London; Barry
Stern Galleries, Sydney 1978.
Represented Phoenix Art Museum, Arizona USA; Leicestershire Educational Authority,
UK; Nuffield Foundation Collection, UK; Surrey Educational Authority, UK; Biennale
Americana Arte South America; National Gallery, Canberra; Margaret Carnegie Collection
of Contemporary Art in Australia, USA and UK.

MARTIN, Jane WA
Born Vic. 1949. Painter, portraitist, teacher.
Studies Perth TC 1965–67; WAIT 1969; Has taught in many institutions and summer

schools since 1968, and recently Fremantle Art Centre 1987 and Albany Summer School 1988.

Exhibitions Solo shows at Greenhill Gallery, Perth and Kalgoorlie 1985; Numerous group shows include Holdsworth Contemporary Gallery, Sydney 1987 and Undercroft Gallery, Perth 1987, 88.

Represented Institutional and private collections in Australia and overseas.

MARTIN, Kim VIC

Born Melbourne Vic 1952. Ceramic artist.

Exhibitions Solo show at Ballarat Fine Art Gallery 1982; Participated at Golden Age Gallery, Ballarat 1982 and 'Contemporary Australian Ceramics' show to tour USA and Canada 1982–83.

Represented National Gallery of Vic; Art Gallery of WA, Caulfield City Art Collection and private collections.

MARTIN, Mandy ACT

Born Adelaide SA 1952. Figurative painter in oil; Printmaker and teacher.

Studies Graduated from SA School of Art 1975; Lectures in printmaking at the Canberra School of Art.

Exhibitions Over twenty-five solo shows since 1977 including Robin Gibson Galleries, Sydney 1980; Solander Gallery, ACT 1980; Roslyn Oxley9 Gallery, Sydney 1983, 84, 85, 86, 89, 91; Powell Street Gallery 1981, 83; IMA, Brisbane 1984; Milburn + Arté Gallery, Brisbane 1986, 88; Robert Steele Gallery, Adelaide 1989. Participated in a host of group shows since 1975 including NGV 1980, 82; *Australian Perspecta* '81, AGNSW; Paris Biennale des Jeunes 1982; Guggenheim Museum, New York 1984; AGNSW and QAG 1984; 'Heartland' Wollongong City Gallery 1985; Heide Museum & Art Gallery, Melb. 1985; Ivan Dougherty Gallery, Sydney 1985; Adelaide Festival and CAS Gallery 1986; Kuntshalle, Nurnberg, 3 Internationale Triennale Der Zeichnung, 1985, 86; Holdsworth Cont. Galleries and Sixth Biennale of Sydney 1986; NGV 1987.

Awards McGregor Award; Peter Stuyvesant; Gold Coast Art Prize Purchase; Alice Springs Art Prize Purchase; Australian participant, Biennale des Jeunes, Paris 1982; John McCaughey Prize, National Gallery of Vic 1983; Half VAB Grant 1984; Commission for mural panorama at new Parliament House, Canberra 1988; Hugh Williamson Prize, Ballarat 1986; Alice Prize 1990.

Represented ANG; NGV; AGNSW; AGSA; Aust. War Memorial; Artbank; AGWA; QVMAG; Many Regional Galleries and institutions and collections in Australia and overseas.

Bibliography *Directory of Australian Printmakers*, 1982, 88; Arthur McIntyre; 'Mandy Martin — An Artist with something to say', *Aspect*, Vol 4 No 1 1979; *Heresies No 1*, January 1977; *The Visual Arts*, Jacaranda Press, Second edition 1980; *Art and Australia* Vol.28 No.2; *Artists & Galleries of Australia*, Max Germaine: Craftsman House 1990.

MARTIN, Molly Napurrula NT

Warlpiri Aboriginal painter in synthetic polymer on canvas from Yuendumu, NT.

Exhibitions Lauraine Diggins Fine Art, Melb. 1989.

MARTIN, Seraphina NSW

Born Naples Italy 1954. Painter and printmaker.

Studies Workshop Arts Centre, Sydney 1969; Prahran College, Melbourne 1971; Les Beaux-Arts, Paris 1974–77; Japan 1973; BA Fine Arts, Uni. of Sydney 1984–86; Tutor at Sydney University Art Workshop; Ku-ring-gai Community Art Centre; Waverley-Woollahra Art Centre; Study tour to UK, Europe 1983, 89.

Exhibitions 'Eight Women Artists' at Glebe Town Hall, Sydney; Solo show in Sydney and

group show in Paris, France and Gallery 79, Sydney; Invited to exhibit at the Alliance Francaise with Genevieve Duches in 1982; Sydney Printmakers 1985–90; Uni. of Sydney Workshop 1986–89; Richard King Gallery.
Awards Moya Dyring Studio, Paris.
Represented Private collections in Paris and Australia.

MARTIN, Susan NSW
Born NSW. Naive painter, teacher.
Exhibitions Solo shows at Heyday Gallery, Melb. 1980, 81; Gallery Art Naive Melb. 1983, 85, 88. Numerous group shows.
Represented Institutional and private collections in UK, Europe , USA, Singapore and Australia.

MARTIN, Valerie Napaljarri NT
Warlpiri Aboriginal painter in synthetic polymer on canvas from Yuendumu, NT.
Exhibitions Lauraine Diggins Fine Art. Melb. 1989.

MARTINS, Fernanda SA
Born Sydney 1955. Aboriginal painter, printmaker, designer, teacher.
Studies ESTC 1971–72; SASA 1974, 77, 78; Graduated BA from Torrens CAE 1979; ESTC 1983, 85; Sydney CAE 1986–87, graduated Dip. Arts Ed. 1987. Founding member of Boomalli Aboriginal Artists Co-op 1987.
Exhibitions Art Unit, Sydney 1982, 84; Adelaide Festival 1986; Boomalli Aboriginal Artists Co-op., Sydney 1987, 88, 89, 90; Performance Space, Sydney 1988; *Australian Perspecta* —Artspace Gallery, Sydney 1989; The Wilderness Society, Melbourne 1989; Tjilbruke Gallery, Adelaide 1990; Gallery Heritage, Melbourne 1990; St Alban Art Festival 1990.
Commissions Has carried out many commissions for designs, illustrations and murals since 1975. Received VAB Grant 1980.

MARTORANA, Bev VIC
Born Melbourne Vic 1938. Painter and teacher.
Studies Graduated Diploma of Art and Design, Fine Art, majoring in Painting and Drawing, Caulfield Institute of Technology, Vic 1974–77; Travelled England, Europe, USA, Japan, Philippines 1978, 85, 89, 90; Lived in Rome, sent by Vic Premier's Dept as part of the Loch Art Award for Painting 1979; Travelled England, Europe, USA, Japan, Philippines 1980; Taught Painting and Drawing, Melbourne School of Art 1981–.
Exhibitions Solo shows at Clive Parry Galleries, Melbourne 1978; Drummond Street Galleries, Melbourne 1981; Recent group shows include Mornington Peninsula Art Centre 1981 and Profile Gallery, Melbourne 1982; Somers Studio 1987; La Trobe Uni. Gallery 1989.
Awards Southern Cross, Vic 1975; Loch Art Award, Vic 1978; MPAC Purchase 1983; La Trobe University Purchase 1989.
Represented National Trust of Vic; CIT Collection and private collections in UK, Europe, Japan and Australia.
Bibliography *Artists & Galleries of Australia*, Max Germaine: Craftsman House 1990.

MARY NT
Born c. 1942. Aboriginal acrylic painter from Yuendumu region, Central Australia. Warlpiri language group.
Represented Art Gallery of SA.

MASON, Elizabeth NSW
Born Ararat Vic 1925. Painter, potter, applique wallhangings.

Studies Pottery at ESTC 1964–68; Co-founder of the Annandale Association.
Exhibitions 'Eight Women Artists'. Glebe Town Hall, Sydney 1982.

MASON, Gwen VIC
Born Melbourne Vic 1922. Naive painter and illustrator of children's books.
Studies Basic art training at St Mary's College, Bendigo; Study tour to China 1978; UK, Europe, USA 1980.
Exhibitions Georges Gallery, Melbourne and one-woman shows at Australian Galleries, Melbourne 1980, 1983, 1987; Hogarth Galleries, Sydney 1984; Participated in Howard Street Gallery Perth 1983; Rainsford Gallery, Sydney 1984, 89; Gallery Art Naive, Melb. 1981–84.
Publications *Travels with Grandma*, written and illustrated by Gwen Mason, Butterfly Press 1985; *A Wrong Kind of Magic*, Butterfly Press 1987.
Represented Swan Hill Regional Gallery and private collections.

MASON, Penny TAS
Born Hobart 1950. Painter, teacher.
Studies Hobart S of A 1968–70; Taught Tas. Ed. Dept. 1971–72; Vic. Ed. Dept. 1972–73, SIT, Launceston 1985–.
Exhibitions Solo shows at Cockatoo Gallery, Launceston 1983; With David Marsden at Chameleon, Hobart 1984 and TSIT Launceston 1987. Participated at QVMAG, Devonport and Burnie AG's 1985; Handmark, Hobart 1986; Salamanca Place, Hobart 1987.
Represented Devonport AG; Devonport TC, TSIT, Launceston; QVMAG.
Bibliography *Tasmanian Artists of the 20th Century,* Sue Backhouse 1988.

MASTERS, Dot VIC
Born England. Naive painter, printmaker and ceramic artist.
Studies Salford Technical Institute, UK and after wartime service in the WRAF had further art training under the Government Rehabilitation Scheme.
Exhibitions Gallery Art Naive, Melbourne 1983.
Represented Private collections in UK, Europe, Malta and Australia.

MATHER, Gai NSW
Born NSW. Painter, ceramic artist.
Studies Willoughby Art Workshop 1966–79; Hornsby TAFE 1979–82; ESTC 1984–85; Working at Inner City Studio 1987–90.
Exhibitions Solo shows at Access Gallery, Sydney 1987, 88, 90; Group shows include Noella Byrne 1984, 85, 86; ESTC 1986; Access 1986, 87, 88.
Awards First prizes include Ku-ring-gai 1986, 87, 88.
Represented Corporate, institutional and private collections around Australia.

MATHER, Jenni VIC
Born Melb. 1946. Painter, sculptor, photographer.
Studies Dip. FA, Caulfield CAE; Part Dip. Photography, Prahran CAE.
Exhibitions La Trobe Uni. 1980, 82; Monash Uni. 1980.
Represented ANG, institutional and private collections.

MATHRICK, Pauline VIC
Born Bendigo, Vic 1948. Painter.
Studies Bendigo CAE.
Exhibitions BCAE Graduate Show 1982; Bendigo Reg. Gallery 1982; Alice Springs Art Foundation 1983, 84; Roar 2 Studio 1986.
Represented Bendigo CAE and private collections.

MATLAKOWSKI, Yolanda VIC
Born Melb. 1956. Painter and printmaker.
Studies VCA, Melb. and Dip FA, BA, RMIT.
Exhibitions Solo shows at Wattletree Gallery 1983; Niagara Gallery 1983, 85; Group shows include MPAC 1982; Japan 1984; ROAR Gallery 1984.
Represented MPAC and private collections in Japan and Australia.

MATSON, Patricia Jean (Pat) WA
Born Perth WA 1928. Landscape painter in oil and watercolour; Teacher.
Studies Mostly self-taught, she is lecturer in oil, drawing, ceramics and watercolour at the Albany Technical College; Overseas study tour 1983; Member of Albany Art Prize Committee; Vice-President of Albany Art Group; Member of Perth Society of Artists.
Exhibitions Has held one-woman shows at Melville Library and Manjimup; Participated with past winners of Albany Art Prizes at Perth Airport and at Cremorne Art Gallery with members of the Albany Art Group; Also at the Hotchin Gallery 1983.
Awards Radio 6VA Art Prize (four times) between 1964–75; Katanning Watercolour Prize 1967; Wagin Art Prize (watercolour) 1967; Busselton Watercolour Prize 1968; Harvey Watercolour Prize 1969, 1971, 1972; Bunbury Art Purchase Prize 1969, 1971; Beverley Art Prize 1971, 1972; Manjimup Art Prize 1972, 1974, 1976, 1978, 1980; Art Exhibitions Shire Prize 1973; Denmark Art Exhibition 1974, 1975; Williams Art Competition 1975, 1977; City of Belmont Purchase 1979.
Represented Perth Hospital; Sir Claude Hotchin Art Gallery; Shenton Park Annex, Swan Homes; Melville Shire; Albany High School; Albany Shire; Albany Hospital; Albany Technical College; Bunbury Art Gallery; Manjimup Town Hall; Albany Town Council Reception Rooms; Beverley Shire; Katanning Art Centre; Harvey Agriculture High School; Radio 6VA Albany.

MATWIEJEW, Magda VIC
Born Federal Republic of Germany 1948, arrived Aust. 1950. Painter.
Studies RMIT 1969–73; Melb. State College 1974.
Exhibitions Solo shows at Pinacotheca Gallery, Melb. 1982, 84; Realities Gallery, Melb. 1986, 88, 90; Anima Gallery, Adelaide 1987; Her work was included in *A New Generation 1983–88* at the ANG, Canberra 1988.

MAUDSLEY, Helen VIC
Born Melbourne Vic 1927. Painter in oil, gouache, watercolour, pen and ink. Tapestry designer.
Studies Under James Quinn at Melbourne National Gallery School.
Exhibitions Solo shows at Standfield Gallery, Melb. 1982, 86, 87, 89. Participated at ANG, Canberra 1982, 88; NGV 1988; The Victorian Tapestry Workshop completed a tapestry designed by her in 1986 and 1989.
Represented ANG Canberra, NGV, Newcastle Regional Gallery; VCA and private collections.
Bibliography *Australian Contemporary Drawing,* Arthur McIntrye 1988.

MAUGHAN, Jocelyn NSW
Born NSW. Landscape and portrait painter in oil and watercolour; Teacher.
Studies Diploma with Honours, National Art School, Sydney 1959; Overseas study tours to UK, France, Spain, Italy, Germany, Holland 1979; Taught at the National Art School, later Dept of Technical and Further Education from 1960 to present time; Senior Head Teacher, School of Art and Design, Meadowbank, Sydney; Frequent exhibitor in Archibald, Wynne and Portia Geach competitions; AWI 1989; Wall Gallery, Darlinghurst 1991.
Awards Portia Geach 1976; Le Gay Brereton Prize 1957; Margaret Fesq Memorial Prize

1983; Hawkesbury Agricultural 1978.
Represented Grafton Regional Gallery and private collections around Australia and overseas.

MAURER, Anne VIC
Born Melbourne Vic 1947. Painter in pastel and watercolour.
Exhibitions Solo shows in Manyung Gallery, Melbourne 1980, 81.
Awards Bendigo Rotary 1980, 1981.
Represented University of Sydney and private collections in Australia, Mexico, Italy and UK.

MAXWELL, Edwina NSW
Born Sydney NSW 1954. Printmaker, sculptor and teacher.
Studies National Art School, Sydney 1973–74; Alexander Mackie CAE, Diploma of Art 1975–76; New Crane Studio, London UK 1977–79; Travelled Europe 1977–79; Teaching, Cranbrook School, Sydney.
Exhibitions Solo shows at Balmain Art Gallery 1981; Participated numerous group shows and recently at Miniature Print Show, Korea 1980; Editions Galleries, Melbourne 1981; Tynte Gallery, Adelaide 1988.
Awards B. & M. Hooper Scholarship 1976; Art Gallery of NSW Travelling Scholarship 1977; Dyason Bequest 1977, 1978.
Represented Institutional and private collections in Australia and overseas.
Bibliography *Directory of Australian Printmakers* 1982.

MAXWELL, Mary Winifred (Mollie) TAS
Born St. Helens, Tas. 1922. Landscape painter, portraitist, teacher.
Studies Hobart TC 1941–45, 45–46; ESTC 1946; Goldsmith's Cottage, London 1949; La Grande Chaumiere, Paris 1950; Taught privately 1947–51; With Tas. Ed. Dept. 1953–78; Overseas study tours 1961, 69, 78, 82.
Exhibitions Held seven solo shows in Hobart and Launceston 1965–76. Regular exhibitor with Tas. Group of painters at TMAG 1945–68 and with the CAS 1963–73.
Bibliography *Tasmanian Artists of the 20th Century*, Sue Backhouse 1988.

MAY, Carolyn VIC
Born Staffordshire, UK 1939. Sculptor.
Studies Ravensbourne College of Art and Design, UK.
Exhibitions Hawthorn Gallery 1981; Mildura Sculpture Triennial 1982 and 1985; World Trade Centre, Melb. 1985.
Represented Institutional and private collections in UK, Europe and Australia.

MAY, Maggie VIC
Born Warrnambool Vic 1944. Printmaker, ceramic artist, sculptor and teacher.
Studies Graduated Art School, RMIT 1964; Fine Art, Melbourne University 1974; Fellowship Diploma in Ceramics, RMIT 1976.
Exhibitions One-woman shows at Ewing Gallery, University of Melbourne 1978; Craft Council Centre, Sydney 1979; Numerous group shows include Faenza, Italy 1980; Geelong, Ballarat and Launceston Galleries 1981–82; Travelling Ceramic Exhibition, Australia, NZ, USA 1982; Craft Council Centre, Sydney 1982; Ian Potter Foundation sculpture commission 1984; Second Aust. Sculpture Triennial, Melb. 1984; Monash Uni. 1984.
Awards John Childian Award, RMIT 1964; Diamond Valley 1978.
Represented ANG, Canberra; National Gallery of Vic; Art Gallery of WA; Museum of Applied Arts and Sciences, NSW; Geelong Art Gallery, Vic; Ballarat Fine Art Gallery, Vic; McClelland Gallery, Vic; Vic State Collection; University Collection, Melbourne

University; Diamond Valley Collection.
Bibliography Catalogue, *Contemporary Australian Ceramics*, travelling exhibitions K. Hood, National Gallery of Vic. 1982.

MAYNARD, Margaret QLD
Born South Africa 1942. Painter, weaver, designer and teacher.
Studies Bachelor of Arts from Rhodes University 1963; Diploma of Dress, Courtauld Institute of Art 1969; Master of Arts (history of art) London University 1971; Costume designer for the Performing Arts Council of Transvaal, South Africa; Editorial assistant, Visual Publications, London; Graphic designer, Dept of Education, Papua New Guinea; Assistant lecturer, Courtauld Institute of Art in Dress, London; Presently lecturer in art at the University of Qld; Has published quite a lot on Australian art and especially Qld, and co-authored a book on Qld art exhibitions and contributors, also a number of filmstrips on the History of Costume.

MAYO, Robyn NSW
Born Goulburn, NSW 1943. Printmaker and watercolour painter.
Studies Nth Sydney TC; Beaux Arts, Geneva, Switzerland 1964 and with a number of private tutors.
Exhibitions Sydney Printmakers, Berrima Art Society 1987, 90; Solo at Blaxland Gallery, Sydney 1990. Many group shows since 1976.
Awards Commissioned painting of 'Lindsay' for Womens Committee, National Trust, Sydney 1987; Commissioned painting of Bowral Old Hospital 1988; Parks and Wildlife Bicentennial Print Prize 1988.
Bibliography *PCA Directory* 1988.

MAZER, Adrienne W. (Axelrad) VIC
Born Detroit, Michigan USA 1948, arrived Melbourne 1974. Painter, photographer, printmaker, sculptor and teacher.
Studies Wayne State University, Michigan USA, Bachelor of Science (art education) 1966–70; Diploma of Art and Design at Caulfield Institute of Technology 1974–77; Wide experience as an art and craft teacher in America and Vic; Teaching at Sunshine North Technical School; Study tours to Central Australia and Hong Kong.
Exhibitions Shared show with Herman Pekel at Profile Gallery, Melbourne 1983; Numerous group shows since 1970.
Awards St Kevins, Melbourne 1982.
Represented Institutional and private collections in USA, Hong Kong and Australia.

MEADMORE, Samantha NSW
Sculptor, niece of Clement Meadmore.
Exhibitions Melb., New York and Blaxland Gallery, Sydney 1988.

MEANEY, Lesley WA
Born England 1945. Representational painter, teacher, graphic designer, arrived WA 1969.
Studies Nat. Diploma in Design and art teachers diploma in London and Liverpool, UK. Taught at Fremantle TC and Karratha College, Perth; Lived Fiji 1984–86; Solo shows in UK, Perth and Fiji.
Represented Institutional and private collections in UK, Europe, Fiji and Australia.
Bibliography *The Australian Artist*, November 1988.

MEARES, Helen R (Edwards) NSW
Born Merriwa NSW 1935. Painter and illustrator.
Studies National Art School, Sydney 1954–56 and with private tutors.

Exhibitions The St. Ives Gallery, Sydney.

MEATS, Joan NSW
Born England. Painter and teacher.
Studies Dip. Painting, Cheltenham C of A, London, UK 1950. Taught art UK 1951–61
and Nat. Art School, Sydney 1962–75.
Exhibitions Numerous solo shows include Holdsworth 1979; and retro show at
Wollongong City Gallery 1985; Group shows include Royal Academy, Royal Institute of
Oil Painters and Royal Portrait Society, London, UK.
Awards Prizes include Shoalhaven 1973; Wollongong 1974; RAS Easter Show Still Life
1973.
Represented Institutional and private collections in UK, Europe, NZ and Australia.

MEDLAND, Lilian Marguerite NSW
Born North Finchley UK 1880, arrived Aust. 1923, died Sydney 1955. No formal art train-
ing. Married to Tom Iredale who worked at the Australian Museum 1924–44 and was a
member and Past President of the Royal Zoological Society of NSW 1931–44. He wrote
over 400 books, papers and articles on animals, birds and shells many of which were illus-
trated by his wife. She also illustrated books by other noted scientists and designed postage
stamps.
Publications Notable volumes include; *The Birds of the British Islands* by Charles Stonham:
Grant Richards, London 1906–11; *A Manul of the Birds of Australia*, G.M. Mathews and T.
Iredale: Witherby, London 1921; *Birds of Paradise and Bower Birds*, Tom Iredale: Georgian
House, Melb. 1950; *Birds of New Guinea*, Tom Iredale: Georgian House, Melb. 1957.
Represented National Library of Australia, Canberra; Institutions, libraries and private
collections in UK, Europe, USA and Australia.
(*Author's Note.* This artist is long deceased and previously unrecorded, is included to ensure
her place in Australia's art history.)

MEDLIN, Pru SA
Born Maitland SA 1928. Designer and weaver.
Studies SA School of Art 1944–48; School of Art, Oxford College of Technology, UK two
years; With Louise Todd in Philadelphia USA; Director, Textile Design Workshop, Jam
Factory Workshops including SA from 1975–78; Member, Arts Grants Advisory
Committee, SA; Member, Crafts Board, Australia Council.
Exhibitions Wool Exhibition, Art Gallery of SA 1972; Art Gallery of NSW Travelling
Exhibition 1972; Bonython Gallery, Sydney 1972; Realities Gallery, Melbourne 1972;
Desborough Gallery, Perth 1974; Playhouse Gallery, Adelaide Festival of Arts 1976; Jam
Factory Gallery, Adelaide 1976; Australian Embassy, Washington 1977; Jam Factory
Gallery, Adelaide Festival of Arts 1978; Australian Crafts Exhibition 1978.
Award Grants from Crafts Board, Australia Council 1974, 1975 to have trainees in work-
shop.
Represented Crafts Board, Australia Council; Crafts Council of Australia; Art Gallery of
SA; Murchison Collection, Dallas Texas; Crown Prince of Jordan; Numerous private collec-
tions.

MEE, Sheelah QLD
Born Eastbourne UK 1920, arrived Australia 1954. Painter and teacher.
Studies In London with Arthur Lindsay and later at the Sheffield College of Art; Studied
drawing at Central Technical College, Brisbane with Mervyn Moriarty 1954; Joined the
Australian Flying Art School as a tutor in 1974; Teaches at the Brisbane Eastaus Art School.

MEEKS, Jean WA
Born UK 1942. Printmaker.

Studies Dip. Printmaking, Perth TC.
Exhibitions Fremantle Printmakers.
Bibliography *PCA Directory* 1988.

MEESON, Angela NSW
Born London UK. Painter and sculptor.
Studies Auckland University School of Fine Art for three years. Diploma of Fine Art
Conservation from Dunedin Public Art Gallery NZ. Worked and studied UK, Europe
1978–80.
Exhibitions Held numerous solo shows in New Zealand 1973–78; Centrepoint, Sydney
1988; Painters Gallery 1988; Holland Fine Art 1989; Argyle Centre 1990. Has also held
solo shows at her Sydney Studio Gallery 1984–91.
Represented Institutional and private collections in Australia and overseas.

MEGALOCONOMOS, Louise NSW
Born Sydney NSW 1953. Painter and weaver.
Studies Diploma of Art Education, Alexander Mackie CAE 1974–77; Art teacher at
Eurobodalla Technical College, Moruya NSW.
Exhibitions First one-woman show at Gallery La Funambule, Malua Bay NSW 1982;
Participated at Ivan Dougherty Gallery 1977; David Jones' Gallery 1977, 1978, 1979.
Represented Private collections in NSW, Vic and Qld.

MEILERTS, Ludmilla (Krastins) VIC
Born Latvia 1908. Painter and teacher.
Studies Graduated at the Latvian Academy of Art in 1940; Later travelled and studied in
Italy, France, Greece, Sweden and Germany where she held her first one-woman show; Has
held eleven solo shows in Australia; Member of Melbourne Society of Women Painters and
Sculptors and the VAS where she is a regular exhibitor; Lecturer at International Summer
School, Sweden 1939.
Awards Bendigo 1951; Dunlop 1952; Camberwell, Caulfield and Morwell 1973;
Healesville 1974; Royal Melbourne Show 1975–77; VAS Pirstitz Gold Medal 1982.
Represented State Galleries in Tas, Vic and NSW; Regional Galleries at La Trobe Valley,
Gosford, Bendigo, Portland and private collections in UK, Europe, USA and Australia.
Bibliography *Latvian Artists in Australia*, Society of Latvian Artists, ALMA 1979;
Monography of Ludmilla Meilerts, Melbourne 1987.

MEIN, Annemieke VIC
Born Holland 1944, arrived Australia 1952. Textile sculptures. No formal art training;
Member, Crafts Council of Vic 1980–83; Tutor and guest lecturer.
Exhibitions Sale Regional Arts Centre 1979, 1980, 1981, 1982; National Gallery of Vic
1981; Swedish Trade Fair, Sydney 1982; Ararat Art Gallery 1982; NSW House, London UK
1983; Woolloomooloo Gallery, Sydney 1984.
Awards Coats Patons/Family Circle Craft Award to USA 1978; Work purchased by Crafts
Board of Australia; Council for 'Crafts-in-Gear' national exhibition 1980; Winner Hoechst
Australia Ltd, Textile Award 1980; Grant — Crafts Board of the Australia Council 1980;
Fibre Forum 'The Secret Garden' — best individual award 1982; Awarded AM 1988.
Represented Australian National Gallery, Canberra; National Gallery of Vic; Hoechst
International Collection; Sale Regional Arts Centre (six works); Ararat Art Gallery (two
works); Art Gallery of Qld; Private collections in Holland, USA and Australia.
Bibliography *Craft Australia*, Winter 1980; *The Bulletin*, Sydney June 1984.

MELLINS, Biruta (Flood) VIC
Born Latvia 1938. Sculptor.

Studies RMIT 1975–76.
Exhibitions One-woman show at Pinocotheca Gallery, Melbourne 1975; Participated at Mildura Sculpture Triennial and National Gallery of Vic 1975.
Bibliography *Latvian Artists in Australia*, Society of Latvian Artists ALMA 1979.

MELVILLE, Jan NSW
Born Aust. 1947. Painter and printmaker.
Studies Certificate in Art & Design, Gymea College of TAFE 1982; National Art School, Painting 1983, Printmaking 1989. Also studied at Mitchell CAE.
Exhibitions Solo shows at Balmain Watch House 1987, 88, 89; Punch Gallery 1990, 91; Group show at Eaglehawke Gallery 1990.
Represented Institutional and private collections in Australia and overseas.

MENDOZA, June UK
Born Melbourne Vic. Portraitist; Daughter of writer, musician Dot Mendoza.
Studies Member, Royal Society of Portrait Painters and Royal Institute of Oil Painters, London; Studied art at Swinburne Technical College, Melbourne four years; Went to London 1950 where she won a London Council Scholarship to St Martins Art School; Married Keith Mackrell and spent five years in the Philippines with husband and family where she painted prolifically; On return to London set up house on Wimbeldon Common where they still reside. Member, Royal Society of Portrait Painters, Royal Institute of Oil Painters, Contemporary Portrait Society, London. Hon. D. Lit., Bath University.
Commissions Regarded as one of London's top portrait painters, she has painted many famous people and was commissioned by The Lords Taverners of London to paint their portrait of Prince Philip, Duke of Edinburgh; Her portrait of Melbourne cartoonist and writer Les Tanner hangs in the *Age's* office, Melbourne; Other subjects include the Archbishop of Canterbury, Sammy Davis Jnr, Sean Connery, Diane Cilento, Sir William McMahon and Prince Edward.
Awards AO for services to the arts 1989.

MEPHAM, Tricia QLD
Born Woking UK 1941. Representational painter, mostly of people and figures in oil.
Studies Under William Baker, Brisbane.
Exhibitions University of Qld Club, St Lucia 1978; Les Galleries du Paddington, Brisbane.
Represented Brisbane General Hospital and private collections.

MERCER, Anne SA
Born Adelaide SA 1945. Ceramic artist and craft teacher.
Studies SA School of Art; Diploma of Art Teaching and Ceramics, Western Teachers College 1963–65, 1966–68; Taught art in secondary schools in SA 1966–73; Established first pottery studio; Currently working as full-time studio potter and lecturing part-time at Adelaide College of the Arts and Education 1974; Bachelor of Design (ceramics) degree, SA College of Advanced Education 1983.
Exhibitions Numerous solo and group shows including Montrichard Galleries, Adelaide 1980, 1982; Cooks Hill Galleries, Newcastle 1983, and Dept of Foreign Affairs show to SE Asia.
Awards Bendigo Pottery 1975; Pugmill Pottery 1977; Alice Springs 1980; Mayfair Award 1980; SA Arts Advisory Grant 1980.
Represented WA Art Gallery; Qld Art Gallery; Art Gallery of SA; Australia Council Crafts Board; Ararat Regional Art Gallery, Vic; Bendigo Pottery Museum, Epsom, Vic; Museum of Applied Arts and Sciences, Sydney NSW; Artbank; Collection of Sir Zelman Cowan; Australian Embassy, Belgrave Yugoslavia; Araleun Collection, Alice Springs NT.

MERRINGTON, Wendy NSW
Born Sydney 1957. Painter, printmaker.
Diploma in Art Education 1979–86. Studied printmaking at Willoughby Art Workshop
1985; Overseas study tour 1986.
Exhibitions Barry Stern, Gates Gallery, Bridge Street, Etchers Workshop and Pochoir in
Sydney.
Awards Hunters Hill, Cheltenham, *Sun Herald* Waratah. Hilton Hotel Prints.
Represented Institutional and private collections in Australia and overseas.

METZ, Deborah VIC
Born Melbourne Vic 1950. Printmaker and teacher.
Studies RMIT 1970–72; Ruskin School of Drawing and Fine Art, Oxford UK 1974–77;
State College of Vic, Toorak 1978.
Exhibitions Oxford UK 1976–77; Boston USA 1977; Monash Arts Centre 1979;
Gippsland IAE 1980–81.
Represented Institutional and private collections in UK, Europe, USA and Australia.
Bibliography *Directory of Australian Printmakers* 1982.

MEYERS, Beth NSW
Born Sydney NSW. Painter and sculptor.
Studies Diploma of Art (sculpture) from East Sydney Technical College with honours and
awarded Bronze Medal; Painting with Henry Justellius and Desiderius Orban.
Exhibitions One-woman show of paintings at Roseville Galleries 1982; Exhibiting mem-
ber of RAS of NSW.

MEZAKS, Maggie VIC
Born Russia, arrived Australia aged four years. Painter.
Studies Study tour to Europe, USA, Greece 1972–73.
Exhibitions One-woman shows at Munster Arms Gallery, Melbourne 1970, 1973;
Greenhill Galleries, Adelaide 1973; David Sumner Galleries, Adelaide 1977; Holdsworth
Galleries, Sydney 1978; Group shows at Connoisseurs Collection, Monash University 1971;
Women Painters and Sculptors Annual 1971; Adelaide Festival 1974; Multi-media group
exhibition, 'The Vanishing Rain Forests of Australia', Canberra.
Awards W and G Dean Prize, VAS 1964, 1967; Bundaberg Prize 1969; Italia Art Prize
1971; Equal First Camberwell Rotary Club 1971; Kiwanis Art Prize 1975.

MICHALSKA, Danuta VIC
Born Poland 1933. Painter and illustrator.
Studies Postgraduate Dip. Advertising, Warsaw 1966–68; M. Fine Arts, Academy of Fine
Arts, Warsaw 1951–66. Member of VAS.
Exhibitions Numerous shows in Europe 1955–77; Museum Bistro Gallery, Melbourne
1981; Polish Art Foundation 1982; Shepparton, Vic. 1987; Caulfield Arts Complex 1990;
VAS 1990; Sky Gallery 1990.
Awards France 1966; Poland 1966; CAS, Seymour, Vic. 1989.
Represented Institutional and private collections in Europe and Australia.
Bibliography *Alice 125*, Gryphon Gallery: University of Melbourne 1990.

MICHELL, Patricia Mary SA
Born London UK 1934. Illustrator and fibre craftsman.
Studies Cambridge School of Art, UK; Full-time course plus Certificate, SA School of Arts;
Won scholarship to Cambridge UK; Exhibited in various mixed exhibitions and craft shows
including 'Meyer Lifestyle', leading Toronto Garment Parade; Caltex Sculptural Exhibition
1978; Director of Woolgatherers Weavers Workshop where fibre crafts are taught and pro-

moted 1979.

MICHELL, Wendy SA
Born Adelaide 1957. Painter, craftworker, teacher.
Studies Dip. Fine Art (Painting), Torrens CAE 1975–78; Grad. Dip. in Education, Darwin Community College 1981; worked with Art-Zone Gallery 1985–88, Fellow, RSASA 1988.
Exhibitions Numerous shows at Art-Zone and RSASA 1988.
Represented Institutional and private collections.

MICHELMORE, Mary SA
Born Victor Harbor SA 1932; Small wildlife sculptures, silversmith, mostly self-taught; Fellow of RSASA; Part-time RMIT 1971 and Jam Factory, Adelaide 1972.
Exhibitions Manyung Galleries, Melbourne 1978; RSASA Gallery 1979, 1981; Greenhill Galleries 1980; Wildlife Art Society of Australia 1980, 1981–90; SA Museum 1988; Beaver Galleries 1984; Himeji, Japan 1989; Christchurch NZ 1990; RSASA Gallery 1981–91.
Awards Victoria Council Tourism Design 1987.
Commissions for bronze sculptures include Walker Ceramics, Mallinckrodt Nuclear Award, HMAS Platypus and SAFCOL, SA.
Represented Institutional and private collections in Australia and overseas.

MICKAN, Helen SA
Born Mt. Barker, SA 1941. Painter, teacher.
Studies SA School of Art 1959–61. Dip. Mus. A. (Performance), Elder Conservatorium of Music 1962. Taught art 1962–66, 72–91. Dip. T. (Art/Sec), Western Teachers College 1970. B. Ed. (Communication Design), SACAE 1988.
Exhibitions Solo show at Studio Z 1971; Gallery de Graphic 1978; Kensington Gallery and Arts Council of SA and CAS 1970–90; RSASA 1978–90.
Awards Scholarship to SA School of Art 1957.
Represented Institutional and private collections in Canada, USA, Australia.

MIFSUD, Bette NSW
Born Sydney 1958. Painter, photographer, administrator.
Studies BA Visual Arts (Painting) SCOTA 1982–84. Administrative assistant ACP 1986–87, assistant curator 1987–88; Co-Administrator, Artspace, Sydney 1989; Taught at Hornsby College of TAFE 1990; Temporary secretary, Art Law Centre of Australia 1990; Senior tutor, Tin Sheds, University of Sydney 1991.
Exhibitions Solo shows since 1985 include Union St. Gallery 1986; Artspace, Sydney and CAC, Adelaide 1988, 89; AGNSW 1990, 91. Group shows include SCOTA Gallery 1984; Artspace 1986; Mori Gallery 1986; George Paton Gallery, Reconnaissance Gallery, ACCA, Melbourne 1988; Heineken Village, Tokyo 1990.
Awards VA/CB, Australia Council — residency Tokyo Studio 1990. Project grants 1987, 89.
Represented Institutional and private collections around Australia and overseas.

MIKELSONS, Lucija WA
Born Latvia. Ceramic artist and sculptor.
Studies Collie Technical College; Perth Technical College under E. Tristam 1975–77.
Bibliography *Latvian Artists in Australia*, Society of Latvian Artists, ALMA 1979.

MILANI, Lyndall QLD
Born Brisbane, 1945. Sculpture, installations, performance.
Studies Society of sculptors in the 1970s; Kelvin Grove CAE 1973; Resident sculptor Qld C of A 1980–82. VAB Grants 1985, 87. Also studied physiotherapy at Uni. of Qld. 1964–67.

Exhibitions Many solo shows since 1984 including BMG Adelaide 1987 and Mildura 1988. Participated Sculpture Society of Qld 1971–81; IMA 1983; The Centre Gallery 1987; Mildura Sculpture Triennial 1988. SASA Gallery, Adelaide; Irving Galleries, Sydney; Gryphon Gallery, Melb. 1989; Fourth Australian Sculpture Triennial 1990.
Bibliography *A Homage to Women Artists in Queensland:* The Centre Gallery 1988; *Art and Australia* 28/3; *Artists & Galleries of Australia*, Max Germaine: Craftsman House 1990.

MILEO, Ellen VIC
Born Melbourne 1934. Painter.
Studies BA (Fine Arts) completed at PI and privately with Bill Coleman.
Bibliography *Alice 125*, Gryphon Gallery: University of Melbourne 1990.

MILLER, Michelle Elizabeth WA
Born Sydney NSW 1956. Colourist painter in oil. Teaches art at Primary Schools.
Studies Claremont Technical College 1976–79. Gaining Dip. Fine Art. Drawing 7 Design at Leederville TC 1975–76.
Exhibitions Solo shows at Old Bakery Gallery, Balingup WA 1979, 82; Kelsue Gallery, Bunbury 1984; Claremont S of A Gallery 1986; Perth Galleries 1989, 90. Participated at University of WA 1978 and WA Guild Art Prize 1977–78. Numerous other group shows include Goodridge Gallery 1987; University of WA 1988; Kings College, Sydney 1988; Bay Gallery, Claremont 1988; Royal George Community Centre 1988; Gunyulgup Galleries 1988, 90; Burswood Convention Centre 1989.
Represented Private collections in WA, SA and Vic.

MILLER, Muriel VIC
Born North Plymouth UK. Printmaker and painter of cats, dogs and horses.
Studies Reading University UK; École des Beaux Arts, Paris.
Exhibitions Solo show at Juniper Gallery, Melbourne 1978; Participated at Royal Society of British Artists and United Artists, London; PCA Show 1980.
Awards Premier Prix de Gravure sur Bois, Rennes, France 1938.
Represented Institutional and private collections in UK, Europe, USA and Australia.
Bibliography *PCA Directory*, 1988.

MILLER, Sally VIC
Born Melb. 1949. Printmaker.
Studies Swinburne TC 1968–70; BA, SCOTA 1980–81, Postgrad. 1982–83.
Exhibitions Numerous shows include Blaxland Gallery, Sydney 1985; 70 Arden St. Melb. 1988; Grafton Regional Gallery 1988; Artery Gallery, Geelong, Vic 1988.
Bibliography *PCA Directory* 1988.

MILLER, Shirley QLD
Born Brisbane, Qld. Semi-abstract painter in oil, watercolour, acrylic; Printmaker and ceramic artist.
Studies Diploma course at Central Technical College, Brisbane 1948–51; Worked in commercial art 1951–60; Studied pottery with Carl McConnell 1963–66, painting with Roy Churcher 1967–69 and Mervyn Moriarty 1969–70; Studied Sir John Cass School of Art, Whitechapel London and Morley College, Lambeth London 1972; Studied with John Olsen, David Rose, Ruth Faeber, Andrew Sibley, Ray Beattie and at Kelvin Grove CAE 1974–83.
Exhibitions Solo shows at Design Arts Centre, Brisbane 1975 and Ralph Martin Gallery, Townsville 1978; Town Gallery, Brisbane, Boston Gallery, Brisbane. Numerous group shows at Design Arts Centre and Printmakers Gallery; Editions Gallery, Melb.
Awards Mt Gravatt 1969; Brookfield 1970; Redlands 1971; Westfield 1975; Cairns Caltex 1979; RQAS 1985, 86.

Represented National Collection, Canberra; Tas Museum and Art Gallery, Private collections in Qld, NSW and overseas.
Bibliography *Directory of Australian Printmakers* 1982, 88.

MILLER COLEMAN, Lynn VIC
Born New York 1939. Painter, printmaker, curator.
Studies B.Sc., State University of New York 1961. B. Fine Arts 1962 and M. Fine Arts 1964 from Yale University. Assistant curator of prints, Andrew Dixon White Art Museum, Cornell University; Lecturer, Dept. of Art, University of Maryland. Moved to Australia 1987.
Exhibitions Numerous shows in American galleries and universities 1960–87. Solo show at Deutscher Brunswick Street Gallery, Melbourne 1990.
Represented Institutional and private collections in USA.

MILLIKIN, Ruby Eva NSW
Born Lismore NSW 1924. Painter, printmaker and teacher.
Studies Newcastle National Art School and Newcastle CAE, Diploma in Art Education 1976; Past president of Newcastle Society of Artists; Taught art at Maitland TAFE 1979–82 and Community Centre, Lake Macquarie 1979–83.
Exhibitions Solo show at Seaview Gallery, Newcastle 1978; Participated at Newcastle Printmakers Shows 1979–89 Gallery 62, Newcastle 1983.
Awards Contemporary Art Prize, Newcastle Show 1977; Raymond Terrace 1977; Dobell Wangi Show 1979. NZ Insurance 1986.
Represented Westmead Hospital and private collections around Australia.
Bibliography *Directory of Australian Printmakers* 1982, 88.

MILLS, Diana TAS
Born Hobart 1923. Printmaker.
Studies Launceston TC under Bea Maddock 1965–70.
Exhibitions Solo shows at Launceston Print Gallery 1980; Gallery-up-Top, Rockhampton Qld 1981; Exhibits with Tas. Independent Artists.
Represented Artbank, QVMAG, Burnie AG.

MILLS, Wendy QLD
Born Sydney 1950. Sculptor, teacher.
Studies Nat. Art School Sydney 1967–70; Qld C of A 1977–79, Diploma FA (Sculpture). Artist-in-Residence, Qld, AG 1984 and Brisbane City Council 1988. Taught Qld C of A, various workshops and AFAS 1987–88.
Exhibitions Solo shows at 40 Charlotte St. Brisbane 1983; Qld Art Gallery 1984; Noosa Regional Gallery Qld 1986; Roz MacAllan Gallery 1988. Group shows since 1980 include Mildura Sculpture Triennials 1982, 85, 88; Aust. Sculpture Triennials, Melb. 1984, 87, 90; The Centre Gallery, Gold Coast 1987.
Awards L & A Pedersen Prize 1980; Caltex Warana 1980; VAB Grants 1982, 84, 86; Minister for the Arts award 1987; Brisbane City Council Commission 1988.
Represented MCA, Brisbane; Artbank; Mildura Gallery; Qld AG; Institutional and private collections.
Bibliography *A Homage to Women Artists in Queensland,* The Centre Gallery 1988; *Contemporary Australian Sculpture*, Graeme Sturgeon: Craftsman House 1991.

MILLS-STANLEY, Yvonne QLD
Born Qld 1941. Expressionist painter in oil.
Studies Drawing at QIT 1958; Life classes at CAS and private tutors; Secretary, CAS, Qld 1969–70. Foundation member of Institute of Modern Art, Qld.

Exhibitions Solo shows at Galerie Baguette, Brisbane 1982, 84, 86. Participated at CAS shows, Holdsworth Gallery, Sydney, 1988 and The Centre Gallery, Gold Coast 1988.
Awards Castlemaine Perkins 1981.

MILLSTEAD, Diane NSW
Born Melbourne Vic 1948. Painter and cartoonist.
Studies RMIT 1967–68 and then took up a position as a theatre painter at the Ulmer Stadt Theatre, West Germany for some years, during which time she had one-woman shows at Ulm and Dusseldorf; Returning to Australia, she held solo shows at Munster Arms and Cameron galleries, Vic and group showings at Macquarie and Mosman Galleries, NSW; Showed by Invitation at Edicions Graphiques, London 1977, 1978; Successful solo show at Bartoni Gallery, Melbourne in August 1978 comprised ten oil paintings and 66 drawings, many of Hollywood personalities done on a recent visit there with Barry Humphries; Married Barry Humphries 1979; Major exhibition of work Piccadilly Galleries, London July 1979.

MILNE, Elizabeth Grace WA
Born Guildford WA 1905. Realist painter of landscapes and still-life in oil and watercolour; printmaker.
Studies Diplomas in Art Studies and Printmaking, Perth Technical College; With William Boissevain; Member of the Perth Society of Artists.
Exhibitions Perth Society of Artists; Perth Drawing Prize Exhibition at Art Gallery of WA; Printmakers Association of WA Show at Art Gallery of WA and the Undercroft Gallery at University of WA.
Represented Private collections in all states.

MILSOM, Elizabeth VIC
Born King Island 1960. Printmaker.
Studies VCA 1983–85.
Exhibitions Numerous shows since 1983 including MPAC 1986, 88; 70 Arden St. 1985–88.
Awards Clifton Pugh Prize 1983; Flinders 1986; George Hicks Scholarship 1983; VCA Prize 1985; VAB 1987.
Bibliography *PCA Directory* 1988.

MILTON, Carole Louise VIC
Born Melbourne Vic 1937. Realist painter in oil and pastel.
Studies Box Hill Technical School, Vic 1960; With Ian Armstrong at National Art School, Melbourne 1965; Vic Artists' Society Life Classes 1975; Member of the Realist Guild of Artists, Vic Artists' Society and Sherbrooke Arts Society.
Exhibitions Shepparton Gallery, Vic 1977; Waterfall Gallery, Melbourne 1978; Balmoral Art Gallery, Geelong, Vic 1979; Waterfall Gallery, Melbourne 1980; Edwin Vincent Fine Arts, Melbourne 1981; Dingley Village Galleries, Vic 1982; Balmoral Art Gallery, Geelong Vic 1983; Gallery 21, Melbourne 1983.
Awards Royal Show, Melbourne 1967; Chadstone Rotary 1976; Mt Evelyn and Yarra Valley 1977; Bayswater Rotary 1978; Alexandra Rotary 1981.
Represented Private collections in Australia and overseas.

MILTON, Janet NSW
Born SA 1924. Painter and printmaker.
Studies Workshop Arts Centre, Willoughby under Sue Buckley and Jennie Pollak.
Exhibitions One-woman show at Mavis Chapman Gallery, also shows with Print Circle and Eight Graphic Artists.

Represented Private collections UK, USA and Australia.
Bibliography *Directory of Australian Printmakers* 1982, 88.

MILTON, Mary SA
Born Victor Harbor SA 1928. Portrait, wildlife and landscape painter, printmaker and
teacher; Married to artist Jonas Rudzinskas.
Studies SA School of Arts, full-time, four years; Associate of Advertising Institute of
Australia; Fellow and council member of the Royal SA Society of Arts; Part-time lecturer at
SA School of Art and University of Adelaide; WEA courses; Has designed and illustrated
many books for Rigby Ltd; Member of RQAS; VAS; Adelaide, Whyalla and Goulburn Art
Societies; Overseas study tours 1951–52; 1971–72.
Exhibitions Recent one-woman shows include Jolly Frog Gallery, Adelaide 1981, 1982,
1983; Many group shows since 1953 include Adelaide Festival of Arts 1982; RSASA
Gallery 1982, 1983; Whyalla SA 1983.
Awards Over twenty awards since 1953 include City of Elizabeth, SA 1982; Noosa Qld
1982; Grafton NSW 1982; Marion Council, SA 1982; Brisbane Valley 1983.
Represented Murray Park CAE; Bunbury Art Gallery; Marion SA and Grafton NSW
Council Collections and private collections in Australia and overseas.

MILWARD-BASON, Patricia VIC
Born NSW 1942. Painter, printmaker, sculptor, video artist, teacher.
Studies National Art School, Sydney 1962–64; RMIT, Melb. 1966–67; Gordon Institute,
Geelong 1975–76; Swinburne College of Technology, Melb. 1978; Diploma in Fine Art;
Graduate Diploma in Film and Television (video art).
Exhibitions Geelong AG 1976, 86; NGV 1978; Artery Gallery, Geelong Vic 1988.
Presently Co-Director, The Geelong School of Drawing and Painting.

MIMOVICH, Leopoldine VIC
Born Neumarkt Italy of Austrian parents 1920, arrived Australia 1949. Sculptor, mostly in
wood, also an etcher.
Studies Professor Gusty Mundt-Amman School, Vienna 1940–43; School of Wood
Sculpture, Hallstadt Austria 1943–49; Overseas study tour to Europe 1970.
Exhibitions Numerous exhibitions since 1955 including recent shows at VAS 1978 and
Wiregrass Gallery, Melbourne 1980 when both etchings and sculpture were shown.
Commissions Since 1959 has received a great number of Commissions for religious sculp-
tures extending widely around Australia and to New Guinea, London and New York; In
1983 a two metre wood sculpture of Chirst at Seaford Vic and a bust of Sir Thomas More at
Mt Eliza Vic.
Awards OAM for services to the arts 1985.
Represented United Nations Building, New York, Antarctica, London, Europe, Japan,
New Guinea, Korea and many institutional and private collections in Australia.
Bibliography *Australian Sculptors*, Ken Scarlett, Nelson 1980.

MINCHIN, Roxanane NSW
Born Gosford NSW. Photo-realist painter.
Studies No formal art training, mostly self taught but studied under husband Eric and other
members of the Brushmen of the Bush fraternity.
Exhibitions Solo show at Mentone Gallery, Melbourne; Numerous group shows include
Southlands Gallery, Canberra; Jinhilla Gallery, Dubbo; Robert Fields Gallery, Tulsa USA
and the Broken Hill Exhibition at St. Angelo, Texas.
Represented Municipal, institutional and private collections in USA and Australia.

MINTY, Peg ACT
Born Gordon, NSW. Painter, teacher.

Studies Private tutors and at Summer Schools under Frank Hodgkinson. Taught at Canberra TC, is hon. life member of Artists Society of Canberra.
Awards Tumut 1976; Queanbeyan City Award 1978.

MISSO, Yona VIC
Born Colombo. Painter.
Studies Painting under William Frater for ten years, music at Royal Academy of Music, London UK.
Exhibitions Solo shows at VAS 1974, 1977, 1981 and Eltham Gallery 1982.
Awards 1971 Flotto Laura first prize; 1973 Ivanhoe Art Society Award; 1973 Tumut Art Award; 1975 Ivanhoe Art Society Award; 1975 Flinders Caltex Art Award; 1976 Sunbury Art Award for best portrait; 1981 Brighton Art Society first prize.
Represented La Trobe University, Xavier College; Private collections in UK, Europe, USA and Australia.

MITCHELL, Jan (Hassett) VIC
Born Vic. Graphic designer, illustrator, printmaker.
Studies Swinburne TC 1956–59. Worked in the television and film industry in UK and Ireland 1968–83. Now back in Australia is involved as a printmaker and illustrator viz. *Free Stuff for Kids*: Five Mile Press; *Snow on the Salt Bush*; Geoffrey Dutton; *Such Pleasure*: Martin Boyd.
Exhibitions Australian Galleries, Melb. 1987; Pochoir Gallery, Sydney 1987.

MITCHELL, Jenni VIC
Born Eltham, Vic. 1955. Painter, printmaker, teacher.
Studies At Montsalvat, Vic, aged 10 later PIT for three years gaining Diploma of FA; Teaches a-1; Echuca Art Group.
Exhibitions Gallery 21 Melb. 1982; Ross House Gallery 1984; Sturt and Nolan Gallery 1985 and her own studio. Wallace Bros. Gallery Castlemaine Vic 1988.
Awards Mountbatten Award 1984; International Football Federation 1985.
Represented City of Echuca and many private collections in Australia and overseas.
Publications *Sketches* 1982. *The Lake Eyre Drawings* 1984.

MITCHELL, Kathleen VIC
Born Adelaide 1927. Painter.
Studies Dip. Music, Uni. of Melb. painting with William Frater.
Exhibitions Avant Gallery 1974; Clive Parry Gallery 1975; Swan Hill Regional Gallery 1984; VAS shows 1965 onwards.
Represented Institutional and private collections in Australia and overseas.

MOGENSEN, Diana Hoddle VIC
Born Melbourne Vic 1929. Painter and graphic artist. Great grand-daughter of Robert Hoddle, artist and first Surveyor General of Vic.
Studies Melbourne Church of England Girls' Grammar School and the University of Melbourne (Bachelor of Arts 1953); Caulfield Institute of Technology, Melb 1964–65; Académie de la Grande Chaumiére, Paris 1967–69; Fine Arts, University of Melb. 1978–80; Travels since 1974 in Asia, Europe and the Pacific; Studied lithography at Tamarind Workshop, Sydney 1987.
Exhibitions Solo shows at Australian Galleries, Melb. 1971; Old Mill Gallery, Holbrook NSW 1972; Ararat Regional Gallery, Vic 1973; Stuart Gerstman Galleries, Melb 1977; Niagara Lane Galleries, Melb. 1981; Niagara Galleries 1987; Gray Street Gallery, Hamilton 1987, 89. Participated VAS 1965, 66; Spring Festival of Drawing MPAC 1977, 79, 81, 83, 85, 87; Stuart Gerstman 1977, 78; Uni. of Melb. 1983; Dempsters Gallery 1983–88, 89;

Niagara Galleries 1985; NGV 1987; Centre Gallery, Gold Coast and MPAC 1989.
Awards Flinders 1980; MPAC 1977, 81; Gold Coast 1981; NGV Acquisition 1988; State Library of Vic. Acquisition 1988; Swan Hill Acquisition 1990.
Represented NGV; MPAC; La Trobe Collection, State Library of Victoria; Gold Coast City Art Collection, Qld; City of Hamilton Art Gallery, Vic; Musée Léon Dierx, Saint-Denis de la Réunion; Jardine Fleming, Victoria.
Publications Portrait of pioneer educationalist D.J. Ross in J. Epstein, *A Golden String*, Greenhouse, Melbourne, 1981 (dustjacket); Drawings in *Northern Territory*, SEE Australia, Research Publications, Melbourne 1981; Drawings in SLAV, Australian School Librarian, Research Publications 1981.
Bibliography *Images of Women, Prints and Drawings of Twentieth Century*, publication Fine Arts Dept, University of Melbourne 1983. Alan McCulloch, *Encyclopedia of Australian Art*, Hutchinson, Australia 1984; *Artists & Galleries of Australia*, Max Germaine: Craftsman House 1990.

MOLAN, June SA
Born Adelaide 1935. Realist painter.
Studies Life classes in Hammersmith, London UK and seminars in Adelaide. No formal art education. Member RSASA.
Exhibitions Lombard Gallery 1986; Steam Flour Mill 1986; High St. Kensington 1989; Studio Z 1989; Himeji, Japan 1989; Elders Gallery 1990; Butchers Hooks 1990; Christchurch NZ 1990. Regularly with RSASA.
Awards Kiwanis 1987, 88; Tea Tree Gully 1989; Port Adelaide 1989.
Represented Institutional and private collections in Australia, UK, Europe.

MOLNAR, Eva NSW
Born Szigetvar Hungary 1946, arrived Australia 1957. Contemporary figurative painter in pastel, acrylic, and fabric.
Studies Julian Ashton School 1964; Kogarah Technical College 1974; Alexander Mackie CAE, Postgraduate Diploma 1976–81; Founding member and secretary of Antares, artists co-operative; Founding member and secretary of Sydney Art Vogue, to further and assist needs of ethnic artists, President 1984; BA (Visual Arts), City Art Institute 1984; Graduate Diploma in Art Education, Sydney CAE 1985.
Exhibitions Solo shows at East End Art Gallery 1980, 81, 82; Gallery One 1984, 85, 88; Seymour Theatre Centre 1983; Santorini Cultural Centre, Greece 1989. Group exhibitions FMK Gallery Budapest 1985–1989; Del Bello Gallery Toronto, Canada 1986, 87, 88; Guillio Rodino Naples, Italy 1984; International Exhibition Osaka, Japan 1984; Metaphysical Art Forum Warsaw Poland 1986; Punch Gallery, Sydney 1990 (solo).
Awards St George Technical College, Liverpool Art Society, Guillio Rodino, Naples.
Represented Vassarely Gallery and FMK Gallery Budapest, Hungary, and numerous private collections in Australia, New Zealand, England, Japan, America, Greece and Japan.

MONTAGUE, Sally Therese NSW
Born Australia 1957. Painter and portraitist.
Studies Alexander Mackie CAE 1975–79.
Exhibitions Kimilia Galleries, Paddington 1979; Blaxland Galleries 1979; Painters Gallery, Sydney 1987, 88; Included in Moët & Chandon Touring Exhibition 1988.
Represented Institutuional and private collections around Australia.

MONTGARRETT, Julie VIC
Born Melb. 1955. Painter and textile artist.
Studies RMIT, Grad. Dip. Embroidery 1980–81.
Exhibitions Solo shows at Harbourfront Gallery, Toronto, Canada 1982; Market Row

Gallery, Sydney 1982; Meat Market Centre, Melb. 1982; Darwin Crafts Council 1983; Numerous group shows.

Represented QAG, Ararat and Tamworth Regional Galleries, private collections.

MONTGOMERY, Anne VIC
Born Melbourne Vic. Painter and printmaker.

Studies National Gallery Art School, Melbourne Technical College and George Bell School 1927–32; Etching from Jessie Traill who was a family friend; Mural painting under Napier Waller at MTC and taught colour, design and drawing in the School of Architecture there from 1935–73; Painted with the George Bell Group from late 1930s for many years; Was runner-up to Eileen Robertson in the National Gallery Travelling Scholarship 1932; An early member of the Melbourne Contemporary Artists.

Represented State Galleries of NSW and Vic and Regional Galleries.

Bibliography Catalogue, *The Printmakers*, Important Women Artists Gallery, Melbourne 1978; *Alice 125*, Gryphon Gallery: University of Melbourne 1990.

MOODY, Glenda QLD
Printmaker.

Studies Uni. of Qld. Philosophy Dip. Fine Art, Townsville CAE.

Exhibitions Nth Qld Galleries.

Awards Pacific Festival 1979; Cairns 1983.

Bibliography *PCA Directory*, 1988.

MOON, Margaret NSW
Born NSW. Figurative painter.

Awards Permanent Trustee Art Award at Royal Easter Show 1979.

MOON, Margaret (Kench) TAS
Born Hobart 1931. Painter, photographer.

Studies Hobart S of A 1974–78. Ceramics at TAFE 1982.

Exhibitions Solo shows at Warehouse Gallery, Hobart 1979; Saddlers Court Gallery, Richmond, Tas. 1985. Shows with Art Society of Tas.

MOOR, Lyndal NSW
Born Sydney NSW 1944. Ceramic artist and teacher.

Studies Art, East Sydney Technical College 1962–64; Sydney Teachers' College 1965; Ceramics, East Sydney Technical College 1974–75; Studied glaze technology with Ian Currie 1979–80; M. Creative Arts, Wollongong 1987. Taught St. Marys HS 1966; PLC Sydney 1971–73; Cranbrook School, Sydney 1974; Australian Flying Art School 1981–82; Appointed Board of Qld Potters Association 1980–81 and Board of Australian Flying Art School 1983. Taught Kelvin Grove CAE 1985–87.

Exhibitions Solo shows at Holdsworth Galleries, Sydney 1977, 79, 86, 87; Victor Mace Gallery, Brisbane 1978; Participated in Potters' Society of Australia Show at Holdsworth Galleries, Sydney 1976 and further shows annually in NSW and Qld.

Awards Royal Easter Show Ceramics, First Prize 1976.

Represented Qld Art Gallery; Qld Potters Association; Rockhampton Art Gallery; Brisbane Civic Art Gallery; Artbank and private collections.

Bibliography *A Homage to Women Artists in Queensland*, The Centre Gallery 1988.

MOORE, Edith (Hughston) VIC
Born Broken Hill NSW 1905. Sculptor, printmaker and teacher.

Studies National Gallery School, Melbourne 1926–29; Chelsea Polytechnic, London UK under Henry Moore 1933; Taught art in Qld 1929–32 and Vic 1935; Foundation member of

the Plastic Group 1936–39 and foundation and exhibiting member of the CAS 1938–40.
Exhibitions With the Plastic Group 1936–39, CAS 1939–40 and the Melbourne Society of Women Painters and Sculptors 1939–45.
Awards La Trobe Valley Art Centre 1972–73.
Represented La Trobe Valley Art Centre and private collections.
Bibliography *The Development of Australian Sculpture,* Graeme Sturgeon, Thames and Hudson 1978; Catalogue to the *Campbell Hughston Collection*, La Trobe Valley Art Centre, Morwell, Vic 1974.

MOORE, Lorna Mary (Woolcock) SA
Born Adelaide 1913. Painter, printmaker, teacher.
Studies North Adelaide School of Fine Arts and with a number of private tutors. Worked as a fashion artist in London UK and Australia during the 1930's. Taught with the Adelaide Art Society and the WEA until 1990. Fellow, RSASA.
Exhibitions RSASA and Adelaide Art Society.

MOORE, Lyn NSW
Born Sydney 1943. Sculptor.
Studies Hammersmith School of Art UK (part-time) 1969; Nat. Art School, Sydney 1971; Canberra School of Art 1975–80.
Exhibitions Solo shows at Arts Council Gallery, Canberra 1983; Irving Sculpture Gallery 1984; Participated First Aust. Sculpture Triennial, Melb. 1981; Irving Sculpture Gallery, 1984, 85; Second Aust. Sculpture Triennial, NGV 1984; World Expo '88, Brisbane 1988.
Represented Institutional and private collections in UK and Australia.

MOORE, Mary WA
Born WA 1957. Painter and printmaker.
Studies Diploma in Fine Art, Claremont Technical College 1973–75; WA Institute of Technology 1976–77; Royal College of Art, London 1979–80; Part-time lecturer in art from 1977 and at WAIT, Perth 1981–83.
Exhibitions Solo shows at Undercroft Gallery, University of WA 1977; Fremantle Arts Centre 1979; Gallery 52, Perth 1981, 1983; Gallery A, Sydney 1982; Many group shows since 1978 include Nexus Gallery 1982; Fremantle Arts Centre 1982; Claremont Art School 1982; Art Gallery of WA 1983.
Awards University of WA, Guild of Undergraduates, Prize for Drawing 1975; Rural and Industries Bank, Prize for Drawing 1975; TVW Channel 7, Young Artist's Award 1977; Rossmoyne Art Prize for Drawing and Watercolour 1977; Arts Council Grant to study in London 1979; Awarded the Dyson Bequest, Art Gallery of NSW 1980 (unable to take up due to return from London); Arts Council Grant to work with Maylands CYSS 1981–82; Inaugural Sir James Carruthers Fellowship 1982; Included in the Moët & Chandon Touring Exhibition 1991.
Represented Art Gallery of WA; University of WA; WA Institute of Technology; Rural and Industries Bank of WA; Gyngell Collection, Sydney; Royal College of Art, London; Claremont College of Advanced Education; Holmes à Court Collection; Artbank; Visual Arts Board and numerous private collections in Australia and Great Britain.
Bibliography *Art and Australia*, Vol 19 No 2; *The Perth Scene*, Ted Snell; *Western Australian Painters and Printmakers*, Fremantle Centre Press, Ed. M.Mason 1981.

MORA, Mirka VIC
Born Paris France 1928, arrived Australia 1951. Painter, illustrator and teacher.
Studies Paris and London; Was very active in Melbourne in the 1950s in support of modern art and the Contemporary Art Society with her husband, Georges Mora; Added interests in recent years have been making dolls and painting murals; Taught at CAE classes from 1973,

at the Exchange Workshop, RMIT from 1978, and at PIT 1980–82; Workshops and lectures in Tas and Vic; Artist-in-Residence at Geelong Grammer School 1983.
Exhibitions Realities Gallery, Melbourne (dolls) 1971; *Tympanum* with Roger Kemp, George Baldessin, Andrew Sibley, Les Kossatz, Realities Gallery 1977; Embroidery exhibition, Regional Galleries 1978; *Peaches*, Exchange Workshop, RMIT 1978; Aherns, Perth WA 1983; Tolarno Gallery, Melbourne 1983; Distelfink 1985.
Commissions Crafts Board (Sydney) Travelling Show in community centres 1978; 'Paint a Tram'; Ministry of the Arts, Melbourne 1978; Pilot project 'Artists in School', Visual Arts Board 1978; Murals at Adelaide Festival Centre 1983; Perth Festival 1983; Burdekin theatre and library, Ayr, Qld 1983. Designed the puppets for *Bennelong* at Sydney Opera House 1988.
Publications *The Artist Craftsman in Australia*, Fay Bottrell, Jack Pollars Pty Ltd; *Young Crafts*, Sue Walker, Macmillan; Interviews in *Aspect*, Rudy Krautman; *Mirka*, Ulli Beier, McMillan 1980.
Bibliography *Alice 125*, Gryphon Gallery: University of Melbourne 1990.

MORAN, Greta R. NSW
Born Sydney 1931. Realist painter in oil and watercolour.
Studies RASNSW under H.A. Hanke and in UK, Europe.
Exhibitions With the RASNSW and joint shows with Molly Flaxman at Tamworth and Pambula NSW.
Represented University of Western Sydney; Institutional and private collections in UK, Europe, USA.

MORAN, Patricia VIC
Born Melb. Painter, teacher. Teaches at VAS, Melb. Member AGRA.
Exhibitions Solo shows at Thomsons Gallery, Melb. 1978; Eltham Gallery 1979; Jellat Gallery 1981; VAS Gallery 1984, 85; Manyung Galleries 1988. Group shows at VAS 1982, 84, 86; McCelland Regional Gallery 1984; Balmoral Galleries, Geelong 1987, 89.
Awards Two Camberwell Rotary Gold Medals; The Alice Bale Overseas Study Award.
Represented Wangaratta Regional Gallery; Monash Uni. and private collections in Australia and overseas.
Bibliography *Australian Artist* July 1986, 87; *Australian Impressionist and Realist Artists*, Tom Roberts: Graphic Management Services 1990.

MORGAN, Ailsa NSW
Born Brisbane Qld 1953. Painter and printmaker.
Studies Studied National Art School, Sydney (painting) 1971–75; Postgraduate Etching, Central School of Art, London 1979–80; Teaching printmaking, Gymea Technical College, Sydney 1981; Teaching, City Art Institute (part-time) 1982–83.
Exhibitions Solo shows at Gallery A, Sydney 1981; Bloomfield Galleries, Sydney 1987. Participated Bonython Gallery, Sydney 1973, 1974; Opera House, Sydney 1975; Ewing Gallery, University of Melbourne 1975; Royal College of Art, London 1979–80; Gallery A, Sydney 1981, 1982, 1983; Bloomfield Galleries 1986, 88; Albury Regional Gallery 1988; Sydney Printmakers at Blaxland Galleries 1988.
Awards George Galton Memorial Print Prize, Maitland Art Gallery, NSW,
Represented Maitland City Gallery; BHP Collection; Alexander Mackie College of Advanced Education, Sydney; Kelvin Grove College of Advanced Education, Brisbane; Michell Foundation, National Gallery of Vic, Melbourne; Parliament House, NSW.

MORGAN, Betty C. QLD
Born Sydney NSW 1912. Painter, portraitist and teacher.
Studies Under Datillo Rubbo, Sydney and in UK, Europe. Later taught at the Datillo

Rubbo School, the RAS of NSW and for many years at her studio at Mosman NSW. In 1984 she moved to her new Lailani Gallery and studio at Springbrook Qld to exhibit and teach.

MORGAN, Chere NSW
Born Sydney 1945. Painter, magazine editor.
Studies Dip. Graphic Arts, School of Visual Arts, Sydney 1981; Dip. Marketing, University of NSW 1982; BA (Visual Arts), City Art Institute 1984–87; Postgrad. Dip. Professional Art Studies, City Art Institute 1988. Editor, *Healthy Life News* (part-time).
Exhibitions Solo shows at Arthaus Gallery 1987; North Sydney Contemporary Gallery 1989. Numerous group shows include The Works Gallery 1987, 88, 89; Manly Regional Gallery 1989, 90; Artlook Gallery 1990.
Commissions Artists and co-ordinator for the Hurstville Centenary Theatre Curtain.
Represented Institutional and private collections around Australia.

MORGAN, Elisabeth NSW
Born Le Mans, France 1954. Painter and teacher.
Studies ESTC 1978–79.
Exhibitions Solo shows at James Harvey Gallery, Sydney 1983; Cintra Gallery, Brisbane 1990. Numerous group shows.
Awards Aboriginal Arts Board Grant.
Represented Institutional and private collections in Paris and around Australia.

MORGAN, Margaret USA
Born Sydney NSW 1958. Painter in mixed media.
Studies Alexander Mackie CAE 1977–79; DAAD, West Berlin 1983.
Exhibitions Solo shows at Mori Gallery, Sydney 1980, 81, 84, 86, 89; Heide 1985; Drew Gallery UK 1982; Avago Sydney 1986; Jon Gerstad, New York 1987. A host of group shows since 1982 includes *Perspecta '83* and *Perspecta '85* at the AGNSW; Holdsworth Contemporary Galleries 1986; ANG, Canberra 1987; Minor Injury Gallery, New York 1987; CAS Gallery, Adelaide 1988; Flaxman Gallery, London UK 1988; Mori at United Artists, Melb. 1987; Moët & Chandon Touring Exhibition 1989, 91.
Awards NSW University Travelling Scholarship 1981; Power Institute Studio, Paris 1982; Berlin and New York.
Represented National Gallery of Vic, University of NSW and private collections.
Bibliography *Catalogue of Australian Perspecta* 1983, Art Gallery of NSW.

MORGAN, Sally WA
Born Perth 1951. Aboriginal painter, writer, printmaker.
Studies BA (Psychology), Postgraduate Diploma in Counselling Psychology, Diploma in Library Studies from Uni. of WA. Embraced her career as an artist as a result of her dust cover design for 1st award winning book *My Place*: Fremantle Arts Centre Press, tracing her Aboriginal heritage.
Exhibitions Solo shows at Birukmarri Aboriginal Gallery, Fremantle 1989; Painters Gallery, Sydney 1989. Many group shows at same galleries and Blaxland, Melb. 1987; PCA 1987; Adelaide 1988; London UK 1988; Hogarth Sydney 1988, 89; *Australian Perspecta* 1989.
Awards Human Rights Commission Award 1987; WA Non-fiction Writers Award 1988.
Represented ANG, AGWA, Dobell Foundation and many institutional and private collections in Australia and overseas.

MORGAN, Shelagh NSW
Born Malawi, Africa 1955. Painting, printmaking, collage.
Studies BA Visual Arts (Printmaking), University of New England 1985–87; Postgrad.

Dip. Printmaking Qld C of A 1988. Tutor, Australian Flying Arts School 1989–90; Co-ordinator, Access Contemporary Art Centre, University of New England 1989– ; Tutor UNE 1991– .

Exhibitions Solo shows at Lismore Regional Gallery 1983, 85; Roz MacAllan Gallery 1989; Tin Sheds Gallery, Brisbane 1990; Gold Coast City Gallery 1991; Legge Gallery, Sydney 1991. Numerous group shows since 1987.

Awards UNE Student Printmaking Prize; Byron Bay Award.

Represented ANG; QAG; municipal and private collections.

MORLEY, Malle NSW

Born Estonia 1941. Painter and teacher.

Studies ESTC 1960–62, 63–64; Sydney Uni. 1962; Putney Art School, London UK 1965; Hornsby TC 1973–74; BA, Visual Arts, Nepean CAE 1986–88. Taught art at St. Leos 1967–68; St. Benedicts 1973–74; McKillop Girls High 1985– .

Exhibitions Solo show in London UK 1971; Byzantine Gallery Sydney 1972; Numerous group shows including Chelsea Contemporary Gallery 1990 and Art Studio, Baulkham Hills 1990.

Awards Ten prizes in local competitions since 1970.

Represented Institutional and private collections in UK, Europe and Australia.

MORRIS, Colleen (Zeeng) VIC

Born Vic 1948. Semi-abstract painter in acrylic and pastel; Printmaker and teacher.

Studies Associate Diploma of Fine Arts (painting); RMIT under Peter Clarke and Jan Senbergs 1967–68; One year post diploma study for approved graduates, Fine Arts A and C seminar studies, Melbourne University, Professor Burke and Basil Gilbert, 1971–72; Study tour Indonesia 1971; Tutor, Council of Adult Education, Melbourne, Art Workshop, Horsham and painting and drawing classes 1973; Studio in UK, study of major collections Europe and USA; Tutor, CAE Melbourne 1975; Tutor painting and printmaking at Melbourne State College 1975–76; Gained Technical Teachers Certificate from State College of Vic, Hawthorn 1970; Has taught art in a number of Vic secondary schools; Presently studio painting.

Exhibitions One-woman shows at Drawings and Paintings, Powell Street Gallery, Melb. 1970; Drawings and Paintings, Stuart Gerstman Galleries, Melbourne 1973; Drawings, Ewing Gallery, Melbourne University 1974; Paintings and Drawings, Warehouse Galleries, Sth Melbourne 1978; Participated in Robin Gibson Sydney 1979; Student Paintings and Prints, Gallery 99, Carlton 1966; *Industrial Experience* Exhibition, Lecture Room, RMIT Art Building 1969; Stuart Gerstman Galleries, Melbourne 1973; *Artists' Artists Drawings*, National Gallery of Vic 1975; Staff Drawings, Gryphon Gallery, Melbourne State College 1976.

Awards Dandenong Festival, Drawing Prize, Judge Bernard Smith 1966; Perth International Drawing Prize, Judge William Scott 1973; American Bicentennial Exhibition, Brisbane 1976; Purchase of painting of Vic Council for the Arts 1977.

Represented Art Gallery of WA; Qld Art Gallery; Purchase Collection of Vic Council for the Arts on loan to Melbourne State College.

MORRIS, Jackie QLD

Born Birmingham, UK 1961. Painter, illustrator, designer.

Studies Hereford College of Art, UK 1980–81; Bath Academy of Art, BA (Hons) 1981–84. Designer and illustrator for leading London Publishers.

Exhibitions Solo shows at Rooksmoor Gallery, Bath 1986, 87; Minski Gallery, London 1986; Islington Gallery, London 1987; Gallery Nino Tucci, Qld 1988.

Represented Institutional, corporate and private collections in UK, Europe and Australia.

MORRIS, Julie Dianne (Coles) NSW
Born Adelaide SA 1945. Painter of Australian birds and animals, mostly in gouache.
Studies SA Institute of Technology; Originally a fashion artist, she travelled to England in
1973 to develop her skills in the study of small birds; Since 1976 has produced many wildlife
studies for a marketing company for limited edition calendars which have gone all around
the world.
Exhibitions Wildlife paintings with Terence Lindsey, Roseville Galleries, Sydney 1980,
1981.
Represented In institutional and private collections in UK, Europe, Japan, USA, Australia
and NZ.

MORRIS, Linda VIC
Born La Trobe Valley, Vic 1950. Naive painter, no formal art training.
Exhibitions First one-woman show at Gallery Art Naive, Melbourne 1983.

MORRIS, S.E. (Nell) QLD
Born Qld. Traditional painter.
Studies Maryborough, Qld TAFE College 1968 and WA Technical College.
Exhibitions Solo shows at her own Bimbadean Gallery, Gympie.
Awards Gayndah Caltex 1977; Kilkivan Acquisitive 1978.
Represented Institutional and private collections in NSW, Qld and WA.

MORRIS, Valda NSW
Born Auckland NZ 1925. Surrealistic painter in oil and acrylic; Designer and teacher.
Studies Elam School of Art, Auckland; National Art School, Sydney circa 1943–50; Later
under Professor M. Feuerring 1963–68; Conducted an Art School for 12 years in Killara,
NSW.
Exhibitions Studio 183, Edgecliff 1964; Sydney University 1967; The Little Gallery,
Roseville NSW 1977; B'nai B'nth Centre 1988.
Represented University of NSW; Wolper Hospital, Sydney; Acrow Engineering
Collection; Ethiopian Consultate; Institutional and private collections in UK, USA,
Jerusalem and Australia.

MORRISON, Moira VIC
Born Glasgow Scotland 1952, arrived Australia 1964. Painter and printmaker, teacher.
Studies Diploma of Art from Preston Institute of Technology, Vic 1971–75; Graphic art
and painting at RMIT 1969–70.
Exhibitions *Drawing — some definitions*, Ewing Gallery, Melbourne University Union 1976;
Eight Women Realists Exhibition, Vic College of the Arts, Melbourne 1978; Glenfiddich
Whisky sponsored tour 1978; Geelong Art Gallery – Capital Permanent Building Society
1978; Coventry Gallery, Sydney 1978; The Gallery, Brighton Vic. 1983.
Represented Private and institutional collections in Vic and overseas.

MORRISON, Tessa NSW
Born Sydney 1954. Printmaker.
Studies WAC, Willoughby NSW; Exeter Art College, UK; Mitchell CAE, Bathurst; ESTC.
Awards Mudgee 1985, 86, 87; Kinross Walleroi, Orange NSW 1988.
Bibliography *PCA Directory* 1988.

MORROW, Romola (Clifton) WA
Born Perth WA 1935. Painter, illustrator, portraitist and teacher.
Studies Slade School of Art, London UK 1954–55; Study tour of Europe 1961; Teaches art
at Claremont Technical College and Fremantle Arts Centre.

Exhibitions Solo shows at Skinner Galleries, Perth 1959, 1960, 1964, 1966; Showed watercolours in 1977, 1978.
Awards Hotchin WC Prize 1956; Helena Rubinstein Portrait Prize 1960.
Represented Art Gallery of WA; WAIT Collection; Q.E. Hospital, Perth and institutional and private collections in Australia and overseas.
Bibliography *Australian Watercolour painters 1780–1880*, Jean Campbell, Rigby 1982.

MORTEAN, Mary VIC
Born London UK 1933, arrived Australia 1957. Contemporary painter and designer, mostly in oil.
Studies Hornsey School of Art, Caulfield Institute of Technology 1966–67; Diploma of Art and Design, Caulfield Institute of Technology 1973–75.
Exhibition *Eight Women Realists* Exhibition, Ewing Gallery, Melbourne University Union 1978.
Represented Private collections in Vic, NSW and UK.

MORTON, Ann NSW
Born Cowra NSW 1958. Painter and portraitist.
Studies Mostly self taught. Has studied and painted portraits on commission in UK, USA and India.
Awards Finalist's Prize, Doug Moran National Portraits Prize 1990.

MOSMAN, Margery Jean NSW
Born Armidale NSW 1927. Landscape painter, mostly in watercolour; Teacher.
Studies RAS of NSW from 1965 under G.K. Townshend, Mollie Flaxman and Alison Faulkner; Associate of the Society from 1977.
Exhibitions Joint show at Barbizon Gallery, Sydney with Winifred Beamish 1981; Regular exhibitor with RAS.
Represented UK, Europe, USA, Canada and Australia.

MOUNTCASTLE, Robyn Anne SA
Born Lismore NSW 1936. Painter, teacher and graphic artist.
Studies Brisbane Central Technical College 1950–54; Byam Shaw School of Art and School of Printing and Graphic Art, London UK; Summer schools with Guy Warren and George Baldessin 1969, 1970, 1971; Brisbane College of Art 1972–74; Has worked in commercial art in London and Australia and taught at the Brisbane College of Art.
Exhibitions Has shown widely in Qld since 1970.
Bibliography *Australian Watercolor Painters 1780–1980*, Jean Campbell, Rigby 1982.

MOY, Patricia NSW
Born Sydney NSW 1935. Traditional painter in pastel, watercolour, gouache of animal studies.
Studies Julian Ashton School 1953 and under G.K. Townshend 1956; Graduate, Dept TFE 1979 and RAS of NSW and private tutors; Worked part-time in Australian Museum art dept 1978; Postgraduate study in watercolour 1981–84 and calligraphy 1987–88. Vice-President, Pastel Society of NSW 1989– ; Teaches at Ku-ring-gai Art Centre, where she is an exhibiting member and at Pastel Workshops at Sturt University, Bathurst; Canberra Art Centre and Waverley-Woollahra Art Centre.
Exhibitions Kenthurst Gallery 1980; Gallery 680, Killara 1981; Vivian Gallery 1982; Seasons Gallery 1988; Rainsford Gallery 1985, 88.
Awards AD Indyk Prize, Macquarie University 1982; Capron Carter Drawing 1986; North Shore Heritage 1987; Asco Prize 1987; KAS Miniature Prize 1988.
Represented Private collections in UK, Europe, USA and Australia.

MOYLAN, Patricia　　　　　　　　　　　　　　　　　　　　　　　　**NSW**
Born Leigh UK 1950. Painter, photographer and teacher.
Studies National Art School, Sydney 1968–72; Sydney Teachers College 1973.
Exhibitions Solo shows at Watters Gallery, Sydney 1980, 83, 85; 'Ockerfunk' touring show 1976–77; Realities Gallery, Melbourne 1976; Pinacotheca Gallery, Melbourne 1977; Art Gallery of NSW 1982; Ballarat, Bendigo and Wollongong Regional Galleries 1983–84; First Australia Contemporary Art Fair, Melb. 1988; Max Watters Collection at Muswellbrook Gallery 1988.
Represented Institutional and private collections in UK and Europe.

MULLINS, Joyce　　　　　　　　　　　　　　　　　　　　　　　　**QLD**
Born Rockhampton Qld 1930. Progressive contemporary painter in acrylic, pastel and charcoal; Teacher.
Studies Under Mervyn Moriarty with Australian Flying Art School and Arts Council Vacation Schools with leading tutors; Studied printmaking with Brian Hatch 1981. Member, Half Dozen Group; Teaches painting for TAFE, Qld.
Exhibitions Solo shows at Eagle Street Gallery, Brisbane 1979; Qld University Staff Club 1979, 1980; Artists Gallery 1980; Mary Gilmour Gallery 1982; Red Hill Gallery 1982; Numerous groups shows since 1976.
Awards Brookfield Show, Brisbane 1979; Corinda Festival 1979.
Represented Institutional and private collections in Qld, NSW and overseas.
(Died May 1991)

MULLINS, Patricia　　　　　　　　　　　　　　　　　　　　　　　**VIC**
Born Melb. 1952. Painter, designer, illustrator.
Studies RMIT printmaking and graphic arts. Illustrated a number of childrens books during the 1970s for publishers Angus & Robertson and Paul Hamlyn. Received VAB grant for overseas study.
Exhibitions Hawthorn City Art Gallery, Melb. 1975.
Bibliography *Encyclopedia of Australian Art*, Alan McCulloch; Hutchinson 1984.

MUNKARA, Teresina　　　　　　　　　　　　　　　　　　　　　　**NT**
Born 1953. Bark painter, textile designer, sculptor from Bathurst Island, a member of the Tiwi tribe.
Exhibitions ANG, Canberra 1989.
Represented ANG.
Bibliography *Windows on the Dreaming,* ANG 1989.

MURPHY, Fiona　　　　　　　　　　　　　　　　　　　　　　　　**VIC**
Born Melb. 1958. Ceramic artist.
Studies Diploma of Art & Design with High Distinction, Prahran CAE 1980; Postgraduate Diploma PIT, Melb. 1984.
Exhibitions Solo shows at Distelfink Gallery, Melb. 1981, 82, 84; Macquarie Galleries, Sydney 1985, 87, 88, 89; Christine Abrahams, Melb. 1987; Many group shows since 1980 including PIT Postgraduate Show 1985.
Awards The Prahran College of Art Award of Excellence in Ceramics 1980; Crafts Board Grant for travels in Europe to research ceramics 1983; Crafts Board Grant 1986; Bathurst Regional Gallery Art Prize 1986.
Commission Benalla Mural Garden (Series of Mural Caves) 1985.
Represented ANG; NGV; Victorian State Craft Collection; Geelong Art Gallery; Artbank.
Bibliography *Craft Arts* Sept/Nov. 1988.

MURPHY, Patricia NSW
Born Holbrook NSW. Traditional landscape painter.
Exhibitions Boronia Gallery, Sydney 1983; Noella Byrne Gallery 1982, 84, 86.
Represented Corporate and private collections in UK, Europe, Japan, Thailand and Australia.

MURRAY, Edith Ann QLD
Born Australia 1950. Potter.
Studies Diploma (hons) Ceramcis from Qld College of Art; Two year apprenticeship with Victor Greenaway.
Exhibitions Solo show at Nerang Gallery, Qld 1982.

MURRAY, Jan VIC
Born Ballarat 1957. Painter.
Studies Ballarat CAE 1976–78; VCA Melb. 1980–81. Lived and worked in Berlin 1984–85; Currently lecturing at VCA.
Exhibitions *Australian Perspecta* 1983, Sydney; Australian Artists at Guggenheim Museum, New York 1984; Uni. of Melb. Gallery 1985; Roslyn Oxley9 Gallery, Sydney 1986, 91; Uni. of Melb. Gallery 1984, 85; Kunstlerhaus Bethanien, Berlin 1985; Realities, Melb. 1989, 91. Her work was included in *A New Generation 1983–88* at the ANG Canberra 1988 and in many group shows since 1982 and recently in the Moët & Chandon Touring Exhibition 1990; Realities Gallery 1990; ACAF 2, Melbourne 1990.
Awards VAB Grant 1982; VAB, Kunstlerhaus Bethanien Residency, Berlin 1984.
Represented AGNSW; NGV; Metropolitan Museum of Art and the Guggenheim Museum, New York; Artbank; Institutional and private collections in Australia and overseas.
Bibliography *Catalogue of Australian Perspecta* 1983, Art Gallery of NSW; *Artists & Galleries of Australia*, Max Germaine: Craftsman House 1990.

MURRAY, Kerin NSW
Born Sydney 1960. Painter.
Studies SCOTA 1978; Uni. of NSW 1979; SASA 1983–85.
Exhibitions Participated at Experimental Art Foundation, Adelaide 1986, 88, 89; *A New Generation 1983–88*, ANG Canberra 1988; Moët & Chandon Touring Exhibition 1988, 90.
Represented Artbank and institutional collections.

MYERS, Joy NSW
Born NSW 1932. Printmaker, teacher.
Studies Penrith TAFE 1976–80; BA Visual Arts, Nepean CAE 1985–88; Taught art 1981–90.
Exhibitions Solo shows at Raymond St. Gallery 1981; Street Walker Restaurant 1984, 85; Blacktown Civic Centre 1987; Saddlers Restaurant, Maitland 1988; Penrith Regional Gallery 1990. Many group shows since 1979 include First Draft Gallery and Braemar Gallery 1988, 90; State Parliament House 1988; Bridge St Gallery 1988; Blaxland Galleries; PCA Gallery, Melbourne 1989; Sydney Dance Theatre 1989.
Awards Penrith 1978, 84, 85, 86, 90; Campbelltown 1982; Ryde 1983, 84; Macquarie Uni. 1983; Singleton 1984, 87; Weston 1987, 88; Hunters Hill 1989; Tamworth 1989, 90; Fairfield 1990.

N

NABARULA, Nancy NT
Born c. 1944 at Coniston Station NT. Aboriginal painter in acrylic of the Napperby group.

NADEBAUM, Denise VIC
Born Melb. 1952. Printmaker.
Studies Dip. Art and Design CIT 1975–77; Dip. Ed. Melb. State College 1978. Exhibits with PCA.
Awards City of Oakleigh 1984.
Bibliography *PCA Directory* 1988.

NAGEL, Sue (Holden) NSW
Born Vic 1942. Naive painter in oil.
Studies Was interested in art at school but has had no formal art training; Became interested in the centre and outback of Australia through the books of Ion Idriess, and has spent much time there painting the people and animals and towns in the arid, dry, red soil.
Exhibitions London, UK 1984; Perth, WA 1987; La Jolla, Cal. USA 1987; Solo shows at Casey Gallery and Libby Edwards Gallery 1988, 91.
Bibliography *Australian Naive Painters*, Bianca McCullough, Hill of Content, Melbourne 1977.

NAKAMARRA, Beryl Gibson NT
Born c. 1944. Warlpiri Aboriginal painter in synthetic polymer on canvas from Lajamanu, NT.
Exhibitions Lauraine Diggins Fine Art, Melb. 1989.

NAKAMARRA, Daisy NT
Born 1935. Aboriginal bark painter from Northern Australia.
Represented AGSA.

NAKAMARRA, Florrie Wilson WA
Born 1951. Warlpiri Aboriginal painter in synthetic polymer on canvas from Balgo Hills area, WA.
Exhibitions Lauraine Diggins Fine Art, Melb. 1989.

NAKAMARRA, Jane Gordon WA
Born 1957. Jaru Aboriginal painter in synthetic polymer on canvas from the Balgo Hills area WA.
Exhibitions Lauraine Diggins Fine Art, Melb. 1989.

NAMATJIRA, Elaine NT
Aboriginal acrylic painter from the Mt. Hermannsburg region of Central Australia.
Exhibitions Bloomfield Galleries, Sydney 1989.

NAMATJIRA, Jillian NT
Born c. 1945. Aboriginal watercolour painter from the Mt. Hermannsburg region of Central Australia. Daughter of Enos, sister of Hermann, half sister Gabriel, granddaughter of Albert.
Exhibitions Sylvester Studios 1988; Bloomfield Galleries 1989.
Represented AGSA.

Bibliography *Artlink* Autumn/Winter 1990.
(Died 20/5/91)

NAMPIJINPA, Clarise NT
Born NT. Aboriginal painter in acrylic on canvas from the Yuendumu region NW of Alice
Springs NT.
Bibliography *Artlink* Autumn/Winter 1990.

NAMPITJINPA, Eubena WA
Born 1921 Kukatja, Balgo Hills WA. Aboriginal painter in acrylic. Married to painter
Wimmitji Tjapangarti.
Exhibitions Gallery Gabrielle Pizzi, Melb. 1988, 89, 90; NGV 1989.
Represented ANG; NGV.

NAMPITJINPA, Fabrianne Petersen NT
Born Papunya NT 1965. Aboriginal painter in acrylic and teacher from Mt. Leibig in the
Papunya area.
Exhibitions Moët & Chandon Touring Exhibition 1987.

NAMPITJINPA, Petra Turner NT
Born Papunya NT 1966. Aboriginal painter in acrylic of the Warlpiri tribe.
Exhibitions Moët & Chandon Touring Exhibition 1987.

NAPALJARRI, Hilda NT
Born c. 1941. Aboriginal painter in acrylic from the Ngarlu-Yuendumu region of Central
Australia. Has been assisted with large works by Lucy and Ruth.
Exhibitions Editions Gallery, Fremantle 1986; New York 1988.
Represented SA Museum.

NAPALJARRI, Linda Syddick NT
Born NT. Aboriginal painter in acrylic from the Yuendumu area 300 km NW of Alice
Springs.
Bibliography *Artlink* Autumn/Winter 1990.

NAPALJARRI, Louisa (Pupiya) Lawson NT
Born c. 1939. Warlpiri Aboriginal painter in synthetic polymer on canvas from the
Lajamanu area of NT.
Exhibitions Lauraine Diggins Fine Art, Melb. 1989.

NAPALJARRI, Lucy NT
Born c. 1926. Aboriginal painter in acrylic from the Ngarlu-Yuendumu region of Central
Australia. Has painted with Hilda and Ruth on large works.
Exhibitions Editions Gallery, Fremantle 1986; New York 1988.
Represented SA Museum.

NAPALJARRI, Marjorie NT
Painter in acrylic from the Papunya area NT. Wife of Michael Nelson Jakamarra and at times
assists him with large paintings.
Exhibitions New York 1988.
Represented SA Museum.

NAPALJARRI, Rhoda NT
Warlpiri Aboriginal painter in synthetic polymer on canvas from the Tennant Creek area of

NT.
Exhibitions Lauraine Diggins Fine Art, Melb. 1989.

NAPAJARRI, Ruth **NT**
Born c. 1940. Aboriginal painter in acrylic from the Ngarlu-Yuendumu region of Central
Australia. Has painted with Hilda and Lucy on large works.
Exhibitions Editions Gallery, Fremantle 1986; New York 1988.
Represented SA Gallery.

NAPANANGKA, Bridget Mudjidell **WA**
Born near Lake Dennis, WA c. 1935. Aboriginal painter of the Warlayirti group at Balgo
Hills, WA.

NAPANANGKA, Eileen **NT**
Born c. 1956 at Mbungara, NT. Aboriginal painter in acrylic of the Napperby group.
Exhibitions Sydney, Brisbane, Adelaide, Melbourne.

NAPANANGKA, Gladys **NT**
Aboriginal painter in acrylic on canvas from the Papunya area of Central Australia.
Represented AGSA.

NAPANANGKA, Maggie **NT**
Aboriginal painter in acrylic on canvas from the Yuendumu area of Central Australia, some-
times assists Paddy Jupurrurla Nelson with larger works.
Represented AGSA.

NAPANANGKA, Nancy Naninurra **WA**
Born 1936. Warlpiri Aboriginal painter in synthetic polymer on canvas from Balgo Hills
area, WA.
Exhibitions Lauraine Diggins Fine Art, Melb. 1989.

NAPANANGKA, Topsy **NT**
Born 1924. Aboriginal painter in acrylic on canvas from Papunya area of Central Australia.
Exhibitions ANG, Canberra 1989.
Represented ANG.
Bibliography *Windows of the Dreaming*, ANG 1989.

NAPANGARDI, Denise Robertson (Napangarti) **NT**
Born c. 1958. Warlpiri Aboriginal painter in synthetic polymer on canvas from Lajamanu,
NT.
Exhibitions Lauraine Diggins Fine Art, Melb. 1989.

NAPANGARTI, Bye Bye **WA**
Born 1939 Western Desert. Aboriginal painter in acrylic from the Stanmore Ranges region
of WA. Kukatja language group. Presently painting with the Warlayirti artists at Balgo
Hills, WA.
Exhibitions Birukmarri Gallery, Fremantle; Dreamtime Gallery, Perth; Deutscher Gallery,
Melb.; Gallery Gabrielle Pizzi, Melb.
Represented AGWA.

NAPANGARTI, Njamme **WA**
Born 1940. Kukatja Aboriginal painter in synthetic polymer on canvas board from the
Balgo Hills area of WA. Married to Jimmy Njamme.

Exhibitions Lauraine Diggins Fine Art, Melb. 1989.

NAPANGARTI, Pansy NT
Born Haasts Bluff late 1940's. Aboriginal painter in acrylic on canvas from the Yuendumu region of Central Australia. Warlpiri/ Luritja language group. Won the 1989 National Aboriginal Art Award. One of Papunya Tula's foremost artists.
Exhibitions Gallery Gabrielle Pizzi, Melb. 1988; Bloomfield Galleries, Sydney 1989; NGV 1989; Michael Milburn, Brisbane 1991.
Awards National Aboriginal Art Award 1989.
Represented NGV, NTMAG.

NAPANGARTI, Patricia Lee WA
Born Balgo Hills c.1961. Aboriginal painter of the Warlayirti group at Balgo Hills, WA.
Represented ANG.

NAPANGARTI, Susie Bootja Bootja WA
Born near White Hills, WA c.1932. Married to Mick Gill. Aboriginal painter of the Warlayirti group at Balgo Hills, WA.
Exhibitions Numerous with the Warlayirti artists.
Represented Holmes à Court Collection.

NAPURRULA, Peggie and Maggie NT
Warlpiri Aboriginal painters in synthetic polymer on canvas from the Yuendumu area NT.
Exhibitions Lauraine Diggins Fine Art, Melb. 1989.

NAPURRULA, Rosie Tasman NT
Born c. 1937. Warlpiri Aboriginal painter in synthetic polymer on canvas from Lajamanu, NT.
Exhibitions Lauraine Diggins Fine Art, Melb. 1989.

NATION, Olga (Langdale) TAS
Born Hobart 1904. Naive painter.
Studies School of Art, Hobart under Jack Carington Smith and Molly Stephens 1965–66.
Exhibitions Solo shows at Georgian House, Hobart 1967; The Buttery, Hobart 1968; Cathedral Centre, Hobart 1985. Numerous group shows since 1966 including Groningen, Holland; Canberra, Melbourne and Illinois USA.
Bibliography *Tasmanian Artists of the 20th Century*, Sue Backhouse: Pandani Press 1988.

NAUGHTON, Miriam NSW
Born Sydney 1925. Painter, gallery director.
Exhibitions Barry Stern Galleries 1986; Rainsford Galleries 1986; Gallery Art Naive, Melb. 1986; Blaxland Gallery 1986; Naughton Studio of Naive Art 1987; AGNSW 1988.
Awards Waverley Prize 1986; Garuda Airways Commission.
Represented Institutional, corporate and private collections in PNG, Indonesia, Australia.

NEIL, Barbara NSW
Born Sydney NSW 1953. Painter in oil and acrylic, self-taught.
Exhibitions Solo shows at Mori Gallery, Sydney 1980, 1982; Participated at Axiom Gallery, Melbourne 1982 and Mori Gallery 1981–82.
Respresented Private collections in London, New York, Greece, Sydney, Artbank.

NEILL, Mary Elizabeth (May) NSW
Born Lurgan Northern Ireland 1910. Traditional painter in oil and watercolour.

Studies After leaving school went to Lurgan Technical College on a scholarship to study art; On arriving in Australia, studied at National Art School whilst working as a commercial artist and fashion designer in Sydney; Study tour to Europe 1947 and studied under Dennis Arnold; Back in Australia studied at the Dattilo Rubbo School under Hayward Veal and G.K. Townshend; Associate of the Royal Art Society of NSW; Foundation member of the Ryde Art Society; Member of the Australian Guild of Realist Artists; Retired from her position as journalist and artist with *Woman's World* in 1975 and is now full-time painter. Taught art until 1981.

Exhibitions Many one and two-person shows over the years and regularly with the arts societies with which she is associated. Solo shows at Cede Gallery, Mittagong 1982, 1983.

Awards YWCA Prize 1955; Eastwood Chamber of Commerce Prize 1957, 1958; Ryde (traditional oil) 1962, 1967; Albury (oil) 1963; Drummoyne (oil) 1965, 1967.

Represented Bendigo Teachers College and many private collections in Australia and overseas.

Bibliography *Who's Who in Art and Antiques*, Cambridge, UK 1976.

NEILSEN, Ellie QLD
Born Brisbane Qld 1927. Modern painter in acrylic; Printmaker and muralist.

Studies A.FAS 1980 and with tutors from Brisbane CAE also workshops and seminars 1979–86.

Exhibitions Solo shows at Amanda Gallery, Bundaberg 1981, 82; Sherwood Gallery Biloela 1983; Ardrossan Gallery, Brisbane 1986; City Council, Gladstone 1986; Mill Gallery, Yeppoon 1988; Biloela Civic Centre 1988. Participated AFAS 1980–89; RQAS 1981–89; Warrnambool Reg. Gallery, Vic 1986; Seoul, Korea 1986; Travelling show to NZ.

Awards Moura 1979; Biloela 1983; Monto 1984, 86, 88; Gayndah 1985; Rockhampton 1986; Gladstone 1986. Numerous commissions for murals and logos.

Represented Artbank, institutional and private collections in USA, UK, Europe, Australia.

NEILSON, Judith NSW
Born Bulawayo, Rhodesia. Painter and graphic artist.

Studies Natal Art School 1961–63. Worked as graphic artist and art director in commercial advertising for some years.

Exhibitions Numerous Sydney galleries.

NELSON, Jan VIC
Born Melb. 1955. Modern abstract expressionist painter.

Studies VCA, Melb. 1981–83.

Exhibitions Solo shows at Christine Abrahams Gallery, Melb. 1984, 86; 70 Arden Street Gallery, Melb. 1987. Her work was included in *A New Generation 1983–88* at the Australian National Gallery, Canberra 1988; Most recent solo show at Realities, Melb. 1989, 91 and included in the Moët & Chandon Touring Exhibition 1987.

Represented Budget Transport Industries *Young Australians* Collection.

NELSON, Marjorie QLD
Born London England 1919, migrated to Australia 1949. Abstract painter in oil and mixed media; Teacher.

Studies SA School of Arts; Fellow of Royal SA Society of Arts; Taught art in SA 1968–70; Tutor of Adult Education Department, Central Highlands Region, Qld.

Exhibitions One-woman shows at CAS, Adelaide 1968; Stairway Gallery, Adelaide 1969; Adelaide Festival of Arts 1970; Flinders University 1973.

Awards First prizes at Royal SA Society of Arts 1969; Weerama Festival, SA 1970; Central Highlands Rotary, Qld 1974; Rockhampton, Qld 1974; Emerald Shire Council, Qld 1976;

Parliamentary Acquisition, Brisbane 1977.
Represented Parliament House, Brisbane; Mildura Arts Centre, Vic; Private collections in Australia and overseas.

NELSON, Nora Nabaldjarr NT
Aboriginal painter in acrylic from the Yuendumu region of Central Australia. Warlpiri language group. Wife of Frank.
Exhibitions Gallery Gabrielle Pizzi, Melb. 1988; Dreamtime Gallery, Perth 1989; Paris 1989; Madrid 1989.

NETOLICKY, Cecilia (nee Williams nee Freedman) WA
Painter and teacher.
Studies University of Wisconsin, USA 1966–71; BA (Anthropology) UWA, Perth 1974–77; Incomplete Ph.D. studies 1978–81. Has taught art in various colleges since 1968; Currently teaching at Paraquad Recreation Centre, Perth.
Exhibitions Papua New Guinea 1981, 82; Perth Concert Hall 1988; Swan Brewery and Staffords Studios, Perth 1989.

NETTE, Susan VIC
Born Melbourne Vic 1938. Realist painter in oil; Chinese brush painter and teacher.
Studies National Gallery School, Melbourne under Lance McNeil and Alan Martin.
Exhibitions Has held one-woman exhibitions at Shepparton Regional Gallery; Vic Artists Society and Nette Gallery, Vic; For the last six years has taught at her own private art school in Melbourne and Romsey, Vic and given public demonstrations and lectures including Camberwell Rotary Art Exhibition.
Represented Private collections in UK, Europe, USA, Singapore and Australia.

NETTING, Joanne QLD
Born Melb. 1963. Modern naive style painter, self-taught.
Exhibitions Solo shows at The Centre Gallery, Gold Coast Qld 1986; Gallery Art Naive, Melb. 1987, 88; Rainsford Gallery, Sydney 1987; Libby Edwards Gallery, Melb. 1988; Naughton Naive Gallery, Sydney 1988, 89; Gallery Nae, Tokyo 1989.
Represented Institutional and private collections in Australia, USA, Japan.

NETTLETON, Liz VIC
Born Adelaide SA 1952. Tapestry, soft sculpture; Teacher.
Studies Diploma in Teaching, Bedford Park Teachers College, Flinders University 1969–72; Certificate of Italian Langauge, Florence University 1973; Diploma in Art, Preston IT and Melbourne College of Textiles 1975–77; Workshop Magdalena, Abakanowicz 1976. Taught RMIT 1978–83; Caulfield Arts Centre 1979–80; Study in Europe 1973, 1974, 1981, 1982, 1983.
Exhibitions Many shows since 1975 and recently solo show at Bridge Gallery, Warrandyte 1982 and participated in Distelfink Gallery 1980; Sydney Trade Fair 1982; Crafts Expo '82, Sydney and Melbourne.
Awards Diamond Valley 1975, 1976, 1979; Tamworth 1978; Crafts Board Grant 1980, 1981; Member, Craft Association of Vic; Craft Council of Australia.
Represented Private and public collections in most Australian states, USA, England and Ireland.
Bibliography *Craft Victoria* 1982.

NEWMAN, Anita NSW
Born UK 1946. Traditional painter of landscapes and people.
Studies Under private tutors including Newton Hedstrom 1969–73 and a Chinese brush

painting course 1975.

Exhibitions Northbridge Gallery, Sydney 1976–78; Barbizon Gallery, Sydney 1979; Manyung Gallery, Melbourne 1983; Participated at Saints Gallery, Sydney 1980–83; Sheridan Gallery, Brisbane 1983.

Awards Peter Campbell Art Award 1981.

Represented Private collections around Australia and in UK, USA, Canada and Hong Kong.

NEWMAN, Carole ACT

Born NSW. Graphic designer, wood sculptor.

Studies Dip. Art, Alexander Mackie CAE. Grad. Dip. Ed., Sydney Teachers College.

Exhibitions Cuppacumbalong Craft Centre ACT 1986, 87, 88. Many craft and sculpture commissions.

Represented New Parliament House, Canberra, corporate, diplomatic, institutional and private collections.

Bibliography *Craft Aust. Year Book* 1986.

NEWMAN, Elizabeth VIC

Born Melb. 1962. Expressionist painter.

Studies BA, VCA 1981–83; Postgraduate 1984.

Exhibitions Solo shows at George Paton Gallery, Melb. 1986; City Gallery, Melb. 1988, 89; Roslyn Oxley9 Gallery, Sydney 1988; and included in Murdoch Travelling Fellowship Show 1985; 200 Gertrude St. 1986, 87; 'Chaos', Roslyn Oxley9 Gallery and touring NSW and SA Reg. Galleries 1987; Ivan Doughtery, Sydney 1987; *A New Generation 1983–88*, ANG, Canberra 1988; The Centre Gallery, Qld 1987.

Represented ANG, Artbank, institutional and private collections.

NEWMAN, Nichole VIC

Born Paris France 1949, arrived Australia 1951. Sculptor.

Studies National Gallery School, Melb. 1967–70; San Francisco Art Institute, USA 1972; Postgraduate studies at Vic College of the Arts 1973–74.

Exhibitions Solo shows at Avant Galleries, Melb. 1972, 75; Hogarth Gallery, Sydney 1976; Melb. Contemporary Gallery 1989; Reconnaissance Gallery 1989; Melbourne Contemporary Art Gallery 1990.

Represented Australian National Gallery, ACT.

Bibliography *Australian Sculptors*, Ken Scarlett, Nelson 1980.

NEWMARCH, Ann SA

Born Adelaide SA 1945. Contemporary painter in oil; Printmaker and teacher.

Studies SA School of Art 1964–67; Very active member of the Progressive Art Movement of SA; Lecturer at the SA School of Art since 1969; Studies overseas for six months with Visual Arts Board Grant and at Flinders University, SA 1973–74.

Exhibitions Solo shows include Ray Hughes Gallery, Brisbane 1971; Llewellyn Gallery, Adelaide 1971; Bonython Gallery, Sydney 1972, 1974; Ivan Dougherty Gallery, Sydney 1988; Riddoch Gallery, SA 1990. Numerous group shows since 1969 include National Gallery of Vic and Sydney Biennale 1979; New York USA; Adelaide Festival of Arts and Art Gallery of SA 1980; Travelling shows from Experimental Art Foundation and Art Gallery of SA and *Australian Perspecta*, Art Gallery of NSW 1981.

Awards OAM for services to the arts 1988.

Represented State Galleries of SA and Vic; Newcastle Regional Gallery and institutional and private collections around Australia and overseas.

Bibliography *Directory of Australian Printmakers* 1976; *Art and Australia*, Vol 9/1, page 30; *Catalogue of Australian Perspecta* 1981, Art Gallery of NSW; *Artists & Galleries of Australia*,

Max Germaine: Craftsman House 1990.

NEWSOME, Mary VIC
Born Melbourne Vic 1936. Printmaker, painter and teacher.
Studies Bachelor of Arts in English at Melbourne University 1954–56; Art courses in Oxford and London 1960–72; Printmaking, Prahran College of Advanced Education 1975–78; Taught adult art and craft classes in UK; Toorak State College of Vic 1978 Grad. Dip. Art Ed.
Exhibitions Group shows in UK 1968–72; Mornington Print Show 1976; Contemporary Melbourne Women Printmakers 1977; Print Council of Australia Travelling Exhibitions 1978; Joint show with Louise Baker at Bookshelf Gallery, Melbourne 1978. Solo shows at Consortium Gallery, Adelaide 1979, Niagara Galleries 1985 and participated at Distelfink Gallery, Melbourne 1981. Work on cover of 'LIP' 1978–79 and article. Shows with Print Council, Aichi Prefecture, and Distelfink Gallery 1984.
Represented Art Gallery of SA; Qld Art Gallery; Toorak State College and private collections in UK, Europe and Australia.

NICHOLS, Maris QLD
Born Sydney 1932. Painter and printmaker.
Studies Europe privately 1956–58; Indonesia 1969–72; Graduated Associate Diploma in Art at BCAE, Kelvin Grove Campus, Brisbane 1985–88.
Exhibitions Solo shows at Boston Gallery, Brisbane 1982, 88. Participated in many Brisbane painting and printmakers shows 1976–88.

NICHOLSON, Julie NSW
Born Transylvania Hungary, arrived Australia 1949. Painter and teacher.
Studies Academy of Art, Budapest. Joined teaching staff at the Nursery School Teachers' College, Sydney where she is in charge of the art collection.
Exhibitions Solo show at Murray Crescent Galleries, ACT 1979.

NICMANIS, Aina NSW
Born Latvia. Semi-abstract texture painter in acrylic, mixed media and watercolour.
Studies National Art School, Wollongong 1959–1963. Between 1963–1965 texture painting with William Peascod. European study tours 1973, 1976. Canada and America 1978. Watercolour studies at Mitchell College of Advanced Education, 1981. Member, Wollongong Art Society, Goulburn Art Society.
Exhibitions Wollongong 1967, 1974; Latvian House, Strathfield 1968 and 1972; Sydney 1968, 1969, 1973; Melbourne 1970; Orange 1968; Armidale 1984; and Group exhibitions throughout Australia.
Awards Since 1967 has won twenty-four prizes for her paintings in NSW country and Sydney competitions.
Represented Bathurst Art Gallery, Nowra Shire Council, Ryde Shire Council, Orange Ex-Services Club, Ashfield Shire Council, Gosford Shire Council, Bunbury Art Gallery, La Trobe University and in private collections in Latvia, Canada, USA, England and Australia.
Bibliography *Latvian Artists in Australia*, by ALMA 1979.

NIGHTINGALE, Susan VIC
Born Melbourne Vic. Sculptor in mixed media.
Exhibitions One-woman show at Realities Gallery, Melbourne 1983, 85, 90.

NIGRO, Jan QLD
Born Gisborne NZ 1920. Figurative painter in oil, pen, pencil, collage.
Studies Elam School of Fine Arts, Auckland 1936–38; Member of Committee of

Management National Art Gallery, Wellington 1970–73; Member, Visual Arts Committee, Auckland Festival Society 1967–70; Part-time tutor, Auckland Society of Arts; Now resident in Brisbane.

Exhibitions Sixteen one-woman shows including Velasque and Georges Galleries, Melbourne 1948, 1950; Holdsworth Galleries, Sydney 1974 and Barry Lett Galleries, Auckland; CAS Shows, Melbourne, Sydney and Brisbane; Expo 70; Osaka Japan; Commonwealth Games, Christchurch; 'NZ Painting', Noumea; Noted for her *Pioneer* and *Encounter* Series. Dunedin Public Gallery 1987.

Awards Dunlop (Vic) 1950; Waikato Competition for Religious Art 1958; Hays Art Competition, Christchurch 1963; Finalist Jacaranda, Grafton NSW 1963; Finalist, Benson and Hedges Art Award NZ 1968, 1970, 1972, 1974.

Represented National Gallery, Wellington; Auckland City Gallery, University of London UK; Robert Melville Collection, UK; Harold Mertz Collection, USA.

Bibliography *Two Hundred Years of NZ Painting*, Gil Docking, Lansdowne Press 1971.

NIKULINSKY, Philippa — WA

Born WA. Botanical artist; Her book *Flowering Plants of the Eastern Goldfields of WA* was published by Carr Boyd Ltd, Perth in 1983.

NILAND, Deborah — NSW

Born NZ. Realist painter in oil, acrylic and watercolour; Illustrator.

Studies Julian Ashton School, Sydney.

Exhibitions Prouds, Solveig and Seasons Galleries, Sydney.

Awards Le Gay Brereton Drawing Prize 1971.

Publications Numerous works include *Mulga Bill's Bicycle*, Wm. Collins 1973 with her sister Kilmeny, and *When The Wind Changes* a prize-winning book written by her mother Ruth Park and published by Wm. Collins in 1981.

NILAND, Kilmeny — NSW

Born NZ. Realist painter and illustrator.

Studies Julian Ashton School, Sydney.

Exhibitions Barry Stern Galleries, Sydney 1978, 1980, 1984.

Publications Numerous works include *Feathers, Fur and Frills*, a book of Australian animals published by H & S in 1980.

NIMMO, Lorna (Muir) — NSW

Born Katoomba NSW 1920. Painter in watercolour and oil; Teacher.

Studies East Sydney Technical College 1936–40; Lecturer ESTC 1952; Studies overseas in Paris, Slade School and Cortauld Institute, London 1952–54; Lecturer and originator in course favouring contemporary art, University of NSW 1955–80 also in charge of graphics at School of Architecture; Study tour to UK, Europe, USA 1969–70. Has exhibited with the AWI since 1942 and was President 1955–58; Not much painting done since retirement due to illness and accident but presently setting up a new studio at Murrurundi NSW to start painting again in both oil and watercolour.

Awards NSW Travelling Scholarship 1941; Wynne Prize 1941.

Represented Art Gallery of NSW; Art Gallery of SA; Australian National Gallery and institutional and private collections in UK, Europe, USA and Australia.

NOBLE, Jill — VIC

Born Adelaide 1962. Modern painter and sculptor.

Studies SA School of Art, Adelaide 1980–82. Founding member of ROAR Studios 1982.

Exhibitions Solo shows at Coventry Gallery, Sydney 1987, 88, 89, 90; Participated at ROAR Studios 1982, 83; Cockatoo Galleries, Launceston 1984; Chameleon Gallery,

Hobart 1984; Coventry Gallery 1985, 86, 88, 90; Realities, Melb. 1985; *A New Generation 1983–88*, ANG Canberra 1988; Linden Gallery, Melbourne 1989.
Represented ANG, Artbank, NGV, institutional and private collections.

NOETH, Nelly VIC
Born Santiago, Chile 1962. Expressionist painter, ceramic artist, jeweller, teacher.
Studies BA, Queensland College of the Arts 1989; Presently teaching at a secondary school.
Bibliography *Alice 125*, Gryphon Gallery: University of Melbourne 1990.

NOLAN, Jinx VIC
Born Vic. 1941. Painter.
Studies BA Bennington College, Vermont USA 1964; Dip. Museum School, Boston USA 1979.
Exhibitions Solo shows at Peasant Stock Gallery, Cambridge, Mass. USA 1982; Holdsworth Contemporary Galleries 1987; Numerous group shows around USA 1979–86.
Awards Boit Prize, Boston USA.

NOLAN, Rose VIC
Born Melb. 1959. Paintings and constructions.
Studies Dip. Art, VCA 1978–80, Degree 1983.
Exhibitions Solo show at Uni. of Melb. George Paton Gallery 1984; Participated VCA Gallery 1980, 83; Keith and Elisabeth Murdoch Show 1981, 83.
Represented Institutional and private collections.

NORRIE, Mary QLD
Born Shepparton Vic. Contemporary painter in oils, acrylic, watercolour; Printmaker; Sculptress.
Studies Graduate BA and B Com, Melbourne University. Studied art at Central Technical College, Brisbane, under Melville Haysom. Later studies under Roy Churcher, Bronwyn Thomas, Nevil Matthews, and Brian Hatch; Arts Council of Queensland Vacation School for Creative Arts; New England Vacation Schools at Armidale under George Baldessin. In 1977 studied etching under Nora Anson at the College of Art, Brisbane. Former member of Contemporary Art Society. Member of Royal Queensland Art Society, Institute of Modern Art, and Society of Sculptors — Queensland.
Exhibitions Design Arts Centre, Brisbane, 1970; Gallery 99, Melbourne, 1971; Italia Gallery, Brisbane, 1975; Martin Gallery, Townsville, 1975; Hawthorn City Art Gallery, 1976; Linton Gallery, Toowoomba, 1976; Bakehouse Galleries, Mackay, 1976; Fantasia Galleries, Canberra, 1976; RQAS Gallery, Brisbane, 1986; The Centre Gallery, Gold Coast 1988.
Awards Has won 73 First Prizes and 28 Second Prizes in art competitions in Queensland since 1964.
Represented Institutional and private collections.
Bibliography *A Homage to Women Artists in Queensland, Past and Present*, The Centre Gallery 1988.

NORRIE, Susan NSW
Born Sydney NSW 1953. Modern painter in oil and acrylic; Teacher.
Studies East Sydney Technical College 1973; Vic College of the Arts 1974–76. Part-time lecturer in painting at Sydney College of the Arts. Artist-in-Residence, University of Melb. 1984. Studied in Europe 1987–88.
Exhibitions Solo shows at Mori Gallery, Sydney 1980, 82, 86, 88; Realities Gallery, Melb. 1983; Uni. of Melb. Gallery 1986; United Artists Gallery, Melb. 1987; Hotel Pozzo di Borgo, Paris 1987; Troyes, France 1988; Wollongong City Gallery 1989; Nancy Hoffman

Gallery, New York 1990. Recent group shows include *Perspecta* 1983, 85 AGNSW; Biennale of Sydney 1986, *Artworkers Union Annual Fundraiser Exhibition*, Artspace, Sydney 1984, 85, 86; Institute of Modern Art, Brisbane; *Moët & Chandon Fellowship Exhibition*, Art Gallery of Western Australia, and touring; Helde Gallery, Melb.; Guggenheim Museum, New York; Australian National Gallery, Canberra 1987; *A New Generation 1983–88*, Australian National Gallery, Canberra 1988; Auckland City Art Gallery 1988; Mori Gallery 1989; Monash University, SACAE, Heide Park & Art Gallery, Ivan Dougherty Gallery 1990; Chicago International Art Exposition 1991.

Awards *SMH* Sydney Heritage Award 1983; Moët & Chandon Award 1986. Included in Bicentennial Print Folio 1988.

Represented State Galleries of NSW and WA; Wollongong City Gallery; and private collections.

Bibliography *Catalogue of Australian Perspecta* 1983, Art Gallery of NSW; *Art and Australia*, Vol 18 No 2 Exhibition commentary; *Artists & Galleries of Australia*, Max Germaine: Craftsman House 1990.

NORRIS, Maree WA

Born Perth WA 1954. Genre painter in oil, pastels, ink, chalk, collage; Ceramic artist.

Studies Associate, Fine Arts at WA Institute of Technology.

Exhibitions Ceramics, Collectors Gallery, Perth 1976, 1977; Ceramics, Old Court House, Busselton WA 1977; Drawings, paintings, ceramics, Collectors Gallery 1978; Ceramics WA University 1978; Ceramics, Studio Zero, Qld 1978; Ceramics, Fremantle Art Centre 1978; Eric Car Gallery, Fremantle 1979, 1980, 1981, 1982; Old Court House 1980, 1981, 1982.

Represented WAIT and private collections around Australia and New York.

NORTH, Diana Alice TAS

Born Launceston, Tas. 1958. Painter, printmaker, arts administrator.

Studies Dip. Arts TCAE, Launceston 1984; B. Fine Arts TSIT, Launceston 1988. Assistant director, Community Mural Project (VAB funded), Georgetown, Tas. 1985. Artist-in-Residence, 'Eskleigh' Perth, Tas. 1990.

Exhibitions First solo exhibitions at Chameleon Gallery, Hobart 1986, 89; Cockatoo Gallery, Launceston 1985. Participated Mill Art Centre, Launceston 1983 and Chameleon, Hobart 1985; QVMAG 1984; TSIT Gallery 1988, Long Gallery, Hobart 1988, 89; Cockatoo Gallery 1989; PCA Gallery, Melbourne 1989; Gallery Cimitiere, Launceston 1989; Tas. Print Calendar, Arthouse, Launceston 1990. Overseas study tours to UK, Europe, India, Middle East.

Awards TAAB Printmaking Grant 1989.

Bibliography *Tasmanian Artists of the 20th Century*, Sue Backhouse: Pandani 1988.

NORTON, Lynne WA

Born Fairlight NSW 1950. Painter; daughter of artists Frank Norton.

Studies Dip Fine Art (Painting) Claremont School of Art, WA 1982–84; BA (Fine Art) Curtin University WA 1985–88.

Exhibitions Solo shows at University of WA 1984; Gallery 350 1990. Numerous group shows since 1984 include Stedelijk Museum, Sint-Niklaas, Belgium 1989.

Awards Beverley Drawing Prize 1988, 89; City of Belmont 1988.

Represented University of WA, institutional and private collections in Australia and Belgium.

NOWICKA, Sophie VIC

Born Lodz, Poland 1953. Textile and fibre artist. Arrived Australia 1981.

Studies Graduated from the School of Fine Art, Lodz 1980 after study of industrial textiles

and fibre.
Exhibitions Joint shows at Gryphon Gallery, Melb. 1983; Ararat Regional Gallery, Vic 1983; Artists Space, Melb. 1987 and 4th Biennial Exhibition of Contemporary Fibre and Textiles, Ararat Gallery 1987.
Represented Ararat Regional Gallery, Vic.

NOWLAN, Annabel NSW
Born NSW 1956. Paintings, assemblages, video.
Studies ESTC, Higher Art Certif. 1984–87; BA, City Art Institute 1988. Worked in New York 1989.
Exhibitions Solo shows at Access Gallery, Sydney 1988, 89, 90, 91. Group shows include Burrangong Gallery, Young NSW 1979–84; EMR Gallery 1988; Access Gallery 1987; New York 1989; Coventry Gallery 1990; ACAF 2, Melbourne 1990; University of NSW Gallery 1990; Ten Taylor St. Gallery 1991; The Sydney Cove Oyster Bar 1991.
Awards Art Expo Prize, New York 1988.
Represented Institutional and private collections in USA and Australia.

NOWLAND, Aileen NSW
Born NSW. Watercolour painter of animals, landscapes and wildlife.
Exhibitions RAS Easter and Castle Hill Shows 1984.
Awards Frank Ireland Special Award, Castle Hill 1984.

NUM, Andrea SA
Born Adelaide SA 1948. Abstract painter, printmaker and teacher.
Studies SA School of Art 1965–69, (Diploma Fine Art Painting); Torrens College of Advanced Education 1975 (Diploma Secondary Teaching Art); SA College for the Arts and Education 1981 (Bachelor of Fine Art, Painting); Sturt College of Advanced Education 1982 (painting research). Travelled and studied in Hong Kong, Japan, USSR, UK, Europe, Turkey, India, Singapore 1974–75; New Guinea 1977; USA, Ireland, UK, Europe, Crete 1980–81; China 1983. Has taught art for SA Education Dept since 1970. Studies Flinders Uni. 1987.
Exhibitions Participated in Flotta Lauro Exhibition, Sydney 1967; University of Tas Print Prize Exhibition, Australia 1968, Singapore 1969; Geelong Print Prize Exhibition 1968; Rigby Art Gallery, Adelaide 1969; Llewellyn Gallery, Adelaide 1970; Sydenham Gallery, Adelaide 1973, 1974, 1977; Mornington Peninsular Print Prize Exhibition 1974; Old Adelaide Gallery 1975; University of Adelaide Club 1980; Contemporary Art Society, Adelaide 1966–82; Bundaberg Festival Exhibition, Qld 1982; Royal SA Society of Arts, members exhibitions; Limeburners Gallery, SA 1983; Whyalla, SA 1986; Elizabeth, SA 1988.
Awards Geelong Print Prize 1968; Royal SA Society of Arts Prize for Composition 1969; Moya Dyring Studio residency (Cité Internationale des Arts, Paris) 1980; Tea Tree Gully 1984.
Represented Geelong Art Gallery and private collections in Australia and overseas.
Bibliography *Directory of Australian Printmakers* 1982, 88.

NUNAN, Shona VIC
Born Daylesford Vic 1959. Painter and sculptor.
Studies Bachelor of Arts in Fine Art, RMIT 1977–81; Study tour to Europe and Asia 1980.
Exhibitions Solo sculpture shows at Emerald Gallery, Vic 1976, 1982; Holdsworth Galleries 1987, 88, 89; Wallace Bros., Castlemaine, Vic. 1989.
Represented Private collections in Australia, UK, Europe and India.

NUNGALA, Janet Forrester NT
Born 1959. Promising Aboriginal painter from the Napperby Station area of Central

Australia. Paints in synthetic polymer on canvas.
Exhibitions Masterpiece Gallery, Hobart 1989.

NUNGALA, Madeline Gibson NT
An emerging Aboriginal painter in acrylic on canvas from the Anmatyerre tribe who paint in the Napperby Station area of Central Australia.
Exhibitions Bloomfield Galleries, Sydney 1989.

NUNGARRAYI, Lady NT
Born c. 1933. Aboriginal painter in acrylic from the Yuendumu region of Central Australia. Warlpiri language group.
Exhibitions Editions Gallery, Fremantle 1986; Blaxland Galleries, Sydney 1987, AGSA 1987.
Represented SA Museum.

NUNGARRAYI, Mary NT
Born c. 1942. Aboriginal painter in acrylic from the Yuendumu region of Central Australia. Warlpiri language group.
Exhibitions Editions Gallery, Fremantle 1986; Blaxland Galleries, Sydney 1987, AGSA 1987.

NUNGERAYAI, Muntja (Nungarrayi) WA
Born near Lake Tobin, WA c.1930, married to John Mosquito. Aboriginal painter in acrylic on canvas working in the region of the Canning Stock Route.
Exhibitions Birukmarri Gallery, Fremantle; Dreamtime Gallery, Perth; AGSA.
Represented ANG, Canberra.

NUNGERAYI, Ena Gimme WA
Born near The Canning Stock Route c.1953; Daughter of Eubena. Aboriginal painter of the Warlayirti group at Balgo Hills, WA.
Exhibitions With the Warlayirti artists and in London UK 1990.

NUNGERAYI, Lucy Loomoo WA
Born near Jupiter Well, WA c.1935. Aboriginal painter of the Warlayirti group at Balgo Hills, WA.
Exhibitions With the Warlayirti artists.

NUNGERAYI, Elizabeth Nyumi WA
Born near Jupiter Well, WA c.1945. Aboriginal painter of the Warlayirti group at Balgo Hills, WA. Married to Palmer Gordon.
Exhibitions With the Warlayirti artists and in London, UK 1990.

NUNGORAYI, May NT
Born 1942. Aboriginal painter in synthetic polymer on canvas from the Central Australian Desert.
Exhibitions Masterpiece Gallery, Hobart 1989.

NUNN, Mary WA
Born Greenmount WA. Painter.
Studies Perth TC; Nat. Gallery School, Vic.; George Bell School, Melb.; Committee member of Perth Society of Artists.
Exhibitions Newspaper House, Perth; Delahaye Gallery, Cirencester UK; Beach Thomas

Gallery Oxford.
Represented Institutional and private collections in UK, Europe, USA, Australia.

O

OATES, Denese NSW
Born Orange NSW 1955. Painter, sculptor.
Studies Alexander Mackie CAE 1974–77.
Exhibitions Macquarie Galleries, Sydney 1978, 1979, 1980, 1981, 1982, 1983, 1984, 1985, 1987; Fremantle Art Gallery, Penrith Reg. Art Gallery 1983. Many group shows include *Continuum*, Ivan Dougherty Gallery 1981; Wollongong Reg. Gallery 1982; International Paper Conference, Kyoto, Japan 1983; TMAG 1984; Macquarie Galleries 1985, 89.
Awards VAB Grant 1979.
Represented City Art Institute, Sydney; Wollongong City Art Gallery; Burnie Art Gallery; Artbank; Rockhampton Art Gallery; Private Collections.

OBERZANEK, Alexandra VIC
Born Poland 1945. Painter in oil.
Studies Diploma in Fine Art (painting) RMIT 1976–80; Lived in Israel 1967–74.
Exhibitions Solo shows at Profile Gallery, Melb. 1983, 85. Participated at Women's Art Forum, Prahran IT 1982.

O'BRIEN, Daphne NSW
Born Wellington NSW 1923. Painter, teacher, gallery director.
Studies Under numerous private tutors for painting and printmaking since 1964. Director of Gallery D Albion Park NSW. Member, Peninsular Art Society.
Exhibitions Old Bakery Gallery, Lane Cove 1979; Woollahra Galleries 1981; Group shows include Barrenjoey Art Gallery 1985; Q Gallery 1987; Wollongong Regional Gallery 1987.
Awards Has won over fifteen prizes in art competitions since 1976 and more recently at Royal Easter Show Seascape 1985; Kiama Art Society 1989, 90.
Represented Municipal and private collections.

O'BRIEN, Kate VIC
Born Mackay Q. 1913. Illustrator and cartoonist.
Studies Trained as a fashion designer and illustrator and has worked for Georges, Myers and David Jones. Has illustrated over twelve books and her comic strip *Wanda* appeared in Australian newspapers 1942–51.
Bibliography *Alice 125*, Gryphon Gallery: University of Melbourne 1990.

O'BRIEN, Marian QLD
Born Tamworth NSW 1936. Painter.
Studies BA, Dip. Ed., UNE, Armidale NSW, 1957. Owned and directed Buderim Art Gallery 1986–87. Introduced to painting through creative drawing with Nancy Grant of Beaumaris Art Group and attended workshops and seminars by well known artists.
Exhibitions Solo show at Sketch Gallery, Noosa Qld.
Awards Sunshine Coast 1981, 83, 88; Noosa Rotary 1983, 84, 87; Currabubula Red Cross 1988; Redland Bay WC (shared) 1988.
Represented Redcliffe Municipal Collection 1987, and local and overseas private collections.

O'CONAL, Judith NSW
Born Newcastle NSW 1936. Painter and portraitist, mostly in oil.
Studies Dattilo Rubbo School 1949–52; Julian Ashton School 1952–60; Royal Art Society
School 1969; Albert Rydge 1970, Graeme Inson's School 1971–76; Associate of Royal Art
Society of NSW.
Exhibitions Exhibits with Prouds Gallery, Sydney and regularly with RAS shows and
Portia Geach Competition.
Awards Baulkham Hills 1975; Campbelltown (portraiture) 1976; Castle Hill 1976; Opera
House Auditions Committee Art Competition 1977; Numerous portrait commissions.
Represented University of Wollongong Art Collection; Institutional and private collec-
tions in NSW, Vic and Qld.

O'DWYER, Roisin VIC
Born Dublin, Ireland 1961. Painter.
Exhibitions 200 Gertrude St. Gallery 1986, 87; Moët & Chandon Touring Exhibition
1990.
Represented The Myer Foundation, Melbourne.

OFFICER, Denise VIC
Born Vic 1955. Contemporary painter and stage designer.
Studies Diploma of Art and Design, Prahran Technical College, Melbourne.
Exhibitions First one-woman show at Gallery de Tastes, Melbourne 1978; Has produced
stage and set designs for Melbourne Theatre Company.

OGILVIE, Helen VIC
Born NSW 1902. Painter and printmaker.
Studies National Gallery School, Melbourne 1919–21; Some of her early hand-coloured
linocuts were published by the Booklovers Bookshop, Melbourne about 1927; She began
colour linocut printing in 1928 after reading Claude Flight's book on colour printing,
Linocuts, London 1927; Exhibited colour linocuts and wood engravings with the New
Melbourne Art Club in the mid 1930s; Produced wood engravings for the book, *Flinders
Lane* in 1947; First director of the Peter Bray Gallery, Melbourne and held exhibitions of
paintings, 'Australian Country Dwellings' at the Leicester Galleries, London 1963, 1967
and in Australia in the same years; Her work was included in the Australian Gallery
Directors Council Travelling Exhibition to Indonesia 'Landscape and Image' 1978;
Deutscher Galleries 1978; Josef Lebovic Gallery, Sydney 1987, 89; aGOG Gallery Canberra
1991.
Represented National Collection, Canberra; State Galleries of Vic and NSW; Regional
Galleries at Ballarat and Castlemaine, Vic; Many private collections in Australia and over-
seas.
Bibliography Catalogue *Landscape and Image*, Australian Gallery Directors Council
Travelling Exhibition to Indonesia 1978; *A Survey of Australian Relief Prints 1900–1950*,
Deutscher Galleries, Melbourne 1978.

OGLESBY, Penny TAS
Born Launceston 1943. Painter and teacher.
Studies Hobart S of A 1963–65. Taught with Tas. Ed. Dept. 1966–69; Studied UK, Europe
1969–74; Teaching in Tas.
Exhibitions Mersey Gallery, Devonport 1978, 80; Westella Gallery, Ulverstone 1979;
Windsor Galleries, Kingston Beach 1979; Ritchies Mill Gallery 1980; Village Gallery,
Carrick 1982.
Bibliography *Tasmanian Artists of the 20th Century*, Sue Backhouse, 1988.

O'GRADY, Gladys NSW
Born 1897. Painter of Australian wildlife in watercolour.
Publications *Illustrated Australian Birds and their Young*, text by Terence Lindsay 1982.

O'HARRIS, Pixie NSW
Born Wales UK 1903, arrived Australia 1921. Magic and romantic painter in oil and water-
colour, printmaker and illustrator of children's books and portraitist.
Studies and Achievements One of nine children whose father George F. Harris was a noted
portrait painter; Aunt to Rolf Harris, artist and entertainment celebrity; At the age of four-
teen she was the youngest person ever admitted to the South Wales Royal Art Society, UK;
Soon after her arrival she became known for her drawings for children and has written and
illustrated 22 children's books; She has also illustrated fourteen books by other authors
including Frank Dalby Davison and C.J. Dennis; Over the years she has decorated the walls
of over 60 hospitals, day nurseries, orphanages and schools.
Exhibitions Has held many one-woman exhibitions including Rosalind Humphries
Galleries, Block Galleries and Frances Jones Galleries in Melbourne and Barry Stern,
Bonython and Bloomfield Galleries in Sydney; Bathurst Regional Gallery 1983; Barry Stern
1984; Gallery Art Naive, Melb. 1985.
Awards Patron of the Royal Alexandra Hospital for Children; Awarded MBE in 1976 and
Coronation Medal 1977 for her services to art.
Represented Princesses' Nursery, Buckingham Palace; National Collection, Canberra;
University of NSW; Many Australian and overseas collections.
Publications *The Fairy who Wouldn't Fly*, Angus & Robertson 1976; *Pixie O'Harris Gift
Book*, Dymocks Ltd ND; *Pearl Pinkie and Sea Greenie* 1925 and *Marmaduke, the Possum in the
Cave of the Gnomes* 1979; Autobiography *Was It Yesterday?*, Rigby 1983.
Bibliography *Artists & Galleries of Australia*, Max Germaine: Craftsman House 1990.

OHLSSON, Bridget NSW
Born Sydney 1960. Painter, graphic artist.
Studies SCOTA 1980; Dip. Art Canberra S of A 1981–83; Postgrad. Dip. from City Art
Institute 1986–87; UK, Europe 1980–81.
Exhibitions Solo shows at Garry Anderson Gallery 1983; Tynte Gallery, Adelaide 1984.
Numerous group shows since 1982 and recently at ROAR Studios, Melb. 1986; Michael
Milburn, Brisbane 1987.
Represented Artbank, institutional and private collections in Australia.

OKTOBER, Tricia NSW
Born Australia. Surrealist painter, self-taught.
Studies Studied sculpture with Tom Bass.
Exhibitions Cassanova Gallerie, Place Royale, Paris France 1974; Gallerie De La Rougerie,
Conflans, Sur Loing France 1974; Montcalm Gallery, Quebec City Canada 1976; Moulin
Des Artes, St Etienne Canada 1976; Samuel Holland, Quebec City Canada 1976; Gallerie
Rene Bayeur, Boston USA 1977; Gallerie Charles Huot, Quebec City Canada 1977, 1978;
Balcon Des Images, Montreal Canada 1978; Holdsworth Galleries, Sydney 1979.

OLAH, Elizabeth (Liz) NSW
Born Hungary 1944, arrived Australia 1957. Painter, sculptor and jeweller.
Studies Prahran Technical College for art and jewellery trade from her father.
Exhibitions Many shows since 1965 and recently Maker's Mark, Melbourne 1980 and Barry
Stern, Sydney 1981; Participated in touring show to Far East 1980; Australian jewellery,
touring Europe 1982–83; Craft Survey, Qld Art Gallery 1982.
Awards NSW Jewellery Award 1975; Diamond Valley Award 1981.
Represented Qld Art Gallery, Australia Council and institutional and private collections in

Australia and overseas.

OLD, Ursula NSW
Born Sydney NSW 1916. Painter in oil of birds, flowers and people; Printmaker.
Studies East Sydney Technical College under Fred Leist, Douglas Dundas and Frank Medworth 1934–39; Silk screen printing under David Rose at University of New England Summer School 1972.
Exhibitions Solo show at Belmont NSW 1983; Participated at Ku-ring-gai, Drummoyne, Central Coast Art Societies and Newcastle 1976–82.
Awards Drummoyne 1976; Ku-ring-gai 1981; Wellington 1982; Wyong 1985; Narrabri 1986; Ryde 1990.
Represented The Mitchell Library, Sydney and private collections.
Bibliography *PCA Directory* 1988; *Artists & Galleries of Australia*, Max Germaine: Craftsman House 1990.

OLDFIELD, Eva Nungarrayi NT
Warlpiri Aboriginal painter in synthetic polymer on canvas from Yuendumu, NT.
Exhibitions Lauraine Diggins Fine Art, Melb. 1989.

OLIVER, Anne SA
Born Budapest, Hungary 1947. Photographer, teacher.
Studies SASA, Underdale Campus — Ass. Dip. in Photography 1981–85; VAB Grant to Europe 1985–86; Taught Europe, USA, Aust. 1986–89.
Exhibitions Solo shows at Media Resource Centre, Adelaide 1979; Womens Art Movement, Adelaide 1981; Festival Theatre 1984; Canon Photographic Gallery, Amsterdam 1986. Group shows include Sturt CAE 1980; Developed Image Gallery 1985; Tynte Gallery 1987; Festival Theatre 1988.
Represented Museums, institutional and private collections in UK, Europe, Canada, USA and Australia.

OLIVER, Bronwyn NSW
Born Inverell NSW 1959. Sculptor, teacher.
Studies Bachelor of Education (Art), Alexander Mackie CAE, Sydney 1977–80; Master of Art (Sculpture), Chelsea School of Art, London 1982–83. Visiting lecturer at seven major art schools in London and the South of England 1984; Teaching, sculpture at CAI, Sydney 1985 and at SCOTA 1986.
Exhibitions Solo shows at Roslyn Oxley9 Gallery 1986, 87, 88, 89; Christine Abrahams Gallery, Melb. 1987, 89. Numerous group shows since 1981 include Irving Sculpture Gallery 1981, 82; Kyoto, Japan, Artspace, ICI Galleries, and Christies, London UK 1983; NSW House and Bluecoat Gallery, Liverpool UK 1984; Mildura Triennial 1985, 88; *Perspecta* 1986, AGNSW; *Chaos*, Roslyn Oxley9 Gallery 1987; Bicentennial Show, Melb. Showground 1988. *A New Generation 1983–88*, ANG, Canberra 1988; Chapelle Salpetriere, Paris 1989; Fourth Australian Sculpture Triennial, Melbourne 1990.
Awards New South Wales Travelling Art Scholarship 1981–83; Dyason Bequest Scholarship 1982–83; Fellowship in Sculpture, Gloucester Institute of Arts, Cheltenham 1983–84; Residency, Moya Dyring Bequest Studio, Cité Internationale des Arts, Paris 1984; French/Australian Artists Exchange, Artist-in-Residence Programme 1988.
Represented Institutional, public and private collections in UK, Europe and Australia.
Bibliography *Artists & Galleries of Australia*, Max Germaine: Craftsman House 1990; *Contemporary Australian Sculpture*, Graeme Sturgeon: Craftsman House 1991.

OLIVER, Dot WA
Born Bruce Rock WA 1934. Potter and ceramic artist.

343

Studies Bunbury TAFE; Exhibits Serendip Pottery Gelorup WA and group shows.
Award Bunbury TAFE Prize 1979.
Represented Bunbury City Council, Bunbury Technical College and private collections.

OLLEY, Margaret NSW
Born Lismore NSW 1923. Expressionist painter in oil, watercolour, pen and wash, mostly of landscape and still-life subjects.
Studies Diploma of Art and East Sydney Technical College under Frank Medworth and at the Brisbane Technical College; Travelled overseas in 1949 and continued her studies at the Grande Chaumière, Paris and later studied and painted in Spain, Portugal and Italy; Has painted a number of murals in Australia, one of the best known being the early Circular Quay scene at the NSW Leagues Club in Sydney; Has herself been the subject of portraits by the late Sir William Dobell, Archibald Prize 1948 and Sir Russel Drysdale.
Exhibitions One-woman shows in London and Paris and her first in Australia was at the Macquarie Galleries, Sydney in 1948, followed by regular showings in Melbourne, Adelaide, Perth, Brisbane, Canberra and Newcastle; Her most recent major exhibitions of still-life subjects at Holdsworth Galleries, Sydney in 1978, 1980, 1982; Philip Bacon Galleries, Brisbane 1979, 1981, 1984, 1989; Solander Gallery, Canberra 1980, 1982; The Centre Gallery, Gold Coast, Qld 1988; Australian Galleries, Melbourne 1990; Greenhill Galleries — Adelaide Festival 1990.
Awards Helena Rubinstein Portrait Prize; Royal National Agricultural and Industrial Association of Qld Rural Prize; Finneys Centenary Art Prize; Johnsonian Club Art Prize for Portraiture; Bendigo Art Prize and Redcliffe Art Prize several times. Hon. Doc. Letters from Macquarie University 1991. AO 1991.
Represented National Collection, Canberra; State Galleries of NSW, Vic, SA, WA and Qld; Many Australian and overseas private collections.
Bibliography *Art and Australia*, Vol 2/2; *Australian Painters of the 70s*, Mervyn Horton, Ure Smith 1976; *Art in Queensland 1859–1959*, Vida Lahey; *Australian Painting 1788–1970*, Bernard Smith, Oxford University Press 1974; Catalogue, *A Homage to Women Artists in Queensland, Past and Present*, The Centre Gallery 1988; *Art and Australia* 28/3; *Artists & Galleries of Australia*, Max Germaine: Craftsman House 1990; *Margaret Olley*, Christine France: Craftsman House 1990.

OLSEN, Maria VIC
Born Christchurch NZ 1947. Painter and teacher.
Studies Ilam School of Art, University of Canterbury NZ 1962–64; Lived in Australia and taught art 1967–69; Overseas study 1977, 79, 81, 84, 87; Artist-in-Residence, Prahran Campus, Victoria College, Melbourne 1979.
Exhibitions A number of solo shows since 1980 mostly in NZ and recently at Deutscher Brunswick, Melbourne 1990. Many group shows since 1976 include Australian Biennale, AGNSW, NGV 1988; National Museum of Modern Art, Seoul 1988; Deutscher, Gertrude St. Melbourne 1989.
Represented National, regional, institutional and private collections in NZ.

OLVER, Elve M. VIC
Born Aust. Painter, teacher, gallery director.
Studies ESTC — Diploma FA 1959. Taught at PLC Orange and in Canberra 1965–82. Presently Director, The Robb Street Gallery Bairnsdale Vic.

O'MALLEY, Jennifer NSW
Born Australia. Painter.
Studies Studied art in UK and Europe.
Exhibitions Solo shows at Holdsworth Galleries, Sydney 1979, 1981.

Represented The Lodge, Canberra, Gosford City Council and private collections in USA, Canada, UK and Australia.

OMBERG, Siri VIC
Born Melbourne Vic 1947. Jeweller and silversmith.
Studies National Gallery School and Preston Institute of Technology, Melbourne and extensive study in UK, Europe, Middle East and USA.
Exhibitions Avant Gallery, Powell Street Gallery, The Craft Centre, Melbourne and Holdsworth Galleries, Sydney. Recently at Distelfink Gallery, Melbourne and Emerald Hill Gallery 1991.

O'MEARA, Rhonda VIC
Born Aust. 1949. Weaver, textile artist, teacher.
Studies Domestic Arts, TSTC 1968; Diploma, Domestic Arts, Rusden State Col. 1978; Graduate Diploma, Royal Melb. Inst. of Tech. 1983.
Exhibitions A host of shows since 1981 and recently Beaver Gallery, Canberra, Caulfield Arts Centre, Villas Gallery, Wellington NZ, Textile Show, Indonesia 1985; Commonwealth Cultural Festival, Edinburgh, Scotland and Woolloomooloo Gallery, Sydney 1986. Has conducted many workshops in Aust. and NZ.
Represented Institutional and private collections in Australia and overseas.

O'NEILL, Betty SA
Born Kadina SA 1925. Printmaker and painter in oil and acrylic.
Studies SA School of Arts and Crafts; Fellow of the Royal SA Society of Arts where she is a regular exhibitor; Works mainly on prints in her own workshop.
Exhibitions CAS 'The Women's Show' 1977 and Adelaide Group 1964, 1972.
Awards For etching at Kiwanis exhibition 1974.
Represented 'MISST' and Tahara Galleries, SA.

OOM, Karin NSW
Born Sydney 1933. Painter, printmaker, teacher.
Studies Diploma of Painting — Nat. Art School, Sydney 1954; Uni. of Sydney — Diploma of Education 1959. Lithography Workshop, Workshop Arts Centre, Sydney 1977; Overseas study UK, Europe 1955–58, 67–69; Member of PCA and Print Circle. Part-time teacher of painting and drawing in TAFE colleges since 1971.
Exhibitions One-woman shows at Blaxland Galleries 1964; Macquarie Galleries 1966, 1972, 1974; Drian Galleries, London 1969; Divola Gallery 1975; Art of Man Gallery, Sydney 1979; Woolloomooloo Gallery, Sydney 1986, 88, 89; Ocean St Gallery, Melb. 1987; Casey Gallery, Sydney 1988; PCA, Melb. 1988. Numerous group shows since 1961 include Print Circle, 1979–84, a travelling exhibition Germany 1980, The Workshop Arts Centre 1984–87 and the Beth Mayne Gallery, Sydney 1986; Painters Gallery 1985, 88; Woolloomooloo Gallery 1988, 89; 70 Arden St Melb. 1988.
Represented AGNSW, MPAC, institutional and private collections in UK, Europe and Australia.
Bibliography *Artists & Galleries of Australia*, Max Germaine: Craftsman House 1990.

ORCHARD, Jenny NSW
Born Ankara, Turkey 1951. Sculptor, ceramic artist, arrived Aust. 1975.
Studies CAI, Sydney 1977–79, but basically self-taught.
Exhibitions Distelfink Gallery, Melb. 1981, 85; Blackfriars Gallery, Sydney 1981; Meat Market Centre, Melb. 1981, 82, 83, 84, 85; Crafts Council Centre, Sydney 1983, 84, 85; Orange Reg. Gallery and Darling Downs CAE 1985; Shepparton Reg. Gallery touring show 1985; Macquarie Galleries, Sydney 1985, 86, 87, 88.

Represented ANG; Artbank; NGV; QGMAG; TMAG; AGSA; Victoria State Craft Collection; Shepparton Regional Gallery; Bathurst Regional Gallery, NSW; Orange Regional Gallery, NSW; Museum of Applied Arts and Sciences, Sydney; Darling Downs CAE Collection; Aichi Prefectural Government Design Collection, Japan.

ORR, Fiona VIC
Born Melbourne Vic 1955. Sculptor and teacher.
Studies Prahran CAE 1972–75; Vic College of the Arts — graduate diploma 1975–78; Part-time lecturer in sculpture at Vic College of the Arts and Melbourne State College; Organised workshops for the Gallery Society of Vic at Vic College of the Arts 1978–83; Lecturer (part-time) Victorian College of the Arts, Melbourne and Melbourne College of Advanced Education 1987.
Exhibitions Solo shows at Axiom Gallery 1981, 1983; Port Melbourne Gallery 1979; Christine Abrahams 1983, 85, 89; Irving Sculpture Gallery, Sydney 1988. Many group shows since 1978 include Mildura Sculpture Triennial 1978, 82, 85; Aust. Sculpture Triennial, Melb. 1981, 84, 87; Qld Art Gallery to Museum of Modern Art, Saitama, Japan 1987; Vic Arts Centre, Melb. 1987; Shepparton Regional Gallery 1989.
Awards VAB Grant 1981.
Commissions Australian Ground Water Consultants, Melbourne; Australian Sportwoman of the Year Awards, Sydney; The Ian Potter Sculpture Commission 1984.
Represented Melb. CAE; NGV; VAB; Monash Uni.
Bibliography G. Sturgeon, *Australian Sculpture Now*, Second Australian Sculpture Triennial, 1984; K. Scarlett, Ikebana Ryusei, Jan. 1 1986; Third Australian Sculpture Triennial, NGV 1987, Catalogue; *Artists & Galleries of Australia*, Max Germaine: Craftsman House 1990; *Contemporary Australian Sculpture*, Graeme Sturgeon: Craftsman House 1991.

ORR, Jill VIC
Born Melb. 1952. Expressionist painter, dancer, performance artist.
Studies Melb. CAE 1970–75; UK, Europe 1980; Artist-in-Residence TCAE 1978, Darwin CAE 1978, IMA, Brisbane 1978. Amsterdam Workshop 1983.
Exhibitions Many important shows since 1978 highlighted by Mildura Sculpture Triennial 1978, 87; Ewing Gallery, Uni. of Melb. 1978, 80; IMA, Brisbane 1979; Adelaide Festival 1980; Paris Biennale 1980; Holland 1980, 81; ICA Gallery, London 1982; Belgium 1982; *Continuum*, Japan 1983; Christine Abrahams Gallery, Melb. 1985; Reconnaissance Gallery, Melb. 1986; ACCA, Melb. 1987; 312 Lennox St Gallery, Melb. 1987, 89; ACCA 1989.
Represented NGV; Institutional and private collections in UK, Europe and Australia.
Bibliography *Field of Vision*, Janine Burke: Viking, Melbourne 1990.

ORR, Jill NSW
Born Adelaide 1954. Painter and teacher.
Studies Dip. Visual Arts (Painting), Canberra S of A 1976–78; Grad. Dip. Professional Art Studies, City Art Institute 1980. Worked Ghana, West Africa 1974–75; Angela Flowers Gallery, London 1979; Director, Swains Gallery, Sydney 1982–83; Teaching part-time, Hamilton College of TAFE, NSW 1988–91.
Exhibitions Many shows since 1965 and recently at Maitland City Gallery 1987, 90; von Bertouch Galleries 1987; Rex Irwin Fine Art 1987; Campbelltown City Gallery 1990; Robin Gibson Gallery 1990; Newcastle Regional Gallery 1991.
Awards Canberra Junior Art Prize 1965; Peter Sparke Pastel 1987; Newcastle Show Drawing 1990. Commission for mural in Garema Place ACT 1978 and Villa Maria Society Portrait, Melbourne 1981.
Represented Institutional and private collections in UK and Australia.

ORTON, Dianna VIC
Born Vic 1960. Painter, graphic designer, calligrapher.

Studies First and second years diploma of Art & Design at Wangaratta TC 1978–79. Dip. Fine Art, Bendigo CAE 1980–81. Photographic screen printing certificate with H & M Day 1985. Design at RMIT 1987. Theatre set designing 1984–89.

Exhibitions Solo shows at Quarry Design Gallery 1988; Massoni Gallery and Corporate Connections Gallery 1989. Group shows include Wangaratta College of TAFE 1978, 79; Bendigo Regional Gallery 1981; Port Melbourne Festival 1984; The Art Centre Wangaratta 1985; Seamans Mission Art Centre 1987.

Represented Institutional and private collections around Australia.

OSBORNE, Betty (Marjorie) NSW

Born Australia 1928. Landscape painter in oil and watercolour.

Exhibitions One-woman show at Old Mill Gallery, Braidwood NSW 1973; Participated Crookwell NSW 1968, 1970, 1972; Canberra 1973; Beth Mayne Gallery, Prouds Gallery, Sydney 1975; Exhibiting member of RAS of NSW and the Goulburn Art Club.

Awards Goulburn WC 1967, 1968; Wellington 1969; Braidwood Landscape 1973.

Represented Institutional and private collections in Australia and overseas.

OSBORNE, Cecilie VIC

Born Melbourne Vic 1921. Abstract painter in oils; Printmaker.

Studies Swinburne Technical College, Melbourne; Member, Ringwood Art Society 1966–70; CAS, Melbourne 1977–83, councillor 1979–83.

Exhibitions Myer Textile Show 1953; Ringwood group shows 1966–69; CAS shows 1977–82; One-woman show Joan Gough Gallery 1983.

Represented Private collections in Australia and the Philippines.

OSBORNE, Cheryl Sylvia VIC

Born Brighton Vic 1956. Painter, printmaker and teacher.

Studies Lived in Holland and travelled UK, Europe, USA 1972–75; Diploma of Art and Design from Chisholm Institute of Technology 1977–80; Diploma in Education from Melbourne State College 1981; Grad. Dip. Fine Art, Chisholm IT 1983. Tutor in drawing and printmaking Monash and Melbourne Universities 1982– (part-time) and teaching children's art at Beaumaris Art Group 1983–84. Private schools 1984–88; Tutor, National Gallery of Vic. Summer School 1988–90.

Exhibitions Niagara 1983; Swan Hill Reg. 1984; Brighton UK 1984; Excelsior Gallery, Sydney 1985; Hogarth, Sydney 1985; Print Guild, Melb. 1987; Reflections Gallery 1990. Numerous group shows since 1980 include Touring exhibition of Scottish Art School Galleries; VCA, Drummond St. Gallery, QAG, and The Lyceum Club 1982, 85, 88, 90; San Francisco Exchange; Swan Hill Regional Gallery and the Oculous Gallery 1989.

Awards Arches Rives Acquisitive 1980; Sheila Kirk Drawing, Flinders Vic 1982; Sandringham City Council 1983; Yarra Valley Grammar 1984; Villa Decor Printmaking 1985.

Represented Chisholm Institute of Technology Collection, Arches Rives Collection; Education Dept of Vic Collection; Sandringham City Council Collection; Represented in private collections throughout Australia and the UK.

Bibliography *PCA Directory* 1988.

OSBORNE, Frances Lillian VIC

Born Westgarth Vic 1913. Painter of flowers, figures and portraits in oil and watercolour.

Studies Under Louis Kahan; Member of Vic Artists Society and Balwyn Art Group.

Exhibitions One-woman shows at Manyung Galleries, Mt Eliza Vic 1975–79, 1983, and with VAS.

Represented Private collections in Australia and overseas, and a portrait in the Telecom Tower, ACT.

OSBORNE, Irene WA
Born Perth WA 1952. Painter, potter, teacher.
Studies Dip. Fine Arts, Claremont TC, WA 1975; Sydney 1981; Sumi Paintaing, Melbourne 1982; Perth 1986–87; Completed first year BA course, Karratha College, Curtin University WA 1989. Has taught art at numerous colleges since 1978; Presently lecturer, Karratha College of TAFE.
Exhibitions Solo shows at Dwellingup Gallery 1985; Tresillian Gallery 1987; Wickham Gallery 1990; Group shows include Mandurah 1986, 87, 89; 'A' Shed Gallery, Fremantle 1990; Glyde Gallery 1991; Ireme's Art Studio, Wickham WA 1991.
Awards Pinjarra Rotary 1985, 86; Harvey Prize 1986; Cossack Prize 1987; Karratha 1988, 90; Port Headland 1990; Mandurah 1991.
Represented Government, institutional and private collections in UK, Europe, USA, Canada, Japan and Australia.

OSBORNE, Laura E. VIC
Born Melbourne Vic 1952. Painter and printmaker.
Studies Prahran CAE, Melbourne; Ecole Superieure des Art Decoratifs, Paris.
Exhibitions ABC Taille Douce, Paris 1979; Mornington Peninsula Arts Centre, Vic 1980; Axiom Gallery, Melbourne 1980; Tynte Gallery, Adelaide 1981.
Represented Bibliotheque Nationale, Paris and institutional and private collections in UK, France and Australia.

OSBORNE, Lyndal CANADA
Born Newcastle NSW. Printmaker and teacher.
Studies National Art School, Sydney; University of Wisconsin (Madison), USA (MFA) Professor, Art and Design Dept. University of Alberta, Edmonton, Alberta Canada.
Exhibitions Alberta Art, Japan 1979; Solo exhibition, Vancouver BC 1980; Solo exhibition, Edmonton Alberta 1981; Solo exhibition, Quebec City Canada 1982; Solo exhibition, Montreal Quebec 1983; Solo exhibition, Washington DC 1983.
Selected international group exhibitions Cracow Poland 1974, 1976, 1980; Bradford UK 1974; 1981; Seoul Korea 1981; Ljubljana Yugoslavia 1980, 1983; Fredrikstad Norway 1982; *Canadian Printmakers '82*, New York USA; PCA Exhibition, 1982 on tour throughout Australia; *Printmakers '82*, Toronto Ontario.
Awards One of three Canadian printmakers selected for presentation to the seven ministers attending 1981 Summit, Ottawa 1981.
Represented Many institutional and private collections in Australia, Canada, UK, Europe and USA.

OUTRIDGE-FIELD, Stephanie QLD
Born Camden NSW 1957. Ceramic artist.
Studies SCOTA — Diploma Visual Arts (ceramics) 1977–79. Postgraduate Diploma 1980; Crafts Board Residency Grant to Griffith Uni. 1983.
Exhibitions Solo shows at Qld C of A 1982; Griffith Uni. 1983; Lyrebird Gallery, Brisbane 1983; Qld Potters Assoc. 1984; Roz MacAllan Gallery 1987, 88. Numerous group shows since 1980 include SCOTA 1980; Uni. of Sydney 1983; Elgin Gallery, Melb. 1985; Perc Tucker Gallery, Townsville 1985; Manly AG, Penrith AG, Sydney 1986; Fremantle AG 1986; Gladstone AG, Holdsworth Galleries, Sydney, and The Centre Gallery, Gold Coast 1988.
Represented Institutions, Regional Galleries and private collections in Australia and overseas.
Bibliography *A Homage to Women Artists in Queensland Past and Present*, The Centre Gallery 1988.

P

PACE, Mary NSW
Born Sydney 1951. Painter, portraitist, teacher.
Studies Art Certificate, Seaforth College of TAFE 1982–84; BA Visual Arts, City Art
Institute 1984–87; Postgraduate Dip. Professional Art Studies, City Art Institute 1988.
Teaches at a number of art schools and privately. Member, Peninsula Art Society.
Exhibitions Solo show at Arthaus Gallery 1988; Numerous group shows include Manly Art
Gallery 1984–90; Ivan Dougherty Gallery 1988; The Works Gallery 1988, 89; Blaxland
Gallery 1988; Artlook Gallery 1990.
Represented Institutional and private collections in Australia and overseas.

PACHUCKA, Ewa (Jaroszynska) TAS
Born Lublin Poland 1936, arrived Australia 1971. Soft sculptures, printmaker.
Studies Lyceum Sztuk Plastycznych, Lublin 1951–56; Academia Sztuk Plastycznych, Lodz
1957–58; Member of Craft Council of Australia.
Exhibitions Grabowski Gallery, London 1970; Rudy Komon Gallery 1972, 1973, 1977;
QVMAG, Little Theatre, Zeehan, AEB Centre Burnie, Tas. 1972; NGV, Melb. 1978. Many
group shows since 1957 include New York 1968–69; Sweden 1969–70; AGNSW 1973;
TMAG 1976; S of A Gallery, Hobart 1980; American Federation of Arts Touring America
1981–83. Completed sculpture commissions for the Australian Archives Building Hobart
1982 and New Parliament House Canberra, 1987.
Represented ANG; AGNSW; TMAG; Lars Wetterling Collection, Sweden; National
Museum, Stockholm; Grabowski Gallery, London; Omne Gallery, Silkeborg Denmark and
private collections.
Bibliography *Australian Sculptors*, Ken Scarlett, Nelson 1980.

PACI, Anna NSW
Born Pesaro Italy 1940, arrived Australia 1979. Performance and installation artist.
Studies University of Torino, Italy 1958–60.
Exhibitions Alexander Mackie CAE 1979; VAB Paddington Studio 1980; *Australian
Perspecta* 1981 with Giorgio Colombo.
Bibliography *Catalogue of Australian Perspecta* 1981, Art Gallery of NSW.

PAGE, Joan VIC
Born Korumburra Vic 1929. Painter and ceramic sculptor.
Studies Painted with Beaumaris Art Group and later with Roda Milkovic and Dudley
Drew; Studied pottery and ceramic sculpture at Caulfield Technical School in the 1960s.
Awards Marylyn Award 1981; Amanda Callister Memorial 1982; Monbulk Rotary 1983.
Paints landscapes, seascapes and flowers on commission.
Represented Queen's College, University of Melbourne; Members' Room, Parliament
House, Melbourne; Institutional and private collections in Australia and overseas.

PALAITIS, Josonia (Jo) NSW
Born Sydney NSW 1949. Realist painter in oil and watercolour, teacher.
Studies East Sydney Technical College 1969–72; City Art Institute 1983–84.
Exhibitions Holdsworth Galleries, Sydney 1981, 1982, Poynton Gallery, Wentworth Falls
1982; Australian Museum, Sydney 1983; Martin Gallery, Townsville Qld 1986; First
Impressions Gallery 1986; St Leonards Studio, Sydney 1988. Retro show of portraits,
Workshop Arts Centre, Sydney 1988. Part-time art teacher for TAFE, Sydney 1978–86.
Director, St Leonards Studio, Sydney.

Awards Lord Howe Island Commission 1982.
Represented Institutional and private collections in Australia, UK, Europe.

PALMER, Davida WA
Born Perth WA 1948. Stoneware, porcelain and textiles.
Studies TAFE Perth; Technician at TAFE ceramics 1980–83 and textiles 1983; Exhibits with ceramic groups.
Awards Art Studies Prize 1980, 1981.
Represented Bunbury City Council and private collections.

PALMER, Janet NSW
Born Sydney NSW 1940. Painter in oil and acrylic.
Studies Graduated Sydney University School of Pharmacy 1961; Studied under Rodney Milgate 1974, David Aspden 1975 and drawing under John Olsen 1975, 1977.
Exhibitions One-woman show at Holdsworth Galleries, Sydney 1975, 1976; Prouds Gallery 1982; Wagner Gallery 1985.
Awards KAS Art Award for Modern Painting 1976; Sir Warwick Fairfax *Human Image* Prize 1976; Permanent Trustees' Award for Modern Painting 1977.
Represented Private collections in Australia and overseas.

PALMER, Robyne L. NSW
Born Grafton NSW. painter, photographer, descendant of Thomas Flintoff, colonial artist 1811–91.
Studies Workshop Arts Centre, Sydney 1971–73; Sydney TC 1973–74; Pittsburgh USA 1974–75.
Exhibitions Solo shows at Hilton Galleries, Sydney 1987; Reade Art Gallery, Adelaide 1988; Holdsworth Galleries, Sydney, 1988, 1990. Numerous group shows since 1978.
Awards Manly Art Gallery 1983; Hunters Hill Prize 1985; Forbes Art Prize 1987; Harmony Art Prize, Penrith 1989.
Represented Corporate, Vice Regal, institutional and private collections in UK, Japan, Canada, Hong Kong, Australia.
Bibliography *The Australian Artist*, April 1985.

PAPACEK, Karen OVERSEAS
Painter and teacher.
Studies Dip. Creative Arts, Darling Downs IAE. Dip. Teaching from McAully College, Brisbane; Instructor, QCA 1987– .
Exhibitions Solo shows at QCA 1983; Brisbane Community Arts Centre 1985; Metro Arts, Brisbane 1988, 89; Australian Embassy, Paris 1991. Numerous group shows since 1979.
Represented MCA, Brisbane; Institutional and private collections in Australia and overseas.

PAMEIJER, Janna QLD
Born Qld 1955. Sculptor of Australian wildlife in bronze and ceramics, teacher.
Studies Diploma in Fine Art (ceramics) from Warrnambool CAE, Vic. Founded Qld Wildlife Artists Society 1983.
Exhibitions Society of Wildlife Artists, Australia 1979, 1980, 1981, 1982; Solo shows at Cintra House, Brisbane 1981 and Baguette Gallery, 1982; QWAS 1983–89.
Awards AWAS, Melb. 1982.
Represented Caulfield Institute of Technology, Vic; Kelvin Grove CAE, Qld and private collections.

PARAMANATHAN, Jandy VIC
Born Melbourne Vic 1958. Printmaker and painter.

Studies Bachelor of Arts (painting) RMIT 1976–78; Study tour UK, Europe and USA 1979, 1980.

Exhibitions Numerous print shows since 1977 including 3rd Seoul International, Korea 1981; Ruskin School of Art, Oxford UK 1982; Travelling show to West Germany 1983; Bolitho Gallery, ACT 1983; The Darling Street Galleries, Sydney 1983; Solo show at Drummond Street Gallery, Melbourne 1982.

Represented Coburg and Toorak State Colleges and private collections in Australia and overseas.

PARISH, Vicki NSW

Impressionist painter, teacher.

Studies Uni. of Sydney BA (Hons) 1972–76; Julian Ashton School Dip. Painting 1977–80. City Art Institute, Postgraduate Dip. 1985. Overseas study UK, Europe 1982–83. Tutor at Uni. of Sydney 1978, 80–82, 86, 87; Uni. of Qld 1987; Mitchell Creative Workshop, Bathurst 1988.

Exhibitions Lee St Gallery 1981, 83; Bathurst Reg. Gallery 1983, 86; Blaxland Galleries 1985.

Represented Institutional and Private Galleries in UK, Europe, Australia.

PARKER, Colleen M. NSW

Born Parkes NSW. Painter, Australian school, mostly oil, some watercolour and pen and ink; Married to artist, Colin Parker.

Studies Early art studies at PLC Pymble; Member of Royal Art Society Young Artists Group 1962; Worked in enamels and was member of North Shore Art and Crafts Group 1964–68; Studied under Kevin Oxley 1972; Currently attending the Hawkesbury Community Workshop 1978–; Associate of RAS of NSW 1982.

Exhibitions Enamels, Roselands Gallery and Beard Watson Gallery, Sydney 1967; One-woman show at Pitt Gallery, Richmond NSW 1976; Group shows at Lochiel House Gallery, Kurrajong Heights NSW 1978; Hesley Gallery, Canberra 1978; St Georges Terrace Gallery, Parramatta NSW 1978; North Shore Gallery 1985; Styles Gallery 1988.

Awards Hawkesbury Agricultural Show 1976, 1977, 1978; Prospect County Council (purchase) 1976; Colo Shire Council (purchase) 1977; Windsor Municipal Council (purchase) 1978, 1981; Wyong 1981; Toohey's Paint-a-Pub 1981; Blacktown Purchase 1979; Port Macquarie 1982, Royal Easter Show and Blackheath 1981; Penrith 1982; Royal Easter Show 1983.

Represented Private and institutional collections in NSW and overseas.

Bibliography *Artists & Galleries of Australia*, Max Germaine: Craftsman House, 1990.

PARKER, Margaret VIC

Born Melbourne 1959. Painter, designer, printmaker, teacher.

Studies Dip. Art & Design, Wangaratta TC 1976–77; Bendigo CAE 1978–79; Victorian Printmakers Guild 1980; Hobart CAE 1981; Dip. Ed. Hawthorn IE; Worked and studied in UK, Europe 1982–84, 88; Teaching at Melbourne College of Textiles 1989– .

Exhibitions Solo show at Terra Australis Gallery 1991; Group shows include Wangaratta TC 1976–77; Bendigo Regional Gallery 1979; Artspace, Bendigo 1984; The Eclectic Easel; 1989.

Represented Institutional and private collections in Australia and UK, Europe.

PARKER, Valerie WA

Born London UK 1938. Painter and draughtswoman.

Studies Perth TC. Has exhibited widely and won many awards in WA.

Bibliography *Australian Watercolour Painters*, Jean Campbell, Craftsman House 1989.

PARKES, Maria June NSW

Born Croydon NSW 1926. Painter of flora and fauna.

Studies Privately with R.E. Foote, mostly self taught. Has taught art since 1976.

Exhibitions Solo shows at King Street Gallery on Burton 1986, 91. Group shows include Lewers Bequest and Penrith Regional Gallery; Collier Gallery and Gloria Grieves Gallery, Blue Mountains.

PARNELL/CONNORS, Sheryl NSW

Born Toowoomba Qld. 1951. Painter and teacher.

Studies Graduated from Tranby Aboriginal Co-op. College 1986 also B. Ed. (Visual Arts) from University of NSW 1990. Studied in UK and Asia for some years; Taught art at Tranby College 1987–89; Joined Boomalli Aboriginal Artist Co-op. 1988. Artist-in-Residence at the Australian Museum 1990–91. Culture Shop Gallery 1991.

Exhibitions Cumberland College 1986; Performance Space 1988; Tin Sheds Gallery 1988; Boomalli Show 1988, 89; Bondi Pavilion 1989; AFI Cinema 1989.

Awards University of Sydney Neighbourhood Centre Mural; Lands Council Booklet 1989.

Represented Municipal, institutional and private collections.

PARRY, Susie VIC

Born Gundagai NSW. Painter illustrator, teacher.

Studies Dip. Art and Design, Prahran CAE 1974; Dip. Ed., Hawthorn State College 1980; Has taught part-time at Boronia TC 1982–89.

Exhibitions Solo show at Greenfrog Galleries, Melb. 1988; Numerous group shows include Hawthorn City Gallery 1981.

Commissions Illustrations for children's books published by Martin Educational.

PARSONS, Julie WA

Born Corrigin WA 1953. Painter in oil, acrylic, pastel, textiles, designer of the theatre sets and teacher.

Studies Claremont School of Art, WA 1970; Associateship in Fine Art from WAIT 1974. Lecturer, History of Costume, Fremantle Technical 1975; Sculpture & painting, Bunbury Technical 1977–83; Conducted workshops for Bunbury Arts Council 1976–82. Lecturer, South West College of TAFE, Bunbury.

Exhibitions Solo shows at Bunbury 1977, 79; Fremantle Arts Centre 1987; Has participated in many group shows and competitions since 1974.

Commissions Many set designs for theatre groups and the Bunbury Arts Festival 1975–89. Received South West Award for Excellence 1979.

Represented Municipal, institutional and private collections in Australia and overseas.

PARSONS, Mary WA

Born Aust. Flower painter in pastel and watercolour, teacher with TAFE in WA.

Studies ESTC, Melb. Art Gallery School, WAIT and in Perth with Henry Froudist.

Bibliography *The Australian Artist*, September 1988.

PARTLETT, Launa NSW

Born Qld. 1918. Painter and portraitist.

Studies Privately with Justin O'Brien and at Hurstville Evening College with Ross Doig 1952–53.

Exhibitions Solo shows at Roselands Galleries and group shows with The Bankstown Art Society.

PATE, Klytie VIC

Born Melbourne 1912. Ceramic artist, potter, teacher.

Studies National Gallery School, Melbourne 1930's with W.B. Innes and Charles Wheeler and at Melbourne TC. Taught art at Melbourne TC c.1938–45.
Exhibitions Kosminsky Gallery, Melbourne 1941 and many shows around Australia since including NGV 1983; Macquarie Galleries, Sydney 1989, 90.
Represented ANG, NGV, Powerhouse Museum, Sydney, regional and private collections.

PATERSON, Nan QLD
Born Mackay Qld 1923. Realist expressionist painter in oil and pastel; Portraitist.
Studies National Gallery of Vic Art School 1942–46; Private tutor in Sydney 1965–68 and Brisbane 1968–82.
Exhibitions Solo shows at West Street Gallery, Sydney 1966, 1967; Kennigo Gallery, Brisbane 1969, 1970; McInnes Gallery 1972; Italia Gallery 1977.
Awards Albury, Blackheath, Mosman, Redcliffe, Caltex (RQAS), Westfield.
Represented Private collections in Australia, UK, Europe, NZ.

PATEY, Julie VIC
Born Junee, NSW 1955. Painter.
Studies PIT, Melb. — Diploma FA 1977.
Exhibitions Solo shows at George Paton Gallery, Uni. of Melb. 1980; Axiom Gallery 1982; Christine Abrahams 1984, 87; Roz MacAllan, Brisbane 1988. Numerous group shows.
Represented Artbank and institutional and private collections in Australia.

PATRONI, Lisa ACT
Born Canberra 1963. Printmaker.
Studies Canberra S of A 1982–85; SCOTA 1986–88; Travelling scholarship to UK, Europe 1985.
Exhibitions EMR Gallery, Linden Gallery, 70 Arden St 1988.
Commissions PCA 100 x 100 Print Portfolio 1988.
Bibliography *PCA Directory* 1988.

PATTERSON, Alice TAS
Born Hobart Tas. Painter in oil and pastel.
Studies Rosamund McCulloch, Tas School of Art, Jack Carington Smith.
Exhibitions Exhibiting member of the Art Society of Tas, Tas Art Group, Royal Qld Art Society; Participated in numerous group shows, one-woman shows, Hibiscus Gallery, Hobart.
Represented Private collections in Australia and overseas.

PAUL, Laurie QLD
Born Richmond NSW 1928. Abstract expressionist and surrealist painter in oil and mixed media.
Studies Professor Bisietta, Sydney 1956. Seminars and summer schools, Universities of New England and Qld under Rapotec, Orban, Reddington, Laycock and Daws. Studied and painted in UK, Europe, USA 1979–83.
Exhibitions Has held eleven solo shows in Melbourne, Sydney, Brisbane and the Gold Coast from 1966–78; Juarez Gallery, Los Angeles 1983; Broadbeach Gallery, Gold Coast Qld 1981, 83, 84; 33 Clam St, Gold Coast 1986, 88; Gold Coast International Gallery 1987; Group show at The Centre Gallery 1988.
Awards Springbrook, Qld (oil) 1965–67; Grafton 1965; Cowra-Lachlan Valley 1966; Warana-Caltex, Qld 1970, 1972, 1974, 1977; Gold Coast Apex 1974; Maryborough-Wide Bay, Qld 1976; Trinity Purchase 1986.
Represented Bailey Henderson Memorial Hospital, Toowoomba (14 paintings); Tas Museum and Art Gallery; Grafton City Gallery, Gold Coast City Collection; Geelong

Teachers College; Private and commercial collections Australia, Europe, USA, Philippines, Singapore, NZ.
Bibliography *A Homage to Women Artists in Queensland, Past and Present*, The Centre Gallery 1988.

PAVLI, Karen-Kaye SA
Born Adelaide 1959. Printmaker.
Studies SA C of A 1977–79; BA Fine Arts, SASA 1980–83; Dip. Art, Gilles Plains TAFE 1987.
Exhibitions Tynte Gallery 1983; Adelaide Festival 1984, 86, 88; CAS Gallery 1985; Art Zone 1986–87.
Bibliography *PCA Directory* 1988.

PAVLOVIC, Maryanne NSW
Born 1957. Painter, printmaker, teacher.
Studies BA Visual Arts, City Art Institute 1984; Diploma in Education, Secondary Art 1986. Taught art at high schools 1987–88. Secretary Newcastle Printmakers Workshop 1979–80.
Exhibitions Royal College of Art, London 1984; Arthaus Gallery, Sydney 1985; Art Zone, Sydney 1988.
Awards Uni. of Newcastle Print Prize 1979.
Represented Institutional and private collections in UK and Australia.

PAWLOWICZ, Ann VIC
Born Lwow Poland. Painter and printmaker.
Studies RMIT; Diploma in Art and Design from Prahran CAE 1971.
Exhibitions Warrnambool Regional Art Gallery and Field Workshop Show 1981; Annual exhibitor with VAS.
Represented La Trobe Valley Art Centre, University High School Collection, Monash University and private collections.
Bibliography *Directory of Australian Printmakers* 1982.

PAXTON, Mollie Dorothea LONDON
Born Sydney NSW 1914. Semi-abstract painter in oil, watercolour, pastel, often religious subjects.
Studies East Sydney Technical College 1932–38; Married painter, Brian Midlane 1939; Study tour to UK and Europe; Presently living in London; Foundation member, Contemporary Art Society of NSW.
Exhibitions Large triptych was shown in the Sulman Prize Exhibitions and later in the UNESCO International Exhibition, Paris 1946; 'Australian Contemporary Painting', Australia House, London 1947; Joint show with Brian Midlane, Leicester Galleries, London 1948; International Exhibition of Religious Art, Cologne 1949; Jointly with Brian Midlane, Cambridge University 1960; La Palette Bleu, Paris 1967, 1969; David Jones' Gallery, Sydney 1972.
Represented Private collections in Australia and overseas.

PAYNE, Julie TAS
Born Scottsdale, Tas 1959. Sculptor.
Studies Launceston S of A, TCAE 1979–81; Study tour to USA 1980.
Exhibitions QVMAG, Devonport and Burnie Regional Galleries 1981; Crafts Council Gallery, Hobart 1982; Fremantle AG 1982; Long Gallery, Hobart 1982.
Awards Andrew and Lilian Pedersen Memorial Prize, Qld 1982.
Commissions Sorell District School Summer Hill Medical Centre 1982.

PAYNE, Patricia NSW
Born Aust. 1955. Printmaker.
Studies BA, SCOTA 1978–81; Postgrad. Dip. 1982–83.
Exhibitions Union St Gallery 1985; MPAC 1984; Print Biennale, Barcelona, Spain 1983; Sydney Printmakers 1984–86; Hogarth Gallery 1986–87; Roz McAllan Gallery 1987; 70 Arden St 1988.
Commissions PCA 100 x 100 Print Portfolio 1988.
Bibliography *PCA Directory* 1988.

PAZOLLI, Athina ACT
Colour painter.
Studies BA, Canberra S of A 1987.
Exhibitions Solo shows at Playhouse Gallery, Canberra 1988; Giles St Gallery, Canberra 1988, Access, Sydney 1989.

PEACH, Dianne QLD
Born Brisbane 1947. Ceramic artist, potter.
Studies Brisbane Central TC under Milton Moon and David Smith 1965–66. Study tour UK, Europe 1976–77. Attended McGregor Summer School in Toowoomba 1981. Former member Crafts Board of Aust.
Exhibitions Solo shows include Gold Coast Gallery 1967, 72; Potters Gallery, Brisbane 1979, 81, 83; Cooks Hill Gallery, Newcastle 1982, 84; Potters Society Gallery, Sydney 1984; Jam Factory, Adelaide 1984. Many group shows since 1981 include Qld AG 1982; Perc Tucker Gallery, Townsville 1983; Meat Market Centre, Melb. 1985, 88; Museum of Contemporary Art, Los Angeles 1986; Touring show to Calgary, Canada 1988; The Centre Gallery, Gold Coast, Qld 1988.
Represented ANG, AGSA, AGWA, QVMAG, Qld AG; Parliament House, Canberra and Queensland. Many institutions and private collections in Australia and overseas.
Bibliography *A Homage to Women Artists in Queensland Past and Present*, The Centre Gallery 1988.

PEACOCK, Kay NSW
Born Sydney 1952. Painter and printmaker.
Studies Nat Art School, Sydney 1969–70 and in UK 1977–79.
Exhibitions Trinity College, Oxford 1977; Royal Birmingham Society of Artists 1978, 79; WAC, Sydney 1981; Casey Gallery, Sydney 1987.
Represented Institutional and private collections in UK, Europe, Australia.

PEAKE, Alison VIC
Born Melbourne 1954. Painter, textile and ceramic artist, teacher.
Studies Completed B. Ed. (Fine Arts).
Bibliography *Alice 125*, Gryphon Gallery: University of Melbourne 1990.

PEAKE, Barbara (Begg) VIC
Born Hobart Tas 1925. Traditional painter of landscape and seascapes; Teacher.
Studies Swinburne TC, Melb. 1944–46, 61–64; Frankfurt Art Academy, West Germany 1972. Taught at Malvern Artists Society and privately 1968–79. Geelong Art Society 1983–84. Founding member of the Burnie Coastal Art Group 1953.
Exhibitions Solo shows include Tas. Tourist Bureau, Melb. 1959, 62. Malvern Artists Society 1975, 77; AMP Gallery, Melb. 1976–84; Swan Hill Gallery 1983; Egans Gallery, Vic 1985. Numerous group shows.
Bibliography *Tasmanian Artists of the 20th Century*, Sue Backhouse 1988.

PEARL, Leslie R. VIC
Born Melb. 1958. Printmaker.
Studies Dip. Art and Design (part) Prahran CAE 1979–80; Dip. Art and Design, Tas. S of A
1985–88.
Exhibitions 70 Arden St 1988.
Commissions PCA 100 x 100 Print Portfolio 1988.
Bibliography *PCA Directory* 1988.

PEARSON, Vida VIC
Born Vic. 1957. Printmaker.
Studies Dip. Art, Nth Adelaide S of A 1982.
Exhibitions Ararat Art Centre 1985; Elkira Gallery, Alice Springs 1985; Kintore Gallery,
Adelaide 1986; Mulgrave Gallery, Vic 1987; Framed Gallery, Darwin 1987.
Commissions BMG, prints for Sheraton Hotel 1985.
Bibliography *PCA Directory* 1988.

PEATE, Cherie (Grant) NSW
Born Scotland, arrived Aust. 1954. Painter, ceramicist, teacher.
Studies Glasgow S of A 1949–53, Dip. Drawing and Painting. Worked Perugia Uni., Italy,
UK and Greece 1956–60, 74–75; Taught in Sydney 1976–87.
Exhibitions Solo shows at Barry Stern Galleries 1963; Cooper Gallery, Sydney 1987–88;
Arthaus Too Gallery 1990.
Represented Institutional and private collections in UK, Europe, Australia.

PECK, Gina VIC
Born Melbourne Vic 1957. Painter, Daughter of Joy Peck.
Studies Graduated Bachelor of Arts, University of Melbourne 1976; Extensive study tour to
UK, Europe and Greece 1977.
Exhibitions First one-woman show Manyung Gallery, Mt Eliza 1976, 78; Hilton Hotel
1978; Russell Dains Gallery 1980, 84; Included in numerous group shows.
Represented Private collections in Australia and overseas.

PECK, Jill ACT
Born Kent UK 1939. Sculptor.
Studies Canberra S of A 1978–80, Postgraduate 1982–83.
Exhibitions Stadia Graphics, Sydney 1980; First and Second Aust. Sculpture Triennials,
Melb. 1981, 1984; Irving Sculpture Gallery, Sydney 1984; Heide Park and Gallery, Melb.
1988.

PECK, Joy VIC
Born Warrnambool Vic 1931. Painter in oil, watercolour, enamellist; Teacher.
Studies Warrnambool Technical School; National Gallery Art School, Melbourne under Sir
William Dargie; Taught painting, pottery and vitreous enamelling for Adult Education
Dept, Eltham Vic for six years and Christchurch Grammar School for three years.
Exhibitions One-woman shows at Richman Art Gallery 1960; South Yarra Gallery 1962,
1965, 1968; Douglas Gallery, Brisbane 1965; Manyung Gallery, Mt Eliza 1970; Realities
Gallery, Melbourne 1973; Sebert Gallery, Sydney 1974; Numerous group showings includ-
ing the Biennale International des Enmaux, Limoges France 1977; Libby Edwards Gallery,
Melb. 1989.
Represented Limoges Museum, France; Institutional and private collections in Australia
and overseas.

PECK, Marilyn QLD
Born Melb. 1932. Realist-marine and abstract-fantasy using acrylic, watercolour and mixed

media; Printmaker.
Studies Caulfield Institute of Technology and in the UK; Member of Ku-ring-gai Art Society, Peninsula Art Society, Royal Art Society NSW, Royal Art Society Queensland, North Shore Art Society, Australian Society of Miniature Art NSW (Foundation Member), Australian Society of Miniature Art Qld (Foundation Member, and 1988 President).
Exhibitions Solo shows at Uni. of NSW 1983; Ku-ring-gai Motor Yacht Club 1983; Boronia, Mosman 1983, 84, 85.
Awards Royal Easter Show — Lady Fairfax Prize 1985; Macquarie Award 1985.
Represented Institutional and private collections in Australia and overseas.

PEDEN, Ludij (Pesch) QLD
Born Amsterdam 1942, arrived Aust. 1948. Realist-traditional painter in watercolour and oil. No formal art training, mainly self-taught. Member of Cairns Art Society Inc.; FNQ Regional Art Gallery Inc. (executive member); National Assoc. of the Visual Arts; Australian Flying Art School; Watercolour Society of Queensland; Royal Queensland Art Society; Artists Guild of Australia.
Exhibitions Solo shows at Palette & Brush, Darwin 1973, 74, 76, 77; Abbott Gallery, Brisbane 1974; Twelfth Night Gallery, Brisbane 1976; Upstairs Gallery, Cairns 1981, 88, 89, 90; Christy Palmerston Gallery, Port Douglas 1985; Framed Showcase Gallery, Darwin 1988, 91. Many group shows since 1972.
Awards Has won twenty-eight first prizes in Qld art competitions since 1980.
Represented Municipal, institutional and private collections around NT and Qld.

PEEL, Victoria NSW
Born Sydney 1948. Painter and teacher.
Studies Byam Shaw School of Art, London 1970–74; ESTC 1981; Postgrad. Dip., City Art Institute 1982. Teaches at Seaforth TAFE, Sydney TC and City Art Institute.
Exhibitions Solo shows at Hogarth Galleries and recently at BMG, Sydney 1988, 89. Participated at both Performance Space and Cell Block, East Sydney 1989.
Bibliography *New Art Four*, Craftsman House 1990.

PEITSCH, Florence (Stumphf) SA
Born Canada 1953. Painter, printmaker, teacher.
Studies BA, Chicago USA 1974. Fellow of RSASA; Has taught art at numerous colleges since 1982 and at the Ruth Tuck School 1990– .
Exhibitions Solo shows at Wilfried Laurier University, Ontario 1981; Fullarton Community Centre, SA 1982; Gillians Gallery 1983; Canada & USA Touring Exhibition 1984–86; Driden Gallery, Clarendon SA 1988, 89; Performing Arts Centre, Darwin 1990; The Quail Gallery, Mt. Gambier SA 1990; Kensington Gallery, Adelaide 1991. Participated in many group shows in SA since 1980 and regularly with the RSASA.
Awards Has won twenty-two prizes for painting in SA since 1980 and carried out numerous painting and portrait commissions.
Represented Institutional and private collections in Canada, USA and Australia.
Bibliography *Australian Watercolour Painters*, Jean Campbell, Craftsman House 1989.

PELL, Anne NSW
Born UK 1941. Painter, teacher, art critic.
Studies London University Teacher Training 1959–61; Taught art 1961–65; BA (Visual Arts), Newcastle NSW CAE 1980–83; Grad. Dip. in Art (Textiles) 1984–85; Part-time lecturer in art, Maitland TC 1987–88; Art critic for 'In Tempo' ABC 2NA 1988–89.
Exhibitions Solo show at Newcastle CAE 1985; Numerous group shows since 1982 include Lake Macquarie Regional Gallery 1982, 84, 86; Maitland City Gallery 1985, 88; City Art Institute, Sydney 1985; Newcastle Contemporary Artists Gallery 1987, 88; Holdsworth

Contemporary Galleries 1987; von Bertouch Galleries 1990.
Represented Institutional and private collections in UK and Australia.

PENGILLEY, Vivienne NSW
Born UK 1944, arrived Australia 1970. Painter; Assembles collage, tapestry.
Studies Sutton School of Art, UK 1962–64.
Exhibitions Pinkney Gallery, London 1968; Gallery A, Sydney 1972, 1973, 1974, 1977, 1978, 1980, 1981; Griffith Gallery, Canberra 1975; Warehouse Galleries, Melbourne 1976–78; Solander Galleries, Canberra 1976, 1981; Bonython Galleries, Adelaide 1977, 86; Allegro Gallery, Kenthurst NSW 1982; Participated in joint exhibition Chica Lowe, Gallery A, Sydney 1971; Invited Fifth Orange Festival of Art, Orange NSW; Invited *Life Style 70s*, Adelaide 1973; *Fabric Art*, Project 20, Art Gallery of NSW 1977; *Australian Crafts*, Art Gallery of SA; Art Gallery of NSW; Caulfield Arts Centre, Vic; Tas Art Gallery; Brisbane Civic Art Gallery; Undercroft Gallery, University of WA 1978; Invited National Craft Exhibition, Tas Museum and Art Gallery, Hobart; Burnie Art Gallery, Tas; Queen Victoria Museum and Art Gallery, Launceston Tas; Australian Craft Exhibition, Jam Factory, Adelaide 1979; *Australian Perspecta* 1981, Art Gallery of NSW; Group Exhibition, Bonython Gallery, SA; 'Women Artists', Gallery A, Sydney — in conjunction with Women and Arts Festival, October, NSW 1982.
Awards AM for services to the arts 1988.
Represented Australian National Gallery, Canberra; Ararat Art Gallery, Vic; Crafts Board, Australia Council; Craft Council of Australia; Macquarie University, commissioned for University Union; Nursery School Teachers College, Sydney; Royal Alexandra Hospital for Children (donated by the artist).
Bibliography *Art and Australia*, Vol 9/4; *The Artist/Craftsman in Australia*, Faye Bottrell 1972; 'Five Artists Who Happen to be Women', *Cosmopolitan* 1974; 'Stitched-On Art', *National Times*, 1977, Susanna Short; 'Crafts We'll Show the World', *Woman's Day* 1978; *Catalogue of Australian Perspecta* 1981; *Artists & Galleries of Australia*, Max Germaine: Craftsman House 1990.

PENGLASE, Marjory NSW
Born Echuca Vic 1922. Painter and theatre designer; Married to Newton Hedstrom.
Studies Melbourne Technical College under John Rowell and Murray Griffin; Extended overseas study tours UK, Europe 1976; Europe 1980; China 1982; Member of AWI and Peninsula Art Society.
Awards Warringah Open 1979; Lane Cove Open 1986; Young NSW Open 1986.
Represented Art Gallery of NSW; Manly and Armidale Regional Galleries; Sydney University and private collections in NSW, Vic, Qld and WA and overseas.
(Died 1989)

PENNEFATHER, Judy NSW
Born Sydney NSW 1934. Painter of modern landscapes and portraits in oil, pencil and dry brush.
Studies Ceramics with Trudy Arthur and a growing interest in portrait sculpture on to painting; Has studied at Royal Art Society of NSW under Allan Hansen since 1974.
Exhibitions Annual exhibitor with RAS; Three-woman show 1982; Hung in Archibald 1981. Solo show at The Fiveway Gallery 1988.
Award Portia Geach Memorial Award 1980.

PENNINGTON, Leonora Mary (Lee) QLD
Born England 1939. Painter of birds, wildflowers and collage.
Studies Bath Art School UK by scholarship 1952; ESTC and Hawkesbury Agricultural College 1976–80.

Exhibitions Solo shows at Victor Mace Gallery 1983; Broadbeach Gallery 1982, 83; Nerang Gallery 1984, 86. Numerous group shows include Gallery Baguette, Brisbane 1983 and The Centre Gallery, Gold Coast 1988.
Awards Currumbin 1982; Miami Open, Qld 1982; Lady Fairfax Prize, Sydney Royal Show 1983.
Commissions Sitmar Cruise Lines, mural with Elizabeth Tanke 1986.
Represented Institutional and private collections in NSW and Qld.
Bibliography *A Homage to Women Artists in Queensland Past and Present*, The Centre Gallery 1988.

PERCEVAL, Celia VIC

Born Melbourne Vic 1949. Contemporary landscapist in oil and acrylic; Daughter of John Perceval and Mary Boyd.
Studies Her interest in art emerged within the Perceval-Boyd family circle and she studied and painted in London 1963–65 and in UK, France and Italy 1967–71.
Exhibitions Hilton Gallery, London and Cremorne Gallery, Sydney 1971; Australian Galleries, Melbourne 1973, 1976; Bonython Galleries, Sydney 1975; Barry Stern, Sydney 1984; Wagner Art Gallery 1990.

PERCEVAL, Tessa VIC

Born Melbourne Vic 1947, daughter of John Perceval and Mary Boyd. Contemporary landscapist in oil and acrylic.
Studies Her interest in art was aroused within the Perceval-Boyd family circle and she has studied and worked in London and Florence and painted in many parts of Europe including UK, France, Italy, Spain, Corfu, Holland, Scotland, Wales and Ireland; She returns periodically to Australia.
Exhibitions Hilton Gallery, London 1971; Australian Galleries, Melbourne 1972, 1973, 1976; Bonython Galleries, Sydney 1976; von Bertouch Galleries, Newcastle 1977 and Philip Bacon Galleries, Brisbane 1977.

PEROVAN, Justina SA

Born Budapest, Hungary 1931, arrived Aust. 1950. Painter.
Studies SASA 1962–70; Fellow, RSASA; Study tours to Europe 1973, 79, 83; with private study in Budapest.
Exhibitions Solo shows since 1967 include Miller Anderson Gallery 1970, 82; Lidums Gallery 1976; Numerous group shows at David Sumner Gallery 1973, 74, 75, 76; USA 1982, 85, 86; Hungarian Cultural Convention, Adelaide 1988; Kensington Gallery 1989; Retrospective 25 years at Flinders University Art Museum 1990.
Represented Institutional, diplomatic and private collections in UK, Europe, Russia, USA, Japan, Australia.

PERRET, Shirley NSW

Born Armidale NSW 1928. Impressionist painter in oil and pastel.
Studies Julian Ashton School, Hurstville Technical and RAS of NSW; Study tours to UK, Europe, USA and South Africa.
Exhibitions Jan Taylor Galleries, Sydney 1980; Saints and Cooks Hill Galleries.
Represented Benalla Regional Gallery, Vic and private collections in Australia and overseas.

PERRIN, Yvonne NSW

Born New York 1922, arrived Australia 1969. Painter, designer and illustrator.
Studies Hammersmith School of Art, UK, Member, Society of Scribes & Illustrators, UK.
Awards Currabubula NSW 1979, 1980, 1982; Ku-ring-gai 1980.

Publications Has produced many children's books since 1950 and recently *Possum One, The Outback Rocketship* 1981; *Australian Poems to Read to the Very Young* 1982; *Professor Cockatoo's Amazing Weather Dust* 1983; Background artist for animated film, *The Golden Medallion*; Member of RAS of NSW and exhibits at Prouds Gallery, Sydney.

PERRY, Nancye Kent VIC
Born Killara NSW 1918. Traditional and semi-abstract painter, mostly in oil.
Studies Bachelor of Science, University of Sydney; Did entomological research in UK and Australia 1946–57; Studied art with private tutors 1930s and 1968–73 and with VAS and Australian Guild of Realist Painters.
Exhibitions Solo shows at ANZ Bank Gallery, Melbourne 1974; VAS 1984.
Awards Royal Overseas League 1971.
Represented National Bank Collection; Private collections throughout Australia and in England, Canada, USA, South Africa, West Germany, Turkey, Italy and Japan.

PERRY-CARTER, Margaret NSW
Born Trinidad West Indies 1946. Painter, maker of wall hangings and teacher.
Studies St Martins School of Art, London UK 1964–68; Emigrated to Australia and taught painting at Newcastle School of Art, NSW until 1971; Moved to Canberra and continued to teach at the School of Art there until 1977.
Exhibitions One-woman show at East End Art, Sydney 1982.
Represented Institutional and private collections in Australia and overseas.

PETYARRE, Gloria, Nora and Pansy NT
Emerging Aboriginal batik painters from the Utopia Station region some 240 km NE of Alice Springs NT and traditional home of the Anmatyerre and Alyawarre peoples.
Exhibitions Bloomfield Galleries, Sydney 1989.
Represented Robert Holmes à Court Collection.

PETYARRE, Jessie, Annie and Suzy NT
Alyawarre Aboriginal batik painters from the Utopia area of the NT.
Exhibitions Lauraine Diggins Fine Art, Melb. 1989.

PETYARRE, Margaret and Rosemary NT
Aboriginal batik painters from the Utopia area of the NT.
Exhibitions Their work was included in a travelling exhibition to UK, Europe and USA 1990–91.
Bibliography *Artlink* Autumn/Winter 1990.

PHILLIPS, Charmian Rosa WA
Born Perth WA 1927. Semi-abstract painter in oil and acrylic.
Studies Graduated Bachelor of Science from University of WA 1947 and Associateship in Art from WA Institute of Technology; Secretary of Contemporary Art Society, WA 1980–82; Has taught art for the Technical Education Division, WA, the YWCA and private classes; Study tour UK and Europe 1983.
Exhibitions Perth Prize for Drawing International Show 1971; One-woman show at Churchill Gallery 1976, 1978, 1982; Participated at Cremorne Gallery 1981; *WA Women Artists* 1981 and CAS shows 1980–83.
Represented Private collections around Australia and in UK and Europe.

PHILLIPS, Jill WA
Born Birmingham UK 1939. Ceramic sculptor and potter.
Studies Perth Technical College; Works in functional and sculptural stoneware in her own

pottery at Robin Phillips Galleries, Roleystone WA in which she is a partner.

PHILLIS, Victoria NSW
Born Sydney 1954. Painter, teacher.
Studies Newcastle TC 1974–75; Dip. and Postgraduate at Newcastle CAE 1977–80.
Studied in Europe 1981, 83; Completed Higher Certificate Art Course at Newcastle TC
1985; Teaches at WEA.
Exhibitions Newcastle TC 1980; Lake Macquarie Community Gallery 1985, 86; von
Bertouch Gallery Collectors Choice 1979–89.

PHILP, Jenny NSW
Born Hobart 1952. Painter, teacher.
Studies Hobart S of A 1969–71, 74; Taught with Tas. Ed. Dept. 1972–73, 77–80.
Exhibitions Solo shows at Salamanca Place Gallery 1976; Don Camillo Gallery, Hobart
1979.
Represented Institutional and private collections in Australia.

PICKERING, Mary-Jane WA
Born Somerset UK, arrived Australia 1968. Painter, portraitist and teacher.
Studies National Dip. Art & Design, Oxford University UK 1958–60, studied and taught
art in UK, Europe 1961–63, since arrival in Australia has taught at a number of colleges and
at Claremont School of Art 1985.
Exhibitions Numerous shows in UK and more recently at Greenhill Galleries 1982, 83;
Howard Gallery 1985; Glyde Gallery 1987; Perth Gallery 1989.
Represented Institutional and private collections in UK, Europe and Australia.

PIDGEON, Rosemary WA
Born Bunbury WA. Figurative painter and portraitist in oil and watercolour.
Studies Under Henry Froudist (oils, life, portraiture); Edith Flaherty (watercolours);
Member, Perth Society of Artists and Centaur Group; Graudated Bachelor of Arts from
University of WA 1981; Overseas study tours UK, Europe, USA and Canada 1968, 1975,
1982.
Exhibitions Cremorne Gallery, Perth 1971, 1973, 1975; Participates in many prize shows
and with CAS and Perth Society of Artists.
Awards University Art Prize 1963; Mt Barker 1964; Bunbury 1962, 1968.
Represented Parliament House, Perth; Bunbury Municipal Art Gallery; St Boniface
Cathedral Crypt; Kiernan High School, Manjimup; St Hilda's School, Mosman Park;
Karrakatta Club, Perth; Central Law Courts Building, Perth.

PIERCE, Eileen NSW
Born UK, Naive painter.
Exhibitions Gallery Art Naive, Melb. and Rainsford Gallery, Sydney 1987, 89. Her work
appears on greeting cards and calendars.

PIERONI, Margaret (Hellmers) WA
Born NSW 1936. Painter, designer, illustrator.
Studies ESTC and in UK, Europe as a graphic artist. Member, WSWA.
Bibliography *Australian Watercolour Painters*, Jean Campbell, Craftsman Press 1989.

PIGOTT, Gwyn (Hanssen) QLD
Born Ballarat Vic 1935. Potter.
Studies Bachelor of Arts Degree, University of Melbourne 1954; Apprenticeship training
with Ivan McMeekin at Sturt Pottery, Mittagong NSW 1955–57; Worked in UK, Europe

with leading potters for over ten years and on return to Australia in Hobart, Adelaide and Brisbane.

Exhibitions One-woman shows at Primavera, London 1961, 1963, 1965; British Crafts Centre, London 1971; Galerie des Deux Tisserands, Paris 1972; Blackfriars Gallery, Sydney; Victor Mace, Fine Art Gallery, Brisbane 1983; Casson Gallery, London 1984; Potters Gallery, Sydney 1984; Distelfink Gallery, Melb. 1986; Handmark Gallery, Hobart 1987; Garry Anderson, Sydney 1987, 89; Jam Factory, Adelaide, Devise Gallery, Melb. 1988; Garry Anderson Gallery 1990. Participated at *British Potters*, Molton Gallery, London 1970; *Ten British Potters*, German Tour — arranged by British Crafts Council 1972–73; Vallhauris, all work bought by French Government for the Sevres Museum 1972; *The Craftsman's Art*, Victoria and Albert Museum 1973; Crafts Board Exhibition, *Funtional Ceramics*, Craft Centre South Yarra 1978; *Wilderness Exhibition*, Bowerbank Mill, Deloraine Studio 20, Blackwood, SA 1979; Craft Centre, South Yarra 1980; *Travelling Tableware Exhibition* by selected potters, *The Gift Exhibition*, Canberra 1981; With J. Pigott, Jam Factory Gallery, Adelaide; Australia Crafts 1981, Meat Market Craft Centre, Melbourne 1987; St Louis USA 1987 and has won many awards.

Represented AGNSW, AGWA, QAG, TMAG; Sevres Museum, France; V & A Museum, London; Institutional and private collections in UK, Europe and Australia.

Bibliography *Art and Australia* 28/3; *Artists & Galleries of Australia*, Max Germaine: Craftsman House 1990.

PIGGOTT, Lyn VIC

Born Canterbury Vic 1931. Silversmith and teacher.

Studies RMIT and Melbourne Teachers College 1950–52; Secondary school art teacher 1953–57; Study tours to UK and Europe 1961, 1976; In recent years has worked mainly on commissions.

Exhibitions Many group shows since 1980 including National Fibre Conference, Frankston Vic 1980; Sale Regional Gallery 1982, 83, 84, 85, 86; and recently Makers Mark, Melb., Robb St Gallery, Bairnsdale, Westwal Gallery, Tamworth NSW all in 1988.

Commissions Soroptomist Society, Mornington Peninsula, Presidents Chain of Office 1968; Chain of Office, Shire Bairnsdale 1987–88.

Represented Corporate, institutional and private collections around Australia and overseas.

PIGGOTT, Rosslynd VIC

Born Frankston Vic 1958. Painter.

Studies Melb. CAE 1977–80.

Exhibitions Solo show at 200 Gerturde Street Gallery, Melb. 1987. Her work was included in *A New Generation 1983–88* at the ANG Canberra 1988; RMIT Gallery 1983; Powell Street Grahics 1988; Moet and Chandon Touring Exhibition 1991.

PILGRIM, Pam VIC

Born Terang, Vic. 1935. Painter, textile artist, soft sculptor.

Studies Presently lecturer in Textiles at the University of Melbourne. Has exhibited widely.

Bibliography *Alice 125*, Gryphon Gallery: University of Melbourne 1990.

PILKINGTON, Lena Marion SA

Born Adelaide SA 1918. Painter, semi-traditional in oil, pastel, acrylic and pen.

Studies Frankston Technical College; Peninsula Arts Society; Council of Adult Education, Vic; Part-time Canberra Technical College.

Awards Corio Rotary 1973; Kiwanis, Adelaide 1979; RSASA 1980.

Represented Corio Shire Collection and private collections around Australia and overseas.

PINKAS, Anne VIC
Born Melb. 1948. Printmaker.
Studies Dip. Art and Design, CIT 1980; BA Fine Arts Uni. of Melb. 1988. Overseas studies
UK, Europe, Japan, USA 1972–74.
Exhibitions Eltham Gallery 1985.
Awards MPAC Purchase 1978; Oculos Gallery 1982, 83.
Commissions Comalco 1986; International Marine Pilots 1988.
Bibliography *PCA Directory* 1988.

PINNEY, Sharon NSW
Born Kingston, Canada. Painter, photographer.
Studies B. Fine Arts, Queens University, Kingston, Canada 1984–86; B. Creative Arts,
University of Wollongong 1987–88; Photography Studies, Sydney TC 1989.
Exhibitions Solo show at Coventry Gallery 1989; Group shows include Kingston Public
Library 1986; Spoleto Festival, Melbourne 1987; Nextu Studios 1987; EMR Gallery 1988;
Sylvester Studios 1989; S.H. Ervin Gallery 1989.
Represented Institutional and private collections in Canada and Australia.

PINNOCK, Mary NSW
Born Wagga NSW 1951. Painter, decorative artist.
Studies Wagga TC with Alfred Morris 1963–65; Camden Institute, London UK 1971–73;
Royal Academy, London 1973; Batik art in SE Asia 1975; Alexander Mackie Art School,
Sydney 1976; Member ICA, London 1973.
Exhibitions Wagga Art Society 1965; Arkwright Gallery, London, 1974; Holdsworth
Galleries, Sydney 1982; Wagga Art Gallery 1983; Barry Stern Galleries, Sydney 1983, 84,
86, 87, 89; Design Warehouse Melb. 1985, 87; Festival of Sydney 1983, 85; Aptos Cruise
Galleries, Adelaide 1987; South Yarra Galleries 1988.
Awards VAB Grant 1976.
Represented Institutional and private collections in UK, Europe, USA and Australia.

PINSENT, Mary M. NSW
Born UK 1934. Animaliere sculptor in cold cast bronze.
Exhibitions Manyung Gallery, Mt Eliza Vic; McInnes Gallery, Brisbane; Also in Canberra
ACT and Toowoomba Qld 1977, 1978 and a permanent display at her Realities cold cast
foundry at Thora NSW.
Commissions Barcoo Bush Ballad Award, Qld and a Pegasus, Flying Horse for Mobil
(Australia); Brahman International Conference and many Arab and Quarter Horse shows.

PITMAN, Clare NSW
Born NSW. Ceramic artist and sculptor.
Studies Sydney Art School under Henry Gibbons and Grace Crowley; Chelsea Polytechnic,
London UK; Has worked and travelled widely overseas; Works mostly on commission.
Exhibitions Arts and Crafts, Sydney 1952; David Jones' Gallery, Regent Street
Polytechnic, London and recently at Murray Crescent Gallery, ACT 1980.
Represented Bust of late Professor Denis Winston, Memorial Library, Faculty of
Architecture, University of Sydney.

PITMAN, Joan (Cotton) TAS
Born Hobart 1917. Painter, graphic artist, teacher.
Studies Hobart TC under Mildred Lovett and Lucien Dechaineux 1929–30, 1931–35.
Worked in commercial art 1935–41; Taught at HTC 1942–46.
Exhibitions TMAG, Tas. Group of Painters 1941–45, 47; Art Society of Tas. 1943, 44;
AWI, Sydney 1944.

Bibliography *Tasmanian Artists of the 20th Century*, Sue Backhouse 1988.

PITMAN, Phyllis (Green) TAS
Born Hobart 1913. Painter, theatre designer, teacher.
Studies Hobart TC under Lucien Dechaineux 1928–29, 1930–37; Taught HTC 1933–43.
Exhibitions Art Society of Tas. 1933–37; Macquarie Galleries, Sydney 1937; Contemporary Group, Sydney 1939–44; AWI, Sydney 1944; Arts Council, Canberra 1950; *A Survey of Australian Relief Prints 1900–1950* Deutscher Galleries, Melb. 1978.
Bibliography *Tasmanian Artists of the 20th Century*, Sue Backhouse 1988.

PLAMKA, Fay VIC
Born Germany 1947. Painter, designer, art director.
Studies Nat. Gallery School, Vic 1967–68; Bezalel Academy of Art, Israel 1968–96. Assistant to Ernst Fuchs at School of Fantastic Realists, Vienna 1970.
Exhibitions Baden-Baden, Germany 1971; Consortium Gallery, Adelaide 1976; Recconnaissance Gallery, Melb. 1989; Libby Edwards Gallery, Melb. 1989.
Commissions Numerous commissions include Australia Post 1984, 85; Vic Tapestry Workshop 1988; City of Melb. — 1996 Olympic Games 1988.

PLANT, Joyce VIC
Born Vic. Painter of flowers, wildlife, figures and portraits.
Studies Under Archibald Colquhoun and Wesley Penberthy in Melbourne; President of the Peninsula Arts Society.
Exhibitions Solo shows with Whittlesea Art Gallery and Abercrombie Galleries, Melbourne 1981.

PLATTEN, Anna SA
Born Adelaide 1957. Painter.
Studies SASA 1976–80, 83.
Exhibitions *A New Generation 1983–88*, ANG, Canberra 1988.
Represented ANG, Canberra.

PLATTEN, Bronwyn SA
Born Adelaide 1959. Painter.
Exhibitions Solo show at CAC, Adelaide 1989; Group shows include Jam Factory 1986, 88; Festival Centre 1988; AGSA 1988; *Australian Perspecta* 1989, AGNSW.

PLAYNE, Moira VIC
Born Edinburgh, Scotland 1938. Printmaker.
Studies BA, Fine Art, RMIT 1978.
Exhibitions Solo show at Makers Gallery, Melb. 1986; Participated MPAC 1987; 70 Arden St 1988.
Commissions PCA 100 x 100 Print Portfolio 1988.
Bibliography *PCA Directory* 1988.

PLUMMER, Lyn ACT
Born Brisbane Qld 1944. Sculptor working with mixed media and tissue; Painter.
Studies Brisbane School of Art 1960–61; Diploma of Art (visual) Canberra School of Art 1979–81; Graduate Diploma in Fine Art (sculpture) Vic College of the Arts 1982–83; Taught art for Qld Adult Education Board 1966–67; Lived for six years in various area of Papua New Guinea between 1968 and 1981; Travelled widely throughout PNG; Travelled to Philippines and Hong Kong 1975; Worked with students at the National Art School, Port Moresby 1975–76; Taught art at the Port Moresby International High School 1981;

Lecturer, Brisbane S of A 1982; VCA 1984, 85, 86; Riverina-Murray IHE 1985–89; Gippsland IAE 1986; Bendigo CAE 1987; Cheltenham S of A, UK; University of Newcastle-upon-Tyne, UK 1988; Glasgow S of A, UK 1988. Founder/President, Link Artists Access Studios 1985; Presently at School of Creative Arts, Charles Sturt University, NSW.

Exhibitions Solo shows at Arts Council, Port Moresby 1974, 1976, 1977; Susan Gillespie Gallery, ACT 1977; Ray Hughes Gallery, Brisbane 1982; Gallery A, Sydney 1982; Albury Regional Gallery 1986; Roz MacAllan Gallery, Brisbane 1988; QAG 1990. Participated Port Moresby 1975; Canberra Times Award 1979; University of Qld 1982; Gallery A 1982; Heide Gallery, Melbourne 1983; VCA Gallery 1983; Canberra School of Art 1984; Roz MacAllan Gallery, Brisbane 1988; VCA 1987; Tenth Mildura Sculpture Triennial 1988; Albury Regional Gallery 1989.

Awards Papua New Guinea Biennial 1974; Rabaul 1974, 1976; VAB Grants 1983, 86; Riverina-Murray IHE — UK, Europe, USA Travel 1988.

Represented Papua New Guinea Government Collection and many private collections in Australia and NZ. Institutional collections in UK, Europe and USA.

POCIUS, Ieva (Sakalauskaite) SA

Born Lithuania 1923, arrived Australia 1951. Sculptor in wood and metal; Teacher.

Studies Diploma Fine Art (sculpture) SA School of Art 1962; 1975 part-time lecturer, SA School of Art (sculpture) 1964–75; Bronze Casting Course at International Summer Academy, Salzburg 1975.

Exhibitions Argus Gallery, Melbourne 1965; Bolton Gallery, Adelaide 1969; Llewellyn Gallery, Adelaide 1971; Contemporary Art Society Gallery, Adelaide 1973; Sydenham Art Gallery, Adelaide 1975; Avenel Bee Art Gallery 1979; Montrichard Art Gallery 1981; Numerous shared and group shows since 1963 include Mildura Sculpture Triennial 1967, 1970, 1982; Qld Art Gallery Invitation 1982.

Awards RSASA Prizes 1963, 1965, 1967; Lithuanian Festival, Melbourne 1966; Bundaberg Qld Centenary 1967 (shared); Prize of Honour, International Summer Academy, Salzburg Austria 1970.

Represented Art Gallery of SA; SA School of Art; Reserve Bank; RC Church, Hectorville SA; Institutional and private collections in Australia, UK and Europe.

Bibliography *Australian Sculptors*, Ken Scarlett, Nelson 1980; *Who's Who in the Commonwealth*, Cambridge UK 1982.

POCKLEY, Lesley Haslewood NSW

Born Sydney NSW. Abstract impressionist painter in oil, acrylic and mixed media.

Studies Education at Ascham School, Sydney; Chelsea Polytechnic, London and Julian Ashton School, Sydney; Private studies with Jean Bellette, Judy Cassab, Professor Feuerring and summer schools at University of New England, tutor were Sibley, Baldessen and Ball; Overseas study 1980, 1983.

Exhibitions Barry Stern Galleries 1963, 1965, 1986, 1989; Yoseido Gallery, Ginza Tokyo 1965 (first Australian to hold one-woman show of oils in Japan); Macquarie Galleries, Sydney 1970, 1974; Toorak Gallery, Melbourne 1971; Wagner Gallery, Sydney 1978, 1983; Qantas Gallery, London UK 1980; Gallery 460, Gosford NSW 1987.

Awards Wollongong 1967; Royal Easter Show for Still-Life 1974; Portia Geach Portrait Prize 1974; Berrima Prize 1978; Mosman 1978; Royal Easter Show, still-life 1986, 87; Seascape 1990.

Bibliography *Art and Australia*, Vols 9/1, 10/3.

POLLAK, Audrey NSW

Born Sydney 1928. Painter, printmaker, sculptor, teacher.

Studies Zoology, University of Sydney 1945–48; Dip. Ed., University of New England and

part-time museum curator 1953–75; Putney School of Arts, UK 1976; Willoughby Workshop Art Centre 1977; Certificate and Post-certificate art courses, Hornsby TC 1984–91; Sculpture at WAC 1989–91.
Exhibitions WAC Gallery 1978, 79; Barry Stern 1981; Bloomfield Galleries 1982, 83; Blaxland Gallery 1983, 84; Mori Gallery 1985; Tin Sheds Gallery 1989; Braemar Gallery 1990, 91; Djuric Gallery 1990.
Represented Institutional and private collections in UK and Australia.

POLLACK, Jenny NSW
Born Sydney 1954. Painter.
Studies With Julian Ashton; Private student of Brian Dunlop 1973–77; Vienna, University of Art and Architecture under Professors Lassnig and Frohner 1981–82.
Exhibitions Solo shows at Gallery 380A, 1978; Prouds Gallery 1980; Robin Gibson Gallery 1986. Group shows at Macquarie Galleries 1977; Prouds Gallery 1978.
Represented Institutional and private collections in UK, Europe and Australia.

POLLINGTON, Viola VIC
Born Hobart Tas. Romantic impressionist painter.
Studies Commercial art and worked in that field for some years; Attended Melbourne University night classes under Wesley Pemberthy; Attends Vic Artists Society classes; Study tour to Italy 1981, 84.
Exhibitions Solo shows at Manyung Gallery, Melb. 1977; Colonial House 1981; Craft Affair, Mornington 1980; Participated at Allerton Gallery 1984; Caulfield Art Centre 1978; VAS, Melb. 1977.
Award Manyung Gallery Watercolour Prize 1976.
Represented Private collections in Australia, UK and Europe.

POOLE, Sarah VIC
Born Leicester, UK 1955. Painter, illustrator, graphic artist, teacher.
Studies Graphic Design at Swinburne TC; Dip. Art & Design, Prahran CAE. Presently teaching at senior level.
Exhibitions Prahran CAE 1982; Edinburgh College, Scotland UK 1983; Mitcham High School 1984.
Bibliography *150 Victorian Women Artists*, Visual Arts Board/WAM 1988.

PORCH, Debra L. NSW
Born USA 1954. Painter, printmaker, teacher.
Studies San Diego State University, California USA, BA 1973–76; MA 1977–79 lectured USA 1978–79, SACAE, Adelaide 1985, presently part-time lecturer in printmaking Nepean CAE, NSW 1989–.
Exhibitions Many shows since 1979 and in recent years at Riddoch Art Gallery SA 1985, 89; Jam Factory, Adelaide 1985; CAC, Adelaide 1986, 88; Del Bello Gallery, Ontario, Canada 1986–87; SASA Gallery 1987; The Centre Gallery, Gold Coast, Qld 1988.
Represented Riddoch Art Gallery, Mt Gambier, SA; University of Wisconsin; University of Illinois; San Diego State University; Private collections in the USA and Australia.

PORTER, Fay NSW
Born Sydney NSW 1933. Painter in oil and enamel; Teacher.
Studies Evening student at East Sydney Technical College; Worked commercially in display, publishing and as art director; Teaches part-time at Armidale Technical College.
Exhibitions One-woman show at Armidale City 1981, 88; Participated in numerous group shows since 1975 including Art of Man Gallery, Paddington 1978; Tamworth City Gallery 1981, 1982; Coventry Gallery, Sydney 1982; New England Art Museum 1983.

Represented New England Art Museum, Tamworth City Gallery; Private collections around Australia and in London, UK.

PORTER, Gaye NSW
Born Sydney 1943. Sculptor and teacher.
Studies ESTC 1961; North Sydney TC with Bim Hilder 1970; Ceramics at Brookvale TC 1975. Has taught sculpture at schools and art centres since 1983. Member, The Sculptors Society, Sydney; Studied New York USA 1985.
Exhibitions Numerous shows since 1978 include Irving Sculpture Gallery and Centre Art Space, Chatswood 1983; Woollahra Galleries 1984; Old Bakery Gallery 1985; Holdsworth Galleries 1986; Painters Gallery 1988; Sydney Opera House Sculpture Symposium 1990; Access Gallery 1990.
Commissions Numerous commissions include TV Channel 9 1986; Sculpture Park, Gosford NSW 1987; Bicentennial Wall of History 1986; Bicentennial Park, Pymble 1987; Snow Leopard Sculpture, Taronga Zoo 1990; 'Buddy Williams' sculpture; Twin Waters Resort, Qld 1990.

POULSEN, Julie (nee Lyle) QLD
Born Brisbane 1958. Painter.
Studies Majored in painting with distinction awards, Darling Downs IAE 1977–80.
Exhibitions Grafton House Galleries, Cairns 1989.
Awards Yungaburra Festival 1987.

POWELL, Barbara (Weise) SA
Born Melbourne Vic 1927. Painter of landscapes in oil and watercolour, teacher.
Studies East Sydney Technical College 1942–46; Emerson College, UK and Switzerland, watercolour 1975–76; Packaging designer; Fellow of Royal SA Society of Arts. Member, Adelaide Art Society. Hon. guest tutor Torrens CAE. Studied in Russia and Europe 1987.
Exhibitions One-woman show at Stairway Restaurant 1967; Osborne Gallery 1970; Lombard Street Gallery 1972 and Pepes 1974, all in SA; Group show at Salisbury House, SA 1964; CBS Court, SA 1965; Quorn Mill and Mews Galleries, SA 1968; Young Australian Gallery, Brisbane 1973; Hyde Park Gallery, SA 1975; *Art and the Creative Woman*, RSASA 1975; McClelland Reg. Gallery Vic 1983; Kintore AG Adelaide and Steiner House Sydney 1984; Warrah School, Sydney 1986; Manyung Gallery 1986.
Awards RSASA Landscape 1966; Repatriation National Art Contest Print Prize 1968; Griffiths Caltex 1973; Victor Harbor, SA 1980, 81; West Lakes 1981. Numerous mural and painting commissions.
Represented Corporate, institutional and private collections in UK, Europe, NZ, USA, Australia.
Bibliography *Artists & Galleries of Australia*, Max Germaine: Craftsman House 1990.

POWER, Anne Marie VIC
Born Melbourne Vic 1945. Soft sculptures, textiles; Teacher.
Studies Diploma in Art, RMIT and Creative Arts Diploma, North Brisbane CAE 1963–66; Member, Craft Council of Australia and Fibre Forum Group; Sessional lecturer, part-time, textiles, Melbourne State College 1981; Creative Embroidery Tutor, part-time, Gordon Technical College, Geelong 1983; Workshops in Textiles by Invitation 1981–83; Art — Gifted Children's Programs 1981, 1983. Artist-in-Residence, City of Hamilton, Vic 1988.
Exhibitions Recent shows include Craft Council of NT 1981; Stirling Festival SA 1981; La Trobe Valley Arts Centre 1982; Tamworth Fibre Exhibition 1982; Georges Gallery, Melbourne 1982, 1983; Meat Market Craft Centre, Melbourne 1983; Arts and Crafts Society, Melbourne 1983; Distelfink Gallery, Melbourne 1983; Ararat Regional Gallery Vic 1988.

Represented Qld Art Gallery and private collections.

PRATT, Gwen ACT

Born Sydney NSW 1917. Traditional painter and portraitist in oil, watercolour and pastel.
Studies Under J.S. Watkins from the age of twelve; Much later she continued her studies in 1958 under Henry Gibbons and Richard Ashton at the Julian Ashton School and with Henry Hanke and Allan Hansen of the Royal Art Society of NSW and for some years with Douglas Pratt, a relative by marriage; Several overseas study tours; Fellow of the Royal Art Society of NSW with whom she exhibits; Her exhibitions also include paintings on porcelain.
Represented Farrell Shipping Lines USA; Mercedes Benz Company Collection; Private and institutional collections in Australia and overseas.

PRATTEN, Valmai NSW

Born Herberton North Qld 1918. Traditional painter in oil and watercolour.
Studies Peter Panoro School, Julian Ashton School, Brian Beauchard and Royal Art Society of NSW.
Exhibitions Regularly with groups and the Royal Society of NSW and Kenwick Galleries, Beecroft.
Awards Royal Easter Show 1966; Nepean District A.H. & I. Society 1976; Castle Hill Show 1974.
Represented Private collections in NSW, Vic and Qld.

PRENTICE, Patricia QLD

Born Qld 1922. Painter, teacher.
Studies With William Bustard RQAS; Painting at Byam Shaw School of Art, London and ceramics at Central Art School, London. Worked in UK and East Africa for some years 1954–74.
Exhibitions First solo shows at Johnstone Gallery, Brisbane 1949, 53 followed by Commonwealth Institute, London; Qantas Gallery, London; East Africa and in recent times at Creative 92 Gallery, Toowoomba and Boston Gallery, Brisbane. Numerous group shows and recently at The Centre Gallery, Qld 1988.
Represented QAG, Commonwealth Institute, London, institutional and private collections in UK, Europe, East Africa, Canada, Japan, Australia.
Bibliography *A Homage to Women Artists in Queensland, Past and Present*, The Centre Gallery 1988.

PRESA, Elizabeth VIC

Born Melb. 1956. Sculptor, teacher, gallery director.
Studies Victorian College of the Arts (Dip. Sculpture) 1975–77; Phillip Institute (Postgraduate Sculpture) 1980; University of Melbourne 1978, 83–85; Director of Wagga Wagga Regional Gallery 1978–79; Part-time tutor in art philosophy, Riverina College of Advanced Education 1980–81; Part-time tutor in sculpture, Sculpture department Melbourne CAE 1984–85; Since 1985 employed as a part-time tutor in sculpture in the Prahran sculpture department of the Victoria College.
Exhibitions Mildura Sculpture Triennial 1982; 1st Australian Sculpture Triennial La Trobe University 1981; *Preston to Phillip — A Survey* Reconnaissance Gallery.
Represented Sculpture Park Colac Victoria, *Black Torso*; Private collections in Australia and England.

PREST, Cedar SA

Born Vic. Stained glass artist and teacher.
Studies Life drawing classes at National Art School, Melbourne. Graduated Bachelor of

Arts University of Melbourne 1960 and later Diploma of Education. Studied stained glass at Wimbledon College of Art, London and Hornsey College of Art 1965–66. In 1973 assisted by an Australia Council Crafts Board Grant studied in Germany and in 1974 worked in a glass-blowing workshop with Sam Herman at the Jam Factory, Adelaide. Throughout the 1970s she has maintained her own studio, taught at Craft Association of SA summer schools and lectured and studied overseas at many places including the Mendocino Art Centre, California; Maryland Institute College of Art, Baltimore USA; Foley College, Stourbridge and the Glass Centre, Brierly Hill UK.

Exhibitions World Craft Council Exhibition, Toronto Canada 1974; Fells Paint Gallery, Baltimore USA 1969–70; Aldgate Crafts, UK 1972. Her special show of glass doors called *Doors of Perception* was exhibited in both Melbourne and Canberra and she has participated in many Craft Council shows throughout Australia.

Commissions Many glass windows in churches and public buildings including the University of Adelaide; SA Craft Authority; St Michael's Ukranian Church, Croydon; St Anne's Church, Marion and St John's Church, Maitland SA. She has been coordinating and assisting the development of a series of community created stained glass windows for the Araluen Centre, Alice Springs NT since 1982 sharing her skills with young local Aborigines. As a Bicentenary project Aborigine artist Wenten Rubunta designed a stained glass centrepiece and this was executed by Cedar Prest.

PRETZEL, Marian NSW
Born Lvov Poland 1922, arrived Australia 1949. Broad expressionist painter.
Studies Trained as a graphic designer in Poland and Austria.
Exhibitions Roseville Galleries, Sydney.
Awards Parramatta Art Award (historical section) 1972, 2nd Prize in Open Section 1971, 1973; Designed and painted decor in Latin Quarter Restaurant, Pitt St, Sydney.
Represented *Sydney Morning Herald*, Fairfax Collection; Parramatta Historical Society; Private collections in Australia and overseas.

PRICE, Janet NSW
Born NSW. Landscape painter in oil.
Studies ESTC and worked and studied in S.E. Asia.
Exhibitions Had several exhibitions in Sydney in the early 1980's. Some of her work is reminiscent of that of The Brushmen of the Bush.

PRICE, Julia VIC
Born Australia. Semi-abstract painter and operatic singer.
Exhibitions Tuesday Painters, Melbourne 1975 and solo show at Juniper Gallery 1977. Member, VAS and Waverley Art Society. Showed at Waverley City Gallery 1989.

PRICE, Sue NSW
Born Sydney. Painter, graphic artist.
Studies Julian Ashton School, Sydney.
Exhibitions Solo show at Legacy House Gallery, Sydney 1987.
Represented Private collections in Australia, South Africa, USA, Canada, New Zealand and Europe.

PRICTOR, Lois VIC
Born Kynteon Vic 1927. Wildlife painter in watercolour.
Studies Bachelor of Science (botany) University of Melbourne night classes in art.
Exhibitions Kyneton Gallery, Vic 1980, 1981, 1982 and with VAS.
Represented Private collections in Australia and UK.

PRIEST, Margaret Kennedy WA

Born Scotland 1922, arrived Australia 1951. Painter, sculptor and teacher.

Studies Diploma in Fine Arts from Glasgow School of Fine Arts; Jordanhill Teachers Training College; Postgraduate study in Paris 1947. Taught art Glasgow 1944–49; NZ 1950; WA 1952–77; Part-time lecturer in sculpture at WAIT 1969–73 and 1975, 1976; Since then freelance professional practice. Member, Perth Society of Artists, foundation president of WA Association of Sculptors. Studied sculpture and language in Japan 1982.

Exhibitions Has exhibited widely since 1954 including Perth Society of Artists and Skinner Galleries 1958–61; Mildura Arts Centre 1961, 1962; Newcastle City Art Gallery 1962; Transfield Prize 1966; WAIT 1973, 1975; Art Gallery of WA 1974.

Awards Benno Schotz Prize, UK 1940; Postgraduate scholarship, Glasgow 1943; Guthrie Award, Glasgow 1944; Keppie Scholarship, France 1947.

Represented Art Gallery of WA; Tas Museum and Art Gallery, many schools, churches and public buildings in WA and Glasgow.

Bibliography *Australian Sculptors*, Ken Scarlett, Nelson 1980.

PRINCE, Joan NSW

Born Bexley NSW. Genre pen and watercolour painter.

Studies Dattilo Rubbo Art School, Sydney 1951–55; Primary school teacher, graduate NSW Conservatorium of Music ARAS of NSW 1983.

Exhibitions Solo shows at Gulgong Festival 1983; Lochiel House Gallery 1984; Collier Galleries 1987. Participated RAS of NSW; Galerie Tapande Canberra 1980, 81, 87, 88; Tamworth 1986; Priory Court, Sydney 1985.

Awards Has won nine first prizes in NSW art shows.

Represented Private collections in Australia, Great Britain, USA, Denmark, Germany and Japan.

PRINGLE, Dorothy QLD

Born Dunedin NZ. Paintings and portraits.

Studies Dunedin School of Art and under private tutors in Australia. Member, RQAS, Watercolour Society of Qld. and Ascot Art Group.

Exhibitions The Blue Marble Gallery, Buderim; RQAS; Ascot and Sunshine Coast Groups.

Awards Has won seven first prizes including Quota Club; RQAS; Ascot Annual; Sunshine Coast Annual.

Represented Maroochy Shire Council, corporate and private collections in Australia and NZ.

PRIOR, Elizabeth VIC

Born Ormond Vic 1929. Figurative expressionist painter of landscapes in oil.

Studies Uni. of Melb. — Fine Arts. Member of Vic Artists Society; Vice-president CAS Vic, 1972–73; President Beaumaris Art Group 1981, 1982, 1983.

Exhibitions Two-person show, Tas Tourist Bureau Gallery, Vic 1965; *Four Painters*, Toorak Art Gallery, Vic 1966; One-woman show at Three Sisters Gallery, Brighton Vic 1968; Vic Artists Society 1971; Rosalind Humphries Galleries, Vic 1974; Russell Davis Gallery, Vic 1975; Sydenham Gallery, SA 1975; Clive Parry Galleries, Vic 1977; Swan Hill Regional Gallery, Vic 1977; Hawthorn City Art Gallery 1980; Russell Davis Gallery 1982; Kerang Arts Council 1983. Victorian Artists Heritage Show 1985; Leveson St Gallery 1985.

Awards Mordialloc Arts Festival Prize 1965; W and G Dean Prize, Vic Artists' Society 1966; Purchased the Gold Coast Prize 1967; Healesville Art Award 1971; Rotary Club of Camberwell Special Prize 1974; Flinders Art Award, for peninsula landscape 1974; City of Oakleigh Prize 1974; Brighton City Council Prize 1974; Melbourne City Council Prize 1976–78; Clayton Arts Council, Commonwealth Banking Corporation, Special Commendation 1978; Applied Chemicals Prize 1980; City of St Kilda Acquisition 1982;

City of Sandringham Purchase 1982.
Represented La Trobe University, Vic; Gold Coast City Art Gallery, Qld; Melbourne City Council, Vic; City of Brighton, Vic; City of Sandringham, Vic; City of Oakleigh, Vic; State Savings Bank of Vic; ANZ Bank Collection; Women's Art Register slide collection; Caringbush Regional Library; City of St Kilda Collection.

PRIOR, Gladys Jauncey VIC
Born Herefordshire UK 1918, arrived Australia 1924. Traditional realist painter and por-traitist in oil, watercolour, pastel and pen.
Studies Took up painting after early retirement from the nursing profession. Studied under private tutors 1974–77; VAS 1977–78 and private tutors 1979–82, with overseas study tours; Member Australian Guild of Realist Artists, VAS and Sherbrooke Art Society where she is a regular exhibitor. One-woman show at Swan Hill 1983; North Balwyn 1984.
Awards Sherbrooke Art Society Black and White Award 1982; Jack Montgomery Award 1983; Kyabram Rotary 1984; Melb. Royal Ag. Show 1984.
Represented Private collections in UK, USA and Australia.

PROCIV, Patricia NSW
Born Sydney 1947. Printmaker.
Studies Meadowbank TAFE 1981–84; Sydney TAFE 1983–84; BA Visual Arts, Nepean CAE 1985–87.
Exhibitions First Draft, Sydney 1988; ESTC, Cell Block 1988; The Centre Gallery, Qld 1988; 70 Arden St, Melb.
Commissions PCA 100 x 100 Print Portfolio 1988.
Bibliography *PCA Directory* 1988.

PROPSTING, Ruth QLD
Born Qld 1951. Painter, printmaker.
Studies Qld C of A 1974–76; Gippsland IAE 1985; Uni. of Tas. 1986–87.
Exhibitions Solo shows at IMA, Brisbane 1984; Gippsland IAE 1985; Uni. of Tas. 1987; Bellas Gallery, Brisbane 1987, 88. Group shows include IMA, Brisbane 1983, 84, 86; Chameleon Gallery, Hobart 1987, 88; Uni. of Tas., Hobart 1988.
Bibliography *PCA Directory* 1988.

PROWSE, Anne Louise VIC
Born Cootamundra NSW 1953. Realist painter in egg tempera and coloured pencils.
Studies RMIT 1973–74; Vic College of the Arts, Graduate Diploma and Postgraduate Diploma (painting) 1976–79. Part-time lecturer, Canberra S of A and botanical illustrator, Nat. Botanical Gardens, Canberra 1980.
Exhibitions Solo shows at Gallery Huntly, Canberra 1983; Tynte Gallery, Adelaide 1985; Group shows include *Australian Student Printmakers*, Gryphon Gallery, Melbourne, Vic (toured overseas) 1975; *Six Young Artists*, SA School of Art, Adelaide SA 1976; Postgraduate Exhibition, Vic College of the Arts Gallery, Melbourne Vic 1979; 17th Biennial Piedmont Grahpics Exhibition, Greenville County Museum of Art, Greenville, South Carolina USA 1981; The Andrew and Lillian Pedersen Memorial Prize for Drawing Exhibition, Qld Art Gallery, Qld 1982; Gallery Huntly, Canberra 1985, 87; Lyttleton Gallery, Castlemaine, Vic 1984; First Aust. Contemporary Art Fair, Melb. 1988; Grafton Reg. Gallery 1988.
Awards Visual Arts Board Grant 1983, 85.
Represented Vic College of the Arts, Melbourne Vic; Artbank; Gallery Huntly, Canberra ACT; Mitchell College of Advanced Education, Bathurst NSW; Private collections in Australia, USA and Sweden.

PROWSE, Heather VIC
Born NSW 1942. Printmaker.

Studies RMIT 1976–77; MA prelim. La Trobe Uni. 1980; Dip. Ed. Hawthorn Institute 1983.
Exhibitions PCA Melb. 1981.
Bibliography *PCA Directory* 1988.

PUGH, Betty QLD
Born Nairobi, East Africa 1916. Painter.
Studies Brisbane TC under Roy Churcher 1968–71; Overseas study 1972; Brisbane
University Vacation Schools under John Olsen.
Exhibitions Solo shows include Design Art Centre, Brisbane 1978; Milburn Galleries
1982; Martin Gallery, Townsville 1984; Fairhill Gallery, Yandina 1985, 86; Holdsworth
Galleries, Sydney 1987; La Plage Gallery, Noosa 1987, 89; The Galaxy Gallery, Balmain
1987, 88; Noosa Regional Gallery 1988; The Centre Gallery, Gold Coast 1988; Blue Marble
Gallery, Buderim 1991.
Represented Institutional and private collections in Australia and overseas.

PULTARA, Kitty NT
Born c. 1924. Aboriginal painter and female artist of the highest profile from the Napperby
Station group in Central Australia.
Exhibitions USA, Sydney, Melb. Brisbane, Adelaide.

PULTARA, Lisa NT
Born c. 1959. Aboriginal painter renowned for meticulous dot paintings from the Napperby
Station group in Central Australia.
Exhibitions USA, Sydney, Melbourne, Adelaide, Brisbane.
Represented ANG; New Parliament House, Canberra; Ramada Hotel Mural, Sydney.

PULTARA, Mary NT
Born c. 1960. Aboriginal painter from the Napperby Station group of Central Australia.
Exhibitions Alice Springs, Melbourne, Adelaide, Brisbane.

PURDY, Susan Leigh VIC
Born Victoria 1957. Painter, photographer, teacher.
Studies B.Ed. from SCV, Rusden Campus 1974–78. Currently lecturer in photography,
School of Visual Arts, Monash University College, Gippsland.
Exhibitions Visability Gallery, Melbourne 1984; LaTrobe Regional Commission, Vic.
1988. Many group shows since 1977 and latterly at ROAR Studios 1987; Latrobe Valley
Arts Centre 1987, 88; Albury Regional Gallery 1988; 70 Arden Street, Gallery 1989.
Bibliography *150 Women Artists*, Visual Art Board/WAM 1988.

PURVIS, Marion NSW
Born Sydney 1932. Figurative painter, printmaker.
Studies Dattilo Rubbo School; Willoughby Workshop Arts Centre; Hornsby TC; Ku-ring-
gai Art Centre, UK, Europe, Japan, USA, PNG. Member, RASNSW, Peninsula and Ku-
ring-gai Art Societies.
Exhibitions Holdsworth Galleries, Sydney 1987, 88, 89; Group shows Wagner Gallery
1969–80.
Awards Numerous prizes in last ten years and recently The Print Award, Sydney Royal
Easter Show 1988, 89.
Bibliography *Directory of Australian Printmakers* 1982, 88; *Artists & Galleries of Australia*,
Max Germaine: Craftsman House 1990.

PWERLE, Lucy NT
Alyawarre Aboriginal batik painter from the Utopia area of the NT.

Exhibitions Lauraine Diggins Fine Art, Melb. 1989.

PYKE, Guelda VIC
Born Melbourne Vic. 1905. Painter, mostly collage.
Studies Commercial art at Swinburne Technical College; Worked with clay at Doubledays School, London; Studied with George Bell and Mary Cecil Allen 1945–50; Worked with Balinese artists in 1939 and again after the 1939–45 war, and travelled through Greece, India, Pakistan, Persia in the 1960s.
Exhibitions One-woman show at Leveson Street Gallery, Melbourne 1963.
Represented Australian National Gallery; National Gallery of Vic and private collections in Australia, London and Denmark.
Bibliography *Alice 125*, Gryphon Gallery: University of Melbourne 1990.
Represented Institutional and private collections in NSW and Qld.
Represented Institutional and private collections in NSW and Qld.

Q

QUAIFE, Lin NSW
Born Melb. 1938. Painter and printmaker.
Studies Uni. of New England Tech. College 1973–78; UNE Summer Schools 1974, 82.
Exhibitions Solo shows at Parmenter Gallery, Walcha NSW 1982, 85; Earle Page College, University of New England 1986; University of New England Union Gallery 1990. Participated at Umberumberka Gallery, Armidale 1979, 81, 82; PCA Travelling Show 1984; The Gallery Image, Armidale 1985.
Awards Rusden Miniature 1979, 80.
Represented Institutional and private collections UK, Europe, USA, Canada, Australia.

QUAILL, Avril NSW
Born Aust. Painter, illustrator, curator, arts administrator.
Studies BA Visual Arts, SCOTA 1985; Foundation member of Boomalli Aboriginal Artists Co-op since 1987; Studied UK, Europe and Asia 1989.
Exhibitions Solo show at Boomalli Co-op. 1990; Group shows include Experimental Art Foundation, Adelaide 1984; Artspace, Sydney 1984; Boomalli Co-op. 1987, 88; Performance Space 1987; Tin Sheds Gallery 1988; ANG 1989; Coo-ee Gallery 1989.
Awards Aboriginal Arts Board 1986.
Represented Institutional and private collections.

QUELHURST, Betty QLD
Born Laidley Qld 1919. Painter and teacher.
Studies Central Technical School, Brisbane; National Gallery School, Melbourne and in London and Paris; Art teacher with Qld Dept of Education.
Awards Qld Wattle League Scholarship 1950; Redcliffe Landscape Prize 1957.
Represented Institutional and private collections in Australia and overseas.
Bibliography *Australian Watercolour Painters 1780–1980*, Jean Campbell, Rigby 1982.

QUINN, Loretta VIC
Born Hobart 1956. Collage arrangements, puppeteer, teacher.
Studies Tas. CAE, Hobart 1976–79; VCA, Melb. 1982–83, Postgraduate. Involved widely as a puppeteer in Tas, Vic, NSW and SA 1977–83; Taught Preston TC, Melb. 1981.

Exhibitions Solo shows at Anthill Theatre, Melb. 1981; Roslyn Oxley9 Gallery Sydney 1982; Christine Abrahams, Melb. 1983; Performance Space, Sydney 1985; Pinacotheca, Melb. 1985; Caulfield Arts Centre 1982–86. Numerous group shows since 1980 include First Australian Sculpture Triennial, Melb. 1981 and the second in 1984; Ninth Mildura Sculpture Triennial 1985; S of A Hobart 1985. Her work was included in *A New Generation 1983–88* at the ANG, Canberra 1988, and with The Art Gallery at the Australian Contemporary Art Fair Melb. 1988.

Represented ANG, Canberra, institutional and private collections in Australia and overseas.

Bibliography *Artists & Galleries of Australia*, Max Germaine: Craftsman House 1990.

QUINN, Patricia Wade NSW
Born Manly NSW 1930. Calligrapher, Chinese Brush Painter, sculptor.
Studies Julian Ashton School, Sydney. Nanyang Academy of Fine Arts, Singapore 1974–78. Studied sculpture with Ng Eng Teng. Foundation Member, Australian Chinese Painting Society, Sydney; Director, Workshop Art Centre.
Exhibitions Solo show at Raffles Hotel 1981; Participated in many shows including Singapore Museum of Art and joint show with daughter Bronwen van Leeuwen at Balmain Watch House 1986.
Represented Institutional and private collections in Singapore, Malaya and Australia.

QUINTAL, Lynn VIC
Born Norfolk Island 1952. Painter.
Studies PIT, Melb. 1976–79; Postgraduate 1980.
Exhibitions Solo shows at Reconnaissance Gallery 1982; United Artists 1984; 312 Lennox St 1988. Numerous group shows since 1980.
Represented ANG, Canberra, municipal and private collections.

QUIRK, Bonnie NSW
Born Sydney NSW 1932. Painter and printmaker.
Studies Polytechnic School of Design, Wellington NZ.
Exhibitions One-woman shows at Stuart Gerstman Galleries, Melbourne 1980; Paton Gallery, University of Melbourne 1980; La Trobe Valley Art Centre 1980; Numerous solo and group shows in NZ 1968–80.
Bibliography *Prints and Printmakers in NZ*, Collins, Auckland 1974.

R

RACKHAM, Melinda NSW
Born Sydney 1959. Sculptor, designer, art administrator.
Studies BA (Visual Arts) University of NSW Faculty of Fine Arts, (City Art Institute) 1986–89; Associated with the organisation of The Works Gallery 1987 and Arthaus Gallery 1988.
Exhibitions Solo show at Tamworth Regional Gallery 1991; Group shows include Arthaus 1985, 87, 88, 89; Ivan Dougherty Gallery 1990; NT Centre for Contemporary Art 1990; Art Dock, New Caledonia 1990; Performance Space, Sydney 1991.
Awards CAI, Sculpture 1989; CAI Alumni Award 1990.
Represented Tamworth City Gallery; Artbank; Institutional and private collections.

RADOK, Stephanie ACT
Born Melb. 1954. Printmaker.
Studies Canberra S of A 1981.
Exhibitions Bitumen River Gallery, ACT 1983; Warrnambool Reg. Gallery 1984.
Represented ANG, Warrnambool Reg. Gallery, private collections.
Bibliography *PCA Directory* 1988.

RAE, Judy NSW
Born Sydney 1955. Painter.
Studies Diploma in Life Drawing and Painting, Julian Ashton Art School 1969–75; BA University of Sydney (Fine Arts major) 1976–80; Graduate Diploma in Professional Art Studies, City Art Institute 1984; Presently completing MA (Visual), City Art Institute 1987.
Exhibitions Painters Gallery, Sydney 1987, 88; Bathurst Reg. Gallery 1983, 86; Ivan Dougherty Graduate show 1984.
Represented Institutional and private collections around Australia.

RAFT, Philippa NSW
Born Sydney NSW 1936. Weaver.
Studies With Desiderius Orban and two years at East Sydney Technical College 1957; Studied stage and set design at Brera Academy of Art, Milan Italy under Professor Varisco 1969; Started making soft dolls in Sydney 1960; Studied weaving in UK through Birmingham College of the Arts 1967–69; Taught weaving at Arts Council of Australia spring school at East Sydney Technical College 1970; Taught weaving Woollahra Arts Centre 1971; Taught at Randwick Technical College and went on three-month overseas study tour 1972 and again in 1979.
Exhibitions One-woman shows at Bonython Gallery, Sydney 1971, 1975 and Adelaide 1978; Art of Man Gallery, Sydney 1978; Also showed at Ewing Gallery, Melbourne University 1974.
Awards Crafts Board Grants 1974, 1977.
Represented Large wall-hanging at Colonial Mutual Life Building, Martin Place, Sydney.

RAMSAY, Mary NSW
Born Quirindi NSW. Painter and printmaker.
Studies Workshop Arts Centre 1967–69 and with Sue Buckley 1972–75.
Exhibitions Regularly with The Print Circle, Sydney and in NSW competitions.
Awards Boggabri Print Prize 1975.

RANKINE, Pie VIC
Born Adelaide 1960. Painter.
Studies Flinders Uni. SA 1977; VCA, Melb. 1979–81.
Exhibitions Solo shows at United Artists 1985; City Gallery 1988. Participated Uni. of Tas. 1984; *A New Generation 1983–88*, ANG, Canberra 1988; Realities Gallery 1985; Ben Grady Gallery, Canberra 1986, 87; Moët & Chandon Touring Exhibition 1988, 89; CAS, Adelaide 1988.
Represented NGV, St Kilda Municipal Council Melb. and private collections.

RANKINE, Susan VIC
Born Adelaide 1953. Painter.
Studies Torrens CAE 1972–75; VCA, Melb. 1980–81.
Exhibitions Solo shows at Realities, Melb. 1986, 88; Roslyn Oxley9, Sydney 1983; Gippsland IAE 1985; Participated *A New Generation 1983–88*, ANG, Canberra 1988; Biennale of Sydney 1982; *Australian Perspecta* 1983; Realities Gallery, Melbourne 1983.

Represented Institutional and private collections in Australia and overseas.
Bibliography *Catalogue of Sydney Biennale* 1982 and *Australian Perspecta* 1983, Art Gallery of NSW.

RANSOME, Joanna VIC
Born London UK. Painter, teacher, writer.
Studies BA Fine Art Chisholm IT 1983; Grad. Dip. Art Education, Victoria College, Toorak 1980; Postgrad. (part-time) Chelsea School of Art, London UK 1981–82. Lecturer in painting, Ballarat CAE 1985 and at RMIT 1987 and at Homesglen CAE 1988 Arts writer and reviewer for radio and various publications 1984–87, 89–90.
Exhibitions Solo shows at Victoria College, Toorak 1980; ROAR Studios 1984; Alliance Francaise Gallery 1989; Capricorn Galleries 1991. Numerous group shows since 1979 include Hawthorn City Gallery 1979, 83; Chisholm Institute 1977, 78, 79, 89; VAS 1983; ROAR Studios 1983, 86, 88, 89; Rhumbarallas 1984, 85; Ballarat CAE 1985; Il Punto Gallery 1985, 86, 87; Libby Edwards Gallery 1989; Blaxland Gallery 1990.
Awards Caltex Award 1980.
Represented Artbank, institutional and private collections in Australia and UK.

RASEY, Jean QLD
Born Brisbane Qld. Semi-abstract painter in oil and acrylic of landscapes, still-life and portraits.
Studies Under Wilson Cooper, Roy Churcher, John Rigby, Caroline Barker.
Exhibitions Franz Beak Gow Gallery 1969; Garowrie and Linton Galleries 1975; Para Gallery 1977; Linton Gallery 1978.
Awards Caltex Warana Prize Traditional 1974; Brisbane Women's Club Exhibition.
Represented Widely in private collections in Qld.

RASFAS, Val (Connor) VIC
Born Lismore Vic 1948. Painter, printmaker and teacher.
Studies Diploma of Fine Art (painting and printmaking) from Gordon Institute of Technology, Geelong. Exhibited in Print Council shows 1975, 1978.
Represented Private collections in Vic, SA and overseas.

RASPOVIC, Joy VIC
Born Melbourne Vic. Painter.
Studies Vic College, Burwood Campus, Vic.
Exhibitions One-woman shows at Russell Davis Gallery, Melbourne 1980, 1982.

RATNAM-KEESE, Enid NSW
Born Penang Malaysia 1939. Sculptor, printmaker and teacher.
Studies Associate Diploma in Fine Art (sculpture) RMIT 1970–74; BA, Uni. of New England 1981–83; Taught printmaking Nepean CAE, presently teaching part-time at Penrith TAFE.
Exhibitions Wagner Gallery 1984, 85, 87; BMG, Sydney 1989; Numerous group shows include MPAC 1987, 88, also Korea and Sweden.
Awards Bowral Rotary 1988; Mosman Print and Drawing 1988.
Represented Institutional and private collections in Korea, Germany, Sweden and Australia.
Bibliography *Directory of Australian Printmakers* 1982, 88.

RAU, Jennifer VIC
Born Vic. Painter.
Studies Bachelor of Arts University of Melbourne; Studied part-time with George Bell;

Presently studying for Master of Educational Studies at Monash University.
Exhibitions Mornington Gallery 1981 and McClelland Gallery *Twenty Peninsula Painters* 1982.

RAY, Maitreyi SA
Born Calcutta, India 1954. Painter.
Studies Fine arts at University of Melbourne 1972–75.
Exhibitions BMG Fine Art, Adelaide 1991; Numerous group shows since 1972 include Calcutta, New Delhi; Dacca; Melbourne and Sydney.
Represented Institutional and private collections in India, USA, UK, Europe and Australia.

RAYMOND, Margaret QLD
Born Stirling SA 1922. Painter and teacher.
Studies SA School of Arts 1936–39; Moved to Qld 1945 and studied under John Rigby, Caroline Barker and Madge Staunten. Art librarian RQAS 1958–73, committee member to 1983; Council member 1958–73. Art teacher at Nudgee Junior College 1971–81. Exhibits in group shows and with RQAS.
Represented Private collections in Australia and overseas.

RAYNER, Ingrid NSW
Born WA. Semi-abstractionist painter in all media, teacher.
Studies Under J.W.R. Linton in Perth. ESTC under Fred Leist. Taught at Perth TC. Numerous overseas study tours. Member AWI.
Exhibitions Solo show at 'Q' Gallery, Hunters Hill NSW 1985 and regularly at Delmar Weekend Gallery.

RAYNER, Raewyn Turner VIC
Born NZ 1953. Painter, stage set designer, muralist.
Studies Dip. Fine Arts, Elam School, Uni. of Auckland. Studied UK, USA, Canada, Europe 1975–83, 87.
Exhibitions Denis Cohn Gallery, Auckland 1980, 82; Niagara Galleries, Melb. 1987; Participated ROAR Studios, Melb. 1986, 87, 88; The Centre Gallery, Gold Coast, Qld 1988; Reconnaissance, Melb. 1988; Eltham Art Awards 1989; The Tin Sheds 1990.
Awards Nat. Bank NZ 1971, 78; Auckland S of A, Portrait 1973; QE II Grant 1972.
Represented Institutional and private collections in UK, Europe, USA, Canada, Australia.

RAYS, Lenore NSW
Born Bangalow NSW 1917. Painter, designer and teacher.
Studies Royal Art Society and Datillo Rubbo's classes in the 1930s; Fashion artist at Farmers Dept Store, Sydney 1935–39. Married to sculptor Tom Bass 1941–75; Retrained at Liverpool Technical 1978–79; Taught art at Frencham School, Mittagong, NSW 1981 and at Yean House, Bowral for Adult Education 1986.
Exhibitions One-woman shows at the Painters Gallery, Sydney 1981; Casey Gallery, Sydney 1987; Numerous group shows including Gallery Huntly, ACT 1983, 87; First Aust. Contemporary Art Fair, Melb. 1988 and May Barrie, Albion Park NSW; Graham Gallery, Wollongong; Little Gallery, Toorak, Vic; Beth Hamilton, Sydney; Paper Place, Bowral.
Commissions Has designed works which are included at Civic Square, Canberra; Catholic Church, Warren NSW; St Augustine Church, Yass; P & O Building, Sydney; Church of Assumption, Charleville Qld and completed a painting of the Unilever Complex at Balmain NSW; MTIA Paintings, Sydney 1985; Flower paintings for PRE and Varro Ville Homestead 1985.
Represented Artbank and institutional collections in Australia and overseas.

READ, Helen a'Beckett VIC
Born Sandringham Vic 1903. Traditional painter in oil, and only daughter of the 'first of the Boyds', Arthur Boyd and E.M. a'Beckett Boyd; Her brothers, all deceased, were Merric (noted potter, sculptor and painter), Martin, one of Australia's well-known novelists and Penleigh, a brilliant painter and etcher.
Exhibitions Has had many over the years and in recent times shows at the Anvil Art Gallery near Wodonga Vic.
Represented Many private collections in Australia and overseas.

REANEY, Ann-Maree NSW
Born Maryborough Qld. 1959. Sculptor and teacher.
Studies Dip. Visual Arts, DDIAE 1979–81; M. Fine Arts, University of Tasmania 1983–85; Dip. Ed. University of Tasmania 1987; Currently enrolled in M. Ed. course; Has lectured and taught art since 1985, and at Fahan School, Hobart 1989–90.
Exhibitions Solo shows at University of Tas. 1985; CAS, Brisbane 1986; Bunbury Regional Art Gallery, WA 1987; Roz MacAllan Gallery, Brisbane 1990. Many group shows since 1981 and recently at Chameleon Gallery, Hobart 1988; Paris Studio 1988; QCC 1990; Downlands, Toowoomba 1990; Gold Coast Arts Centre, Qld. 1990.
Awards Cth. Scholarship 1985; VAB Grant 1986; Grant to Cité Internationale des Artes Studio, Paris 1988; TAAB Grant 1988, 90; VA/CB Grant 1990.
Represented Institutional and private collections in Australia and Europe.

REDGATE, Jacky NSW
Born London UK 1955. Photographer, video artist, arrived Aust. 1967.
Exhibitions Solo show at Images Gallery, Sydney 1983. Participated in many shows since 1984 including ANG, Canberra 1985; Perspecta 1985 and The Bicentennial Perspecta 1988, AGNSW; Aust. Centre of Photography, Sydney 1986; *The Biennale of Sydney*, AGNSW 1986; *Apparitions*, travelling show to Europe 1986–87; Tokyo 1987, and *Edge to Edge*, Japan tour 1988. Elsewhere, ICI Gallery, London UK 1988; The Australian Biennale, AGNSW 1988; Mori Gallery 1990.
Represented Institutional and private collections in UK, Europe, Japan, Australia.
Bibliography *Artists & Galleries of Australia*, Max Germaine: Craftsman House 1990.

REDMAN, Joy SA
Born Adelaide SA 1928. Traditional painter in oil and acrylic; Printmaker.
Studies SA School of Art; Fellow of the Royal SA Society of Artists; Member CAS and councillor; Life member of Art Society for the Handicapped where she was voluntarily in charge of painting for ten years; Works as art therapist for Western Regional Rehabilitation Service one day a week, otherwise paints full-time in her workshop.
Exhibitions One-woman shows at Lombard Street Gallery 1977; Adelaide Fine Arts 1978; Gillians Gallery 1983; Greenhill Galleries 1986. Participated RSASA shows including SA Printmakers 1982; CAS shows including travelling micro show and Landscape 1980; Microworks, Savings Bank of SA 1981; Mini Print Show, Korea 1982, 86; Cadaques, Spain 1985–86; Taller Galeria Fort 1987.
Awards Kiwanis Printmaking and Painting 1974, 1975, 1976, 1977.
Represented School and private collections in Australia and overseas.
Bibliography *PCA Directory* 1988.

REDMAN, Suzanne SA
Born Adelaide 1962. Painter.
Studies SASA, Adelaide 1979–81, 86.
Exhibitions Solo show at Lenin's Cafe, Adelaide 1988. Her work was included in *A New Generation 1983–88* at ANG, Canberra 1988.

REDPATH, Norma VIC

Born Melbourne Vic 1928. Sculptor and teacher.

Studies Swinburne and Melbourne Technical Colleges; University of Perugia Italy; Awarded a special scholarship by the Italian Government to study in a bronze casting foundry in Milan in 1962; Former Council member and vice-president of the Vic Sculptors Society; Creative Arts Fellow, ANU 1972.

Exhibitions Regularly with the Vic Sculptors Society in the 1950s and has shown with Rudy Komon, Sydney 1970.

Awards OBE for services to the arts 1970; Transfield Prize 1966; Mildara Prize 1961, 1964.

Commissions Some important ones include mural carving at Baillieu Library, University of Melbourne; Bronze relief, BP building Melbourne; Treasury fountain, Canberra; Vic State Coat of Arms; Facade at Vic Arts Centre, Melbourne; Sculpture column, Reserve Bank of Australia, Brisbane; Professor Rubbo Memorial, University of Melbourne.

Represented National Gallery, Canberra; State Galleries of Vic and WA; Many institutional and private collections in Australia and overseas.

Bibliography *Art and Australia*, Lenton Parr, Vol 6/3; *The Arts in Australia: Sculpture*, Longmans, Melbourne 1961; *Norma Redpath*, Gallery A, Grayflower Publications, Melbourne 1963; *Encyclopedia of Australian Art*, McCulloch, Hutchinson 1977; *Notable Australians*, Prestige Press 1978; *Australian Sculptors*, Ken Scarlett, Nelson 1980.

REES, Linda NSW

Born Bristol UK 1942, arrived Australia 1960. Painter and designer.

Studies Commercial art for some years in Swansea UK and worked as a fashion designer in the retail trade both in UK and Australia. Joined the Australian Watercolour Institute to gain experience with watercolour techniques; Living in Japan 1980–84.

Exhibitions Genkan Gallery, Tokyo 1984; Morpeth Gallery 1987; von Bertouch Galleries, Newcastle 1989. Exhibiting member of AWI.

Awards Raymond Terrace 1979; Wyong 1980. Her work has been seen in a number of group shows in NSW.

REES-HARRISON, Wendy VIC

Born Ballarat, Vic. Painter and printmaker, niece of the late Lloyd Rees.

Studies Caulfield TC and at the NGV; Overseas study in UK, Europe, China.

Exhibitions Latest solo show at Five Ways Galleries, Vic. 1989.

Awards Royal Overseas League Omega Prize 1989.

REEVES, Kate VIC

Born Melb. 1957. Printmaker.

Studies BA, Hons. Uni. of Melb. 1975–78; BA Fine Art, PIT 1980–83; Grad. Dip VCA 1986–87; UK, Europe study 1986–87.

Exhibitions Westpac Gallery 1986; RMIT 1986; VCA 1987; Ararat Reg. Gallery 1988; Stuart Gerstman 1988.

Awards Christine Abrahams Prize 1986; VCA Printmaking 1989.

Bibliography *PCA Directory* 1988.

REID, Virginia NSW

Born Aust. 1963. Painter, printmaker.

Studies BA Visual Arts, City Art Institute 1981–84; Grad. Dip. Prof. Art Studies, Canberra S of A 1985; Worked in Paris 1987; Studio in New York 1986–88.

Exhibitions Canberra S of A 1985; Blaxland Galleries 1986; Travelling printmakers show to USA; Rudkers Museum, New Jersey 1988; Blanco y Negro en Colores, New York 1988.

Represented Institutional and private collections in USA, UK, Europe, Australia.

REISBERG, Leonie NSW

Born Australia. Photographer, painter and teacher.

Studies Photography at RMIT 1972–73; Prahran Technical College, Photography Dept 1974–75; Taught part-time at St John's College, Melbourne 1976; MFA School of the Art Institute of Chicago, Illinois USA 1977–78; Full-time lecturer in photography at Torrens College of Art and Education, Adelaide 1979; Travelled overseas throughout England and Scotland 1980; Taught part-time at Torrens CAE, SA 1981; Taught part-time at Newcastle CAE, NSW and Australian Centre for Photography Workshop, Sydney 1982.

Exhibitions One-woman shows at Metaform Gallery, Adelaide 1979; Polaroid Gallery, Sydney 1980; Australian Centre for Photography, Sydney 1980; The Developed Image Gallery, Adelaide 1981; Participated in numerous group shows including Chicago USA 1977; Art Gallery of NSW 1981; VAB Travelling Show 1981; Art Gallery of SA 1981; RSASA 1982.

Represented State Galleries in SA and NSW; Polaroid USA Collection; VAB and Philip Morris Collections.

REISSAR, Tiiu NSW

Born Viljandi Estonia 1936. Printmaker and teacher.

Studies Canterbury University School of Arts, UK 1955–57; Royal Academy School, London 1965–67; Presently Head of School of Art, Seaforth Technical College; Presently Head at Liverpool College of TAFE Art School.

Exhibitions Solo shows, Stockholm Sweden 1967; Sydney 1969, 1974; Included in Print Council of Australia Print Prize Exhibition 1968 at Australian Galleries 1968–69 and Singapore 1969; International Triennale of Xylography, Carpi Italy 1969–72; Sydney Printmakers 1990.

Represented ANG, Private collections in UK, Europe and Australia.

Bibliography *Directory of Australian Printmakers* 1982, 88; *Artists & Galleries of Australia*, Max Germaine: Craftsman House 1990.

RESCHKE, Maureen Joy SA

Born Mannum SA 1933. Traditional painter.

Studies Girls Central Art School, Adelaide and later under David Dridan; Numerous one-woman shows, including *Off the Beaten Track* 1970 at The Gallery, Clarendon SA; Kew Gallery and Greythorn Galleries, Melbourne.

Awards Second Prize *The News* Bicentennial Art Competition 1970; First Prize special award Camberwell Rotary Exhibition 1972 judged by Sir William Dargie.

Bibliography *Australian Artists Today*, Gallery Press, Melbourne 1974.

REW, Wendy VIC

Born Masterton NZ 1955. Photographer.

Studies BA University of Sydney Faculty of Arts/Law 1977. Dip. Art & Design Prahran CAE 1982.

Exhibitions La Trobe University, Vic. 1981; ACP, Sydney 1982; ROAR Studios, Melbourne 1982; Visability Gallery, Melbourne 1985.

Bibliography *150 Victorian Women Artists*, Visual Arts Board/WAM 1988.

RHODES, Karen VIC

Born Melb. 1963. Paintings, prints, collage.

Studies BA Fine Art, RMIT 1981–83; Dip. Ed. Hawthorn IE 1987.

Exhibitions Solo show at Niagara Galleries 1986, 88; Participated RMIT 1984; Linden 1985; Niagara 1986, 88; ROAR Studios 1987; First Australian Contemporary Art Fair, Melb. 1988.

Bibliography *PCA Directory* 1988.

RICHARDS, Else WA
Born Copenhagen Denmark 1933. Weaver and teacher.
Studies Kunsthaandaerker Skolen (Art and Craft School), Copenhagen; Teaches at summer
schools, Fremantle Arts Centre and privately.
Exhibitions Craft Association of WA 1975; Festival of Perth.
Awards Grant for weaving exhibition 1974.
Commissions Include two large wall hangings, designed by Leonard French for restaurant
and hotel in Melbourne.

RICHARDS, Rae NSW
Born Melbourne Vic. Painter, tapestries and wall hangings.
Studies National Art School, painting and design; Study tour to Europe 1968. Graduate
Diploma, Professional Art Studies, Alexander Mackie CAE, Sydney 1981.
Exhibitions Little Gallery, Sydney 1965; von Bertouch Galleries 1966, 1967, 1973, 1980,
90; Macquarie Galleries 1968, 1972; John Gild Gallery, Perth 1969; Qantas Gallery,
London 1974; Armstrong Gallery, Morpheth 1981.
Awards May Day Prize 1960; Maitland 1961, 1969.
Represented Newcastle Region Art Gallery; Maitland Art Gallery; University of
Newcastle; NSW Department of Education; Australian Mutual Providence Society; Private
collections in Australia, USA, GB and Eire; Christchurch Cathedral; Newcastle Reserve
Bank, Sydney.

RICHARDSON, Ada Cecilia QLD
Born Brisbane Qld. Abstract and figurative painter in oil and acrylic. Married to water-
colourist Charles Ludlow.
Studies Brisbane Art School 1963–65 and with various tutors. Member of Half Dozen
Group and vice-president of RQAS.
Exhibitions One-woman shows at RQAS 1981; Group shows at McInnes Gallery and
Design Arts Centre.
Awards Redcliffe and Brookfield.
Represented Private collections in Australia and overseas.

RICHARDSON, Agnes (Barker) QLD
Born Melbourne Vic 1907. Painter, sculptor, ceramic artist and teacher.
Studies Sculpture and ceramics under L.J. Harvey; Oil painting under Caroline Barker;
Oriental brush painting with Ming Freedman; Pewter modelling and various craft works in
London; Life member of RQAS where she has been a regular exhibitor over the years;
Demonstrated arts and crafts on Channel 7 weekly television show for twelve months.
Represented Qld Art Gallery for Ceramics; Landscape in the National Museum of History,
Taiwan. Private collections in Australia, USA, Canada, Japan, England and Germany.

RICHARDSON, Berris NSW
Born Sydney NSW 1945. Printmaker and teacher.
Studies National Art School, Sydney 1963–66; The Institute Allende, Mexico 1973–75;
The Tamarind Institute, New Mexico 1979–80; Lecturer in lithography at Alexander
Mackie CAE 1975–79; Instructor in screen printing, University of NSW 1976–79.
Exhibitions Solo shows in Sydney 1979 and has participated in print shows including
Mexico 1974–75; Sydney Printmakers 1977, 1981; PCA Australia and Japan 1977, 1978;
Denver Colorado 1981, 82; New Mexico 1981; Hogarth Galleries, Sydney 1979; Blaxland
Galleries 1981.
Represented San Francisco Art Institute; Private collections in Australia, USA and Mexico.
Bibliography *Directory of Australian Printmakers* 1982, 88.
(Died 1989)

RICHARDSON, Freda QLD

Born Hawthorn Vic. Painter in pastel.
Studies Swinburne Technical College, Melbourne; National Gallery Art School and sculpture at RMIT; Member of Half Dozen Group and RQAS where she is a regular exhibitor.
Represented Private collections around Australia.

RICHARDSON, Penelope NSW

Born Sydney 1964. Painter of environmental subjects in oil.
Exhibitions Solo show at Art Gallery 'X', Sydney 1988. Has participated in many group shows including SCOTA Gallery 1987, 88; Tin Sheds Gallery 1988, 89; Moët & Chandon Touring Exhibition 1990.
Represented Artbank and private collections.

RICHENS, Jane QLD

Born Brisbane 1966. Laser copy artist, arts administrator.
Studies Qld C of A 1984–85.
Exhibitions CAC Brisbane 1986, 87; MCA, Brisbane 1987; Milburn + Arte 1988, 89; New York 1988; Centre Gallery, Gold Coast 1988.

RIESE, Tanja VIC

Born Melb. 1965. Printmaker, painter.
Studies BA Fine Arts, SCOTA 1984–87; Grad. Dip. Canberra S of A 1988.
Exhibitions W. Germany 1986; Vic. Print Workshop 1987; Oculos Gallery 1988; 70 Arden St 1988; Gallery X, Sydney 1989.
Commissions *PCA Directory* 1988.
Bibliography *PCA Directory* 1988.

RILEY, Jo NSW

Born Melb. Painter.
Studies Under Dora Jarrett, Justilius, John Ogburn, and Ross Davis 1960–82. Member, Willoughby Art Centre Workshop 1973–88. Travelled overseas 1975, 77, 80, 82, 83, 84, 86, 87.
Exhibitions Numerous solo shows since 1975 and recently at Access Gallery, Sydney 1986, 88. Many group shows.
Awards Lane Cove Purchase 1984; Lane Cove Award 1986, 87; Willoughby Workshop Bicentennial 1988.
Represented Artbank, Corporate and private collections in UK, Europe, Canada, SE Asia, Australia.

RIPPON, Lesley NSW

Born Sydney NSW 1936. Modern colour and realist painter, sculptor, teacher.
Studies Lyndon Art School, Epping NSW 1969–75, and privately with Malcolm Peryman and Fred Martin; Meadowbank Technical College 1980–81. Overseas study tours 1985, 86, 88, 89; Taught at Willandra Art Centre, Sydney 1981–86; Committee member and secretary, Ryde Municipal Art Society 1966–71. Exhibiting member RAS of NSW; Peninsula Art Society; Trinity Society of Artists.
Exhibitions Solo shows at Priory Court Gallery, Sydney 1985; RAS Lavender Bay Gallery 1989; Numerous group shows.
Awards Meadowbank Art Certificate 1979–80; Castle Hill 1985, 86, 87; Condobolin 1984; Port Macquarie 1986 and numerous others.
Represented Institutional and private collections in UK, Europe, USA, Canada and Australia.
Bibliography *Who's Who, Australia & SE Asia*, IBC, Cambridge UK 1990; *Who's Who,*

Women of the World, IBC, Cambridge UK 1991.

RITSON, Sarah VIC
Born Vic 1964. Printmaker.
Studies Prahran College 1984; BA Fine Arts, VCA 1985–87.
Exhibitions VCA 1987; Fremantle Arts Centre 1988; MPAC 1988; 70 Arden St 1988.
Bibliography *PCA Directory* 1988.

RIVER, Eleni NSW
Born Crete 1953. Watercolour painter and occasional performance artist.
Studies Diploma of Art, Claremont Art College, WA; Diploma of Art, Alexander Mackie
CAE; Postgraduate Diploma, City Art Institute, Sydney; Teaching watercolour painting at
Willoughby Arts Centre from 1981.
Exhibitions Numerous group shows around Australia; Organised the Bondi Pavilion
Women's Watercolour Show 1982; First one-woman show in 1982 in collaboration with
poet Dorothy Featherstone-Fortes; Work illustrated *Art and Australia*, Vol 20 No 4.
Represented Private collections around Australia.

ROBERTS, Carole NSW
Born Sydney 1958. Painter.
Studies ESTC 1979–80; SCOTA 1981–83.
Exhibitions Solo shows at Mori Gallery, Sydney 1984, 86, 87, 89, 91; Various Artists
Gallery 1987; Bellas Gallery, Brisbane 1987. Included in *A New Generation 1983–88* at
ANG, Canberra 1988.
Bibliography *Eyeline*, September 1988.

ROBERTS, Claire VIC
Born Melbourne Vic 1959. Traditional Chinese painting.
Studies 1978 Melbourne State College: Arts and Crafts Course (1st year); 1980–81 (2 yrs)
Studying Traditional Chinese painting, Central Academy of Fine arts, Peking.
Exhibitions May 1982 Group Exhibition at AMP Building, Melbourne with members of
AACA; East & West Art, Melbourne 1983.

ROBERTS, Heidi NSW
Born Illinois USA 1959. Painter and portraitist, specialising in animal studies in pastel.
Studies Bachelor of Science (Applied Science) studied art with her parents, and part-time at
Julian Ashton School.
Exhibitions Annually with Roberts family shows at Armidale NSW 1976–83.
Represented Private collections in Australia and overseas.

ROBERTS, Joanne TAS
Born Melbourne Vic 1952. Painter, printmaker, teacher.
Studies Perth Technical College 1970–73; Hobart S of A 1974–76; Teaches with Tas. Ed.
Dept.
Exhibitions Devonport Gallery and Arts Centre, Tas. 1977, 78, 79, 81; Handmark Gallery
and Uni. of Tas. Hobart 1982.
Awards Burnie Awards 1978.
Represented Burnie and Devonport Regional Galleries and private collections.
Publications Illustrated limited edition book, *Last Rite and other Poems*, Faie Watson 1983.

ROBERTS, Judith ACT
Born Sydney NSW 1932. Painter of Australian landscapes and historic buildings in oil and
watercolour; Teacher.

Studies Graduated Bachelor of Arts, Sydney and studied art in USA.
Exhibitions Has had four one-woman shows and annually with the rest of the family at Armidale NSW before the recent move to Canberra.
Represented Widely around Australia and overseas.

ROBERTS, Lisa VIC
Born Norfolk Island 1949, arrived Australia 1954. Painter, sculptor, film-maker and teacher.
Studies National Gallery Art School, Vic under Lenton Parr 1970–72; Postgraduate studies in printmaking and film techniques 1974; Great granddaughter of Tom Roberts; Part-time teacher, Wesley College, Melbourne 1978.
Exhibitions One-woman shows at Ewing Gallery, University of Melbourne 1974; Mornington Print Gallery 1979; Ewing Gallery, Melbourne University with Ben Fenessy 1972; Two films, lithographs and drawings 1974, and solo show of three films projected simultaneously 1975; Participated in *Grid Show* (sculpture) and films at *Women's Show* 1975; Paintings at Joseph Brown Gallery, Melbourne 1976; Completed film *Still Lives* made on an Experimental Film and Television Fund Grant (reviewed in *Cinema Papers*, Issue 16, April–June 1978) 1977; Participated in *Map Show*, Ewing Gallery (paintings) 1978; La Mamma Theatre 1980; film *Still-Lifes*; Hawthorn City Art Gallery 1980; Heyday Gallery 1981; Performance piece with artist/choreographer Barbara Weiss 1983; Reflections Gallery, Melb. 1989.

ROBERTS, Tania NSW
Born Armidale NSW 1962. Traditional painter.
Studies Julian Ashton School, Sydney and with her parents.
Exhibitions Annually with Roberts family shows at Armidale NSW 1976–83.
Represented Private collections in Australia and overseas.

ROBERTS, Victoria NSW
Born New York USA 1957. Illustrator and cartoonist.
Studies National Art School, Sydney 1974–76.
Exhibitions Watercolours and cartoons at Stadia Graphics, Sydney 1978; Watercolours at Rex Irwin Gallery 1982; Group shows at Coventry Gallery 1977; Stadia Graphics, Black and White Art and Galeria San Miguel (Mexico) 1978; Black and White Art 1979, 1980; Geelong Regional Gallery 1980; Prouds Gallery, Sydney 1981; First cartoons published in the *National Times*; Cartoon strip, 'My Day' in the *Age* and weekly cartoon strip, 'My Sunday' in *National Review*.
Awards Grants from the Australia Film Commission to produce animated films, *Goodbye Sally Goldstein* and *Cycle*; Illustrated works include *The Maitland and Morpeth Quartet*, Nick Enright; *Town Tales*, Tony Lintermans; *The Uncensored Adams*, Phillip Adams; *My Sunday*, Victoria Roberts.

ROBERTS-GOODWIN, Lynne NSW
Born Sydney 1958. Painter, photographer, teacher.
Studies BA, University of Sydney 1972–75; Dip. Art/B. Visual Arts, Alexander Mackie CAE 1975–78; M. Fine Arts, Manchester Polytechnic, UK 1979–80; Assoc. Dip. Teaching, SCAE, Sydney 1986–87.
Exhibitions Solo shows in London, Manchester and Paris 1980–84; Image Gallery, Sydney 1984; Orange City Art Gallery 1985; Cité Internationale des Artes, Paris 1986; Camera Lucida, Sydney 1989; ROAR 2 Studios, Melbourne 1990. Has participated in many group shows in Australia and overseas since 1977.
Awards Basil and Muriel Hooper Travelling Art Scholarship 1976, 77, 78; Dyason Bequest 1978, 79, 80; VACB Travel Grant 1983; Moya Dyring Paris Studio, VACB 1983;

Australian Film Commission 1989.
Represented AGNSW; Artbank; Regional galleries; Public and institutional collections in UK, Europe, USA and Australia.

ROBERTSHAW, Freda NSW
Born NSW 1917. Landscape painter in oil and watercolour.
Studies East Sydney Technical College under Charles Meere.
Exhibitions Royal Art Society of NSW; NSW Society of Artists; Australian Watercolour Institute; S.H. Ervin Gallery, Sydney.
Represented Art Gallery of NSW; Tasmanian Art Gallery; Queensland Art Gallery; Private collections in Australia and overseas.
Bibliography *Society of Artists Yearbook, 1945–46*, Ure Smith, Sydney; *Aust. Financial Review* 14/4/88.

ROBERTSON, Christian Clare NT
Born Oxford UK 1946. Painter.
Studies Diploma of Fine Arts (painting), SA School of Art. Lectured on art NTU 1977–91; PIT 1976; CIT 1975; Presently Assistant Curator of Prints & Drawings, AGSA. Travelled to Antarctica in 1989 as guest of Australian Antarctic Division aboard ship 'Icebird'.
Exhibitions Solo shows at North Adelaide Galleries 1968; Llewellyn Galleries 1972; Toorak Gallery, Melbourne 1974; Macquarie Galleries, Canberra 1976; Sydney 1977, 1981; CAS Adelaide 1979; Darwin NT 1980; Moore Park Gallery, Armidale 1983; NTMAG 1985, 86, 89; Tynte Gallery, Adelaide 1987; Parliament House, Canberra 1991. Numerous group shows since 1970.
Awards Ronald Prize La Trobe Valley Art Centre 1971; Flotta Lauro Travelling Scholarship.
Represented Australian National Gallery; State Galleries in Qld and SA; Hamilton and La Trobe Valley Regional Galleries, State College, Frankston, Vic; Flinders University; Alice Springs Art Foundation.

ROBERTSON, Denise VIC
Realist painter, studied under Lance McNeill.
Exhibitions Solo shows at Willis Frames, Wagga 1981; Gilberton Gallery, Adelaide 1983; Old Brewery Gallery, Wagga 1984, 85.
Awards Cowra Caltex, Realist Artists, Melb. 1984. Commissioned to illustrate book *Historic Narrandera* 1986.

ROBERTSON, Toni NSW
Born Sydney 1953. Painter, printmaker, teacher.
Studies BA, Uni. of Sydney 1975; Tutor Macquarie and Sydney Uni's 1975–79; Honours in Fine Arts, Uni. of Sydney 1980; Artist-in-Residence, Experimental Art Foundation, Adelaide 1981; Lecturer Canberra S of A 1982–84; Panel Member VAB 1984.
Exhibitions A host of shows since 1975 and in recent times at Tas. School of Art Gallery 1982; Institute of Contemporary Art, London 1982; AGNSW 1982; Continuum '83, Japan 1983; Artspace, Sydney 1983; Uni. Art Museum, Qld 1983, 1986–87; ANG, Canberra 1983; Jam Factory, Adelaide and Praxis, Perth 1984; Orange NSW, Festival of Arts 1985; AGSA 1985; Arts Council Gallery, Canberra 1985; Lake Macquarie Gallery 1987; Watters Gallery, Sydney 1976, 77, 85.
Represented Artbank, AGNSW, AGSA, ANG, Institutional collections around Australia and overseas.

ROBERTSON, Yvonne Diana WA
Born Yorkshire England 1951. Painter, printmaker, teacher. Lived USA 1952–57, arrived

Aust. 1969.

Studies Graphics, Leeds Graphics Studio; Diploma Fine Arts, Claremont School of Art 1969–73; Lecturing in printmaking, painting and drawing part-time from 1974 CSA; Curtin University external studies 1988.

Exhibitions One-woman shows at Robin Phillips Gallery WA 1974; Claremont School of Art Gallery 1984; Perth Zoo inaugural exhibition 1986; New Collectables Gallery WA Mini Retrospective 1988. Participated in numerous group exhibitions including Undercroft Gallery University of WA 1976; Gallery 52 staff exhibition 1980; Fremantle Art Gallery staff exhibition 1981; Quentin Gallery staff exhibition 1983; CSA Gallery group exhibition 1985; Printmakers Association of WA 1985; CSA Monoprint exhibition 1986; Women Artists of WA, Perth College 1986–1988; Fremantle Arts Centre print award 1986, 87, 88; WA Art Gallery peace show 1986; Maritime Art exhibition of WA Contemporary Artists 1986; Allendale Square's main foyer 1986; Dempster Gallery Melbourne 1987; Access Gallery, Sydney 1988; Greenhill Gallery with Clifton Pugh 1988; Perth Gallery *Small is Beautiful* 1988; New Collectables Gallery Xmas Show 1988.

Awards Mt Barker WA painting prize 1972; University of WA painting prize 1976; WA Printmakers prize 1984 and 1986.

Represented Exploration House WA; Norseman Gold; Mallina Holdings; Claremont School of Art collection; Wembley Technical College and many private, corporate and institutional collections in Australia and overseas.

ROBINSON, Andrea VIC
Born Melb. 1955. Printmaker.
Studies Dip. Fine Art RMIT 1975–77; Postgrad. 1979; Dip. Ed. Melb. State College 1981.
Exhibitions Chrysalis Gallery, Melb. 1979; Print Biennial, Brazil 1985–86; Salvaldor, Sth America 1986; Printed Image, Melb. 1986; Art Expo, New York 1987.
Bibliography *PCA Directory* 1988.

ROBINSON, Conty QLD
Born Armidale NSW. Painter and printmaker.
Studies Central Technical College, Brisbane and with Tutors Rapotec, Warren and Churcher; Attended Summer School at Qld University for Screen Printing Course conducted by Alexander Butler 1973.
Exhibitions Solo show at Design Arts Centre, Brisbane 1976; Participated in numerous group shows at RQAS 1966–76 and recently at New York USA 1987 and the National Womens Art Award at The Centre Gallery, Gold Coast, Qld 1988; Sydney Printmakers 1990.
Awards RNA Landscape 1973; Westfield (graphics) 1973; Bribie Island Purchase 1983; Gatton Award 1984.
Represented Private collections in Australia, UK, South Africa, Australia and Ireland.
Bibliography *Directory of Australian Printmakers* 1989.

ROBINSON, Faith QLD
Born UK 1957. Sculptor, potter and teacher.
Studies Diploma in Applied Arts from Seven Hills College of Art 1977.
Exhibitions Sunshine Art Gallery, Qld and Lilian Pedersen Sculpture Exhibition.

ROBINSON, Kay QLD
Born Brisbane Qld 1943. Chinese brush painter and teacher.
Studies Nanyang Academy of Fine Arts, Singapore, graduated 1976 and two years postgraduate study of Chinese brush painting; Further study at Brisbane Art School 1982; Overseas tours to UK, Europe, SE Asia; Taught Chinese brush painting TAFE, Qld 1982–83.

Exhibitions Singapore 1974, 1975, 1976; Tower Mount Gallery and Gregory Terrace Gallery, Brisbane 1982.

Represented Nanyang Academy, Singapore and institutional and private collections in Indonesia, Singapore, UK, Europe and Australia.

ROBINSON, Sally NSW

Born UK 1952, arrived Australia 1960. Painter and printmaker using photographic techniques, including colour separation, posterisation and halftone reproductions.

Studies National Art School Sydney 1970–73; Part-time teaching at Alexander Mackie CAE 1976–78; Since 1974 artist/designer at Australian Museum, Sydney.

Exhibitions Solo shows at Bonython Gallery, Sydney 1976; Art Gallery of SA 1976; Robin Gibson Gallery, Sydney 1979, 1981, 1984, 1988; Ray Hughes Gallery, Brisbane 1979; Penrith Regional Gallery 1982; Anima Gallery, Adelaide 1987; Stuart Gerstman, Melb. 1989; Many important group shows since 1974 include Tokyo Japan 1979; Australian Printmakers, UK, USA 1979–84; Biennial of Graphic Art, Yugoslavia 1981; *Continuum* and *Serigraphy*, Ivan Dougherty Gallery, Sydney 1981; *Perspecta*, Art Gallery of NSW 1981; *Blue Mountains*, National Trust Gallery, Sydney 1982; *On the Beach*, Travelling Art Exhibition, Art Gallery of NSW 1982; *Women's Imprint*, Art Gallery of NSW 1982; *Australian Screenprints*, Australian State and Regional Art Galleries 1982–85; David Murray Print Gallery, Adelaide Festival of Arts 1984; AGSA 1984; ANG 1984; Warrnambool and Penrith Reg. Galleries 1985; QAG 1986; NTMAG 1986.

Awards Gosford 1972; PCA Member Print 1975; Tapestry design, Warrnambool performing Arts Centre 1982; Artbank Poster 1983.

Commissions Australia Post 1984; Beaufort Hotel, Darwin, Print 1985; AGNSW Print 1986.

Represented ANG; AGNSW; NGV; AGSA; QAG; QVMAG; Fremantle Art Gallery, Fremantle WA; Geelong Art Gallery, Vic; Penrith Regional Art Gallery, Emu Plains NSW; New England Regional Art Museum, Armidale NSW; City Art Institute, Sydney; Macquarie University, Sydney; University of WA, Perth; Monash University, Vic; NSW Institute of Technology, Sydney; WA Institute of Technology, Perth; Fitzroy Library, Vic; Australian Broadcasting Commission; Broken Hill Pty Ltd; Trans Australian Airlines; Philip Morris Collection; Artbank.

Bibliography *Catalogue of Australian Perspecta* 1981, Art Gallery of NSW; *Directory of Australian Printmakers* 1982; *Artists & Galleries of Australia*, Max Germaine: Craftsman House 1990.

ROCHE, Carol QLD

Born Newcastle NSW. Painter and sculptor.

Studies With Professor Yann Reinard in Eire. Went to Ireland as a child and returned in 1986. Member, RQAS and Society of Sculptors Qld.

Exhibitions Solo shows at Redhill Gallery; Corbould Gallery, McWhirters Artspace, Brisbane. Group shows in New York, RQAS and Society of Sculptors, Qld.

Represented Institutional and private collections in UK, Europe, USA and Australia.

RODEN, Pauline VIC

Born Port Moresby New Guinea 1953. Printmaker and teacher.

Studies Diploma of Fine Art (printmaking) from RMIT and Preston Institute of Technology; Presently teaching printmaking.

Exhibitions Two-artists show at Mildura 1976; Participated print shows at Mildura, Swan Hill 1975–79 and Melbourne 1981.

Represented Private collections in Vic, NSW and SA.

Bibliography *Directory of Australian Printmakers* 1982.

RODRIGUEZ, Judith VIC
Born Perth WA 1936. Printmaker and writer of many poems, stories and review articles for
literary periodicals; Teaches at La Trobe University 1978.
Exhibitions Linocuts for book launching, Webber's Bookshop, Melbourne 1977; One-man
show linocuts, Bookshelf Gallery, Melbourne 1978; Won SA Biennial Prize for Literature at
Adelaide Festival 1978.
Publications *A Question of Ignorance* (four poets) Cheshire 1962; *Nu-Plastic Fanfare Red*,
poems, Qld University Press 1973; *Water Life*, poems and linocuts, Qld University Press
1976; *Shadow on Glass*, poems and linocuts, Open Door Press 1978; *Hecate's Daughters*, col-
lection of women's poetry, linocuts 1978.

ROE, Beatrice NSW
Born UK. Painter and printmaker.
Studies Julian Ashton School, Sydney under Henry Gibbons 1957–60 with Ross Doig and
his Chatswood classes, and printmaking at Workshop Art Centre, Willoughby NSW;
Member, Nine Printmakers, Lane Cove Art Society and Drummoyne Art Society.
Exhibitions Sydney Printmakers and Print Circle Women's Group.
Awards Drummoyne NSW; Boggabri NSW; Lane Cove NSW.
Represented Lane Cove Municipal Collection and private collections in Australia and over-
seas.
Bibliography *Directory of Australian Printmakers* 1982, 88.

ROGERS, Aileen Jessie NSW
Born Wagga Wagga 1916. Painter.
Studies Desiderius Orban School, Sydney 1965–77 and extensively overseas.
Exhibitions Numerous shows since 1973 include S.H. Erwin Gallery; Desiderius Orban
Studio and Artarmon Galleries.
Awards Mosman Art Prize 1977; Pring Prize 1985.

ROGERS, Catherine NSW
Born NSW 1952. Photographer, painter.
Studies Dip. Graphic Design — ESTC and Randwick TC 1971–74; Grad. Dip., Art and
Photography, SCOTA 1983–84; MA — City Art Institute 1986–87. Member, Board of
ACP 1986–87 and Council of SCOTA 1986, 87. Presently lecturer, photography, SCOTA
1988– .
Exhibitions Solo shows at George Paton Gallery, Uni. of Melb. 1977; ACP, Sydney 1984;
Mori Gallery, Sydney 1986, 88, 90; Chameleon Gallery, Hobart 1987. Many group shows
include ACP 1976, 82, 86 and touring show 1983; SCOTA 1982, 85; NSW State Library
1985; Artspace 1984; First Draft 1986; United Artists 1987; New York 1988; New Mexico
1988; *Brush with Nature* Community Project, Royal Nat. Park 1988.
Awards VAB Study Grant to USA 1978.
Represented Institutional and private collections in USA, UK, Europe, South America,
Australia.

ROGERS, Charlotte VIC
Born Melbourne 1950. Painter, illustrator, child therapist.
Studies Trained in the Rudolf Steiner philosophy and uses art therapy with adults and chil-
dren. Has illustrated a number of books.
Bibliography *Alice 125*, Gryphon Gallery: University of Melbourne 1990.

ROGERS, Jennifer QLD
Born Melbourne Vic 1945. Printmaker and designer.
Studies Diploma of Art (printed textiles), RMIT 1966.

Exhibitions Participated in numerous Qld group shows 1970–83, and had solo show in Brisbane 1981. QAG 1982–83; Brisbane River Touring Print Show 1988.

Award Warana Caltex (graphic) 1981.

Represented Griffith University, Qld; Private collections in ACT, Melbourne and Brisbane.

Bibliography *Directory of Australian Printmakers* 1982, 88.

ROGERS, Sue NSW

Born Sydney NSW 1940. Painter and maker of portrait masks.

Studies Formal training under Maximilian Feuerring.

Exhibitions Holdsworth Galleries 1980, 1983; Distelfink Gallery, Melbourne 1981; Bonython Gallery, Adelaide 1983; BMG, Sydney 1989.

Represented Many private collections around Australia and overseas.

ROGERS-PERAZZO, Gail NSW

Born NSW 1950. Painter, illustrator, graphic artist.

Studies ESTC and Randwick TC 1966–70. Worked and studied overseas 1971–80.

Exhibitions Galleria Primitif, Mexico City 1973; Museu D'Arte Moderna, Bahia, Brazil 1979; Beth Mayne Gallery, Sydney 1988; Woolloomooloo Gallery 1987; Avoca Gallery 1989.

ROGGENKAMP, Joy QLD

Born Roma Qld 1928. Expressionist painter, mostly watercolour, some oil and acrylic.

Studies Brisbane Technical College and under private tutors P. Stanhope Hobday, Mel Hayson and Jon Molvig.

Exhibitions One-woman shows, Johnstone Galleries, Ray Hughes and Cintra House Galleries, Brisbane; Macquarie and Darlinghurst Galleries, Sydney; Australian Galleries, Melbourne; *The Barn*, Adelaide and Macquarie Galleries, Canberra; Most recent one-woman shows at Holdsworth Galleries, Sydney 1979; Cintra House, Brisbane 1980 and Macquarie Galleries, ACT 1980. Many group shows since 1950 include Qld Art Gallery 1951, 59, 78; AGNSW 1962, 66, 67; Uni of Qld, Art Museum 1985; Qld C of A Gallery 1987; The Centre Gallery, Gold Coast 1988.

Awards Lismore 1958; Redcliffe 1959, 62, 64; Half Dozen Centenary 1959; L.J. Harvey Memorial Drawing 1959; AGNSW Trustees Watercolour Prize 1962; Pring Prize 1966, 67.

Represented ANG, Canberra; NGV; AGNSW; Uni of Qld; Institutional and private collections in Australia and overseas.

Bibliography *A Homage to Women Artists in Queensland Past and Present*, The Centre Gallery; *Artists & Galleries of Australia*, Max Germaine: Craftsman House 1990.

ROLES, Chris QLD

Born Sydney 1947. Painter.

Studies Brisbane IFA 1982–83; Kelvin Grove BCAE — Dip VA 1984.

Exhibitions Solo show at Centre Gallery, Metro Arts Brisbane 1987. Participated MOCA Brisbane and Centre Gallery, Gold Coast 1988.

ROODENRYS, Bronwen NSW

Born Wollongong NSW 1945. Painter.

Studies Wollongong TC and Canberra Art School.

Exhibitions Solo shows at NTMAG, Darwin 1986; Tynte Gallery, Adelaide 1989; Participated at Rainsford Gallery, Sydney 1987; Beauford Gallery, Darwin 1987.

ROONEY, Elizabeth Ursula NSW

Born Sydney NSW 1929. Printmaker and painter.

Studies Diploma of Fine Art at East Sydney Technical College 1949; Etching as extra-curricular with Herbert Gallop 1948–49. Helped Joy Ewart establish etching facilities at Workshop Art Centre, Willoughby NSW, and is currently producing etchings.

Exhibitions One-woman shows at Willoughby Workshop Art Centre 1963; Macquarie Galleries 1968, 71, 73, 75; von Bertouch Galleries, Newcastle 1976, 79, 86; Artarmon Galleries 1985; Beth Hamilton Gallery 1988. Participated WAC 1977; Printers Gallery 1980; Oldenberg, W. Germany 1979; Early print shows include New York 1958; Washington 1966; British Print Biennale 1968–69; Shows with Sydney Printmakers in UK, NZ 1982; Artarmon Galleries 1988; Sydney Printmakers 1990.

Awards Mosman Print Prize 1966; PCA Print Prize 1968; Blue Circle Prize 1976; Berrima 1981, 87; Police Award 1985, 86, 87; Willoughby Print Prize 1987; BDAS Print Prize (shared) 1988.

Commissions PCA Print Edition 1987.

Represented Art Gallery of NSW and institutional and private collections in UK, Europe, USA and Australia.

Bibliography *Art and Australia*, Vols 3/2, 6/4, 9/4; *Directory of Australian Printmakers* 1976, 1982, 1988; *Artists & Galleries of Australia*, Max Germaine: Craftsman House 1990.

ROSATI, Gabriel NSW

Born Sydney 1956. Painter, sculptor, weaver, teacher.

Studies Design and Colour Diploma — Shillito Design School, Sydney 1973–76; Tom Bass Sculpture School, Sydney 1975–76; Weaving Apprenticeship — Master Weaver Erika Semlar, Sydney 1979–80; Study under Professor Abakanowicz, Academy of Art, Poznan, Poland 1980–81. Overseas study tours 1976–79, 1980–82; Taught at Long Bay Gaol 1988; Arts and Craft Co-ordinator for the Toomelah Aboriginal Reserve 1989.

Exhibitions Solo shows at Painters Gallery 1988; Tamworth Reg. Gallery 1987; Performance Space, Sydney 1986; Jam Factory, Adelaide 1989. Numerous group shows since 1979 include Hogarth Galleries 1979; Academy of Art, Poznan, Poland 1981; Tamworth National Fibre Exhibition 1984, 86; University of Tasmania 1986; Bondi Pavilion 1988; Craft Council Gallery, Sydney, Grafton Regional Gallery and Community Arts Centre, Brisbane 1989.

Awards VAB Grants 1980, 88.

Represented Municipal and private collections in Australia and overseas.

ROSE, Kristine NSW

Born UK, emigrated to Australia with husband, musician John Rose 1976. Painter and installation and performance artist.

Studies Croydon School of Art, London UK.

Exhibitions Participated at Art Gallery of NSW and Watters Gallery with husband and dancer Caroline Lung and at Ivan Dougherty Gallery, Sydney with her husband 1983; Roslyn Oxley9 Gallery 1987.

ROSENGREN, Mary VIC

Born Wodonga, Vic 1956. Painter, printmaker, teacher.

Studies Prahran CAE 1975–76; VCA — Diploma of Art (Painting) 1978; SCOTA — Graduate Diploma 1981. Artist-in-Residence, Amalgamated Metal Workers Union 1986–87 and at Jolimont Train Depot 1985. VMA, *Artist-in-the-Community* 1984–85.

Exhibitions Solo shows at Painters Gallery, Sydney 1985; Mori Gallery 1981; George Paton Gallery, Uni. of Melb. 1979. Numerous group shows since 1980 and recently Artspace, Sydney and Jam Factory, Adelaide 1987; United Artists, Melb. 1988.

Awards Sir Lindesay Clark Scholarship 1978.

Represented Institutional and private collections in Australia.

ROSS, Christine

Born Newcastle NSW 1944. Painter, critic and teacher.

Studies National Art School, Newcastle 1962–63; National Art School, Sydney; Diploma in Painting 1964–66; Part-time teacher of art, National Art School, Newcastle 1967–74; Lecturer, Newcastle College of Advanced Education 1975; Art critic, ABC Newcastle 1968; Art critic *Newcastle Morning Herald* since 1971; Member, International Art Critics Association 1976; Study tours, Thailand 1969, New Guinea 1971, Japan, Europe 1973, Indonesia, Philippines 1978; America, UK, Europe 1979–80; Artist-in-Residence SA School of Art, SACAE sponsored by the VAB 1983; Hunter IHE 1988.

Exhibitions One-woman shows at von Bertouch Galleries, Newcastle 1969, 1972, 1976, 1981, 1984, 1988; SACAE Gallery, Adelaide 1984; Participated at *Four Newcastle Artists*, CAS Gallery, Adelaide 1969–74; *Four Painters*, Maitland Gallery, NSW 1975; Invitation Exhibitions at Newcastle City Art Gallery 1967, 1969, 1972; Tas Art Gallery 1971 and Maitland Art Gallery 1977, 1983; Newcastle Regional Gallery 1980, 1982; Art Gallery of NSW 1981; Ivan Dougherty Gallery, Sydney 1981; Wollongong Art Gallery 1981; von Bertouch Galleries 1983; Muswellbrook Regional Gallery 1983, 1988; Newcastle Reg. Gallery 1986; Holdsworth Reg. Gallery 1986; Holdsworth Contemporary Gallery 1987; Tamworth Reg. Gallery 1988; Lake Macquarie and Albury Galleries 1988; Hunter IHE Staff Show 1988.

Awards Weston 1966; Kurri Kurri 1968; Cowra 1968; Bradmill Prizes 1970–71; Raymond Terrace, Watercolour 1973; Scone Art Prize 1977.

Represented Australian National Collection, Canberra; Newcastle City Art Gallery; University of Armidale; Maitland City Gallery; Prospect City Council Collection; Scone City Collection, NSW.

ROSS, Joan

Born Glasgow, Scotland 1961, arrived Australia 1962. Painter.

Studies Liverpool TC, Sydney 1979–80; Post Certificate in Painting from ESTC 1981; BA Visual Arts, City Art Institute 1983–85.

Exhibitions Solo shows at Arthaus, Sydney 1985; Roslyn Oxley9 Gallery 1989. Numerous group shows since 1980 include Mori Gallery 1985; Ivan Dougherty Gallery 1986; S.H. Ervin Gallery 1989.

Awards Royal Easter Show Student Prize 1981; Lloyd Rees Bicentennial Youth Art Award 1988.

Represented Institutional and private collections.

ROSS, May

Born Rockhampton Qld. Watercolour painter of birds and flowers.

Studies VAS and with private tutors. Member and regular exhibitor with Australian Wildlife Artists Society since 1978.

Represented Private collections in UK and around Australia.

ROSSER, Margot

Born Aust. 1956. Photographer.

Studies Dip. Art Prahran College 1975–77. Dip. Ed. Hawthorn State College 1979.

Exhibitions Solo show at Visability Gallery 1984; Group show at Swinburne TC Gallery 1979; Hamilton Regional Gallery 1980; Albury Regional Gallery 1982.

Bibliography *150 Victorian Women Artists*, Visual Arts Board/WAM 1988.

ROSS-MANLEY, Jan

Born Melb. 1953. Textile artist.

Studies Caulfield IT — Diploma, Art and Design 1970–74; RMIT, Graduate Diploma of Embroidery Studies 1980.

Exhibitions Solo shows at Ararat AG 1983; Craft Council of Tas, QVMAG, Burnie AG 1984–85. Numerous group shows.
Represented Qld AG, institutional and private collections around Australia.

ROTH, Marianne (Freund) VIC
Born Germany 1926. Painter, sculptor, printmaker and teacher.
Studies Breslau and Berlin Germany; Caulfield Institute of Technology 1953; 1974–82 (part-time); Diploma of Arts and Crafts from Mercer House Teachers College, Melbourne; Taught art at Camberwell Girls Grammar, Shelford, Sacred Heart, Oakleigh and for 19 years at PLC Burwood, Vic; Member VAS, Malvern Art Society and Bezalel Fellowship of Arts; Overseas study tours 1974, 1978, 1981.
Exhibitions Joint showing at Eckersley Gallery, Prahran 1980; Regular shows with VAS.
Represented Private collections in New York, UK, Europe and Australia.

ROTHLISBERG, Victoria QLD
Born San Diego USA 1945. Paintings, collage, textiles.
Studies Qld C of A, BA and Dip. Fine Art, Uni. of Northern Arizona, USA; Grossmont Community College, California.
Exhibitions Solo shows at Homestead Gallery, Capalaba Qld 1981; Dabbles on Days, Brisbane 1984; Windaroo Gallery 1985; Mellersh Gallery, Qld 1986; Olympia, Washington USA 1987; Nakina Fine Art, Qld 1988. Numerous group shows.
Awards Beenleigh 1984; Redlands 1976, 80.
Represented Institutional and private collections in USA and Australia.

ROUND, Michele TAS
Born Hobart 1954. Photographer, teacher.
Studies Hobart S of A, 1972–75; Overseas study 1980; Teaches with Tas. Ed. Dept.
Exhibitions Solo show at Burnie AG 1982. Numerous group shows in Melb. and around Tas.
Represented Burnie AG; Institutional and private collections.

ROUSE, Frances QLD
Born Toowoomba,Qld 1950. Painter, graphic designer, writer.
Studies Brisbane TC, Associate Diploma in Graphic Design 1969–72; McGregor Summer Schools 1970, 72; Worked and studied in UK, Europe, USA 1973–75; Has worked in the arts and as a writer since 1975.
Exhibitions Numerous shows since 1984 include Signatures Gallery, Toowoomba 1985, 90; Excelsior Gallery, Sydney 1986–87; Prouds Gallery, Sydney 1988–89; McWhirters Artspace, Brisbane 1990.
Represented Institutional and private collections in Australia and overseas.

ROUSSEAU, Fifi VIC
Born Greece 1954. Painter and teacher.
Studies Dip. Art Prahran IT and Postgrad. at VCA.
Exhibitions Melbourne University Gallery; MPAC; Warrnambool Regional Gallery; VCA Gallery.
Bibliography *150 Victorian Women Artists*, Visual Arts Board/WAM 1988.

ROVAY, Rachel VIC
Born Jerusalem 1955. Painter. Arrived Aust. 1970.
Studies Chisholm IT — Diploma, Art and Design 1977; Diploma of Education 1980. Visited Israel 1982.
Exhibitions Solo shows at Clive Parry Gallery 1979; Profile Gallery 1985; Realities, Melb.

1988; Holdsworth, Sydney 1989.
Represented Institutional and private collections in Israel and Australia.

ROWBOTHAM, Marjory **WA**
Born Vic 1923. Painter in all media and teacher; Daughter of Walter Rowbotham.
Studies Diploma in Commercial Art and Art Teachers Diploma from Perth Technical
College; National Diploma in Design from Wimbledon School of Art, London UK; Taught
art at Perth Technical College for 21 years; Exhibited in father and daughter shows in Perth.
Awards Albany 1973, 1975, 1976, 1978; Bunbury 1973, 1975; Manjimup 1973, 1975,
1977, 1979.
Represented Royal Perth Hospital and private collections in UK, Europe and Australia.

ROWE, Cybele **NSW**
Born Sydney 1963. Painter, ceramic sculptor.
Studies BA Visual Arts, City Art Institute 1982–88; Grad. Dip. 1987; Life drawing under
Marie Santry 1981–88 with Northwood Drawing Group; Studied UK, Europe, USA 1988.
Exhibitions Blaxland Galleries 1986–89, 90; Sydney Textile Museum 1987; Cooper
Gallery 1987; Barry Stern Galleries 1989; Artarmon Galleries 1988.
Awards Aust. Arts Council Travelling Scholarship 1987.
Represented Institutional and private collections.

ROWLEY, Jann **WA**
Born Sydney 1941.
Studies B. Ed. and Dip. Teaching, Alexander Mackie CAE.
Exhibitions Recent solo show at Casey Galleries, Sydney 1989.
Represented Institutional and private collections in UK, Europe, Hong Kong, Australia.

ROWLEY, Pat **NSW**
Born Gunnedah NSW 1929. Painter and printmaker.
Studies East Sydney Technical College, privately with Desiderius Orban and Maximilian
Feuerring and at Willoughby Workshop Arts Centre 1967–68.
Exhibitions The Print Circle 1981, 1982; Tamworth City Gallery 1982; New England
Regional Gallery 1983; Excelsior Gallery, Sydney; The Gallery Image Armidale NSW
1986; Sydney Printmakers 1990.
Awards Moree, Lane Cove, Gunnedah (4), Narrabri (2), Bellata, Quirindi.
Represented Municipal Collections at Lane Cove and Narrabri; Channel 9 Tamworth and
many private collections.

ROXBURGH, Margaret **TAS**
Born Launceston Tas 1931. Semi-abstract painter in watercolour, oil and chalk.
Studies Hobart Technical College under Jack Carington Smith; East Sydney Technical
College under John Passmore, Godfrey Miller and Dorothy Thornhill and the Slade School,
London UK; Hobart S of A c. 1975.
Exhibitions Solo shows at Art Centre Gallery, Hobart 1970, 74; Ivy Cottage, Richmond
1972; Participated with Tas. Group of Painters 1955–65; Art Society of Tas 1971–76;
Devonport AG 1978.
Represented TMAG; QVMAG; Devonport AG and private collections.
Bibliography *Tasmanian Artists of the 20th Century*, Sue Backhouse 1988.

RUCK, Amanda H. **ACT**
Printmaker.
Studies Canberra S of A 1984; BA Visual Arts 1987; Printmaking, Canberra IA 1987.
Exhibitions Bitumen River Gallery 1986; Canberra S of A 1987; ANG Drill Hall 1988;

PCA Gallery 1988.
Bibliography *PCA Directory* 1988.

RUDYARD, Carol WA
Born England UK 1922, arrived Australia 1950. Painter and audio visual artist.
Studies Associateship in Art, WAIT 1970; Bachelor of Arts in Fine Arts 1979; Graduate
Diploma of Art and Design 1981. Taught art at WAIT 1971–73; Mt Lawley CAE 1974;
WAIT 1975–80; Perth Technical College 1981–83.
Exhibitions One-woman shows at Old Fire Station Gallery 1973; WAIT 1980; Gallery 52
1982; Art Gallery of WA 1982. Numerous group shows include Art Gallery of NSW
1971–73; Adelaide Festival of Arts 1972; Galerie Dusseldorf 1981; Fremantle Arts Centre
1982; Uni. of WA 1984; Praxis Gallery 1987; *The Australian Bicentennial Perspecta*, AGNSW
1988; Solo show at Roslyn Oxley9 Gallery 1988, 89, 91.
Awards Festival of Perth Poster 1963; Mundaring Abstract 1970; WA Arts Council 1982,
88, 89; VAB 1982, 86; Guy Grey Smith Travel Grant 1986; Residency-Oraxis, Fremantle
1987.
Represented AGNSW; AGWA; University of WA; WAIT and private collections.
Bibliography *Catalogue of the Australian Bicentennial Perspecta* 1988, AGNSW; *Artists &*
Galleries of Australia, Max Germaine: Craftsman House 1990.

RUE, Carol E. NSW
Born Canowindra 1959. Painter, printmaker, papermaker.
Studies NRCAE 1987–88; Papermaking with Jacki Parry, Glasgow 1989.
Exhibitions Solo shows at Portia's Place, Lismore 1989; Network Art Gallery, Byron Bay
1990; Numerous group shows include University of Hawaii 1987; Access Art Centre,
Lismore 1989, 90; Lismore Regional Gallery and Tamworth Regional Gallery 1990.
Awards Visual Arts Faculty Prize 1987; Mitchell Student Prize and Travel Bursary.
Represented Institutional and private collections in Australia and overseas.

RUNCIMAN, Mary Anne SA
Born Tanzania 1954. Printmaker, painter.
Studies BA, Hons, Uni. of Natal 1977; BA Fine Art, Grad. Dip. SACAE, Adelaide 1982.
Worked and studied UK, Europe, China 1983–86.
Exhibitions Solo show in UK 1984; Hill-Smith Gallery, Adelaide 1988, Chesser Gallery
1990; BMG Fine Art 1991. Numerous group shows since 1981.
Bibliography *PCA Directory* 1988.

RUSSELL, Antoinette NSW
Born Melbourne. Painter and sculptor.
Studies Painting with Jon Peaty, London UK 1965–68; Camden Art School, UK 1967–68.
Sculpture with Mitzi Finey, Willoughby Art Centre 1970–72 and with Tom Bass 1974–77.
Member of The Sculptors Society.
Exhibitions Solo show at Mavis Chapman Gallery, Sydney 1978; Group shows include
London 1967; Both Chenil and Strawberry Hill Galleries, Sydney 1971; Holland Fine Art,
Sydney 1989.
Represented England, Italy, USA and Australia.

RUSSELL, Deborah NSW
Born Melb. 1951. Painter, printmaker, illustrator.
Studies RMIT — Diploma of painting and printmaking 1970–74; Beaux Arts
Printmaking School, Paris 1975; Worked as illustrator and cartoonist for various magazines
in London and Aust. 1976–80.
Exhibitions Solo shows at Heyday Gallery, Melb. 1981; Mori Gallery, Sydney 1985, 86, 87,

88; Hamilton Reg. Gallery, Vic 1987; Group shows include ACCA Touring Show of Aust. and NZ 1987–89; Savage Club, Melb. 1988; Mori Gallery 1984, 85, 88, 89.
Commissions Murals at Flaine, France 1975; Williamstown, Vic 1979–80; Mori Gallery 1984; Vic. Print Workshop 1988.
Represented Artbank; Hamilton Regional Gallery, Vic; Myer Collection; IBM Collection, Perth; Reg Grundy Collection, Los Angeles.

RUSSELL, Elayne NSW
Born Sydney. Painter.
Studies BA (Hons) Psychology, Uni. of Sydney; ESTC and with John Ogburn.
Exhibitions Solo shows at Aladdin Gallery 1970; Robin Hood Gallery 1972; Holdsworth Galleries 1981, 82, 84, 85, 88, 89; Uni. of Sydney 1983; Gallery III, Rockhampton, Qld 1985; Gallery Image, Armidale 1986.
Awards Bathurst Purchase 1983; Port Macquarie 1984.
Represented Institutional and private collections.

RUSSELL, Elsa NSW
Born Sydney NSW 1909. Figurative painter in oil, gouache and watercolour.
Studies Abbotsleigh School; East Sydney Technical College; Under Dattilo Rubbo, later in Paris; Well-known for her earlier theatre and circus paintings.
Exhibitions David Jones' Gallery, Sydney 1952; Paris 1955; Bissietta Gallery, Sydney 1957; Barefoot Gallery 1968–70; Painters Gallery 1986; Nat. War Memorial, Canberra 1989; Retrospective show at Woolloomooloo Gallery, Sydney 1989.
Awards Tumut Prize 1961.
Represented Aust. War Memorial, ACT; Manly Art Gallery; Institutional and private collections in Australia and overseas.

RUSSELL, Joan VIC
Born India of English parents 1905. Painter.
Studies Grosvenor School of Modern Art, London 1936–38; St Martins School of Art, London 1946–48; Lived Kenya 1948–56; Lived and painted in Australia since 1970.
Exhibitions Royal Academy; Royal Society of British Artists; Royal Institute of Oil Painters; The New English Art Club; Numerous shows in Australia and recently at Bridget McDonnell Gallery, Melbourne 1987.
(Died February 1991)

RUSSELL, Meredith NSW
Painter, printmaker, papermaker.
Exhibitions Hogarth Galleries 1988.
Publications *The Sun Is In My Heart*, limited edition linocuts following painting trip to North Africa, published by Editions Australia.

RYALL, Glenda VIC
Born Melbourne Vic 1959. Sculptor.
Studies Diploma in Fine Art (sculpture) RMIT 1980 and Postgraduate Diploma with Distinction 1981.
Exhibitions First one-woman show at Australian Galleries, Melbourne 1983.

RYAN, Amanda NSW
Born NSW. Modern painter.
Exhibitions First one-woman show at Mori Gallery, Sydney 1983 favourably commented

on by Terence Maloon.

RYAN, Rosemary VIC
Born Tas. Romantic painter, mostly in oil and acrylic.
Studies National Gallery School 1950–51; George Bell School, Chelsea Polytechnic 1955–56.
Exhibitions Solo shows, South Yarra Gallery, Melbourne 1963, 1965, 1967; Gallery A 1966; Johnstone Gallery, Brisbane 1967; Australian Galleries, Melbourne 1973; Powell Street Galleries, Melbourne 1976; Leveson Street Gallery, Melb. 1978; Heyday Gallery 1980; Participated in exhibitions, Redfern Galleries, London and Georges, Melbourne; TMAG, Hobart; Rosalind Humphries Galleries, Melb.
Represented Many private collections in Australia and overseas.
Bibliography *Art and Australia*, Vol 9/2, page 119; *Tasmanian Artists of the 20th Century*, Sue Backhouse 1988.

RYAN, Siobhan VIC
Born Melbourne 1959. Modern allegorical painter in oil.
Exhibitions ROAR Gallery 1982; Gertrude Street Gallery 1985; Crescent Gallery, Dallas USA 1987; 70 Arden St. Gallery 1987; Included in the Moët & Chandon Touring Exhibition 1988.

RYDER, Mona WA
Born Brisbane 1945. Sculptor, printmaker, teacher.
Studies Brisbane CAE 1976–80, where she taught intermittently 1981–84. Studied in France 1985. Lives in Perth WA.
Exhibitions Solo shows at Kimilia Gallery, Sydney 1979; Brisbane CAE 1980; Uni. of Qld Art Museum 1984; Michael Milburn Galleries, Brisbane 1984, 85, 87; The Centre Gallery, Gold Coast 1987. Numerous group shows since 1976 include *Australian Perspecta 1985*, AGNSW; Roz MacAllan Gallery, Brisbane 1988. A major survey of her work was held at Uni. of Qld Art Museum 1984.
Awards VAB Travel Grant to Vence Studio, France 1985. Andrew and Lilian Pedersen Printmaking Prize 1987.
Represented Qld Art Gallery, Uni. of Qld, Art Museum and institutional and private collections in Australia and overseas.
Bibliography *A Homage to Women Artists in Queensland Past and Present*, The Centre Gallery 1988.

RYDER, Therese NT
Born 1954. Aranda Aboriginal watercolour painter from the Santa Teresa area of the NT.
Exhibitions Lauraine Diggins Fine Art, Melb. 1989.

RYMILL, (Lady) Margaret SA
Born Mildura Vic 1913. Flower painter in oil, especially roses and camellias.
Studies School of Fine Arts, North Adelaide under Frederick Millward Grey 1928–32.
Exhibitions Osborne Gallery, Adelaide with Paul Jones and Joan Law Smith 1978; Prouds Art Gallery with Robert Cox 1978; Also participated at Lombard Gallery 1981; Kingston House Gallery 1982; Old Clarendon Gallery 1980, 1983.
Represented Private collections in Australia, England and USA.
Publications *Lady Rymill's Flower Paintings*, Aldgate Publishers 1986.

S

SABEY, Jo VIC

Born Adelaide SA 1947. Contemporary painter in acrylic, gouache, pastel, and coloured pencil; Teacher.

Studies SA School of Art 1965–68. Diploma Art Teaching 1968. Taught art in Secondary schools in Adelaide and Melbourne 1968–72.

Exhibited In group shows; Yuerilla Galleries, Uraidla SA; Stuart Gerstman Galleries, Melbourne and Leverson Gallery, Melbourne between 1974–81. Solo exhibitions Eltham Gallery 1981; *Contemporary Women Painters*, Eltham Gallery 1982; Greenhill Galleries, Adelaide 1982; Eltham Gallery 1984; Editions Gallery, 1985, 86, 88; Her work has appeared as limited edition prints.

Represented Many corporate, institutional and private collections in Australia, UK, Japan.

SACCARDO, Marilyn SA

Potter.

Studies SA Studio Potters Club 1970–71. Fellow, RSASA 1981.

Exhibitions RSASA Gallery 1974–81; Myer Gallery 1982–86; David Jones' Gallery 1986; Greenhill Galleries 1988; Bernadette Gallery 1989; Studio Z 1990; Adelaide Town Hall 1991.

Awards Handbuilt section, Tea Tree Gully.

Represented Institutional and private collections in Australia and overseas.

SACHS, Lori NSW

Born Vienna 1909. Designer, painter and printmaker.

Studies Commercial art and design in Vienna 1927–30; Diploma at Kokoschka Summer School, Salzburg Austria 1964; Etching course at Morley College, London 1973; In Australia, painting with Joy Ewart and Desiderius Orban 1961–62; Printmaking at Workshop Arts Centre, Willoughby NSW under Sue Buckey, Elizabeth Rooney, Michael West.

Exhibitions Has held seven one-woman shows and participated in University of Tas Print Prize 1968; *Thirty-six Australian Prints* shown in Armidale NSW and Naracoorte SA 1971; Adelaide Festival of Arts 1972.

Award First Prize Gulgong Council Exhibition, Etchings 1970.

Represented University of Tas.

SACKVILLE, Pam NSW

Born Melb. Flower painter, illustrator, teacher.

Studies Toorak Teachers College, Vic 1962–64; Teaching experience in USA and Aust 1966–75; Travelled overseas to Canada and England 1976; Bachelor of Visual Art, City Art Institute, Sydney 1981–83; Illustrator, Flowers Column, *Weekend Australian* 1981–82; Completed illustrating *Sydney is a Garden*, written by Elaine Diamond, published David Bateman Ltd 1983; Teaching adult and high school classes 1983–86; Illustrated *Flowers for all Seasons*, published Doubleday, April 1984–86.

Exhibitions Solo shows at Robin Gibson Gallery 1984, 86.

SAGES, Jenny WA

Born Shanghai, China 1933, arrived Aust 1948. Painter and illustrator.

Studies ESTC under Frances Shilito; New York Franklin School of Art. Her work has appeared widely in fashion magazines and book covers.

Exhibitions Following a visit to the Bungle Bungle area of the north of WA she held a major

show of 42 of the resultant paintings at Blaxland Gallery, Sydney 1988, 90.

SAGES, Tanya NSW
Born Australia. Jeweller and designer; daughter of Jenny.
Exhibitions Blaxland Gallery, Sydney 1990, 91.

SAIL, Margaret VIC
Born Melbourne 1940. Sculptor and potter.
Exhibitions Regional touring show of sculptures 1990.
Bibliography *Alice 125*, Gryphon Gallery: University of Melbourne 1990.

ST LEDGER, Colleen QLD
Born Brisbane 1959. Contemporary painter. No formal art training.
Exhibitions First solo show at Milburn + Arte, Brisbane 1989.

SALNAJS, Venita NSW
Born Zwickau Germany 1945 of Latvian parents. Painter in watercolour and mixed media;
Teacher.
Studies East Sydney Technical College and Alexander Mackie Teachers College, Sydney
1963–66; Married to artist Reinis Zusters; Teacher of Art (full-time, Kempsey High School
1967–68) and part-time in Secondary schools and Evening Colleges 1969–75; 1979
Research study at the Sturt College of Advanced Education, Adelaide SA 1979. Member,
AWI.
Exhibitions Solo shows at Holdsworth Galleries, Sydney 1977, 1979, 1982, 1985, 1987;
Breewood Gallery 1988. Participated in *Women and Arts Festival* and AWI show, Sydney
1982 and Blue Mountains Artists Show at Penrith Regional Gallery 1983, 86; Von
Bertouch Galleries 1989.
Awards Ryde, Hunters Hill, Cheltenham, Castle Hill, Drummoyne 1967–78; Mercedes
Benz Watercolour, Royal Agricultural Show, Sydney 1976; Pring Prize, Art Gallery of
NSW 1976.
Represented James Cook University, Qld; Trinity Grammar, Summer Hill NSW; Blue
Mountains City Council.
Bibliography *Spiral Vision*, Reinis Zusters, Bay Books Pty Ltd 1981; *Landscape Art and the
Blue Mountains*, Hugh Speirs, Alternative Publishing Co-operative Ltd 1981; *Latvian Artists
in Australia*, Society of Latvian Artists in Australia, ALMA 1979.

SANDS, Jenny NSW
Born Sydney. Painter and portraitist.
Studies Julian Ashton School, Sydney; University of Architecture and Arts, Vienna.
Exhibitions Solo shows at Robin Gibson, Sydney, Prouds and Gallery 380A; Participated at
Blaxland Galleries; Bologna Book Fair, Italy 1990.
Awards Portia Geach Portrait Prize 1989; Finalist in the Doug Moran National Portrait
Prize 1990.

SANKEY, Olga SA
Born Adelaide 1950. Printmaker.
Studies Uni. of Adelaide 1968–71; BA Fine Art SASA 1977–80; Dip Lith. State Institute
of Art Urbino, Italy 1981. Grad. Dip SASA 1982.
Exhibitions Solo shows at Il Navile Gallery, Bologna, Italy 1981; Tynte Gallery, Adelaide
1985; Holdsworth Contemporary Galleries, Sydney 1987. Numerous group shows.
Awards Arts Council Grant to Italy 1980; Grand Prix, Seoul, Korea 1982; PCA Member
Print 1983; Mini Art, Toronto, Canada 1986.
Represented AGSA, Regional Galleries, Institutional and private collections in UK,

Europe, Korea, Canada, Australia.
Bibliography *PCA Directory* 1988.

SAUNDERS, Anne NSW
Born Edinburgh Scotland 1955. Painter and printmaker, married to artist Allan Mann.
Studies Duncan of Jordanstone College of Art, Scotland, BA Illustration and Printmaking.
Member of Association of Illustrators, London UK; Print Council of Australia; World Print
Council. Member, Chartered Society of Designers, London. Designer/ Lecturer Darling
Down IAE 1977–81; Lecturer, Murray IHE 1981–83; Director, Old Joinery Gallery
1983–87; Lecturer Ballarat CAE 1987–.
Exhibitions Major shows include Compass Gallery, Glasgow 1976, 1979; Robin Gibson
Gallery, Sydney 1978; Gold Coast City Gallery, Qld 1979, 1982; CAS, Adelaide 1980;
Brisbane City Gallery 1980; Editors Gallery, Melbourne 1981; Old Brewery Gallery, Wagga
Wagga City Gallery, Gold Coast Gallery 1982; Eden Court Gallery, Inverness 1985
(Scotland); Upstairs Gallery, Albury NSW 1987; Old Brewery Gallery 1988.
Represented Institutional and private collections in UK and Australia.

SAVAGE, Julie NSW
Born 1953. Printmaker.
Studies Canberra and Sydney S of A.
Exhibitions Solo shows at Mitchell CAE 1984; Macarthur IHE 1987.
Bibliography *PCA Directory* 1988.

SCHAFFER, Chris TAS
Born Toowoomba Qld 1952. Painter, printmaker, teacher.
Studies Tas School of Art, Hobart 1969–75; Teaches adult education printmaking and
youth theatre; Active with women's art movement, Adelaide SA.
Exhibitions One-woman show, Salamanca Gallery, Hobart 1976 and Women's Show at
same gallery 1971, 1977, 1978; Print Council of Australia Exhibition 1978.
Represented National Gallery, Wellington NZ; Rudi Komon Gallery, Sydney.

SCHARF, Lotte VIC
Born Prague Czechoslovakia. Painter and textile designer. Member VAS.
Exhibitions Solo show at Caulfield Arts Centre 1981.

SCHEPERS, Karin SA
Born Germany 1927, arrived Australia 1955. Painter and printmaker.
Studies Kolner Werkschulen 1946–53; Kolner Press print atelier 1952–53; Study tour
Israel 1969 and 1975; Holland, France, UK 1975.
Exhibitions Cincinatti Colour Lithography Biennale, USA 1958; Australian Print Survey
1963–64; Print Council of Australia Prize Exhibition 1967; *Historical Survey-Printmaking in
Australia*, Newcastle City Art Gallery 1967; Produced over 90 etchings and lithographs
between 1950–64; Taught SA School of Arts from 1959; Lecturer in charge of art studies,
Kingston College of Advanced Education SA 1976–.
Represented National Gallery of Vic; Art Gallery of SA; Newcastle City Art Gallery, NSW;
Cologne West Germany.

SCHERGER, Joy VIC
Graphic artist, illustrator, wildlife painter, trained in commercial art, and spent some time
at the Nat. Art School, Melb.
Exhibitions Solo shows at Old Brewery Gallery Wagga, NSW 1987, 88. Numerous group
shows, cards and prints of her works are distributed around Australia and overseas.

SCHIPPER, Lisa QLD
Born 1967. Paintings and collage.
Studies Qld. College of Art Certificate 1983–86; B. Fine Arts 1986–89. Teaching drawing 1989– .
Exhibitions 'That Gallery', Brisbane 1987; Galerie Brutal, Brisbane 1989; McWhirters Artspace, Brisbane 1990.

SCHMID, Monica VIC
Born Vienna 1939. Printmaker.
Studies Institute of Textile Design, Vienna 1953–58; Academy of Applied Art, Vienna 1958–59; Prahran CAE, Melb. 1979–81.
Exhibitions Solo shows at Stuart Gerstman Galleries 1985–88. Numerous group shows.
Bibliography *PCA Directory* 1988.

SCHNEIDER, Phyl QLD
Born Adelaide SA 1917. Painter of interior and still-life in oil and watercolour.
Studies SA School of Arts in the 1930s; Private study with John Rigby and David Fowler in Brisbane 1960–70; Evening classes at Byam Shaw Art School, London UK 1970.
Exhibitions Solo shows at The Town Gallery, Brisbane 1985, 87. Participated at RQAS 1964 to present and Martin Gallery, Townsville 1980 and Gallery Alpha, Qld 1981; The Centre Gallery, Gold Coast 1988.
Awards Gympie 1967; Brisbane Rotary 1978; RQAS Caltex 1979.
Represented Artbank, Brisbane City Council and institutional and private collections around Australia.
Bibliography *A Homage to Women Artists in Queensland Past and Present*, The Centre Gallery 1988.

SCHOENHEIMER, Joy QLD
Born Sydney NSW. Painter and ceramic artist.
Studies Brisbane Technical College 1965–68; Kelvin Grove CAE — Associate Diploma VA (Ceramics) 1977.
Exhibitions Solo shows at Holdsworth Galleries, Sydney 1979; Victor Mace, Brisbane 1980, 82, 89; The Craft Centre, Melb. 1982; Broadbeach Gallery 1985; The Centre Gallery 1988; Group shows include Canberra School of Art 1981; Meat Market Centre, Melb. 1982; Bloomfield Galleries, Sydney 1984.
Represented Qld Art Gallery; National Gallery of Vic; Brisbane Civic Art Gallery; Vic State Collection, Meat Market Gallery, Melbourne; Kelvin Grove and North Brisbane CAE Collections, Brisbane.
Bibliography *A Homage to Women Artists in Queensland Past and Present*, The Centre Gallery 1988.

SCHRAMM, Eva VIC
Born Kiel W. Germany 1956. Sculpture and video.
Studies RMIT 1978–80. Lectured in video at Melbourne State College 1982; Guest lecturer at Phillip Institute of Tech, Melbourne 1982. Guest curated *Nu-View Review* for Australian Film Institute 1982.
Exhibitions One-woman shows at Reconnaissance Gallery 1981, 1982. Adelaide State Library 1982; Adelaide University 1982; Participated in Adelaide Festival of Arts 1980; First Australian Sculpture Triennial, Melbourne 1981; Allerbamer Halle, Munich 1982; Biennale of Sydney 1982; *Australian Perspecta* 1983.
Bibliography *Catalogues of Biennale of Sydney* 1982 and *Australian Perspecta* 1983, Art Gallery of NSW.

SCHRAPEL, Stephanie

Born Adelaide SA 1944. Painter, sculptor, craftworker, teacher, writer, critic.

Studies University of Adelaide, summer schools and inservice courses: BA, Dip Ed, Dip T, MACE, SASA and Flinders Uni.; Fellow RSASA and President 1985–; Fellow, Royal Anthropological Institute, Member, Australian College of Education. Taught in SA schools 1966–72 and is prominent in many historical and educational causes. Overseas study tours 1977–78, 79, 80, 81, 84, 85, 89. Collaborated with E.A. French to illustrate and publish books, Rigby Ltd viz *Tie Dyeing, Batik and Fabric Printing, Crafts from Scrap Materials* and *Macrame*. Art critic, Advertiser Newspapers Ltd. and The News Ltd.

Exhibitions CAS and RSASA shows; Lidums Gallery, SA; Sunfish Gallery, Qld and Art Gallery of WA; Kensington Gallery 1982; CAS; Women's Art Movement and Adelaide Festival of Arts 1982, 88; Recent solo shows include Kensington Gallery 1982; Centre Gallery 1983, 84; Kintore Gallery 1986; Flinders Uni 1986, 87; Naracoorte Gallery 1986; ANG, Canberra 1986; Springton Gallery 1986; Art Zone 1987; SA Museum 1987; SA Regional Galleries 1987; Festival Theatre 87; Gorman House, Canberra 1989. Group shows include RSASA and CAS 1966–89; Adelaide Festival 1982; Tynte Gallery 1987; SA Centre for Photography 1988–89; Kensington Gallery 1989; David Jones' Gallery 1989; Himeji, Japan 1989; Christchurch NZ 1990; Flinders University Art Museum 1990.

Represented Artbank, institutional and private collections in Australia and overseas.

Bibliography *PCA Directory* 1988; *CAS Print Workshop, The First Years*, 1985; *Artists & Galleries of Australia*, Max Germaine: Craftsman House 1990.

SCHULTZ, Debra

Born Portland, Vic 1966. Printmaker.

Studies BA, Warrnambool IAE 1983–86.

Exhibitions 70 Arden St, Melb. 1988; Commissioned 100 x 100 Print Portfolio.

Bibliography *PCA Directory* 1988.

SCHULTZ, Pamela A.

Born Melb. Painter, textile artist.

Studies CIT, Melb. 1972–74; Studed UK, Europe for three years.

Exhibitions Waterfall Place Fine Art and Grafton House Galleries, Cairns 1988.

Awards Mulgrave Shire Art Award 1983, 85, 88.

Represented Municipal, institutional and private collections in UK, Europe, Australia.

SCHUMACHER, Marion

Born Kiel, W. Germany 1952. Traditional painter of landscapes and portraits in oils. Has had several shows at The Art Salon, Camden, NSW.

SCHWARTZ, Kay

Born La Trobe, Tas 1939. Printmaker.

Studies Dip. Physiotherapy, Melb. 1959. Assoc. Dip. Tas S of A 1985; B. Fine Art, 1988. Travel UK, Europe, South America 1964–71.

Exhibitions Don Camillo, Hobart 1984; Tas S of A 1987; Strickland Gallery 1988.

Bibliography *PCA Directory* 1988.

SCHWARZ, Charis

Born Stawell Vic 1939. Painter; Married to artist, George Schwartz.

Studies No formal art training; Paints decorative works in ink, gouache, also uses video and film.

Exhibitions One-woman show, Hogarth Galleries, Sydney 1974 and various women's group shows.

Publications *Erotica Varia*, Herd Publishing Company, Sydney 1973; *Erotic Art in*

Australia, Sun Books, Sydney 1978.

SCOLZ-WULFING, Denise NSW
Born Sydney 1962. Painter, teacher, printmaker.
Studies City Art Institute BA Visual Arts 1983; ESTC 1985–87; Completed Dip Ed.
(Secondary) at Sydney Institute of Education 1986; Overseas study tour 1984; Casual art
teaching for Dept of Ed. 1987–.
Exhibitions Solo show at Russell Sharps Gallery, Sydney 1985; Holdsworth Contemporary
Galleries 1987; Participated at Balmain Watchhouse 1987.

SCOTT, Gillian QLD
Born London UK 1933. Wildlife painter, technical illustrator and biologist, teacher.
Studies Professional biologist for 25 years graduating Bachelor of Science, Doctor of
Philosophy, M.I. Biol. Tutored in art techniques with Mary Grierson, UK and Barry Thomas
and Rex Backhaus-Smith, Australia; Fellow, Society of Botanical Artists, UK.
Exhibitions Solo shows at Rockhampton CIAE 1980; Ardrossan Gallery, Brisbane 1987;
Creative 92 Gallery, Toowoomba 1989. Participated at QWAS 1983; London UK 1986, 87,
88; Norsart Winter School, Ayr, Qld 1987; Studio Craft Gallery, Box Hill, Vic 1988;
Showcase Gallery, Darwin 1988.
Commissions and Publications Illustrated *Western Grasses*, B. Roberts and R. Silcock,
DDIP, 1983; Various issues of *Australian Weeds*, edit J. Swarbrick, Inkata Press; Is painting
Noxious Weeds of Queensland for the State Lands Commission; Has painted for private commis-
sions; Wrote and illustrated (line work) *The Funnel Web*, DDIP 1980; Bicentennial project,
The Natural History of Lake Broadwater 1988.

SCOTT, Jill NSW
Born Melbourne Vic 1952. Paintings, audio and performance artist, teacher.
Studies Prahran College of Advanced Education, Melbourne (Diploma of Art and Design)
1970–73; Melbourne Teachers College (Diploma of Education) 1974; San Francisco
University (Masters Degree in Fine Art) 1976–77.
Exhibitions Has held twenty-eight solo shows since 1975 in UK, Europe, USA and
Australia including International Cultreel Centrum, Antwerp Belgium; Los Angeles
Contemporary Exhibitions, Los Angeles USA; London Video Arts, AIR Gallery, London
UK; Cable Vision, Channel 26, San Francisco USA 1981; 80 Langton Street Gallery, San
Francisco USA; International Cultreel Centrum, Antwerp Belgium 1982; Avago, Sydney
Australia; Roslyn Oxley Gallery, Sydney Australia; Heidelberg Kunstuerein, Heidelberg
West Germany; Freiberg Kunstuerein, Freiberg West Germany 1983; Avago, Sydney 1984;
Govett — Brewster, New Plymouth NZ 1985; Performance Space, Sydney 1985 (Artist-in-
Residence) Roslyn Oxley9 Gallery 1985, 89. Has participated in many group shows since
1971 and more recently at *Kunstler Bucher*, curated by Jennifer Phipps, Frankfurt Germany;
Selected Video by Women, The Kitchen, New York USA; *Sound Corridor*, curated by Bill
Hellerman, P.S.1. Queens, NY; *The Sydney Biennale* Video, Sydney Australia; *ACT 111, 10
Australian Performance Artists*, Canberra Australia; *New Imagery*, The Museum of Modern
Art, New York USA 1982; *A.U.S.T.R.A.L.I.A.* at Zona, Florence Italy; *Anzart in Hobart*,
Collaboration, Radio, Tas; *Let me Give a Comment about those Outside* with Piotr Olszanski at
the Contemporary Artspace, Adelaide. Performance via telephone; *Continuum*, Australian
Art in Japan, Tokyo Japan; Women's Festival, Koln West Germany. Curated by Ulrike
Rosenbach 1983. Video Festivals in Montreal, Madrid, Vienna, UK, Europe, Yugoslavia
1984–85; Aust. Centre for Photography, Sydney 1985; *Perspecta* 1985, AGNSW.
Installation at Powerhouse Museum, Sydney 1988; Ars Electronica, Vienna; Downtown
Television Centre, New York; Locarno Festival, Italy and Montreal Festival, Canada 1989.
Awards VAB Publishing Grant 1980.
Bibiography *Catalogue of Biennale of Sydney* 1982, Art Gallery of NSW; *Artists & Galleries of*

Australia, Max Germaine: Craftsman House 1990.

SCOTT, Joyce SA

Born UK 1942. Potter and sculptor.
Studies Graduate Diploma of Education (Adelaide CAE), Diploma Design (Ceramics) (Adelaide CAE), Association Diploma Ceramics (Adelaide CAE), FRSASA. Part-time lecturer, SASAE and University of SA.
Exhibitions Major show include Greenhill Galleries, Adelaide 1974, 1976, 1980, 1982, 1988; Solander Galleries, Canberra 1978; Bonython Galleries, Adelaide 1983; Holdsworth Galleries 1986. Numerous group shows since 1974 include Australian Crafts Touring Exhibition to State Galleries 1978; Greenhill Galleries 1983; MAGNT 1984; Mino, Japan 1986; Tokyo 1988; Nagoya 1989; 2nd Biennale Internazionale di Ceramics, Contemporanea, Italy 1989.
Awards University of Adelaide Pottery Prize 1974; National Ceramics Award, Bathurst 1974; Member of first delegation of Australian potters to China as guests of that country 1975; Contributing SA artist to the first national ceramic conference 1978; Japan awards 1986, 88, 89.
Represented ANG; Artbank; Crafts Resource Productions, Crafts Council of Australia slide library; Mitchell Regional Gallery, NSW; SA College of Advanced Education; Craft Council of Australia, Sydney NSW; Canberra College of Advanced Education; Private collections throughout Australia and UK.

SCOTT, Mary Gale TAS

Born New Norfolk, Tas 1957. Painter, puppeteer.
Studies Canberra S of A 1976–78; Worked at ANG, Canberra 1979–82.
Exhibitions Bolitho Gallery, Canberra 1982, 83; Iceberg Gallery, Melb. 1983.
Represented TMAG; Private collections.
Bibliography *Tasmanian Artists of the 20th Century*, Sue Backhouse 1988.

SCOTT, Rona NSW

Born Newcastle NSW 1934. Abstract-symbolist painter, mostly in oil, and portraitist; Has worked on sculptural painting and religious themes.
Studies Newcastle Art School under Paul Beadle, John Passmore, Brian Cowley, Andrew Fergusson; Member of Contemporary Art Society; Overseas study tour to SE Asia 1975; Art teacher at St Aloysius Girls High School for some years, presently painting and teaching in Sydney.
Exhibitions First solo show at the Coffee House, Broadmeadow NSW 1962, followed by von Bertouch Gallery, Newcastle 1966, 1974; Barefoot Gallery, Avalon NSW 1975; Participated at Newcastle Regional Art Gallery 1962; Young Painters Exhibition, Blaxland Gallery, Sydney 1964; Gallery A, Sydney with Wolfgang, Graesse and O. Blair 1968; Her retrospective exhibition 1949–78 was mounted by the Maitland City Art Gallery in September 1978; NBN Channel 3 made a pocket documentary film based on her sculptural paintings in 1968 which was shown widely in USA.
Represented Newcastle Regional Art Gallery; Maitland City Art Gallery; Many institutional and private galleries in Australia and overseas.

SEBERRY, Jo-Anne VIC

Born Melbourne 1957. Painter, mostly in pastel.
Studies With John Balmain for five years. With Daniel Greene in New York 1988 and in UK, Europe 1988. Member, American Pastel Society and Victorian Pastel Society.
Exhibitions First solo show at Capricorn Gallery, Melbourne 1990; Numerous group shows include American Pastel Society 1988, 90.
Awards Finalist, Camberwell Rotary Travel Scholarship 1987, 91; Wesley College 1989;

Canson Award, Camberwell 1990; Board of Directors Award, American Pastel Society 1990.
Represented Institutional and private collections in UK, Europe, USA and Australia.

SEEMAN, Pamela (Crawford) QLD
Born Brisbane 1921. Painter, stage designer.
Studies Brisbane Central TC 1942–45, RQAS and with a number of private tutors.
Exhibitions Participated in many shows since 1944 and in recent times The University Art Museum, Brisbane and The Centre Gallery, Gold Coast 1988.
Bibliography *A Homage to Women Artists in Queensland Past and Present*, The Centre Gallery 1988.

SEIDEL, Nola SA
Born Lameroo SA. Impressionist painter in oil and ceramic artist.
Studies Mostly self-taught; Influenced by the late May Griggs and the late William Frater; Fellow of the Royal SA Society of Artists whose other special interests are children's art classes and hand-building ceramic forms.
Exhibitions Hahndorf Academy 1967; Plymptom Art Studio 1969; Newton Gallery 1974; Ceramics Show at Newton Gallery 1975.
Award First Prize Kiwanis Art Competition 1974.

SEYMOUR, Helene VIC
Born Cornwall, UK 1942. Painter.
Studies CIT, Melb. and with Lindsay Scott and Malcolm Cameron 1974–76. Exhibiting member of VAS and Waverley Art Society.
Exhibitions Joint show at Mulgrave Art Gallery, Vic.
Awards Flinders 1980; Royal Melb. Show 1984; Mt View 1986; Hamilton Nth, Rotary 1986.
Commissions Paintings for Huntingdale Golf Club, Melb. 1984.
Represented Institutional and private collections in Australia and overseas.

SGRO, Catrina VIC
Born Melb. 1961. Printmaker.
Studies BA Fine Arts, RMIT 1981–83; Grad. Dip., Rusden College 1988. Travel Europe 1986.
Exhibitions RMIT Travelling 1982; ROAR Studios 1985–86.
Bibliography *PCA Directory* 1988.

SHANNON, Pat VIC
Born Melbourne. Painter and printmaker.
Studies Graduated from Swinburne TC; Part-time study at National Gallery School, Melbourne and in UK, Europe. Tutor with CAE 1976–90.
Exhibitions Solo shows since 1967 include Warehouse Gallery 1975, 76; Susan Gillespie Gallery, Canberra 1978; Niagara Gallery 1981, 84; CAE-Moore Gallery 1985; 47 Davis Av. South Yarra Studio Gallery 1987, 88, 89. Many group shows include CAS Gallery 1960–70; Womens Art Forum 1977–80; MPAC 1983–85, 89; Seaways Gallery, Sydney 1988; Linden Gallery 1989.
Commissions Lithograph for Art Horizons 1987; Posters for Art Forms, Aust. 1987.
Represented Artbank, municipal collections.

SHARK-LeWITT, Vivienne
(Vivienne Thwaites) VIC
Born Vic 1956. Contemporary painter.

Studies Adelaide Uni. 1974–79; Tas. CAE 1976–79; Alexander Mackie CAE 1980–81.
Exhibitions Solo shows at Roslyn Oxley9 Gallery 1984, 85, 87. Numerous group shows include *Australian Perspecta* 1983, AGNSW; George Paton Gallery 1983; Musée d'Art Moderne de la Ville de Paris, Paris 1983; Edinburgh and New York 1985; Biennale of Sydney, AGNSW 1986; Heide Gallery, Melb. 1986; IMA, Brisbane 1987; *Chaos* Roslyn Oxley9 Gallery 1987. Participated in *A New Generation 1983–88* at ANG, Canberra 1988 and *Australian Biennale 1988*, AGNSW.
Commissions Bicentennial Art Poster.
Represented ANG, Canberra; University of Melbourne; Solomon R. Guggenheim Museum, New York; Derwent Collection, Tasmania; Vitrix Camden Collection.
Bibliography *Catalogue of Australian Perspecta '83*, Art Gallery of NSW; *Artists & Galleries of Australia*, Max Germaine: Craftsman House 1990.

SHARPE, Wendy NSW
Born Aust. 1960. Painter.
Studies Seaforth TC 1978–79; BA Visual Arts, City Arts Institute 1980–82; Grad. Dip. 1984; Grad. Dip. Ed., Sydney IE 1983. Marten Bequest Travelling Scholarship and Dyason Bequest with tenancy of Paris Studio 1987–88.
Exhibitions Hunters Hill Gallery 1982; Manly Art Gallery 1983; Blaxland Gallery 1985; Nicholson St Gallery 1985; First Impressions Gallery 1986; Performance Space 1986; Nidus Gallery, Sydney 1987; DC Art, Sydney 1989.
Awards UN Poster Prize 1985; Shared Sulman Prize, AGNSW 1986.
Represented Institutional and private collections in UK, Europe, Australia.

SHAW, Adele VIC
Born Poland. Colourful painter of Australian flora and fauna and worker in stained glass, portraitist.
Studies Early studies in Poland; On arrival in Australia studied with George Bell and at the Caulfield Institute of Technology, Melbourne; Overseas study tour 1979.
Exhibitions One-woman shows, Manyung Galleries, Mt Eliza Vic 1977, 1978; Hilton Hotel, Melbourne 1977; Participated in many group shows since 1956 including Argus Gallery, Toorak Gallery, CAS Gallery, Georges Gallery.
Commissions Sixteen stained-glass windows of biblical themes at the Elwood Synagogue, Melbourne; Panel of the Psalms of King David at the Strathfield Synagogue, Sydney; Seven stained-glass windows, Montefiore Homes, Melbourne; Five stained-glass windows, Elwood Synagogue, Melbourne; Ten stained-glass windows for the Holocaust Centre, Melbourne; A design for a monument at Holon, Israel.
Awards 'Woman of the Year' (artist), Gold Coast, Qld. 1989 and Parliament House ACT 1990.
Represented Institutional and private collections in Israel, UK, Europe, USA, Canada and Australia.

SHAW, Alison QLD
Born UK 1941, arrived Australia 1968. Traditional landscapist in oil.
Studies Trained as a nursing sister at Guy's Hospital, London 1959–63 and mostly self-taught as an artist; Shortly after arriving in Australia, she met her future husband, artist Geoff McKenzie while working at the hospital at Townsville Qld; Has made many study and painting tours to northern and central Australia.
Exhibitions Held joint exhibition with Geoff McKenzie at Armidale Regional Gallery, NSW 1972; Sale Regional Gallery, Vic 1973 and Balmoral Galleries, Geelong Vic 1977; Also exhibited at gallery studios owned in partnership with her husband viz, House of Shells and Art, Burleigh Heads Qld; Goldfields Art Gallery, Guildford Vic; Woombye Gallery, Qld; Montville, Qld; Also shows at The Blue Marble Gallery, Buderim.

Represented Collections throughout Australia, NZ, USA, Canada, Germany, Holland, Switzerland, Japan and Middle East.

SHAW, Denise NSW
Born Geelong Vic 1936. Painter and portraitist, mostly self-taught, overseas study tour 1975.
Exhibitions One-woman shows at Flinders Gallery, Geelong 1974; And Sydney 1974.
Awards Macquarie University Prize 1975, 1979; Lismore and Ku-ring-gai 1976; Muswellbrook 1979; Nepean County Council 1979; Lismore 1979.
Represented Private collections in UK, Europe and Australia.

SHAW, Doreen Jardi WA
Born NSW. Expressionist painter in oil, pastel and watercolour.
Studies Perth Technical College, WA; Secretary, Perth Society of Artists; Member of Royal Agricultural Society WA Sponsored Art committee since its beginning in 1974; Co-Founder of Centaur Art Group with Elizabeth Blair Barber.
Exhibitions Exhibits with Australian Watercolour Institute and Perth Society of Artists; Cremorne Gallery, Perth 1969–78.
Represented Portrait at Trinity College; Mural at Melville City Council, WA and in private collections.

SHAW, Jan NSW
Born Sydney NSW 1939. Sculptor, potter and teacher.
Studies Avoca Street School of Fine Arts and The Sculpture Centre 1974. Bronze casting at Sydney University; Tutor in sculpture at The Sculpture Centre, Sydney 1980–83 and All Saints College, Bathurst Artists Week 1980–87; Member, The Society of Sculptors, and The Sculpture Guild of NSW.
Exhibitions Numerous shows since 1977 and in recent times Gallery 460, Avoca NSW; Centre Art Space, Chatswood; Woollahra Gallery; Sculpture '85, Melb; Irving Scupture Gallery, Sydney; Wyong Art Festival 1980–85; Hilton Gallery 1985; Sculptor-in-Residence at Gallery 460 for the Bicentennial Project 'Sculpture Park '88'.
Awards Wyong Festival of Arts, First prize 1985, 1986, 1987, 1990.
Commissions Gosford Council, Kibble Park 1987; Paul Terry, Perth WA 1988–89; Jennings Retirement Services, NSW 1989; Opera House Sculpture Symposium 1990; Taronga Park Zoo 1990.
Represented Many institutional and private collections in Australia and overseas.

SHAW, Peggy Perrins VIC
Born Vic. Abstract painter in oil and gouache.
Studies National Gallery Art School of Vic 1948–50; First prizes in final year for still-life and abstract painting; George Bell School 1949–50; Chelsea Polytechnic, London 1952; St Martins School of Art, London 1952; Academie de la Grande Chaumiére Paris and Atelier of Andre L'hote, Paris 1953–56; Desiderius Orban, John Olsen and Bob Klippel, Sydney 1956–64.
Exhibitions Group shows with the Contemporary Art Society, NSW 1956–64; One-artist shows, Athenaeum Gallery, Melbourne 1970; Invitee exhibitor to Connoisseurs' Collections, Monash University 1971; Group shows, Contemporary Art Society, Vic 1965–73; One-artist show Georges Gallery, Melbourne 1974, 1978, 1981; Lyceum Club, Melbourne 1981; Qantas Gallery, London 1982; Group show LIP 1977.
Represented ANG, NGV, QAG, QVMAG, TMAG, Regional Galleries, institutional and private collections in UK, Europe, USA, India, NZ, Australia.

SHEARER, Mitzi WA
Born Bratislava, Czechoslovakia 1909. Printmaker.

Studies Capetown SA 1965–76; Perth TC 1977–81.
Exhibitions Solo shows at Capetown 1975; Fremantle 1979–81; Melb. 1987 and at Charles Nodrum Gallery, Melbourne 1990.
Bibliography *PCA Directory*, 1988.

SHEEHAN, Beatrice VIC
Born Adelaide 1958. Painter, designer, photographer.
Studies BA University of Melbourne 1985.
Exhibitions Experimental Art Foundation, Adelaide 1980; WAM, Melbourne 1981.
Bibliography *150 Victorian Women Artists*, Visual Arts Board/WAM 1988.

SHEEN, Lynne WA
Born Uralla NSW 1940. Potter and designer, mostly self-taught; overseas study in Europe and USA.
Exhibitions Busselton Arts Council, Crafts Council of WA.
Bibliography *Pottery in Australia*, Vol 19 No 2 and Vol 21 No 2.

SHEPPARD, Ann NSW
Born Cheshire, UK 1949, arrived Aust. 1971. Illustrator and painter of flora and fauna. B.Sc (Hons) Zoology, Wales, M.Sc. Liverpool 1971. Worked Canada 1975–78; Studied art with private tutors and at Broken Hill College of TAFE 1988–89. President of the Willyama Art Society, Broken Hill 1989.
Exhibitions With the Brushmen of the Bush, Eastend Gallery and AFFA Gallery, Bendigo, Vic.
Represented Collections in UK, Europe, USA, Canada and Australia.

SHEPPARD, Margie SA
Born 1953. Painter, printmaker, teacher.
Studies SASA 1970–74; Taught at TAFE and with Ruth Tuck for some years.
Exhibitions Solo shows at Union Gallery, Uni of Adelaide 1979; CAS Gallery 1981; Greenhill Galleries 1985, 87, 90.
Represented Institutional and private collections.

SHERIDAN, Susan NSW
Born Sydney NSW 1939. Abstract impressionist painter in oil, acrylic and watercolour.
Studies National Art School, Sydney 1958–60, 62; part-time 1959–60 and drawing classes at Julian Ashton School, Sydney 1960; Fellow of RAS of NSW.
Exhibitions Solo shows at The Stables, Pymble NSW 1967; Beard Watson 1968; Mosman Gallery 1972; Cooks Gallery, Newcastle 1977, 1979; Wagner Gallery 1979, 1980, 1983, 85, 87, 89; Bolitho Gallery, ACT 1982; Bridge St. Gallery 1989, 91.
Awards First Prize, Cheltenham GHS 1968; First Prize, Wee Waa 1977; Margaret Fesq Memorial Royal Easter Show 1982; Scone Landscape 1981; Mosman 1984; Bowral-Mittagong 1990.
Commissions Hayman Island Resort – 15 watercolours.
Represented Manly Art Gallery; University of NSW; University of Newcastle; Joint Coal Board and many boardrooms and private collections in UK, Europe, USA and Australia.
Bibliography *Art and Australia*, Vols 11/2 and 20/1; *Artists & Galleries of Australia*, Max Germaine: Craftsman House 1990.

SHERRIFF, Norma VIC
Born Melbourne Vic 1931. Painter, sculptor and enamellist.
Studies Sculpture and life drawing at RMIT 1963–65; Self-taught vitreous enamellist on all medals; Married to artist Gareth Jones-Roberts.

Exhibitions One-woman at Australian Galleries, Vic 1961; Barry Stern, Sydney 1966; White Studios, Adelaide 1969; Group shows at 'Design 1962', National Gallery of Vic; Bonython Gallery, Adelaide; von Bertouch Gallery, Newcastle NSW; Contemporary Arts Society of Vic.

Award Eltham Open Award (purchased by Melbourne University) 1966.

Commissions Enamelled bowls for Batman Inn Motel by Robin Boyd 1962; The altar for the Holy Trinity Church of England, Balaclava Vic 1970; Four symbols of Matthew, Mark, Luke and John for the crucifix in St Stephen's Peace Memorial Church, Mount Waverley Vic 1969.

Represented National Gallery of Vic; Melbourne University, Vic; Sydney University, NSW; Reserve Bank of Australia; National Collection of Australia, Canberra; Lady Casey; Sir William and Lady Oliver; Dr Bernard Smith; Japan, Canada, USA, Britain, France and Italy.

SHILLAM, Kathleen QLD

Born Torquay UK 1916, arrived in Australia 1927. Sculptor, teacher.

Studies Brisbane Technical College 1932–33, where she worked with painter Francis Lymburner and her future husband, Leonard Shillam; Study tour to Europe 1961–64; Studied Florence Academy of Art, Italy and Royal College of Art, London UK. Awarded AM for services to the arts 1986.

Exhibitions Joint shows with her husband Leonard Shillam at Moreton Galleries, Brisbane 1949, 51 and the Johnstone Gallery, Brisbane 1954, 57, 60, 65, 68, 72; Bloomfield Galleries, Sydney 1991; Participated in many shows since 1951 and in 1982 at Irving Sculpture Gallery, Sydney also Victor Mace and The Society of Sculptors.

Awards Harvey Prize for Drawing, Brisbane 1955, 1957; Southport School religious sculpture 1982; Godfrey Rivers Medal — Brisbane Tech College.

Commissions Sir Donald Cleland Memorial, Port Moresby 1978; Qld University bronze portrait medallions 1972–83; Qld Cultural Centre Bronze Sculpture 1985; Fountain St. Pauls College, Uni. of Sydney 1983; Redcliffe Award, Qld 1988; Member, Sculptors Society NSW, Qld; Gold Coast.

Represented ANG; AGNSW; AGWA; QAG; TMAG; Uni. of Qld Art Museum; Newcastle Regional Art Gallery and institutions and private collections in UK, Europe, USA and Australia.

Bibliography *A Homage to Women Artists in Queensland Past and Present*, The Centre Gallery 1988; *Australian Painting and Sculpture*, Kym Bonython; *Sculpture in Australia*, Lenton Parr; *Queensland Artists*, Vida Lahey; *Australian Sculpture*, Ken Scarlett; *Artists & Galleries of Australia*, Max Germaine: Craftsman House 1990.

SHIMMEN, Heather Jane VIC

Born Melbourne Vic 1957. Painter, printmaker and teacher.

Studies Bachelor of Arts in Fine Arts RMIT 1976–78; Overseas study UK, Europe, USA 1979–80; Hong Kong, New Guinea, NZ; Part-time teacher in printmaking, Lincoln Institute of Technology, Melbourne.

Exhibitions One-woman show at Drummond Street Gallery 1982; Anthill Theatre 1983; Bitumen River Gallery, ACT 1984; RMIT Gallery 1985; Realities 1986, 90, 91; Participated in many group shows since 1977 including Mornington Peninsula Arts Centre 1979, 1980, 1981; South Korea 1980; PCA Travelling Show 1981; Qld Art Gallery 1982; Ruskin School of Art, Oxford UK 1982–83; Bayreuth University, Bavaria 1983; Ellimatta Galleries, Sydney 1983; PCA Travelling Show 1984; RMIT 1985; NGV 1987; Newcastle Regional Gallery 1988; 200 Gertrude St., Linden Gallery, PCA and ACCA, Melbourne 1989; Swan Hill Regional Gallery and Blaxland Gallery 1990.

Awards Prints acquired by RMIT 1978, Warrnambool Regional Gallery 1980; PCA 1981; Education Dept Catalogue Cover 1981; VA/CB Grants 1983, 89.

Represented Australian War Memorial; ANU Collection; Tamworth City Gallery; Bendigo Art Gallery; PIT Collection; Canberra S of A; Chisholm Institute Collection: Warrnambool Regional Gallery; RMIT; Coburg Tech School and private collections in South Korea, UK and Australia.

SHORE, Ivy NSW
Born Vic 1918. Painter and portraitist; Married to artist Graeme Inson.
Studies Max Meldrum method under Graeme Inson 1959–69, and overseas study tours.
Awards Portia Geach Portrait Prize 1979.

SHORT, Susanna NSW
Born Sydney NSW 1944. Painter, writer and art critic.
Studies Educated Sydney Church of England Girls Grammar School 1955–65; Sydney University (Bachelor of Arts Degree) 1962–65 and Slade School of Fine Art, University College, London (postgraduate student painting, tutor Keith Vaughan) 1968–69.
Cadetship, journalism, Sydney *Daily Telegraph* 1965–68; Feature writer *Reveille*, *Daily Mirror* Newspapers, London 1969–72; Freelance journalist London and Sydney 1972–76; Art journalist and art critic for *National Times* 1977–80 and for *Sydney Morning Herald* 1980.

SIBLEY, Irena VIC
Born Lithuania 1943. Painter, printmaker, teacher, wife of Andrew Sibley.
Studies ESTC c.1958.
Publications Is noted for her linocuts and illustrations but seldom exhibits her work. Her successful book *Rainbow* was the first of several and she has also illustrated six other books and calendars featuring hand-coloured linocuts of Australian marsupials and posters.

SIEBOLS, Jeannette NSW
Born Holland 1952. Sculptor, teacher.
Studies ESTC 1977–80; part-time teacher TAFE 1983–86.
Exhibitions Solo show at Irving Sculpture Gallery 1986; Participated ESTC Gallery 1980; Manly Art Gallery 1981; Eighth Mildura Sculpture Triennial 1982; Irving Sculpture Gallery 1982, 84; Ninth Mildura Triennial 1985.
Represented Corporate and private collections in UK, Europe and Australia.

SIKORA, Barbara-Basienka NSW
Sculptor.
Studies RMIT – BA, Fine Arts, Sculpture 1980–83; VCA, Melb. Bronze Course, Noosa-Canadian Workshop Qld. 1987.
Exhibitions Solo show at Irving Sculpture Gallery 1987; Participated in many Qld. Sculpture shows since 1984.
Awards Warana-Caltex 1986; New York 1988.
Represented Corporate, institutional and private collections in USA and Australia.

SILVER, Anneke QLD
Born The Hague, Holland 1937; Figure and landscape painter in acrylic; Teacher.
Studies Amsterdam, Brisbane; Townsville; Toowoomba – BA and Postgraduate Diploma, James Cook University; Taught at Townsville College of Advanced Education and Townsville College of Art; Travelled in Europe in 1974, 1977; Currently teaches Townsville TAFE.
Exhibitions Solo shows at Barefoot Gallery, Sydney; Martin Gallery, Townsville 1972; Young Australian Gallery, Brisbane 1973; Bakehouse Art Gallery, Mackay 1974–81; Trinity Gallery, Cairns 1975; Martin Gallery, Townsville 1978, 80, 82, 84, 86, 87; Painters Gallery, Sydney 1988; Perc. Tucker Regional Gallery 1989; Capricorn Gallery, Melbourne

1989; Many group shows since 1975 include Perc Tucker Regional Gallery 1982, 84, 85, 87, 89; Qld AG 1982, 87, 88; The Centre Gallery, Gold Coast 1988.

Awards Mt Isa Art Prize; Sam Allen Art Prize 1971; Innisfail Prize Contemporary Art; Mt Isa Art Prize 1972; VAB Grant 1974; Sam Allen Art Prize 1974; Charters Towers Art Prize 1975; Caltex Art Prize; Ernest Henry Memorial Prize 1976, 80; Parliament House Prize 1978; Cloncurry 1978; Stan Strange WC, 1983; Qld Pacific Festival Prize 1972, 74, 77, 85, 86, 87; Maxwell Drawing 1983; SGIO; Ernest Henry Memorial; Hinchbrook 1985, 87; Nerang 1986; Mackay Bicentennial 1988; Townsville Miniature 1988.

Represented James Cook University of North Qld; Townsville College of Advanced Education; Townsville City Council; Mt Isa City Council; Charters Towers City Council; Qld Parliament House; Pacific Festival Committee; Artbank.

Bibliography *Art and Antiques*, Peter Brown 1972; *A Homage to Women Artists in Queensland Past and Present*, The Centre Gallery 1988; *Artists & Galleries of Australia*, Max Germaine: Craftsman House 1990.

SILVER, Judy ACT
Born New York USA 1950. Painter and teacher.

Studies Graduated High School of Music and Art, New York City 1967; Graduated, Bachelor of Fine Arts, Philadelphia College of Art 1972; Graduated Master of Fine Arts, Maryland Institute, College of Art 1974; Instructor in Painting, Maryland Institute, College of Art 1973–74; Instructor in Painting, Design and Colour Theory, Northern Virginia Community College 1974–75; Instructor in Colour and Design Community College of Baltimore 1976; Priz de Rome Award, Fellow at American Academy in Rome, Italy 1976–78; Lecturer, Canberra School of Art, ACT Australia 1981–; Worked at Jabberwock Paper Mill, Tas 1981; Travelled to Japan to attend Paper Conference 1983.

Exhibitions Numerous one-woman shows since 1974 and recently American Academy in Rome 1977, 1978, Gallery A, Sydney 1981; Gallery Huntly, Canberra 1981, 84; Christine Abrahams, Melb. 1983; Rex Irwin, Sydney 1984, 87, 89; Participated in numerous important group shows in USA and Europe since 1967 and most recently Robley Gallery, Roslyn New York; 'Paperworks 80', Hudson River Museum, Yonkers, New York 1980; 'Jabberwock Paper Show', Macquarie Galleries, Sydney, Bonython Gallery Adelaide; Collage Show, Wollongong City Gallery, Wollongong; 'Cast & Manipulated Paper Show', Wollongong City Gallery, Wollongong 1982; Second Aust. Sculpture Triennial, Melb. 1984.

Awards Gained six awards in USA and Rome 1966–78; Guest artist, Jabberwock Paper Mill, Tas School of Art, 1982; Canberra Times National Art Award 1985.

Represented Artbank; Regional Galleries, institutional and private collections in UK, Europe, USA and Australia.

Bibliography *Artists & Galleries of Australia*, Max Germaine: Craftsman House 1990.

SILVERMAN, Lynn SA
Born Australia. Painter of Central Australian scenes and landscapes.

Exhibitions David Murray Print Gallery, Adelaide Festival of Arts 1984.

SIME, Dawn Francis (Westbrook) VIC
Born Melbourne Vic 1932. Semi-abstract painter; Wife of Eric Westbrook.

Studies RMIT 1948; Council member, Contemporary Art Society, Melbourne.

Exhibitions Has shown in one-woman and group shows in Melbourne, in particular with the CAS; Her work was included in the exhibition of Australian art at the Tate Gallery, London 1962.

Awards Minnie Crouch Prize, Ballarat 1964; Carnegie Fellowship Grant 1965.

Represented National Collection, Canberra; National Gallery of Vic; Art Gallery of WA; Auckland City Art Gallery, NZ; Reserve Bank of Australia Collection and private collec-

tions in Australia, UK and USA.
Bibliography *Art and Australia*, Vol 2/3, page 175.

SIMMONS, Marion NSW
Born Sydney 1947. Painter, printmaker, teacher.
Studies Hornsby College of TAFE, Art Certificate 1980–84; Post Certificate 1986; Taught at Hornsby TAFE 1987–88; Taught privately 1988–90. Member, Hornsby Art Society.
Exhibitions Solo show at Centre Arts Space, Chatswood 1987; Group shows at Berrima Gallery 1989; Christies Gallery 1989; Djuric Gallery 1990.
Represented Institutional and private collections around Australia and overseas.

SIMMUL, Ilme VIC
Born Hobart 1951. Printmaker.
Studies Tas. S of A 1969–71; NGS, Melb. 1972–73.
Exhibitions Solo shows at Pinacotheca, Melb. 1973; George Paton, Uni. of Melb. 1978; Powell St. 1987.
Bibliography *PCA Directory* 1988.

SIMONS, Christina K. VIC
Born Lismore NSW 1948. Painter, teacher.
Studies La Trobe University 1967–71; Worked as a teacher's aide and factory worker 1968–74; Study tour to Europe and Asia; Diploma of Art, Preston Institute of Technology 1973–75; Lecturer in drawing, Preston Institute of Technology 1977.
Exhibitions Solo shows at Pinacotheca Gallery, Melb. 1976, 79, 81, 83, 85; Numerous group shows include VCA Gallery 1978; Adelaide Festival 1980; Ballarat Regional Gallery 1984.
Represented Artbank, NGV, institutional and private collections.

SIMS, Bessie Nakamarra NT
Warlpiri Aboriginal painter in synthetic polymer on canvas from Yuendumu, NT.
Exhibitions Lauraine Diggins Fine Art, Melb. 1989.

SINCLAIR, Margaret SA
Born Adelaide SA 1918. Sculptor and ceramic artist. Her parental grandparents came from County Tyrone, Northern Ireland and settled in Victoria and her maternal grandparents came from Newcastle-upon-Tyne. This grandfather being a stone-mason. The painters John and Will Longstaff were cousins of her mother.
Studies SA School of Art , Adelaide 1930s; Artist for Museum of Natural History, Adelaide 1937–39; Travelled UK, Ireland, Europe 1956; Part-time study at SA School of Art 1957–60; Taught art and craft in technical high schools 1961; SA School of Art, Diploma of Fine Arts (sculpture) 1962–64; Taught sculpture for WA Adult Education Board 1964–66; Awarded a Churchill Fellowship, travelled and studied in Mexico, Peru, Colombia, South America, UK, USA, France, Greece, worked and studied for five months in bronze foundry in Milan Italy 1966; Mexico 1970; Worked in bronze and marble in Italy 1972; Travelled in UK and extensively in Spain, 1974; Member, Contemporary Art Society of SA 1960–70; Royal SA Society of Arts 1959–65, and Flinders University Art Society (from inception to close); part-time lecturer at Hartley CAE 1979; Overseas study tour China 1981; Japan 1982.
Exhibitions Numerous solo and group shows since 1959 and in recent times a solo show at Bonython-Meadmore, Adelaide 1984; 'Bronze Age Revival' Aptos Cruz Galleries, Adelaide, Festival Exhibition 1988; Wilderness Fine Art Exhibition 1988; Kensington Gallery Exhibition 'Affordable Treasures' 1988; Mixed exhibition Bonython-Meadmore Adelaide 1988; Polished and patinated bronzes in conjunction with Arthur Boyd, BNG,

Sydney 1989.

Awards SA Contemporary Art 1962, 1963, 1964; Society Prizes for Sculpture; Clarkson Prize for Sculpture 1963; Winston Churchill Memorial Fellowship 1965; Mildura Purchase Award (for smaller work) 1967; Gladstone Prize for Ceramics 1979.

Represented Art Gallery of SA; Flinders University of SA; Festival Centre, Adelaide; Churchill House, Canberra ACT; Numerous private collections in Australia, USA, Italy, NZ; Gladstone Art Gallery Qld; Adelaide Casino.

Bibliography *Encyclopedia of Australian Art*, McCulloch, Hutchinson 1968; *Art and Artists of SA*, Nancy Benko, Hyde Park Press, 1969; *Australian Sculptors*, Ken Scarlett, Nelson 1980; *The Development of Australian Sculpture 1788–1975*, Graeme Sturgeon, Thames and Hudson 1978; *Artists & Galleries of Australia*, Max Germaine: Craftsman House 1990.

SINGLETON, Deborah NSW
Painter.
Studies Postgraduate Diploma of Art, Sydney.
Exhibitions Solo shows at Union St. Gallery 1985, 86; Mori Gallery 1987; Group shows include First Draft Gallery 1986 and George Paton Gallery Uni. of Melb. 1986; Mori at United Artists, Melb. 1987.

SINGLETON, Judie VIC
Born Hornsby, NSW 1963. Painter.
Studies One year towards BA, Underdale CAE, SA 1981; Degree, Stanley Street 1982; Craft teacher at NUNC 1982; Moved to Melb.; Committee member ROAR Studies 1983.
Exhibitions Solo shows at William Mora Gallery, Melb. 1987, 89; Australian Galleries, Sydney 1989; Group shows include ROAR Studios 1983, 84; Coventry Gallery, Sydney 1985,86, 87, 88; Realities Melb. 1985; Rhumbarallas Melb. 1986; *A New Generation 1983–88*; ANG, Canberra 1988.
Commissions Restaurant Murals, ANG. Canberra.
Represented ANG; New Parliament House, Canberra and institutional and private collections in Australia and overseas.

SINN, Mary-Rose NSW
Born Melbourne Vic 1953. Painter and sculptor.
Studies RMIT 1972–75; Royal Academy, London 1983–84; Chelsea School of Art, London UK 1984–85.
Exhibitions Solo shows at Sydney College of the Arts 1980; Gallery Lunami, Tokyo 1981; Institute of Modern Art, Brisbane and Art/Empire/Industry, Sydney 1982; Avago Gallery 1985; Studio 3, London UK 1987; First Draft, Sydney 1988; Included in *A New Generation 1983–88* at ANG, Canberra 1988; Participated at Crafts Centre, Melbourne 1974; National Gallery of Vic 1975; Vic Festival Show 1978; Contemporary Jewellery to SE Asia 1979; First Australian Sculpture Triennial, Melbourne 1981; *Australian Perspecta* 1983, Sydney.
Bibliography *Catalogue of Australian Perspecta* 1983, Art Gallery of NSW.

SINNOTT, Pam NSW
Born Townsville, Qld. Ceramic artist, teacher.
Studies Associate Diploma in Fine Art, College of Art, Brisbane, 1974; Graduate Diploma in Teaching, Kelvin Grove CAE, Brisbane 1975; Art Teacher with Queensland Department of Education in Brisbane and Townsville, 1976–78; Bachelor of Arts (Ceramics) Bendigo CAE 1979; Grant by the Craft Board of the Australia Council for $4000 to work as a trainee for 12 months spent with Kelvin Grealy at Queensland Potters' Workshop at Kelvin Grove CAE 1980; Director on Crafts Council of Queensland, 1980; Lecturer in Ceramics at Newcastle College of Advanced Education 1980–88; Graduate Diploma in Art 1987.
Exhibitions Solo shows at The Potters Gallery, Brisbane 1982; Gallery 62, Newcastle 1983.

Many group shows since 1979 include Maitland City Gallery 1983; Muswellbrook Gallery 1983, 88; Lewers Bequest Gallery 1986; Newcastle Contemporary Gallery 1987; Lake Macquarie and Albury Galleries 1988; Hunter IHE Staff Show 1988.
Awards Warana, Brisbane 1980.
Represented Institutional and private collections around Australia.

SISTER DOROTHY NSW
See under Dorothy Gray.

SJOQUIST, Kirsten NSW
Born Denmark, arrived Australia 1939. Printmaker.
Studies Workshop Art Centre, Willoughby NSW; Exhibits with Print Circle and Nine Printmakers. One-woman show in Copenhagen Denmark 1983; Participated in 'Women and Art' project Sydney 1982.
Bibliography *Directory of Australian Printmakers* 1976, 1982.

SKERRATT, Jean TAS
Born Wales UK 1930. Painter, illustrator, brass rubbings.
Studies Bournemouth School of Art, UK, also worked as a commercial artist in 1977; Set up Hobart Brass Rubbing Centre; Member Tas. Art Society; Tas Art Group and AGRA.
Exhibitions Four solo shows at Hibiscus Gallery, Hobart; Numerous group shows in UK and Australia and recently a solo show at the Lady Franklin Museum, Hobart.
Represented Institutional and private collections in UK, Europe and Australia.

SKIPPER, Myra VIC
Born Melbourne Vic. Painter and jewellery designer; Wife of Matcham Skipper.
Studies Worked as an engraver with a firm of manufacturing jewellers while she studied at the RMIT, Melbourne and the George Bell School; Joined the Justus Jorgensen School of Arts at Montsalvat, Eltham Vic.
Exhibitions von Bertouch Galleries, Newcastle 1977, 86.

SKROBAR, Metka QLD
Born Yugoslavia 1948. Painter, teacher arrived Aust. 1957.
Studies Dip. Teaching; Ascot Vale Teachers College, Vic 1967–69; Darling Downs IAE 1977–79; Studied UK, Europe 1987, 88; Member RQAS,
Exhibitions Solo shows at Yugoslavia 1987; Visions Gallery, Gold Coast 1988; Eltham Gallery, Melb. 1989; ANA Hotel, Gold Coast 1990; Hyatt Hotel, Canberra 1990; McWhirters Artspace 1991. Participated Yugoslavia 1987, 88; The Centre Gallery, Gold Coast 1988; Mezzanine Gallery, Brisbane 1989; AGRA, Melb. 1990; Jabiru Gallery, Gold Coast 1991.
Awards Marymount College 1982; Trinity College 1983; RQAS 1984; Nerang 1986; Tweed Mall 1987; Currumbin 1988.
Represented Institutional and private collections in UK, Europe and Australia.

SMAGARINSKY, Larissa NSW
Born Belogorsk, USSR; Sculptor in all media, arrived Australia 1982.
Studies Degree in Architectural and Decorative Sculpture from Leningrad Arts Institute.
Exhibitions Solo shows at Richard King Gallery 1984, 85; Holdsworth Galleries 1985; Bondi Pavilion 1986; Westpac Plaza 1986; Sydney Opera House 1987; Artmet Gallery 1988. Many group shows since 1969; Holland Fine Art, Sydney 1990.
Commissions Many commissions in USSR 1968–78 and bust of Mr Neville Wran QC for Parliament House, Sydney 1987; Darling Harbour bronze sculpture 1988.
Represented State and institutional collections in USSR and Australia.

SMART, Sally SA
Born Quorn SA 1960. Painter, teacher.
Studies SASA 1978–81; Member, Central Studio Co-op and Floor Two Studio Co-Op
1983–84. Artist-in-Residence Gippsland Institute, Vic. and part-time teacher 1985.
Exhibitions Uni. of Adelaide 1983, 85; Adelaide Festival Centre 1984; Gippsland Institute
1985; Reconnaissance, Melb. 1986; Roslyn Oxley9 Sydney 1986; Gallery Max Honigsberg
1988; 200 Gertrude St. Melb. 1989; Moët & Chandon Touring Exhibition 1991.
Represented Institutional and private collections in Australia and overseas.

SMITH, Belinda QLD
Born Warwick Qld 1957. Wildlife painter in watercolour and acrylic.
Studies Diploma of Creative Arts from Darling Downs IAE, Toowoomba Qld 1978.
Overseas study tour to UK, Europe, USA 1982.
Exhibitions One-woman show at McInnes Gallery, Brisbane 1982; Creative 92 Gallery,
Toowoomba 1983; Participated at Prouds Gallery, Sydney 1981; International Wildlife
Show, Beckett Gallery, Ontario Canada 1981; Jinchilla Gallery, NSW 1982; Canberra Civic
Centre 1983.
Represented Institutional and private collections in UK, Europe, Canada and Australia.

SMITH, Fay VIC
Born Melb. 1918. Painter.
Studies Under William Rowell, Ian Bow, Wes Penberthy; Member, VAS, Waverley Art
Society, Old Watercolour Society Club; AGRA.
Exhibitions Regularly with VAS and art groups in Victoria. Since 1975 has won twenty five
first prizes in Melb. art competitions; Showed recently at Five Ways Galleries, Vic. 1989.
Represented Public and private collections in UK, Japan and Australia.

SMITH, Heather VIC
Born Vic. Painter and printmaker.
Exhibitions One-woman show at Australian Galleries, Melbourne 1981.

SMITH, Janet VIC
Born Melbourne 1952. Ceramic artist.
Studies BA, Monash University; Dip. Art & Design, Victoria College.
Exhibitions Distelfink Gallery 1984; Seal Gallery 1983; Gryphon Gallery 1983; Arts &
Craft Society, Melbourne 1983.
Bibliography *150 Victorian Women Artists*, Visual Arts Board/WAM 1988.

SMITH, Joan NSW
Born Roseville NSW 1916.
Studies Workshop Arts Centre, Willoughby NSW under Elizabeth Rooney (etching), Sue
Buckley (woodcut), David Rose (serigraphy).
Exhibitions With Sydney Printmakers and Print Circle annual exhibitions in NSW; Held
one-woman shows in Sydney 1969, 1972, 1974; Beth Hamilton Gallery, Sydney 1988;
Christchurch NZ 1980–88.
Awards Tamworth Print Prize 1973; Two Taree Purchase Prizes 1973; Kempsey Open
Prize 1975; Narrabri Graphic Prize 1975.
Bibliography *PCA Directory* 1988.

SMITH, Kate QLD
Born England 1947, lived mostly in NZ arrived Australia 1980. Painter, printmaker, potter.
Studies Mostly self-taught, some tuition in printmaking at art school, Auckland University
and Auckland Tech College; Griffith Uni. Qld.

Exhibitions First solo show at Lady Hamilton Gallery, Auckland 1974; Auckland Exhibition Centre 1977; Participated at Helensville NZ 1975, 1976; Marlborough 1977; Commercial gallery groups 1979–81; NZ Printmakers in Australia 1981; Field Workshop, Melbourne 1981. In recent times at The Blue Marble Gallery, Buderim.

Awards Warragul Rotary, Vic WC Award 1981; Nerang Festival 1983; Toowoomba, Moreton, Caloundra, Aberdare, Caboolture, Beenleigh, Suncorp.

Represented Auckland City Library; New Zealand Embassy, Bahrain; Private collections throughout Australia, New Zealand, Switzerland, America, Canada, Scotland and England.

SMITH, Kathie NSW

Painter, graphic designer, printmaker.

Studies Graphic Design Diploma, SCOTA 1977; Graduate Diploma in Professional Art Studies, City Art Institute 1984; BA Conversion Course, SCOTA 1985; Graphic Designer with News Ltd 1978; Graphic Designer at AVSU Macquarie University 1978–.

Exhibitions Macquarie Uni. 1981, 83; Images Gallery 1984; Excelsior Gallery 1985; Seymour Centre 1983–85; Mosman Gallery 1988.

Awards Macquarie Uni. 1981, 83; Southern Cross 1983.

Represented Institutional and private collections in Australia and overseas.

SMITH, Lindy Rose NSW

Born Sydney 1950. Ceramic artist, potter, teacher.

Studies ESTC 1973; School of Colour and Design, Certificate 1983–84; Hornsby TAFE, Certificate 1984–85; Brookvale TAFE, Certificate 1987; BA (Ceramics), SCOTA 1988–89. Member, Crafts Council of NSW 1976–; Studio supervisor SCOTA 1989–; Editorial committee of 'Pottery in Australia' 1990–; Taught art at Hornsby TAFE part-time 1985–89 and from 1990–.

Exhibitions Solo show at Djuric Galleries, Sydney 1991; Many group shows include Balmain Galleries 1984; Hornsby College of TAFE 1985; Brookvale College of TAFE 1987; SCOTA Gallery 1988; Pier 13 Graduates Show 1989.

Represented Institutional and private collections.

SMITH, Lynn TAS

Born Hobart 1961. Printmaker, photographer.

Studies S of A, Uni. of Tas. 1978–81; SCOTA 1983; MFA from S of A, Hobart 1985.

Exhibitions Barcelona, Spain 1981; Crafts Council Gallery, Hobart 1982; ACP, Sydney 1982; Developed Image Gallery, Adelaide 1984.

SMITH, Mahgo VIC

Born Belfast, Northern Ireland 1929. Painter in oil, watercolour, pastel and charcoal; Teacher.

Studies Willesden Institute of Technology, London UK 1950–53; Lived in London and Borneo before coming to Australia in 1960. Teaches at her own studio and also part-time at Chisholm Institute of Technology, Melbourne 1972–75; Philip, State College of Vic at Coburg 1975; Council of Adult Education, Melbourne 1975.

Exhibitions Solo shows at Princes Hill Gallery, Melbourne 1966; Gallery 99, Melbourne 1971; Emerald Gallery, Vic 1972; Bartoni Gallery, Melbourne 1977; Wm Drew Gallery, Kyneton Vic 1977; Solander Gallery, Canberra 1977; Studio Gallery, Melbourne 1977; Bartoni Gallery, Melbourne 1978; Zanders Bond Gallery, Melbourne 1981; Devise Gallery, Melb. 1989; Participated at Contemporary Art Society 1964–68 Vic; Leveson Gallery, Melbourne 1964; Toorak Gallery 1970; Inez Hutchinson, Beaumaris Vic 1971–72; Andrew Fairley, Shepparton, Vic 1972; McClelland Gallery Summer Show, Vic 1976; Clive Parry Gallery 1976–77 Melb; Studio Gallery, Melbourne 1978; Wiregrass Gallery, Melbourne 1978; Century Gallery, London 1979; Women's Art Forum, Melbourne 1979–81; The

Gentle Art, McClelland Gallery, Vic 1982; Women's Images, Prahran Gallery, Vic College 1982.

Awards Resident for five months at the Karolyi International Foundation for Artists and Writers at Vence, South France 1979.

Represented Philip, State College of Vic at Coburg; Extensively represented in private collections in Australia, also in private collections in Ireland, London, Italy, Canada, Japan, Hong Kong, Malaysia, New Zealand and USA.

SMITH, Mary Farquhar TAS

Born Zeehan Tas 1905. Traditional painter in watercolour.

Studies Launceston Technical College under Hope Evershed and later with Geoff Tyson and Alan McIntyre. Vice-president of the Launceston Art Society and council member for over thirty years.

Represented Many private and institutional collections throughout Australian and New Zealand.

SMITH CLARK, Robyn VIC

Born Warragul, Vic. 1951. Ceramic artist and designer.

Studies Bendigo CAE.

Exhibitions Craft Board, Bendigo; Tarrawingee Country Crafts, Beechworth; Meat Market Craft Centre, Melbourne; The Old Barn, Bright, Vic.

Bibliography *150 Victorian Women Artists*, Visual Arts Board/WAM 1988.

SMITH, Rose QLD

Born Vic. Japanese Brush Painter, designer, textile artist.

Studies Dip. Dress Design from RMIT. Studied in Tokyo during the 1960s and on return graduated with Art Certificate from Seaforth TC and Dip. Art (Painting) from the City Art Institute; Now specialises in textiles. Member, Australian Forum of Textile Arts, Craft Council of Qld., and the Embroiderers Guild.

Exhibitions The Blue Marble Gallery, Buderim.

SMITH, Treania NSW

Born Brisbane Qld 23rd December 1901. Landscape painter in oil.

Studies During the early 1920s Treania attended the Meldrum Art School and later studied sculpture at the Technical College, Melbourne; Departed for Europe in 1928; After some time in London, commenced studies at the Edinburgh College of Art, under among others, Alexander Carrick (sculpture) and William Gillies (drawing and painting); Returned to Australia at the end of 1930 and settled in Sydney as her father was then the Government Architect of NSW. Continued painting and also attended sculpture classes at the East Sydney Technical College under Rainer Hoff from 1932–34; Through meeting Beryl Young at these classes she later met John Young and in 1936 became his assistant at Macquarie Galleries.

Exhibitions Held one-woman exhibitions at Macquarie Galleries in 1934, 1935 and 1936; Exhibited with Society of Artists 1932–49 and was elected member of the Contemporary Group in 1936 and continued exhibiting with this group and in mixed exhibitions at Macquarie Galleries in the 1940s and 1950s; In 1938 in partnership with Lucy Swanton she took over Macquarie Galleries where she remained director until 1976; solo show at Painters Gallery, Sydney 1982, 85.

Represented Private collections in Vic, NSW, Qld, UK and Europe.
(Died 1990)

SMYRNIOS, Tina VIC

Born Egypt 1957. Printmaker.

Studies BA, RMIT 1976–78; Dip. Ed. Melb. CAE 1979–80; VPW 1982; Worked UK, Europe 1989.
Exhibitions Solo shows at Christine Abrahams Gallery 1983, 87, 91; Numerous group shows include Rudy Komon Gallery 1977; Print Show to Victorian Regional Galleries 1984; PCA 1988; MPAC 1988; Ballarat CAE 1988; ROAR Studios 1989; Gertrude St. Artists Space 1989; ANG 1989; Swan Hill Regional Gallery 1990.
Awards 100 x 100 PCA; Print Portfolio Commission 1988.
Represented Regional Galleries; Institutional and private collections.
Bibliography *PCA Directory* 1988.

SNELL, Audrey C. VIC
Born Sydney NSW 1922. Traditional painter of landscapes and still-life in oil.
Studies National Gallery School, Melbourne 1939–45 under Charles Wheeler and William Rowell.
Exhibitions Regular exhibitor with the 'Twenty Melbourne Painters' Group and has had one-woman shows in Melbourne and Vic and NSW country centres; Landscape hung in the Royal Institute, London.
Awards Rutherglen Centenary Art Prize, Vic and Corowa NSW Art Prize 1971.
Represented Private collections in Australia and overseas.

SOLLING, Wendy NSW
Born Maitland NSW 1926. Sculptor.
Studies East Sydney Tech College under Lyndon Dadswell and for a short time at the Slade School of Art, London UK; Worked in London 1947–51 and then freelanced in Sydney until 1956 when she entered an enclosed contemplative order of Anglican nuns in the UK and returned to Australia in 1975 and as Sister Angela founded a new house at Stroud NSW.
Exhibitions Apollinaire Galerie, London UK 1951 and David Jones' Gallery, Sydney 1952.
Bibliography *Australian Sculptors*, Ken Scarlett, Nelson 1980.

SOMERSET, Patti NSW
Born Sydney NSW 1939. Abstract and expressionist painter, printmaker and teacher.
Studies Diploma of Physiotherapy, Sydney 1960; Painting and drawing part-time at Hornsby Technical College 1972; Workshop Art Centre, Sydney 1970–73; Bachelor of Arts in Visual Arts, City Art Institute 1982 and Postgraduate Diploma 1983; Has taught children's art at WAC since 1978; Member, World Print Council and the PCA; Study tours to UK, Europe and USA 1978–83.
Exhibitions Solo shows at Holdsworth Contemporary Galleries, Sydney 1987, 88; With Sydney Print Circle since 1975 and more recently Blaxland Gallery, Sydney and Cologne W. Germany 1982; Manly Regional Gallery 1980, 1981, 1983; Old Bakery Gallery 1981; Painters Gallery 1982 and work included in Exhibition of Miniature Prints to tour Australia 1984; Workshop Arts Centre 1984–87; von Bertouch Galleries, Newcastle, 1986; 70 Arden St, Melb. 1988; PCA 100 x 100 Commissioned Print Portfolio 1988.
Bibliography *Directory of Australian Printmakers* 1988.

SOUTHGATE, Myrna NSW
Born Sydney NSW 1931. Watercolour painter, mostly self-taught, but some tuition Nance Le Merle; Known also for her drawings of historical buildings in the Parramatta area; A folio of drawings was published by St Georges Terrace Gallery 1978.
Exhibitions Solo shows at St Georges Terrace Gallery; Lochiel House Gallery; Kenthurst Arts and Crafts and Fantasy Fair Gallery, Dural.
Awards Orange Blossom Festival and Castle Hill Show 1973, 1975, 1976, 1978.
Represented Institutional and private collections around NSW.

SPAFFORD, Judy VIC
Born Melbourne 1941. Painter and photographer.
Studies Dip. Fine Art and Fellowship, Fine Art, RMIT.
Exhibitions Solo show at Clive Parry Gallery, Warrnambool Regional Gallery.
Bibliography *150 Victorian Women Artists*, Visual Arts Board/WAM 1988.

SPAOJEVIC, Natalia VIC
Born Albury NSW 1959. Sculptor.
Studies Alexander Mackie SAE graduating with B. Art Education 1980 and Postgraduate at VCA Melbourne 1985.
Bibliography *150 Victorian Women Artists*, Visual Arts Board/WAM 1988.

SPARKE, Franki ACT
Born Newcastle NSW 1953. Printmaker.
Studies Dip VA, Canberra S of A.
Exhibitions Solo shows at Sporting Roundup, ACT 1982; My Place, ACT 1987.
Bibliography *PCA Directory* 1988.

SPARKS, Catriona NSW
Born Sydney 1965. Photographer and designer.
Studies BA Visual Arts from City Art Institute 1984–86.
Exhibitions Artarmon Galleries 1989.
Awards Bulletin-Mumm Black & White Photographic Prize 1988.

SPATHAROS, Bessie NSW
Born Zante Greece 1960, arrived Australia 1966. Printmaker, painter and teacher.
Studies Diploma of Applied Arts from Riverina CAE, Wagga NSW 1979–81; Works and teaches at Sidestreet Studio, Wagga.
Exhibitions Participated at Darling Downs Printmakers 1980; Wagga Regional Gallery 1981; Riverina CAE 1982.

SPEIRS, Dawn VIC
Born Echuca, Vic. 1934.
Studies Dip. Fine Art, CIT 1978–80.
Exhibitions MPAC 1983; World Trade Centre 1983–88.
Bibliography *PCA Directory* 1988.

SPEIRS, Susie VIC
Born Vic. 1949. Post-contemporary painter.
Studies Uni. of Melb; One year Arts; Prahran TC Dip. Art 1967–70; Studied India 1970–74 and extensively in UK, Europe, Africa, USA over eight years.
Exhibitions Solo shows at Heyday Gallery, Melb. 1979, 80, 83; Howard St. Gallery, Perth 1981; Bang Bang Gallery, Bangalow NSW 1984; Wm. Mora Galleries, Melb. 1988.

SPENCER, Jan NSW
Born Albury 1954. Printmaker and papermaker.
Studies Armidale College of TAFE 1982–86. Printmaking, papermaking, Art Certificate. Studied UK, Europe 1985, Japan 1986; Artist-in-Residence Dept. Education Northern NSW 1986 and Accessible Arts Sydney 1987.
Exhibitions Solo shows at Access Gallery 1988, 89, 90, 91; Participated Fenwicke House, Walcha NSW 1987; Rondeau Gallery 1988; Access Gallery 1987, 88.
Represented Artbank; Institutional and private collections in UK, Europe, Japan and Australia.

SPICER, Vera NSW
Born West Wyalong NSW 1926. Traditional painter of colourful Australian landscapes in oil; Fellow of the Australian Institute of History and Art.

SPILSBURY, Margaret SA
Born Qld. Traditional landscape painter.
Studies Brisbane TC.
Exhibitions Miller Anderson Gallery, Adelaide; Ocean St. Gallery, Victor Harbor, SA.
Represented Institutional and private collections around Australia.

SPIVAKOVSKY, Ruth VIC
Born Germany of Austrian parents, arrived Australia 1939. Painter, mostly with pencils; Sculptor.
Studies Kunstakademy Vienna 1937; Worked as fashion designer 1938; Has joined with a group of artists in France to develop her different 'painting with pencils' technique; Member of Vic Artists Society and the Malvern Artists Society.
Exhibitions VAS 1978, 1982, 1983; Malvern Artists Society 1982; Manyung Gallery 1981; Caulfield Arts Centre 1980, 85; Participated at Vaison La Romaine, France; Galerie Zwinger, Hamburg W Germany; London UK.
Awards Caulfield Arts Centre (drawings); VAS (sculpture).
Represented Caulfield City Council Collections and private collections in UK, Europe and Australia.

SPOGIS-ERDMANIS, Vija NSW
Born Latvia 1938. Painter, designer and teacher.
Studies Graduated from National Art School, East Sydney Technical College with Design Diploma, First Class Honours and the College Medal Award; Worked as a designer with a larger textile firm for some years and successfully participated in textile design award exhibitions; Lectured in design at the East Sydney Technical College 1962–70 and studied graphic arts at the University of NSW; Over several years designed sets for the Vienna Theatre and the Latvian Theatre, Sydney, seventeen in all, and won several awards.
Exhibitions Six solo shows, Sydney Latvian House.
Awards Waratah First Prize 1963; Southern Cross, Hornsby, Drummoyne, Katoomba, Griffith 1975; Lithgow 1976; Much of her time is taken up with teaching, lecturing, seminars, summer and weekend schools and art societies.

SPOWART, Ruby QLD
Born Numurkah Vic 1928.
Studies Associate Dip. Visual Arts 1988– Qld C of A; Executive Director, Australia Photographic Society 1983–88; Co-director, Imagery Gallery, Brisbane.
Exhibitions Solo shows at Imagery Gallery 1985, 87, 88; Centre Gallery, Gold Coast 1985; Mackay City Library 1988; Shades of Ochre Gallery, Darwin NT 1989; Numerous group shows and recently at The Centre Gallery, Gold Coast 1988; Kodak Gallery, Sydney 1987, 88, 89, 90; China and Japan 1989; Numerous joint shows with son Doug Spowart 1983–91.
Awards McGregor Prize for Photography 1984, 85, 86, 87, 88, 89, 90, 91; Suncorp Award 1987.
Represented Regional Galleries, institutional and private collections.
Bibliography *A Homage to Women Artists in Queensland Past and Present:* The Centre Gallery 1988.

SPRECAPANE, Ivana WA
Born Italy 1946, arrived Australia 1973. Painter and poetess.
Studies Graduate of Fine Arts School of Brera. With a group of young artists has published

two Quaderni of alternative poetry.
Exhibitions Solo shows at Young Originals Gallery, Perth 1981 and in Italy.

STACEY, Robyn NSW
Born Brisbane 1952. Photographer.
Studies BA Fine Art, University of Qld; Currently completing MFA at University of NSW.
Exhibitions Solo shows at George Paton Gallery 1983; ACP, Sydney 1983; Mori Gallery
1985, 1987, 1989, 1990; Graphic Station, Tokyo 1989; Pomeroy Purdy Gallery, London
UK 1989; 200 Gertrude St. Melbourne 1990; National Art Gallery of NZ, Wellington
1991; Artspace, Auckland NZ 1991. Many group shows since 1980 and recently at ANG
1986, 88; Air Gallery London 1988; Esslingen Germany 1989; NGV 1989; Photographers
Gallery, London 1990; AGSA, AGNSW and QAG 1990–91.
Represented ANG, NGV, AGNSW, AGSA, QAG, institutional and private collections in
Australia and overseas.

STAMP, Susan VIC
Born Cooma NSW 1958. Painter and teacher.
Studies Dip. Art & Design, Victoria College, Prahran 1981. Currently teaching drawing at
Victoria College.
Exhibitions Solo show at Niagara Galleries, Melb. 1986; Numerous group shows.

STANLEY, Aileen WA
Born Jandee WA 1929. Traditional painter in oil and watercolour.
Studies Commercial art at Perth Modern School and worked as commercial artist for some
years; Studies painting with Henry Froudist, Dan Mazotte, Alan Baker; Exhibited regularly
with the Perth Society of Artists, also with the Centaur Group.

STANNAGE, Miriam WA
Born Northam WA 1939. Painter and printmaker.
Studies No formal art training; Travelled in UK, Europe, USA and Canada 1962–63;
Secretary of Contemporary Art Society of WA 1966–68; Occupied Power Bequest Studio in
Paris 1971; Has taught art part-time with Education Dept. of WA since 1971; Received
major grant from Visual Arts Board of the Australia Council 1974; Member of Printmakers
Association of WA.
Exhibitions One-woman shows at Old Fire Station Gallery, Perth 1970, 1973, 1975;
Hogarth Galleries, Sydney 1974, 1976, 1977; Tolarno Galleries, Melbourne 1975; Nolan
Room, University of WA 1976; Greenhill Galleries, Adelaide 1977; Hogarth Galleries
1980, 1982; Quentin Gallery, Perth 1981; ACCA, Melb. 1989; Major retro, AGWA 1989;
Participated in Bunbury Art Prize 1969, 1976; Albany Art Prize 1970; Old Fire Station
Gallery, Perth 1971, 1972; Contemporary Art Society of WA, Fremantle Arts Centre 1973;
'Young Contemporaries', Undercroft Gallery, University of WA 1974; 'Boxes', Ewing
Gallery, University of Melbourne; Georges Annual Invitation Art Prize (award for drawing)
Melbourne; In 1975 – 'Grid Show', Ewing Gallery, University of Melbourne; 'Art and the
Creative Woman', Royal Society of Arts, Adelaide; Perth Prize for Drawing International,
Art Gallery of WA; 'It's Great to be an Australian Woman?', Hogarth Galleries, Sydney; Old
Fire Station Gallery, Perth 1976; In 1976–77 – Annual Exhibition, Printmakers
Association of WA, Undercroft Gallery, University of WA; Print Award Exhibition,
Fremantle Arts Centre; 'Spectrum WA', Greenhill Galleries, Adelaide; Contemporary WA
Painters and Printmakers, Fremantle Art Gallery, Perth 1980; WA Artists, University of
WA, Perth 1981; Sydney Biennale, Art Gallery of NSW, Sydney 1982; 'The Seventies'
National Gallery of Vic, Melbourne 1982; WA Photographers, Australian Centre for
Photography, Sydney 1982; Critic's Choice Exhibition, WA Art Gallery, Perth 1982;
Australia Perspecta 1983, Art Gallery of NSW, Sydney 1983.

Represented Australian National Gallery; Art Gallery of WA; Power Institute of Contemporary Art; University of Sydney; Ararat Art Gallery, Vic; Bunbury Art Gallery, WA; University of WA; WA Institute of Technology; National Gallery of Vic and private collections.

Bibliography *Catalogue of Biennale of Sydney* 1982 and *Australian Perspecta* 1983, Art Gallery of NSW; *Art and Australia* 'Miriam Stannage', Ted Snell, Vol 20 No 2; *Artists & Galleries of Australia*, Max Germaine: Craftsman House 1990.

STARK, Laura NSW
Born Trieste Italy 1940. Painter, printmaker and teacher.

Studies Canterbury University School of Art, NZ 1956–60 and graduated with the Diploma of Fine Art; Obtained the NZ Diploma in Teaching; Studied printmaking at the Wellington Polytechnic (NZ) 1967–69; Studied and travelled in Europe 1964–66 and again 1979–80; Has taught art in secondary schools, technical colleges and university extension courses; teaching printmaking at St George Technical College, Sydney; President of Southern Printmakers Association 1982–83; Work until 1974 signed 'Steinberg'.

Exhibitions First major exhibition in Wellington NZ 1968 since then she had held seven solo shows in Sydney 1973–89 and participated in many important group exhibitions, including the NZ Print Council Regional Exhibition Wellington 1972; the Warrnambool Print Prize Exhibition 1973 and the Sydney Print Survey 1980; Q Gallery, Sydney 1983; Print Circle 1984; Nine Printmakers, Sydney 1986; Drummoyne Gallery 1989; Print Circle, Braemar Gallery, Springwood 1990.

Awards Drummoyne 1984; Southern Cross 1983–86.

Represented Government collections in Wellington NZ and Canberra, Warrnambool Technical College collection and private collections in NZ and Australia.

Bibliography *Directory of Australian Printmakers* 1982, 88.

STARK, Marguerite VIC
Born London UK 1931. Painter, teacher.

Studies Regent Street Polytechnic, London 1950, arrived Australia 1954; studied Nat. Gallery School, Melb. 1957–58 and Reshid Bey portrait classes 1959–64; President Hawthorn Artists Society 1987–.

Exhibitions Solo shows at Waverley City Gallery, Melb. 1986, and retrospective show 1958–88 at AMP Square, Melb. 1988; Further solo show at the new Marguerite Stark Gallery 1990.

Represented Institutional and private collection in UK and Australia.

STAUNTON, Madonna QLD
Born Murwillumbah NSW 1938. Paintings, drawings and collage.

Studies Moved to Brisbane 1951; Studied with her mother, Madge Staunton and under Roy Churcher, Jon Molvig, Bronwyn Thomas, Nevil Matthews.

Exhibitions One-woman shows at Ray Hughes Gallery, Brisbane 1976, 1977, 1978, 1980, 1983; IMA 1979; Garry Anderson Gallery, Sydney 1984, 1988; Her work was included in a travelling exhibition by the University of Qld and at the Biennale of Sydney 1979; Art Gallery of SA, Adelaide Festival 1980; Kelvin Grove CAE, Brisbane 1980; CAS Gallery, Adelaide 1980; Ray Hughes at Pinacotheca Gallery, Melbourne 1981; 'Nine Qld Artists', Townsville Regional Gallery 1981; *Australian Perspecta* 1983, 1985 AGNSW; Uni of Qld. Art Museum 1985; Qld AG 1985, 87; Ipswich City Council Gallery 1986, 87; Holdsworth Contemporary Galleries, Sydney 1987; The Centre Gallery, Gold Coast 1988.

Represented ANG; AGNSW; AGWA; Artbank; New Parliament House, Canberra; Numerous Regional Galleries, institutions and private collections in Australia and Japan.

Bibliography *Catalogue of Australian Perspecta* 1983, Art Gallery of NSW; 'Six Brisbane Artists', *Art and Australia*, Vol 18 No 4; *A Homage to Women Artists in Queensland Past and*

Present, The Centre Gallery 1988.

STAVRIANOS, Wendy ACT
Born Melbourne Vic 1941. Modern landscape painter and teacher.
Studies Diploma of Fine Art, RMIT 1957–60; Hermitage, Geelong Vic – teaching
1961–62; Overseas study, mainly Greece, Italy and England 1962–63; Part-time teacher at
RMIT 1963–64; Attended Coburg Technical College as teacher 1966–67; Taught at Emily
Macpherson College 1967–68; Taught at MLC Hawthorn, Vic 1968–69; Studied printmak-
ing at RMIT 1969–70; Taught at Caulfield Grammar School 1970–71; Teaching trip to
Bali 1971–72; Lecturer at Darwin Community College 1973–74; Part-time lecturer at
Canberra Art School 1978–83.
Exhibitions Solo shows at Princes Hill Gallery, Melbourne 1967, 1968; Flinders Gallery,
Geelong 1974; Tolarno Gallery, Melbourne 1976, 1978; Ray Hughes Gallery, Brisbane
1979; Gallery A, Sydney 1980, 1982; Heide Gallery, Melb. 1985; Greenhill Galleries, Perth
1987; Tolarno Galleries, Melb. 1987; Participated Sherwin Gallery, Sydney 1980; Canberra
School of Art 1982; Gallery A 1982; The Art Gallery, Melb. 1989.
Awards Visual Arts Board Grant – Special Projects 1978; MPAV Drawing Festival
Acquisition Award 1977.
Represented Australian National Gallery; National Gallery of Vic; Darwin Art Gallery;
Philip Morris Arts Grant Collection, Canberra; National Bank Collection; Private collec-
tions in Australia, Germany and New York USA.
Bibliography *LIP* 1978–79, page 40.

STEAD, Christine NSW
Born Australia. Painter, illustrator, graphic artist, all media.
Studies East Sydney Tech College. Worked for some time as a fashion illustrator.
Exhibition Joint show of 'Sports' paintings with Otto Schmidinger at Roseville Galleries,
Sydney 1982.

STEDMAN, Jeanette NSW
Born Sydney NSW 1918. Representational painter of landscapes in oil, gouache, water-
colour, pen and ink.
Studies On a scholarship grant at East Sydney Tech College 1936–40; Formerly part-time
teacher at National Art Schools in design, oil and watercolour until 1973.
Awards Wollongong Prize (for both oil and watercolour) 1956; Albury Prize (oil) 1956,
1958; Concord Council Prize (oil) 1957; Wollongong Prize (watercolour) 1960; Royal
Easter Show, Rural Bank $1,000 Prize, traditional oil painting 1963.
Represented Private collections in Australia and overseas.

STEEL, Pennie QLD
Born UK 1947. Painter, teacher. Arrived Australia 1969.
Studies Bournemouth College of Art, UK 1965; Dip. Art Ed. Alexander Mackie CAE
1972; BA Art Ed. 1974; Grad. Dip. Fine Art SASA 1984; Taught art from secondary to
TAFE levels 1971–89.
Exhibitions Solo shows at SASA 1985; Studio, Hahndorf 1986; Gallery 48, Hahndorf
1987; Noosa Regional Gallery and Hyatt Regency, Coolum 1989; Numerous group shows
include Blue Marble Gallery, Buderim 1990.
Awards Sunshine Coast Show 1987, 88.
Represented Corporate and institutional collections.

STEINMANN, Evelyn NSW
Born Bathurst NSW 1959. Painter of wildlife and nature, sometimes surrealist mainly in
acrylic; Sister of artist Heinz Steinmann, no formal art training.

Exhibitions Her paintings of the wilderness of Cape York Peninsula were seen in a joint exhibition with her brother at the Age Gallery, Sydney in 1978, 1979; Further shows at Holdsworth Galleries 1981; Sydney Opera House 1980; Upstairs Gallery, Cairns 1981, 1982; Art World, Brisbane 1982; Tonnoirs Gallery, Townsville 1982; Pacific International Hotel, Cairns 1987; Atelier Gros Greutmann, Zurich 1988; Fine Art Gallery, Cairns 1989; Eldelers Gallery 1989; Holdsworth Galleries 1990.

Represented Private collections around Australia, USA, UK, Europe.

STEPHENS, Bonnie QLD

Born Glen Innes NSW 1919. Traditional painter in oil and watercolour.

Studies East Sydney Tech College 1934–37 with Raynor Hoff, Jean Isherwood, Herbert Gallop and worked as freelance fashion artist for David Jones, Farmers and others in Sydney.

Exhibitions Numerous solo and group shows over the years and a solo show at Young Masters Gallery, Brisbane 1981.

Awards Inverell purchase 1966; Macquarie 1980; Wyong Purchase 1981; Ipswich 1980.

Represented Institutional and private collections in UK, USA, Canada and Australia.

STEPHENSON, June Ethel VIC

Born Melbourne Vic. Decorative realist painter.

Studies Gained Diploma from National Gallery School, Melbourne 1945; Later with George Bell 1957–59; Foundation member and president of Beaumaris Art Group, two years; Member of Melbourne Contemporary Painters, Contemporary Art Society, Vic Artists Society and Women Painters Society; Study tour overseas in 1966; Foundation member of the Essentialist and Figuratives Now Groups in 1967.

Exhibitions One-woman shows at Argus Gallery, Melbourne 1963; Johnstone Gallery, Brisbane 1965, 1969; Pinacotheca Gallery, Melbourne 1967; Town Gallery, Brisbane 1975, 1977; Clive Parry Gallery 1978; Town Gallery, Brisbane 1980, 1983, 1986, 1988, 1991; Leveson Gallery, Melb. 1981, 1985; Cooks Hill Gallery, Newcastle 1982; Swan Hill Regional Gallery 1982; Bloomfield Gallery, Sydney 1984; Anvil Gallery, Vic 1987; Jarman Gallery 1990; Swan Hill Regional Gallery 1991. Many group shows.

Awards Crown Lynn Pottery Design Prize (NZ) 1962; Australian Fabric Design Award, Sydney 1966; Inez Hutchinson Award for Painting, Melbourne 1967; Toowoomba City Art Prize (acquisitive) 1975; Caloundra *Sunday Sun* Prize Acquisitive, Qld 1976; Lismore 1978; Gold Coast John Cooper Award 1980; Qld Art Gallery Trustees 1980; Artbank; Swan Hill Purchase 1985.

Represented Qld AG; Artbank; Numerous Regional Galleries, institutions and private collections in UK, Europe and Australia.

Bibliography *Australian Naive Painters*, Bianca McCullough, Hill of Content, Melbourne 1978; *Figuratives Now – Five Australian Painters*, Elizabeth Young, Melbourne 1972; *Encyclopedia of Australian Art,* McCulloch, Hutchinson, Melbourne 1977; *Who's Who of Australian Women*, Methuen; *A Homage to Queensland Women Painters Past and Present*, The Centre Gallery 1988; *Artists & Galleries of Australia*, Max Germaine: Craftsman House 1990.

STERK, Gabriel SA

Born Europe 1942, arrived Australia 1956. Sculptor of animals and portraits in bronze.

Studies In Italy and later at the Academy of Fine Arts, Amsterdam.

Exhibitions Murray Crescent Galleries, Canberra 1976, 1978; Leveson Street Gallery, Melbourne 1979; In Holland at the Arti et etmecitiae, Rokin Amsterdam, Willy Schoots, Eindhoven and Park Gallery, Mannits St, Utrecht 1976, 1978; Also exhibits at his own gallery and sculpture park at Hahndorf SA; Has recently set up the Adelaide Art Foundry at Aldgate where almost any size bronze sculptures can be cast.

Awards Silver Medal for Sculpture, Prix de Rome; Portrait Award, Institute de France.

Represented Many works in private collections all over the world such as Amro Bank building in Rotterdam, Amsterdam, Utrecht, Zwolle, Alkmaar and many other Dutch cities; Paramambo South America, Venice Italy, Canberra and Melbourne.

STERK-GREGOIRE, Helen SA
Born Europe 1946. Painter of landscapes, figures, portraits in oil and watercolour.
Exhibitions Amsterdam, Utrecht, Hilversum and Adelaide.
Awards Gold Medal, Prix de Rome 1969; Hilversum Art Award 1972.
Represented Town Hall, Breukelen; Rotterdam Bank, Amsterdam; Ouderyn Hospital, Utrecht and many personal portrait commissions.

STEVENSON, Noel Madelon VIC
Born Melbourne Vic 1937. Australian landscape watercolour painter. Founder and director of Gallery 21, Lower Templestowe.
Studies Early training in watercolours by the late Ken McDonald at Vic Artists Society; Member, Vic Artists Society and Old Watercolour Society's Club, Australia. Conducts specialist watercolour classes.
Represented Private collections in Australia, UK and USA.

STEWART, Elsie Davidson NSW
Born Sydney NSW. Watercolour painter and graphic artist.
Studies Diploma of Art from East Sydney Technical College 1940; Exhibits with AWI.
Represented Private collections in UK, USA, Hong Kong, NZ and Australia.

STEWART, Pauline Marie VIC
Born Melbourne Vic 1936. Traditional painter in oil and watercolour.
Studies Oil painting Vic Artists Society, Melbourne 1973–74; Several well-known Vic teachers 1974–79; Studied watercolour 1979–80; Member of Australian Guild of Realist Artists; Vic Artists Society; Sherbrooke Art Society.
Exhibitions Sherbrooke Art Society, VAS and numerous group shows.
Awards Kew Rotary 1982; BP Australia Prize 1981; Lilydale 1981; Thooruna 1980; Marylands 1979.
Represented Private collections in Australia and overseas.

STEWART, Sydney Joy (Dickens) QLD
Born Geelong Vic 1925. Painter, designer and potter.
Studies Swinburne Technical College Art School 1941–45; National Gallery Art School 1946–48; Worked as display artist at Science Museum of Vic; Designer and painter of pottery at the Guy Boyd Pottery; Display artist at Myers 1954–67; Kew Gallery, part-time 1971–78; Foundation member and secretary, Kew Historical Society 1976–81.
Exhibitions One-woman show at Myers 1968; Gallery de L'Isle, Melbourne 1969; ANZ Bank 1975; National Trust, Newcastle NSW 1976; Grafton Gates, Cairns 1983; Cairns Museum 1984; Christy Palmerson Gallery, Port Douglas 1985; Grafton House Galleries, Cairns 1985, 86, 87.
Commissions Kew Historical Society Bicentennial Tapestry 1988.
Publications *Cairns Kaleidoscope* Nos 1, 2, 3, 1987, 88, 89.

STEWART-ELLIS, Maggie SA
Born Ararat, Vic. 1939. Arte-decoupage artist and teacher.
Studies After four years of study and experiment has turned a 17th century art form into a 20th century concept.
Exhibitions Solo show at Greenhill Galleries, Adelaide 1990; Group shows include Barry Newton Gallery, Adelaide 1990 and The Wilderness Exhibition, Adelaide 1991.

STEWART-HALL, Philippa J.C. NSW
Born Sydney 1941. Painter.
Studies Hornsby TC 1976; B.Ed. Art, Alexander Mackie CAE 1977, Postgraduate Dip.
1981; Hon. Degree TBC, Macquarie Uni. 1983; Overseas in UK, Europe, USA and Asia.
Exhibitions Solo shows at Holdsworth Contemporary Galleries 1988; Gallery One 1986;
Macquarie Uni. Staff Club 1985, 86; Group shows include Bloomfield Galleries 1984; Mori
Gallery 1985; King St. Gallery 1987; Del Bello Gallery, Toronto, Canada 1986, 87, 88.
Represented Institutional and private collections in UK, Europe, USA, Canada, Asia and
Australia.

STIMSON, Margaret (Peg) NSW
Born Sydney NSW 1930. Printmaker.
Studies Workshop Arts Centre, Willoughby NSW under Sue Buckley; Exhibits with
Sydney Printmakers and Sydney Print Circle.
Bibliography *Directory of Australian Printmakers* 1976.

STIMSON, Mary VIC
Born Norfolk, UK 1947, arrived Australia 1984. Painter, sculptor, teacher.
Studies Chelsea College of Art and the Camberwell College of Art & Craft, London;
Chisholm IT, Melbourne. Taught art at Salisbury College of Art, UK and at Newchurch,
Kent UK.
Exhibitions Fortnum & Mason Gallery, London; Chisholm College and Watermark
Galleries, Melbourne 1988; Coventry Gallery, Sydney 1990.
Represented Municipal, institutional and private collections in UK and Australia.
Bibliography *New Art Five*, Nevill Drury: Craftsman House 1991.

STIPNIEKS, Margarita (Klebach) SA
Born Latvia 1910. Painter.
Studies Latvian State Academy of Art under G. Eliass.
Exhibitions One-woman shows, John Martin Gallery, Adelaide 1955; With artist Ludmilla
Meilerts, Melbourne 1956; Osborne Gallery, Adelaide 1962; North Adelaide Gallery 1966,
1972; City of Hamilton Art Gallery, Vic 1966; The Block Gallery, Melbourne 1967; White
Studio Gallery, Adelaide 1969; North Adelaide Gallery 1972; Lombard Street Gallery
1978; Group shows in Latvia, Germany, France, Belgium and USA.
Represented National Gallery of SA; Public galleries in Hobart, Perth, Hamilton and
Castlemaine.

STIRLING, Jill QLD
Born Brisbane Qld 1929. Impressionist landscape painter in watercolour and oil.
Studies With William Bustard, watercolour and stained glass artist 1946–47; Julian
Ashton School, Sydney 1948–49 under Henry Gibbons; Landscapes with Lloyd Rees; Arts
Council Vacation schools under various tutors.
Exhibitions Creative 92 Gallery, Qld.
Awards Toowoomba Qld and Royal Show 1969, 1982.
Represented Rockhampton Regional Gallery and private collections in UK, NZ and
Australia.

STIRLING, Liz VIC
Born Melbourne 1961. Painter.
Studies BA, Painting, RMIT 1979–81; Berlin 1983; Uganda 1983–84; Studio, Rome and
Cité Internationale des Arts, Paris 1986; Studio Gertrude St. Artists Spaces 1987–.
Exhibitions Solo shows at Realities, Melb. 1983; Village Voice, Paris 1984; Gertrude St.
Studio 1987; Numerous group shows include 'What is this Thing Called Science?' at Melb.

Uni. Gallery 1987.

Awards VAB Paris Studio 1985; VSB, Desiderius Orban Award 1987.

Represented Institutional and private collections in UK, Europe and Australia.

STOCKILL, Barbara NSW

Born London UK 1943, arrived Australia 1979. Painter and portraitist; Studied art in UK.

Exhibitions Switzerland 1971, 1972; England 1973; Holdsworth Galleries, Sydney 1981; Hilton Gallery, Sydney 1983.

Represented Private collections in UK, Europe, USA and Australia.

STOKES, Constance (Parkin) VIC

Born Miram Piram Vic 1906. Traditional painter.

Studies National Gallery, Melbourne under Bernard Hall; Won travelling scholarship 1929; Studied under Walter Russell and William Mornington at Royal Academy School, London 1930–34; Also during that time went to Paris to study at the school of Andre L'Hote.

Exhibitions Returned to Melbourne in the mid 1930s and exhibited with the Contemporaries and the George Bell Group; Her work was chosen to represent Australia in the show sent to USA by Pro Sizer for the Carnegie Institute in 1941; Four weeks sent to London in 1953 were shown at Burlington House and then in Venice; Major one-woman show at Leveson Street Gallery, Melbourne 1964; *Constance Stokes Paintings and Drawings 1939–74*, Mornington Arts Centre 1974; Included in *Heroic Years* Exhibition 1978; One-woman show at Australian Galleries, Melbourne 1981.

Represented ANG; NGV; AGSA; Institutional and private collections.

Bibliography *Encyclopedia of Australian Art*, McCulloch, London 1968; *Australian Painting*, Bernard Smith, Melbourne 1971; Joseph Brown Gallery, Illustrated catalogues, spring 1972, winter 1972–73, autumn 1973; *Alice 125*, Gryphon Gallery: University of Melbourne 1990.

STOKES, Kerry WA

Born Camperdown NSW 1949. Painter, printmaker, sculptor and teacher.

Studies Diploma Fine Art, Perth Technical College 1967; Graphic Artist STW Channel 9 Perth 1966–70; Graphic artist Selfidges Department Store London 1972–73; Taught Fremantle AC 1978–80; Perth TC 1978–81; Goroka PNG 1983; Perth TC 1984–87; Fremantle AC 1988; Broome Regional Prison 1990–91.

Exhibitions Numerous solo shows include New Collectables Gallery, Perth 1987, 88; Fremantle AC and Fremantle ACT 1988; Numerous groups shows since 1967.

Awards City of Stirling 1981; Katanning Shire 1985; Williams Award 1986; Travel Award WADA 1987; Mural — Alligators Nightclub 1989; Shinju Matsuri Festival Broome, Sculpture Prize 1990.

Represented AGWA; Institutional and private collections in UK, Europe, USA, PNG and Australia.

STOKES, Pip VIC

Born Perth WA 1951. Painter and photographer.

Studies Dip. Ed. and Fine Arts, University of Melbourne.

Exhibitions Solo show at The Verandah Gallery, Sydney 1982; Participated at Chrysalis Gallery, Melbourne 1985.

Bibliography *150 Victorian Women Artists*, Visual Arts Board/WAM 1988.

STOKES, Sally NSW

Born Sydney 1952. Painter.

Studies Meadowbank TC 1971; BA Fine Arts, Flinders University SA 1972–75; Hornsby

TC 1976–78; ESTC 1979. Studied overseas UK, Europe 1972–73, USA 1981. Europe and the East 1989.

Exhibitions Solo shows at James Harvey Gallery, Sydney 1984; Sweet Jamaique Gallery, Melbourne 1988; Pelican Palace Gallery, Sydney 1990. Numerous group shows since 1981.

STOKES, Wendy NSW
Born Wellington NSW 1957. Painter and printmaker.
Studies Newcastle CAE 1976–79, majored in printmaking for Diploma; Grad. Dip. SCOTA.
Exhibitions Solo shows at Thrumster Galleries, Port Macquarie NSW and Blue Goose Gallery, East Gosford NSW 1982; Bridge Street Gallery 1991; Participated in many group shows including Hogarth Galleries 1980; Blaxland Galleries 1980, 1981, 1982, 1983, 1990; Sydney Printmakers Travelling Show 1982 to regional NSW galleries; University of NSW 1982; Warrnambool Regional Gallery, Vic 1983; Print Biennale, Seoul, Korea 1987.
Awards Port Macquarie 1978, 1979, 1980, 1981, 1982, 1983; Wellington 1978, 1981; Boggabri NSW 1980, 1981; Gosford 1981; Bathurst Purchase 1981; Mudgee Acquisitive 1982.
Represented Bathurst Regional Gallery; Municipal collections at Narrabri, Grafton, Gosford, Mudgee and private collections in Australia and Canada.

STONE, Phyllis (Grandma Stone) NSW
Born Rushworth Vic 1905. Naive painter.
Studies After a wide formal education decided to take up painting seriously when aged 52. Spent six years at East Sydney and Newcastle National Art Schools. Overseas study tours 1956, 1961, 1973.
Exhibitions von Bertouch Galleries, Newcastle 1966; Gallery A 1967; Powell Street Gallery, Melbourne 1968, 1971; Newcastle Regional Gallery 1969; Hunter Vallery 1972; San Francisco 1973; Mixed shows 1974–77; Manyung Gallery, Melbourne 1978; Civic Centre, Orange NSW 1979; Art of Man Gallery 1978; Seekers Gallery, Kings Cross 1980; Woolloomooloo Gallery 1987.
Represented Australian National Gallery; Newcastle Regional Gallery; Bendigo Regional Gallery; Newcastle University Collection; The Floating Art Gallery, Sweden and many private collections in Australia and overseas.

STONELEY, Ruth QLD
Born Qld 1940. Textile artist, quiltmaker, designer.
Studies Informal workshops with David Green 1976; Rachel Mason 1976; Jutta Fedderson 1978; Darani Lewers 1981.
Exhibitions recent solo shows include QVMAG, Launceston 1986; Burnie AG 1987; Crafts Council, Hobart 1987; Roz MacAllan Gallery Brisbane 1988; Many group shows since 1974 include Meat Market, Centre, Melb 1983, 84; UK, USA 1984; Japan 1985; Indonesia 1985; Japan 1987; Texas USA 1987; Salzburg, Austria 1988; Tamworth NSW 1988.
Awards Churchill Fellowship to USA 1986.
Represented QAG; AGWA; QVMAG; Institutional and private collections in UK, Europe, USA, Japan, Indonesia, Korea and Australia.
Bibliography *A Homage to Women Artists in Queensland*, The Centre Gallery 1988; *Artists & Galleries of Australia*, Max Germaine: Craftsman House 1990.

STONER, Dorothy Kate TAS
Born Sussex UK 1904. Spent childhood in Canada. Figurative painter in oil, pastel, gouache, watercolour; Teacher.
Studies University of Tas and Hobart Technical College under Lucien Dechaineux and Mildred Lovett; George Bell, Melbourne 1939; Anglo-French Art Centre, Paris; Académie

Chaumiere under Yves Brayer and Eduard McEvoy; Study tour Europe 1949–51; Refresher course at East Sydney Technical College under Godfrey Miller, John Passmore, Dorothy Thornhill 1961; Foundation member of CAS Melbourne; Lecturer in art, Launceston 1936–40 and Hobart Technical College 1940–64.

Exhibitions One-woman shows at El Dorado Gallery 1967; University of Tas 1969; Devonport Little Gallery 1969; Saddler's Court 1975; Queen Vic Art Gallery, Launceston 1978; Devonport and Salamanca Place Gallery 1978; Powell St, Melbourne 1982; TMAG 1983; Retrospective show 1938–1987 at Freeman Gallery, Hobart 1987. Participated in many competitions, viz Archibald, Portia Geach, Blake; Tas State Gallery; Royal Institute of Oil Painters, London; *Womens Weekly* Travelling Show, Tas House, London; Captain Cook 1978; National Gallery of Vic.

Represented Tas Museum and Art Gallery; Queen Victoria Museum and Art Gallery, Launceston; Devonport Gallery; Christian College, Hong Kong; NGV, Institutional and private collections.

Bibliography *Tasmanian Artists of the 20th Century,* Sue Backhouse 1988.

STONES, Elsie Margaret UK
Born Melbourne Vic 1920. Botanical artist.
Studies National Gallery School and Swinburne Tech College, Melbourne; Principal contributing artist to Curtis's Botanical Magazine, UK from 1958. Lives in London.
Exhibitions Solo shows in Melbourne and Sydney 1947–51; Colnaghi's Gallery, London 1952, 1967, 1971, 1973; Qantas Gallery, London 1967; Commonwealth Institute, Edinburgh 1968; The Hague 1968; Melbourne 1968.
Publications An impressive list includes *Snowdrops and Snowflakes* 1956; *Modern Rhododendrons* 1956; *Modern Shrubs* 1958; *Modern Trees* 1961; *The Endemic Flora of Tasmania* 1967–75.
Represented Australian National Gallery; State Gallery of Vic, NSW, Qld and SA; Many institutional and private collections in UK, Europe, USA and Australia.

STRAMPP, Adriane Beth VIC
Born Wisconsin, USA 1960; Contemporary painter in oil, arrived Australia 1977.
Studies Graduated BA, Fine Art, Victoria College, Melb. 1981–84.
Exhibitions Solo shows at Reconnaissance 1986; Holdsworth Contemporary, Sydney 1988. Participated ROAR Studios 1984; Greenhill, Perth 1983, 86, 87, 88; Heide Park and Gallery 1988; Moët & Chandon Touring Exhibition 1990.
Awards Eltham Shire 1988.
Publications *Wildflowers of King's Park*, published by The Western Mail, Perth, WA. *A Year of Orchids*, published by Richard Griffin, Melb.
Represented Institutional and private collections in UK, Europe, USA and Australia.
Bibliography *Alice 125*, Gryphon Gallery: University of Melbourne 1990.

STRANO, Shirley QLD
Born Brisbane 1933. Contemporary landscape painter, potter, printmaker.
Studies QIT in 1950's. Diploma Course, Qld C of A 1977; Study tour to USA 1983.
Exhibitions Downs Gallery, Toowoomba, Beta Gallery, Caloundra, Geoffrey Hoisser Gallery, Brisbane.
Represented Private collections in Australia and overseas.

STRONG, Valerie NSW
Born Singleton NSW. Intimist landscape painter and teacher.
Studies East Sydney Technical College 1955–60; Teaching creative drawing and portraiture at Hornsby Technical College, NSW to 1990; Presently teaching at the Seaforth College of TAFE.

Exhibitions Hung in Art Gallery of NSW Trustees WC Prize competition 1983; Showed at Galaxy Gallery, Sydney 1990.

SULIKOWSKI, Margaret VIC
Born Melbourne 1963. Painter, printmaker, teacher.
Studies B. Fine Art (Painting), RMIT 1982–84; MA (Printmaking) RMIT 1987–88. Since 1985 part-time lecturer in printmaking at RMIT.
Exhibitions Solo show at Powell Street Graphics 1989; Numerous group shows since 1983 include Bathurst, NSW 1984, 86, 87; MPAC 1986; Fremantle Print Award 1987, 88; PCA 1988; Henri Worland, Warrnambool 1989; MPAC 1990.
Awards Bathurst, Printmaking 1986; Fremantle Print Prize 1987; Goldfields Print Prize, Ballarat 1988; Yarra Valley Print Prize 1988, Dr. Haig and Dr. Armitage Printmaking Travelling Scholarship, RMIT 1988; Diamond Valley Award, acquired 1989.
Represented Institutional and private collections in Poland and around Australia.

SUMBERG, Nora VIC
Born Bairnsdale, Vic 1956. Painter and teacher.
Studies Dip. Fine Art, CIT 1973–76; Postgrad. New York Studio School 1978; Dip. Ed. Melb. State College 1979; Taught part-time at Chisholm IT, Melb. 1987–88; Currently lecturer in painting in RMIT.
Exhibitions Solo shows at Stuart Gerstman Galleries, Melb. 1980, 82; 13 Verity St. Melb. 1987, 88; Group shows include Geelong Regional Gallery 1980; Linden Gallery 1986, 89; Heide Park and Gallery 1987; *A New Generation 1983–88* at ANG Canberra 1988; 13 Verity St. Melb. 1987; Michael Wardell Gallery 1988; ACCA, Melb. 1988; RMIT Gallery 1988.
Awards Peter Brown Memorial Scholarship 1978; VAB New York Studio School 1978; VAB Besozzo Studio Italy 1982; VAB Grant 1988; St Kilda City Council Acquisition Drawing Prize 1989.
Represented NGV, Institutional and private collections in UK, Europe and Australia.

SUMNER, Denise NSW
Born Sydney 1949. Painter and arts administrator.
Studies RASNSW 1968. Director, Copperfield Gallery, Mosman 1972–76; Assistant at AGNSW 1976–83.
Awards Meadowbank TC Child Prize 1962, 63; RASNSW Scholarship 1969, 70 Ryde Portrait Award 1989.

SUSSEX, Marian Roscoe QLD
Born 1916. Painter and printmaker.
Studies BA (Hons.) University of Melbourne 1938; BA (Painting & Printmaking) University of Melbourne 1983.
Exhibitions Solo shows at Eltham Gallery 1985, 87, 89; Ikari Art Gallery, Nagoya, Japan 1989.
Represented MPAC, municipal and private collections in Australia and overseas.

SUTHERLAND, Lilian NSW
Born Newcastle NSW. Semi-traditional painter in oil, watercolour, pen and wash.
Studies Newcastle Technical College.
Exhibitions Strawberry Hill Gallery, Sydney 1970, 1971, 1972, 1976; Toorak Art Gallery, Melbourne 1971; von Bertouch Gallery, Newcastle 1973, 1978, 1983; 1985, 1988; Wagner Gallery, Sydney 1982, 1984, 1986; Mosman Gallery, Sydney 1975; Munster Arms Gallery, Melbourne 1977, 1979; Participated in 'Australian Art' Exhibition, Kuala Lumpur 1963; Exhibition by four women artists, Canberra 1971; Exhibition by five artists, Toorak Gallery, Melbourne 1972; Australian Contemporary Paintings and Graphics in Focus Hong Kong

Arts Centre, Hong Kong 1985; Recent Watercolours, Wagner Gallery 1988; Australian Painters, Hong Kong 1988.

Awards Bradford Cotton Mills Prize, Maitland NSW 1962; Traditional Prize, Muswellbrook NSW 1963; Traditional Prize, Tumut NSW 1964; Religious Prize, Albury NSW 1964; Modern Watercolour, Cheltenham NSW 1967; 'Human Image', Royal Easter Show, Sydney 1969.

Represented Australian National Collection; Manly Art Gallery; Muswellbrook Council Collection; Conzinc Rio Tinto Collection; Newmont (Australia) Ltd Collection; St Vincent's Hospital, Vic Collection; Private collections throughout Australia.

(Died 1989)

SUTTON, Dorothy VIC
Born Burma 1922, arrived Australia 1949. Semi-traditional painter in oil of historical sub-jects and portraits. Works with Vic Dept of Education.

Studies Art Teachers Diploma from Leeds College of Art, UK 1940–44.

Exhibitions With Royal Society of Portrait Painters; International Society of Women Painters and Royal Scottish Academy.

Represented Private collections in Australia and overseas.

SUTTON, Rosalind Harvey NSW
Born Sydney NSW. Traditional painter and portraitist.

Studies Graduated Bachelor of Arts Diploma of Education with honours from Sydney University; Studied with Sir William Dargie, Melbourne and at the Julian Ashton School, Sydney.

Exhibitions Beth Mayne Studio Gallery, Geo Styles Gallery, Parker Gallery; Legacy Gallery, Sydney.

Represented Australian War Memorial, Canberra; Corporate and private collections around Australia.

SWAN, Merrilee NSW
Born Wollongong NSW 1942. Painter.

Studies Art Certificate 1979, Post Certificate 1982 Wollongong TC; Associate Diploma in Arts Wollongong Uni. College 1985.

Exhibitions Solo show at Holdsworth Contemporary Gallery 1986, 88; Group shows Wollongong City Gallery 1985; Coventry Gallery, Sydney 1984.

Represented Institutional and private collections.

SWANN, Terry NSW
Born Sydney 1942. Watercolour painter and teacher.

Studies NAS 1972–73. Taught at Roseville Community Arts Centre 1981–89.

Exhibitions Solo shows at Holdsworth Galleries 1978, 82, 84, 86, 88; Bahrain, Middle East 1988; Included in Warana Festival, Brisbane 1990. Subjects include Qld rainforest regions and old mining areas.

Awards Ku-ring-gai Watercolour Prize 1976, 77.

Bibliography *Australian Watercolour Painters*: Jean Campbell, Craftsman House 1989.

SWARBRICK, Barbara VIC
Born Manchester UK 1945, arrived Australia 1973. Textile designer, printmaker and ceramic artist.

Studies Bolton College of Art, UK 1961–65; National Diploma, design, lithography and printed textiles 1965; Leeds University, Institute of Education 1965–66; Art Teachers Diploma 1966; Taught art and craft in comprehensive schools, UK 1966–73; Worked in a Studio Pottery, Devon UK 1973; Began ceramic sculptures after being inspired by

Indonesian art.
Exhibition Craft Purchase Exhibition, Melbourne 1978.

SWEENEY, Elizabeth QLD
Born Bendigo, Vic. Painter, designer, teacher.
Studies RMIT; Worked as a fashion designer in London and Melbourne; Taught in Victorian Technical Schools; Worked and studied in UK, Europe, Canada and Fiji.
Exhibitions Noosa Regional Gallery; Centre Gallery, Gold Coast; Vincent Gallery, Adelaide.
Represented Institutional and private collections in UK, Europe, Canada, Fiji and Australia.

SWEENEY, Rebecca QLD
Born Cairns 1961. Painter and teacher.
Studies Dip. Fine Art, Townsville TAFE College 1981–83; Graduated as Secondary Art Teacher, Kelvin Grove 1984; Studied Europe 1983; Has taught art at various schools since 1985, presently part-time at Johnstone College of TAFE and Innisfail High. Toured Burma 1987.
Exhibitions Martin Gallery, Townsville 1988; Palms Gallery Townsville 1988; Pacific International, Cairns 1989.
Awards Pacific Festival Open 1983; Townsville 1988 (shared); Innisfail Art Society; Capricorn Gallery, Melb. 1988; Galaxy Gallery, Sydney 1989; Qld Wildlife 1989.

SWEN, Hiroe NSW
Born Kyoto, Japan 1934. Painter, ceramic and batik artist, teacher, gallery director.
Studies Under Master Painter J. Iwata, Kyoto 1949–54; Ceramics at Kyoto Crafts Institute 1957–58; apprenticed to Master Potter Heihachiro Hayashi 1957–62; Arrived Australia with husband Cornel 1968; Member Potters Society of Aust; Part-time teacher Canberra TC 1971–73; appointed lecturer in Ceramics, Canberra S of A 1981; Co-director of Pastoral Gallery, NSW with husband Cornel. Has had many solo shows in Japan and Aust. since 1957; Her tenth being at David Jones, Sydney in 1981; Conducts many workshops, exhibits jointly with her husband and permanently at Pastoral Gallery. Numerous group and touring shows.
Represented ANG; AGNSW; AGSA; TMAG; QAG; AGWA; Regional Galleries, Embassies, institutions in UK, USA, Japan and Australia.

SYMONDS, Beverly Joan (Kent) NSW
Born Melb. Painter.
Studies ESTC by Commonwealth scholarship to gain Dip FA. Worked in advertising and commercial art for many years. Fellow and Councillor of RAS of NSW. Member AWI.
Exhibitions Many shows include Tininburra Galleries, Tamworth 1988.
Awards Southern Cross 1987; Tumut 1987; Liverpool West Rotary 1988.
Represented Corporate and private collections.

SYMONDS, Carole NSW
Born Sydney NSW 1936. Sculptor, painter and teacher.
Studies Julian Ashton School, Sydney 1960–65; Taught art, experimented with polarised light and kinetics, and trained as an electronic technician 1965–73 including four overseas study tours.
Exhibitions Held shows of kinetic art at Macquarie Galleries, Sydney 1970, 1971 and Holdsworth Galleries 1975.
Awards Helena Rubinstein Prize 1966, 1967; Corio 1967, 1968; NBN, Channel 3 Prize 1968; H.C. Richards Memorial Prize 1968, 1969; Perth Drawing Prize 1970; VAB Grant

1976.
Represented University of NSW; Shalom College.
Bibliography *Australian Sculptors,* Ken Scarlett, Nelson 1980.

SYMONS, Suellen NSW
Born Newcastle NSW 1955. Photographer and teacher.
Studies Dip. Art. Alexander Mackie CAE 1981; Grad. Dip. Ed. Sydney CAE 1982; BA,
City Art Institute 1983; Postgrad Dip. Photography 1984.
Exhibitions Solo shows include Avago Gallery, Sydney 1987; CAC, Adelaide 1987;
Solander Galleries, Canberra 1988; Adams Nat. Bank, Washington DC 1989; Many group
shows.
Awards VAB Grant 1985; Australia Council New York Greene St. Loft 1988.

SZARUKAN, Eliza VIC
Born Hungary 1927, arrived Australia 1949. Painter of genre subjects.
Studies Privately in Hungary 1940–43 and at Atelier Fur Kunst, Austria 1945–48;
Member of Australian Guild of Realist Artists.
Exhibitions Solo shows at Greenwich Gallery, Melbourne 1978, 1979 and Fiveways
Gallery, Kalorama Vic 1982, 1984, 1985, 1987, 1988; Waverley City Gallery, Melb. 1984,
1986, 1988, 89.
Represented Municipal, institutional and private collections in UK, Europe and Australia.

SZELECZKY, Annemarie VIC
Born Budapest 1945. Painter and teacher.
Studies Caulfield IT under Fred Cress. Currently teaching life drawing at Victoria College,
Prahran.
Exhibitions Solo shows at Chevy Chase Gallery 1982; Leveson Gallery 1984; Group shows
at Argus Gallery 1966; MPAC 1983; ROAR Studios 1985.
Bibliography *Alice 125*, Gryphon Gallery: University of Melbourne 1990.

SZULC, Rose Marie VIC
Born Melbourne 1956. Textile artists and designer.
Studies BA Textile Design, RMIT 1981–83. Australian Network for Art & Technology 1990.
Exhibitions Solo shows at RMIT Union 1983; Crafts Council of NSW, Ararat Gallery and
Blackwood St. Gallery 1989; Adelaide Festival Centre 1991. Many group shows since 1985
and currently the International Travelling Quilt Exhibition 1991–93.
Awards Fibres Award, Mornington Peninsula 1988; Balnarring Craft Event, Vic. 1989.
Represented Institutional and private collections around Australia and overseas.

T

TABACCO, Wilma VIC
Born Italy 1953, arrived Aust. 1957. Painter, printmaker, teacher.
Studies BA, Dip. Ed., Uni. of Melb. 1970–73; Dip. Fine Arts, PIT 1979–81. Taught art at
VCA, Melb. 1985–87; Lecturing at School of Visual Arts, University of Melb. 1989–91.
Exhibitions Solo shows at Niagara Galleries, Melb. 1988, 89, 91; Holdsworth Contemporary
Gallery, Sydney 1988. Numerous group shows include Reconnaissance, Melb. 1986;
Fremantle Print Award and MPAC 1987; Swan Hill Regional Gallery 1987; PCA Touring
Show 1988; PCA — 70 Arden St. 1988; ACAF, Melb. 1988, 90; Ballarat Fine Art Gallery
and MPAC 1988; Niagara at Watters 1989; Linden Gallery, Melb. 1989; Niagara at Hill-
Smith, Adelaide 1990; University of Tas. 1990.

Awards VA/CB Overseas Residency, Italy; PCA Print Commission 1988.
Represented ANG; Artbank; Institutional and private collections in UK, Europe, USA and Australia.
Bibliography *PCA Directory* 1988; *Artists & Galleries of Australia*, Max Germaine: Craftsman House 1990.

TALACKO, Judy (Grave) VIC
Born Melbourne Vic 1942. Floral and landscape painter and portraitist.
Studies Diploma of Art from RMIT; Left Australia in 1971 to live in Sweden when her accountant husband was transferred there; They returned to Melbourne in 1980.
Exhibitions Solo shows in Melbourne and Echuca 1964–67; Five in Sweden 1976–79; Manyung Gallery, Mt Eliza Vic 1980 and Massan Gallery, Gothenberg Sweden 1982; Participated in twelve group shows 1969–80 including five in London UK and four in Sweden.
Represented In public and private collections in Australia, England, France, Sweden, Canada, Germany, NZ, Panama and USA.

TALBOT, Jennifer VIC
Born Melbourne Vic 1941. Painter, printmaker, writer and teacher.
Studies City and Guilds of London Art School 1964–65; Obtained degrees in Law and Arts from University of Melbourne and Diploma in Painting from National Gallery Art School, Melbourne; Has taught art for the Council of Adult Education and the Cheltenham and Brighton Art Groups.
Exhibitions One-woman shows at Argus Gallery 1969; Thirty-nine Steps Gallery 1969; Gallery 99 1971; Hawthorn City Gallery 1972, 1974; VAS 1976, 1977, 1979; Participated Mornington Peninsula Art Centre 1976; Ewing Gallery, University of Melbourne 1977; Portland Arts Centre 1978; VAS 1978; Niagara Gallery 1984; Wilderness Society 1988.
Awards Grace Joël Scholarship.
Represented Institutional and private collections in UK, Europe and Australia.
Publications *Whales* by Jennifer Talbot, Greenhouse 1981.

TALBOT, Mary OVERSEAS
Born Melbourne Vic 1931. Illustrator and painter.
Studies National Gallery School, Melbourne and later in UK, Europe.
Exhibitions Sydney and Melbourne 1957; New Art Centre, London 1959; Jeffress Gallery, London 1961; Galeries Jean Giraudoux, Paris 1962.
Represented National Gallery of Vic and corporate and private collections in UK, Europe, USA and Australia.
Bibliography *Australian Watercolour Painters 1780–1980*, Jean Campbell, Rigby 1982.

TANKE, Elizabeth (Liz) QLD
Born Dungog, NSW 1941. Paintings and collage, teacher.
Studies Kyogle High School and Newcastle Teachers College, summer schools and workshops.
Exhibitions Numerous shows in Qld since 1981 and recently at The Centre Gallery, Gold Coast 1988.
Awards Kyogle Festival 1982; Tweed Festival 1984, 85; Gold Coast Purchase 1985, 86.
Commissions Mural artist for Sitmar Cruise Lines 1986. NSW Ed. Dept Grants 1981, 82, 83, 84.
Bibliography *A Homage to Women Artists in Queensland, Past and Present*, The Centre Gallery 1988.

TANNER, Carol QLD
Born England 1935. Painter, printmaker.

Studies Qld University Vacation Schools with Churcher and Rapotec; University of New England with Sibley, and visual arts course at Kedron CAE; Dip VA, Graphics 1986; Studied in France 1988.
Exhibitions Solo shows at Boston Gallery, Brisbane 1980, 87; Ardrossan Gallery 1985; Gallery Image, Armidale 1986; Carawah Gallery 1987, 88.
Awards Peter Stuyvesant, Cairns 1964; Garden City 1977; Brisbane Warana 1981 (shared); Caloundra WC 1985; Cairns WC 1988.
Represented Private collections in NSW, Qld and overseas.

TANNER, Lynn NSW
Born Tas. Painter in oil and watercolour.
Studies With John Ogburn for six years.
Exhibitions One-woman show at Mosman Gallery, Sydney 1975 and presently at Delmar Gallery and Beth Mayne Studio Gallery, Sydney.
Awards Pring Prize 1973; Hornsby 1966.
Represented Private collections in UK and Australia.

TAPLIN, Bee FRANCE
Born Melb. 1911. Painter, stage designer, gallery director.
Studies Slade School, London 1929; Royal Academy, London 1931; Interior decorator in Melb. 1946–73, then mostly overseas. Established Galerie de la Panetiere near Cannes, France 1987.
Exhibitions Has shown widely including New York, Paris, Rome 1958; NGV, Melb. 1970; Qantas Gallery, New York 1973; Noumea 1983; Bath Festival, UK 1984; Paris 1988 and collection of textile designs at NGV 1988.
Represented Institutional and private collections in UK, Europe, USA, India, Sri Lanka, Noumea, Australia.

TAPP, Joan NSW
Born Hobart Tas. Impressionist painter in oil and watercolour; Portraitist.
Studies Diploma of Art from Hobart Technical College under Jack Carington Smith; East Sydney Technical College under Douglas Dundas; Swinburne Technical College, Melbourne under Laurence Pendlebury and Desiderius Orban School, Sydney; Art teacher at Seaforth Technical College 1973–83; Paints mostly on commission.

TARLING, Marjorie WA
Born Kings Norton UK. Painter and teacher, arrived Aust. 1911.
Studies BA, Claremont Teachers College WA 1921–24. Taught for Education Dept 1920–39, PLC 1942–78. Member, Perth Society of Artists.
Exhibitions Showed widely over the years including Newspaper House Gallery, Undercroft Gallery, Uni. of Perth and Perth Society of Artists.

TATAROVIC, Francies NSW
Born Sydney 1969. Installations and painter in mixed media.
Studies Dip. Fine Arts, ESTC 1987–90; Currently completing MA at City Art Institute.
Exhibitions The Works Gallery 1990; The Cell Block 1990; Arthaus 1991.

TAYLOR, Ann NSW
Born Brisbane Qld 1943. Contemporary painter and sculptor using Australian bush materials.
Studies National Art School, East Sydney 1959–64; Diploma of Art (painting).
Exhibitions One man shows: Macquarie Galleries 1968, 1971; Arts Council Gallery, Sydney *Season of Painters* 1972; Bonython Gallery, Sydney 1975; Art of Man Gallery, Sydney

1979; Balmain Art Gallery, Sydney 1980; Bloomfield Galleries, Sydney 1981; Roslyn Oxley Gallery, Sydney 1982; Group shows 1975–83 include Crafts Council Centre 1983; Penrith Reg. Gallery 1984 and QAG 1984. North Coast Installation at Lismore Reg. Gallery 1984.
Awards Robin Hood Art Prize 1980; Lane Cove Art Prize 1980; Maitland Purchase Prize 1981; Hunters Hill Craft Prize 1981; Robin Hood Art Prize 1981; Maitland Purchase Prize 1983; Blake Prize 1983 (shared).
Represented Maitland Art Gallery plus private collections in Australia and overseas.

TAYLOR, Bethwyn WA
Born WA. Painter of landscapes and seascapes in oil and pastel.
Studies Studied under private tutors; Taught part-time adult courses for ten years in philosophy and theology at University of WA and at Methodist Ladies College.
Exhibitions Fine Arts Gallery, Perth; Solo shows 1980, 1981, 1982.
Awards Melville Art Purchase 1980.
Represented England, Germany, Canada and Australia.

TAYLOR, Helen WA
Born India 1943, arrived WA 1952. Painter, printmaker and teacher.
Studies Started painting in 1961; Study tours to India, UK and Europe 1962; Studied Claremont Technical College WA 1972–74; Dip. Printmaking, Perth TC 1976; M. Fine Art, University of Tasmania 1984; Part-time teacher, WA Institute of Technology 1975; Member, Print Council of Australia and president of Printmakers Association of WA 1978–82; Lecturer at University of Tas. 1984, Perth TC 1985, 87, Curtin University 1987, 88–89, WACAE 1988–89, 90.
Exhibitions Annual exhibition, Printmakers Association of WA, Undercroft Gallery, University of WA 1974, 1977; Art Gallery of WA 1975; Print Award Exhibition, Fremantle Arts Centre 1976, 1977; In 1977, Australian Print Exhibition, Print Council of Australia, Tokyo, Kanagawa and Saitama Japan; Duplicate exhibition *Contemporary Australian Prints*, Art Gallery of WA and Suva Fiji; *Seven WA Artists*, Undercroft Gallery, University of WA; *Twelve WA Printmakers*, Arts Access, Fremantle Arts Centre, touring WA; Solo show at Bonython Gallery, Adelaide 1978; Tolarno Gallery, Melbourne 1979; Sydney 1980; Tas. S of A 1984; Praxis, WA 1985; Gallery 52 1987; Performance Space, Sydney 1987; Delaney Galleries, Perth 1991; Auckland NZ 1991; Participated at Fremantle Art Centre 1979; University of WA 1980; Women's Art Group, WA 1981; Second Western Pacific Print Biennale 1978; Australian Contemporary Printmakers to UK, USA, Canada 1979–84; Printmakers Association of WA 1981; Avago Gallery, Sydney 1983; Univesrity of NSW 1985; Praxis, WA 1986, 87; Air & Space, London UK 1986; AGWA 1988, 89; PICA, Perth 1989; Beach Gallery 1989; Adelaide Festival 1990.
Represented Australian National Gallery; Art Galleries of WA and SA; WAIT; University of WA; PCA Collection; VAB Collection; City of Fremantle; Wagga City Gallery; Clare CFE, SA; Waikato Art Museum, NZ; and private collections.

TAYLOR, Kristyn NSW
Born Wellington NZ 1959. Sculptor and ceramics artist.
Studies B. Sc. (Hons.) University of NSW 1977–81; Ceramic classes at Willoughby Art Workshop 1983–86; M. Psychology, Macquarie University 1985–88; Member Inner City Clayworkers Gallery 1988–90.
Exhibitions Numerous exhibitions since 1987 include Painters Gallery 1988; Beaver Galleries, Canberra 1988; Australian Naive Galleries 1990; Gallery Art Naive, Melbourne 1990 and solo show at Terracotta, Sydney 1990.
Awards Sculpture, Artcraft Bicentennial National Exhibition 1988.

TAYLOR, Sandra NSW
Born Sydney NSW 1942. Ceramic artist.

Studies Ceramics Certificate from East Sydney Technical College 1965–66.

Exhibitions Participated in International Ceramic Exhibition, Faenza Italy 1977; First one-woman show at Art of Man Gallery, Sydney 1977 followed by another at Realities Gallery, Melbourne 1978, 87; Robin Gibson, Sydney 1986. Exhibited in Sydney Biennale 1979.

Awards Gold Medal Credito Romagnolo, Faenza Italy 1977.

Represented National Collection, Canberra; Melbourne State College, Vic and private collections.

TAYLOR, Vera NSW

Born England, arrived Australia 1958. Marine painter, fashion designer, ceramic artist, printmaker.

Studies Worked as a dress designer and studied art in UK. Worked and sailed in a square-rigged sailing ship along the East Coast of Australia for some years. Member of The Print Circle.

Exhibitions Solo show at Seaways Gallery 1989; Group shows include Workshop Art Centre 1987, 88; First Fleet Re-enactment Exhibition at the von Bertouch Galleries, Newcastle 1988.

TAYLOR, Victoria (Vicky) VIC

Born Murray Bridge SA 1946. Printmaker, painter in oil, watercolour and gouache; Teacher and illustrator.

Studies Diploma in Teaching Art, SA School of Art 1967; Art and Craft teacher in secondary schools in SA and Vic 1967–74; Study tour of Europe and Asia 1975–76; Studied French language at the Alliance Francaise, in Paris France 1977–80; Worked as a printmaker at the Atelier de la Main d'Or in Paris 1977–80; Tutor in Printmaking at the Council of Adult Education, Melbourne 1981–83.

Exhibitions Solo shows at Jester Press, Melb. 1982; Wallace Bros. Gallery, Castlemaine Vic 1987; Tynte Gallery, Adelaide 1988; Wiregrass Gallery, Melb. 1988. Exhibited etchings with three other women printmakers at Cimaises Ventadour, Paris September 1979; Participated in an exhibition of etchings at Atelier 24, Paris April 1980; The Tynte Gallery, North Adelaide, *Four Melbourne Printmakers*, August 1981; The Fine Arts Gallery in Bendigo 1982; Assisted in the production of *Lillies at Dusk, an anthology of etchings*, by Paul Cavell in 1982; MPAC 1986; Swan Hill Gallery 1987; Atrim Pan Pacific Hotel, Kuala Lumpur 1988; Bridge St Gallery, Sydney 1988.

Represented Bendigo Regional Art Gallery; Swan Hill Regional Art Gallery; State Library Victoria; Education Department Victoria; Box Hill City Council; Private collections in Europe, Asia and Australia.

Bibliography *PCA Directory* 1988; *Artists & Galleries of Australia*, Max Germaine: Craftsman House 1990.

TEAKEL, Wendy NSW

Born Wagga NSW 1957. Sculptor.

Studies Riverina CAE 1977–79.

Exhibitions Solo show at Canberra C of A 1984 and with David Jensz at RCAE 1979 and Jam Factory, Adelaide 1980. Participated First and Second Sculpture Triennial, Melb. 1981 and 1984; Fourth Australian Sculpture Triennial, Melbourne 1990.

TEGEL, Nola NSW

Born NSW. Painter in many mediums.

Studies Dip. Art, RASNSW 1987.

Exhibitions Numerous shows in recent years and recent solo exhibition at Willandra Galleries, Sydney 1990.

Awards Recent prizes include Camden, Fishers Ghost, Fairfield; Macquarie Towns and

commissions from John Sands Calendars.
Represented Campbelltown Municipal Collection; Koshigawa City Collection (Japan) and private collections around Australia.

TEISSIER, Rose Marie WA
Born Tunisia, North Africa. Painter, designer, illustrator.
Studies Art Diploma from The Belvedere, Tunisia. Worked in the international film industry for some years in UK, Europe, USA, Malaya and Thailand.
Exhibitions Matilda Gallery and Stafford Studios, Perth WA.
Represented Princess Margaret Hospital for Children, Perth; Institutional and private collections in many countries and Australia.

TEMPLETON, Jane QLD
Born Qld. Landscapist in oil and watercolour.
Studies Art at her family's central Qld property with the help of the Flying Art School which she drove many miles to attend.
Exhibitions Two one-woman shows at Design Art Centre, Brisbane 1976–78; Of her first exhibition a critic wrote, 'the work of a talented, highly individual, instinctive painter'.

TENNANT, Cherry VIC
Born 1938, arrived Australia 1986. Painter, sculptor, teacher.
Studies Associate of Arts Degree (Hons.), College of Du Page, Illinois USW 1978; BA Studio Art, Scripps College, Claremont USA 1984; Santa Fe Institute of Fine Arts, New Mexico USA 1986; Grad. Dip. Ed., Hawthorn IE, Melb. 1989; MA Women's Studies, University of Melbourne 1991. Has taught art since 1971 in USA and the Middle East and recently at Monash University Arts & Craft Centre, Melb. 1989– . Chairperson, Women's Art Register from 1991.
Exhibitions Solo shows in Egypt 1982, 83; Chrysalis Gallery, Claremoint USA 1984; The Little Gallery, Melb. 1988. Many group shows since 1972 and recently at Qdos Gallery, Lorne, Vic. 1988, 89; Hibiscus Gallery, Hobart 1988–90; The Little Gallery, Melb. 1988.
Awards Phi Beta Kappa, USA 1978, 84; Royal Horticultural Society, UK, Grenfell Award 1974.
Represented Institutional and private collection in UK, Europe, USA and Australia.

THALBEN-BALL, Pamela NSW
Born London UK 1927. Traditional painter in oil and pastel; Portraitist.
Studies Heatherley Art School, London UK 1946–50; Secretary of the Chelsea Art Society, London 1964–68; Associate of RAS of NSW and member of Peninsula Art Society (NSW); Fellow, RASNSW 1985.
Exhibitions Walker's Galleries, London 1955; Chenil Galleries, London 1963, 1968; Sladmore Gallery, London 1972; Graduates Club, Sydney 1974; Macdonald Galleries, Sydney 1975, 1976; Yeppoon Qld 1979; Galeria Tapande, Canberra 1979, 1981, 1983, 1986; Tininbuna Gallery, Tamworth 1985, 89.
Awards Currabubula 1980, 1981; Royal Easter Show 1981; Goulburn 1981; Participated at Royal Academy, London 1974; Currabubula 1985.
Represented Australian War Memorial, ACT; Australia House, London and institutional and private collections in Australia and overseas.
Bibliography *Artists & Galleries of Australia*, Max Germaine: Craftsman House 1990; *Australian Impressionist & Realist Artists*, Tom Roberts: Graphic Management Services, Melbourne 1990.

THANCOUPIE, (Gloria Fletcher) QLD
Born Weipa NT 1937. Aboriginal painter and potter.

Studies Had her first introduction to the art world after meeting Ansett pilot, Percy Trezise, when he flew into her tribal country at Weipa in Cape York; Thancoupie exhibited bark paintings in a joint show with Dick Roughsey and Percy Trezise, in Cairns in 1962; Thancoupie was fascinated by the pottery studio then conducted by Trezise and eventually completed a three year diploma course at East Sydney Technical College; She now has her own studio at Trinity Beach, near Cairns. Much of her stoneware pottery and ceramic tile panels portray Aboriginal mythology and culture. Honorary positions previously held include: Member of Aboriginal Arts Board; Cultural Commissioner to South America; Director, Aboriginal Artists Agency, Sydney; Delegate, Festival of the South Pacific 1980, 84; Consultant to Aboriginal Cultural Centre, Trinity Beach, Cairns. Many design commissions and Artist-in-Residence projects.

Exhibitions Volta Gallery, Sydney 1972, 75; Heritage Gallery Cairns 1977; Realities Gallery, Melb. 1978; Marshall Gallery, Cairns 1980; Townsville Gallery 1981; Sao Paulo, South America 1986; Mexico City and Houston, USA 1986; The Centre Gallery, Gold Coast 1987; Hogarth Galleries, Sydney 1988; Aboriginal Artists Gallery, Sydney 1989; Many group shows since 1979.

Represented ANG, AGSA, QAG, NGV, Institutional and private galleries in Australia and overseas.

Bibliography *A Homage to Women Artists in Queensland, Past and Present*, The Centre Gallery 1988; *Artists & Galleries of Australia*, Max Germaine: Craftsman House 1990.

THERIOS, Voula VIC
Born Melb. 1965. Painter.
Studies VCA, Melb. 1982–85.
Exhibitions Her work was selected to hang in *A New Generation 1983–85* at ANG, Canberra 1988.

THEW, Joanne NSW
Born Sydney NSW 1952. Traditional painter with abstract qualities mostly in oil.
Studies East Sydney Tech College 1970–73; Fellow, RAS of NSW 1987.
Exhibitions Solo show at Saints Gallery, Sydney 1988; Group shows at Rainsford Gallery 1976, 81; RAS 1979, 82, 87.
Awards Has won over 100 prizes in local art shows since 1970.
Represented Institutional and private collections in UK, Europe, South Africa, Australia.

THIELE, Lexie NSW
Born NSW. Painter and ceramic artist, landscape architect.
Studies ESTA under Peter Rushforth and Mollie Douglas also awarded Certificate of Horticulture and Landscape Design at Ryde School of Horticulture. Member of Ryde Art Society, Ku-ring-gai Art Society and RASNSW.
Exhibitions Lennox Gallery 1981; Willandra Gallery 1982, 85, 90.
Awards Won twenty-three prizes in NSW local and country art shows 1982–90, and was joint winner of the 'Artist of the Year Award' by the Combined Art Societies of Sydney at Sydney Opera House 1991.

THODEY, Charlotte A. NSW
Born NZ 1951. Painter and illustrator.
Studies Salisbury UK and in Europe for four years. Worked as a fashion designer for two years. Has illustrated a number of books.
Exhibitions Solo shows at Exiles Gallery, Sydney 1980; Bathurst 1982; Royal Botanic Gardens, Sydney 1990; Participated at Orange Civic Gallery and Seasons Gallery, Sydney 1981.
Represented Institutional and private collections in UK, Europe and Australia.

THOMAS, Alison TAS
Born Hobart 1959. Painter, printmaker, teacher.
Studies Hobart S of A 1977–80; MFA 1983–84. Teaches with Dept. of Ed.
Exhibitions Uni. of Tas. 1984; Salamanca Place Gallery 1984; Particpated at Harrington St
1980; Long Gallery 1983; Chameleon Gallery 1984; Don Camillo 1984.
Represented Institutional and private collections in Aust. and overseas.

THOMAS, Beverley VIC
Born Melb. 1932. Painter, printmaker.
Studies B. Com., Uni. of Melb.; Dip. Ed., Monash Uni.; Dip FA, Chisholm IT 1979–82.
Exhibitions Solo show at Powell St Graphics 1984; Included in PCA touring shows to USA
and Japan 1984, 85; Swan Hill Reg. Gallery 1987.
Bibliography *PCA Directory* 1988.

THOMAS, Janet Elizabeth NSW
Born Sydney 1963. Painter.
Studies Europe, New York 1983–84.
Exhibitions Solo show at Eddie Glastra Gallery 1988; Installation at AGNSW 1982.
Represented Institutional and private collections in UK, Europe, USA, Australia.

THOMAS, Janet VIC
Born Melbourne Vic 1951. Realist painter in oil of animals, especially racehorses; No formal
art training; Works on commission for Racing Clubs, owners and trainers; Her painting of
Phar Lap was published as a print and her calendar of famous racehorses appeared for
Christmas 1983.

THOMPSON, Dorothy NSW
Born NZ 1953. Paintings, sculptures, assemblages, video and performance.
Studies SA School of Art in Diploma of Art (sculpture) 1976; Since her first one-woman
show at Contemporary Art Society Gallery, Adelaide in 1977 she has become known for her
bird paintings, particularly budgerigars and solo exhibitions at the Sculpture Centre,
Sydney in 1977, 1978 by Adelaide's 'budgie lady' attracted great interest; Group shows and
performances include, Sculpture, CAS Gallery 1974; *The Mask Show*, Mildura Arts Centre
1975; *Flash* and *Clothing*, CAS 1977; *Budgies vs Galahs*, Hi-jack by Guerilla Parro-tistes,
Mildura Sculpture Exhibition 1975; *Budgie Lecture*, Experimental Art Foundation, Adelaide
1976; *Budgie Bingo*, Mildura Arts Centre 1978; First Australian Sculpture Triennial,
Melbourne 1981; International Video Biennale, Guatemala 1978.
Bibliography *Art Network 3 & 4*, page 24.

THOMPSON, Maggie QLD
Born UK, arrived Aust. 1953. Genre painter, portraitist, teacher.
Studies Privately 1960–70 in Melb. and Sydney; Dip. FA from Townsville TAFE College
1987, teaches for TAFE.
Exhibitions Many shows since 1970 and recently at Martin Gallery, Townsville 1986 and
Perc Tucker Reg. Gallery 1987.
Awards First Prizes include Townsville Art Society 1985, 86, 87; Burdekin Art Society
1986, 87 RNA, Brisbane 1988; RQAS (joint) 1988; Brisbane Valley 1988.
Represented Institutional and private collections in UK, Europe, India, Japan, USA,
Africa, Australia.

THOMSON, Ann NSW
Born Brisbane Qld. Abstract expressionist painter, mostly in oil and acrylic.
Studies Privately under Jon Molvig; East Sydney Technical College 1957–62; Taught art,

Church of England Girls Grammar School, Darlinghurst 1963–74; Resident, Power Institute Studio, Cité Internationale des Arts, Paris 1978; Study tour of UK, Europe and USA; Lecturer in Drawing and Painting, Brisbane College of the Arts, Diploma Studies 1975–77; Part-time teaching at College of Advanced Education, Newcastle 1979–80; Part-time Lecturer at East Sydney Technical College, Sydney 1980; Resident Arthur Boyd Studio, Paretaio Colleoli Award, Italy, London, 1985.

Exhibitions Solo shows at Watters Gallery 1965; Ray Hughes Gallery, Brisbane 1973, 1976; Gallery A, Sydney 1974, 1977, 1979, 1982, 1983; Institute of Modern Art, Brisbane 1977; Monash University, Melbourne 1980; Christine Abrahams Gallery, Melbourne 1983; Coventry Gallery, Sydney 1984, 86, 90; Stadia Graphics Gallery, Sydney 1984; Michael Milburn Gallery, Brisbane 1985, 86; Australian Galleries, Melb. 1988, 89; BMG, Adelaide 1989. Numerous group shows since 1962 include *Landscape and Image* to Indonesia 1978; Canberra Times Show, ACT 1981; Macquarie University, NSW 1982; Musée de l'art Wallon, Liege, Belgium 1984; *Salute to Lloyd Rees*, Macquarie Galleries, Sydney; *Contemporary Australian Art*, The Warwick Arts Trust, London, UK; Galleriea Lillo, Venice, Italy; *Australian Perspecta '85*, Artspace, Sydney 1985; Coventry Gallery, Sydney 1986, 87; Touring exhibition of Regional Galleries of Queensland, *Australia on Paper* 1986–87; *Australian Works on Paper*, Aion Fine Art, Dallas, USA 1987; QAG, Blaxland Gallery, Sydney, AGNSW, *Australian Prints*, Bradford, UK 1988; Dempsters Gallery, Melb. 1988; Print Biennale, Bradford UK 1988–89; New England Regional Gallery 1988; ANG 1988; Coventry 1989; Ivan Dougherty 1990.

Awards David Jones Prize, Brisbane 1976; Visual Arts Board Grant 1978, 80; *Canberra Times* National Award 1980; University of New South Wales Purchase 1984; *The Sydney Morning Herald* Art Prize; Awarded Arthur Boyd studio in Tuscany, Italy 1985; John McCaughey Award, AGNSW 1986.

Commissions University of Queensland, Malley Refectory Mural 1977; Darling Harbour Convention Centre 1987.

Represented ANG; AGNSW, Artbank, QAG, Regional Galleries, institutional and private collections in UK, Europe, Australia.

Bibliography Catalogue *Landscape and Image*, Australian Gallery Directors' Council, Indonesia 1978; *A Homage to Queensland Women Artists Past and Present*, The Centre Gallery 1988; *Artists & Galleries of Australia*, Max Germaine: Craftsman House 1990.

THORPE, Lesbia (Lee Baldwin) VIC
Born Melbourne Vic. Painter, printmaker, teacher and theatre designer.
Studies Under Datillo Rubbo, Sydney for six years and printmaking in London with Gertrude Hermes for one year; Study tour, UK, Europe 1960–62; Japan 1965; Java and Bali 1970; Europe 1972–75; Taiwan 1976–78; Member of Wood Engravers Society of Great Britain and Royal Society; In recent years has been mainly engaged in woodcut printmaking.
Exhibitions One-woman shows at Minerva Gallery, Sydney 1941; Kozminski Galleries, Melbourne 1946, 1947, 1950; Georges Gallery 1949; Johnstone Gallery, Brisbane 1956, 1964; Royal SA Society of Arts 1959; Carrick Gallery, Tas 1960, 1964, 1966; Yoseido Gallery, Tokyo 1965; Arts and Crafts Society, Melbourne 1966; White Studio Galleries, Adelaide 1967; Robert Wardrop, Sydney 1971; Australian Galleries, Melbourne 1980, 1982; Holdsworth Galleries, Sydney 1980; Printmakers Gallery, Brisbane 1981; Tynte Galleries, Adelaide 1982; Barry Stern Galleries, Sydney 1982; Town Gallery, Brisbane 1984; Stanthorpe Reg. Gallery, Qld 1985; Australian Galleries, Melb. 1986; Freeman Gallery, Hobart 1988. Many shared and group shows including joint exhibition with William Salmon at Leveson Street Gallery, Melbourne 1966; Included in PCA travelling show 1980, in Australia and another show to Sweden.
Awards Vizard-Wholohan Prize 1958, 1964; Vic Artists Print Prize 1959; Geelong Print Prize 1963 and Portland Print Prize 1966; PCA Patrons Print 1982; Toowoomba Purcahse

1984, 85; Darling Downs 1985; Stanthorpe Purchase 1985.
Represented ANG; State Galleries in Vic, SA, NSW, WA, Qld, Tas, NT; Regional Galleries at Geelong and Hamilton, Vic; Bristol Education Collection, UK; Artbank; ICI Collection, Melbourne; Manchester UK; Gosford Shire; Deakin University, Vic; Canberra School of Art; Qld Institute of Technology; ABC, Adelaide, and private collections in Australia and overseas.
Bibliography *Encyclopedia of Australian Art*, McCulloch, Hutchinson 1967; *Directory of Australian Printmakers* 1988; *Artists & Galleries of Australia*, Max Germaine: Craftsman House 1990.

THRELFALL, Shirley WA
Born WA 1931. Traditional painter in oil and watercolour, mostly WA landscapes. Has won many prizes over the years but now only exhibits at Threlfall Galleries Mandurah WA.
Represented Institutional and private collections in UK, Europe, USA, NZ and Australia.

THURLOW, Elaine NSW
Born Aust. Painter and portraitist.
Studies Part-time at Newcastle Art School 1948–50 and Technical College Art School 1956–70; Previously worked as a commercial artist.
Exhibitions Solo show at Warabrook Gallery, Newcastle 1985. Group shows with Armstrong Gallery, Morpeth and von Bertouch Galleries, Newcastle 1973–88.

TICKNER, Pauline NSW
Born Camberwell Vic. Painter, printmaker and teacher.
Studies Inglesby Workshop 1973–76; Newcastle School of Art and Design 1978–81; Study tour to Japan 1982; Part-time teacher at Community Art Centres and WEA, Newcastle.
Exhibitions von Bertouch Galleries, Newcastle 1975; PCA Students 1979; Hunter Valley Artists 1981; PCA Exhibition 10 1982; Mornington Peninsula Art Centre 1982; Armstrong Gallery, Morpeth NSW 1983. Solo show at Morpeth Gallery NSW 1986; Participated Newcastle Reg. Gallery 1985, 88; Jam Factory, Adelaide 1986; Maitland and Muswellbrook Reg. Galleries 1986; Newcastle Contemporary Gallery 1987, 88.
Awards Valentine Spring Fair 1977, 1981.
Represented Westmead Medical Centre; Lake Macquarie Municipal Council; Newcastle Technical College; Vic Education Dept and private collections.
Bibliography *Directory of Australian Printmakers* 1982, 88.

TILBROOK, Lois WA
Born Perth WA 1943. Representational painter, some historical subjects in most media; Writer.
Studies Graduate Master of Arts in Anthropology from University of WA. Studied art at Midland Tech College and in Singapore 1965–69; Mostly self-taught.
Exhibitions Cremorne Gallery, Perth 1981; Pash Art Gallery 1981; Melville City Council Show 1981, 1982; Bunbury 1981; Albany 1981; Katanning 1981; Perth Society of Artists 1982; New Norca Benedictine Community 1982.
Awards Judges selection, Darlington 1980.
Publications Regular contributor to journals, has written a number of books including Nyungar Tradition: *Glimpses of Aborigines of South Western Australia 1829–1914*, University of WA Press 1983.

TILLER, Joan TAS
Born Wales, UK 1920. Painter, arrived Tas 1957.
Studies Hobart S of A 1975–77; Study tours to UK, Europe 1978, 82.

Exhibitions Numerous shows since 1971 include TMAG 1975; Uni. of Tas. 1977; Adelaide Festival 1978; Coughton Galleries, Hobart 1978; Salamanca Place Gallery, Hobart 1979.

Represented Institutional and private collections in Australia and overseas.

TILLEY, Lezlie NSW

Born Sydney 1949. Painter, illustrator, printmaker, teacher.

Studies ESTC 1967; Newcastle School of Art & Design 1973–75, 79–80; BA Visual Art, Newcastle CAE 1981–83; Illustrator with Hodder & Stoughton, Aust. 1984–85; Part-time lecturer, Newcastle School of Art & Design 1986–89.

Exhibitions Solo shows at Newcastle Contemporary Gallery 1988; Access Gallery, Sydney 1991. Many group shows since 1980 include Tynte Gallery, Adelaide 1981; Maitland City Gallery 1987; Gryphon Gallery, Melbourne 1988; von Bertouch Galleries, Newcastle 1990.

Awards NSW Special Art Scholarship 1967; von Bertouch Galleries Prize 1980; Dattilo Rubbo Prize 1984.

Represented Artbank; Maitland and Warrnambool Regional Galleries, private collections.

TIPO, Lolita QLD

Born 1968. Printmaker.

Studies Assoc. Dip Arts and Crafts — Aboriginal and Islanders, Cairns.

Exhibitions Kingston ACT 1986; Cairns, Qld 1986–87.

Bibliography *PCA Directory* 1988.

TIPPETT, Pamela NSW

Born Lismore NSW 1950. Painter, sculptor, teacher.

Studies Graduated B.Sc. — Uni. of Sydney 1972; Dip Ed. Canberra CAE 1973; Studio Simi, Florence, Italy 1977–80; Painted USA and Italy 1983–85; Currently teaching and painting in Sydney.

Exhibitions Papua New Guinea; Italy; USA; Lismore, NSW.

Awards Elizabeth Greenshields Foundation Grant to paint in rural France 1980. Finalist, Doug Moran Portrait Prize 1990.

Bibliography *Australian Impressionist & Realist Artists*, Tom Roberts: Graphic Management Services 1990. *Artists & Galleries of Australia*, Max Germaine: Craftsman House 1990.

TJANGALA, Caroline NT

One of the younger Pitjantjatjara Aboriginal batik painters from the Ernabella region which straddles the SA/NT border.

Exhibitions Bloomfield Galleries, Sydney 1989.

TODD, Sheila NSW

Born Dubbo NSW 1924. Impressionist painter of landscapes, mostly in watercolour.

Studies Sydney Technical College with G.K. Townshend in the 1940s and later with Joshua Smith, Allen Hansen, Malcolm Perryman and watercolour in UK with Aubrey Sykes; Has been teaching art privately for a number of years.

Exhibitions Has held a number of one-woman shows at Styles Gallery, Sydney and Keswick Gallery, Beecroft and a joint show with watercolourist, Joan Maxwell at Oberon NSW; Most recently a solo show at Manuka Art Centre, ACT.

Award Castle Prize (oils).

Represented Private collections in Australia and overseas.

TOMASETTI, Sarah VIC

Born 1968. Painter.

Studies B. Fine Art (Drawing), Prahran Campus, Victoria College 1988. Worked in Fiji

1990.
Exhibitions Solo shows at Reflections Gallery and Delbridge St. Gallery 1991.
Awards Pallas Award for Art 1983; C.M. Andrews Art Award 1985. Illustrated, *Poems in their Times 1953–1991* by Glen Tomasetti.

TOMESCU, Aida NSW
Born Bucharest 1955. Printmaker, painter.
Studies Dip. Art, Institute of Fine Arts, Bucharest 1973–77; Grad. Dip. Visual Arts, City Art Institute, Sydney 1983. Study Europe, USA 1984–85.
Exhibitions Solo shows at Holdsworth Galleries 1981; Coventry Gallery 1985, 87; Design Centre, Los Angeles 1986; Reconnaissance, Melb. 1987; Ben Grady, Canberra 1987. Numerous group shows since 1978 and recently at Artspace 1983; Performance Space 1984; Reconnaissance 1986; Coventry 1986, 87, 88, 89, 90; Holdsworth Contemporary 1987; International Print Biennale, Bradford UK 1988; King St Studio 1988; Stuart Gerstman, Melb. 1989.
Awards Bucharest Arts Council 1978, 79; VAB 1980; Myer Foundation 1986.
Represented Artbank, institutional and private collections.
Bibliography *Art and Australia* Vol. 28, No. 2; *Artists & Galleries of Australia*, Max Germaine: Craftsman House 1990; *New Art Five*, Nevill Drury: Craftsman House 1991.

TOOP, Wilma NSW
Born 1917. Soft sculptures; Weaver.
Studies Graduated with Doctor of Philosophy in English Literature which she has taught in Sydney; In the late 1970s studied with Jutta Feddersen at Alexander Mackie CAE.
Exhibitions First one-woman show of life-size woven figures and wall hangings at Holdsworth Galleries 1980.

TOP, Claudine VIC
Born Toulouse, France, arrived Aust 1972. Sculptor, printmaker.
Studies Ecolé Nationale des Beaux Arts, Versailles; Bolton Street College of Technology, Dublin; Ecolé Speciale d'Architecture, Paris, where she graduated as Architect.
Exhibitions Solo show at Dempsters Gallery 1990; Numerous group shows include MPAC 1982, 85; Swan Hill Reg. Gallery 1982; World Trade Centre, Melb. 1985; Cockatoo Gallery, Launceston 1986; Dempsters Gallery, Melb. 1986, 87, 88, 90; NZ Travelling Show 1987; Linden Gallery, Melb. 1985, 86, 87, 88; Two shows in Paris, France 1987; Linden Gallery, Eiditions Gallery, Solander Gallery 1988; Galerie Hautefeuille, Paris 1989; Association of Sculptors, Melbourne 1989, 90.
Awards Kew Municipal 1987; William Hogan 1987.
Represented In private and corporate collections in Australia, Europe and Japan.
Bibliography *PCA Directory* 1988; *Artists & Galleries of Australia*, Max Germaine: Craftsman House 1990.

TORY, Fabia NSW
Born Sydney. Decorative expressionist painter.
Studies Alexander Mackie CAE.
Exhibitions Solo at Seasons Gallery 1988, 90; Group at Ivan Dougherty and Blaxland Gallery.

TOURVAS, Dina NSW
Born Greece 1940, arrived Aust. 1959; Sculptures and arrangements.
Studies SCOTA 1979–82; Sydney Institute of Education 1984; Uni. of Sydney 1987.
Exhibitions Solo shows at Images Gallery, Sydney 1982; Performance Space Gallery and Greek Community Gallery 1985; Participated at ACP, Sydney 1982, 87; Canberra Art

Centre 1986; Corfu, Greece 1986; United Artists, Melb. 1988; *Outgrowing Assimilation*, Centre for the Arts, Uni. of Tas. 1988.
Represented Institutional and private collections in Greece and Australia.

TOWNSEND, Amanda NSW
Born Burnie, Tas. 1961. Printmaker.
Studies Dip. Art, Riverina CAE 1980–81.
Exhibitions Solo shows at Tamarind Print Gallery 1987.
Bibliography *PCA Directory* 1988.

TOWNSEND, Lillian Corris VIC
Born Melbourne 1934. Painter, teacher.
Studies CIT — Dip. Art and Design 1974–76; Overseas study tour 1981.
Exhibitions Solo shows at Stuart Gerstman 1978; Niagara Galleries 1983, 87; The Womens Gallery 1989. Numerous group shows include MPAC 1981, 84; QAG 1983; Linden Gallery 1988; MCAG 1989; Castlemaine Drawing Prize 1990; The Womens Gallery 1990.
Represented VAB and La Trobe University, Artbank; MPAC, institutional and private collections.

TOWT, Margaret VIC
Born Vic. Painter of birds and wildlife.
Exhibitions Solo shows at Whittlesea and Eltham Galleries, Melbourne 1977, 1978; Has painted bird studies for Australia Post and Spicers Ltd, Australia.
Represented Institutional and private collections in Australia, UK, Germany and USA.

TRACEY, Beverley QLD
Born Goondiwindi, Qld 1939. Painter, teacher.
Studies With Mervyn Moriarty at AFAS, Brisbane 1974–78.
Exhibitions Solo shows at Boston Gallery 1981, 82, 84; Artisan Gallery 1986; Red Hill Gallery 1988. Participated Geoffrey Hoisser Gallery 1985; Seasons Gallery, North Sydney 1987; Moree Reg. Gallery 1989.
Awards Goondiwindi, Redcliffe, Toowoomba Caltex.
Represented Institutional and private collections.

TRACEY, Lynne VIC
Born Melbourne 1955. Freelance illustrator and designer.
Studies Dip. Art and Design with a special interest in calligraphy and heraldry.
Exhibitions Solo show of Heraldry and Illuminated Calligraphy 1987.
Bibliography *Alice 125*, Gryphon Gallery: University of Melbourne 1990.

TREISTER, Aloma VIC
Born Iraq 1944. Painter, illustrator, designer, teacher.
Studies American High School, Tehran 1961; London College of Printing, UK 1968–70; B. Fine Art (Painting) RMIT 1981; Dip. Ed. Hawthorn Institute, Melb. 1987.
Exhibitions Solo shows at Bartoni Gallery 1975; Womens Gallery, Fitzroy 1990; Weather Vane Gallery, Melb. 1991; No Vacancy Gallery, Melb. 1991. Numerous group shows.
Commissions Illustrating series of ten readers for Bath Rifka College; Teaches part-time at Bialik College and Monash University.
Represented Institutional and private collections in UK, Europe, USA, Middle East and Australia.

TRELOAR, Su VIC
Born Melb. 1951. Printmaker.

Studies BA, Fine Arts, PIT 1986.
Exhibitions ROAR Studios, Oculus Gallery, Swan Hill Reg. Gallery and 70 Arden Street 1988.
Commissions 100 x 100 PCA Print Portfolio 1988.
Bibliography *PCA Directory* 1988.

TRENGOVE, Jane VIC
Born Melbourne 1953. Painter and photographer.
Exhibitions Mori Gallery, Sydney 1981; ROAR Studios, Melbourne 1985; Bathurst Regional Gallery 1986; Gryphon Gallery 1987; 70 Arden Street Gallery 1988; Moet & Chandon Touring Exhibition 1989.

TRESZ, Betty QLD
Born Sydney NSW 1925. Traditional watercolourist.
Studies Trained as draughtsman at Sydney Technical College; Began painting Brisbane 1964 studying three years under the late Melville Haysom; Current member of Half Dozen Group of Artists.
Awards RNA, Redlands and Corinda.
Exhibitions Two-man shows at McInnes Galleries, Brisbane during 1970s; Solo exhibition at Sheridan Gallery, Brisbane 1982; Annually with Half Dozen Group.
Represented Private collections in Australia and overseas.

TREVILLIEN, Patricia VIC
Born Newcastle NSW 1928. Painter, quiltmaker, musician.
Studies With John Passmore, Newcastle and Isabel Foster, Melbourne.
Bibliography *Alice 125*, Gryphon Gallery: University of Melbourne 1990.

TRIBE, Barbara UK
Born Sydney NSW 1913. Sculptor and teacher.
Studies Diploma in sculpture from East Sydney Technical College under Rayner Hoff 1928–33; Assistant to Rayner Hoff and taught at ESTC 1932–35; Studied at Royal Academy School and at City and Guilds School of Art, London 1935–40; During war years worked for the Ministry of Works and studied when possible at the Regent Street Polytechnic and St Martins School of Art; Since 1946 has been working and teaching from her studio in Penzance, Cornwell UK; Travels and visits Australia periodically; Fellow of the Royal British Sculptors Society and the Society of Portrait Sculptors, UK; Life Member of Association Internationalé des Arts Plastiques, Unesco Paris.
Awards ESTC Bronze Medal 1933; NSW Travelling Art Scholarship to UK 1935; A very large number of commissions in Australia and around the world.
Exhibitions Society of Artists, Sydney 1932–34 and in recent years at Prouds Gallery, Sydney; Other shows include: The Royal Academy, London Group, Fieldborne Galleries, London; Newlyn and St Ives Society of Artists; The Scottish Academy and Royal Cambrian Academy of Art; Sydney, NSW; Canberra, Tas, Australia; The Far East, Kyoto Japan and Bangkok Thailand; Europe, Paris Salon, Brussels, Vienna, USA and Canada; Major *Restrospective* exhibition, sculpture, painting and drawing, at the City Museum and Art Gallery, Stoke-on-Trent, September–October 1979; *Winter Exhibition* 1980; Fieldborne Galleries, London; Lithographs *Spring Exhibition* 1980, Fieldborne Galleries, London, Bronzes; Summer 1980, Inter-Celtic Festival in Brittany, France, Bronzes and Lithographs; September 1980, Royal West of England Academy, group exhibition, Bronzes. April–May 1981, Major Retrospective Exhibition of Sculpture, painting and drawings, Guildford House Gallery, Guildford; Newlyn Orion Galleries, Bath 1981; Galeria Artica, Cruxhaven W Germany 1981. Solo shows at von Bertouch Galleries, Newcastle NSW 1986 and Barry Stern Galleries, Sydney 1987. Visited Australia 1989.

Represented ANG; Australian War Museum; AGNSW; Esperanto Museum, Vienna; *Battle of Britain*, RAF Hendon Museum, London 1979; The City Museum and Art Gallery, Stoke-on-Trent; Spode Potteries Museum and in many private collections in the UK, Europe, USA, Canada, Australia, Far East, Japan, Hong Kong and Thailand.
Bibliography *Who's Who in International Art and Antiques*, Melrose Press, Cambridge UK 1976; *Australian Sculptors*, Ken Scarlett, Nelson 1980.

TROFIMIUK, Zoja VIC
Born Prague 1952. Sculptor, painter, illustrator.
Studies Polish Academy of Fine Art. Arrived Australia 1984. Has completed M. Fine Art at RMIT.
Bibliography *Alice 125*, Gryphon Gallery: University of Melbourne 1990.

TROMPP, Jan NSW
Born Sydney. Self-taught painter of flora and fauna, illustrator of books, cards and calendars.
Awards Fellowship, Aust. Institute of History and Arts 1986.

TRUJILLO, Elizabeth NSW
Born NSW 1945. Painter and ceramic artist.
Studies ESTC and Liverpool TC NSW.
Exhibitions Gallery 460, Gosford NSW.
Awards Port Hacking Ceramic Award.

TUCK, Ruth SA
Born Cowell SA 1914. Watercolour painter and teacher. Married to artist Mervyn Smith.
Studies SA School of Arts under Marie Tuck, Mary Harris, Dorrit Black and Ivor Hele; Study tour to UK, Europe, India 1969 to study German Expressionists Emil Nolde and Kathe Kollwitz; Lecturer in Art, Newcastle Art School, NSW; Lecturer in Architecture Dept, Newcastle Technical College, NSW; Art Therapist, Newcastle Hospital, NSW; Lecturer SA School of Art; Lecturer Architecture Dept, SA Institute of Technology; Lecturer University of Adelaide Dept of Adult Education; Since 1955 has conducted the Ruth Tuck School, catering especially for children, with some adult classes; Enrolments now exceed 300 annually; Her students have 10 times won the Nehru Medal in India, and twice the Foreign Miniter's Award in Japan; Foundation member of the Contemporary Art Society of SA and Hon Life Member; Fellow and Honorary Life Member of the Royal SA Society of Arts; *Advertiser* art critic 1968, 1970–72.
Exhibitions Since 1947 has held thirty one-woman shows and recently at Hahndorf Academy, SA 1980, 1982; Greenhill Galleries, Perth and Adelaide 1982, 1983; Ludwigsburg and Stuttgart W Germany 1983 and 1984 (musician drawings); Retrospective show *Five Decades of Painting* at Greenhill Galleries, Adelaide in 1986 and a further solo show in 1988. Numerous group shows include Roger Duncan Gallery, Paris 1975; AWI 1976, 1978; Art Gallery of SA 1980, 1981; McClelland Gallery, Vic 1983; Has designed a number of theatre sets with Mervyn Smith.
Awards Order of Australia for services to the arts 1981.
Represented State Galleries of WA and SA; Adelaide University Collection; Manly Art Gallery, NSW.
Bibliography *Art and Artists of South Australia*, Nancy Benko, Lidums; *Encyclopedia of Australian Art*, Alan McCulloch, Hutchinson; *Artists & Galleries of Australia*, Max Germaine: Craftsman House 1990; *Australian Impressionist & Realist Artists*, Tom Roberts: Graphic Management Services, Melbourne 1990.

TUCKSON, Margaret NSW
Born Gordon NSW 1921. Ceramic artist.

Studies East Sydney Technical College, ceramics 1939–42 and domestic earthenware 1948–52; Part-time teacher at East Sydney Technical College 1963–65; Adult Education Evening College 1959–63; Potters Society, ceramic study group, Arts Council of NSW weekend country schools 1970–78; Researching and compiling data on the pottery of Papua New Guinea 1985.
Exhibitions Group shows with Potters Society, Macquarie Galleries 1951–52 and at Potters Gallery, Woolloomooloo 1960.
Represented National Gallery, Melbourne; Mildura Arts Centre; Museum of Applied Sciences, Sydney; Newcastle Art Gallery.

TUCKWELL, Louise NSW
Born Sydney 1963. Painter illustrator, theatrical designer.
Studies Julian Ashton School 1981–83; ESTC 1984–86. Overseas study 1989.
Exhibitions Access Gallery 1986–89; Galaxy Gallery 1988.

TUPICOFF, June QLD
Born Healesville, Vic 1949. Painter, teacher.
Studies With Leonard French and Neil Douglas 1966; With Mervyn Moriarty, Anne Thompson, Sydney Ball, Jeff Makin 1973–84; Lecturer in painting, Mervyn Moriarty Art School 1985, and at Kelvin Grove BCAE 1986.
Exhibitions Solo shows at Ray Hughes Gallery, Brisbane 1985, 88, 89 and Sydney 1987, 88, 90. Numerous group shows since 1973 include Hogarth Gallery, Sydney 1980; QAG 1982; *Australian Perspecta*, AGNSW 1985; Ipswich City Art Gallery 1987; Ipswich City Gallery, Kelvin Grove CAE, QAG and Galerie San Vidal, Venice, Benalla Regional Gallery 1990. QAG 1991.
Bibliography *Catalogue of Australian Perspecta '85*, AGNSW; *Contemporary Australian Collage and its Origins*, Arthur McIntyre: Craftsman House 1990.

TURNBULL, Dorothy VIC
Born Vic. Painter.
Studies Swinburne School of Technology 1948–49. Member, Peninsula Art Society, Vic, McClelland Guild of Artists, Aust. Guild of Realist Artists.
Awards City of Chelsea Art Award, Vic 1988.

TURNER, Anna QLD
Born Scotland 1945. Weaver, wall hangings and rugs.
Studies Scottish College of Textiles, Galashiels; Designer at Tibor Reich Fabrics, Stratford-upon-Avon, UK 1968–70 and at Morris Mills, Qld 1970–83.
Exhibitions Joy Bowman Galleries, Qld 1981, 1982.
Awards Dr Oliver Scholarship 1967 and Medal for Design 1968 (Scotland); Australian Design Award for Furnishing Fabrics 1975, 1983.

TURNER, Anthea TAS
Born Hobart Tas 1952. Sculptor using galvanised steel sheeting, copper sheeting, wood, particularly Huon and King William Pine, clear and coloured acrylic sheets, mirrored acrylic sheets, aluminium mesh and macrame yarns.
Studies Teachers Diploma of Art, Tas School of Art 1969–71; Diploma of Education, University of Tas 1972; Teaching at Glenora District School, Tas 1973–74; Overseas travel, visiting galleries and museums throughout UK, Western Europe and USA; Summer term studying sculpture North-east London Polytechnic, UK 1975; Teaching at Ogilvie High School, New Town Tas 1976–78; Married to Malcolm Wallhead.
Exhibitions One-woman sculpture shows, Don Camillo Restaurant, Sandy Bay Tas 1972; Salamanca Place Gallery and Ansett Airlines city terminal, Hobart 1973; *Sculptures in 74*

Environment, A Survey of Tas Artists Exhibition, Hobart 1974; One-woman sculpture show, Devonport Gallery and Arts Centre, Tas 1975; Sculpture show, Gallery One, Hobart 1976; Sculptures in *By Invitation* Exhibition, Devonport Gallery and Arts Centre, Tas 1976; Ran the Hunter Island Gallery for thirteen months with sculptor Malcolm Wallhead; Continuous, mixed exhibitions of sculptures and pictures and major sculpture exhibition there in 1977; Womens Art, Bellerive 1980; Friends School 1981, 1982; Salamanca Place Gallery 1982; Mobil Outdoor Show, Hobart 1983.

Commissions Sculpture for Lysaght Steel Co, Tas; Suspended ceiling sculpture for Plexus Boutique, Hobart; Sculpture for *The Chateau*, Coles Bay Tas; Sculpture for Electrolytic Zinc Co, Hobart; Indirect commission for HEC, a sheet metal section 1978.

Represented Mainly sculptures in private collections in Brisbane, Perth, Darwin and throughout Tas; Gallery One, Hobart and Avant Galleries, Melbourne.

Bibliography *Tasmanian Artists of the 20th Century*, Sue Backhouse 1988.

TURNER, Beth VIC
Born Burnie Tas 1946. Representational and romantic painter; Printmaker.

Studies Tas School of Art, Hobart and St Martins School of Art, London 1964–68; Twelve months in France 1980–81; Book jacket designs for Penguin 1983.

Exhibitions One-woman shows, Don Camillo Gallery, Hobart 1969; Little Gallery, Devonport 1972–77; Bonython Gallery, Sydney 1976; Salamanca Place Gallery, Hobart 1976; Geo Paton Gallery, University of Melbourne 1980; Pinacotheca Gallery, Vic 1982, 1984; James Harvey Gallery, Sydney 1983; Avago Gallery, Sydney 1984; Rhumbarallas Gallery, Melb. 1986; Handmark Gallery, Hobart 1986. Numerous group shows since 1969 include TMAG 1969, 74; Bonython Gallery, Sydney 1976; Qld AG 1980, 83; MPAC 1985.

Awards Under Twenty-five Perth International Drawing Prize 1971; North-west Coast Prize for Drawing 1971; Albury City Council Art Prize 1974.

Represented WA Art Gallery, Tas Museum and Art Gallery; Albury City Gallery; Tubemakers of Australia Ltd Collection; Collections of Kym Bonython and Mrs Jean Thomas.

Bibliography *Tasmanian Artists of the 20th Century*, Sue Backhouse 1988.

TURNER, Christine QLD
Born Vic. Painter and portraitist.

Studies AFAS with Rod Milgate, Bev Budgen, David Burnett and at The McGregor School with Andrew Sibley 1989–90.

Exhibitions Solo shows at Galerie Brutal, Brisbane 1990; McWhirters Artspace 1990, 91. Numerous group shows.

Awards Bundaberg 1988, 89; Wide Bay 1989; Gladstone 1990.

Represented Institutional and private collections.

TURNER, Maize Karen NSW
Born Sydney 1954. Painter, printmaker, photographer, teacher.

Studies BA Fine Art (Photography & Printmaking) SASA 1976–79. Worked and studied in UK, Europe and tutored at Community Arts Project in London 1984–87. Working at School of Visual and Performing Arts, Newcastle University NSW 1989– .

Exhibitions Solo shows at Bondi Pavilion 1982; Bitumen River Gallery ACT 1983; Jam Factory, Adelaide 1983; International Gallery, Milan, Italy 1984; Sommerville College, Oxford UK 1986. Many group shows in Australia and overseas since 1977 include London and Paris 1986; Holdsworth Galleries 1987; King St. Gallery 1988; Installation at Nexus Nightclub, Newcastle 1989; Newcastle Contemporary Gallery 1990; Greenhill Galleries, Adelaide 1991; Jan Taylor Gallery, Sydney 1991.

Awards Dyson Bequest Scholarship for studio in Italy.

Represented AGNSW, NGV, Artbank, institutional and private collections in Australia

and overseas.

TURNER, Margaret Ellen NSW
Born NZ 1948. Sculptor, printmaker, teacher.
Studies Grad. Dip. City Art Institute; BA Visual Arts, Alexander Mackie CAE; Art Certificate, Liverpool TAFE 1977–82; M. Fine Art (Sculpture), Reading University UK 1986–87; Part-time teaching at CAI, Sydney 1982–85, South Hill Park Arts Centre UK 1987, Liverpool TAFE 1989.
Exhibitions Australian Sculpture Triennials 1981, 84; Ivan Dougherty Gallery 1982; Irving Gallery, Sydney (solo) 1984; AGWA 1985; UK (four shows) and Munster, West Germany 1987–88; Macquarie Galleries, Sydney 1989 (solo).
Awards Liverpool TAFE 1978; Hozumi Momota Award for study in Japan 1978; Mitchell Cotts Award 1983; VAB Grants 1983, 85; Clifford Norton Award UK 1986; Carter Memorial Sculpture Prize UK 1987; VAB London Studio Grant 1988.
Represented Regional, institutional and private collections in UK, Europe and Australia.

TURNER, Maggie NSW
Born NZ 1948. Sculptor.
Studies Liverpool TC 1977–78; Alexander Mackie CAE 1979–81; City Art Institute 1982–83.
Exhibitions Solo show at Irving Sculpture Gallery 1984. Participated at First and Second Aust. Sculpture Triennial, Melb. 1981 and 1984.

TURNER, Sonda NT
Aboriginal painter in acrylic on canvas from the Yuendumu region of Central Australia.
Exhibitions Bloomfield Galleries, Sydney 1989.
Represented AGSA.

TUXEN, Patricia Mavis (Chinnery) VIC
Born Melbourne Vic 1923. Painter and printmaker.
Studies Melbourne Technical College under John Rowell and Murray Griffin 1939; With H.S. Power and at National Gallery School 1944; Member of Beaumaris Art Group; Working on a New Guinea historical project 1974.
Exhibitions Beaumaris Workshop Gallery 1971; Niagara Lane Gallery, Melb.; Makers Gallery, Melb. 1985.
Publications Limited edition of Tennyson's *Lady of Shallot*, designed, etched and printed by Patricia Mavis Tuxen 1982.
Bibliography *Directory of Australian Printmakers* 1988.

TWIGG-PATTERSON, Janet ACT
Born Sydney NSW 1938. Traditional Chinese brush painter and teacher.
Studies Painting at technical colleges at Brisbane, Canberra, Perth, Chinese brush painting under Wong Shiu Hong at ANU, Canberra and with tutors in Malaysia; Teaches at own studio in Canberra.
Exhibitions One-woman shows at Sum Gallery, Kuala Lumpur 1975; Metung Gallery, Vic and Solander Gallery, ACT 1976; Participated at East and West Art, Melbourne 1977, 1980, 1983; Flair Gallery, ACT 1978; Umberumberka Gallery, Armidale NSW 1981, 1982; Art Council of Australia, ACT 1982.
Represented Private collections in Australia and overseas.

TYSON, Hilma TAS
Born Launceston 1924. Painter, printmaker.
Studies Launceston TC 1942–46. Worked as commercial artist 1944–47. Studied with pri-

vate tutors 1965–72. Married artist Geoff Tyson (deceased) in 1947; Overseas study tour 1973–74.

Exhibitions Numerous joint and group shows include Salamanca Place Gallery, Hobart 1969 and Bowerbank Mill Gallery, Deloraine 1977.

Bibliography *Tasmanian Artists of the 20th Century*, Sue Backhouse 1988.

TYSSEN, Ingeborg NSW
Born Holland 1945, arrived Australia 1957. Photographer, teacher.
Studies BA Visual Arts, SCOTA 1981; Postgrad. Dip. 1982; Grad. Dip. Ed. 1987. Working for MA at Macquarie University 1990– . Has taught at numerous colleges since 1975; Presently Co-ordinator of Art History and Theory at ESTC 1989– ; Member of Board of Management of Artspace 1987–89.
Exhibitions Solo shows at Images Gallery 1982, 83; Developed Image, Adelaide 1983; Foton Photography Gallery 1986; Canberra School of Art 1987; First Draft 1989; Avago 1990; Performance Space 1991. Numerous group shows include NGV 1975, 76, 78, 90; AGSA 1980; AGNSW 1981, 82, 83, 89; Australian Centre for Photography 1975, 81, 82; Wollongong Regional Gallery 1984; Newcastle Regional Gallery 1984; QAG 1991.
Awards VAB Grants 1977, 83; Polaroid Australia Grant 1981.
Represented ANG; AGNSW; AGSA; NGV; TMAG; Artbank; Bibliotheque Nationale, Paris; Institutional and private collections in Australia and overseas.

U

UHRIG, Ruth NSW
Born NSW 1931. Contemporary painter in oil and mixed media; Teacher.
Studies Art, Newcastle and East Sydney Technical Colleges; Was a supervisor for the Creative Leisure Movement in Sydney from 1966–71 and taught painting to children and adults; Now conducts her own classes; Study tour to Italy in 1975 and again in 1979, 1980.
Exhibitions One-woman shows at von Bertouch Galleries, Newcastle 1976; Armstrong Gallery, Morpeth NSW 1979, 1984; Shared show with Guy Warren at von Bertouch Galleries 1981, and with five other artists *Women as Social Documentors* at Lake Macquarie Galleries 1982; Annually in Collectors Show at von Bertouch Galleries.
Represented Private collections in Australia, USA, Italy and South Arica.

UNGAR, Thora NSW
Born Sydney NSW. Painter of landscapes and portraits in oil, watercolour and acrylic.
Studies East Sydney Technical School and under Datillo Rubbo; Lived and painted in China 1937–41; Europe 1975; Studying lithography at Workshop Art Centre, Willougby NSW 1978; Illustrator with *Australian Womens Weekly* and *The Sydney Morning Herald* 1942–56.
Exhibitions One-woman shows at Barry Stern Galleries, Sydney and von Bertouch Galleries, Newcastle NSW.
Awards Tumut Portrait 1958; Royal Easter Show Portrait 1967, 1974; Gold Coast Portrait 1968; Manly Purchase 1972; Hinton Collection Portrait 1973; Royal Easter Show 1974, 83, 84, 86, 90; Kempsey 1988; Scone 1989; Gunnedah 1989; Numerous portrait commissions.
Represented Institutional and private collections in UK, Europe, China and Australia.

UNGAR, Thora NSW
Born Sydney NSW. Painter of landscapes and portraits in oil, watercolour and acrylic.

Studies East Sydney Technical School and under Datillo Rubbo; Lived and painted in China 1937–41; Europe 1975; Studying lithography at Workshop Art Centre, Willougby NSW 1978; Illustrator with *Australian Womens Weekly* and *The Sydney Morning Herald* 1942–56.

Exhibitions One-woman shows at Barry Stern Galleries, Sydney and von Bertouch Galleries, Newcastle NSW.

Awards Tumut Portrait 1958; Royal Easter Show Portrait 1967, 1974; Gold Coast Portrait 1968; Manly Purchase 1972; Hinton Collection Portrait 1973; Royal Easter Show 1974, 83, 84, 86, 90; Kempsey 1988; Scone 1989; Gunnedah 1989; Numerous portrait commissions.

Represented Institutional and private collections in UK, Europe, China and Australia.

UNGUNMERR, Miriam-Rose NT

Born NT. Aboriginal painter, illustrator and teacher; Member of the Moil Tribe of the Daly River area, south-west of Darwin.

Studies Art and teacher training, Melbourne three years; Member of the Commonwealth Teaching Service, she travels throughout the NT supervising art classes and projects; She spent a year completing the twenty illustrations for Alan Marshall's book of Aboriginal myths, *People of the Dreamtime*, published by Hyland House.

UNKALPI NT

Aboriginal painter in tempera from the Pitjantjatjara people of the Western Desert.

Exhibitions Aboriginal Cultural Institute.

Bibliography *Artlink* Autumn/Winter 1990.

UNTARU, Renate QLD

Born W. Germany 1922. Painter of flowers and genre subjects.

Studies Sydney TC and RAS of NSW.

Exhibitions Kimberley Gallery, Brisbane.

Awards Royal Brisbane Show 1985; Tweed Heads 1986.

Represented Institutional and private collections in Australia and overseas.

UNWIN, Sonya SA

Born Aust. Painter.

Studies For a short time at SACAE, Adelaide 1986; North Adelaide S of A 1987, 88; Presently working as a graphics designer.

Awards Nat. Art Award 1985.

UPTON, Christine NSW

Born 1951. Textile and batik artist and designer.

Studies Dip. Art Ed. (Hons.) — Newcastle Nat. Art School 1969–73.

Exhibitions Windmill Gallery, Rutherglen Vic 1984–85, 86; Shoestring Gallery, Wangaratta 1986, 87, 89; Perc Tucker Reg. Gallery 1987.

Represented Corporate, institutional and private collections.

URBAN, Maggie NT

Aboriginal Papunya Tula painter in acrylic from the Western Desert NT.

Exhibitions With Papunya Tula artists at Michael Milburn Gallery, Brisbane 1991.

UREN, Alinta TAS

Born Sydney 1942. Painter teacher.

Studies Prahran CAE, Melb. 1973–76; Hobart S of A 1985. Overseas study 1968–70.

Exhibitions Firehouse Gallery, Perth 1970; Leveson St Gallery, Melb. 1970.

Awards Perth 1963; Flinders, Vic 1976.

Bibliography *Tasmanian Artists of the 20th Century*, Sue Backhouse 1988.

V

VALADON, Rosemary NSW
Born Sydney. Painter in oil and pastel.
Studies SCOTA.
Exhibitions Solo show at First Draft Gallery 1988; Participated at Artspace 1984, 87.
Awards Muswellbrook Prize 1988.

VALAMANESH, Angela SA
Born SA 1953. Ceramic artist.
Studies Diploma in Design (ceramics) from SA School of Art 1974–77; Potter at Jam Factory Workshop, Adelaide 1978; Established workshop at Norwood SA 1979, moved to Forestville 1982.
Exhibitions *Art of Craft* travelling show 1979–80; Jam Factory Gallery 1980.
Awards Pug Mill Ceramic Award 1978; Crafts Council Grant 1982.

VANDERLUGT, Denise QLD
Born Rockhampton, Qld 1949. Textile artist, quiltmaker.
Exhibitions With Adriaan Vanderlugt at Barry Stern Galleries, Sydney 1985, 89; Grafton House, Cairns 1986; Dallas, USA 1986; World Expo, Brisbane 1988; Link Gallery, Canberra 1988.
Represented Private collections Canada, USA, Australia.

van der MERWE, Linda WA
Born Nairobi, Kenya 1955. Painter of Australian outback subjects, teacher.
Studies Dip. Fine Arts (Painting), Claremont TC. Dip. Tech. Ed. Perth WA. Has studied and painted widely in central and outback Australia. Lecturer, Claremont School of Art, Curtin University, Fremantle Arts Centre and Arts Access Workshops in the Kimberleys 1974–87.
Exhibitions Solo shows at Gallery 52 1981, 83; Bassendean Library 1986. Numerous group shows include AGWA 1982, 83, 86; Fremantle Art Gallery 1984; Undercroft Gallery 1986, 89; Bay Gallery 1988; Fremantle Arts Centre 1989.
Awards Health Credit Union Award 1988; Mundaring 1989; Exmouth Cape National Park Commissions.
Represented Institutional and private collections.

van GENDT, Katrina VIC
Born Melbourne 1951. Painter, illustrator, writer.
Studies Has worked for many years on graphics and animation for the television industry and in particular for the series 'Playschool'.
Publications Author and illustrator of *Bananas in Pyjamas* 1990.
Bibliography *Alice 125*, Gryphon Gallery: University of Melbourne 1990.

van LEEUWEN, Bronwen NSW
Born Sydney. Chinese brush and watercolour painter, teacher.
Studies Dip. Fine Arts, Nanyang Academy, Singapore 1973–76; B. Ed. University of NSW, City Art Institute 1981–85; Grad. Dip. Adult Education, NSW University of Technology 1988–90. Director of WAC; Has taught art in various colleges and institutions and studied and travelled extensively in UK, Europe and USA.
Exhibitions Balmain Watch House 1986; Copper Triangle, SA 1990; Watters Gallery 1990.

Represented Institutional and private collections in Australia and overseas.

van RIEMSDYK, Fran VIC
Born Melbourne Vic 1952. Printmaker.
Studies Fellowship Diploma Printmaking at RMIT; Exhibited, Print Council of Australia Student Printmakers 1973; RMIT Student Exchange with Japan 1973; RMIT Student Exhibition, Hawthorn Art Gallery, Vic 1974; Teaching printmaking at RMIT 1978–.
Represented NGV, Artbank, institutional and private collections.
Bibliography *Directory of Australian Printmakers* 1978–82, 88.

VARVARESSOS, Vicki NSW
Born Sydney NSW 1949; Figurative expressionist painter in acrylic.
Studies National Art School, Sydney 1970–73; Travelled Europe 1978.
Exhibitions In 1975 — Solo show, Watters Gallery, Sydney; *Woman in Art*, WA Institute of Technology; Group drawing show and another exhibition of drawings, Watters Gallery, Sydney; In 1976 — Solo show, Watters Gallery, Sydney; *East Coast drawings, Towards Some Definitions*, Institute of Modern Art, Brisbane; Group drawing show, Watters Gallery, Sydney; In 1977 — Solo show, Watters Gallery, Sydney; Georges Invitation Prize; *Recent Women's Images of Women*, Watters Gallery, Sydney; In 1978 — Solo show, Watters Gallery, Sydney; CAS Exhibition, *Australian Women Artists*, Paddington Town Hall, Sydney; Group show, *Lost and Found*, Ewing Gallery, University of Melbourne; *Drawing 79*, Stuart Gerstman Gallery, Melbourne 1979; Watters Gallery 1979–80; *Australian Perspecta* 1981; Art Gallery of NSW, Survey 1956–81; Tas School of Art, Hobart 1982; Civic Centre, Orange NSW 1983; Biennale of Sydney 1984. Further solo shows at Watters Gallery 1985, 87, 88, 89, 91; Niagara Galleries, Melb. 1986, 88; Recent group shows include Ballarat and Campbelltown Reg. Galleries 1984; ANG, AGNSW, AGWA 1985; Benalla and Shepparton Reg. Galleries 1986; Centre for the Arts, Uni of Tas 1986; Solander Gallery, Canberra 1987; Ballarat Fine Art Gallery 1988; CAC, Adelaide 1988; First Aust Contemporary Art Fair, Melb. 1988. Included in The Bicentennial Print Portfolio 1988.
Represented ANG; NGV; Artbank; AGNSW; University of NSW; Wollongong Art Gallery; University of Tas; Gold Coast Collection and private collections in UK, Europe, USA and Australia.
Bibliography *Catalogue of Australian Perspecta* 1981, Art Gallery of NSW; *Art and Australia* Vol 19 No 4; 'Vicki Varvaressos', Janine Burke; *Artists & Galleries of Australia*, Max Germaine: Craftsman House 1990.

VAUGHAN, Elspeth (Hope-Johnstone) TAS
Born Hobart 1926. Watercolour painter and teacher.
Studies Melb. Kindergarten Teachers College and Swinburne TC 1944–46; Hobart TC under Jack Carington Smith. Overseas travel grants 1959–60, 69, 78–80; Life Member, Art Society of Tas.
Exhibitions Many solo shows since 1965 include Coughton Galleries, Hobart 1978, 80, 83, 84, 85; Beaver Galleries, Canberra 1985. Group shows from 1949 include TMAG 1968, 69, 73–76; AWI Sydney 1973, 74, 76, 77; Salamanca Place Gallery 1978.
Awards Smith Mundt Teacher Grant; Fulbright Travel Grant.
Represented TMAG; QVMAG; Institutional and private collections in UK, Europe, USA and Australia.
Bibliography *Australian Watercolour Painters 1780–1980*, Jean Campbell, Rigby 1982; *Tasmanian Painters of the 20th Century*, Sue Backhouse 1988.

VAUGHAN, Margot NSW
Born Punchbowl NSW 1928. Landscapes and flower studies in oil, watercolour and ink.
Studies Scholarship to East Sydney Technical College 1943–46; Worked in commercial art

for ten years and attended ESTC night classes; Member St George and Sutherland Art Societies and the RAS of NSW.
Exhibitions Saints Gallery and Von Dorff Gallery, Sydney 1980–83; Sylvania Gallery, Sydney 1989.
Awards Rockdale 1977; Kogarah 1978; Oyster Bay 1979–80; Ryde 1980; Blackheath 1978, 1980; Portland Acquisition 1981; Gloucester 1983.
Represented Private collections in Australia and overseas.

VENNER, Ruth SA
Born Wallasey, UK 1944. Calligrapher, illustrator, teacher.
Studies With international calligraphy masters Donald Jackson, Ieuan Rees and Charles Pearce. Taught for WEA 1983–88; Has own studio at The Jam Factory, Adelaide. Board Member, Crafts Council SA 1985–87. President of the Calligraphy Society of SA 1988–.
Exhibitions Numerous shows include UK 1987, 88; RSASA 1988, 89, 90; Adelaide Festival 1988; Jam Factory 1988; State Library of SA 1989; Calligraphy Society of SA Touring Show 1990–91; Beijing, China 1990. Has carried out many major commissions.
Represented Institutional and private collections in Australia, UK, Europe, USA, China.

VERCOE-GRIEB, Elizabeth VIC
Born NZ 1934. Painter, printmaker, designer.
Studies Dip. Interior Design and Cert. of Art, RMIT. Printmaking at Prahran CAE.
Exhibitions Solo show at Bolitho Gallery, ACT 1984; Participated Design Centre, Sydney 1969–70; Allegro Gallery, Sydney 1982; Niagara Gallery, Melb. 1983.
Awards Dunhill Design 1972; Elgee Park, Vic 1984.
Represented Institutional and private collections in Australia and overseas.

VERNON, Sonia WA
Born Toodyay WA. Painter and printmaker.
Studies Perth TC; Member Perth Society of Artists.
Exhibitions Cremorne Gallery 1969; Fremantle 1983, 87.

VERSTRAETEN, Marylyn VIC
Born Perth WA 1935. Miniature sculptures of Australian wildlife; Gold and silversmith.
Exhibitions Numerous solo shows since 1974 and recently at Beaver Galleries, Canberra 1979; Sale Regional Arts Centre, Vic 1982; Wildlife Artists Exhibition, Melbourne 1982 (group).
Represented Collection of King and Queen of Jordan 1976; Sale Regional Gallery and many Australian and overseas collections.

VERTES, Anna NSW
Born Budapest Hungary 1920. Semi-impressionist painter in oil and pastel; Portraitist.
Studies Hungarian Academy of Fine Arts and under Ludwig Kirschner, Vienna; Has exhibited in Australia and overseas since 1965.

VICKERS, Rose NSW
Born Sydney NSW 1941. Painter, printmaker and teacher.
Studies National Art School, East Sydney Technical College 1960–64; Central School of Arts and Crafts, London 1966–67; Travelled in Europe, India and Asia 1966–69; Taught at National Art School, East Sydney Technical College 1968–77; Tour of South America as curator of *Australian Graphics* arranged by the Visual Arts Board and Dept of External Affairs, July 1974 to January 1975; Founded Zero Print Workshop (later known as Miller Street Print Workshop) with Max Miller and George Schwartz 1973; Manager of Miller Street Print Workshop 1976–78; Teacher full-time at Alexander Mackie College, Sydney

1979; Co-manages (with George Schwartz and Kate Briscoe) Print Workshop Zero, Sydney 1979; Teaching printmaking at the City Art Institute, Sydney 1983–; Secretary of Sydney Printmakers 1983; Presently teaching at Uni. of NSW Fine Arts.

Exhibitions Arts Council, Sydney 1971; ESTC Print Survey 1980; Printmakers of NSW to UK 1982; Stephen Mori Gallery 1982, 85; Bradford International Print Biennale, UK 1982; Annually with Sydney Printmakers; Recently with Studio One, Canberra Touring Show.

Awards Drummoyne Print Prize 1977; PCA Member Print 1979, 80.

Represented Art Gallery of NSW; New England Regional Gallery; Shepparton Art Gallery, Vic; Caulfield Arts Centre, Melbourne and institutional and private collections in Australia and overseas.

Bibliography *Directory of Australian Printmakers* 1976, 88; *Artists & Galleries of Australia*, Max Germaine: Craftsman House 1990.

VIDLER, Karen VIC

Born Melb. 1966. Printmaker.

Studies BA Visual Arts — Gippsland IAE.

Exhibitions 70 Arden St, Melb. 1988.

Commissions PCA 100 x 100 Print Portfolio 1988.

Bibliography *PCA Directory* 1988.

VILA-BOGDANICH, Memnuna WA

Born Mostar Yugoslavia 1934. Painter in most media; Printmaker.

Studies School for Applied Arts, Sarajevo 1950–55; Masters Degree in Printmaking, Academy of Fine Arts, Belgrade, 1955–62; Member of PCA 1974–80.

Exhibitions One-man shows, Belgrade 1963, 1965, 1969; Mostar 1964; Rimini Italy 1966; Perth 1972–73; Fremantle WA 1974; Churchill Gallery, Perth 1975, 1976; Dickey and Bogne 1976; Collectors Gallery 1977; Palace Hotel 1978; Galerie Dusseldorf 1979, 1980; State Galleries in Mostar and Sarajevo, Yugoslavia 1979; Hawks Hill Gallery, Perth 1981; Work included in *Young Balkans Graphics Review*, Bucharest, Sofia, Athens, Ankara, North Africa 1959; With Roter Reiter Group, Munich, The Hague 1962 and Santa Cruz, Grand Canary, Las Palmas, Madrid, Algeria, Morocco, Dahomey, Nigeria 1963 then Buenos Aires, Mar del Plata, Rio de Janeiro, Havana 1966; Yugoslavian Group in Rome 1964; Rimini Italy 1965; Yugoslavian Graphics in Yugoslavia 1965 and Keil, Bonn, Lima, Amsterdam, Berlin 1970; International Biennials, Ljubljana Yugoslavia 1961–69, Alexandria 1968; Australasian Print Competition, Te Awamutu NZ 1973; Yugoslavian Graphics, Fremantle WA 1973; Alice Springs Prize 1973–74; Print Council of Australia 1973; Arts Council, Vic 1974; Recent group shows include W Germany, Sweden, Yugoslavia 1980; Yugoslavia and Barry Stern Galleries, Sydney 1981; Yugoslavia and Fremantle Arts Centre 1982; Fremantle Arts Centre 1983; West Germany and Yugoslavia 1983.

Awards Mostar Graphic Prize 1954; Belgrade Academy of Fine Arts Prize 1966; Sarajevo Publisher Prize for Graphics 1967; Alice Springs Graphic Prize 1973; Perth Prize for Drawing, International 1975; Rockingham Award 1977; Sir Charles Gairdner Hospital Prize 1979.

Represented ANG, Canberra; Academy of Fine Arts, Belgrade; Museum of Contemporary Arts, Belgrade; Art Gallery of Bosnia and Herzegovina, Sarajevo, National Library, Rimini; The WA Art Gallery, Perth; Alice Springs Art Foundation; University of WA; WA Institute of Technology; Rural and Industries Bank of WA; Fremantle Arts Centre; Bunbury Art Gallery; Esperance Art Foundation; Claremont Teachers College; Graylands Teachers College, Murdoch University, Perth WA; Private collections in Yugoslavia, Italy, Holland, West Germany, Sweden, Rumania, USA, Switzerland, Australia and Sir Philip Hendy's of London.

Bibliography *Contemporary WA Painters and Printmakers*, Fremantle Arts Centre Press 1979.

VILKS, Erna NSW

Born Latvia 1914, arrived Australia 1951. Traditional painter in gouache and oil, collage.
Studies National Art School, Riga and under George Bell in Melbourne; Member of the Blue Brush Group; Professional fashion designer in Melbourne for some years and now a full-time painter residing in Sydney.
Exhibitions Latvian Art Museums and in group shows in Australia and a tour of USA and France.
Represented Latvia, Germany and Australian collections.
Bibliography *Australian Paintings 1788–1970*, Bernard Smith, Oxford University Press, Melbourne 1974.

VINCENT, Annette SA

Born NZ 1946. Painter and printmaker.
Studies B. Sc. Canterbury Uni NZ 1969; Assoc. Dip. Liberal Studies, Hartley College Adelaide 1979–83; BA Fine Arts (Printmaking), Underdale Campus, University of SA 1986. Associate Member, RSASA; Founding Member of Hindmarsh Art Centre 1990. Overseas study USA 1987, UK, Europe, USA 1991.
Exhibitions Solo shows in Boston USA 1987; Group shows include Mitchell CAE, Bathurst 1986; Printmakers of Australia & NZ to USA 1986; Tynte Gallery, Adelaide 1989; Off-Centre Gallery, Bristol UK 1989; Royal Hibernian Academy, Dublin, Ireland 1990; Adelaide Festival 1990; West Bend Gallery, Wisconsin USA 1990; Swan Hill Regional Gallery 1990; Toronto, Canada 1990; Seoul, Korea 1990; Lodz, Poland 1991.
Awards Burnside Jubilee Prize, Adelaide 1986.
Represented Public, institutional and private collections in Australia, UK, Europe, USA.
Bibliography *PCA Directory* 1988.

VINCENT, Jan NSW

Born 1935. Watercolour painter and teacher.
Studies Privately with tutors including Janine Bravery, David Taylor and Louise Foletta. Teaches at Ku-ring-gai Community Arts Centre and Forestville Community Arts Centre; Formerly tutor at Sturt University, Bathurst.
Exhibitions Solo shows at Warrendyte Gallery, Vic. 1979; Seaview Gallery, Newcastle 1986. Exhibits in group shows as a member of RASNSW, Ryde Municipal Art Society, Ku-rin-gai Art Society and the Australian Society of Miniature Art.

VOCE, Margaret VIC

Born Victoria 1942. Painter and teacher.
Studies Art Training Institute, Melbourne 1960–61; Morwell TC 1980–81; Gippsland IAE 1982–86 gaining Dip. Visual Arts; Grad. Dip. Visual Arts (Painting) 1986; Grad. Dip. Ed. 1987.
Exhibitions Solo show at Yallourn, Vic. 1963; Group shows include La Trobe Valley Arts Centre 1983, 88; Mitchell CAE Gallery, Bathurst 1984; Warragul Arts Centre 1986; Pyramid Gallery, Sale, Vic. 1989.
Represented La Trobe Valley Arts Centre and private collections.

W

WAGNER, Shirley Josephine NSW

Born Sydney NSW 1932. Romantic painter in oil and watercolour.
Studies Max Meldrum School, Melbourne; Swinburne Technical College, Melbourne and

National Art School, Brisbane; Studied drawing privately under Frances Lymburner; In recent years has been most active in the commercial gallery field, establishing Barefoot Gallery at Avalon Beach NSW in 1968, and presently at Wagner Gallery, Paddington NSW, which she established in 1977.

WALDEN, Teifi QLD
Born Wales UK. Painter and sculptor.
Studies Mostly self-taught but has attended summer schools at Universities of Qld and New England.
Exhibitions Wales and London UK; Participated at Tas Museum and Art Gallery, Qld Art Gallery and Towen Mountain Gallery, Qld.
Award Kenneth McQueen Watercolour Prize 1964.
Represented Private collections in UK and Australia.

WALKER, Connie VIC
Born Redcliffs Vic 1924. Traditional and modern painter, mostly in watercolour, studied with private tutors. Foundation member and past-president of Waverley Arts Society, member of VAS, Tuesday Painters Old Watercolour Society Club and Society of Women Painter and Sculptors.
Exhibitions Peninsula Galleries, Portsea Vic 1974, 1978; VAS 1976, 1978; McClelland Regional Gallery 1980.
Awards Has won 20 first prizes around Vic since 1971.
Represented Corporate and private collections in Australia and overseas.

WALKER, Deborah VIC
Born Aust 1954. Painter, printmaker, teacher.
Studies Degree, Fine Art Caulfield IT 1974; Grad. Dip. VCA 1981. Currently Lecturer in Printmaking, Deakin University. Overseas study UK, Europe, USA 1978, 85, 88.
Exhibitions Solo shows at Harrington St Gallery, Hobart; OZ Gallery, Melb. 1979; Hawthorn City Gallery 1983; Stuart Gerstman Galleries, Melb. 1984, 86; Many group shows since 1978 include Uni of Melb. 1983; ANG, Canberra 1985; ACCA and McClelland Gallery, Melb. 1985; Holdsworth Galleries, Sydney and RMIT Gallery 1986; Gerstman Abdullah Fine Art 1987; NGV 1989; Blaxland Gallery 1989; ANG 1989; WAG Auction 1989; Realities Gallery 1990.
Awards Henri Worland 1978, 80, 83; VCA Grant 1980; St Kilda Festival 1981; VCA Scholarship 1981; NGV Trustees 1981; Diamond Valley 1985; VAB Grant 1986; VAB Travel Grant New York 1987; Trades Hall Studio Residency 1989.
Represented ANG, NGV, TMAG, municipal, institutional and private collections UK, Europe, USA, Australia.
Bibliography *PCA Directory* 1988; *Artists & Galleries of Australia*, Max Germaine: Craftsman House 1990.

WALKER, Edith Jean (Brown) VIC
Born Vic 1922. Watercolour painter, illustrator, teacher.
Studies RMIT and MITC 1938–41; With J.H. Boyd 1941–45. Has had several exhibitions.
Publication Wrote and illustrated with sister Betty Maloney *Designing Australian Bush Gardens* 1967, (Book of the Year Award). Presently illustrating children's books.
Bibliography *Australian Watercolour Painters*, Jean Campbell, Craftsman House 1989.

WALKER, Gwen VIC
Born Albury NSW. Traditional painter in watercolour, oil, pen and wash.
Studies Diploma in Fashion Art from RMIT. Member, VAS, Malvern Artists Society and Sherbrooke Art Society.

Exhibitions ANZ Bank Gallery, Melbourne and other venues.
Awards Kiwanis Brighton 1976; Diamond Valley 1977; Cranbourne 1976; Maryborough 1980.
Represented Private collections in Australia and overseas.

WALKER, Heather (Warrie) QLD
Born Rockhampton Qld. Linocut and batik artist.
Studies Nth Qld Art Centre for Aborigines and Islanders.
Exhibitions Pacific Hotel Cairns 1987; Aboriginal Arts, Sydney and Qld Museum, Brisbane 1988.

WALKER, Jane VIC
Born Melbourne Vic 1943. Painter and illustrator.
Studies Diploma of Illustration from RMIT under Harold Freedman; Etching under Noela Hjorth 1974–75; Freelanced for Oxford University Press and Melbourne University Press, also works by private commission; Currently serving on Vic Children's Book Council.
Exhibitions One-woman show of watercolours, pen and ink drawings at Joan Gough Studio Gallery, Melbourne 1978; Leveson Gallery 1979; Raya Gallery 1982, 83, 84; Cintra House Galleries, Brisbane 1984.
Represented Numerous private and institutional collections in Australia and overseas.
Publications Illustrations for *Life in Australia* and *Early Australians* series, Oxford University Press; *Australian Aboriginal Portraits*, Chas P. Mountford and *Stories of Australia*, Gordon Connell, Melbourne University Press; Covers and illustrations for handbooks and poems, Nelson Stockland Press, Heinemann and Joint Board of Christian Education; Posters and covers designs for Vic Children's Book Council 1977 booklist.

WALKER, Krysten NSW
Born Newcastle NSW 1958. Figurative sculptor in ceramics, bronze, wood, mostly self-taught; Married to painter Graham Cox; Taught for NSW Dept of Education 1979–82.
Exhibitions Pokolbin Gallery, NSW 1974; Cooks Hill Galleries, Newcastle 1977, 1982, 1983, 1984.
Commissions C of E Diocese of Newcastle 1977; University of Newcastle 1978; Christchurch Cathedral, Newcastle 1979; General Assurance Co, Sydney 1981; Amatil, Sydney 1982 and 1983.

WALKER, Linda Marie NSW
Born 1950. Photographic artist.
Exhibitions (with Paul Hewson) First Draft, Sydney 1987; Jam Factory, Adelaide 1988, 89; Artspace, Sydney 1986, 89; Vancouver, Canada 1989; CAC, Adelaide 1989; *Australian Perspecta* 1989, AGNSW.

WALKER, Rebecca Driffield VIC
Born Melb. 1952. Printmaker, painter, teacher.
Studies Swinburne TC 1971–73; Camden Arts Centre, London UK 1974; Melb. State College 1976. Teaches with Vic Ed Dept.
Exhibitions One-woman show at Blackman Graphics, Sydney 1981; Participated MPAC 1981; Ministry for the Arts 1982.
Represented MPAC Vic and private collections in UK, USA and Australia.
Awards MPAC Drawing 1981.
Bibliography *Encyclopedia of Australian Art*, Alan McCulloch 1984.

WALKER, Rona NSW
Born Ipswich Qld. Painter of landscapes, botanical subjects, still-life in oil, acrylic, water-

colour; Portraitist, sculptor and teacher.

Studies Central Technical College, Brisbane; Hobart Technical College under Jack Carington Smith; Impington College, Cambridge UK; Norwich School of Art (sculpture) UK; Canberra Technical College; Worked as graphic artist for three years, and in physics dept, University of Tas on a joint paper for Journal of Botany; Art teacher, Blyth School, Norwich UK, Meridan School, Sydney; Taught at Lauriston Girls School, Melbourne; Also interested in theatre design and production.

Exhibitions Held one-woman shows, Norwich UK; Kings Lynne Festival, UK; Participated at Blaxland Gallery, Sydney, Australian Watercolour Institute; Tas Museum and Art Gallery; Wildlife Artists of Australia; Shoalhaven Art Show, NSW 1983; Presently setting up a studio and teaching adult SEA classes on NSW south coast; Has won a number of art awards in Australia and overseas, and carried out many portrait and sculpture commissions.

WALLACE, Margaret TAS

Born Hobart Tas 1919. Semi-abstract painter in oil, pastel, pen and wash; Portraitist.

Studies Hobart Technical College under Jack Carington Smith; School art teacher 1961–64; Diploma of Fine Art 1960; School art teacher 1961–64; Extensive overseas study tour 1983–84; Presently teaching at her own studio.

Exhibitions Solo show at Foscan Gallery 1975; Participates regularly in Art Society of Tas exhibitions; Her landscape *Farm on the Hill* was purchased by the Tas Museum and Art Gallery 1973.

Represented Tas Museum and Art Gallery, Hobart and private collections in all states.

WALLER, Lorna VIC

Born Auckland NZ 1912. Painter and worker in stained glass. Wife of the late Mervyn Napier Waller.

Studies Slade School of Art, London UK; Elam School of Art, University of Auckland NZ; RMIT with Napier Waller. In 1952 was appointed assistant to Napier Waller for the stained glass windows in the Hall of Memory, Australian War Memorial, Canberra; The job took six years.

Exhibitions One-woman show in Melbourne 1977 and numerous group shows; Has completed several murals and mosaics for public buildings. Retro show at Gryphon Gallery, Melb. 1988.

Represented St Hilda's College, Melbourne; Institutional and private collections.

WALLER, Ruth NSW

Born Sydney NSW 1955. Painter, illustrator.

Studies Alexander Mackie CAE 1974–78, Dip Art.

Exhibitions Solo shows at Watters Gallery 1981, 1982, 1986, 1988; Artspace, Sydney; CAS, Adelaide 1982–83; ACP, Sydney; Wollongong City Gallery 1985; Jam Factory, Adelaide 1986. Participated S.H. Ervin Gallery, Sydney and First Aust Contemporary Art Fair, Melb. 1988.

Awards Artist-in-Residence, Union Media Services 1984; Wollongong City Council Project 1984–85; VAB Grant 1985.

Represented ANG, AGNSW, NGV, Regional Galleries, institutional and private collections.

WALLER, Vicki SA

Born Kent UK 1940. Textile artist and printmaker.

Studies Bromley School of Art, UK 1957; Art & Craft Certificate from Aldgate College, SA 1978–80; BA, SACAE 1987–90. Tapestry Summer School, North Adelaide School of Art 1990; Grad. Dip. Religious Education, University of SA 1991–92. Member, Adelaide Art

Society; Fellow, RSASA.
Exhibitions Solo shows at Clare 1974; Coober Pedy 1977; Strathalbyn 1979; Plympton, Adelaide 1990. Participated in many group shows since 1980 with Adelaide Art Society and RSASA; Christchurch NZ 1990; Seymour College 1990; Greenhill Galleries 1991; Loft Galleries 1991 and 'Personal Visions' RSASA 1991.
Represented Institutional and private collections in UK, Europe, USA, NZ, Australia.

WALTER, Colette NSW
Born Sydney NSW 1949. Graphic artist, designer and painter.
Studies Associate Diploma in Graphic Design from National Art School, Sydney. Worked in commercial art for some years for Rothmans, and freelance. Presently director of Vivian Gallery, Sydney.
Exhibitions Saints Gallery and Vivian Gallery, Sydney.
Represented Institutional and private collections in USA, UK and Australia.

WALTERS, Carol QLD
Born Yorkshire UK 1946. Figurative expressionist painter in oil, acrylic and collage.
Studies University of WA 1964–65; WAIT 1972–73; Associate Diploma of Fine Art from Qld College of Art 1975–77; Postgraduate Diploma of Fine Art from Leeds Polytechnic, UK 1978–79; Taught art Qld TAFE 1981, 1983, Brisbane Art School from 1981 and Community Arts Centre and Griffiths University 1983.
Exhibitions Numerous solo and mixed shows since 1972 and recently solo at Leeds Polytechnic 1979 and Sunnybank Galleries, Brisbane 1980 and mixed at Nerang Galleries 1982, Milburn Galleries 1982 and Brisbane Art School Gallery 1982.
Represented Griffith University Collection and private collections in UK, USA, Papua New Guinea and Australia.

WALTERS, Kath VIC
Born Bendigo, Vic 1958. Printmaker, teacher.
Studies Dip Visual Arts (Printmaking) Canberra S of A 1980. For some years worked as an instructor in an Aboriginal Employment and Training Program in Central Australia.
Exhibitions Numerous shows since 1977 include Bitumen River Gallery, ACT 1983; AGNSW 1985; Warsaw, Poland 1986; George Paton Gallery touring show 1986; Lahti, Finland 1987; ACCA Melb. and 70 Arden St, Melb. 1988.
Commissions PCA 100 x 100 Print Portfolio 1988.
Represented ANG, institutional and private collections in UK, Europe, Australia.
Bibliography *PCA Directory* 1988.

WALTER, Rhondda Maree NSW
Born Sydney 1931. Painter, teacher, musician.
Studies Orban Studio, Sydney 1970–76 and with private tutors; Taught in partnership with Desiderius Orban, Sydney 1976–83; Studied UK, Europe 1984–88.
Exhibitions Solo shows at Roseville Galleries 1982; Burns Koldy Gallery, Newcastle 1987; Holdsworth Galleries 1986, 89; Numerous group shows since 1974.
Represented Institutional and private collections in UK, Europe, Australia.

WALWICZ, Ania VIC
Born Poland 1951. Printmaker.
Studies Graduate Diploma, Vic College of the Arts 1971–75.
Exhibitions Print Council of Australia, Student Printmakers 1972 and Print Prize Exhibition 1973; Geelong and Mornington Prize Exhibitions 1972, 1974; Henri Worland Memorial Prize Exhibition, Warrnambool 1973; *Artists' Artists* Drawings, National Gallery of Vic 1975; Heide Park and Gallery 1985; Mori Gallery 1990.

Awards Elaine Target Drawing Prize 1973; Mornington Print Award (acquisition) 1974; Henri Worland Print Prize (acquisition) 1974.
Represented Warrnambool Art Gallery; Mornington Art Centre, Vic.

WANJIDARI, (Leanne Reid) QLD
Born Woorabinda Mission, west of Rockhampton 1966. Of the Wadja Wadja tribe. Aboriginal painter and printmaker.
Studies Assoc. Dip. of Art, Aboriginal and Torres Strait Islander Cairns College of TAFE 1985–86.
Exhibitions Raintrees Gallery, Cairns 1985; Ben Grady Gallery, Canberra 1986; Upstairs Gallery, Cairns 1987; PCA Travelling Show 1987–88; QAG 1987; Gould Galleries, Melb. 1989.
Represented QAG; BHP and Robert Holmes à Court Collections; Institutional and private collections in Australia and overseas.

WANN, Valma NSW
Born Sydney NSW 1930. Traditional painter, illustrator, portraitist in oil and pastel.
Studies Julian Ashton School, Sydney; Worked as newspaper artist in Sydney for six years, then to UK and Europe for six years as freelance fashion illustrator and painter; Presently working in Sydney.
Represented Institutional and private collections in UK, Europe and Australia.

WANSTALL, Mignon QLD
Born Wallangarra Qld. Genre painter.
Studies East Sydney Tech College.
Exhibitions One-woman show at The Queensland Room Gallery, Brisbane. Her work has been included in a restricted print issue by Boolarong, Brisbane 1983.
Represented Institutional and private collections in Australia and overseas.

WARBURTON, Toni NSW
Born Aust. 1951. Sculptor, ceramic artist.
Exhibitions Solo shows at Mori Gallery 1982, 84; Christine Abrahams 1985; Griffith University 1986; Baroda and New Delhi, India 1988. Numerous group shows include Mori Gallery 1981, 82, 84; Potters Society 1981; Crafts Council 1983; Meat Market Centre 1984; Manly Art Gallery 1985, 87; Griffith University 1985; Holdsworth Galleries 1985; Fremantle Craft Centre 1985; *Australian Perspecta* 1985; AGNSW 1985; Penrith Regional Gallery 1986; ANG 1987, 88; Mori Gallery 1981.
Awards Commonwealth Fellowship to India 1986.
Represented ANG; Institutional and private collections in Australia and overseas.
Bibliography *Art and Australia* Vol. 28, No. 1.

WARD, Billi (Rose-Marie) VIC
Born Norton UK. Painter and teacher.
Studies Sheffield College of Art and Edinburgh College of Art, UK. Completed Building Construction Course at RMIT 1962–65. Professional artist from 1978. Member, VAS.
Exhibitions Solo show at Hope, Sheffield UK. Paints mainly on commission.
Represented Institutional and private collections in UK and Australia.

WARD, Karen Lee VIC
Born Melb. 1952. Paintings and collage.
Studies Prahran CAE 1970–73; VCA 1975–76; Melb. State College 1977.
Exhibitions Solo show at Axiom Gallery 1982; Participated Stuart Gerstman 1979; Niagara 1980; MPAC 1982; Christine Abrahams 1989.

Represented MPAC, institutional and private collections.

WARD, Virginia WA
Born Perth WA 1958. Sculptor.
Studies Claremont College of Fine Art, WA, Dip Fine Arts 1979–81; Curtin Uni, BA Fine Arts 1985–86; VCA, Melb. MA Fine Arts, Sculpture 1989.
Exhibitions Numerous shows since 1981 include AGWA 1981; Alexandria Library, Perth 1984; Praxis Gallery 1985; Galerie Dusseldorf 1986; Camberwell Fine Arts, London UK 1988; The Beach Gallery, Perth 1989; EMR Gallery, Sydney 1989.
Bibliography *Art and Australia* Vol 23/4.

WARE, Silver Ley (Collings) NSW
Born Sydney NSW 1940. Painter, sculptor and teacher.
Studies Diploma in Art (sculpture) from East Sydney Tech College 1960; Worked with Alan Ingham and Douglas Annand 1961; Overseas study tour 1963–66 and 1974; Taught at East Sydney Tech College; Randwick Tech School 1966–74 and Newcastle CAE from 1975 to 1983; Set up new studio with husband, Lawrence Ware at North Epping NSW 1983.
Exhibitions Numerous at Newcastle Society of Sculptors and Ann von Bertouch Galleries.
Awards Mirror-Waratah, Sydney 1963, 1964.
Represented Art Gallery of NSW; Monash Country Club; Manly County Council; Teachers Federation and private collections in Australia and overseas.
Bibliography *Australian Sculptors*, Ken Scarlett, Nelson 1980.

WARNE, Judith VIC
Born Charlton, Vic. 1935. Painter and illustrator in ink; ceramic artist, silversmith; theatrical producer.
Studies B. Applied Art, Warrnambool College of TAFE 1990.
Bibliography *Alice 125*, Gryphon Gallery: University of Melbourne 1990.

WARNER, Melanie NSW
Born NSW. Modern painter, teacher.
Studies Art Certif Course — ESTC 1979, BA Visual Arts 1982, Gradute Dip 1983; Grad Dip Secondary Ed — Sydney IE 1984.
Exhibitions Ivan Dougherty 1981, 82, 83; Wollongong City, Canberra S of A 1982–83; International Biennale, Barcelona, Spain 1985; Painters Gallery, Sydney 1987.
Represented Institutional and private collections in UK, Europe, Australia.

WARREN, Freda (Richardson) QLD
Born Hawthorn Vic. Painter and sculptor; Married to artist, Alan Warren.
Studies National Gallery School, Melbourne and RMIT (sculpture); Member of the Half Dozen Group, Brisbane; Previously exhibited with the Vic Artists Society for some years.
Represented Qld Art Gallery and private collections.

WASON, Coralie QLD
Born Cairns. Batik painter and quiltmaker.
Studies Aboriginal and Torres Strait Islander College of TAFE, Cairns.
Exhibitions Pacific Hotel, Cairns 1989; Rockhampton Community Centre 1989.
Represented Aust Institute of Aboriginal Studies, Canberra.

WATERMAN, Marie (Lynne) WA
Born Nedlands WA 1937. Painter in oil, ink and acrylic, mixed media and pastels.
Studies Mostly self-taught. Attended painting classes under Laurie Knott 1971–73;

Claremont Technical College 1979–80.

Exhibitions Has held one-woman shows at Churchill Gallery, WA 1973; Ric's Gallery, WA 1981; Joint exhibitions at Megalong Gallery, WA 1974; Ric's Gallery, WA 1980; Fine Arts Gallery, WA 1982; Has participated in numerous group exhibitions.

Awards WA Society of Artists prizes 1973 and 1982; Commended Artist of the Year, Mundaring 1973; Commendation Canning Art Award 1973; Bunbury Art Gallery City Art Purchase 1982.

Represented Bunbury City Art Gallery, Beverley Art Gallery and private collections in Australia and overseas.

WATERS, Erica VIC
Born Melb. 1963. Printmaker, sculptor.
Studies BA, Sculpture, RMIT 1984; BA Fine Art, VCA 1986.
Awards Arches-Rives Prize 1980.
Bibliography *PCA Directory* 1988.

WATKINS, Julie VIC
Born Melbourne Vic 1949. Realist painter in oil and acrylic.
Exhibitions Solo shows at Stuart Gerstman Galleries, Melbourne 1976, 1977; Participated in group show, Rudy Komon Galleries, Sydney 1970; Flotta Lauro Prize 1972; Corio Prize 1973; *Supernatural Natural Image* 1974; Stuart Gerstman 1976; Macquarie Galleries, Canberra 1976.
Represented Private collections in NSW, Vic and ACT.

WATSON, Jenny VIC
Born Melbourne 1951. Realist painter, oil, acrylic and pencil.
Studies Diploma of Painting, National Gallery Art School 1972; Diploma of Education, State College of Vic, Melbourne 1973. Study tours UK, Europe, USA 1975–76, 78, 79, 80, 82, 84, 87, 88, 89; Europe, India 1985–86; Japan 1989. Taught part-time VCA 1988–89.
Exhibitions Chapman Powell Street Gallery, Melbourne 1973; Powell Street Gallery 1974, 1975, 1977, 1978; Abraxas Gallery, Canberra 1975; Ray Hughes Gallery, Brisbane 1975, 1980; Institute of Modern Art, Brisbane 1980; Axiom Gallery, Melbourne 1980; Art Projects, Melbourne 1981, 82, 83, 84; Roslyn Oxley9 Gallery, Sydney 1983, 85, 86, 87, 88, 89; Uni of Melb. Gallery 1985; Christine Abrahams Gallery, Melb. 1986, 87; United Artists Gallery, Melb. 1987; Roz MacAllan Gallery, Brisbane 1987; Tolarno Galleries, Melb. 1988; City Gallery, Melb. 1988. Participated in many important group shows 1973–83 including *Aust Perspecta* '81 and Biennale of Sydney 1982 and in recent years at AGWA 1984; Fifth Biennale of Sydney, AGNSW 1984; ACCA, Melb.; Artspace, Sydney 1985; Venice, Italy 1985; 3rd Internationale Triennale der Zaichnung, Nurnberg 1985; Sixth Triennale — India, Delhi 1986; Heide Park, Melb. 1986, 87; Roz MacAllan Gallery, Brisbane; Roslyn Oxley9 Gallery, Sydney 1987; NGV 1987; *Aust Bicentennial Perspecta*, AGNSW 1987; VCA Gallery 1988; Retro 1968–88, Roslyn Oxley9 Gallery 1988; *Ten by Ten*, 200 Gertrude St Gallery 1988; *Edge to Edge*, Japan 1988; Venice Biennale 1991.
Awards Shared Georges Invitation Art Prize 1975; Overseas travel grant from Visual Arts Board 1975; Larger Painting Project, City Square, Melbourne 1975; Alliance Francaise Art Fellowship to Paris 1979; VAB Grants 1979, 1981; Overseas study 1975–76, 1978, 1979, 1980, 1982; Gold Medal, Indian Triennale, Delhi 1986; Newcastle Art Prize (joint winner with Mike Parr) 1987; Portia Geach Portrait Prize 1990.
Commissions Bicentennial Art Poster, and included in Bicentennial Print Folio.
Represented ANG; NGV; AGNSW; Regional Galleries; Institutional and private collections in UK, Europe, USA and Australia.
Bibliography *Catalogue of The Australian Bicentennial Perspecta*, AGNSW 1987; *Art and Australia* 28/3; *Alice 125*, Gryphon Gallery: University of Melbourne 1990; *Artists &*

Galleries of Australia, Max Germaine: Craftsman House 1990.

WATSON, Judy QLD
Born Mundubbera, Qld 1959. Aboriginal painter and printmaker.
Studies Darling Downs IAE 1977–79; BA Fine Arts, Uni of Tas 1980–82; Grad Dip Gippsland IAE 1986.
Exhibitions Solo at Gippsland IAE 1986; Aboriginal Artists Gallery, Sydney 1988; aGoG Gallery, Canberra 1991. Participated Perc Tucker Reg. Gallery 1983, 84, 85; Fremantle Reg. Gallery 1987; New York 1987; CAS, Adelaide 1988; Centre Gallery, Gold Coast 1988; *Australian Perspecta* — Artspace Gallery, Sydney 1989; Griffith Uni 1989; Moët & Chandon Touring Exhibition 1990; Deutscher Brunswick St. Gallery 1991.
Awards Warana 1978; Gold Coast 1980; Pacific Festival 1982; SGIO Purchase 1985; Mackay, Qld 1987; QAG, William Buttner Scholarship 1987.
Represented Institutional and private collections.
Bibliography *A Homage to Women Artists in Queensland Past and Present*, The Centre Gallery 1988.

WATTS, Kay (Millikan) ACT
Born Melbourne Vic 1946. Painter and teacher.
Studies National Gallery Art School, Melbourne; Worked and exhibited in California USA 1973–76.
Exhibitions Adelaide Festival of Arts 1979; Gallery Art Naive, Melbourne 1983.
Represented Private collections in USA and Australia.

WATTS, Maureen VIC
Born Melb. 1952. Potter.
Studies Uni of Melb.; Ballarat CAE.
Exhibitions Station Gallery, Daylesford, Vic 1982–83; Ballarat Reg. Gallery 1984.

WEBB, Hilda Namoi NSW
Born Sydney NSW 1901. Ceramic artist.
Studies MLC Sydney and ceramic course at St George, Kogarah Technical College, Sydney; Member, Potters Society of Australia and Kabin Potters Group.
Exhibitions Many shows with Potters Society of Australia, St George Potters Group, Kabin Potters Group, Sydney.
Awards Royal Easter Show, Two First Awards in 1965 and the same in 1969.

WEBB, Lovoni NSW
Born Sydney NSW. Painter, teacher.
Studies Part-time classes at Sydney Technical College 1946–48 and Newcastle Technical College 1950–52; Study tour to UK and Europe 1953; Studied drawing and painting under John Passmore and Paul Beadle at Newcastle Technical College 1954–55; Full-time study, National Art School, East Sydney 1956–59; Diploma (painting) 1959; Studied, Sydney Teachers College 1960 and etching classes 1969–72; Taught art at NSW secondary schools for NSW Dept of Education since 1961; Study tour, Europe and USA 1971, 73, 79–80; Postgraduate Diploma — City Art Institute 1984; Retired from teaching 1980.
Exhibitions Solo shows at Macquarie Galleries 1973 and recently at von Bertouch Galleries, Newcastle 1987.
Represented Institutional and private collections in Australia and overseas.

WEBB, Philippa QLD
Born Qld. Naive artist.
Exhibitions Baguette Gallery, Brisbane 1987; Naughton Studio Sydney 1988; Rainsford

Gallery, Sydney 1988, 89; World Expo, Qld 1988; Bridge St. Gallery 1990; The Blue Marble Gallery, Buderim 1990.
Awards Nat. Trust 1984; Aberdare 1984; Aust Bicentennial Art Commission 1987.
Represented Institutional and private collections in UK, Europe, USA, Canada and Australia.

WEBBER, Diana NSW
Figurative sculptor in glass and bronze.
Exhibitions Joint show 1981 and solo show 1982 at East End Art, Sydney and solo show at Bloomfield Galleries, Sydney 1985.

WEBSTER, Joan QLD
Born Qld. Ceramic artist.
Studies Diploma in Studio Ceramics, Coorparoo Technical College, Qld 1974–77.
Award Won Warana Caltex prize (ceramics) 1973.
Represented Stanthorpe Art Gallery, Qld.

WEEDON, Lani QLD
Born Qld 1958. Painter.
Studies Darling Downs IAE 1975–78; Tas S of A 1979–80; Flinders Uni Adelaide 1981–82; Awarded occupancy of Owen Tooth Memorial Studio, Vence, France 1985; Artist-in-Residence Darwin IT 1987.
Exhibitions Solo shows at CAS, Adelaide 1983; Museums and Art Galleries of NT, Darwin 1987; Participated in *A New Generation 1983–88* at ANG, Canberra 1988.

WEEKS, Judy VIC
Born Melb. 1941. Painter.
Studies Wollongong TC — Art certificate 1980, Associate Diploma 1985.
Exhibitions Holdsworth Contemporary Gallery 1986, 88; Coventry Gallery, Sydney 1984; Group shows at Coventry 1984; Art Arena 1984 and Wollongong City Gallery 1985, 88.
Awards Cordeaux Heights, Wollongong 150th Art Comp and the A.H. & I. Society Prize.
Represented Institutional and private collections in Aust and overseas.

WEEKS, Marie A VIC
Born Melbourne Vic 1943. Realist painter, studied with Lance McNeill. Vice-president of the Australian Guild of Realist Artists; Member of VAS.
Exhibitions Ordon Gallery, North Ringwood 1974, 1975; Malvern Fine Art Gallery 1976, 1978; Artists Showcase, Vic 1981; Five Ways Galleries, Kalorama, Vic 1986, 88, 90.
Awards Bright 1978; Ringwood Rotary 1978; Essendon Rotary 1979; Korumburra 1980; Mordialloc Rotary 1982; Alexandra Rotary 1983; Bayswater Rotary 1985; Monbulk Rotary 1985; Mornington Rotary 1987; St. Albans Rotary 1987; Mt. View-Glen Waverley 1989.
Represented Institutional and private collections in Australia and overseas.

WEGE, Jane QLD
Born South Africa 1940, arrived Aust 1971. Painter and teacher.
Studies Durban TC 1957; Uni of Pietermaritzburg 1958; Dip Fine Art, Qld C of A 1973–75; Dip Art Ed Newcastle CAE; Lecturer Qld C of A 1987–.
Exhibitions Solo shows in South Africa and at Martin Gallery, Townsville 1985; Contemporary Art Space, Brisbane 1986; Participated at Perc Tucker Reg Gallery 1984, 85.
Represented Artbank, Regional Galleries, Institutional and private collections.
Bibliography *Tropical Visions*, John Millington, UQP 1987.

WEINBERG, Aileen VIC
Born Mildura Vic. Painter and portraitist.

Studies National Gallery School, Melbourne under Sir William Dargie and six years under Leslie Sinclair at Montsalvat. Diploma in Arts in Fine Art from Bendigo CAE 1977; Diploma in Education from Hawthorn State College 1978. Council member of VAS 1973–79; Exhibiting member of Melbourne Society of Women Painters and Sculptors; Animation artist with CSIRO 1960–74; Currently teaching with Vic Dept of Education.
Represented Collection of VAS and private collections in UK, Europe, USA and Australia.

WEINBERG, Lilian NSW
Born Melbourne Vic. Tapestries, wallhangings and paintings.
Studies Graduated with Diploma of Textile Design and Certificates in Art and Interior Design, RMIT; Worked as a fabric designer in London for two years; Further developed her interest in fabric art in Italy and returned to Sydney to consult in large textile production plant.
Exhibitions Solo shows including oil paintings at Holdsworth Galleries, Sydney 1977, 1979, 1985; Hawthorn City Art Gallery, Melbourne 1978 and Craftscentre, Melbourne 1978.
Represented Private collections in Australia, Tel Aviv, London and New York.
Bibliography 'Expose of Australian Women in the Arts', Australian Arts Council, *Craft* magazine, Vol 2, 1978.

WEINFELD, Sonya VIC
Born Poland. Painter and sculptor.
Studies Degree in Fine Art from Academy of Art, Cracow and in Paris 1947–48.
Exhibitions Numerous shows overseas and Ben Uri Galleries, Melbourne 1964; Flamingo Galleries, Melbourne 1980.
Represented Private collections in UK, Europe, USA, Israel and Australia.

WEISS, Johanna VIC
Born Melb. 1959. Printmaker.
Studies B. Ed., Melb. State College 1977–81.
Exhibitions Rhumbarallas, Melb. 1985; Excelsior Gallery, Sydney 1985; Gryphon Gallery 1983 group shows.
Represented QVMAG; Tamworth Reg. Gallery, institutional and private collections.
Bibliography *150 Victorian Women Artists*, VAB 1985.

WEISS, Rosemary VIC
Born Melb. 1958. Printmaker, painter, designer, teacher.
Studies Melb. State College, 1977–79, 81–82. Has taught art at High Schools and Pentridge Prison, Melb. in recent years; Presently teaching drawing at Melb. CAE.
Exhibitions Solo shows at Reconnaissance Gallery 1986; 13 Verity St Gallery 1989; Many group shows since 1982 include Heide Park and Gallery 1987; Gryphon Gallery 1983, 87; Chameleon Gallery, Hobart 1987; Warrnambool and Horsham Reg. Galleries 1988; *A New Generation 1983–88*, ANG, Canberra 1988; 70 Arden St Melb. 1988.
Commissions Mitchelton Label 1983; PCA Member Print 1984; 100 x 100 PCA Print Portfolio 1988.
Represented ANG, NGV, Artbank, Regional Galleries, institutional collections in Japan and Australia.
Bibliography *150 Victorian Women Artists*, VAB 1985; *PCA Directory* 1988.

WEISZMANN, Cathy NSW
Born Sydney 1967. Sculptor.
Studies ESTC 1985–90.
Exhibitions Robin Gibson Gallery 1990, 91; 10 Taylor St. Gallery 1990, 91; ESTC Staff

Exhibition 1991.
Commissions Two bronzes for Holdsworthy Army Base 1990.

WENDE, Esther WA
Born Kenya East Africa 1947, arrived in Australia in 1961. Painter and printmaker.
Studies Perth Technical College, WA 1961.
Exhibitions Acquisition show at Geelong Art Gallery, Vic 1974; Print Council of Australia Student Printmakers 1975; Printmakers Association of WA, exhibitions 1974, 1975; Fremantle Arts Centre Print Award Show, WA 1976; Print was acquired for City of Fremantle Collection; Westminster Gallery, SA 1979.
Bibliography *Directory of Australian Printmakers* 1976.

WENZEL, Valerie VIC
Born Adelaide 1940. Painter, illustrator of animals and still life.
Studies Trained as a Medical Research Assistant and Illustrator at Adelaide Uni Medical School.
Exhibitions Solo shows at Libby Edwards Gallery, Melb. 1983, 86, 89.
Represented Institutional and private collections around Australia.

WEST, Frances NSW
Born Orange NSW 1927. Self-taught potter. Member of Potters Society since 1972.
Exhibitions Craft Expo 1981, Sydney.

WHITE, Bernice NSW
Born Portland, Vic. 1954. Photographer.
Studies Since completing her B. Applied Science degree has been working on techniques for the colourizing of black and white photographs.
Bibliography *Alice 125*, Gryphon Gallery: University of Melbourne 1990.

WHITE, Fiona VIC
Born Melb. 1964. Painter.
Studies Prahran TAFE, Melb. 1982.
Exhibitions Solo shows at Reconnaissance Gallery, Melb. 1987, 88. Included in *A New Generation 1982–88* at ANG, Canberra 1988.

WHITE, Judith NSW
Born NSW. Painter, graphic designer, teacher.
Studies BA, University of New England and Sydney University; Nat Art School, Sydney. Founded her own art school at Narrabeen 1978; President, Peninsula Art Society 1985–86; Member AWI; Teaches at Mitchell College, Bathurst Summer and Winter Schools.
Exhibitions Solo shows at Boronia and Gallery 460 1988; Bridge St Gallery 1989.
Awards John Oxley 1980; Dubbo 1981; Southern Tablelands 1981; Calleen 1983; Mosman 1983; Campbelltown WC 1984; Wyong 1984; Margaret Fesq Memorial 1984; Manly Daily 1986; Woollahra Bicentennial 1988.

WHITE, Lorraine VIC
Born Melb. 1935. Painter.
Studies Nat Gallery School, Dip Fine Arts; Lecturer RMIT.
Exhibitions Many shows since 1965 including Toorak Gallery 1972–75; Bartoni Gallery 1977; Fremantle Arts Centre 1977; Warehouse Galleries 1979; Holdsworth Galleries, Sydney 1981.

WHITE, Sheila NSW
Born UK 1927, arrived Aust 1968. Painter; Fellow, RAS of NSW 1988.

Studies John Ogburn Studio, privately with Desiderius Orban and Henry Justelius, and at RAS of NSW.
Exhibitions Solo show at Q Gallery, Hunters Hill NSW 1985 and numerous group shows.
Represented Municipal and private collections in Australia and overseas.

WHITE, Susan Dorothea NSW
Born Adelaide SA 1941. Figurative painter and printmaker. Works mainly in polymer painting on wood, watercolour painting, drawing and lithography. Also in collage, sculpture, etching and woodcut.
Studies Diploma course SA School of Art 1959–60; Julian Ashton Art School, Sydney and East Sydney Technical College 1960–61; Workshop Art Centre 1972, 1975; Red Cedar Workshop, Sydney 1985, 87; Sculpture Centre, Sydney 1987–88. Established auto-lithographic workshop in 1975; Introduced lithography to Annandale Public School, honorary art teacher (P/T) 1978; Worked, studied in Europe 1979, 1980; Teaches weekly community classes in drawing and watercolour, Glebe Neighbourhood Centre, Sydney 1982–84; Annandale Centre 1985; Strathfield Evening College 1987–; Member of International Association of Art, International Graphic Art Foundation, Print Council of Australia, Sculptors Society.
Exhibitions One-woman shows, Broken Hill Technical College, NSW 1962; Adelaide Festival, Sydenham Gallery 1972; University of Sydney Seymour Centre (coninituous exhibition of new works) 1977–80; Blackfriars Gallery, Sydney 1978; Die Galerie Arndt, Munich 1980; NSW Women and Arts Festival, Open Studio, Sydney 1982; Goethe Institute, Sydney 1983; Balmain Art Gallery 1986; Since 1957 has participated in many group shows around Australia and since 1980 has represented Australia in over thirty biennales and exhibitions in Yugoslavia, Korea, Japan, Spain, Brazil, Italy, Taiwan, W. Germany, Hungary, Poland, Canada and France and in 1990 at Galerie Art & Architecture, Amsterdam, Holland, and in 1991 at the Galerie am Buttermarkt, Holland.
Awards Scholarship, SA School of Art; Rowney Painting Prize, SA School of Art 1959; Sands and McDougall Drawing Prize, SA School of Art 1959; Prizes and Awards in Broken Hill exhibitions 1958, 60, 61, 62; John Gero Painting Prize, Macquarie University 1975; MPAC Print Purchase 1978; Various awards, local council exhibitions, Sydney 1974–77.
Represented ANG, Canberra; Mornington Peninsula Arts Centre, Vic; Westmead Centre, NSW; Schwedisches Institut, Munich; Goethe Institut, Munich; Majdanek Museum, Gallery of Modern Art, Poland; Fiatal Muveszek Klubja Gallery, Budapest; Private collections in Australia, NZ, UK, W. Germany.
Bibliography *Directory of Australian Printmakers*, 1988; *Australian Watercolour Painters 1780–1980*, J. Campbell, Rigbys, Sydney 1983; *Artists & Galleries of Australia*, Max Germaine: Craftsman House 1990.

WHITEHEAD, Cate (Glover) VIC
Born Stawell Vic. 1955. Painter and sculptor.
Studies B. Fine Arts (Sculpture) Ballarat CAE 1986–88. Member CAS and WAR.
Exhibitions Solo shows at N.1 Treasury Place, Melbourne 1990; Ararat Regional Gallery 1991. Numerous group shows since 1980.
Awards Ararat Rotary 1990.
Represented Institutional and private collections.

WHITEHEAD, Rhonda OVERSEAS
Born Sydney NSW 1945. Painter, sculptor and teacher.
Studies Byam Shaw Art School 1966–68; Master of Arts in Fine Art from Royal College of Art, London 1968–71; Hornsey College of Art, London 1971–72; Since 1968 has taken an interest in Kinetic art with her husband, architect David Whitehead.
Exhibitions *The Kinetics Show*, Utrecht, Holland 1974 (with husband).

Represented Art Museum, Ostend, Belgium and institutional collections in UK, Europe and USA.
Bibliography *Australian Sculptors*, Ken Scarlett, Nelson 1980.

WHITEHEAD-GRIFFITHS, Dorothy VIC
Born Melbourne Vic. Painter and teacher.
Studies Under Harold Herbert, John Rowell, Max Meldrum and A.D. Colquhoun; Art teacher with Vic Education Dept for ten years; Married to artist Harley Cameron Griffiths; Member of VAS and hon secretary of the Twenty Melbourne Painters' Society for nine years; Overseas study tours with her husband 1950, 1955, 1968.
Exhibitions One-woman show at Athenaeum, Georges and Kozminsky Galleries, Melbourne.
Represented Widely in institutional and private galleries in Australia and overseas.

WHITEHURST, Bess VIC
Born Albert Park Vic 1916. Flower painter in watercolour and oil.
Studies National Gallery School, Melbourne under Wes Penberthy, Alan Martin and privately with Mrs R.W. Sturgess; Member of Vic Artists Society, and GAMA, Geelong.
Exhibitions City, Country, Private and Regional Galleries.
Awards Werribee and Royal Agricultural Show, 1973; Keilor Heights, Geelong, Eisteddfod Vic 1974.
Represented Balmoral and Corio Galleries, Geelong Vic.

WHITFORD, Wendy VIC
Born Ballarat, Vic 1942. Printmaker.
Studies Dip Fine Art, Ballarat CAE.
Exhibitions PCA Mini Prints, Aichi, Japan 1984; Melb. and Ballarat 1985–86.
Bibliography *PCA Directory* 1988.

WHITING, Lorraine ITALY
Born Melbourne Vic 1927. Painter and sculptor.
Studies RMIT 1945.
Exhibitions Melbourne 1951 (sculpture); Since 1955 has exhibited paintings and collage in Europe and USA; Sometimes signs work 'Lorri'.
Represented National Gallery of Vic; CAS London; Philadelphia Art Museum, USA; Menagor Museum, Topaco Texas and private collections.
Bibliography *Australian Sculptors*, Ken Scarlett, Nelson 1980.

WHITLOCK, Judy R. NSW
Born Sydney NSW 1948. Landscape painter in watercolour; Also pen/ink plant studies.
Studies Fort Street Girls High School, National Art School; Later working in the fields of pottery, screen printing and photography; Travelled extensively through the Outback and Central Australia collecting material; Commenced work in 1982 on the first book of a projected series relating to these trips.
Exhibitions One-woman shows at the Darghan Street Gallery, Gallery 680, and Hunters Hill Gallery, Sydney 1980; St Georges Terrace Gallery, Parramatta 1981, 1982; Pokolbin Gallery, Hunter Valley 1982; Balmain Art Gallery 1984; Canberra Studio Gallery 1985. Joint shows with son, Gene, at Westpac 1986; with mother Mary Lett and son Gene at Westpac 1987 and joint shows at Golden Helmet Gallery and Murulla Gallery 1989.
Represented Institutional and private collections in UK, Europe, USA, Australia.

WHITTAM, Sheila SA
Born Burnley UK 1944, arrived Australia 1965. Painter in oil, acrylic, pastel, gouache and

ink; Theatre set designer.

Studies SA School of Art, and under John Olsen, Ronald Miller and Jo Caddy while attending University courses at Goolwa WA; Currently teaching painting and drawing to two adult classes for the Riverland Community College (SA) — one of which is at the Cadel Prison Farm.

Exhibitions First exhibition *Mother and Child* series in gouache, held at The Wiregrass Gallery in 1978; Exhibition with three other artists in 1979 at the Royal SA Society of Arts; 1981 solo exhibition at Jolly Frog Gallery, Adelaide and again in 1983; Participant, by invitation, in special exhibition at the McClelland Regional Gallery, Langwarrin (Vic) entitled *The Gentle Art*, an exhibition of watercolours by women painters; 1982 exhibition of watercolours and gouache *Call to Love* series at The Wiregrass Gallery; Participant by invitation in DVA Awards 1982.

Awards The Barmera Easter Prize (SA) in 1977; Twice won the Merbein Art Prize (SA) 1978, 1982.

Represented La Trobe University Collection; Royal Melbourne Children's Hospital; Eltham College; Royal Adelaide Children's Hospital; Waikerie Hospital, SA; Commonwealth Artbank Collection.

WIENHOLT, Anne USA
Born Leura NSW 1920. Painter and sculptor.

Studies ESTC 1938–41; Art Students League, New York 1945; Brooklyn Museum of Fine Art and Atelier 17 1947–48; Graphics under Stanley William Hayter 1948–50; Married to furniture designer Masato Takashige; Presently working and living in the USA.

Exhibitions Periodical shows in Australia and overseas and recently at David Jones' Gallery, Sydney 1989; Greenhill Galleries, Adelaide 1990. Numerous group shows include California 1980, 83, 84; ANG, Canberra 1985; S.H. Ervin Gallery 1988; AGNSW 1990; San Rafael, USA 1990.

Awards NSW Travelling Art Scholarship 1944.

Represented ANG; AGNSW; Institutional and private collections in USA and Australia.

WIGHT, Normana QLD
Born Melbourne Vic 1936. Painter and printmaker.

Studies Diploma (painting) RMIT; Fellowship (printmaking), Central School of Arts and Crafts, London 1962–63; Short course in Renaissance art history, Florence University; Began printmaking in Sydney in 1964; Overseas study tour 1978; Lectured at third National Conference of Print Workshops of UK and Eire, Edinburgh 1980; Lecturer in printmaking at Darling Downs IAE, Toowoomba Qld.

Exhibitions Solo shows since 1966 include Pinacotheca, Melbourne 1968; Central Street Gallery 1968; Crossley 1970; Art Gallery of SA with Peter Rosman 1978; Curwen Gallery, London 1980; Darling Downs IAE Gallery 1982; Participated in PCA exhibitions since 1967; Print Prize Show 1968, 1969 in all State Galleries and Singapore 1969; *Images*, India 1972; *Screenprint Sofa*, commissioned for PCA member print edition in 1975; Won Gold Coast Purchase Prize 1982; Included in Contemporary Australian Printmakers I and II to UK and USA 1979–84; Powell St Graphics 1985; Grahame Galleries, Brisbane 1988.

Represented State Galleries of SA and Qld; Regional Galleries at Newcastle, Shepparton, Fremantle; Monash University; Private collections in Australia and overseas.

Bibliography *Directory of Australian Printmakers* 1976, 1982, 1988.

WILD, Joanne (Roberts) TAS
Born Melb. 1952. Printmaker, illustrator, teacher.

Studies Perth TC 1973; Dip Fine Art, Tas S of A 1976; Dip. Ed. TSIT 1977–81; Has taught art since 1980 and 1990–91 was Printmaking and Drawing teacher at Devonport TC.

Exhibitions Solo shows at Devonport Arts Centre 1984; Burnie Art Gallery 1985;

Cockatoo Gallery, Launceston 1987; Numerous group shows since 1978 include Bowerbank Mill 1981; The Design Centre 1983–84; MPAC 1987; Oculos Gallery, Melbourne 1988; Cockatoo Gallery 1990; Devonport Art Gallery 1990.
Awards Commonwealth Scholarship, Perth WA 1968; Circular Head Print Prize 1985; PCA Print Portfolio 1988; Silver Pica Book Cover Award (Japan) 1988.
Bibliography *PCA Directory* 1988.

WILDMAN, Narelle NSW
Born Sydney NSW 1946. Naive painter in oil.
Studies East Sydney Technical College 1962–64.
Exhibitions Solo shows at Hogarth Gallery 1981; Prouds Gallery 1982, 86; Gallery Art Naive, Melb. 1982; Rainsford Gallery 1983, 84; Madison Gallery, Los Angeles, USA 1988. Group shows at Gallery Art Naive 1985, 87, 88, 89; Rainsford Galleries 1985, 87, 88, 89; Naughton Studio of Naive Art 1987, 88, 89; North Shore Gallery 1987, 88, 89, 90; Paris Musée d'Art Naif, France 1990.
Commissions Villeroy & Boch, Luxembourg to paint an Australian series onto China for world release November 83; Commissioned by Channel 9, Sydney to paint 183 x 122 cm painting of Willoughby; Her work was included in *Sydney Harbour in Sunshine and Shadows*, Lindsay Campbell 1983; Commissioned by Michael Parkinson to paint pictures of the Elton John wedding, Sydney 1984; Aided by a VAD overseas grant commissioned to paint the Seven Natural Wonders of the World onto ceramics 1984.
Represented Corporate, institutional and private collections in UK, Europe, USA, Australia.

WILKIE, Sue QLD
Born NZ 1947, arrived Aust 1971. Painter and printmaker.
Studies Elam School of Art, Uni of Auckland 1966–67.
Exhibitions Christy Palmerston Gallery, Port Douglas Qld 1986, 87.
Awards Cairns Caltex 1979; Trinity Bay 1979; Many commissions for private collections and companies 1987–80.

WILLCOX, Scamp WA
Born Dublin Ireland 1921. Weaving, batik and silk collages.
Studies Bath School of Art, UK.
Exhibitions One-woman show at Fremantle Arts Centre, Desborough Gallery, Perth; Bunbury Art Centre and Busselton Art Centre; Various commissions for large department stores.

WILLIAMS, Ann NSW
Born Western Qld 1942. Painter and illustrator.
Studies Worked in publishing, advertising and animation in Australia, UK, Europe and USA until 1969; Painting in Indian Himalayas in early 1970s.
Exhibitions Solo shows at Sydney Galleries; Bonython 1973, 1975; Holdsworth 1979, 1980; Robin Gibson 1982.
Represented Corporate and private collections in UK, Europe, USA and Australia.

WILLIAMS, Caroline VIC
Born Wellington NZ 1945. Modern landscape painter and portraitist.
Exhibitions Tolarno Galleries, Melb. 1987; Commonwealth Institute, London UK 1988; Australian Biennale 1988, AGNSW; *A Horse Show*, Heide Park and Gallery 1988.
Bibliography *Alice 125*, Gryphon Gallery: University of Melbourne 1990.

WILLIAMS, Elizabeth NSW
Born London UK. Painter and printmaker.

Studies Completed her first Art Certificate course majoring in printmaking in 1980 at Hornsby TC. Completed a further three-year course in printmaking at Hornsby College of TAFE in 1989. Has had a long association with the Ku-ring-gai Art Society where she is an exhibiting member.
Exhibitions Gallery D, Albion Park NSW and 77 Glebe Point Road Gallery, Sydney.
Awards Numerous prizes over the years include the Ku-ring-gai Art Society Jubilee Trophy 1990.
Represented Institutional and private collections around Australia and overseas.

WILLIAMS, Hazel Verna QLD
Born Gladstone, Qld. 1909. Naive painter, textile artist, embroiderer.
Studies No formal art training. Mother-in-law of Kay.
Exhibitions Her work appears widely around Queensland and she had a solo show at Boston Gallery, Brisbane 1983.
Represented Many municipal, institutional and private collections around Australia.

WILLIAMS, Kay Breeden QLD
Born Qld 1939; Wildlife artist.
Studies No formal art training; Worked at the Queensland Museum for over 6 years; Lived in Central Australia for thirteen years (mainly under canvas), whilst drawing and painting its creatures; Commissioned by Australia Post to paint a complete series of postage stamps 1978–80, 82, 85. With Stan Breeden as co-author has illustrated and published seven books on Australian wildlife and completed many commissions for book covers, magazines and tourism.
Exhibitions New Central Gallery 1975; Boston Gallery 1983; Sheridan Gallery 1984; Private Studio 1987, 88; The Blue Marble Gallery, Buderim 1990, 91.
Represented Institutional and private collections in UK, Europe, USA, Canada, Japan and Australia.
Bibliography *Artists & Galleries of Australia*, Max Germaine: Craftsman House 1990.

WILLIAMS, Liz NSW
Born Adelaide 1942. Sculptor, ceramist and teacher.
Studies SASA 1972–75; Jam Factory, Adelaide 1978–79; Goldsmiths College, London; Scripps College, Los Angeles; Also completed apprenticeship under Gwyn Hanssen-Pigott in Tasmania. Taught at Darwin IT and presently part-time at SACAE.
Exhibitions Scripps College, Los Angeles 1981; BMG Fine Art, Adelaide 1988.
Represented AGSA; Overseas and Australian institutional and private collections.
Bibliography *New Art Four*: Craftsman House 1990.

WILLIAMS, Mary QLD
Born Brisbane Qld 1957. Painter, printmaker and sculptor.
Studies Diploma of Fine Art from College of Art, Seven Hills 1977.
Exhibitions Solo shows at University of Qld 1978; Boston Gallery 1979, 1981, 1982; Point Danger Gallery, Tweed Heads 1981; Included in Qld CAE Travelling Show to Japan and Canada 1976–77; International Print Biennial, Fredren Germany 1980.
Awards Gold Coast 1978; Townsville 1978, 1980; Cairns 1979, 1980; Recliffe 1980; SGIO 1980; RNA 1981.
Represented Regional Galleries at Dalby, Gold Coast, Caloundra, Macleay, Townsville, Cairns, Mareeba, Biloela, Bathurst, Wollongong, Lismore and numerous institutional and private collections.

WILLIAMS, Robyn NSW
Born NSW. Porcelain painter.

Studies Diploma in Fine Art from Meadowbank Technical College; Porcelain painting under Wanda Hurcombe.
Awards First, second and third prizes at Sydney Royal Easter Show.

WILLIAMS, Wilmotte NSW
Born Sydney NSW 1916. Painter of old buildings, terrace houses and landscapes in oil.
Studies By scholarship to East Sydney Technical College, also studied at Julian Ashton School; Did very little painting for period of ten years while her family were growing up, then did refresher course at WEA with John Santree and night classes with G. Lawrence; Taught art at Long Bay and Parramatta Gaols for some years; Prints of many of her paintings have been made by Legion Press.
Exhibitions First one-woman shows at Sydney, Brisbane, Canberra, Perth; Held joint show at Prouds Gallery, Sydney with Ric Elliot; Her work is shown widely in permanent exhibitions in Prouds Gallery, Sydney and other Sydney, country and interstate galleries; Solo shows at Prouds Gallery 1982, 1983; Qantas Gallery, London 1983.
Awards Ryde 1961; Parramatta 1965; Warialda 1970; Also Castle Hill and Grafton NSW.
Represented National Collection, Canberra; Vincent Price Collection, USA; Commonwealth Bank, London UK; Australian diplomatic and trade commissions offices; Private collections in Australia, UK, Europe, Japan and USA.

WILLIAMSON, Shirley TAS
Born Franklin, Tas 1929. Painter and teacher.
Studies Hobart S of A 1969; TCAE 1972–74; Overseas study 1975; Teaching since 1976.
Exhibitions Solo shows at Rosny College 1979; Uni of Tas 1980; AMP Gallery Hobart 1984. Numerous group shows.
Bibliography *Tasmanian Artists of the 20th Century*, Sue Backhouse 1988.

WILLIS, Anne (Paulding) NSW
Born UK 1937. Painter and teacher.
Studies Manchester College of Art and design 1955–59; Nat Diploma and Diploma of Associateship 1959; Victoria Uni, Manchester Teachers Dip Art 1980; Uni of Alberta, Canada, MFA 1964–66. Has taught in Qld and NSW since 1970 and presently part-time at SCOTA and St George IHE. Study trip to India 1982–83.
Exhibitions Solo shows include Jacox Gallery, Edmonton 1964–66; Stage Door Gallery, Townsville 1970; Gallery Up Top, Rockhampton 1971; Bakehouse Gallery, Mackay 1973; Martin Gallery 1973, 74, 75; Hogarth Gallery, Sydney 1974; Trinity Gallery, Cairns 1974; Natal Uni South Africa 1976; Pavilion Gallery, Bondi 1981; Nepean CAE 1981. Numerous group shows.
Awards Cloncurry 1971, 72, 73; Kern Prize 1972; Innisfail 1972; Townsville 1973; Samuel Allen Prize 1974; Rockhampton 1975; VAB Grant 1975.
Represented Lancashire and Cheshire Education Authorities UK; Uni of Alberta; Institutional and private collections, in UK, Canada, Australia.

WILLIS, Georgina VIC
Born Melb. c. 1968. Painter and sculptor.
Exhibitions Solo show of paintings and sculpture at Cooper Gallery, Sydney 1989.

WILLS, Judith (Connard) VIC
Born Charlton Vic. Realist painter in oil and watercolour.
Studies Under A.D. and Amalie Colquhoun 1947–49; Member of VAS, Twenty Melbourne Painters, and Melbourne Society of Women Painters and Sculptors.
Exhibitions Has held seven one-woman shows at VAS Gallery; Tom Roberts, Kew Gallery; Colonial House Gallery; Heathmont Art Gallery, Melbourne.

Awards Altona Rotary 1979, 1982; Clayton Festival 1979; Sherbrooke Art Society 1980, 1981; Mordialloc 1980, 1981; Ringwood Rotary 1980; Cranbourne Rotary 1982; Mordialloc 1983; Chelsea Rotary 1983; Mt Waverley 1983 (shared).
Represented Institutional and private collections around Australia and overseas.
Bibliography *Encyclopedia of Australian Art*, Alan McCulloch, Hutchinson 1967.

WILLS, Margaret　　　　　　　　　　　　　　　　　　　　　　　　　　NSW
Born SA 1933. Painter, traditional in most media.
Studies SASA and later in the 1970s under private tutors in Sydney. Fellow of RAS of NSW, exhibiting member of Ku-ring-gai Art Society, Foundation Member of Miniature Art Society. Numerous exhibitions over the past ten years, and recently at Canberra Theatre Gallery and St Ives Gallery 1988; Vaughan College, Marsfield NSW 1990.
Represented Boardrooms and private collections in Australia and overseas.

WILSON, Audrey　　　　　　　　　　　　　　　　　　　　　　　　　　　TAS
Born UK 1928. Realist expressionist painter of landscapes and portraits in oil and mixed media.
Studies Diploma of Fine Art, Launceston School of Art 1971; Part-time painting and print-making teacher Launceston School of Art.
Exhibitions One-woman shows at Ledra Palace, Nicosia Cyprus 1963; Charles Wesley Gallery, Launceston 1973; Oakburn College, Launceston (portraits) 1974; Bowerbank Mill Gallery, Deloraine 1975; Design Centre, Launceston 1977, 78, 79, 81, 82, 85; Salamanca Place Gallery, Hobart 1977; Devonport AG 1980; Freeman Gallery, Hobart 1986; Cockatoo Gallery, Launceston 1987. Participated in Tas Artists Show, Tas House, London 1978; Ikeda, Japan 1980; Newcastle NSW 1981; Gillians Gallery, Adelaide 1981; Salamanca Place Gallery 1982; Long Gallery, Hobart 1988. Commissioned to paint portraits of over 60 persons, mostly leading Tasmanians.
Represented QVMAG, Artbank, Private and institutional collections in Australia and overseas.
Bibliography *Tasmanian Artists of the 20th Century*, Sue Backhouse 1988.

WILSON, Carole　　　　　　　　　　　　　　　　　　　　　　　　　　　VIC
Born Canberra 1960. Collage and screenprints.
Exhibitions Visibility Gallery, 1983; RMIT 1983; Meat Market Centre 1984; Bitumen River Gallery, ACT 1985.

WILSON, Heather　　　　　　　　　　　　　　　　　　　　　　　　　　VIC
Born UK 1961. Sculptor, ceramic artist, teacher.
Studies Graduated B. Ed. (Art & Craft) from Melbourne State College. Currently teaches art and craft at secondary level.
Exhibitions Solo show of ceramic mythical beasts and dragons in Melbourne 1989.
Bibliography *Alice 125*, Gryphon Gallery: University of Melbourne 1990.

WILSON, Lynette　　　　　　　　　　　　　　　　　　　　　　　　　　TAS
Born Tas 1932. Painter, teacher.
Studies Launceston TC 1947–48; Hobart S of A 1951–53; Taught with Tas Ed Dept and Adult Ed 1954–69, 80.
Exhibitions TMAG 1973 and with Art Society of Tas and CAS since 1970.
Bibliography *Tasmanian Artists of the 20th Century*, Sue Backhouse 1988.

WILSON, Margaret　　　　　　　　　　　　　　　　　　　　　　　　　NSW
Born Melbourne Vic 1939. Painter, printmaker and teacher.
Studies RMIT 1957–58; Overseas study tours to USA 1966–68, UK, Europe 1972–73;

National Art School and Alexander Mackie CAE 1973–76 — Dip Art; Taught at Workshop Art Centre, Willoughby NSW 1977–.

Exhibitions One-woman shows at Macquarie Galleries, Sydney 1978, 1979, 1980, 1981, 1983, 1986, 1988; Martin Gallery, Townsville 1984; Milburn + Arte, Brisbane 1988. Participated in numerous printmakers, AWI and prize shows since 1975 including Perc Tucker Gallery, Townsville 1984, 85, 87; Cairns Community Arts Centre 1984, 85; Tia Galleries, Toowoomba 1986.

Awards Camden 1976; Gruner Prize, Art Gallery of NSW 1976; Wollongong Purchase Prize 1976; Muswellbrook Purchase Prize 1977; Drummoyne WC 1977; Pacific Arts Festival, Townsville 1984; Finalist, The James Hardie Wildlife Art Prize 1991.

Represented Artbank; New Parliament House, Canberra; Regional Galleries, institutional and private collections in UK, Europe, USA, Australia.

WILSON, Patricia NSW

Born Tamworth NSW 1944. Printmaker. Works mainly in engraving and coloured etchings.

Studies National Art School, East Sydney 1962–66; Etching and Earle Backen 1967–68; Atelier 17, Paris with S.W. Hayter 1969–72; Study tours to UK and Europe 1969–72; New Guinea 1974; California USA 1976; Lecturer, printmaking, Newcastle CAE 1975–86; Currently at Hunter IHE 1988.

Exhibitions One-woman shows at Foyer Le Pont, Paris 1970; Oxley Gallery, Tamworth 1972; von Bertouch Galleries, Newcastle 1976; Susan Gillespie Gallery, Canberra 1978; Participated in group shows with Atelier 17 in New Jersey USA, Frankfurt Germany, Reykjavik Iceland, Pesaro Italy, Perth and Newcastle Australia 1970–72; Represented in the Ninth International Exhibition of Graphic Art, Ljubljana Yugoslavia 1971; Showed with Islington Studio Group, Upper Street Gallery, London 1972; Group show to mark International Women's Year, von Bertouch Galleries 1975; Contemporary Australian Printmakers Travelling Show 1977; Wiregrass Gallery, Vic 1979; Maitland City Gallery, Tynte Gallery, Adelaide 1980 and Lake Macquarie Community Gallery 1981, 1982; Printmakers of NSW to UK 1982; Gallery 62, Newcastle 1982; Warrnambool City Gallery and Qld Art Gallery 1982; Mornington Peninsula Arts Centre 1984; Newcastle Region Art Gallery, 1984; NRAG 1985; Association Trace, Paris, France 1986; Holdsworth Contemporary Art Gallery, Sydney 1987; NCAE Staff Show, Muswellbrook and Tamworth Regional Galleries 1987; Newcastle to Berkeley — Kala Institute, Berkeley California, USA 1987; Prix Trace — Immedia, Paris France 1988; 1st Small Format Triennale Chamalieres France 1988; Mini Print Exhibition, Cadaques, Spain 1988; Lake Macquarie, Muswellbrook and Albury Art Galleries 1988; Staff Show — Hunter IHE 1988.

Awards Print Prize, Tamworth 1972; Visual Arts Board Grant to assist with establishing studio 1973; PCA Print 1977; Maitland Print Prize 1978; Newcastle Art Gallery Print Commission 1980, VAB Grant 1985.

Represented Tamworth City Art Gallery; Newcastle Region Art Gallery; Biblioteque Nationale de Paris; Stanthorpe Art Gallery, Qld; Family Law Courts, Melbourne; Copeland College, Canberra; Qld Art Gallery, Brisbane; Macquarie University Union Collection.

Bibliography *Directory of Australian Printmakers* 1982; *Artists & Galleries of Australia*, Max Germaine: Craftsman House 1990.

WILTSHIRE, Helen QLD

Colourful painter of North Qld subjects, trained as a fashion designer.

Exhibitions Solo show at Holdsworth Contemporary Galleries, Sydney 1988. Participated in Denis McKinley show to Los Angeles 1985 and at Capricorn Gallery, Melbourne 1990.

WINCH, Madeleine NSW

Born Melb. 1950. Painter, printmaker, illustrator.

Studies Nat Art School, Sydney 1965–67, 80; Worked extensively in UK, Europe, Greece with husband John Winch 1978, 84, 86, 87, 89.
Exhibitions Solo shows at Blackfriars Gallery 1978, 81, 82, 85; Prouds 1980, 81, 82, 85; Seasons Gallery 1980, 82, 85, 88; von Bertouch Galleries, Newcastle 1985, 87; Gallery Art Naive 1985. Important group shows include Orange Regional Gallery 1986; Penrith Regional Gallery 1987, 90; Australian Museum of Childhood 1990; State Library of NSW 1990.
Represented Institutional and private collections in UK, Europe, Greece and Australia.
Publications Illustrated the children's book *Edward Wilkins and his friend Gwendoline*, by B. Bolton (Angus & Robertson) which was shortlisted for Junior Book of the Year in 1986; *Come by Chance*, a children's book which she both wrote and illustrated was recently released by Angus & Robertson in late 1988. The original illustrations were exhibited at the Orange Regional Gallery in 1989 and will travel to the other State Galleries within NSW.

WINKLER, Viola NSW
Born Vienna, Austria. Painter, teacher.
Studies Dip. Art, Vienna; Dip. Art, Alexander Mackie SAE; Teaches North Sydney Girls High School.
Exhibitions Solo shows at Beth Hamilton Gallery 1988; Centre Artspace 1988; Holdsworth Galleries 1990; Wycombe Gallery 1989.
Awards First prizes include Hunters Hill 1982 (shared); Drummoyne 1988; Willoughby 1990.

WINTERS, Lynn NSW
Born Aust 1950. Embroiderer, textile artist.
Exhibitions Aust Craftworks, Sydney 1985; Orange Reg. Gallery 1986; Gates Gallery, Sydney 1987; Old Shire Gallery, Dubbo 1988; Breewood Galleries 1988; Seasons Gallery, Sydney 1989.
Bibliography *Craft Arts International* No 14, Summer 1988.

WISHNEY, Dorothy NSW
Born Scotland 1949, arrived Aust 1978. Painter, teacher.
Studies Glasgow School of Art 1967–1971; Jordanhill College, UK 1972; Taught in UK 1973–1977; Painted in USA and NZ.
Exhibitions Solo shows at von Bertouch Galleries, Newcastle 1980, 87; Holdsworth Galleries, Sydney 1982; David Ellis, Melb. 1989; Morpheth Gallery, NSW 1984; Numerous group shows include above galleries and Blackfriars Gallery 1982; Maitland City Gallery 1987; David Ellis, Melb. 1989.
Represented Institutional and private collections in UK, USA, NZ, Australia.

WOJAK, Anna NSW
Born Sydney 1954. Sculptor.
Studies Bankstown TC 1972; Academy of Fine Arts, Krakow, Poland 1976–77; State College of Fine Arts, Gdansk, Poland 1978–83, MA, Fine Arts and Graphic Design 1983.
Exhibitions Several solo shows in Europe since 1978 and Artmet, Sydney 1989. Numerous group shows include Hogarth Galleries 1987; Third Aust Sculpture Triennial, Melb. 1987; Performance Space, Sydney 1988; Roslyn Oxley9, Sydney 1988; Blaxland Gallery 1988.
Represented Institutional and private collections in UK, Europe, Australia.

WOOD, Suzie VIC
Born Hobart Tas, grew up in Melbourne. Painter of portraits and miniatures on porcelain.
Studies Qualified as State Registered Nurse and completed Diploma of Arts course at RMIT; Worked for some time as an illustrator and fashion artist.

Exhibitions One-woman show at Australian Galleries, Melbourne 1984.

WOODCOCK, Rose SA
Born UK 1960, arrived Aust 1963. Painter.
Studies Elizabeth TAFE 1978–79; SASA 1980–84.
Exhibitions Solo show at Adelaide Festival Centre 1985; Participated at ANG, Canberra, *A New Generation 1983–88*, 1988.

WOODFORD, Amanda VIC
Born Vic. Printmaker.
Studies Dip Fine Art, PIT.
Exhibitions York Street Gallery, Melb. 1988.
Bibliography *PCA Directory* 1988.

WOODFORD-GANF, Rosemary VIC
Born Dorset UK 1949. Painter of Australian wildlife.
Studies Daughter of a veterinarian who specialises in wildlife diseases; Her father initially inspired her love of animals; After short period in an art school in UK, she developed her own technique for wildlife painting; She went to live in Queen Elizabeth National Park, Uganda in 1969 where her father was working, and she painted African wildlife and flowers; Left Africa for Europe where she married and continued to paint African wildlife in 1972; Came to Australia via Nairobi in 1974 where she held her second solo show at Tryon Gallery in that city; She is now specialising in Australian wildlife; She held a solo show at Australian Galleries, Melbourne in August 1976.

WOODGER-GRANT, Lyn NSW
Born Sydney NSW 1942. Painter, art teacher and art historian.
Studies Studied at National Art School gaining diploma (ASTC) in 1964; Taught art at same institution from 1965 to 1978; Also tutor with the Arts Council of NSW (Summer and Autumn Schools); In 1970 commenced part-time studies at Sydney University being awarded Bachelor of Arts in 1974, majoring in anthropology and fine arts. In 1974 became resident Art Tutor at the Women's College, Sydney University; Postgraduate research undertaken in the Dept of Fine Arts, Sydney University; Awarded Master of Arts 1982; Painting and sketching tours to New Guinea 1964, Europe 1966 and SE Asia 1968.
Exhibitions One-man shows in Sydney, Strawberry Hill Gallery 1969; Byzantine Gallery 1971; University of Sydney International House (opened by Douglas Dundas) 1972; University of Sydney International House (opened by Prof Bernard Smith) 1973; Macquarie University (Union) 1973; International Gallery Grace Bros Broadway (opened by John Coburn) 1974; Blaxland Gallery 1986; Grace Gallery, Chatswood 1986, 88; South African Embassy 1988; Royal Art Society (shared with H.A. Hanke) 1978 and with AWI.
Awards Mirror Waratah 1964, 1966; Ryde 1965, 1976; Cheltenham 1967; Drummoyne 1967, 1982; Hawkesbury 1968, 1980; Gloucester Bicentenary 1970; Scone 1970, 1971; Roselands 1970 (shared); Castle Hill 1970; Grenfell 1972; Oakhill 1972; Grace Bros Rotary 1974; Cheltenham 1974; Ku-ring-gai 1981.
Represented Private and institutional collections in Australia and abroad including University of Sydney (International House Collection), University of Sydney (Women's College Collection), Macquarie University, Moscow University, University of Glasgow, Lochnaw Castle, Scotland, Legislative Council Papua New Guinea, Campbelltown Municipal Council, Ryde Municipal Council, Castle Hill Municipal Council.
Publications *Alchemical Gold*, Lyn Woodger-Grant 1986.

WOODS, June VIC
Born Vic. Painter, portraitist, teacher.

Studies Malvern Artists' Society and the VAS, also with private tutors.
Exhibitions Solo shows at Malvern Artists Society 1984; VAS 1986; Silver K Fine Art 1988, 90. Teaches at her own school.

WOODS, Maeve NSW
Born Melbourne Vic 1932. Painter, teacher, film maker, innovator.
Studies Attended National Gallery of Vic Art School 1949–51; Was a teacher, mainly with National Art School, Sydney for a number of years; graduated BA (Hons) in Philosophy from University of Sydney 1980; Travelled Italy and Sardinia 1981, and Europe, USA, Iceland 1982.
Exhibitions Barry Stern Galleries, Sydney 1964; 'Woman of Stamina', Watters Gallery, Sydney 1970; 'Butterflies and Other Paintings', Watters Gallery, Sydney 1974; 'Turn of the Square', link show, Art Gallery of SA 1976; 'Big Diamond', Watters Gallery, Sydney 1976; Participated in 'Ocker Funk', Watters Gallery, Sydney; Inaugural exhibition, Gallery Society, Devonport Tas; 'Woman in Art', WA Institute of Technology 1975; 'Ocker Funk' Exhibition touring Vic Regional Galleries 1976, 1977; 'Ocker Funk', Realities, Melbourne 1976; George Crouch Invitation Exhibition, Ballarat Art Gallery, Vic and 'Watters at Pinacotheca', Pincotheca Melbourne 1977; Further solo shows at Watters Gallery, Sydney 1981–82, 83, 85, 87, 89; Participated Differenca Gallery, Lisbon, Living Art Museum, Rejkjavik, Modern Art Galerie, Vienna, Glassel School, Rice University, Houston USA 1982; Modern Art Galerie Vienna 1982; First Aust. Contemporary Art Fair, Melb. 1988; First Draft Gallery, Sydney 1988; Max Watters Collection, Muswellbrook Gallery 1988; MCA, Brisbane 1988.
Represented ANG, AGNSW, institutional and private collections in UK, Europe, Australia.

WOODS, Pauline Nakamarra NT
Born NT. Aboriginal painter in acrylic from the Yuendumu area NW of Alice Springs NT. Chairwoman of the Jukurrpa group.
Exhibitions Anima Gallery, Adelaide 1988.
Awards National Aboriginal Art Award 1988.
Bibliography *Artlink* Autumn/Winter 1990.

WOODWARD, Margaret NSW
Born Sydney NSW. Painter, teacher and sculptor.
Studies National Art School, Sydney 1956–60 with John Passmore and Godfrey Miller; Study tours to Europe 1967, 1972; Indonesia 1977; Canning Stock Route and Lake Disappointment, WA 1977; Lecturer, Fine Arts Institute of Technology, Perth 1972–77; Lectured in Fine Arts at Hornsby College of TAFE; Designer of various course programmes for WAIT Fine Arts' curriculum, including the Extended Studies programme; Member of Committees for the Arts in Perth and in Sydney 1978–85.
Exhibitions One-man shows at John Gild Gallery, Perth 1972; Holdsworth Galleries, Sydney 1975, 1977, 1978, 1979; Greenhill Galleries, Adelaide 1978, 1979, 1981, 1984; Perth 1981, 1984, 1987; Holdsworth Galleries 1980, 83; Barry Stern Galleries, Sydney 1986, 1987, 1989; Brisbane Hilton 1988; Gallery 460, Gosford NSW 1987, 1988, 1989, 1990; Mosman Gallery 1988. Group shows at Desborough, Perth 1973; Art Gallery of WA 1974, 1976; Greenhill Galleries, Adelaide 1977; Art Gallery of SA; Artarmon and Clive Galleries, Sydney; Collector's and Old Fire Station Galleries, Perth; Georges, Melbourne 1979; Philip Bacon, Brisbane 1978; NGV 1979; Uni of NSW 1983, 85; *Mandorla* Perth WA 1985; Cooks Hill Gallery, Newcastle 1985; Gallery 460, Gosford 1986, 88, 89; Barry Stern 1987, 88; Editions Gallery, Melb. 1988, 89; BMG Fine Art, Adelaide 1990.
Awards Robert Le Gay Brereton Prize for Drawing 1959; Hunters Hill 1966; Ashfield 1966; Wynne Prize, Art Gallery of NSW 1971; Portia Geach 1983, 1984; Gosford Prize

1985; Wyong Prize 1986, 87.
Represented AGNSW; Darwin Art Gallery; Institute of Technology, Perth; University of NSW; University of WA and Murdoch University, WA; Private collections in Australia and overseas.
Bibliography *Artists & Galleries of Australia*, Max Germaine: Craftsman House 1990.

WOOLCOCK, Marjorie VIC
Born Melbourne Vic. Painter, sculptor and printmaker.
Studies Privately under George Reynolds; Sculpture under John Davie at RMIT; Under Shore and Bell at George Bell School from 1936–39; Foundation member of Melbourne Contemporary Artists; Member of Melbourne Society of Women Painters and Vic Artists Society.
Exhibitions The Printmakers Exhibition at Important Women Artists Gallery, Melbourne 1977.

WOOLLARD, Margaret Helene VIC
Born Melbourne Vic 1947. Painter of landscapes, seascapes and still-life in oil, watercolour, pastel and ink.
Studies National Gallery School, Melbourne 1963–66 under Ian Armstrong; Overseas study tour 1979; Etching — Prahan Technical College 1979–80; Stained glass with David Wright 1981–82; Drawing with Ming Mackay 1981–82.
Exhibitions Solo shows at Colonial House Gallery, Vic 1976, 1980, 1982; Leveson Gallery 1978; Abercrombie Gallery 1980; Participated at Niagara Galleries 1980; Women's Art travelling show 1981, VAS 1981.
Awards Dandenong Festival, drawing 1965 and oil and watercolour 1973; Burwood City 1974; Kiwanis, Brighton Art Prize 1976; Royal Overseas League, Watercolour 1977; J. Pettit Watercolour Prize 1977 and Royal Overseas League, open oil 1978; Cth Bank 1978; Caltex NSW 1978, 1979, 1980; Frankston 1979; Warrnambool 1980; Ringwood Rotary 1981; Preston Rotary 1981; Numurkah Rotary 1982; Benalla Rotary 1982; Preston Rotary 1982.
Represented Municipal collections at Doncaster, Templestowe, Frankston, Ringwood, Wangaratta, Warrnambool; Bank of Tokyo; Mobil Collection; AMP Collection; Paul Fitzgerald Collection; Private collections in Australia, Italy, Canada and UK.

WOOLLETT, Beverley NSW
Born Cohuna, Vic. 1933. Painter, printmaker, teacher.
Studies National Art School, Melbourne; Seaforth College of TAFE, Sydney; Printmaking at WAC; Also qualified in Melbourne as an occupational therapist; Teaches WC painting at Mosman Evening College. Member, RASNSW, Warringah Print Workshop, Peninsula Art Group.
Exhibitions Barbizon Gallery 1982, 83; Mosman Festival 1987; AWI 1988, 89; RASNSW 1990; Also represented at Beth Hamilton, Seasons and Okamoto Galleries.
Represented Institutional and private collections.

WOOLLEY, Frances S. UK
Born Perth WA 1930. Abstract figurative painter of the Australian landscape.
Studies Perth Technical College; National Gallery School, Melbourne; Slade School, University of London, UK; Painted in Australia 1957–67; Now resides in London with frequent return visits.
Exhibitions London, Melbourne and more recently von Bertouch Galleries, Newcastle, NSW and Holdsworth Galleries, Sydney.
Award National Gallery of Vic Travelling Scholarship 1953.
Represented Private collections in UK, USA and Australia.

WORTELHOCK, Samantha NSW
Born Nairobi, Africa. Naive painter. Arrived Australia 1987.
Exhibitions Solo show at 111 Queens Street, Woollahra Gallery 1990.

WORTH, Georgina NSW
Born Sydney NSW. Painter, weaver and teacher.
Studies D. Orban Studio; East Sydney Technical College — Diploma 1955, studied and
taught art in Canberra and overseas for some years; Since 1970 has taught part-time at many
locations including Kogarah Technical School, Vaucluse Art School, Guild Teachers
College, Meadowbank, Seaforth and East Sydney Technical Colleges, and workshop Art
Centre, Willoughby; Currently teaching part-time at Hornsby and St George College,
Kogarah.
Exhibitions Solo shows at Stables Gallery 1963; Six in country areas 1970–78; Painters
Gallery, Sydney 1983, 85; Chapman Gallery, Canberra 1986, 88.
Awards Waratah 1970; Cheltenham 1971; Campbelltown 1970, 1972, 1975; Drummoyne
1974; Lismore 1977; Camden 1977; Royal Easter Show, Sydney 1977; Dubbo 1977;
Lismore 1977; Camden 1979.
Represented Artbank, Dixson Gallery, Mitchell Library, Sydney; Municipal collections at
Lismore, Dubbo, Camden and Campbelltown and private collections around Australia and
overseas.

WORTH, Margaret G. SA
Born Adelaide. Painter, printmaker, teacher.
Studies Dip. Art, SA School of Art 1963–67; Advanced Studies Certificate, School of Visual
Arts, New York 1969–70; MFA, Columbia University, New York 1970–72; Worked and
studied overseas 1970–72, 77–78, 79–83. Taught SA School of Art 1988–90; Artist-in-
Residence, Canberra School of Art 1990; Consultant and Public Art Co-ordinator for
Airport to Adelaide Gateway Proposal with Land Systems EBC 1991.
Exhibitions Numerous solo shows since 1968 mostly in New York and recently at Art
Zone, Adelaide 1989, 90; Tynte Gallery, Adelaide 1989. Regular group shows since 1966
and latterly at Greenhill Galleries 1986; AGSA 1988; CAE Gallery 1989; Touring show to
Adelaide, Canberra, Sydney, Tweed Heads and Brisbane 1990; Anima Gallery 1990; CAC,
Adelaide 1990; Jan Taylor Gallery, Sydney 1990. Outdoor Sculpture Component,
University of West Sydney, Nepean 1991.
Awards Scholarships, USA 1969–70, 70–71, 71–72; SA Dept. for the Arts 1987, 88, 89;
RMAX Sponsorship 1989; VA/CB Grant 1989.
Represented AGSA, Artbank, institutional and private collections in USA and Australia.
Bibliography *Art & Artists in South Australia*, Nancy Benko 1969.

WRAGG, Pamela VIC
Born Melbourne Vic 1938. Sculptor.
Studies Diploma of Art and Design (sculpture), Prahran College of Advanced Education
1974–76; Postgraduate studies in sculpture at Vic College of the Arts 1977–78; Presently
working in wood and steel; Study tour to Hong Kong, Japan, Taiwan 1975.
Exhibitions Toorak and South Yarra Galleries, Melbourne 1975; Caulfield Arts Centre
1975; Gryphon Gallery, State College 1976; Vic College of the Arts 1977; Mildura
Triennial, La Trobe University and Vic College of the Arts 1978; Second Aust Sculpture
Triennial, NGV 1984; Christine Abrahams Gallery, Melb. 1981, 88.
Represented Private collections in Australia.

WREFORD, Elaine SA
Born Nairobi Kenya 1913 of Australian parents, arrived SA 1923. Semi-traditional painter
in oil, gouache, oil/pastel, ink and gold leaf.

Studies SA School of Fine Arts under F. Millward Grey for four years; Later under David Dridan; Overseas study tour 1976–77; Fellow of Royal SA Society of Artists, served on council for some years.

Exhibitions One-woman shows at Osborne Gallery, Adelaide 1964, 1966, 1969, 1971, 1974; Skinner Galleries, Perth 1965; South Yarra Galleries, Melbourne 1965; New Stanley Gallery, Nairobi Kenya 1968; Hamilton City Gallery, Vic 1971; The Barn Gallery, SA 1975, 1981; Lombard Street Gallery, SA 1978; Avenel Bee Gallery 1979; Greenhill Galleries, Perth 1981; Adelaide 1986; Joint show with Matthew Percival 1983; Particpated in Adelaide Festival of Arts (four times); Tas Art Gallery 1967; Melrose Portrait Shows at Art Gallery of SA (twice).

Represented National Collection, Canberra, Art Gallery of SA; Hamilton City Art Gallery, Vic; Private collections in Australia, NZ, USA, UK.

Bibliography *Art and Artists of SA*, Nancy Benko 1966; *Encyclopedia of Australian Art*, Alan McCulloch 1984.

WRIGHT, Helen TAS

Born Sydney 1956. Printmaker, teacher.

Studies Hobart S of A 1976–79; Alexander Mackie CAE 1981; Enrolled MFA course Hobart 1986; Part-time teacher S of A.

Exhibitions Solo show at Hobart S of A Gallery 1980; Numerous group shows include Ivan Dougherty Gallery, Sydney 1981; NGV 1981; Sydney Uni 1983; Chameleon Gallery, Hobart 1984, 86; Uni of Tas 1986.

Represented ANG, NGV, Institutional and private collections.

Bibliography *Tasmanian Artists of the 20th Century*, Sue Backhouse 1988; *PCA Directory* 1988.

WRIGHT, Judith QLD

Born Brisbane 1945. Paintings and collage; illustrator and teacher.

Studies Eastaus Art School with Mervyn Moriarty 1973–75; Study tour New York; Taught part-time at Eastaus School and Brisbane CAE. Tutor in Art, Brisbane CAE 1986; Lecturer, Queensland University of Technology 1990–91.

Exhibitions Solo shows at Design Art Centre 1977, 79; Solander Gallery, Canberra 1981; Brisbane CAE 1982; Michael Milburn Galleries 1987, 89, 90; 312 Lennox St. Melbourne 1989; Artspace, Sydney 1991. Numerous group shows since 1980 include QAG 1980, 82; Uni Art Museum 1985; The Centre Gallery, Gold Coast 1987, 88; First Aust Contemporary Art Fair, Melb. 1988; *Australian Perspecta* 1989, AGNSW; Qld Uni. of Tech. Gallery 1990; 2nd ACAF, Melbourne 1990; University of Wollongong Gallery 1991.

Awards Gold Coast Prize 1987.

Represented Artbank, institutional and private collections in Australia and overseas.

Bibliography *A Homage to Women Artists in Queensland, Past and Present*, The Centre Gallery 1988.

WRIGHT, Mary-Anne (Thomas) QLD

Born Portsmouth UK 1946. Impressionist landscape painter in most media; Printmaker, portraitist and teacher.

Studies Portsmouth College of Art 1962–64; Diploma in Art and Design (hons) from West of England College of Art, Bristol 1964–67; Taught art in London schools 1968–81; Currently tutor in portraiture at RQAS and with the Yurara Art Group; Councillor of RQAS 1982.

Exhibitions Portrait retrospective at Bourne Hall, Surrey UK 1979; Participated at Marlborough Gallery, London 1967–68 and Ballymore Centenary Show, Brisbane 1982; Commissions include portrait of the Queen Mother for the Royal Marines Sargeants Mess, Eastney UK.

Represented Institutional and private collections in UK and Australia.

WROBEL, Andrea NSW
Born Sydney 1959. Jeweller and designer.
Studies Randwick External East Sydney College 1978–79; Sir John Cass School of Art,
London Polytechnic, UK 1980–82.
Exhibitions Randwick TC 1978–79; Craft Council ACT 1980; Holdsworth Galleries
1979; Woolloomooloo Gallery 1986.

WROBEL, Edwina NSW
Born Sydney 1962. Painter.
Studies East Sydney Technical College, obtained Higher Art Certificate 1981–83.
Exhibitions Solo shows at Woolloomooloo Gallery, Sydney 1985, 86, 88, 89; Participated
at Manly Art Gallery 1985; von Bertouch Galleries, Newcastle 1986.
Represented Newcastle and Wollongong Reg Galleries.

WUBUKWUBUG, Clara NT
Born 1950. A Ganalbingu aboriginal bark painter from Central Arnhem Land.
Exhibitions Bloomfield Galleries, Sydney 1989.
Represented ANG, Canberra.

WURFEL, Anna-Rose VIC
Born East Berlin Germany 1945, arrived Australia 1982. Naive painter, particularly of cats.
Encouraged in her art by fashion designer mother and professional painter father.
Exhibitions Joint show at Gallery Art Naive, Melbourne 1983, 85.

WYATT, Susan Rose WA
Born WA. Painter, illustrator, portraitist.
Studies James Street TC, graphic design 1970–71; Claremont TC, Fine Arts 1974;
Kalgoorlie TC, ceramics 1977. In 1974 worked as a nursing assistant in remote areas near
the Gibson Desert when she became aware of the Aboriginal fringe-dwellers in the area.
Exhibitions Kyana Art Festival; Murals in City of Perth and town of Bevesley.
Awards $25,000 Aboriginal Arts Fellowship to spend a year portraying the lives of fringe-
dwellers 1991.

WYERS, Susan VIC
Born Melbourne 1959. Painter.
Studies Graduated B. Fine Art (Painting) from RMIT.
Exhibitions Solo shows at George Paton Gallery 1987; Realities Gallery 1990.

WYNN, Tomono SA
Born Yotsuya, Japan 1951. Painter and printmaker.
Studies Brush Calligraphy School, Japan from the age of five. Arrived Aust. 1972, BA Fine
Arts, SA School of Art 1975–79; Postgraduate Dip. Ed. at Flinders Uni. Taught art in Japan
1981–83.
Exhibitions CAS, Adelaide 1984; Greenhill Galleries 1986, 89.

WYNN-MOYLAN, Karen NSW
Born NSW 1953. Modern Australian landscape painter, mostly in watercolour; Illustrator
and film maker; Has worked as fashion illustrator and tutor in a film and TV School.
Exhibitions One-woman shows at Stokers Siding, NSW 1980, 1982; Beaver Gallery,
Canberra 1981; Mackay Harrison Gallery, Ballina NSW 1982; Westwal Gallery, Tamworth
1983.
Represented Institutional and private collections.

Y

YAJA, (Jadwiga Hadrys) NSW
Born Poland 1955, arrived Aust 1975. Collage, photographs, textiles.
Studies BA, Visual Communication — SCOTA 1982. Study tours to UK, Europe, India 1987.
Exhibitions Solo shows at Holdsworth Galleries, Sydney 1986; Warsaw, Poland 1981, 87.
Represented Institutional and private collections in UK, Europe, India, Australia.,

YATES, Jill WA
Born Kalgoorlie WA 1956. Painter, printmaker.
Studies WAIT 1977–79.
Exhibitions Solo show at COG Gallery, Sydney 1987; Included in *A New Generation 1983–88* at the ANG, Canberra 1988.

YOUNG, Christine Maree ACT
Born Ryde NSW 1960. Painter.
Studies Art Certificate First Prize from Meadowbank TAFE 1984–85; B. Visual Arts, CAI 1986–88.
Exhibitions Solo show at The Works Gallery 1989; Participated at The Regional Arts Centre, Casula 1990, 91.
Represented Institutional and private collections.

YOUNG, Deborah NSW
Born Griffith NSW 1957. Painter, designer, jeweller, actress.
Studies Designed jewellery 1978–83; Studied SCOTA 1979; Actor and Artist-in-Residence with The Operating Theatre; Higher Art Certificate from the National Art School 1986–88.
Exhibitions Solo show at Access Gallery 1990; Group shows include Australian Council 1986; National Art School 1986, 87; Cell Block 1988; Tin Sheds Gallery 1989.
Awards Record cover painting for the 'Get Real' project.

YOUNG, Jenni Mary ACT
Born Essex UK 1954, arrived Australia 1957. Sculptor and ceramic artist.
Studies Diploma of Sculpture from Canberra Art School 1971–75; Diploma of Education from Canberra CAE 1976; Presently studying for a degree in Aboriginal Studies with SA College, TAFE and majoring in Aboriginal art. Retired from sculpture temporarily in 1978.
Awards ANU Prize Ceramics 1974, Sculpture 1975; Monaroo Water Ski Association Badge; Sculpture float for Lake Burley Griffin (not proceeded with because of lack of finance).

YOUNG, Jenny TAS
Born UK 1941. Painter, portraitist, teacher, formerly Jenny Boam, arrived Tas 1964.
Studies Nottingham College of Art 1958–61; Bradford College of Art 1961–62; Taught art in UK 1962–63, Tas 1964–65, TCAE 1972–77; St Michaels Collegiate School 1978–82.
Exhibitions Solo shows include Salamanca Place Gallery 1970, 80, 83, 84; Saddlers Court, Richmond 1976, 87; Chapman Gallery, Canberra 1979; Devonport Reg Gallery 1982; Numerous group shows since 1964 including TMAG 1970, 71, 75, 76 and several joint shows with Paul Boam.
Bibliography *Tasmanian Painters of the 20th Century*, Sue Backhouse 1988.

YOUNG, June NSW
Painter and teacher.
Studies Linden Art School, Epping NSW part-time 1971–76; Meadowbank TC with Fred
Bates 1978; Taught at Willandra Art Centre, Ryde NSW 1983–85; Overseas study tours
1979, 81, 85, 87, 88, 89; Member RAS of NSW; President of NSW Medical Art Group,
Sydney 1981–82; Vice-President Ryde Municipal Art Society, Epping NSW 1984.
Exhibitions Gallery 460, Gosford 1986–87; Participated AWI show at S.H. Erwin Gallery
1988.
Awards Cooma Caltex 1983; Lend Lease Ryde 1987; Gosford Law Courts Commission
1986.
Represented Municipal and private collections.

YOUNGER, Jay QLD
Born 1960 Qld. Photomontage.
Studies Darling Downs IAE.
Exhibitions Numerous shows since 1979 include Gladstone Reg Gallery 1985; IMA,
Brisbane, Uni of Qld and ACP, Sydney 1986; Michael Milburn, IMA, Qld C of A and
Gertrude St, Melb. 1987; ANG, Canberra, ACCA, Melb. and DDIAE touring show to
China 1988; Centre Gallery, Gold Coast 1988; NGV, QAG, Imagery Gallery, Brisbane,
DDIAE Gallery, and New York 1988.
Represented ANG; QAG; Institutional and private collections in Australia and overseas.
Bibliography *A Homage to Women Artists in Queensland, Past and Present*, The Centre Gallery
1988.

YOUNGER, Jill NSW
Born Sydney. Expressionist painter.
Studies ESTC and in UK, Europe.
Exhibitions Solo shows at Beth Hamilton Galleries, Sydney, participated in travelling show
to China.
Represented Institutional and private collections in UK, Europe, USA and Australia.

Z

ZAHALKA, Anne NSW
Photographer.
Studies Kunstlerhaus Bethanien, Berlin.
Exhibitions ACP, Sydney 1987; Stories of Australia, Commonwealth Institute, London
1988; Camerawork Gallery, London 1988.

ZAKARAUSKAS, Aldona NSW
Born Lithuania 1943. Contemporary painter in oil/ collage and various media.
Studies Associateship, Sydney Technical College, National Art School, East Sydney 1965;
Taught art, secondary schools, Sydney 1966–70; Taught painting, National Art School,
Newcastle 1970–71; Travelled extensively in Europe; Whilst living in UK, studied at
School of Painting, Royal College of Art, London 1971–74; Completed Master of Arts
degree, Royal College of Art; Returned to Australia and resumed teaching at National Art
School, Newcastle 1974; Senior lecturer, dept of Art, Newcastle College of Advanced
Education 1975.
Exhibitions One-woman shows, von Bertouch Galleries, Newcastle 1969, 1971, 1975;

Lidums Gallery, Adelaide 1970; Royal College of Art, London (Degree Show) 1974; Participated in *Four Newcastle Artists*, CAS of SA 1971.

ZANDBERG, Anna
VIC

Born Poland, arrived Australia 1950. Realist painter in oil and watercolour.
Studies Privately under William Frater, Dorothy Baker, Adela Shaw and Brian Gilligan.
Exhibitions One-woman show at Malvern Art Society 1981, also exhibits with VAS and Bezalel Art Society.
Represented Private collections in Australia and overseas.

ZANETTI, Margaret Rintoul
NSW

Born WA. Painter, teacher.
Studies Perth TC under Ivor Hunt; Croydon College of Art, UK; Dip FA — Alexander Mackie CAE, Sydney; BA Fine Arts — Uni of Sydney. Teaches watercolour painting at Hornsby TC.
Exhibitions Solo show at Mosman Gallery 1987; Thackeray Gallery, London UK 1990; Perth Galleries, WA 1991.
Represented Private collections in Australia and overseas.

ZANNELLA, Anna
WA

Born Fremantle WA 1961. Printmaker, photographer, film maker.
Studies B Fine Arts, WAIT 1979–81; Member, founding committee Beach Gallery, Perth 1987.
Exhibitions Beach Gallery 1987, 88; Perth ICA 1989.

ZAPPALA, Ivy
QLD

Born Gordonvale North Qld 1933. Semi-traditional painter and portraitist.
Studies Australia Flying Art School student under Bela Ivanyi and Mervyn Moriarty, also Fred Cress; New England Summer School — Gordon Samstag; Adult Education — Eula Jensen.
Exhibitions Solo shows at Gordonvale Centre 1980, Royal Hotel, Ingham 1986. Numerous group shows.
Awards Mulgrave Shire Council Centenary Award 1976; Tully Open Award 1977; Herberton Shire Council Award 1978 (to hang in Parliament House, Brisbane); Caltex Traditional Award, Innisfail Qld 1978; Atherton Open 1980; Mulgrave Shire 1981; Wide Bay Open 1983; Wide Bay — Maryborough Council 1983; Mareeba Shell 1986; Mulgrave Bicentennial 1988; New York USA 1988.
Represented Municipal, institutional and private collections in UK, Europe, USA, Australia.
Bibliography *Artists & Galleries of Australia*, Max Germaine: Craftsman House 1990.

ZARINS, Dagnija
NSW

Born Latvia 1942. Impressionist painter and teacher.
Studies East Sydney Tech College 1960–63; Diploma of Art (painting) from RMIT 1965. Set up painting and teaching studio in Port Moresby 1966–70; Studied with John Ogburn and at Sydney Tech College to gain teacher's diploma 1972. Presently teaching art.
Exhibitions One-woman shows at Latvian Community Centre, Sydney 1965, 1977, group shows at Orban Studio.
Represented Institutional and private collections in USA, Papua New Guinea and Australia.
Bibliography *Latvian Artists in Australia*, Society of Latvian Artists ALMA 1979.

ZELAZNE, Helen
NSW

Born Sydney; Painter, designer, illustrator, trained in commercial art; Member Ku-ring-gai

Art Society.
Exhibitions Solo shows at Holdsworth Galleries, Sydney 1987, 88; Participated Bnai Brith Centre 1988.
Awards Ku-ring-gai WC Prize 1986.
Represented Corporate, institutional and private collections in Israel and Australia.

ZERBINI, Barbara SA
Born Adelaide SA 1942. Painter and teacher.
Studies Diploma of Fine Art (painting) from SA School of Art 1958–62; Lecturer at SA College of AE 1976–85; Working in Italy 1983; Lecturer in Painting and Drawing (part-time) Hamilton College, TAFE, Newcastle 1988–89.
Exhibitions Solo shows at Lombard Street Gallery, Adelaide 1973; Sydenham Gallery 1975; Bonython Gallery 1979, 1982; Axiom Gallery, Melbourne 1981; Robin Gibson Gallery, Sydney 1982. Numerous group shows since 1963 include Qld Art Gallery 1979; National Gallery of Vic 1980, 1981; Adelaide Festival 1980; BMG, Adelaide 1982, 84, 88; Painters Gallery, Sydney 1985; Anima Gallery 1986; Gladstone Reg. Gallery 1986; Participated recently at Adelaide Festival 1980, 86; AGSA 1988; Centre Gallery, Qld 1988.
Awards VAB Grant 1982; Arts Development 1980, 84, 87.
Represented AGSA, NGV, Artbank, institutional and private collections in UK, Europe, Australia.

ZERNER, Kerry QLD
Born Qld. 1957. Textile artist, printmaker, sculptor, teacher.
Studies Dip. Visual Arts (Textiles) DDIAE. Studio Ceramics at Bundaberg College of TAFE 1984–85; Brisbane C of A 1977. Worked in printmaking studio at DDI 1988; Lecturer in Textiles, DDI, Toowoomba 1989. Studied in UK, Europe 1989–90.
Exhibitions Numerous shows include DDI Gallery 1987, 88, 89; Australian Bicentennial Travelling Exhibition 1988; Toowoomba Regional Art Gallery 1988; McWhirters Artspace 1991.
Awards Australian Wool Corporation and mural for the Toowoomba Turf Club.
Represented Institutional and private collections in Australia and overseas.

ZILLES, Lauretta VIC
Born Ballarat 1960. Photographer.
Studies Ballarat CAE, Dip Fine Arts; PSC, Melb — Dip Illustrative Photography.
Exhibitions Lighthouse Gallery, Melb. 1984; Developed Image, Adelaide 1984.
Bibliography *150 Women Artists*, Visual Arts Board/WAM 1988.